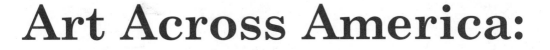

Art Across America:

A Comprehensive Guide
to
American Art Museums and
Exhibition Galleries

Edited by John J. Russell and Thomas S. Spencer

2000

Published by Friar's Lantern, Inc.
P.O. Box 641, 1900 Monkton Road
Monkton, Maryland 21111
Telephone: 410-472-3748 Telecopier: 410-472-3774
E-Mail: flantern@aol.com

Front cover:
Samuel F.B. Morse (1791-1872), *Gallery of the Louvre*, 1831-1833, oil on canvas, 73¾ x 108 inches, Terra Foundation for the Arts, Daniel J. Terra Collection, 1992.151; photograph courtesy of Terra Museum of American Art, Chicago, Illinois.

Spine:
Craig Nutt, *Tomato Table*, 1996, Stained tulip poplar inlaid with bloodwood and curly maple, and black gum with oil-based paint. Museum purchase made possible by Dr. and Mrs. Sidney Yarbrough II & Edward Swift Shorter Bequest Fund. Photograph courtesy of The Columbus Museum, Columbus, Georgia.

Back cover (clockwise from top):
Edward Hopper, *Sunlight on Brownstones*, 1956, oil on canvas. Wichita Art Museum, Roland P. Murdock Collection. Photograph courtesy of Wichita Art Museum, Wichita, Kansas.

William H. Johnson, *Going to Church*, ca. 1940-41, oil on burlap, 38 1/8 x 45½ inches. Gift of the Harmon Foundation, National Museum of American Art. Photograph courtesy of the National Museum of American Art, Smithsonian Institution, Washington, District of Columbia.

Henri Matisse, *Woman in Blue*, 1937, Philadelphia Museum of Art. Photograph courtesy of Philadelphia Museum of Art, Philadelphia, Pennsylvania.

El Greco, *Pieta*, 1575-1577. The Hispanic Society of America. Photograph courtesy of The Hispanic Society of America, New York, New York.

Published by Friar's Lantern, Inc.
P.O. Box 641, 1900 Monkton Road, Monkton, Maryland 21111.

Library of Congress Cataloguing-in-Publication Data
Russell, John J., 1945-, and Spencer, Thomas S., 1946-
Art Across America: A Comprehensive Guide to American
Art Museums and Exhibition Galleries,
1st edition.
Includes index.
ISBN # 0-9667144-1-5
Library of Congress Card Number 00-106757

First Printing, 2000
Printed and manufactured in the U.S.A.
Cover design by Put-It-In-Print
Mapping software licensed from Cartesia Software

Table of Contents

Editors' Introduction

This book is a comprehensive guide to American art museums and non-profit exhibition galleries. It is portable, readable, and useful. Like our first guidebook, *Art on Campus*, it is neither a coffee table art book nor a periodical guide to temporary art exhibitions. It is intended to enable the art lover to plan more productive and enjoyable excursions by providing essential information on institutions and their collections.

It is unique in its scope, focusing on approximately 1,700 venues. No other source contains detailed information on nearly so many institutions. We have sought to be as inclusive as possible, the thought being to permit the reader to make an informed decision about whether to visit a museum, which he can do only after being made aware of its existence and becoming conversant with salient infromation about it. To this end, we have included not only traditional art museums with permanent collections, but also non-commercial galleries (including college facilities) that present only temporary exhibitions. We have also included a number of specialized facilities (e.g. maritime museums, historic houses, ethnic museums, corporate facilities, and others) with what we believe are significant fine arts collections.

Our book is "current" in that it provides complete and accurate basic information about each organization. It also describes the museum's collection and the facility itself, in many instances illustrating one or the other with a photograph. These descriptions and illustrations not only help the reader to place the museum as to type, but also, along with facts about annual attendance, gallery size, membership availability, and other topics, permit the reader to make qualitative and quantitative judgments about it. Of course, the sophisticated museumgoer knows that such a process is not without its dangers; there are hundreds of wonderful small and, sadly, sparsely attended museums in the United States. But how can such places be identified? As a partial answer to this question, we include a list of approximately seventy-five lesser-known but intriguing museums, and invite readers to suggest additions to our list.

A few words about accuracy are in order. First, space limitations have prevented us from setting forth in as much detail as we would have liked certain particulars regarding facilities and operations. For example, a museum listed as accessible to the disabled may be only partly so. Second, some attendance figures may include persons attending related facilities, such as theatres. Third, some institutions listed have not responded fully to our repeated requests for information, perhaps in a few cases resulting in publication of dated or misinterpreted information. Fourth, we have chosen to not include specific information on the scheduling and nature of temporary exhibits in the belief that such transitory information is most reliably gained by contacting the institution directly as close to the time of a proposed visit as possible.

We have made every possible effort to verify the information contained in this book, by sending each facility a questionnaire, making follow-up telephone calls, visiting web sites, and checking a number of secondary sources. Nevertheless, the data in this book can be no more accurate than that which we have received (we hope no less accurate), and therefore, when in doubt, the reader should contact the museum directly. We apologize for any inconvenience caused by errors in this book, whatever the source. We also welcome suggestions from those who use this book regarding institutions that should be added or other changes that would make future editions more useful.

<div align="right">
John J. Russell and Thomas S. Spencer
Monkton, Maryland
August 15, 2000
</div>

How to Use This Book

We have approached questions of design and organization in this book from the point of view of the reader; ease of use and accessibility are our paramount concerns. To that end, we have tried to be consistent in format and to avoid unnecessary and annoying abbreviations as much as possible, even though to do so uses more space on the page.

The main body of the guide is organized alphabetically by state, community, and then organization name. (If there is an initial "The" in an institution's name, it is ignored in determining entry order. "The University of Arizona Museum of Art" falls under U, not T.) Each state listing is preceded by a map, which indicates the communities in which museums/galleries may be found. (Maps for the metropolitan areas of Boston, Los Angeles, New York, Philadelphia, and San Francisco appear after their respective state maps.) The number in parentheses after a community shown on the map indicates the number of facilities listed in this guide in that community; the absence of a number means that there is only one such facility listed. The maps are intended merely to indicate the approximate location of communities with museums or galleries, in order to assist the reader in planning excursions, not to function as detailed roadmaps.

Various types of information occupy the same relative position from entry to entry. Contact information immediately follows the organization name, followed by data on admission fees, attendance, year established, availability of membership, accessibility to the disabled, and parking arrangements.

Next is information on hours of operation. The data following "*Open:*" are the regularly scheduled hours of operation. Following "*Closed:*" are the exceptions to the hours shown in "*Open:*", such as holidays. Please note that if an institution is regularly closed on Mondays, it will be shown as "*Open:* Tuesday to Saturday"; Monday would not appear under "*Closed:*", as its status is understood from the "*Open:*" section.

"*Facilities:*" and "*Activities:*" have been designed to allow the reader to skim the listings for a particular piece of information without having to read the entire text. The categories in bold type are in alphabetical order followed by specific information in parentheses when appropriate. For instance, if one wishes to know which museums in a certain city have libraries, one simply looks under "*Facilities:*" in each entry. One might find, for example, "**Library** (12,000 volumes; non-circulating; Tues-Wed, 11am-1pm)".

This is followed by information on the institution's publications. Finally, there is a more detailed description of the institution, designed to give the reader a "feel" for the facility, its permanent collection, and its exhibitions.

The Index, in addition to the formal name of each institution, includes cross-references to facilitate finding the entries of organizations for which the proper name is unknown. For example, "(The) University of Arizona - Center for Creative Photography" may also be found in the Index under "Arizona, University of - Center for Creative Photography", "Center for Creative Photography - University of Arizona", and its acronym, "CCP".

We encourage users of this guide to contact us with any suggestions for improving the organization and presentation of data in future editions.

Editors' Suggestions

In preparing this guide, we have concluded that there are many museums throughout the United States that are not sufficiently appreciated by the museum-visiting public. This conclusion is based largely on a comparison of the museums' reported attendance and their descriptions of their holdings and facilities provided to us. With respect to some institutions, we know from first-hand experience that they deserve greater attendance. With respect to others, their questionnaires caught our attention, making us want to visit them ourselves. Rather than housing encyclopaedic collections, many of these institutions have a more narrowly defined focus, assembling with a clear eye meaningful and provocative collections and exhibitions. Perhaps some museums are more concerned with the quality of their collections than they are with self-promotion. In other cases, geography no doubt adversely affects attendance. In any event, we present below our list of less-visited (that is, with fewer than 50,000 reported visitors each year) but intriguing institutions and invite our readers to test the wisdom of our choices. We stress that our list is both non-exhaustive and to some extent subjective; all of us (readers and editors) would benefit from your informing us of our more glaring omissions. There certainly will be space (and probably sufficient reason) to make the list larger in future editions.

Arizona
Fleischer Museum (Scottsdale)

California
East Los Angeles College - Vincent Price Gallery (Monterey Park)
The Irvine Museum (Irvine)
Mills College Art Gallery (Oakland)
St. Mary's College - Hearst Art Gallery (Moraga)
UCR/California Museum of Photography (Riverside)
University of California, San Diego - Stuart Collection (La Jolla)

Connecticut
Connecticut College - Lyman Allyn Art Museum (New London)
Florence Griswold Museum (Old Lyme)
Hartford Steam Boiler Inspection & Insurance Co. - Art Collection (Hartford)
Housatonic Community College - Housatonic Museum of Art (Bridgeport)
New Britain Museum of American Art (New Britain)
University of Connecticut - William Benton Museum of Art (Storrs)

Delaware
Sewell C. Biggs Museum of American Art (Dover)

District of Columbia
American University - Watkins Gallery (Washington)
Dumbarton Oaks Research Library and Collection (Washington)

District of Columbia, cont.
The Kreeger Museum (Washington)

Florida
The Charles Hosmer Morse Museum of American Art (Winter Park)
Florida International University - The Wolfsonian (Miami Beach)

Georgia
Morris Museum of Art (Augusta)

Hawaii
The Contemporary Museum and Garden (Honolulu)

Illinois
Governors State University - Nathan Manilow Sculpture Park (University Park)
Mitchell Museum at Cedarhurst (Mount Vernon)
University of Chicago - The David and Alfred Smart Museum of Art (Chicago)

Indiana
Midwest Museum of American Art (Elkhart)
Swope Art Museum (Terre Haute)
Valparaiso University - Brauer Museum of Art (Valparaiso)

Iowa
Cornell College - Armstrong Gallery (Mount Vernon)

Kansas
Garnett Public Library - Mary Bridget McAuliffe Walker Art Collection (Garnett)

Louisiana
Masur Museum of Art (Monroe)
The R.W. Norton Art Gallery (Shreveport)
The Zigler Museum (Jennings)
Maine
Bowdoin College Art Museum (Brunswick)
Maryland
American Visionary Art Museum
 (Baltimore)
Washington County Museum of Fine Arts
 (Hagerstown)
Massachusetts
Amherst College - Mead Art Museum
 (Amherst)
Brandeis University - Rose Art Museum
 (Waltham)
Cape Ann Historical Museum (Gloucester)
Mount Holyoke College Art Museum
 (South Hadley)
Phillps Academy Andover - Addison Gallery
 of American Art (Andover)
Wellesley College - Davis Museum and
 Cultural Center (Wellesley)
Michigan
Muskegon Museum of Art (Muskegon)
Saginaw Art Museum (Saginaw)
Missouri
The Albrecht Kemper Museum of Art
 (Saint Joseph)
Saint Louis University - Museum of
 Contemporary Religious Art (Saint Louis)
Nebraska
University of Nebraska-Lincoln -
 Great Plains Art Collection (Lincoln)
New Hampshire
Dartmouth College - Hood Museum of Art
The Currier Gallery of Art (Manchester)
New Jersey
Gallery at Bristol-Myers Squibb (Princeton)
Rutgers University - Jane Voorhees
 Zimmerli Art Museum (New Brunswick)
New Mexico
University of New Mexico -
 Harwood Museum (Taos)
New York
Arnot Art Museum (Elmira)
Canajoharie Library and Art Gallery
 (Canajoharie)
The Hebrew Home for the Aged (Riverdale)
Heckscher Museum of Art (Huntington)

New York, cont.
The Hyde Collection (Glens Falls)
Isamu Noguchi Garden Museum
 (Long Island City)
The Parrish Art Museum (Southampton)
Storm King Art Center (Mountainville)
Vassar College - The Frances Lehman Loeb
 Art Center (Poughkeepsie)
North Dakota
North Dakota Museum of Art
Ohio
Oberlin College - Allen Memorial Art
 Museum (Oberlin)
Pennsylvania
Allentown Art Museum (Allentown)
Bucknell University - The Center Gallery
 (Lewisburg)
Cigna Museum and Art Collection
 (Philadelphia)
La Salle University Art Museum
 (Philadelphia)
The Rosenbach Museum and Library
 (Philadelphia)
Ursinus College - Philip and Muriel
 Berman Museum of Art (Collegeville)
Westmoreland Museum of American Art
 (Greensburg)
South Carolina
Bob Jones University Museum and
 Gallery, Inc. (Greenville)
Tennessee
Fisk University - Galleries (Nashville)
Texas
Chinati Foundation/Fundacion Chinati
 (Marfa)
Cy Twombly Gallery -
 Menil Collection (Houston)
Southern Methodist University -
 The Meadows Museum (Dallas)
Vermont
St. Johnsbury Athenæum Public Library
 and Art Gallery
Virginia
Hampton University Museum (Hampton)
Randolph Macon Woman's College -
 Maier Museum of Art (Lynchburg)
University of Virginia - Bayly Art Museum
 (Charlottesville)
Washington
Frye Art Museum (Seattle)

Alabama

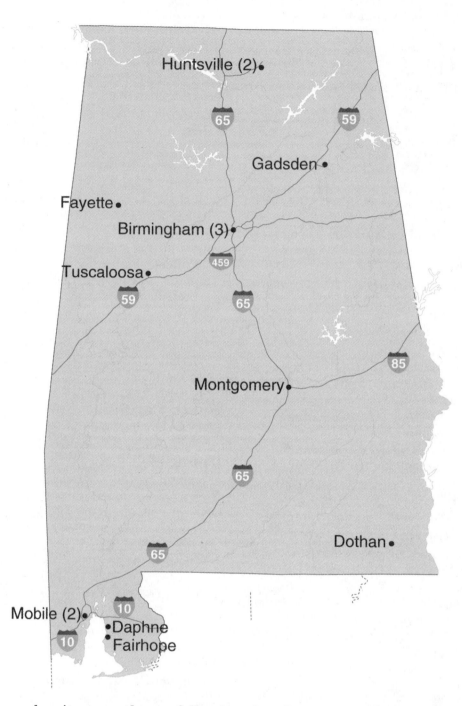

The number in parentheses following the city name indicates the number of museums/galleries in that municipality. If there is no number, one is understood. For example, in the text three listings would be found under Birmingham and one listing under Montgomery.

Alabama

Birmingham

Birmingham Museum of Art (BMA)

2000 8th Avenue North at 21st St.
Birmingham, AL 35203-2278
Tel: (205) 254-2565
Fax: (205) 254-2714
Internet Address: http://www.artsBMA.org
Director: Ms. Gail Treschel
Admission: free, voluntary contribution.
Attendance: 160,000 *Established:* 1951
Membership: Y *ADA Compliant:* Y
Parking: free; adjacent to museum.
Open: Tuesday to Saturday, 10am-5pm;
Sunday, noon-5pm.
1st Thursday in month. 10am-9pm.

Albert Bierstadt, *Looking Down Yosemite Valley*, 1865, Birmingham Museum of Art. Photograph courtesy of Birmingham Museum of Art, Birmingham, Alabama.

Closed: New Year's Day, Thanksgiving Day, Christmas Day.
Facilities: **Architecture** Art Moderne building (1959 by Warren, Knight, and Davis), Renovation/Expansion (1993 by Edward Larrabee Barnes); **Auditorium** (340 seats; hearing assisted devices); **Exhibition Area** Permanent Collection (30 galleries, including 1 in garden,, Temporary Areas (9 spaces, including 2 in garden); **Food Services** Restaurant (170 seats, Tues-Sat 11am-2pm; Jazz Brunch 1st Sun in month); **Library** (12,000 volumes; large collection on Wedgwood); **Museum Store** (one-of-a-kind arts & crafts, books, educational toys, jewelry); **Sculpture Garden** (30,000 square feet).
Activities: **Arts Festival**; **Concerts**; **Education Programs** (adults and children); **Films** (1st Thurs in month, 6:30pm, $6); **Gallery Talks**; **Guided Tours** (Tues-Fri, 11:30am and 12:30pm; Sat-Sun, 2pm; free); **Lectures**; **Temporary Exhibitions**; **Traveling Exhibitions**.
Publications: collection catalogue, "Masterpieces East and West"; exhibition catalogues; newsletter (bi-monthly).

The largest municipal museum in the southeast, the BMA has a nationally recognized collection of over 19,000 works of art dating from ancient to modern times. The main, art moderne building, designed by the architectural firm of Warren, Knight, and Davis, was begun in 1959 and subsequently expanded several times. A renovation and expansion designed by New York architect Edward Larrabee Barnes, including the addition of two wings, was completed in 1993. The multi-level outdoor sculpture garden, designed by New York sculptor Elyn Zimmerman in close collaboration with architect Barnes, enables art to be seen indoors and outdoors in a continuous flow. Notable collections include the Kress Collection of Renaissance painting with works by Bordone, Mainardi, Tintoretto and Veneziano; the Simon Collection of Art of the American West, including 12 Remington bronzes; the Beeson Collection of Wedgwood, the largest and finest outside England; the Eugenia Woodward Hitt Collection of 18th-century French painting and decorative arts; the Lamprecht Collection of Decorative Cast Iron, the largest such collection in the world; and the largest and most comprehensive collection of Asian Art in the southeast.

Birmingham-Southern College - Durbin Gallery

Kennedy Art Center, 900 Arkadelphia Road, Birmingham, AL 35204
Tel: (205) 226-4926
Internet Address: http://www.bsc.edu/arts/durbin/default.htm
Admission: free.
Open: Monday to Friday, 9am-4:30pm.
Facilities: **Exhibition Area**.
Activities: **Temporary Exhibitions**.

The Gallery presents traveling, faculty, and student exhibitions. Annual events include the Southeast Regional High School Art Competition, the senior art exhibition, and a juried student art exhibition.

Birmingham, Alabama

University of Alabama at Birmingham - Visual Arts Gallery

University of Alabama at Birmingham, 900 13th St. South, Birmingham, AL 35294-1260
Tel: (205) 934-4941
Fax: (205) 975-6639
Internet Address: http://main.uab.edu/show.asp?durki=1925
Curator: Ms. Antoinette Nordan
Admission: voluntary contribution.
Attendance: 5,000 *Established:* 1972 *Membership:* N *ADA Compliant:* Y
Open: Tuesday to Friday, 1pm-6pm; Saturday, 1pm-5pm; Sunday, 2pm-5pm.
Closed: New Year's Day, ML King Day, Independence Day, Labor Day, Thanksgiving Day,
 Christmas Day.
Facilities: **Gallery; Temporary Exhibition Space.**
Activities: **Films; Guided Tours; Lectures; Traveling/Temporary Exhibitions.**
Publications: collection catalogue (annual); posters.
The Visual Arts Gallery features a changing series of exhibitions of contemporary and historical art by internationally known artists, as well as by students and faculty. The gallery also maintains a permanent collection primarily of works on paper dating from the mid-18th century to the present and of works by faculty and students.

Daphne

American Sport Art Museum and Archives

One Academy Drive, Daphne, AL 36526
Tel: (334) 626-3303
Fax: (334) 626-1149
Chief Executive Officer: Dr. Thomas P. Rosandich
Admission: voluntary contribution.
Attendance: 1,200 *Established:* 1985 *Membership:* Y *ADA Compliant:* Y
Open: Monday to Friday, 10am-2pm.
Closed: Legal Holidays.
Facilities: **Auditorium** (100-seat); **Museum Store.**
Activities: **Guided Tours; Temporary/Traveling Exhibitions.**
The collection contains art works in a variety of media focusing on sport-related subjects.

Dothan

Wiregrass Museum of Art

126 Museum Avenue (across from the Civic Center), Dothan, AL 36303
Internet Address: http://www.wiregrassmuseumoart.org
Tel: (334) 794-3871
Fax: (334) 615-2217
Executive Director: Mr. Sam W. Kates
Admission: suggested contribution-$1.00.
Attendance: 20,000 *Established:* 1988
Membership: Y *ADA Compliant:* Y
Open: Tuesday to Saturday, 10am-5pm;
 Sunday, 1pm-5pm.
Closed: Legal Holidays.
Facilities: **Architecture** (1912-13 building,
 redesigned by Donofrio & Associates);
 Library (400 volumes).

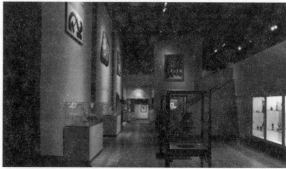

View of gallery, Wiregrass Museum of Art. Photograph courtesy of Wiregrass Museum of Art, Dothan, Alabama.

Wiregrass Museum of Art, cont.

Activities: **Docent Program**; **Education Program** (adults and children); **Guided Tours** (reserve three weeks in advance); **Lectures**; **Temporary Exhibitions**; **Traveling Exhibitions**.
Publications: newsletter, "Sketches" (quarterly).

The Museum offers changing exhibitions and a permanent collection of 20th-century art, including galleries for decorative arts, African arts, and works on paper. Listed on the National Register of Historic Places, the former electric plant/warehouse was redesigned as a museum, while retaining an ambience reflecting the structure's history.

Fairhope

Eastern Shore Art Center (ESAC)

401 Oak Street, Fairhope, AL 36532
Tel: (334) 928-2228
Fax: (334) 928-5188
Managing Director/C.E.O.: Robin Fitzhugh
Admission: voluntary contribution.
Attendance: 25,000 *Established:* 1952
Membership: Y *ADA Compliant:* Y
Parking: on site, regular and handicapped.
Open: Monday to Saturday, 10am-4pm.
Closed: Legal Holidays.

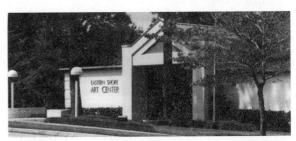

Exterior view of Eastern Shore Art Center. Photograph courtesy of the Eastern Shore Art Center, Fairhope, Alabama.

Facilities: **Architecture** (early 20th-century wood-burning kiln); **Central Courtyard**; **Classrooms** (4, plus darkroom); **Galleries** (5, total 12,000 square feet); **Library**.
Activities: **Education Program** (studio classes); **Lectures**; **Outdoor Shows** (3rd weekend in March and October); **Temporary/Traveling Exhibitions** (monthly).
Publications: newsletter, "The Artline" (monthly).

The Art Center offers five galleries for viewing local, regional, and national art; five studios for students of the Eastern Shore Academy of Fine Arts; a landscaped central courtyard; and an art library. The wood-burning kiln behind the building is on the historic register of the State of Alabama.

Fayette

Fayette Art Museum

530 Temple Ave., N., Fayette Civic Center, Fayette, AL 35555
Tel: (205) 932-8727
Fax: (205) 932-8878
Director and Curator: Mr. Jack Black
Admission: voluntary contribution.
Established: 1969 *Membership:* N *ADA Compliant:* Y
Parking: free on site.
Open: Monday to Tuesday, 9am-noon & 1pm-4pm; Thursday to Friday, 9am-noon & 1pm-4pm.
Closed: Legal Holidays.
Facilities: **Auditorium** (365 seats); **Library** (school building, 1930).
Activities: **Arts Festival**; **Guided Tours** (with prior arrangement); **Temporary/Traveling Exhibitions**.

Six galleries on the main floor focus on 20th-century American painting. Six galleries on the ground floor feature folk art. Among the many works of Southern folk artists displayed are full galleries devoted to the work of Jimmy Lee Sudduth, Benjamin F. Perkins, and Sybil Gibson.

Gadsden

Gadsden Museum of Fine Arts

Elliot Community Center, 2829 W. Meighan Blvd. (Highway.431), Gadsden, AL 35904
Tel: (205) 546-7365
Internet Address: http://www.the-matrix.com/gadsden/gma.html

Gadsden Museum of Fine Arts, cont.

C.E.O.: Ms. Sherrie Hamil
Admission: voluntary contribution.
Attendance: 25,000 *Established:* 1965 *Membership:* Y *ADA Compliant:* Y
Open: Monday to Wednesday, 10am-4pm; Thursday, 10am-8pm; Friday, 10am-4pm;
 Sunday, 1pm-5pm.
Closed: Legal Holidays.
Facilities: **Library.**
Activities: **Guided Tours**; **Temporary Exhibitions.**
Publications: brochures.

The Museum houses both a permanent art collection and historical exhibits. Annual exhibitions that run for one month feature works from area schools, local arts organizations, and photographers, as well as folk art and solo shows by regional and local artists. While the Museum's main focus is on local and regional artists, the Fowler Memorial Collection does include examples of European Impressionism as well as contemporary art. This collection also features whimsical assemblages, sculptures, antique china, and crystal. The historical collection features artifacts from the area.

Huntsville

Huntsville Museum of Art

300 Church Street South, Huntsville, AL 35801
Tel: (205) 535-4350
Fax: (205) 532-1743
Internet Address: http://www.hsv.tis.net/hma
President: Mr. Richard P. Loring
Admission: voluntary contribution.
Attendance: 65,000 *Established:* 1970
Membership: Y *ADA Compliant:* Y
Open: Tuesday to Friday, 10am-5pm;
 Saturday, 9am-5pm;
 Sunday, 1pm-5pm.

Exterior view of Huntsville Museum of Art. Photograph courtesy of Huntsville Museum of Art, Huntsville, Alabama.

Closed: New Year's Day, Thanksgiving Day, Christmas Day.
Facilities: **Auditorium** (100 seats); **Galleries** (7); **Library** (2,000 volumes).
Activities: **Docent Program**; **Education Program** (children and adults); **Films**; **Gallery Talks**; **Guided Tours**; **Temporary Exhibitions**; **Traveling Exhibitions.**
Publications: brochures; calendar (quarterly); exhibition catalogues.

The HMA displays works from its permanent collection on a rotating basis, organizes temporary shows of local and regional art, and hosts traveling exhibitions. The permanent collection totals approximately 1,800 objects, with the focus being on 20th-century American graphic art and photography.

University of Alabama in Huntsville - Art Galleries

Department of Art and Art History, UAH Campus, Sparkman and University Drives
Huntsville, AL 35899
Tel: (256) 890-6114
Fax: (256) 890-6411
Internet Address: http://www.uah.edu/colleges/liberal/art/gallery.html
Gallery Administrator: Marilyn T. Coffey
Admission: free.
Established: 1975 *Membership:* N *ADA Compliant:* Y
Open: Call for hours.
Facilities: **Architecture** (Greek Revival church, 1840's); **Exhibition Area** (Union Grove, 900 square feet; University Center Gallery, 500 square feet).
Activities: **Art Talks**; **Changing Exhibitions**; **Installations**; **Lectures**; **Traveling Exhibitions.**

University of Alabama in Huntsville - Art Galleries, cont.

The Department of Art and Art History directs and operates two gallery spaces on campus. The galleries play host to a yearly series of exhibitions of the work of local, regional, and national artists. In addition, the galleries are used for annual student exhibitions, senior student solo shows, and faculty exhibitions. The Union Grove Gallery & Meeting Hall, a one-room church built in the Greek Revival-style (circa 1840), was donated to the University in 1973 and was renovated by UAH students in 1974. A second gallery area is located in the UAH University Center.

Mobile

Mobile Museum of Art

4850 Museum Drive, Langan Park
Mobile, AL 36608
Tel: (334) 343-2667
Fax: (334) 343-2680
TDDY: (334) 434-2667
C.E.O.: Mr. Joseph B. Schenk
Admission: free, voluntary contribution.
Attendance: 110,000 *Established:* 1964
Membership: Y *ADA Compliant:* Y
Open: Tuesday to Sunday, 10am-5pm.
Closed: Legal Holidays, Local Holidays.
Facilities: Library (3,500 volumes).

Exterior view of Mobile Museum of Art. Photograph courtesy of Mobile Museum of Art, Mobile Alabama.

Activities: **Arts Festival**; **Concerts**; **Education Program** (adults and children); **Films**; **Gallery Talks**; **Guided Tours**; **Lectures**; **Temporary Exhibitions**; **Traveling Exhibitions**.
Publications: calendar (bi-monthly); exhibition catalogues.

The Mobile Museum of Art has a permanent collection of over 5,000 works of art spanning over 2,000 years of cultural history and highlights important artists, periods, cultures, and media. Each year, the museum offers numerous traveling exhibitions from prestigious museums and collections throughout the country. The Museum has a satellite gallery in downtown Mobile (see separate listing).

Mobile Museum of Art - Downtown Gallery

300 Dauphin St., Mobile, AL 36602
Tel: (334) 343-2667
Admission: free.
Parking: metered on street & commercial lots.
Open: Monday to Friday, 8:30am-4:30pm.
Facilities: **Gallery**.
Activities: **Temporary Exhibitions**.

A satellite location, the Downtown Gallery presents a series of temporary exhibitions. For information on the Main Museum, see separate listing.

Montgomery

Montgomery Museum of Fine Arts

One Museum Drive, Montgomery, AL 36117
Tel: (334) 244-5700
Fax: (334) 244-5774
Internet Address: http://www.mmfa.org
Director: Mr. Mark M. Johnson
Admission: free, voluntary contribution.
Attendance: 150,000 *Established:* 1930
Membership: Y *ADA Compliant:* Y

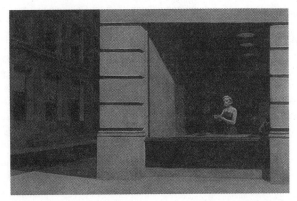

Edward Hopper, *New York Office*, 1962, the Blount Collection, Montgomery Museum of Fine Arts. Photograph courtesy of Montgomery Museum of Fine Arts, Montgomery, Alabama.

Montgomery Museum of Fine Arts, cont.

Parking: free on site.

Open: Tuesday to Wednesday, 10am-5pm; Thursday, 10am-9pm; Friday to Saturday, 10am-5pm; Sunday, noon-5pm.

Closed: Legal Holidays.

Facilities: **Architecture** (1988, designed by Bargainier, McKee, Sims Architects Associated); **Food Services** Café M (Tue-Sat: lunch, 11am-2pm); **Library** (3,000 volumes; by appointment); **Museum Store** (daily, 10am-4pm; Sun, 1pm-4pm).

Activities: **Education Programs** (children, ARTWORKS hands-on gallery and studio); **Films**; **Guided Tours** (Sat-Sun, 1pm & Thurs, 6:30pm; groups of 10+ by appointment); **Lectures**; **Temporary Exhibitions**; **Traveling Exhibitions**.

Publications: annual report; brochures; exhibition catalogues; newsletter, "On Exhibit" (quarterly).

The Montgomery Museum of Fine Arts is the oldest fine arts museum in the state of Alabama. The Museum's facility provides spacious, light-filled galleries, and attractive vistas. Located in the Wynton M. Blount Cultural Park, the Museum is adjacent to the Alabama Shakespeare Festival and the future home of the Montgomery Ballet. In addition to its permanent collection, the Museum features a variety of traveling exhibits each year, offering a diverse selection of cultural and regional shows. A unique learning experience awaits visitors in ARTWORKS, where visitors of all ages explore art first hand in an interactive exhibit. The Museum's permanent collection includes the Blount Collection, an outstanding array of 19th- and 20th- century paintings arranged in chronological order to illustrate the development of the important artists, art movements, and styles of American art history. Among the works in the collection are masterpieces by John Singleton Copley, John Singer Sargent, and Edward Hopper. The Museum is also home to some of the finest examples of works of art on paper by such masters as Dürer, Rembrandt, Picasso and Whistler. Southern regional art found in the Museum's holdings reflects the distinguished legacy of the Southeast and the continuing vitality of its contemporary art. Eighteenth-century Worcester Porcelain and 19th-century Chinese export wares, in addition to art nouveau glass and other functional arts, are featured in changing exhibits in the Decorative Arts Gallery.

Tuscaloosa

University of Alabama - Sarah Moody Gallery of Art

College of Arts and Sciences
103 Garland Hall
Tuscaloosa, AL 35487-0270

Tel: (205) 348-1890

Fax: (205) 348-2087

Internet Address:
http://www.as.ua.edu/calendar.htm/#Galleries

Director: Mr. Bill Dooley

Admission: voluntary contribution.

Attendance: 10,000 *Established:* 1967

ADA Compliant: Y

Open: **During School Year**,
Monday to Friday, 9am-4:30pm;
Sunday, 2pm-5pm.

Facilities: **Gallery**.

Garland Hall. Photograph courtesy of Sarah Moody Gallery of Art, University of Alabama, Tuscaloosa, Alabama.

Activities: **Films**; **Lectures**; **Temporary Exhibitions**; **Traveling Exhibitions**.

Publications: exhibition catalogues.

The Gallery provides the local university community, residents of west Alabama and visitors with an opportunity to view the work of mid-career artists who enjoy regional as well as national recognition. The Sarah Moody Gallery maintains a permanent collection of works on paper, which it began in 1967 and continues to expand. Each year the collection is featured in the gallery, with particular emphasis given to new acquisitions. The collection includes works by Robert Rauschenberg,

University of Alabama - Sarah Moody Gallery of Art, cont.

Manuel Neri, Carrie Mae Weems, Alexander Calder, Picasso, Vija Celmins, Ida Applebroog, Ansel Adams, Salvador Dali, and Judy Pfaff. Works are acquired through the support of the Farley Moody Galbraith Endowment Fund. Other campus galleries include the Ferguson Center Gallery and the Art Students League Gallery in Woods Hall (open: Mon-Fri, 9am-4:30pm; Sun, 2pm-5pm).

Alaska

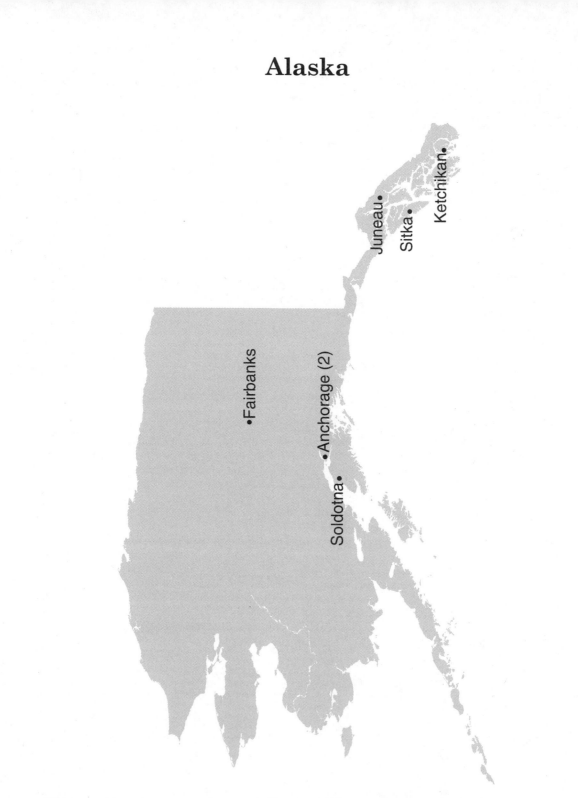

The number in parentheses following the city name indicates the number of museums/galleries in that municipality. If there is no number, one is understood. For example, in the text two listings would be found under Anchorage and one listing under Juneau.

Alaska

Anchorage

Anchorage Museum of History and Art

121 West Seventh Ave., Anchorage, AK 99501

Tel: (907) 343-4326

Fax: (907) 434-6149

Internet Address:
 http://www.ci.anchorage.ak.us/Services/Departments/Culture/Museum/Index.html

Director: Ms. Patricia B. Wolf

Admission:
 fee: adult-$5.00, child-free, senior-$4.00.

Attendance: 280,000 *Established:* 1968

Membership: Y *ADA Compliant:* Y

Open: **mid September to early May**,
 Tuesday to Saturday, 10am-6pm
 Sunday, 1pm-5pm.
 early May to May 31,
 Daily, 9am-6pm.
 June to August,
 Sunday to Thursday, 9am-9pm
 Friday to Saturday, 9am-6pm.
 September 1 to mid-September,
 Daily, 9am-6pm.

Closed: Legal Holidays.

Exterior view of Anchorage Museum of History & Art. Photograph courtesy of Anchorage Museum of History & Art, Anchorage, Alaska.

Facilities: **Auditorium** (240 seat); **Classrooms**; **Food Services** Gallery Café; **Galleries** (12); **Library** (10,000 volumes); **Shop**.

Activities: **Arts Festival**; **Dance Recitals**; **Docent Program**; **Education Program** (adults and children; children's hands-on gallery); **Guided Tours**; **Lectures**; **Temporary Exhibitions** (over 20/year); **Traveling Exhibitions**.

Publications: exhibition catalogues; newsletter (monthly).

The Anchorage Museum of History and Art offers the opportunity to see objects from Alaska's exciting past and present. Three thousand-year-old spear points, contemporary paintings, Russian icons, and Eskimo ivory carvings help illustrate the art, history, and ethnography of Alaska. Spacious galleries house informative and educational exhibits of the permanent collection and temporary exhibits from around the world. In the Alaska Gallery, visitors will find more than 1,000 objects portraying the history of Alaska. The Museum's library and archives are an important source of historical documents, photographs, and publications for researchers and the public. Housed in a striking facility of 93,000 square feet (designed by Mitchell/Giurgola Architects and Maynard and Partch Architects) that was completed in 1984, it is the largest museum in Alaska. Located on the first floor, the Museum's collection of historical and contemporary Alaskan art is arranged chronologically from the days of the early explorers to the newest artworks. The collection also includes favorite masters such as Sydney Laurence, Thomas Hill, and Rockwell Kent.

University of Alaska, Anchorage - Galleries

Kimura Art Gallery: Arts Building, 2nd Floor, 3211 Providence Drive, Anchorage, AK 99508

Tel: (907) 786-1799

Internet Address: http://www.uaa.alaska.edu

Professor of Art History: Dr. Charles E. Licka

Admission: free.

Attendance: 5,000 *Established:* 1986 *Membership:* N *ADA Compliant:* Y

Parking: free on site.

Open: Monday to Friday, 10am-5pm.

Facilities: **Exhibition Area** (1,200 square feet).

Activities: **Temporary Exhibitions**.

University of Alaska, Anchorage - Galleries, cont.

Publications: brochures (occasional);
monographs (occasional).

The Gallery focuses on contemporary art and presents a wide range of international, national, and Alaskan art. These exhibitions are independently curated and consist of solo. group, faculty, invitational, and BFA thesis exhibitions. The Gallery's express purpose is to serve as an educational space not only for the University, but also for the city of Anchorage and the state of Alaska. There is also site-specific sculpture at various campus locations. Also of possible interest on campus is the Campus Center Gallery (786-1219) located in Campus Center Room 229, 3211 Providence Drive (Open: Monday-Thursday, 10am-7pm; Friday, 10am-5pm).

Dennis Oppenheim, *Image Intervention*, 1984, Collection of University of Alaska Anchorage. Photograph courtesy of University of Alaska Anchorage, Anchorage, Alaska.

Fairbanks

University of Alaska Museum

University of Alaska-Fairbanks, 907 Yukon Drive, Fairbanks, AK 99775-6960

Tel: (907) 474-7505

Fax: (907) 474-5469

Internet Address: http://www.uaf.alaska.edu

Director: Ms. Aldona Jonaitis

Admission: fee-$5.00.

Attendance: 124,000 *Established:* 1929 *Membership:* Y *ADA Compliant:* Y

Open: **September to May**, Daily, 9am-5pm.
 June to August, Daily, 9am-7pm.

Closed: New Year's Day, Thanksgiving Day, Christmas Day.

Facilities: **Museum Store.**

Activities: **Guided Tours**; **Temporary Exhibitions**; **Traveling Exhibitions**.

Publications: brochures; exhibition catalogues; newspaper (annual).

There are over a million objects in the Museum's cultural and natural history collections. The fine arts collection constitutes an invaluable record of Alaska's cultural richness and aesthetic diversity and includes nearly 3,000 works of art. The major focus of the collection is Alaskan regional art, historic through contemporary, and includes all major media of visual expression. To make full use of the art collection's potential, the Museum offers a multitude of exhibitions, educational programs, and public events. The collection serves as an important tool for scholarly research in the art history of Alaska and for classroom support in the study of drawing, painting, photography, printmaking, and sculpture.

Juneau

Alaska State Museum

395 Whittier St., Juneau, AK 99801-1718

Tel: (907) 465-2901

Fax: (907) 465-2976

Internet Address: http://www.educ.state.ak.us/lam/museum/

Chief Curator: Mr. Bruce Kato

Admission: fee: adult-$3.00, child-free, student-free.

Attendance: 80,000 *Established:* 1900 *Membership:* Y *ADA Compliant:* Y

Open: **mid-September to mid-May**, Tuesday to Saturday, 10am-4pm.
 mid-May to May 31, Monday to Friday, 9am-6pm.
 Summer, Monday to Friday, 9am-6pm; Saturday to Sunday, 10am-6pm.
 September to mid-September, Monday to Friday, 9am-6pm.

Alaska State Museum, cont.

Closed: Legal Holidays.

Facilities: **Conservation Facilities; Gallery; Library; Shop.**

Activities: **Education Program** (adults and children); **Guided Tours** (docent-led, summer; groups must reserve in advance, year-round); **Temporary Exhibitions; Traveling Exhibitions.**

Publications: brochures; collection catalogue; educational materials.

About half of the Museum's space is devoted to permanent exhibits focusing on the geology, biology, anthropology, and history of Alaska. Temporary exhibitions, including many devoted to the fine arts, rotate through the remaining space. The Museum is home to over 25,000 artifacts and works of fine art.

Exterior view of Alaska State Museum. Photograph courtesy of Alaska State Museum, Juneau, Alaska.

Ketchikan

Totem Heritage Center

601 Deermount, Ketchikan, AK 99901

Tel: (907) 225-5900

Fax: (907) 225-0448

Director: Mr. Michael Naab

Admission: fee-$4.00.

Attendance: 90,000 *Established:* 1976 *Membership:* N *ADA Compliant:* Y

Parking: 15 spaces adjacent.

Open: **May 15 to September**, Daily, 8am-5pm.

 October to May 14, Tuesday to Friday, 1pm-5pm.

Closed: New Year's Day, Easter, Veterans Day, Thanksgiving Day, Christmas Day.

Facilities: **Exhibition Area; Library.**

Activities: **Demonstrations; Guided Tours; Lectures.**

Publications: report, "Ketchikan Museums Calendar".

The Totem Heritage Center preserves and exhibits a collection of 33 19th-century totem poles recovered from abandoned native village sites in southeast Alaska. The Center also offers an active program of classes, workshops, and seminars in Native Alaskan arts.

Sitka

Sheldon Jackson Museum

104 College Drive (behind the library)

Sitka, AK 99835-7657

Tel: (907) 747-8981

Fax: (907) 747-3004

Internet Address: http://www.seed.state.ak.us/lam/museum/home.html

Admission: fee: adult-$4.00, child (<19)-free.

Established: 1887

Open: **mid-May - mid-Sept,**

 Daily, 9am-5pm.

 mid-Sept - mid-May

 Tuesday to Saturday, 10am-4pm.

Facilities: **Architecture** (National Register building, 1895); **Exhibition Area.**

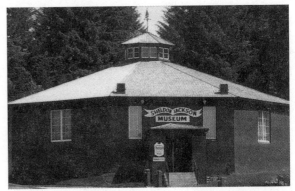

Exterior view of Sheldon Jackson Museum. Photograph courtesy of Sheldon Jackson Museum, Sitka, Alaska.

Sheldon Jackson Museum, cont.

Activities: **Demonstrations** (summer); **Education Programs; Traveling Exhibitions**.

Located in the oldest concrete building in Alaska on the edge of the Sheldon Jackson College campus, the Museum houses a collection of Alaskan ethnographic material, including objects from the Eskimo, Aleut, Athabaskan, Tlingit, Haida, and Tsimshan cultures. Since 1984 it has been one of the Alaska State Museums.

Soldotna

Kenai Peninsula College - Campus Art Gallery

University of Alaska, Anchorage, 34820 College Drive, Soldotna, AK 99669

Tel: (907) 262-0370

Fax: (907) 262-0358

Internet Address: http://www.uaa.alaska.edu/kenai/AboutKPC/ArtGallery.html

Director: Mr. Gary Freeburg

Admission: free.

Attendance: 6,000 *Established:* 1985 *Membership:* N *ADA Compliant:* Y

Parking: free on site.

Open: Monday to Daily, 8am-8pm.

Facilities: **Exhibition Area** (66 linear feet).

Activities: **Temporary Exhibitions** (change monthly).

The Gallery presents in monthly exhibitions works by local and regional artists in a wide range of media and expressions.

Arizona

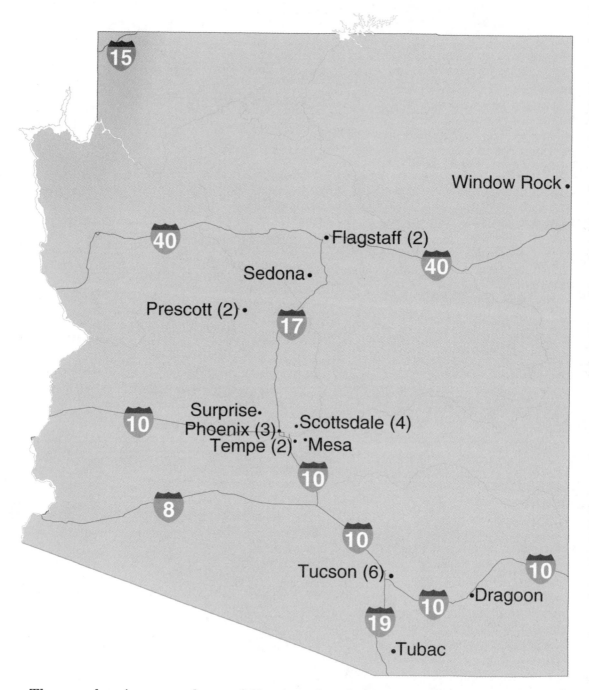

The number in parentheses following the city name indicates the number of museums/galleries in that municipality. If there is no number, one is understood. For example, in the text six listings would be found under Tucson and one listing under Dragoon.

Arizona

Dragoon

The Amerind Foundation, Inc.

2100 N. Amerind Road (off I-10, between Benson and Wilcox), Dragoon, AZ 85609-0400

Tel: (520) 586-3666

Fax: (520) 586-4679

Internet Address: http://www.amerind.org

Director: Dr. Anne I. Woosley

Admission: fee: adult-$3.00, child-free,
 student-$2.00, senior-$2.00.

Established: 1937

Membership: N *ADA Compliant:* N

Parking: free on site.

Open: **September to May**,
 Daily, 10am-4pm.
 June to August,
 Wednesday to Sunday, 10am-4pm.

Closed: New Year's Day, Easter,
 Independence Day,
 Thanksgiving Day, Christmas Day.

Native American clay vessel. Amerind Foundation, Inc.
Photograph courtesy of Amerind Foundation, Inc., Dragoon,
Arizona.

Facilities: **Architecture** (Spanish Colonial Revival, designed by H.M. Starkweather); **Exhibition Area**; **Food Services** Picnic Area; **Library** (20,000 volumes, by appointment); **Reading Room**; **Shop** (Southwest crafts, books).

Activities: **Guided Tours**; **Lectures**; **Temporary Exhibitions**.

Publications: series, "Amerind Foundation Archeology"; series, "Amerind New World Studies".

Located 64 miles east of Tucson in the massive rock formations of Texas Canyon, the Amerind Foundation is an archeological research facility and museum devoted to the study of Native American culture and history. Archeological collections on exhibit include artifacts collected during Amerind-sponsored excavations in the Southwest and Mexico. Displays also chart the beginning of historical times as Spanish explorers and colonists contacted American Indian groups, changing native lifestyles forever. Historic Indian cultures from across America are presented in Amerind's ethnographic collections, from Cree snowshoe-making tools to 19th-century Navajo weavings. Exhibits include examples of Plains beadwork and costumes, ritual masks, shields, and weapons, as well as children's toys and clothing. In addition to its museum, the Amerind Art Gallery contains works on western themes by such artists as William Leigh, Carl Oscar Borg, and Frederic Remington, and a variety of other paintings and sculptures by 19th- and 20th-century Anglo and Native American artists.

Flagstaff

Museum of Northern Arizona

3101 N. Fort Valley Road, Flagstaff, AZ 86001

Tel: (520) 774-5213

Fax: (520) 779-1527

Internet Address: http://www.musnaz.org

Director and C.E.O.: Mr. Michael J. Fox

Admission: fee: adult-$5.00, child-$2.00, student-$3.00, senior-$4.00.

Attendance: 90,000 *Established:* 1928 *Membership:* Y *ADA Compliant:* Y

Open: Daily, 9am-5pm.

Closed: New Year's Day, Thanksgiving Day, Christmas Day.

Facilities: **Hall** (225 seats); **Library**; **Museum Store**.

Activities: **Education Program** (children); **Guided Tours** (reserve 4 weeks in advance, fee, 774-5211 x220); **Lectures**; **Temporary Exhibitions**; **Traveling Exhibitions**.

Museum of Northern Arizona, cont.

Publications: magazine, "Plateau Journal" (semi-annual); newsletter (quarterly); research publications (occasional).

Dedicated to the understanding of the Colorado Plateau, the Museum conducts research, displays exhibits and presents educational programs on biology, geology, anthropology, and fine arts. Fine arts of the region are displayed in the Lockett Fine Arts Gallery, which also highlights work from the Museum's collection of art and sculpture. The Babbitt Gallery, featuring a reading area with a fireplace, is intended to display the Museum's ceramics collection. A special exhibits gallery is used for changing exhibits throughout the year, including an annual Native American sales exhibit of Hopi, Navajo and Zuni art from May through September.

Northern Arizona University Art Museum and Galleries

Old Main Building, North Campus, Knoles Drive and McMullen Circle, Flagstaff, AZ 86011

Tel: (520) 523-3471

Fax: (520) 523-1424

Internet Address: http://www.nau.edu/~art_museum-p/

Director: Dr. Joel S. Eide

Admission: voluntary contribution.

Established: 1961 *Membership:* N

Open: **Old Main Art Museum**, Monday to Friday, 8am-5pm; Sunday, 1pm-4pm.
Beasley Art Museum, Monday to Friday, 8am-5pm.
Summer, call for hours.

Closed: Legal Holidays, Academic Holidays.

Facilities: **Museum Store.**

Activities: **Arts Festival; Films; Gallery Talks; Guided Tours; Lectures; Temporary Exhibitions; Traveling Exhibitions.**

Publications: exhibition catalogues.

Located in the historic Old Main building on Northern Arizona University's north campus in Flagstaff, the Old Main Art Museum features contemporary art exhibitions by local, state, national, and international artists. The NAU Art Museum and Galleries also include the Charles E. Beasley Art Museum and Gallery, which features 30-day exhibits of contemporary art as well as a permanent display of selected works by Mr. Beasley. Works by NAU students are also highlighted, including annual juried exhibits and biannual BFA exhibits. (The Richard E. Beasley Art Museum and Gallery is located on the second floor of the Creative and Communication Arts building on central campus. The closest cross streets are Knoles and Riordan.)

Mesa

Mesa Contemporary Arts

Mesa Arts Center, 155 N. Center

Mesa, AZ 85211-1466

Tel: (602) 644-2056

Fax: (602) 644-2901

Internet Address:
http://www.mesaarts.com

Admission: free.

Attendance: 7,000 *Established:* 1981

Membership: Y *ADA Compliant:* Y

Parking: free on site.

Open: Tuesday to Friday, noon-8pm;
Saturday, noon-5pm.

Facilities: **Exhibition Area** (1300 square feet).

Activities: **Juried Exhibits** (7/year); **Temporary Exhibitions** (8/year).

Publications: gallery guides.

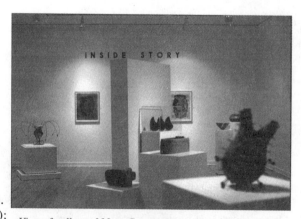

View of gallery of Mesa Contemporary Arts during installation "Inside Story" (1966). Photograph courtesy of Mesa Contemporary Arts, Mesa, Arizona.

Mesa Contemporary Arts, cont.

The mission of the Mesa Contemporary Arts is to present thematic, national juried exhibitions of contemporary art by emerging and mid-career artists from across the country. Each exhibition presents the work of about twenty-five to thirty artists and remains on display for four weeks.

Phoenix

Heard Museum

2301 North Central Ave.
Phoenix, AZ 85004-1323
Tel: (602) 252-8840
Fax: (602) 252-9757
Internet Address: http://www.heard.org
Director: Frank H. Goodyear, Jr.
Admission:
 fee: adult-$7.00, child-$3.00, student-free, senior-$6.00.
Attendance: 250,000 *Established:* 1929
Membership: Y *ADA Compliant:* Y
Parking: on campus.
Open: Daily, 9:30am-5pm.
Closed: New Year's Day, Easter, Memorial Day,
 Independence Day, Labor Day, Thanksgiving Day,
 Christmas Day.
Facilities: **Architecture** (Spanish Colonial Revival Building,
 1929 by Herbert Green); **Courtyards** (4); **Galleries** (10);
 Library (45,000 volumes); **Shop and Bookstore.**
Activities: **Arts Festival; Films; Gallery Talks; Guided
Tours** (Daily, call for times; group tours, reserve 3 weeks in
advance); **Lectures; Temporary Exhibitions; Traveling
Exhibitions.**

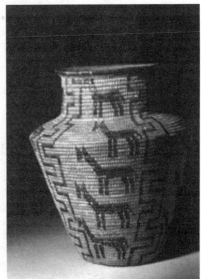

Pima Basket, early 1900's, coiled willow and martynia. Heard Museum. Photograph courtesy of Heard Museum, Phoenix, Arizona.

Publications: books; catalogues (occasional); newsletter, "Earth Song" (quarterly).

The internationally acclaimed Heard Museum is one of the best places to experience and learn about the fascinating cultures and art of Native Americans of the Southwest. Founded by Dwight B. and Maie Bartlett Heard to house their personal collection of primarily Native American artifacts, the Museum today is known for its extensive collections of Native American objects and fine art, unique exhibits and innovative programming. The museum's award-winning, permanent exhibit "Native Peoples of the Southwest" is filled with thousands of artifacts, including baskets, jewelry, pottery and textiles. Exhibits are complemented by the daily presence of Native American artists demonstrating their arts in the galleries, and talented Native American entertainers perform weekends in the auditorium. Visitors of all ages are invited and encouraged to participate in hands-on exhibits throughout the Museum that demonstrate Native American cultures and traditions. The museum also features five galleries that change exhibits regularly.

Phoenix Art Museum

1625 N. Central Avenue, Phoenix, AZ 85004-1685
Tel: (602) 257-1222
Fax: (602) 253-8662
Internet Address: http://www.phxart.org
Director: Mr. James K. Ballinger
Admission: fee: adult-$7.00, child-$2.00, student-$5.00, senior-$5.00.
Attendance: 500,000 *Established:* 1959 *Membership:* Y *ADA Compliant:* Y
Parking: free on site.
Open: Tuesday to Wednesday, 10am-5pm; Thursday, 10am-9pm; Friday to Sunday, 10am-5pm.
Closed: Major Holidays.

Phoenix Art Museum, cont.

Facilities: **Classrooms** (3 for studio art); **Food Services** Café; **Galleries**; **Lecture Hall** (295 seats); **Library** (50,000 volumes); **Shop** (books, cards, gifts and jewelry).

Activities: **Arts Festival**; **Docent Program**; **Education Programs** (adults and children, ArtWorks children's' gallery); **Gallery Talks** (Tues-Sun, noon; Thurs, 7pm); **Guided Tours** (Tues-Sun, 1pm/2pm; Thurs, 6pm; group tours call (602) 257-4356); **Lectures**; **Temporary Exhibitions**; **Traveling Exhibitions**.

Publications: brochures; exhibition catalogues (occasional); magazine (monthly).

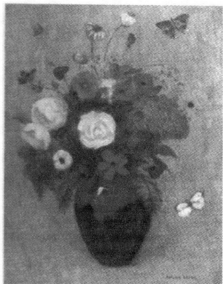

Odilon Redon, *Flowers in a Vase*, Gift of Mr. and Mrs. Donald D. Harrington, Phoenix Art Museum. Photograph courtesy of Phoenix Art Museum, Phoenix, Arizona.

With nearly 16,000 works in its collection and over 160,000 square feet of space, the Museum is the largest visual arts institution between Denver and Los Angeles. The collection and its many galleries are divided into three areas of emphasis, each marked by portals: "Art of Asia", "Art of the Americas & Europe to 1900", "Art of Our Time: 1900 to the Present". Each portal defines the scope of the galleries behind it. For example, the "Art of the Americas & Europe to 1900" portal marks entrance to the American Gallery, three Western galleries, Spanish Colonial Gallery, Fashion Design Gallery, Decorative Arts Gallery and 14th-19th Century European Galleries. Visitors can learn about the collection in the Museum's Orientation Theater. The Museum also features a child-friendly interactive gallery called ArtWorks that offers entertaining ways to experience art. The Steele Gallery, with its 40-foot high ceiling, showcases large exhibitions. The Orme Lewis Gallery presents smaller changing exhibitions. The Museum's collections emphasize American Art; European Art of the 14th-19th Centuries; Asian Art; Western American Art; Modern and Contemporary Art; Spanish Colonial Art; Latin American Art; and 18th-20th Century Fashion Design. The collection also includes the Thorne Miniature Rooms.

Shemer Art Center and Museum

5005 E. Camelback Road, Phoenix, AZ 85018-3015

Tel: (602) 262-4727

Fax: (602) 262-1605

Director: Ms. Christine Hall

Admission: free.

Attendance: 16,000 *Established:* 1984

Membership: Y *ADA Compliant:* Y

Parking: free on site.

Open: Monday, 10am-5pm
Tuesday, 10am-9pm;
Wednesday to Friday, 10am-5pm;
Saturday, 9am-1pm.

Facilities: Galleries.

Activities: **Arts Festival**; **Education Programs** (adults and children, children's gallery); **Juried Exhibits**; **Lectures**; **Temporary Exhibitions**.

View of exterior, Shemer Art Center. Photograph copyright 1994 by Robert Machinski, courtesy of Shemer Art Center and Museum, Phoenix, Arizona.

Publications: promotional, "Points of Pride" (annual).

The Museum, housed in an early 20th-century Santa Fe-mission style residence, promotes art in education and displays works in a wide variety of media created by Arizona's emerging artists, as well as nationally known artists. Exhibitions change monthly and exhibition opportunities are offered to artists of all levels of experience, medium, style, and technique. The permanent collection includes works by Diane Maxey, Brad Diddams, Roberta Hancock, and Rose Johnson.

Prescott

Phippen Museum

4701 Highway 89 North
(7 miles north of Courthouse Square)
Prescott, AZ 86301
Tel: (520) 778-1385
Fax: (520) 778-4524
Director: Mrs. Sue Willoughby
Admission:
 fee: adult-$3.00, student-$1.00, senior-$2.00.
Attendance: 15,000 *Established:* 1984
Membership: Y *ADA Compliant:* Y
Parking: Free parking.
Open: Monday, 10am-4pm;
 Wednesday to Saturday, 10am-4pm;
 Sunday, 1pm-4pm.
Closed: New Year's Day, Thanksgiving Day,
 Christmas Day.

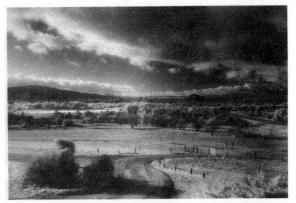

View from Phippen Museum of boulders and ranch lands on the outskirts of Prescott. Photograph courtesy of Phippen Museum, Prescott, Arizona.

Facilities: **Library**; **Ranch-style Building** (6,500 square feet); **Shop**.
Activities: **Education Program** (adults and children); **Guided Tours**; **Lectures**; **Temporary Exhibitions** (6 per year); **Traveling Exhibitions**.
Publications: gallery guides; newsletter, "Phippen Museum Newsletter" (triennial).

Resembling a rustic ranch house, the Phippen Museum contains an outstanding collection of historic art and artifacts by prominent Western artists, together with contemporary art depicting the American West by a variety of well-known artists.

The Prescott Fine Arts Gallery

Prescott Fine Arts Association
208 N. Marina at Willis, Prescott, AZ 86301
Tel: (520) 445-3286
Internet Address: http://www.az.arts.asu.edu.prescott
Director: Ms. Maureen Anderson
Admission: voluntary contribution.
Attendance: 4,000
Membership: Y *ADA Compliant:* N
Parking: free on site.
Open: Wednesday to Saturday, 11am-4pm;
 Sunday, noon-4pm.
Facilities: **Gallery**.
Activities: **Temporary Exhibitions**.

The Gallery presents approximately nine temporary exhibitions per year, featuring local artists or juried shows attracting artists from throughout the Southwest.

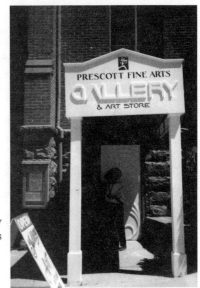

View of entrance, Prescott Fine Arts Gallery. Photograph courtesy of Prescott Fine Arts Gallery, Prescott, Arizona.

Scottsdale

Fleischer Museum

17207 N. Perimeter Drive (Pima and Bell Roads), Scottsdale, AZ 85255
Tel: (480) 585-3108
Fax: (480) 585-2225
Internet Address: http://www.fleischer.org
Director: Ms. Donna H. Fleischer

Scottsdale, Arizona

Fleischer Museum, cont.

Admission: voluntary contribution.
Attendance: 60,000 *Established:* 1990
Membership: N *ADA Compliant:* Y
Parking: free on site.
Open: Daily, 10am-4pm.
Closed: Legal Holidays.
Facilities: **Gallery**; **Library** (100 volumes).
Activities: **Guided Tours** (Monday-Friday, by appointment only); **Lectures**.
Publications: books - impressionism.

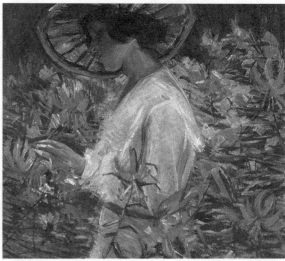

The Fleischer Museum is the first museum dedicated to American Impressionism, California School, the late 19th-century art style blending American and European elements. Initiated in California by formally trained, professional artists who traveled and painted internationally before settling in the west, their work is characterized by plein air painting, depicting the abundance of sunlight and brilliantly colored landscapes. The collection represents

Donna Norine Schuster, *In the Garden, 1917*, 30 x 30 inches, oil on canvas, detail. Fleischer Museum. Photograph courtesy of Fleischer Museum, Scottsdale, Arizona.

more than 80 artists from this period of American Impressionism. Included are works by Franz A. Bischoff, Paul Dougherty, Paul Lauritz, Edgar Alwin Payne, Hanson Duvall Puthuff, Arthur Grover Rider, Guy Rose, Christian von Schneidau, Donna Norine Schuster, J. Christopher Smith, Elmer Wachtel, and William Wendt.

Heard Museum North

El Pedregal Festival Marketplace, 34505 N. Scottsdale Road at Carefree Highway.
Scottsdale, AZ 85308-2038
Tel: (480) 252-8840
Internet Address: http://www.heard.org
Admission: fee (free admission to shop): adult-$2.00, child-$1.00.
Open: Monday to Saturday, 10am-5:30pm; Sunday, noon-5pm.
Facilities: **Gallery**; **Shop**.
Activities: **Temporary Exhibitions**.

Located at el Pedregal Festival Marketplace on Scottsdale Road and Carefree Highway in north Scottsdale, the Heard Museum North has one exhibit gallery and a museum shop. The gallery gives visitors a glimpse of the collection of the Heard Museum in downtown Phoenix, featuring changing exhibitions by Native American artists. Like the shop of the Heard Museum's main facility, the Museum Shop at the Heard Museum North includes a selection of authentic fine and craft art, purchased directly from Native American artists. For information on the Heard Museum, see Phoenix, Arizona.

Scottsdale Museum of Contemporary Art (SMOCA)

7373 Scottsdale Mall
(Scottsdale Civic Center and 2nd St.)
Scottsdale, AZ 85251
Tel: (480) 994-2787
Fax: (480) 874-4699
TDDY: (480) 994-2787
Internet Address: http://www.scottsdalearts.org
Director: Dr. Robert Knight
Admission: fee: adult-$5.00, child-free, student-$3.00.

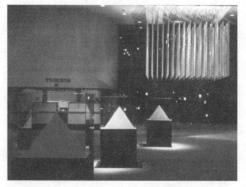

Dale Eldred, *Time Light Fusion*, Scottsdale Museum of Contemporary Art. Photograph courtesy of Scottsdale Center for the Arts, Scottsdale, Arizona.

Scottsdale Museum of Contemporary Art, cont.

Attendance: 380,000 *Established:* 1975 *Membership:* Y *ADA Compliant:* Y

Parking: free on site.

Open: Monday to Wednesday, 10am-5pm; Thursday to Saturday, 10am-9pm; Sunday, noon-5pm.

Closed: Legal Holidays.

Facilities: **Galleries** (5, 18,826 square feet); **Museum Store**; **Sculpture Garden** (6½ acres, 16 works of art, fountains); **Theatre** (838 seats).

Activities: **Arts Festival**; **Concerts**; **Education Program** (adults and children); **Films**; **Guided Tours**; **Lectures**; **Temporary Exhibitions** (4 per year); **Traveling Exhibitions**.

Publications: calendar (bi-monthly); exhibition catalogues; newsletter (monthly).

The Scottsdale Museum of Contemporary Art located on a site adjacent to the Scottsdale Center for the Arts. Pursuant to a design by The Studio of William P. Bruder Architect, Ltd., the former movie theatre has been transformed into a museum featuring five indoor galleries and an outdoor sculpture garden. The museum is international in scope and dedicated to collecting, preserving, exhibiting, and interpreting modern and contemporary art, architecture and design. Exhibitions focus on international modern/contemporary artists, with special emphasis given to artists living and working in Arizona, and include works from the City of Scottsdale's permanent collection of approximately 800 work of art. When considered in context with existing exhibition spaces in the Scottsdale Center for the Arts, the numerous exhibits of Scottsdale's public art program, and the satellite gallery at the Grayhawk Development in North Scottsdale, the Museum serves as the headquarters for a city-wide museum without walls. The Scottsdale Cultural Council, the parent organization of the Museum, is also responsible for the city's public art program, which commissions permanent works and temporary project spaces.

Sylvia Plotkin Judaica Museum of Temple Beth Israel

10460 North 56th St.
Scottsdale, AZ 85253

Tel: (480) 951-0323

Fax: (480) 951-7150

Internet Address:
 http://www.museum@templebethisrael.org

Director: Ms. Pamela Levin

Admission: donation: $3.00.

Attendance: 12,000 *Established:* 1967

Membership: Y *ADA Compliant:* Y

Open: Tuesday to Thursday, 10am-3pm.

Closed: Legal Holidays, Jewish Holidays.

Facilities: **Exhibition Area**.

Activities: **Education Programs**; **Films**; **Guided Tours**; **Permanent Exhibits**; **Temporary Exhibitions** (3/year).

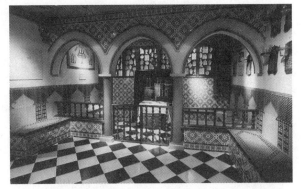

View of David and Belle Bush Gallery in Plotkin Judaica Museum, showing recreation of Tunisian synagogue using authentic artifacts donated by Steven Orlikoff. Photograph courtesy of Plotkin Judaica Museum, Scottsdale, Arizona.

The permanent collection at the Plotkin Judaica Museum consists of Jewish ceremonial art, Tunisian synagogue artifacts, and Jewish art of the 20th century. The Museum also mounts three temporary exhibitions per year.

Sedona

Sedona Arts Center, Inc. (SAC)

15 Art Barn Road (Highway 89A at Art Barn Road), Sedona, AZ 86336

Tel: (520) 282-3809

Fax: (520) 282-1516

Internet Address: http://www.amdest.com/az/sedona/sac/

Executive Director: Mr. Craig O. Thompson

Admission: voluntary contribution.

Attendance: 25,000 *Established:* 1961 *Membership:* Y

Parking: on campus and at Signagna Plaza.

Sedona Arts Center, Inc., cont.

Open: Monday to Saturday, 10am-4:30pm; Sunday, 11am-4pm.

Closed: Memorial Day, Independence Day, Labor Day, Thanksgiving Day, Christmas Day, New Year's Day.

Facilities: **Classrooms**; **Exhibition Gallery**; **Library** (15 volumes); **Shop**; **Studio** (ceramics/sculpture); **Theatre** (170 seats).

Activities: **Arts Festival** Sculpture Walk (annual, 1st weekend in October at Los Abrigados Resort); **Concerts**; **Docent Program**; **Education Program** (adults and children); **Films**; **Guided Tours**; **Lectures**; **Temporary Exhibitions**; **Traveling Exhibitions**.

Publications: class schedule (quarterly); exhibition catalogues (occasional); newsletter (bi-monthly).

The oldest, continuously operating art organization in northern Arizona, SAC presents temporary exhibitions in its gallery.

Surprise

West Valley Art Museum

17425 N. Avenue of the Arts, Surprise, AZ 85374-2579

Tel: (623) 972-0635

Fax: (623) 972-0456

Director: Dr. Wallace A. Steffan

Admission: fee: adult-$4.00, student-$1.00, senior-$3.00.

Attendance: 30,000 *Established:* 1980 *Membership:* Y *ADA Compliant:* Y

Parking: 203 spaces.

Open: Tuesday to Sunday, 10am-4pm.

Closed: Legal Holidays, Easter.

Facilities: **Food Services** Tea Room; **Gallery**; **Library** (2,050 volumes); **Museum Store**.

Activities: **Concerts**; **Education Program** (adults and children); **Guided Tours**; **Lectures**; **Temporary Exhibitions**; **Traveling Exhibitions**.

Publications: newsletter (monthly).

The Museum's permanent collection focuses on ethnic dress from throughout the world, American art (especially works of Henry Varnum Poor and George Resler), as well as Oriental art. It also mounts a variety of temporary exhibitions, including juried shows and traveling exhibitions.

Tempe

Arizona State University Art Museum

Matthews Center: Campus Center

Nelson Fine Arts Center: 10th St. & Mill Ave.

Tempe, AZ 85287-2911

Tel: (602) 965-2787

Fax: (602) 965-5254

Internet Address: http://www.asuam.fa.asu.edu

Director: Ms. Marilyn Zeitlin

Admission: free.

Attendance: 52,000 *Established:* 1950

Membership: Y *ADA Compliant:* Y

Open: **Matthews Center**,
Tuesday to Saturday, 10am-5pm.
Nelson Fine Arts Center,
Tuesday, 10am-9pm;
Wednesday to Saturday, 10am-5pm;
Sunday, 1pm-5pm.

Closed: Legal Holidays.

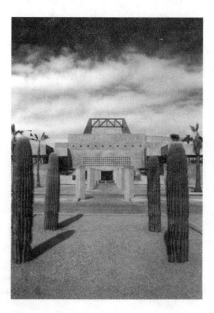

Exterior View of Arizona State University Art Museum, Nelson Fine Arts Center (1989), designed by Antoine Predock. Photograph courtesy of Arizona State University Art Museum, Tempe, Arizona.

Arizona State University Art Museum, cont.

Facilities: **Architecture** Nelson Fine Arts Center (Post-Modern building, 1989 design by Antoine Predock); **Exhibition Area** Matthews Center (4 galleries, permanent collection and experimental gallery, Nelson Fine Arts Center (5 galleries, changing exhibitions); **Library** (500 volumes); **Print Study Room; Reading Room; Sculpture Terraces and Court; Shop.**

Activities: **Education Programs; Film and Video Festival; Gallery Talks; Guided Tours; Lectures; Performances; Temporary Exhibitions; Traveling Exhibitions.**

Publications: exhibition catalogues.

The Museum is housed in two facilities: the Nelson Fine Arts Center and the Matthews Center. The Nelson Fine Arts Center, an elegant post modern building located on the edge of the campus, serves as the primary museum exhibition space. The Matthews Center, formerly the ASU library and located in the center of the campus, houses the University's permanent collection, the College of Fine Arts student-run galleries (Harry Wood, Northlight, and Step), and other exhibitions more relevant to the students. With a collection of over 8,500 objects, the Museum focuses on contemporary art (new media and innovative presentations), crafts (American ceramics and wood turned objects), prints (historic and contemporary - American and European), art from the Southwest with emphasis on Latino artists, and Latin American Art. Also of possible interest on campus is the Computing Commons Gallery, which presents exhibitions of technology-based artwork including national on-line computer art networks and holographic displays, as well as more traditional two-dimensional graphic presentations. (Monday-Friday, 10am-4pm; 965-3609).

Tempe Arts Center

54 West First St., Tempe, AZ 85281

Tel: (602) 968-0888

Fax: (602) 968-0888

Executive Director: Ms. Vicki Stouffer

Admission: voluntary contribution-$2.00.

Attendance: 250,000 *Established:* 1982 *Membership:* Y *ADA Compliant:* Y
Parking: 85 spaces on site.

Open: Tuesday to Sunday, noon-5pm.

Facilities: **Gallery** (800 square feet); **Sculpture Garden; Shop** (features handmade items by Arizona artists).

Activities: **Education Programs; Guided Tours** (reserve in advance); **Lectures; Temporary Exhibitions; Traveling Exhibitions.**

Publications: newsletter, "Centered on Art" (quarterly).

Tempe Arts Center is a private, nonprofit arts organization exhibiting contemporary crafts and sculpture by regionally, nationally, and internationally recognized artists. The Center operates a main gallery, sculpture garden, classroom, gift shop, and office in historic Tempe Beach Park in downtown Tempe. The Center also operates a satellite gallery at the Tempe Public Library.

Tubac

Tubac Center of the Arts

9 Plaza Road, Tubac, AZ 85646-1911

Tel: (520) 398-2371

Fax: (520) 398-9511

C.E.O.: Ms. Coleen Lester

Admission: voluntary contribution.

Attendance: 40,000 *Established:* 1963 *Membership:* Y *ADA Compliant:* Y
Parking: adjacent to Center, front and back.

Open: **September to May**, Tuesday to Saturday, 10am-4:30pm; Sunday, 1pm-4:30pm.

Closed: Memorial Day, Thanksgiving Day, Christmas Eve to Christmas Day,
 New Year's Eve to New Year's Day.

Facilities: **Galleries** (3,500 square feet); **Gallery Shop; Library.**

Activities: **Art Exhibitions; Art Sales; Film Series; Guided Tours; Lectures; Performances.**

Tubac, Arizona

Tubac Center of the Arts, cont.

Publications: newsletter.

From September to May, the Center sponsors a variety of member-artist, regional, and national exhibits in three galleries.

Tucson

De Grazia Gallery in the Sun

6300 N. Swan Road, Tucson, AZ 85718

Tel: (520) 299-9191

Fax: (520) 299-1381

Director: Mr. John Reyes

Admission: free.

Established: 1977

Membership: N *ADA Compliant:* Y

Open: Daily, 10am-4pm.

Closed: Easter, Thanksgiving Day,
 Christmas Day.

Facilities: **Galleries** (10 rooms); **Library**; **Shop**.

Activities: **Education Programs**; **Films**; **Guided Tours**; **Temporary Exhibitions**; **Traveling Exhibitions**.

View of Gallery in the Sun. Photograph courtesy of The De Grazia Foundation, Tucson, Arizona.

Publications: books; collection catalogue; exhibition catalogues.

Devoted to the work of a single artist, De Grazia, the Gallery in the Sun was designed by the artist and constructed under his supervision. The Gallery contains the largest and most complete collection of his art in existence. The size of this collection prevents it from being exhibited in its entirety. Therefore, the museum has developed a policy whereby certain rooms have been set aside for permanent exhibits, while other areas are dedicated to rotating exhibits. Beside the Gallery stands De Grazia's Mission in the Sun. The little chapel was built in honor of Padre Kino, and dedicated to Our Lady of Guadeloupe, patron saint of Mexico. The artist designed the building and carried out its construction.

Tucson Museum of Art (TMA)

140 N. Main Ave., Tucson, AZ 85701

Tel: (520) 624-2333

Fax: (520) 624-7202

Internet Address: http://www.tucsonarts.com

Director: Mr. Robert A. Yassin

Admission: fee: adult-$2.00, student-$1.00, senior-$1.00.

Attendance: 180,000 *Established:* 1924 *Membership:* Y *ADA Compliant:* Y

Parking: TMA pay lot across from main entrance.

Open: **Labor Day to Memorial Day**, Monday to Saturday, 10am-4pm; Sunday, noon-4pm.
 Memorial Day to Labor Day, Tuesday to Saturday, 10am-4pm; Sunday, noon-4pm.

Closed: Legal Holidays.

Facilities: **Architecture** (five historic homes, 1850-1906); **Food Services** (Café); **Galleries**; **Library** (6,000 volumes, daily, 10am-3pm); **Sculpture Garden**; **Shop** (featuring works by Arizona artists and craftspeople).

Activities: **Education Programs** (museum school - art classes, workshops); **Gallery Talks** (November-March: Monday and Thursday, 1:30pm in Art Education Building); **Lectures**; **Temporary or Traveling Exhibitions** (15-20/year focusing on the Art of the Americas).

Publications: brochures (quarterly); exhibition catalogues; newsletter (quarterly).

Situated on the site of Tucson's Spanish Presidio (established in 1775), the TMA Historic Block consists of the Museum Galleries and five of Tucson's most historic homes: La Casa Cordova, the Romero House, the newly renovated J. Knox Corbett House, the Stevens House, and the John

Tucson Museum of Art, cont.

K. Goodman Pavilion of Western American Art. As a regional museum, TMA focuses on the art of the Americas, with an emphasis on art related to the Southwest and its strong Hispanic and Native American traditions and history. This collections policy supports the Museum's mission to stress the importance of the diverse cultural and historic heritage of Tucson. The Museum maintains a permanent collection of more than 6,000 works of art. Each year the Tucson Museum of Art presents fifteen to twenty changing exhibitions of work in all media organized by the Museum or traveling exhibitions organized by other institutions. The focus of the collection is on art of the Americas, much of which is on permanent display. Main areas are Pre-Columbian, Spanish Colonial, and Hispanic Folk Arts (433 objects); The American West in 19th- and 20th-century Art (460 paintings, sculptures and works on paper, including works by Remington, Russell, Catlin, Weighorst, and Nicolai Fechin); 20th-century Art (2,200 pieces, including excellent examples of early 20th-century American masters such as Dove, Hartley, Bellows and Sloan; contemporary works by Southwestern artists with national reputations such as Luis Jimenez, Larry Bell, Bruce Nauman, and Harmony Hammond; important Mexican artists such as Cuevas and Rarfios-Martinez; and representative artists of Arizona).

The University of Arizona - Center for Creative Photography (CCP)

The University of Arizona, 1030 N. Olive
Tucson, AZ 85721-0103
Tel: (520) 621-7968
Fax: (520) 621-9444
Internet Address: http://www.ccp.arizona.edu/ccp.html
Director: Mr. Terence R. Pitts
Admission: free.
Attendance: 70,000 *Established:* 1975
Membership: Y *ADA Compliant:* Y
Parking:
 public pay in the visitors' section of Park Ave. garage.
Open: Monday to Friday, 11am-5pm;
 Sunday, noon-5pm.
Closed: Legal Holidays.
Facilities: **Gallery**; **Library** (15,000 volumes); **Photo Archives** (use by appointment with archivist); **Print Viewing Area** (available to public in afternoon, reserve in advance); **Shop** (books, cards, jewelry, posters and videos).
Activities: **Gallery Talks**; **Guided Tours** (groups reserve in advance with Curator of Education); **Lectures**; **Temporary Exhibitions** (approximately every 6 weeks); **Traveling Exhibitions**.
Publications: books; exhibition catalogues; serial publication, "The Archive".

Edward Weston, *Charis Wilson, 1935*, Center for Creative Photography. Photograph courtesy of Center for Creative Photography, The University of Arizona, Tucson, Arizona. Copyright 1989 Center for Creative Photography, Arizona Board of Regents.

Located on the campus of the University of Arizona, the Center for Creative Photography is a research institution and museum housing a collection of more than 60,000 fine prints, over 40 photographers' archives, galleries, a library and research facilities. Over 2,000 photographers are represented in the Center's extensive fine print collection. Included are works by Ansel Adams, Edward Weston, Louise Dahl-Wolfe, Richard Avedon, Lola Alvarez Bravo, W. Eugene Smith, and Diane Arbus.

The University of Arizona - Joseph Gross Gallery

Fine Arts Complex, Speedway and Park, Tucson, AZ 85721
Tel: (520) 626-4215
Fax: (320) 621-6930
Internet Address: http://www.arts.arizona.edu/galleries/
Curator: Ms. Julie Sasse
Admission: free.
Established: 1978

The University of Arizona - Joseph Gross Gallery, cont.

Parking: parking at visitor's garage.

Open: **September to April,**
Sunday, 1pm-4pm;
Monday to Friday, 10am-5pm.
May to August,
Monday to Friday, 10am-5pm.

Facilities: **Galleries** (2).

Activities: **Temporary Exhibitions.**

The Joseph Gross Gallery, located in the Fine Arts Complex, presents the work of students, faculty, and professional artists

Laurie Lundquist, *The Fisherman's Wife*, 1997, mixed media, 10 x 6 x 4 feet, "Surface Tension" mixed media installation, Joseph Gross Gallery. Photograph courtesy of The University of Arizona, Tucson, Arizona.

The University of Arizona Museum of Art (UAMA)

Park and Speedway, Tucson, AZ 85721

Tel: (520) 621-7567

Fax: (520) 621-8770

Internet Address: http://www.artmuseum.arizona.edu

Interim Director: Lee Karpisink

Admission: free.

Attendance: 30,000 *Established:* 1955 *Membership:* Y *ADA Compliant:* Y

Parking: garage on Park Ave. at corner of Speedway Blvd.

Open: **September to mid-May,** Monday to Friday, 9am-5pm; Sunday, noon-4pm.
May 15 to Labor Day, Monday to Friday, 10am-3:30pm; Sunday, noon-4pm.

Closed: University Holidays.

Facilities: **Galleries** (2 floors, 14,000 square feet); **Library**; **Shop** (books, catalogues, posters).

Activities: **Guided Tours**; **Lectures**; **Permanent Exhibits**; **Temporary Exhibitions**; **Traveling Exhibitions.**

Publications: collection catalogue; exhibition catalogues.

With more than 4,000 paintings, sculptures, drawings and prints, UAMA presents one of the most comprehensive university collections of Renaissance and later European and American Art in the Southwest. The permanent collection is complemented by a continuous series of temporary exhibitions, including crafts, graphics, painting and sculpture. Of particular note are the Samuel H. Kress Collection of 14th through early 19th-century European paintings, including 26 panels of a 15th-century Spanish altarpiece from the Cathedral of Ciudad Rodrigo and a permanent exhibit of 61 clay and plaster models and sketches by 20th-century sculptor Jacques Lipchitz. Other strengths of the collection include a concentration in American paintings and prints of the 1930's, modernist paintings from 1920-1970, more than 2,000 prints from the last five centuries, and more than 60 works on paper by Maynard Dixon and Paul Landacre, two important Southwestern artists from earlier in this century.

The University of Arizona Student Union Galleries

University of Arizona, Student Union Building, Tucson, AZ 85721

Tel: (520) 621-8046

Fax: (520) 621-6930

Internet Address: http://www.arts.arizona.edu/galleries/

Gallery Curator: Ms. Julie Sasse

Admission: free.

Attendance: 32,000 *Established:* 1971 *Membership:* N *ADA Compliant:* Y

Parking: pay parking at 2nd and Mountain Ave.

The University of Arizona Student Union Galleries, cont.

Open: Monday to Friday, 10am-4pm.

Closed: Legal Holidays, Installation Days.

Facilities: **Food Services** Restaurant; **Gallery**.

Activities: **Guided Tours** (upon request); **Temporary Exhibitions** (approximately 30/year); **Traveling Exhibitions**.

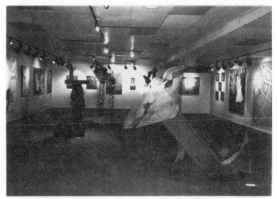

The three Union Galleries (Union, Rotunda and Arizona) function as an integral part of the Memorial Student Union, offering approximately 30 exhibitions annually. The galleries display original art by regional and national artists. Works in a variety of media are shown, including painting, sculpture, graphics, ceramics, fiberwork, and performance. Past exhibits include alumni art invitationals, juried student art competitions, student and faculty shows, and traveling and curated exhibitions.

View of Union Gallery during "Tucson Connection: Annual Alumni Invitational", November 1997. Photograph courtesy of University of Arizona Student Union Galleries, Tucson, Arizona.

Window Rock

Navajo Nation Museum

Highway 264 and Post Office Loop Road, Window Rock, AZ 86515

Tel: (520) 871-7941

Fax: (520) 871-7942

Deputy. Director: Geoffrey I. Brown

Admission: free, donations welcomed.

Attendance: 11,000 *Established:* 1961 *Membership:* N *ADA Compliant:* Y

Parking: free on site.

Open: Monday to Tuesday, 8am-5pm; Wednesday, 8am-8pm; Thursday to Friday, 8am-5pm; Saturday, 9am-5pm.

Closed: Legal Holidays, Tribal Holidays.

Facilities: **Conference Facilities**; **Shop** (books, gift items).

Activities: **Guided Tours**; **Temporary Exhibitions**; **Traveling Exhibitions**.

Publications: booklets, "Navajo - A Century of Progress".

The Museum's collection includes items of historical, artistic, ethnographic and archeological interest, including Navajo rugs, jewelry, baskets and pottery.

Arkansas

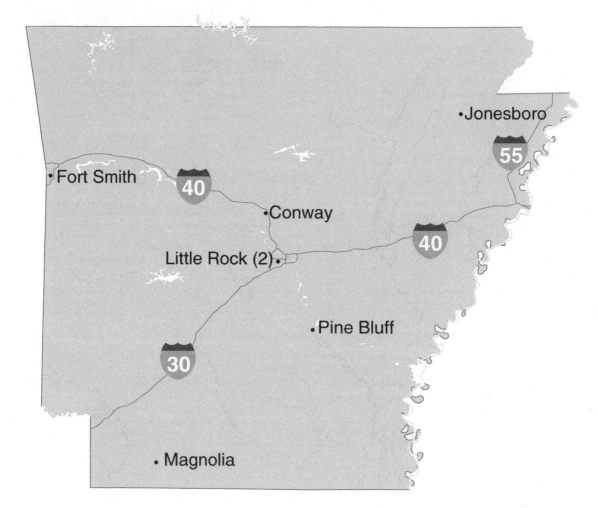

The number in parentheses following the city name indicates the number of museums/galleries in that municipality. If there is no number, one is understood. For example, in the text two listings would be found under Little Rock and one listing under Pine Bluff.

Arkansas

Conway

University of Central Arkansas - Baum Gallery of Fine Art

University of Central Arkansas, 201 Donaghey Ave., Conway, AR 72035

Tel: (501) 450-5793

Fax: (501) 450-5958

Internet Address:
 http://www.uca.edu/art/baumhome/index.htm

Gallery Director: Mr. Garlan Jenkens

Admission: free.

Attendance: 15,000 *Established:* 1994

Membership: Y *ADA Compliant:* Y

Parking: free, in blue zones in front of gallery.

Open: Monday, 10am-4pm;
 Tuesday, 10am-8pm;
 Wednesday to Saturday, 10am-4pm.

Closed: Academic Holidays.

Facilities: Galleries (5).

Activities: **Guided Tours**; **Temporary Exhibitions**.

Publications: brochures; exhibition catalogues.

Marshall Arisman, *El Salvadore aka Priest 589*, 1995, oil on paper, 30.5 x 38 inches. Baum Gallery of Fine Art. Photograph courtesy of Baum Gallery of Fine Art, University of Central Arkansas, Conway, Arkansas.

The Gallery presents approximately forty temporary exhibitions per year including major traveling exhibitions and changing shows drawn from its permanent collection. There are annual BFA and BA senior student expositions. The permanent collection includes works by Marshall Arisman, Roger Bowman, Dr. Andrew Cohen, Warren Criswell, Don Netzer. Laura Phillips, Julian Stanczak, and Larry Zox.

Fort Smith

Fort Smith Art Center (FSAC)

423 North 6th Street, Fort Smith, AR 72901

Tel: (501) 784-2787

Fax: (501) 784-9071

Administrative Director: Ms. Kay Dishner

Admission: voluntary contribution.

Attendance: 17,000 *Established:* 1948 *Membership:* Y *ADA Compliant:* Y

Parking: free on site.

Open: Tuesday to Saturday, 9:30am-4:30pm; Sunday, 1pm-4pm.

Closed: Independence Day, Labor Day, Thanksgiving Day, December 21 to January 2.

Facilities: **Gallery**; **Shop**.

Activities: **Education Programs**; **Gallery Talks**; **Guided Tours**; **Lectures**; **Temporary Exhibitions** (monthly); **Traveling Exhibitions**.

Publications: bulletin (monthly).

The Center features changing monthly exhibits of local regional and nationally recognized artists. The collection is primarily of two-dimensional art works and includes purchase award winners from annual competitions and works by regional artists. There is also a large collection of Boehm porcelain.

Jonesboro

Arkansas State University Art Gallery

Caraway Road, Jonesboro, AR 72467

Tel: (870) 972-3050 *Fax:* (870) 972-3932

Internet Address: http://www.astate.edu/docs/acad/cfa/art

Chairman, Department of Art: Mr. Curtis Steele

Arkansas State University Art Gallery, cont.

Admission: free.

Attendance: 3,600 *Established:* 1967 *Membership:* N *ADA Compliant:* Y

Parking: Free, with visitor's pass.

Open: Monday to Friday, 10am-4pm.

Closed: Legal Holidays.

Facilities: **Auditorium**; **Gallery** (1,600 square feet).

Activities: **Education Programs**; **Temporary Exhibitions** (4-6/year); **Traveling Exhibitions**; **Visiting Artist Program**.

Publications: calendar.

The Gallery exhibits the work of contemporary American and international artists in 4-6 shows during the academic year. In addition, there are an annual juried student exhibition, graduate thesis exhibitions, and an annual holiday sale. During the summer months selections from the university's permanent collection are exhibited. In the fall, the annual Delta National Small Prints Exhibition, a national juried competition, is on display.

Little Rock

The Arkansas Arts Center

MacArthur Park (9th and Commerce Streets), Little Rock, AR 72202

Tel: (501) 372-4000

Fax: (501) 375-8053

Internet Address: http://www.arkarts.com

Director and Chief Curator: Mr. Townsend Wolfe

Admission: voluntary contribution.

Attendance: 350,000 *Established:* 1937 *Membership:* Y *ADA Compliant:* Y

Open: Wednesday, 10am-5pm; Thursday to Friday, 10am-8:30pm; Saturday, 10am-5pm; Sunday, 11am-5pm.

Closed: Christmas Day.

Facilities: **Food Services** Restaurant; **Library** (7,000 volumes); **Shop**; **Theatre** (389 seats).

Activities: **Education Programs**; **Gallery Talks**; **Guided Tours**; **Lectures**; **Temporary Exhibitions**; **Traveling Exhibitions**.

Publications: calendar; collection catalogue; exhibition catalogues; members bulletin.

Both a museum of art and an arts center, the Center offers temporary exhibitions and education programs in the visual and performing arts. The permanent collection includes modern prints, photography, paintings, drawings, and sculpture.

University of Arkansas at Little Rock Art Galleries (UALR Art Galleries)

Department of Art, 2801 S. University

Little Rock, AR 72204-1099

Tel: (501) 569-3182

Fax: (501) 569-8775

Internet Address:
 http://www.ualr.edu/~artdept/gallery.html

Gallery Curator: Ms. Shannon Dillard Mitchell

Admission: free.

Attendance: 7,500 *Established:* 1972

Membership: N *ADA Compliant:* Y

Open: **Academic Year**,
 Monday to Friday, 9am-5pm;
 Sunday, 2pm-5pm.

Closed: Legal Holidays, Christmas Week, Academic Holidays.

Facilities: **Galleries** (3, total 4,100 square feet).

UALR Gallery during a faculty exhibition. Photograph courtesy of University of Arkansas at Little Rock, Department of Art, Little Rock, Arkansas.

University of Arkansas at Little Rock Art Galleries, cont.

Activities: **Education Programs** (tours and workshops for k-12 students); **Gallery Talks** (with visiting artists); **Lectures** (usually in evening with guest lecturers or visiting artists); **Temporary Exhibitions**; **Traveling Exhibitions**.

Publications: calendar (biennial); exhibition catalogues.

UALR presents temporary and traveling exhibitions in three galleries.

Magnolia

Southern Arkansas University - Art Gallery

Brinson Fine Arts Building, State Route 355, Magnolia, AR 71753

Tel: (870) 235-4242

Fax: (870) 235-5005

Internet Address: http://www.saumag.edu

Admission: free.

Open: Call for hours.

Facilities: Exhibition Area.

Activities: **Temporary Exhibitions**.

The Gallery exhibits work by artists of national and international reputation, faculty, and students. There are also periodic visits by artists and other art professionals each semester.

Pine Bluff

The Arts & Science Center for Southeast Arkansas

701 Main Street at 8th Street
Pine Bluff, AR 71601

Tel: (870) 536-3375

Fax: (870) 536-3380

Executive Director: Ms. Mary Brock

Admission: free.

Attendance: 43,000 *Established:* 1968

Membership: Y *ADA Compliant:* Y

Parking: ample on site.

Open: Monday to Friday, 10am-5pm;
Saturday to Sunday, 1pm-4pm.

Closed: New Year's Day, Easter, Independence Day, Thanksgiving Day, Christmas Eve to Christmas Day.

Exterior view of The Arts and Science Center (1994), designed by A.W. Nelson - Nelson Architectural Group Inc. Photograph courtesy of The Arts and Science Center, Pine Bluff, Arkansas.

Facilities: **Galleries** (4); **Library** (100 volumes); **Studio Classroom**; **Theatre** (232 seats).

Activities: **Arts Festivals**; **Concerts**; **Dance Recitals**; **Education Programs**; **Film Series**; **Gallery Talks** (occasional during openings and by arrangement); **Guided Tours** (reserve in advance, $0.75/person); **Permanent Art Collection**; **Temporary Exhibitions**.

Publications: annual report; brochures; calendar (monthly); exhibition catalogues; newsletter (bi-monthly).

The Center provides opportunities for the practice, teaching, performance, enjoyment and understanding of the arts and sciences. Temporary art exhibits draw from the permanent collection; local arts organizations; and regional, national and international artists. With over 1,000 works, the permanent collection, while focusing on Arkansas artists, African-American artists, and representers of the Delta culture, includes international artists as well.

California

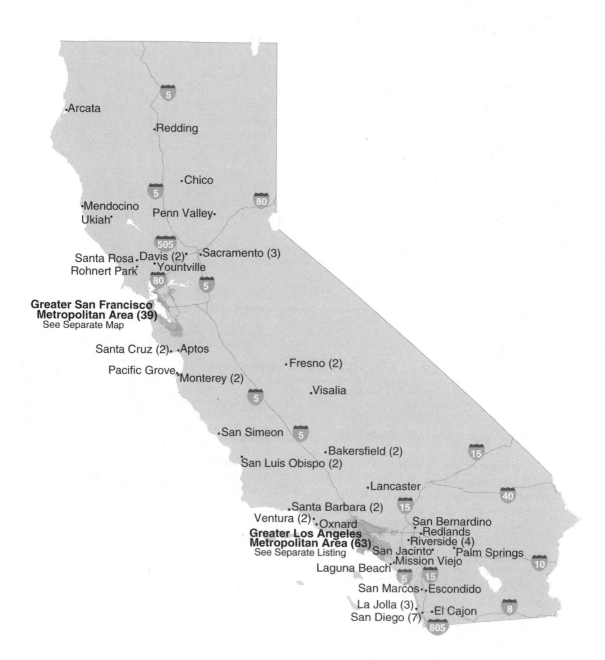

- •Arcata
- •Redding
- •Chico
- •Mendocino
- Ukiah•
- Penn Valley•
- Santa Rosa •Davis (2)• •Sacramento (3)
- Rohnert Park• •Yountville
- **Greater San Francisco**
- **Metropolitan Area (39)**
- See Separate Map
- Santa Cruz (2)• •Aptos
- Pacific Grove•
- Monterey (2)
- •Fresno (2)
- •Visalia
- •San Simeon
- •Bakersfield (2)
- San Luis Obispo (2)
- •Lancaster
- •Santa Barbara (2)
- Ventura (2)•
- •Oxnard
- **Greater Los Angeles**
- **Metropolitan Area (63)**
- See Separate Listing
- San Bernardino
- •Redlands
- •Riverside (4)
- San Jacinto• •Palm Springs
- •Mission Viejo
- Laguna Beach•
- San Marcos••Escondido
- La Jolla (3)•
- San Diego (7)• •El Cajon

The number in parentheses following the city name indicates the number of museums/galleries in that municipality. If there is no number, one is understood. For example, in the text four listings would be found under Riverside and one listing under Palm Springs. Cities within the greater Los Angeles and San Francisco metropolitan areas will be found on the respective maps on the facing page.

Greater Los Angeles Metropolitan Area

(including Brea, Carson, Claremont, Costa Mesa, Downey, Fullerton, Glendale, Irvine, Long Beach, Los Angeles, Malibu, Monterey Park, Newport Beach, Northridge, Ontario, Orange, Pasadena, Pomona, Rancho Cucamonga, Rancho Palos Verdes, San Marino, Santa Ana, Santa Monica, Torrance, and Walnut.)

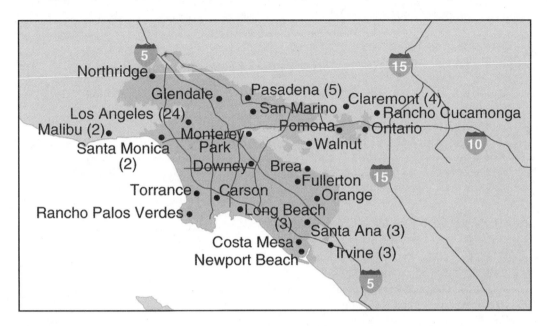

Greater San Francisco Metropolitan Area

(including Belmont, Berkeley, Cupertino, Hayward, Moraga, Oakland, Palo Alto, Richmond, San Francisco, San Jose, Santa Clara, Stanford, and Walnut Creek)

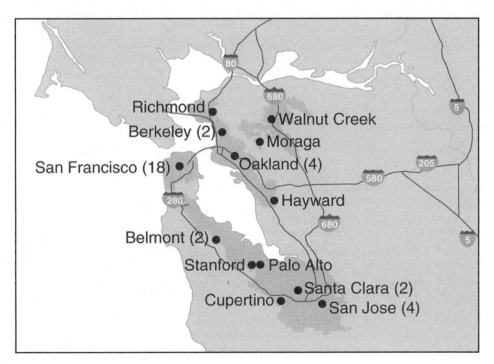

California

Aptos

Cabrillo College Art Gallery

Room 1002, 6500 Soquel Drive, Aptos, CA 95003
Tel: (831) 479-6308
Fax: (831) 479-5045
Internet Address: http://www.cabrillo.cc.ca.us/divisions/vapa/artgallery/
Director: Mr. Tobin Keller
Attendance: 10,000 *Established:* 1972 *ADA Compliant:* Y
Parking: metered parking.
Open: Monday, 9am-4pm; Tuesday, 9am-4pm & 7pm-10pm; Wednesday, 9am-4pm;
 Thursday, 9am-4pm & 7pm-10pm; Friday, 9am-4pm.
Facilities: **Exhibition Area** (1,300 square feet).
Activities: **Temporary Exhibitions**; **Traveling Exhibitions**.
Publications: announcements (occasional).

The Cabrillo College Art Gallery mounts temporary and traveling exhibitions consisting of the work of nationally- and internationally-recognized artists in a diversity of media.

Arcata

Humboldt State University - Reese Bullen Gallery

Humboldt State University, Art Building 101, 1 Harpst Street, Arcata, CA 95521
Tel: (707) 826-5802
Fax: (707) 826-3628
Internet Address: http://www.humboldt.edu/~artrbg/
Gallery Director: Mr. Martin Morgan
Admission: free.
Attendance: 5,000 *Established:* 1970 *Membership:* N *ADA Compliant:* Y
Open: **September to May**, Monday to Friday, 11am-4pm.
Closed: Academic Holidays.
Facilities: **Gallery** (1,500 square feet).
Activities: **Education Programs**; **Guided Tours**; **Loan Exhibitions**; **Temporary Exhibitions**.
Publications: exhibition catalogues.

The gallery features changing exhibitions of works by significant modern and contemporary artists. There are annual juried student and senior student exhibitions. A second, smaller facility, the Foyer Gallery, is also on campus.

Bakersfield

Bakersfield Museum of Art

1930 R Street, Bakersfield, CA 93301
Tel: (805) 323-7219
Fax: (805) 323-7266
Internet Address: http://www.csub.edu/bma
Executive Director: Mr. Charles G. Meyer
Admission:
 fee: adult-$4.00, student-$2.00, senior-$2.00.
Attendance: 13,500 *Established:* 1987
Membership: Y *ADA Compliant:* Y
Open: Tuesday to Saturday, 10am-4pm;
 Sunday, noon-4pm.
Closed: August, New Year's Day, ML King Day,
 President's Day, Independence Day,
 Labor Day, Thanksgiving Day,
 Christmas Day.
Facilities: **Library** (700 volumes); **Shop.**

Artist's rendering of planned addition to Bakersfield Museum of Art, scheduled for completion in Winter, 1999. Picture courtesy of Bakersfield Museum of Art, Bakersfield, California.

Bakersfield Museum of Art, cont.

Activities: Arts Festival; Education Programs; Films; Gallery Talks; Guided Tours; Lectures; Temporary Exhibitions; Traveling Exhibitions.

Publications: exhibition catalogues; newsletter (bi-monthly); posters.

The Museum mounts several temporary exhibitions each year, which include works by artists of national and international reputation. Its permanent collection focuses on works on paper by California artists.

California State University, Bakersfield - Todd Madigan Gallery

9001 Stockdale Highway (adjacent to the Dore Theatre), Bakersfield, CA 93301

Tel: (805) 664-2238

Fax: (805) 665-6901

Internet Address: http://academic.csubak.edu/home/acadpro/departments.art/Toad.htm

Director: Ms. Margaret Nowling

Admission: free.

Established: 1981 *ADA Compliant:* Y

Parking: limited.

Open: **mid-September to mid-June**, Tuesday to Thursday, noon-4pm; Saturday, 1pm-4pm.

Closed: mid-June to mid-September, University Holidays.

Facilities: Gallery.

Activities: Temporary Exhibitions.

The Madigan Gallery presents temporary exhibitions of works of professional artists, the CSUB faculty, and students. Previous exhibits have featured the works of Henri Matisse, John Altoon, Cézanne, Goya, Rembrandt, Titian, and Mary Kelley, as well as many others. A listing of Gallery events and exhibits is published quarterly and may be obtained by contacting the Fine Arts Office at (805) 664-3093.

Belmont

College of Notre Dame - The Wiegand Gallery

College of Notre Dame, Madison Art Center, 1500 Ralston Ave., Belmont, CA 94002-1997

Tel: (650) 508-3595

Fax: (650) 508-3488

Internet Address: http://www.cnd.edu

Director: Mr. Charles Strong

Admission: voluntary contribution.

Attendance: 3,600 *Established:* 1970 *Membership:* Y *ADA Compliant:* Y

Parking: free on site.

Open: Tuesday to Saturday, noon-4pm.

Closed: Between Exhibitions, Major Holidays.

Facilities: Gallery; Theatre (40 seats).

Activities: Gallery Talks; Lectures (artist talks); Traveling Exhibitions (4/year).

Publications: exhibition catalogues.

Exterior, Wiegand Gallery - Madison Art Center. Photograph courtesy of Wiegand Gallery, Belmont, California.

The Gallery is housed in the Madison Art Center, a stone building that was originally built as a carriage house on the site of the country estate of 19th-century financier William Chapman Ralston. The exhibition space, with its porthole windows and skylights, is an unusually warm, inviting environment in which to experience art. The Gallery is dedicated to changing exhibitions that exemplify a broad range of artistic expression. As a venue for California and Bay Area 20th-century art, the Gallery has promoted the work of emerging younger artists, mid-career artists, and unusual or rarely seen work by such established artists as Elmer Bischoff, Joan Brown, Richard Diebenkorn, Paul Kos, James Melchert, Manuel Neri, Katherine Porter, Hassel Smith, and Wayne Thiebaud.

Belmont, California

The San Mateo County Arts Council

1219 Ralston Ave., Belmont, CA 94002
Tel: (415) 595-2787
Fax: (415) 593-4716
Exec. Director: Mr. Matias Varelas
Admission: voluntary contribution.
Attendance: 70,000 *Established:* 1972
Membership: Y *ADA Compliant:* Y
Open: Monday to Friday, 9am-5pm; Sunday, 1pm-4pm.
Closed: Legal Holidays.
Facilities: **Galleries**; **Shop**.
Activities: **Arts Festival**; **Concerts**; **Films**; **Gallery Talks**; **Guided Tours** (by appointment); **Juried Competition** ("Bay Arts", area-wide juried competition); **Lectures**; **Open Studios** (annual tour of artists' studios).
Publications: "Guide to San Mateo County Arts Organizations"; newsletter, "The Newscalendar" (monthly).

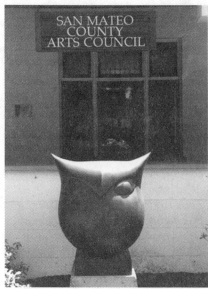

Headquartered at Twin Pines Manor, a 26-room restored mansion, the Council operates galleries and studios, hosts exhibit openings, seminars, and studio art classes. At Twin Pines, the Council schedules rotating contemporary exhibitions in the Manor House Gallery and maintains a Craft Gallery. Temporary exhibitions are also scheduled at The Corridor Gallery at the San Mateo County Government Center.

Exterior view of entrance, San Mateo County Arts Council. Photograph courtesy of San Mateo County Arts Council, Belmont, California.

Berkeley

Judah L. Magnes Memorial Museum

2911 Russell Street, Berkeley, CA 94705
Tel: (510) 549-6950
Fax: (510) 849-3673
Internet Address: http://www.jfed.org/magnes/magnes
Director and C.E.O.: Susan Morris
Admission: suggested contribution-$3.00.
Attendance: 15,000 *Established:* 1962
Membership: Y *ADA Compliant:* Y
Parking: plentiful on street parking.
Open: Sunday to Thursday, 10am-4pm.
Closed: Federal Holidays, Jewish Holidays.
Facilities: **Archives** (Western Jewish History Center); **Library** (10,000 volumes on Judaica); **Shop** (handcrafted Judaica, gifts, books, cards).
Activities: **Guided Tours** (docents available Wednesday and Sunday; group tours by appointment); **Lecture Series**; **Poetry & Video Competitions** (Jewish themes); **Temporary Exhibitions**; **Traveling Exhibitions**.
Publications: books; collection catalogue; exhibition catalogues.

The Judah L. Magnes Museum collects, preserves, and exhibits treasures of Jewish art, history, and culture from around the world and encourages intercultural dialogue. The permanent collection galleries display rare treasures from synagogues, textiles and holiday objects used in Jewish homes in many countries and

Rimonin (Torah finials), made by Franz Anton Gutwein, Augsburg, 1799-1800, silver. Permanent Ceremonial Objects Collections, Magnes Museum. Photograph courtesy of Magnes Museum, Berkeley, California.

times, and materials documenting periods of persecution of the Jews. Changing exhibitions in the Reutlinger and Koshland galleries feature the work of Jewish artists and highlight Jewish history, culture, and communities. Group and individual shows present innovative contemporary art. Important exhibitions from the Israel Museum, the Jewish Museum of Amsterdam, the Smithsonian Institution,

Judah L. Magnes Memorial Museum, cont.

and other renowned museums are regularly presented. In its permanent collections are over 10,000 objects of Jewish ceremonial art, folk art, and fine art, including paintings, sculpture, prints, and drawings by Moritz Daniel Oppenheim, Marc Chagall, Max Liebermann, Issachar Ryback, Raphael Soyer, and many other artists. Museum libraries house thousands of rare books, manuscripts, photographs, and the archives of the Western Jewish History Center.

University of California, Berkeley Art Museum & Pacific Film Archive (BAM/PFA)

University of California, 2626 Bancroft Way
Berkeley, CA 94704
Tel: (510) 642-0808
Fax: (510) 642-4889
TDDY: (510) 642-8734
Internet Address:
 http://www.bampfa.berkeley.edu
Director: Mr. Kevin E. Consey
Admission: fee: adult-$6.00, child-$4.00,
 student-$4.00, senior-$4.00.
Attendance: 260,000 *Established:* 1965
Membership: Y *ADA Compliant:* Y
Parking:
 metered on street and nearby public lots.
Open: Wednesday to Sunday, 11am-5pm;
 Thursday, 11am-9pm.
Closed: Academic Holidays.
Facilities: **Food Services** (Monday-Sunday, 11am-4pm); **Library** (film reference); **Sculpture Garden**; **Shop**; **Theatre** (234 seat).

View of Durant Avenue entrance, University of California, Berkeley Art Museum and Pacific Film Archive, with bronze sculpture "Rotante dal foro centrale" (1971) by Arnaldo Pomodoro. Photograph by Ben Blackwell, courtesy of University of California, Berkeley.

Activities: **Films**; **Gallery Talks**; **Lectures**; **Temporary Exhibitions**.
Publications: brochures; calendar (bi-monthly); exhibition catalogues.

The University of California, Berkeley Art Museum and Pacific Film Archive is the university's principal visual arts center and one of the largest university art museums in the United States. Its distinctive building, designed by Mario Ciampi & Associates (San Francisco) and completed in 1970, arranges fan-shaped galleries in overlapping terraces that provide views of artwork from different perspectives. International in scope, the museum's permanent collection of over 10,000 objects comprises a full range of art. Selections from the collection are on view year-round, together with special and traveling exhibitions. Its cutting-edge MATRIX program explores contemporary art in a series of exhibitions that form a continuous survey. Each spring, the museum mounts an exhibition of work by Master of Fine Arts students. The Pacific Film Archive offers one of the nation's most comprehensive academic film programs. PFA's daily exhibition program emphasizes excellence and diversity. It highlights challenging works of independent film and video, and rare archival prints of classic cinema, and premiers, retrospectives, and rediscoveries from world cinema. A complementary education program of guided tours, lectures, symposia, and other special events is an important facet of the museum's outreach to the Berkeley campus and to the entire Bay Area. PFA Information (24-hours): (510) 642-1124. The U.C. Berkeley Art Museum has developed an impressive art collection of paintings, sculptures, and works on paper. The collection contains works by old masters such as Peter Paul Rubens, Giovanni Savoldo, and Giovanni Caracciolo; important collections of American primitive painting and early California landscapes; and a significant collection of European and American prints and drawings. Early 20th-century masters such as Fernand Léger, René Magritte, Aristide Maillol, and Joan Miró are represented. Of particular note is its collection of late twentieth-century art, including works by Alexander Calder, Mark Rothko, Helen Frankenthaler, Hans Hoffman, Theresa Kyung Cha, Nancy Spero, David Ireland, and Nayland Blake. The Museum also houses an outstanding Asian art collection of paintings, drawings, woodblock prints, sculpture, and ceramics, primarily from China, Japan and India. The Pacific Film Archive maintains a collection of 7,000 titles, with strengths in Soviet, American avant-garde, and Japanese cinema.

Brea

City of Brea Gallery

One Civic Center Circle, Brea, CA 92621
Tel: (714) 990-7730
Fax: (714) 990-2258
Gallery Director: Ms. Janice Ledgerwood
Admission: fee-$1.00.
Attendance: 16,000 *Established:* 1980 *Membership:* N *ADA Compliant:* Y
Parking: ample free parking below the gallery.
Open: Wednesday, noon-5pm; Thursday to Friday, noon-8pm; Saturday to Sunday, noon-5pm.
Closed: Legal Holidays.
Facilities: **Art in Public Places Program** (catalogue with self-guided tour available, (714) 990-7177); **Gallery**; **Shop** (featuring work by regional artists).
Activities: **Children's Art Space** (hands-on children's gallery); **Juried Exhibits**.
Publications: brochures; newsletter.

The City of Brea Gallery presents exhibitions throughout the year, including an annual open competition and a watercolor exhibition. The City also has an Art in Public Places Program, which has placed 110 sculptures in public view throughout the city. This sculpture collection features a wide range of media, styles and approaches by prominent and emerging artists.

Carson

California State University, Dominguez Hills - University Art Gallery

1000 E. Victoria St., Carson, CA 90747
Tel: (310) 243-3334
Fax: (310) 217-6967
Internet Address: http://www.csudh.edu
Director: Ms. Kathy Zimmerer
Admission: free.
Attendance: 10,000 *Established:* 1978 *Membership:* Y *ADA Compliant:* Y
Parking: permit parking all CSU lots - $2.00.
Open: **September to May**, Monday to Thursday, 9:30am-4:30pm.
Closed: Academic Holidays.
Facilities: **Gallery** (2,150 square feet).
Activities: **Education Programs**; **Guided Tours** (upon request); **Lectures**; **Temporary Exhibitions** (6/year).
Publications: exhibition catalogues (3/year); newsletter, "Art Department Newsletter" (annual).

The University Art Gallery is considered to be one of the major exhibition spaces of the South Bay area. The gallery supports and enhances the Art Department instructional program while giving students from other disciplines and interested community members a valuable opportunity to explore and experience contemporary and historical works of art. The gallery, with over 2,000 square feet of floor space and 18 foot high ceilings, accommodates large-scale paintings and sculptures by artists of local and national reputation. There are five exhibitions per year with an emphasis on multi-cultural art and artists and an annual art exhibition of work by BA graduates. In conjunction with the exhibitions program, the Art Gallery publishes three exhibition catalogues per year and sponsors a related guest lecture series. The Gallery is also often used as a forum for student art critique classes, discussions with artists, and university and community events, and provides tours to the community and schools. The Gallery does not maintain a permanent collection.

Chico

California State University, Chico - Janet Turner Print Collection & Gallery

California State University, Chico, Laxson Auditorium, 1st and Salem Streets, Chico, CA 95929
Tel: (530) 898-4476
Fax: (530) 898-4082
Internet Address: http://www.csuchico.edu/hfa/hfa/Janet/html

California State University, Chico - Turner Print Collection & Gallery. cont.

Curator: Ms. Catherine Sullivan Sturgeon
Admission: free.
Attendance: 5,000 *Established:* 1981
Membership: Y *ADA Compliant:* Y
Parking: municipal lot near site.
Open: Monday to Friday, 11am-4pm;
and during auditorium events.
Facilities: Auditorium; Gallery; Library (150 volumes).
Activities: Gallery Talks; Lectures.

Located on the campus of California State University, Chico in the mezzanine of Laxson Auditorium, the Gallery presents temporary exhibitions, including an annual "Student Printmakers Invitational and Collection Acquisition Competition" each spring. Prints from the collection are also displayed in cases on the first floor of Ayres Hall, where most CSU, Chico art classes are held. The collection consists of approximately 2,700 original prints representing a spectrum of printmaking techniques from over forty countries and spanning six centuries.

Kitagawa Utamaro, *Woman with Child*, Japanese color relief wood cut. Turner Print Collection & Gallery. Photograph courtesy of Turner Print Collection & Gallery, California State University, Chico, California.

Claremont

Claremont Graduate School - East and West Galleries

251 East 10th St., Claremont, CA 91711
Tel: (909) 621-8071
Internet Address: http://www.cgu.edu/arts/art/calendar.html
Director: Mr. Dean DeCocker
Open: Call for hours.
Facilities: Exhibition Area.
Activities: Lectures; Temporary Exhibitions.

The Claremont Graduate School presents temporary exhibitions of the work of professional artists, faculty and students in two galleries, Peggy Phelps Gallery (West Gallery) and East Gallery.

Pomona College - Montgomery Gallery

330 N. College Ave., Claremont, CA 91711-6344
Tel: (909) 621-8283
Fax: (909) 621-8989
Internet Address: http://www.pomona.edu/montgomery
Director: Ms. Marjorie L. Harth
Admission: free.
Attendance: 9,000 *Established:* 1958
Membership: N *ADA Compliant:* Y
Parking: on street.
Open: Tuesday to Friday, noon-5pm; Saturday
to Sunday, 1pm-5pm.
Closed: Academic Holidays, Legal Holidays,
Summer.

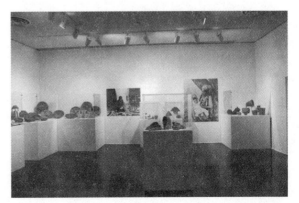

From the exhibition "Rich Traditions Continue: The Arts of Native American Woman", Montgomery Gallery, 11/9-12/14/97, works from the Pomona College permanent collection. Photograph courtesy of Montgomery Gallery - Pomona College, Claremont, California.

Pomona College - Montgomery Gallery, cont.

Facilities: Gallery.

Activities: Gallery Talks; Guided Tours; Lectures; Temporary Exhibitions; Traveling Exhibitions.

Publications: exhibition catalogues.

Montgomery Gallery displays the permanent collections of Pomona College, presents a schedule of temporary exhibitions during the academic year, trains students in museum practice, and participates actively in the teaching mission of the College. The Pomona College collections number approximately 8,000 objects. Important holdings include the Kress Collection of 15th- and 16th-century Italian panel paintings; over 5,000 examples of pre-Columbian to 20th-century Native American art and artifacts (ceramics, baskets, and beadwork); a large collection of American and European prints, drawings and photographs; and contemporary painting and sculpture.

Scripps College - Clark Humanities Museum - Study

Humanities Building, Scripps College, 1030 Columbia Avenue, Claremont, CA 91711

Tel: (909) 607-3606

Fax: (909) 621-8323

Internet Address: http://www.scrippscol.edu

Chairman, Museum Committee: Dr. Eric T. Haskell

Admission: free.

Established: 1970 *Membership:* N

Open: Monday to Friday, 9am-noon & 1pm-5pm.

Closed: Academic Holidays.

Facilities: Gallery; Library.

Activities: Education Programs; Temporary Exhibitions.

Publications: exhibition catalogues.

The Museum's collection includes American paintings, Japanese prints, and African Sculpture.

Scripps College - Ruth Chandler Williamson Gallery

Millard Sheets Art Center, 9th and Columbia Ave., Claremont, CA 91711-3948

Tel: (909) 607-3517

Fax: (909) 621-8323

Internet Address: http://www.scrippscol.edu/~dept/ gallery/wrwgallery/GalleryHome.html

Director: Ms. Mary Davis MacNaughton

Admission: free.

Attendance: 7,700 *Established:* 1993

Membership: N *ADA Compliant:* Y

Open: Wednesday to Sunday, 1pm-5pm.

Closed: Legal Holidays,
December 17 to January 2,
June 1 to August 30.

Facilities: Gallery (3,000 square feet, designed by Anshen and Allen).

Activities: Education Programs; Films; Gallery Talks; Lectures; Temporary Exhibitions; Traveling Exhibitions.

Publications: "Revolution in Clay: The Marer Collection of Contemporary Ceramics"; exhibition catalogues; "Alison and Lezley Saar"; "Ceramic Annual 2000".

Jun Kaneko, *Plate*, 1971, stoneware, raku fired, partially glazed, Scripps College, Marer Collection. Photograph by Susan Einstein, courtesy of Ruth Chandler Williamson Gallery, Scripps College, Claremont, California.

Scripps College - Ruth Chandler Williamson Gallery, cont.

The Ruth Chandler Williamson Gallery presents both historical and contemporary exhibitions in a variety of media. Each year, the Gallery presents the Scripps Ceramic Annual, which is the best known and longest running exhibition of contemporary ceramics in the United States. In conjunction with this exhibition, the Gallery presents an artist panel discussion. Other activities include exhibition-related lectures, symposia, films, gallery talks, and a large Clay Day and Music Festival. The gallery presents loan exhibitions and participates in inter-museum loans. Juried student and senior studio art major exhibitions are held annually in the spring. The permanent collection consists of the General Edward Clinton Collection of American paintings and works on paper; the Dr. and Mrs. William E. Ballard Collection of Japanese prints; the Fred and Estelle Marer Collection of Japanese prints and contemporary American, British, Korean, Mexican, and Japanese ceramics; the Mary Wig and James Johnson Collections of Japanese prints; the Dorothy Adler Routh Collection of cloisonné; the Wagner Collection of African sculpture; and American prints, drawings and photographs.

Costa Mesa

Orange County Museum of Art - South Coast Plaza Gallery (OCMA)

3333 Bristol St., Suite 1000 (Carousel Court entrance), Costa Mesa, CA 92626
Tel: (714) 662-3366
Internet Address: http://www.ocma.net
Director: Dr. Naomi Vine
Open: Monday to Friday, 10am-9pm; Saturday, 10am-7pm; Sunday, 11:30am-6:30pm.
Closed: New Year's Day, Independence Day, Thanksgiving Day, Christmas Day.
Facilities: Gallery.
Activities: Temporary Exhibitions.

OCMA features a permanent collection of California art from the turn of the century through today, an array of changing exhibitions, and education programs at two locations, Costa Mesa and Newport Beach (see separate listing).

Cupertino

De Anza College - Euphrat Museum of Art

De Anza College, 21250 Stevens Creek Blvd., Cupertino, CA 95014
Tel: (408) 864-8836
Fax: (408) 864-8738
Internet Address: http://wwwdeanza.fhda.edu/Euphrat
Director: Jan Rindfleisch
Admission: voluntary contribution.
Attendance: 10,000 *Established:* 1971 *Membership:* Y *ADA Compliant:* Y
Open: Late Sept. to Mid-June,
 Tuesday to Thursday, 11am-4pm; Wednesday, 11am-4pm and 6pm-8pm;
 Saturday, 11am-2pm.
Facilities: Gallery; Library (300 volumes).
Activities: Education Programs; Guided Tours (groups by appointment); Lectures; Temporary Exhibitions; Traveling Exhibitions.
Publications: booklets (annual).

The Museum houses a collection of contemporary art in a variety of media and presents traveling and community exhibitions.

Davis

Pence Gallery

212 D Street, Davis, CA 95616
Tel: (530) 758-3370 *Fax:* (530) 758-4670e
Director: Ms. Nancy M. Servis
Admission: free.
Attendance: 6,500 *Established:* 1975 *Membership:* Y *ADA Compliant:* Y

Davis, California
Pence Gallery, cont.
Parking: on street.
Open: **September to July**,
Tuesday to Saturday, noon-4pm.
Closed: New Year's Day, August,
Thanksgiving Day, Christmas Day.
Facilities: **Gallery** (450 square feet); **Outdoor Stage**.
Activities: **Art Auction**; **Concerts and Performances** (on outdoor stage, day and evening, mainly spring and fall); **Gallery Talks** (monthly); **Lecture Series**; **Temporary Exhibitions** (monthly); **Tours** (artists' studios, gardens, local art museums).
Publications: exhibition catalogues; newsletter, "PENCEvents" (quarterly).

Marc Lancet, *Untitled, Torso JEFB Series*, 1997, Pence Gallery. Exterior view of Pence Gallery in background. Photograph courtesy of Pence Gallery, Davis, California.

The gallery fosters an awareness, understanding, and appreciation of the arts, history, and culture of California through museum-caliber exhibitions and educational programs.

University of California, Davis - Richard L. Nelson Gallery & The Fine Arts Collection

University of California, Davis, 124-125 Art Bldg., 1 Shields Ave., Davis, CA 95616
Tel: (530) 752-8500
Fax: (530) 754-9112
Internet Address: http://idea.ucdavis.edu/art/nelson/
Director: Mr. Price Amerson
Admission: voluntary contribution.
Attendance: 13,400 *Established:* 1976 *Membership:* Y *ADA Compliant:* Y
Open: **September to July**, Monday to Friday, noon-5pm; Sunday, 2pm-5pm.
Closed: Legal Holidays, Academic Holidays.
Facilities: **Gallery**; **Library** (550 volumes); **Shop**.
Activities: **Education Programs**; **Guided Tours**; **Lectures**; **Temporary/Traveling Exhibitions**.
Publications: exhibition catalogues (annual).

The major program of the Nelson Gallery is a schedule of changing exhibitions focusing on contemporary and historical American and northern Californian art. The exhibition program is supplemented with lectures, publications, video presentations, and other events. The Fine Arts Collection brings together works of art that have been acquired (primarily through gifts from private donors) since the 1960s. Presently, the collection contains over 3,000 works representing various historical periods and cultures as well as contemporary art. Changing exhibits of pieces from the collection are mounted on a regular basis in the collection's Entry Gallery (adjacent to the Nelson Gallery, the Buehler Alumni & Visitor Center, and other campus locations. A number of works, including "The Egghead Series" by Professor Emeritus Robert Arneson, are permanently sited on the UC Davis campus as part of the Campus Art in Public Places program. Also of possible interest on campus are the Design Gallery (752-6223) located in 145 Walker Hall (open: Mon-Fri, noon-5pm; Sun, 2pm-5-pm) and the Memorial Union Gallery (752-2885) located in Room 241 on the 2nd Floor of the Memorial Union Building (Mon-Fri, 9am-5pm). Additionally, the Native American Studies Department's C.N. Gorman Museum located in 1316 Hart Hall hosts five exhibits each year featuring northern California Artists.

Downey

Downey Museum of Art
10419 Rives Ave., Downey, CA 90241
Tel: (562) 861-0419
Fax: (562) 928-8609
Consulting Director: Ms. Kate Davies
Admission: voluntary contribution.

Downey Museum of Art, cont.

Attendance: 20,000 *Established:* 1957 *Membership:* Y *ADA Compliant:* Y
Open: Monday to Saturday, noon-5pm; Sunday, 1pm-4pm.
Closed: Legal Holidays.
Facilities: Galleries (6).
Activities: Arts Festival; Education Programs; Films; Gallery Talks; Guided Tours;
 Lectures; Temporary Exhibitions; Traveling Exhibitions.
Publications: exhibition catalogues; newsletter; posters.

Located in Furman Park, the Museum has an extensive collection of California modern and contemporary art, including works by Boris Deutsch, Gordon Wagner, Hans Burkhardt, and Marc Chagall. Temporary exhibitions at the Museum feature the work of modern and contemporary artists, including work in glass, fiber, and ceramics.

El Cajon

Grossmont College - Hyde Gallery

8800 Grossmont College Drive, El Cajon, CA 92020-1799
Tel: (619) 644-7299
Fax: (619) 644-7922
Curator: Charlene S. Engel, Ph.D.
Admission: voluntary contribution.
Established: 1961 *Membership:* Y *ADA Compliant:* Y
Open: Monday to Wednesday, 10am-6:30pm; Thursday, 10am-8pm; Friday, 10am-2pm.
Closed: Academic Holidays.
Facilities: Gallery.
Activities: Concerts; Films; Gallery Talks; Temporary Exhibitions; Traveling Exhibitions.
Publications: catalogues, exhibit announcements; posters.

Primarily a contemporary gallery, Hyde Gallery also has a small permanent collection consisting of 20th-century photographs, prints, and ceramic objects as well as paintings.

Escondido

Museum, California Center for the Arts, Escondido

340 N. Escondido Blvd., Escondido, CA 92025
Tel: (760) 738-4120
Fax: (760) 743-6472
Internet Address: http://www.artcenter.org
Admission: fee:
 adult-$5.00, student-$3.00, senior-$4.00.
Established: 1992
Membership: Y *ADA Compliant:* Y
Open: Tuesday to Saturday, 10am-5pm;
 Sunday, noon-5pm.
Closed: New Year's Day, Thanksgiving Day,
 Christmas Day.

Facilities: Architecture (facility designed by
 Charles Moore (1994)); Concert Hall (1,532
 seats); Galleries (3); Library; Sculpture
 Court; Store; Studios; Theatre (400 seats).

Exterior view of Museum, California Center for the Arts Escondido. Photograph courtesy of California Center for the Arts, Escondido, California.

Activities: Artist Lectures and Residencies; Gallery Talks; Guided Tours (Tues-Sat, 1pm-3pm;
 group tours by appointment).
Publications: exhibition catalogues.

The Museum consists of a sculpture court and three galleries linked by halls that also function as display areas. Exhibitions are organized on distinct themes or ideas with each gallery exploring different, but related works. Media encompass painting, photography, sculpture, installation, and decorative arts. Adjacent to the Museum are studios, performance spaces, classrooms, workspaces for

Museum, California Center for the Arts, Escondido, cont.

visiting artists, and the library. The Museum is developing a permanent collection with emphasis on the development of art in California. The goal of the collection is to define the roots and progress of California's visual arts culture as well as to develop a body of the most significant art of our time.

Fresno

California State University, Fresno - Phebe Conley Art Gallery

5241 Maple Drive, Fresno, CA 93740
Tel: (559) 278-2516
Fax: (559) 278-4706
Internet Address: http://www.csufresno.edu
Open: Weekdays, 8am-noon and 1pm-5pm.
Facilities: Exhibition Area.
Activities: Temporary Exhibitions.

The Gallery presents temporary exhibitions including an annual student exhibition in the spring. Also of possible interest on campus are the President's Gallery located in the Thomas Administration Building (open: weekdays, 8am-5pm) and the Dean's Gallery located in Room 186 of the Music Building (open: weekdays, 8am-noon and 1pm-5pm).

Fresno Art Museum

2233 N. First Street (between Clinton and McKinley Aves.), Fresno, CA 93703
Tel: (559) 441-4221
Fax: (559) 441-4227
C.E.O.: Michael James Chappell
Admission: fee: adult-$4.00, child-free, student-$2.00, senior-$2.00.
Established: 1949 *Membership:* Y *ADA Compliant:* Y
Parking: free on site.
Open: Tuesday to Friday, 10am-5pm; Saturday to Sunday, noon-5pm.
Closed: Legal Holidays.
Facilities: **Auditorium** (152 seats); **Gallery; Library; Sculpture Garden; Shop.**
Activities: **Artist-in-Residence Program; Concerts; Education Programs; Films; Guided Tours** (group tours reserve in advance); **Lectures; Readings; Temporary Exhibitions** (30/year); **Traveling Exhibitions.**
Publications: exhibition catalogues.

Dedicated to the exploration of social and artistic issues of the 20th-century, the Museum offers up to 30 exhibitions per year, as well as an extensive artist-in-residence program. Its permanent collection includes Mexican art, Post-Impressionist graphics and sculptures by Robert Cremean.

Fullerton

California State University, Fullerton - Art Galleries

800 N. State College Blvd., Visual Arts Center, Fullerton, CA 92834-6850
Tel: (714) 278-3262
Fax: (714) 278-2390
Internet Address: http://www.arts.fullerton.edu/events
Gallery Director: Prof. Mike McGee
Admission: suggested contribution-$3.00.
Established: 1967 *Membership:* Y *ADA Compliant:* Y
Open: Monday to Thursday, noon-4pm; Sunday, 3pm-5pm.
Closed: Legal Holidays.
Facilities: **Auditorium** (150 seats); **Food Services** Cafeteria; **Galleries** (4; Main Gallery, 2,500 square feet); **Library** (1,500 volumes); **Shop; Theatre.**
Activities: **Arts Festival; Education Programs; Films; Gallery Talks; Guided Tours; Lectures; Temporary Exhibitions; Traveling Exhibitions.**

California State University, Fullerton - Art Galleries, cont.

Publications: exhibition catalogues (quarterly).

In all, there are four galleries at CSU Fullerton. The Main Art Gallery in the Visual Arts Center often features presentations of work of emerging and recognized contemporary artists. Since its opening in 1970, 150 exhibitions have been presented with the publication of some 80 catalogues. Integral to the program is the ability to provide space and physical assistance for artists to install environmental and ephemeral and transitory works. The mission of the gallery program is to bring carefully developed exhibitions to the campus. Three galleries exhibit student work. The East and West Galleries are scheduled to showcase the current work of graduate students. The range of work is as broad as the varied disciplines represented in the graduate program. Exhibitions are changed each week in these galleries during the academic year. The Exit Gallery, under the supervision of a committee of undergraduates, showcases the individual and collaborative work of undergraduate students and also is changed on a weekly basis in order to give students the opportunity to show their current work.

Glendale

Brand Library & Art Center Galleries

1601 W. Mountain St., Glendale, CA 91201-1209
Tel: (818) 548-2051
Fax: (818) 548-5079
TDDY: (818) 543-0367
Library Administrator: Mr. Joseph Fuchs
Admission: voluntary contribution.
Attendance: 130,000 *Established:* 1956 *Membership:* Y *ADA Compliant:* Y
Open: Tuesday, 1pm-9pm; Wednesday, 1pm-6pm; Thursday, 1pm-9pm;
 Friday to Saturday, 1pm-5pm.
Facilities: **Concert Hall** (150 seats); **Galleries**; **Library** (50,000 volumes, 600 art prints).
Activities: **Concerts** (4/year, free); **Lectures**; **Temporary Exhibitions** (8/year).
Publications: exhibition catalogues.

The Brand Library is an art and music library housing an collection of books, compact discs, records, videos, slides, prints, and periodicals. It also contains art galleries and a recital hall available for performance art and music events. The Galleries offer some of the largest and most stunning exhibit spaces in Southern California. Presenting eight exhibits a year, the galleries feature emerging artists from the area as well as an annual juried show. For most exhibits, two artists are selected, one for the Atrium Gallery, the other for the larger Skylight Gallery.

Hayward

California State University, Hayward - Art Gallery

Art and Education Building, 25800 Carlos Bee Blvd, Hayward, CA 94542
Tel: (510) 881-3299
Internet Address: http://www.csuhayward.edu/UA/artgallery2.html
Director: Lew Carson
Admission: free.
Open: Monday to Tuesday, 11am-3pm; Wednesday to Thursday, 1pm-7pm.
Facilities: **Exhibition Area.**
Activities: **Temporary Exhibitions.**

The Gallery presents a series of temporary exhibitions by students, faculty and outside artists, including an annual juried student show.

Irvine

Irvine Fine Arts Center

14321 Yale Ave., Irvine, CA 92604
Tel: (949) 724-6880
Fax: (949) 552-2137
Director: Toni McDonald Pang

Irvine Fine Arts Center, cont.

Open: Monday to Thursday, 9am-9pm; Friday, 9am-5pm; Saturday, 9am-3pm; Sunday, 1pm-5pm.
Facilities: **Exhibition Area.**
Activities: **Exhibitions; Lectures; Tours.**

The Fine Arts Center presents a variety of solo shows and group theme exhibitions of emerging and established southern California, national, and international contemporary artists.

The Irvine Museum

18881 Von Karman, 12th Floor, Suite 1250, Irvine, CA 92612
Tel: (714) 476-2565
Fax: (714) 476-2437
Internet Address: http://www.ocartsnet.org/irvinemuseum
Director: Mr. Jean Stern
Admission: free.
Attendance: 16,000 *Established:* 1992 *Membership:* N *ADA Compliant:* Y
Parking: free, in parking structure.
Open: Tuesday to Saturday, 11am-5pm.
Closed: Legal Holidays.
Facilities: **Gallery; Shop** (wide selection of books on California Impressionism).
Activities: **Education Programs** (school outreach program); **Guided Tours** (Thursday, 11:15pm; group tours by appointment); **Lectures** (a variety of slide illustrated lecture series and courses).
Publications: exhibition catalogues, "All Things Bright and Beautiful: California Impressionist Painting".

Dedicated to the display and preservation of art of the California Impressionist period (1890 to 1930), The Irvine Museum presents temporary exhibitions, illustrated programs and traveling exhibits of paintings from this significant regional variant of American Impressionism. Exhibitions are changed every four months and the bookstore offers a wide selection of books on this important subject. The collection includes painting by all the best known painters of this style, including Guy Rose (1867-1925), William Wendt (1865-1946), Edgar Payne (1883-1947), Granville Redmond (1871-1935), Franz Bischoff (1864-1929), Anna Hills (1882-1930), and many others.

University of California, Irvine - The Art Gallery

UCI, W. Peltason Road, Irvine, CA 92717-2771
Tel: (714) 824-8251
Fax: (714) 824-5297
Internet Address: http://www.arts.uci.edu/studioart/html/galleryinfo.html
Director: Mr. Brad Spence
Admission: free.
Attendance: 10,000 *Established:* 1965 *Membership:* Y *ADA Compliant:* Y
Open: **October to mid-June**, Monday to Saturday, noon-5pm.
Closed: New Year's Day, Easter, Christmas Eve to Christmas, Academic Holidays.
Facilities: **Gallery; Shop.**
Activities: **Guided Tours; Lectures; Traveling Exhibitions.**
Publications: exhibition catalogues.

The Gallery is devoted temporary exhibitions, including MFA student thesis exhibitions. Events include talks by faculty and visiting lecturers.

La Jolla

Museum of Contemporary Art, San Diego (MCA La Jolla)

700 Prospect Street, La Jolla, CA 92037
Tel: (858) 454-3541
Fax: (858) 454-6985
Internet Address: http://www.mcasandiego.org
Director: Dr. Hugh M. Davies

Museum of Contemporary Art, San Diego, cont.

Admission: fee: adult-$4.00, student-$2.00, senior-$2.00.

Attendance: 135,000 *Established:* 1941 *Membership:* Y *ADA Compliant:* Y

Parking: ample on street parking, 2-hour limit.

Open: **Day after Labor Day to Day before Memorial Day,**
Monday to Tuesday, 11am-5pm;
Thursday, 11am-8pm; |
Friday to Sunday, 11am-5pm.
Memorial Day to Labor Day,
Monday to Tuesday, 11am-8pm;
Thursday to Friday, 11am-8pm
Saturday to Sunday, 11am-5pm.

Closed: New Year's Day, Thanksgiving Day,
Christmas Day.

Facilities: **Architecture** (renovation/expansion, 1996 by Venturi, Scott Brown & Assocs.; former residence of Ellen Browning Scripps, 1916 design by Irving Gill; museum, 1941); **Auditorium** (500 seats); **Food Services** Café; **Galleries**; **Library** (4,000 volumes); **Orientation Gallery**; **Shop**.

Museum of Contemporary Art, San Diego - La Jolla museum. Photograph by Timothy Hursley, courtesy of Museum of Contemporary Art, San Diego, California.

Activities: **Concerts**; **Dance Recitals**; **Education Programs**; **Films**; **Guided Tours** (Tues, 2pm; Thurs, 6pm/8pm; Sat-Sun, 2pm/4pm); **Lectures**; **Temporary Exhibitions**; **Traveling Exhibitions**.

Publications: brochures; exhibition catalogues; newsletter, "View" (quarterly).

In La Jolla, MCA's flagship building, perched on a cliff overlooking the Pacific Ocean, has been a landmark since it became an art museum in 1941. An extensive renovation and expansion, designed by architects Venturi, Scott Brown and Associates, was completed in March 1996. The Museum of Contemporary Art enjoys an international reputation and is widely known for vanguard, thought-provoking exhibitions, an outstanding permanent collection, and a range of innovative education programs for children and adults. Special exhibitions, most originated by MCA, highlight recent art by an international roster of artists. MCA's collection of contemporary art, considered one of the finest of its kind in the United States, comprises more than 3,000 works of painting, sculpture, installation, drawings, prints, photography, video, and multimedia works. The holdings include every major art movement of the past half-century, with a strong representation by California artists and particularly noteworthy examples of minimalism, light and space work, conceptualism, installation, and site-specific art. Among the artists represented are John Baldessari, Vija Celmins, Vernon Fischer, Robert Grinder, Ann Hamilton, Ellsworth Kelly, and Doris Salcedo. MCA also maintains a downtown location in San Diego, California (see separate listing). A special 3-day pass for admission to both locations is available for $4.00.

University of California, San Diego - Stuart Collection

University of California, San Diego, 406 University Center, La Jolla, CA 92093-0010

Tel: (619) 534-2117

Fax: (619) 534-9713

Internet Address: http://stuartcollection.ucsd.edu

Director: Ms. Mary L. Beebe

Admission: voluntary contribution.

Established: 1981

Membership: N *ADA Compliant:* Y

Parking: parking permit required; obtain at campus entrance.

Open: Daily, 24 hours.

Facilities: **Sculpture throughout Campus** (obtain brochure and map from kiosk at campus entrance).

Activities: **Guided Tours** (group tours by appointment); **Lectures**; **Temporary Exhibitions**.

Publications: brochures.

La Jolla, California

University of California, San Diego - Stuart Collection, cont.

The Stuart Collection of Sculpture at the University of California, San Diego seeks to enrich the cultural, intellectual, and scholarly life of the UCSD campus and of the San Diego community by building and maintaining a unique collection of site-specific works by leading artists of our time. The entire 1,200-acre campus, situated on a dramatic mesa above the Pacific Ocean, may be considered as sites for commissioned sculpture. The Collection is further distinguished from a traditional sculpture garden by integration of some of the projects with university buildings. Throughout the proposal, design and construction processes, artists select and tailor their work to a specific UCSD site. A significant number of the artists represented have been better known for their work in other media before creating their first permanent outdoor sculptures for the Stuart Collection. The collection includes works by Terry Allen, Michael Asher, Jackie Ferrara, Ian Hamilton Finlay, Richard Fleischner, Jenny Holzer, Robert Irwin, Bruce Nauman, Nam June Paik, Niki de Saint Phalle, Alexis Smith, Kiki Smith, and William Wegman.

Alexis Smith, *Snake Path*, 1992, Stuart Collection, University of California, San Diego. Photograph courtesy of Stuart Collection, University of California, San Diego, California.

University of California, San Diego - University Art Gallery

Mandeville Center Building, 9500 Gilman Drive, La Jolla, CA 92093-0327
Tel: (858) 534-0419
Fax: (858) 534-0668
Internet Address: http://orpheus.ucsd.edu/gallery/info.html
Admission: free.
Attendance: 25,000 *Established:* 1974 *Membership:* Y *ADA Compliant:* Y
Open: Tuesday to Saturday, 11am-4pm.
Closed: Legal Holidays.
Facilities: **Architecture** (designed by Quincy Jones, FAIA); **Exhibit Space** (2,800 square feet).
Activities: **Guided Tours**; **Lectures**; **Symposia**; **Temporary Exhibitions** (5-6/year).
Publications: exhibition catalogues (periodically).

The mission of the University Art Gallery is to exhibit, research, and interpret the art of contemporary artists. The Gallery displays a continually changing series of exhibitions, and the Mandeville Annex Gallery, located on the lower level, is directed by visual arts graduate and undergraduate students.

Laguna Beach

Laguna Art Museum

307 Cliff Drive
Laguna Beach, CA 92651
Tel: (714) 494-8971
Fax: (714) 494-1530
Internet Address:
 http://www.lagunaartmuseum.org
Director: Bolton Colburn
Admission: fee:
 adult-$5.00, student-$4.00, senior-$4.00.
Attendance: 200,000 *Established:* 1918
Membership: Y *ADA Compliant:* Y
Open: Tuesday to Sunday, 11am-5pm.

Exterior view of Laguna Art Museum. Photograph courtesy of Laguna Art Museum, Laguna Beach, California.

56

Laguna Art Museum, cont.
Facilities: **Library** (3,000 volumes, archives on Southern California artists since 1918); **Rental Gallery**; **Shop** (books, ceramics & jewelry with emphasis on local artists).
Activities: **Art Auction** (annual); **Education Programs**; **Guided Tours** (Tuesday-Sunday, 2pm, free); **Lectures** (includes 1/month Sunday morning series).
Publications: exhibition catalogues; newsletter, "Laguna Art Museum News" (quarterly).

Located in a stunning setting just steps from the Pacific Ocean, the Laguna Art Museum is dedicated to California art. The Museum features continuously changing exhibitions of works by historical, contemporary and emerging artists. Galleries feature works ranging from paintings and drawings to photography, sculpture and installations.

Lancaster
Antelope Valley College Gallery
3041 W. Avenue K, Lancaster, CA 93536
Tel: (805) 722-6395
Fax: (805) 722-3102
Internet Address: http://avc.edu/ArtGalry/index.html
Director: Ms. Patricia Hinds
Admission: free.
Open: Monday to Thursday, 9am-3pm and 7pm-9pm.
Facilities: **Gallery**.
Activities: **Temporary Exhibitions**.

The Gallery displays traditional and contemporary work by visiting professional artists, local artists, faculty, and students.

Long Beach
California State University, Long Beach - University Art Museum
1250 Bellflower Blvd., Long Beach, CA 90840
Tel: (562) 985-5761
Fax: (562) 985-7602
Internet Address: http://www.csulb.edu/~uam
Director: Ms. Constance W. Glenn
Admission: voluntary contribution.
Attendance: 55,000 *Established:* 1949
Membership: Y *ADA Compliant:* Y
Parking: metered Parking Lot A,
 or with reservation, Parking Lot 11.
Open: **Fall to Spring**,
 Tuesday to Thursday, noon-8pm;
 Friday to Sunday, noon-5pm.
 Summer, Call for hours.
Closed: Academic Holidays.

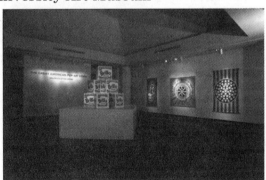

View of Gallery, University Art Museum, during exhibit of "The Great American Pop Art Store: Multiples of the Sixties". Photograph courtesy of University Art Museum - California State University, Long Beach, California.

Facilities: **Auditorium**; **Food Services** Food Court on campus (many selections); **Library** (main campus library); **Outdoor Sculpture** (throughout campus, 21 works); **Theatre** (nearby university performing arts center).
Activities: **Education Programs** (adults and students); **Films**; **Gallery Talks** (regularly scheduled; call for information); **Guided Tours** (on request; call for information); **Temporary Exhibitions**; **Traveling Exhibitions**.
Publications: brochures; exhibition catalogues (biennial); newsletter (biennial).

Centrally located on the CSULB campus, near the Richard and Karen Carpenter Performing Arts Center and the Pyramid Events Center, the UAM occupies a ground-level facility with ample parking. In addition to the 10,000 square-foot indoor space, the new museum extends outdoors, with attractive sites for sculpture and installations. The UAM presents diverse and imaginative exhibitions devoted to the work of contemporary artists. It offers artists a place to experiment, innovate, and present new work. The site-specific outdoor sculpture collection of twenty-one works sited across the

California State University, Long Beach - University Art Museum, cont.

322-acre CSULB campus may be toured with a map available at the UAM. In addition to featuring the finest in contemporary art, the UAM introduces the accomplishments of the design community to West Coast audiences. The Museum's collections of site-specific outdoor sculpture and works of art on paper feature examples of the work of important contemporary masters. Presented as major exhibitions, offered for examination by students and scholars, and circulated to national institutions, the UAM collections are a permanent, regional visual arts resource and archive of contemporary culture.

Long Beach Museum of Art

2300 East Ocean Blvd., Long Beach, CA 90803
Tel: (562) 439-2119
Fax: (562) 439-3587
Internet Address: http://www.lbma.org
Director: Mr. Harold B. Nelson
Admission: fee:
 adult-$5.00, child-free, student-$4.00, senior-$4.00.
Attendance: 30,000 *Established:* 1950
Membership: Y *ADA Compliant:* Y
Parking: free parking lot.
Open: Tuesday to Sunday, 11am-7pm.
Closed: Legal Holidays.
Facilities: **Food Services** Café (Tues-Sun, 7:30am-
 4:30pm); **Gardens** (Tues-Sun, 7:30am-7pm); **Store.**
Activities: **Concerts**; **Education Programs**; **Films**;
 Guided Tours; **Lectures/Workshops** (by working
 artists); **Performances.**

Exterior view of Long Beach Museum of Art. Photograph courtesy of Long Beach Museum of Art, Long Beach, California.

Publications: exhibition catalogues; newsletter; posters.

Located on a bluff overlooking the Pacific Ocean, the Museum is housed in an Arts and Crafts-style former residence. On the grounds are gardens, an indoor/outdoor café, and gift shop. The Museum's permanent collection features over 5,000 paintings, drawings, sculptures, decorative arts pieces, and videos. The changing exhibition program highlights the collection's strengths - California Modernism, 20th-century European painting, contemporary ceramics, media arts, and 300 years of American decorative art.

Museum of Latin American Art

628 Alamitos Ave., Long Beach, CA 90802
Tel: (562) 437-1689
Fax: (562) 437-7043
Internet Address: http://wwwmolaa.com
Director: Gregorio Luke.
Established: 1996
Open: Tuesday to Saturday, 11:30am-7:30pm; Sunday, noon-6pm.
Facilities: **Food Services** Restaurant: Viva (Latin American cuisine); **Galleries**; **Library and**
 Artist's Registry; **Shop** (contemporary art, folk and decorative art, jewelry, books).
Activities: **Art Workshops**; **Lectures**; **Performances**; **Permanent Exhibits**; **Temporary**
 Exhibitions.

Located in the former Hippodrome skating rink in the East Village Arts District of downtown Long Beach, the Museum houses the Robert Gumbiner Foundation Collection of Latin American Art; galleries for temporary exhibitions; a research library, archive, and Artists' Registry; and areas to accommodate lectures and performances. The museum forms part of a complex which includes a restaurant and an intimate park featuring a trompe l'oeil mural entitled "Casa Alamitos". The Robert Gumbiner Foundation Collection of Latin American Art comprises contemporary paintings, prints, drawings, and sculpture from Mexico, Central and South America and the Caribbean. The collection focuses on the work of artists who have lived and worked in Latin America since 1945, especially those whose art interprets indigenous or regional themes and reflects the culture and geography of the country in which they live. Artists represented in the collection include Raul A. Anguiano,

Museum of Latin American Art, cont.

Alejandro Arango, Alfredo Castenada, Alejandro Colunga, José Luis Cuevas, Javier de la Garza, Arturo Elizondo, Julio Galan, Sergio Hernández, Maximino Javier, Wifredo Lam, Fernando Luis, Javier Marin, Lucía Maya, Carlos Merida, Rodolfo Morales, Dulce Maríia Nuñez, José Clemente Orozco, Rodrigo Pimentel, Claudia Rodriguez, Cécilio Sanchez, Rufino Tamayo, Francisco Toledo, and Nauhm B. Zenil, and Francisco Zuniga, among many others.

Los Angeles

Autry Museum of Western Heritage

4700 Western Heritage Way (Griffith Park, adjacent to the Zoo), Los Angeles, CA 90027-1462

Tel: (323) 667-2000

Fax: (323) 660-5721

Internet Address: http://www.autry-museum.org

President/C.E.O.: John Gray

Admission: fee: adult-$7.50, child-$3.00, student-$5.00, senior-$5.00.

Attendance: 500,000 *Established:* 1988

Membership: Y *ADA Compliant:* Y

Parking: free on site.

Open: Tuesday to Wednesday, 10am-5pm;
Thursday, 10am-8pm;
Friday to Sunday, 10am-5pm;
Select Holidays, Monday, 10am-5pm.

Closed: Christmas Day, Thanksgiving Day.

De L'Esprie, *Back in the Saddle Again*, bronze. Autry Museum of Western Heritage. Exterior view of Museum in background. Photograph courtesy of Autry Museum of Western Heritage, Los Angeles, California.

Facilities: **Archives**; **Food Services** Café (9:30am-4:30pm); **Galleries** (9); **Library** (40,000 volumes).

Activities: **Education Programs**; **Guided Tours** (groups of 5+, specific weekend hours, reserve in advance); **Temporary Exhibitions**; **Traveling Exhibitions**.

Publications: brochures; exhibition catalogues; newsletter, "Spur" (quarterly).

The Autry Museum is devoted to the distinctive history and mythology of the American West, from its prehistoric roots to its Gold rush days and the romantic notions created by Hollywood. It is the only museum to span so broadly the West's geographic and artistic scope and to present the region's diverse ethnic and cultural elements. Its nine galleries present a collection of national treasures - the art of Frederic Remington, Albert Bierstadt and Thomas Moran; the armor of Spanish conquistadors; the spurs and saddles of cowboys and vaqueros, and costumes and posters from America's most beloved Western films.

California African-American Museum

600 State Drive, Exposition Park, Los Angeles, CA 90037

Tel: (213) 744-7432

Fax: (213) 744-2050

Internet Address: http://www.caam.ca.gov

Exec. Director: Jamesina E. Henderson

Admission: free, voluntary contribution.

Attendance: 250,000 *Established:* 1981 *Membership:* Y *ADA Compliant:* Y

Parking: pay, Exposition Park lot, $5.00/auto.

Open: Tuesday to Sunday, 10am-5pm.

Closed: New Year's Day, Thanksgiving Day, Christmas Day.

Facilities: **Library** (9,000 volumes); **Shop**; **Theatre**.

Activities: **Concerts**; **Education Programs**; **Films**; **Guided Tours** (daily; group tours reserve in advance, $2/adult); **Lectures**; **Temporary Exhibitions**; **Traveling Exhibitions**.

Publications: calendar.

The California African American Museum researches, collects, preserves, and interprets the art, history, and culture of African Americans with emphasis on California and the western United States.

Los Angeles, California

California State University, Los Angeles - Luckman Fine Arts Gallery

Luckman Fine Arts Complex
5151 State University Drive
Los Angeles, CA 90032-8116
Tel: (213) 343-6604
Fax: (213) 343-6423
Internet Address: www.calstatela.edu/
Exec. Director: Dr. Clifford Harper
Admission: free.
Established: 1994
Parking: free on site.
Open: Monday to Thursday, noon-5pm;
Saturday, noon-5pm.
Facilities: Gallery (7000 square feet).
Activities: Temporary Exhibitions.

Exterior view of Luckman Fine Arts Complex, site of Luckman Fine Arts Gallery. Photograph courtesy of Luckman Fine Arts Gallery, Los Angeles, California.

The Gallery features temporary exhibitions of the work of nationally recognized artists.

The Geffen Contemporary at MOCA

152 N. Central Ave. (in Little Tokyo), Los Angeles, CA 90013
Tel: (213) 626-6222
Internet Address: http://www.MOCA-LA.org
Director: Mr. Richard Koshalek
Admission: fee, valid for both sites: adult-$6.00, student-$4.00, senior-$4.00.
Open: Tuesday to Wednesday, 11am-5pm; Thursday, 11am-8pm; Friday to Sunday, 11am-5pm.
Closed: New Year's Day, Christmas Day.
Facilities: **Architecture** (former warehouse, redesigned by architect Frank Ghery); **Exhibition Area** (42,000 square feet); **Food Services** Coffee Bar; **Reading Room**; **Shop**.
Activities: **Education Programs** (adults, children and families); **Temporary Exhibitions**; **Traveling Exhibitions**.

Originally a hardware store and subsequently a city warehouse and service garage for municipal vehicles, The Geffen Contemporary at MOCA (originally known as MOCA at the Temporary Contemporary) opened in September 1983 as a temporary exhibition space while the MOCA at California Plaza was being constructed. The vast scale of the space proved so suitable for exhibiting all types of contemporary art, however, that MOCA's board of trustees voted to make it permanent. MOCA collects, exhibits and interprets art created since 1940 in all media and preserves it for future generation. Changing selections from its permanent collection are on view throughout the year. The museum presents more than 20 exhibitions, including historical and thematic shows, one-person retrospectives, newly commissioned projects and works by emerging artists. These feature not only painting, sculpture and drawing, but also video, photography, film, music, dance, performance, design, architecture, and new forms that combine various disciplines. Many of the exhibitions are part of an active exchange program with other nationally and internationally prominent museums. MOCA's permanent collection now numbers more than 5,000 works, including masterpieces of abstract impressionism and pop art. The collection includes works by Diane Arbus, John Baldessari, Willem de Kooning, Sam Francis, Robert Frank, Ann Hamilton, Robert Irwin, Jasper Johns, Lee Krasner, Ellsworth Kelly, Franz Kline, Roy Lichtenstein, Brice Marden, Agnes Martin, Joan Miró, Louise Nevelson, Claes Oldenburg, Jackson Pollock, Robert Rauschenberg, James Rosenquist, Mark Rothko, Sarah Seager, Richard Serra, Cindy Sherman, Alexis Smith, Cy Twombly and Andy Warhol, among many others. MOCA maintains two sites: The Geffen Contemporary at MOCA and MOCA at California Plaza (see separate listing). A single admission fee is valid for both museums on the same day. There is shuttle bus services between the two buildings.

The J. Paul Getty Museum

1200 Getty Center Drive, Los Angeles, CA 90049-1681
Tel: (310) 440-7300
Fax: (310) 440-7722
TDDY: (310) 440-7305
Internet Address: http://www.getty.edu/getty.html
Director: Mr. John Walsh
Admission: free.
Attendance: 400,000 *Established:* 1953 *Membership:* N *ADA Compliant:* Y
Parking: On site, reservation required - $5.00.
Open: Tuesday to Wednesday, 11am-7pm; Thursday to Friday, 11am-9pm;
 Saturday to Sunday, 10am-6pm.
Closed: New Year's Day, Independence Day, Thanksgiving Day, Christmas Day.
Facilities: **Auditorium** (250 seats); **Conservation Facilities**; **Food Services** Café (11am-3pm,
 indoor and outdoor dining areas;, Café Espresso (carts located throughout Center), Museum Café
 (self service cafeteria, open until 30 minutes before closing), Restaurant; **Picnic Area**; **Shop**.
Activities: **Dance Recitals**; **Education Programs**; **Gallery Talks**; **Lectures**; **Performances**;
 Temporary Exhibitions.
Publications: collection catalogue; gallery guides; research publications.

The museum is located at The J. Paul Getty Center, a 6-building, 110-acre campus designed by Richard Meier in the foothills of the Santa Monica Mountains. Extensive gardens include a 3-acre Central Garden designed by Robert Irwin. The Museum offers permanent, temporary, and special exhibitions drawn from its extensive permanent collections. The permanent collection is divided into seven curatorial departments: antiquities, paintings, drawings, sculpture and works of art, photographs, manuscripts, and decorative arts. The Museum's collection of classical antiquities, temporarily housed at the Museum during the renovation of the Getty Villa at Malibu, includes sculpture, Greek vases, Greek and Roman gems, and luxury wares such as Hellenistic silver and Roman glass. The Getty Museum's collection of pictures from the 13th to the 19th century includes works by such artists as Fra Bartolommeo, Breughel the Elder, Cézanne, Correggio, Daddi, Dossi, Ensor, Gainsborough, Géricault, Liotard, Mantegna, Pontormo, Rembrandt, Rubens, Van de Cappelle, and van Gogh. The drawing collection is especially strong in Old Master drawings. Since the early 1990s the collection's focus has shifted toward acquiring drawings made in the 1800s and 1900s. Included in the collection are works by Cézanne, Cortona, Leonardo da Vinci, Daumier, Degas, Gainsborough, Holbein, Piranesi, Rembrandt, Turner, van Gogh, and Watteau. The permanent collection of European sculpture, spanning the period from the Middle Ages to the end of the 19th-century, has strengths in bronze sculpture, such as Cellini's "Satyr"; Northern European sculpture, such as Adriaen de Vries's "Juggling Man"; and French 18th- and 19th-century works, such as Jean Baptiste Carpeaux's "Bust of Jean Léon Gérôme". The Photograph Collection, formed in 1984, is the only curatorial department with works from the 20th- century. The collection includes 25,000 individual prints ranging in date from the 1830s to the 1960s, thousands of daguerreotypes, and about 30,000 stereographs and cartes-de-visite. While maintaining a comprehensive collection, the department concentrates on securing works by master photographers. It is especially rich in examples dating from the early 1840s, including major holdings by William Henry Fox Talbot, David Octavius Hill, Robert Adamson, and Hippolyte Bayard. Since 1984, the department has concentrated on photographs produced by masters of the first half of this century. Especially notable among these are images by Gertrude Käsebier, Frederick Sommer, Alfred Stieglitz, Paul Strand, Doris Ulmann, and Edward Weston. There are also comprehensive collections of manuscripts and the European decorative arts. The former Getty Museum, now styled The Getty Villa in Malibu, will display the Museum's collection of classical antiquities. It is closed for renovations and will reopen in 2001.

The Los Angeles Art Association - Gallery 825/LAAA

825 N. La Cienega Blvd., Los Angeles, CA 90069-4707
Tel: (310) 652-8272
Fax: (310) 652-9251
Director: Ms. Ashley Emenegger

The Los Angeles Art Association - Gallery 825/LAAA, cont.

Admission: free.
Attendance: 5,000 *Established:* 1925
Membership: Y *ADA Compliant:* Y
Parking: free, lot at rear of building.
Open: Tuesday to Saturday, noon-5pm.
Closed: Legal Holidays.
Facilities: **Gallery**; **Multi-media Artist Space.**
Activities: **Lectures**; **Exhibitions** (8 competitive shows/year, plus one-person shows); **Workshop** (drawing and art demonstrations).
Publications: newsletter, "Artline" (quarterly).

Elizabeth Hoffman, II, *Ruby*, 1996, acrylic, varnish, wooden frame, 29 x 20 inches. Los Angeles Art Association. Photograph courtesy of Gallery 8256/LAAA, Los Angeles, California.

Gallery 825/LA Art Association is a non-profit visual arts organization committed to supporting southern California contemporary artists in furthering and achieving their diverse artistic visions. Gallery/LAAA provides exposure, education, and resources, as well as fostering public awareness through its collaborative environment. Membership screenings are held semi-annually.

Los Angeles City College - Da Vinci Art Gallery

Da Vinci Hall, 855 N. Vermont Ave., Los Angeles, CA 90029
Tel: (213) 953-4118
Internet Address: http://www.lacc.cc.ca.us
Director: Mr. Raoul De la Sota
Admission: free.
Attendance: 5,000 *Established:* 1963 *ADA Compliant:* Y
Parking: on street.
Open: Monday to Thursday, 10am-2pm and 6pm-8pm; Friday, 10am-2pm.
Facilities: **Exhibition Area** (412 square feet, 802 square feet hanging space).
Activities: **Temporary Exhibitions** (6/year).

The Gallery mounts exhibitions of the work of professional artists, faculty, and students.

Los Angeles Contemporary Exhibitions

6522 Hollywood Blvd., Los Angeles, CA 90028
Tel: (323) 957-1777
Fax: (323) 957-9025
Exec. Director: Ms. Irene Tsatsos
Admission: suggested donation: adult-$3.00, student-$2.00.
Attendance: 7,000 *Established:* 1977 *Membership:* Y *ADA Compliant:* Y
Parking: on street or pay lot at rear of building on Wilcox Avenue.
Open: Wednesday to Saturday, noon-6pm.
Facilities: **Gallery** (2 rooms, total 2,125 square feet).
Activities: **Exhibitions** (all media); **Gallery Tours and Artist Talks** (in conjunction with exhibitions).
Publications: exhibition catalogues.

Los Angeles Contemporary Exhibitions is a non-profit interdisciplinary artists' organization that presents arts and ideas and serves as a forum for an evolving dialogue between artists and their audiences. The organization mounts solo and group exhibitions of innovative works in a wide variety of media, including conceptual art, temporary installations, and site-specific, multi-disciplinary work, as well as new media. Its galleries have served as the proving grounds for new artists and art forms, and its programs have provided the impetus for dialogue about contemporary arts and culture. It does not maintain a permanent collection.

Los Angeles County Museum of Art (LACMA)

5905 Wilshire Blvd. (between Fairfax Avenue & La Brea Boulevard), Los Angeles, CA 90036

Tel: (323) 857-6000
Fax: (323) 857-6214
TDDY: (323) 857-0098
Internet Address: http://www.lacma.org
President and C.E.O.: Ms. Andrea L. Rich
Admission: fee: adult-$7.00, child (6-17)-$1.00, student-$5.00, senior-$5.00.
Attendance: 800,000 *Established:* 1910 *Membership:* Y *ADA Compliant:* Y
Parking: across from Wilshire Blvd. entrance, free after 7pm.
Open: Monday to Tuesday, noon-8pm; Thursday, noon-8pm; Friday, noon-9pm;
 Saturday to Sunday, 11am-8pm.
Closed: Thanksgiving Day, Christmas Day.
Facilities: **Auditorium** (100 seats); **Conservation Facilities**; **Food Services** Plaza Café (Mon-
 Tues & Thurs, noon-8pm; Fri, noon-9pm; Sat-Sun, 11am-8pm); **Library** (117,000 volumes);
 Sculpture Gardens; **Shop**; **Theatre** (600 seats).
Activities: **Concerts**; **Education Programs**; **Films**; **Gallery Talks**; **Guided Tours**; **Lectures**;
 Temporary Exhibitions; **Traveling Exhibitions**.
Publications: bulletins; collection catalogue; exhibition catalogues; magazine (monthly).

LACMA is the largest art museum in the western United States. Within its more than 200,000 square feet of exhibition space, the museum presents an international collection of art dating from prehistory to the present day. Five buildings surround the Times Mirror Central Court. The Ahmanson Building houses objects from a wide range of cultures and a remarkable span of years. Special loan exhibitions are presented in the Hammer Building, which also houses galleries for the exhibition of prints, drawings, and photographs drawn from the Museum's collections. Lectures, films, and concerts take place in the Leo S. Bing Theater and the Dorothy Collins Brown Auditorium, both in the Bing Center. The Robert O. Anderson Building accommodates a burgeoning collection of 20th-century art and present major special exhibitions. The Pavilion for Japanese Art houses Japanese paintings, sculpture, ceramics, netsuke, and the internationally renowned Shin'enkan Collection of painted screens and scrolls. The B. Gerald Cantor Sculpture Garden features bronze works by the French sculptor August Rodin and his contemporaries. Modern and contemporary outdoor sculpture is installed throughout the East Sculpture Garden. The museum also has created the Doris Stein Research and Design Center for Costumes and Textiles, the American Quilt Research Center, and the Robert Gore Rifkind Center for German Expressionist Studies. In addition to the permanent collection, museum visitors are privy to a number of LACMA-organized special exhibitions, many of which travel nationally and internationally. The museum also hosts an outstanding schedule of traveling exhibitions from other institutions. Major portions of its permanent collection exhibits were reorganized and reinstalled in 1997, allowing new acquisitions to be placed on view for the first time and some older works in the collection not on public view to be returned to the galleries. More than 150,000 works constitute the museum's holdings. The permanent collections offer Greek and Roman art; European paintings, sculpture, and decorative arts from the Middle Ages through the twentieth century; American paintings, sculpture, and decorative arts from colonial times to the present; modern and contemporary art; pre-Colombian art; Egyptian, Islamic, and ancient West Asian art; Far Eastern art; and Indian and Southeast Asian art. Among the American artists represented are George Wesley Bellows, Paul Cadmus, Mary Cassatt, Thomas Cole, John Singleton Copley, Childe Hassam, Winslow Homer, John Singer Sargent, Julius L. Stewart, John Smibert, William Wetmore Story, Henry Ossawa Tanner, and Benjamin West. Jean-Baptiste Chardin, Edgar Degas, Andrea Della Robbia, Georges De La Tour, René Magritte, Rembrandt van Rijn, Guido Reni, Auguste Rodin, and Anthony Van Dyck are among the European painters and sculptors whose work is included in the collection.

Los Angeles Municipal Art Gallery

Barnsdall Art Park, 4804 Hollywood Blvd., Los Angeles, CA 90027

Tel: (213) 485-4581
Fax: (213) 485-8396
TDDY: (213) 660-4254
Program Director and Curator: Mr. Noel Korten

Los Angeles, California

Los Angeles Municipal Art Gallery, cont.

Admission: fee-$1.50.

Attendance: 60,000 *Established:* 1954 *Membership:* Y *ADA Compliant:* Y

Open: **Gallery**,
 Tuesday to Thursday, 12:30pm-5pm; Friday, 12:30pm-8:30pm;
 Saturday to Sunday, 12:30pm-5pm.
 Hollyhock House,
 Tours; Tuesday to Sunday, noon, 1pm, 2pm, 3pm.

Closed: New Year's Day, Independence Day, Thanksgiving Day, Christmas Day.

Facilities: **Architecture** (Hollyhock House, 1921 design by Frank Lloyd Wright); **Gallery**; **Theatre** (300 seats).

Activities: **Guided Tours**; **Performances**; **Temporary Exhibitions**.

Publications: exhibition catalogues.

A subsidiary of the Cultural Affairs Department of the City of Los Angeles, the Municipal Art Gallery primarily presents changing exhibitions of work by contemporary southern California artists.

Loyola Marymount University - Laband Art Gallery

7900 Loyola Blvd. (just north of LA International Airport), Los Angeles, CA 90045-8345

Tel: (310) 338-2880

Fax: (310) 338-1948

Internet Address: http://www.lmv.edu/colleges/cfa/art/laband

Director: Mr. Gordon Fuglie

Admission: voluntary contribution.

Attendance: 6,500 *Established:* 1985 *Membership:* N *ADA Compliant:* Y

Parking: free parking.

Open: **Mid-August to May**, Wednesday to Friday, 11am-4pm; Saturday, noon-4pm.

Closed: Summer, Major Holidays.

Facilities: **Auditorium** (212 seats); **Gallery** (2,300 square feet).

Activities: **Arts Festival**; **Concerts**; **Dance Recitals**; **Education Programs**; **Films**; **Gallery Talks**; **Guided Tours**; **Lectures**.

Publications: brochures (occasional); exhibition catalogues (3/year).

A part of the LMU campus on bluffs overlooking Marina del Rey and the Pacific Ocean, the Laband is located in the Fritz B. Burns Fine Arts Center. Its exhibitions are defined by three concepts: (1) thematic projects featuring traditional and non-traditional spirituality; (2) the exploration of social and political issues; and (3) ethnological and/or anthropological displays. On occasion, an exhibition will encompass two or all three of these concerns. In addition, the gallery hosts the National Biennial Exhibition of the Los Angeles Printmaking Society, the only ongoing survey of recent American graphic art in Southern California. The adjacent Murphy Concert Hall is used for slide lectures or conferences related to the gallery's programs.

Mount St. Mary's College - José Drudis-Biada Gallery

12001 Chalon Road, Los Angeles, CA 90049

Tel: (310) 954-4362

Internet Address: http://www.msmc.la.edu

Director: Jody Baral

Admission: free.

Established: 1974

Parking: free on site.

Open: **Academic Year**, Tuesday to Saturday, noon-5pm.

Closed: Academic Holidays.

Facilities: **Exhibition Area** (2000 square feet).

Activities: **Temporary Exhibitions**.

The Gallery presents temporary exhibitions of the work of Los Angeles artists.

64

Museum of Arts Downtown Los Angeles (MADLA)

605 W. Olympic Blvd. (Standard Oil Bldg.)
Los Angeles, CA 90015
Tel: (213) 627-7849
Fax: (213) 627-0772
Internet Address: http://www.madla.org
Director: Ms. Madla Hruza
Admission:
 fee: adult-$4.00, child-free, student-$2.00, senior-$2.00.
Attendance: 3,800 *Established:* 1996
Membership: Y *ADA Compliant:* Y
Parking: metered on street.
Open: Tuesday to Saturday, 11am-7pm.
Facilities: **Galleries - 2** (11000 square feet).
Activities: **Performances**; **Temporary Exhibitions** (monthly).

Jeremy Thomas Kunkel, *Conductor*, 1994, silver gelatin print, 8 x 10 inches. Museum of Arts Downtown Los Angeles. Photograph courtesy of Museum of Arts Downtown Los Angeles, Los Angeles, California.

The Gallery is located on the ground floor of the historic Standard Oil Building in an elegant industrial environment. It presents monthly exhibitions of contemporary paintings, photography, and sculpture, which deal with a particular subject or theme. Three thousand square feet of its gallery space is devoted to its permanent collection.

The Museum of Contemporary Art, Los Angeles - MOCA at California Plaza

250 S. Grand Ave. at California Plaza, Los Angeles, CA 90012
Tel: (213) 626-6222
Fax: (213) 620-8674
TDDY: (213) 621-1651
Internet Address: http://www.MOCA-LA.org
C.E.O.: Mr. Richard Koshalek
Admission: fee, valid for both sites: adult-$6.00, child-free, student-$4.00, senior-$4.00.
Attendance: 350,000 *Established:* 1979 *Membership:* Y *ADA Compliant:* Y
Parking: pay public lot and structure at 1st St. & Central Ave..
Open: Tuesday to Wednesday, 11am-5pm; Thursday, 11am-8pm; Friday to Sunday, 11am-5pm.
Facilities: **Architecture** (1986 designed by Japanese architect Arata Isozaki); **Exhibition Area** (24,500 square feet); **Food Services** The Patinette at MOCA; **Sculpture Plaza**; **Shop**.
Activities: **Education Programs**; **Performances**; **Temporary Exhibitions**; **Traveling Exhibitions**.
Publications: exhibition catalogues; newsletter (quarterly).

MOCA at California Plaza was named one of the ten best works of American architecture completed since 1980 by architects participating in a national survey conducted by the American Institute of Architects. MOCA collects, exhibits and interprets art created since 1940 in all media and preserves it for future generations. Changing selections from its permanent collection are on view throughout the year. The museum presents more than 20 exhibitions each year, including historical and thematic shows, one-person retrospectives, newly commissioned projects and works by emerging artists. These feature not only painting, sculpture and drawing, but also video, photography, film, music, dance, performance, design, architecture, and new forms that combine various disciplines. Many of the exhibitions are part of an active exchange program with nationally and internationally prominent museums. MOCA's permanent collection now numbers more than 5,000 works, including masterpieces of abstract impressionism and pop art. The collection includes works by Diane Arbus, John Baldessari, Willem de Kooning, Sam Francis, Robert Frank, Ann Hamilton, Robert Irwin, Jasper Johns, Lee Krasner, Ellsworth Kelly, Franz Kline, Roy Lichtenstein, Brice Marden, Agnes Martin, Joan Miró, Louise Nevelson, Claes Oldenburg, Jackson Pollock, Robert Rauschenberg, James Rosenquist, Mark Rothko, Sarah Seager, Richard Serra, Cindy Sherman, Alexis Smith, Cy Twombly,

The Museum of Contemporary Art, Los Angeles - MOCA at California Plaza, cont.

and Andy Warhol, among many others. MOCA maintains two sites: MOCA at California Plaza and The Geffen Contemporary at MOCA (see separate listing). A single admission fee is valid for both buildings on the same day. There is shuttle bus service between the two sites.

Museum of Neon Art (MONA)

501 W. Olympic Blvd., Los Angeles, CA 90015-1433

Tel: (213) 498-9918

Fax: (213) 489-9932

Internet Address: http://www.neonmona.org

Director and Curator: Ms. Kim Koga

Admission: fee: adult-$5.00, child-free, student-$3.50, senior-$3.50.

Attendance: 23,000 *Established:* 1981 *Membership:* Y *ADA Compliant:* Y

Parking: commercial adjacent to site.

Open: Wednesday to Saturday, 11am-5pm; Sunday, noon-5pm.
 2nd Thursday in month, 11am-8pm.

Closed: major holidays.

Facilities: **Shop.**

Activities: **Education Programs**; **Films**; **Gallery Talks**; **Guided Tours**; **Lectures.**

Publications: newsletter, "Transformer" (quarterly).

The permanent collection of the MONA consists of neon signs and art in electric media.

Occidental College - Weingart and Arthur G. Coons Galleries

1600 Campus Road, Los Angeles, CA 90041

Tel: (213) 259-2749

Fax: (213) 259-2930

Internet Address: http://www.oxy.edu

Director: Ms. Linda Lyke

Open: Tuesday to Friday, 1pm-4:30pm.

Facilities: **Exhibition Area.**

Activities: **Temporary Exhibitions.**

The College presents temporary exhibitions of contemporary art in two galleries: The Arthur G. Coons Lower Gallery and Weingart Gallery.

Otis College of Art and Design - Galleries

Otis College of Art and Design., 9045 Lincoln Blvd., Los Angeles, CA 90045-3550

Tel: (310) 665-6905

Internet Address: http://www.otisart.edu

Director: Dr. Anne Ayres

Admission: free.

Attendance: 5,000 *Established:* 1957 *Membership:* Y *ADA Compliant:* Y

Open: **September to May**,Tuesday to Saturday, 10am-5pm.
 June to August, Call for programming.

Closed: Thanksgiving Day to Thanksgiving Friday, Christmas Eve to New Year's Day.

Facilities: **Galleries (2).**

Activities: **Temporary Exhibitions**; **Traveling Exhibitions**.

Publications: exhibition catalogues.

The College maintains two galleries. The Otis Gallery showcases national and international contemporary art. The Bolsky Gallery, a student-run facility, features the work of students.

Plaza de la Raza

3450 N. Mission Road, Los Angeles, CA 90031

Tel: (213) 223-2475

Fax: (213) 223-1804

Internet Address: http://www.plazaraza.org

Plaza de la Raza, cont.

Exec. Director: Ms. Rose Marie Cano
Admission: call.
Established: 1969 *Membership:* Y *ADA Compliant:* Y
Open: Call for hours.
Facilities: **Gallery**; **Theatre** (2, outdoor theatre 350 seats & indoor theatre, 160 seats).
Activities: **Arts Festival** (semi-annual); **Concerts**; **Dance Recitals**; **Education Programs**; **Films**; **Temporary Exhibitions**; **Traveling Exhibitions**.
Publications: brochures; exhibition catalogues (annual); newsletter.

Situated in the heart of East Los Angeles, in century-old Lincoln Park, Plaza de la Raza Cultural Center for the Arts and Education is the only multi-disciplinary cultural arts center for Latinos in Los Angeles. Through its exhibition and education programs, Plaza offers venues for the Latino visual and performing artist community. The once-threatened boathouse is now a gallery, surrounded by the Administration Building, the 350-seat Willie Velásquez Outdoor Stage, the Dance Building, the 160-seat Margo Albert Theatre, the Rubén Salazar Art Building, and the Frank and Anne López Music Building. The School of Performing and Visual Arts (SPVA) is an after-school program established at Plaza in 1975 that has grown to provide 500 to 600 students each week with a full curriculum in four major disciplines: theater, dance, music and visual arts. The school offers a variety of courses, from entry-level classes (available free of charge to low income students) to conservatory-level workshops (conducted by master artists and performers). The Plaza's permanent collection includes 28 paintings, prints and works on paper donated by the Anheuser Busch company; ceramic, wood and stone artifacts donated by Vincent Price from his personal collection; a collection of 180 silver gelatin prints donated by the photographer José Galvéz; and an extensive collection of Mexican folk art (1,940 items).

Skirball Cultural Center

2701 N. Sepulveda Ave., Los Angeles, CA 90049
Tel: (310) 440-4500
Fax: (310) 440-4595
President: Mr. Uri Herscher
Admission: fee: adult-$8.00, child-free, student-$6.00, senior-$6.00.
Attendance: 350,000 *Established:* 1996
Membership: Y *ADA Compliant:* Y
Parking: Parking available.
Open: Tuesday to Saturday, noon-5pm; Sunday, 11am-5pm.
Facilities: **Auditorium** (350 seats); **Classrooms**; **Conference Center**; **Food Services** Café/Restaurant (440-4515); **Gallery**; **Shop** (books, fine art, gifts, and Judaica).

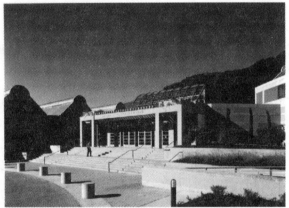

Exterior view of Skirball Cultural Center, designed by Moshe Safdie and Associates. Photograph by Timothy Hursle, courtesy of Skirball Cultural Center, Los Angeles, California.

Activities: **Concerts**; **Education Programs**; **Films**; **Guided Tours**; **Lectures**; **Temporary Exhibitions**.
Publications: brochures; calendar (bi-monthly); exhibition catalogues; membership magazine, "Oasis" (semi-annual); program guide (bi-monthly).

The Center's 200,000 square foot complex, designed by architect Moshe Safdie and constructed at a cost of $65 million, is located on a 15-acre site just off the San Diego Freeway, in the Santa Monica Mountains in Los Angeles. An affiliate of Hebrew Union College, it was conceived as "an oasis in the city, where people from the entire community can meet one another and feel comfortable." Its purpose is to deepen the appreciation of Jewish culture and American democratic values through museum exhibitions, a children's Discovery Center, concerts, lectures, performances, readings, symposia, film and video screenings, a simulated outdoor archaeological dig, and educational offerings for adults and children of all ages and backgrounds. Changing galleries investigate and expand upon the presentation of the core exhibition, offering temporary exhibitions with themes relating to Jewish culture and history, and American pluralism. The permanent collection is one of the largest assemblages of art and

Skirball Cultural Center, cont.

artifacts relating to Judaism and American life. In an innovative approach, the open storage area within the Museum's subterranean facility affords the public and scholars alike the opportunity to initiate in-depth study of specific items and categories of the permanent collection.

Southwest Museum

234 Museum Drive, Los Angeles, CA 90065

Tel: (323) 221-2164

Fax: (323) 224-8223

Internet Address:
http://www.southwestmuseum.org

Director: Dr. Duane H. King

Admission: fee: adult-$6.00, child-$3.00, student-$4.00, senior-$4.00.

Attendance: 63,211　*Established:* 1907

Open: Tuesday to Sunday, 10am-5pm.

Closed: major holidays.

Facilities: Ethnobotanical garden; Exhibition Area (4 main halls); Library Braun Research Library (Wed-Sat, 1pm-5pm, 50,000 volumes, non-circulating).

Raven rattle, 19th century, Tlinget. Southwest Museum collection. Photograph by Lawrence Reynolds, courtesy of Southwest Museum, Los Angeles, California.

Activities: Education Programs; Festivals; Films; Guided Tours; Lectures; Performances; Temporary Exhibitions; Traveling Exhibitions.

The oldest museum in Los Angeles, the Southwest Museum holds one of the nation's most important museum, library, and archive collections related to the American Indian. In addition, it has extensive holdings of Pre-Hispanic, Spanish Colonial, Latino, and Western American art and artifacts. The museum's four main exhibit halls focus on the native people of the Southwest, California, the Great Plains, and the Northwest Coast. Exhibit highlights include a replica of a Santa Susana Mountains Chumash Indian rock art site and an 18-foot Southern Cheyenne tipi. Visitors may survey prehistoric Southwest painted pottery and enjoy rotating displays from the museum's collection. Traveling exhibitions from other museums and changing exhibitions from the Southwest Museum permanent collection are also presented throughout the year. In 1925, the Museum took on the stewardship of the Casa de Adobe (4605 N. Figueroa, Los Angeles, CA 90065). Built in 1917, the Casa is a replica of a Mexican California ranch house of the early 19th century. It consists of an adobe structure, built according to traditional methods, whose rooms form a quadrangle with a central patio and garden. The Casa houses the Museum's collections of materials pertaining to the Spanish presence in the New World. The collections of the Southwest Museum represent Native American cultures from Alaska to South America. Beyond this primary emphasis, the Southwest Museum holds important collections of Meso-American and South American pre-Columbian pottery and textiles, and Hispanic folk and decorative arts.

UCLA at the Armand Hammer Museum of Art and Cultural Center

10899 Wilshire Blvd. at Westwood Blvd. (Westwood Village), Los Angeles, CA 90024-4201

Tel: (310) 443-7000

Fax: (310) 443-7099

TDDY: (310) 443-7094

Internet Address: http://www.arts.ucla.edu/hammer/main.html

Director: Mr. Henry Hopkins

Admission: fee: adult-$4.50, child-free, student-$3.00, senior-$3.00.

Attendance: 120,000　*Established:* 1994　*Membership:* Y　*ADA Compliant:* Y

Parking: pay, under museum, $2.75 for 1st 3 hours.

Open: Tuesday to Wednesday, 11am-7pm; Thursday, 11am-9pm; Friday to Saturday, 11am-7pm; Sunday, 11am-5pm.

Closed: Independence Day, Thanksgiving Day, Christmas Day.

UCLA at the Armand Hammer Museum of Art and Cultural Center, cont.

Facilities: **Architecture** (1990, designed by Edward Larrabee Barnes); **Exhibition Area** (14,000 square feet); **Food Services** Courtyard Café (food cart serving light refreshments, Tues-Sun, 11am-5pm); **Library** (55,000 volumes); **Rental/Sales Gallery** (Tuesday-Saturday, 11am-4pm; Sunday, noon-4pm); **Sculpture Garden**; **Shop** (books, jewelry, prints, posters, and gifts).

Activities: **Children's Programs**; **Gallery Talks**; **Guided Tours** (Tues-Sun, 1pm; groups 20+, reserve in advance, $3/person); **Lectures**; **Readings**; **Temporary Exhibitions**; **Traveling Exhibitions**.

Publications: collection catalogue; exhibition catalogues; newsletter.

Located in the heart of Westwood Village, UCLA at the Armand Hammer Museum of Art and Cultural Center serves as a meeting place and showcase for the arts. Throughout the year, visitors can enjoy a variety of arts programs organized by UCLA or major national and international institutions. In addition to offering a diverse schedule of historical and contemporary art exhibitions, the Museum presents music, dance, poetry, video, gallery talks, symposia, and docent tours for people of all ages. The Armand Hammer Collection features primarily Impressionist and Post-Impressionist paintings by such artists as Mary Cassatt, Claude Monet, Camille Pissarro, John Singer Sargent, and Vincent van Gogh. Paintings by John Constable, Pablo Picasso and others from UCLA's collections are also on view. Exhibitions drawn from the Armand Hammer Daumier and Contemporaries Collection are also shown on a rotating basis and include the painting, sculpture and lithography of 19th-century French artist Honoré Daumier and his contemporaries. The Museum also displays exhibitions drawn from the extensive collection of the UCLA Grunwald Center for the Graphic Arts (see separate listing), one of the finest university collections of graphic arts in the country. The Museum staff also administers the Franklin D. Murphy Sculpture Garden, one of the most distinguished outdoor sculpture collections in the country. Spanning more than five acres on UCLA's North Campus, the Sculpture Garden features over 70 works by such artists as Jean Arp, Alexander Calder, Claire Falkenstein, Barbara Hepworth, Gaston Lachaise, Jacques Lipchitz, Henri Matisse, Henry Moore, Isamu Noguchi, Auguste Rodin, David Smith and Francisco Zuñiga.

View from the courtyard of UCLA at the Armand Hammer Museum of Art and Cultural Center. Photograph by Tim Strett-Porter, courtesy of UCLA at the Armand Hammer Museum of Art and Cultural Center, Los Angeles, California.

UCLA - Grunwald Center for the Graphic Arts at the Armand Hammer Museum of Art and Cultural Center

10899 Wilshire Blvd. at Westwood Blvd. (3rd Floor, Gallery Level)
Los Angeles, CA 90024-4201
Tel: (310) 443-7076
Fax: (310) 443-7099
TDDY: (310) 443-7094
Internet Address: http://www.ucla.edu/museums/hammer_frame.html
Director: Mr. David Rodes
Admission: free.
Attendance: 76,000 *Established:* 1956 *Membership:* Y *ADA Compliant:* Y
Parking: underground garage - $2.75 for 3 hours.
Open: Monday to Friday, 10am-4pm, by appointment only.
Facilities: **Library** (55,000 volumes); **Print Study Room** (by appointment, (310) 443-7078).
Publications: books; exhibition catalogues.

UCLA - Grunwald Center for the Graphic Arts at the Hammer Museum, cont.

Located on the third floor (gallery level) of the Armand Hammer Museum of Art and Cultural Center at UCLA, the Grunwald Center is one of the finest university collections of graphic arts in the nation. The Center's holdings consist of more than 45,000 prints, drawings, photographs and artists' books dating from the Renaissance to the present. A primary resource for teaching and research, the Center serves UCLA students, faculty, and the public. Independently and in association with major museums and libraries around the world, the Center organizes exhibitions and publishes catalogues. The Center provides a valuable resource for artists, art historians and museum professionals and is open by appointment only. Among the 5,000 pre-19th-century prints and drawings held by the Center are works by Canaletto, Dürer, Mantegna, Rembrandt, and Tiepolo. A comprehensive collection of 19th- and 20th-century art includes works by Cézanne, Toulouse-Lautrec, Kirchner, Kollwitz, Nolde, Matisse, and Picasso, as well as by contemporary artists such as Carlos Almaraz, Richard Diebenkorn, Jasper Johns, Barbara Morgan, Joyce Treiman, and June Wayne. The Richard Vogler George Cruikshank archives contain over 3,000 prints, drawings, and illustrations by the English caricaturist. The Center also manages the 10,000 works in the Armand Hammer Honoré Daumier and contemporaries Collection. Additionally, the Center is the repository for the complete archives of Corita Kent and the Tamarind Lithography Workshop. Japanese works on paper are also represented with a sizeable archive. The Center's holdings are highlighted by a collection of 20th-century artists' books and also include a considerable number of 20th-century American photographs.

George Cruikshank, *Snuffing Our Boney*, 1814, etching with hand coloring. Grunwald Center for the Graphic Arts at UCLA. Reproduction courtesy of Grunwald Center for the Graphic Arts at UCLA, Los Angeles, California.

University of Southern California - Fisher Gallery

823 Exposition Blvd., Harris Hall (between Figueroa and Watt Way), Los Angeles, CA 90089-0292
Tel: (213) 740-4561
Fax: (213) 740-7676
Internet Address: http://www.usc.edu/dept/Fischer_Gallery
Director: Dr. Selma Holo
Admission: free.
Attendance: 11,000 *Established:* 1939 *Membership:* N *ADA Compliant:* Y
Parking: on campus ($6) or metered on Exposition Blvd. & Vermont Ave.
Open: **September to June**, Tuesday to Friday, noon-5pm.
 During Exhibitions, Tuesday to Friday, noon-5pm; Saturday, 11am-3pm.
 Summer, Call for hours.
Facilities: **Galleries.**
Activities: **Films; Gallery Talks; Guided Tours** (during exhibition, Tues, 1pm); **Lectures; Permanent Exhibits; Temporary Exhibitions; Traveling Exhibitions.**
Publications: exhibition catalogues.

Fisher Gallery, the accredited art museum of the University of Southern California, offers exhibitions ranging from antiquities and Old Master artists through contemporary works by artists with local, national and international reputations. In addition to showing the permanent collection, the Gallery presents traveling exhibitions and organizes its own exhibitions. The exhibition schedule includes regular year-long exhibitions of the permanent collection in the Walter and Hertha Klinger Gallery in the Quinn Wing and changing exhibitions (of about 12 weeks duration) in the main galleries. Between the two facilities is a reading room where catalogs and other relevant materials are placed to encourage reflection by Museum audiences. Small focus exhibitions or orientation materials are also placed in the reading room. Klinger Gallery, Quinn Wing, the museum's permanent collection exhibition space, is open during the academic year and by appointment during the summer

University of Southern California - Fisher Gallery, cont.

months. Permanent collections include groups of 19th-century American landscapes; 18th- and 19th-century Northern European paintings; 18th-century British portraiture; 19th-century Barbizon paintings; and 20th-century works on paper, paintings, and sculpture.

Watts Towers Arts Center

1727 E. 107th Street, Los Angeles, CA 90002
Tel: (213) 847-4646
Fax: (213) 564-7030
TDDY: (213) 789-2151
Director: Mr. Mark S. Greenfield
Admission: free.
Attendance: 25,000 *Established:* 1975 *Membership:* Y *ADA Compliant:* Y
Parking: on site.
Open: Tuesday to Saturday, 10am-4pm;
 Sunday, noon-4pm.
Closed: Legal Holidays.
Facilities: Gallery.
Activities: **Arts Festival**; **Concerts** (Jazz Festival, annual, late-Sept; Drum Festival, annual); **Education Programs**; **Films**; **Juried Exhibits**; **Lectures**; **Temporary Exhibitions**; **Traveling Exhibitions**.

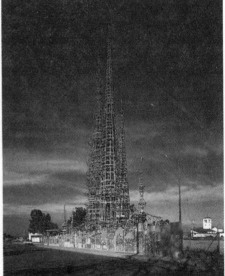

Simon Rodia, *The Watts Towers of Simon Rodia*, 1954, steel, cement, and mosaic. The Watts Towers Art Center. Photograph courtesy of The Watts Towers Art Center, Los Angeles, California.

The Watts Towers Arts Center, founded by a number of citizens concerned with the restoration and preservation of the historic Towers and the cultural well-being of a community ravaged by civil unrest, houses two galleries, an education area, and offices. It offers an array of activities including art exhibitions, lectures, and classes in painting, drawing and dance. The Center's main gallery features changing exhibitions of contemporary art by local and national, emerging and established artists. The Center organizes the annual Simon Rodia Watts Towers Jazz Festival and concurrent Day of the Drum held during the last weekend in September. Both events embrace the concept of multiculturalism and draw crowds from all parts of the city. In 1989, Dr. Joseph Howard, one of the leading authorities on and collectors of percussion instruments in the world, donated a portion of his extensive collection to the Center, where it is on permanent display. The Center also possesses a collection of African Sculpture. Located at 1765 E. 107th St., the Watts Towers consist of nine major sculptures, constructed of structural steel covered in mortar and ornamented with trencadis mosaic. They are the sole work of Simon Rodia, a construction worker by profession, who labored single-handedly for 33 years to build his masterpiece, which he called "Nuestro Pueblo". The tallest tower stands 99½ feet. The structure is listed on the National Register of Historic Places.

Malibu

The Getty Villa at Malibu

17985 Pacific Highway, Malibu, CA 90265
Tel: (310) 459-7611
Fax: (310) 454-6633
TDDY: (310) 394-7448
Assistant Director: Ms. Barbara Whitney
Admission: fee.
Established: 1953
Open: Scheduled to reopen in 2001.

The Getty Villa at Malibu, cont.
Facilities: Architecture (modeled after Villa dei Papiri, a Roman country villa).

Formerly the site of the J. Paul Getty Museum, the Villa is being renovated and is scheduled to reopen in 2001 as a center for comparative archaeology and cultures, featuring the Museum's collection of classical antiquities. The Getty Antiquities Collection, temporarily exhibited at the Getty Center, will then return to the Villa in Malibu, where it will remain. In its new role, the Villa will house galleries for special exhibitions, a center for scholarly research, and a graduate program and exhibition gallery dedicated to the preservation of cultural heritage. The Museum building, a re-creation of a Roman country villa, will be refurbished to show ancient art on both floors. The Ranch House, Mr. Getty's original home on the property and the site of the first Getty Museum (1954-74), will be renovated to house a library, seminar rooms, and offices for scholars. The Getty's extensive collection of classical antiquities includes sculpture, Greek vases, Greek and Roman gems, and luxury wares such as Hellenistic silver and Roman glass.

Pepperdine University - Frederick R. Weisman Museum of Art
24255 Pacific Coast Highway
Malibu, CA 90263
Tel: (310) 456-4851
Fax: (310) 456-4556
Internet Address: http://www.pepperdine.edu
Director: Mr. Michael Zakian
Admission: free.
Attendance: 20,000 *Established:* 1992
Membership: Y *ADA Compliant:* Y
Parking: free.
Open: Tuesday to Sunday, 11am-5pm.
Closed: Memorial Day, Independence Day,
 Labor Day, Thanksgiving Day,
 Christmas Day to New Year's Week.
Facilities: Exhibition Area (3,000 square feet).
Activities: Temporary Exhibitions.

Exterior view of Frederick R. Weisman Museum of Art. Photograph courtesy of Frederick R. Weisman Museum of Art, Pepperdine University, Malibu, California.

The Museum hosts a new temporary exhibition of historic or contemporary art every two months as well as senior student exhibitions. Selections from the Frederick R. Weisman Art Foundation are usually on view in the mezzanine gallery. The permanent collection focuses primarily on 20th-century American and contemporary California art. For theatre guests, the Museum is open one hour prior to evening performances through first intermission.

Mendocino

Mendocino Art Center (MAC)
45200 Little Lake Street, Mendocino, CA 95460
Tel: (707) 937-5818
Fax: (707) 937-1764
Internet Address: http://www.mendocinoartcenter.org
Executive Director: Dena Berry Nye
Admission: voluntary contribution.
Attendance: 36,000 *Established:* 1959 *Membership:* Y *ADA Compliant:* Y
Open: Daily, 10am-5pm.
Closed: New Year's Day, Thanksgiving Day, Christmas Day.
Facilities: Auditorium (90 seats); Galleries (2); Library (2,000 volumes); Sculpture Garden.
Activities: Arts Festival; Education Programs; Films; Lectures; Performances.
Publications: magazine (bi-monthly).

The Center presents one-person shows, competitions, retrospectives, and other temporary exhibitions in two galleries: Mendocino Gallery and A.D. Abramson Gallery.

Mission Viejo

Saddleback College Art Gallery

Fine Arts Complex, 28000 Marguerite Parkway, Mission Viejo, CA 92692
Tel: (714) 582-4924
Fax: (714) 347-0580
Internet Address: http://iserver.saddleback.cc.ca.us/div/fac/artexhibit.html
Gallery Director: Ms. Karen Collins-McGuire
Open: **September to May**,
 Monday to Wednesday, noon-4pm; Thursday, 5pm-8pm; Friday, 10am-2pm; by appointment.
Facilities: **Gallery**.
Activities: **Temporary Exhibitions**.

The Art Gallery presents temporary exhibitions featuring the work of locally, regionally and nationally recognized artists. Shows are chosen for "their ability to provoke thought and to challenge assumptions and pre-conceived ideas, as well as their social, political and cultural focus". There is a juried student exhibition in May of each year.

Monterey

Monterey Museum of Art at Civic Center (MMA)

559 Pacific St. (across from Colton Hall)
Monterey, CA 93940
Tel: (831) 372-5477
Fax: (831) 372-5680
Internet Address: http://wwwmontereyart.org
Executive Director: Mr. Richard W. Gadd
Admission: fee: adult-$5.00, student-$2.50.
Attendance: 55,000 *Established:* 1959
Membership: Y *ADA Compliant:* Y
Parking: on street, 2 hours free.
Open: Wednesday to Saturday, 11am-5pm;
 Sunday, 1pm-4pm.
 3rd Thursday in Month, 11am-8pm.
Closed: New Year's Day, Thanksgiving Day,
 Christmas Day.

Armin Hansen, *Nino*, 1926, oil on canvas. Monterey Museum of Art. Photograph courtesy of Monterey Museum of Art, Monterey, California.

Facilities: **Education Center**; **Galleries** (7); **Library**; **Store**.
Activities: **Lectures**; **Temporary Exhibitions**.
Publications: exhibition catalogues; newsletter (quarterly).

Located across from Colton Hall in the historic center of Monterey, the Museum includes seven galleries, as well as an education center and a library. Exhibitions concentrate on the artistic heritage of the region. The Museum's permanent collection includes California art, photography, Asian art, and international folk art, and features significant bodies of work by Armin Hansen, William Ritschel, Ansel Adams and Edward Weston. The Museum also maintain a second location, the Monterey Museum of Art at La Mirada (see separate listing).

Monterey Museum of Art at La Mirada

720 Via Mirada (off Freemont St., opposite Lake El Estero)
Monterey, CA 93940
Tel: (831) 372-3689
Fax: (831) 372-5680
Internet Address: http://wwwmontereyart.org
Admission: fee: adult-$5.00, student-$2.50.
Open: Wednesday to Saturday, 11am-5pm; Sunday, 1pm-4pm.
Facilities: **Architecture** (Dart Wing 1993, designed by Charles Moore); **Galleries** (4); **Store** (Thurs-
 Sun, 1pm-4pm).

Monterey, California

Monterey Museum of Art at La Mirada, cont.
Activities: Temporary Exhibitions.

Surrounded by magnificent gardens and picturesque stone walls, the Monterey Museum of Art at La Mirada is situated in one of Monterey's oldest neighborhoods. Its history is colorful. It began as a two-room adobe and later became an elegant home where international and regional celebrities were entertained. Visitors today will experience the same exquisitely furnished home, rose and rhododendron gardens, and the ambience of early California. With the addition of the Dart Wing in 1993, designed by architect Charles Moore, visitors also view the museum's permanent collection and changing exhibitions in four contemporary galleries, which complement the original estate. The Monterey Museum of Art has two locations. For administrative offices and main galleries see listing for Monterey Museum of Art at Civic Center.

Entrance to Monterey Museum at La Mirada. Photograph courtesy of Monterey Museum of Art, Monterey, California.

Monterey Park

East Los Angeles College-Monterey Park - Vincent Price Gallery
1301 Avenida Cesar Chavez, Monterey Park, CA 91754
Tel: (323) 265-8841
Fax: (323) 265-8763
Internet Address: http://www.elac.cc.ca.us/gallery.htm
Director: Mr. Thomas Silliman
Admission: free.
Parking: on street in front of campus.
Open: Monday to Friday, noon-3pm; additional hours may be arranged by appointment.
Facilities: Gallery.
Activities: Guided Tours; Temporary Exhibitions (6/year).

It was in 1951 that Price first visited the campus of East Los Angeles College. Invited to lecture on the "Aesthetic Responsibilities of the Citizen", Price arrived to find he was (in his words) "speaking in a Quonset hut on a mud flat." Struck by the spirit of the students and the community's need for the opportunity to experience original art works first hand, Price donated some ninety pieces to establish the first "teaching art collection" owned by a community college in the United States. Over the decades, Price and other patrons donated to the collection with the goal of illustrating diverse periods, styles, media, and techniques. Facilities consist of the main gallery (Building F5-104), a smaller permanent gallery (Building F6), and an exhibit preparation workshop. Assembled with works from private and public art collections, the Gallery's own collection, and student art work, the exhibits produced by the Gallery are curated, prepared and installed by students as part of an educational program. Meant to be a hands-on teaching tool, the collection of over 2,000 works features a variety of artistic techniques: wood carving from Africa, New Guinea, and Pre-Columbian Mexico; ceramics from ancient Peru, Mexico and Etruria; Aztec and ancient Egyptian sculpture; watercolor painting by William Bryce; oil and acrylic painting by Hans Burckhardt and Rafael Coronel; ink drawing by Frank Romero and Joseph Giasco; pastel drawing by John Paul Jones and Howard Warshaw; pencil drawing by William Wiley, Aristide Maillol and Eugene Delacroix; lithography by Jose Luis Cuevas, Fritz Scholder and Roy Lichtenstein; etchings by Peter Winslow Milton and Francisco Goya; serigraphy by Friedensreich Hundertwasser and Victor Vasarely; woodcut printmaking by Ito Shinsui and Albrecht Dürer; and gouache painting by Paul Burlin and Jesus "Chucho" Reyes. Other important artists represented include Bonnard, Daumier, Dali, Diebenkorn, Hiroshige I, Hockney, Manet, Piranesi, Picasso, Redon, Rothko, Rouault, Siqueiros, Tamayo, Utrillo, and other major contributors to world art history.

Moraga

St. Mary's College - Hearst Art Gallery

1928 St. Mary's Road (across from Soda Activity Center), Moraga, CA 94575

Tel: (510) 631-4379

Fax: (510) 376-5128

Internet Address:
 http://gaelnet.stmarys-ca.edu/gallery/intro.html

Dean for Academic Resources: Tom Carter

Admission: suggested contribution-$1.00.

Attendance: 16,000 *Established:* 1977

Membership: Y *ADA Compliant:* Y

Parking: free on site.

Open: Wednesday to Sunday, 11am-4:30pm.

Closed: Legal Holidays, Between Exhibits.

Facilities: **Food Services** (campus coffee shop); **Galleries** (2); **Picnic Area**; **Shop**.

Activities: **Guided Tours** (groups, arrangements in advance); **Lectures**; **Temporary Exhibitions** (5/yr.); **Traveling Exhibitions**.

Publications: exhibition catalogues; leaflets.

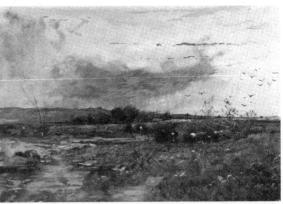

William Keith, *Gray Rain Clouds; Cattle in Meadow*, late 1880's. Hearst Art Gallery. Photograph courtesy of Hearst Art Gallery, Saint Mary's College, Moraga, California.

The Hearst Art Gallery was built with the aid of a grant from the William Randolph Hearst Foundation. It opened in 1977, replacing a smaller William Keith Gallery originally established in 1934. The College had already been collecting and exhibiting art for several decades, including many works by William Keith (1838-1911), a key figure in the history of California art. The William Keith Collection continues as a special feature of the Gallery, with a selection of Keith's paintings always on view. The Gallery actively collects and exhibits 19th- and 20th-century California landscapes by other artists and in other media as well. Christian imagery in art is another focus of the collection and of occasional exhibitions. From German 15th-century carved-wood Madonnas, to Russian and Greek icons, to contemporary artists' responses to traditional Christian themes, the Gallery examines the religious tradition that has inspired so much of Western art. Each year a student show of work by art majors and other undergraduates is organized and installed by a student committee in consultation with the gallery curator. Saint Mary's College has a collection of about 2,200 art objects. Some highlights include 150 paintings by Keith; 150 other American paintings, primarily by late 19th- to early 20th-century artists, including Albert Bierstadt, Norton Bush, William Coulter, Armin Hansen, George Inness, Maurice Logan and J. Francis Murphy; 21 drawings and watercolors by Morris Graves; 32 etchings by renowned California printmaker Roi Partridge; 20 drawings and prints and one oil painting by California artist Frank Van Sloun; 577 photographs of California landscapes by Stanley Truman; and large scale color prints by modern masters Manuel Neri, Nathan Oliveira and Wayne Thiebaud.

Newport Beach

Orange County Museum of Art (OCMA)

850 San Clemente Drive
Newport Beach, CA 92660

Tel: (714) 759-1122

Fax: (714) 759-5623

Internet Address: http://www.ocma,net

Director: Dr. Naomi Vine

Admission: fee:
 adult-$5.00, child (<16)-free, student-$4.00, senior-$4.00.

Attendance: 70,000 *Established:* 1962

Richard Diebenkorn, *Ocean Park #36*, 1970, oil on canvas, 93 x 81 inches. Gift of David H. Steinmetz, Orange County Museum of Art in Newport Beach. Photograph courtesy of Orange County Museum of Art, Newport Beach, California.

Newport Beach, California
Orange County Museum of Art, cont.
Membership: Y　　*ADA Compliant:* Y
Parking: free on site.
Open:　Tuesday to Sunday, 11am-5pm.
Closed: New Year's Day, Independence Day, Thanksgiving Day, Christmas Day, Independence Day.
Facilities: **Auditorium** (108 seats); **Galleries** (15); **Library** (2,000 volumes); **Sculpture Garden**; **Shop.**
Activities: **Concerts**; **Films**; **Gallery Talks**; **Guided Tours**; **Lectures**; **Performances.**
Publications: exhibition catalogues; newsletter, "Insight" (quarterly).

OCMA features a permanent collection of California art from the turn of the century through today, an array of changing exhibitions, and education programs. OCMA maintains two locations, Newport Beach and Costa Mesa (see separate listing).

Northridge

California State University, Northridge - Art Galleries
Art Dome, Music Lawn 236, 18111 Nordhoff Street, Northridge, CA　91330-8299
Tel: (818) 677-2226
Fax: (818) 677-5910
Internet Address: http://www.csun.edu/artgalleries/
Director: Ms. Louise Lewis
Admission: free.
Attendance: 36,000　　*Established:* 1972　　*Membership:* Y　　*ADA Compliant:* Y
Parking:　$1.75 in student lots; free on weekends.
Open:　**September to May,**
　　　　Monday to Saturday, noon-4pm; Tuesday to Friday, 10am-4pm, during exhibitions.
Closed: June to August, University Holidays.
Facilities: **Food Services** (on campus); **Gallery**; **Shop** (art books, cards, gift items, ethnic artifacts).
Activities: **Concerts**; **Dance Recitals**; **Education Programs**; **Gallery Talks**; **Guided Tours** (docent tours for groups, reserve in advance); **Lectures**; **Temporary Exhibitions** (4-5/year).
Publications: exhibition catalogues (4-5/year).

The Art Galleries conduct an art program from international and multicultural perspectives. Historical and contemporary, thematic and media-oriented exhibitions are presented, to reflect the broad spectrum of art in today's global society and to accommodate an equally broad audience. Special events such as lectures, performances, video and film presentations, symposia, and tours have also become an integral part of the Gallery program. CSU Northridge Galleries are located in temporary space as a result of the earthquake in 1994; a new building is scheduled to open in the spring of 2001. In addition to exhibitions at the Art Dome, each year three to five shows are mounted in the Performing Arts Center Gallery-USU and changing exhibitions of work by Master's Degree candidates, faculty, students and visiting artists are displayed in North Gallery (677-2156), Halstead House 1102. CSU Northridge Art Galleries do not maintain a permanent collection.

Oakland

California College of Arts and Crafts - Steven H. Oliver Art Center
5212 Broadway at College Ave., Oakland, CA　94618
Tel: (510) 594-3650
Fax: (510) 428-1346
Internet Address: http://www.ccac-art.edu
C.E.O.: Michael S. Roth
Admission: free.
Attendance: 21,000　　*Established:* 1907　　*Membership:* Y　　*ADA Compliant:* Y
Open:　Monday to Tuesday, 11am-5pm; Wednesday, 11am-9pm; Friday to Saturday, 11am-5pm.
Closed: Legal Holidays.
Facilities: **Gallery.**

California College of Arts and Crafts - Steven H. Oliver Art Center, cont.

Activities: **Education Programs**; **Gallery Talks**; **Guided Tours** (for organized groups); **Lecture Series**; **Temporary Exhibitions**.

Publications: exhibition catalogues.

Founded at the height of the Arts and Crafts movement, CCAC offers programs of study in drawing, painting, printmaking, ceramics, glass, jewelry/metals arts, sculpture, textiles, wood/furniture, photography, film/video/performance, fashion design, graphic design, industrial design, illustration, architecture and interior architecture. The Oliver Center presents temporary exhibitions and programs in the fields of art, architecture, and design. CCAC has two campuses. The Oliver Art Center is located on the Oakland campus (please see separate listing for the Logan Center Galleries at the San Francisco campus).

Mills College Art Museum

5000 MacArthur Blvd., Oakland, CA 94613

Tel: (510) 430-2164

Fax: (510) 430-3168

Internet Address: http://www.mills.edu/MCAM/mcam.home.html

Director: Dr. Katherine B. Crum

Admission: free.

Attendance: 9,000 *Established:* 1925 *Membership:* Y *ADA Compliant:* Y

Open: September to May, Tuesday to Saturday, 11am-4pm; Sunday, noon-4pm.

Facilities: **Galleries**.

Activities: **Lecture Series**; **Temporary Exhibitions**.

Publications: brochures; bulletin, "Mills College Art Museum Bulletin"; catalogues.

Housed in a Spanish Colonial revival building constructed in 1923, The Mills College Art Museum had one of the first collections of contemporary art on the West Coast when it opened, and since the 1920s it has continued a tradition of exhibiting recent art from around the world. Important modernists appeared at Mills in the 1930s including Picasso, Albers, Léger, and Feininger. In recent years, the Museum has held exhibitions by Adolph Gottlieb, Sophie Calle, Jennifer Bartlett, Elizabeth Murray, John Cage, Alice Neel, and Albert York. The program also includes exhibitions from the permanent collection and shows by graduating seniors and MFA students. Mills has the largest permanent collection of any liberal arts college on the West Coast, numbering more than 6,000 objects. It has particular strength in Old Master and modern American and European prints and drawings (including work by Dürer, Delacroix, Redon, Cassatt, Sloan, Baldessari); Asian textiles; Japanese, ancient American, and modern ceramics; and California regionalist paintings.

Oakland Museum of California

1000 Oak Street, Oakland, CA 94607

Tel: (510) 238-2200

Fax: (510) 238-2258

TDDY: (510) 451-3322

Internet Address: http://www.museumca.org

Executive Director: Dr. Dennis M. Power

Admission: fee: adult-$6.00, student-$4.00, senior-$4.00.

Attendance: 250,000 *Established:* 1969 *Membership:* Y *ADA Compliant:* Y

Open: Wednesday to Saturday, 10am-5pm; Sunday, noon-5pm.

Closed: New Year's Day, Independence Day, Thanksgiving Day, Christmas Day.

Facilities: **Auditorium**; **Food Services** Restaurant; **Galleries**; **Gardens**; **Shop**; **Theatre**.

Activities: **Concerts**; **Education Programs**; **Films**; **Gallery Talks**; **Guided Tours**; **Lectures**; **Performances**; **Temporary Exhibitions**; **Traveling Exhibitions**.

Publications: brochures; calendar; collection catalogue, "The Art of California: Selected Works from the Collection of the Oakland Museum"; exhibition catalogues (annual); magazine (quarterly).

The Museum features exhibits in art, history and science. Its Art Department, founded in 1916 as the Oakland Art Gallery, houses a comprehensive California regional collection. Major artists represented in the gallery include Ansel Adams, John Baldessari, Albert Bierstadt, Anne Brigman,

Oakland, California

Oakland Museum of California, cont.

Deborah Butterfield, Robert Colescott, Lia Cook, Imogen Cunningham, Maynard Dixon, John Graham, Thomas Hill, Mildred Howard, Robert Hudson, Margo Humphrey, Alvin Light, Marvin Lipofsky, Xavier Martinez, Michael C. McMillen, Eadweard Muybridge, Manuel Neri, Lucy Puls, Betye Saar, Raymond Saunders, Wayne Thiebaud, Edward Weston and Peter Voulkos. The Department also mounts temporary exhibitions, often in collaboration with other museums. Among the Oakland Museum's most impressive collections are the Dorothea Lange Archive; the Arthur and Lucia Mathews Collection of Arts and Crafts furniture and paintings; architectural photographs by Roger Sturtevant; Bay Area figurative art by such renown artists as Elmer Bischoff, Nathan Oliveira, David Park, Richard Diebenkorn, Joan Brown, James Weeks, and others; and California landscapes, including paintings by the Society of Six. The museum is respected for its craft collection of contemporary jewelry, fiber, glass, wood, metal and ceramics. The Art Department continues to be active in the acquisition and exhibition of art in all media.

Oakland Museum of California - Sculpture Court at City Center

1111 Broadway at 12th, Oakland, CA 94607
Tel: (510) 238-3401
Chief Curator: Mr. Philip Linhares
Admission: voluntary contribution.
Membership: N
Open: Monday to Friday, 7am-7pm; Saturday, 8am-4pm; Sunday, 10am-4pm.
Closed: Legal Holidays.
Facilities: **Sculpture Garden**.

The Sculpture Court contains the work of contemporary California sculptors.

Ontario

Museum of History and Art, Ontario

225 S. Euclid Ave. at Holt Blvd., Ontario, CA 91761
Tel: (909) 983-3198
Fax: (909) 983-8978
Internet Address: http://www.ci.ontario.ca.us/resident/ontariomuseum.htm
Director: Ms. Theresa Hanley
Admission: voluntary contribution.
Attendance: 13,000 *Established:* 1979 *Membership:* Y *ADA Compliant:* Y
Parking: immediately available.
Open: Wednesday to Sunday, noon-4pm.
Closed: New Year's Eve to New Year's Day, Easter, Memorial Day, Independence Day,
 Christmas Day.
Facilities: **Auditorium** (75 seats); **Shop**.
Activities: **Arts Festival**; **Films**; **Guided Tours**; **Lectures**; **Temporary Exhibitions**.
Publications: newsletter.

Located in Ontario's 1937 Works Progress Administration former City Hall, the Museum features permanent exhibits on the social and cultural history of Ontario and its surrounding communities. Temporary exhibits present the work of regional, student, and emerging artists as well as interpretive exhibitions on a variety of regional and national topics. Lectures, artist receptions, hands-on art workshops, and musical and storytelling performances are held throughout the year.

Orange

Chapman University - Guggenheim Gallery

1 University Drive, Orange, CA 92666
Tel: (714) 997-6729
Internet Address: http://www.chapman.edu/comm/art/c_gall.htm
Directors: Maggi Owens and Richard Turner
Admission: free.

Chapman University - Guggenheim Gallery, cont.

Open: Call for hours.

Facilities: **Gallery.**

Activities: **Temporary Exhibitions.**

The Gallery provides a venue for artists and exhibitions that question aesthetic conventions and the role of the arts in society, addressing artistic and social issues that are often timely and provocative. The gallery encourages programming that crosses cultural boundaries and offers exhibition opportunities for emerging under-recognized and minority artists. The Guggenheim Gallery sponsors an annual schedule of exhibitions that includes four major shows of works by local, national and internationally known artists, two department-wide student shows, one at the end of each semester, as well as small group and solo shows for junior art majors and graduating seniors. The departmental show at the end of each semester is a student production from the initial call for entries, through the hanging, opening reception to the final de-installation. Junior-year art majors exhibit their work in small group shows and seniors have individual exhibitions of their work. When the schedule allows, some of the department's more ambitious students will mount shows of their most recent work.

Oxnard

Carnegie Art Museum

424 South C Street, Oxnard, CA 93030

Tel: (805) 385-8157

Fax: (805) 483-3654

Internet Address: http://www.vcnet.com/carnart/

Director: Ms. Suzanne Bellah

Admission: fee: adult-$4.00, child-$1.00, student-$2.00, senior-$2.00.

Attendance: 15,000 *Established:* 1980 *Membership:* Y *ADA Compliant:* N

Parking: free, lot adjacent to site.

Open: Thursday to Saturday, 10am-5pm; Sunday, 1pm-5pm.

Closed: Holidays.

Facilities: **Architecture** (1907 design by Los Angeles architect Franklin Burnham); **Galleries; Shop.**

Activities: **Concerts; Education Programs; Films; Guided Tours** (group tours, Thurs-Fri by appointment, (805) 385-8157); **Lectures; Temporary Exhibitions; Traveling Exhibitions.**

Publications: brochures; exhibition catalogues; gallery guides; newsletter.

A library from 1907 to 1963, the Neo-Classical Carnegie now houses Oxnard's municipal art collection, which was begun in 1924. Besides showing traveling exhibits that change every two months, the Museum exhibits its permanent collection of 500 paintings, drawings and photographs, and 350 ethnographic artifacts. Selections from the permanent collection rotate every quarter. The permanent collection include works by Arthur Beaumont, Cornelius Botke, Jesse Arms Botke, Colin Campbell Cooper, Katherine Leighton, Leo Politi, Millard Sheets, and Hamid Zavareei, as well as contemporary California artists.

Pacific Grove

Pacific Grove Art Center, Associates, Inc.

568 Lighthouse Ave., Pacific Grove, CA 93950

Tel: (408) 375-2208

Admission: free.

Attendance: 16,000 *Established:* 1968

Open: Wednesday to Saturday, noon-5pm; Sunday, 1pm-4pm.

Closed: Legal Holidays.

Facilities: **Galleries** (4); **Studios.**

Activities: **Concerts; Dance Recitals; Education Programs; Temporary Exhibitions.**

Publications: newsletter.

The Art Center mounts temporary exhibitions.

Palm Springs

Palm Springs Desert Museum, Inc.

101 Museum Drive, Palm Springs, CA 92262
Tel: (760) 325-7186
Fax: (760) 327-5069
Internet Address: http://www.psmuseum.org
Executive Director: Janice Lyle, Ph.D.
Admission: fee: adult-$7.50, student-$3.50, senior-$6.50.
Attendance: 160,000 *Established:* 1938 *Membership:* Y *ADA Compliant:* Y
Open: Tuesday to Saturday, 10am-5pm; Sunday, noon-5pm.
Facilities: **Auditorium** (90 seats); **Galleries** (54,000 square feet); **Library** (3,500 volumes); **Sculpture Gardens** (3); **Shop**; **Theatre** (450 seats).
Activities: **Education Programs** (adults and children); **Films**; **Gallery Talks**; **Guided Tours**; **Lectures**; **Performances**; **Temporary Exhibitions**; **Traveling Exhibitions**.
Publications: books; exhibition catalogues.

The Palm Springs Desert Museum promotes a greater understanding of art, natural science and performing arts through collections, exhibitions, and programs The permanent art collection features 19th- and 20th-century American art, contemporary California art, western American art, Native American artifacts, graphics, and photography.

Palo Alto

Koret Gallery - Albert L. Schultz Jewish Community Center

Albert L. Schultz Jewish Community Center, 655 Arastradero Road, Palo Alto, CA 94306-3838
Tel: (415) 493-9400
Director/Curator: Ms. Nancy Gordon
Admission: free.
Open: Tuesday to Friday, 11am-3pm; Sunday, noon-4pm.
Facilities: **Exhibition Area.**
Activities: **Temporary Exhibitions** (5/year).

A wide range of exhibits features contemporary arts and crafts of museum quality, ceremonial objects, and Jewish history and culture. Emerging and established artists have an opportunity to display their work in invitational and juried shows. Lectures, slide shows, and musical programs enhance many of the exhibits.

Pasadena

Armory Center for the Arts

145 N. Raymond Ave., Pasadena, CA 91103
Tel: (626) 792-5101
Fax: (626) 449-0139
Internet Address: http://www.armoryarts.org
Exec. Director: Ms. Elisa Greben Crystal
Admission: free.
Attendance: 67,000
Membership: Y *ADA Compliant:* Y
Parking: limited/metered.
Open: Wednesday, noon-5pm;
Thurs to Fri, noon-5pm & 6:30pm-9pm;
Saturday to Sunday, noon-5pm.
Facilities: **Classrooms/Studios** (4,000 square feet); **Gallery** (3,000 square feet).
Activities: **Artist-in-Residence Program**; **Concerts** (weekends, suggested donation, $5); **Education Programs** (adults and children); **Performances/Readings** (Friday night, suggested donation, $5); **Temporary Exhibitions**; **Workshops**.

Exterior view of Armory Center for the Arts, a converted Art Deco National Guard Armory (1932). Photograph courtesy of Armory Center for the Arts, Pasadena, California.

Armory Center for the Arts, cont.

Publications: exhibition catalogues (quarterly).

Acommunity art center, the Armory presents exhibitions, performances, and educational programs in its gallery and studio space. Exhibitions feature contemporary works in a variety of media by emerging and nationally recognized artists. Exhibitions are also regularly presented in the Armory's Community Room, including student artwork and shows organized by community-based organizations.

Art Center College of Design - Alyce de Roulet Williamson Gallery

1700 Lida St., Pasadena, CA 91103

Tel: (818) 396-2244

Fax: (818) 405-9104

Internet Address: http://www.artcenter.edu/exhibit/williamson.html

Director: Mr. Stephen Nowlin

Admission: free.

Established: 1991

Parking: free on site.

Open: Tuesday to Wednesday, noon-5pm; Thursday, noon-9pm; Friday to Sunday, noon-5pm.

Facilities: **Gallery** (4,600 square feet); **Sculpture Garden**.

Activities: **Temporary Exhibitions**.

The Alyce de Roulet Williamson Gallery is a 4,600 square-foot space designed by the Santa Monica architectural firm of Frederick Fisher and Partners and constructed in 1991. Located in the center of the college's landmark steel-and-glass International Style building, the gallery features temporary exhibitions of work by both established and emerging fine artists and designers. Works by students are exhibited year-round in a separate gallery.

Norton Simon Museum

411 W. Colorado Blvd. at Orange Grove Blvd.

Pasadena, CA 91105-1825

Tel: (626) 449-6840

Fax: (626) 796-4978

Internet Address: http://www.nortonsimon.org

President: Ms. Jennifer Jones Simon

Admission: fee: adult-$6.00, child-free, student-free, senior-$3.00.

Attendance: 150,000 *Established:* 1924

Membership: Y *ADA Compliant:* Y

Parking: free on site.

Open: Wednesday to Thursday, noon-6pm; Friday, noon-9pm; Saturday to Sunday, noon-6pm.

Norton Simon Museum, Gallery 14 (Southeast Wing). Photograph by Jim Mayner, courtesy of Norton Simon Museum, Pasadena, California.

Closed: New Year's Day, Thanksgiving Day, Christmas Day.

Facilities: **Architecture** Building (1969, designed by Ladd & Kelsey), Renovation (1998, designed by Frank Gehry); **Galleries** (30); **Sculpture Garden** (designed by Nancy Goslee Power); **Shop** (books, prints, sculptures, posters, cards).

Activities: **Private Tours** (by appointment, $200-$250/25 persons, (626) 844-6923).

Publications: collection catalogue, "Masterpieces of the Norton Simon Collection"; exhibition catalogues; newsletter.

In a tranquil environment of 30 galleries and a sculpture garden, one thousand works are on view regularly. Seven centuries of European art from the Renaissance to the 20th-century are in the collection, including works by such artists as Raphael, Botticelli, Rubens, Rembrandt, Zurbaran, Watteau, Fragonard and Goya. The Museum boasts a particularly celebrated Impressionist and Post-Impressionist collection with paintings by Manet, Renoir, Monet, Degas, van Gogh, Toulouse-Lautrec and Cézanne. In addition, there are 20th-century works by Picasso, Matisse and the German Expressionists. Complementing the Western art is a group of Asian sculpture from India and Southeast Asia spanning a period of 2,000 years. Special exhibitions present parts of the permanent

Norton Simon Museum, cont.

collection on a rotating basis. The Museum was founded in 1924 as the Pasadena Art Institute; the present building, designed by Ladd & Kelsey, opened to the public in 1969 as the Pasadena Art Museum. It was reorganized and remodeled in 1974 under the direction of Norton Simon. In 1998, an extensive interior renovation directed by architect Frank O. Gehry was completed.

Pacific Asia Museum

46 N. Los Robles Ave.
(between Union St. and Colorado Blvd.)
Pasadena, CA 91101
Tel: (626) 449-2742
Fax: (626) 449-2754
Internet Address:
 http://www.sci.csupomona.edu/ige/pamhp2.html
Executive Director: Mr. David L. Kamansky
Admission: fee: adult-$5.00, child-free,
 student-$3.00, senior-$3.00.
Attendance: 52,000 *Established:* 1971
Membership: Y *ADA Compliant:* Y
Parking: free adjacent to museum.
Open: Wednesday to Sunday, 10am-5pm.
Closed: New Year's Eve to New Year's Day,
 Independence Day, Thanksgiving Day,
 Christmas Day.

Chinese-style gardens, Pacific Asia Museum. Photograph courtesy of Pacific Asia Museum, Pasadena, California.

Facilities: **Auditorium** (100 seats); **Conservation Facilities**; **Library** (Wed & Fri, noon-4pm by appointment; 6,600 volumes); **Shop** (Wed-Fri, noon-5pm; Sat-Sun, 10am-5pm).
Activities: **Concerts** (occasional, usually Asian music); **Dance Recitals**; **Education Programs**; **Films**; **Gallery Talks**; **Guided Tours** (Sun, 1pm); **Lectures** (related to Asian art and culture); **Temporary Exhibitions**; **Traveling Exhibitions**.
Publications: exhibition catalogues; newsletter (bi-monthly); posters.

The former gallery and home of Grace Nicholson, the Chinese Imperial Palace-style building was commissioned in 1924 and designed by Marston, Van Pelt and Maybury. Through its exhibition, education and outreach programs, Pacific Asia Museum preserves, presents, and interprets the varied arts and cultures of the Pacific Islands and Asia. Its courtyard is a Chinese garden replete with statues, koi pond, tai-hu style rocks and specimen plants. The Museum's permanent collection includes more than 17,000 objects spanning more than 5,000 years of history and including both rare and representative examples of art and ethnographic objects from throughout the Pacific Islands and Asia.

Pasadena City College Art Gallery and Boone Sculpture Garden

1570 E. Colorado Blvd., Pasadena, CA 91150
Tel: (626) 585-7412
Internet Address: http://www.paccd.cc.ca.us
Parking: parking lots, east side of campus.
Open: Call for hours.
Facilities: **Gallery**; **Sculpture Garden** (1996 design by Jody Pinto).
Activities: **Permanent Exhibits**; **Temporary Exhibitions** (8/academic year).
Publications: exhibition catalogues; posters.

The Art Division mounts temporary exhibitions of professional work during the academic year including a guest-curated show, a group faculty show, and an artist-in-residence exhibit. There are additionally a juried student show, a scholarship exhibition, and a summer group series featuring student independent studies. Additionally, the Division is closely involved in the development of a permanent contemporary art collection on exhibition in the Shatford Library. Also of possible interest, the Boone Sculpture Garden, designed by nationally recognized artist Jody Pinto, is located in the center of the PCC campus.

Penn Valley

Museum of Ancient and Modern Art (MAMA)

11392 Pleasant Valley Road, Penn Valley, CA 95946

Tel: (916) 432-3080

Fax: (916) 272-0184

Internet Address: http://www.mama.org

Chairman of the Board: Dr. Ann-Victoria Hopcraft

Admission: voluntary contribution.

Attendance: 18,000 *Established:* 1981 *Membership:* Y *ADA Compliant:* Y

Open: Daily, noon-5pm.

Facilities: **Library** (1,500 volumes); **Shop.**

Activities: **Concerts**; **Education Programs**; **Gallery Talks**; **Guided Tours**; **Lectures**; **Temporary Exhibitions**; **Traveling Exhibitions.**

Publications: exhibition catalogues (bi-monthly); newsletter.

MAMA is dedicated first and foremost to educating the public through a variety of services and programs and secondarily to assembling a collection of works of art worthy of preservation. It specializes in the presentation authentic artifacts in reconstructed settings, which provide an accessible visual context. MAMA specializes in works on paper from the 15th- to 20th-centuries and important historical art books containing original etchings, engravings and woodcuts. The collection includes an extensive collection of Rembrandt etchings and works by Chagall, Delacroix, Goya, Manet, Matisse, Miró, Picasso, Pissarro, and Renoir. MAMA's permanent collection of antiquities is primarily from the Near East, including a large collection of Egyptian 18th Dynasty artifacts excavated at Tel el Amarna. Most western Asian and Mediterranean classical civilizations are represented. Objects include statues, pottery, masks, jewelry and a variety of artifacts from daily life. There are smaller collections of Far Eastern (China, Tibet and Japan) artifacts and Pre-Columbian pottery and statues. The Theodora Van Runkel Collection of Ancient Gold spans thousands of years of gold-smithing techniques. The Museum also has a collection of African masks and statues representing over 20 different tribes.

Pomona

California State Polytechnic University - W. Keith & Janet Kellogg Art Gallery

Student Union Building, 3801 W. Temple Ave, Pomona, CA 91768

Tel: (909) 869-4302

Fax: (909) 869-4939

Internet Address: http://www.csupomona.edu/~kellogg_gallery/

Gallery Director: Patrick Merrill

Admission: free.

Open: Tuesday to Friday, 11am-4pm; Saturday, noon-4pm.

Facilities: **Galleries** (3; 4,200 square feet).

Activities: **Concerts, Dance Performances**; **Readings**; **Screenings**; **Seminars**; **Temporary Exhibitions** (7/year).

Located at the front of the Student Union building, the Kellogg Art Gallery holds seven exhibitions throughout the fall, winter, and spring quarters. In January, the gallery presents the annual Ink and Clay Juried Exhibition featuring the finest print and ceramic art from California. At the end of the spring quarter the best of Cal Poly's graduating art students present their Senior Projects.

Rancho Cucamonga

Chaffey College - Wignall Museum/Gallery

Chaffey College, 5885 N. Haven Ave., Rancho Cucamonga, CA 91737-3002

Tel: (909) 941-2703

Fax: (909) 941-2783

Administrative Director: Ms. Virginia M. Eaton

Admission: voluntary contribution.

Attendance: 30,000 *Established:* 1972 *Membership:* Y *ADA Compliant:* Y

Chaffey College - Wignall Museum/Gallery, cont.

Parking: on campus, Lot #5.

Open: **August to May**, Monday to Friday, 10am-4pm; Sunday, noon-4pm.

Closed: Major Holidays, Academic Holidays.

Facilities: **Gallery**.

Activities: **Arts Festival**; **Concerts**); **Education Programs**; **Guided Tours** (groups, reservations in advance); **Lectures**; **Performances**; **Temporary Exhibitions**; **Traveling Exhibitions**.

Publications: exhibition catalogues.

The Gallery features temporary exhibits of work by college faculty and students, and occasional displays of artwork by local artists or on loan from local collectors. The Gallery also presents a schedule of cultural activities, including concerts, lectures, artist receptions, and readings.

Rancho Palos Verdes

Palos Verdes Art Center

5504 W. Crestridge Road at Crenshaw Blvd., Rancho Palos Verdes, CA 90275

Tel: (310) 541-2479

Fax: (310) 541-9520

Internet Address: http://www.pvartcenter.org

Executive Director: Mr. Scott Ward

Admission: voluntary contribution.

Attendance: 15,000 *Established:* 1931 *Membership:* Y *ADA Compliant:* Y

Open: Monday to Friday, 9am-5pm; Saturday, 10am-4pm; Sunday, 1pm-4pm.

Closed: New Year's Day, Memorial Day, Independence Day, Thanksgiving Day, Christmas Day.

Facilities: **Galleries** (4); **Sales Galleries** (Artists' Studio Gallery at Art Center & The Brick Walk); **Studios** (painting/drawing, printmaking, ceramics, sculpture, photography).

Activities: **Education Programs** (adults and children, 200+ classes/year); **Guided Tours**; **Lectures**; **Temporary Exhibitions** (20-25/year).

Publications: exhibition catalogues; newsletter, "ARTifacts" (8/year).

The Palos Verdes Art Center, a not-for-profit community arts organization, promotes appreciation and expression of the arts in southwest Los Angeles County through education, exhibitions and outreach programs. Four galleries are available for exhibits: the Beckstrand, the Stewart, the Collectors, and the Norris Film Galleries. The Center produces 20-25 exhibitions of its own each year, complemented by opening events, catalogues, docent tours, lectures and workshops. Exhibitors include professional artists, members of the Art Center, and students in Palos Verdes Peninsula public and private schools. Two ongoing exhibition series feature California artists. "California Legacy" highlights artists, both as individuals and in groups, whose work is representative of a significant period in California's art history. "Visions" presents emerging and mid-career artists from the Los Angeles area who have created a comprehensive body of work defining an aesthetic direction.

Redding

Redding Museum of Art and History

56 Quartz Hill Road, Redding, CA 96003-2120

Tel: (916) 243-8801

Fax: (916) 243-8929

Internet Address: http://www.shasta-co.k12.ca.us/rmah/

Exec. Director: Ms. Patricia Leach

Admission: fee: adult-$1.00, child-$0.50.

Attendance: 50,000 *Established:* 1963 *Membership:* Y *ADA Compliant:* Y

Open: Tuesday to Sunday, 10am-5pm.

Closed: Legal Holidays.

Facilities: **Gallery**; **Library**; **Shop**.

Activities: **Arts Festival**; **Education Programs**; **Guided Tours**; **Temporary Exhibitions**.

Redding Museum of Art and History, cont.

Publications: exhibition catalogues; newsletter (monthly).

Ageneral museum, the Redding includes an art gallery in which temporary exhibitions are presented.

Redlands

San Bernardino County Museum

2024 Orange Tree Lane, Redlands, CA 92374

Tel: (909) 307-2669 or (888) 247-3344

Fax: (909) 307-0539

Internet Address: http://www.co.san-bernardino.ca.us/museum.htm

Director: Kevin G. Thomas

Admission: fee: adult-$4.00, child-$2.00, student-$3.00, senior-$3.00.

Attendance: 120,000 *Established:* 1959 *Membership:* Y *ADA Compliant:* Y

Open: Tuesday to Sunday, 9am-5pm.

Closed: New Year's Day, Thanksgiving Day, Christmas Day.

Facilities: **Botanical Garden**; **Galleries**; **Shop**.

Activities: **Arts Festival**; **Concerts**; **Family Programs**; **Juried Exhibits**; **Lectures**; **Temporary Exhibitions**; **Tours**; .

Publications: newsletter (bi-monthly).

The San Bernardino County Museum is a regional cultural and natural history museum with exhibits on anthropology, archaeology, history, biological science, and earth sciences, as well as fine arts.

Richmond

Richmond Art Center

2540 Barrett Ave.
Richmond, CA 94804

Tel: (510) 620-6772

Fax: (510) 620-6771

Executive Director: Suzanne Tan

Admission: voluntary contribution.

Attendance: 50,000 *Established:* 1936

Membership: Y *ADA Compliant:* Y

Open: Tuesday to Friday, 10am-4:30pm;
 Saturday, noon-4:30pm.

Joe Sam, *Hide N'Seek*, 1996, Richmond Art Center collection. Entrance to Richmond Art Center in background. Photograph courtesy of Richmond Art Center, Richmond, California.

Facilities: **Exhibition Area** (3 galleries; 6,000 square feet); **Sculpture Courtyard**; **Shop**; **Studios** (6).

Activities: **Education Programs** (adults and children, 200+ classes/year); **Guided Tours**; **Lectures**; **Temporary Exhibitions**.

Publications: calendar; exhibition catalogues; newsletter.

RAC promotes awareness of, expression in, and appreciation of the visual arts and crafts through exhibition, education and outreach programming to Richmond and West Contra Costa County. Its exhibition program features the work of emerging and mid-career artists with an emphasis on Bay Area art and artists from diverse cultural backgrounds. Such established artists as Richard Diebenkorn, Joan Brown, and Nathan Oliveira were shown at RAC early in their careers.

Riverside

La Sierra University - Brandstater Gallery

4700 Pierce St., Riverside, CA 92515

Tel: (909) 785-2959

Fax: (909) 785-2901

Internet Address: http://www.lasierra.edu/art

Director: Ms. Susan Patt

La Sierra University - Brandstater Gallery, cont.

Admission: free.

Parking: free on site.

Open: Mon to Thurs, 10am-noon & 1:30pm-4pm; Sunday, 2pm-5pm.

Closed: University Holidays.

Facilities: **Gallery** (1200 square feet).

Activities: **Temporary Exhibitions**.

Publications: exhibition catalogues (occasional).

The Gallery features regularly scheduled temporary exhibitions of work by students, alumni, and regionally and nationally recognized artists.

Exterior view of La Sierra University Visual Art Center, site of Brandstater Gallery. Photograph courtesy of Brandstater Gallery, Riverside California.

Riverside Art Museum

3425 Mission Inn Ave., Riverside, CA 92501

Tel: (909) 684-7111

Fax: (909) 684-7332

Director: Bobbie Powell

Admission: suggested contribution-$2.00.

Attendance: 50,000 *Established:* 1931 *Membership:* Y *ADA Compliant:* Y

Open: **September to July**, Monday to Saturday, 10am-4pm.

Closed: Legal Holidays.

Facilities: **Architecture** (Mediterranean-style building, 1929 designed by Julia Morgan); **Food Services** Atrium Restaurant (Mon-Sat, 10am-4pm); **Galleries** (3); **Shop** (original art, jewelry, ceramics, books).

Activities: **Arts Festival**; **Education Programs** (adults and children); **Gallery Talks**; **Guided Tours** (by appointment); **Lectures**; **Temporary Exhibitions** (15/year); **Traveling Exhibitions**; **Workshops**.

Publications: exhibition catalogues; newsletter (bi-monthly).

Housed in a former YMCA designed by Hearst Castle architect Julia Morgan, the building was placed on the National Register of Historic Places in 1988. The Museum's mission is to serve the "various communities of Riverside and its surrounding areas by providing visual art of the finest quality and related educational and interpretive programs." Additionally, it is the Museum's responsibility to exhibit art that addresses local and regional history and art that explores contemporary social issues, themes and media techniques. To further this mission, the museum mounts approximately 15 major exhibitions a year in three galleries.

UCR/California Museum of Photography (UCR/CMP)

3824 Main Street (Main St. Pedestrian Mall & University Ave.), Riverside, CA 92501

Tel: (909) 784-3686

Fax: (909) 787-4797

Internet Address: http://www.cmp.ucr.edu

Director: Prof. Jonathan Green

Admission: free.

Attendance: 35,000 *Established:* 1973 *Membership:* Y *ADA Compliant:* Y

Open: Tuesday to Sunday, 11am-5pm.

Closed: Easter, Thanksgiving Day, Christmas Day, New Year's Eve to New Year's Day.

Facilities: **Galleries**; **Shop**.

Activities: **Guided Tours**; **Lectures**; **Temporary Exhibitions**; **Traveling Exhibitions**.

Publications: exhibition catalogues; Foto Text.

UCR/California Museum of Photography, cont.

UCR/California Museum of Photography, a facility of the University of California, Riverside, is dedicated to promoting the understanding of photography and related media through collection, research, exhibition, and instruction. UCR/CMP showcases photography and related imaging technologies and the apparatuses that support these visual forms. UCR/CMP is housed in an acclaimed four-story facility on Riverside's popular pedestrian mall. Renovated by architect Stanley Saitowitz, this one-time dime store now portrays a machine in the service of art. Saitowitz's design treats the building as a metaphor of the camera. Such elements as a third-floor, walk-in camera obscura built into the building's outer facade, dark rubber floors, and exposed air ducts produce an environment in which the people inside may be seen as the camera's film, absorbing light and information, becoming vehicles for transmission of the museum experience. Across from the Museum's admissions desk is the Internet Gallery, where the public can explore UCR/CMP's World Wide Web site, as well as "visit" the collections of other museums from around the world. Many items from the permanent collections and archives can be seen in the museum's main-level. In addition to the museum's permanent gallery installation, UCR/CMP presents changing exhibitions that address visual culture as fine art, as social commentary, and as history. UCR/CMP's permanent collections include the Keystone-Mast archive of

Exterior view of UCR/California Museum of Photography. Photograph courtesy of UCR/California Museum of Photography, Riverside, California.

350,000 stereographs dating from 1870 to 1940, the Bingham Technology Collection of 10,000 cameras and viewing devices, and the University Print Collection, which features work by well-known artists such as Ansel Adams, Lewis Baltz, Francis Bedford, Manuel Alvarez Bravo, Larry Clark, Elliot Erwitt, Walker Evans, Francis Frith, William Klein, Barbara Morgan, Albert Renger-Patzch, Adam Clark Vroman, Carlton Watkins, and Edward Weston.

University of California, Riverside - Sweeney Art Gallery

Watkins House, 3701 Canyon Crest Drive
Riverside, CA 92521
Tel: (909) 787-3755
Fax: (909) 787-3798
Internet Address: http://sweeney.ucr.edu
Director: Ms. Katherine V. Warren
Admission: voluntary contribution.
Attendance: 7,500 *Established:* 1963
Membership: Y *ADA Compliant:* Y
Parking:
 limited behind building and metered in lot #24.
Open: Wednesday to Friday, 11am-4pm;
 Saturday to Sunday, noon-4pm.
Closed: Legal Holidays.
Facilities: **Galleries** (3).
Activities: **Lectures**; **Temporary Exhibitions** (12/year); **Traveling Exhibitions.**
Publications: exhibition catalogues; newsletter (quarterly).

Alexander Calder, *Untitled*, no date, lithograph. Permanent collection Sweeney Art Gallery. gift of Henry W. Coil, Jr. Photograph courtesy of Sweeney Art Gallery, University of California, Riverside, Riverside, California.

The Gallery, located in Watkins House across from the main campus of the University of California, Riverside presents temporary exhibitions and holds a small, but growing, permanent collection. The Gallery's exhibitions are integrated with the University curriculum when possible.

Rohnert Park

Sonoma State University - University Art Gallery

1801 E. Cotati Ave., Rohnert Park, CA 94928
Tel: (707) 664-2295
Fax: (707) 664-2505
Internet Address: http://www.sonoma.edu/ArtGallery/
Director: Mr. Michael Schwager
Admission: free.
Established: 1978 *Membership:* Y *ADA Compliant:* Y
Open: **September to May**, Tuesday to Friday, 11am-4pm.
 October to May, Saturday to Sunday, noon-4pm.
Facilities: **Exhibition Area** (2 galleries, 2,500 square feet); **Shop.**
Activities: **Art Auction**; **Education Programs**; **Lectures**; **Temporary Exhibitions.**
Publications: exhibition catalogues; posters.

The University Art Gallery is devoted to changing exhibitions of works of art from important private and public collections as well as new work directly from the artists' studios. The Gallery presents exhibitions in two adjoining galleries, public lectures, and educational outreach programs and also publishes catalogues and brochures on contemporary artists of regional, national, and international significance. A brief list of artists whose work has been exhibited includes Terry Allen, Jennifer Bartlett, Enrique Chagoya, Chuck Close, Sue Coe, Viola Frey, Mineko Grimmer, The Guerrilla Girls, Mildred Howard, Mike Kelly, Maya Lin, James Luna, Manuel Ocampo, Judy Pfaff, John Roloff, Joan Snyder, Bill Viola, William Wegman, and Terry Winters. In addition to programs devoted to artists from outside the University, the Art Gallery presents several exhibitions featuring the work of faculty and students. Annual exhibitions by graduating BFA students and the Juried Student Show are presented each spring. Work by the Sonoma State University Art Department faculty is shown in the Gallery every other year. The Art Gallery also hosts a variety of events, including the annual Art from the Heart fund raising art auction, which features donated works of art by emerging and nationally recognized artists from around the country.

Sacramento

California State University, Sacramento - Art Galleries

Fine Arts Building, Sinclair (off State University Drive), Sacramento, CA 95819
Tel: (916) 278-6166
Internet Address: http://www.asn.csus.edu/art/
Admission: free.
Open: **Academic Year**, Daily, noon-5pm.
Facilities: **Galleries** (2).
Activities: **Temporary Exhibitions.**

The University boasts two galleries, both located in the Fine Arts Building. The Robert Else Gallery and the Witt Gallery mount temporary exhibitions throughout the academic year of work by professional artists, undergraduates and graduate students, including annual juried shows.

Crocker Art Museum

216 O Street (between 2nd and 3rd Streets), Sacramento, CA 95814
Tel: (916) 264-5423
Fax: (916) 264-7372
TDDY: (916) 446-4563
Internet Address: http://www.crockerartmuseum.org
Director: Mr. Stephen C. McGough
Admission: suggested contribution: adult-$5.50, child (<7)-free (7-17)-$3.50, senior (>65)-$4.50.
Attendance: 100,000 *Established:* 1885 *Membership:* Y *ADA Compliant:* Y
Parking: metered on site and city parking lots.
Open: Tuesday to Wednesday, 10am-5pm; Thursday, 10am-9pm; Friday to Sunday, 10am-5pm.
Closed: New Year's Day, Independence Day, Thanksgiving Day, Christmas Eve to Christmas Day.

Crocker Art Museum, cont.

Facilities: **Architecture** (Crocker Mansion, 1873 designed by Seth Babson; Crocker Mansion Wing, 1989 designed by Edward Larrabee Barnes); **Library** (2,000 volumes); **Museum Store** (books, gifts, one-of-a-kind items by local artists).

Activities: **Antique Show and Sale**; **Appraisal Day**; **Art Auction**; **Concerts** Classical (October-May, selected Sundays, 3pm;, Jazz (3rd Thursday in month, 5:30pm); **Education Programs**; **Gallery Talks** (1st Thursday in month, 5:30pm); **Guided Tours** (groups 15+ reserve 2 weeks in advance, Mon-Fri, 10am-noon); **Lectures**; **Temporary Exhibitions**; **Traveling Exhibitions**.

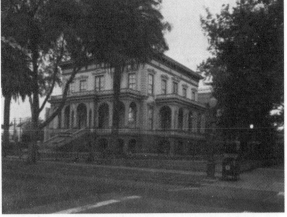

Exterior view of Crocker Art Museum Mansion. Photograph courtesy of Crocker Art Museum, Sacramento, California.

Publications: exhibition catalogues (annual); members' newsletter (bi-monthly).

Founded by Judge Edwin B. and Margaret Crocker in 1885, the Crocker Art Museum was the first public art museum in the West. European and American paintings from its collection of more than 700 works are displayed in the rooms and galleries of the original building. The California Gallery features works by early California artists and California landscapes. The top floor of the Crocker Mansion Wing is devoted to works by northern California artists from the 1960's to the present. The Museum offers interpretive installations of its collections, temporary exhibitions from around the world, special events and lectures, as well as an extensive education program. Major collections include European art, old master drawings, 19th- and 20th-century California art, Asian art, ceramics, photography, and Victorian decorative arts.

La Raza/Galería Posada

704 O Street, Sacramento, CA 95814
Tel: (916) 446-5133
Fax: (916) 447-7891
Internet Address: http://edweb.sdsu.edu/edfirst/Prophets/galeriacontact.html
Executive Director: Mr. Luis Chabolla
Admission: voluntary contribution.
Established: 1972 *Membership:* Y *ADA Compliant:* Y
Open: Monday to Friday, 10am-6pm; Saturday, 11am-5pm.
Closed: Columbus Day, Thanksgiving Day, Christmas Day.
Facilities: **Architecture**; **Conservation Facilities**; **Shop**.
Activities: **Guided Tours** (arrange in advance); **Temporary Exhibitions**; **Traveling Exhibitions**.
Publications: catalogue of books (annual); newsletter (quarterly).

La Raza was founded as a bookstore in 1972, a place for the community to learn about the traditions of Mexicano and indigenous life and history, as well as contemporary Raza culture. The Galería Posada was added in 1980 and became the first exhibition space in Central California dedicated to presenting Chicano/Latino, and native American visual artists. The Gallery presents temporary exhibitions of young and emerging talent, as well as internationally recognized artists.

San Bernardino

California State University, San Bernardino - Robert V. Fullerton Art Museum

Visual Arts Center, 5500 University Parkway, San Bernardino, CA 92324
Tel: (909) 880-7373
Fax: (909) 880-7068
Internet Address: http://www.csusb.edu
Director of Operations: Ms. Eva Kirsch
Admission: voluntary contribution.
Attendance: 12,000 *Established:* 1972 *Membership:* Y *ADA Compliant:* Y

San Bernardino, California

California State University, San Bernardino - R.V. Fullerton Art Museum, cont.

Parking: pay on site - $1.50.

Open: **Fall to Spring**,
 Tuesday to Wednesday, 11am-5pm;
 Thursday, 1pm-7pm;
 Friday, 10am-4pm;
 Saturday to Sunday, noon-5pm.
 Summer,
 Call for hours.

Closed: Legal Holidays.

Facilities: **Gallery** (6,500 square feet).

Activities: **Education Programs**; **Temporary Exhibitions**; **Traveling Exhibitions**.

Publications: collection catalogue; exhibition catalogues (annual).

In addition to presenting loan exhibitions, the museum displays objects from its permanent collection, including Asian and Etruscan ceramics, Huichol paintings, African sculpture, Egyptian antiquities, prints, and drawings.

Shawabti figure, ca.1303-1200 B.C., New Kingdom, Dynasty XIX, height 9 3/8 inches, painted wood. Harer Family Trust Collection, Robert V. Fullerton Art Museum. Photograph courtesy of California State University, San Bernardino, California.

San Diego

Mingei International Museum

1439 El Prado, Plaza de Panama, Balboa Park, San Diego, CA 92101

Tel: (619) 239-0003

Fax: (619) 239-0605

Internet Address: http://www.mingei.org

Director: Martha W. Longenecker

Admission: fee: adult-$5.00, child-$2.00, student-$2.00.

Attendance: 105,000 *Established:* 1974 *Membership:* Y *ADA Compliant:* Y

Parking: free lots in park.

Open: Tuesday to Sunday, 10am-4pm.

Closed: National Holidays.

Facilities: **Food Services** Restaurant; **Library** (2,000 volumes); **Shop** Collector's Gallery.

Activities: **Gallery Talks**; **Guided Tours** (reserve in advance); **Lecture Series**; **Temporary Exhibitions**; **Traveling Exhibitions**.

Publications: exhibition catalogues; videos.

The Museum offers changing exhibitions focusing on traditional and contemporary folk art, craft and design in a wide range of media from all cultures. Folk art manifests a direct simplicity and reflects a joy in making, by hand, useful objects that are satisfying to the human spirit. (The word "Mingei" was coined in the early 20th by a Japanese scholar from the Japanese for "all people" and "art". It conveys the sense of the innate beauty of objects that are integrally related to life and are born of a state of mind not attached to a conscious aesthetic.)

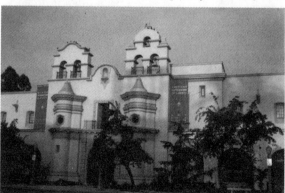

Exterior view of front entrance, Mingei International Museum of Folk Art. Photograph by Robert Reap, courtesy of Mingei International Museum of Folk Art, San Diego, California.

Museum of Contemporary Art, San Diego - Downtown Galleries (MCA Downtown)

1001 Kettner Blvd. at Broadway (across from the Santa Fe Depot)
San Diego, CA 92101
Tel: (619) 234-1001
Internet Address: http://www.mcasandiego.org
Admission: free.
Membership: Y *ADA Compliant:* Y
Parking: underground parking at America Plaza.
Open: Thursday to Tuesday, 11am-5pm.
Closed: New Year's Day, Thanksgiving Day, Christmas Day.
Facilities: **Exhibition Area**; **Shop**.
Activities: **Gallery Talks**; **Temporary Exhibitions**.

Apart of the Helmut Jahn-designed America Plaza, MCA Downtown is an anchor of the city's cultural arts scene. The museum showcases MCA's internationally recognized permanent collection and a full schedule of contemporary exhibitions, educational programming and special events. The Museum's principal location is in La Jolla, California (see separate listing). A special 3-day pass for admission to both locations is available for $4.00.

Museum of Photographic Arts (MoPA)

1649 El Prado, Balboa Park, San Diego, CA 92101
Tel: (619) 238-7559
Fax: (619) 238-8777
Internet Address: http://www.mopa.org
Director: Mr. Arthur Ollman
Admission: General Admission fee-adult-$6.00, student-$4.00, child (<12)-free,.senior-$4.00.
 Film Admission fee: adult-$7.50, students-$5.00, senior-$5.00.
Attendance: 75,000 *Established:* 1983 *Membership:* Y *ADA Compliant:* Y
Open: Daily, 10am-5pm.
Closed: Major Holidays, Exhibit Installation.
Facilities: **Building** (32,000 square feet); **Exhibition Area** (7,500 square feet, designed by David Raphael Singer); **Library** (25,000 volumes); **Shop**.
Activities: **Education Programs**; **Guided Tours** (Sun, 1pm, free; groups 15+, advance reservation required); **Lectures**; **Temporary Exhibitions** (8-12/year).
Publications: calendars; exhibition catalogues; newsletter.

Dedicated to photography, cinema, and video, the Museum of Photographic Arts provides the opportunity to view work by some of the most celebrated artists in the history of these media. The exhibition schedule offers eight to twelve shows each year. MoPA displays works from the entire history of photography: daguerreotypes and albumen prints from the 19th-century; pictorialism from the 1910's and 20's; master works from mid-20th century, and contemporary works and photojournalism by many of the best photographers working today. Periodic exhibitions are assembled from the permanent collection. The film program presents more than 300 films each year augmented by presentations, lectures, and workshops led by filmmakers, actors, and scholars. The Museum's collection reflects the central role photography plays in our image-based culture, both as an expressive medium and as a documentary record. Holdings currently include 6,000 photographs that span the history of photography, including 19th century works by Matthew Brady, Jeremiah Gurney, Julia Margaret Cameron, Hill & Adamson, and expeditionary photographers Francis Frith, Samuel Bourne and John Thomson. Early 20th century holdings include works by Alfred Stieglitz, Clarence White, Edward Steichen, Eugene Atget, Alvin Langdon Coburn, Paul Strand, Peter Henry Emerson and Lewis Hine. World War II and Depression-era images are well represented by photographs by such artists as Berenice Abbott, Weegee, Lisette Model, Dorothea Lange, Arthur Rothstein, Horace Bristol, Andre Kertesz, Henri Cartier-Bresson, August Sander, and Ben Shahn and photomontage work by John Heartfield. The collection also contains works by a number of Latin-American artists, including Manuel Alvarez Bravo, Lazaro Blanco-Fuentes, Mario Cravo Neto, Graciela Iturbide, Alberto Korda, Miguel Rio Branco, Sebastiao Salgado, Rafael Serrano, Flor Garduno and Mariana Yampolski. Social documentary and photojournalism are also well represented with images by W. Eugene Smith,

San Diego, California

Museum of Photographic Arts, cont.

Margaret Bourke-White, Susan Meiselas, Alex Webb, Charles Moore, Max Alpert, Ivan Shagin, Georgi Zelma and Max Yavno. In recent years more than 274 rare and important documentary images from the Stalinist-era USSR were acquired, including works by Russian constructivist Alexander Rodchenko. Contemporary works, especially post-World War II American photography, constitute the strength of the permanent collection, with works by Ansel Adams, Wynn Bullock, Harry Callahan, Eileen Cowin, Roy DeCarava, Robert Heinecken, Birney Imes, Danny Lyon, Sally Mann, Joel Meyerowitz, Duane Michals, Irving Penn, Aaron Siskind, Lou Stoumen, Patrick Nagatani, Mark Klett, Abelardo Morell, Len Jenschel, Judith Golden, Arnold Newman, Larry Clark and Garry Winogrand. Reflecting the museum's commitment to the future, mid-career and emerging artists are represented with works by Debbie Fleming-Caffery, Liz Birkholz, Steven DePinto and Gavin Lee.

San Diego Art Institute (SDAI)

House of Charm, Balboa Park, 1439 El Prado, San Diego, CA 92101-1617
Tel: (619) 236-0011
Fax: (619) 236-1974
Internet Address: http://www.sandiego-art.org
Administrative Director: Mr. Timothy Field
Admission: free: adult-$3.00, child-free,
 student-$2.00, senior-$2.00.
Attendance: 90,000 *Established:* 1941
Membership: Y
Parking: on site.
Open: Tuesday to Saturday, 10am-4pm;
 Sunday, noon-4pm.

Exterior view of San Diego Art Institute. Rendering courtesy of San Diego Art Institute, San Diego, California.

Facilities: **Gallery** (10,000 square feet); **Sculpture Garden** (handcrafted jewelry and gift items).
Activities: **Temporary Exhibitions**.
Publications: newsletter, "Journal" (monthly).

Neither a museum nor a for-profit gallery, the Art Institute functions much like a municipal gallery, offering a comprehensive overview of the visual art scene in San Diego. A new exhibition of works opens every six weeks. These juried exhibits display work in a variety of media including oil, acrylic, watercolor, pen and ink, monoprint, collage, assemblage, mixed media, photography, and sculpture. A solo show of work by an Institute member is also featured along with the main gallery exhibition. The David Fleet Young Artists Gallery showcases work from local schools.

San Diego Museum of Art (SDMA)

1450 El Prado, Balboa Park, San Diego, CA 92101
Tel: (619) 232-7931
Fax: (619) 232-9367
Internet Address: http://www.sdmart.com
Director: Don Bacigalupi, Ph.D.
Admission: fee:
 adult-$8.00, child-$3.00, student-$6.00, senior-$6.00.
Attendance: 400,000 *Established:* 1926
Membership: Y *ADA Compliant:* Y
Parking: free parking available in Balboa Park.
Open: Tuesday to Sunday, 10am-4:30pm.
Closed: New Year's Day, Thanksgiving Day, Christmas Day.
Facilities: **Architecture** (Plateresque style, 1926 by architect Wm. Templeton Johnson); **Auditorium** (400 seats); **Food Services** Sculpture Garden Bistro (Tues-Fri, 10am-3pm; Sat-Sun, 10am-5pm,, Sculpture Garden Café (Tues-Sun, 11am-2pm); **Library** (30,000 volumes); **Sculpture Garden**; **Shop** (books, calendars, posters, jewelry).

Façade, San Diego Museum of Art. Photograph courtesy of San Diego Museum of Art, San Diego, California.

San Diego Museum of Art, cont.
Activities: **Concerts**; **Education Programs**; **Gallery Talks**; **Guided Tours** (daily, call for times); **Lectures**; **Temporary Exhibitions**; **Traveling Exhibitions**.
Publications: collection catalogue; exhibition catalogues.

The San Diego Museum of Art, located in the center of Balboa Park, contains approximately 10,000 objects, from Egyptian and Pre-Colombian periods to the twentieth century. Its permanent collection includes Italian Renaissance and Spanish Baroque old masters, American art, 19th-century European paintings, 20th-century paintings and sculpture, and the Frederick R. Weisman Gallery for California Art. Asian art includes a world-renowned collection of Indian paintings. The Museum's Interactive Multimedia Art Gallery Explorer (IMAGE) system, featuring more than 300 of the Museum's most significant works catalogued on user-friendly computers and reproduced in full-color images, is now a permanent part of the Museum's facility. In addition to the impressive permanent collection, the San Diego Museum of Art hosts special international traveling exhibitions each year. Educational programs, including lectures, performances, classes for children and adults and family activities are offered on an almost daily basis. The permanent collection of the Museum is comprehensive. European paintings include a core of Spanish works by Juan Sánchez Cotán, Goya, El Greco and Francisco de Zurbarán. Italian painting is represented by Bernardo Bellotto, Canaletto, Carlo Crivelli, Giorgione, Francesco Guardi, and Luca Signorelli. Oil sketches by Peter Paul Rubens and Frans Hals and flower pieces by Rachel Ruysch, Daniel Seghers, and Erasmus Quellinus highlight Dutch and Flemish collections. European art of the 19th- and 20th-centuries includes work by Max Beckmann, William-Adolphe Bouguereau, Salvador Dali, Honoré Daumier, Giorgio De Chirico, Jean Dubuffet, Raoul Dufy, Jean-Auguste-Dominique Ingres, Wilhelm Lehmbruck, René Magritte, Franz Marc, Henri Matisse, Claude Monet, Gabriele Munter, Emil Nolde, Paul Signac, Yves Tanguy, Henri de Toulouse-Lautrec, Alexej von Jawlensky, and Edouard Vuillard. American paintings include works by Albert Bierstadt, Mary Cassatt, William Merritt Chase, Asher B. Durand, Thomas Eakins, George Inness, Eastman Johnson, Raphaele Peale, and Ammi Phillips, and also several paintings by early California artists Maurice Braun and Charles Reiffel. Twentieth-century paintings include works by George Bellows, Thomas Hart Benton, Stuart Davis, Arthur Dove, Robert Henri, Georgia O'Keeffe, John Sloan, and Frank Stella. SDMA exhibits an extensive collection of contemporary California art, featuring artists such as Edward Ruscha, David Hockney, Billy Al Bengston, John Baldessari, Alexis Smith, and John Altoon. It is expanding its holdings in Latin American art and owns works by such important artists as Diego Rivera, Rufino Tamayo and Francisco Zuñiga. Works on paper include an outstanding collection of more than one hundred Henri de Toulouse-Lautrec graphics and a small, but distinguished collection of watercolors. Twentieth-century sculpture includes works by Aristide Maillol, Gaston Lachaise, Anna Hyatt Huntington, Henry Moore, Barbara Hepworth, Alexander Calder, Louise Nevelson, Joan Miró, Marino Marini, and David Smith. The East Asian collections, among the most important and beautiful holdings of the museum, are comprehensive in the areas of Chinese, Japanese and Korean decorative arts, sculpture, and paintings. The South Asian collection includes works in a variety of media from a wide geographic area roughly bounded by Turkey, Tibet, Vietnam, Indonesia and Sri Lanka. Also notable is the museum's internationally acclaimed collection of Indian, Persian and Turkish paintings (c. 1300-1650).

San Diego State University - University Art Gallery
5500 Campanile Drive, San Diego, CA 92182-4805
Tel: (619) 594-4941
Fax: (619) 594-1217
Internet Address: http://psfa/sdsu.edu/school_of_art/maingallery/maingallery.html
Director: Ms. Tina Yapelli
Admission: voluntary contribution.
Membership: Y *ADA Compliant:* Y
Open: **September to May**, Monday to Thursday, noon-4pm; Saturday, noon-4pm.
Closed: Legal Holidays.
Facilities: **Gallery**.
Activities: **Education Programs**; **Lectures**; **Temporary Exhibitions**; **Traveling Exhibitions**.
Publications: brochures (triennial); exhibition catalogues (triennial).

San Diego, California

San Diego State University - University Art Gallery, cont.

The University Art Gallery features major exhibitions by nationally and internationally known contemporary artists. There are two additional galleries on campus. Graduate thesis exhibitions and select group shows are held in The Everett Gee Jackson Gallery, and undergraduate exhibits are primarily mounted in The Flor y Canto Gallery.

Timken Museum of Art

1500 El Prado, Balboa Park, San Diego, CA 92101
Tel: (619) 239-5548
Fax: (619) 233-6629
Internet Address: http://govt.ucsd/sj/timken
Director: Mr. John Petersen
Admission: voluntary contribution.
Attendance: 93,000 *Established:* 1965
Membership: Y *ADA Compliant:* Y
Open: October to August,
 Tuesday to Saturday, 10am-4:30pm;
 Sunday, 1:30pm-4:30pm.
Closed: September, Legal Holidays.
Facilities:
 Galleries (6, plus rotunda); **Library** (200 volumes).
Activities: **Guided Tours.**
Publications: collection catalogue; exhibition catalogues; exhibition catalogues; gallery guide.

Moscow School, *Our Lady of Jerusalem*, 17th-century, tempera on wood panel, 51 9/16 x 41 15/16 inches. Timken Museum of Art. Photograph courtesy of Timken Museum of Art, San Diego, California.

The Timken Museum of Art is devoted to the presentation of the Putnam Foundation's collection of European and American paintings and Russian icons. The European collection includes works by François Boucher, Pieter Bruegel the Elder, Paul Cézanne, Jean Baptiste Camille Corot, Jacques Louis David, Jean Honoré Fragonard, Frans Hals, Claude Lorrain, Bartolomé Esteban Murillo, Camille Pissarro, Rembrandt van Rijn, Peter Paul Rubens, Jacob van Ruisdael, and Veronese. Artists represented in the American collection include Albert Bierstadt, Thomas Birch, John Singleton Copley, Jasper Cropsey, John Joseph Enneking, Martin Johnson Heade, George Inness, Eastman Johnson, Fitz Hugh Lane, and Benjamin West.

San Francisco

Academy of Art College Galleries

410 Bush St., San Francisco, CA 94108
Tel: (415) 274-2204
Fax: (415) 274-8672
Internet Address: http://www.academyart.edu
Vice President: Ms. Ann Lawrence
Open: Monday to Saturday, 10am-5pm.
Facilities: **Galleries** (3).
Activities: **Temporary Exhibitions.**

The College also maintains galleries at 180 New Montgomery Street (415-788-6044) and 551 Sutter Street (415-274-8600). Call for hours. The galleries display temporary exhibitions of the work of students, faculty, and professional artists.

Ansel Adams Center for Photography

250 Fourth Street (across from the Moscone Center), San Francisco, CA 94103-3117
Tel: (415) 495-7000
Fax: (415) 495-8517
Internet Address: http://www.visualradio.com/photoarts/fop/fopj.html
Director: Ms. Deborah Klochko
Admission: fee: adult-$5.00, child-free, student-$3.00, senior-$2.00.
Attendance: 60,000 *Established:* 1967 *Membership:* Y *ADA Compliant:* Y

Ansel Adams Center for Photography, cont.

Parking: commercial lots and on street parking.

Open: Tuesday to Sunday, 11am-5pm; 11am-8pm, 1st Thurs in month.

Closed: Legal Holidays.

Facilities: **Gallery**; **Shop**.

Activities: **Lectures**; **Temporary Exhibitions** (10/year).

Publications: exhibition catalogues; journal; newsletter, "Re:View".

Operated by The Friends of Photography, the exhibition program at the Ansel Adams Center for Photography is innovative both in its content and in its manner of presentation. Contemporary shows often are paired with historical counterparts. Education Gallery presentations are intended to acquaint children and adults with the medium's creative, technical, and functional traditions. The Friends has published more than 60 major catalogues, monographs, and critical anthologies on photography. A wide range of educational programs is offered for audiences of diverse backgrounds, including public lectures, gallery talks, a children's darkroom program, and seminars. The Center maintains a collection of the work of Ansel Adams.

Asian Art Museum of San Francisco, The Avery Brundage Collection

Golden Gate Park (entrance from 8th Ave. & J.F. Kennedy Drive), San Francisco, CA 94118

Tel: (415) 379-8800

Fax: (415) 668-8928

TDDY: (415) 752-2635

Internet Address: http://www.asianart.org

Director: Ms. Emily Sano

Admission: fee: adult-$7.00, child-$4.00, student-$5.00, senior-$5.00.

Attendance: 482,000 *Established:* 1966 *Membership:* Y *ADA Compliant:* Y

Parking: metered on street.

Open: Tuesday to Sunday, 9:30am-5pm; 1st Wednesday in month, 9:30am-8:45pm.

Facilities: **Auditorium** (385 seats); **Conservation Facilities**; **Family Festivals**; **Library** (30,000 volumes); **Shop**.

Activities: **Films**; **Guided Tours** (daily; group tours (415) 379-8839); **Lectures**; **Performances**; **Temporary Exhibitions**; **Traveling Exhibitions**.

Publications: collection catalogue; exhibition catalogues.

The Asian Art Museum of San Francisco is one of the largest museums in the Western world devoted exclusively to Asian art. Opened in 1966 as a result of a gift to the City of San Francisco by industrialist Avery Brundage, the Museum's holdings include more than 12,000 art objects spanning more than 6,000 years and representing more than 40 nations throughout Asia. On exhibit are examples of Chinese, Japanese, Indian, Korean, Himalayan, Southeast Asian and Islamic art. The Museum regularly organizes major exhibitions, and frequently presents educational programs relating to Asian arts and culture. Nearly one-half of the Museum's holdings are of Chinese origin and include extensive collections of paintings, bronzes, and sculptures, dating from the early Neolithic period to the 20th century. The founding Avery Brundage Collection represents approximately 65% of the holdings of the Museum and consists of almost 7,800 objects, including more than 1,500 jade artifacts. As a result of a bond measure approved by San Francisco voters in 1994, the Museum is scheduled to relocate from its current location in Golden Gate Park to the Old Main Library building at Civic Center in 2002.

California College of Arts and Crafts - Logan Center Galleries

San Francisco Campus, 1111 8th St. at 16th and Wisconsin, San Francisco, CA 94107

Tel: (415) 551-9210

Fax: (415) 551-9260

Internet Address: http://www.ccac-art.edu/institute

Director, Institute for Exhibitions & Public Programs: Mr. Lawrence Rinder

Admission: free.

Attendance: 21,000 *Established:* 1907 *Membership:* N *ADA Compliant:* Y

Open: Monday, 11am-5pm; Tuesday, 11am-9pm; Wednesday to Saturday, 11am-5pm.

Closed: Legal Holidays

Facilities: **Galleries**.

California College of Arts and Crafts - Logan Center Galleries, cont.

Activities: **Education Program**; **Gallery Talks**; **Guided Tours** (for organized groups); **Lecture Series**; **Temporary Exhibitions**.

Publications: exhibition catalogues.

Founded at the height of the Arts and Crafts movement, CCAC offers programs of study in drawing, painting, printmaking, ceramics, glass, jewelry/metals arts, sculpture, textiles, wood/furniture, photography, film/video/performance, fashion design, graphic design, industrial design, illustration, architecture and interior architecture. The Logan Center Galleries present temporary exhibitions and programs in the fields of art, architecture, and design. CCAC has two campuses. The Logan Center Galleries are located on the San Francisco campus (please see separate listing for the Oliver Art Center at the Oakland campus).

Cartoon Art Museum

814 Mission Street at 4th St., 2nd Floor, San Francisco, CA 94103
Tel: (415) 227-8666
Fax: (415) 243-8666
Exec. Director: Rod Gilchrist
Admission: fee: adult-$5.00, child-$2.00, student-$3.00, senior-$3.00.
Attendance: 23,000 *Established:* 1984 *Membership:* Y *ADA Compliant:* Y
Open: Tuesday to Friday, 11am-5pm; Saturday, 10am-5pm; Sunday, 1pm-5pm.
Closed: New Year's Day, Independence Day, Thanksgiving Day, Christmas Day.
Facilities: **Classroom**; **Gallery** (6,000 square feet); **Library**; **Shop**.
Activities: **Guided Tours**; **Lectures**; **Temporary Exhibitions** (7/year); **Traveling Exhibitions**.
Publications: exhibition catalogues; newsletter (quarterly).

After several years of exhibiting in other local museums and corporate exhibit spaces, the Museum constructed its own site with the aid of an endowment from Charles M. Schulz, creator of the "Peanuts" comic strip. The Cartoon Art Museum is dedicated to the preservation, documentation, and exhibition of cartoon art in all its forms. In addition to seven major exhibitions a year, the Museum organizes traveling exhibitions and other exhibit-related activities such as artist-in-residence lecture series and outreach activities. Facilities include a classroom for cartoon art, a bookstore, and a research library. The permanent collection includes approximately 11,000 original works.

Chinese Culture Center of San Francisco

750 Kearney Street (Holiday Inn Hotel, 3rd Floor)
San Francisco, CA 94108
Tel: (415) 986-1822
Fax: (415) 986-2825
Internet Address: http://www.c-c-c.org
Exec. Director/Curator: Ms. Manni Liu
Admission: voluntary contribution.
Attendance: 75,000 *Established:* 1965
Membership: Y *ADA Compliant:* Y
Parking: Holiday Inn lot.
Open: Tuesday to Sunday, 10am-4pm.
Closed: Legal Holidays.

View of Main Gallery, Chinese Culture Center.
Photograph courtesy of Chinese Culture Center,
San Francisco, California.

Facilities: **Auditorium** (400 seats); **Galleries** (2, total 14,000 square feet); **Shop** (original art work, cards, sculptures).
Activities: **Gallery Talks**; **Lectures**; **Performances** (Chinese opera and dance); **Spring Festival** (annual); **Tours** (Chinatown heritage walks & culinary walks, reserve in advance); **Workshops** (Chinese music and dance).
Publications: brochures; exhibition catalogues; newsletter, "Chinese Culture Center Newsletter" (quarterly).

Since its opening in 1973, the Center has offered a variety of educational and cultural programs for the Chinese and the larger public, including visual arts exhibitions, lectures, films, genealogy research, workshops, classes, performances, and international cultural-exchange programs. Temporary exhibitions feature archaeological and historical artifacts, contemporary Chinese and Chinese-American art, as well as traditional Chinese arts. Its facilities include an auditorium, exhibition galleries, workshop/classroom areas, a gallery shop, and offices.

The Fine Arts Museums of San Francisco, California Palace of the Legion of Honor

34th Avenue and Clement Street, Lincoln Park
San Francisco, CA 94121
Tel: (415) 750-3600
Fax: (415) 750-3656
Internet Address: http://www.legionofhonor.org
Director: Mr. Harry S. Parker, III
Admission: fee:
 adult-$8.00, child (<12)-free (12-17)-$5.00, senior-$6.00.
Attendance: 750,000 *Established:* 1894
Membership: Y *ADA Compliant:* Y
Open: Tuesday to Sunday, 9:30am-5pm;
 2nd Wednesday in month, 9:30am-8:45pm.
Facilities: **Architecture** (1921, designed by Mullgardt); **Conservation Facilities**; **Food Services** Café and Garden Terrace (Wednesday-Sunday, 9:30am-4pm); **Shop** (books, jewelry, posters, cards, gift items); **Theatre.**
Activities: **Concerts** (organ); **Education Programs**; **Films**; **Guided Tours**; **Lectures**; **Temporary Exhibitions**.
Publications: collection catalogues; exhibition catalogues; magazine, "Fine Arts" (semi-annual).

California Palace of the Legion of Honor. Photograph by Richard Barnes, courtesy of Fine Arts Museums of San Francisco, San Francisco, California.

The California Palace of the Legion of Honor, located in Lincoln Park, west of the Golden Gate Bridge, was dedicated in 1924, the gift of Alma de Bretteville Spreckels to the City of San Francisco, in memory of the Californians who died in World War I. Its collections span 4,000 years and include the 70,000 prints and drawings in the Achenbach Foundation for Graphic Arts, a 15th-century Spanish ceiling, Roman, Greek, and Assyrian art, and paintings by Rembrandt, Rubens, El Greco, Watteau, de la Tour, Vigée Le Brun, Cézanne, Degas, Monet, Renoir, Seurat, Dali, and Picasso, among other Dutch, Italian, German, English, and French masters. The Legion is particularly known for an extensive collection of sculpture by Auguste Rodin, including "The Thinker", the "Age of Bronze", "John the Baptist", and "The Three Shades". The Legion was renovated, expanded, and seismically upgraded in 1992-95 and now features the sky-lit Rosekrans Sculpture Court on the terrace level, six new exhibition galleries, a large cafe, and a new store. Two museums comprise the Fine Arts Museums of San Francisco, the California Palace of the Legion of Honor and the M.H. de Young Memorial Museum (see listing below).

The Fine Arts Museums of San Francisco, M.H. de Young Memorial Museum

75 Tea Garden Drive, Golden Gate Park, San Francisco, CA 94118-4501
Tel: (415) 750-3600
Fax: (415) 750-7692
Internet Address: http://www.thinker.org
Director: Mr. Harry S. Parker, III
Admission: fee: adult-$7.00, child-$4.00, student-free, senior-$5.00.
Attendance: 750,000 *Established:* 1895
Membership: Y *ADA Compliant:* Y
Open: Closing December 31, 2000 for construction of a new facility.
 Call for hours.
Facilities: **Architecture** (beaux-arts building, 1924 design by George Applegarth); **Auditorium**; **Conservation Facilities**; **Food Services** Café (Wed-Sun, 9:30am-4pm; 1st Wednesday in month, 6pm-8pm); **Shop**; **Theatre**.
Activities: **Concerts**; **Education Programs**; **Films**; **Guided Tours**; **Temporary Exhibitions**.
Publications: collection catalogues; exhibition catalogues; magazine, "Fine Arts" (semi-annual).

Exterior view of M.H. de Young Memorial Museum. Photograph courtesy of Fine Arts Museums of San Francisco, San Francisco, California.

The Fine Arts Museums of San Francisco, M.H. de Young Memorial Museum, cont.

The M.H. de Young Memorial Museum, San Francisco's oldest public museum, is located in Golden Gate Park and dates to the 1894 Midwinter Exposition. It has become the repository for the most comprehensive collection of American paintings on the West Coast, as well as major collections of art from the pre-Columbian Americas, African art, art from Oceania, and an extensive collection of textiles. Recent acquisitions focus on paintings and sculpture by contemporary Bay Area artists. The de Young Museum also maintains a permanent exhibition for children, Gallery One, the only on-going installation of its kind in the United States. The American Art Study Center at the de Young serves a large academic community and is linked to the Smithsonian Institution's Archives of American Art. Two museums comprise the Fine Arts Museums of San Francisco, the M.H. de Young Memorial Museum and the California Palace of the Legion of Honor (see listing above). The de Young Museum will close in December 31, 2000 for the construction of a new facility designed by Herzog & de Meuron ArchitekenAG (Basel, Switzerland).

Intersection for the Arts - Gallery
446 Valencia St. (between 15th and 16th Streets), San Francisco, CA 94105
Tel: (415) 626-2787 *Fax:* (415) 626-1636
Internet Address: http://www.theintersection.org
Exec. Director: Deborah Cullinan
Admission: free.
Established: 1965
Open: Wednesday to Saturday, noon-5pm.
Facilities: **Exhibition Area** (1,000 square feet, 100 linear feet); **Theater**.
Activities: **Dramatic Performances**; **Jazz**; **Literary Programs**; **Temporary Exhibitions**.

San Francisco's oldest alternative non-profit art space, Intersection presents challenging new works in literature, theater, and the visual and interdisciplinary arts. Located on the second floor of its building in the heart of the North Mission District, Intersection's gallery emphasizes vision, risk-taking, and discovery. Artists may be presented in solo, two-person, and group exhibitions. Intersection also provides technical support to more than 60 Bay-area artists and projects.

The Jewish Museum San Francisco
121 Steuart Street (between Mission and Howard Streets), San Francisco, CA 94105
Tel: (415) 543-8880
Fax: (415) 543-4180
President: Rabbi Brian L. Lurie
Admission: fee: adult-$5.00, student-$2.50, senior-$2.50.
Attendance: 10,500 *Established:* 1984
Membership: Y *ADA Compliant:* Y
Open: Monday to Wednesday, 11am-5pm;
 Thursday, 11am-8pm;
 Sunday, 11am-5pm.
Closed: Jewish Holidays.
Facilities: **Exhibition Area** (6,670 square feet); **Shop**.
Activities: **Education Programs**; **Guided Tours**; **Lectures**; **Temporary Exhibitions**.
Publications: exhibition catalogues; newsletter (quarterly).

David Damkoehler, *Kiddush Cup and Cover*, 1997, stainless steel, 10 x 3 inches. Jewish Museum of San Francisco. Photograph courtesy of Jewish Museum of San Francisco, San Francisco, California.

The emphasis of the Museum's programming is on the contemporary expression of traditional motifs to create a living heritage, as opposed to an historical museum that preserves Jewish culture through collections of artifacts, documents, or memorabilia. The Museum organizes special exhibitions and hosts traveling exhibitions that explore Jewish art and culture with contemporary relevance. The Museum also hosts invitational programs in which Jewish and non Jewish artists are invited to create works based on Jewish themes. The Museum maintains a permanent collection of contemporary Judaica. The Museum is constructing a new facility in the historic Jessie Street Substation at the Yerba Buena Gardens arts center. The new facility, scheduled to open in 2001, will include areas for special exhibitions, workshops, lectures, films, performances and school programs.

The Mexican Museum

Fort Mason Center, Bldg. D (Laguna & Marina Blvd.), San Francisco, CA 94123
Tel: (415) 441-0445
Fax: (415) 441-7683
Director: Ms. Marie Acosta-Colon
Admission: fee: adult-$3.00, student-$2.00, senior-$2.00.
Attendance: 25,000 *Established:* 1975 *Membership:* Y *ADA Compliant:* Y
Open: Wednesday to Sunday, noon-5pm.
Closed: Legal Holidays.
Facilities: **Library** (100 volumes); **Shop** La Tienda (Tues-Sun, noon-5pm; crafts, jewelry, books).
Activities: **Guided Tours**; **Lectures**; **Temporary Exhibitions**.
Publications: collection catalogue; newsletter (quarterly).

The Museum is dedicated to promoting the art and culture of Mexicano people through its permanent collection, exhibitions, publications, educational and interpretive programs. Selections from the permanent collections are displayed on a rotating basis in the Orientation Gallery in conjunction with rotating exhibitions in the main galleries. The Museum's permanent collection holds more than 9,000 objects. It includes artifacts from native cultures predating the Hispanic conquest and examples of art from Mexico's colonial period. Its collection of folk art is complemented by over 500 objects from The Nelson A. Rockefeller Collection of Mexican Folk Art. Among the artists represented in the Museum's collection of 20th-century Mexican Fine Art are Lilia Carrillo, Alejandro Colunga, Jose Luis Cuevos, Gunther Gerzso, Jose Clemente Orozco, Diego Rivera, David Alfaro Siqueiros, Rufino Tamayo, and Francisco Zuniga. The Museum's collection of Mexican American and Chicano contemporary art includes works on paper and mixed media constructions by artists Carlos Almaraz, Gronk, Patssi Valdez, Magu, Carmen Lomas Garza, and Gloria Maya.

Museo ItaloAmericano

Ft. Mason Center, Bldg. C
San Francisco, CA 94123
Tel: (415) 673-2200
Fax: (415) 673-2292
Internet Address:
 http://www.museoitaloamericano.org
Curator: Ms. Valentina Fogher
Admission: fee:
 adult-$3.00, student-$2.00, senior-$2.00.
Attendance: 24,000 *Established:* 1978
Membership: Y *ADA Compliant:* Y
Parking: free on site.
Open: Wednesday to Sunday, noon-5pm.
Facilities: **Galleries** (2, total 3,700 square feet);
 Library.
Activities: **Concerts**; **Education Programs**;
 Films; **Lectures**.

Francesco Clemente, *Yes or No*, 1982, aquatint print, printed by Crown Point Press, San Francisco. Collection of the Museo ItaloAmericano. Photograph courtesy of Museo ItaloAmericano, San Francisco, California.

Publications: brochures; exhibition catalogues; newsletter (bi-monthly).

The Museo ItaloAmericano is dedicated to the exhibition of works by Italian and Italian-American artists and to the documentation of the Italian experience in this country through objects and photographs. It presents both thematic and solo temporary exhibitions. It also sponsors an annual "Mostra" competition, a group show demonstrating the talents of both local and national Italian-American artists. The Museo maintains a small permanent collection of paintings, sculptures, photographs, and works on paper by prominent Italian and Italian-American artists. Included are works by painters Giuseppe Cadenasso, Sandro Chia, Francesco Clemente, Rinaldo Cuneo, Rico Lebrun, Nino Longobardi, Luigi Lucioni, Tom Marioni, Mimmo Paladino, Gottardo Piazzoni, Emilio Tadini, and Guiseppe Zigaina, and sculptors David Bottini, Arnoldo Pomodoro, and Italo Scanga. The Museo also has holdings of works by Bay Area artists Veronica Di Rosa, Tony Ligamari, Sam Provenzano, Maria Olivieri Quinn, and Bruno Rigacci.

San Francisco, California

Museum of Craft & Folk Art

Fort Mason Center, Landmark Building A
San Francisco, CA 94123-1382
Tel: (415) 775-0990
Fax: (415) 775-1861
Internet Address: http://www.mocfa.org/
~latitutde/museums/m_sfcfam.htm
Exec. Director: Mr. J. Weldon Smith
Admission: fee: adult-$3.00, student-$2.00,
senior-$2.00, family-$5.00.
Attendance: 60,000 *Established:* 1983
Membership: Y
Parking: 400 spaces in complex.
Open: Tuesday to Friday, 11am-5pm;
Saturday, 10am-5pm;
Sunday, 11am-5pm;
1st Wednesday in month; 11am-7pm.
Closed: New Year's Day, Independence Day,
Thanksgiving Day, Christmas Day.

Shiang-shin Yeh, *Set of Structural Bowls*, 1995, 12 x 12 x 5 inches (larger bowl), from "MetalSpeaks: The Unexpected" exhibition, 1997 at San Francisco Craft and Folk Art Museum. Photograph courtesy of San Francisco Craft and Folk Art Museum, San Francisco, California.

Facilities: **Exhibition Area** (2 galleries, total 1,500 square feet); **Library** (for use of members); **Shop** (ethnic art and contemporary crafts).
Activities: **Films**; **Guided Tours**; **Lectures**; **Temporary/Traveling Exhibitions** (6-10/year); **Workshops**.
Publications: exhibition catalogues; journal, "A REPORT" (quarterly).

The Museum of Craft & Folk Art fosters an appreciation of the artistic qualities of contemporary craft and recognition of the vigor and richness of folk art from diverse cultures, through exhibitions, educational programs, publications and a research library. The Museum's exhibitions of contemporary fine craft display the work of skilled artists using glass, ceramics, textiles, wood, and metal. Exhibitions of traditional ethnic art explore the heritage of tribal cultures from around the world. American folk art exhibitions focus on the work of contemporary untrained artists, or "outsider art". Lectures and demonstrations for the public accompany exhibitions. The Museum does not maintain a permanent collection.

San Francisco Art Institute Galleries

800 Chestnut Street, San Francisco, CA 94133
Tel: (415) 749-4564
Fax: (415) 749-1036
Internet Address: http://www.sfai.edu/
Director: Ms. Jean-Edith Weiffenbach
Admission: free.
Attendance: 18,000 *Established:* 1871 *Membership:* Y *ADA Compliant:* Y
Open: Tuesday to Wednesday, 10am-5pm; Thursday, 10am-8pm; Friday to Saturday, 10am-5pm;
Sunday, noon-5pm.
Closed: Legal Holidays.
Facilities: **Auditorium** (250 seats); **Gallery**; **Library** (27,000 volumes).
Activities: **Performances**; **Temporary Exhibitions**.
Publications: exhibition catalogues.

The Walter/McBean Gallery features temporary exhibitions. Project Space, upstairs at Walter/McBean, features small-scale solo exhibitions of new work primarily by California artists who are at the edge of artistic invention. Student work is exhibited weekly in the Diego Rivera Gallery with a reception on every Thursday evening, 5:30pm-7:30pm. One of Diego Rivera's first fresco commissions outside of Mexico, "The Making of a Fresco Showing the Building of a City" (1930), is at the Institute.

San Francisco Camerawork Inc.

115 Natoma Street, San Francisco, CA 94105
Tel: (415) 764-1001
Fax: (415) 764-1063
Internet Address: http://www.sfcamerawork.org
Exec. Director: Marnie Gillett
Admission: free.
Attendance: 30,000 *Established:* 1974
Membership: Y *ADA Compliant:* Y
Parking: limited.
Open: Tuesday to Saturday, noon-5pm.
Facilities: **Bookstore**; **Library** (2,500 volumes)
Activities: **Films**; **Lecture Series**; **Temporary**
 Exhibitions; **Traveling Exhibitions**.
Publications: exhibition catalogues; magazine,
 "Camerawork: A Journal of Photographic Arts"
 (biennial).

Richard Barnes, *Still Rooms & Excavation*, 1997, SF Camerawork. Photograph courtesy of SF Camerawork, San Francisco, California.

San Francisco Camerawork is a non-profit, artists' organization whose purpose is to stimulate dialogue, encourage inquiry, and communicate ideas about contemporary photography and related technologies through a variety of artistic and educational programs. Since its inception, SF Camerawork has presented over 350 exhibitions highlighting local and national contemporary photographers.

San Francisco Museum of Modern Art (SFMOMA)

151 3rd Street (between Mission and Howard Streets), San Francisco, CA 94103
Tel: (415) 357-4000
Fax: (415) 357-4037
TDDY: (415) 357-4154
Internet Address: http://www.sfmoma.org
Deputy Director: Ms. Lori Fogarty
Admission: fee: adult-$9.00, child-free,
 student-$5.00, senior-$6.00.
Attendance: 600,000 *Established:* 1935
Membership: Y *ADA Compliant:* Y
Open: **Labor Day to Memorial Day**,
 Monday to Tuesday, 11am-6pm;
 Thursday, 11am-9pm;
 Friday to Sunday, 11am-6pm.
 Memorial Day to Labor Day,
 Monday to Tuesday, 10am-6pm;
 Thursday, 10am-9pm;
 Friday to Sunday, 10am-6pm.
Closed: New Year's Day, Independence Day,
 Thanksgiving Day, Christmas Day.

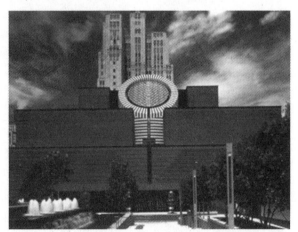
Exterior view of San Francisco Museum of Modern Art. Photograph courtesy of San Francisco Museum of Modern Art, San Francisco, California.

Facilities: **Architecture** (modernist building, 1995 design by Swiss architect Mario Botta); **Classroom** (100 seats); **Conservation Facilities**; **Exhibition Area** (50,000 square feet); **Food Services** Café Museo; **Library** (80,000 volumes); **Photography/Graphic Arts Study Area**; **Shop** (daily); **Theatre** (299 seats); **Workshops/Studios**.
Activities: **Concerts**; **Education Programs**; **Guided Tours**; **Lectures**; **Temporary Exhibitions**; **Traveling Exhibitions**.
Publications: annual report; calendar (bi-monthly); exhibition catalogues.

Located in the heart of the downtown South-of-Market district, SFMOMA presents modern and contemporary painting and sculpture, photography, architecture and design, and media arts in four floors of galleries. A large gallery on the third floor of the Museum is devoted to "Picturing Modernity: Photographs from the Permanent Collection", a permanent exhibition that offers a synoptic history of the medium. Two thousand square feet of specially-designed gallery space

San Francisco Museum of Modern Art, cont.

on the fourth floor enables the Museum to present works of media arts from the permanent collection on an ongoing schedule and to incorporate works from temporary exhibitions. Among the programs offered by the Museum is "Modem Art Adventures", a program of behind-the-scenes tours of art spaces in the Bay Area. SFMOMA's permanent collection consists of over 15,000 works, including 4,700 paintings, sculptures and works on paper; approximately 9,000 photographs; 1,500 architectural drawings, models and design objects; and a growing collection of works related to the media arts. The painting and sculpture collection represents California, American and international artists, and is distinguished by major paintings by artists associated with American Abstract Expressionism, notably Clyfford Still, Jackson Pollock and Philip Guston. Additional strengths of the painting and sculpture collection include Fauvism, particularly the works of Henri Matisse; German Expressionism; Latin-American painting; the art of the San Francisco Bay Area with extensive holdings of paintings by Richard Diebenkorn; works by Paul Klee; and a distinctive collection of artworks by contemporary artists. SFMOMA's collection of photography includes holdings of works by Alfred Stieglitz, Ansel Adams, Edward Weston, the German avant-garde artists of the 1920s and the European surrealists of the 1930s. The architecture and design collection features a diverse range of design objects and architectural drawings and models by figures associated with the West Coast and the Pacific Rim, such as Timothy Pflueger, Charles and Ray Eames, Charles Moore and William Turnbull, Frank Gehry, Shiro Kuramata and Tomatsu Yagi. The media arts department boasts seminal works by video pioneers Nam June Paik, Mary Lucier, Bill Viola, Vito Acconci, Dan Graham and Steina and Woody Vasulka, as well as more recent time-based works by Carolee Schneeman, Doug Hall and Dara Birnbaum.

San Francisco State University - Art Department Gallery

College of Creative Arts, 1600 Holloway Ave (Arts & Industry Bldg. Add.), San Francisco, CA 94132
Tel: (415) 338-6535
Internet Address: http://www.sfsu.edu/~artdept/artgallery.html
Gallery Manager: Ms. Sharon Spain
Admission: free.
Open: Call for hours.
Facilities: Gallery (3,800 square feet).
Activities: Temporary Exhibitions.

The Art Department Gallery is a teaching facility that presents both professional and student-oriented exhibitions each semester. Professional exhibitions are organized to features the range and diversity of both contemporary and historical art. Student exhibitions include the Stillwell Show (juried exhibition) and the Annual MFA Thesis Exhibition.

University of San Francisco - Mary and Carter Thacher Gallery

Gleeson Library/Geshke Center, 2130 Fulton Street, San Francisco, CA 94117-1080
Tel: (415) 422-5555
Internet Address: http://www.usfca.edu/library/thacher
Director: Thomas M. Lucas, S.J., Ph.D.
Admission: free.
Open: Library Hours.
Facilities: Exhibition Area.
Activities: Temporary Exhibitions.

The Gallery presents temporary exhibitions by international, national, and Bay Area artists.

Yerba Buena Center for the Arts

701 Mission Street, San Francisco, CA 94103-3138
Tel: (415) 978-2787
Fax: (415) 978-9635
Internet Address: http://www.YerbaBuenaArts.org
Exec. Director: Mr. John R. Killacky
Admission: fee: adult-$5.00, child-$3.00, student-$3.00, senior-$3.00.

Yerba Buena Center for the Arts, cont.

Attendance: 150,000 *Established:* 1993
Membership: Y *ADA Compliant:* Y
Open: Tuesday to Wednesday, 11am-6pm;
 Thursday to Friday, 11am-8pm;
 Saturday to Sunday, 11am-6pm.
Facilities: **Architecture** (Galleries & Forum, 1993 design by architect Fumihiko Maki); **Food Services** Internet Café (food, IMACs, zines); **Galleries** (3, total 8,200 square feet; also Forum, 6,700 square feet); **Screening Room** (96 seats); **Sculpture Court**; **Theatre** (Theater, 1993 design by James Stewart Polshek & Partners).
Activities: **Concerts**; **Education Programs**; **Films**; **Lectures**; **Performances** (Theater and Dance); **Temporary Exhibitions**.
Publications: brochures; exhibition catalogues.

View of Center for the Arts Galleries and Forum, designed by Fumihiko Maki. Photograph by Richard Barnes, courtesy of Yerba Buena Center for the Arts, San Francisco, California.

Located in the South-of-Market district of downtown San Francisco, Yerba Buena Center for the Arts is a visual and performing arts complex dedicated to presenting arts and entertainment reflecting the San Francisco Bay Area's diverse cultural populations. The Center, which opened in 1993, consists of two arts facilities: the Center for the Arts Galleries and Forum features three main galleries, an outdoor sculpture court, a 96-seat media screening room, and a large multi-use event and performance space; and the Center for the Arts Theater, a 755-seat proscenium theater. The fountain filled East Garden provides a refreshing resting-place and intimate outdoor performance area and the adjacent 5½-acre Esplanade features an outdoor performance area with lawn seating for 3,000 persons. The Galleries, created on the model of the European kunsthalles with no permanent collection, present temporary exhibits of contemporary works by a wide spectrum of artists with local, national and international reputations.

San Jacinto

Mount San Jacinto College - Fine Arts Gallery

1499 N. State St., San Jacinto, CA 92583
Tel: (909) 487-6752 *Ext:* 1531
Fax: (909) 654-6236
Internet Address: http://www.msjc.cc.ca.us
Director: Ms. Lucinda Luvaas
Open: Monday, 10am-4pm; Tuesday, 10am-4pm and 7pm-9pm; Wednesday to Friday, 10am-4pm;
 Saturday, 1pm-4pm.
Facilities: **Gallery**.
Activities: **Temporary Exhibitions**.

The Gallery features temporary exhibitions of the work of locally, regionally, and nationally recognized artists.

San Jose

American Museum of Quilts and Textiles of San Jose

60 S. Market St. (between San Fernando and Santa Clara Streets), San Jose, CA 95113
Tel: (408) 971-0323
Fax: (408) 971-7226
Admission: fee: adult-$4.00, child-free, student-$3.00, senior-$3.00.
Established: 1977 *Membership:* Y
Open: Tuesday to Wednesday, 10am-4pm; Thursday, 10am-8pm; Friday to Sunday, 10am-4pm.
Closed: Major Holidays.
Facilities: **Exhibition Area**.

San Jose, California

American Museum of Quilts and Textiles of San Jose, cont.

Activities: **Education Programs**; **Guided Tours** (groups, reserve in advance); **Lectures**; **Permanent Exhibits**; **Temporary Exhibitions**; **Workshops**.

The Museum supports the art, craft, and history of quilts and textiles through regularly changing exhibits featuring contemporary and historical quilts and textile art, education programs, lectures and workshops.

Rosicrucian Egyptian Museum and Planetarium

Rosicrucian Park, Park and Naglee Aves., San Jose, CA 95191

Tel: (408) 947-3636

Fax: (408) 947-3638

Internet Address: http://www.rosicrucian.org/mus-plan/O-museum.html

Director: Ms. Jill Freeman

Admission: fee: adult-$7.00, child-$3.50, student-$5.00, senior-$5.00.

Attendance: 150,000 *Established:* 1929

Membership: Y *ADA Compliant:* N

Parking: free lot on site.

Open: Monday, 10am-5pm;
 Wednesday to Sunday, 10am-5pm.

Closed: New Year's Day, Easter,
 Thanksgiving Day,
 Christmas Eve to Christmas Day.

Facilities: **Exhibition Area**; **Museum Store** (books, statues, jewelry).

Activities: **Films**; **Guided Tours** (museum; rock cut tomb, groups 25+ reserve in advance); **Lectures**.

Rosicrucian Egyptian Museum. Photograph courtesy of Rosicrucian Egyptian Museum, San Jose, California.

Publications: "Rosicrucian Digest" (bimonthly); "Scribe" (quarterly).

Sponsored by the Rosicrucian Order, an educational and philosophical organization, The Rosicrucian Museum's design was inspired by the Fifth Dynasty temples and structures at Karnak, Egypt. The Museum has an extensive collection of Egyptian ritual items, objects used in daily life, mummies, and a replica rock tomb.

San Jose Museum of Art (SJMA)

110 S. Market St. at San Fernando St., San Jose, CA 95113-2383

Tel: (408) 294-2787

Fax: (408) 294-2977

Internet Address: http://www.sjmusart.org

Director: Ms. Josi Callan

Admission:
 fee: adult-$7.00, student-$4.00, senior-$4.00.

Attendance: 200,000 *Established:* 1969

Membership: Y *ADA Compliant:* Y

Parking: pay lots and on street parking.

Open: Tuesday to Wednesday, 10am-5pm;
 Thursday, 10am-8pm;
 Friday to Sunday, 10am -5pm.

Closed: New Year's Day, Thanksgiving Day,
 Christmas Day.

Facilities: **Architecture**; **Food Services** Café (Tues-Wed & Fri-Sun, 9am-5pm; Thurs, 9am-8pm); **Library**; **Sculpture Court**; **Shop** (cards, posters, books, jewelry, toys, art-related gift items).

Exterior view of San Jose Museum of Art. Photograph by Dana I. Grover, courtesy of San Jose Museum of Art, San Jose, California.

104

San Jose Museum of Art, cont.

Activities: **Concerts** (monthly); **Education Program** (adults and children, Art School); **Guided Tours** (daily, 12:30pm & 2:30pm; Thursday, 6:30pm; groups reserve in advance); **Signed Tours for Hearing Impaired**.

Publications: "Frameworks" (quarterly).

Located in the heart of the city of San Jose, SJMA is comprised of two wings: the Historic Wing which was designed in 1892 by Willoughby Edbrooke, and the New Wing, which was designed by Skidmore, Owings & Merrill and opened in 1991. The Museum presents a full range of changing exhibitions with a focus on 20th-century art, including painting, sculpture, installations, works on paper, photography, and video. Also on view are long-term exhibitions of selected masterworks from the permanent collection of the Whitney Museum of American Art in New York. The Museum schedules a wide variety of special events such as jazz and classical concerts, opera recitals, lectures, and children's activities to complement the current exhibitions. The Museum also operates an Art School, dedicated to providing visual art education of the highest caliber to children and adults The SJMA permanent collection of nearly 1,000 20th-century artworks, with an emphasis on post-1980 Bay Area artists, includes sculpture, painting, prints, and drawings by such artists as Robert Arneson, Joan Brown, Deborah Butterfield, Dale Chihuly, Ron Davis, Richard Diebenkorn, Jim Dine, Sam Francis, Rupert Garcia, Oliver Jackson, Manuel Neri, Long Nguyen, Nathan Oliveira, Deborah Oropallo, Wayne Thiebaud, and William Wiley.

San Jose State University Art Galleries

Art Dept., One Washington Square, San Jose State University, San Jose, CA 95192-0089

Tel: (408) 924-4328

Fax: (408) 924-4326

Internet Address: http://www.sjsu.edu/depts/art_design/events/galleries.html

Director: Ms. Ann Ostheimer

Admission: free.

Attendance: 14,000 *Established:* 1959 *ADA Compliant:* Y

Parking: call for parking pass.

Open: **September to May**, Tuesday, 11am-4pm and 6pm-8pm; Wednesday to Friday, 11am-4pm.

Facilities: **Gallery** (new exhibition every 6 weeks during academic year).

Activities: **Education Program** (students); **Guided Tours**; **Lecture Series** (during academic year, Tues, 5pm); **Temporary/Traveling Exhibitions** (new exhibit every six weeks).

Publications: brochures; exhibition catalogues.

The main gallery, The Natalie and James Thompson Art Gallery, presents six exhibits annually of work by professional artists. Each year there are exhibits of contemporary design and history of art, a collaborative exhibition with other art institutions in the Bay Area, and a special exhibition and residency. In addition to the Thompson Gallery there are eight small student galleries. Included in this matrix is a special installation/performance space and small design gallery. There are additional exhibition spaces in cases throughout the Art Building. In most of the galleries, exhibits of student art work change weekly, resulting in over 160 exhibitions annually.

San Luis Obispo

California Polytechnic State University - University Gallery

171 Dexter Bldg (adjacent of Kennedy Library), University Drive and Poly Vue

San Luis Obispo, CA 93407

Tel: (805) 756-1148

Fax: (805) 756-6321

Internet Address: http://artdesign.libart.calpoly.edu/webpages/html/gallery.html

Director: Ms. Crissa Hewitt

Admission: free.

Open: Monday to Tuesday, 11am-4pm; Wednesday, 11am-4pm and 7pm-9pm; Thursday to Sunday, 11am-4pm.

Facilities: **Exhibition Area**.

Activities: **Temporary Exhibitions** (6/year).

San Luis Obispo, California

California Polytechnic State University - University Gallery, cont.

The University Gallery presents exhibitions of work in a wide variety media by nationally and internationally recognized artists, as well as artwork by students, alumni and faculty. Exhibitions are supplemented by other on-site programs. Also of possible interest on campus, the Galerie (756-1182) located in Room 221 of the University Union presents exhibitions featuring contemporary and historical works of art in a variety of media.

Cuesta College Art Gallery

Library, Highway 1, San Luis Obispo, CA 93403
Tel: (805) 546-3202
Internet Address: http://www.cuesta.cc.ca.us/finearts/gallery.htm
Director: Ms. Marta Peluso
Open: **Fall to Spring**, Monday to Thursday, 7:30am-9pm; Friday, 7:30am-4pm; Sunday, noon-6pm.
 Summer, Monday to Thursday, 7:30am-4pm; Friday, 7:30am-1pm.
Facilities: **Exhibition Area.**
Activities: **Lectures**; **Temporary Exhibitions**.

The Gallery presents temporary exhibitions of contemporary work by locally, regionally, and nationally recognized artists.

San Marcos

Palomar College - Boehm Gallery

1140 Mission Road, Palomar College, San Marcos, CA 92069-1487
Tel: (760) 744-1150 *Ext:* 2304
Fax: (760) 744-8123
Internet Address: http://www.palomar.edu
Director: Mr. Harry Bliss
Admission: voluntary contribution.
Attendance: 65,000 *Established:* 1964 *ADA Compliant:* Y
Open: **September to June**,
 Tuesday, 10am-4pm; Wednesday to Thursday, 10am-7pm; Friday to Saturday, 10am-2pm.
Closed: Academic Holidays.
Facilities: **Galleries** (2000 square feet); **Library** (8,500 volumes); **Reading Room.**
Activities: **Gallery Talks**; **Lectures**; **Temporary Exhibitions**.
Publications: exhibition catalogues.

The permanent collection of the Boehm Gallery numbers approximately two hundred works, dating from the 15th through 20th centuries, in a variety of media. The Gallery features six exhibitions per year, including student and faculty work, as well as that of nationally recognized professional artists.

San Marino

The Huntington Library, Art Collections, and Botanical Gardens

1151 Oxford Road, San Marino, CA 91108
Tel: (626) 405-2100
Fax: (626) 405-0225
Internet Address: http://www.huntington.org
President: Dr. Robert Allen Skotheim
Admission: fee: adult-$8.50, child-free, student-$5.00, senior-$7.00.
Attendance: 565,000 *Established:* 1919 *Membership:* Y *ADA Compliant:* Y
Open: **Labor Day to Memorial Day**,
 Tuesday to Friday, noon-4:30pm; Saturday to Sunday, 10:30am-4:30pm.
 March to Labor Day,
 Tuesday to Sunday, 10:30am-4:30pm.
Closed: New Year's Day, Memorial Day, Independence Day, Labor Day, Thanksgiving Day,
 Christmas Eve to Christmas Day.

The Huntington Library, Art Collections, and Botanical Gardens, cont.

Facilities: **Architecture** (beaux arts mansion, 1910 design by Myron Hunt); **Auditorium** (500 seats); **Botanical Garden** (150 acres); **Food Services** Restaurant (175 seats;, Tea Room; **Galleries** (three locations); **Library** (600,000 volumes); **Shop** (books, prints, gift items).

Activities: **Education Programs**; **Gallery Talks**; **Guided Tours**; **Temporary Exhibitions**.

Publications: brochures; newsletter, "Calendar" (bi-monthly); scholarly books.

The Huntington Library, Art Collections, and Botanical Gardens is an oasis of art and culture set amidst 150 acres of gardens. Three art galleries and a library showcase collections of rare books and manuscripts, 18th- and 19th-century British and French art, and American art from the 18th- to the early 20th-century. The Huntington Gallery, originally the Huntington residence, contains a comprehensive collection of British and French art of the 18th- and 19th-centuries and hosts special changing exhibitions. The Virginia Steele Scott Gallery of American Art brings together American paintings from the 1730's to the 1930's, a permanent exhibition devoted to the work of early 20th-century Pasadena architects Charles and Henry Greene, as well as changing exhibitions. The Arabella Huntington Memorial Collection is housed in the west wing of the Library and features Renaissance paintings and 18th-century French sculpture, tapestries, porcelain, and furniture. Highlights include Gainsborough's "Blue Boy", Lawrence's "Pinkie", the Ellesmere manuscript of Chaucer's "Canterbury Tales" (c. 1410), a Gutenberg Bible on vellum (c. 1455), the double-elephant folio edition of Audubon's "Birds of America", and an extensive collection of early editions of Shakespeare.

Thomas Gainsborough, *Jonathan Buttell: The Blue Boy*, ca 1770, oil on canvas. The Huntington Art Collection. Photograph courtesy of The Huntington, San Marino, California.

San Simeon

Hearst Castle - Hearst San Simeon State Historical Monument

750 Hearst Castle Road (off Route #1)
San Simeon, CA 93452-9741
Tel: (805) 927-2020
Fax: (805) 927-2031
TDDY: (800) 274-7275
Internet Address: http://www.hearstcastle.org
Director: Mr. Kirk Sturm
Admission: fee: adult-$14.00, child-$8.00.
Attendance: 820,000 *Established:* 1958
 Membership: N *ADA Compliant:* Y
Parking: free on site.
Open: Daily, 8am-4pm.
 Spring and Fall, Friday to Saturday, evenings.
Closed: New Year's Day, Thanksgiving Day, Christmas Day.
Facilities: **Architecture** (Mediterranean Revival, 1919-47 design by Julia Morgan); **Grounds** (127 acres, 8 acres of gardens); **Museum Exhibit** (free); **Shop**.
Activities: **Films**; **Guided Tours** (reservations recommended, (800) 444-4445).

Casa Grande façade, Hearst Castle (under construction from 1919 to 1947), designed by Julia Morgan. Photograph courtesy of Hearst San Simeon State Historical Monument, San Simeon, California.

Hearst Castle, once the private estate of publisher William Randolph Hearst, took nearly 28 years to construct. Though excavation for Casa Grande, the estate's main house, began in 1922, the building was not ready for full-time occupancy until 1927 and additional work continued until 1947. The estate has 165 rooms in the main building and three guest houses, and 127 acres of gardens, terraces, pools and walkways. The paintings on display are predominantly of Italian and Spanish origin. Paintings by Dutch, Flemish, German, and French artists also can be found. Sculpture

Hearst Castle - Hearst San Simeon State Historical Monument, cont.

is present throughout the house and gardens, including original Greek, Roman and Egyptian pieces; marble copies of ancient statues; a broad spectrum of medieval and Renaissance religious art from Spain, Italy, and France; and the works of American artists. The ceilings at Hearst Castle are mostly Spanish and Italian, dating from the 14th- to the18th century. Once they arrived at San Simeon, many of the old ceilings were reworked to make them fit their intended rooms. Plaster was used extensively as a substitute for wood. Leftover beams and corbels from one room were used to finish ceilings in other rooms. Similarly, many of the architectural elements have been adapted from their original context to fit both the intended room and the furnishings chosen for that room. Hearst Castle is open for tours daily with four distinct daytime tours available. An additional evening tour is available on Fridays and Saturdays during the Spring and Fall. Tickets are sold for specific tour times. Since tours often sell out in advance, reservations are strongly suggested and may be made up to 8 weeks in advance for individuals.

Santa Ana

Bowers Museum of Cultural Art

2002 N. Main Street, Santa Ana, CA 92706

Tel: (714) 567-3600

Fax: (714) 567-3603

Internet Address: http://www.bowers.org

President: Peter C. Keller, Ph.D.

Admission: fee: adult-$8.00, child (<5)-free, child (5-12)-$5.00, student-$6.00, senior-$6.00.

Attendance: 150,000 *Established:* 1936

Membership: Y *ADA Compliant:* Y

Parking: free on site.

Open: Tuesday to Sunday, 10am-4pm.

Closed: New Year's Day, Thanksgiving, Christmas.

Facilities: **Conference Center**; **Food Services** Topaz Café; **Galleries**; **Kidseum** (hands-on children's museum); **Shop** (cultural artworks, jewelry, clothing, books).

Entrance, Bowers Museum of Cultural Art. Photograph courtesy of Bowers Museum of Cultural Art, Santa Ana, California.

Activities: **Community Festivals**; **Education Programs**; **Films**; **Guided Tours**; **Lectures**; **Temporary and Traveling Exhibitions**.

Publications: exhibition catalogues; gallery guides; newsletter (quarterly).

Permanent exhibitions include African, Native American, Asian, pre-Columbian and Oceanic Art, plus paintings by California artists and historical artifacts of the old West. The Museum also hosts an array of traveling exhibitions and colorful community festivals throughout the year. The Kidseum, an adjacent facility, provides young visitors with avenues for creativity, communications and understanding in an interactive environment.

Orange County Center for Contemporary Art (OCCCA)

208 N. Broadway, Santa Ana, CA 92701

Tel: (714) 667-1517

Internet Address: http://www.breakaway.org/OpenStudio/OCCCA/index.html

Director: Mr. Jeffrey Frisch

Open: Wednesday to Sunday, 11am-4pm.

Facilities: **Exhibition Area**.

Activities: **Temporary Exhibitions**.

A non-profit, artists-operated organization, OCCCA was founded in 1980 by a group of California State University, Fullerton graduate students. It provides emerging and established artists a forum for the exploration and development of ideas in contemporary art. The Center provides exhibitions, performances, and public outreach and community art services.

Santa Ana College - SAC Main Gallery (SAC)

17th at Bristol Streets, 1530 W. 17th St., Santa Ana, CA 92706
Tel: (714) 564-5615
Fax: (714) 564-5629
Internet Address: http://www.rancho.cc.ca.us/rsccd/sac/sac_home.htm
Director: Ms. Mayde Herberg
Admission: free.
Attendance: 9,000 *Established:* 1970 *Membership:* N *ADA Compliant:* Y
Parking: metered lots.
Open: Monday, 10am-2pm; Tuesday to Wednesday, 10am-2pm and 6:30pm-8:30pm;
Thursday, 10am-2pm.
Closed: Academic Holidays, Legal Holidays.
Facilities: **Galleries** (1,100 square feet); **Library** (exhibition catalogues).
Activities: **Education Programs**; **Guided Tours** (by appt.); **Lectures Series** (Mon, 12:30pm).
Publications: exhibition catalogues (3/year).

The SAC Main Gallery was established on campus to provide an educational site for art. An additional gallery, the RSC Arts Gallery, was opened in 1996 in Santa Ana's 'Artists Village', downtown (207 N. Broadway; Wed-Sat, noon-4pm; tel. 564-5605). This gallery annex doubles the display area available for the study of art and exhibition design. Both galleries are devoted to the display of current work by professional artists as well as that of faculty and students. The College does not maintain a permanent collection.

Santa Barbara

Santa Barbara Museum of Art

1130 State Street, Santa Barbara, CA 93101-2746
Tel: (805) 963-4364
Fax: (805) 966-6840
TDDY: (805) 963-2240
Internet Address: http://www.sbmuseart.org
Director: Mr. Robert H. Frankel
Admission: fee: adult-$5.00, child-$2.00, student-$2.00, senior-$3.00.
free: Thursday and 1st Sunday in month.
Attendance: 130,000 *Established:* 1941
Membership: Y *ADA Compliant:* Y
Open: Tuesday to Thursday, 11am-5pm;
Friday, 11am-9pm;
Saturday, 11am-5pm;
Sunday, noon-5pm.
Closed: New Year's Day, Thanksgiving Day,
Christmas Day.
Facilities: **Auditorium** (153 seats); **Food Services** Café; **Library** (Tuesday-Friday, noon-4pm); **Shop** (catalogues, books, jewelry, posters, gift items).
Activities: **Concerts**; **Education Programs**; **Films**; **Gallery Talks** (daily, noon & 2pm); **Guided Tours** (Tues-Sun, 1pm; focus tours, Wed/Thurs/Sat, noon); **Lectures**; **Temporary Exhibitions**.
Publications: calendar; exhibition catalogues; gallery guides.

André Derain, *La Citrouille (Still Life with Pumpkin)*, 1939, oil on canvas. Bequest of Wright S. Ludington, Santa Barbara Museum of Art. Photograph courtesy of Santa Barbara Museum of Art, Santa Barbara, California.

At the Santa Barbara Museum of Art the visitor can discover treasures that span 41 centuries, from Greek and Roman sculpture surrounding a serene pool to the exciting art of our own time. In addition to exhibitions drawn from the permanent collection, the Museum presents over 12 shows annually drawn from museums and private collections worldwide. On the Main Level is an extensive

Santa Barbara Museum of Art, cont.

collection of antiquities, including a group of Greek and Roman sculptures dating from the 4th century BC, among them the famed Landsdowne Hermes in the atrium. Works on paper and photography are exhibited in the Campbell Gallery. The Davidson Gallery houses works from the Museum's extensive 20th-century collection. The Preston Morton and Von Romberg Galleries feature American art. California art is presented in the new Emmons Gallery, and 19th- and early 20-century European art is on view in the new Ridley-Tree Gallery. Artists represented in the Museum's permanent collections include Calder, Chagall, Copley, Dali, Eakins, Homer, Hopper, Kandinsky, Matisse, Monet, O'Keeffe, Picasso, Rivera, Sargent, Sisley, and Stella. A variety of special exhibitions, classes, workshops, and art camps are offered throughout the year at the Ridley-Tree Education Center of the Santa Barbara Museum of Art at McCormick House, 1600 Santa Barbara Street, Santa Barbara, CA 93101; 962-1661. Gallery hours at McCormick House are Monday-Friday, 9:30am-noon and 2pm-5pm.

University of California, Santa Barbara - University Art Museum (UAM)

University of California, El Colegio Road, Santa Barbara, CA 93106-7130
Tel: (805) 893-2951
Fax: (805) 893-3013
Internet Address: http://www.uam.ucsb.edu
Director: Marla C. Berns
Admission: free.
Attendance: 20,000 *Established:* 1959 *Membership:* Y *ADA Compliant:* Y
Parking: park in Lot #22.
Open: Tuesday, noon-8pm; Wednesday to Sunday, noon-5pm.
Closed: Major Holidays.
Facilities: **Galleries**; **Shop** (893-8266).
Activities: **Education Programs**; **Gallery Talks**; **Exhibitions**.
Publications: exhibition catalogues.

The Museum presents permanent, temporary, and traveling exhibitions. Permanent collections include the Morgenroth Collection of Renaissance Medals and Plaquettes; the Sedgwick Collection of old master paintings; and works on paper, including drawings and photographs. A collection of over 350,000 architectural drawings, mostly the work of California architects, is housed separately (1332 Arts Building - (805) 893-2724). The Museum completed a major renovation in May 2000, creating a new entrance with an adjoining plaza and six exhibition spaces. The renovation allows the permanent collection galleries to remain open during the installation of temporary exhibits.

Santa Clara

Santa Clara University - de Saisset Museum

Santa Clara University, 500 El Camino Real
Santa Clara, CA 95053-0550
Tel: (408) 554-4528
Fax: (408) 554-7840
TDDY: (800) 735-2929
Internet Address: http://www.scu.edu/
 SCU/Departments/deSaisset/information
Director: Ms. Rebecca M. Schapp
Admission: voluntary contribution.
Attendance: 30,000 *Established:* 1955
Membership: Y
Parking: free visitor's parking pass at campus entrance.
Open: Tuesday to Sunday, 11am-4pm.
Closed: Legal Holidays, Good Friday, M. L. King Day.
Facilities: **Auditorium** (200 seats); **Building** (17,000 square feet); **Library** (1,200 volumes); **Shop**.

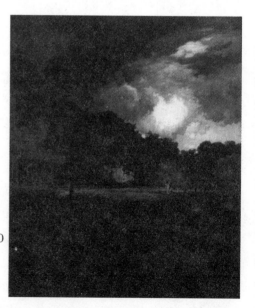

Thomas Moran, *East Hampton, Long Island,* 19th-century. de Saisset Museum, gift of Robert M. Husband. Photograph courtesy of de Saisset Museum, Santa Clara University, Santa Clara, California.

Santa Clara University - de Saisset Museum, cont.

Activities: Guided Tours; Temporary Exhibitions; Traveling Exhibitions.

Publications: exhibition catalogues; newsletter, "California Artist Profiles".

The de Saisset Museum, located adjacent to Mission Santa Clara de Asís in the heart of the Santa Clara University campus, is the University's museum of art and history. The Museum's permanent collection contains a wide range of artworks in a variety of media. While the collection is rich in contemporary prints and photographs, it possesses historical old-world flavor with Renaissance prints, works by Albrecht Dürer, and the acclaimed sculpture "Othello" by 19th-century Italian artist Gian-Pietro Calvi. The Museum presents temporary exhibitions of contemporary and historically important art, ranging from local artists to touring national exhibits, often on ethical and moral themes. In addition, there are lectures, concerts, and films for the educational and cultural benefits of the University community, local residents, and visitors. The de Saisset Museum is also the caretaker of the University's California History Collection, which includes historical and ethnographic artifacts from the Native American period through the founding of the Mission and College. These are displayed in three galleries focusing on the Ohlone Indian, Mission, and early College periods. The Museum's art collection includes paintings, prints, and sculptures by European and American artists from the 16th century to the present; European and Asian decorative art; and African tribal art. Among the many contemporary works in the collection is the largest public collection of the influential and historically important early 20th-century artist Henrietta Shore. In addition the collection contains works by Arnold G. Mountfort, Sam Francis, Bruce Conner, and many other artists of national and international renown. Also of note are works from the Depression-era New Deal art program; film documentation of experimental performance art in the early 1970s; the Helen Johnston Collection of photographs by artists such as Ansel Adams, Ruth Bernhard, Wynn Bullock, Imogen Cunningham, Judy Dater, Annie Leibovitz, Les Krims, Lisette Model, and Edward Weston; and archival prints from the Palo Alto fine arts press, Smith Andersen Editions, by Stanley Boxer, David Gilhooly, Joseph Goldyne, Frank Lobdell, Marguerite M. Saegesser, Inez Storer, and others. Wheelchair accessibility is limited to the galleries located on the main floor.

Triton Museum of Art

1505 Warburton Ave., Santa Clara, CA 95050
Tel: (408) 247-3754
Fax: (408) 247-3796
Internet Address: http://www.tritonmuseum.org
Exec. Director: Mr. George Rivera
Admission: voluntary contribution.
Attendance: 27.500 **Established:** 1965
Membership: Y **ADA Compliant:** Y
Open: Tuesday, 10am-9pm;
 Wednesday to Sunday, 10am-5pm.
Closed: Legal Holidays.
Facilities: **Building** (22,000 square feet); **Library** (1,000 volumes); **Shop.**
Activities: **Concerts; Education Programs; Gallery Talks; Guided Tours; Lectures; Studio Classes.**

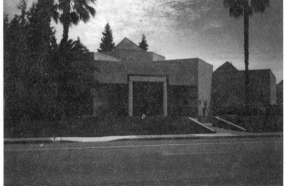

Exterior view of Triton Museum of Art building (1987), designed by Barcelon & Jang. Photograph courtesy of Triton Museum of Art, Santa Clara, California.

Publications: brochures; exhibition catalogues; newsletter (bi-monthly).

The Museum collects and exhibits contemporary and historical works with an emphasis on artists of the Greater Bay Area. The permanent collection includes Native American art and artifacts from the Southwest, California, and the Pacific Northwest. Exhibitions extend to include the art of the Pacific Rim, Europe, and beyond with the goal of creating diverse, thought-provoking exhibitions that reach beyond traditional presentations of art.

Santa Cruz

Museum of Art and History (MAH)

McPherson Center, 705 Front St. at Cooper St., Santa Cruz, CA 95060
Tel: (831) 429-1964
Fax: (831) 429-1954

Museum of Art and History, cont.

Internet Address: http://www.santacruzmah.org
Exec. Director: Mr. Charles Hilger
Admission: fee: adult-$3.00, child-free, student-free.
Attendance: 41,000 *Established:* 1996
Membership: Y *ADA Compliant:* Y
Parking: adjacent to museum.
Open: Tuesday to Wednesday, 11am-5pm;
 Thursday, 11am-9pm;
 Friday to Sunday, 11am-5pm.
Closed: New Year's Day, Thanksgiving Day,
 Christmas Day.
Facilities: **Facility** (20,000 square feet);
 Galleries (4); **Sales Gallery** (works by Santa
 Cruz artists); **Shop.**
Activities: **Education Programs**; **Films**;
 Guided Tours; **Lectures**; **Workshops**.
Publications: exhibition catalogues; journal,
 "The Santa Cruz History Journal" (annual);
 newsletter (quarterly).

Façade of Museum of Art and History at the McPherson Center. Photograph courtesy of Museum of Art and History, Santa Cruz, California.

Formed by the merger in 1996 of two institutions, the Museum of Art and History presents ten to twelve exhibitions annually, along with correlated education programs for both adults and children. The Museum's permanent collection includes works of art and regional historical artifacts. There is a special emphasis on education for all ages. In addition to the four galleries located at the McPherson Center, the Museum owns and maintains two historical sites, Evergreen Cemetery and the Davenport Jail. Evergreen Cemetery offers monthly tours to enable the public to learn about the community's past in an interactive manner. The Museum also uses the Octagon, originally the 1882 Hall of Records, as the site of the museum store.

University of California, Santa Cruz - Mary Porter Sesnon Art Gallery

Porter College, U. C. Santa Cruz, 1156 High Street, Santa Cruz, CA 95064
Tel: (831) 459-3606
Internet Address: http://arts.ucsc.edu/sesnon
Director: Shelby Graham
Admission: free.
ADA Compliant: Y
Open: **Fall to Spring**, Tuesday to Sunday, noon-5pm.
Closed: Academic Holidays, Summer.
Facilities: **Exhibition Area.**
Activities: **Temporary Exhibitions.**

The Sesnon Gallery operates a museum-oriented program for educational purposes. The Gallery organizes an annual schedule of temporary exhibitions that represents a broad range of methods, media, and cultures in a local/regional/national context with a focus on contemporary practice.

Santa Monica

Santa Monica College Art Gallery

Santa Monica Community College District, 1900 Pico Blvd., Santa Monica, CA 90405
Tel: (310) 452-9231
Internet Address: http://www.smc.edu
Parking: Free at Airport Parking Lot.
Open: Tuesday to Thursday, 11am-3pm and 5:30pm-8:30pm; Friday, 11am-3pm;
 Saturday, 11am-4pm.
Facilities: **Gallery.**
Activities: **Temporary Exhibitions.**

The Gallery presents temporary exhibitions of the work of both students and professional artists.

Santa Monica Museum of Art

Bergamont Station Arts Center, 2525 Michigan Ave., Building G1
Santa Monica, CA 90404
Tel: (310) 586-6488
Fax: (310) 586-6487
Internet Address: http://www.netVIP.com/smmoa
Exec. Director: Elsa Longhauser
Admission: suggested contribution: adult-$3.00, child-free, student-$2.00, senior-$2.00.
Attendance: 35,000 *Established:* 1988 *Membership:* Y *ADA Compliant:* Y
Parking: free on site.
Open: Tuesday to Saturday, 11am-6pm.
Closed: New Year's Day, Independence Day, Thanksgiving Day, Christmas Day.
Facilities: **Exhibition Area** (10,000 square feet, designed by Narduli/Grinstein); **Gallery**; **Shop**.
Activities: **Education Program** (children); **Evening Salons**; **Lectures**; **Temporary Exhibitions**.
Publications: newsletter (quarterly).

The Museum features the exhibition of works by emerging and mid-career artists, particularly from Southern California. International and multi-disciplinary, the Museum is a non-collecting, artist-driven organization which presents both group and one-person exhibitions, while serving as an active laboratory to encourage artistic expression and experimentation. Museum exhibition programs include the Artist Project Series, an ongoing series of commissioned work by contemporary artists; major thematic, scholarly, group, and one-person exhibitions; and special, intimately-scaled projects. Over the last ten years, it has presented the work of over 1,000 artists. In addition to organizing exhibitions, the Museum publishes scholarly catalogs and artist books and sponsors lectures and public programs.

Santa Monica Museum of Art's new facility at Bergamot Station Arts Center. Photograph courtesy of Santa Monica Museum of Art, Santa Monica, California.

Santa Rosa

Santa Rosa Junior College - Jesse Peter Native American Art Museum

Santa Rosa Junior College, 1501 Mendocino Ave., Santa Rosa, CA 95401
Tel: (707) 527-4479
Fax: (707) 527-4816
Internet Address: http://www.santarosa.edu
Director: Mr. Foley C. Benson
Admission: voluntary contribution.
Attendance: 17,000 *Established:* 1932 *Membership:* N *ADA Compliant:* Y
Parking: parking available; fee charged.
Open: **September to June**, Monday to Friday, noon-4pm.
Closed: Academic Holidays.
Facilities: **Exhibition Area**.
Activities: **Guided Tours**; **Lectures**.
Publications: monographs (occasional).

The Museum presents exhibitions of traditional and contemporary Native American art and artifacts. Also of possible interest, the Art Gallery presents a schedule of exhibitions of work in diverse media with an emphasis on artists not generally exhibited locally. Located in the former museum building near the center of the campus, the Gallery is open Sunday and Tuesday through Friday, noon to 4pm.

Stanford

Stanford University - Iris & B. Gerald Cantor Center for Visual Arts at Stanford University

Lomita Drive and Museum Way, Stanford, CA 94305-5060
Tel: (650) 725-4177
Fax: (650) 725-0464
TTY: (650) 723-1216
Internet Address: http://www.stanford.edu/dept/ccva
Director: Mr. Thomas K. Seligman
Admission: free.
Established: 1885 *Membership:* Y *ADA Compliant:* Y
Parking: metered in front of Center and in parking structure at Campus Drive and Roth.
Open: Wednesday, 11am-5pm; Thursday, 11am-8pm; Friday to Sunday, 11am-5pm.
Facilities: **Auditorium**; **Food Services** Café (725-4758); **Library**; **Shop**.
Activities: **Concerts**; **Gallery Talks**; **Guided Tours** (group, 723-3469); **Lectures**; **Temporary Exhibitions**; **Traveling Exhibitions**.
Publications: exhibition catalogues; journal.

Closed after the 1989 earthquake, the Stanford Museum reopened as the Iris & B. Gerald Cantor Center for Visual Arts in January of 1999. The facility, totaling approximately 120,000 square feet, includes the historic museum building, the B. Gerald Cantor Rodin Sculpture Garden, new sculpture garden areas, and a new wing. The latter includes galleries for the display of special exhibitions and the permanent collection of contemporary art, a café, a bookshop, and a lecture/performance room. Stanford University has significant collections of outdoor art. In addition to the Museum's sculpture gardens, works by such artists as Josef Albers, Alexander Calder, Joan Miró, Henry Moore, James Rosati, George Segal, and Kenneth Snelson are installed throughout the campus. A Papua New Guinea Sculpture Garden is located near the intersection of Lomita Drive and Santa Teresa Street. Stanford maintains extensive permanent collections in virtually all areas. The European Painting Collection includes examples dating from the Renaissance through the end of the 19th-century with particular focus on British and French works from the later 18th- and early 19th-centuries. Seventeenth-century Holland and Italy are represented by smaller groups of paintings. The Museum's collection of European sculpture spans the fifteenth through nineteenth centuries. A highlight of the collection is a group of over 200 works by the French sculptor Auguste Rodin, many of which are on permanent display in the Iris and B. Gerald Cantor Rodin Sculpture Garden. The American Painting Collection ranges from the early 19th-century into the 20th-twentieth century, with particular strengths in later 19th-century landscapes, including important paintings from the 1870's by the California painter William Keith. The museum holds many works by William Trost Richards, Rex Slinkard, and Theodore Wores. The Modern and Contemporary Collections include in the collection are significant works by painters affiliated with Stanford such as Richard Diebenkorn, Nathan Oliveira and Frank Lobdell, as well as works by Bay Area artists such as Paul Wonner, Theophilus Brown and Wayne Thiebaud. The Print and Drawing Collections include more than 3,500 prints and 1,500 drawings, mainly from the 18th- and 19th-centuries. In the drawing collection, areas of particular interest include images of artists, academic studies, and caricatures, as well as works by Fragonard, G.B. and G.D. Tiepolo, J. R. Cozens, Turner, Delacroix, Gericault, Menzel, Prendergast, Gwen John, Mark Tobey, and de Kooning. The strength of the print collection lies in early 19th-century French lithographs, including a fine selection by Theodore Gericault, Richard P. Bonington's complete oeuvre, as well as many caricatures. The Photography Collection spans the history of the medium from prints by Eadweard Muybridge and William Henry Fox Talbot to work by the most important contemporaries. The Art of the Americas spans the Western Hemisphere in ancient and modem times. Pre-Columbian collection concentrate on the ceramic traditions in Peru, Mexico, and the Southwestern United States. The 19th- and 20th- century collections deal in greater detail with North America, especially California. The Ancient Collection includes two thousand examples of ancient Cypriot terracotta, Greek and Roman works, sculpture from kingdom of Palmyra, and Egyptian artifacts. The African Collection concentrates on traditional sculpture of sub-Saharan Africa dating from the 19th- and 20th-centuries.The Museum also has substantial collections of Asian and Pacific art. Also of possible interest on campus is the T. W. Stanford Art Gallery (Tues-Fri, 10-5; Sat-Sun, 1-5).

Torrance

El Camino College Art Gallery

16007 Crenshaw Blvd., Torrance, CA 90506
Tel: (310) 660-3010
Fax: (310) 660-3798
Internet Address: http://www.elcamino.cc.ca.us/cmart.htm
Art Gallery Curator: Ms. Susanna Meiers
Admission: free.
Open: Monday to Tuesday, 10am-3pm; Wednesday to Thursday, 10am-8pm; Friday, 10am-2pm.
Facilities: **Exhibition Area.**
Activities: **Temporary Exhibitions.**
The gallery presents exhibitions of works by professional artists, faculty, and students.

Ukiah

Grace Hudson Museum and The Sun House

431 S. Main St., Ukiah, CA 95482
Tel: (707) 467-2836
Fax: (707) 467-2835
Internet Address: http://www.gracehudsonmuseum.org
Director: Ms. Sherrie Smith-Ferri
Admission: suggested contribution-$2.00, family-$5.00.
Attendance: 12,000 *Established:* 1975 *Membership:* Y
ADA Compliant: Y
Open: Wednesday to Saturday, 10am-4:30pm; Sunday, noon-4:30pm.
Closed: Legal Holidays.
Facilities: **Architecture** (Craftsman bungalow, 1911); **Gallery**; **Shop.**
Activities: **Guided Tours**; **Lectures**; **Temporary Exhibitions.**
Publications: *The Painter Lady: Grace Carpenter Hudson.*

Grace Hudson, *The Tar Weed Gatherer, #67*, 1896, The Ivan B. and Elvira Hart Collection, Grace Hudson Museum. Photograph courtesy of Grace Hudson Museum, Ukiah, California.

The Grace Hudson Museum is an art, history, and anthropology museum focusing on the lifework of Grace Hudson, Dr. John W. Hudson, and other members of a distinguished local family. Permanent and changing exhibits tell stories of the native Pomoan-speaking peoples, the history of California's north coast region, the artistic career of Grace Hudson, and the long professional collaboration she enjoyed with her ethnologist husband. Grace and John Hudson built their Craftsman bungalow home, The Sun House, on a large lot in central Ukiah in 1911, the twenty-first year of their marriage. The six-room Sun House retains the flavor of the Hudsons bohemian lifestyle, furnished with items from the eclectic collection. The City of Ukiah owns and operates the Grace Hudson Museum and Sun House (California Historical Landmark #926 and listed on the National Register of Historic Places).

Ventura

Ventura College - Art Galleries

4667 Telegraph Road, Ventura, CA 93003
Tel: (805) 648-8974
Fax: (805) 654-6466
Internet Address: http://www.ventura.cc.ca.us
Director: Ms. Deborah McKillop
Open: Call for hours.
Facilities: **Galleries.**

Ventura College - Art Galleries, cont.

Activities: **Temporary Exhibitions.**

The Ventura College art galleries, Gallery2 and New Media Gallery, present faculty and student work, as well as artwork by professional artists from throughout the United States. Exhibitions have featured among others the work of Carlos Almaraz, Don Bachardy, Billy Al Bengston, Gary F. Brown, Robert Frame, Louise Nevelson, and Julian Schnabel. The College's permanent art collection includes works by Goya, Dali, and Chagall, which may be seen in the campus library.

Ventura County Museum of History and Art

100 E. Main St., Ventura, CA 93001
Tel: (805) 653-0323
Fax: (805) 653-5267
Internet Address: http://www.vcmha.org
Exec. Director: Tim Schiffer
Admission: fee: adult-$3.00, child-free.
Attendance: 70,000 *Established:* 1913
Membership: Y *ADA Compliant:* Y
Open: Tuesday to Sunday, 10am-5pm.
Closed: New Year's Day, Thanksgiving Day,
 Christmas Day.
Facilities: **Galleries** (5, total 5,000 square feet);
 Library (3,600 volumes); **Shop.**
Activities: **Guided Tours** (reserve in advance);
 Lectures.
Publications: journal, "Ventura County
 Historical Society Quarterly" (quarterly);
 newsletter, "Heritage & History" (monthly).

Exterior view of Ventura County Museum of History and Art. Photograph courtesy of Ventura Museum of History and Art, Ventura, California.

Founded as the Pioneer Museum, the Ventura County Museum of History and Art promotes education, awareness and research pertaining to the history and culture of Ventura County and the Southern California region. In addition to a permanent history exhibit and a collection of George Stuart one-quarter life-size historical figures, the Museum presents changing exhibitions in its Hoffman Gallery focusing on artists and historical topics relating to the area.

Visalia

College of the Sequoias - COS Gallery

915 S. Mooney Blvd., Room 214A (opposite the Administration Building), Visalia, CA 93277
Tel: (559) 737-4861
Internet Address: http://infinity.sequoias.cc.ca.us/art/division/gallery.htm
Director: Mr. Richard Lee Peterson
Admission: free.
Open: Monday to Friday, noon-5pm.
Facilities: **Exhibition Area.**
Activities: **Lectures** (sponsored by the Visalia Art League); **Temporary Exhibitions.**

The Gallery presents a schedule of temporary exhibitions.

Walnut

Mount San Antonio College Art Gallery

1100 N. Grand Ave., Walnut, CA 91789
Tel: (909) 594-5611 *Ext:* 4328
Fax: (909) 468-3954
Internet Address: www.mtsac.edu

Mount San Antonio College Art Gallery, cont.

Director: Ms. Fatemeh Burnes
Admission: free.
Established: 1946
Parking: on site, $2.00.
Open: Tuesday, 11am-2pm and 5pm-8pm;
Wednesday to Thursday, 11am-2pm.
Facilities: **Gallery** (2,000 square feet).
Activities: **Temporary Exhibitions.**

The Gallery presents temporary exhibitions of the work of emerging artists as well as those with national and international reputations.

Craig Attebery, *Richard*, 1998, (detail), oil on paper, 23.25 x 15.5 inches. Exhibited in temporary exhibition at Mt. San Antonio Gallery, 1999. Photograph courtesy of Lizard/ Harp Gallery, Los Angeles, California.

Walnut Creek

Dean Lesher Regional Center for the Arts - Bedford Gallery

1601 Civic Drive at Locust St., Walnut Creek, CA 94596
Tel: (510) 295-1417
Fax: (510) 943-7222
Internet Address: http://www.ci.walnut-creek.ca.us/RCA.html
Director of Cultural Services: Mr. Gary Schaub
Admission: suggested contribution-$2.00.
Established: 1963 *Membership:* N *ADA Compliant:* Y
Parking: adjacent public garage and metered on street.
Open: Tuesday to Sunday, noon-5pm; during performances, 6pm-8pm.
Closed: Legal Holidays.
Facilities: **Gallery.**
Activities: **Education Programs**; **Gallery Talks**; **Guided Tours**; **Temporary Exhibitions.**
Publications: calendar; exhibition catalogues; magazine, "Diablo Arts".

Located on the first level of the Dean Lesher Regional Center for the Arts, the Bedford Gallery presents temporary exhibitions of contemporary art. The Center is owned and operated by the City of Walnut Creek.

Yountville

Napa Valley Museum

55 President Circle (Veterans Home grounds), Yountville, CA 94599
Tel: (707) 944-0500
Director: Eric Nelson
Admission: fee: adult-$4.50, child-$2.50, student-$3.50, senior-$3.50.
Attendance: 15,000 *Established:* 1973 *Membership:* Y
Open: Monday, 10am-5pm; Wednesday to Sunday, 10am-5pm.
Closed: New Year's Day, Thanksgiving Day, Christmas Day.
Facilities: **Exhibition Area**; **Shop.**
Activities: **Education Programs**; **Lectures**; **Temporary Exhibitions.**
Publications: newsletter (quarterly).

Located on the grounds of the Veterans Home of California, NVM is a general museum with exhibits in the arts, anthropology, history, and the natural sciences. Highlights of the permanent collection include 19th century watercolors of native California wildflowers and the Henry Evans portfolio of botanical prints.

Colorado

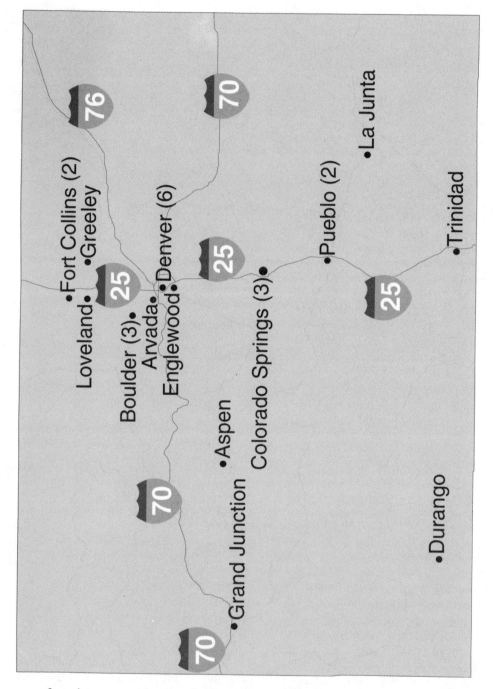

The number in parentheses following the city name indicates the number of museums/galleries in that municipality. If there is no number, one is understood. For example, in the text six listings would be found under Denver and one listing under Aspen.

Colorado

Arvada

Arvada Center for the Arts and Humanities

6901 Wadsworth Blvd., Arvada, CO 80003-9985
Tel: (303) 431-3939
Fax: (303) 431-3083
TDDY: (303) 431-3081
Exec. Director: Ms. Deborah F. Jordy
Admission: free.
Established: 1976 *Membership:* Y *ADA Compliant:* Y
Open: Monday to Saturday, 9am-5pm; Sunday, 1pm-5pm.
Closed: Legal Holidays.
Facilities: **Auditorium**; **Gallery**; **Museum**.
Activities: **Dance Recitals**; **Education Programs**; **Films**; **Guided Tours**; **Lectures**; **Performances**; **Temporary/Traveling Exhibitions** (12-15/year).
Publications: magazine, "Center" (quarterly).

The Arvada Center for the Arts and Humanities offers theater, concerts and dance year-round; art galleries with changing exhibitions; a historical museum; and classes in ceramics, dance, writing, acting, and visual arts. The Center's galleries offer 12 to 15 exhibitions each year with an emphasis on contemporary art - a combination of national touring exhibitions and presentations of regional artists' work. Other exhibitions showcase folk art, diverse cultures, crafts, and history. The Museum visually describes the historical and cultural heritage of Arvada.

Aspen

The Aspen Art Museum

590 N. Mill St., Aspen, CO 81611
Tel: (970) 925-8050
Fax: (970) 925-8054
Internet Address: http://www.aspenonline.com/aam
Exec. Director: Ms. Suzanne Farver
Admission: fee:
 adult-$3.00, child-free, student-$2.00, senior-$2.00.
Attendance: 15,000 *Established:* 1979
Membership: Y *ADA Compliant:* Y
Parking: lot with limited space.
Open: Tuesday to Wednesday, 10am-6pm;
 Thursday, 10am-8pm;
 Friday to Saturday, 10am-6pm;
 Sunday, noon-6pm.
Closed: New Year's Day, Independence Day, Thanksgiving Day, Christmas Day.

View of Aspen Art Museum building and grounds. Photograph courtesy of Aspen Art Museum, Aspen, Colorado.

Facilities: **Architecture** (former hydroelectric plant, ca.1885); **Library**; **Reading Room**.
Activities: **Classes**; **Gallery Talks**; **Guided Tours**; **Lectures**; **Temporary Exhibitions**; **Traveling Exhibitions**.
Publications: exhibition catalogues; posters.

Housed in an historic brick building on the Roaring Fork River, the Aspen Art Museum features rotating exhibitions including contemporary art and art of other historic periods. Ongoing programs presented by the Aspen Art Museum feature highly acclaimed artists, curators and museum directors from prominent U.S. museums. Recent exhibitions have included the works of Georgia O'Keeffe, William Wegman, Andy Warhol, Ana Mendieta, Peter Saul, Nancy Rubins, and Tony Oursler. Guest lecturers have included artist Christo, Phillippe De Montebello of the Metropolitan Museum of Art and Peter Hassrick, Founding Director of the Georgia O'Keeffe Museum. Many guest curators have lent their expertise to produce exhibits at the Aspen Art Museum, including Mark Rosenthal from the National Gallery and Klaus Kertess, known for his work with the Whitney Biennial.

Boulder

Boulder Museum of Contemporary Art (BMoCA)

1750 13th St. (between Arapahoe Road and Canyon Blvd.), Boulder, CO 80302

Tel: (303) 443-2122

Fax: (303) 447-1633

Internet Address: http://www.bmoca.com

Exec. Director: Cydney M. Payton

Open: Wednesday to Friday, noon-8pm; Saturday, 9am-5pm; Sunday, noon-5pm.

Facilities: **Exhibition Areas** (3).

Activities: **Education Programs**; **Lectures**; **Performances**; **Temporary Exhibitions** (21/year); **Workshops**.

BMoCA hosts twenty-one shows each year highlighting the work of contemporary artists in three exhibitions spaces.

Leanin' Tree Museum of Western Art

6055 Longbow Drive, Boulder, CO 80301

Tel: (303) 530-1442 Ext.: 299

Fax: (303) 581-2152

Internet Address: http://www.leanintree.com

C.E.O.: Mr. Thomas E. Trumble

Admission: free.

Attendance: 40,000 *Established:* 1974

Membership: N *ADA Compliant:* Y

Open: Monday to Friday, 8am-4:30pm;
 Saturday to Sunday, 10am-4pm.

Closed: Legal Holidays.

Facilities: **Exhibition Area**; **Shop** (greeting cards).

Activities: **Guided Tours**; **Temporary Exhibitions**.

Gary Ernest Smith, *Oregon Pioneers*, Leanin' Tree Museum of Western Art. Photograph courtesy of Leanin' Tree Museum of Western Art, Boulder, Colorado.

The Museum collection is housed in the corporate headquarters of Leanin' Tree, publishers of greeting cards. One of the nation's largest private collections of modern and contemporary Western Art, the Leanin' Tree Museum displays over 200 paintings and 80 bronze sculptures. Special gallery rooms feature work by humorist Lloyd Mitchell, desert artist John W. Hilton, and train artist Howard Fogg, and cowboy paintings by Colorado artist Jack Roberts. Recently opened is the main floor Red Gallery, with many new paintings and bronzes, among them works by well-known artists of the Cowboy Artists of America and the National Academy of Western Artists.

University of Colorado - CU Art Galleries

University of Colorado, Broadway, Boulder, CO 80309

Tel: (303) 492-8300

Fax: (303) 492-4886

Internet Address: http://www.colorado.edu

Director: Ms. Susan Krane

Admission: voluntary contribution: adult-$2.00, student-free.

Attendance: 30,000 *Established:* 1978 *Membership:* N *ADA Compliant:* Y

Parking: public parking lot.

Open: Monday, 8am-5pm; Tuesday, 8am-8pm; Wednesday to Friday, 8am-5pm;
 Saturday, noon-4pm.

Closed: New Year's Eve, New Year's Day, Independence Day, Christmas Vacation.

Facilities: **Exhibition Area** (3 galleries; total 6,000 square feet).

University of Colorado - CU Art Galleries, cont.

Activities: Gallery Dialogues; Lectures; Permanent Collection Exhibits; Temporary Exhibitions; Traveling Exhibitions.

Publications: exhibition catalogues.

The CU Art Galleries of the University of Colorado at Boulder are committed to enhancing public understanding of the visual arts and to advocating interdisciplinary approaches to the social, cultural, technological, and historical contexts of art. The Galleries present exhibitions of regional, national, and international significance and related educational events. Student exhibitions of work by MFA and BFA candidates are also scheduled. Its activities serve the academic community of the University, the metropolitan area, and statewide populations. The Art Galleries are stewards of the Colorado Collection, a permanent study and teaching resource for the citizens of the State. They promote the preservation, interpretation and exhibition of the Colorado Collection, and its use for scholarly endeavors and outreach efforts.

George Grosz, *Street Scene*, (detail), 19 x 24½ inches, ca. 1928, drawing - pen and ink on paper. CU Art Galleries. Photograph courtesy of CU Art Galleries, University of Colorado, Boulder Campus, Boulder, Colorado.

Colorado Springs

Colorado Springs Fine Arts Center

30 W. Dale St., Colorado Springs, CO 80903

Tel: (719) 634-5581

Fax: (719) 634-0570

Exec. Director: Mr. David Turner

Admission: fee: adult-$4.00, child-$2.00, student-$2.00, senior-$2.00.

Attendance: 125,000 *Established:* 1936 *Membership:* Y *ADA Compliant:* Y

Open: Tuesday to Friday, 9am-5pm;
 Saturday, 10am-5pm;
 Sunday, 1pm-5pm.

Closed: Federal Holidays.

Facilities: **Architecture** (pueblo-style, art deco building, 1936 design by John Gaw Meem); **Conference Facilities**; **Food Services** Balcony Restaurant (Summer, Mon-Fri, 11:30am-2:30pm, reservations recommended); **Library** (26,000 volumes: Tues-Fri,1pm-5pm; Sat, 10am-noon & 1pm-5pm); **Sculpture Garden**; **Shop** (pottery, art calendars, greeting cards, books, jewelry); **Theatre** (450 seats).

Façade of Colorado Springs Fine Arts Center (1936), pueblo-style, art deco building designed by John Gaw Meem. Photograph courtesy of Colorado Springs Fine Arts Center, Colorado Springs, Colorado.

Activities: **Education Programs**); **Films**; **Gallery Talks**; **Guided Tours** (Sat, 10:30am; also Tues-Fri, 10:30am during Summer); **Lectures**; **Temporary Exhibitions**; **Traveling Exhibitions**.

Publications: annual report; exhibition catalogues; magazine, "Artsfocus" (bi-monthly).

The Colorado Springs Fine Arts Center features a world-class collection of Native American and Hispanic art as well as 19th- and 20th-century art by such artists as Arthur Dove, Georgia O'Keeffe, Charles Russell, and John Singer Sargent. The continuing exhibit, "Sacred Land", provides

Colorado Springs Fine Arts Center, cont.

an entertaining and comprehensive overview of the arts of four important southwestern cultural groups, featuring works by the Hispanic people of New Mexico and Southern Colorado, as well as the Pueblo, Navajo and Apache Indians of New Mexico and Arizona. This exhibition includes an authentic Talpa Chapel. In addition, the museum's changing exhibition schedule offers a variety of works throughout the year. Offering "all the arts in one place," the Fine Arts Center also houses The Taylor Museum for Southwestern Studies, the Bemis School of Art, and the Repertory Theatre Company.

Colorado Springs Museum

215 S. Tejon, Colorado Springs, CO 80903
Tel: (719) 578-6650
Fax: (719) 578-6718
Director: William Holmes, Ph.D.
Admission: voluntary contribution.
Attendance: 70,000 *Established:* 1937
Membership: Y *ADA Compliant:* Y
Parking: adjacent parking garage.
Open: **May to October,**
 Tuesday to Saturday, 10am-5pm.
 Sunday, 1pm-5pm.
 November to April,
 Tuesday to Saturday, 10am-5pm
Closed: Legal Holidays.
Facilities: **Architecture** (1903 El Paso County Courthouse); **Auditorium; Galleries; Library.**
Activities: **Education Programs; Guided Tours; Temporary Exhibitions; Traveling Exhibitions.**

Exterior view of Colorado Springs Museum (1903). Photograph by David Diaz Guerrero, courtesy of Colorado Springs Pioneers Museum, Colorado Springs, Colorado.

Publications: brochures; gallery guides (occasional); newsletter (bi-monthly); research publications (occasional).

The Colorado Springs Museum is located in the former El Paso County Courthouse. The historic building is being restored, and it is surrounded by gardens, outdoor sculpture, and a granite fountain. Temporary exhibitions at the Museum have featured subjects as diverse as Western art, antique quilts, Plains and Pueblo Indian culture, and icons of popular culture. The Museum contains a series of murals on local history painted by Eric Bransby. The Museum's collection totals over 40,000 objects, including quilts, Van Briggle art pottery, and an extensive collection of regional art.

University of Colorado, Colorado Springs - Gallery of Contemporary Art

1420 Austin Bluffs Parkway, Colorado Springs, CO 80918
Tel: (719) 262-3567
Fax: (719) 262-3183
TDDY: (719) 262-3621
Internet Address: http://harpy.uccs.edu/gallery/framesgallery.html
Director: Assistant Professor Gerry Riggs
Admission: fee: adult-$1.00, child-free, student-$0.50, senior-$0.50.
Attendance: 28,000 *Established:* 1981 *Membership:* Y *ADA Compliant:* Y
Open: Monday to Friday, 10am-4pm; Saturday, 1pm-4pm.
Closed: Legal Holidays.
Facilities: **Galleries.**
Activities: **Concerts; Education Programs; Guided Tours; Lectures; Temporary Exhibitions; Traveling Exhibitions.**

The goal of the Gallery of Contemporary Art is to organize and host exhibitions of acclaimed regional, national, and international contemporary artists.

Denver

Denver Art Museum (DAM)

100 W. 14th Ave. Parkway, Denver, CO 80204
Tel: (720) 865-5000
Fax: (720) 913-0001
TDDY: (720) 865-5003
Internet Address:
 http://www.denverartmuseum.org
Director: Dr. Lewis I. Sharp
Admission: fee: adult-$4.50, child-free,
 student-$2.50, senior-$2.50.
Attendance: 334,000 *Established:* 1893
Membership: Y *ADA Compliant:* Y
Parking: parking across street.
Open: Tuesday, 10am-5pm;
 Wednesday, 10am-9pm;
 Thursday to Saturday, 10am-5pm;
 Sunday, noon-5pm.
Closed: Most Legal Holidays.

Mark di Suvero, *Lao-Tzu*, steel sculpture. Denver Art Museum collection. View of Denver Art Museum (designed by Gio Ponti, in collaboration with James Sudler Associates) in background. Photograph courtesy of Denver Art Museum, Denver, Colorado.

Facilities: **Architecture** (1971 design by Gio Ponti of Italy in collaboration with James Sudler Associates of Denver); **Food Services** Palettes Express (Tues-Sat, 11am-5pm; Sun, noon-5pm), Palettes Restaurant (Tues and Thurs-Sat, 11am-5pm; Wed, 11am-9pm; Sun, noon-5pm); **Library** (40,000 volumes; Mon-Thurs, 10am-5pm, arrange in advance); **Shop** (books, calendars, jewelry).
Activities: **Education Programs**; **Films**; **Guided Tours**; **Lectures**; **Performances**; **Temporary Exhibitions**; **Traveling Exhibitions**.
Publications: annual report; books on collections; collection catalogue; exhibition catalogues; magazine, "On and Off the Wall" (bi-monthly).

Founded in 1893, the Denver Art Museum is renowned for its collection of world art, especially the art of the Americas. The Museum's American Indian collection and its pre-Columbian and Spanish Colonial collection are particularly outstanding. Other collections include Painting & Sculpture, Asian, Architecture, Design & Graphics, and Modern & Contemporary. Two newly renovated floors - devoted to European and American painting, sculpture, decorative art, textiles, Western painting and sculpture, and photography - opened in 1997. The building itself is also a work of art; covered with over one million faceted gray tiles, the shimmering structure stands on the edge of the Civic Center.

Metropolitan State College of Denver - Center for the Visual Arts (Metro Center)

1734 Wazee St., Denver, CO 80202-1231
Tel: (303) 294-5207
Fax: (303) 294-5210
Internet Address: http://www.mcsd.edu./~metroart
Director: Ms. Sally L. Perisho
Admission: voluntary contribution.
Attendance: 25,000 *Established:* 1991 *Membership:* Y *ADA Compliant:* Y
Parking: metered parking.
Open: Tuesday to Friday, 10am-5pm; Saturday, 11am-4pm.
Closed: Legal Holidays.
Facilities: **Architecture** (historic warehouse); **Galleries.**
Activities: **Education Programs**.
Publications: newsletter (quarterly).

The Metro Center hosts exhibitions of culturally diverse artists and offers lectures, workshops and tours. Also of possible interest is the Emmanuel Gallery at 10th and Lawrence Way, which presents contemporary art in all media (tel: 556-8337; open weekdays, 11am-5pm; free parking at Auraria Parking Center, 7th street and Lawrence Way).

123

Museo de las Americas

861 Santa Fe Drive, Denver, CO 80204

Tel: (303) 571-4401

Fax: (303) 607-9761

Exec. Director: Mr. Jose Aguayo

Admission: fee: adult-$3.00, child-free, student-$1.00, senior-$2.00.

Attendance: 10,000 *Established:* 1991 *Membership:* Y *ADA Compliant:* Y

Open: Tuesday to Saturday, 10am-5pm.

Closed: New Year's Day, Independence Day, Thanksgiving Day, Christmas Day.

Facilities: Galleries.

Publications: newsletter, "Notitas".

The Museo exhibits the art, history, and culture of Latinos in the Americas from ancient times to the present. It offers year-round exhibitions, lectures, and educational programs.

Rocky Mountain College of Art & Design - Philip J. Steele Gallery

6875 E. Evans Ave., Denver, CO 80224

Tel: (303) 753-6046

Fax: (303) 759-4970

Internet Address: http://www.rmcad.edu

Gallery Director: Ms. Lisa Spivak

Admission: free.

Established: 1963 *Membership:* N

Open: Monday to Friday, 8am-6pm; Saturday, 9am-4pm.

Closed: New Year's Day, Memorial Day, Independence Day, Labor Day, Thanksgiving Day, Christmas Day.

Facilities: Galleries; Library; Shop.

Activities: Education Programs; Lectures.

The Gallery presents temporary exhibitions of contemporary art.

University of Denver - School of Art and Art History Gallery

2121 East Asbury Ave., Shwayder Art Building, Denver, CO 80208

Tel: (303) 871-2846

Fax: (303) 871-4112

Internet Address: http://www.du.edu/art

Admission: free.

Established: 1940 *Membership:* N *ADA Compliant:* Y

Open: Monday to Friday, 9am-4pm; also Saturday to Sunday, noon-4pm (during exhibits).

Facilities: Galleries.

Activities: Lectures.

Located on the University of Denver campus, the Gallery presents temporary exhibitions including the work of students and faculty, as well as that of regionally, nationally, and internationally recognized contemporary artists.

Vance Kirkland Studio and Museum

1311 Pearl St., Denver, CO 80203

Tel: (303) 832-8576

Fax: (303) 832-8404

Curator: Mr. Hugh Grant

Admission: free.

Attendance: 400 *Established:* 1932 *Membership:* N *ADA Compliant:* N

Open: Monday to Friday, 9am-6pm.

Closed: Legal Holidays.

Facilities: **Architecture** (1911 commercial building); **Dinnerware Exhibit**; **Galleries**; **Library** (1,600 volumes); **Shop**.

Vance Kirkland Studio and Museum, cont.

Activities: **Lectures**; **Temporary Exhibitions**; **Traveling Exhibitions**.

The Vance Kirkland Studio and Museum house the archives of the Kirkland Collection of the Denver Art Museum. The late Vance Kirkland was the founding director of the University of Denver School of Art and Art History.

Durango

Fort Lewis College - Art Gallery

101 Art Building (off the Main Lobby), 1000 Rim Drive, Durango, CO 81301

Tel: (970) 247-7167

Fax: (970) 247-7520

Internet Address: http://www.fortlewis.edu/acad-aff/arts-sci/art/artpages/gallery.html

Gallery Director: Ms. Mary E. Tso

Admission: free.

Open: Monday to Friday, 10am-4pm, or by appointment.

Facilities: **Exhibition Area** (130 linear feet).

Activities: **Lectures**; **Temporary Exhibitions**; **Workshops**.

The Gallery offers exhibitions of historical, mainstream, and avant-garde work in both traveling and special artist exhibitions. In addition, exhibitions of student and faculty work complement the art gallery's calendar with solo and group shows, including the Senior Art Major and Juried Student Exhibitions each spring. Also of possible interest, student work is often on display in the Adjunct Gallery, located in the Student Lounge.

Englewood

Museum of Outdoor Arts (MOA)

1000 Englewood Parkway

Englewood, CO 80110

Tel: (303) 741-3609

Fax: (303) 741-1029

Internet Address: http://www.moaonline.org

President: Ms. Cynthia M. Leitner

Admission: free.

Attendance: 50,000 *Established:* 1982

Membership: Y *ADA Compliant:* Y

Parking: surface parking at select locations.

Open: Monday to Friday, 8:30am-5:30pm;
Saturday, occasionally.

Closed: New Year's Day, Labor Day,
Memorial Day, Thanksgiving Day,
Thanksgiving Friday, Christmas Day.

Entrance, Museum of Outdoor Arts. Photograph courtesy of Museum of Outdoor Arts, Englewood, Colorado.

Facilities: **Amphitheater** (18,000 seats); **Galleries**; **Sculpture Garden**.

Activities: **Arts Festival**; **Concerts**; **Education Programs**; **Guided Tours** (adult-$3, child-$1).

Publications: book, "Portrait of a Museum"; brochure.

The Museum has placed 55 sculptures set in Greenwood Plaza Business Park and City Center Englewood. Among the artists represented are Giovanni Antonazzi, Leslie Atkinson, Michelle Brower, Beniamino Bufano, George Carlson, Red Grooms, George W. Lundeen, Harry Marinsky, Ivan Mestrovic, Henry Moore, Mario Moschi, Arnoldo Pomodoro, Joseph Raffael, Joe Snyder, Pietro Tacca, and Lynn Tillery.

Fort Collins

Colorado State University - Hatton Gallery

Visual Arts Building, Prospect and South College, Fort Collins, CO 80523

Tel: (970) 491-6774

Fax: (970) 491-0505

Internet Address: http://www.colostate.edu

Fort Collins, Colorado

Colorado State University - Hatton Gallery, cont.

Director: Ms. Linda Frickman

Admission: voluntary contribution.

Attendance: 7,000 *Established:* 1970

Membership: N *ADA Compliant:* Y

Parking: free on site.

Open: **Fall & Spring Semesters,**
Monday to Friday, 8:30am-4:30pm;
Saturday, 1pm-4pm.
Summer,
Call for hours.

Closed: New Year's Day, Independence Day,
Thanksgiving Day, Christmas Day.

Facilities: **Galleries.**

Activities: **Education Programs; Lectures; Temporary Exhibitions; Traveling Exhibitions.**

Installation in Hatton Gallery: Tenth Colorado International Invitational Poster Exhibition, 1997, various artists. Photograph courtesy of Hatton Gallery, Colorado State University, Fort Collins, Colorado.

Publications: exhibition catalogues; posters.

The Hatton Gallery has a small permanent collection of contemporary posters and Japanese prints. It presents frequent temporary exhibitions of the work of students and professional artists as well as art historical exhibitions.

OneWest Art Center

201 S. College Ave., Fort Collins, CO 80524

Tel: (970) 482-2787

Exec. Director: Ms. Angela Brayham

Admission: suggested contribution: adult-$2.00, student-$1.00, senior-$1.00.

Attendance: 12,000 *Established:* 1990 *Membership:* Y *ADA Compliant:* Y

Parking: free on site.

Open: Tuesday to Saturday, 10am-5pm.

Closed: Legal Holidays.

Facilities: **Library; Shop.**

Activities: **Education Programs; Guided Tours; Lectures.**

Publications: newsletter (biennial).

OneWest Art Center is a non-collecting art gallery with a focus on regional contemporary art. Located in a 1911 Italian Renaissance Revival post office building, the Art Center presents ten to twelve shows per year in two spacious galleries.

Grand Junction

Western Colorado Center for the Arts

1803 N. 7th, Grand Junction, CO 81501

Tel: (970) 243-7337

Fax: (970) 243-2482

President: John Howe

Admission: fee: adult-$2.00, child-free.

Attendance: 42,000 *Established:* 1953 *Membership:* Y *ADA Compliant:* Y

Open: Tuesday to Saturday, 9am-4pm.

Closed: Legal Holidays.

Facilities: **Galleries; Library** (250 volumes); **Reading Room; Shop; Theatre.**

Activities: **Concerts; Dance Recitals; Education Programs; Films; Gallery Talks; Lectures; Performances; Temporary Exhibitions.**

Publications: newsletter (monthly).

The Center has a permanent collection of Western and Native American art, and it also presents temporary exhibitions.

Greeley

University of Northern Colorado - Mariani Gallery

8th Ave. & 18th St., Guggenheim Hall, Greeley, CO 80639
Tel: (970) 351-2184
Fax: (970) 351-2299
Internet Address: http://arts.unco.edu/visarts/visarts/galleries
Chairman: Ms. Trista Lynch
Admission: voluntary contribution.
Attendance: 110,000 *Established:* 1972 *Membership:* N *ADA Compliant:* Y
Parking: metered parking.
Open: Monday to Friday, 9am-4pm.
Closed: Summer.
Facilities: **Galleries** (2, total 1,500 square feet).

The Mariani Gallery presents temporary exhibitions. Also of possible interest on campus, the Oak Room Gallery in Crabbe Hall presents the work of student, alumni, and other artists.

La Junta

Koshare Indian Museum, Inc. (Koshare Kiva)

115 W. 18th, La Junta, CO 81050
Tel: (719) 384-4411 or (800) 693-kiva
Fax: (719) 384-8836
Internet Address: http://www.koshare.org
Exec. Director: Ms. Linda E. Powers
Museum Admission: fee:
 adult-$2.00, child-$1.00, senior-$1.00.
Attendance: 20,000 *Established:* 1949
Membership: N *ADA Compliant:* N
Parking: adjacent parking available.
Open: Monday, 10am-9pm
 Tuesday, 10am-5pm
 Wednesday, 10am-9pm
 Thursday to Sunday, 10am-5pm.
Closed: Legal Holidays.

Interior view of kiva gallery, Koshare Indian Museum. Photograph courtesy of Koshare Indian Museum, La Junta, Colorado.

Facilities: **Architecture** (kiva - largest log-supported roof in world); **Galleries**; **Library** (2,000 volumes); **Trading Post**.
Activities: **Gallery Talks**; **Guided Tours**; **Interpretive Native American Dance and Lore**; **Exhibitions and Artist Demonstrations** (monthly).
Publications: book, "Koshare"; brochures; newsletter, "Koshare News" (semi-annual).

The Koshare Indian Museum serves as a dual home for the Koshare Indian Dancers and a renowned collection of Native American art and artifacts. The collection contains artwork of Oscar Berninghaus, Bert Phillips, E.I. Couse, Buck Denton, Woody Crumbo, Joseph Imhof, Clayton Staples, Ernesto Zepeda, and others, as well as pottery, beadwork, quillwork and jewelry from a number of Native American pueblo and plains tribes.

Loveland

Loveland Museum/Gallery

5th and Lincoln, Loveland, CO 80537
Tel: (970) 962-2410
Fax: (970) 962-2910
TDDY: (970) 962-2833
Internet Address: http://www.ci.loveland.co.us
Director: Ms. Susan P. Ison
Admission: voluntary contribution.

Loveland, Colorado
Loveland Museum/Gallery, cont.
Attendance: 55,000 *Established:* 1937
Membership: Y *ADA Compliant:* Y
Parking: public lots adjacent to site.
Open: Tuesday to Wednesday, 10am-5pm;
Thursday, 10am-9pm;
Friday, 10am-5pm;
Saturday, 10am-4pm;
Sunday, noon-4pm.
Closed: Legal Holidays.
Facilities: **Gallery** (4000 square feet).
Activities: **Education Programs**; **Guided Tours**
(upon request); **Lectures**; **Temporary
Exhibitions**.
Publications: brochures; exhibition catalogues.

Exterior view of Loveland Museum/Gallery. Photograph by Joel Radke, courtesy of Loveland Museum/Gallery, Loveland, Colorado.

Art exhibits at the Gallery feature the work of regional, national, and international artists.

Pueblo

Sangre de Cristo Arts & Conference Center
210 N. Santa Fe Ave., Pueblo, CO 81003
Tel: (719) 543-0130
Fax: (719) 543-0134
Exec. Director: Ms. Maggie Divelbiss
Admission: voluntary contribution (Buell Children's Museum: fee: adult-$3.00, child-$2.00).
Attendance: 200,000 *Established:* 1972 *Membership:* Y *ADA Compliant:* Y
Open: Monday to Saturday, 11am-4pm.
Closed: Legal Holidays.
Facilities: **Children's Museum**; **Galleries**; **Shop**; **Theatre**.
Activities: **Concerts**; **Guided Tours**; **Lectures**; **Performances**; **Temporary/Traveling
Exhibitions** (25-30/year).
Publications: books; exhibition catalogues; newsletter (monthly).
The Center maintains a permanent collection and presents temporary exhibitions.

University of Southern Colorado Fine Art Gallery
2200 Bonforte Blvd, Pueblo, CO 81001-4901
Tel: (877) 872-9653
Internet Address: http://www.uscolo.edu/art/aboutart/.html
Director: Mr. Dennis Dalton
ADA Compliant: Y
Parking: free on site.
Open: Monday to Friday, 8am-5pm.
Facilities: **Gallery**.
Activities: **Lectures**; **Temporary Exhibitions**.
The Fine Art Gallery presents bi-monthly exhibits of the work of professional artists. There are also exhibits of student work.

Trinidad

A.R. Mitchell Memorial Museum of Western Art
150 E. Main St., Trinidad, CO 81082
Tel: (719) 846-4224
Fax: (719) 846-0690
C.E.O.: Ms. Peggy Weurding

A.R. Mitchell Memorial Museum of Western Art, cont.

Admission: voluntary contribution.

Attendance: 15,000 *Established:* 1979 *Membership:* Y *ADA Compliant:* Y

Open: **April to September**, Monday to Saturday, 10am-4pm.

Facilities: **Galleries; Shop.**

Activities: **Guided Tours; Temporary Exhibitions; Traveling Exhibitions.**

The Museum's collection includes Hispanic folk art and Western art, notably many works by illustrator A.R. Mitchell.

Connecticut

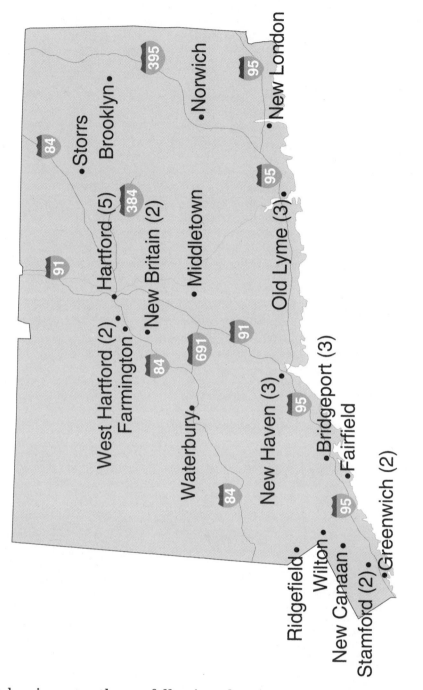

The number in parentheses following the city name indicates the number of museums/galleries in that municipality. If there is no number, one is understood. For example, in the text five listings would be found under Hartford and one listing under Middletown.

Connecticut

Bridgeport

The Discovery Museum

4450 Park Ave., Bridgeport, CT 06604

Tel: (203) 372-3521 *Ext:* 123

Fax: (203) 374-1929

Internet Address:
 http://www.bridgenet/org/discovery/museum.html

President: Ms. Elena de Murias

Admission: fee: adult-$7.00, child (3-18)-$5.50, student-$5.50, senior-$5.50.

Attendance: 90,000 *Established:* 1958

Membership: Y *ADA Compliant:* Y

Parking: free on site.

Open: **September to June**,
 Tuesday to Saturday, 10am-5pm; Sunday, noon-5pm.
 July to August,
 Monday to Saturday, 10am-5pm; Sunday, noon-5pm.

Closed: New Year's Day, Easter, Memorial Day, Independence Day, Labor Day, Thanksgiving Day, Christmas Day.

Exterior view, Discovery Museum, designed by Chan-Krieger & Associates. Photograph courtesy of Discovery Museum, Bridgeport, Connecticut.

Facilities: **Architecture** (1788 historic house; not open to the public); **Auditorium** (80 seats); **Food Services** Cafeteria; **Galleries** (3); **Shop.**

Activities: **Education Programs**; **Films**; **Gallery Talks**; **Guided Tours**; **Lectures**; **Temporary Exhibitions.**

Publications: exhibition catalogues (quarterly); newsletter (bi-monthly).

The Discovery Museum, Connecticut's adventure in art and science, is the largest hands-on art and science museum between New York and Boston. Its facilities include the Henry B. duPont III Planetarium; Simpson Galleries, which feature five specially curated art exhibitions annually; Challenger Learning Center, a sophisticated, computer simulated space station and mission control facility; Discovery Preschool Center, with a dozen skill-development activities for preschooler and parent; Wonder Workshop, an early childhood education center; 132 hands-on art and science exhibits for all ages; and a gift shop. The museum encourages adults and children to explore topics of physical science and the arts and their interrelationships through experimentation with exhibits, demonstrations, workshops, and other specialized programming.

Housatonic Community College - Housatonic Museum of Art

900 Lafayette Blvd., Bridgeport, CT 06604

Tel: (203) 332-5203

Fax: (203) 332-5123

Internet Address:
 http://www.hctc.commnet.edu /artmuseum/index.html

Director: Ms. Robbin Zella

Admission: free.

Attendance: 7,500 *Established:* 1967

Membership: N *ADA Compliant:* Y

Parking: free parking in student lot across street.

Open: **During academic year**.

Closed: Academic Holidays.

Facilities: **Food Services** Restaurant; **Galleries** (2 - total of 2000 square feet); **Library** (2,000 volumes); **Sculpture Garden.**

Hugo Schieber, *Head of a Woman*, 1920, gouache on board, 29 x 23¾ inches, gift of Dr. Lee Goldstein, Housatonic Museum of Art. Photograph courtesy of Housatonic Museum of Art, Bridgeport, Connecticut.

Housatonic Community College - Housatonic Museum of Art, cont.

Activities: **Films; Gallery Talks; Guided Tours; Lectures; Temporary Exhibitions** (6 per year); **Traveling Exhibitions.**

Publications: exhibition catalogues.

Housatonic Museum of Art is part of Housatonic Community College, within walking distance of the train station, in downtown Bridgeport. The Museum has an important permanent collection and also presents temporary exhibitions. The collection consists chiefly of 20th-century American art and significant ethnographic holdings, featuring African sculpture. It includes works by Archipenko, Chagall, Christo, Elaine de Kooning, Lichtenstein, Marsh, Miró, Moore, Oldenberg, Ossorio, Picasso, Rauschenberg, Renoir, Rivers, Schieber, and Shinn, among many others.

University of Bridgeport - The University Gallery

Bernhard Arts & Humanities Center
Corner of University and Iranistan Avenues
Bridgeport, CT 06601-2449
Tel: (203) 576-4402
Fax: (203) 576-4051
Internet Address: http://www. bridgeport.edu
Director: Professor Kaz McCue
Admission: free.
Attendance: 3,000 *Established:* 1972
Membership: N *ADA Compliant:* Y
Parking: free on site.
Open: mid-Jan. to mid-May & September to mid- Dec.;
 Tuesday to Thursday, 1pm-7pm;
 Friday to Saturday, 1pm-4pm.
Facilities: **Galleries** (3,500 square feet).
Activities: **Gallery Talks; Lectures; Temporary Exhibitions; Traveling Exhibitions.**
Publications: exhibition catalogues.

Red Grooms, *Woman in Man's Arms*, 1973, Lithograph, 34/250. University Gallery. Photograph courtesy of University Gallery, University of Bridgeport, Bridgeport, Connecticut.

The University Gallery maintains a permanent collection and presents exhibitions focusing primarily on modern and contemporary art. The permanent collection of the Gallery includes works by Josef Albers, Ellsworth Kelly, Romare Bearden, Louise Nevelson, Red Grooms, and James Rosenquist.

Brooklyn

New England Center for Contemporary Art, Inc.

248 Pomfret Road, Brooklyn, CT 06234
Tel: (860) 774-8899
Fax: (860) 774-4840
Director: Mr. Henry Riseman
Admission: voluntary contribution.
Attendance: 12,000 *Established:* 1975 *Membership:* Y *ADA Compliant:* Y
Parking: free on site.
Open: Tuesday to Friday, 10am-5pm; Saturday to Sunday, 1pm-5pm.
Facilities: **Galleries; Library; Sculpture Garden; Shop.**
Activities: **Arts Festival; Education Programs; Films; Guided Tours; Performances; Traveling Exhibitions.**
Publications: exhibition catalogues.

The Center for Contemporary Art presents exhibitions of contemporary American painting and sculpture and paintings from the People's Republic of China.

Fairfield

Fairfield University - Thomas J. Walsh Art Gallery

Regina A. Quick Center for the Arts, N. Benson Road, Fairfield, CT 06430

Tel: (203) 254-4242

Fax: (203) 254-4113

Internet Address: http://www.fairfield.edu

Communications: Dr. Philip Eliasoph

Admission: free.

Attendance: 10,000 *Established:* 1990 *Membership:* N *ADA Compliant:* Y

Open: Tuesday to Saturday, 11am-5pm; Saturday, noon-4pm.

Closed: Memorial Day, Legal Holidays, Thanksgiving Day, Christmas Day.

Facilities: **Galleries.**

Activities: **Arts Festival; Concerts; Education Programs; Films; Lectures; Performances; Temporary Exhibitions; Traveling Exhibitions.**

Publications: collection catalogue.

The Walsh Art Gallery hosts six temporary exhibitions per year.

Farmington

Hill-Stead Museum

35 Mountain Road, Farmington, CT 06032

Tel: (860) 677-4787

Fax: (860) 677-0174

Exec. Director: Linda Steigleder

Admission: fee: adult-$7.00, student-$6.00, senior-$6.00.

Attendance: 35,000 *Established:* 1946

Membership: Y *ADA Compliant:* Y

Parking: parking available.

Open: **Call for info.**

Facilities: **Architecture** (1901 building. by T. Pope with McKim, Mead & White); **Library**; **Shop.**

Activities: **Guided Tours.**

Publications: gallery guides.

The Hill-Stead Museum, a National Historic Landmark, is an outstanding example of Colonial Revival domestic architecture set on 152 acres of fields and woodlands. The grounds boast a sunken garden designed by Beatrix Farrand. The collection includes French and American Impressionist paintings, Chinese porcelains, and Japanese woodblock prints.

Exterior view of Hill-Stead Museum (1901), designed by Theodate Pope and McKim, Mead & White. Photograph courtesy of Hill-Stead Museum.

Greenwich

The Bruce Museum

One Museum Drive (near Greenwich Metro North RR Station), Greenwich, CT 06830

Tel: (203) 869-0376

Fax: (203) 869-0963

Internet Address: http://www.brucemuseum.com

Exec. Director: Mr. Hollister Sturges, III

Admission: fee: adult-$3.50, student-$2.50, senior-$2.50.

Attendance: 71,000 *Established:* 1912 *Membership:* Y *ADA Compliant:* Y

Parking: free on site.

Open: Tuesday to Saturday, 10am-5pm; Sunday, 1pm-5pm.

Closed: Legal Holidays.

The Bruce Museum, cont.

Facilities: **Architecture** (housed partly in Victorian manor house, 1909); **Auditorium**; **Library**; **Seaside Museum Annex**; **Shop**.

Activities: **Films**; **Lectures**; **Temporary Exhibitions**; **Traveling Exhibitions**.

Publications: calendar (monthly); exhibition catalogues.

Bruce Museum is a teaching museum of the arts and earth sciences. The collection of the Museum includes 19th-century paintings, prints, and sculpture, and American art pottery.

Historical Society of the Town of Greenwich (HSTG)

39 Strickland Road, Greenwich, CT 06807

Tel: (203) 869-6899

Fax: (203) 869-6727

Exec. Director: Dr. Debra Walker Mecky

Admission: fee: adult-$6.00, child (<12)-free, student-$4.00, senior-$4.00.

Attendance: 14,000 *Established:* 1931

Membership: Y *ADA Compliant:* Y

Parking: 30 parking spaces.

Open: Wednesday to Friday, noon-4pm;
Saturday, 11am-4pm;
Sunday, 1pm-4pm.

Closed: New Year's Day, Thanksgiving Day, Christmas Day.

Facilities: **Architecture** (18th-century Bush-Holley House); **Auditorium** (50 seats); **Library** (1,100 volumes); **Shop**.

Activities: **Education Programs**; **Guided Tours** (Jan-Mar, weekends only); **Lectures**; **Temporary Exhibitions**.

Publications: journal, "Greenwich History" (annual); newsletter, "The Post" (quarterly).

Exterior view of Bush-Holley House (c.1732), National Historic Landmark. Photograph courtesy of Historical Society of the Town of Greenwich.

Operated by the Historical Society of the Town of Greenwich, Bush-Holley House Historic Site features the circa 1730 National Historic Landmark Bush-Holley House, center of Connecticut's first art colony. From 1890 to 1920, over 200 art students studied at the the Holley's boarding house with leading American Impressionists John Henry Twachtman, J. Alden Weir, Theodore Robinson, and Childe Hassam. Guided tours feature 18th- and early 19th-century Connecticut furniture and Impressionist art. A visitor center houses changing exhibitions, a sound and light show, and a family hands-on history gallery.

Hartford

Connecticut Historical Society (CHS)

1 Elizabeth St. (near Elizabeth Park), Hartford, CT 06105-2292

Tel: (860) 236-5621 *Fax:* (860) 236-2664

Internet Address: http://www.chs.org

Exec. Director: Mr. David M. Kahn

Admission: fee: adult-$6.00, child-$3.00, student-$3.00, senior-$3.00.
free: 1st Saturday and Sunday in month.

Attendance: 30,000 *Established:* 1825 *Membership:* Y *ADA Compliant:* Y

Parking: free on site.

Open: Tuesday to Sunday, noon-5pm.

Closed: New Year's Day, Easter, Independence Day, Thanksgiving Day, Christmas Day.

Facilities: **Galleries** (8); **Library** (100,000 volumes, 3 million manuscripts, genealogy collection; Tues-Sat, 10am-5pm).

Activities: **Education Programs**; **Gallery Talks**; **Guided and Group Tours**; **Lectures**; **Temporary Exhibitions**; **Traveling Exhibitions**.

Publications: newsletter, "CHS Newsletter" (quarterly).

Connecticut Historical Society, cont.

The Connecticut Historical Society, consisting of a museum, library, and education center, collects, preserves, and interprets the history of the diverse people who have lived in the state. The Museum's collections of Connecticut-related furniture, silver, pewter, costumes, paintings, tavern signs, and graphic material are among the largest in existence.

Hartford Steam Boiler Inspection & Insurance Co. - Art Collection

One State St., 12th Floor, Hartford, CT 06102

Tel: (860) 722-5473

Internet Address: http://www.hsb.com

Admission: free.

Parking: pay on site.

Open: **by appointment**, Monday to Friday, 8:30am-4pm.

Facilities: **Exhibition Area.**

The collection of the Hartford Steam Boiler Inspection & Insurance Co. concentrates on works of art created in the State of Connecticut from the early 19th to the early 20th century. There are works by Weir, Hassam, Twachtman, Metcalf, Simmons, Vonnoh, Hale, Rook, Lawson, and Ochtman in the Company's holdings.

The Mark Twain House

351 Farmington Ave., Hartford, CT 06105-4498

Tel: (860) 247-0998

Fax: (860) 278-8148

Internet Address: http://www.hartnet.org/twain

Exec. Director: Mr. John Vincent Boyer

Admission: fee: adult-$9.00, child-$5.00, Youth-$7.00, senior-$8.00.

Attendance: 55,000 *Established:* 1929 *Membership:* Y *ADA Compliant:* Partial (1st floor only)

Parking: free on site.

Open: **January to April**,
 Monday, 9:30am-5pm;
 Wednesday to Saturday, 9:30am-5pm;
 Sunday, noon-5pm.

 May to October,
 Monday to Saturday, 9:30am-5pm.
 Sunday, noon-5pm

 November,
 Monday, 9:30am-5pm;
 Wednesday to Saturday, 9:30am-5pm;
 Sunday, noon-5pm.

 December,
 Monday to Saturday, 9:30-5pm;
 Sunday, noon-5pm.

Exterior view of Mark Twain House (1874), designed by Edward Tuckerman Potter. Photograph courtesy of Mark Twain House, Hartford, Connecticut.

Closed: New Year's Day, Easter, Thanksgiving Day, Christmas Eve to Christmas Day.

Facilities: **Architecture** (High Victorian building); **Shop.**

Activities: **Concerts**; **Guided Tours**; **Lectures.**

Publications: newsletter, "Mark Twain News" (quarterly).

The Mark Twain House was designed by Edward Tuckerman Potter and built in 1874 in the High Victorian style. It served as the Twain family home until 1891, and it is now a National Historic Landmark. It contains an important collection of fine and decorative arts, including the only remaining domestic interiors by Louis Comfort Tiffany.

Trinity College - Widener Gallery

Austin Arts Center, 300 Summit St, Hartford, CT 06106

Tel: (860) 297-2133 *Fax:* (860) 297-5349

Internet Address: http://www.trincoll.edu

Curator: Felice Caivano

Trinity College - Widener Gallery, cont.

Admission: free.

Established: 1964 *Membership:* N *ADA Compliant:* N

Open: Weekdays, 1pm-5pm.

Closed: Academic Holidays.

Facilities: **Galleries**; **Theatre**.

Activities: **Education Programs.**

The Gallery sponsors three exhibitions per year of the work of professional artists from outside the Trinity community. In addition, there are two student shows and one faculty show each year. The permanent collection is spread around the campus.

Wadsworth Atheneum

600 Main St., Hartford, CT 06103

Tel: (860) 278-2670

Fax: (860) 527-0803

C.E.O.: Mr. Peter Sutton

Admission: fee: adult-$7.00, child-free,
 student-$5.00, senior-$3.00.

Attendance: 160,000 *Established:* 1842

Membership: Y *ADA Compliant:* Y

Parking: metered on street and commercial lots.

Open: Tuesday to Sunday, 11am-5pm.
 1st Thurs of month, 11am-8pm.

Closed: Thanksgiving Day, New Year's Day,
 Independence Day, Christmas Day.

Facilities: **Architecture** (Gothic Revival, 1844.); **Auditorium** (295 seats); **Food Services** Restaurant; **Library** (25,000 volumes); **Sculpture Garden**; **Shop.**

Exterior view of Wadsworth Atheneum (1844), designed by Ithiel Town and A. J. Davis. Photograph courtesy of Wadsworth Atheneum, Hartford, Connecticut.

Activities: **Concerts**; **Education Programs**; **Films**; **Gallery Talks**; **Guided Tours**; **Lectures**; **Temporary Exhibitions**; **Traveling Exhibitions.**

Publications: annual report; collection catalogue; exhibition catalogues; gallery guides; magazine (quarterly).

Founded by Daniel Wadsworth in 1842, the Wadsworth Atheneum is America's oldest public art museum. In addition to displaying a portion of its permanent collection of over 50,000 objects, the museum presents more than ten special exhibitions per year. The Atheneum's permanent collection includes Egyptian, Greek, and Roman bronzes; Renaissance and baroque paintings; the largest collection of Hudson River School landscapes in the United States; French and American Impressionist paintings; and 20th-century masterpieces.

Middletown

Wesleyan University - Davison Art Center (DAC)

301 High St., Middletown, CT 06459-0487

Tel: (860) 685-2500

Fax: (860) 685-2501

Internet Address: http://www.wesleyan.edu/dac/homehtml

Curator: Ms. Stephanie Wiles

Admission: free.

Attendance: 6,000 *Established:* 1952 *Membership:* Y *ADA Compliant:* N

Parking: nearby on-street parking.

Open: **September to Early June**, Tuesday to Sunday, noon-4pm.

Closed: Academic Holidays, Legal Holidays.

Facilities: **Architecture** (1838-1840 Alsop House); **Library** (3,000 volumes); **Reading Room.**

Activities: **Gallery Talks**; **Lectures.**

Wesleyan University - Davison Art Center, cont.

Publications: exhibition catalogues.

The Davison Art Center of Wesleyan University maintains an impressive, high-quality collection of artworks, chiefly on paper. The collection is augmented frequently, with works that contribute to the educational mission of the Center. The Center's print collection includes work by Dürer, Rembrandt, Italian Renaissance artists, Goya, Manet, Millet, and modern and contemporary American artists, especially Jim Dine, along with a substantial collection of Japanese woodcuts. The photography collection ranges from the 1840's to the present and includes works by Muybridge, Atget, Steichen, Bourke-White, Mark, and Trager. The drawings in the Center's collection include works by many important French and American artists, such as Lalanne, Sargent, and Whistler. The painting collection is small, but also of high quality (e.g., Charles Sheeler). There is also a sculpture collection. Also of possible interest on campus is the Ezra and Cecile Zilkha Gallery, dedicated to temporary exhibitions of contemporary art in all media. Its exhibition program consists of 4-5 shows per year. The Zilkha Gallery is open Tues-Sun, noon-4pm; tel. 685-2684.

New Britain

Central Connecticut State University Museum

Samuel T. Chen Arts Center, Maloney Hall, 1615 Stanley St., New Britain, CT 06050

Tel: (860) 832-2633

Fax: (860) 832-2634

Internet Address: http://wwwas.ccsu.ctstateu.edu/depts/ART/GALLERY.html

Director: Mr. Ron Todd

Admission: free.

Attendance: 3,000 *Established:* 1965 *Membership:* N *ADA Compliant:* Y

Open: **During Exhibitions**,
 Tuesday to Wednesday, 1pm-4pm; Thursday, 1pm-7pm; Friday, 1pm-4pm.

Facilities: **Exhibition Area** (200 linear feet); **Library**.

Activities: **Education Programs**.

The University Gallery presents six major exhibitions of contemporary art during each academic year. It also houses a small permanent collection.

New Britain Museum of American Art (NBMAA)

56 Lexington St., New Britain, CT 06052

Tel: (860) 229-0257

Fax: (860) 229-3445

Internet Address: http://www.nbmaa.org

Director: Douglas Hyland

Admission: voluntary contribution (Saturday, 10am-noon-free):
 adult-$4.00, child (<12)-free, student-$2.00, senior-$3.00 .

Attendance: 30,000 *Established:* 1903 *Membership:* Y *ADA Compliant:* Y

Parking: free on street.

Open: Tuesday to Friday, noon-5pm; Saturday, 10am-5pm; Sunday, noon-5pm.

Closed: New Year's Day, Independence Day, Thanksgiving Day, Christmas Day.

Facilities: **Exhibition Area**; **Library** (200 volumes); **Reading Room**; **Shop** (Tues-Sun, 1:30pm-
 4:30pm; books, ceramics, jewelry, pewter, textiles).

Activities: **Arts & Crafts Fair**; **Concerts**; **Education Programs** (adults and children);
 Film/Video Series, First Fridays Series; **Gallery Talks**; **Guided Tours** (schedule 3 weeks in
 advance); **Lectures**; **Permanent Exhibitions**; **Temporary Exhibitions**.

Publications: guide to permanent collection; newsletter, "Looking at Art" (quarterly).

Founded in 1903, NBMAA was the first collection of strictly American art in the country. Holdings, now exceeding 4,300 works, have particular strengths in colonial portraiture, the Hudson River School, American Impressionism, and the Ash Can School. Of particular note is Thomas Hart Benton's mural series, "The Arts of Life in America". The Museum relies heavily on its permanent collection for exhibitions and programming, supplemented by a significant number of borrowed shows and work by emerging artists.

New Canaan

Silvermine Guild Arts Center

1037 Silvermine Road, New Canaan, CT 06840
Tel: (203) 966-5617
Fax: (203) 966-2763
Gallery Director: Ms. Helen During
Admission: suggested contribution-$2.00.
Attendance: 12,000 *Established:* 1922 *Membership:* Y *ADA Compliant:* Y
Parking: free on site.
Open: Tuesday to Saturday, 11am-5pm; Sunday, 1pm-5pm.
Closed: New Year's Day, Easter, Independence Day, Thanksgiving Day, Christmas Day.
Facilities: **Architecture** (1890 barn); **Auditorium**; **Galleries**; **Library**; **Sculpture Garden**; **Shop**; **Theatre**.
Activities: **Arts Festival**; **Concerts**; **Education Programs**; **Gallery Talks**; **Guided Tours**; **Lectures**; **Temporary Exhibitions**.
Publications: exhibition catalogues; newsletter (bi-monthly).

The Silvermine Guild Arts Center presents over 20 exhibitions of contemporary art each year.

New Haven

New Haven Colony Historical Society

114 Whitney Ave., New Haven, CT 06510
Tel: (203) 562-4183
Fax: (203) 562-2002
Exec. Director: Mr. Peter Thomas Lamothe
Admission: fee:
 adult-$2.00, child-$1.00, student-$1.50, senior-$1.50.
Attendance: 8,000 *Established:* 1862
Membership: Y *ADA Compliant:* Y
Parking: 13 spaces on site.
Open: Tuesday to Friday, 10am-5pm;
 Saturday to Sunday, 2pm-5pm.
Closed: Legal Holidays.
Facilities: **Auditorium** (175 seats); **Galleries**; **Library** (25000 volumes).
Activities: **Education Programs**; **Films**; **Gallery Talks**; **Permanent Exhibitions**; **Recitals**; **Temporary Exhibitions**.
Publications: exhibition catalogues; magazine, "Journal"; newsletter, "News & Notes" (biennial).

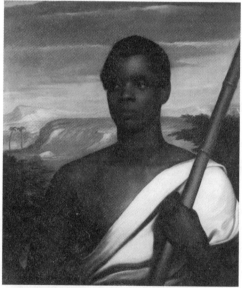

Nathaniel Jocelyn, *Cinque*, 1840, portrait (leader of the Amistad captives). New Haven Colony Historical Society. Photograph courtesy of New Haven Colony Historical Society, New Haven, Connecticut.

The New Haven Colony Historical Society is a history museum with a good fine arts collection, focusing on paintings, including landscapes by local artists, portraits from the 18th and 19th centuries, watercolors, prints, and drawings. The museum also holds decorative arts and objects pertaining to Connecticut's maritime history.

Yale Center for British Art

1080 Chapel Street, New Haven, CT 06510
Tel: (203) 432-2800
Fax: (203) 432-9695
Internet Address: http://www.yale.edu/ycba
Director: Mr. Patrick McCaughy
Admission: voluntary contribution.

138

Yale Center for British Art, cont.

Attendance: 110,000 *Established:* 1977
Membership: Y *ADA Compliant:* Y
Parking: lot behind building.
Open: Tuesday to Saturday, 10am-5pm;
 Sunday, noon-5pm.
Closed: New Year's Eve, New Year's Day,
 Independence Day, Thanksgiving Day,
 Christmas Eve, Christmas Day.
Facilities: **Architecture** (1977, final building
 designed by Louis I. Kahn); **Auditorium** (200
 seats); **Library** (20,000 volumes); **Shop**.
Activities: **Films**; **Gallery Talks**; **Guided
 Tours**; **Lectures**; **Temporary Exhibitions**.
Publications: exhibition catalogues.

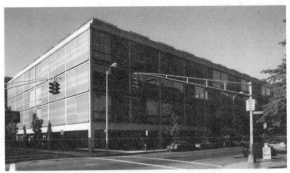

Exterior view of Yale Center for British Art (1977), designed by Louis Kahn. Photograph by Richard Caspole, courtesy of Yale Center for British Art, New Haven, Connecticut.

The Yale Center for British Art contains masterpieces by the leading artists who have worked in Britain from the 16th century to the present, including paintings by Hogarth, Gainsborough, Reynolds, Stubbs, Constable, Turner, and Bonington. British sporting art, the Pre-Raphaelite Brotherhood, the Camden Town School, and the Bloomsbury Group are well represented, together with more recent 20th-century British art. Extensive collections of watercolors, drawings, prints, and rare books are available for public consultation. The Center mounts a regular program of changing exhibitions throughout the year and offers films, concerts, lectures, gallery talks, docent tours, and special programs for children - all free and open to the public. Given to Yale University by Paul Mellon, the Center was designed by Louis Kahn and opened in 1977. It stands across from Kahn's first museum commission, the Yale University Art Gallery(see below).

Yale University Art Gallery (YUAG)

1111 Chapel Street, New Haven, CT 06520
Tel: (202) 432-0600
Fax: (204) 432-7159
Internet Address: http://www.yale.edu/artgallery
Director: Mr. Jock Reynolds
Admission: voluntary contribution.
Attendance: 103,000 *Established:* 1832 *Membership:* Y *ADA Compliant:* Y
Parking: metered on street and commercial garage at 150 York Street.
Open: Tuesday to Saturday, 10am-5pm; Sunday, 1pm-6pm.
Closed: New Year's Day, Independence Day, August, Thanksgiving Day, Christmas Day.
Facilities: **Architecture** Original Building (Italian Gothic-style 1928, designed by Edgerton Swartout), Second Building (1953, designed by Louis I. Kahn); **Auditorium** (400 seats); **Sculpture Garden**; **Shop** (books, jewelry, accessories, museum publications).
Activities: **Concerts**; **Films**; **Gallery Talks** (Art à la Carte, selected Wednesdays, 12:20pm); **Guided Tours** (Sat, 11am and Sun, 3pm); **Lectures**; **Temporary Exhibitions**.
Publications: booklets (occasional); calendar (quarterly); exhibition catalogues (occasional).

Since its founding in 1832, the Yale University Art Gallery's collections have grown to number over 80,000 objects from around the world, dating from ancient Egypt to the present day. Among the highlights are masterpieces by Van Gogh, Manet, Monet, Picasso, Hopper, Homer, Eakins, and many contemporary artists, as well as notable collections of Etruscan and Greek vases, early Italian paintings, and African and Asian art. The Art Gallery's American paintings and decorative arts collections are among the finest in the world. The Art Gallery maintains a rigorous schedule of special exhibitions, educational programs, gallery talks, lectures, and symposia. It is used extensively for scholarly research in the history of art and museum training for graduate and undergraduate students. An entrance for persons using wheelchairs is at 201 York Street, with an unmetered parking space nearby. For further information on accessibility for the disabled call 432-0601 or 432-0620.

New London

Connecticut College - Lyman Allyn Art Museum

625 Williams Street, New London, CT 06320
Tel: (860) 443-3433
Fax: (860) 442-1280
Internet Address: http://www.conncoll.edu/CAT/LymanAllyn/general.html
Exec. Director: Mr. Charles A. Shepard, III
Admission: fee: adult-$3.00, child-free, student-$2.00, senior-$2.00.
Attendance: 20,000 *Established:* 1930 *Membership:* Y *ADA Compliant:* Y
Parking: free on site.
Open: Tuesday to Saturday, 10am-5pm; Sunday, 1pm-5pm.
Closed: Legal Holidays.
Facilities: **Architecture** (Whaling mansion); **Auditorium** (100 seats); **Downtown Artspace**; **Library** (10,000 volumes); **Sculpture Garden**; **Shop**.
Activities: **Education Programs**; **Gallery Talks**; **Guided Tours**; **Lectures**; **Temporary Exhibitions**; **Traveling Exhibitions**.
Publications: collection catalogue; newsletter, "Columns" (quarterly).

Exterior view of west entrance, Lyman Allyn Art Museum. Photograph courtesy of Lyman Allyn Art Museum, New London , Connecticut.

Situated near Connecticut College and overlooking the U.S. Coast Guard Academy, the Lyman Allyn Art Museum is the principal comprehensive art museum serving southeastern Connecticut. With an impressive collection of more than 15,000 objects spanning 5,000 years and five continents, the Museum displays contemporary, modern, and primitive fine arts; 18th- and 19th-century American decorative arts; Connecticut Impressionist paintings; and three-dimensional art in its sculpture garden. The Museum also mounts temporary exhibitions. It is housed in a Neo-Classical building designed by Charles A. Platt, who also designed The Freer Gallery of Art and several buildings on the Connecticut College campus, with which the Museum has recently affiliated.

Norwich

The Slater Memorial Museum

108 Crescent Street, Norwich, CT 06360
Tel: (860) 887-2506
Fax: (860) 889-6196
Director: Mr. Joseph P. Gualtieri
Admission: fee: adult-$2.00, child-free.
Attendance: 39,000 *Established:* 1888
Membership: Y *ADA Compliant:* N
Parking: free on site.
Open: **September to June**,
 Tuesday to Friday, 9am-4pm;
 Saturday to Sunday, 1pm-4pm.
 July to August,
 Tuesday to Sunday, 1pm-4pm.
Closed: Holidays.

Exterior view of Slater Memorial Museum (1886), designed by Stephen Earle. Photograph courtesy of Slater Memorial Museum, Norwich, Connecticut.

Facilities: **Architecture** (Romanesque Revival building, 1886); **Exhibition Area**; **Shop**.
Activities: **Gallery Talks**; **Guided Tours** (available on request); **Lectures**; **Temporary Exhibitions** (every six weeks).
Publications: brochures; collection catalogues.

The Slater Memorial Museum, cont.

On the campus of the Norwich Free Academy, The Slater Memorial Museum holds a collection of Greek, Roman, and Renaissance casts, American art and furniture from the 17th through the 20th centuries, American Indian artifacts, the Vanderpoel Collection of Oriental Art, African and European art, and textiles.

Old Lyme

Florence Griswold Museum

96 Lyme Street, Old Lyme, CT 06371

Tel: (860) 434-5542

Fax: (860) 434-9778

Director: Mr. Jeffrey W. Andersen

Admission: fee: adult-$5.00, child-free, student-$4.00, senior-$4.00.

Attendance: 32,000 *Established:* 1936 *Membership:* Y *ADA Compliant:* Y

Parking: free on site.

Open: **January to March**, Wednesday to Sunday, 1pm-5pm.
April to December, Tuesday to Saturday, 10am-5pm; Sunday, 1pm-5pm.

Facilities: **Architecture** (1817, Florence Griswold House); **Library**; **Shop**.

Activities: **Films**; **Guided Tours**; **Lectures**; **Temporary Exhibitions**.

Publications: books; collection catalogue; exhibition catalogues; pamphlets.

The Florence Griswold Museum is housed in a late Georgian-style mansion designed by Samuel Belcher and built in 1817. The building contains period rooms and is surrounded by gardens restored to their appearance when the house was occupied by Florence Griswold around 1900. The Museum's holdings include over 900 works by approximately 130 American artists, many of whom were members of the art colony at Old Lyme, either as part of the "American Barbizon" movement or as Impressionists, such as Ebert, Chadwick, Hassam, and Metcalf.

Lyme Academy of Fine Arts - Galleries

84 Lyme St., Old Lyme, CT 06371

Tel: (860) 434-5232

Internet Address: http://www.lymeacademy.edu

Admission: donation.

Open: Tuesday to Saturday, 10am-4pm; Sunday, 1pm-4pm.

Facilities: **Exhibition Area**.

Activities: **Temporary Exhibitions**.

The Lyme Academy emphasizes traditional figurative instruction in its courses. Exhibitions include the work of professional artists, students, and alumni.

Lyme Art Association

Lyme St., Old Lyme, CT 06371

Tel: (860) 434-7802

Admission: free.

Open: Call for hours.

Facilities: **Exhibition Area**.

The Lyme Art Association, located next door to the Florence Griswold Museum, mounts temporary exhibitions of contemporary painting and sculpture.

Ridgefield

The Aldrich Museum of Contemporary Art

258 Main St., Ridgefield, CT 06877

Tel: (203) 438-4519

Fax: (203) 438-0198

Director: Mr. Harry Philbrick

Admission: fee: adult-$5.00, child-free, student-$2.00, senior-$2.00.

Attendance: 40,000 *Established:* 1964 *Membership:* Y *ADA Compliant:* Y

Ridgefield, Connecticut

The Aldrich Museum of Contemporary Art, cont.

Parking: free on site.

Open: Tuesday to Thursday, noon-5pm;
Friday, noon-8pm;
Saturday to Sunday, noon-5pm.
Other times, by appointment.

Facilities: Architecture (1783 mansion); **Exhibition Area; Sculpture Garden; Shop.**

Activities: **Concerts; Education Programs; Gallery Talks; Lectures; Temporary Exhibitions; Traveling Exhibitions.**

Publications: exhibition catalogues (3/year); newsletter (3/year).

Exterior view of Aldrich Museum of Contemporary Art. Photograph courtesy of Aldrich Museum of Contemporary Art, Ridgefield, Connecticut.

The Aldrich Museum of Contemporary Art is a non-collecting museum devoted exclusively to exhibiting contemporary art, mounting approximately ten exhibitions per year, included in which are works by internationally-recognized artists (e.g., Antoni, Close, Gober, Hamilton, Serrano). The Museum also features a sculpture garden.

Stamford

Stamford Museum and Nature Center

39 Schofieldtown Road, Stamford, CT 06903

Tel: (203) 322-1646

Fax: (203) 322-0408

Director: Mr. Gerald E. Rasmussen

Admission: fee: adult-$4.00, child-$3.00, senior-$3.00.

Attendance: 110,000 *Established:* 1936 *Membership:* Y *ADA Compliant:* Y

Open: Monday to Saturday, 9am-5pm; Sunday, 1pm-5pm; Holidays, 9am-5pm;

Closed: New Year's Day, Thanksgiving Day, Christmas Day.

Facilities: **Galleries** (6); **Non-art-related facilities; Shop.**

Activities: **Concerts; Education Programs; Lectures; Temporary Exhibitions.**

Publications: newsletter (bi-monthly).

The Museum offers exhibitions of contemporary art, and its permanent collection consists of 19th- and 20th-century paintings, sculpture, and graphics.

Whitney Museum of American Art, Fairfield County

400 Atlantic St., Stamford, CT 06921

Tel: (203) 358-7630

Fax: (203) 358-2975

Manager: Ms. Cynthia Roznoy

Admission: free.

Established: 1981 *Membership:* N *ADA Compliant:* Y

Parking: free on site.

Open: Tuesday to Saturday, 11am-5pm.

Closed: Major Holidays.

Facilities: **Exhibition Area** (3,500 square feet); **Shop.**

Activities: **Concerts; Dance Recitals; Education Programs; Films; Gallery Talks; Guided Tours; Lectures; Temporary Exhibitions.**

Publications: brochures.

The Whitney Museum of American Art, Fairfield County is the Connecticut branch of the Whitney Museum of American Art in New York. The gallery space features changing exhibitions of American art, primarily of the 20th century and frequently drawn from the permanent collection of the Whitney in New York.

Storrs

University of Connecticut - The William Benton Museum of Art

University of Connecticut, 245 Glenbrook Road U-140, Storrs, CT 06269-2140

Tel: (860) 486-4520

Fax: (860) 486-0234

Internet Address: http://www.benton.uconn.edu

Acting Director: Mr. Salvatore Scalora

Admission: voluntary contribution.

Attendance: 20,000 *Established:* 1966 *Membership:* Y *ADA Compliant:* Y

Open: Tuesday to Friday, 10am-4:30pm; Saturday to Sunday, 1pm-4:30pm.

Closed: Legal Holidays, Between Exhibitions.

Facilities: **Galleries**; **Shop**.

Activities: **Films** (related to exhibitions); **Gallery Talks**; **Lectures**; **Temporary Exhibitions**.

Publications: exhibition catalogues.

Housed in a National Register building (a converted dining hall), the Museum traces its roots to the donation to the University of his art collection by former University President Beach. His bequest included works by Hassam, Ranger, Lawson, and Wiggins. Since then, the collection has grown to include works by Cassatt, Benton, Bellows, Marsh, Rembrandt Peale, Braque, and Burne-Jones, now totaling some 4,000 objects. Also of possible interest on campus is the Atrium Gallery (875 Coventry Road; Monday-Friday, 8:30-4:30; 486-3930).

Waterbury

The Mattatuck Museum of the Mattatuck Historical Society

144 W. Main Street, Waterbury, CT 06702

Tel: (203) 753-0381

Fax: (203) 756-6283

Internet Address: http://www.mattatuckmuseum.org

Curator: Ms. Ann Smith

Admission: fee: adults (>16)-$4.00).

Attendance: 60,000 *Established:* 1877

Membership: Y *ADA Compliant:* Y

Parking: pay on site.

Open: **July to August**,
> Tuesday to Saturday, 10am-5pm.
> **September to June**,
> Tuesday to Saturday, 10am-5pm; Sunday, 10am-5pm.

Facilities: **Auditorium** (300 seats); **Food Services** Café; **Library**; **Shop**.

Activities: **Education Programs**; **Gallery Talks**; **Guided Tours**; **Lectures**; **Performances**; **Temporary Exhibitions**; **Traveling Exhibitions**.

Publications: annual report; books; exhibition catalogues; newsletter (3/year).

Items from collection of Mattatuck Museum. Photograph courtesy of Mattatuck Museum, Waterbury, Connecticut.

The Mattatuck Museum possesses a rich collection featuring Connecticut fine and decorative arts, as well as exhibits dealing with the agricultural and industrial history of the state. The art collection includes works by John Trumbull, Erastus Salisbury Field, Ralph Earl, Ammi Phillips, Frederic Church, J. F. Kensett, Maurice Prendergast, John Twachtman, Henry Ranger, Josef Albers, Alexander Calder, and Arshile Gorky, among others.

West Hartford, Connecticut

West Hartford

Saint Joseph College Art Gallery

Mercy Hall, 1678 Asylum Ave., West Hartford, CT 06117
Tel: (860) 232-4571
Fax: (860) 233-5695
Internet Address: http://www.sjc.edu
Director: Ms. Vicenza Uccello
Admission: free.
Attendance: 500 *Established:* 1932 *Membership:* N *ADA Compliant:* Y
Open: Monday to Friday, 10am-4pm.
Closed: Legal Holidays.
Facilities: **Galleries**; **Library**.
Activities: **Education Programs**; **Temporary Exhibitions**.
Publications: brochures.

The Art Gallery presents exhibitions of works from its permanent collection. It is located in the new arts complex, which includes five exhibition galleries, expanded storage facilities, and a print study room.

University of Hartford - Joseloff Gallery, Hartford Art School

Harry Jack Gray Center, 200 Bloomfield Ave., West Hartford, CT 06117
Tel: (860) 768-4090
Fax: (860) 768-5159
Internet Address: http://www.uhavax.hartford.edu/~artschool/joseloffgallery.html
Director: Ms. Zina Davis
Admission: voluntary contribution.
Attendance: 10,000 *Established:* 1970 *Membership:* Y
Open: Tuesday to Friday, 11am-4pm; Saturday to Sunday, noon-4pm.
Closed: Academic Holidays, Legal Holidays.
Facilities: **Auditorium**; **Exhibition Area** (3,500 square feet).
Activities: **Education Programs**; **Temporary Exhibitions**.
Publications: brochures; calendar (annual); exhibition catalogues.

The Gallery presents exhibitions by internationally known artists along with an annual faculty exhibition.

Wilton

Weir Farm National Historic Site

735 Nod Hill Road, Wilton, CT 06897
Tel: (203) 834-1896
Fax: (203) 834-2421
Internet Address: http://www.nps.gov/wefa
Superintendent: Mr. Roy D. Cortez
Admission: voluntary contribution.
Attendance: 15,000 *Established:* 1990
Membership: Y
Parking: free on site; very limited.
Open: Grounds: Daily, dawn-dusk
 Visitor Center: 8:30am-5pm.
Closed: New Year's Day, Thanksgiving Day, Christmas Day.

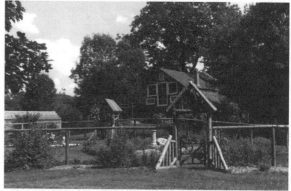
View of Weir garden and art studio. Photograph courtesy of Weir Farm National Historic Site, Wilton, Connecticut.

Facilities: **Architecture** (J. Alden Weir's farm and studio); **Auditorium** (50 seats); **Historic Gardens**; **Library**; **Shop**.

Weir Farm National Historic Site, cont.

Activities: **Education Programs**; **Hiking and Self-Guided Walking Trails**; **Historic Art Studio Tours** (Wed-Sun, 11am/1pm/3pm); **Lectures**; **Temporary Exhibitions**.

Publications: bulletin; newsletter (quarterly).

The only National Park Service site dedicated to an American painter, Weir Farm National Historic Site preserves the summer home and workplace of Julian Alden Weir (1852-1919), a leading figure in American art and the development of American Impressionism. The house, studios, farm buildings, and landscape integral to Weir's vision survive largely intact. The 18th-century farm has been used continually by artists since 1882. The tour includes Weir's studio and sculptor Mahonri Young's 1930's studio.

Delaware

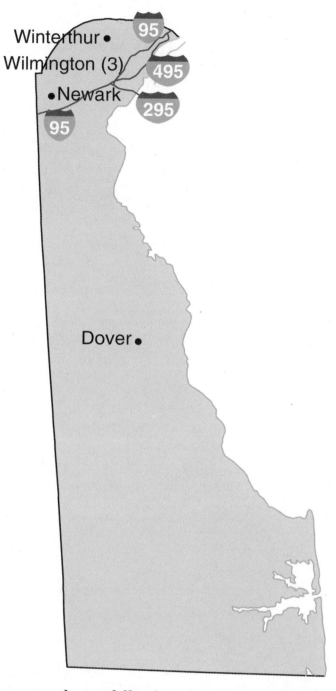

The number in parentheses following the city name indicates the number of museums/galleries in that municipality. If there is no number, one is understood. For example, in the text three listings would be found under Wilmington and one listing under Newark.

Delaware

Dover

Sewell C. Biggs Museum of American Art

406 Federal Street (between The Green and Legislative Mall), Dover, DE 19903
Tel: (302) 674-2111
Fax: (302) 674-5133
Internet Address: http://www.biggsmuseum.org
Director: Karol A. Schmiegel
Admission: voluntary contribution.
Attendance: 8,000 *Established:* 1992
Membership: Y *ADA Compliant:* Y
Parking: free near site.
Open: Wednesday to Saturday, 10am-4pm;
 Sunday, 1:30pm-4:30pm.
Closed: State Holidays.
Facilities: Galleries (14).
Activities: Concerts; Guided Tours; Lectures;
 Temporary Exhibitions.
Publications: calendar of events (bimonthly);
 newsletter (quarterly).

Albert Bierstadt, *Niagara Falls*, oil on cardboard, probably 1869. Sewell C. Biggs Museum of American Art. Photograph courtesy of Sewell C. Biggs Museum of American Art, Dover, Delaware.

The Museum's 14 galleries provide an intimate setting for its collection of American fine and decorative arts. The paintings provide a survey of American art: portraits, landscapes, marine views, and still lifes, in a variety of styles. Major artists represented include William Merritt Chase, Charles Willson Peale, Gilbert Stuart, Thomas Cole, Albert Bierstadt, and Childe Hassam. A special feature is the focus on regional artists such as Delaware's Frank H. Schoonover. Sculpture, drawings, and decorative arts including silver, furniture, and tall clocks are also displayed. Small changing exhibitions complement the permanent collection.

Newark

University of Delaware - University Gallery

Main Street at N. College Ave., Newark, DE 19716
Tel: (302) 831-8242
Fax: (302) 831-4330
Internet Address: http://www.Seurat.art.udel.edu
Director: Ms. Belena S. Chapp
Admission: voluntary contribution.
Attendance: 15,000 *Established:* 1978 *Membership:* N *ADA Compliant:* Y
Open: Tuesday to Friday, 11am-5pm; Saturday, 1pm-5pm.
Closed: Academic Holidays.
Facilities: Architecture (1832 Greek Revival building); Exhibition Area; Gallery.
Activities: Education Programs; Temporary Exhibitions.
Publications: exhibition catalogues.

The University Gallery presents exhibitions of regional and national significance. The Gallery houses over 6,000 art objects and ethnographic artifacts spanning the ancient period through the present. Its holdings include large collections of photographs by Kasebier, paintings by Walkowitz, WPA graphics, pre-Columbian ceramics, Russian icons, and works by Maillol, Rodin, Cassatt, and Moholy-Nagy, among others.

Wilmington

Delaware Art Museum

2301 Kentmere Parkway, Wilmington, DE 19806
Tel: (302) 571-9590 *Fax:* (302) 571-0220
Internet Address: http://www.delart.org

Delaware Art Museum, cont.

Exec. Director: Mr. Stephen T. Bruni

Admission: fee: adult-$7.00, child-free, student-$2.50, senior-$5.00.

Attendance: 70,000 *Established:* 1938 *Membership:* Y

ADA Compliant: Y

Parking: free on site.

Open: Tuesday, 9am-4pm;
Wednesday, 9am-9pm;
Thursday to Saturday, 9am-4pm;
Sunday, 10am-4pm.

Closed: New Year's Day, Thanksgiving Day, Christmas Day.

Facilities: **Auditorium** (175 seats); **Café** (light fare); **Galleries**; **Library** (40,000 volumes); **Shop**.

Activities: **Concerts**; **Education Programs**; **Gallery Talks**; **Guided Tours** (groups 10+, reserve 4 weeks in advance); **Lectures**; **Temporary Exhibitions**; **Traveling Exhibitions**.

Publications: exhibition catalogues; newsletter.

The permanent collection of the Delaware Art Museum includes an extensive display of Pre-Raphaelite art; substantial holdings of American illustration, including a large collection of works by Howard Pyle; and American painting from 1840 to the present, including works by Church, Inness, Eakins, Hassam, Homer, Hopper, Sloan, Calder, Nevelson, and Held. To complement its collections, the Museum regularly presents temporary exhibitions.

Dante Gabriel Rossetti, *Mnemosyne*, 1881, oil on canvas. Delaware Art Museum. Photograph courtesy of Delaware Art Museum, Wilmington, Delaware.

Delaware Center for the Contemporary Arts

103 East 16th St., Wilmington, DE 19801

Tel: (302) 656-6466

Fax: (302) 656-6944

Admission: free.

ADA Compliant: N

Open: Tuesday to Friday, 11am-5pm; Saturday to Sunday, 1pm-5pm.

Facilities: **Galleries** (4).

Activities: **Temporary Exhibitions**.

The mission statement of DCCA provides in part as follows: "Exhibitions and programs will include, but not be limited to, work that explores the boundaries of contemporary art, reflects the interests of artists and the community and brings into focus national directions and current issues..." The Center consists of four galleries, which present some twenty-seven exhibitions each year, featuring the work of emerging and nationally recognized artists, thematic exhibits, contemporary crafts, and the work of regional artists.

Nemours Mansion and Gardens

1600 Rockland Road, Wilmington, DE 19803

Tel: (302) 651-6912

Tour Coordinator: Francesca Biella Bonny

Admission: fee-$10.00.

Established: 1977

Membership: N

Open: **May to November**,
Tuesday to Saturday, 9am/11am/1pm/3pm;
Sunday, 11am/1pm/3pm.

Facilities: **Architecture** (1910 Louis XVI-style chateau); **Formal French Gardens**.

Exterior view of Nemours (1910), designed by Carrère and Hastings. Photograph courtesy of Nemours Mansion and Gardens, Wilmington, Delaware.

Nemours Mansion and Gardens

Activities: Guided Tours.

Nemours, the site of the duPont ancestral home in France, was chosen by Alfred I. duPont as the name for his 300-acre estate north of Wilmington, Delaware. Here he created a lovely home with landscaped gardens surrounded by natural woodlands. The mansion is a modified Louis XVI chateau, designed by Carrère and Hastings, and completed in 1910. Containing 102 rooms, the house is furnished with fine examples of antique furniture, rare rugs, tapestries, and outstanding works of art. The gardens were created in the French style and offer impressive views from many vantage points.

Winterthur

Winterthur Museum, Garden & Library

State Route 52, Winterthur, DE 19735

Tel: (302) 888-4600

Fax: (302) 888-4880

TDDY: (302) 888-4907

Internet Address:
 http://www.udel.edu/winterthur

Director: Mr. Dwight P. Lanmon

Admission: fee: adult-$8.00, child-$4.00,
 student-$6.00, senior-$6.00.

Attendance: 200,000 *Established:* 1930

Membership: Y *ADA Compliant:* Y

Parking: free on site - over 400 spaces.

Open: Monday to Saturday, 9am-5pm;
 Sunday, noon-5pm.

Closed: New Year's Day, Thanksgiving Day,
 Christmas Day.

Exterior view of Winterthur Museum. Photograph by Robert Lautman, courtesy of Winterthur Museum, Winterthur, Delaware.

Facilities: **Auditorium** (350 seats); **Botanical Gardens**; **Food Services** Restaurant; **Library** (70,000 volumes); **Shops** (2).

Activities: **Education Programs**; **Films**; **Guided Tours**; **Lectures**.

Publications: collection catalogue; magazine (quarterly); newsletter; research publications.

The Winterthur Museum houses a permanent collection of more than 80,000 objects made or used in America between 1640 and 1860, including furniture, textiles, paintings, prints, silver, pewter, ceramics, glass, needlework, and brass. The Museum consists of two buildings, one with 175 period rooms, and the other with three exhibition galleries. Known primarily for its great collection of American decorative arts, the Museum does contain important works of fine art, including paintings by Stuart, Copley, and Peale.

District of Columbia

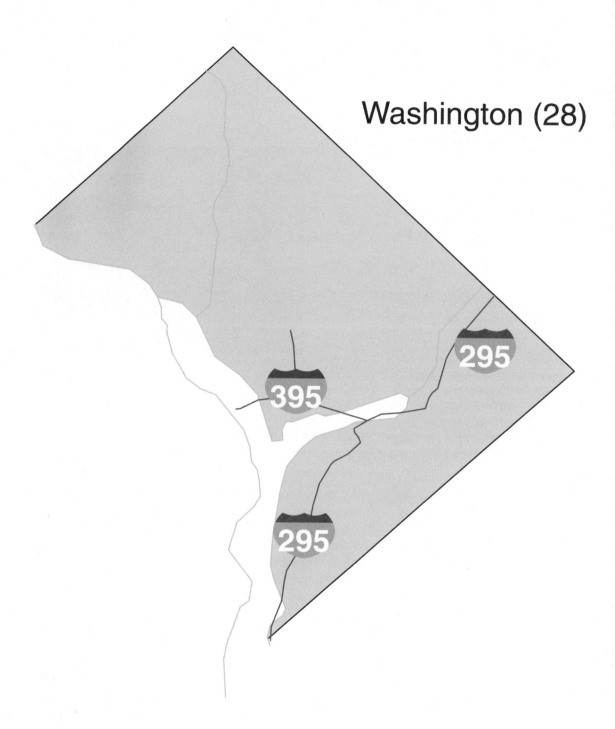

Washington (28)

The number in parentheses following the city name indicates the number of museums/galleries in the District.

District of Columbia

Washington

American Red Cross History and Education Center

1730 17th Street, N.W., Washington, DC 20006
Tel: (202) 639-3330
Fax: (202) 628-1362
Internet Address: http://www.arc.org
Curator of Collections: Ms. Vicki Watson Sopher
Admission: open to public.
Established: 1995
Open: Monday to Friday, 9am-4pm.
Facilities: **Exhibition Area**.
Activities: **Guided Tours** (by reservation).
Publications: brochures.

The permanent holdings include an important collection of original poster art by such illustrators as Howard Chandler Christy, Harrison Fisher, James Montgomery Flagg, Norman Rockwell, Jessie Wilcox Smith, and N.C. Wyeth. Also of possible interest, the History and Education Center maintains a satellite gallery, the Gallery at Jefferson Park (located in the ARC Building at 811 Gatehouse Road, Falls Church, Virginia 22042 - (703) 206-8869).

Howard Chandler Christy, *Spirit of America*, 1919, poster. Photograph courtesy of American Red Cross History and Education Center, Washington, District of Columbia.

American University - Watkins Gallery

American University, 4400 Massachusetts Ave., N.W., Washington, DC 20016-8004
Tel: (202) 885-1064
Fax: (202) 885-1132
Internet Address: http://www.american.edu/academic.depts/cas/art/general/watkins.html
Director: Mr. Ron Haynie
Admission: free.
Established: 1945
Membership: N *ADA Compliant:* Y
Parking: metered on street - limited.
Open: Monday to Friday, 10am-noon and 1pm-5pm.
Facilities: **Exhibition Area** (700 square feet).
Activities: **Lectures**; **Temporary Exhibitions** (16/year).

In addition to the various student exhibitions, which are part of American University's graduate and undergraduate studio art programs, the Gallery hosts five changing exhibitions each year, one of which is curated from the 4,000-piece Watkins Collection. The Watkins Collection began with the gift of a group of paintings by artist friends as a memorial to C. Law Watkins after his death in 1945. It has grown to include more than 450 paintings, and thousands of prints and drawings, with a focus primarily on 20th-century American art. Holdings include works by Karel Appel, Milton Avery, Pierre Bonnard, Marc Chagall, Giorgio de Chirico, Arthur Dove, Elaine de Kooning, Adolphe Gottlieb, Francisco Goya, Grace Hartigan, Marsden Hartley, Earl Kerkam, Paul Klee, Karl Knaths, Fernand Léger, John Marin, Reginald Marsh, Henri Matisse, Robert Rauschenberg, Kurt Schwitters, John Sloan, Jack Tworkov, and Edouard Vuillard, among others.

Karl Appel, title unknown, 27½ x 21½ inches. Gift of Muriel Miller Pear, Watkins Collection, American University. Photograph courtesy of the Watkins Gallery, American University, District of Columbia.

151

Arthur M. Sackler Gallery

1050 Independence Ave., S.W., Washington, DC 20560
Tel: (202) 357-4880
Fax: (202) 357-4911
TDDY: (202) 786-2374
Internet Address: http://www.si.edu/Asia
Director: Dr. Milo C. Beach
Admission: free.
Attendance: 600,000 *Established:* 1982
Membership: Y *ADA Compliant:* Y
Parking: limited free parking on mall and
 metered on street.
Open: **Fall to Spring**,
 Daily, 10am-5:30pm.
 Summer,
 Monday to Wednesday, 10am-5:30pm
 Thursday, 10am-8pm;
 Friday to Sunday, 10am-5:30pm.

Exterior view of entrance pavilion, Arthur M. Sackler Gallery. Photograph courtesy of Arthur M. Sackler Gallery, Washington, D.C.

Closed: Christmas Day.
Facilities: **Galleries**; **Library** (55,000 volumes); **Shop**.
Activities: **Concerts**; **Education Programs**; **Films**; **Gallery Talks**; **Guided Tours**; **Lectures**;
 Temporary Exhibitions.
Publications: calendar (bi-monthly); exhibition catalogues; magazine, "Asian Art" (triennial).

A national museum of Asian art at the Smithsonian Institution, the Gallery presents exhibitions of Asian art from around the world and from its permanent collection. The Gallery is dedicated to research, education, and exhibition of Asian art from the shores of the Mediterranean to the Japanese archipelago, spanning 5,000 years, from Neolithic times to the present. The Gallery houses nearly 3,000 examples of Asian art, including ancient Chinese jades and bronzes, ancient Near Eastern metalwork, South Asian sculpture, and paintings and manuscripts from Iran and India. It has also augmented its collection with contemporary Japanese ceramics and prints, South Asian textiles, Chinese paintings and contemporary ceramics, and photographs.

Arts Club of Washington

2017 Eye St., N.W., Washington, DC 20006
Tel: (202) 331-7282
Fax: (202) 857-3678
Manager: Mr. Alex Morr
Admission: free.
Established: 1916 *Membership:* N
Open: Tuesday, 10am-5pm; Wednesday, 2pm-5pm; Thursday, 10am-5pm; Friday, 2pm-5pm;
 Saturday, 10am-2pm; Sunday, 1pm-5pm.
Closed: August.
Facilities: **Architecture** (1802 home of James Monroe); **Galleries** (18).
Activities: **Exhibitions**.

The Arts Club of Washington occupies two of Washington's best known downtown houses, the Federal-style Monroe House (1802-1806) and the MacFeely House (1870). The Arts Club houses a permanent collection of portraits and 19th-century Western art and it also mounts temporary shows.

B'nai B'rith Klutznick National Jewish Museum

1640 Rhode Island Ave., N.W., Washington, DC 20036-3278
Tel: (202) 857-6572
Fax: (202) 857-1099
C.E.O.: Mr. Sidney Clearfield
Admission: voluntary contribution.
Attendance: 40,000 *Established:* 1957 *Membership:* Y *ADA Compliant:* Y

B'nai B'rith Klutznick National Jewish Museum, cont.

Open: Sunday to Friday, 10am-5pm.

Closed: Jewish Holidays, Legal Holidays.

Facilities: **Galleries; Jewish Sports Hall of Fame; Sculpture Garden; Shop.**

Activities: **Concerts; Education Programs; Films; Guided Tours; Lectures; Temporary Exhibitions.**

Publications: collection catalogue; exhibition catalogues.

The B'nai B'rith Klutznick National Jewish Museum addresses the entire sweep of Jewish culture and history from antiquity to the present day. The permanent collections consist of ritual and folk art that reflects the life and festival cycles of Jewish tradition, together with archaeological artifacts and diverse works by contemporary Jewish artists. Changing exhibitions highlight art, history, and ethnography, and explore Jewish culture within the context of other cultures. The Museum also houses the National Jewish American Sports Hall of Fame and the Holocaust Art Restitution Project.

Marc Chagall, *Lithograph of Asher Window at Hadassah Hospital, Jerusalem,* Lithographer: Ch. Sorlier, Paris, 1959-1961. Collection of National Jewish Museum. Photograph courtesy of B'nai B'rith Klutznick National Jewish Museum, Washington, D.C.

Catholic University of America - Salve Regina Art Gallery

Salve Regina Hall, First Floor, Harewood Road, Washington, DC 20064

Tel: (202) 319-5282

Internet Address: http://www.acad.cua.edu

Director: Mr. John Figura

Admission: free.

Open: Monday to Friday, 9am-5pm; Saturday, 1pm-5pm.

Facilities: **Exhibition Area**.

Activities: **Temporary Exhibitions** (7/academic year).

The Gallery presents exhibitions of work by students, faculty, and professional artists of local and national prominence. A juried exhibition of student work concludes the year's schedule each April.

Corcoran College of Art and Design - Hemicycle Gallery

17th St. and New York Ave., N.W., Washington, DC 20006-9484

Tel: (202) 639-1800

Fax: (202) 639-1802

Internet Address:
 http://www.corcoran.edu/csa/gallery/hemicy.htm

Director of School Exhibitions:
 Mr. Paul W. Brewer

Admission: free.

Established: 1890

ADA Compliant: Y

Parking: metered on street.

Open: Wednesday, 10am-5pm;
 Thursday, 10am-9pm;
 Friday to Monday, 10am-5pm.

Facilities: **Exhibition Area**.

Activities: **Temporary Exhibitions** (10/year).

Interior view, Hemicycle Gallery, Corcoran College of Art and Design. Photograph courtesy of Corcoran College of Art and Design, Washington, D.C.

The Hemicycle Gallery, considered by many to be the Corcoran Museum of Art's most beautiful gallery, was restored in 1991 as an exhibition center for the Corcoran College of Art and Design, a private college offering a four-year program of study leading to a BFA degree. The Gallery features the work of Corcoran senior students, alumni, and faculty, as well as contemporary artists from the region and beyond. March through May is reserved for thesis exhibitions of work by graduating seniors.

153

Washington, District of Columbia

The Corcoran Museum of Art

500 17th St., N.W. at New York Ave. (one block west and south of the White House)
Washington, DC 20006-4804
Tel: (202) 639-1700
Fax: (202) 639-1768
Internet Address: http://www.corcoran.org
Director: Mr. David C. Levy
Admission: suggested contribution: adult-$3.00, child-free, student-$1.00, senior-$1.00, family-$5.00.
Attendance: 250,000 *Established:* 1869 *Membership:* Y *ADA Compliant:* Y
Parking: metered on street and nearby commercial lots.
Open: Monday, 10am-5pm; Wednesday, 10am-5pm; Thursday, 10am-9pm; Thanksgiving, 10-5; Friday to Sunday, 10am-5pm.
Closed: New Year's Day, Christmas Day.
Facilities: **Architecture** Beaux Arts building (1897 designed by Ernest Flagg), Clark Wing (1925 designed by Charles Platt); **Food Services** Café des Artistes (daily, 11am-3pm; Thurs, 11am-8:30pm); **Galleries**; **Library** (16,000 volumes, use by appointment); **Shop**.
Activities: **Arts Festival**; **Concerts**; **Education Programs** (adults, graduate/undergraduate students and children); **Films**; **Gallery Talks**; **Guided Tours** (Daily, noon; also Sat-Sun, 10:30am & 2:30pm; Thurs, 7:30pm); **Lectures**; **Performances**; **Permanent Exhibits**; **Temporary Exhibitions**; **Traveling Exhibitions**.
Publications: annual report; calendar (monthly); exhibition catalogues.

Founded in 1869 by William Wilson Corcoran, the Corcoran Gallery of Art is the District's largest non-Federal museum and one of the oldest fine art museums in the nation. In addition to presenting a diverse program of exhibitions of historical and contemporary art assembled by the Gallery or by other leading art institutions from around the world, the Gallery presents concerts, lectures, and related public programs. It also maintains a fully accredited School of Art. Its permanent collection of over 14,000 objects features American and European art. The American works include early portraiture, landscapes (including a notable group of Hudson River School paintings), and contemporary art. Artists include Albert Bierstadt, Alexander Calder, Mary Cassatt, Thomas Cole, Willem de Kooning, John Kensett, John Singer Sargent, and James Abbott McNeill Whistler. The Evans-Tibbs Collection, one of the most respected assemblages of African American art, includes works by Grafton Tyler Brown, Aaron Douglas, William Harper, and Sylvia Snowdon. The strengths of the European holdings are the Clark Collection of Dutch, Flemish, and French paintings (including the Salon Doré, an 18th-century period room) and the Walker Collection of late 19th-century and early 20th-century French painting, with works by Courbet, Monet, Pissarro, and Renoir. Holdings also include over 6,500 prints and drawings and over 4,000 photographs. Special needs access is at 1701 E Street, around the corner from the 17th Street entrance.

Dumbarton Oaks Research Library and Collection

1703 32nd St., N.W. (east of Wisconsin Ave., between R and S Streets), Washington, DC 20007-2961
Tel: (202) 339-6410
Internet Address: http://www.doaks.org
Director: Angeliki Laiou
Admission: free (gardens in season, $4).
Attendance: 38,000 *Established:* 1940
Parking: on street, two hour limit weekdays.
Open: **Museum:**, Tuesday to Sunday, 2pm-5pm.
 Gardens: April to October, Daily, 2pm-6pm (admission fee, $4).
 Gardens: November to March, Daily, 2pm-5pm (free).
Closed: Legal Holidays, Christmas Eve, Garden closed in inclement Weather.
Facilities: **Architecture** (19th century Federal-style house; wing, 1963 designed by Philip Johnson); **Galleries**; **Gardens** (10 acres, formal gardens); **Research Library** (available to accredited scholars); **Shop** (books, cards).

Dumbarton Oaks Research Library and Collection, cont.

Activities: **Concerts**; **Guided Tours** (in advance, 339-6409); **Lectures**; **Permanent Exhibits**.

Publications: book, "Dumbarton Oaks"; catalogues; handbook, "The Byzantine Collection"; handbook, "The Robert Wood Bliss Collection of Pre-Columbian Art"; monographs.

A gift of Mildred and Robert Woods Bliss to Harvard University, Dumbarton House maintain research facilities in the areas of Byzantine studies, pre-Columbian studies, and the history of landscape architecture. The collections of Byzantine and pre-Columbian art and rare books and prints relating to gardens are on exhibit. Its Byzantine collection, consisting mainly of small, luxurious objects from the imperial, ecclesiastical, and secular realms ranks among the most important in the world. It also includes several illuminated manuscripts, pavement mosaics from Antioch, sculptures from the late Roman through middle Byzantine periods, and a small collection of textiles and post-Byzantine icons. Housed in the new wing designed by Philip Johnson, the collection of Pre-Columbian art includes objects from cultures that flourished in Mexico, Guatemala, Costa Rica, Panama, Colombia, and Peru.

Federal Reserve Board Art Gallery

20th and C Streets, N.W., Washington, DC 20551

Tel: (202) 452-3000

Fax: (202) 452-3102

Director: Ms. Mary Anne Goley

Admission: free.

Established: 1975

Parking: metered on street and commercial lots.

Open: Monday to Friday, 11am-2pm.

Closed: Legal Holidays.

Facilities: **Architecture** (1937 design by Paul Cret); **Gallery**.

Activities: **Temporary Exhibitions**.

Publications: exhibition brochures.

The central bank of the United States, the Federal Reserve Board initiated an art program in 1975 following a tradition set by foreign central banks. There is a public exhibition program and a permanent art collection of primarily American works dating from 1840 to the present. The collection may be viewed only by appointment.

Edith Mitchell Prellwitz, *Summer Landscape (Cornish)*, oil on canvas, 28½ x 37 inches. Gift of Samuel Prellwitz in honor of the Twentieth Anniversary of the Fine Arts Program, Federal Reserve Board. Photograph courtesy of Federal Reserve Board, Washington, DC.

Fondo del Sol Visual Arts Center/El Museo Fondo del Sol

2112 R St., N.W., Washington, DC 20008

Tel: (202) 483-2777

Fax: (202) 265-1078

Director: Marc Zuver

Admission: suggested contribution: adult-$3.00, child-free, student-$1.00, senior-$2.00.

Attendance: 50,000 *Established:* 1973

Membership: Y *ADA Compliant:* Y

Open: Wednesday to Saturday, 12:30pm-5:30pm.

Closed: Legal Holidays.

Facilities: **Exhibition Area** (2½ floors, 7 galleries); **Sculpture Garden**.

Activities: **Arts Festival** (annual Caribbean Arts Festival); **Concerts**; **Films**; **Guided Tours**; **Lectures**; **Readings**; **Temporary Exhibitions**; **Traveling Exhibitions**.

Publications: brochures (monthly); exhibition catalogues (annual).

Santero and other religious works, 19th-20th century, New Mexico/Puerto Rico/Mexico, Fondo del Sol Visual Arts and Media Center. Photograph courtesy of Fondo del Sol Visual Arts and Media Center, Washington, District of Columbia.

Fondo del Sol Visual Arts Center/El Museo Fondo del Sol, cont.

The second oldest Latino/Caribbean multicultural museum in the United States, the Fondo del Sol Visual Arts Center is a non-profit arts organization directed by artists and community members dedicated to presenting, promoting, and preserving the cultural heritage and arts of the Americas. The Center offers changing exhibitions of the work of contemporary artists/craftsmen and mounts periodic major national and international touring exhibits dealing with Latino, Mexican, Caribbean, and Afro American art and heritage. Additionally, the Center exhibits portions of its permanent collection of pre-Columbian art; 19th- and 20th-century santos and retablos from Mexico, New Mexico, and Puerto Rico; folk art; and contemporary art. The Museum has small sculpture garden with works by Pedro Lujan and Manuel Pereira.

Freer Gallery of Art

Jefferson Drive at 12th St., S.W., Washington, DC 20560

Tel: (202) 357-4880
Fax: (202) 357-4911
TDDY: (202) 786-2374
Internet Address: http://www.si.edu/asia
Director: Dr. Milo C. Beach
Admission: free.
Attendance: 583,000 *Established:* 1906
Membership: Y *ADA Compliant:* Y
Parking: limited free parking on mall.
Open: Daily, 10am-5:30pm;
 also Summer, Thursday, 5:30pm-8pm.
Closed: Christmas Day.
Facilities: **Architecture** (1923, designed by Charles Platt); **Auditorium** (300 seats); **Library** (55,000 volumes); **Reading Room**; **Shop**.
Activities: **Concerts**; **Dance Recitals**; **Films**; **Gallery Talks**; **Guided Tours** (Daily, 11:30am & 12:30pm); **Lectures**; **Temporary Exhibitions**.
Publications: "Ars Orientalis"; booklets; books; exhibition catalogues; monograph series, "Freer Gallery of Art Occasional Papers"; monogaph series, "Freer Gallery of Art Oriental Studies"; pamphlets.

View of North façade, Freer Gallery of Art. Photograph by John Tsantes, courtesy of Freer Gallery of Art, Washington, D.C.

A national museum of Asian art at the Smithsonian Institution, the Freer Gallery also houses a renowned collection of 19th- and early 20th-century American art, including a large group of works by James McNeill Whistler. Among the highlights of the Freer's collection of 26,000 works of Asian art are Japanese screens, ancient Chinese bronzes, jades, Indian painting, Buddhist sculpture, Korean ceramics, and Islamic arts of the book.

George Washington University - Dimock Gallery

Lower Lisner Auditorium, 730 21st St., N.W., Washington, DC 20052

Tel: (202) 994-1525
Fax: (202) 994-1632
Internet Address: http://www.gwu.edu/~dimock
Curator: Ms. Lenore D. Miller
Admission: free.
Attendance: 3,500 *Established:* 1964 *Membership:* N
Parking: metered on street.
Open: Tuesday to Friday, 10am-5pm.
Closed: Legal Holidays.
Facilities: **Gallery**.
Activities: **Lectures**; **Temporary Exhibitions** (8-10/year).
Publications: exhibition catalogues.

George Washington University - Dimock Gallery, cont.

Located on the lower level of Lisner Auditorium, the Dimock Gallery is the professional showcase for art within The George Washington University. Six to eight exhibitions are featured each year and include University-related shows, such as student, faculty, alumni, and permanent collection exhibitions, as well as shows of historical and contemporary importance, often with a focus on the Washington, DC area.

Georgetown University Art Gallery

Walsh Building 191, 1221 36th St., N.W., Washington, DC 20057

Tel: (202) 687-7010

Fax: (202) 687-3048

Internet Address: http://www.georgetown.edu/departments/AMT/gallery.html

Coordinator: Mr. John Morrell

Admission: free.

Open: Call for hours.

Facilities: **Exhibition Area.**

Activities: **Temporary Exhibitions.**

Publications: collection catalogue.

Located off the Walsh Building's main lobby on the ground floor, the art department's gallery presents regular exhibitions of work by faculty, visiting artists and students. Also of possible interest on campus, University memorabilia, decorative art, and works by European and American masters from the Georgetown University Antique and Art Collection are displayed in the Carroll Parlor, a period room located at 37th and O Streets (call for hours, 687-4406).

Hillwood Museum & Gardens

4155 Linnean Ave., N.W., Washington, DC 20008-3806

Tel: (202) 686-8500

Fax: (202) 966-7846

TDDY: (202) 363-3056

Internet Address: http://www.Hillwoodmuseum.org

Director: Mr. Frederick J. Fisher

Admission: reservation deposit required.

Attendance: 40,000 *Established:* 1977

Membership: Y *ADA Compliant:* Y

Open: **March to January,**
 Tuesday to Saturday, by reservation in advance.

Closed: Legal Holidays.

Facilities: **Architecture** (Federal-style former residence of Marjorie Merriweather Post, built 1926); **Food Services** Café; **Grounds and Gardens** (25 acres); **Library** (non-circulating, by appointment only); **Shop.**

Activities: **Concerts**; **Education Programs**; **Guided Tours**, **Audio Tours** .

Publications: collection catalogue, "A Taste for Splendor: Russian Imperial & European Treasures from the Hillwood Museum"; "Hillwood Collection Series"; "Hillwood Museum & Gardens: The Estate and Art Collections of Marjorie Merriweather Post"; newsletter, "The Post" (semi-annual).

Artist Unkown, *Nuptial Crown*, Photograph courtesy of Hillwood Museum, Washington, District of Columbia.

A decorative arts museum, Hillwood contains the largest assemblage of 18th- and 19th-century Russian objects, liturgical and decorative, outside Russia. It also houses an extensive collection of 18th-century European, primarily French, furniture and porcelain. More than 10,000 pieces are presented in a home setting, exhibited intact and interpreted as an art collector's home. Set among 25 acres of trees, azaleas and other flowering shrubs, Hillwood is also regarded for its collection of small gardens and plant specimens. Advance tour reservations are required.

Washington, District of Columbia

Hirshhorn Museum and Sculpture Garden - Smithsonian Institution

Independence Ave. at 7th St., S.W.
Washington, DC 20560
Tel: (202) 357-2700
Fax: (202) 786-2682
TDDY: (202) 633-8043
Internet Address: http;//www.si.edu/hirshhorn
Director: Mr. James T. Demetrion
Admission: free.
Attendance: 784,221 *Established:* 1966
Membership: N *ADA Compliant:* Y
Parking: limited free parking on mall and
 nearby commercial lots.
Open: **Fall to Spring**,
 Daily, 10am-5:30pm.
 Summer,
 Daily, 10am-5:30pm;
 also Thursday, 5:30pm-8pm.
Closed: Christmas Day.

Alexander Calder, *Two Disks*, 1965, painted steel plate and bolts, Gift of Joseph H. Hirshhorn, 1966. In background is exterior of Hirshhorn Museum. Photograph by Lee Stalsworth, courtesy of Hirshhorn Museum and Sculpture Garden, Washington, District of Columbia.

Facilities: **Architecture** (1974 design by Gordon Bunshaft); **Auditorium** (274 seats); **Exhibition Area** (galleries, total 60,000 square feet); **Food Services** Full Circle Café (outdoor plaza; Memorial Day to Labor Day, daily, 11:30am-3pm, Thursday to 8pm); **Library** (42,000 volumes, non-circulating, by appointment); **Sculpture Garden** (7:30am-dusk); **Shop** (catalogues, books, reproductions, jewelry, posters, toys).

Activities: **Concerts**; **Education Programs** (adults, graduate/undergraduate students and children); **Films**; **Gallery Talks**; **Guided Tours** (Mon-Fri,10:30am and noon; Sat-Sun, noon and 2pm; seasonal sculpture garden tours); **Lectures**, **Permanent Exhibits**; **Temporary/Traveling Exhibitions** (3 major and 6 smaller/year); **Workshops** ("Young at Art", "Improv Art", "Art Explores").

Publications: calendar (seasonal); collection catalogue, "A Garden for Art"; collection catalogue, "Hirshhorn Museum & Sculpture Garden: 150 Works of Art"; "Family Guide"; exhibition catalogues; gallery brochures.

The Museum is named after modern art collector Joseph H. Hirshhorn, whose gifts and bequest to the nation of more than 6,000 works of art form the core of the permanent collection of approximately 12,000 objects. Its modern sculpture collection is one of the most comprehensive in the United States. Other collection strengths are contemporary art, European painting since World War II, and American painting since the late 19th century. About 600 works from the permanent collection are on view in the galleries, plaza, and garden at any given time. In the galleries a representative sample of the Museum's holdings are presented in two long-term, floor-wide installations: "Celebrating Modern Art" and "Celebrating Contemporary Art". "Collection in Context" shows (lasting six months) interpret objects in the permanent collection, often using documentary materials and artifacts borrowed from other Smithsonian sources. Full-fledged retrospectives of an artist's oeuvre and groups shows elucidating today's art or recreating historical movements are presented in the second floor Special Exhibition galleries. The smaller "Directions" space on the third floor focuses on cutting-edge work by younger artists. Holdings include 5,000 paintings, 3,000 sculptures and mixed-media pieces, and 4,000 works on paper. Constantin Brancusi, Alexander Calder, Edgar Degas, Mark di Suvero, Alberto Giacometti, Henri Matisse, Henry Moore, Auguste Rodin and David Smith are all represented by important holdings in modern sculpture. Francis Bacon, Balthus, Willem de Kooning, Richard Diebenkorn, Jean Dubuffet, Edward Hopper, Frank Stella, and Clyfford Still are among 20th-century painters with significant holdings at the Hirshhorn. The spectrum and evolution of contemporary art are reflected in diverse works by Joseph Beuys, Chuck Close, Tony Cragg, Lucian Freud, Felix Gonzalez-Torres, Anish Kapoor, Anselm Kiefer, Brice Marden, Agnes Martin, Ana Mendieta, Elizabeth Murray, Bruce Nauman, Claes Oldenburg, Sigmar Polke, Gerhard Richter, Martin Puryear, Alison Saar, Wayne Thiebaud, Andy Warhol, Rachel Whiteread, and numerous others.

Howard University Gallery of Art

2455 6th St., N.W., Washington, DC 20059
Tel: (202) 806-6405
Fax: (202) 806-6503
Internet Address: http://www.founders.howard.edu/finearts/FineArts/GALLERy_FINAL/Gallery
Director: Dr. Tritobia H. Benjamin
Admission: free.
Established: 1928 *ADA Compliant:* Y
Parking: metered on street.
Open: **Academic Year**, Monday to Friday, 9:30am-5:30pm; Sunday, 1pm-4pm.
Closed: Legal Holidays.
Facilities: **Gallery**; **Print Study Room**.
Activities: **Permanent Exhibits**; **Temporary Exhibitions**; **Traveling Exhibitions**.
Publications: catalogues.

Serving as a study and research facility for the University and scholarly communities, the Gallery offers temporary exhibitions drawn from its permanent collections and from the work of nationally and internationally recognized artists. The Gallery's African American Collection, including paintings, sculpture, drawings, and prints, is one of the most extensive collections of works by black artists extant. Its African Art Collection includes traditional artifacts from the 18th through early 20th centuries. Other collections include Far Eastern and Decorative Arts, the Kress Study Collection (12 Renaissance and Baroque paintings), the Irving Gumbel Print Collection (European works from the 15th to 19th centuries), and the Twentieth Century Fine Art Collection (prints, paintings and tapestry, including a set of 14 wall hangings designed by Alexander Calder).

The Kreeger Museum

2401 Foxhall Road, N.W., Washington, DC 20007
Tel: (202) 337-3050
Fax: (202) 337-3051
Internet Address: http://www.kreegermuseum.com/
Director: Ms. Judy A. Greenberg
Admission: suggested contribution-$5.00.
Attendance: 13,000 *Established:* 1994
Membership: N *ADA Compliant:* Partial
Parking: free on site.
Open: **September to July**,
 Tues to Sat, 10:30am & 1:30pm.
Closed: New Year's Day, ML King Day,
 Presidents Day, Memorial Day,
 Independence Day, August, Labor Day,
 Columbus Day, Thanksgiving Day,
 Thanksgiving Friday, Christmas Eve,
 Christmas Day.

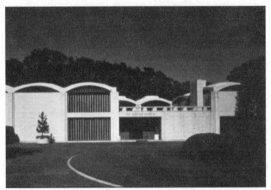

Exterior view of front of Kreeger Museum (1967), designed by architects Philip Johnson and Richard Foster. Photograph by Franko Khoury, courtesy of Kreeger Museum, Washington, District of Columbia.

Facilities: **Architecture** (former Kreeger residence, 1967 design by Philip Johnson and Richard Foster); **Grounds** (5½ wooded acres); **Library**.
Activities: **Artists Talks**; **Concerts**; **Group Tours** (up to 35, reserve in advance, 338-3552); **Guided Tours** (Tues-Sat, 10:30am and 1:30pm, by reservation only, 338-3552).

Located in upper Northwest Washington, The Kreeger Museum is a private, non-profit museum occupying the former residence of Carmen and the late David Lloyd Kreeger. Designed by architect Philip Johnson, it showcases the Kreegers' permanent art collection. Numbering approximately 180 works of art, it features 19th- and 20th-century painting and sculpture, as well as traditional African and Indian art. Two dimensional art in the collection includes works by Milton Avery, Max Beckmann, Georges Braque, Paul Cézanne, Marc Chagall, Jean Baptiste Camille Corot, Gustave Courbet, Edgar Degas, Nicholas de Stael, Jean Dubuffet, Arshile Gorky, Hans Hofmann, Wassily

The Kreeger Museum, cont.

Kandinsky, Joan Miró, Claude Monet, Edvard Munch, Pablo Picasso, Larry Poons, Pierre Auguste Renoir, James Rosenquist, Frank Stella, Clyfford Still, and Vincent van Gogh. Sculpture holdings include works by Jean Arp, Alexander Calder, Jacques Lipchitz, Aristide Maillol, Henry Moore, Isamu Noguchi, Auguste Renoir, Auguste Rodin, Medardo Rosso, David Smith, and Francesco Somaini. The Museum conducts two docent-escorted tours each day, Tuesday through Saturday. Advance reservations are required. Only the main floor of the Museum is accessible to the disabled. Children under twelve are not admitted.

National Gallery of Art

On the National Mall
(between 3rd and 9th Streets at Constitution Ave., N.W.)
Washington, DC 20565
Tel: (202) 737-4215
Fax: (202) 842-2356
TDDY: (202) 842-6176
Internet Address: http://www.nga.gov
Director: Dr. Earl A. Powell, III
Admission: free.
Attendance: 6,000,000 *Established:* 1937
Membership: Y *ADA Compliant:* Y
Parking:
 limited free parking on mall and metered on streets.
Open: Monday to Saturday, 10am-5pm;
 Sunday, 11am-6pm.
Closed: New Year's Day, Christmas Day.

View of the West Building of the National Gallery of Art (1941), looking east towards the U.S. Capitol along Constitution Avenue. Photograph by Dennis Brack/Black Star, courtesy of the National Gallery of Art.

Facilities: **Architecture** (East Building, 1978 designed by I.M. Pei; West Building, Neo-Classical, 1941 design by John Russell Pope); **Food Services** Cascade Café, Cascade Buffet, Coffee Bar, Garden Café, Terrace Café; **Galleries**; **Library** (scholars and art researchers by appointment only, 842-6511); **Shops** (4 locations).

Activities: **Concert Series**; **Education Programs** (children); **Films**; **Lectures**; **Permanent Exhibits**; **Special Exhibitions** (15-20/year); **Tours**.

Publications: annual report; calendar of events (bi-monthly); calendar of films; collection catalogues; exhibition catalogues.

A gift of Andrew W. Mellon to the nation, the Gallery was established by joint resolution of Congress in 1937. The Gallery's permanent collection of some 100,000 paintings, drawings, prints, photographs, sculpture, and decorative art traces the development of Western art from the Middle Ages to the present. The original structure, the West Building, which opened to the public in 1941, includes European (13th - early 20th century) and American (18th - early 20th century) works. A comprehensive survey of Italian painting and sculpture, including the only painting by Leonardo da Vinci in the Western Hemisphere is presented here. Rich in Dutch masters and French impressionists, the collection offers excellent surveys of American, British, Flemish, Spanish, and 15th- and 16th-century German art. Visitors are also invited to explore the Micro Gallery, a comprehensive, interactive, multi-media computer system. The Gallery's newer East Building, funds for the construction of which were given by the son and daughter of the founder and The Andrew W. Mellon Foundation, opened to the public in 1978. It was planned to accommodate the Gallery's growing collection and expanded exhibition schedule, as well as to house the Center for Advance Study in the Visual Arts, a research library, an increasingly large collection of drawings and prints, an extensive photographic archive, and administrative offices. It is especially suited for displaying contemporary art; among the major 20th-century artists represented in the collection are Calder, Matisse, Miró, Picasso, Pollock, and Rothko. Additionally, the National Gallery of Art Sculpture Garden, given to the nation by The Morris and Gwendolyn Cafritz Foundation, is located on the Mall at 7th Street and Constitution Avenue. It presents seventeen major works in a 6.1-acre landscaped setting. Included are important new acquisitions of post-World War II sculpture by such internationally-renowned artists as Louise Bourgeois, Mark di Suvero, Roy Lichtenstein, Claes Oldenburg and Coosje van Bruggen, and Tony Smith.

National Gallery of Caricature and Cartoon Art

1317 F St, N.W., Ground Floor, Washington, DC 20004
Tel: (202) 638-6411
Admission: free.
Established: 1998
Open: Tuesday to Saturday, 11am-4pm.
Facilities: **Exhibition Area.**
Activities: **Education Programs; Permanent Exhibits; Temporary Exhibitions.**

The basis of the permanent collection is the private collection of editorial cartoonist Art Wood, totaling 45,000 original works by 3,000 artists and spanning the period from 1747 to the present.

National Museum of African Art, Smithsonian Institution

950 Independence Ave., S.W., Washington, DC 20560
Tel: (202) 357-4600
Fax: (202) 357-4879
TDDY: (202) 357-4814
Internet Address: http://www.si.edu/nmafa
Director: Dr. Roslyn A. Walker
Admission: free.
Attendance: 281,000 *Established:* 1964
Membership: N *ADA Compliant:* Y
Parking: on street, limited.
Open: Daily, 10am-5:30pm.
Closed: Christmas Day.
Facilities: **Archives** (300,000 photographs and transparencies; 120,000 feet of unedited film, videos); **Exhibition Area**; **Library** (20,000 volumes; Mon-Fri, 9am-5:15pm, by appointment); **Shop.**
Activities: **Demonstrations; Education Programs** (college students); **Films; Guided Tours; Lectures; Performances.**

Kweku Kakanu, Flag, ca. 1935, cotton, 42½ x 60 inches, Fante/Ghanaian, Museum purchase, National Museum of African Art. Photograph by Franko Khoury, courtesy of National Museum of African Art, Smithsonian Institution, Washington, District of Columbia.

Publications: exhibition catalogues; pamphlets.

Founded in 1964 as a private institution, the Museum became part of the Smithsonian Institution in 1979. The Museum celebrates the visual traditions of the diverse cultures of Africa and fosters an appreciation of African art and civilizations. While the Museum's primary focus is collecting and exhibiting the traditional arts of sub-Saharan Africa, it collects and exhibits the arts of northern Africa and the ancient and contemporary arts of the entire continent. Exhibitions on the Museum's first level are drawn from the permanent collection of over 7,000 objects. Primary works in wood, metal, ceramics, cloth, and ivory, as well as new acquisitions are exhibited on a rotating basis. Highlights of the permanent collection include collections of royal Benin art and central African ceramics. Small experimental exhibitions, usually focused on works from the permanent collection, are also presented on the first level. A gallery devoted to major temporary exhibitions is located on the second level.

National Museum of American Art, Smithsonian Institution

8th and G Streets, N.W., Washington, DC 20560
Tel: (202) 357-2700
Fax: (202) 357-3108
TDDY: (202) 357-1729
Internet Address: http://www.nmaa.si.edu
Director: Dr. Elizabeth Broun
Admission: free.
Attendance: 400,000 *Established:* 1846 *Membership:* Y *ADA Compliant:* Y
Parking: metered on street and nearby commercial lots.
Open: Closed for renovations until 2003.
Closed: Christmas Day.

National Museum of American Art, cont.

Facilities: **Architecture** (Greek Revival Old Patent Office, 1836 design by Robert Mills, completed 1867); **Food Services** Patent Pending Cafeteria (daily, 10am-3:30pm); **Galleries**; **Lecture Hall**; **Shop.**

Activities: **Concerts**; **Education Programs**; **Films**; **Guided Tours** (Weekdays, noon & 2pm); **Lectures**; **Permanent Exhibits**; **Temporary Exhibitions**; **Traveling Exhibitions.**

Publications: books; calendar (monthly); exhibition catalogues; journal, "American Art".

The National Museum of American Art of the Smithsonian Institution houses the first federal art collection. The museum grew out of gifts from private collections and art organizations established in the nation's capital during the two decades preceding the founding of the Smithsonian in 1846. Today the collection contains more than 37,500 works in all media, spanning more than 300 years of the nation's artistic achievement. Officially designated the National Museum of American Art by an act of Congress in 1980, it has since then been devoted exclusively to this country's art and artists. All regions, cultures, and traditions in the United States are now represented in the museum's holdings, research resources, exhibitions, and public programs. Colonial portraiture, 19th-century landscape, American impressionism, 20th-century realism and abstraction, New Deal projects, sculpture, photography, graphic arts, crafts, and the work of self-taught artists are featured in the galleries. The permanent collection includes early American paintings from

William H. Johnson, *Going to Church*, c. 1940-41, oil on burlap, 38 1/8 x 45½ inches. Gift of the Harmon Foundation, National Museum of American Art. Photograph courtesy of the National Museum of American Art, Smithsonian Institution, Washington, District of Columbia.

the colonial and federal periods by John Singleton Copley, John Trumbull, and Charles Willson Peale; Hispanic colonial art; landscape paintings by Alvan Fisher, Thomas Cole, Thomas Moran, and Albert Bierstadt; more than 450 paintings from George Catlin's Indian Gallery; American Impressionist and Gilded Age art, including in-depth holdings of works by Thomas Wilmer Dewing, Childe Hassam, Albert Pinkham Ryder, and John Twachtman, as well as works by Mary Cassatt, Winslow Homer, John LaFarge, John Singer Sargent, Abbott H. Thayer, and James McNeill Whistler; more than 2,000 artworks by African-American artists. including extensive holdings by William H. Johnson, as well as works by Robert Scott Duncanson, Henry Ossawa Tanner, Romare Bearden, Jacob Lawrence, Lois Mailou Jones, and Sam Gilliam; 20th century art including works by David Bates, William Christenberry, Gene Davis, Stuart Davis, Eric Fischl, David Hockney, Edward Hopper, Luis Jiménez, Willem de Kooning, Franz Kline, Lee Krasner, Ellsworth Kelly, Morris Louis, Kenneth Noland, Georgia O'Keeffe, Pepón Osorio, Nam June Paik, Robert Rauschenberg, Frank Romero, Pat Steir, Renée Stout, Mark Tansey, and Masami Teraoka; the Herbert Waide Hemphill, Jr. collection of more than 400 works of folk art; and photographs, including masterworks by such early photographers as Carleton Watkins, John K. Hillers, and William H. Jackson and extensive holdings by Aaron Siskind and Irving Penn. The museum also has the nation's largest collection of art produced for projects of the New Deal, including numerous studies for post office murals, including work by Moses Soyer, Agnes Tait, and Stuart Davis. The Museum's holdings of sculpture feature works by 19th-century masters Hiram Powers, Edmonia Lewis, and Augustus Saint-Gaudens, as well as by distinguished 20th-century artists such as Paul Manship, Louise Nevelson, and Isamu Noguchi. The Renwick Gallery of the National Museum of American Art, exhibiting American craft and decorative arts, is located in a separate building across from the White House. The Old Patent Office Building is also the home of the National Portrait Gallery. (For further information on the Renwick Gallery and the National Portrait Gallery, see separate listings.) While the Museum is closed, five hundred of its finest artworks will tour the United States.

The National Museum of Women in the Arts (NMWA)

1250 New York Ave., N.W., Washington, DC 20005
Tel: (202) 783-5000
Fax: (202) 393-3235
Internet Address: http://www.nmwa.org
Exec. Director: Nancy Risque Rohrbach
Admission: suggested contribution:
 adult-$3.00, student-$2.00, senior-$2.00.
Attendance: 110,000 *Established:* 1981
Membership: Y *ADA Compliant:* Y
Parking: metered on street and nearby commercial lots.
Open: Monday to Saturday, 10am-5pm; Sunday, noon-5pm.
Closed: New Year's Day, Thanksgiving Day, Christmas Day.
Facilities: **Architecture** (Renaissance Revival former Masonic
 Temple, 1907 design by Waddy Butler Wood); **Auditorium**
 (200 seats); **Classrooms**; **Exhibition Area** (2 floors, plus
 Great Hall and Library); **Food Services** Café (Mon-Sat,
 11:30pm-2:30pm); **Library** (8,000 volumes, use by
 appointment; Mon-Fri, 10am-5pm); **Shop**.
Activities: **Concerts**; **Education Programs** (adults and chil-
 dren); **Films**; **Guided Tours** (reserve in advance); **Lectures**;
 Temporary Exhibitions; **Traveling Exhibitions**.

Elisabeth Vigée-Le Brun, *Portrait of Princes Belozersky*, 1798, National Museum of Women in the Arts. Photograph courtesy of National Museum of Women in the Arts, Washington, District of Columbia.

Publications: brochure; exhibition catalogues; magazine, "Women in the Arts" (quarterly).

The Museum is dedicated to acquiring, preserving, exhibiting, and researching the work of women artists of all periods and nationalities. The permanent collection provides a comprehensive survey of art by women from the 16th century to the present. Beginning with such early works as "Holy Family with St. John" by Renaissance artist Lavinia Fontana, the collection ranges from floral still lifes by Rachel Ruysch and prints by Mary Cassatt to sculpture by Camille Claudel and photographs by Louise Dahl-Wolfe. Other well-known artists in the collection include Rosa Bonheur, Helen Frankenthaler, Frida Kahlo, Georgia O'Keeffe, Alma Thomas, and Elisabeth Vigée-Le Brun. Other special collections include over 100 silver objects by 18th-century women silversmiths and the botanical and zoological prints of Maria Sibylla Merian. NMWA's special exhibitions include historic exhibitions, individual and group shows highlighting modern and contemporary art, and thematic shows examining women's changing roles in society.

National Portrait Gallery, Smithsonian Institution

F St. at 8th St., N.W., Washington, DC 20560
Tel: (202) 357-2700
Fax: (202) 357-2307
TDDY: (202) 357-1729
Internet Address: http://www.npg.si.edu
Director: Mr. Marc Pachter
Admission: free.
Attendance: 350,000 *Established:* 1962 *ADA Compliant:* Y
Parking: metered on street and nearby commercial lots.
Open: Closed for renovations until 2003.
Closed: Christmas Day.
Facilities: **Architecture** (Old Patent Office, 1836 design by
 Robert Mills, completed 1867); **Auditorium** (100 seats);
 Classrooms; **Food Services** Patent Pending Café (Daily,
 10am-3:30pm); **Galleries**; **Library** (60,000 volumes); **Reading
 Room**); **Shop**.

Edgar Degas, *Mary Cassatt*, Gift of Morris and Gwendolyn Cafritz Foundation and Regents' Major Acquisitions Fund, Smithsonian Institution. Photograph courtesy of National Portrait Gallery, Smithsonian Institution, Washington, District of Columbia.

National Portrait Gallery, Smithsonian Institution, cont.

Activities: **Education Programs** (adults and children); **Films**; **Gallery Talks**; **Guided Tours** (Mon-Fri, 10am-3pm by request; Sat-Sun, 11:15am & 1pm); **Lectures**; **Permanent Exhibits**; **Temporary Exhibitions**.

Publications: collection catalogues; exhibition catalogues.

Sharing the Greek Revival Old Patent Office Building with the National Museum of American Art (see separate listing), the National Portrait Gallery exhibits portraits and statues of individuals "who have made a significant contribution to the history, development, and culture of the people of the United States." Portraits are admitted to the permanent collection ten years after the subject's death; portraits of Presidents of the United States and others under special circumstances may be accepted earlier for later addition to the collection. The permanent collection of more than 16,000 works is supplemented by an array of special collections and a study collection. While the building is closed for renovations, several exhibitions organized by the Gallery, including four drawn from the Gallery's permanent collection, will tour the United States and abroad.

Organization of American States - Art Museum of the Americas

201 18th St., N.W., Washington, DC 20006

Tel: (202) 458-6016

Fax: (202) 458-6021

Director: Ms. Ana Maria Escallon

Admission: free.

Attendance: 50,000 *Established:* 1976 *Membership:* Y

Parking: metered on street.

Open: Tuesday to Saturday, 10am-5pm.

Closed: Major Holidays.

Facilities: **Galleries**; **Library**.

Activities: **Films**; **Guided Tours**; **Lectures**; **Temporary Exhibitions**; **Traveling Exhibitions**.

Publications: calendar (quarterly); exhibition catalogues.

With its unique regional focus, the Art Museum of the Americas is an important repository of Caribbean and Latin American art. The Museum houses a permanent collection and also presents temporary exhibitions. The Spanish colonial style building was designed by Paul Cret and built in 1912 as the residence for the Secretaries General of the OAS. The permanent collection of the Museum numbers almost 2,000 objects of 20th-century Latin American art in various media: painting, sculpture, prints, and drawings.

The Phillips Collection

1600 21st St., N.W., Washington, DC 20009

Tel: (202) 387-2151

Fax: (202) 387-2436

Internet Address:
 http://www.phillipscollection. org

Chief Curator: Mr. Jay Gates

Admission: weekend fee/weekday contribution:
 adult-$7.50, child-free, student/senior-$4.00.

Attendance: 200,000 *Established:* 1921

Membership: Y *ADA Compliant:* Y

Parking:
 metered on street and nearby commercial lots.

Open: Tuesday to Wednesday, 10am-5pm;
 Thursday, 10am-8:30pm;
 Friday to Saturday, 10am-5pm;
 Sunday, noon-7pm.
 Summer, Hours may vary.

Pierre-Auguste Renoir, *Luncheon of the Boating Party*, c. 1880-81, oil on canvas, Phillips Collection. Photograph courtesy of Phillips Collection, Washington, District of Columbia.

Closed: New Year's Day, Independence Day, Thanksgiving Day, Christmas Day.

Facilities: **Architecture** (Georgian Revival residence, 1897); **Food Services** Café (Tues-Sat, 10:45am-4:30pm, Sun, noon-6pm); **Library** (8,000 volumes, open to public by appointment); **Shop**.

The Phillips Collection, cont.

Activities: **Concerts** (Sept-May, Sun, 5pm); **Gallery Talks** (1st and 3rd Thurs in month, 12:30pm); **Lectures; Permanent Exhibits; Public Tours** (Wed & Sat, 2pm; group, reserve one month in advance); **Temporary Exhibitions.**

Publications: brochures; exhibition catalogues; members' bulletin; self-guided walking tour map.

In 1921 Duncan Phillips, an heir to the Jones and Laughlin steel fortune, as a memorial to his father and brother created a museum of modern art and its sources in two rooms of his family home. Now occupying the complete home and an annex, The Phillips Collection remains a uniquely intimate setting in which to experience some of the world's finest paintings. European painters represented in the collection include Bonnard, Braque, Cézanne, Chardin, Degas, El Greco, Gauguin, Klee, Manet, Matisse, Monet, Picasso, Renoir, van Gogh, and Vuillard. American artists are equally celebrated in the collection with works by Diebenkorn, Dove, Eakins, Hartley, Homer, Jacob Lawrence, Marin, Pippin, Prendergast, Rothko, Ryder, and Whistler. The Collection also presents an active schedule of temporary exhibitions.

Renwick Gallery of National Museum of American Art, Smithsonian Institution

Pennsylvania Ave. at 17th St., N.W.
Washington, DC 20006
Tel: (202) 357-2531
Fax: (202) 786-2810
TDDY: (202) 357-1729
Internet Address: http://www.nmaa.si.edu/
Curator-in-Charge: Mr. Kenneth R. Trapp
Admission: free.
Attendance: 200,000 *Established:* 1972
ADA Compliant: Y
Parking:
 metered on street and nearby commercial lots.
Open: Daily, 10am-5:30pm.
Closed: Christmas Day.

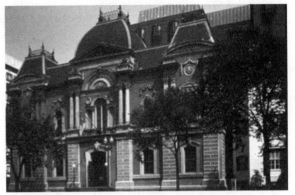

Exterior view of Renwick Gallery at Pennsylvania Avenue and 17th Street. Photograph courtesy of National Museum of American Art, Smithsonian Institution, Washington, District of Columbia.

Facilities: **Architecture** (2nd Empire-style building, 1859 design by James Renwick, Jr.); **Gallery; Shop.**

Activities: **Concerts; Demonstrations; Films; Guided Tours** (group, Monday-Friday, 10am/11am/1pm, reservations 3 weeks in advance); **Lectures; Temporary Exhibitions.**

Publications: calendar (monthly); exhibition catalogues; pamphlets.

The Renwick Gallery of the National Museum of American Art, located in a historic Second Empire-style building across from the White House, exhibits American crafts and decorative arts and includes the Grand Salon and Octagon period rooms furnished in the styles of the 1860s and 1870s. The Gallery features a permanent collection of outstanding contemporary works in glass, ceramics, wood, fiber, and metal. Complementing the acquisition program are exhibitions, fellowships for scholarly research in the modern craft movement, and a variety of educational programs, including lectures, craft demonstrations, and films. Barrier free access is available via a ramp on 17th St. The Renwick Gallery's parent organization, the National Museum of American Art (see separate listing) is located at 8th and G Streets, Northwest.

The Textile Museum

2320 S St., N.W., Washington, DC 20008
Tel: (202) 667-0441
Fax: (202) 483-0994
Internet Address: http://www.textilemuseum.org
Director: Ms. Ursula E. McCracken
Admission: suggested contribution-$5.00.
Attendance: 30,000 *Established:* 1925 *Membership:* Y *ADA Compliant:* Y
Parking: metered on street, 2 hour limit.

The Textile Museum, cont.

Open: Monday to Saturday, 10am-5pm;
Sunday, 1pm-5pm.

Closed: Legal Holidays.

Facilities: **Architecture** (Myers family residence, 1912 design by John Russell Pope; gallery building, 1908 design by Waddy B. Wood); **Exhibition Area**; **Library** (16,000 volumes); **Shop** (books, jewelry, handmade scarves, ethnographic textiles).

Activities: **Classes and Workshops**; **Films**; **Gallery Talks**; **Guided Tours** (Sept-May, Wed/Sat/Sun, 2pm); **Lectures**; **Temporary Exhibitions**; **Traveling Exhibitions**.

Publications: "Bulletin" (quarterly); books on collection; exhibition catalogues; journal (annual).

Exterior view of The Textile Museum. Photograph by Charles Rumph, copyright The Textile Museum, Washington, District of Columbia.

The Textile Museum is devoted exclusively to the hand-made textile arts, presenting several exhibitions each year, which range from Oriental carpets to contemporary fibre art. The Textile Learning Center at The Textile Museum provides an opportunity for visitors to learn about how textiles are made and their cultural and artistic significance. Two galleries comprise the Center: the Activity Gallery and the Collections Gallery. In the Activity Gallery, visitors can look, touch, and try a variety of hands-on activities including learning where natural dyes come from or how to spin wool. Visitors can also explore textiles and their relationship to tradition, economy, environment, and lifestyle. In the Collections Gallery, visitors can see the wealth and diversity of The Textile Museum's collections of non-Western historic and ethnographic rugs and textiles. The Museum's collection of Oriental carpets is particularly extensive with strengths in Turkish, Caucasian, Chinese, Egyptian (Mamluk), Spanish, and Persian carpets. Its collections of Coptic, Islamic, and pre-Columbian Peruvian textiles are also among the finest in the world. Additionally, the Museum has significant holding of the textiles of India, Indonesia, China, and Africa, as well as 20th-century ethnographic textiles from the Americas.

Florida

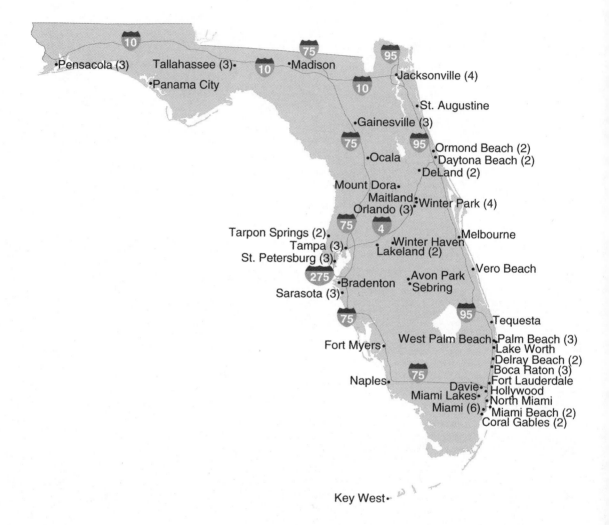

•Pensacola (3) Tallahassee (3)• •Madison
•Panama City
Jacksonville (4)
•St. Augustine
•Gainesville (3)
Ormond Beach (2)
•Ocala •Daytona Beach (2)
•DeLand (2)
Mount Dora•
Maitland• Winter Park (4)
Orlando (3)•
Tarpon Springs (2)• •Melbourne
Tampa (3)• •Winter Haven
St. Petersburg (3)• Lakeland (2)
•Vero Beach
Avon Park•
•Bradenton •Sebring
Sarasota (3)•
•Tequesta
West Palm Beach•Palm Beach (3)
Fort Myers• •Lake Worth
•Delray Beach (2)
•Boca Raton (3)
Naples• Fort Lauderdale
Davie• •Hollywood
Miami Lakes• •North Miami
Miami (6)• •Miami Beach (2)
Coral Gables (2)

Key West•

The number in parentheses following the city name indicates the number of museums/galleries in that municipality. If there is no number, one is understood. For example, in the text six listings would be found under Miami and one listing under Naples.

Florida

Avon Park

South Florida Community College - Museum of Florida Art and Culture

South Florida Community College Campus, 600 W. College Drive, Avon Park FL 33825

Tel: (863) 382-6900

Internet Address: http://www.mofac.org

Director: Mr. Jim Fitch

Admission: free.

Open: Call for hours.

Facilities: Exhibition Area.

Activities: **Guided Tours** (groups, reserve in advance); **Temporary Exhibitions** (6-8 weeks).

The Museum is dedicated to the artists of Florida whose work in any medium is visually linked to Florida's history, heritage, or environment. Works on display include examples by the Highwaymen, of the art movement known as the Indian River School.

Boca Raton

Boca Raton Museum of Art

801 W. Palmetto Park Road, Boca Raton, FL 33486

Tel: (561) 392-2500

Fax: (561) 391-6410

Internet Address: http://www.bocamuseum.org/

Exec. Director: Mr. George S. Bolge

Admission: fee: adult-$3.00, child-free, student-$1.00, senior-$2.00.

Attendance: 100,000 *Established:* 1950 *Membership:* Y *ADA Compliant:* Y

Parking: free on site.

Open: Tuesday, 10am-4pm; Wednesday, 10am-8pm; Thursday to Friday, 10am-4pm;
 Saturday to Sunday, noon-4pm.

Closed: Legal Holidays.

Facilities: **Classroom**; **Gallery**; **Library**; **Sculpture Garden**; **Shop**.

Activities: **Arts Festival**; **Concerts**; **Films**; **Gallery Talks**; **Guided Tours**; **Lectures**; **Traveling Exhibitions**.

Publications: exhibition catalogues; newsletter.

The Boca Raton Museum of Art houses a permanent collection of international, historic, modern, and contemporary art, including works by Matisse, Nevelson, Picasso, and Steichen, as well as West African and Oceanic art. It also presents a diverse schedule of temporary exhibitions.

Florida Atlantic University - University Galleries

77 Glades Road, Boca Raton, FL 33431-0991

Tel: (561) 297-2966

Fax: (561) 367-2166

Internet Address: http://www.fau.edu/galleries

Director: W. Rod Faulds

Admission: free.

Open: Tuesday, noon-4pm; Wednesday, 1pm-6pm; Thursday to Friday, noon-4pm;
 Saturday, 1pm-4pm.

Facilities: **Galleries** (2).

Activities: **Temporary Exhibitions**.

The University maintains two galleries, which serve to present and interpret a wide range of visual arts and other humanities disciplines through exhibitions and exhibition-related public programs such as lectures, performances, and films. The primary focus of both galleries is innovative contemporary art. The Schmidt Center Gallery, located in the Dorothy F. Schmidt Center for the Performing Arts, features six to eight presentations each year of contemporary visual art by regionally, nationally, and internationally recognized artists. As a more formal and publicly accessible space than the Ritter Art Gallery, The Schmidt Center Gallery seeks to present exhibition programs of interest to both university and public audiences in the South Florida region. The gallery will occasionally

Boca Raton, Florida

Florida Atlantic University - University Galleries, cont.

also present anthropology, history, and other humanities-based exhibitions, supporting the wider mission of the Schmidt College of Arts and Humanities, in collaboration with its faculty and selected outside scholars. The Ritter Gallery, located on the upper level of the Breezeway east of the Wimberly Library, presents six to eight exhibitions each year, many of which provide FAU art students with their initial experiences in public presentation of their work. The gallery is also available to students and college professors representing other humanities disciplines that can be interpreted through exhibiting historic or contemporary material culture. Finally, the gallery seeks to present non-traditional or experimental visual art and other presentations that may benefit from the informal nature of this gallery space.

International Museum of Cartoon Art

201 Plaza Real, Boca Raton, FL 33432
Tel: (561) 391-2200
Fax: (561) 391-2721
Internet Address: http://www.cartoon.org/home.htm
Curator: Mr. Stephen Charla
Admission: fee: adult-$6.00, child-$3.00, student-$4.00, senior-$5.00.
Attendance: 50,000 *Established:* 1974 *Membership:* Y *ADA Compliant:* Y
Parking: on street.
Open: Tuesday to Saturday, 10am-6pm; Sunday, noon-6pm.
Closed: New Years Day, Thanksgiving Day, Christmas Day.
Facilities: **Classrooms**; **Exhibition Area**; **Food Services** Café; **Library** (10,000 volumes); **Rental Gallery**; **Sculpture Garden**; **Shop**; **Theatre**.
Activities: **Education Programs** (adults and children); **Films**; **Guided Tours**; **Lectures**; **Temporary Exhibitions**; **Traveling Exhibitions**.
Publications: magazine, "Inklings" (quarterly).

The permanent collection of the International Museum of Cartoon Art consists of over 160,000 original drawings of every genre of cartoon art: animation, comic books, comic strips, gag cartoons, illustration, editorial cartoons, greeting cards, caricature, graphic novels, sports cartoons, and computer-generated art.

Bradenton

Art League of Manatee County

209 9th St., West, Bradenton, FL 34205
Tel: (941) 746-2862
Fax: (941) 746-2319
Director: Ms. Patricia H. Richmond
Admission: voluntary contribution.
Attendance: 6,000 *Established:* 1937 *Membership:* Y *ADA Compliant:* Y
Open: **September to July**, Monday to Friday, 9am-4:30pm.
Closed: New Year's Day, Good Friday, Memorial Day, Independence Day, Christmas Day.
Facilities: **Exhibition Area**; **Library** (750 volumes, non-circulating, by permission); **Reading Room**; **Shop**.
Activities: **Arts Festival**; **Classes**; **Education Programs** (adults and children); **Films**; **Gallery Talks**; **Lectures**.
Publications: newsletter (monthly); yearbook (annual).

The Art League presents temporary exhibitions.

Coral Gables

Latin American Art Museum

4006 Aurora St., Coral Gables, FL 33146
Tel: (305) 444-7060
Fax: (305) 261-6996
Internet Address: http://sss.latinoweb.com/museo/

Latin American Art Museum, cont.

Director: Mr. Raul Oyuela
Admission: free.
Attendance: 10,000 *Established:* 1991
Membership: Y *ADA Compliant:* Y
Open: Tuesday to Friday, 11am-5pm;
 Saturday, 11am-4pm.
Facilities: **Exhibition Area** (6,500 square feet).
Activities: **Lectures**; **Music**; **Readings**.
Publications: exhibition catalogues (monthly).

The Florida Museum of Hispanic and Latin American Art is dedicated to the preservation, diffusion, and promotion of Hispanic and Latin American contemporary art. It mounts eleven temporary exhibitions per year of the work of artists from Spain and throughout Latin America, and it has a permanent collection of over 400 works.

Rimaj Sunqo Barrientos, *Retrato de una familia (Portrait of a Family)*, triptych, 120.5 x 80 inches. Latin American Art Museum. Photograph courtesy of Latin American Art Museum, Coral Gables, Florida.

University of Miami - Lowe Art Museum

1301 Stanford Drive, Coral Gables, FL 33124-6310
Tel: (305) 284-3535
Fax: (305) 284-2024
Internet Address: http://www.lowemuseum.org
Director: Mr. Brian A. Dursum
Admission: fee: adult-$5.00, child-free, student-$3.00, senior-$3.00.
Attendance: 106,000 *Established:* 1950 *Membership:* Y *ADA Compliant:* Y
Parking: pay on site.
Open: Tuesday to Wednesday, 10am-5pm; Thursday, noon-7pm; Friday to Saturday, 10am-5pm; Sunday, noon-5pm.
Closed: Legal Holidays.
Facilities: **Classrooms**; **Galleries**; **Library** (5,000 volumes, non-circulating); **Sculpture Garden**; **Shop**.
Activities: **Arts Festival**; **Concerts**; **Education Programs** (children); **Films**; **Gallery Talks**; **Lectures**; **Permanent Exhibits**; **Temporary Exhibitions**; **Traveling Exhibitions**.
Publications: catalogues; newsletter (quarterly).

The Lowe Art Museum houses an extensive collection of art from around the world, including Egyptian, Greek, and Roman antiquities; the Samuel H. Kress Collection of Renaissance and Baroque Art (works by Cranach the Elder, Guardi, della Robbia, and Tintoretto); European art (works by Dandini, Gainsborough, Monet, Gauguin, and Picasso); American art (works by Allston, Rembrandt Peale, Bierstadt, Inness, Henri, Sloan, Lichtenstein, Stella, Botero, Grooms, Nevelson, Warhol, and Lam); Native American art (particular strength in both North and South American textiles); Pre-Columbian art (art in all media representing diverse cultures from Mexico to Chile); African art (objects from various sub-Saharan cultures of West Africa); and Asian art (objects from China, Korea, Japan, and South Asia, including Chinese ceramics from the Neolithic Period to the 20th century, Indian stone sculpture, and Tibetan and Nepalese bronze miniatures).

Davie

Broward Community College Fine Arts Gallery

3501 SW Davie Road, Davie, FL 33314
Tel: (954) 475-6517
Internet Address: http://fs.broward.cc.fl.us/central/art/gallery.html
Admission: free.
Open: Monday to Friday, 9am-2pm; Saturday, 10am-3pm.

Davie, Florida

Broward Community College Fine Arts Gallery, cont.
Facilities: **Exhibition Area.**
Activities: **Juried Exhibit** (annual); **Temporary Exhibitions.**
The Gallery presents exhibitions of work in a variety of media by students and professional artists.

Daytona Beach

Daytona Beach Community College - Southeast Museum of Photography
Daytona Beach Community College, Building 37, 1200 W. International Speedway Blvd.
Daytona Beach, FL 32114
Tel: (904) 254-4475
Fax: (904) 254-4487
TDDY: (904) 254-3023
Internet Address: http://www.dbcc.cc.fl.us /dbcc/htm/smp/smp home.htm
Director: Ms. Alison Devine Nordstrom
Admission: voluntary contribution.
Attendance: 40,000 *Established:* 1979
Membership: Y *ADA Compliant:* Y
Parking: on campus.
Open: Monday, 9:30am-4:30pm;
 Tuesday, 9:30am-7pm;
 Wednesday to Friday, 9:30am-4:30pm;
 Saturday to Sunday, noon-4pm.
Closed: Legal Holidays.
Facilities: **Auditorium** (500 seats); **Exhibition Area** (8,000
 square feet); **Library** (500 volumes).
Activities: **Education Programs** (undergraduate college stu-
 dents); **Films; Guided Tours; Lectures.**
Publications: catalogues (occasional); newsletter (quarterly).
The Southeast Museum of Photography presents solo and
 group temporary exhibitions of contemporary and historical
photography.

Eli Reed, *Million Man March*, 1995, exhibited 1998 at Southeast Museum of
Photography. Photograph copyright Eli Reed, courtesy of Southeast Museum of
Photography, Daytona Beach, Florida.

The Museum of Arts and Sciences and Center for Florida History, Inc.
1040 Museum Blvd., Daytona Beach, FL 32114-4597
Tel: (904) 255-0285 *Ext:* 15
Fax: (904) 255-5040
Internet Address: http://www.moas.org
Director: Mr. Gary Russell Libby
Admission: fee: adult-$5.00, child-$1.00.
Attendance: 150,000 *Established:* 1971 *Membership:* Y *ADA Compliant:* Y
Parking: free on site.
Open: Tuesday to Friday, 9am-4pm; Saturday to Sunday, noon-5pm.
Closed: Legal Holidays.
Facilities: **Galleries; Lecture Hall** (268 seats); **Library** (5,000 volumes, non-circulating, for mem-
 bers); **Shop.**
Activities: **Education Programs** (adults and children); **Films; Guided Tours; Lectures;
 Temporary Exhibitions.**
Publications: exhibition catalogues; magazine, "Arts and Sciences Magazine"; members bulletin
 (quarterly); monograph (annual); books on related topics.

The Museum of Arts and Sciences and Center for Florida History, Inc., cont.

MOAS presents an active schedule of temporary exhibitions, both of works on loan from other institutions and works from the permanent collection. The permanent collection at the Museum is divided into four groups. The African Collection is displayed in order to foster an appreciation of the different forms and uses of traditional African art and cultural objects. There is a broad selection of masks, sculpture, religious objects, weaponry, and decorative arts from eleven African cultural groups including the Hirshhorn Collection of Asante Gold. The Cuban Collection contains 18th-, 19th-, and early 20th-century maps, documents, lithographs, paintings, furniture, sculpture, and ceramics. The Dow Gallery of American Arts is a chronological survey of 17th- through 19th-century fine and decorative arts. There are portraits by Stuart, Blackburn, Jennys, Sully, Morse, and Elliott; landscapes by Bonfield, Moran, Cropsey, Sonntag, Inness, Enneking, Vedder, and Durand; and still-lifes and seascapes by Raphaele Peale, Audubon, Waugh, Heade, Jacobsen, and Buttersworth. Finally, the Bouchelle Gallery exhibits decorative arts, including Meissen, Berlin, and Vienna porcelain; Staffordshire pottery; English and American silver; collections of bronze and glass, and the Levine Collection of Antique Jewelry..

DeLand

The Deland Museum of Art

The Cultural Arts Center, 600 N. Woodland Blvd., DeLand, FL 32720-3447

Tel: (904) 734-4371

Admission: free, donation accepted.

Attendance: 18,000 *Established:* 1951 *Membership:* Y *ADA Compliant:* Y

Parking: free on site.

Open: Tuesday to Saturday, 10am-4pm; Sunday, 1pm-4pm.

Closed: Legal Holidays.

Facilities: **Classrooms**; **Galleries**; **Shop** (books, posters, publications).

Activities: **Gallery Talks**; **Guided Tours**; **Lectures**; **Temporary Exhibitions**; **Traveling Exhibitions**; **Workshops**.

Publications: catalogue; exhibition brochures & programs; newsletter (quarterly).

The DeLand Museum of Art features changing exhibitions of traditional and contemporary art by national and international artists. Its permanent collection includes North American Indian baskets, contemporary American crafts, and works by Florida artists, 1900 to the present.

Stetson University - The Duncan Gallery of Art

Stetson University, Sampson Hall, Michigan Avenue, DeLand, FL 32720-3756

Tel: (904) 822-7266

Fax: (904) 822-7268

Internet Address: http://www.stetson.edu/departments/art

Gallery Director: Mr. Dan Gunderson

Admission: free.

Attendance: 10,000 *Established:* 1965 *Membership:* Y *ADA Compliant:* Y

Parking: free on site.

Open: Monday to Friday, 10am-4pm; Saturday to Sunday, 1pm-4pm.

Closed: Academic Holidays, Legal Holidays.

Facilities: **Gallery** (2,200 square feet).

Activities: **Demonstrations**; **Education Programs** (undergraduate college students); **Gallery Talks**; **Lectures**; **Traveling Exhibitions**; **Workshops**.

Publications: exhibition catalogues.

The Duncan Gallery mounts temporary exhibitions on a monthly basis.

Delray Beach

Cornell Museum of Art and History

51 N. Swinton Ave., Delray Beach, FL 33444

Tel: (561) 243-7922

Fax: (561) 243-7018

Delray Beach, Florida

Cornell Museum of Art and History, cont.

Internet Address: http://www.oldschool.org
Director: Ms. Gloria Rejune Adams
Admission: fee: adult-$3.00, child (<6)-free (6-12)-$1.00.
Attendance: 31,000 *Established:* 1990 *Membership:* Y *ADA Compliant:* Y
Parking: commercial adjacent to site.
Open: **November to April**, Tuesday to Saturday, 11am-4pm; Sunday, 1pm-4pm.
 May to October, Tuesday to Saturday, 11am-4pm.
Closed: New Year's Day, Easter, Memorial Day, Independence Day, Labor Day, Thanksgiving Day to
 Thanksgiving Friday, Christmas Eve to Christmas Day, ML King Day, June to August.
Facilities: **Gallery** (5).
Activities: **Arts Festival**; **Guided Tours** (by appointment); **Juried Exhibits**; **Lectures**;
 Temporary/Traveling Exhibitions (5/year).
Publications: newsletter, "News from the Square" (quarterly).

The Cornell Museum is located in a converted school, which is listed on the National Register of Historic Places. It features five exhibitions each year of the works of local and regional artists, including "Inspirations", an all-Florida, multi-media juried art show in March. It also hosts national and international traveling exhibitions.

The Morikami Museum and Japanese Garden

4000 Morikami Park Road, Delray Beach, FL 33446-2305
Tel: (407) 495-0233
Fax: (407) 499-2557
Internet Address: http://www.icsi.com/ics/morikami
Exec. Director: Mr. Larry Rosensweig
Admission: fee: adult-$2.00, child-$2.00, student-$3.75.
Attendance: 150,000 *Established:* 1977
Membership: Y *ADA Compliant:* Y
Parking: free on site.
Open: Tuesday to Sunday, 10am-5pm.
Closed: New Year's Day, Easter,
 Independence Day, Thanksgiving Day,
 Christmas Day.
Facilities: **Bonsai Collection**; **Exhibition
 Area**; **Japanese Garden** (200 acre park);
 Japanese restaurant (open 11am-3pm);
 Library (3,000 volumes, non-circulating, by
 request); **Picnic Area**; **Theatre** (225 seats).
Activities: **Guided Tours** (groups of 15 or more);
 Permanent Exhibits; **Temporary
 Exhibitions** (5 - 7 per year).
Publications: exhibition catalogues; newsletter
 and calendar (quarterly).

Exterior view of Main Museum Building, The Morikami Museum and Japanese Gardens. Photograph by Trudi Mitchell, courtesy of The Morikami Museum and Japanese Gardens, Delray Beach, Florida.

The museum at the Morikami Museum and Japanese Gardens is set in a 200-acre park of pine forests and Japanese-style gardens. The 32,000-square-foot museum itself is devoted exclusively to the living culture of Japan. It features varying exhibitions of Japanese fine and folk art, crafts, and artifacts. A highlight of the museum is the teahouse, where regularly-scheduled demonstrations of the Japanese tea ceremony are conducted.

Fort Lauderdale

Museum of Art, Fort Lauderdale (MoA)

1 E. Las Olas Blvd., Fort Lauderdale, FL 33301-1807
Tel: (954) 525-5500
Fax: (954) 524-6011
Internet Address: http://www.museumofart.org

Museum of Art, Fort Lauderdale, cont.

Director: Ms. Kathleen Harleman
Admission: fee: adult-$10.00, child (<5)-free (5-18)-$2.00, student-$6.00, senior-$8.00.
Attendance: 102,000 *Established:* 1958 *Membership:* Y *ADA Compliant:* Y
Parking: metered lot on SE 1st Ave.
Open: Tuesday to Saturday, 10am-5pm;
 Sunday, noon-5pm.
Closed: Legal Holidays.
Facilities: **Auditorium** (256 seats); **Galleries**; **Library** (1,000 volumes, non-circulating, for members); **Shop**.
Activities: **Arts Festival**; **Education Programs** (adults and children); **Guided Tours** (Tues, 1pm and 7pm; Thurs-Fri, 1pm; group reservations required); **Lectures**.
Publications: annual report; bulletin (quarterly); exhibition catalogues.

William Glackens, *Dancer in Blue,* c. 1905, oil on canvas, 48 x 30 inches. Ira Glackens Bequest, Museum of Art, Fort Lauderdale. Photograph courtesy of Museum of Art, Fort Lauderdale, Fort Lauderdale, Florida.

The Museum of Art, Fort Lauderdale occupies a 74,000-square-foot structure in downtown Fort Lauderdale. The building was designed by Edward Larrabee Barnes and completed in 1985. In addition to the display of permanent exhibitions, the Museum mounts a continuing series of major temporary exhibitions, drawing on works from its own collection as well as from other major institutions in this country and abroad. The permanent collection of the Museum consists of over 5,400 works, and focuses on 20th-century European and American art. Its collection includes works by Picasso, Calder, Moore, Abbott, Rivers, Lawrence, and Stella. A highlight of the holdings is the nation's largest collection of works by American Impressionist William Glackens with over 500 drawings, oils, watercolors, and graphics. There is also a large collection of CoBrA art, that is, Abstract Expressionism by artists working in Copenhagen, Brussels, and Amsterdam after World War II.

Fort Myers

Edison Community College Gallery of Fine Art

Humanities building (L), 8099 College Pkwy., S.W., Fort Myers, FL 33906
Tel: (941) 489-9314
Fax: (941) 489-9482
Internet Address: http://www.edison.edu
Curator: Ronald Bishop
Admission: free.
Attendance: 15,000 *Established:* 1979 *Membership:* Y *ADA Compliant:* Y
Open: Tuesday to Friday, 10am-4pm; Saturday, 11am-3pm; Sunday, 1pm-5pm.
Facilities: **Auditorium** (200 seats); **Classrooms** (multi-use); **Exhibition Area**; **Gallery** (250 running feet); **Library**.
Activities: **Guided Tours. Lectures; Traveling Exhibits**.

Each year, the Gallery of Fine Arts presents six to eight temporary exhibitions focused on fine art from historic to contemporary periods. Exhibits run six to eight weeks and include the work of regional, national and international artists. Recent exhibits include Russian painter Maxim Kantor, Florida photographer Clyde Butcher, and internationally recognized artist Robert Rauschenberg. The Gallery accepts proposals from mid-career artists with full documentation.

Gainesville

Santa Fe Community College - Santa Fe Gallery

Santa Fe Community College, 3000 NW 83rd St.Building P, Room 201, Gainesville, FL 32606
Tel: (352) 395-5621
Fax: (352) 395-5281

Santa Fe Community College - Santa Fe Gallery, cont.

Internet Address: http://www.santafe.cc.fl.us
Admission: free.
Attendance: 10,000 *Established:* 1978
Membership: Y *ADA Compliant:* Y
Parking: free on site.
Open: Tuesday to Friday, 10am-3pm.
Closed: Academic Holidays.
Facilities: **Exhibition Area** (1,800 square feet).
Activities: **Education Programs** (undergraduate and graduate college students); **Guided Tours** (on request); **Lectures**; **Participatory Exhibits**.
Publications: exhibition brochures.

Focusing on contemporary art, the Santa Fe Gallery holds eight exhibitions per year, including one faculty show and two student shows.

Jim Atyeo, *The Great Alachua Savanna*, 1997, installation in Santa Fe Gallery. Photograph courtesy of Santa Fe Gallery, Santa Fe Community College, Gainesville, Florida.

University of Florida - Samuel P. Harn Museum of Art

University of Florida, S.W. 34th Street and Hull Road, Gainesville, FL 32611
Tel: (352) 392-9826
Fax: (352) 392-3892
Internet Address: http://www.arts.ufl.edu/harn
Director: Inez S. Wolins
Admission: voluntary contribution.
Attendance: 65,000 *Established:* 1981
Membership: Y *ADA Compliant:* Y
Parking: metered on site.
Open: Tuesday to Friday, 11am-5pm;
Saturday, 10am-5pm;
Sunday, 1pm-5pm.
Closed: New Year's Day, ML King Day, Memorial Day, Independence Day, Labor Day, Veterans Day, Thanksgiving Day to Thanksgiving Friday, Christmas Day.
Facilities: **Auditorium** (250 seats); **Exhibition Area** (22,000 square feet); **Library**; **Object Study Room**; **Shop**; **Study Center** (800 square feet).
Activities: **Concerts**; **Education Programs** (adults, undergraduate/graduate students, and children); **Films**; **Gallery Talks**; **Guided Tours** (Wed, 12:30pm; Sat-Sun, 2pm; family 2nd Sun in month, 1;15pm); **Lectures**; **Performances**; **Temporary Exhibitions**; **Traveling Exhibitions**.

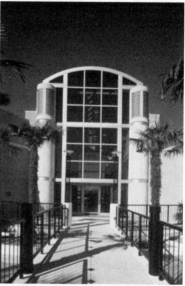

Exterior view of the entrance and east face of the Harn Museum of Art. Photograph courtesy of Harn Museum of Art, University of Florida, Gainesville, Florida.

Publications: exhibition catalogues; newsletter, "Collection Exchange" (monthly); report (biennial).

The Harn Museum of Art offers approximately fifteen changing exhibitions per year, consisting of both historical and contemporary art, from its own collection as well as from other major institutions and collections. The Harn's own collection of more than 5,500 paintings, prints, and sculptures dates to the pre-Columbian era. The American collection features early 20th-century artists, including Bellows, Marin, Soyer, Kent, and Avery, along with work by contemporary artists. The Asian collection includes selections from China, Korea, Southeast Asia, and India. There are also African and Oceanic collections.

University of Florida - University Gallery

School of Art and Art History (intersection of SW 13th St. and 4th Ave.), Gainesville, FL 32611
Tel: (352) 392-0201
Fax: (352) 846-0266
Internet Address: http://www.arts.ufl.edu/galleries.html
Director: Mr. James Wyman
Admission: free.
Attendance: 7,500 *Established:* 1965 *Membership:* Y *ADA Compliant:* Y
Parking: By permit only; call for instructions.
Open: Tuesday, 10am-8pm; Wednesday to Friday, 10am-5pm; Saturday, 1pm-5pm.
Closed: Legal Holidays.
Facilities: **Exhibition Area**; **Library** (30,000 volumes).
Activities: **Gallery Talks**; **Lectures**; **Public Art Program**; **Temporary Exhibitions** (approximately 6/year); **Traveling Exhibitions**.
Publications: exhibition catalogues (occasional).

Located at the east end of the Fine Arts Campus Complex, the University Gallery presents exhibitions of contemporary art in a variety of media, as well as student and faculty shows. Also of possible interest on campus are the Focus Gallery (located in Fine Arts Building C; open Monday-Friday, 8am-11:45pm and 1pm-4:45pm), displaying the work of students or emerging artists; and the Grinter Gallery (located in Grinter Hall; open Monday-Friday, 10am-4pm), specializing in international artwork. For information on the University's Samuel P. Harn Museum of Art, see separate listing.

Hollywood

Art and Culture Center of Hollywood

1650 Harrison St., Hollywood, FL 33020
Tel: (954) 921-3274
Fax: (954) 921-3273
Director: Cynthia B. Miller
Admission: fee: adult-$3.00, child-free.
Established: 1975 *Membership:* Y
ADA Compliant: Y
Parking: free on site.
Open: Tuesday to Saturday, 10am-4pm; Sunday, 1pm-4pm.
Closed: Major Holidays.
Facilities: **Art School**; **Exhibition Area** (4 galleries; 3500 square feet, doubles as a performance space); **Library** (use by special permission)
Activities: **Concerts**; **Education Programs** (children); **Films**; **Gallery Talks**; **Guided Tours** (every other Sunday); **Lectures**; **Temporary Exhibitions**.
Publications: newsletter, "Center Lines" (bi-monthly).

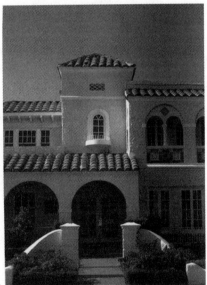

View of entrance of Art and Culture Center (1924). Photograph by Ray Carson, courtesy of Art and Culture Center, Hollywood, Florida.

A multi-disciplinary institution, the Art and Culture Center of Hollywood is located in the historic Kagey Mansion in Hollywood, midway between Fort Lauderdale and Miami. In addition to featuring exhibitions of primarily contemporary art, the Center conducts art classes and workshops and schedules musical and dance performances. For example, in Spring 2000, the Center produced and presented *Ocean Dance,* a free event held on Hollywood Beach featuring performances by Mikhail Baryshnikov and others.

Jacksonville

Cummer Museum of Art & Gardens

829 Riverside Ave., Jacksonville, FL 32204
Tel: (904) 356-6857
Fax: (904) 353-4101
Internet Address: http://www.cummer.org

Jacksonville, Florida

Cummer Museum of Art & Gardens, cont.

Director: Dr. Kahren J. Arbitman

Admission: fee: adult-$6.00, student-$3.00, senior-$4.00.

Attendance: 88,000 *Established:* 1958

Membership: Y *ADA Compliant:* Y

Parking: across street on Riverside Ave..

Open: Tuesday, 10am-9pm;
Wednesday, 10am-5pm;
Thursday, 10am-9pm;
Friday to Saturday, 10am-5pm;
Sunday, noon-5pm.

Closed: Christmas Day, New Year's Day, Thanksgiving Day.

Thomas Moran, *Ponce de Leon in Florida*, Cummer Museum of Art & Gardens collection. Photograph by Superstock, Inc., courtesy of Cummer Museum of Art & Gardens, Jacksonville, Florida.

Facilities: **Formal Gardens**; **Galleries**; **Interactive Art Education Center**; **Library** (5,000 volumes, available by application); **Shop**.

Activities: **Children's Activities**; **Concerts**; **Guided Tours** (Sun, 12:15pm); **Lectures**; **Permanent Exhibits**; **Temporary Exhibitions**.

Publications: calendar (monthly); exhibition catalogues (annual).

The setting of the Cummer Museum is on two and one half acres of formal gardens on the west bank of the St. Johns River. The Museum has an active exhibition schedule, displaying works from its own collection and from major institutions around the country. The permanent collection of the Museum consists of nearly 5,000 objects, ranging in date from 2,000 B.C. to the present. The strength of the collection is Old Master and American painting, but works of Egyptian, Greek, Etruscan, and Roman antiquity, the art of the Middle Ages, the early and late Renaissance, Mannerism, and early 20th-century art are also included in the collection, along with pre-Columbian ceramics and Japanese inro and netsuke.

Jacksonville Museum of Contemporary Art

4160 Boulevard Center Drive, Jacksonville, FL 32207

Tel: (904) 398-8336

Fax: (904) 348-3167

Director: Mr. Henry Flood Robert, Jr.

Admission: fee: adult-$3.00, child-free, student-$2.00, senior-$2.00.

Attendance: 100,000 *Established:* 1948 *Membership:* Y *ADA Compliant:* Y

Parking: free on site.

Open: Tuesday to Wednesday, 10am-4pm; Thursday, 10am-10pm; Friday, 10am-4pm;
Saturday to Sunday, 1pm-5pm.

Closed: Legal Holidays.

Facilities: **Auditorium** (100 seats); **Classrooms**; **Exhibition Area**; **Library** (600 volumes, non-circulating, by application); **Reading Room**; **Sculpture Garden**; **Shop**; **Studios**.

Activities: **Arts Festival**; **Education Programs** (adults and children); **Films**; **Gallery Talks**; **Guided Tours** (reservations in advance); **Permanent Exhibits**; **Temporary Exhibitions**; **Traveling Exhibitions**; **Workshops**.

Publications: class schedules (quarterly); exhibition catalogues; newsletter (monthly).

The Jacksonville Museum of Contemporary Art is housed in a 30,000-square-foot facility completed in 1966. The Museum presents its permanent collection in some of its galleries, while others are reserved for changing exhibitions. The Museum has at least one major exhibition per year, showcasing an artist of national or international importance.

Jacksonville University - The Alexander Brest Museum and Gallery

Jacksonville University, 2800 University Blvd., North, Jacksonville, FL 32211

Tel: (904) 744-3950 *Ext:* 7371

Fax: (904) 745-7375

Jacksonville University - The Alexander Brest Museum and Gallery, cont.

Internet Address: http://www.junix.ju.edu/ju/abmg.htm
Curator: Mr. David Lauderdale
Admission: free.
Attendance: 21,000 *Established:* 1977 *Membership:* Y *ADA Compliant:* Y
Open: Monday to Friday, 9am-4:30pm;
 Saturday, noon-5pm.
Closed: Memorial Day, Independence Day, Labor Day,
 Veterans Day, Thanksgiving Day,
 Christmas Day.
Facilities: **Exhibition Area** (4,250 square feet).
Activities: **Concerts**; **Guided Tours**; **Lectures**;
Temporary Exhibitions.
Publications: "A Guide to the Collection: The
Alexander Brest Museum and Gallery".

The Museum presents temporary exhibitions of the work of faculty, students, and local, regional, national, and international artists. It also displays objects from its permanent collection, which includes 17th-through 19th-century European and Oriental ivory, pre-Columbian artifacts, Steuben glass, Chinese porcelain and cloisonné, Tiffany glass, and Boehm porcelain.

Cluster lamp with pond Favrile lily design, c. 1903-1906, Tiffany, bronze. Alexander Brest Museum collection. Photograph by Richard Sowell, courtesy of Alexander Brest Museum, Jacksonville University, Jacksonville, Florida.

University of North Florida - University Gallery

4567 St. Johns Bluff Road, Jacksonville, FL 32216
Tel: (904) 620-2534
Fax: (904) 646-2505
Internet Address: http://www.unf.edu/dept/gallery
Director: Mr. Paul C. Karabinis
Admission: free.
Open: Monday/Wednesday/Friday, 9am-3pm; Tuesday/Thursday, 9am-5pm.
Closed: Legal Holidays.
Facilities: **Exhibition Area** (900 square feet).
Activities: **Lectures**; **Performances** (concert series); **Temporary Exhibitions**.

The gallery presents a variety of exhibitions featuring regionally and nationally recognized artists, as well as the annual Visual Arts Faculty Art Show, Graduating Senior Show, and Juried Student Art Show.

Key West

East Martello Museum

3501 S. Roosevelt Blvd., Key West, FL 33040
Tel: (305) 296-3913
Fax: (305) 296-6206
Exec. Director: Mr. Kevin J. O'Brien
Admission: fee: adult-$6.00, child-$2.00.
Attendance: 25,000 *Established:* 1951
Membership: Y *ADA Compliant:* Y
Parking: on site.

Exterior view, East Martello Museum. Photograph courtesy of East Martello Museum, Key West, Florida.

179

Key West, Florida

East Martello Museum, cont.

Open: Daily, 9:30am-5pm.
Closed: Christmas Day.
Facilities: **Architecture** (converted fort built in 1862); **Exhibition Area**; **Grounds**; **Shop**.
Activities: **Guided Tours**; **Permanent Exhibits**; **Temporary Exhibitions** (monthly).
Publications: brochure; magazine, "KWAHS Connection"; newsletter.

The Museum's permanent collection includes Stanley Papio sculptures and art by Mario Sanchez.

Lake Worth

Palm Beach Institute of Contemporary Art (PBICA)

601 Lake Ave., Lake Worth, FL 33460
Tel: (407) 582-0006
Fax: (407) 582-0504
Internet Address: http://www.palmbeachica.org
Interim Administrator: Michael McManus
Admission: fee:
 adult-$5.00, student-$3.00, senior-$3.00.
Attendance: 6,000 *Established:* 1989
Membership: N *ADA Compliant:* Y
Parking: public lot and street parking.
Open: Tuesday to Sunday, 11am-5pm.
Closed: Christmas Day, New Year's Day,
 ML King Day, Independence Day,
 Thanksgiving Day.
Facilities: **Architecture** (Art Deco former
 movie theatre, 1939); **Exhibition Area**
 (6,000 square feet); **Library** (300 volumes).
Activities: **Education Programs** (adults and
 children); **Temporary Exhibits**; **Traveling
 Exhibitions**.

Drawing of Museum of Contemporary Art. Courtesy of Museum of Contemporary Art, Lake Worth, Florida.

The Museum, housed in a converted 1939 Art Deco theatre, is dedicated to the exhibition of the work of contemporary artists.

Lakeland

Florida Southern College - Melvin Gallery

Florida Southern College, 111 Lake Hollingsworth Drive, Lakeland, FL 33801
Tel: (941) 680-4220
Internet Address: http://www.flsouthern.edu/art/gallery.html
Department Chairman: Dr. James Rogers
Admission: free.
Open: Call for hours.
Facilities: **Exhibition Area**.
Activities: **Temporary Exhibitions**.

The gallery presents temporary exhibitions, including annual faculty, juried student, and juried professional shows.

Polk Museum of Art

800 E. Palmetto, Lakeland, FL 33801
Tel: (863) 688-7743
Fax: (863) 688-2611
Exec. Director: Mr. Daniel Stetson
Admission: voluntary contribution.
Attendance: 143,000 *Established:* 1966 *Membership:* Y *ADA Compliant:* Y

Polk Museum of Art, cont.

Parking: free on site.

Open: Monday, 10am-5pm;
Tuesday to Friday, 9am-5pm;
Saturday, 10am-5pm;
Sunday, 1pm-5pm.

Closed: Major Holidays.

Facilities: **Auditorium**; **Galleries**; **Library** (3,500 volumes); **Sculpture Garden**; **Shop**; **Student Gallery and Art Discovery Room**; **Studio Classrooms**.

Activities: **Arts Festival**; **Concerts**; **Education Programs** (adults and children); **Film Series**; **Guided Tours**; **Lectures**; **Permanent Exhibits**; **Temporary Exhibitions**; **Workshops**.

View of exterior of Polk Museum of Art. Photograph by Phillips, courtesy of Polk Museum of Art, Lakeland, Florida.

Publications: brochure; catalogues; newsletter (quarterly); self-guided tour brochure.

The Polk Museum of Art houses nine exhibition galleries on two floors, with a changing exhibition schedule and an outdoor sculpture garden with a water wall. The permanent collection includes American art from 1900 forward, pre-Columbian artifacts, 15th- through 19th-century European decorative arts, including a collection of Georgian silver, and Asian art.

Madison

North Florida Community College Art Gallery

Turner Davis Drive, Madison, FL 32340

Tel: (850) 973-2288

Fax: (850) 973-9288

Internet Address: http://www.nflcc.cc.fl.us

Director: Mr. William F. Gardner, Jr.

Admission: free.

Established: 1975 *ADA Compliant:* Y

Parking: free on site.

Open: Monday to Friday, 8am-3pm.

Facilities: **Classrooms**; **Gallery**; **Theatre**.

Activities: **Arts Festival**; **Education Programs** (adults, undergraduate college students, and children); **Films**; **Gallery Talks**; **Guided Tours**; **Lectures**; **Permanent Exhibits**.

The Art Gallery presents a wide variety of art in temporary exhibitions and also maintains a small permanent collection.

Maitland

Maitland Art Center

231 W. Packwood Ave.
Maitland, FL 32751-5596

Tel: (407) 539-2181

Fax: (407) 539-1198

Internet Address: http://www.maitartctr.org

Exec. Director: Mr. James G. Shepp

Admission: voluntary contribution.

Attendance: 66,700 *Established:* 1938

Membership: Y *ADA Compliant:* Y

Parking: across street from Center.

View of entrance of Maitland Art Center. Photograph by Randy Chapman/ Lawrence Taylor, courtesy of Maitland Art Center, Maitland, Florida.

Maitland, Florida

Maitland Art Center

Open: Monday to Friday, 9am-4:30pm; Saturday to Sunday, noon-4:30pm.
Closed: Legal Holidays.
Facilities: **Galleries** (4); **Gardens with relief sculpture**; **Shop**; **Studios**.
Activities: **Art Classes** (quarterly); **Concerts**; **Guided Tours** (by appointment); **Lecture Series** (Thursday evening); **Permanent Exhibits**; **Temporary Exhibitions**.
Publications: annual report; exhibition catalogues; newsletter, "The Maitland Art Center" (quarterly); school schedule (quarterly).

The Maitland Art Center is a complex of twenty-two stucco buildings, highly decorated with cement carvings resembling art from the Mayan and Aztec cultures. It is listed on the National Register of Historic Places. There are also gardens among the buildings. The exhibitions at the Art Center consist of works by contemporary American artists and craftsmen, both established and emerging.

Melbourne

Brevard Museum of Art and Science, Inc. (BMAS)

1463 Highland Ave., Melbourne, FL 32935
Tel: (407) 242-0737
Fax: (407) 242-0798
Exec. Director: Ms. Sheila Stewart-Leach
Admission: fee:
 adult-$5.00, child-$2.00, student-$2.00, senior-$3.00.
Attendance: 33,000 *Established:* 1978
Membership: Y *ADA Compliant:* Y
Parking:
 free lot on Pineapple Ave. across from museum.
Open: Tuesday to Saturday, 10am-5pm;
 Sunday, 1pm-5pm.
Closed: Legal Holidays.
Facilities: **Auditorium** (100 seats); **Galleries**; **Library** (1,000 volumes); **Shop**; **Studios**.

Faience Statuettes, Egyptian, Old Kingdom. Brevard Museum of Art & Science. Photograph courtesy of Brevard Museum of Art & Science, Melbourne, Florida.

Activities: **Arts Festival**; **Concerts**; **Education Programs** (adults and children); **Films**; **Gallery Talks**; **Guided Tours** (Tues-Fri, 2pm-4pm; Sat, 12:30pm-2:30pm; Sun, 1pm-5pm); **Lectures**; **Temporary Exhibitions**; **Traveling Exhibitions**.
Publications: catalogues; newsletter, "Museletter" (quarterly).

The Brevard Museum of Art & Sciences features exhibitions by internationally and nationally known artists, as well as Florida artists representing a wide variety of styles, periods, and media. The Museum's multiple gallery spaces allow for simultaneous exhibitions or the showcasing of a spectacular work, an individual artist, or a special theme exhibition. The museum presents eight to ten exhibitions per year of works from public, private, and corporate collections. The collections at the Museum include contemporary works by many American artists, such as Emery, Schapiro, and Nevelson. There is also European, Asian, ancient Egyptian, and traditional African art.

Miami

Florida International University - The Art Museum

University Park, PC110, S.W. 112th Avenue, Miami, FL 33199
Tel: (305) 348-2890
Fax: (305) 348-2762
Internet Address: http://www.fiu.edu/museum.html
Director: Ms. Dahlia Morgan
Admission: free.
Attendance: 76,000 *Established:* 1977 *Membership:* Y *ADA Compliant:* Y
Parking: metered in PC lot.
Open: Monday, 10am-9pm; Tuesday to Friday, 10am-5pm; Saturday, noon-4pm.
Closed: Academic Holidays.

Florida International University - The Art Museum, cont.

Facilities: **Auditorium**; **Galleries**; **Library** (non-circulating); **Sculpture Park**.

Activities: **Education Programs** (adults and children); **Gallery Talks**; **Temporary Exhibitions**;
Traveling Exhibitions.

Publications: exhibition catalogues.

The Art Museum at Florida International University in an important cultural resource. It mounts approximately ten temporary exhibitions per year, showing student and faculty work as well as major traveling exhibitions. The most notable aspect of the permanent collection at the Museum is its outdoor sculpture. The collection of 57 pieces includes works by Dubuffet, Miró, Nevelson, Calder, Noguchi, and Serra. The general collection consists of works on paper (works by Gottlieb, Kelly, Oldenburg, Motherwell, Rosenquist, Rauschenberg, and Indiana); photographs (by Abbott, Hassam, and Eggleston); pre-Columbian art from numerous cultures; and painting, especially Haitian and Brazilian folk art. The Metropolitan Museum

Jonathan Borofsky, *The Hammering Man at 2,938,405*, 1977-1985, Cor-Ten steel, motorized, height 24 feet. Margulies Family Collection, The Art Museum at Florida International University. Photograph courtesy of The Art Museum at Florida International University, Miami, Florida.

and Art Center Collection includes paintings (by Hoffmann, Tamayo, Glackens, Chase, and Bermudez); prints (by Warhol, Lichtenstein, Indiana, and Hockney); Asian art (Japanese netsuke, Benin bronzes); sculpture (pieces by Rodin and Lipchitz); and photographs (works by Muybridge). Finally, the Oscar B. Cintas Fellowship Foundation Collection consists of works by artists of Cuban descent who have received Cintas Fellowships and includes paintings, prints, and drawings. The Museum is in the process of constructing a 40,000-square-foot facility to house its collection and to serve as a more suitable venue for exhibitions.

Miami Art Museum (MAM)

101 W. Flagler St., Miami, FL 33130
Tel: (305) 375-3000
Fax: (305) 375-1725
Director: Ms. Suzanne Delehanty
Admission: fee: adult-$5.00, child (<12)-free,
student-$2.50, senior-$2.50.
Attendance: 52,000 *Established:* 1984
Membership: Y *ADA Compliant:* Y
Parking: pay on site.
Open: Tuesday to Wednesday, 10am-5pm;
Thursday, 10am-9pm;
Friday, 10am-5pm;
Saturday to Sunday, noon-5pm.

Facilities: **Architecture** (1983 design by Philip Johnson); **Food Services**; **Galleries** (16,000 square feet); **Picnic Area**; **Sculpture Court**; **Shop**.

Luis Cruz Azaceta, *Tough Ride Around the City*, 1981, acrylic on canvas, 66 x 72 inches. Miami Art Museum, gift of Carlos and Rosa de la Cruz. Photograph courtesy of Miami Art Museum, Miami, Florida.

Activities: **Films**; **Guided Tours** (1st Tues in month, 12:15pm; Thurs, 7pm; family 2nd Sat, 1pm);
Lectures (Thursday evenings); **Temporary Exhibitions**; **Traveling Exhibitions**.

Publications: exhibition catalogues; newsletter, "MAM News" (quarterly).

Miami Art Museum is part of the Philip Johnson-designed Miami-Dade Cultural Center located in the heart of Miami. It exhibits and collects international art with an emphasis on the art of the western hemisphere from the 1940's to the present. The Museum presents approximately ten temporary exhibitions per year, of works from its permanent collection and the New Work Series, for which MAM commissions works by leading contemporary artists. The permanent collection includes

Miami Art Museum, cont.

works by José Bedia, Gene Davis, Jean Dubuffet, Edouard Duval-Carrié, Helen Frankenthaler, Adolph Gottlieb, Ann Hamilton, Alfredo Jaar, Ana Mendieta, Robert Rauschenberg, Gerhard Richter, James Rosenquist, Susan Rothenberg, Lorna Simpson, and Frank Stella.

Miami-Dade Community College - Kendall Campus Art Gallery

11011 Southwest 104th St., Miami, FL 33176-3393

Tel: (305) 237-2322

Fax: (305) 237-2901

TDDY: (800) 955-8771

Internet Address: http://www.kendall.mcdd.edu/art/gallery.htm

Director: Lilia Fontana

Admission: free.

Attendance: 7,000 *Established:* 1970 *ADA Compliant:* Y

Parking: free in student lots.

Open: **September to May**,
> Monday, 8am-4pm; Tuesday to Wednesday, noon-7:30pm; Thursday to Friday, 8am-4pm.
June to early-August,
> Monday, 8am-4pm; Tuesday to Wednesday, noon-7:30pm; Thursday, 8am-4pm.

Closed: Legal Holidays.

Facilities: **Auditorium** (300 seats); **Exhibition Area** (3,000 square feet); **Food Services** Restaurant (300 seats).

Activities: **Education Programs** (college students); **Films**; **Guided Tours**; **Lectures**; **Temporary Exhibitions**; **Traveling Exhibitions**.

Publications: exhibition catalogues.

The Art Gallery mounts temporary exhibitions of the work of professional artists as well as an annual student exhibition.

Miami-Dade Community College-North Campus - Gallery North

11380 Northwest 27th Ave., Leroy Collins Campus Center, Room 4207-1, Miami, FL 33167-3418

Tel: (305) 237-1532

Fax: (305) 237-1850

TDDY: (800) 955-8771

Internet Address: http://www.mdcc.edu/a-l/ap_galnorth.htm

Acting Director: Mr. Juan Espinosa-Almodovar

Admission: free.

Open: Monday to Thursday, 10am-4pm.

Facilities: **Exhibition Area**.

Activities: **Temporary Exhibitions**.

The Gallery mounts temporary exhibitions.

Miami-Dade Community College - Wolfson Campus Galleries

300 Northeast 2nd Ave., Miami, FL 33132-2297

Tel: (305) 237-3278

Fax: (305) 237-3645

Internet Address: http://www.mdcc.edu/wolfson/cultural/caffcal.html

Gallery Director: Goran Tomcic

Admission: free.

Open: Monday to Wednesday, 9am-5pm; Thursday, 10am-7pm; Friday, 9am-5pm.

Facilities: **Exhibition Area**.

Activities: **Temporary Exhibitions**.

There are two galleries on the M-DCC's Wolfson Campus. The Centre Gallery (Room 1365) features exhibitions of experimental works as well as national and international collections. The Francis Wolfson Art Gallery (Room 1531) features works by faculty, students, and Florida artists.

New World School of the Arts - New World Gallery

25 Northeast 2nd St., Miami, FL 33132
Tel: (305) 237-3620
Fax: (305) 237-3794
Internet Address: www.mdcc.edu/nwsa/
Dean of Visual Arts: Dr. Mel Alexenberg
Admission: free.
Attendance: 2,500 *Established:* 1987
Membership: N *ADA Compliant:* Y
Parking: municipal garage.
Open: Monday to Friday, 9am-5pm.
Facilities: **Exhibition Area.**
Activities: **Temporary Exhibitions** (6/year).

The New World Gallery exhibits contemporary art and the work of its students and faculty in approximately six shows per year.

Mel Alexanberg and Miriam Benjamin, *Art Throne*, 1998, mixed-media 20-foot sculpted seat, created through intergenerational and multicultural collaboration. Photograph courtesy of New World Gallery, Miami, Florida.

Miami Beach

Bass Museum of Art

2121 Park Ave. (between 21st and 22nd Streets), Miami Beach, FL 33139
Tel: (305) 673-7530
Fax: (305) 673-7062
Internet Address: http://ci.miami-beach.fl.us/culture/bass
Exec. Director: Ms. Diane W. Camber
Admission: fee: adult-$5.00, student-$3.00, senior-$3.00.
Attendance: 50,000 *Established:* 1964 *Membership:* Y *ADA Compliant:* Y
Parking: metered parking in municipal lot and on street.
Open: Tuesday to Saturday, 10am-5pm; Sunday, 1pm-5pm; 2nd & 4th Wed in month, 1pm-9pm.
Closed: Legal Holidays.
Facilities: **Architecture** (Art Deco building, 1930 design by Russel Pancoast; 15,500 square feet; addition, 1964 by Robert Swartburg); **Galleries; Shop.**
Activities: **Art Classes; Concerts; Films; Gallery Talks; Lectures; Permanent Exhibits; Temporary Exhibitions** (6-9/year).
Publications: brochures; collection catalogue; exhibition catalogues; newsletter.

The Museum develops and mounts exhibitions drawn from its permanent collection and presents traveling exhibitions of national and international collections. The Foyer, Main, and South galleries exhibit portions of the permanent collection of works from the 14th through 20th centuries. An additional gallery on the main level and three galleries on the second level are used for temporary exhibitions. The core of the permanent holdings is a 500-piece collection of European art donated by Museum founding donors John and Johanna Bass. The permanent collection includes 14th- to 20th-century European art; Baroque paintings and sculpture; textiles; and contemporary American art, architecture, and design. Included are works by Bol, Delacroix, Dürer, Guillaumin, Hopper, Sir Thomas Lawrence, Makart, van Haarlem, Toulouse-Lautrec, and the studio of Peter Paul Rubens. The Museum will be expanding and renovating its facilities during 1999. Designed by architect Arata Isozaki, the project includes increased exhibition space, outdoor sculpture terrace, café, courtyard, 250-seat auditorium, and children's gallery.

Florida International University - The Wolfsonian

1001 Washington Ave., Miami Beach, FL 33139
Tel: (305) 531-1001
Fax: (305) 531-2133
Internet Address: http://www.wolfsonian.org/

Florida International University - The Wolfsonian, cont.

Director: Ms. Cathy Leff

Admission: fee:
adult-$5.00, child-$3.50, student-$3.50, senior-$3.50.

Attendance: 26,000 *Established:* 1986

Membership: Y *ADA Compliant:* Y

Parking: valet, municipal lots, and metered on-street parking.

Open: Monday to Tuesday, 11am-6pm;
Thursday, 11am-9pm;
Friday to Saturday, 11am-6pm;
Sunday, noon-5pm.

Facilities: **Exhibition Area** (15,000 square feet); **Library** (35,000 volumes); **Shop** (prints, books, cards, jewelry, publications).

Activities: **Concerts**; **Education Programs** (adults); **Guided Tours** (groups, reserve in advance); **Lectures**; **Permanent Exhibitions**; **Temporary Exhibitions**; **Traveling Exhibitions**.

Publications: "The Wolfsonian Bulletin"; books; catalogues.

Exterior view of The Wolfsonian. Photograph courtesy of The Wolfsonian - Florida International University, Miami Beach, Florida.

Located in the heart of Miami Beach's Art Deco District, the Wolfsonian-FIU was founded in 1986 to promote the collection, preservation, and understanding of art and design from the period 1885-1945. In 1997, it joined the state's public education system as a division of Florida International University. Permanent, temporary, and traveling shows address broad themes of the 19th and 20th centuries, such as nationalism, political persuasion, industrialization, architecture and urbanism, consumerism and advertising, transportation, and world's fairs. Although drawing primarily on its own holdings, the Wolfsonian also features exhibitions and objects on loan from other institutions. The Wolfsonian holds more then 70,000 objects, predominantly from North American and Europe, providing rich evidence of the cultural, political, and technological changes that swept the globe in the century preceding World War II. The collection features furniture, decorative arts, industrial design, paintings, sculpture, architectural models, works on paper, books, and ephemera. Notable among these are Depression-era prints and mural studies by WPA artists, items from the British Arts and Crafts movement and the German Werkstäten and Werkbund, and artifacts of political propaganda.

Miami Lakes

Jay I. Kislak Foundation

7900 Miami Lakes Drive West, Miami Lakes, FL 33016

Tel: (305) 364-4208

Fax: (305) 821-1267

Internet Address: http://www.jayikislakfoundation.org

Administrative Director: Mr. Arthur Dunkelman

Admission: free.

Attendance: 500 *Established:* 1988

Membership: N *ADA Compliant:* Y

Parking: free on site.

Open: Monday and Friday, 10am-5pm, by appointment.

Facilities: **Exhibition Area** (2,000 square feet); **Library** (5,000 volumes, available to scholars by appointment).

Activities: **Guided Tours** (groups 3+, by appointment); **Permanent Exhibits**.

Publications: bibliographic series.

Monumental Jaguar Sculpture, painted earthenware, height 25 inches, Mexico - southern Veracruz, Late Classic (600-900 A.D.). Jay I. Kislak Foundation. Photograph courtesy of Jay I. Kislak Foundation, Miami Lakes, Florida.

Jay I. Kislak Foundation, cont.

The Jay I. Kislak Foundation, Inc. is a non-profit research institution devoted to the history and archaeology of the circum-Caribbean region, Florida, Mexico and Central America. Its pre-Columbian collection demonstrates the artistic genius of indigenous craftsmen in a wide range of media, including objects fashioned from bone, clay, stone, jade, textiles, gold and feathers. In addition to pre-Columbian art, a collection of rare books and manuscripts focus especially on the early exploration of and discoveries in the New World. Approximately 300 volumes from The Rare Book and Manuscript Collection are displayed in the gallery. The Foundation's extensive collection of rare books, manuscripts and maps form an important source of primary research materials for scholars. The collection of pre-Columbian artifacts represents over twenty-five centuries of the development of civilization in all regions, from the precocious Olmecs on the Gulf of Mexico to the ambitious Aztecs in highland Mexico. Relatively smaller groups of pieces come from lower Central America and South America (including examples of goldwork, textiles, and featherwork) and pre-Columbian artifacts from the West Indies, including Arawak Indian carvings.

Mount Dora

Mount Dora Center for the Arts

138 East 5th Ave., Mount Dora, FL 32757
Tel: (352) 383-0880
Fax: (352) 383-7753
President: Mr. John McCowan
Admission: voluntary contribution.
Attendance: 8,000 *Established:* 1985 *Membership:* Y *ADA Compliant:* Y
Open: Monday to Saturday, 10am-4pm.
Closed: Legal Holidays.
Facilities: **Exhibition Area** (700 square feet).
Activities: **Arts Festival**; **Education Programs** (adults and children); **Lectures**; **Temporary Exhibitions**.
Publications: newsletter, "MDCA Newsletter" (quarterly).

The Center presents temporary exhibitions and sponsors the annual Mount Dora Arts Festival.

Naples

Naples Museum of Art and Philharmonic Center for the Arts Galleries

5833 Pelican Bay Blvd., Naples, FL 34108
Tel: (941) 597-1111
Fax: (941) 597-7523
Internet Address: www.naplesphilcenter.org
President and CEO: Ms. Myra Janco Daniels
Admission: fee: adult-$6.00.
Attendance: 14,000 *Established:* 1989
Membership: Y *ADA Compliant:* Y
Parking: free on site.
Open: **October to May**, Tuesday to Sunday, 10am-4pm..
Facilities: **Exhibition Area** (20,000 square feet); **Lecture Hall** (200 seats); **Sculpture Gardens**; **Shop**; **Theatres** (2, 1,221 seats).
Activities: **Concerts**; **Guided Tours**; **Lectures**; **Performances**; **Temporary Exhibitions**; **Traveling Exhibitions**.
Publications: exhibition brochures.

The Museum and Galleries present exhibitions of works from its permanent collection and traveling shows. Holdings include American Modern Art (1900-1950), ancient Chinese art and artifacts; photography and sculpture.

View of exhibition gallery, Philharmonic Center. Photograph by Carl J. Thome, courtesy of Philharmonic Center for the Arts, Naples, Florida.

North Miami, Florida

North Miami

Museum of Contemporary Art (MOCA)

Joan Lehman Building, 770 Northeast 125th St., North Miami, FL 33161
Tel: (305) 893-6211
Fax: (305) 891-1472
Exec. Director: Ms. Lou Anne Colodny
Admission: fee: adult-$5.00, student-$3.00, senior-$3.00.
Attendance: 35,000 *Membership:* Y *ADA Compliant:* Y
Parking: free adjacent to site.
Open: Tuesday to Saturday, 11am-5pm; Sunday, noon-5pm.
Closed: New Year's Day, Thanksgiving Day, Christmas Day.
Facilities: **Exhibition Area** (23,000 square feet).
Activities: **Education Programs** (undergraduate/graduate college students and children); **Films**; **Guided Tours** (Sat & Sun, 2pm); **Lectures**; **Temporary Exhibitions** (8-12/year).
Publications: catalogues; newsletter (quarterly).

MOCA presents exhibitions drawn from its permanent collection of contemporary art and also mounts temporary exhibitions.

Ocala

The Appleton Museum of Art

4333 N.E. Silver Springs Blvd., Ocala, FL 34470-5000
Tel: (352) 236-7100
Fax: (352) 236-7136
Internet Address: http://www.fsu.edu/~svad/Appleton/AppletonMuseum.htm/
Director: Ms. Sandra Talarico
Admission: fee: adult-$5.00, child-free, student-$2.00.
Attendance: 34,000 *Established:* 1987
Membership: Y *ADA Compliant:* Y
Parking: free on site.
Open: Tuesday to Saturday, 10am-4:30pm; Sunday, 1pm-5pm.
Closed: New Year's Day, Easter, Independence, Day, Thanksgiving Day, Christmas Day.
Facilities: **Auditorium** (250 seats); **Exhibition Area** (34,000 square feet); **Library**; **Shop** (handcrafted jewelry, reproduction, books, children's items).
Activities: **Concerts**; **Education Programs** (adults, graduate/undergraduate students and children); **Films**; **Guided Tours** (Tues-Fri, 1:15pm); **Lectures**; **Temporary Exhibitions**; **Traveling Exhibitions**.

Exterior view of Appleton Museum of Art. Photograph courtesy of Appleton Museum of Art, Ocala, Florida.

Publications: calendar; collection catalogue, "The Appleton Collection"; newsletter, "Artifacts" (quarterly).

Jointly owned by the Florida State University Foundation and the Central Florida Community College Foundation, The Appleton Museum is a fine arts museum housing permanent collections of European painting, sculpture, and decorative arts; pre-Columbian, African, and Asian art; Islamic ceramics; and Antiquities. Beginning with classical antiquities from Egypt, Greece, Rome and Persia, the permanent collections lead the viewer on an historical and geographic survey of art history. The Asian galleries display objects from China, India, Japan, and Tibet. The pre-Columbian galleries show an extensive collection of South and Meso-American grave goods from cultures now extinct for almost 500 years. The African galleries highlight the traditional cultures of sub-Saharan Africa. The European collection, housed on the second floor of the museum, extends from Medieval manuscript pages through contemporary art, with large selections of Romantic, Social Realist, and Barbizon art.

Orlando

Orlando Museum of Art (OMA)

Orlando Loch Haven Park, 2416 N. Mills Ave., Orlando, FL 32803-1483

Tel: (407) 896-4231

Fax: (407) 896-9920

Internet Address: http://www.OMArt.org

Exec. Director: Ms. Marena Grant Morrisey

Admission: fee: adult-$6.00, child (4-11)-$2.00,
 student-$4.00, senior (55+)-$.4.00.

Attendance: 80,000 *Established:* 1924

Membership: Y *ADA Compliant:* Y

Parking: free on site.

Open: Tuesday to Saturday, 10am-5pm;
 Sunday, noon-5pm.

Closed: Holidays.

Facilities: **Auditorium** (250 seats); **Children's
 Hands-on Exhibit**; **Classrooms**; **Galleries**
 (23,242 square feet); **Library** (Wed & Fri, 1pm-
 4pm; 1,600 volumes); **Shop** (books, posters, jewelry,
 games and toys).

Activities: **Education Programs** (adults and chil-
 dren); **Discovery Centers** (children); **Guided
 Tours** (call for times or to schedule a group);
 Lectures; **Traveling Exhibitions**.

Publications: exhibition catalogues; newsletter.

Rembrandt Peale, *Portrait of Three Children*, oil on
canvas. Long-term loan by Martin and Gracia
Andersen, Orlando Museum of Art. Photograph cour-
tesy of Orlando Museum of Art, Orlando, Florida.

The OMA is dedicated to collecting, preserving and interpreting notable works of art. It exhibits items drawn from its permanent collections and presents a diverse schedule of temporary exhibitions, which are curated by OMA and/or obtained from national and international museums and private collections. Holdings include important collections of 19th- and 20th-century American, pre-Columbian, and African art. The American Collection contains over 675 works, including paintings by John Chamberlain, April Gornik, Childe Hassam, George Inness, Morris Louis, Thomas Moran, Georgia O'Keeffe, Jules Olitski, John Singer Sargent, and Charles Sheeler; sculpture by Malcolm Morley; and graphics by Katherine Bowling, John Hammond, Jasper Johns, Robert Rauschenberg, and Andy Warhol. The Pre-Columbian Collection contains over 500 artifacts of pottery, jade, stone, textiles, gold, and silver from over 30 different cultural groups. The African Collection contains over 70 ceremonial and utilitarian artifacts mainly from West African cultures.

Terrace Gallery, City of Orlando

City Hall, 400 S. Orange Ave., Orlando, FL 32801

Tel: (407) 246-4279

Fax: (407) 246-4329

Public Art Coordinator: Mr. Frank Holt

Open: Monday to Friday, 8am-9pm; Saturday to Sunday, noon-5pm; Holidays, noon-5pm.

Facilities: **Exhibition Area**.

Activities: **Temporary Exhibitions**.

Operated by the City of Orlando, the Terrace Gallery presents rotating exhibits focusing on Florida artists and themes.

University of Central Florida Art Gallery

University of Central Florida Main Campus, Visual Arts Building, 4000 Central Fla. Blvd
Orlando, FL 32816

Tel: (407) 823-2676

Fax: (407) 823-6470

Internet Address: http://www.oir.ucf.edu/

Admission: free.

Orlando, Florida

University of Central Florida Art Gallery, cont.
Open: Monday to Friday, 9am-4pm.
Facilities: **Exhibition Area.**
Activities: **Temporary Exhibitions.**

The Gallery features exhibitions of the works of established and emerging artists from Florida, the region, and abroad.

Ormond Beach

Fred Dana Marsh Museum
Tomoka State Park, 2099 N. Beach St., Ormond Beach, FL 32174
Tel: (904) 676-4050
Fax: (904) 676-4060
Park Manager: Mr. Benny M. Woodham, Jr.
Admission: fee: $3.25/auto.
Attendance: 25,000 *Established:* 1967
Open: Daily, 9:30am-4:30pm.
Facilities: **Exhibition Area** (4,000 square feet).

In addition to cultural and natural history exhibits, the Museum houses work by Ormond native, sculptor and architect Fred Dana Marsh.

Ormond Memorial Art Museum and Gardens
78 E. Granada Blvd., Ormond Beach, FL 32176-6358
Tel: (904) 676-3347
Fax: (904) 676-3244
Director: Ms. Ann Burt
Admission: suggested contribution-$1.00.
Attendance: 13,000 *Established:* 1946 *Membership:* Y *ADA Compliant:* Y
Open: Monday to Friday, 10am-4pm; Saturday to Sunday, noon-4pm.
Closed: Legal Holidays.
Facilities: **Exhibition Area** (1,800 square feet); **Grounds** (4-acre botanical garden).
Activities: **Education Programs** (children); **Guided Tours** (groups); **Temporary/Traveling Exhibitions** (monthly).
Publications: newsletter (semi-annual).

Located in a botanical garden featuring native flora, the Museum was initiated by the gift of 56 paintings by the artist Malcolm Fraser to the City of Ormond Beach. In addition to displaying Fraser's work, the Museum presents a schedule of temporary art exhibitions.

Palm Beach

Flagler Museum
Cocoanut Row and Whitehall Way, Palm Beach, FL 33480
Tel: (561) 655-2833
Fax: (561) 655-2826
Internet Address: http://www.flagler.org
Exec. Director: Mr. John Michael Blades
Admission: fee: adult-$8.00, child-$3.00.
Attendance: 80,000 *Established:* 1959 *Membership:* Y *ADA Compliant:* Y
Parking: in front of museum.
Open: Tuesday to Saturday, 10am-5pm; Sunday, noon-5pm.
Closed: New Year's Day, Thanksgiving Day, Christmas Day.
Facilities: **Architecture** (Whitehall Mansion, 1902; designed by Carrère and Hastings; designated a National Historic Landmark); **Shop.**
Activities: **Concerts**; **Guided Tours**; **Lectures**; **Permanent Exhibits**; **Temporary Exhibitions.**
Publications: booklet, " Flagler Museum: An Illustrated Guide".

Flagler Museum, cont.

An historic house museum, the Flagler features "Whitehall", Henry Flagler's wedding present to his wife, Mary Lily Kenan. When it was completed in 1902, Whitehall was hailed by the New York Herald as "more wonderful than any palace in Europe, grander and more magnificent than any other private dwelling in the world." After a career as a founding partner with John D. Rockefeller in Standard Oil, Henry Morrison Flagler turned his interests to developing Florida. Eventually, Flagler's Florida East Coast Railway, and the luxury hotels he built along the way, linked the entire east coast of Florida, establishing agriculture and tourism as Florida's leading industries and Palm Beach as one of the world's great winter resorts. Flagler's private railcar is displayed on the South Lawn of the Museum. In addition to tours of Whitehall, the Flagler presents special programs and changing exhibits during the year.

Hibel Museum of Art

150 Royal Poinciana Plaza, Palm Beach, FL 33480
Tel: (561) 833-6870
Fax: (561) 848-9640
Internet Address: http://www.hibel.com
Director: Ms. Mary Johnson
Admission: voluntary contribution.
Attendance: 25,000 *Established:* 1977
Membership: Y *ADA Compliant:* Y
Parking: free behind museum.
Open: Tuesday to Saturday, 10am-5pm;
 Sunday, 1pm-5pm.
Closed: New Year's Day, Independence Day,
 Thanksgiving Day, Christmas Day.
Facilities: **Galleries**; **Library** (500 volumes); **Shop**.
Activities: **Arts Festival** (fall); **Concerts** (Nov-June, 2nd
 Sunday in month, 2pm); **Guided Tours**; **Lectures**;
 Permanent Exhibits.
Publications: books, "Edna Hibel: Her Life and Art";
 brochure; exhibition catalogue; newsletter.

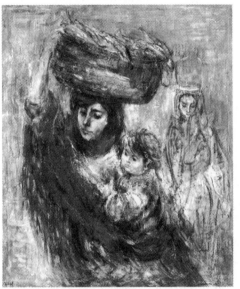

Edna Hibel, *Portuguese Mother and Child*, 1965, oil glaze on canvas, 48 x 40 inches. Permanent collection, Hibel Museum of Art. Photograph courtesy of Hibel Museum of Art, Palm Beach, Florida.

The Museum is dedicated to displaying the art of Edna Hibel. The permanent collection of over 1,000 works by Hibel includes paintings, drawings, stone lithographs, and porcelains. Special exhibits are arranged several times each year. Repeated themes in Hibel's art include mothers and children, people from many lands, biblical persons, landscapes and florals.

The Society of the Four Arts - Gallery

2 Four Arts Plaza, Palm Beach, FL 33480
Tel: (407) 655-7227
Fax: (407) 655-7233
Internet Address: http://www.pbol.com/4arts/
Interim Director: Nancy Mato
Admission: suggested contribution-$3.00.
Attendance: 35,000 *Established:* 1936 *Membership:* Y *ADA Compliant:* Y
Parking: free on site.
Open: **Gallery: December to mid-April**, Monday to Saturday, 10am-5pm; Sunday, 2pm-5pm.
 Gardens: May to October, Monday to Friday, 10am-5pm.
 Gardens: November to April, Monday to Friday, 10am-5pm; Saturday, 9am-1pm.
Closed: Gallery: May to October.
Facilities: **Architecture** (gallery design by Addison Mizner, renovation 1974 by John Volk);
 Auditorium (717 seats); **Galleries**; **Horticultural Gardens**; **Library** (60,000 volumes, non-circulating; children's library); **Reading Room**; **Sculpture Gardens**.

Palm Beach, Florida

The Society of the Four Arts - Gallery, cont.

Activities: **Concerts** (Dec-Mar, 1/month); **Education Programs** (children); **Film Series** (Jan-Mar, Fri, 2:30pm/5:15pm/8pm, $3); **Gallery Talks** (Sat of week following exhibition opening, 3pm); **Lectures** (Jan-Mar, Tues, 3pm); **Temporary Exhibitions** (monthly); **Traveling Exhibitions**.

Publications: exhibition catalogues (4/year); schedule of events (annual).

The Society of the Four Arts was founded in 1936 by a group of Palm Beach residents to meet the cultural needs of the resort community. Its original building on Four Arts Plaza by Maurice Fatio now houses the Library. The Esther B. O'Keeffe Gallery Building designed by architect Addison Mizner contains galleries and an auditorium to accommodate art exhibitions and other programs. The Rovinsky Building, designed by Addison Mizner and renovated in 1974 by John Volk, contains administrative offices and a children's library on the second floor. The Gallery presents monthly temporary exhibitions from early December through mid-April. The Philip Huilitar Sculpture Garden contains works by Carlos Castenada, Edward Fenno Hoffman, III, and Isamu Noguchi.

Panama City

Visual Arts Center of Northwest Florida

19 East 4th St. at Harrison, Panama City, FL 32401

Tel: (850) 769-4451

Fax: (850) 785-9248

Internet Address: http://www.visualartscenter.org

Interim Director: Mr. Jerry Williams

Admission: fee-$1.00-5.00.

Attendance: 25,000 *Established:* 1988 *Membership:* Y *ADA Compliant:* Y

Parking: free public parking near site.

Open: Tuesday/Thursday, 10am-8pm; Wednesday/Friday, 10am-4pm; Saturday to Sunday, 1pm-5pm.

Closed: New Year's Eve to New Year's Day, July 4th Week, Christmas Eve to Christmas Day.

Facilities: **Art Studios**; **Children's Interactive Gallery** ("Impressions"); **Exhibition Area** (2 galleries; total 2,850 square feet).

Activities: **Guided Tours**; **Lectures** (quarterly); **Visiting Artist Program**; **Workshops**.

Publications: newsletter, "Images".

The Center presents the work of at least 375 Florida artists annually in two galleries, the 2,100-square foot Main Gallery and the 750-square-foot Higby Memorial Gallery. The Main Gallery mounts a variety of temporary exhibitions, including juried competitions, museum-coordinated traveling exhibits, and works by contemporary artists. The lower galleries offer the work of emerging artists and community-sponsored competitions and collections. The Center maintains a permanent collection of work primarily by local and regional artists.

Pensacola

Pensacola Junior College - Visual Arts Gallery

Pensacola Junior College, 1000 College Ave., Pensacola, FL 32504

Tel: (850) 484-2563

Fax: (850) 484-2564

Internet Address: http://www.dept.pjc.cc.fl.us/art/events.html

Director: Mr. Allan Peterson

Admission: free.

Attendance: 28,000 *Established:* 1970 *ADA Compliant:* Y

Open: **September to May**, Monday to Thursday, 8am-9pm; Friday, 8am-3:30pm.

Closed: Holidays.

Facilities: **Exhibition Area**; **Studio Complex**.

Activities: **Education Programs** (college students); **Guided Tours**; **Temporary Exhibitions**.

Publications: announcements; brochures; catalogues; posters.

The Gallery presents a schedule of exhibitions during the school year, including faculty and student shows.

Pensacola Museum of Art

407 S. Jefferson St., Pensacola, FL 32501

Tel: (904) 432-6247

Fax: (904) 469-1532

Internet Address: http://www.artsnwfl.org/pma/index.html

Director: Linda P. Nolan, Ph.D.

Admission: fee: adult-$2.00, student-$1.00.

Attendance: 75,000 *Established:* 1954 *Membership:* Y *ADA Compliant:* Y

Parking: free lot across street.

Open: Tuesday to Friday, 10am-5pm; Saturday, 10am-4pm.

Closed: Legal Holidays.

Facilities: **Architecture** (old city jail, 1908); **Auditorium** (100 seats); **Classrooms**; **Library** (1,500 volumes); **Shop**.

Activities: **Education Programs** (adults and children); **Films**; **Guided Tours**; **Lectures**; **Permanent Exhibits**; **Temporary Exhibitions**; **Traveling Exhibitions**.

Publications: exhibition catalogues; newsletter.

The PMA presents temporary exhibits as well as maintaining collections and a reference library. In addition to extensive holdings in European and American glass and sub-Saharan traditional art, the permanent collection includes works by noted artists such as Milton Avery, Linda Benglis, Thomas Hart Benton, Alexander Calder, Salvador Dali, Alex Katz, John Marin, Fairfield Porter, and Miriam Schapiro.

University of West Florida Art Gallery

11000 University Parkway, Pensacola, FL 32514

Tel: (850) 474-2045 *Ext:* 2696

Fax: (850) 474-3247

Internet Address: http://www.uwf.edu/~art

Admission: voluntary contribution.

Attendance: 11,000 *Established:* 1970

Membership: Y *ADA Compliant:* Y

Parking: free in lots adjacent to building.

Open: **mid-January to early December**,
Monday to Thursday, 10am-5pm;
Friday, 10am-4pm;
Sunday, 1pm-4pm.

Closed: Easter Friday, Veterans Day, Thanksgiving Day.

View of Gallery during Art Faculty Exhibition. Photograph courtesy of University of West Florida Art Gallery, Pensacola, Florida.

Facilities: **Gallery** (1,650 square feet, plus smaller exhibit space).

Activities: **Films** (several/year); **Gallery Talks** (often during opening reception for exhibit); **Guided Tours** (call to arrange); **Lectures** (adjunct art faculty lecture series, plus other speakers); **Temporary Exhibitions**; **Traveling Exhibitions** (1/year).

Publications: catalogues; posters.

The Art Gallery's major exhibition emphasis is on Contemporary Art, but the Gallery also exhibits art from other historical periods and various cultures in accord with its educational mission. In addition, the Art Gallery has a small permanent collection of Modern and Contemporary works on paper, which are exhibited on a regular basis.

Saint Augustine

Lightner Museum

City Hall Museum Complex, 75 King St., Saint Augustine, FL 32084

Tel: (904) 824-2874

Fax: (904) 824-2712

Director: Mr. Robert Harper

Saint Augustine, Florida

Lightner Museum, cont.

Admission: fee: adult-$6.00, child-$2.00, student-$2.00.

Attendance: 107,000 *Established:* 1948

ADA Compliant: Y

Parking: metered on street.

Open: Daily, 9am-5pm.

Closed: Christmas Day.

Facilities: **Architecture** (former Alcazar Hotel, 1888; designed by Carrère and Hastings); **Courtyard Garden; Food Services** Restaurant; **Galleries; Library** (6,000 volumes); **Museum Shop.**

Activities: Concerts; Lectures; Permanent Exhibits; Temporary Exhibitions.

Publications: exhibition catalogues; guidebooks.

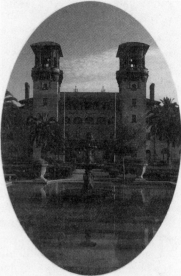

Exterior view of former Alcazar Hotel, home of Lightner Museum. Photograph courtesy of Lightner Museum, Saint Augustine, Florida.

A gift to the City of Saint Augustine by Otto C. Lightner, founding editor of Hobbies Magazine, the Lightner Museum is housed in the former Alcazar Hotel. The building, which is listed on the National Register of Historic Places, is the Museum's most prized possession. Its elaborate architecture provides an authentic and appropriate setting for the Museum's exhibits of fine and decorative arts featuring "Brilliant Period" cut glass, Victorian art glass, and a room showcasing the work of Louis Comfort Tiffany; porcelain; furnishings; costumes; mechanical musical instruments, and other artifacts of 19th-century life.

Saint Petersburg

Florida International Museum

100 2nd St. North, Saint Petersburg, FL 33701-3312

Tel: (800) 777-9882

Fax: (727) 898-0248

Internet Address: http://www.floridamuseum.org

Admission: fee: adult-$13.95, child (<6)-free (6-18)-$5.95, college student-$7.95, senior-$12.95.

Established: 1995 *ADA Compliant:* Y

Open: Monday to Saturday, 9am-6pm; Sunday, noon-6pm.

Closed: New Year's Day, Thanksgiving Day, Christmas Day.

Facilities: **Exhibition Area.**

Activities: Exhibitions.

L ocated in a former department store building, Florida International Museum was created as a venue for major traveling educational, cultural, or historical exhibitions. Between its opening in 1995 and 1998, the Museum hosted four exhibitions with a combined attendance of nearly 2 million people. A Smithsonian Affiliate, the Museum hosts temporary exhibitions from the Smithsonian Institution. The Museum is also the permanent home of the largest private collection of Kennedy artifacts.

Museum of Fine Arts

255 Beach Drive, N.E.. Saint Petersburg, FL 33701-3498

Tel: (727) 896-2667

Fax: (727) 894-4638

Internet Address: http://www.fine-arts.org

Director: Mr. Michael Milkovich

Admission: fee: adult-$6.00, child (<7)-free, student-$2.00, senior-$5.00.

Attendance: 125,000 *Established:* 1961 *Membership:* Y *ADA Compliant:* Y

Parking: free on site and on street.

Open: Tuesday to Saturday, 10am-5pm; Sunday, 1pm-5pm.

Closed: New Year's Eve to New Year's Day, Thanksgiving Day, Christmas Day.

Museum of Fine Arts, cont.

Facilities: **Architecture** (Palladian-style building, 1965 design by John Volk); **Galleries** (20); **Gardens** (Membership Garden); **Lecture/Performing Arts Hall** (225 seats); **Library**; **Sculpture Garden**; **Shop**.

Activities: **Concert Series** (primarily Sun afternoons); **Docent-led Tours** (Tues-Fri, 10am/11am/1pm/2pm; Sat, 11am/1pm/2pm/3pm; Sun, 1pm/2pm); **Education Programs** (adults and children); **Film Series** (usually Wed afternoons); **Gallery Talks**; **Lectures**; **Performances**; **Permanent Exhibits**; **Special Exhibitions**.

Publications: "Catalogue of Collection"; exhibition catalogues; newsletter, "Mosaic" (quarterly).

Georgia O'Keeffe, *Poppy*, 1927, oil on canvas, 30 x 36 inches. Collection of Museum of Fine Arts. Photograph by Thomas Gessler, courtesy of Museum of Fine Arts, St. Petersburg, Florida.

The Museum is housed in an elegant Palladian-style building designed by John Volk. The building, itself a work of art, combines the styles of a classic art museum and a Mediterranean villa at home in Florida's tropical climate. In addition to permanent exhibits of its collection and special exhibitions, there are several period rooms, including the Jacobean Room, originally part of a Staffordshire manor house built around 1610 and furnished with carved oak furniture, fine pewter, and 17th-century prints by such masters as Dürer and Rembrandt, and an elegant Georgian Room from about 1740 believed to have come from the Bulls Inn in London. The permanent collection of more than 4,000 works is comprehensive, extending from antiquity to the present day. Holdings are particularly strong in 19th-century French and American painting, early to mid 20th-century American painting, and photography. Among the French artists represented in the collection are Cézanne, Corot, Daumier, Fragonard, Gauguin, Gerôme, Monet, Morisot, Picabia, Renoir, Robert, and Rodin. American artists with work in the collection include Bellows, Henri, Homer, Inness, Lichtenstein. Luks, Thomas Moran, O'Keeffe, Prendergast, Rauschenberg, Rosenquist, Frank Stella, Warhol, and Whistler. The photography holdings feature works by Adams, Arbus, Avedon, Cartier-Bresson, Siskind, Steichen, Strand, Fox Talbot, and Weston. Also on view are ancient Greek and Roman, pre-Columbian, Asian, and American Indian art, and decorative arts, including a gallery of Steuben glass.

Salvador Dali Museum

1000 3rd St. South (adjacent to the University of South Florida, Bayboro Campus)
Saint Petersburg, FL 33701
Tel: (727) 823-3767
Fax: (727) 894-6068
Internet Address: http://www.salvadordalimuseum.org
Director: Mr. Marshall Rouseau
Admission: fee: adult-$9.00, child-free, student-$5.00, senior-$7.00.
Attendance: 250,000 *Established:* 1982 *Membership:* Y *ADA Compliant:* Y
Parking: free on site.
Open: Monday to Wednesday, 9:30am-5:30pm; Thursday, 9:30am-8pm; Friday to Saturday, 9:30am-5:30pm; Sunday, noon-5pm.
Closed: Thanksgiving Day, Christmas Day.
Facilities: **Galleries**; **Library** (5,000 volumes, use by appointment); **Shop** (books on Dali and Surrealism, reproductions, posters).
Activities: **Concerts**; **Education Programs** (children); **Films**; **Guided Tours**; **Lectures**; **Permanent Exhibits**; **Temporary Exhibitions**.
Publications: books; exhibition catalogues.

Salvador Dali Museum, cont.

The Museum houses the most comprehensive collection of the artist Salvador Dali's works. Holdings include 95 oil paintings, over 100 watercolors and drawings, approximately 1,300 graphics, sculptures, objet d'art, photographs, and archival material. A retrospective of oil paintings on permanent display is complemented by periodic rotation of other works from the collection and changing special exhibitions. The Museum also organizes three to four special exhibitions annually featuring works by other surrealists on themes related to Dali or Surrealism.

Sarasota

Art Center Sarasota

707 N. Tamiami Trail, Sarasota, FL 34236

Tel: (941) 365-2032

Fax: (941) 366-0585

Exec. Director: Lisa-Marie Confessore

Admission: donation: $2.00.

Attendance: 20,000 *Established:* 1926 *Membership:* Y *ADA Compliant:* Y
Parking: on site, front and side.

Open: Tuesday to Sunday, 10am-4pm.

Closed: Easter, Thanksgiving Day, Christmas Day to New Year's Day.

Facilities: **Exhibition Area**; **Library** (200 volumes, non-circulating); **Sculpture Garden**.

Activities: **Arts Festival**; **Demonstrations**; **Gallery Talks**; **Guided Tours**; **Juried Exhibits**; **Lectures**; **Temporary Exhibitions**; **Workshops**.

Publications: bulletin (monthly); workshop brochures; yearbook, "Sarasota Art Association Yearbook" (annual).

The Art Center serves the community as a venue for exhibitions featuring contemporary art and classes for adults and children.

John and Mable Ringling Museum of Art

5401 Bayshore Road (south of Sarasota-Bradenton International Airport), Sarasota, FL 34243

Tel: (941) 359-5100

Fax: (941) 359-5745

Internet Address: http://www.ringling.org

Director: Dr. David Ebitz

Admission: fee: adult-$9.00, child-free, senior-$8.00.

Attendance: 280,000 *Established:* 1928 *Membership:* Y *ADA Compliant:* Y
Parking: free on site.

Open: Daily, 10am-5:30pm.

Closed: New Year's Day, Thanksgiving Day, Christmas Day.

Facilities: **Architecture** Museum (Italian Renaissance-style, 1927-29), Ringling Mansion, "Ca' d'Zan" (Venetian Gothic-style1924-26); **Classrooms**; **Food Services** Banyan Café (May-Oct, daily, 11am-4pm; Nov-Apr, daily, 11am-5pm); **Galleries**; **Library** (50,000 volumes, non-circulating); **Sculpture Garden**; **Shop**; **Theatre** (200 seats).

Activities: **Education Programs** (adults and children); **Gallery Talks**; **Guided Tours** (Mon-Fri, 10:15/10:30/11:15/11:45am/12:45/1:15/1:45/2pm); **Lectures**; **Permanent Exhibits**; **Temporary Exhibitions**; **Traveling Exhibitions**.

Publications: book, "The John and Mable Ringling Museum of Art"; collection catalogues; exhibition catalogues; newsletter, "Ringling Museum Newsletter" (quarterly).

The Museum of Art is part of a complex which also contains John and Mable Ringling's fantastic, 31-room winter home, the Ca' d'Zan, the Museum of the Circus, a19th-century Italian theatre, and archives. The Museum of Art's permanent collection, spanning 500 years of European and American art, is particularly strong in European 16th- and 17th-century paintings, featuring Peter Paul Rubens' painting cycle "The Triumph of the Eucharist", and also including works by Hals, Jordaens, Poussin, Strozzi, Tiepolo, Van Dyck, Velasquez, Veronese, and Vouet. Bronze replicas of classical and Baroque sculpture made in the 19th and 20th centuries are displayed in the Courtyard.

Ringling School of Art and Design - Selby Gallery

2700 N. Tamiami Trail
(on Dr. Martin Luther King, Jr. Way)
Sarasota, FL 34234
Tel: (941) 359-7563
Fax: (941) 359-7517
Internet Address: http://www.rsad.edu
Director: Mr. Kevin Dean
Admission: voluntary contribution.
Attendance: 24,000 *Established:* 1986
Membership: Y *ADA Compliant:* Y
Parking: free on site.
Open: **During Exhibitions**,
 Monday to Saturday, 10am-4pm.
Closed: Academic Holidays.

Exterior view of Selby Gallery. Photograph courtesy of Selby Gallery, Ringling School of Art and Design, Sarasota, Florida.

Facilities: **Auditorium** (125 seats); **Exhibition Area** (3,000 square feet).
Activities: **Concerts**; **Gallery Talks**; **Lectures**; **Readings**; **Temporary Exhibitions** (8+/year).
Publications: exhibition catalogues.

L̲ocated on the campus of the Ringling School of Art and Design, the Selby Gallery presents a season of art exhibitions by nationally and internationally known artists and designers. Although the Gallery focuses on contemporary art, photography, illustration, graphic design, interior design, and computer animation, exhibitions of historical importance are also presented. In addition, the Gallery highlights the work of faculty, staff, and students through annual exhibitions.

Sebring

Highlands Museum of the Arts (Highlands Art League)

Altvater Cultural Center on Lake Jackson, 351 W. Center Ave. (directly behind library)
Sebring, FL 33870
Tel: (863) 385-5312
President: Gene Brenner
Admission: voluntary contribution.
Established: 1966 *Membership:* Y *ADA Compliant:* Y
Parking: free public parking.
Open: Monday to Friday, noon-4pm.
Closed: Legal Holidays.
Facilities: **Classrooms**; **Gallery**; **Shop** (unique crafts and original art).
Activities: **Arts Festival** (2nd Sat in Nov); **Classes**; **Crafts Festival** (final Sat in Feb).
Publications: newsletter, "Brushstroke" (bi-monthly).

L̲ocated in the Allen C. Altvater Cultural Center, the Museum Gallery features shows of the work of established artists, member artists, and Highlands Art League students.

Tallahassee

Florida A&M University - Foster-Tanner Fine Arts Gallery

Foster-Tanner Building
Gamble Street and M.L. King Blvd.
Tallahassee, FL 32307
Tel: (850) 599-3161
Fax: (850) 599-8761
Internet Address: http://www.famu.edu
Director: Gylbert G. Coker
Admission: free.
Established: 1997

Interior view, Foster-Tanner Fine Arts Gallery. Photograph courtesy of Florida A&M University, Tallahassee, Florida.

Florida A&M University - Foster-Tanner Fine Arts Gallery, cont.

Parking: University garage.
Open: Monday to Friday, 9am-5pm.
Facilities: Galleries (2).
Activities: Temporary Exhibitions; Traveling Exhibitions.
Publications: exhibition catalogues (occasional).

The Gallery presents six exhibitions each season, including the work of students and local artists, as well as traveling exhibitions.

Florida State University - Museum of Fine Arts

Fine Arts Building, Copeland and W. Tennessee Streets
Tallahassee, FL 32306
Tel: (904) 644-6836
Fax: (904) 644-7229
Internet Address:
 http://www.fsu.edu/~svad/FSUMuseum/index.html
Director: Dr. Allys Palladino-Craig
Admission: free.
Attendance: 45,000 *Established:* 1950
Membership: Y *ADA Compliant:* Y
Parking: metered and pay lot parking on West Call St.
Open: **September to April**, Monday to Friday, 10am-4pm; Saturday to Sunday, 1pm-4pm.
 May to August, Monday to Friday, 10am-4pm.
Closed: Academic Holidays.
Facilities: **Galleries (7); Lecture Room; Sculpture Courtyard.**
Activities: **Education Programs; Gallery Talks; Guided Tours** (groups, 644-1299); **Lectures; Performances; Permanent Exhibits; Temporary Exhibitions; Traveling Exhibitions.**

Trevor Bell, *Gumbaranjon*, 1991, acrylic on shaped canvas, 7' 1" x 6' 9". From 1994 exhibition of contemporary painting, "Chroma", Museum of Fine Arts, Florida State University, Tallahassee, Florida. Photograph courtesy of Trevor Bell.

Publications: art history journal, "Athanor"; brochures; curatorial publication, "Thematic"; exhibition catalogues.

The Museum of Fine Arts, a division of the School of Visual Arts and Dance at Florida State University, is the largest art museum within two hours driving time of Tallahassee. At the time of its formation in 1950, it occupied one small room, operated without specific funding, and was administered by faculty on a volunteer basis. Spurred on particularly by the move in 1970 into a new facility of over 16,000 square feet and by the establishment of the School of Visual Arts in 1973, the growth of the Museum has been significant and steady. The Museum presents a balanced schedule of changing exhibitions based on available resources, categories of media, art historical periods and contemporary issues. The scope ranges from national impact exhibitions, often scholarly presentations of works never previously exhibited, to the work of regional artists or students. Lower level exhibitions run concurrently with upper gallery changing exhibitions.

LeMoyne Art Foundation, Inc.

125 N. Gadsden, Tallahassee, FL 32301
Tel: (904) 222-8800
Fax: (904) 224-2714
Director: Mr. Richard L. Puckett
Admission: fee-$1.00.
Established: 1964 *Membership:* Y *ADA Compliant:* Y
Parking: free on site.

LeMoyne Art Foundation, Inc., cont.
Open: **September to July**, Tuesday to Saturday, 10am-5pm; Sunday, 2pm-5pm.
Closed: New Year's Day, Independence Day, Christmas Day.
Facilities: **Architecture** (Meginnis-Munroe House, 1854); **Classrooms**; **Exhibition Area**; **Sales Gallery**; **Sculpture Garden**; **Shop**.
Activities: **Concerts**; **Education Programs** (adults and children); **Gallery Talks**; **Guided Tours**; **Lectures**; **Permanent Exhibits**; **Temporary/Traveling Exhibitions** (8-12/year).
Publications: newsletter.

Named for Jacques LeMoyne, a French artist who traveled through North Florida in 1554, the LeMoyne Art Foundation promotes the visual arts through exhibits, educational programs, and special events. It presents eight to twelve exhibitions each year and has a permanent collection representing examples of all forms of the visual arts by well-known and developing artists.

Tampa

Tampa Museum of Art
600 N. Ashley Drive (adjacent to Curtis Hixson Park), Tampa, FL 33602
Tel: (813) 274-8130
Fax: (813) 274-8732
Internet Address: http://www.tampamuseum.com
Director: Ms. Emily S. Kass
Admission: fee: adult-$5.00, child (<6)-free (>6)-$3.00, student-$3.00, senior-$4.00
donation: Thursday, 5pm-8pm & Saturday 10am-12pm.
Attendance: 80,000　*Established:* 1979　*Membership:* Y　*ADA Compliant:* Y
Parking: pay on site.

Open: Tuesday to Wednesday, 10am-5pm;
Thursday, 10am-8pm;
Friday to Saturday, 10am-5pm;
Sunday, 1pm-5pm.
Closed: New Year's Day, Independence Day, Thanksgiving Day, Christmas Day.
Facilities: **Classroom**; **Galleries** (7); **Lecture Room**; **Library**; **Sculpture Court**; **Shop** (museum hours, plus Mon, 10am-5pm).
Activities: **Concerts**; **Education Programs** (adults and children); **Films**; **Guided Tours** (Wed & Sat, 1pm; Sun, 2pm); **Lectures**; **Permanent Exhibits**; **Traveling Exhibitions**; **Workshops**.
Publications: exhibition catalogues; gallery guides; magazine; newsletter & calendar, "ArtMuse".

The Museum presents exhibits of works drawn from its permanent collection and traveling exhibitions. Its permanent collection includes an extensive group of Etruscan, Greek, and Roman antiquities; contemporary American painting; works on paper, and 19th to 20th-century photography.

Interior view of the Barbara and Costas Lemonopoulos Gallery. Photograph courtesy of the Tampa Museum of Art, Tampa, Florida.

University of South Florida Contemporary Art Museum (USF CAM)
W. Holley Drive (adjacent to the College of Fine Arts), Tampa, FL 33620
Tel: (813) 974-2849
Fax: (813) 974-5130
Internet Address: http://www.arts.usf.edu/museum
Director: Ms. Margaret A. Miller
Admission: free.
Attendance: 52,000　*Established:* 1968　*Membership:* Y　*ADA Compliant:* Y
Parking: free on site.
Open: Monday to Friday, 10am-5pm; Saturday, 1pm-4pm.
Closed: Academic Holidays.

Tampa, Florida

University of South Florida Contemporary Art Museum, cont.

Facilities: **Galleries** (4; 2 exhibition galleries, 2 apart from museum); **Shop.**

Activities: **Education Programs** (undergraduate and graduate college students); **Gallery Talks**; **Guided Tours** (groups, reserve two weeks in advance, 974-4133); **Lectures**; **Temporary Exhibitions**; **Traveling Exhibitions**.

Publications: calendar (biennial); exhibition catalogues; newsletter; posters.

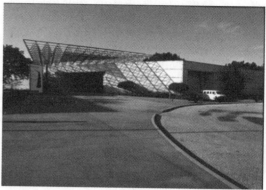

Exterior view of University of South Florida Contemporary Art Museum. Photograph courtesy of University of South Florida Contemporary Art Museum, Tampa, Florida.

USF CAM presents changing exhibitions, designed to introduce students, faculty, and the community to current trends in contemporary fine art from Florida, the United States, and around the world. The Museum also maintains the University's art collection of over 3,500 artworks. Its primary strength is in contemporary graphics. Many of CAM's holdings have been produced at USF's Graphicstudio, an internationally recognized print atelier. CAM's holdings include works by such artists as Vito Acconci, Arakawa, Sandro Chia, Chuck Close, Jim Dine, David Hockney, Jasper Johns, Roy Lichtenstein, Robert Maplethorpe, Matt Mullican, Robert Rauschenberg, James Rosenquist, Richard Serra, and Andy Warhol. Additionally, site specific works have been placed throughout the USF campus under Florida's Art in State Buildings Program. Major public arts projects include works by Dale Eldred, Richard Fleischner, Doug Hollis, Nancy Holt, Tim Rollins and K.O.S., Ned Smyth, and Elyn Zimmerman.

University of Tampa - Lee Scarfone Gallery

401 W. Kennedy, Tampa, FL 33606

Tel: (813) 253-3333

Fax: (813) 258-7211

Internet Address: http://www.utampa.edu/acad/clas/art/gallery.htm

Director: Ms. Dorothy C. Cowden

Admission: voluntary contribution.

Attendance: 11,000 *Established:* 1977 *Membership:* Y *ADA Compliant:* Y

Parking: parking lot near building.

Open: **August to May**, Tuesday to Friday, 10am-4pm; Saturday, 1pm-4pm.

Closed: June to July, Academic Holidays.

Facilities: **Architecture** (renovated WPA building, 1977 design by architect Lee Scarfone); **Exhibition Area** (2 galleries, 5,800 square feet); **Lecture Facility** (25 seats).

Activities: **Arts Festival**; **Concerts**; **Dance Recitals**; **Films**; **Guided Tours**; **Lectures**; **Performances**; **Temporary Exhibitions** (9-11/year).

Publications: brochures; exhibition catalogues.

Lee Scarfone Gallery, the University of Tampa's teaching gallery, provides a venue for exhibitions of work by national, international, and regional artists, faculty, and students. Multimedia events including lectures, workshops, and performances complement the visual arts exhibitions. In the lecture hall, there is a continuing exhibit of monotypes created in the STUDIO-f guest artist program.

Tarpon Springs

St. Petersburg Junior College - Leepa-Rattner Museum of Fine Art

SPJC Tarpon Springs Center, 600 Klosterman Road, Tarpon Springs, FL 34683

Tel: (727) 341-3141

Internet Address: http://www.spjc.fl.us/webcentral/welcome/museum.htm

Director: Lynn Whitelaw

Established: 2000

Parking: nearby college lots.

St. Petersburg Junior College - Leepa-Rattner Museum of Fine Art, cont.

Open: Opens to the public, Fall, 2001. Call for hours.

Facilities: Classrooms; Galleries; Library; Shop.

Activities: Education Program; Permanent Exhibitions; Temporary and Traveling Exhibitions.

Scheduled to open in 2001, the Museum will serve as a repository for the permanent collection, as a venue for traveling and student exhibitions, and as an educational/research facility. The permanent collection primarily consists of works by figurative expressionist Abraham Rattner, abstractionist Allen Leepa; and sculptor/printmaker Esther Gentle. Additionally represented in the collection are works by artists such as Marc Chagall, Max Ernst, Henry Moore, Pablo Picasso, and Georges Roualt.

Universalist Church - Tarpon Springs

57 Read Street, Tarpon Springs, FL 34689

Tel: (727) 937-4682

Open: **October to May,**
Tuesday to Sunday, 2pm-5pm.

Facilities: Exhibition Area.

Activities: Permanent Exhibit (largest collection of paintings by George Inness, Jr.).

The Church houses a collection of eleven works by George Inness, Jr., including three landscape panels painted to be used temporarily in place of windows destroyed by a hurricane in 1918.

George Inness, Jr., *Promise, Realization, Fulfillment,* 1918, Collection of Unitarian Universalist Church. Photograph by David Wright courtesy of Unitarian Universalist Church, Tarpon Springs, Florida.

Tequesta

Lighthouse Center for the Arts

373 Tequesta Drive, Tequesta, FL 33469

Tel: (561) 746-3101

Fax: (561) 746-3241

Director: Ms. Margaret Inserra

Admission: voluntary contribution.

Attendance: 32,500 *Established:* 1965

Open: **September to May,** Monday to Saturday, 9:30am-4:30pm.
June to August, Monday to Friday, 9:30am-4:30pm

Closed: Legal Holidays.

Facilities: Exhibition Area; School; Shop.

Activities: Art Classes; Concerts (Jazz Series); Lectures; Temporary Exhibitions (monthly).

The gallery presents monthly exhibitions of work by nationally recognized artists and from adult and children's art classes.

Vero Beach

Center for the Arts

3001 Riverside Park Drive, Vero Beach, FL 32963-1807

Tel: (561) 231-0707

Fax: (561) 231-0938

Internet Address: http://www.centerforthearts.com

Exec. Director: Mr. John Z. Lofgren

Admission: suggested contribution-$2.00.

Attendance: 100,000 *Established:* 1986 *Membership:* Y *ADA Compliant:* Y

Parking: free on site.

Vero Beach, Florida

Center for the Arts, cont.

Open: Monday to Wednesday, 10am-4:30pm;
Thursday, 10am-8pm;
Friday to Saturday, 10am-4:30pm
.Sunday, 1pm-4:30pm.

Facilities: **Auditorium** (250 seats); **Educational Facilities; Exhibition Area; Library** (3,500 volumes); **Sculpture Garden; Shop** (Mon-Fri, 10am-4:30pm; Sat, 10am-4pm; Sun, 1am-4pm).

Activities: **Art and Humanities Classes** (over 150/year); **Children's Arts Festival; Concerts; Cultural Celebrations; Films; Family and Youth Events; Guided Tours** (Oct-Apr, Wed-Sat, 1:30-3:30; groups, by advance appointment); **Lectures; Seminars; Temporary Exhibitions.**

Publications: annual report; exhibition catalogues, "Gallery Guide"; "Center for the Arts News" (bi-monthly).

Haydyn Llewellyn Davie, *Trevan's Arch*, brakeform aluminum, 19 x 19 x 28 feet. Center for the Arts collection, gift of Susan Mallinson. In background is exterior view of Center for the Arts. Photograph courtesy of Center for the Arts, Vero Beach, Florida.

Exhibitions in the Center's Holmes Gallery include works by artists of national and international reputation. The Schumann Florida Gallery shows works by Florida artists, featuring one-person shows by established as well as emerging artists, selected group presentations, and professionally juried exhibitions. Works from the Center's permanent collection are curated into special exhibitions and exhibited regularly in the Center's Stark Permanent Collection galleries. The permanent collection of over 800 objects is dedicated to the preservation and presentation of American art and Florida artists in particular.

West Palm Beach

Norton Museum of Art

1451 S. Olive Ave.
(just south of Okeechobee Blvd.)
West Palm Beach, FL 33401
Tel: (561) 832-5196
Fax: (561) 659-4689
Internet Address: http://www.norton.org
Director: Dr. Christina Orr-Cahall
Admission: fee: adult-$6.00, child-free, student (13-21)-$2.00.
Attendance: 180,000 *Established:* 1941
Membership: Y *ADA Compliant:* Y
Parking: free on site.
Open: Tuesday to Saturday, 10am-5pm;
Sunday, 1pm-5pm.

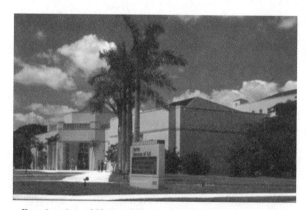

Exterior view of Norton Museum of Art. Photograph by Jeff Goldberg/Esto, courtesy of Norton Museum of Art, West Palm Beach, Florida.

Closed: New Year's Day, Independence Day, Thanksgiving Day, Christmas Day.

Facilities: **Architecture** (renovation/expansion, 1997 by Chad Floyd, Centerbrook Architects of Connecticut; Art Deco/Neo-classic building, 1941 design by Marion Sims Wyeth); **Auditorium** (220 seats); **Food Services** Café (seasonal, closed during summer); **Galleries** (19); **Gardens** (3); **Library** (4,000 volumes); **Shop.**

Activities: **Concerts; Education Programs** (undergraduate students & children; children's program on Sun); **Films; Gallery Talks; Guided Tours** (groups 15+, reserve 2 weeks in advance, 659-6555;, Artventures (Sept-May, Tues-Sun, 2pm; June-Aug, Sat-Sun only), Lunchtime (Tues-Fri, 12:30pm); **Lectures; Performances; Permanent Exhibits; Traveling Exhibitions.**

Norton Museum of Art, cont.

Publications: collection catalogues; exhibition catalogues; posters.

The Norton Museum of Art permanent collection features European, American, Chinese, and Contemporary art, photography, old masters and works on paper. European Impressionists and modern masters, such as Jean Arp, Pierre Bonnard, Constantin Brancusi, Georges Braque, Paul Cézanne, Marc Chagall, Georgio de Chirico, Edgar Degas, Robert Delaunay, Raoul Dufy, Max Ernst, Paul Gauguin, Juan Gris, Paul Klee, Fernand Léger, Jacques Lipchitz, Aristide Maillol, Henri Martin, Henri Matisse, Joan Miró, Claude Monet, Pablo Picasso, Camille Pissarro, Pierre Auguste Renoir, Georges Seurat, Louis Valtat, and Maurice Vlaminck are well represented, as are works by American greats such as George Bellows, Alexander Calder, Stuart Davis, Charles Demuth, Arthur Dove, Duane Hanson, Marsden Hartley, Winslow Homer, Edward Hopper, Jacob Lawrence, John Marin, Robert Motherwell, Kenneth Noland, Georgia O'Keeffe, Claes Oldenburg, Jackson Pollick, Ben Shahn, Charles Sheeler, Frank Stella, and Andy Warhol. The Chinese collection has particular strengths in archaic bronzes, jades, ceramics, and monumental Buddhist sculpture.

Winter Haven

Polk Community College Art Gallery

Winter Haven Campus, Fine Arts Complex, 999 Avenue H, N.E.
Winter Haven, FL 33881-4299
Tel: (941) 297-1050
Fax: (941) 297-1053
Internet Address: http://www.polk.cc.fl.us
Admission: free.
Open: **August to April**, Monday to Friday, 10am-2pm.
May to July, Monday to Thursday, 10am-3pm.
Facilities: **Gallery**.
Activities: **Temporary Exhibitions**.

The Gallery features temporary exhibitions of the work of local artists.

Winter Park

Albin Polasek Museum and Sculpture Garden

633 Osceola Ave., Winter Park, FL 32789
Tel: (407) 647-6294
Fax: (407) 647-0410
Internet Address: http://www.polasek.org
Director: Ms. Heather Wolfe
Admission: suggested donation.
Attendance: 8,000 *Membership:* Y
Parking: free on site; can accommodate large tour bus.
Open: Tuesday to Saturday, 10am-4pm;
Sunday, 1pm-4pm.
Closed: July to August.
Facilities: **Architecture** (home & studio of sculptor Albin Polasek); **Galleries** (2); **Sculpture Garden** (3 acres).
Activities: **Permanent Exhibits**.

Located in the home and studio of the Czech-American sculptor Albin Polasek (1879-1965), the gardens and galleries contain many of the sculptor's works. Antiquities from his collection are on display in the salon of his home. An intimate chapel on the grounds is also open for viewing.

Albin Polasek, *The Pilgrim at the Gate*, Albin Polasek Museum and Sculpture Garden. Photograph courtesy of Albin Polasek Museum and Sculpture Garden, Winter Park, Florida.

The Charles Hosmer Morse Museum of American Art

445 Park Ave. North (between Cole & Canton Aves.)
Winter Park, FL 32789
Tel: (407) 645-5311
Fax: (407) 647-1284
Director: Dr. Laurence J. Ruggiero
Admission: fee: adult-$3.00, student-$1.00.
Attendance: 75,000 *Established:* 1942
Membership: Y *ADA Compliant:* Y
Parking: free behind museum.
Open: Tuesday to Saturday, 9:30am-4pm;
 Sunday, 1pm-4pm.
Closed: New Year's Day, Memorial Day,
 Independence Day, Labor Day,
 Thanksgiving Day, Christmas Day.
Facilities: **Galleries**; **Shop**.
Activities: **Guided Tours** (available during public
 hours; groups by reservation); **Lectures**.

The Charles Hosmer Morse Museum of American Art houses the world's most comprehensive collection of the works of Louis Comfort Tiffany, a major collection of American art pottery and representative collections of late 19th- and early 20th-century American painting, graphics and the decorative arts.

Spring, leaded glass window, 39 x 35 inches, from "The Seasons", designed by Louis Comfort Tiffany for the Paris Exposition of 1900. Charles Hosmer Morse Museum of American Art. Photograph courtesy of Charles Hosmer Morse Museum of American Art, Winter Park, Florida.

Crealdé School of Art - Galleries

600 St. Andrews Blvd., Winter Park, FL 32792
Tel: (407) 671-1886
Fax: (407) 671-0311
Internet Address: http://www.crealde.org
Exec. Director: Mr. Peter Schreyer
Admission: free.
Established: 1975
Membership: Y *ADA Compliant:* Y
Parking: free on site.
Open: Monday to Thursday, 9am-5pm;
 Friday to Saturday, 9am-1pm.
Facilities: **Exhibition Area** (2 galleries); **Sculpture Garden**.
Activities: **Classes**; **Lectures**; **Temporary Exhibitions**.
Publications: newsletter, "Program Guide" (5/year).

Crealdé School of Art mounts temporary exhibitions in two galleries. The Alice & William Jenkins Gallery presents exhibitions of work by nationally and internationally recognized artists in painting, drawing, photography, ceramics, and sculpture. The Crealdé Community Gallery offers exhibits of student work and special exhibitions from Crealdé's outreach programming. In addition, its outdoor sculpture garden features over twenty works by prominent Central Florida three-dimensional artists.

Exterior view of Crealdé School of Art. Photograph courtesy of Crealdé School of Art, Winter Park, Florida.

Rollins College - Cornell Fine Arts Museum

Rollins College, 1000 Holt Ave. Winter Park, FL 32789-4499
Tel: (407) 646-2526
Fax: (407) 646-2524
Internet Address: www// rollins.edu/cfam
Director: Arthur R. Blumenthal, Ph.D.

Rollins College - Cornell Fine Arts Museum, cont.

Admission: free.

Attendance: 24,372 *Established:* 1978 *Membership:* Y *ADA Compliant:* Y

Parking: free in adjacent Lot H and in parking garage.

Open: Tuesday to Friday, 10am-5pm;
Saturday to Sunday, 1pm-5pm.

Closed: Major Holidays (but open Easter Sunday).

Facilities: Galleries.

Activities: **Concert Series**; **Film Series** (Sunday); **Gallery Talks**; **Guided Tours** (groups, Mon-Fri, schedule in advance); **Lecture Series**; **Lectures**; **Permanent Exhibitions**; **Temporary Exhibitions**; **Traveling Exhibitions**.

Publications: collection handbook; exhibition catalogues; posters; postcards.

Sir Thomas Lawrence, *Portrait of Harriet Gordon*, ca. 1820, oil on canvas. Gift of Myers family in memory of John C. Myers, Sr., Cornell Fine Arts Museum. Photograph courtesy of Cornell Fine Arts Museum, Rollins College, Winter Park, Florida.

Located at the end of Holt Avenue on the Winter Park campus of Rollins College, the Cornell Fine Arts Museum boasts the oldest and one of the most distinguished permanent collections in Florida. Nationally known for exhibitions of contemporary and historical art (Gregory Gillespie, Cosimo Rosselli, Winslow Homer, The Ash Can School, etc.), the Cornell Museums also shows Florida artists annually and presents a Senior Art Show every May. Its permanent collection of 6,000 objects contains part of the Kress Collection of Renaissance paintings and widely-recognized paintings from the Hudson River School. It also has an extensive collection of early 20th-century English art from the Bloomsbury Circle.

Georgia

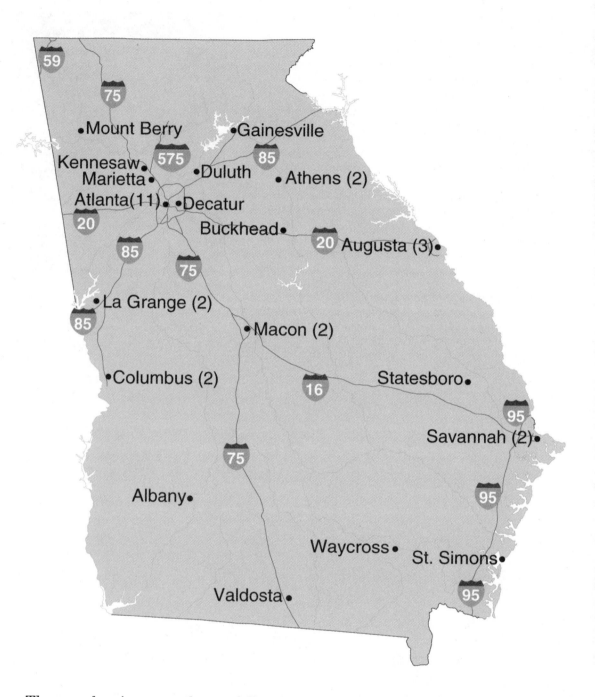

The number in parentheses following the city name indicates the number of museums/galleries in that municipality. If there is no number, one is understood. For example, in the text eleven listings would be found under Atlanta and one listing under Marietta.

Georgia

Albany

Albany Museum of Art (AMA)

311 Meadowlark Drive at Gillionville Road (next to Darton College), Albany, GA 31707

Tel: (912) 435-0977

Fax: (912) 434-4289

Internet Address: http://members.surfsouth.com/%7Eamaedu/

Exec. Director: Mr. Timothy Close

Admission: free.

Attendance: 30,000 *Established:* 1964 *Membership:* Y *ADA Compliant:* Y

Parking: free on site.

Open: Tuesday, 10am-5pm; Wednesday, 10am-7pm; Thursday to Saturday, 10am-5pm; Sunday, 1pm-4pm.

Closed: Legal Holidays.

Facilities: **Auditorium** (200 seats); **Classroom**; **Galleries**; **Shop**.

Activities: **Art Films**; **Arts Fair** (children); **Auction**; **Education Programs** (adults and children); **Guided Tours**; **Lectures**; **Permanent Exhibits**; **Temporary Exhibitions**; **Traveling Exhibitions**.

Publications: newsletter, "ARTalk" (bi-monthly).

The AMA offers twenty exhibitions annually, including its own permanent collection, which includes an extensive holdings of traditional, sub-Saharan African art.

Athens

Lyndon House Art Center

293 Hoyt St. (north end of Jackson St.), Athens, GA 30601

Tel: (706) 613-3623

Director: Ms. Nancy Lukasiewicz

Admission: voluntary contribution.

Established: 1973 *ADA Compliant:* Y

Parking: in front of building and lot off Monroe St..

Open: Tuesday, 11am-8pm; Wednesday to Friday, 11am-5pm.

Closed: Legal Holidays.

Facilities: **Architecture** (Greek Revival Ware-Lyndon House, 1850); **Classrooms**; **Exhibition Area**; **Grounds** (perennial garden); **Library**; **Studios**.

Activities: **Arts Festival**; **Education Programs** (adults and children); **Gallery Talks**; **Guided Tours**; **Juried Exhibit** (spring); **Lectures**; **Workshops**.

Publications: catalogues (occasional).

The Center mounts a wide variety of group exhibitions that primarily feature area artists, a juried show each spring, and a Harvest Festival in the fall.

University of Georgia - Georgia Museum of Art (GMOA)

Performing & Visual Arts Complex, University of Georgia, 90 Carlton St., East Campus
Athens, GA 30602-6719

Tel: (706) 542-4662

Fax: (706) 542-1051

TDDY: (706) 542-1007

Internet Address: http://www.uga.edu/gamuseum

Director: William U. Eiland

Admission: suggested contribution-$1.00.

Attendance: 61,000 *Established:* 1948 *Membership:* Y *ADA Compliant:* Y

Parking: adjacent to building.

Open: Tuesday, 10am-5pm; Wednesday, 10am-9pm; Thursday to Saturday, 10am-5pm; Sunday, 1pm-5pm.

Closed: Legal Holidays.

University of Georgia - Georgia Museum of Art, cont.

Facilities: **Auditorium**; **Building** (52,000 square feet); **Food Services** On Display Café (Mon-Fri, 10am-2pm); **Galleries** (10, of which 4 reserved for permanent collection); **Library** (non-circulating); **Shop** (Tues-Sat, 11am-4pm; Sun, 1pm-4pm); **Study Room**; **Theater**.

Activities: **Concerts** (classical and contemporary); **Education Programs** (adults, university students, children and families); **Film Series**; **Gallery Talks** (adults and children); **Guided Tours** (groups of 5+); **Lectures**; **Permanent Exhibits**; **Temporary & Traveling Exhibitions** (20/year).

Publications: bulletin, "Georgia Museum of Art Bulletin" (annual); exhibition catalogues; gallery guides; newsletter (quarterly).

Hosting a variety of culturally diverse exhibitions, the GMOA draws both from its permanent collection and from other museums and private collections, representing all periods of art history. The Lamar Dodd Gallery, the Rachel Cosby Conway Gallery, the Alfred Heber Holbrook Gallery and the Samuel H. Kress Gallery in the C. L. Morehead Jr. Wing feature important American canvases in the permanent collection and Old Master works from the Kress collection. The George-Ann and Boone Knox Gallery of Prints and Drawings presents rotating exhibitions of works on paper from the GMOA's extensive collection and from other private and public collections. The Virginia and Alfred Kennedy and Philip Henry Alston, Jr. Galleries feature temporary exhibitions from private and public collections. The museum's permanent collection of over 7,000 objects features 19th- and 20th-century American paintings, American and European prints and drawings dating from the 16th century to the present, Japanese prints, and

Childe Hassam, *Bridge at Old Lyme*, 1908, oil on canvas, 24 x 27 inches, Eva Underhill Holbrook Memorial Collection of American Art, gift of Alfred H. Holbrook, Georgia Museum of Art. Photograph courtesy of Georgia Museum of Art, Athens, Georgia.

the Samuel H. Kress Study Collection of Italian Renaissance Paintings. The West Foundation Collection is also incorporated into the exhibition of the permanent collection. The collection is on long-term loan to the museum and consists of British watercolors, 19th-century American paintings, and several 19th-century American Neo-classical sculptures.

Atlanta

The Atlanta College of Art Gallery

Atlanta College of Art, 1280 Peachtree St., N.E., Atlanta, GA 30309

Tel: (404) 733-5050

Fax: (404) 733-5201

Internet Address: http://www.aca.edu

Admission: voluntary contribution.

Attendance: 12,000 *Established:* 1928 *Membership:* Y *ADA Compliant:* Y

Open: Tuesday to Wednesday, 10am-5pm; Thursday to Friday 10am-9:30pm; Saturday, 10am-5pm; Sunday noon-5pm.

Facilities: **Exhibition Area** (2 galleries).

Activities: **Temporary Exhibitions**.

The Atlanta College of Art Gallery mounts exhibitions of regional, national, and international importance in addition to showing student, faculty, and alumni work. It also sponsors a visiting artists lecture series. Also of possible interest is Gallery 100, a student-run gallery, hosting weekly student shows featuring individual and group work.

Atlanta International Museum

285 Peachtree Center Ave.
Marquis Tower Two
Atlanta, GA 30303
Tel: (404) 688-2467
Fax: (404) 521-9311
C.E.O.: Angelyn S. Chandler
Admission: fee: $3.00.
Attendance: 10,000 *Established:* 1989
Membership: Y *ADA Compliant:* Y
Open: Monday to Friday, 11am-5pm.
Facilities: **Exhibition Area** (3 galleries); **Shop** (jewelry, giftware, hand-crafted objects from around the world).
Activities: **Gallery Tours** (groups, reserve in advance); **Lectures**; **Temporary Exhibitions.**
Publications: newsletter, "Passport" (quarterly).

Interior view of gallery during opening reception for "POP Goes the Plastic: The Visual and Cultural Aesthetic of a New Technology, 1960-1975" at Atlanta International Museum. Photograph courtesy of Atlanta International Museum, Atlanta, Georgia.

The mission of the Atlanta International Museum is to promote a better understanding among peoples of the world through examination of society's art, design, and culture. A non-collecting institution, the Museum celebrates humankind's creative achievements in the visual arts both through exhibitions of architecture, art/culture, and design/technology and through a comprehensive program of scholarship, education, community outreach, and related activities.

Callanwolde Fine Arts Center - Callanwolde Gallery

980 Briarcliff Road, N.E., Atlanta, GA 30306
Tel: (404) 872-5338
Fax: (404) 872-5175
Internet Address: http://www.mindspring/~callanwolde
Exec. Director: Mr. Sam Goldman
Admission: free.
Established: 1972
Membership: Y *ADA Compliant:* Y
Parking: parking lot in back.
Open: **Gallery Hours,**
 Monday to Saturday, 10am-3pm.
 Center,
 Monday to Friday, 9am-9pm; Saturday, 10am-4pm.
Closed: Legal Holidays.
Facilities: **Architecture** (Gothic-Tudor mansion, 1920 design by Henry Hornbostel); **Building** (27,000 square feet); **Classrooms**; **Exhibition Area** (local artists; 20 x 35 feet); **Gallery**; **Grounds** (12 acres, lawns and formal garden); **Rental Gallery**; **Shop.**
Activities: **Concert Series** (Sunday afternoon); **Education Programs** (adults and children); **Festival** ("Christmas at Callanwolde", 1st two weeks of December); **Guided Tours** (groups 15+); **Performances**; **Temporary Exhibitions** (8/year); **Workshops.**

Exterior view of Callanwolde Fine Arts Center, former home of Charles Howard Candler, eldest son of Asa Candler, founder of Coca-Cola company. Photograph by Richard Lubrant, courtesy of Callanwolde Fine Arts Center, Atlanta, Georgia.

Publications: "Classes Publication" (quarterly); newsletter, "Callanwolde Fine Art Center" (quarterly).

Housed in a Gothic-Tudor mansion (1920) listed on the National Register of Historic Places, the Callanwolde Fine Arts Center is a non-profit organization bringing the visual, literary, and performing arts to the public year round. The Callanwolde Gallery, located on the second floor, offers eight one-person exhibitions each year, showcasing the work of area artists.

Atlanta, Georgia

Clark Atlanta University Art Gallery

James P. Brawley Drive at Fair St., Trevor Arnett Hall, 2nd Floor, Atlanta, GA 30314
Tel: (404) 880-6644
Internet Address: http://www.cau.edu/cau/collections.html
Director: Ms. Tina Dunkley
Admission: free.
Open: **Call for hours.**
Facilities: **Gallery.**
Activities: **Temporary Exhibitions.**

With approximately 500 works of art, the University's art collection's strength is an extensive collection of African American art including works by Catlett, Lawrence, Tanner, and Woodruff. Additional holdings include works by other representative American artists and a collection of African art and Africana. A portion of the collections is displayed regularly in the Catherine Waddell Gallery.

Emory University - Michael C. Carlos Museum

Emory University
571 S. Kilgo St.
Atlanta, GA 30322
Tel: (404) 727-4282
Fax: (404) 727-4292
TDDY: (404) 727-8017
Internet Address: http://www.cc.emory.edu/CARLOS
Director: Mr. Anthony G. Hirschel
Admission: suggested contribution-$5.00.
Attendance: 105,000 *Established:* 1920
Membership: Y *ADA Compliant:* Y
Parking: free on campus and pay at B. Jones Bldg. or Fishburne Deck.
Open: Monday to Saturday, 10am-5pm; Sunday, noon-5pm.
Facilities: **Architecture** Beaux Arts building (1919), Post-modern Renovation/Expansion (1993 designed by Michael Graves; total 45,000 square feet); **Exhibition Area** (29 permanent collection galleries, 8 special exhibition galleries); **Food Services** Café Antico (Mon-Fri, 8:30am-5pm; Sat & Sun, noon-5pm); **Shop** (books, gifts, jewelry).

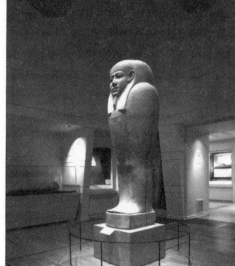

View of Egyptian Gallery, Michael C. Carlos Museum. Photograph by Steven Brooke, courtesy of Michael C. Carlos Museum, Emory University, Atlanta, Georgia.

Activities: **Films; Gallery Talks; Guided Tours** (call 727-0519); **Lectures; Permanent Exhibits; Temporary/Traveling Exhibitions.**
Publications: exhibition catalogues (occasional); handbook, "Michael C. Carlos Museum"; newsletter (quarterly).

Located on the historic quadrangle of the Emory University campus, the Michael C. Carlos Museum has a permanent collection of some 16,000 objects including art from ancient Egypt, Greece, Rome, the Near East, the Americas, Asia, Africa, Oceania, and artworks on paper ranging from the Middle Ages to the 20th century. The Museum also offers special exhibitions of all periods drawn from its own holdings and from other institutions, both national and international.

Georgia Institute of Technology - Richards and Westbrook Galleries

Ferst Center for the Arts, 349 Ferst Drive (across from the Student Center), Atlanta, GA 30332
Tel: (404) 894-9600
Internet Address: http://www.aux.gatech.edu/studentcenter/ferstcenter/html/galleries.htm
Admission: free.
Open: **Call for hours.**
Facilities: **Galleries** (2).
Activities: **Temporary Exhibitions.**

Georgia Institute of Technology - Richards and Westbrook Galleries, cont.

The Ferst Center includes two galleries presenting temporary exhibitions of work by professional artists, as well as a student art show each spring. The galleries also participate in Georgia Tech's spring arts festival.

Georgia State University School of Art and Design Galleries

Georgia State University, University Plaza, Piedmont Ave
Atlanta, GA 30303
Tel: (404) 651-0489
Fax: (404) 651-1779
Internet Address: http://www.gsu.edu
Director: Teri Williams
Admission: free.
Established: 1970
Membership: N *ADA Compliant:* Y
Parking: pay on site.
Open: Monday to Friday, 10am-6pm.
Closed: New Year's Day, Independence Day, Labor Day,
 Thanksgiving Day, Last week in Dec..
Facilities: **Auditorium** (400 seats); **Classrooms**; **Exhibition Area** (2 galleries); **Food Services** Cafeteria (400 seats); **Library** (3,000 volumes, use by special permission); **Reading Room.**
Activities: **Education Programs** (adults, undergraduate/graduate students and children); **Films**; **Gallery Talks**; **Lectures**; **Temporary Exhibitions**; **Traveling Exhibitions**.
Publications: exhibition catalogues.

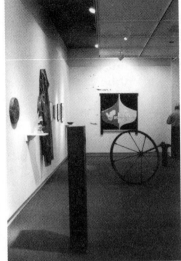

View of student exhibition, School of Art and Design Galleries. Photograph courtesy of Georgia State University, Atlanta, Georgia.

While the School has no permanent collection, it presents temporary exhibitions of student and faculty work that are reflective of the School's curriculum, as well as individual and group shows of works by professional artists.

Hammonds House Galleries and Resource Center

503 Peoples St., S.W., Atlanta, GA 31310
Tel: (404) 752-8730
Fax: (404) 752-8733
Internet Address: http://www.hammondshouse.org
Exec. Director: Mr. Edward Spriggs
Admission: fee: adult-$2.00, child-$1.00, student-$1.00, senior-$1.00.
ADA Compliant: Y
Parking: free on site.
Open: Tuesday to Friday, 10am-6pm; Saturday to Sunday, 1pm-5pm.
Closed: Legal Holidays.
Facilities: **Architecture** (Victorian house, 1857); **Exhibition Area**; **Shop**.
Activities: **Guided Tours**.

Located in a restored Victorian house, the Galleries contain a permanent collection that includes Haitian art, a suite of works by Romare Bearden, and more than two hundred other works by significant artists of African descent. The Galleries also present four to six traveling exhibitions per year.

High Museum of Art

1280 Peachtree St., N.E. (between 15th and 16th Sts.), Atlanta, GA 30309
Tel: (404) 733-4444
Fax: (404) 733-4502
Chief Curator: Mr. Michael E. Shapiro
Admission: fee: adult-$6.00, child-$2.00, student-$4.00, senior-$4.00.
Attendance: 310,000 *Established:* 1926 *Membership:* Y *ADA Compliant:* Y

211

High Museum of Art, cont.

Parking: pay parking available on deck of Woodruff Art Center Building.

Open: Tuesday to Saturday, 10am-5pm; Sunday, noon-5pm; 4th Fri of Month, 10am-9pm.

Closed: New Year's Day, Independence Day, Thanksgiving Day, Christmas Day.

Facilities: **Architecture** (1983 design by Richard Meier); **Auditorium** (226 seats); **Classrooms**; **Food Services** Alon's Bakery Café (Mon, 8:30am-5pm; Sun, 11am-5pm); **Galleries**; **Library** (10,000 volumes); **Reading Room**; **Shop**.

Activities: **Arts Festival**; **Concerts**; **Dance Recitals**; **Education Programs** (adults and children); **Films**; **Gallery Talks**; **Guided Tours**; **Lectures**; **Permanent Exhibits**; **Temporary Exhibitions**; **Traveling Exhibitions**.

Publications: calendar (monthly); exhibition catalogues; newsletter.

Housed in part of the Robert W. Woodruff Art Center, the High Museum of Art displays works from its permanent collection in thematic exhibits in its second and third floor galleries. The Museum also presents a year-round schedule of special and traveling exhibitions complemented by educational programs. Holdings includes European painting and sculpture from the Renaissance to the present; American painting and sculpture from the 18th to the 20th centuries; American and European drawing, prints, and photographs; decorative arts, and sub-Saharan African traditional art. Permanent collection strengths are 19th-century American landscapes, 19th- and 20th-century American furniture, and English ceramics.

The High Museum of Art: Folk Art and Photography Galleries

30 John Wesley Dobbs Ave. (near MARTA Peachtree Center station), Atlanta, GA 30303

Tel: (404) 577-6940

Fax: (404) 653-0916

Internet Address: http://www.high.org

Manager: Ms. Jacqueline P. King

Admission: free.

Attendance: 38,000 *Established:* 1986 *Membership:* Y *ADA Compliant:* Y

Open: Monday to Saturday, 10am-5pm.

Closed: New Year's Day, Memorial Day, Independence Day, Labor Day, Thanksgiving Day, Christmas Day.

Facilities: **Auditorium** (285 seats); **Exhibition Area** (4,500 square feet); **Food Services** Restaurant; **Shop**.

Activities: **Concerts**; **Dance Recitals**; **Education Programs** (adults and children); **Films**; **Guided Tours**; **Lectures**; **Permanent Exhibits**; **Traveling Exhibitions**.

Publications: exhibition catalogues; flyers and calendars (monthly); guides.

A partnership of the Fulton County Arts Council, the High Museum of Art, Metropolitan Life Insurance Company, and Georgia-Pacific Corporation; the Galleries offer a variety of changing folk art and photography exhibitions.

Oglethorpe University Museum

Oglethorpe University, 4484 Peachtree Road, N.E., Atlanta, GA 30319

Tel: (404) 364-8555

Fax: (404) 364-8556

Internet Address: http://www.museum.oglethorpe.edu

Director: Mr. Lloyd Nick

Admission: free.

Attendance: 8,000 *Established:* 1993 *Membership:* Y *ADA Compliant:* Y

Parking: free on site.

Open: **Fall to Spring**, Tuesday to Sunday, noon-5pm.

Closed: Legal Holidays, Christmas Day to New Year's Day.

Facilities: **Auditorium** (100 seats); **Exhibition Area** (3,500 square feet); **Shop**.

Activities: **Guided Tours**; **Lectures**; **Traveling Exhibitions**.

Publications: catalogues; newsletter.

Oglethorpe University Museum, cont.

The Museum presents exhibitions drawn from its permanent collection and temporary/traveling exhibitions from other collections focusing on figurative, representational and spiritual art.

Augusta

Augusta State University - Fine Arts Gallery

2500 Walton Way, Augusta, GA 30904
Tel: (706) 737-1453
Fax: (706) 667-4937
Internet Address: http://www.aug.edu
Director: Prof. Jackson Cheatham
Admission: free.
Membership: N *ADA Compliant:* Y
Parking: free on site.
Open: Monday to Friday, 8am-10pm.
Facilities: **Exhibition Area.**
Activities: **Temporary Exhibitions.**

The Gallery presents temporary exhibitions of student and faculty work, as well as the work of regional and national artists.

Gertrude Herbert Institute of Art

506 Telfair St., Augusta, GA 30901
Tel: (706) 722-5495
Fax: (706) 722-3670
Director: Amy E. Maybohm
Admission: fee: adult-$2.00, child-$1.00, senior-$1.00.
Attendance: 24,000 *Established:* 1937 *Membership:* Y *ADA Compliant:* Y
Open: Tuesday to Friday, 10am-5pm; Saturday, 10am-2pm.
Closed: Independence Day, Thanksgiving Day, Christmas Eve to New Year's Day.
Facilities: **Architecture** (Ware's Folly house, 1818); **Exhibition Area**; **Studios.**
Activities: **Education Programs** (adults and children); **Lectures**; **Temporary Exhibitions.**
Publications: brochure; newsletter (quarterly).

The Institute mounts temporary exhibitions.

Morris Museum of Art

One 10th St., Augusta, GA 30901-1134
Tel: (706) 724-7501
Fax: (706) 724-7612
Internet Address: http://www.themorris.org
Director: Ms. Louise Keith Claussen
Admission: fee (free on sundays): adult-$3.00,
 child-free, student-$2.00, senior-$2.00.
Attendance: 35,000 *Established:* 1992
Membership: Y *ADA Compliant:* Y
Parking: free marked spaces in west lot or
 pay nearby municipal lot.
Open: Tuesday to Saturday, 10am-5:30pm;
 Sunday, 12:30pm-5:30pm.
Closed: New Year's Day, Thanksgiving Day,
 Christmas Day.

Marie Hull, *Sharecropper*, 1947, oil on canvas, 24 1/8 x 22 inches.
Morris Museum of Art. Photograph courtesy of Morris Museum of
Art, Augusta, Georgia.

Morris Museum of Art, cont.

Facilities: **Auditorium** (150 seats); **Exhibition Area** (18,000 square feet); **Library** (5,500 volumes); **Shop**.

Activities: **Concerts** (Sunday afternoon); **Guided Tours** (groups, schedule in two weeks advance); **Lectures** (Sunday afternoon); **Temporary Exhibitions**; **Traveling Exhibitions**.

Publications: exhibition catalogues; newsletter (quarterly).

Housed in the Augusta Riverfront Center, the Morris Museum is home for a broad-based survey collection of Southern art, including both historical works and a diverse contemporary collection. The Museum's galleries occupy the entire second floor of the Riverfront Center; administrative offices and the Center for the Study of Southern Painting are located on the third floor. The exhibition begins with Antebellum Portraiture and continues through galleries devoted to Civil War Art, the Black Presence in Southern Painting, Southern Impressionism, Still-Life Art, Works on Paper, Self-Taught Artists, Twentieth-Century, and Contemporary Paintings. An extensive landscape corridor surrounds the inner galleries, veranda-style, offering a warm, tranquil setting for viewing Southern landscapes. Traveling exhibitions serve to expand and enhance the Museum's core collection. More than 2,100 paintings and drawings form the basis of the permanent collection. In addition to the Southern Collection, holdings include a collection of bird paintings, both historical and contemporary, spotlighting the work of Australian-born watercolorist Robin Hill.

Buckhead

Steffen Thomas Museum and Archives

4200 Bethany Road, Buckhead, GA 30625

Tel: (706) 342-7557

Fax: (706) 342-4348

Internet Address: http://www.steffenthomas.com

Trustee: Ms. Lisa Conner

Open: 2pm-5pm; by appointment only.

Facilities: **Archive**; **Exhibition Area** (5,000 square feet); **Sales Gallery**.

Activities: **Permanent Exhibits**.

Located in the community of Buckhead, approximately 70 miles east of Atlanta, the Museum and Archives are dedicated to the life and work of American German Expressionist Steffen Wolfgang George Thomas. The facility consists of exhibition galleries, archival storage space, and extensive administrative and operational facilities. The Museum is engaged in programs to publish and license for publishing all the images of the artist's life work and to develop, design, and assemble exhibitions for university, museum and commercial galleries. The Archive is charged with housing and preserving various collections of the artist's works, papers, and memorabilia and with assembling complete documentation of the artist's professional life, including an electronic catalogue raisonné. While it houses and displays a significant number of original works by Steffen Thomas, it does so as a service; all are privately owned.

Columbus

The Columbus Museum

1251 Wynnton Road, Columbus, GA 31906

Tel: (706) 649-0713

Fax: (706) 649-1070

Internet Address: http://www.columbusmuseum.com

Director: Mr. Charles Thomas Butler

Admission: free.

Attendance: 91,000 *Established:* 1952 *Membership:* Y *ADA Compliant:* Y

Parking: free on site.

Open: Tuesday to Saturday, 10am-5pm; Sunday, 1pm-5pm.
 Also 3rd Thursday in month, 10am-8pm.

Closed: Legal Holidays.

The Columbus Museum, cont.

Facilities: **Architecture** (Italianate Tuscan-style residence, early 20th century); **Auditorium** (298 seats); **Childrens' Discovery Gallery** ("Transformations"); **Classrooms** (2); **Exhibition Area** (15 galleries, 30,000 square feet); **Landscaped Garden**; **Library** (non-circulating); **Shop**; **Theater** (50 seats).

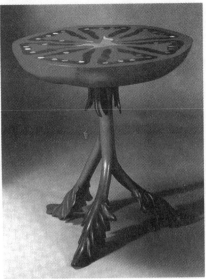

Activities: **Education Programs** (adults and children); **Films**; **Gallery Talks**; **Guided Tours**; **Permanent Exhibits**; **Temporary Exhibitions**; **Traveling Exhibitions**.

Publications: annual report; exhibition catalogues; newsletter (quarterly).

The Columbus Museum focuses on American art and regional history. It features changing art exhibitions, almost 300 years of American fine and decorative art in fifteen galleries. There are also two galleries devoted to permanent exhibitions Chattahoochee Legacy, focusing on regional history, and Transformations, a hands-on discovery gallery.

Craig Nutt, *Tomato Table*, 1996, Stained tulip poplar inlaid with bloodwood and curly maple, and black gum with oil-based paint. Museum purchase made possible by Dr. and Mrs. Sidney Yarbrough II & Edward Swift Shorter Bequest Fund. Photograph courtesy of The Columbus Museum, Columbus, Georgia.

Columbus State University - Gallery

Fine Arts Hall, 4225 University Ave., Columbus, GA 31907
Tel: (706) 568-2001
Internet Address: http://art.colstate.edu/
Open: Call for hours.
Facilities: **Exhibition Area**.
Activities: **Temporary Exhibitions**.

The University maintains two exhibition spaces for the display of work by nationally and internationally recognized artists. The are also numerous student and faculty exhibits, including an annual juried student art show.

Decatur

Agnes Scott College - Dalton Galleries

Dana Fine Arts Building, 141 E. College Ave., Decatur, GA 30030
Tel: (404) 471-6049
Internet Address: http://www.agnesscott.edu/aas/calendars/cal_info/visual_art.htm
Director: Dr. Donna Sadler
Admission: free.
Established: 1957 *ADA Compliant:* Y
Open: **Academic Year**, Monday to Friday, 10am-4:30pm; Sunday, 2pm-4:30pm.
Facilities: **Gallery**.
Activities: **Temporary Exhibitions**.

Located in the Dana Fine Arts Building, the Dalton Galleries present temporary visual arts exhibitions, including an annual student exhibition in the spring.

Duluth

Gwinnett Fine Arts Center

6400 Sugarloaf Pkwy., Bldg. 300, Duluth, GA 30155
Tel: (770) 623-6002
Fax: (770) 623-3555
Director: Ms. Nancy Gullickson
Admission: suggested contribution-$2.00.

Gainesville, Georgia

Gwinnett Fine Arts Center, cont.

Attendance: 11,000 *Established:* 1981 *Membership:* Y *ADA Compliant:* Y
Open: Tuesday to Saturday, 10am-5pm; Sunday, 1pm-5pm.
Closed: New Year's Day, ML King Day, Memorial Day, Independence Day, Labor Day,
 Christmas Day.
Facilities: **Botanical Garden**; **Exhibition Area** (4,000 square feet; additional 2,000 square feet
 apart); **Sculpture Garden**; **Shop**.
Activities: **Arts Festival**; **Concerts**; **Education Programs** (adults and children); **Films**; **Guided
 Tours**; **Lectures**; **Temporary Exhibitions**; **Traveling Exhibitions**.
Publications: newsletter, "Arts Clips & Sketches" (monthly); newsletter, "Artsline" (quarterly).

Owned and operated by Gwinnett Council for the Arts, the Fine Arts Center presents a continuous
calendar of visual arts exhibits, performing arts programs, and quarterly sessions of art classes
for all ages. The adjoining 28,000-square-foot Al Weeks Sculpture Garden is also a part of the Center.

Gainesville

Brenau University - Brenau University Galleries

One Centennial Circle, Gainesville, GA 30501
Tel: (770) 534-6263
Fax: (770) 534-6114
TDDY: (770) 534-6200
Internet Address: http://www.brenau.edu /events/Arts/visualart.htm
Director: Ms. Jean Westmacott
Admission: voluntary contribution.
Attendance: 23,000 *Established:* 1983
Membership: N *ADA Compliant:* Y
Parking: street parking.
Open: **Fall to Spring**,
 Monday to Friday, 10am-4pm;
 Sunday, 2pm-5pm.
 Summer,
 Monday to Thursday, 1pm-4pm.
Closed: Easter, Spring Break, Memorial Day,
 Independence Day, Labor Day, Thanksgiving Week.
Facilities: **Auditorium** (700 seats); **Galleries** (2); **Shop**; **Studios**.
Activities: **Arts Festival**; **Education Programs** (adults and gradu-
 ate/undergraduate college students); **Guided Tours** (by appoint-
 ment); **Lectures** (occasional); **Performances**; **Temporary
 Exhibitions** (7-9/year); **Traveling Exhibitions**; **Workshops**
 (1/year matched with exhibition for K-12 students).
Publications: brochure/catalogue.

In foreground is Simmons Visual Arts Center, home to Brenau Galleries. Photograph by Tommy Thompson, courtesy of Brenau Galleries, Brenau University, Gainesville, Georgia.

As an integral part of the Brenau University academic community, the Brenau University Galleries
provide exhibitions and programs that identify and enhance artistic talent, respond to issues of
special relevance to women, advance scholarship in the visual arts, and encourage understanding and
appreciation of diverse cultures. The gallery program evolved from small annual showings of student
and faculty work to more extensive exhibitions in the mid-1980s. In 1990-91, Brenau strengthened its
support of Fine Arts and gallery programs by renovating the 1914 former library building to create the
new Simmons Visual Arts Center. This renovation added a second gallery on the Brenau campus: the
large Sellars Gallery on the main floor of the Simmons Visual Arts Center adjacent to the President's
Gallery in the Pearce Auditorium Building.

Kennesaw

Kennesaw State University Art Galleries

1000 Chastain Road, Kennesaw, GA 30060
Tel: (770) 499-3223
Internet Address: http://www.kennesaw.edu/visual_arts/ Art_Gallery/GALLERY.html

Kennesaw State University Art Galleries, cont.

Open: Monday to Friday, 10am-4pm.

Facilities: **Exhibition Area** (2 galleries).

Activities: **Lectures**; **Temporary Exhibitions**.

Publications: exhibition catalogues (occasional).

The Sturgis Library and Fine Arts galleries (the latter located in the Mac Wilson Building) present contemporary and traditional art through curated and traveling exhibitions. The galleries also present five senior student art exhibitions, a juried student show, and an alumni invitational exhibition annually. There are approximately fifteen shows each year. The permanent collection consists of 215 paintings and works on paper.

N.C. Wyeth, *Jonathan and David*, oil, 42 x 32 inches. Kenesaw State Universities Art Galleries collection, gift of Dr. Noah Meadows. Photograph courtesy of Kenesaw State University Art Galleries, Kennesaw, Georgia.

LaGrange

Chattahoochee Valley Art Museum

112 Hines St., LaGrange, GA 30240

Tel: (706) 882-3267

Fax: (706) 882-2878

Director: Mr. Keith Rasmussen

Admission: voluntary contribution.

Attendance: 23,000 *Established:* 1963

Membership: Y *ADA Compliant:* Y

Open: Tuesday to Friday, 9am-5pm; Saturday, noon-5pm.

Closed: New Year's Day, Memorial Day, Independence Day, Thanksgiving Day, Christmas Day.

Facilities: **Architecture** (Victorian former county jail, 1892); **Classrooms**; **Gallery**; **Shop**.

Activities: **Arts Festival**; **Education Programs** (adults and children); **Gallery Talks**; **Guided Tours**; **Lectures**; **Temporary Exhibitions**; **Workshops**.

Publications: calendar, "Artsplace" (quarterly); exhibition catalogues; newsletter.

The Museum presents monthly exhibitions of regionally and internationally recognized artists. Its permanent collection of over 400 works focuses on 20th-century artists.

LaGrange College - Lamar Dodd Art Center

302 Forrest Ave., LaGrange, GA 30240

Tel: (706) 812-7211

Fax: (404) 884-6567

Internet Address: http://www.lgc.peachnet.edu

Director: John Lawrence

Admission: free.

Attendance: 5-8,000 *Established:* 1982

ADA Compliant: Y

Parking: free on site.

Open: **Academic Year**,
 Monday to Friday, 9am-4pm;
 Saturday, 1pm-4pm.

Closed: Academic Holidays.

Exterior view of Lamar Dodd Art Center, LaGrange College. Photograph courtesy of Lamar Dodd Art Center, LaGrange College, LaGrange, Georgia.

Facilities: **Architecture** (1982, designed by Louis A Scarbrough); **Exhibition Area** (over 6,000 feet of gallery space).

Activities: **Guided Tours** (on request); **Juried Exhibits** (biennial exhibition, April-May, even years).

Publications: exhibition catalogues; book, "The Truth in Things - The Life and Career of Lamar Dodd".

LaGrange, Georgia
LaGrange College - Lamar Dodd Art Center, cont.

Named in honor of LaGrange native and nationally-known artist Dr. Lamar Dodd, the Center's galleries house a retrospective collection of paintings and drawings by Dodd, the College's art collection, and space devoted to temporary exhibitions of work by professional artists, faculty and students.

Macon

Museum of Arts and Sciences

4182 Forsyth Road, Macon, GA 31210-4806
Tel: (912) 477-3232
Fax: (912) 477-3251
Internet Address: http://www.masmacon.com
Director: Ms. Nancy B. Anderson
Admission: fee: adult-$5.00, child-$2.00, student-$3.00, senior-$4.00.
Attendance: 100,000 *Established:* 1956 *Membership:* Y *ADA Compliant:* Y
Parking: free on site.
Open: Monday to Thursday, 9am-5pm;
 Friday, 9am-9pm;
 Saturday, 9am-5pm;
 Sunday, 1pm-5pm.

Closed: New Year's Day, Independence Day, Labor Day
 Thanksgiving Day, Christmas Eve to Christmas Day.
Facilities: **Auditorium** (150 seats); **Classroom**; **Galleries** (3); **Library** (use by permission); **Planetarium**.
Activities: **Classes/workshops**; **Education Programs** (adults and children); **Films**; **Gallery Talks** (with new exhibit installations, usually Sun, 2pm); **Guided Tours**; **Lectures**; **Permanent Exhibits**; **Temporary Exhibitions** (change every 1-3 months); **Traveling Exhibitions**.
Publications: exhibition catalogues; newsletter, "Museum Muse" (monthly); program guide.

The Museum presents changing art, science, and humanities exhibits, including the whimsical "Discovery House" containing eccentric collections and visitor-activated exhibits.

Viola Frey, *Gesturing Woman*, 1989, ceramic, height 14 feet, with "Discovery House" in the background. Museum of Arts and Sciences. Photograph courtesy of Museum of Arts and Sciences, Macon, Georgia.

Tubman African American Museum

340 Walnut St., Macon, GA 31201
Tel: (912) 743-8544
Fax: (912) 743-9063
Internet Address: http://www.tubmanmuseum.com
Director: Carey Pickard
Admission: fee: adult $3.00.
Attendance: 60,000 *Established:* 1982 *Membership:* Y *ADA Compliant:* Y
Open: Monday to Saturday, 9am-5pm; Sunday, 2pm-5pm.
Closed: New Year's Day, Independence Day, Thanksgiving Day, Christmas Day.
Facilities: **Exhibition Area** (19 galleries); **Library** (6,000 volumes).
Activities: **Concerts**; **Dance Recitals**; **Education Programs**; **Performances**; **Permanent Exhibits**; **Temporary/Traveling Exhibitions**.
Publications: catalogues (6/year).

Tubman African American Museum, cont.

Named in honor of Harriet Tubman, the Museum is dedicated to educating people about all aspects of African American art, history and culture. The Georgia Council for the Arts has consistently ranked the Tubman among the top ten visual arts institutions in Georgia. There are permanent galleries featuring folk art and the mural "From Africa to America", a visual history of black people. In addition, the Museum devotes five galleries to the Noel Collection of African Art, on long term loan from Lynn and Michael Noel of Houston Texas, including 2,000 year-old Nok figures, carved ivory, Asafo flags, and an extensive array of jewelry, textiles and other African objects. The Museum is also the venue for many traveling exhibitions. Art by such artists as Benny Andrews, Betye Saar, and Robert Scott Duncanson has been shown at the Museum.

Marrietta

Marrietta/Cobb Museum of Art

30 Atlanta St., S.E., Marrietta, GA 30060
Tel: (770) 528-1444
Fax: (770) 528-1440
Director: Mr. Aaron Berger
Admission: fee: adult-$5.00, student-$3.00, senior-$3.00.
Attendance: 78,000 *Established:* 1986 *Membership:* Y *ADA Compliant:* Y
Open: Tuesday to Saturday, 11am-5pm; Sunday, 1pm-5pm.
Closed: Major Holidays.
Facilities: **Architecture** (Greek Revival-style, 1909); **Educational Facilities**; **Galleries** (4); **Shop**.
Activities: **Education Programs** (adults and children); **Guided Tours**; **Lectures**.

The Museum periodically exhibits works from its Permanent Collection of 19th- and 20th-century American Art. Three galleries are devoted to displaying traveling exhibitions.

Mount Berry

Berry College - Moon Gallery

Moon Building, 2277 Martha Berry Highway, N.W.
Mount Berry, GA 30149-0528
Tel: (706) 236-2219
Fax: (706) 238-7835
Internet Address:
 http://www.berry.edu/academic/hass/gallery.html
Director: Dr. Thomas J. Mew, III
Admission: free.
Attendance: 1,500 *Established:* 1971
ADA Compliant: Y
Parking: parking lot.
Open: Weekdays, 9am-4pm.
Facilities: **Exhibition Area** (1,600 square feet).
Activities: **Temporary Exhibitions** (7-8/year).

Tommy Mew, *Dolce, Dolce (Italia Series)*, 1995, mixed media drawing, 18 inches x 26 inches. Berry College Permanent Collection. Photograph courtesy of Berry College, Mount Berry, Georgia.

Publications: brochure, "Gallery Brochure with Description of Shows" (annual).

The Gallery presents the work of professional artists in temporary exhibitions, usually of three weeks duration. Student shows include week-long Senior Thesis Exhibitions by art majors and a juried Senior Student Honors Show. The college's permanent collection is housed in both the Moon Building and the Martha Berry Museum.

Saint Simons Island

The Glynn Arts Association

319 Mallory St., Saint Simons Island, GA 31522
Tel: (912) 638-8770
Director: Ms. Lynda Gallagher
Admission: free.

Saint Simons Island, Georgia

The Glynn Arts Association, cont.

Attendance: 10,000 *Established:* 1948 *Membership:* Y *ADA Compliant:* Y

Open: Monday to Friday, 10am-6pm; Saturday, 10am-5pm.

Closed: New Year's Day, Independence Day, Labor Day, Thanksgiving Day, Christmas Day.

Facilities: **Classrooms**; **Exhibition Area**; **Library** (use upon request); **Reading Room**; **Shop**.

Activities: **Education Programs** (adults and children); **Temporary/Traveling Exhibitions**.

Publications: newsletter.

The Association presents temporary exhibitions.

Savannah

Savannah College of Art and Design - Galleries

340 Bull St., Savannah, GA 37402

Tel: (912) 525-4950

Internet Address: http://www.scad.edu

Open: Call for hours.

The Savannah College of Art and Design operates a number of galleries: Alexander Hall, 668 Indian Street (student work); Bergen Hall, 101 Martin Luther King Jr. Blvd. at Broughton Street (photography); Exhibit A Gallery, 340 Bull Street (temporary exhibitions of work by national and international artists); Eichberg Hall, 229 Martin Luther King Jr. Blvd. (student and professional work in temporary exhibits); Ex Libris, 228 Martin Luther King Jr. at Perry Street (traveling exhibitions, works from the permanent collection, and student and faculty work); Hamilton Hall, 522 Indian Street (video art by students, faculty, and professional artists); Pinnacle Gallery, 320 East Liberty street (celebrates multiculturalism through the arts); Rapid Transit Gallery, 342 Bull Street (graduate student thesis shows); and Savannah International Airport Gallery, 400 Airways Avenue (faculty, student, and alumni work).

Telfair Museum of Art

121 Barnard St., Savannah, GA 31401

Tel: (912) 232-1177

Fax: (912) 232-6954

Director: Dr. Diane B. Lesko

Admission: fee: adult-$6.00, child-$1.00/$2.00, student-$2.00, senior-$5.00.

Attendance: 70,000 *Established:* 1875 *Membership:* Y *ADA Compliant:* Y

Parking: metered on street.

Open: Monday, noon-5pm; Tuesday to Saturday, 10am-5pm; Sunday, 1pm-5pm.

Closed: Legal Holidays.

Facilities: **Architecture** (Regency mansion, 1819 designed by English architect William Jay); **Educational Facilities**; **Galleries**; **Shop**.

Activities: **Concerts**; **Education Programs** (adults and children); **Films**; **Gallery Talks**; **Guided Tours**; **Lectures**; **Permanent Exhibits**; **Temporary Exhibitions**.

Publications: books.

The oldest art museum in the Southeast, the Museum is housed in a Regency-style mansion bequeathed by Mary Telfair to the Georgia Historical Society in 1875. The Museum presents artwork from its permanent collection, period rooms, temporary exhibitions and traveling shows. The permanent collection contains examples of American Impressionism by Frederick Frieseke, Childe Hassam, and Gari Melchers; Ash Can School paintings by George Bellows, Robert Henri, and George Luks; European paintings; and decorative arts, including a Philadelphia suite of maple furniture and pieces by Duncan Phyfe and Thomas Cook. There is also a collection of casts of classical sculptures in the Louvre and the Vatican and other Roman collections.

Statesboro

Georgia Southern University - Gallery 303

Foy Fine Arts Building, Third Floor, Statesboro, GA 30460

Tel: (912) 681-5358

220

Georgia Southern University - Gallery 303, cont.

Internet Address: http://www2.gasou.edu/art/gallery/gallery.html
Admission: free.
Open: Monday to Friday, 8am-5pm.
Facilities: **Exhibition Area.**
Activities: **Guided Tours** (by appointment); **Temporary Exhibitions** (8/year).
Publications: gallery calendar (annual).

The Gallery features temporary exhibitions of contemporary artwork by faculty and students. Also of possible interest on campus, the Betty Foy Sanders Art Collection, featuring the art and artists of Georgia, is housed in the Henderson Library.

Valdosta

Valdosta State University Fine Arts Gallery

Fine Arts Building, School of the Arts, Georgia Ave., Valdosta, GA 31698
Tel: (912) 333-5835
Fax: (912) 333-7408
Internet Address: http://www.valdosta.peachnet.edu/art/
Gallery Director: Ms. Karin G. Murray
Admission: voluntary contribution.
Attendance: 10,000 *Established:* 1906 *ADA Compliant:* Y
Open: Monday to Thursday, 10am-4pm; Friday, 10am-3pm.
Closed: Academic Holidays.
Facilities: **Gallery.**
Activities: **Education Programs** (undergraduate college students); **Gallery Talks**; **Guided Tours** (contact VSU public relations at 333-5980).
Publications: exhibition catalogues; posters.

Located on the first floor of the Fine Arts building, the Art Gallery presents traveling exhibitions, national competitive exhibits, invitational exhibits in a variety of media, and annual shows of faculty and student work.

Waycross

Okefenokee Heritage Center Art Gallery

1460 N. Augusta Ave., Waycross, GA 31503
Tel: (912) 285-4260 *Fax:* (912) 283-2858
Director: Ms. Ann Tweedy
Admission: fee: adult-$2.00, child-$1.00.
Attendance: 20,000 *Established:* 1975 *Membership:* Y *ADA Compliant:* Y
Open: Monday to Saturday, 10am-5pm; Sunday, 1pm-5pm.
Closed: Major Holidays.
Facilities: **Classrooms; Gallery; Shop.**
Activities: **Art Classes; Arts Festival** (children's); **Concerts; Guided Tours; Lectures; Performances; Temporary Exhibitions.**
Publications: brochures; exhibition catalogues; newsletter.

A local history and art museum, the Heritage Center's art gallery presents juried art shows, exhibits of work by regional artists, and traveling exhibits.

Guam

A number in parentheses following a city name indicates the number of museums/galleries in that municipality. If there is no number, one is understood. For example, in the text one listing would be found under Mangilao.

Guam

Mangilao

University of Guam - Isla Center for the Arts

15 Dean's Circle, Mangilao, GU 96923
Tel: (671) 735-2965
Fax: (671) 735-2967
Internet Address: http://www.uog.edu/isla
Director: Tom Quinata
Admission: free.
Attendance: 18,000 *Established:* 1980
Membership: Y *ADA Compliant:* Y
Parking: ample.
Open: Monday to Wednesday, 10am-5pm;
Thursday, 10am-9pm;
Friday, 10am-5pm;
Saturday, 10am-2pm.

Ngiraibuuch, storyboard relating myth of Chief Koror receiving a gift of stone money; Palauan. Isla Center for the Arts collection. Photograph courtesy of Isla Center for the Arts, Mangilao, Guam.

Closed: Legal Holidays.
Facilities: **Exhibition Area** (1,000 square feet); **Shop.**
Activities: **Films; Lectures; Temporary Exhibitions; Traveling Exhibitions.**
Publications: exhibition catalogues (quarterly).

The Isla Center for the Arts presents temporary exhibitions that are curated by Center staff or borrowed from international institutions. Its permanent collection of over 500 items is evidence of its dedication to cultural diversity. Highlighted in the collection are many Micronesian artifacts. While focusing mainly on the islands of the western Pacific, it also includes lithographs and prints from such European masters as Rembrandt, Goya, Daumier, Dürer, and Pissaro, as well as antique Japanese woodcuts, Ming Dynasty landscapes, and pre-Columbian pottery.

Hawaii

Kauai
•Lihue

Oahu
•Kaneohe
Honolulu (6)•

Hawaii

Hilo •
Hawaii Volcanoes National Park •

The number in parentheses following the city name indicates the number of museums/galleries in that municipality. If there is no number, one is understood. For example, in the text six listings would be found under Honolulu and one listing under Kaneohe.

Hawaii

Island of Hawaii
Hawaii Volcanoes National Park

Volcano Art Center
Volcano House Hotel, Hawaii Volcanoes National Park, HI 96718
Tel: (808) 967-7565
Fax: (808) 967-8222
Internet Address: http://www.bishop.hawaii.org/vac/home.html
Gallery Manager: Ms. Natalie Pfeifer
Admission: voluntary contribution.
Attendance: 200,000 *Established:* 1974 *Membership:* Y *ADA Compliant:* Y
Open: Daily, 9am-5pm.
Closed: Christmas Day.
Facilities: **Architecture** (Volcano House Hotel, 1877); **Gallery**; **Shop**; **Theatre** (300 seats).
Activities: **Concerts**; **Dance Recitals**; **Demonstrations**; **Education Programs**; **Guided Tours**; **Lectures**; **Performances**; **Traveling Exhibitions**; **Workshops**.
Publications: newsletter, "Volcano Gazette" (bi-monthly).

Located in the first western-style building at Kilauea, the historic hand-crafted Volcano House Hotel (1877), the Center promotes Hawaiian artistic and cultural heritage and explores the relationship among man, art, and earth as expressed in the visual arts.

Hilo

Lyman Museum and Mission House
276 Haili St., Hilo, HI 96720
Tel: (808) 935-5021
Fax: (808) 969-7685
Director: Mr. Paul A. Dahlquist
Admission:
 fee: adult-$7.00, child-$3.00, senior-$5.00.
Attendance: 17,000 *Established:* 1931
Membership: Y *ADA Compliant:* Y
Parking: free parking lot and on street.
Open: **Museum**,
 Monday to Saturday, 9am-4:30pm.
Closed: New Year's Day, Independence Day,
 Thanksgiving Day, Christmas Day.

Exterior view of Lyman Museum. Photograph courtesy of Lyman Museum, Hilo, Hawaii.

Facilities: **Architecture** (mission house, 1839); **Exhibition Area** (9,000 square feet); **Library** (by appointment); **Shop** (unique Hawaiian related gifts).
Activities: **Guided Tours** (walking tour of Hilo by advance reservation; Mission House; 9:30am, 10:30am, 11:30am, 1pm, 2pm, 3pm, 4pm); **Permanent Exhibits**; **Temporary Exhibitions**; **Workshops**.
Publications: exhibition catalogues; newsletter, "Museum Musings".

The Museum consists of an historic home and galleries dedicated to Hawaii's natural and cultural history. The galleries explore the multicultural heritage of the Islands' peoples, Hawaiian landscapes by early artists, Chinese art, and natural history. Guided tours are conducted of the restored 1839 Lyman Mission House.

Island of Kauai
Lihue

Kauai Museum
4428 Rice St., Lihue, HI 96766
Tel: (808) 245-6931
Fax: (808) 245-6864
Director: Ms. Carol Lovell

Lihue (Island of Kauai), Hawaii

Kauai Museum, cont.

Admission: fee: adult-$5.00, child-$1.00,
 student-$3.00, senior-$4.00.
Attendance: 30,000 *Established:* 1960
Membership: Y *ADA Compliant:* Y
Open: Monday to Friday, 9am-4:30pm;
 Saturday, 10am-4pm.
Closed: New Year's Day, Thanksgiving Day,
 Christmas Day.
Facilities: **Exhibition Area**; **Library** (1,000 vol-
 umes, non-circulating); **Shop**.
Activities: **Arts Festival**; **Films**; **Guided Tours**
 (call for info.); **Permanent Exhibits**;
 Temporary Exhibitions.
Publications: exhibition catalogues.

Exterior view of Albert Spencer Wilcox Building (1924),
Kauai Museum, designed by Hart Wood. Photograph by
George Senda, courtesy of Kauai Museum, Lihue, Hawaii.

The Kauai Museum is devoted to the history, culture, and art of the people and islands of Hawaii. In addition to the display of its permanent collection, the Museum mounts temporary exhibitions.

Island of Oahu

Honolulu

The Contemporary Museum and Garden (TCM)

2411 Makiki Heights Drive, Honolulu, HI 96822
Tel: (808) 526-0232
Fax: (808) 536-5973
TDDY: (808) 643-8833
Internet Address: http://www.tcmhi.org
Director: Ms. Georgiana Lagoria
Admission: fee: adult-$5.00, child-free,
 student-$3.00, senior-$3.00.
Attendance: 28,000 *Established:* 1961
Membership: Y *ADA Compliant:* Y
Parking: Limited free parking on site.
Open: Tuesday to Saturday, 10am-4pm;
 Sunday, noon-4pm.
Closed: Legal Holidays.
Facilities: **Architecture** Original Facility
 (Spalding House, 1920 design by Hart Wood),
 Renovation (adapted to museum use by CJS
 Group Architects); **Food Services** Café (Tues-
 Sat, 11am-3pm; Sun, noon-3pm); **Galleries** (6);
 Grounds (3.5 acres, gardens designed by Rev.
 K.H. Inagaki & restored by J.C. Hubbard);
 Sculpture Garden; **Shop** (books, jewelry,
 small sculptural objects, crafts).

Frank Stella, *Then Came a Dog and Bit the Cat*, c. 1982-
1984, mixed media on paper. The Contemporary Museum.
Photograph courtesy of The Contemporary Museum,
Honolulu, Hawaii.

Activities: **Gallery Talks**; **Guided Tours** (Tues-Sun, 1:30pm); **Permanent Exhibits**; **Temporary Exhibitions**; **Traveling Exhibitions**.
Publications: exhibition brochures; exhibition catalogues (quarterly); newsletter.

The Contemporary Museum, located on a 3.5-acre sight in Honolulu's scenic Makiki Heights, is a cultural oasis combining exhibitions of contemporary art with the natural beauty of Hawaii. Changing exhibitions are shown in the five galleries of the main building, the Contemporary Café, and at the museum's downtown annex at First Hawaiian Center (see separate listing). Selections from the Museum's permanent collection are shown periodically in the exhibition schedule. Holdings include over 1,200 works in all media from 1940 to the present by local, national, and international artists. Included are works by Vito Acconci, Josef Albers, Robert Arneson, Deborah Butterfield, Jim

The Contemporary Museum and Garden, cont.

Dine, Robert Graham, Jasper Johns, Edward Kienholz and Nancy Reddin Kienholz, Robert Motherwell, Louise Nevelson, Dennis Oppenheim, Mark Tobey, Andy Warhol, and Tom Wesselman. The collection also includes David Hockney's installation based on his set for the 1925 Ravel opera "L'Enfant et les Sortileges" on permanent view in the Milton Cades Pavilion.

The Contemporary Museum at First Hawaii Center

First Hawaiian Bank, 999 Bishop St., Honolulu, HI 96813

Tel: (808) 526-0232

Fax: (808) 536-5973

Internet Address: http://www.fhb.com

Director: Ms. Georgiana Lagoria

Admission: voluntary contribution.

Established: 1996

Membership: Y *ADA Compliant:* Y

Parking: commercial adjacent to site.

Open: Monday to Thursday, 8:30am-4pm;
Friday, 8:30am-6pm.

Closed: Bank Holidays.

Facilities: **Exhibition Area** (ground floor lobby and second floor gallery).

Activities: **Temporary Exhibitions** (quarterly).

Interior view of First Hawaiian Bank lobby and TCM Gallery. Photograph by David Franzen, courtesy of The Contemporary Museum, Honolulu, Hawaii.

A satellite site of The Contemporary Museum, the TCM at First Hawaii Center presents quarterly exhibitions of work exclusively by Hawaiian artists, artists who once lived in Hawaii, or artists who come to Hawaii to produce art. The second floor gallery includes an art glass wall composed of 90 glass prisms created by architect Jamie Carpenter.

Honolulu Academy of Arts

900 S. Beretania St., Honolulu, HI 96814

Tel: (808) 532-8700

Fax: (808) 532-8787

Internet Address:
 http://www.honoluluacademy.org

Director: Mr. George R. Ellis

Admission: fee: adult-$7.00, child-free,
 student-$4.00, senior-$4.00.

Attendance: 260,000 *Established:* 1922

Membership: Y *ADA Compliant:* Y

Parking:
 Academy Art Center lot and some on street.

Open: Tuesday to Saturday, 10am-4:30pm;
Sunday, 1pm-5pm.

Closed: New Year's Day, Independence Day,
 Labor Day, Thanksgiving Day,
 Christmas Day.

Exterior view of Honolulu Academy of Arts. Photograph courtesy of Honolulu Academy of Arts, Honolulu, Hawaii.

Facilities: **Auditorium** (300 seats); **Classrooms**; **Exhibition Area** (30 galleries); **Food Services** Garden Café (Tues-Sat); **Gardens** (6 courtyards, occidental and oriental gardens); **Library** (40,000 volumes, use by members and scholars); **Reading Room**; **Sculpture Garden**; **Shop**; **Studios**.

Activities: **Art Classes** (adults and children); **Arts Festival**; **Concerts**; **Dance Recitals**; **Education Programs** (adults, undergraduate college students and children); **Films**; **Gallery Talks**; **Guided Tours** (Tues-Sat, 11am; Sun, 1pm); **Lectures**; **Permanent Exhibits**; **Temporary Exhibitions**.

Honolulu Academy of Arts, cont.

Publications: books; calendar, "Calendar News"; exhibition catalogues; pamphlets.

Housed in a facility that is listed on the National Register of Historic Places and is also a state historic site, the Honolulu Academy of Arts is the state's only general fine arts museum. It has an internationally recognized collection of Asian art, including the James A. Michener Collection of Ukiyo-e prints. The Academy also holds a Kress Collection of Italian Renaissance paintings, American and European paintings (including works by Picasso, Monet, Gauguin, and Cézanne) and decorative arts, contemporary art, and a collection of 17,000 works on paper. The collections are presented in thirty galleries surrounding six courtyards. The Academy also presents approximately ten temporary exhibitions per year.

Ramsay Museum

Tan Sing Building, 1128 Smith St.

Honolulu, HI 96817-5194

Tel: (808) 537-2787

Fax: (808) 531-6873

Internet Address: http://www.ramsaymuseum.org

Director: Mr. Russ Sowers

Admission: free.

Attendance: 7,500

Membership: N *ADA Compliant:* Y

Parking: lot diagonally across from corner.

Open: Monday to Friday, 10am-5pm;
 Saturday, 10am-4pm.

Facilities: **Exhibition Area** (5 galleries); **Library** (including biographies of over 200 contemporary Hawaiian artists).

Activities: **Permanent Exhibits**; **Temporary Exhibitions**.

Publications: calendar (quarterly).

Ramsay, *Brick and Mortar*, quill and ink, Ramsay Museum. Photograph courtesy of Ramsay Museum, Honolulu, Hawaii.

Located in Hawaii's historic Chinatown district, one block from the Hawaii Theatre Center, the Museum's ground level contains two galleries featuring changing monthly exhibitions. Three second floor galleries are devoted to quill and ink works by the eponymous museum founder, Ramsay. The adjacent courtyard has an Asian sense of place with indigenous plantings and a lotus pond. The Ramsay Museum Foundation holds 201 works of art created by the artists of Hawaii and a complete collection of block prints by Dietrich Varez.

University of Hawaii at Manoa - Art Gallery

2535 The Mall, Honolulu, HI 96822

Tel: (808) 956-6888

Fax: (808) 956-9659

Internet Address: http://www.hawaii.edu/artgallery

Director: Mr. Tom Klobe

Admission: voluntary contribution.

Attendance: 50,000 *Established:* 1976 *ADA Compliant:* Y

Parking: pay on site - $3.00.

Open: Monday, 10:30am-4pm; Tuesday, 10:30am-8pm; Wednesday to Friday, 10:30am-4pm;
 Sunday, noon-4pm.

Closed: Legal Holidays.

Facilities: **Auditorium** (300 seats); **Classrooms**; **Exhibition Area** (4,200 square feet).

Activities: **Arts Festival**; **Films**; **Gallery Talks**; **Guided Tours**; **Lectures**; **Traveling Exhibitions**).

Publications: exhibition catalogues.

University of Hawaii at Manoa - Art Gallery, cont.

The University of Hawaii Art Gallery presents temporary exhibitions of both historical and contemporary art. The Main Gallery features six major exhibitions per year, while the smaller Commons Gallery showcases student thesis exhibitions, the work of visiting artists, and on-going class work. The Gallery has also initiated and organized twelve traveling exhibitions, which have been presented at museums in the United States, Mexico, Canada, Japan, Taiwan, and Guam. Also of possible interest on campus are the East-West Center Gallery (944-7111), located in Burns Hall (corner of Dole Street and East-West Road) and the School of Architecture Gallery (956-7225), located at 2410 Campus Road. For information on the University of Hawaii Outreach College John Young Museum of Art, see separate listing.

University of Hawaii at Manoa-Outreach College - John Young Museum of Art

University of Hawaii at Manoa, Krauss Hall, 2500 Dole St., Honolulu, HI 96822

Tel: (808) 956-3634

Internet Address: http://www.outreach.hawaii.edu/jymuseum

Curator: L.B. Nerio

Admission: free.

Established: 1999

Parking: campus lots (lower campus suggested), $3.

Open: Tuesday, 10am-1pm; Friday, noon-3pm; Sunday, 1pm-4pm.

Facilities: **Architecture** Krauss Hall (1931, design by Harry Simms Bent); **Exhibition Area**; **Reading Room**; **Water Garden** (design by Betsy Sakata).

Activities: **Group Visits** (by appointment, 956-8866).

Housed in the oldest wood frame building on the UHM campus, the Museum was endowed with a starter collection from the holdings of Hawaii painter John Young. The collection, emphasizing the University's special interest in Asia and the Pacific region, includes ancient artifacts and antiquities from Cambodia, China, India, Japan, Korea, Myanmar, the Pacific Islands, Sri Lanka, and Thailand. Of special note are several authentic Hawaiian koa wood chairs. For information on the University of Hawaii at Manoa - Art Gallery, see separate listing.

Kaneohe

Windward Community College - Gallery Iolani

45-720 Kea'ahala Road, Kaneohe, HI 96744

Tel: (808) 235-7346

Internet Address: http://www.wcc.hawaii.edu

Director: Toni Martin

Open: Tuesday to Saturday, 1pm-5pm.

Facilities: **Exhibition Area**.

Activities: **Temporary Exhibitions**.

The gallery presents temporary exhibitions of cultural and educational diversity.

Idaho

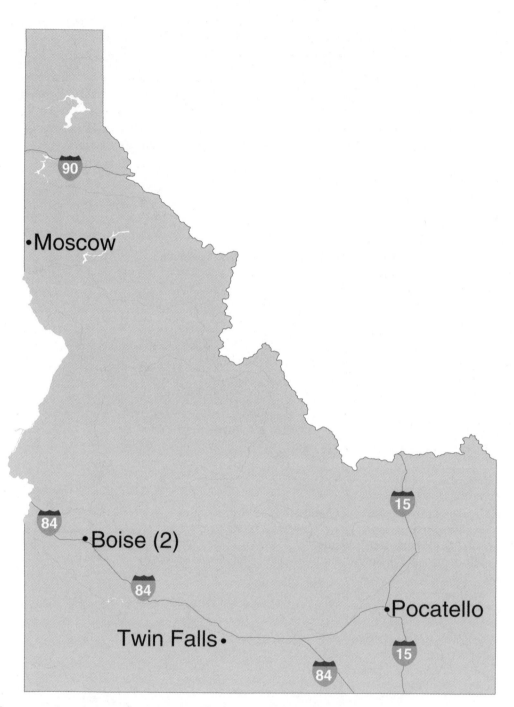

The number in parentheses following the city name indicates the number of museums/galleries in that municipality. If there is no number, one is understood. For example, in the text two listings would be found under Boise and one listing under Pocatello.

Idaho

Boise

Boise Art Museum

670 S. Julia Davis Drive, Boise, ID 83702
Tel: (208) 345-8330
Fax: (208) 345-2247
Internet Address: http://www.boiseartmuseum.org
Exec. Director: Tim Close
Admission: fee:
 adult-$4.00, child-$1.00, student-$2.00, senior-$2.00.
Attendance: 72,000 *Established:* 1931
Membership: Y *ADA Compliant:* Y
Parking: free on site.
Open: Tuesday to Friday, 10am-5pm;
 Saturday to Sunday, noon-5pm.
Closed: Holidays.
Facilities: **Galleries**; **Library** (1,000 volumes, non-circulating, with permission); **Reading Room**; **Sculpture Garden**; **Shop**.
Activities: **Arts Festival** (September); **Concerts**; **Education Programs** (adults and children); **Films**; **Gallery Talks**; **Guided Tours**; **Lectures**; **Temporary Exhibitions**; **Traveling Exhibitions**.

Deborah Butterfield, *Democrat*, 1995, 91" x 109" x 30". Boise Art Museum Collection. Purchased with Museum Acquisition Funds and Collectors Forum Funds. Photograph courtesy of Boise Art Museum, Boise, Idaho.

Publications: exhibition catalogues; newsletter, "BAM Newsletter" (quarterly).

Located in beautiful Julia Davis Park in downtown Boise, the Museum occupies a contemporary 34,000-square-foot building featuring fifteen galleries, an atrium, and an outdoor sculpture garden. Each year, the Museum presents a number of temporary exhibitions of works by Idaho, Northwest, and nationally known artists in shows covering a wide range of historical and contemporary themes. The permanent collection of the Museum features a group of American representational paintings, including examples by Henri, Sloan, Raffael, Brady, and Close; international ceramics; Asian and African artifacts; contemporary photography; and works by Pacific Northwest artists.

Boise State University - Galleries

Gallery 1: Liberal Arts Building, 1874 University Drive
Gallery 2: Hemingway Center Building, 1819 University Drive
Boise, ID 83725
Tel: (208) 426-3994
Fax: (208) 426-1243
Internet Address: http://www.idbsu.edu/art/galsh99.html
Director: Mr. Richard A. Young
Admission: free.
Attendance: 500
Parking: visitors lot, fee.
Open: Monday to Friday, 9am-6pm.
Closed: Academic Holidays.
Facilities: **Exhibition Area**.
Activities: **Rotating Exhibitions**; **Visiting Artist Program**.

The Art Department maintains two galleries. Gallery 1 is located in the Liberal Arts Building (1824 University Drive) and Gallery 2 is located in the Hemingway Center Building (1819 University Drive). Exhibitions include work by regionally, nationally and internationally recognized artists; a bi-annual national juried exhibition; and annual faculty, BFA, MFA, and MA.ed shows.

Moscow

University of Idaho - Prichard Art Gallery

414/416 S. Main St., Moscow, ID 83843

Tel: (208) 885-3586

Fax: (208) 885-3622

Internet Address: http://www.uidaho.edu/art/info

Director: Ms. Gail Siegel

Admission: voluntary contribution.

Attendance: 15,000 *Established:* 1982 *Membership:* Y

Parking: free on site.

Open: **September to May**, Monday to Friday, 11am-8pm; Saturday, 10am-4pm.

 June to August, Tuesday to Friday, 1pm-7pm; Saturday, 9am-3pm.

Closed: during installations.

Facilities: **Exhibition Area**.

Activities: **Guided Tours** (elementary and secondary school students); **Lectures**; **Temporary Exhibitions** (7/year).

Located in downtown Moscow, the Prichard Art Gallery is an outreach facility of the University of Idaho College of Art and Architecture serving the community and the university with a year-round schedule of exhibitions. The Gallery hosts seven to nine exhibitions annually featuring the fine arts, architecture, and landscape architecture. Ceramics, photography, glass art, fine craft, computer art, folk art, and installation art are also exhibited, along with traditional arts, painting, and sculpture.

Pocatello

Idaho State University - John B. Davis Art Gallery

Fine Arts Building (Lower Level), Center Street and 6th Ave., Pocatello, ID 83209

Tel: (208) 236-2442

Fax: (208) 236-4610

Internet Address: http://www.isu.edu

Director: Mr. Doug Warnock

Admission: free.

Open: Monday/Wednesday/Friday, 10am-4pm; Tuesday/Thursday, 10am-4pm and 7pm-9pm.

Facilities: **Exhibition Area**.

Activities: **Temporary Exhibitions**.

The Gallery offers temporary shows including graduate student MFA Thesis exhibitions. Also of possible interest on campus are the Transition Gallery and Mind's Eye Photo Gallery in the Earl Pond Student Union Building.

Twin Falls

The College of Southern Idaho - Herrett Center for Arts and Science

315 Falls Ave., Twin Falls, ID 83303-1238

Tel: (208) 733-9554 *Ext:* 2655

Fax: (208) 736-4712

Internet Address: http://www.csi.cc.id.us/
 support/museum/hcas_king.html

Gallery Manager: Mr. Russell Hepworth

Admission: free.

Parking: free on site.

Open: Tuesday, 9:30am-9pm;
 Wednesday to Thursday, 9:30am-4:30pm;
 Friday, 9:30am-9pm;
 Saturday, 1pm-9pm.

Embroidery, Peruvian Central Coast, 1000 A.D.-1532 A.D.
Permanent collection, Herrett Art Center. Photograph courtesy
of Herrett Art Center, Twin Falls, Idaho.

The College of Southern Idaho - Herrett Center for Arts and Science, cont.

Closed: Federal Holidays.

Facilities: Galleries; Shop.

Activities: Permanent Exhibits; Temporary Exhibitions.

Housed in an architecturally interesting post-modern building, Herrett Center collections are primarily focused on anthropology. Four galleries are dedicated to pre-Columbian America including an ancient art gallery featuring textiles. Additionally, the Jean B. King Gallery of Art, co-sponsored by the College of Southern Idaho Art Department and Associated Students of CSI, presents monthly exhibitions of contemporary art, including works by faculty and an annual juried student show.

Illinois

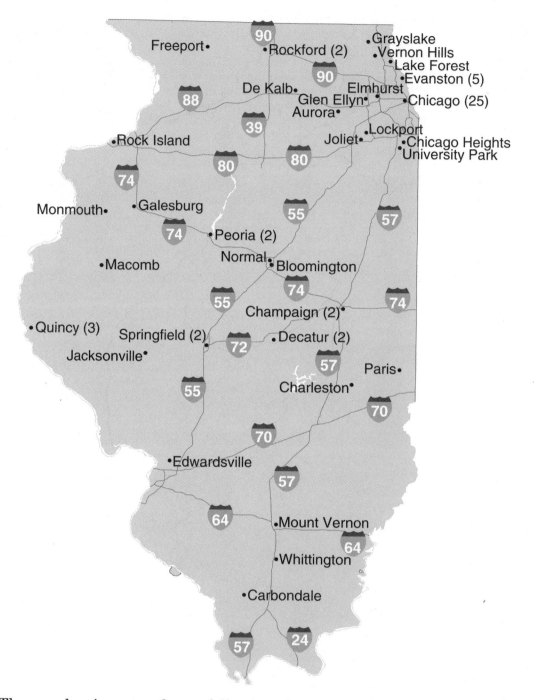

The number in parentheses following the city name indicates the number of museums/galleries in that municipality. If there is no number, one is understood. For example, in the text two listings would be found under Springfield and one listing under Carbondale.

Illinois

Aurora

Aurora University - Schingoethe Center for Native American Cultures

Aurora University, Dunham Hall
347 S. Gladstone
Aurora, IL 60506-4892
Tel: (630) 844-5402
Fax: (630) 844-8884
Internet Address: http://www.aurora.edu
Director: Dr. Dona Bachman
Admission: voluntary contribution.
Attendance: 8,000 *Established:* 1990
Membership: Y *ADA Compliant:* Y
Open: **February to December 15**,
 Tuesday, 10am-8pm;
 Wednesday to Friday, 10am-4pm;
 Sunday, 1pm-4pm.
Closed: Academic Holidays, August.
Facilities: **Exhibition Area**; **Library**.
Activities: **Arts Festival**; **Education Programs** (undergraduate/graduate college students and children); **Guided Tours**; **Lectures**; **Temporary Exhibitions**.

View of gallery. Photograph courtesy of Schingoethe Center for Native American Cultures, Aurora, Illinois.

Publications: newsletter, "Spreading Wings" (monthly).

The Schingoethe Center preserves, interprets, and exhibits historical and contemporary Native American material culture and art.

Bloomington

Illinois Wesleyan University - Merwin and Wakeley Galleries

Joyce Eichhorn Ames School of Art, 302 E. Graham Street, Bloomington, IL 61702-2900
Tel: (309) 556-3822
Internet Address: http://titam.iwu.edu/~art/galler/htm
Director: Ms. Jennifer Lapham
Admission: free.
Open: **September to June**,
 Monday, noon-4pm; Tuesday, noon-4pm and 7pm-9pm; Wednesday to Friday, noon-4pm;
 Saturday to Sunday, 1pm-4pm.
Facilities: **Galleries** (2; Merwin; Wakeley, 2415 square feet; Wakeley, 459 square feet).
Activities: **Temporary Exhibitions**.

The Merwin and Wakeley Galleries present a schedule of temporary exhibitions that support the curriculum, and benefit the University community and the general public. Exhibitions include historical and contemporary exhibits and the work of visiting artists. Student shows include the Annual Juried Student Exhibition, the Sophomore Exhibition, and the BFA/BA Degree Exhibition.

Carbondale

Southern Illinois University, Carbondale - University Museum

Grand Avenue (north end of Faner Hall), Carbondale, IL 62901
Tel: (618) 453-5388
Fax: (618) 453-7409
Internet Address: http://www.museum.siu.edu
Director: Dr. John J. Whitlock
Admission: free.
Attendance: 42,000 *Established:* 1869 *Membership:* Y *ADA Compliant:* Y

Carbondale, Illinois

Southern Illinois University, Carbondale - University Museum, cont.

Parking: metered lot near student center and stadium.

Open: Tuesday to Saturday, 9am-3pm; Sunday, 1:30pm-4:30pm.

Closed: Academic Holidays, Legal Holidays.

Facilities: **Auditorium**; **Galleries** (eight; total of 5,069 square feet); **Library**; **Sculpture Garden**; **Shop**.

Activities: **Artist Studio Tours**; **Concerts** (Wednesday noon; April-October); **Films**; **Guided Tours** (groups schedule in advance); **Lectures**; **Temporary Exhibitions**; **Traveling Exhibitions**.

Publications: newsletter.

The University Museum houses over 52,000 objects in the arts, sciences, and humanities. The art collection consists of 2,500 objects, including European and American paintings, drawings, and prints; 19th- and 20th-century photography; 20th-century sculpture, metals, and ceramics; and musical instruments.

Exterior view of the Southern Illinois University Museum. Photograph courtesy of University Museum, Southern Illinois University, Carbondale, Illinois.

Champaign

Parkland College Art Gallery

2400 W. Bradley Ave., Champaign, IL 61821

Tel: (217) 351-2485

Fax: (217) 373-3899

Internet Address: http://www.parkland.cc.il.us/gallery

Director: Ms. Denise Seif

Admission: voluntary contribution.

Attendance: 15,000 *Established:* 1980

ADA Compliant: Y

Parking: free on site.

Open: **Fall to Spring**,
　　　　Mon to Thurs, 10am-3pm & 6pm-8pm;
　　　　Friday, 10am-3pm;
　　　　Saturday, 10am-noon.
　　　　Summer,
　　　　Monday, 10am-2pm;
　　　　Tues to Thurs, 10am-2pm & 6pm-8pm.

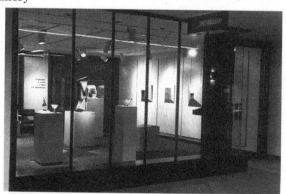

Closed: Academic Holidays, Legal Holidays.

Facilities: **Gallery**.

View of Parkland College Art Gallery. Photograph courtesy of Parkland College Art Gallery, Champaign, Illinois.

Activities: **Lectures**; **Temporary Exhibitions** (change monthly); **Traveling Exhibitions**.

The Parkland College Art Gallery offers temporary exhibitions intended to illustrate a wide range of traditional and innovative work, recognized and new talent, proven forms and fresh ones. There are faculty and juried student shows, and invitational watercolor and ceramics shows.

University of Illinois - Krannert Art Museum

University of Illinois, 500 E. Peabody Drive, Champaign, IL 61820

Tel: (217) 333-1861

Fax: (217) 333-0883

Internet Address: http://www.art.uiuc.edu/kam

Director: Mr. Maarten van de Guchte

Admission: voluntary contribution.

Attendance: 116,000 *Established:* 1961 *Membership:* Y *ADA Compliant:* Y

236

University of Illinois - Krannert Art Museum, cont.

Parking: metered on street.

Open: Tuesday, 9am-4pm; Wednesday, 9am-8pm; Thursday to Friday, 9am-4pm; Saturday, 10am-4pm; Sunday, 1pm-4pm.

Closed: Legal Holidays, Academic Holidays.

Facilities: **Auditorium**; **Food Services** Palette Café; **Galleries.**

Activities: **Education Programs** (adults, undergraduate/graduate students and children); **Gallery Talks**; **Guided Tours**; **Lectures**; **Permanent Exhibits**; **Temporary Exhibitions**; **Traveling Exhibitions.**

Publications: exhibition catalogues; magazine (semi-annual).

The Krannert Art Museum is a 48,000 square-foot facility with ten galleries and a collection of 9,000 works of art. Three of the galleries are devoted to temporary exhibitions, while the remainder display works from the permanent collection. The Museum's permanent collection consists of African art, with a special emphasis on objects from various West and Central African cultures; Asian art, from the cultures of China, Korea, Japan, India, and Thailand; Twentieth Century art, including paintings and sculptures by such artists as Muenter, Beckmann, Guston, Stella, and Warhol; European and American art from the 16th through the 19th centuries; ceramics, glass, and silver from the Renaissance to the present; ancient Mediterranean art from Egypt, Greece, and Italy; Medieval art, including painting, stained glass, and ivory; and pre-Columbian art from various Peruvian cultures.

Charleston

Eastern Illinois University - Tarble Arts Center

South 9th St. at Cleveland Ave., Charleston, IL 61920

Tel: (217) 581-2787

Fax: (217) 581-2722

Internet Address: http://www.eiu.edu/~tarble

Director: Mr. Michael Watts

Admission: voluntary contribution.

Attendance: 21,000 *Established:* 1982 *Membership:* Y *ADA Compliant:* Y

Parking: free on site.

Open: **mid-August to mid-May**, Tuesday to Friday, 10am-5pm; Saturday, 10am-4pm; Sunday, 1pm-4pm.

mid-May to mid-August, Tuesday to Saturday, 10am-4pm; Sunday, 1pm-4pm.

Closed: Legal Holidays.

Facilities: **Classroom**; **Exhibition Area** (6,400 square feet); **Library**; **Sales/Rental Gallery**; **Sculpture Court**; **Shop.**

Activities: **Concerts**; **Education Programs**; **Temporary Exhibitions**; **Traveling Exhibitions.**

Publications: calendar (1/semester); exhibition brochures; exhibition catalogues; newsletter (monthly).

The Tarble Arts Center presents a year-round schedule of changing visual arts exhibitions. It also has a permanent collection consisting of 1,000 pieces, including a 500-piece collection of 20th-century Illinois folk art; works on paper by contemporary Midwestern artists, including Jasper Johns and Claus Oldenberg: and prints by American Regionalists, such as Benton, Curry, Kent, Sample, Soyer, and Wood.

Chicago

ARC Gallery

734 N. Milwaukee, Chicago, IL 60622

Tel: (312) 733-2787

Fax: (312) 733-2787

President: Nancy Bechtol

Admission: free.

Attendance: 6,200 *Established:* 1973 *Membership:* Y *ADA Compliant:* Y

ARC Gallery, cont.

Parking: free on street.
Open: **September to July**,
Wednesday, 11am-5pm
Thursday, 11am-6pm
Friday to Saturday, 11am-5pm.
and by appointment.
Closed: Legal Holidays.
Facilities: **Exhibition Area** (8 galleries; 5000 square feet).
Activities: **Lectures; Temporary Exhibitions.**
Publications: newsletter.

Ellen Petraits, *Untitled: Apiary Series*, 1997, oil on wood, hive panel; 18 x 10 inches. Work by ARC member. Photograph courtesy of ARC Gallery, Chicago, Illinois.

ARC Gallery is a non-profit women's cooperative gallery, providing opportunities for emerging woman artists. The Gallery has monthly group shows and member shows in its galleries. It also offers exhibit opportunities to non-members and reserves another gallery for community-based exhibits. ARC's RAW SPACE is one of the nation's oldest spaces devoted exclusively to the exhibition of installation art. The Media Room, ARC's most recent innovation, is dedicated to electronic artists working with video and computer formats displayed on single channel video.

The Art Institute of Chicago

111 S. Michigan Ave., Chicago, IL 60603-6110
Tel: (312) 443-3600
Fax: (312) 443-0849
TDDY: (312) 443-3890
Internet Address: http://www.artic.edu
Director: Mr. James N. Wood
Admission: suggested contribution: adult-$8.00, child-$5.00, student-$5.00, senior-$5.00.
Attendance: 1,478,000 *Established:* 1879
Membership: Y *ADA Compliant:* Y
Parking:
metered on street and nearby commercial lots.
Open: Monday, 10:30am-4:30pm;
Tuesday, 10:30am-8pm;
Wednesday to Friday, 10:30am-4:30pm;
Saturday to Sunday, 10am-5pm;
Holidays, noon-5pm.
Closed: Thanksgiving Day, Christmas Day.

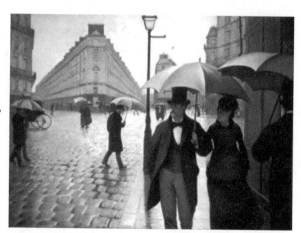

Gustave Caillebotte, *Paris Street; Rainy Day*, 1887. Charles H. and Mary F.S. Worcester Fund, The Art Institute of Chicago. Photograph courtesy of The Art Institute of Chicago, Chicago, Illinois.

Facilities: **Architecture** (Beaux Arts building, 1894 design Shepley, Rutan & Coolidge); **Auditoria** (3); **Court Cafeteria** (Mon & Wed-Sat, 10:30am-4pm; Tues, 10:30am-7pm; Sun, noon-4pm); **Education Center and Reading Room; Food Services** Restaurant on the Park and Court Cafeteria (Mon-Sat, 11am-2:30pm); **Galleries; Library** (220,000 volumes, non-circulating, by request); **Shop; Theatre.**
Activities: **Education Programs** (adults, children and families); **Guided Tours; Lectures** (Tuesday, 6pm; collection lectures daily); **Permanent Exhibits** (10 curatorial departments); **Temporary Exhibitions** (25/year); **Traveling Exhibitions.**
Publications: "Museum Studies" (semi-annual); "The Art Institute of Chicago Annual Report"; newsletter, "News & Events" (bi-monthly).

One can discover forty centuries of human creativity at The Art Institute of Chicago, one of the world's leading museums. From ancient Chinese bronzes to the latest work by today's artists, from Rembrandt paintings to African woodcarvings, the collections include some of the finest art ever produced. On display are paintings, sculpture, prints and drawings, photographs, Asian art, art of Africa and the Americas, textiles, decorative arts, and architectural fragments and drawings. The Art Institute's renowned paintings date from the fourteenth century to the present and include Georges Seurat's masterpiece "A Sunday on La Grande Jatte-1884", Mary Cassatt's "The Bath", and Grant

The Art Institute of Chicago, cont.

Wood's celebrated "American Gothic". Especially noteworthy is the collection of Impressionist and Post-Impressionist pictures, with many examples by Monet, Renoir, Degas, van Gogh, and otherpainters of the period. Additional highlights include a large and distinguished collection of prints and drawings; the recently opened Galleries of Chinese, Japanese, and Korean Art; 68 European and American Thorne Miniature Rooms; 1,000 glass paperweights from the Rubloff Collection; and the historic Trading Room designed by Adler and Sullivan, reconstructed from the original Chicago Stock Exchange Building. The Institute mounts approximately 25 temporary exhibitions each year, many of which are concurrent. It offers free public programs conducted by the Department of Museum Education. The Art Institute organizes its collection among the following curatorial departments: African and Amerindian Art, Architecture, Asian Art, American Arts, European Painting, European Decorative Arts and Sculpture and Classical Art, Photography, 20th-century Painting and Sculpture, Textiles, and Prints and Drawings. "Voices" presentations, which bring the world of the artist to life, are offered every Thursday at noon.

Artemesia Gallery

700 N. Carpenter, Chicago, IL 60622

Tel: (312) 226-7323

Fax: (312) 226-7756

Internet Address: http://www.enteract.com/~artemisi

Admission: free.

Attendance: 3,000 *Established:* 1973 *Membership:* Y *ADA Compliant:* Y

Parking: free on street.

Open: Tuesday to Saturday, 11am-5pm.

Facilities: **Exhibition Area** (3000 square feet in 5 galleries).

Activities: **Guided Tours**; **Lectures**; **Temporary Exhibitions** (monthly); **Traveling Exhibitions**.

Publications: catalogue, "Gallery History"; exhibition catalogues (annual).

Artemesia is a cooperative organization run by women. It mounts temporary exhibitions featuring the work of emerging artists, both Artemesia members and male and female non-members.

The Chicago Architecture Foundation (CAF)

224 S. Michigan Ave., Chicago, IL 60604-2501

Tel: (312) 922-3432

Fax: (312) 922-0481

Internet Address: http://www.architecture.org

Exec. Director: Mr. John Engman

Admission: free for exhibits; charge for tour.

Attendance: 200,000 *Established:* 1966

Membership: Y *ADA Compliant:* Y

Open: Monday to Saturday, 9am-6pm;
Sunday, 10am-5pm.

Facilities: **Exhibition Area**; **Lecture Center**; **Shop**.

Activities: **Architectural Tours of Chicago**; **Lectures** (every Wednesday); **Temporary Exhibitions**.

Publications: "A.I.A. Guide to Chicago"; newsletter, "Insites" (quarterly); tour brochure; tour catalogue (annual).

The Chicago Architecture Foundation offers over sixty architecture tours of Chicago's neighborhoods via foot, bus, boat, and bicycle, led by certified volunteer guides trained by CAF. In addition, CAF offers exhibitions, which focus on various aspects of architecture and design.

View of "Chicago's First Lady" during architecture river cruise. Photograph courtesy of Chicago Architecture Foundation, Chicago, Illinois.

Chicago, Illinois

The Chicago Athenæum: Museum of Architecture and Design

6 N. Michigan Ave., Chicago, IL 60602
Tel: (312) 251-0175
Fax: (312) 251-0176
Internet Address: http://www.chi-athenaeum.org
Director: Mr. Christian Laine
Admission:
 fee: adult-$3.00, student-$2.00, senior-$2.00.
Attendance: 350,000 *Established:* 1988
Membership: Y *ADA Compliant:* Y
Parking: commercial adjacent to site -
Monroe Street Parking Garage.
Open: Tuesday to Saturday, 11am-6pm;
 Sunday, noon-5pm.
Closed: New Year's Day, Easter,
 Thanksgiving Day, Christmas Day.

View of gallery of Chicago Athenaeum showing "Landmark Chicago" exhibit. Photograph by Ionnis Karalias, courtesy of Chicago Athenaeum, Chicago, Illinois.

Facilities: **Architecture** (1st corporate headquarters of Montgomery Ward, 1899); **Auditorium** (300 seats); **Exhibition Area** (16,000 square feet; additional 1,000 apart); **Lecture Room**; **Library** (2,500 volumes); **Rental Gallery**; **Sculpture Garden** (Schaumburg, IL); **Shop**.
Activities: **Lectures**; **Self-guided Tours**; **Temporary Exhibitions**; **Traveling Exhibitions**.
Publications: catalogue, "Good Design" (annual); magazine, "Metropolitan Review" (bi-monthly).

The Chicago Athenæum is an international museum of architecture and design. It displays objects from its permanent collection as well as temporary exhibitions and also offers walking tours, gallery walks, and other programs dealing with design and the urban environment. Highlights of the permanent collection of the Athenæum include architectural drawings and models, building fragments, decorative arts, industrial design (household appliances, business equipment, cameras, electronics), graphic design (graphic arts from corporate logos to poster art), and photographic and film/video archives.

Chicago Cultural Center

78 E. Washington St., Chicago, IL 60602
Tel: (312) 744-6630
Fax: (312) 744-2089
TDDY: (312) 744-2947
Internet Address:
 http://www.cityofchicago.org/Tour/CulturalCenter/
Director, Visual Arts: Mr. Gregory Knight
Admission: free.
Attendance: 700,000 *Established:* 1897
Membership: Y *ADA Compliant:* Y
Open: Monday to Wednesday, 10am-7pm;
 Thursday, 10am-9pm;
 Friday, 10am-6pm;
 Saturday, 10am-5pm;
 Sunday, 11am-5pm.
Closed: Legal Holidays.

Interior view of the Chicago Cultural Center, Tiffany dome in Preston Bradley Hall. Architects: Shepley, Rutan and Coolidge, 1897. Photograph by Degnan/Moloitis courtesy of the Chicago Department of Cultural Affairs, Chicago, Illinois.

Facilities: **Architecture** (former central library, 1897 Beaux Arts design by the Boston firm of Shepley, Rutan, & Coolidge); **Cabaret**; **Concert Halls** (2); **Conservation Facilities**; **Dance Studio**; **Food Services** (Café); **Galleries** (8); **Performing Arts Space**; **Theatres** (2).
Activities: **Concerts**; **Dance Recitals**; **Educational Programs** (elementary and high school students); **Film Series**; **Galley Talks**; **Guided Tours** (Tues-Sat, 1:15pm); **Lectures**; **Panel Discussions**; **Performances**; **Readings**; **Temporary Exhibitions** (40+/year); **Workshops**.
Publications: calendar (monthly); exhibition catalogues.

Chicago Cultural Center, cont.

The Chicago Cultural Center presents more than 1,000 admission-free programs and exhibitions annually. Listed on the Register of National Historic Places, the building housing the Chicago Cultural Center was the first home of the Chicago Public Library. Its interior features rooms modeled on the Doge's Palace, the Palazzo Vecchio, and the Acropolis. Its ornamentation includes two stained-glass domes (one is Tiffany's largest design), marble, mosaics, and coffered ceilings. The Center houses a number of galleries: Landmark Chicago Gallery, three Michigan Avenue Galleries, Sidney R. Yates Gallery, Exhibit Hall, Chicago Rooms, and Renaissance Court. The exhibition program is aimed at complementing the offerings of Chicago's traditional museums and alternative galleries, to broaden the arts audience in Chicago, and to provide opportunities for Chicago artists to exhibit as well as view significant works by their counterparts on the local, regional, national, and international scene. Several major exhibitions are organized annually by the staff of the Chicago Department of Cultural Affairs or guest curators. Exhibitions present a wide range of traditional and new media: painting, sculpture photography, graphics, crafts, architecture, and design. A variety of contemporary, historical, and cultural offerings include national traveling exhibitions as well as one-person shows by local artists.

Chicago Historical Society

Clark St. at North Ave., Chicago, IL 60614-6099
Tel: (312) 642-4600
Fax: (312) 266-2077
TDDY: (800) 526-0857
Internet Address:
 http://www.chicago history.org
President: Mr. Douglas Greenberg
Admission: suggested contribution: adult-$3.00, child-$1.00, student-$2.00, senior-$2.00.
Attendance: 160,000 *Established:* 1856
Membership: Y *ADA Compliant:* Y
Parking: metered on street.
Open: Monday to Saturday, 9:30am-4:30pm; Sunday, noon-5pm.

Exterior view of Chicago Historical Society. Photograph courtesy of Chicago Historical Society, Chicago, Illinois.

Closed: New Year's Day, Thanksgiving Day, Christmas Day.
Facilities: **Auditorium; Galleries; Library; Shop.**
Activities: **Demonstrations; Films; Gallery Talks; Guided Tours; Lectures; Permanent Exhibits; Temporary Exhibitions; Traveling Exhibitions.**
Publications: catalogues; journal, "Chicago History" (quarterly); newsletter, "Past-Times" (quarterly).

The Chicago Historical Society mounts temporary exhibitions focusing on Chicago, Illinois, and American history. While primarily a history museum, the Historical Society does have an art collection. It acquires artifacts that reflect the artistic communities of Chicago, and it also houses a nationally recognized collection of portraits, both in flat art and in sculpture. There is as well a collection of locally-produced decorative arts.

City Gallery

806 N. Michigan Ave. (at Chicago Ave.), Chicago, IL 60602
Tel: (312) 742-0808
Fax: (312) 744-2089
TTY: (312) 744-2947
Internet Address: http://www.cityofchcago.org/Tour/CulturalAffairs
Admission: free.
Open: Monday to Saturday, 10am-6:30pm; Sunday, 10am-5pm.
Closed: Major Holidays.
Facilities: **Architecture** (Gothic Water Tower, 1867 design by William W. Boyington); **Gallery.**
Activities: **Temporary Exhibitions.**

Chicago, Illinois

City Gallery, cont.

City Gallery is located in the Chicago Water Tower, originally erected in 1869 to house a 138-foot-high standpipe and now a memorial to the victims of the Great Chicago Fire of 1871. A project of the Chicago Department of Cultural Affairs, City Gallery is dedicated to displaying Chicago-themed photographs by Chicago photographers.

Columbia College Chicago - The Museum of Contemporary Photography

Columbia College Chicago, 600 S. Michigan Ave., Chicago, IL 60605-1996

Tel: (312) 663-5554

Fax: (312) 360-1656

Internet Address: http://www.colum.edu/museum/index.html

Director: Ms. Denise Miller

Admission: free.

Established: 1976

Membership: Y *ADA Compliant:* Y

Parking: public lot near site.

Open: **September to May**,
Monday to Wednesday, 10am-5pm;
Thursday, 10am-8pm;
Friday, 10am-5pm;
Saturday, noon-5pm.

June to July,
Monday to Friday, 10am-4pm;
Saturday, noon-4pm.

Closed: New Year's Eve to New Year's Day,
ML King Day, Memorial Day,
Independence Day, August, Labor Day,
Thanksgiving Weekend,
Christmas Eve to Christmas Day.

Interior view of Print Study Room, 2nd floor gallery, Museum of Contemporary Photography, Columbia College Chicago. Photograph courtesy of Columbia College Chicago, Chicago, Illinois.

Facilities: **Classrooms**; **Exhibition Area**; **Print Study Room**.

Activities: **Guided Tours**; **Lectures**; **Temporary Exhibitions**; **Traveling Exhibitions**.

Publications: exhibition catalogues (annual).

The Museum of Contemporary Photography was founded by Columbia College Chicago to exhibit, collect, and promote contemporary photography. Each year the Museum presents a wide range of exhibitions in recognition of photography's many roles: as a medium of communication and artistic expression, as a documenter of life and the environment, as a commercial industry, and as a powerful tool in the service of science and technology. In addition, special projects in collaboration with other institutions combine photographic works with different forms of expression and investigate the medium's interaction with various arts, history, science and culture. The Museum fosters research and the appreciation of contemporary image making by ensuring that the photographs in the permanent collection and print study room are accessible to the public through exhibitions, publications, and private examination. The permanent collection focuses on American photography produced since 1959, the United States publication date of Robert Frank's seminal work "The Americans". Holdings are complemented by works from the Midwest Photographers Project, a program featuring works by regional photographers on loan to the print study room for a one-year period. Also of possible interest on the Columbia College Chicago campus are three additional galleries that exhibit the work of students, faculty and professional artists: the Center for the Book and Paper Arts Gallery (Open: Monday-Friday, 10am-5pm, 431-8612); the Art Gallery; and the Hokin Student Center Gallery.

DePaul University Art Gallery

John T. Richardson Library, 2350 N. Kenmore Ave. (at Fullerton), Chicago, IL 60614-3214

Tel: (773) 325-7506

Fax: (773) 325-4506

Internet Address: http://www.depaul.edu/~gallery

Director: Ms. Louise H. Lincoln

DePaul University Art Gallery, cont.

Admission: free.

Attendance: 7,500 *Established:* 1987 *Membership:* N *ADA Compliant:* Y

Parking: university facility one block west at 3221 North Sheffield.

Open: **September to July**(during exhibitions),
 Monday to Thursday, 11am-5pm; Friday, 11am-7pm; Saturday to Sunday, noon-5pm.

Closed: Academic Holidays.

Facilities: **Gallery.**

Activities: **Lectures; Permanent Collection; Temporary Exhibitions; Traveling Exhibitions.**

Publications: exhibition catalogues; gallery notes.

The Gallery mounts diverse exhibitions throughout the academic year and also maintains the University's permanent collection of art, selections of which are exhibited on a rotating basis in the space adjacent to the temporary exhibition area. Spanning the 16th century to the present, University holdings consist mainly of paintings, prints, drawings, and photography and has a strong representation of religious imagery. Among the Artists represented are Jack Beal, William Blake, John Chamberlain, Chryssa, William Conger, Carlo Dolci, Jules Dupre, Gifford Dyer, Jacob Epstein, Thomas Hill, Thomas Lawrence, Gustave Loiseau, Charles Le Brun, Peter Lely, Edgar Payne, Diego Rivera, Seymour Rosofsky, Georges Roualt, William Schwartz, Julia Thecla, Louis Comfort Tiffany, Mark Tobey, Jules Verlet, and Garry Winogrand.

DuSable Museum of African-American History, Inc.

740 East 56th Place, Chicago, IL 60637

Tel: (773) 947-0600

Fax: (773) 947-0677

Internet Address: http://www.dusablemuseum.org

President: Ms. Antoinette Wright

Admission: fee: adult-$3.00, child-$1.00, student/senior-$2.00.

Established: 1961 *Membership:* Y

Open: Monday to Saturday, 10am-5pm; Sunday, noon-5pm.

Closed: New Year's Eve to New Year's Day, Easter,
 Independence Day, Thanksgiving Day, Christmas Day.

Facilities: **Galleries; Library** (6,000 volumes, non-circulating).

Activities: **Classes; Guided Tours; Lectures; Traveling Exhibitions.**

The DuSable Museum of African-American History is the only major independent institution in Chicago established to preserve and interpret the historical experiences and achievements of African-Americans. The Museum's collection numbers more than 10,000 objects and includes paintings, sculpture, print works, and memorabilia. The Museum mounts approximately four exhibits per year.

Exterior view of DuSable Museum. Photograph courtesy of DuSable Museum of African-American History, Inc., Chicago, Illinois.

Hyde Park Art Center (HPAC)

5307 S. Hyde Park Blvd., Chicago, IL 60615

Tel: (773) 324-5520

Fax: (773) 324-6641

Internet Address: http://www.gtwychgo.com/hpac/

Exec. Director: Ms. Kay Grissom

Admission: free.

Attendance: 12,000 *Established:* 1939 *Membership:* Y *ADA Compliant:* Y

Open: Monday to Saturday, 11am-5pm.

Closed: Legal Holidays.

Hyde Park Art Center, cont.

Facilities: **Ceramics Studio; Classroom; Exhibition Area** (2,000 square feet).

Activities: **Education Programs** (adults and children); **Guided Tours; Temporary Exhibitions; Workshops.**

Publications: exhibition catalogues (occasional); newsletter, "News" (quarterly); school calendar (quarterly).

The Hyde Park Art Center is one of the oldest community-based art centers in Chicago. It exhibits a wide variety of work by emerging and established artists, including work by Center students and faculty as well as that of artists working in the community.

Shuko Wada, *Present,* 1997, masking tape and carpet. Installation in Hyde Park Art Center Gallery. Photograph courtesy of Hyde Park Art Center, Chicago, Illinois.

Illinois Art Gallery

James R. Thompson Center, 100 W. Randolph, Suite 2-100, Chicago, IL 60601-3471

Tel: (312) 814-5322

Fax: (312) 814-3471

Director: Mr. Kent J. Smith

Admission: voluntary contribution.

Attendance: 100,000 *Established:* 1985 *Membership:* Y *ADA Compliant:* Y

Parking: metered on street.

Open: Monday to Friday, 9am-5:30pm.

Closed: Legal Holidays.

Facilities: **Exhibition Area** (3,200 square feet); **Galleries** (5); **Shop** (Illinois crafts).

Activities: **Education Programs** (adults and children); **Guided Tours** (on request); **Lectures; Temporary Exhibitions** (10/year).

Publications: brochures; catalogues; newsletter, "Illinois Art Gallery News" (semi-annual).

A program of the Illinois State Museum (Springfield, Illinois), the Gallery is devoted solely to Illinois art and artists. The Gallery mounts approximately 10 exhibitions at six- to eight-week intervals each year. Exhibitions have ranged from contemporary fine art quilting, to a history of Chicago's community mural movement, to computer and electronic art. To date over 1,000 Illinois artists have exhibited work in the Illinois Art Gallery. Also at this site, the Illinois State Museum operates the Illinois Artisans Shop, which mounts special displays of Illinois crafts.

Loyola University - Martin D'Arcy Museum of Art

Loyola University, Lake Shore Campus, 6525 N. Sheridan Road

Chicago, IL 60626

Tel: (773) 508-2679

Fax: (508) 508-2993

Internet Address: http://www.luc.edu/depts/darcy

Director: Dr. Sally Metzler

Admission: free.

Attendance: 6,000 *Established:* 1969

Membership: Y *ADA Compliant:* Y

Parking: pay parking on campus.

Open: **Fall to Spring,** Monday to Friday, noon-4pm.
 Summer, Friday, 10am-5pm.

Closed: Academic Holidays.

Facilities: **Gallery; Library** (10,000 volumes).

Angel with Heraldic Shield, wood with polychrome and gilding, German, later 15th century. Collection of Martin D'Arcy Museum of Art. Photograph courtesy of Martin D'Arcy Museum of Art, Loyola University, Chicago, Illinois.

Loyola University - Martin D'Arcy Museum of Art, cont.

Activities: **Lecture Series** ("Kultur und Kaffee", most Weds, 3:30pm); **Symposia**; **Temporary Exhibitions**; **Tours**.

Publications: exhibition catalogues.

Located within the Cudahy Library on Loyola's Lake Shore Campus, the Martin D'Arcy Museum of Art houses the Loyola University Chicago's museum of medieval, renaissance and baroque art. The Museum provides an intimate setting for over 300 art objects including paintings attributed to Bellini, Tintoretto, and Bassano as well as German and Flemish sculpture, French and Italian furnishings and jewelry, textiles from England, and various liturgical and architectural elements. The Museum's focus is primarily on the permanent collection.

Mexican Fine Arts Center Museum

1852 West 19th St., Chicago, IL 60608
Tel: (312) 738-1503
Fax: (312) 738-9740
Exec. Director: Mr. Carlos Tortolero
Admission: voluntary contribution.
Attendance: 108,000 *Established:* 1987 *Membership:* Y *ADA Compliant:* Y
Open: Tuesday to Sunday, 10am-5pm.
Closed: Legal Holidays.
Facilities: **Educational Facilities**; **Exhibition Area** (18,000 square feet); **Galleries** (3); **Shop** (Mexican folk art, books, exhibition catalogues).
Activities: **Arts Festival**; **Demonstrations**; **Education Programs** (children); **Gallery Talks**; **Guided Tours**; **Lectures**; **Performances**; **Temporary Exhibitions**; **Traveling Exhibitions**.
Publications: exhibition catalogues.

The Museum showcases the diversity of the Mexican artistic experience from the traditional to the avant-garde. It has attempted to maintain an artistic balance between contemporary, traditional, and non-traditional exhibitions, folk art and ethnographical, as well as Meso-American and colonial. The Museum has three galleries; the Main Gallery, where principal exhibitions are mounted; the West Wing Gallery, which is devoted to the work of contemporary Mexican artists and displays of the permanent collection; and finally, the Courtyard Gallery, which presents local and emerging artists and works from the Museum's art classes. The permanent collection totals 2,400 objects in four categories: Prints and Drawings, Photography, Folk Art, and Contemporary Painting and Sculpture.

Museum of Contemporary Art (MCA)

220 E. Chicago Ave., Chicago, IL 60611-2604
Tel: (312) 280-2660
Fax: (312) 397-4095
TDDY: (312) 397-4006
Internet Address: http://www.mcachicago.org
Director & C.E.O.: Mr. Robert Fitzpatrick
Admission: fee: adult-$6.50, child-free, student-$4.00, senior-$4.00.
Attendance: 80,000 *Established:* 1967 *Membership:* Y *ADA Compliant:* Y
Parking: metered on street and nearby commercial lot.
Open: Tuesday, 11am-6pm; Wednesday, 11am-8pm; Thursday to Friday, 11am-6pm;
 Saturday to Sunday, 10am-6pm.
Closed: New Year's Day, Thanksgiving Day, Christmas Day.
Facilities: **Architecture** (1996, design by German architect Josef Paul Kleihues); **Educational Facilities**; **Exhibition Area**; **Food Services** M-Café (Tues, 11am-5pm; Wed, 11am-7pm; Thurs-Fri, 11am-5pm; Sat-Sun, 10am-5pm); **Library** (16,000 volumes); **Sculpture Garden**; **Shops** (gift store and bookshop); **Theatre** (300 seats).
Activities: **Film Series**; **Gallery Talks**; **Guided Tours** (Tues-Fri, 1pm; Sat-Sun, 11:15am/12:15pm/2pm; Wed, 6pm; free); **Lecture Series**; **Performances**; **Temporary Exhibitions**.
Publications: brochure; calendar (quarterly); exhibition catalogues; gallery guides.

Museum of Contemporary Art, cont.

One of the nation's largest facilities devoted to post-1945 art, MCA offers exhibitions documenting contemporary visual culture through painting, performance, photography, sculpture, and video/film. The permanent collection provides an historical perspective for the examination of current trends in contemporary art. The collection consists of approximately 7,000 works with strengths in art made in Chicago, minimalism, postminimalism, conceptualism, surrealism, and artists' books. Among the artists represented are Francis Bacon, Alexander Calder, Ann Hamilton, Alfredo Jaar, Jasper Johns, Donald Judd, Jeff Koons, Sol LeWitt, René Magritte, Bruce Nauman, Ed Paschke, Richard Serra, Cindy Sherman, Lorna Simpson, Robert Smithson, and Andy Warhol.

Northern Illinois University Art Gallery in Chicago (NIU Art Gallery)

215 W. Superior, 3rd Floor, Chicago, IL 60610
Tel: (312) 642-6010
Fax: (312) 642-9635
Internet Address: http://www.vpa.niu.edu/museum
Admission: free.
Attendance: 1,867 *Established:* 1984 *Membership:* Y *ADA Compliant:* Y
Parking: metered on street.
Open: **September to July**, Wednesday to Saturday, 11am-5pm.
Closed: August.
Facilities: **Exhibition Area** (2,000 square feet).
Activities: **Guided Tours**; **Lectures**; **Temporary Exhibitions** (7/year); **Traveling Exhibitions**.
Publications: exhibition catalogues.

A satellite gallery of the NIU Art Museum (De Kalb, Illinois), the Gallery was established to aid in the association and participation of the University in the Chicago art community and to help maintain relations with other Chicago art museums and galleries. Located in Chicago's River North gallery district, it presents temporary exhibitions, which change every six to eight weeks.

School of the Art Institute of Chicago - The Betty Rymer Gallery

280 South Columbus Drive, Chicago, IL 60603
Tel: (312) 443-3703
Fax: (312) 332-5859
Internet Address: http://www.artic.edu/~vartists/
Gallery Director: Ms. Clair Broadfoot
Admission: free.
Attendance: 22,000 *Established:* 1988 *Membership:* N *ADA Compliant:* Y
Parking: nearby public lots.
Open: Monday to Saturday, 10am-5pm; Thursday, 10am-8pm; Friday to Saturday, 10am-5pm.
Closed: Between Shows, Legal Holidays.
Facilities: **Gallery** (28,000 square feet).
Activities: **Temporary Exhibitions**.
Publications: brochure (annual); calendar (monthly); calendar, "Exhibitions & Events" (bi-monthly);
 exhibition catalogues (occasional).

The Betty Rymer Gallery showcases the strength and diversity of the School's programs, highlighting faculty and student work and mounting special exhibitions of the work of professional artists. Also of possible interest is the SAIC's Gallery 2 (563-5262) located at 847 W. Jackson Ave., Chicago, Illinois 60607 (open: Tues-Sat, 11am-6pm). Gallery 2 provides students with the opportunity to exhibit their work within a professional venue in close proximity to a number of other galleries. Students are selected to exhibit their work through an open proposal process. In addition, large theme-related juried shows are scheduled at least twice annually.

Spertus Institute of Jewish Studies - Spertus Museum

618 S. Michigan Ave., Chicago, IL 60605
Tel: (312) 322-1747
Fax: (312) 922-3934
Internet Address: http://www.spertus.edu/Museum.html

Spertus Institute of Jewish Studies - Spertus Museum, cont.

President: Dr. Howard A. Sulkin

Admission: fee: adult-$5.00, child-$3.00, student-$3.00, senior-$3.00; family-$10 (maximum)

Attendance: 70,000 *Established:* 1968 *Membership:* Y *ADA Compliant:* Y

Open: Sunday to Wednesday, 10am-5pm; Friday, 10am-3pm;Thursday (seasonal), 10am-8pm.

Closed: Jewish Holidays, Legal Holidays.

Facilities: **Archaeological Gallery**, the **ARTiFACT** Center (children); **Auditorium**; **Classrooms**; **Galleries**; **Library** (100,000 volumes); **Shop** (traditional and contemporary design objects, books).

Activities: **Concerts**; **Education Programs** (graduate students); **Films**; **Gallery Talks**; **Guided Tours**; **Lectures**; **Permanent Exhibits**; **Temporary Exhibitions**.

Publications: calendar of events; exhibition catalogues; posters.

Through its changing and permanent collection exhibitions, Spertus Museum celebrates the creativity and diversity of Jewish culture. Selections from the permanent collection acquaint visitors with the beauty and customs of Jewish religion and culture from around the world.

State Street Bridge Gallery

Riverwalk at State Street and Wacker Drive, Chicago, IL 60610

Tel: (312) 744-6630

Fax: (312) 744-2089

TTY: (312) 744-2947

Internet Address: http://www.cityofchicago.org/ Tour/CulturalAffairs

Admission: free.

Attendance: 30,000

Open: **May to September**, Monday to Saturday, 10am-7pm; Sunday, 10am-5pm.

Closed: Memorial Day, Labor Day.

Facilities: **Architecture** (historic bridge house); **Gallery**.

Activities: **Temporary Exhibitions**.

A cooperative effort between the Chicago Department of Cultural Affairs and the Chicago Department of Transportation, the Gallery is located within one of Chicago's historic bridge houses. The Gallery offers the opportunity to view changing exhibitions, as well as the machinery of one of the city's moveable bridges.

Terra Museum of American Art

666 N. Michigan Ave. (between Huron and Erie Streets), Chicago, IL 60611

Tel: (312) 664-3939

Fax: (312) 664-2052

Internet Address: http://www.terramuseum.org

Director and Chief Curator: Dr. John Hallmark Neff

Admission:
 fee: adult-$7.00, senior-$3.50, child/student-free.
 free: Tuesday and 1st Sunday in month.

Attendance: 71,000 *Established:* 1979

Membership: Y *ADA Compliant:* Y

Parking: validation at Ontario Self-Park.

Open: Tuesday, 10am-8pm;
 Wednesday to Saturday, 10am-6pm;
 Sunday, noon-5pm.

Closed: New Year's Day, Independence Day,
 Thanksgiving Day, Christmas Day.

Facilities: **Galleries** (5 levels); **Library** (4,500 volumes; by appointment, Mon-Fri); **Shop** (books and merchandise).

Samuel L. Margolies, *Man's Canyon*, 1936, etching and aquatint, 11 7/8 x 8 13/16 inches. Terra Foundation for the Arts, Daniel J. Terra Collection. Photograph courtesy of Terra Museum of American Art, Chicago, Illinois.

Terra Museum of American Art, cont.

Activities: **Gallery Talks** (most Tuesdays, 6pm); **Guided Tours** (Daily, noon; also Sat-Sun, 2pm; group tours reserve in advance); **Lectures** (on Saturdays following exhibition opening); **Permanent Exhibits; Traveling Exhibitions**.

Publications: books; exhibition catalogues.

Devoted exclusively to American art, the Terra houses an extensive collection that focuses on the 19th and 20th centuries. The permanent collection includes paintings, sculpture and works on paper by such artists as Washington Alston, Mary Cassatt, William Merritt Chase, Charles Demuth, Thomas Eakins, George Bellows, Winslow Homer, Edward Hopper, Rockwell Kent, Willard Metcalf, Georgia O'Keeffe, Maurice Prendergast, John Singer Sargent, Walter Ufer, James A. McNeill Whistler, and the Wyeths, among others. Exhibition of the permanent collect is supplemented by an extensive schedule of temporary or traveling exhibitions and educational programs.

University of Chicago - The David and Alfred Smart Museum of Art

University of Chicago, 5550 S. Greenwood Ave., Chicago, IL 60637

Tel: (773) 702-0200

Fax: (773) 702-3121

Internet Address: http://smartmuseum.uchicago.edu

Director: Ms. Kimerly Rorschach

Admission: voluntary contribution.

Attendance: 30,000 *Established:* 1974 *Membership:* Y *ADA Compliant:* Y

Parking: commercial adjacent to site; free evenings and weekends.

Open: Tuesday to Wednesday, 10am-4pm; Thursday, 10am-9pm; Friday, 10am-4pm; Saturday to Sunday, noon-6pm.

Closed: Legal Holidays.

Facilities: **Exhibition Area**; **Food Services** Café (light fare); **Sculpture Garden**; **Shop**.

Activities: **Gallery Talks**; **Guided Tours**; **Lectures**; **Permanent Exhibits**; **Temporary Exhibitions**.

Publications: bulletin, "Smart Museum Bulletin" (annual); collection handbook; exhibition catalogues.

Designed by Edward Larrabee Barnes, the Smart Museum of Art and its adjacent Elden Sculpture Garden house over 7,000 works of art. From ancient Greek vases and Chinese bronzes to medieval sculpture and Old Master paintings; Frank Lloyd Wright furniture and Tiffany glass to modern sculpture by Degas, Matisse, and Rodin; and 20th-century paintings and sculpture by Rothko, Dove, Rivera, Moore, and Hunt, the collection spans 5,000 years of artistic creation. The collection is presented in a series of displays that integrate various media and emphasize art-historical context as well as content. The Museum also presents special temporary exhibitions.

Frank Lloyd Wright, *Dining Table*, 1908, Permanent Collection, Smart Museum of Art. Photograph courtesy of Smart Museum of Art, University of Chicago, Chicago, Illinois.

University of Chicago - Oriental Institute Museum

1155 East 58th St., Chicago, IL 60637-1569

Tel: (773) 702-9520

Fax: (773) 702-9853

Internet Address: http://www.oi.uchicago.edu/OI/mus/OI_museum.html

Museum Director: Karen L. Wilson, Ph.D.

Admission: no charge/donations accepted.

Attendance: 62,000 *Established:* 1894 *Membership:* Y *ADA Compliant:* Y

Parking: metered on street and nearby metered lot on Woodlawn Ave.

Open: Tuesday to Sunday, call for hours.

University of Chicago - Oriental Institute Museum, cont.

Facilities: **Auditorium** (275 seats); **Classrooms**; **Galleries**; **Library** (25,000 volumes, available to members); **Shop** (Tues - Sat, 10am-4pm; Sun- noon-4pm).

Activities: **Education Programs** (adults, graduate/undergraduate students and children); **Films** (Sunday afternoon); **Guided Tours**; **Lectures**; **Permanent Exhibits**; **Temporary Exhibitions.**

Publications: annual report; brochure; exhibition catalogues; guide; newsletter, "News & Notes" (quarterly).

The Oriental Institute Museum is a showcase of the history, art, and archaeology of the ancient Near East. The Museum exhibits a major collection of antiquities from ancient Egypt, Mesopotamia, Syria/Palestine, Persia, and Anatolia. (Portions of the Museum are currently closed for renovation, climate control, and expansion. In the meantime, the gift shop and bookstore remain open, and the Education Office continues to offer a variety of programs. Plans call for the reopening of galleries as work on them is completed. The Egyptian Gallery reopened in May, 1999.)

Human-headed Winged Bull (lamassu); gypsum (?); neo-Assyrian period, ca. 721-705 B.C., Khorsabad, northern Iraq. Oriental Institute Museum. This colossal sculpture was one of a pair that guarded the entrance to throne room of King Sargon II. Photograph courtesy of Oriental Institute Museum, University of Chicago, Chicago, Illinois.

University of Chicago - The Renaissance Society

5811 S. Ellis Ave., Chicago, IL 60637
Tel: (773) 702-8670
Fax: (773) 702-9669
Internet Address:
 http://www.renaissancesociety.org
Director: Ms. Susanne Ghez
Admission: free.
Attendance: 15,000 *Established:* 1915
Membership: Y *ADA Compliant:* Y
Open: **October to June,**
 Tuesday to Friday, 10am-5pm;
 Saturday to Sunday, noon-5pm.
Closed: Legal Holidays.

View of gallery during exhibition. Photograph courtesy of Renaissance Society, University of Chicago, Chicago, Illinois.

Facilities: **Galleries.**
Activities: **Concerts**; **Films and Video Screenings**; **Gallery Talks**; **Lectures**; **Performances**; **Temporary Exhibitions.**
Publications: exhibition catalogues; newsletter.

Founded in 1915 at the University of Chicago to encourage a greater understanding of culture - in the broad, literal sense of the term "renaissance" - the Renaissance Society focuses on the forefront of contemporary art, mounting concept-based, group and solo exhibitions of challenging and provocative art. In its first fifty years, the Society presented works by such artists as Arp, Brancusi, Calder, Chagall, Léger, Miró, Moholy-Nagy, Mondrian, Noguchi, and Picasso. Exhibitions in recent decades have introduced Chicago to the work of Louise Bourgeois, Phyllis Bramson, Mike Kelley, Joseph Kosuth, Bruce Nauman, Ed Paschke, and Julian Schnabel.

University of Illinois at Chicago - Gallery 400

400 S. Peoria St. (two blocks west of Halsted at Van Buren St.), Chicago, IL 60607-7034
Tel: (312) 996-6114
Fax: (312) 996-6115
Internet Address: http://www.uic.edu
Director: Ms. Karen Indeck
Admission: free.

University of Illinois at Chicago - Gallery 400, cont.

Open: Monday to Friday, 9am-5pm; Saturday, noon-4pm.
Facilities: Gallery.
Activities: Lecture Series (visiting artists); Temporary Exhibitions.

The gallery presents temporary exhibitions of contemporary work in the fields of art, architecture and design.

Chicago Heights

Prairie State College - Christopher Art Gallery

202 S. Halsted St., Chicago Heights, IL 60411
Tel: (708) 709-3636
Fax: (708) 709-3774
Internet Address: http://www.prairie.cc.il.us
Gallery Manager: Jan Bonavia
Admission: free.
Established: 1996
Membership: N
Parking: Lot D, off Vollmer Road.
Open: Tuesday, 10am-2pm;
 Wednesday to Thursday,
 10am-2pm & 5pm-7pm.
Closed: Academic Holidays.
Facilities: Gallery (1,300 square feet).
Activities: Temporary Exhibitions.

Interior of Christopher Art Gallery. Photograph courtesy of Prairie State College, Chicago Heights, Illinois.

The Gallery offers six to eight exhibitions annually featuring student work as well as that of local and regional artists. The permanent collection, consisting chiefly of photographs, is also displayed on an occasional basis.

De Kalb

Northern Illinois University Art Museum

Northern Illinois University, Altgeld Hall, Lincoln Highway (SR 38), De Kalb, IL 60115
Tel: (815) 753-1936
Fax: (815) 753-7897
Internet Address: http://www.vpa.niu.edu/museum
Director: Ms. Peggy Doherty
Admission: free.
Attendance: 18,000 *Established:* 1970 *Membership:* Y *ADA Compliant:* Y
Parking: call for information.
Open: Monday to Wednesday, 10am-5pm; Thursday, 10am-7pm; Friday, 10am-5pm;
 Saturday, noon-4pm.
Closed: Legal Holidays.
Facilities: Exhibition Area (5,000 square feet).
Activities: Education Programs (undergraduate and graduate college students); Gallery Talks;
 Guided Tours; Lectures; Temporary Exhibitions; Traveling Exhibitions.
Publications: exhibition catalogues; newsletter, "Museum Notes".

A separate academic unit within the College of Visual and Performing Arts, the NIU Art Museum displays selections from its permanent collection and temporary exhibitions in three galleries. Its main gallery, located on the second floor of Altgeld Hall, presents five exhibitions annually. Also on the De Kalb campus, the Jack Olson Gallery, located on the 2nd floor of Jack Arends Hall in the School of Art, mounts four professional shows each year and provides a venue for MFA exhibitions, design, regional high school, and other outreach exhibitions. The third gallery is located in Chicago; for information on Northern Illinois University Art Gallery in Chicago, see listing under Chicago.

Decatur

Millikin University - Kirkland Fine Arts Center Galleries

1184 W. Main St., Decatur, IL 62522

Tel: (217) 424-6227

Fax: (217) 424-3993

Internet Address: http;//www.millikin.edu

Curator: James Schietinger

Admission: voluntary contribution.

Attendance: 20,000 *Established:* 1969 *ADA Compliant:* Y

Open: Monday to Friday, noon-5pm.

Closed: Academic Holidays.

Facilities: **Auditorium** (2,000 seats); **Classrooms**; **Gallery**; **Theatre**.

Activities: **Arts Festival**; **Concerts**; **Dance Recitals**; **Education Programs** (undergraduate college students); **Performances**; **Temporary Exhibitions**.

Located in Kirkland Fine Arts Center, Perkinson, Studio, and Lower galleries feature a schedule of professional artists exhibits, invitational shows, Senior student B.F.A. exhibits, and an annual Spring Student Show.

Millikin University - The Birks Museum

Millikin University, Gorin Hall, 2nd Floor, 1184 W. Main, Decatur, IL 62522

Tel: (217) 424-6337

Fax: (217) 424-3992

Internet Address: http://www.millikin.edu

Museum Director: Edwin G. Walker

Admission: free.

Attendance: 1,700 *Established:* 1981

Open: **August 21 to May 20**,
 Monday, 3:15pm-5pm; Tuesday, 1:15pm-5pm; Wednesday, 3:15pm-5pm;
 Thursday, 1:15pm-5pm; Sunday, 2pm-4pm.

 May 28 to August 15,
 Sunday, 1pm-4pm or call for reservations.

Facilities: **Galleries**; **Library** (160 volumes, non-circulating).

Activities: **Education Programs** (adults, graduate/undergraduate students and children); **Guided Tours** (groups, reserve in advance); **Lectures**; **Temporary Exhibitions**; **Traveling Exhibitions**.

Publications: brochure, "The Birks Museum".

Located on the second floor of Gorin Hall, the Museum mounts special exhibitions featuring the Birks collection of decorative arts, as well as pieces on loan from collectors or other museums. The core of the Museum's permanent collection is over 1,000 pieces of European, oriental, and American ceramics and glassware. A select number of items date from the 15th and 16th centuries, with the majority dating in the 18th through 20th centuries. There is also some furniture and a selection of Chinese art objects.

Edwardsville

Southern Illinois University, Edwardsville - The University Museum

Southern Illinois University at Edwardsville, SR 159, Edwardsville, IL 62026

Tel: (618) 692-2996

Fax: (618) 692-2995

Internet Address: http://www.siue.edu/ART/Museum.html

Director: Mr. Eric B. Barnett

Admission: free.

Attendance: 20,000 *Established:* 1959 *Membership:* Y *ADA Compliant:* Y

Parking: pay on site.

Edwardsville, Illinois

Southern Illinois University, Edwardsville - The University Museum, cont.

Open: Monday to Friday, 8am-10pm.

Facilities: **Galleries; Sculpture Garden.**

Activities: **Education Programs** (undergraduate and graduate college students); **Guided Tours; Permanent Exhibits; Temporary Exhibitions.**

Publications: catalogue, "Louis H. Sullivan Architectural Ornament Collection".

Southern Illinois University, Edwardsville has adopted the "museum without walls" concept. Works from the University's collections are presented throughout the campus. In cooperation with the Department of Art and Design, the University Museum presents an annual series of art exhibitions. The University's holdings include a collection of architectural ornaments by architect Louis H. Sullivan.

Elmhurst

Elmhurst Art Museum

150 Cottage Hill Ave., Elmhurst, IL 60126

Tel: (630) 834-0202

Fax: (630) 834-0234

Director: D. Neil Bremer

Admission: fee: adult-$3.00, child-free, student-$2.00.

Attendance: 14,000 *Established:* 1974 *Membership:* Y *ADA Compliant:* Y

Parking: on site.

Open: Tuesday, 10am-4pm; Wednesday, 1pm-4pm; Thursday, 10am-4pm; Friday, 1pm-4pm; Saturday, 10am-4pm; Sunday, 1pm-4pm.

Closed: New Year's Day, Easter, Thanksgiving Day, Christmas Day.

Facilities: **Architecture** (McCormick House, designed by Ludwig Mies van der Rohe); **Auditorium; Exhibition Area** (5 galleries).

Activities: **Arts Festival; Guided Tours** (by appointment); **Lectures** (monthly); **Traveling Exhibitions** (2-3/year).

Publications: newsletter, "EAM Newsletter" (bi-monthly).

Incorporating into its structure one of three residences in the United States designed by Ludwig Mies van der Rohe, the Museum offers exhibitions of its permanent collection, special exhibits, and traveling shows; and facilities for classes, meetings, and lectures. The permanent collection focuses on 20th century and regional art.

Evanston

Evanston Art Center

2603 Sheridan Road (just north of Northwestern University), Evanston, IL 60201-1799

Tel: (847) 475-5300

Fax: (847) 475-5330

Director: Ms. Michele Rowe Shields

Admission: voluntary contribution.

Attendance: 10,000 *Established:* 1929 *Membership:* Y *ADA Compliant:* Y

Open: Monday to Wednesday, 10am-4pm; Thursday, 10am-4pm and 7pm-10pm; Friday to Saturday, 10am-4pm; Sunday, 2pm-5pm.

Closed: Legal Holidays.

Facilities: **Classrooms; Galleries** (5); **Studios.**

Activities: **Art Classes; Demonstrations; Films; Lectures; Performances; Workshops.**

Publications: exhibition catalogues; newsletter, "Concentrics" (quarterly); posters.

Located in the Clarke Mansion in Light House Landing Park, the Center presents an active gallery program of temporary exhibitions of contemporary art. Focusing on Midwestern artists in thematic and solo shows, exhibits change every six to eight weeks.

Kendall College - Mitchell Museum of the American Indian

2600 Central Park, Evanston, IL 60201
Tel: (847) 475-1030
Fax: (847) 475-0911
Internet Address: http://www.mitchellmuseum.org
Director: Janice B. Klein
Admission: suggested donation: adult-$5.00, child/senior/student-$2.50, family-$10.00.
Attendance: 10,000 *Established:* 1977 *Membership:* Y
Open: Tuesday to Wednesday, 10am-5pm; Thursday, 10am-8pm; Friday to Saturday, 10am-5pm;
Sunday, noon-4pm.
Closed: August, Academic Holidays.
Facilities: **Galleries** (4 permanent, 1 temporary); **Library/Resource Center; Shop**.
Activities: **Guided Tours; Lectures; Performances; Temporary Exhibitions** (3/year);
Workshops.
Publications: brochure, "The Mitchell Museum"; newsletter.

Apart of Kendall College since 1977, the Museum maintains a permanent collection representative of the native peoples of the United States and Canada. It presents permanent exhibits and mounts temporary thematic exhibitions focusing on the art (including contemporary art), artifacts and culture of Native Americans.

Northwestern University - Dittmar Gallery

Norris University Center, 1999 S. Campus Drive, Evanston, IL 60208
Tel: (847) 491-2348
Internet Address: http://www.stuaff.nwu.edu/norris/dittmar.html
Contact: Lisa Bulten
Admission: free.
Open: Daily, 10am-10pm.
Facilities: **Exhibition Area.**
Activities: **Performances; Temporary Exhibitions**.

Located in the Norris University Center, the Dittmar Memorial Gallery features exhibitions focusing on the work of emerging and mid-career professional artists and artwork by Northwestern University undergraduate and graduate art students.

Northwestern University - Mary and Leigh Block Museum of Art

1967 South Campus Drive
Evanston, IL 60208-2410
Tel: (847) 491-4001
Fax: (847) 491-2261
Internet Address: http://www.nwu.edu/museum
Director: Mr. David Mickenberg
Admission: voluntary contribution.
Attendance: 30,000 *Established:* 1980
Membership: Y *ADA Compliant:* Y
Parking: on site (free after 5pm and Sat-Sun).
Open: **Academic Year**,
Tuesday to Wednesday, noon-5pm;
Thursday to Sunday, noon-8pm.
Summer,
Tuesday to Saturday, noon-5pm.

Barbara Hepworth, *Two Forms (Divided Circle)*, 1969, bronze, Gift of Leigh Block, Mary and Leigh Block Museum of Art. Photograph courtesy of Mary and Leigh Block Museum of Art, Northwestern University, Evanston, Illinois.

Facilities: **Gallery; Sculpture Garden.**
Activities: **Education Programs** (graduate and undergraduate college students); **Films;
Gallery Talks; Guided Tours; Lectures; Permanent Exhibits; Temporary Exhibitions**.
Publications: exhibition catalogues.

Northwestern University - Mary and Leigh Block Museum of Art, cont.

Located on the lakeshore campus of Northwestern University in Evanston, the Mary and Leigh Block Museum of Art has earned a worldwide reputation for its research, exhibitions, publications, and campus and community programs. The Museum's focus is on prints and drawings from many periods and large sculptures produced by 20th-century European and American artists. Its collection currently numbers nearly 2,000 works on paper which range from the 13th century to the present by artists of diverse nationalities. The Block Museum's outdoor sculpture garden features 17 bronze sculptures by major European and American artists and is considered one of the most significant modernist groupings in the region. It features works by Jean Arp, Virginia Ferrari, Barbara Hepworth, Jean Ipousteguy, Jacques Lipchitz, Joan Miró, Henry Moore, Arnoldo Pomodoro, Antoine Poncet, and others. The Museum also hosts nationally-touring exhibits. Also of possible interest on campus, is the Dittmar Gallery, located in the Norris University Center (see entry above).

Noyes Cultural Arts Center

927 Noyes St., Evanston, IL 60201

Tel: (847) 491-0266

Admission: free.

Open: Call for hours.

Facilities: **Gallery**; **Studios**; **Theatre**.

Activities: **Classes**; **Temporary Exhibitions** (6/year).

Located near the Noyes Street "El" station, the Center offers six temporary exhibitions of work by contemporary Chicago-area artists annually, and Noyes resident artists offer classes in all arts disciplines.

Freeport

Freeport Arts Center

121 N. Harlem Ave., Freeport, IL 61032

Tel: (815) 235-9755

Fax: (815) 235-6015

Director: Ms. Becky Connors

Admission: fee: adult-$3.00, child-$2.00, student-$2.00, senior-$2.00.

Attendance: 13,000 *Established:* 1975 *Membership:* Y *ADA Compliant:* Y

Parking: lot behind museum.

Open: Tuesday, 10am-6pm; Wednesday to Sunday, 10am-5pm.

Facilities: **Classrooms**; **Galleries** (8); **Library**.

Activities: **Arts Festival**; **Dance Recitals**; **Education Programs** (adults and children); **Guided Tours**; **Lectures**; **Performances**; **Permanent Exhibits**; **Readings**.

Publications: catalogues; newsletter, "Sketches" (bi-monthly).

The Center offers six permanent galleries (Antiquities, European, Native American, Asian, Ethnographic, and Contemporary) and two galleries presenting special exhibitions of the work of regional artists or theme shows.

Galesburg

Galesburg Civic Art Center

114 E. Main St., Galesburg, IL 61401

Tel: (309) 342-7415

Internet Address: http://www.misslink.net/artcenter/

Director: Ms. Julie E. Layer

Admission: voluntary contribution.

Attendance: 30,000 *Established:* 1923 *Membership:* Y

Open: Tuesday to Friday, 10:30am-4:30pm; Saturday, 10:30am-3pm.

Closed: Legal Holidays.

Galesburg Civic Art Center, cont.

Facilities: **Exhibition Area; Sales/Rental Gallery; Shop.**

Activities: **Arts Festival** ("Art-in-the-Park", 3rd Sat in July in Standish Park); **Education Programs** (children); **Guided Tours** (reservations in advance); **Lectures; Temporary Exhibitions** (10-12/year).

Publications: brochures; newsletter, "Artifacts" (quarterly).

The Center hosts in its main gallery ten to twelve exhibitions annually of contemporary work by regionally and nationally known artists. Its permanent collection of over 350 pieces focuses primarily on the work of 20th-century regional artists.

Glen Ellyn

College of DuPage - Gahlberg Gallery, Arts Center

425 22nd St. and Park Blvd.
Glen Ellyn, IL 60137-6599

Tel: (630) 942-2321 *Ext:* 2321

Fax: (630) 790-9806

Internet Address: http://www.cod.edu/artscntr

Director and Curator: Ms. Eileen Broido

Admission: free.

Attendance: 15,000 *Established:* 1986

Membership: N *ADA Compliant:* Y

Parking: free on site.

Open: Monday to Wednesday, 11am-3pm;
Thursday, 11am-3pm and 6pm-8pm;
Saturday, 11am-3pm.

Facilities: **Gallery.**

Activities: **Lectures; Temporary Exhibitions** (8-10/year).

Publications: brochures; exhibition catalogues.

Nicholas Sistler, *Still Life With Venus*, 1996, gouache on paper, 2.5 x 3.5 inches. Exhibited at Gahlberg Gallery Arts Center, 1997. Photograph courtesy of Gahlberg Gallery, College of DuPage, Glen Ellyn, Illinois.

The Gallery presents eight to ten changing exhibitions per year of both contemporary and historical art, arranged by both in-house and guest curators.

Grayslake

College of Lake County - Community Gallery of Art

19351 W. Washington St., Grayslake, IL 60045

Tel: (847) 543-2240

Fax: (847) 223-7690

Internet Address: http://www.clc/cc.il.us

Director: Mr. Steve Jones

Admission: voluntary contribution.

Membership: Y *ADA Compliant:* Y

Parking: free on site.

Open: Monday to Thursday, 8am-10pm;
Friday, 8am-4:30pm;
Saturday, 9am-4:30pm;
Sunday, 1pm-5pm.

Facilities: **Gallery** (2500 square feet).

Henry J. Darger, *Untitled*, watercolor (two-sided), 19 x 47 inches. Shure Family Collection, exhibited at College of Lake County, Community Gallery of Art, 1998. Photograph by Bill Kniest, courtesy of College of Lake County, Community Gallery of Art, Grayslake, Illinois.

Activities: **Guided Tours; Temporary Exhibitions**.

Publications: brochures for exhibitions.

The Gallery mounts temporary exhibitions of student work as well as that of professional artists with regional, national, and international reputations.

Jacksonville

David Strawn Art Gallery

The Art Association of Jacksonville, 331 W. College Ave., Jacksonville, IL 62650
Tel: (217) 243-9390
Fax: (217) 243-9390
Internet Address: http://www.japl.lib.il.us/community/strawn
Director: Kelly M. Gross
Admission: free.
Attendance: 8,000 *Established:* 1873 *Membership:* Y *ADA Compliant:* Y
Open: **September to May**, Tuesday to Saturday, 4pm-6pm; Sunday, 1pm-3pm.
Closed: June to August, Legal Holidays.
Facilities: **Exhibition Area**; **Library**.
Activities: **Education Programs** (adults and children).
Publications: pamphlets.

The Art Association of Jacksonville was given the David Strawn home in 1915 to be used as an art gallery. The parlor, hallway, and sitting rooms were transformed into gallery viewing spaces. The Gallery presents monthly changing exhibitions of local and regional art work. The permanent collection includes antique and collectible dolls, early Mississippian Native American pottery, and the Charles Prentice Thompson Classical Collection.

Joliet

Joliet Junior College - Laura A. Sprague Art Gallery

1215 Houbolt Road, Joliet, IL 60431-8938
Tel: (815) 729-9020 *Ext:* 2423
Internet Address: http://www.jcc.cc.il.us
Director: Mr. Joe B. Milosevich
Open: Monday to Friday, 9am-8pm.
Facilities: **Exhibition Area**.
Activities: **Temporary Exhibitions**.

The Art Department's Laura A. Sprague Art Gallery features temporary exhibits of works by guest artists, faculty, and students.

Lake Forest

Lake Forest College - Sonnenschein Gallery

555 Sheridan Road, Lake Forest, IL 60045
Tel: (847) 735-5194
Internet Address: http://www.lfc.edu/academics/art/gallery/art0001.htm
Director: Ms. Rebecca Goldberg
Open: Daily, 2:30pm-5pm.
Facilities: **Galleries**.

The Sonnenschein Gallery and the adjacent Albright Room are located in the Durand Art Institute. Changing exhibitions are mounted in the Sonnenschein Gallery throughout the academic year, displaying both student and faculty work as well as selections from the College's permanent collection and works lent by other collections. The Albright Room is used to display the College's collections of Pre-Columbian and African art. The permanent collection at Lake Forest consists of European drawings and prints, contemporary American prints, Pre-Columbian art, African art, and prints, drawings, paintings, and photographs from various periods.

Lockport

Illinois State Museum - Lockport Gallery

Gaylord Building, 2nd & 3rd Floors, 200 West 8th St., Lockport, IL 60441-2878
Tel: (815) 838-7400
Fax: (815) 838-7448
Internet Address: http://www.museum.state.il.us

Illinois State Museum - Lockport Gallery, cont.

Director: Jim L. Zimmer
Admission: voluntary contribution.
Attendance: 15,000
Membership: Y *ADA Compliant:* Y
Parking: free adjacent to site.
Open: Tuesday to Saturday, 10am-5pm;
 Sunday, noon-5pm.
Closed: Holidays.
Facilities: **Architecture** (Gaylord Building, 1838); **Galleries.**
Activities: **Temporary Exhibitions** (5-8/year).

Exterior view of Gaylord Building, housing Lockport Gallery. Photograph courtesy of Illinois State Museum, Springfield, Illinois.

The Lockport Gallery, a branch site of the Illinois State Museum (Springfield, Illinois), provides a place for visitors to explore, contemplate, and discover the fine, decorative, industrial, and ethnographic arts created by past and contemporary Illinois artists and artisans. The Gallery features a wide range of changing exhibitions, educational and interpretive activities, tours, publications, and research.

Macomb

Western Illinois University Art Gallery

1 University Circle
(just north of Sherman Hall)
Macomb, IL 61455
Tel: (309) 298-1587
Fax: (309) 298-2400
Internet Address:
 http://www.wiu.edu/users/miart/gallery.html
Curator of Exhibits: Mr. John R. Graham
Admission: free.
Attendance: 9,000 *Established:* 1899
Membership: N *ADA Compliant:* Y
Parking: obtain temporary permit from
 WIU Office of Public Safety in Mowbray Hall.
Open: **Academic Year**,
 Monday, 9am-4pm;
 Tuesday, 9am-4pm and 6pm-8pm;
 Wednesday to Friday, 9am-4pm.
Closed: Legal Holidays, School Vacations.
Facilities: **Galleries** (3).

Archibald J. Motley, Jr., *The Jazz Singers*, c. 1937, oil on canvas, 32 x 42 inches, WPA. Permanent collection, Western Illinois University Art Gallery. Photograph courtesy of Western Illinois University, Macomb, Illinois.

Activities: **Gallery Talks**; **Lectures**; **Temporary Exhibitions**; **Traveling Exhibitions**.
Publications: exhibition catalogues.

The Gallery presents a schedule of temporary exhibitions of work drawn from its permanent collection, professional artists, faculty, and students. In addition to gallery exhibits, sculptures are sited throughout the campus. Holdings include Works Progress Administration graphics and paintings, contemporary graphics, paintings, sculpture, glass, and ceramics.

Monmouth

Monmouth College - Len G. Everett Gallery

Hewes Library, Monmouth, IL 61462
Tel: (309) 457-2364
Internet Address: http://www.monm.edu/academic/Art/gallery.html
Department Chair: Ms. Cheryl Meeker

Monmouth College - Len G. Everett Gallery, cont.

Admission: free.

Open: Call for hours.

Facilities: Galleries.

Activities: Temporary Exhibitions.

Located in the Hewes Library, the Everett Gallery offers temporary exhibitions of work by professional artists and students, including an annual student exhibition and competition each Spring. There are continuing displays of materials from the collections. The Shields collection includes art and artifacts from ancient Egypt, Rome, and Greece as well as other civilizations and cultures.

Mount Vernon

Mitchell Museum at Cedarhurst

Richview Road, Mount Vernon, IL 62864-0019

Tel: (618) 242-1236

Fax: (618) 242-9530

Exec. Director: Ms. Sharon Bradham

Admission: voluntary contribution.

Attendance: 50,000 *Established:* 1973

Membership: Y *ADA Compliant:* Y

Parking: free on site.

Open: Tuesday to Saturday, 10am-5pm, Sunday, 1pm-5pm.

Closed: Legal Holidays.

Facilities: **Children's Gallery**; **Exhibition Area**; **Library** (1,900 volumes); **Sculpture Park** (85 acres); **Shop**.

Activities: **Arts and Craft Fair** (September); **Chamber Music Series**; **Concerts** (summer); **Dinner Theatre**; **Guided Tours**; **Juried Exhibits**; **Lectures**; **Permanent Exhibits**; **Sculpture Walks**; **Temporary Exhibitions**; **Traveling Exhibitions**.

Publications: brochures; exhibition catalogues; newsletter, "Cedarhurst Quarterly".

Cedarhurst presents at least twelve temporary exhibitions each year in three galleries. Its permanent collection includes works by The Eight and The Ten (e.g., Henri, Glackens, Prendergast, Hassam), Cassatt, Bellows, Eakins, and Sargent, as well as a sculpture park, containing over fifty large-scale works by such artists as Liberman, Trova, Enzmann, Steiner, and Zweygardt.

Childe Hassam, *The Table Garden*, 1910, oil on canvas. Mitchell Museum at Cedarhurst collection. Photograph courtesy of Mitchell Museum at Cedarhurst, Mt. Vernon, Illinois.

Normal

Illinois State University Galleries

110 Center for the Visual Arts, Beaufort Street, Normal, IL 61790

Tel: (309) 438-5487

Fax: (309) 438-5161

Internet Address: http://www.orat.ilstu.edu/cfa/galleries

Director: Mr. Barry Binderman

Open: Monday, noon-4pm; Tuesday, 9:30am-9pm; Wednesday to Friday, 9:30am-4:30pm; Saturday to Sunday, noon-4pm.

Facilities: **Galleries**.

Activities: **Temporary Exhibitions**.

University Galleries is devoted to presenting a wide survey of contemporary art in its three galleries. The facility mounts temporary exhibitions, both self-curated and traveling. A measure of its stature is that it has itself organized fourteen traveling exhibitions since 1990.

Paris

Bicentennial Art Center and Museum

132 S. Central Ave., Paris, IL 61944
Tel: (217) 466-8130
Exec. Director: Ms. Janet M. Messenger
Admission: free.
Attendance: 2,400 *Established:* 1975 *Membership:* Y *ADA Compliant:* Y
Open: Tuesday to Friday, noon-4pm; Saturday to Sunday, 1pm-3pm.
Closed: New Year's Eve to New Year's Day, Easter, Thanksgiving Day, Thanksgiving Day,
 Christmas Eve to Christmas Day.
Facilities: **Classrooms**; **Exhibition Area**.
Activities: **Education Programs** (adults and children); **Temporary Exhibitions**; **Workshops**.
Publications: newsletter (monthly).

The Center presents monthly temporary exhibitions featuring the works of Midwest and local artists and students.

Peoria

Bradley University - Art Galleries

College of Communications and Fine Arts, 1501 West Bradley Avenue, Peoria, IL 61625
Tel: (309) 677-2989
Internet Address: http://gcc.bradley.edu/art/resrc.html
Director: Mr. John Heintzman
Open: **Heuser Gallery**, Monday to Friday, 10am-4pm.
 Hartmann Gallery, Monday to Friday, noon-4pm.
Facilities: **Exhibition Area**.
Activities: **Lectures**; **Permanent Exhibits**; **Temporary Exhibitions**.

The University offers exhibits in two galleries: the Heuser Art Center Gallery and the Hartmann Center for the Performing Arts Gallery. These two galleries provide Bradley with the opportunity to present exhibitions that focus upon artists who work in alternative styles or thematic shows that heighten awareness of contemporary issues in the art world. Bradley University sponsors and organizes the Bradley National Print and Drawing Exhibition, the oldest continuous competition of its kind in the United States. This event expanded its boundaries and included international artists for the first time in 1995. (Because of its size, the exhibition is hosted at four gallery sites in the community: Bradley University's Heuser Art Center Gallery, The Hartmann Center Gallery, The Peoria Art Guild and Lakeview Museum of Arts and Sciences.) Also included in the exhibition program is the annual Jacob and Lorrie Bunn Lectureship in Photography, which brings a fine arts photographer or photojournalist of national prominence to the campus. In addition, as part of the University's Visiting Artists Series, artists of national stature participate in the Master Print Program of Cradle Oak Press, Bradley's printmaking research studio. These visiting artists create limited editions of their work. The Galleries also host the thesis exhibitions of BFA, MA and MFA students. Faculty exhibitions and an undergraduate fine arts competition are held on a biennial basis. Also of possible interest on campus, exhibits in the Cullom-Davis Library often feature artworks.

Lakeview Museum of Arts and Sciences

1125 W. Lake Ave., Peoria, IL 61614-5985
Tel: (309) 686-7000
Fax: (309) 686-0280
Exec. Director: James Richerson
Admission: fee: adult-$4.00, child (4-17)-$3.00, senior-$3.00.
Attendance: 60,000 *Established:* 1965 *Membership:* Y *ADA Compliant:* Y
Parking: free on site.
Open: Tuesday to Thursday, 11am-5pm; Friday, 11am-8pm; Saturday, 10am-5pm;
 Sunday, noon-5pm.

Peoria, Illinois
Lakeview Museum of Arts and Sciences, cont.
Closed: Legal Holidays.

Facilities: **Auditorium**; **Exhibition Area**; **Galleries** (3 permanent, 4 changing exhibitions); **Sales Gallery**; **Sculpture Garden**; **Shop**.

Activities: **Demonstrations**; **Education Programs** (adults and children); **Films**; **Gallery Talks**; **Guided Tours**; **Lectures**; **Permanent Exhibits**; **Temporary Exhibitions**; **Workshops**.

Publications: bulletin (monthly).

A general museum with exhibits in the areas of the fine arts, decorative arts, anthropology, and the natural sciences, Lakeview Museum organizes an active schedule of changing exhibits drawn from its permanent collection or borrowed from other collections. Holdings, numbering more than 15,000 objects, include Illinois folk art (e.g., Jacquard coverlets), Illinois River decoys, landscape paintings, African art, Peruvian textiles and Native American artifacts.

Quincy

The Gardner Museum of Architecture and Design
332 Maine St. at 4th St., Quincy, IL 62301

Tel: (217) 224-6873

Office Manager: Chris Brueck

Admission: free: adult-$2.00, child-$0.50, student-$1.00, senior-$1.00.

Attendance: 3,000 *Established:* 1974 *Membership:* Y *ADA Compliant:* Y

Open: **March to December**, Tuesday to Sunday, 1pm-5pm.

Closed: January to February, Easter, Independence Day, Labor Day, Thanksgiving Day, Christmas Eve to Christmas Day.

Facilities: **Architecture** (Richardsonian Romanesque former public library, 1889); **Galleries**; **Library** (600 volumes); **Sculpture Yard**.

Activities: **Guided Tours** (by appointment); **Lectures**; **Permanent Exhibits**; **Temporary/Traveling Exhibitions**.

Publications: exhibition brochures; exhibition catalogues; newsletter (quarterly).

The Museum mounts exhibits focusing on architecture and design, including stained glass windows and metal, stone, and wood architectural ornamentation.

Quincy Art Center
1515 Jersey St., Quincy, IL 62301

Tel: (217) 223-5900

Fax: (217) 223-6950

Exec. Director: Ms. Julie D. Nelson

Admission: voluntary contribution.

Attendance: 13,000 *Established:* 1923

Membership: Y *ADA Compliant:* Y

Parking: free on site.

Open: Tuesday to Sunday, 1pm-4pm.

Facilities: **Architecture** (carriage house, 1887 designed by Joseph Silsbee); **Classrooms and Studios**; **Galleries**; **Shop**.

Activities: **Education Programs** (adults and children); **Gallery Talks**; **Guided Tours** (by appointment); **Juried Exhibits** (2); **Lectures**; **Temporary Exhibitions**; **Workshops**.

Publications: calendar; exhibition announcements; juried exhibit catalogue.

Exterior view of Quincy Art Center. Photograph courtesy of Quincy Art Center, Quincy, Illinois.

The Quincy Art Center, a museum of the visual arts, is located on the grounds of the former Lorenzo Bull mansion, now the Women's City Club. Occupying an award-winning addition, it consists of the Katharine G. Stevenson Gallery, the Foyer

Quincy Art Center, cont.

Gallery and a Gift Shop with studio space in the lower level. Annual exhibitions include an area high school competition, the QuadState Juried Exhibition, the Mary S. Oakley Area Artists Showcase, and the Quincy Art Center Class/Workshop Exhibition. In addition, a variety of rotating exhibitions are presented throughout the year. Important contemporary Midwestern art is a primary focus, and work by artists of national and international renown is also featured.

Quincy University - Gray Gallery

Brenner Library, 1800 College, Quincy, IL 62301

Tel: (217) 228-5371

Fax: (217) 228-5257

Internet Address: http://www.quincy.edu

Director: Mr. Robert Lee Mejer

Admission: free.

Attendance: 85,000 *Established:* 1968

ADA Compliant: Y

Parking: on site.

Open: Monday to Thursday, 8am-11pm;
Friday, 8am-8pm;
Saturday, 11am-5pm;
Sunday, 1pm-5pm.

Facilities: **Exhibition Area** (foyer and gallery, 110 linear feet); **Library** (15,000 volumes on art).

View of the Gray Gallery during an exhibition of works on paper by Sarah Slavick, 1991. Photograph courtesy of Art Department, Quincy University, Quincy, Illinois.

Activities: **Temporary Exhibitions**.

Housed in the Brenner Library, the Gray Gallery presents an annual exhibition schedule, which includes exhibitions by nationally and regionally noted artists, alumni, art faculty, and students. The Art Faculty Exhibit, Juried Student Art Show and the Baccalaureate Senior Retrospective are held annually.

Rock Island

Augustana College Art Museum

Centennial Hall, 7th Ave. and 38th St., Rock Island, IL 61201-2296

Tel: (309) 794-7231

Fax: (309) 794-7678

Internet Address: http://www.augustana.edu

Director: Ms. Sherry C. Maurer

Admission: free.

Attendance: 40,000 *Established:* 1983 *ADA Compliant:* Y

Parking: free, lot next to Centennial Hall.

Open: **September to May**, Tuesday to Saturday, noon-4pm.

Closed: Academic Holidays.

Facilities: **Exhibition Area** (3,310 square feet).

Activities: **Concerts**; **Education Programs** (adults and undergraduate college students); **Films**; **Guided Tours** (groups, by advance appointment); **Juried Exhibits**; **Lectures**; **Temporary Exhibitions**.

Publications: calendar (annual).

Located in the front of the Centennial Hall auditorium, the Augustana College Art Museum serves the College and the community by presenting temporary visual arts exhibitions and interpretive programs to augment a liberal arts curriculum. Shows include the annual juried Rock Island Fine Arts Exhibition (open to artists residing within a 150-mile radius of the Quad Cities) and student shows. The Art Collection Gallery (est. 1999) features an overview of campus holdings, especially Swedish-American pieces, as well as loans from alumni.

Rockford

Rockford Art Museum (RAM)

711 N. Main St., Rockford, IL 61103-6999
Tel: (815) 968-2787
Fax: (815) 968-0164
Internet Address:
http://www.RAM-artmuseum.rockford.org/
Exec. Director: Ms. Carolyn C. DeLuca
Admission: free.
Attendance: 36,000 *Established:* 1913
Membership: Y *ADA Compliant:* Y
Parking: free on site.
Open: Tuesday to Friday, 11am-5pm;
Saturday, 10am-5pm;
Sunday, noon-5pm.

Harold Gregor, *Illinois Flatscape #14*, 1978, acrylic on canvas. Museum purchase with funds from Women's Art Board and Illinois Arts Council matching grant, Rockford Art Museum. Photograph courtesy of Rockford Art Museum, Rockford, Illinois.

Closed: Federal Holidays, During Installations.
Facilities: **Auditorium**; **Classrooms** (several); **Galleries** (17,000 square feet); **Library** (by appointment); **Sculpture Garden**; **Shop.**
Activities: **Arts Festival** (3rd weekend in September); **Education Programs** (adults and children); **Guided Tours** (groups, reserve 2 weeks in advance, students $1, adults $2); **Lectures**; **Permanent Exhibits**; **Temporary Exhibitions**; **Traveling Exhibitions.**
Publications: brochures; exhibition announcements; exhibition catalogues; newsletter; posters.

Located in the Riverfront Museum Park arts and science complex, the Rockford Art Museum presents a year-round visual arts program, including exhibitions and a variety of educational opportunities. Up to fifteen exhibitions of regional, contemporary art are displayed annually in the Kuller, Funderburg, and Anderson galleries. Exhibitions are assembled from the permanent collection as well as galleries, private collections and museums from around the country. Two recurring exhibitions are organized as part of an effort to support regional artists: the annual juried "Young Artist Show/Youth Art Show" and the biennial "Stateline Vicinity Exhibition". The permanent collection of over 1,200 works reflects the diversity of 20th century of American art. Works by American Impressionist painters; historical and contemporary photographers; and self-taught, African-American artists comprise important focus areas within the collection. Also featured are outstanding works by nationally and internationally known artists working in glass.

Rockford College Art Gallery

Clark Arts Center, 5050 E. State, Rockford, IL 61108
Tel: (815) 226-4034
Fax: (815) 394-5167
Internet Address: http://www.rockford.edu
Director: Nila Petty
Admission: free.
Established: 1847 *Membership:* Y *ADA Compliant:* Y
Parking: free nearby.
Open: **September to May**, Daily, 2pm-5pm.
Facilities: **Exhibition Area** (1,400 square feet).
Activities: **Education Programs**; **Guided Tours** (by appointment); **Lectures**; **Temporary Exhibitions** (7-8/year); **Traveling Exhibitions.**
Publications: exhibition catalogues.

The Gallery mounts seven to eight exhibits each academic year. The College's holdings include 20th century paintings, prints by modern and contemporary masters, photography, ceramics, drawings, installations, assemblages, and ethnographic art.

Springfield

Illinois State Museum (ISM)

Spring and Edwards Streets, Springfield, IL 62706
Tel: (217) 782-7387
Fax: (217) 782-1254
TDDY: (217) 782-9175
Internet Address: http://www.museum.state.il.us
Director: Dr. R. Bruce McMillan
Admission: voluntary contribution.
Attendance: 355,000 *Established:* 1877
Membership: Y *ADA Compliant:* Y
Parking: public parking across street from museum.
Open: Monday to Saturday, 8:30am-5pm;
 Sunday, noon-5pm.
Closed: New Year's Day, Easter, Thanksgiving Day,
 Christmas Day.

Interior view of a gallery at Illinois State Museum. Photograph courtesy of Illinois State Museum, Springfield, Illinois.

Facilities: **Galleries** (2); **Library** (10,000 volumes); **Shop** (arts and crafts, books, jewelry, toys).
Activities: **Education Programs** (adults, undergraduate/graduate students and children); **Films**; **Gallery Talks**; **Guided Tours**; **Lectures**; **Permanent Exhibits**; **Temporary Exhibitions**; **Traveling Exhibitions**.
Publications: magazine, "The Living Museum" (quarterly); newsletter, "Impressions" (quarterly).

The official repository for the State of Illinois's scientific and art collections, ISM features exhibits of Illinois archaeology, geology, history, natural history, and science in addition to art. Its art galleries feature the diversity of fine, decorative, and folk arts in Illinois - from painting, prints, and photographs to sculpture, crafts, and multimedia works. The fine and decorative arts collections document the progression and history of art in Illinois. Strengths include 20th-century painting, Works Progress Administration artwork, 19th-century folk art, historical and contemporary photographs, flat textiles (quilts and coverlets), ceramics, and waterfowl decoys. In addition to it main facility in Springfield, the Museum mounts art exhibitions at the following branch sites: Illinois Art Gallery (Chicago, Illinois), Lockport Gallery (Lockport, Illinois), and Southern Illinois Art Gallery (Whittington, Illinois).

Springfield Art Association

700 North 4th St., Springfield, IL 62702
Tel: (217) 523-2631
Fax: (217) 523-3866
Admission: voluntary contribution.
Established: 1913 *Membership:* Y *ADA Compliant:* Y
Parking: free on site.
Open: **Gallery**, Monday to Friday, 9am-5pm; Saturday, 10am-3pm.
Closed: Legal Holidays.
Facilities: **Architecture** (Edwards Place mansion, 1833); **Classrooms/Studios**; **Exhibit Gallery**.
Activities: **Education Programs** (adults, students, and children); **Temporary Exhibitions** (7 contemporary/year).
Publications: bulletin (quarterly); exhibition catalogues.

Given to the Springfield Art Association in 1913, Edwards Place contains historical furnishings and an adjoining art gallery.

University Park

Governors State University - Nathan Manilow Sculpture Park

Wagner House, University Parkway, University Park, IL 60466
Tel: (708) 534-4105
Fax: (708) 534-8959
TDDY: (708) 534-8650
Internet Address: http://www.govst.edu/users/gscu/pt/park3

University Park, Illinois

Governors State University - Nathan Manilow Sculpture Park, cont.
Director: Ms. Beverly Goldberg
Admission: voluntary contribution.
Attendance: 800 *Established:* 1969
Open: Daily, 24 hours.
Facilities: **Library**; **Sculpture Park** (over 20 works).
Activities: **Guided Tours.**
Publications: brochure; catalogue.

Placed throughout the University's 750 acre campus, art in the Nathan Manilow Sculpture Park comprises one of the largest collections of monumental sculpture in the country. Among the artists represented are Vito Acconci, John Chamberlain, Mark di Suvero, Ted Garner, Charles Ginnever, John Henry, Jene Highstein, Richard Hunt, Terrence Karpowicz, Clement Meadore, Mary Miss, Bruce Nauman, John Payne, Jerry Peart, Martin Puryear, Joel Shapiro, and Edvins Strautmanis.

Vernon Hills

Cuneo Museum and Gardens
1350 N. Milwaukee, Vernon Hills, IL 60061
Tel: (847) 362-3042
Fax: (847) 362-4130
Internet Address: http://www.lake-online.com/cuneo
Director: James H. Bert
Admission: fee: grounds: $5.00/car.
 mansion tour: adult-$10.00, child (<12)-$5.00, student-$5.00, senior-$9.00.
Attendance: 100,000 *Established:* 1991 *Membership:* Y *ADA Compliant:* Y
Open: **February to December**, Tuesday to Sunday, 10am-5pm.
Closed: January, Christmas Day.
Facilities: **Architecture** (Venetian-style Cuneo Mansion, 1914 designed by Benjamin Marshall);
 Conservatory; **Deer Park**; **Exhibition Area** (3,000 square feet); **Food Services** Restaurant
 (100 seats); **Grounds** (75 acres; formal gardens, lakes, fountains).
Activities: **Arts Festival**; **Concerts**; **Education Programs** (adults); **Films**; **Guided Tours**
 (Tues-Sat, 11am/12:30pm/2pm; Sun, self-guided, 11am-3:30pm); **Lectures.**

Originally the residence the founder of Commonwealth Edison, Samuel Insull, the Mansion features a 40-foot high great hall, double formal dining rooms, and a private chapel. Artwork includes Old Master paintings, 17th-century tapestries, sculpture, fresco-style ornamentation, porcelain, oriental rugs, and silver.

Whittington

Southern Illinois Art Gallery
Southern Illinois Artisans Shop and Visitors Center, Rend Lake, Whittington, IL 62897-1000
Tel: (618) 629-2220
Fax: (618) 629-2704
Curator: Ms. Deborah Tayes
Open: **December to March**, Tuesday to Saturday, 9am-5pm.
 April to December, Daily, 9am-5pm.
Facilities: **Gallery**; **Shop.**
Activities: **Arts and Crafts Festival** (annual in Spring); **Demonstrations**; **Temporary**
 Exhibitions.

A branch site of the Illinois State Museum (Springfield, IL), the Gallery of the Southern Illinois Artisans Shop and Visitors Center presents temporary exhibitions featuring historical and contemporary Illinois art and craft.

Indiana

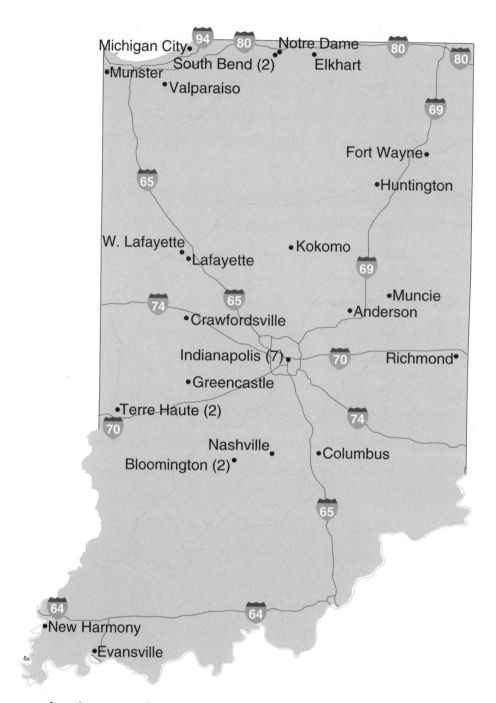

The number in parentheses following the city name indicates the number of museums/galleries in that municipality. If there is no number, one is understood. For example, in the text seven listings would be found under Indianapolis and one listing under Columbus.

Indiana

Anderson

Alford House-Anderson Fine Arts Center

226 Historic West 8th St., Anderson, IN 46016
Tel: (317) 649-1248
Fax: (317) 649-0199
C.E.O.: Ms. Deborah McBratney-Stapleton
Admission: voluntary contribution.
Attendance: 45,000 *Established:* 1966 *Membership:* Y *ADA Compliant:* Y
Parking: free on site.
Open: **September to July**, Tuesday to Saturday, 10am-5pm; Sunday, 2pm-5pm.
Closed: Legal Holidays.
Facilities: **Architecture** (Greek Revival Alford House, 1870); **Classroom**; **Galleries** (3); **Library**; **Sales/Rental Gallery**; **Shop**; **Theatre** (100 seats).
Activities: **Art Classes**; **Arts Festival**; **Education Programs**; **Films**; **Guided Tours**; **Permanent Exhibits**; **Temporary Exhibitions**; **Workshops**.
Publications: "Calendar of Events" (quarterly); collection catalogues; exhibition catalogues.

Housed in historic Alford house, the Anderson Fine Arts Center is a community art center displaying works from its permanent collection and temporary exhibitions.

Bloomington

Indiana University Art Museum (IUAM)

Indiana University, East 7th St.
Bloomington, IN 47405-5401
Tel: (812) 855-5445
Fax: (812) 855-1023
Internet Address:
 http://www.indiana.edu/~iuartmus/home.html
Director: Dr. Adelheid M. Gealt
Admission: free.
Attendance: 70,000 *Established:* 1941
Membership: N *ADA Compliant:* Y
Parking: metered spaces behind Museum and in Main Library lot.
Open: Tuesday to Saturday, 10am-5pm;
 Sunday, noon-5pm.
Closed: New Year's Day, Memorial Day, Independence Day, Labor Day, Thanksgiving Day, Christmas Day.

Exterior view of Indiana University Art Museum (1982), designed by I.M. Pei and Partners. Photograph courtesy of Indiana University Art Museum, Bloomington, Indiana.

Facilities: **Architecture** (1982 design by I.M. Pei and Partners); **Galleries**; **Library**; **Sculpture Garden**.
Activities: **Gallery Talks** ("Noon Talks"); **Guided Tours** (arrange in advance, 855-1045.); **Performances** ("The Arts Connection", monthly concert series); **Permanent Exhibits**; **Temporary Exhibitions**; **Traveling Exhibitions**.
Publications: annual report; calendar (monthly); collection catalogue; exhibition catalogues.

Since its founding, the Museum has grown to include over 30,000 objects - paintings, prints, drawings, photographs, sculpture, ceramics, jewelry, textiles - representing nearly every art-producing culture throughout history. Three permanent collection galleries display the art of the Western world from Byzantine to modern times (1st floor), Ancient and Asian art (2nd floor), and the art of Africa, the Pacific, and pre-Columbian Americas (3rd floor). Temporary exhibitions (rotating, traveling, and School of Fine Arts student and faculty exhibitions) are mounted in the Special Exhibitions, Hexagon, Focalpoint, and Children's Corner galleries. Changing sculpture exhibitions are scheduled periodically in the Museum's outdoor Sculpture Terrace. Arrangements may be made by appointment in advance to view portions of the collections that are in storage.

Bloomington, Indiana

Indiana University - School of Fine Arts Gallery (SOFA Gallery)

Henry Radford Hope School of Fine Arts, Fine Arts Building, 123 E. 7th Street
Bloomington, IN 47405
Tel: (812) 855-8490
Fax: (812) 855-7498
Internet Address: http://www.fa/indiana.edu/~sofa/index.html
Director: Ms. Betsy Stirratt
Admission: voluntary contribution.
Attendance: 20,000 *Established:* 1987 *ADA Compliant:* Y
Open: Tuesday to Thursday, noon-4pm; Friday, noon-8pm; Saturday to Sunday, 1pm-4pm.
Closed: Spring Break, Summer Break, Thanksgiving Day, Christmas Day.
Facilities: **Exhibition Area.**
Activities: **Gallery Talks; Guided Tours; Lectures; Temporary Exhibitions.**

The SOFA Gallery presents contemporary art by significant regionally and nationally known artists, as well as by students within the school.

Columbus

Indianapolis Museum of Art - Columbus Gallery

390 The Commons (3rd & Brown), Columbus, IN 47201-6764
Tel: (812) 376-2597
Fax: (812) 375-2724
Director: Ms. Susie Saunders
Admission: voluntary contribution.
Attendance: 10,000 *Established:* 1974
Membership: Y *ADA Compliant:* Y
Open: Tuesday to Thursday, 10am-5pm;
 Friday, 10am-8pm;
 Saturday, 10am-5pm;
 Sunday, noon-4pm.
Closed: Legal Holidays.
Facilities: **Gallery** (3,000 square feet); **Shop** (372 The Commons Mall, 376-2559).
Activities: **Education Programs** (children); **Guided Tours** (reserve in advance); **Lectures; Temporary Exhibitions** (4/year).
Publications: newsletter, "Gallery Gab" (quarterly).

Located on the second floor of The Commons, IMA-Columbus Gallery is a satellite gallery of the Indianapolis Museum of Art. Four major exhibitions of works from the IMA's collections considered to be of special interest to the Columbus community are offered annually.

Ruth Pratt Bobbs, *Woman in White*, c. 1904-1911, oil on canvas, 37 5/8 x 29¾ inches. Gift of Eleanor Dixon and Otto N. Frenzel, Jr., Indianapolis Museum of Art. Photograph courtesy of Indianapolis Museum of Art, Indianapolis, Indiana.

Crawfordsville

Wabash College - Eric Dean Gallery

Wabash College, 301 W. Wabash Avenue, Crawfordsville, IN 47933
Tel: (765) 361-6364
Internet Address: http://www.wabash.edu
Director: Katherine Nagler
Open: Monday to Friday, 8am-noon and 1pm-4:30pm.
Facilities: **Galleries.**
Activities: **Permanent Exhibits; Temporary Exhibitions.**

In addition to mounting displays of its extensive collection of contemporary art, the Gallery presents temporary exhibitions of the work of professional artists.

Elkhart

Midwest Museum of American Art (MMAA)

429 S. Main St., Elkhart, IN 46515
Tel: (219) 293-6660
Fax: (219) 293-6660
Director: Ms. Jane Burns
Admission: fee: adult-$3.00, child-$1.00, student-$1.00, senior-$2.00, family-$5.00.
Attendance: 25,000 *Established:* 1978
Membership: Y *ADA Compliant:* Y
Parking: nearby free municipal lot.
Open: Tuesday to Friday, 11am-5pm;
 Saturday to Sunday, 1pm-4pm.
Closed: New Year's Day, Memorial Day,
 Independence Day, Labor Day,
 Thanksgiving Day, Christmas Day.
Facilities: **Galleries; Shop.**
Activities: **Concerts; Education Programs** (adults and children); **Films; Gallery Talks; Guided Tours; Lectures; Permanent Exhibits; Temporary Exhibitions** (8 per year); **Traveling Exhibitions.**
Publications: "Art News" (bi-monthly); bulletin, "Midwest Museum"; collection catalogue, "Panorama of American Art"; exhibition catalogues.

George Luks, *Portrait of a Boy,* c. 1918. Collection of and photograph courtesy of Midwest Museum of American Art, Elkhart, Indiana.

The Midwest Museum of American Art is located in a renovated bank building in downtown Elkhart. The Museum displays art in seven galleries covering 25,000 square feet. In addition to the display of its permanent collection, the Museum mounts ten to twelve temporary exhibitions per year. A few of these exhibitions feature local and regional art, while the rest are traveling shows from other institutions across the nation. The permanent collection consists of over 1,100 works and is divided into the following periods or movements: American Primitives, Western Art, American Impressionism, the Ash-Can School, Regionalism, Abstract Expressionism, Pop Art, and contemporary works by the Chicago Imagists. Artists represented include Henri, Luks, Wood, Rockwell, and Green.

Evansville

Evansville Museum of Arts and Science

411 S.E. Riverside Drive, Evansville, IN 47713
Tel: (812) 425-2406
Fax: (812) 421-7507
TDDY: (812) 421-7506
Director: Mr. John W. Streetman, III
Admission: voluntary contribution.
Attendance: 100,000 *Established:* 1926
Membership: Y *ADA Compliant:* Y
Parking: free on site.
Open: Tuesday to Saturday, 10am-5pm;
 Sunday, noon-5pm.
Closed: Legal Holidays.
Facilities: **Classrooms; Galleries; Library** (3,500 volumes); **Outdoor Exhibition Area; Sculpture Garden.**

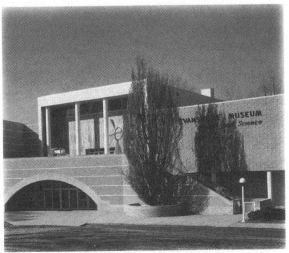

Exterior view of Evansville Museum of Arts and Science. Photograph courtesy of Evansville Museum of Arts and Science, Evansville, Indiana.

Evansville, Indiana

Evansville Museum of Arts and Science, cont.

Activities: **Demonstrations**; **Education Programs** (adults and children); **Guided Tours**; **Lectures**; **Permanent Exhibits**; **Temporary Exhibitions**; **Traveling Exhibitions.**

Publications: books; brochure; exhibition catalogues; newsletter, "The Copia" (quarterly).

The Museum houses a permanent collection and also mounts temporary exhibitions.

Fort Wayne

Fort Wayne Museum of Art

311 E. Main St., Fort Wayne, IN 46802

Tel: (219) 422-6467

Fax: (219) 422-1374

Internet Address: http://www.fwmoa.org

Director: Ms. Patricia Watkinson

Admission:
 fee: adult-$3.00, child-$2.00, family-$8.00.
 free: Wednesday and 1st Sunday in month.

Attendance: 65,000 *Established:* 1922

Membership: Y *ADA Compliant:* Y

Parking: lot adjacent to site.

Open: Tuesday to Saturday, 10am-5pm;
 Sunday, noon-5pm.

Closed: New Year's Day, Memorial Day,
 Independence Day, Labor Day,
 Thanksgiving Day, Christmas Day.

Thomas Moran, *A Glimpse of the Sea, Amagansett*, 1904, oil on canvas, 27 x 20 inches. Fort Wayne Museum of Art, gift of William Telfer. Photograph courtesy of Fort Wayne Museum of Art, Fort Wayne, Indiana.

Facilities: **Auditorium**; **Classroom**; **Galleries**; **Library**; **Sculpture Court**; **Shop.**

Activities: **Education Programs** (adults and children); **Films**; **Gallery Talks**; **Guided Tours**; **Lectures**; **Temporary Exhibitions.**

Publications: annual report; exhibition catalogues; newsletter (bi-monthly).

The Museum mounts traveling exhibitions and also displays its permanent collection of 1,400 works, including painting, sculpture, and works on paper, by 19th- and 20th-century artists, such as Mark di Suvero, Janet Fish, George Inness, Paul Manship, Thomas Moran, and Larry Rivers.

Greencastle

DePauw University - Emison Art Center Gallery

309 S. College Ave., Greencastle, IN 46135

Tel: (765) 658-4336

Fax: (765) 658-4177

Internet Address: http://www,depauw.edu/art

Gallery Curator: Ms. Martha Opdahl

Admission: free.

Membership: N *ADA Compliant:* Y

Parking: free on site.

Open: Monday to Friday, 9am-4pm; Saturday, 10am-4pm; Sunday, 1pm-5pm.

Closed: January, June to August, Academic Holidays.

Facilities: **Gallery.**

Activities: **Temporary Exhibitions.**

Publications: exhibition catalogues (occasional).

The Gallery presents from six to eight exhibitions during the academic year, which showcase work in a variety of media by contemporary artists of regional and national reputation, as well as mainstream and non-Western art. Student and faculty work is also displayed.

Huntington

Huntington College - Robert E. Wilson Gallery

Merillat Centre for the Arts, 2303 College Avenue, Huntington, IN 46750
Tel: (219) 359-4261
Internet Address: http://www.huntcol.edu/mca/mca_gallery.html
Director: Ms. Margaret Roush
Open: Monday to Friday, 9am-5pm; before & after Centre performances.
Facilities: **Exhibition Area**.
Activities: **Temporary Exhibitions**.

The Wilson Gallery presents a series of changing exhibits during the year. Exhibitions by students, faculty, and professional artists feature a wide range of media and themes. The Gallery's permanent collection includes prints by Salvador Dali and paintings by many contemporary American and European artists.

Indianapolis

Eiteljorg Museum of American Indians and Western Art

White River State Park, 500 W. Washington St.
Indianapolis, IN 46204-2707
Tel: (317) 636-9378
Fax: (317) 264-1724
Internet Address: http://www.eiteljorg.org
President: Mr. John Vanausdall
Admission: fee: adult-$5.00, child-$2.00, student-$2.00, senior-$4.00.
Attendance: 102,000 *Established:* 1989
Membership: Y *ADA Compliant:* Y
Parking: free on site.
Open: **Labor Day to Memorial Day**,
 Tuesday to Saturday, 10am-5pm; Sunday, noon-5pm.
 Memorial Day to Labor Day,
 Monday to Saturday, 10am-5pm; Sunday, 10am-5pm.
Closed: New Year's Eve to New Year's Day, Thanksgiving Day,
 Christmas Day.
Facilities: **Exhibition Area**; **Library**; **Shop**; **Theatre** (120 seats).
Activities: **Education Programs** (adults and children); **Guided Tours**
 (groups by appointment); **Lectures**; **Temporary Exhibitions**;
 Traveling Exhibitions.
Publications: "Frontier Legacy"; exhibition catalogues; newsletter,
 "Eiteljorg Museum Newsletter" (quarterly).

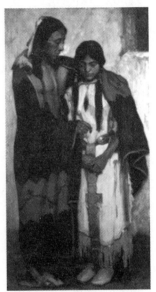

E.I. Couse, *The Wedding*, 1924, Collection of and photograph courtesy of Eiteljorg Museum of American Indians and Western Art, Indianapolis, Indiana.

The Eiteljorg Museum of American Indians and Western Art is the primary venue for Native American art and culture in Indiana. It also is the only museum in the Midwest to offer extensive collections of both Native American and American Western art. The museum holds paintings, drawings and sculpture of and from the American West, from the early 19th century to the present. The highlight of the collection is works by members of the Taos Society of Artists including Joseph Henry Sharp, E.I. Couse, Ernest Blumenschein, and Victor Higgins. The Native American Collection, totaling approximately 3,400 objects, presents the art of cultural groups from coast to coast and includes pottery, basketry, woodcarvings, beadwork, and apparel. The Museum presents a biennial exhibition of contemporary artwork of the West and Native Americans; conducts hands-on workshops and other educational programming related to exhibitions; and hosts an annual festival, the Indian Market, in June, the Midwest's largest juried sale and show of Native American art.

Herron School of Art - Herron Gallery

1701 N. Pennsylvania St., Indianapolis, IN 46202
Tel: (317) 920-2423
Internet Address: http://www.herron.iupui.edu

Indianapolis, Indiana

Herron School of Art - Herron Gallery. cont.

Gallery Director: Mr. David Russick
Admission: free.
Attendance: 35,000 *Established:* 1979 *ADA Compliant:* Y
Open: Monday to Wednesday, 10am-5pm; Thursday, noon-8pm; Friday to Saturday, 10am-3pm; or by appointment 920-2420.
Facilities: **Exhibition Area.**
Activities: **Temporary Exhibitions** (6/year).

The Gallery presents contemporary art, focusing on the latest and often experimental areas in the visual arts. Exhibitions feature the work of locally, regionally, nationally, and internationally recognized artists and range in size from solo shows to theme exhibitions including twenty or more artists.

Indiana State Museum

202 N. Alabama St., Indianapolis, IN 46204
Tel: (317) 232-1637
Fax: (317) 232-7090
TDDY: (317) 232-1637
Internet Address: http://www.state.in.us/ism
Exec. Director: Dr. Richard A. Gantz
Admission: free.
Attendance: 188,000 *Established:* 1869
Membership: Y *ADA Compliant:* Y
Parking: on site, fee charged.
Open: Monday to Saturday, 9am-4:45pm;
 Sunday, noon-4:45pm.
Closed: New Year's Day, Easter,
 Thanksgiving Day,
 Christmas Eve to Christmas Day.

Exterior view of Indiana State Museum. Photograph courtesy of Indiana State Museum, Indianapolis, Indiana.

Facilities: **Auditorium** (225 seats); **Exhibition Area** (9 galleries); **Library** (1,500 volumes); **Shop.**
Activities: **Education Programs** (adults and children); **Gallery Talks; Guided Tours; Lectures; Permanent Exhibits; Temporary Exhibitions.**
Publications: "HoosierISMS" (quarterly).

The structure housing the Indiana State Museum was built in 1907 to serve as the Indianapolis City Hall, and today it is listed on the National Register of Historic Places. The rotunda rises 85 feet and is capped by a large Tiffany-style stained glass skylight The Museum focuses on the natural and cultural history of Indiana . It has a permanent art collection and also mounts temporary exhibitions of art with Indiana connections.

Indianapolis Art Center

820 East 67th St., Indianapolis, IN 46220
Tel: (317) 255-2464
Fax: (317) 254-0486
Internet Address: inartctr@inetdirect.net
Exec. Director: Ms. Joyce A. Sommers
Admission: voluntary contribution.
Attendance: 301,000 *Established:* 1934
Membership: Y *ADA Compliant:* Y
Parking: two parking lots.
Open: Monday to Thursday, 9am-10pm;
 Friday, 9am-5pm;
 Saturday, 9am-3pm;
 Sunday, noon-3pm.

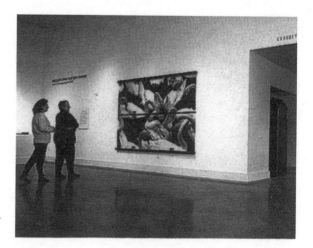

View of gallery, Indianapolis Art Center. Photograph courtesy of Indianapolis Art Center, Indianapolis, Indiana.

Indianapolis Art Center, cont.

Closed: New Year's Day, Memorial Day, Independence Day, Labor Day, Christmas Day.

Facilities: **Auditorium** (224 seats); **Galleries** (6); **Library** (1,100 volumes); **Sculpture Garden**; **Studio Classrooms** (13).

Activities: **Art Classes**; **Concerts**; **Education Programs** (adults and children); **Films**; **Temporary Exhibitions** (local and regional artists).

Publications: exhibition catalogues; newsletter; posters; schedule of classes.

Housed in a facility designed by Michael Graves, the Art Center features temporary exhibitions of contemporary art in a variety of media.

Indianapolis Museum of Art

1200 West 38th St., Indianapolis, IN 46208-4196

Tel: (317) 923-1331

Fax: (317) 931-1978

Internet Address: http://www.ima-art.org

Director: Mr. Bret Waller

Admission: voluntary contribution.

Attendance: 300,000 *Established:* 1956

Membership: Y *ADA Compliant:* Y

Parking: free on site.

Open: Tuesday to Wednesday, 10am-5pm;
Thursday, 10am-8:30pm;
Friday to Saturday, 10am-5pm;
Sunday, noon-5pm.

Closed: New Year's Day, Thanksgiving Day, Christmas Day.

Exterior view of Indianapolis Museum of Art. Photograph courtesy of Indianapolis Museum of Art, Indianapolis, Indiana.

Facilities: **Auditorium** (250 seats); **Exhibit Pavilions** (4 - Hulman, Krannert, Clowes & Lilly); **Food Services** Café (Tuesday-Saturday, 11:30am-2pm,, Garden on the Green Restaurant (Tuesday-Sunday, 11am-1:45pm, reservations recommended); **Formal Gardens**; **Greenhouse**; **Library** (32,000 volumes); **Rental Gallery**; **Shop**.

Activities: **Arts Festival**; **Concerts**; **Education Programs** (adults and children); **Films**; **Gallery Talks**; **Guided Tours** (Tuesday-Sunday, noon & 2pm; also Thursday, 7pm); **Lectures**; **Permanent Exhibits**; **Temporary Exhibitions**; **Traveling Exhibitions**; **Workshops**.

Publications: brochures; calendar; collection catalogue; exhibition catalogues; magazine (bi-monthly).

At the Indianapolis Museum of Art visitors can see permanent and changing exhibitions ranging from ancient artifacts to works by contemporary artists. Galleries in four art pavilions feature paintings, sculpture, textiles, decorative arts, prints, and drawings. The Museum's setting includes fifty acres of gardens and grounds. The Museum's permanent collection is comprehensive and organized as follows: African Art (1,400 objects representing all major art producing regions of sub-Saharan Africa, with particular strength in West African art); American Painting and Sculpture, 1800-1945 (portraits by Stuart and the Peale family, Eakins, Sargent, and Chase; landscapes by the Hudson River School, the Luminists, Inness, and the Tonalists; works by Homer, Hassam, Twachtman, Vonnoh, Weir, Tarbell, and Frieseke; 20th-century works by Hopper, Marsh, Benton, O'Keeffe, Hartley, Marin, and Roszak; and sculpture by Saint-Gaudens, Manship, Storrs, and Lachaise); Asian Art (a fine comprehensive collection of Chinese art, as well as Indian, Korean, Japanese, and Tibetan works); Contemporary Art (pre-1960 European works; installation pieces by Irwin, Acconci, Oppenheimer, and LeWitt; and sculpture by Indiana, Hepworth, di Suvero, and Rickey); European Painting and Sculpture before 1800 (Italian Renaissance works by Modena, Bugiardini, and Titian; Northern European works by Cuyp, van Ruisdael, van Goyen, Kalf, Claez, and van Dyck; 17th-century works by Magnasco, Ricci, Maratta, and Delgado; 18th-century works by Watteau, Boucher, Chardin, Reynolds, Panini, and Canaletto); European Painting and Sculpture, 1800-1945 (a large collection of works by Turner, as well as works by Corot, Daubigny, Monet, Renoir, Pissarro, Cézanne, van Gogh, Gauguin, Vuillard, Bonnard, Redon, and Lacombe, as well as a large collection of works by the Pointillists, including Seurat); 20th-century works by Picasso, Braque, Léger, Modigliani, Utrillo, and Dufy; and

Indianapolis Museum of Art, cont.

sculpture by Barye, Dalou, Rodin, and Maillol); and Prints, Drawings, and Photographs (25,000 works, including prints by Dürer, Rembrandt, Goya, Toulouse-Lautrec, Picasso, Matisse, Chagall, Warhol, and Lichtenstein; drawings by Degas, Cassatt, Ingres, Redon, Chase, Sloan, and Rivers; and photographs by Talbot, Cameron, Smith, Rodchenko, and Frank). The Museum operates a satellite gallery in Columbus, Indiana. (For information on IMA-Columbus Gallery, see listing under Columbus.)

National Art Museum of Sport, Inc.

University Place Conference Center & Hotel, 850 W. Michigan St., Indianapolis, IN 46202-5198

Tel: (317) 274-3627

Fax: (317) 274-3878

Internet Address: universityplace@iupi.edu

Administrative Director: Ms. Ann M. Rein

Admission: free.

Attendance: 150,000 *Established:* 1959

Membership: Y *ADA Compliant:* Y

Parking: pay on site.

Open: Weekdays, 8am-5pm.

Closed: Legal Holidays.

Facilities: **Exhibition Area** (10,500 square feet).

Activities: **Guided Tours**; **Permanent Exhibits**; **Temporary Exhibitions**.

Publications: exhibition catalogues.

Tapestry portraying games at a winter festival, Inuit culture. Collection of and photograph courtesy of National Art Museum of Sport, Indianapolis, Indiana.

The National Art Museum of Sport includes over 750 paintings, prints and sculptures depicting sports ranging from the games of the Inuit people to auto racing, from ice tennis to football. It is a diverse collection representing over 40 sports and many art media. Some of the highlights include an extensive collection of mid-19th century wood engravings by Winslow Homer; a silkscreen by boxer Muhammad Ali; bronzes of lacrosse displayed with engravings of Indians playing the ancient game; on-the-scene action watercolors of football, baseball and track by John Groth; action portraits of legends like Arthur Ashe, Gordy Howe, Sam Snead, Eddie Arcaro, Jack Dempsey, Jim Thorpe, Johnny Unitas, and Bob Cousy in bronze. Some of the artists represented in the collection are Winslow Homer, Fletcher Martin, George Bellows, R. Tait McKenzie and Alfred Boucher. Approximately 175 pieces from the permanent collection are displayed in the public areas of University Place Conference Center, a two-story technically sophisticated facility built in 1987.

University of Indianapolis - Art Galleries

1400 East Hanna Avenue, Indianapolis, IN 46227

Tel: (317) 788-3253

Internet Address: http://www.uindy.edu/~art/

Department Chair: Mr. Dee E. Schaad

Admission: free.

Open: **Academic Year**, Monday to Friday, 9am-9pm.

Closed: Academic Holidays.

Facilities: **Galleries** (2).

Activities: **Temporary Exhibitions** (monthly, during academic year).

The Christel DeHaan Fine Arts Center contains a gallery used for temporary exhibits that complement the Art Department's teaching mission. Student, faculty, one-person and group exhibits are held in the Leah Ransburgh Gallery located on campus in Good Hall. The University has an extensive permanent collection

Leonard Baskin, *Stravismic Jew,* University of Indianapolis Permanent Collection. Photograph courtesy of Christel DeHaan Fine Arts Center, University of Indianapolis, Indianapolis, Indiana.

University of Indianapolis - Art Galleries, cont.

composed mostly of prints, but it does include some painting and sculpture. Holdings include works by Jim Dine, Frank Gallo, Mauricio Lasansky, Louise Nevelson, Picasso, Robert Rauschenberg, and Rembrandt. On display in the hallway of the DeHaan Fine Arts Center and in public access areas of the Krannert Memorial Library, the permanent collection is open to the public daily.

Kokomo

Indiana University Kokomo - IUK Art Gallery

Kelley Center Complex, 2300 S. Washington St., Kokomo, IN 46904

Tel: (765) 455-9523

Fax: (765) 455-9444

Internet Address: http://www.indiana.edu/

Director: Ms. Lynda L. Collins

Admission: free.

Established: 1995

Membership: Y *ADA Compliant:* Y

Parking: free on site.

Open: **August to June**,
Monday to Tuesday, noon-4pm;
Wednesday, noon-8pm;
Thursday, noon-4pm;
Sunday, 3pm-5pm.

Closed: Legal Holidays, July.

Facilities: **Exhibition Area** (2,000 square feet).

View of gallery, Indiana University Kokomo, during exhibition of work of Tom Hale, AWS, 1998. Photograph courtesy of Indiana University Kokomo, Kokomo, Indiana.

Activities: **Guided Tours** (by appointment); **Lectures** (by appointment); **Temporary Exhibitions**.

The IUK Art Gallery is a new exhibition space in the Kelley Center Complex. It presents seven to nine exhibitions per year featuring the work of artists with regional and national reputations.

Lafayette

Greater Lafayette Museum of Art

101 South 9th St., Lafayette, IN 47901

Tel: (765) 742-1128

Fax: (765) 742-1120

Internet Address: http://www.glmart.org

Exec. Director: Ms. Gretchen Mehring

Admission: free.

Attendance: 30,000 *Established:* 1909

Membership: Y *ADA Compliant:* Y

Parking: free on site.

Open: Tuesday to Sunday, 11am-4pm.

Closed: New Year's Day,, Presidents Day,
ML King Day, Memorial Day,
Independence Day, Labor Day,
Thanksgiving Day,
Christmas Eve to Christmas Day.

View of gallery, Greater Lafayette Museum of Art, showing two cases of Rookwood pottery in foreground and "The Cruise of the Elida" by F. Luis Mora in background. Photograph courtesy of Greater Lafayette Museum of Art, Lafayette, Indiana.

Facilities: **Classrooms**; **Galleries** (2 permanent, 4 temporary exhibitions); **Library** (550 volumes, use on premises/loan for members); **Sales/Rental Gallery** (Indiana artists); **Shop**.

Activities: **Education Programs** (adults and children); **Guided Tours**; **Lectures**; **Studio Art Classes**; **Temporary Exhibitions**.

Publications: newsletter, "Visions" (bi-monthly).

The Museum houses two permanent collection galleries that highlight holdings of American and Indianan painting, works on paper, and pottery. Artists represented include Harry A. Davis, Pamela Parsons, Wayman Adams, Jo Ann Giordano, Frederic M. Grant, David B. Johnson, F. Luis Mora, and George Winter. Temporary exhibitions focus on historical themes in art, world cultures, and regional contemporary artists.

Michigan City

John G. Blank Center for the Arts

312 East 8th St., Michigan City, IN 46360
Tel: (219) 874-4900
Exec. Director: Ms. Barbara Stodola
Admission: suggested contribution:
adult-$2.00, child-$0.50.
Attendance: 19,000 *Established:* 1977
Membership: Y *ADA Compliant:* Y
Open: Monday to Friday, 9am-4pm;
Saturday, 10am-2pm.
Closed: Legal Holidays, New Year's Eve.
Facilities: **Architecture** (Beaux Arts former public library, 1895); **Classrooms**; **Library** (100 volumes, non-circulating, on request); **Rental Gallery**; **Shop**.
Activities: **Arts Festival** (3rd weekend in August); **Concerts**; **Education Programs** (adults and children); **Films**; **Gallery Talks**; **Guided Tours**; **Lectures**; **Permanent Exhibits**; **Temporary Exhibitions**; **Traveling Exhibitions**.

Audi Ambrozaitis, *Waiting for Gateau*, Collection of and photograph courtesy of The John G. Blank Center for the Arts, Michigan City, Indiana.

Publications: newsletter, "Artifacts".

The John G. Blank Center for the Arts is housed in an 1895 Beaux Arts building that was the city's first library. The building features fourteen-foot Tiffany-style windows. The Museum's permanent collection includes such diverse items as drawings, prints, and photographs of the Indiana Dunes; fifty pieces of Meso-American style pottery from the 1920s; prints by Oskar Kokoschka and Marc Chagall; and paintings by Victor Petravicius and Karel Appel. There are also monthly temporary exhibitions.

Muncie

Ball State University Museum of Art

2000 W. University Ave., Muncie, IN 47306
Tel: (765) 285-5242
Fax: (765) 285-5275
Director: Mr. Alain Joyaux
Admission: voluntary contribution.
Attendance: 32,000 *Established:* 1936
Membership: Y *ADA Compliant:* Y
Parking: metered on street and nearby commercial lots.
Open: Monday to Friday, 9am-4:30pm;
Saturday to Sunday, 1:30pm-4:30pm.
Closed: Legal Holidays, University Holidays.
Facilities: **Architecture** (Gothic Revival-style building, 1936 designed by George Schreiber); **Exhibition Area** (16,000 square feet); **Sculpture Garden**.
Activities: **Concerts**; **Gallery Talks** (occasional, Sunday, 2:30pm); **Guided Tours**; **Lectures**; **Permanent Exhibits**; **Temporary Exhibitions**; **Traveling Exhibitions**.
Publications: exhibition catalogues.

Mademoiselle Befort, *A Young Woman From Thebes Tending Her Wounded Father*, 1809, Collection of and photograph courtesy of Ball State University Museum of Art , Muncie, Indiana.

Ball State University Museum of Art, cont.

The Museum presents permanent exhibitions plus special shows and events, including an annual student art show and a biennial exhibition of work by faculty members. The collection includes holdings in American 19th- and early 20th-century paintings, European 18th- and 19th-century paintings, 16th- through 20th-century drawings, and ethnographic, Oriental, and decorative arts.

Munster

Northern Indiana Arts Association

1040 Ridge Road, Munster, IN 46321
Tel: (219) 836-1839
Fax: (219) 836-1863
Admission: voluntary contribution.
Established: 1969 *Membership:* Y *ADA Compliant:* Y
Open: Tuesday to Friday, 10:30am-5pm; Saturday, 10:30am-2:30pm; Sunday, noon-4pm.
Facilities: **Auditorium** (370 seats); **Exhibition Area** (5,000 square feet); **Library** (non-circulating); **Shop.**
Activities: **Arts Festival**; **Concerts**; **Education Programs** (adults and children); **Guided Tours**; **Lectures.**

The Northern Indiana Arts Association presents exhibitions of local, regional, national, and international art.

Nashville

Brown County Art Gallery and Museum

1 Artist Drive, Nashville, IN 47448
Tel: (812) 988-4609
Manager: Mrs. Helein Hart
Admission: voluntary contribution.
Attendance: 5,000 *Established:* 1926
Membership: Y *ADA Compliant:* Y
Parking: free on site.
Open: Monday to Saturday, 10am-5pm;
 Sunday, noon-5pm.
Closed: New Year's Day, Thanksgiving Day,
 Christmas Day.
Facilities: **Gallery** (6 rooms).
Activities: **Annual Exhibition**; **Art Workshops**;
 Gallery Talks; **Teas**; **Tours.**
Publications: brochure (annual); newsletter,
 "The Easel" (quarterly).

The permanent collection of the Museum contains over 200 works by Indiana artists, including Ada Schulz, Adolph R. Schulz, Leota Loop, T.C. Steele, and Glen Cooper Henshaw. The Museum also features temporary exhibitions of the work of regional artists.

Ada Schulz, *The Reader*, Brown County Art Gallery. Photograph courtesy of Brown County Art Gallery, Nashville, Indiana.

New Harmony

New Harmony Gallery of Contemporary Art

506 Main St., New Harmony, IN 47631
Tel: (812) 682-3156
Fax: (812) 682-4313
Director: Mr. Blake Cook

New Harmony, Indiana

New Harmony Gallery of Contemporary Art, cont.

Admission: voluntary contribution.
Attendance: 25,000 *Established:* 1975
Membership: Y *ADA Compliant:* Y
Parking: free on site.
Open: Tuesday to Saturday, 9am-5pm.
Facilities: **Consignment Gallery**; **Exhibition Area** (1,000 square feet).
Activities: **Lectures**; **Temporary Exhibitions** (monthly); **Workshops**.
Publications: exhibition catalogues (bi-monthly).

The mission of the Gallery is to promote contemporary art and artists of the Midwest. It mounts eight exhibitions per year and provides tours of both the Gallery itself and Historic New Harmony.

Rendering of exterior of New Harmony Gallery of Contemporary Art. Courtesy of New Harmony Gallery of Contemporary Art, New Harmony, Indiana.

Notre Dame

University of Notre Dame - The Snite Museum of Art

University of Notre Dame, Moose Krause Circle, Notre Dame, IN 46556
Tel: (219) 631-5466
Fax: (219) 631-8501
Internet Address:
 http://www.nd.edu/~sniteart/97/main3.html
Director: Dr. Dean A. Porter
Admission: suggested contribution-$2.00.
Attendance: 102,000 *Established:* 1842
Membership: Y *ADA Compliant:* Y
Parking: university visitors' lot.
Open: Tuesday to Wednesday, 10am-4pm;
 Thursday to Saturday, 10am-5pm;
 Sunday, 1pm-4pm.
Closed: Legal Holidays.
Facilities: **Architecture** (constructed 1980; designed by Ambrose Richardson); **Galleries**; **Library** (20,000 volumes); **Sculpture Garden**; **Shop**.
Activities: **Concerts**; **Education Programs** (adults and children); **Films**; **Gallery Talks**; **Guided Tours**; **Lectures**; **Permanent Exhibits**; **Temporary Exhibitions**; **Traveling Exhibitions**.
Publications: exhibition catalogues.

David Hayes, *Griffon*, 1989, painted steel, height 324 inches. Humana Foundation Endowment for American Art. In background is view of Snite Museum of Art (1980), designed by Ambrose Richardson. Photograph courtesy of Snite Museum of Art, University of Notre Dame, South Bend, Indiana.

The Snite Museum of Art has a comprehensive collection of over 19,000 objects housed in its 70,000-square-foot building. It mounts temporary exhibitions in addition to displaying objects from the collection. The majority of the Museum's exhibit space is devoted to its permanent collection, which includes objects from antiquity to the 20th century, and features important works by Ghirlandaio, Claude, Bloemaert, Boucher, Eakins, Remington, O'Keeffe, Rickey, Joseph Stella, and Jim Dine. Notable collections housed in the Museum include The Kress Study Collection, the Feddersen collection of Rembrandt etchings, the Butkin bequest of 19th-century French paintings, the Reilly collection of Old Master drawings, the Janos Scholz collection of 19th-century European photographs, and the Leighton collection of pre-Classic figurines. The Museum maintains a separate gallery of sculpture and drawings by Ivan Mestrovic, which is the American study center for his art. The Print, Drawing, and Photography Gallery is designed for displaying collections of works on paper, as well as

University of Notre Dame - The Snite Museum of Art, cont.

temporary exhibitions on loan from other institutions and private collectors. The Museum schedules a dozen exhibitions annually on subjects as diverse as Old Master drawings, contemporary prints, and pre-Columbian sculptures. The O'Shaughnessy Galleries host the annual student show and a biennial faculty show. On the lower level are the Museum's ethnographic collections, the John T. Higgins Gallery of American Art, and the museum reference library. Entrance to the Courtyard is at the north end of the atrium and leads to the outdoor sculpture display in the garden. Featured in the courtyard is a George Rickey kinetic sculpture. David Hayes, class of 1953, is the creator of Griffon, the 27-foot steel sculpture at the entrance to the Museum.

Richmond

Richmond Art Museum

350 Hub Etchison Parkway
Richmond, IN 47375
Tel: (765) 966-0256
Fax: (765) 973-3738
Director: Kathleen D. Glynn
Admission: free.
Attendance: 13,000 *Established:* 1898
Membership: Y *ADA Compliant:* Y
Open: Tuesday to Friday, 10am-4pm;
 Sunday, 1pm-4pm.
Closed: Legal Holidays.
Facilities: **Auditorium** (525 seats); **Exhibition Area** (400 running feet); **Library** (1,200 volumes); **Reading Room**; **Sales Gallery**.
Activities: **Art Classes** (children); **Education Programs** (adults and children); **Films**; **Gallery Talks**; **Guided Tours**; **Lectures**; **Permanent Exhibits**; **Temporary Exhibitions** (change every 4 -5 weeks); **Traveling Exhibitions**.

William Merritt Chase, *Self-Portrait*, 1915, Richmond Art Museum. Photograph courtesy of Richmond Art Museum, Richmond, Indiana.

The Richmond Art Museum mounts temporary exhibitions of works by international, national, and regional artists. It also houses a permanent collection of over 2,000 works, including examples by William Merritt Chase, James Lefever Cranstone, and numerous Indiana artists.

South Bend

Indiana University South Bend

1700 Mishawaka Ave., South Bend, IN 46634
Tel: (219) 237-4872
Internet Address: http://www/iusb.edu/~artevent/hytml/gallery.html
Admission: free.
Open: Monday to Friday, 8am-10pm; Saturday, 8am-noon; Sunday, 1pm-6pm.
Facilities: **Exhibition Area**.
Activities: **Gallery Talks**; **Temporary Exhibitions**.

The gallery offers temporary exhibitions.

South Bend Regional Museum of Art (SBRMA)

120 S. St. Joseph Street, South Bend, IN 46601
Tel: (219) 235-9102
Fax: (219) 235-5782
Internet Address: http://sbt.infi.net/~sbrma
Exec. Director: Ms. Susan R. Visser

South Bend Regional Museum of Art, cont.

Admission: suggested contribution-$3.00.

Attendance: 45,000 *Established:* 1947

Membership: Y *ADA Compliant:* Y

Parking: free on street and commercial lots, $3.

Open: Tuesday to Friday, 11am-5pm;
Saturday to Sunday, noon-5pm.

Closed: New Year's Day,, ML King Day, Easter,
Christmas Day, Independence Day,
Thanksgiving Thursday-Friday.

Facilities: **Classrooms**; **Galleries** (four);
Library (1,055 volumes, non-circulating);
Rental/Sales Gallery; **Shop**; **Studio.**

Activities: **Education Programs** (adults and
children); **Gallery Talks**; **Guided Tours**
(arrange in advance); **Lectures**; **Traveling
Exhibitions.**

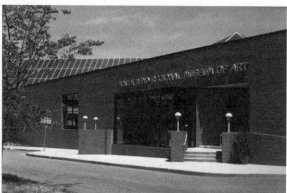

Exterior view of South Bend Regional Museum of Art, part of Century Center, designed by Philip Johnson and John Burgee. Photograph courtesy of South Bend Regional Museum of Art.

Publications: exhibition catalogues (occasional); newsletter (quarterly).

The permanent collection of the Museum consists of 19th- and 20th-century American art. The Museum mounts traveling exhibitions and original shows and also features the work of local and regional artists.

Terre Haute

Indiana State University Art Gallery

ISU, Center for Performing & Fine Arts, 7th and Chestnut Streets, Terre Haute, IN 47809

Tel: (812) 237-3720

Fax: (812) 237-4369

Internet Address: http://www.indstate.edu

Director: Mr. Craig Zollars

Admission: free.

Established: 1953 *ADA Compliant:* Y

Open: Monday to Wednesday, 11am-4pm; Thursday, 1pm-8pm; Friday, 11am-4pm.

Closed: Legal Holidays.

Facilities: **Gallery** (3,700 square feet).

Activities: **Education Programs** (undergraduate and graduate college students); **Lecture Series** (visiting artists); **Temporary Exhibitions** (regional and national contemporary artists).

Publications: exhibition catalogues (2/year).

The Gallery presents temporary exhibitions of works from the permanent collections and by professional artists. The schedule includes semi-annual graduate thesis exhibitions and annual faculty, B.F.A. Senior, and juried student exhibitions. University holdings include nearly 2,000 paintings, sculptures, prints, drawings, and artifacts from various periods and cultures. The collection is particularly strong in 20th-century American art highlighted by 200 works from the Works Progress Administration's Federal Art Project and a collection of works from the 1970s (Pop, Op, and Photo-realist art). While not on permanent exhibition at a central site, many works from the collection are displayed in public areas throughout the campus.

Swope Art Museum

25 South 7th St., Terre Haute, IN 47807-3692

Tel: (812) 238-1676

Fax: (812) 238-1677

Internet Address: http://www.swope.org

Director: Dr. David Butler

Swope Art Museum, cont.

Admission: voluntary contribution.

Attendance: 15,000 *Established:* 1942

Membership: Y *ADA Compliant:* Y

Parking: commercial lot on Ohio Blvd.

Open: Tuesday to Wednesday, 10am-5pm;
Thursday, 10am-8pm;
Friday, 10am-5pm;
Saturday to Sunday, noon-5pm.

Closed: Legal Holidays.

Facilities: **Architecture** (Renaissance Revival building, 1901; Art Deco interior, 1942); **Galleries** (6 permanent, 3 temporary exhibitions); **Sales Gallery**.

Activities: **Art Classes**; **Education Programs** (adults and children); **Gallery Talks**; **Guided Tours**; **Lectures**; **Permanent Exhibits**; **Temporary Exhibitions** (6 - 8 per year); **Traveling Exhibitions**.

Edward Hopper, *Route Six, Eastham*, 1941, oil on canvas, 27½ x 38¼ inches. Swope Art Museum. Photograph courtesy of Swope Art Museum, Terre Haute, Indiana.

Publications: brochure; exhibition catalogues; newsletter (quarterly).

The Swope Art Museum focuses on American art and has an important collection of American Regionalist and Indiana Impressionist paintings. Six of the Museum's eight galleries are reserved for the permanent collection (American paintings and works on paper), and two others are used to mount temporary exhibitions, both traveling and original. Paintings in the collection include works by Wood, Benton, Burchfield, Marsh, Hopper, and Hurd, as well as earlier works by Doughty, Chase, Inness, Bellows, and Luks, and more recent works by Levine, Calder, Porter, and Motherwell. There is also sculpture by Huntington, Manship, Hoffman, Rauschenberg, di Suvero, and Serra; drawings by Cox, Calder, and Curry; prints by Whistler, Homer, Bellows, Hopper, Wood, Lawrence, Motherwell, Rivers, Indiana, Warhol, and Judd.

Valparaiso

Valparaiso University - Brauer Museum of Art

Valparaiso University, Center for the Arts, Chapel Drive
Valparaiso, IN 46383-6349

Tel: (219) 464-5365

Fax: (219) 464-5244

Director: Ms. Rita E. McCarthy

Admission: free.

Established: 1953

Membership: Y *ADA Compliant:* Y

Parking: free on site.

Open: **Academic Year**,
Tuesday, 10am-5pm;
Thursday to Friday, 10am-5pm;
Wednesday, 10am-8:30pm; |
Saturday to Sunday, noon-5pm.
Academic Holidays/Summer,
Tuesday to Sunday, noon-5pm.

Georgia O'Keeffe, *Red Rust Hills*, 1930, oil on canvas, 16 x 30 inches. Sloan Purchase Fund, Brauer Museum of Art. Photograph courtesy of Brauer Museum of Art, Valparaiso, Indiana.

Closed: Good Friday, Easter, Independence Day, Thanksgiving Day, Christmas Eve to Christmas Day, New Year's Eve to New Year's Day.

Facilities: **Galleries** (4); **Recital Hall**; **Shop**; **Theatre**.

Activities: **Gallery Talks**; **Guided Tours** (Sat & Sun, 2pm); **Lectures**; **Permanent Exhibits**; **Temporary Exhibitions**; **Traveling Exhibitions**.

Publications: exhibition guides; newsletter, "Friends Newsletter".

Valparaiso, Indiana

Valparaiso University - Brauer Museum of Art, cont.

The Brauer Museum of Art holds a permanent collection of over 2,300 works, including examples by many leading American artists of the 19th and 20th centuries, such as Anderson, Burchfield, Bricher, Church, Glackens, Hassam, Johnson, Kensett, Marin, O'Keeffe, Sierra, John Sloan, and Warhol. The Museum also maintains the collection of record of the American artist Junius R. Sloan as well as American, prints, photography, and sculpture. The museum also contains international religious art. It hosts special loan exhibitions in addition to its permanent collection and sponsors juried competitions of student art.

West Lafayette

Purdue University Galleries

Beelke Gallery: Creative Art Building #2, Stadium Ave.
Stewart Center Gallery: West Lobby, State St.
Union Gallery: Memorial Union, Room 110, Grant St.
West Lafayette, IN 47907
Tel: (765) 494-3061
Fax: (765) 496-2817
Director: Michael Atwell
Admission: voluntary contribution.
Attendance: 68,000 *Established:* 1978
Membership: Y *ADA Compliant:* Y
Parking: pay university garages and on street.
Open: **Beelke Gallery**,
Monday to Friday, 10am-5pm.
Krannert Gallery,
Monday to Friday, 8am-5pm and 7pm-9pm;
Sunday, 1pm-5pm.
Stewart Center,
Monday to Thursday, 10am-5pm and 7pm-9pm;
Friday, 10am-5pm; Sunday, 1pm-4pm.
Union Gallery,
Monday to Friday, 10am-5pm,
Sunday, 1pm-5pm.

Diego Rivera, *Cabeza de Tehuana: Tehuantepec*, 1930, oil on canvas, 22.25 x 18.25 inches. Purdue University collection, gift of Edward Stowe Akeley and Anna Akeley, 1995. Photograph courtesy of Purdue University, West Lafayette, Indiana.

Closed: Academic Holidays.
Facilities: **Galleries** (Beelke, 1200 square feet; Krannert, 5500 square feet; Stewart, 1200 square feet; Union, 1500 square feet).
Activities: **Concerts**; **Films** (occasional); **Guided Tours** (on request); **Lectures** (exhibit openings and weekly "Brown Bag" noontime talk); **Temporary Exhibitions**; **Traveling Exhibitions**.
Publications: brochure (quarterly); calendar (annual); catalogue (quarterly); newsletter (semi-annual).

The Purdue University gallery program maintains four separate galleries on campus: Ralph G. Beelke Memorial Gallery (494-9355), Krannert Drawing Room (494-9700), Stewart Center Gallery (494-5687), and Union Gallery (496-7777). The Galleries present an active schedule of exhibitions of works from the permanent collection and objects lent by private collectors or other institutions, as well as annual MFA and undergraduate student exhibitions The permanent collection includes pre-Columbian textiles; Native American baskets; modern and contemporary Mexican paintings, drawings, and prints; Japanese woodblock prints; European and American paintings, prints, and sculpture from the 16th century to the present; and photographs from 1839 to the present.

Iowa

The number in parentheses following the city name indicates the number of museums/galleries in that municipality. If there is no number, one is understood. For example, in the text three listings would be found under Des Moines and one listing under Pella.

Iowa

Ames

Iowa State University - Brunnier Art Museum

290 Scheman Building, Iowa State University, Ames, IA 50011

Tel: (515) 294-3342

Fax: (515) 294-7070

Internet Address: http://www.museums.iastate.edu/

Director: Ms. Lynette Pohlman

Admission: voluntary contribution.

Attendance: 31,000 *Established:* 1975 *Membership:* Y *ADA Compliant:* Y

Parking: lot north of building.

Open: Tuesday to Wednesday, 11am-4pm; Thursday, 11am-4pm and 5pm-9pm; Friday, 11am-4pm; Saturday to Sunday, 1pm-4pm.

Closed: Easter, Memorial Day, Independence Day, Labor Day, Thanksgiving Day, Christmas Day.

Facilities: **Galleries**; **Library** (use on premises); **Reading Room**; **Shop**.

Activities: **Arts Festival**; **Demonstrations**; **Education Programs**; **Gallery Talks**; **Guided Tours** (groups, arrange in advance); **Lecture Series**; **Permanent Exhibits**; **Temporary Exhibitions**; **Traveling Exhibitions**; **Workshops**.

Publications: newsletter, "News from University Museums" (quarterly).

Located on the top floor of the Scheman Building, the Brunnier Art Museum has a permanent collection of decorative and fine arts spanning a variety of eras and artistic genres. The permanent collections are regularly on display in short- and long-term exhibits. Groupings of Oriental jades and snuff bottles, ceramics, Russian enamels, and ivory carvings often may be seen in rotating exhibitions. Additionally the Art on Campus Program continues a tradition of integrating buildings and art on the campus. Currently more than 200 major works of public art enhance Iowa State's buildings and landscapes from Christian Petersen statues and library murals designed by Grant Wood to contemporary art such as the G-Nome Project incorporated into the design of the Molecular Biology Building. University Museums offers a self-guiding brochure and a monthly Wednesday Walk tour of the Art on Campus Collection.

The Octagon Center for the Arts

427 Douglas Ave., Ames, IA 50010-6213

Tel: (515) 232-5331

Fax: (515) 232-5088

Director: Teresa Kay Albertson

Admission: free - donations accepted.

Attendance: 35,000 *Established:* 1966 *Membership:* Y *ADA Compliant:* Y

Parking: metered on street.

Open: Tuesday to Friday, 10am-3pm; Saturday, 10am-5pm; Sunday, 2pm-5pm.

Closed: Legal Holidays.

Facilities: **Auditorium** (150 seats); **Galleries** (2); **Shop** (Mon-Fri, 10am-5:30pm; Sat, 10am-5pm); **Studios** (pottery, sculpture, painting, photography).

Activities: **Arts Festival**; **Concerts**; **Education Programs** (adults and children); **Guided Tours**; **Lectures**; **Performances**; **Temporary Exhibitions**; **Traveling Exhibitions**.

Publications: exhibition catalogues; newsletter, "The Octagon Center for the Arts Newsletter" (quarterly).

The Octagon is a community arts center featuring art exhibitions and juried art shows, classes, and workshops for all ages.

Burlington

Art Guild of Burlington

7th and Washington Streets, Burlington, IA 52601

Tel: (319) 754-8069

Fax: (319) 754-4731

Director: Ms. Lois Rigdon

Art Guild of Burlington, cont.

Admission: voluntary contribution.

Attendance: 10,000 *Established:* 1966

Membership: Y *ADA Compliant:* Y

Open: **January 2 to December 24,**
Tuesday to Friday, noon-5pm;
Saturday to Sunday, 1pm-4pm.

Facilities: **Architecture** (former Methodist Church, ca.,1868); **Auditorium** (175 seats); **Exhibition Area** (2,400 square feet); **Library** (100 volumes); **Rental Gallery**; **Sculpture Garden**; **Shop.**

Activities: **Arts Festival**; **Concerts**; **Dance Recitals**; **Films**; **Lectures**; **Temporary Exhibitions**; **Traveling Exhibitions**; **Workshops.**

View of Art Guild All Member Exhibition (December, 1997), harpist Janis Cintron performing for Luminaria Lighting reception. Photograph courtesy of Art Guild of Burlington, Burlington, Iowa.

Publications: class brochure (quarterly); newsletter (monthly).

Located in an adapted 1868 German Methodist Episcopal Church building, the Arts for Living Center is a community arts facility. The Art Guild offers year-round educational programs. Its collection focuses on regional artists.

Cedar Falls

James and Meryl Hearst Center for the Arts

304 W. Seerley Blvd., Cedar Falls, IA 50613

Tel: (319) 273-8641

Fax: (319) 273-8659

Internet Address: http://www.hearstartscenter.com

Director: Ms. Mary Huber

Admission: voluntary contribution.

Attendance: 46,000 *Established:* 1989

Membership: Y *ADA Compliant:* Y

Parking: free public parking.

Open: Tuesday, 8am-9pm;
Wednesday, 8am-5pm;
Thursday, 8am-9pm;
Friday, 8am-5pm;
Saturday to Sunday, 1pm-4pm.

Closed: Legal Holidays.

Facilities: **Architecture** (former home of poet James Hearst); **Classrooms**; **Exhibition Area** (2 galleries, 3,000 square feet); **Library** (1,200 volumes, non-circulating); **Reading Room**; **Recital Hall**; **Rental Gallery**; **Shop.**

Activities: **Concerts**; **Education Programs** (adults and children); **Films**; **Gallery Talks**; **Guided Tours**; **Lectures**; **Temporary Exhibitions**; **Traveling Exhibitions.**

Grant Wood, *Honorary Degree*, lithograph, 12 x 7½ inches. Gift of Mrs. Jane Beard, Hearst Center for the Arts. Photograph courtesy of James and Meryl Hearst Center for the Arts, Cedar Falls, Iowa.

Publications: exhibition catalogues (biennial); newsletter (biennial).

The James and Meryl Hearst Center for the Arts is a multi-disciplinary community arts center. Temporary exhibitions in the Dahl-Thomas and Dresser-Robinson galleries showcase local and regional art, as well as works by artists on the national and international scene. Art in all media is presented. Exhibitions include not only contemporary works, but also artworks from earlier periods and other cultures. Selections from the permanent collection, including works by Gary Kelley, Mauricio Lasansky, Marjorie Nuhn, John Page, and Grant Wood, are frequently displayed in the Reading Room and at other locations throughout the Center. Initiated by a bequest from farmer poet James Hearst and his wife, the Center is a division of the Department of Human and Leisure Services, City of Cedar Falls.

University of Northern Iowa - Gallery of Art

Kamerick Art Building, First Floor, 1227 W. 27th Street, Cedar Falls, IA 50614-0362

Tel: (319) 273-2077

Fax: (319) 273-2731

Internet Address: http://www.uni.edu/artdept/gallery/index.html

Gallery Director: Mr. Shawn Holtz

Admission: free.

Attendance: 13,000 *Established:* 1978 *ADA Compliant:* Y

Open: **Academic Year,**
 Monday to Thursday, 9am-9pm; Friday, 9am-5pm; Saturday to Sunday, 1pm-4pm.
 Summer,
 Monday to Friday, 10am-4pm; Saturday to Sunday, noon-4pm.

Closed: Legal Holidays.

Facilities: **Exhibition Area.**

Activities: **Education Programs** (undergraduate college students and children); **Films; Gallery Talks; Guided Tours; Lectures; Permanent Exhibits; Temporary Exhibitions** (6-8/year); **Traveling Exhibitions.**

Publications: exhibition catalogues.

Located on the first floor of the art building, the Gallery of Art presents six to eight major exhibitions and a number of smaller shows each year, including annual shows by the art faculty in the fall and a competitive student show in the spring. The Gallery is also responsible for the University's permanent art collection, which includes works by such prominent artists as Berenice Abbott, Joseph Albers, Eugene Atget, Romare Bearden, George Grosz, Philip Guston, and Jerry Uelsmann. There are also sculptural works sited around the campus.

Cedar Rapids

Cedar Rapids Museum of Art

410 3rd Ave., S.E. (between 4th and 5th Streets), Cedar Rapids, IA 52401

Tel: (319) 366-7503

Fax: (319) 366-4111

Internet Address: http://www.crma.org

Admission: fee: adult-$4.00, child-$3.00, senior-$3.00.

Established: 1905 *Membership:* Y *ADA Compliant:* Y

Parking: free, lot entrance off 2nd Ave..

Open: Tuesday to Wednesday, 10am-4pm; Thursday, 10am-7pm; Friday to Saturday, 10am-4pm; Sunday, noon-4pm.

Closed: Legal Holidays.

Facilities: **Architecture** (former Carnegie Library, 1908 with addition); **Classrooms; Food Services** Restaurant; **Galleries** (17); **Library** (1,200 volumes, non-circulating); **Rental Gallery; Shop** (ceramics, hand-blown glass, books, toys).

Activities: **Arts Festival; Concerts; Education Programs** (adults and children); **Films; Gallery Talks; Guided Tours; Lectures; Readings; Temporary Exhibitions; Traveling Exhibitions.**

Publications: exhibition catalogues; newsletter.

The Museum has 17 galleries. eight of which are devoted to selections from its permanent collection of over 5,000 works. Holdings include the world's largest collections of works by each of Grant Wood, Marvin D. Cone, and Mauricio Lasansky and a large collection of sculpture by Malvina Hoffman. There are also extensive collections of early 20th-century paintings, Regionalist art from the 1930s and 1940s, 20th-century American prints, work in all media by Iowa artists, and contemporary Midwestern painting and photography. A collection of 21 Roman portrait busts occupy a special gallery on the second floor. Changing exhibits drawn from the permanent collection are supplemented by temporary exhibitions of works from other institutions and solo shows.

Cedar Rapids, Iowa

Coe College - Galleries

Dows Fine Arts Center, First Ave. and 13th Street, Cedar Rapids, IA 52402
Tel: (319) 399-8000
Internet Address: http://www.public.coe.edu/departments/Art/galleries.html
Admission: free.
Open: Call for hours.
Facilities: Galleries.
Activities: **Permanent Exhibits; Temporary Exhibitions.**

The Dows Fine Arts Center, in addition to housing the college's permanent art collection, maintains two art galleries for monthly traveling exhibitions and student shows. With approximately 465 works, the Coe College Collection of Art, diverse in both scope and media, features twelve works by Grant Wood, 56 paintings by Coe graduate and art department founder Marvin Cone, and 45 paintings by another Coe graduate Conger Metcalf. Other artists represented include Karl Appel, Milton Avery, Leonard Baskin, Thomas Hart Benton, Ronald Bladen, Raoul Dufy, Mauricio Lasansky. Aristide Maillol, Henri Matisse, Thomas Nast, Francis Picabia, Pablo Picasso, Mark Rothko, and Henri Toulouse-Lautrec. The campus also features four major outdoor sculptures, as well as other sculptural works in the lobby of the Dow Fine Arts Center.

Davenport

Davenport Museum of Art (DMA)

1737 West 12th St., Davenport, IA 52804
Tel: (319) 326-7804
Fax: (319) 326-7876
Internet Address: http://www.qconline.com/arts/ DMA
Director: Dr. William Steven Bradley
Admission: voluntary contribution.
Attendance: 58,000 *Established:* 1925
Membership: Y *ADA Compliant:* Y
Parking: free on site.
Open: Tuesday to Wednesday, 10am-4:30pm;
 Thursday, 10am-8pm;
 Friday to Saturday, 10am-4:30pm;
 Sunday, 1pm-4:30pm.

Exterior view of Davenport Museum of Art. Photograph courtesy of Davenport Museum of Art, Davenport, Iowa.

Closed: Legal Holidays.
Facilities: **Auditorium** (250 seats); **Classrooms**; **Galleries** (3); **Library** (5,000 volumes, non-circulating); **Shop** (approximately 500 gift items available); **Studio.**
Activities: **Arts Festival; Concerts; Education Programs** (adults, undergraduate college students and children); **Gallery Talks; Guided Tours; Lectures; Permanent Exhibits; Temporary Exhibitions; Workshops.**
Publications: biennial report; collection catalogues; exhibition catalogues; newsletter (quarterly).

One of the oldest public art museums in the Iowa - Western Illinois region, the DMA houses more than 3,200 works of art in seven distinct collections: American art from the Colonial period to 1945; Regionalist art focusing on the work of Grant Wood, Thomas Hart Benton, and John Steuart Curry; European art from the 15th through the 19th centuries; Mexican colonial paintings from the 16th to the18th century; Haitian art since 1940; Asian art from the 18th and 19th centuries; and Contemporary art. The DMA presents six to nine special exhibitions annually.

Decorah

Luther College - Fine Arts Collection

Luther College Library, 700 College Drive, Decorah, IA 52101-1042
Tel: (319) 387-1195
Fax: (319) 387-1657
Internet Address: http://www.luther.edu
Gallery Coordinator: Mr. David Kamm

Luther College - Fine Arts Collection, cont.

Admission: free.

Attendance: 10,000

ADA Compliant: Y

Open: **September to June**,
 Monday to Friday, 8am-10pm;
 Saturday, 9am-5pm;
 Sunday, noon-10pm.

Closed: Academic Holidays.

Facilities: **Exhibition Area** (2,265 square feet).

Activities: **Gallery Talks**; **Temporary Exhibitions**; **Traveling Exhibitions**.

Publications: brochures; exhibition catalogues.

Gerhard Marcks, *Noah*, 1948, woodcut. Fine Arts Collection, Luther College. Photograph courtesy of Luther College, Decorah, Iowa.

The Fine Arts Collection exists to support the general mission of the college by promoting awareness and understanding of a broad spectrum of artistic expression through diversity in media, culture, and historical perspective. Nearly one-third of the collection is on circulating display throughout the campus. Over 1,200 items comprise the fine arts collection, anchored by extensive holdings of the works of Herbjørn Gausta, Marguerite Wildenhain, Gerhard Marcks, and Fritjof Schroeder. The collection, housed in the Preus Library, also includes examples of pre-Columbian pottery and Inuit sculpture. Regional artists are well represented by paintings, prints, and ceramics, and examples of works by such international artists as Oldenburg, Picasso, Rosenquist, Vlaminck, and Whistler are also presented. Works in the collection include paintings, drawings, prints, photographs, sculpture, assemblages, textiles, ceramics, and utilitarian or ritual objects in any medium whose principal value resides in the their aesthetic merit. Also of possible interest on campus, student work is exhibited in the M.O. Running Gallery at Loyalty Hall and four additional galleries in other buildings on campus. These galleries also host exhibitions of work by regionally and nationally recognized artists in solo and group shows.

Des Moines

Des Moines Art Center

4700 Grand Ave., Des Moines, IA 50312-2099

Tel: (515) 277-4405

Fax: (515) 271-0357

Acting Director: Ms. Susan Lubowsky Talbott

Admission: free.

Attendance: 259.371 *Established:* 1948

Membership: Y *ADA Compliant:* Y

Parking: free on site.

Open: Tuesday to Wednesday, 11am-4pm;
 Thursday, 11am-9pm;
 Friday to Saturday, 11am -4pm;
 Sunday, noon-4pm;
 1st Friday in month, 11am-9pm.

Closed: Legal Holidays.

North view of building designed by Richard Meier, Des Moines Art Center. Photograph courtesy of Edmundson Art Foundation, Inc. Des Moines, Iowa.

Facilities: **Architecture** Building (designed by Eliel Saarinen, 1948), Building (designed by I.M. Pei, 1968), Building (designed by Richard Meier, 1985); **Auditorium** (220 seats); **Building Area** (90,000 square feet); **Classrooms**; **Food Services** Restaurant (Tues-Sat, 11am-2pm & Thurs, 5:30pm-9pm); **Library** (13,000 volumes; by appointment, Tues-Fri, 11am-5pm,); **Shop** (one-of-a-kind items, art books, toys, posters, jewelry); **Studios**.

Activities: **Education Programs** (adults and children); **Film Series**; **Gallery Talks**; **Guided Tours** (groups, schedule three weeks in advance); **Lecture Series**; **Performances**; **Permanent Exhibits**; **Temporary Exhibitions**; **Traveling Exhibitions**.

Des Moines Art Center, cont.

Publications: "Visitor's Guide"; bulletin, "News"; exhibition catalogues; gallery guides.

The Art Center itself is an exceptional work of art. Internationally recognized architects Eliel Saarinen, I.M. Pei, and Richard Meier have created three distinctive buildings as part of the complex. The Des Moines Art Center's reputation has been established through collecting 20th-century art with emphasis now placed on acquiring works by living American and European artists. More than 3,500 works are in the permanent collection; among the over 1,600 artists represented are Francis Bacon, Constantine Brancusi, Mary Cassatt, Jean Dubuffet, Francisco Goya, Jasper Johns, Donald Judd, Henri Matisse, Claude Monet, Henry Moore, Georgia O'Keeffe, Claes Oldenburg, Auguste Rodin, Frank Stella, and Andy Warhol. There is also a collection of African art. In addition to displaying works from its permanent collection, the Art Center brings in special art exhibitions from around the United States and abroad.

Drake University - Anderson Gallery

Harmon Fine Arts Center
25th and Carpenter
Des Moines, IA 50311
Tel: (515) 271-1994
Internet Address:
 http://www.drake.edu/artsci/art/calendar.html
Director: Ms. Marie-Louise Kane
Admission: free.
Attendance: 1,500 *Established:* 1996
Membership: N
Parking: on street and school lot on 25th Street.
Open: Tuesday to Sunday, noon-4pm.
Closed: Summer, Academic Holidays.
Facilities: **Exhibition Area** (1,800 square feet).
Activities: **Symposia**; **Temporary Exhibitions**.

View of the Anderson Gallery during the opening reception for "Swedish Textiles: The Ericson Collection", January 2000. Photograph courtesy of Drake University, Des Moines, Iowa.

The Gallery exhibits student and faculty work annually as well as exhibitions by independent artists and gallery-organized exhibitions in the areas of decorative arts, furniture, textiles and installation. While the Gallery does not have a permanent collection, an important mural by American modernist Stuart Davis titled "Allée" (1955) is on permanent display in Olmsted Hall.

Hoyt Sherman Place

1501 Woodland Ave., Des Moines, IA 50309-3283
Tel: (515) 244-0507
Fax: (515) 237-3582
Admission: free.
Attendance: 40,000 *Established:* 1907
Membership: N *ADA Compliant:* Y
Open: Monday to Tuesday, 8am-4pm;
 Thursday to Friday, 8am-4pm.
Facilities: **Architecture** (house, 1877; museum 1907; and theatre, 1923); **Exhibition Area**; **Food Services** Restaurant; **Shop**; **Theatre** (1,400 seats).

ART GALLERY ORIGINAL HOME THEATRE
1907 1877 1923

Exterior view of Hoyt Sherman Place. Rendering courtesy of Hoyt Sherman Place, Des Moines, Iowa.

Activities: **Guided Tours** (reserve in advance, $2.00/person); **Lectures**; **Temporary Exhibitions**.

Maintained by the Des Moines Women's Club, the Sherman complex consists of the original Victorian residence completed in 1877, an art gallery, and a theatre. Des Moines' first art gallery was established in Hoyt Sherman Place in 1907. Its distinctive collection of 19th- and early 20th-century paintings includes works by Frederick E. Church, Frederick Frieseke, George Inness, Thomas Moran, William Richards, Elmer Schofield, Gardner Symonds, and Edwin Lord Weeks. Holdings also include antiques, furniture, statuary, crystal, silver, and other decorative art.

Dubuque

Clarke College - Quigley Gallery

Wahlert Atrium, 1550 Clarke Drive, Dubuque, IA 52001
Tel: (319) 588-6356
Internet Address: http://keller.clarke.edu/~lkames/art_homepage/gallery.html
Director: Mr. Douglas Schlesier
Admission: free.
Open: Monday to Friday, noon-5pm; Saturday to Sunday, 1pm-5pm.
Facilities: **Exhibition Area.**
Activities: **Temporary Exhibitions.**

The Gallery presents temporary exhibitions including BA and BFA student exhibitions.

Dubuque Museum of Art

7th at Washington Park
Dubuque, IA 52001-6817
Tel: (319) 557-1851
Fax: (319) 557-7826
Exec. Director: Mr. Nelson Britt
Admission: suggested donation: adult-$3.00,
 child (<13)-free, student-$2.00, senior-$2.00.
Attendance: 15,000 *Established:* 1874
Membership: Y *ADA Compliant:* Y
Parking: off street.
Open: Tuesday to Friday, 10am-5pm;
 Saturday to Sunday, 1pm-4pm.

Exterior view of Dubuque Museum of Art facility. Photograph courtesy of the Dubuque Museum of Art, Dubuque, Iowa.

Facilities: **Exhibition Area; Studio/Classrooms.**
Activities: **Arts Festival; Concerts; Education Programs** (adults and children); **Gallery Talks; Guided Tours** (on request); **Lectures; Temporary Exhibitions; Workshops.**
Publications: newsletter (quarterly).
The Dubuque Museum of Art fosters, facilitates, and promotes the study and appreciation of the visual arts. The Museum is dedicated to cultural growth, to enhance the quality of life, and to contribute to the general development of the community and region. Exhibitions, gallery tours, outreach programs, gallery talks, and a variety of educational initiatives serving the most diverse audience possible are the foundation of Museum programming.

Fort Dodge

Blanden Memorial Art Museum

920 3rd Ave., South
Fort Dodge, IA 50501
Tel: (515) 573-2316
Fax: (515) 573-2317
Internet Address:
 http://www.Dodgenet.com/~blanden
Director: Charles P. Helsell
Admission: voluntary contribution.
Attendance: 15,000 *Established:* 1930
Membership: Y *ADA Compliant:* Y
Parking: on street & municipal lot on 10th St.
Open: Tuesday to Wednesday, 10am-5pm;
 Thursday, 10am-8:30pm;
 Friday, 10am-5pm;
 Saturday to Sunday, 1pm-5pm.
Closed: National Holidays.

Exterior view of Blanden Memorial Art Museum. Photograph by Thomas A. Lion, courtesy of Blanden Memorial Art Museum, Fort Dodge, Iowa.

Blanden Memorial Art Museum, cont.

Facilities: **Architecture** (neoclassic building, 1932); **Galleries** (3; 5,500 square feet); **Library** (4,000 volumes, non-circulating); **Shop**; **Studio/Classrooms** (2).

Activities: **Artist-in-Residence Workshop**; **Concerts** (6/year); **Education Programs** (all ages); **Films** (occasionally); **Gallery Talks** (minimum of 10/year); **Guided Tours** (groups 5+, reserve in advance); **Lectures** (minimum of 10/year); **Permanent Exhibits**; **Recitals**; **Traveling Exhibitions**.

Publications: collection catalogue, "Handbook of the Permanent Collection"; exhibition catalogues (4-5/year); magazine, "Bulletin" (3/year).

Located in the Oak Hill Historic District, the Blanden Memorial Art Museum was dedicated in 1932 as Iowa's first art museum. The permanent collection counts among its strengths European and Asian art. Holdings include works by internationally known artists Max Beckman, Alexander Calder, Marc Chagall, Joan Miró, and Henry Moore, as well as Iowa Regionalists Marvin Cone, Daniel Rhodes, Tom Savage, and Grant Wood. Throughout the year, the Museum hosts diverse visual arts exhibitions.

Grinnell

Grinnell College Print and Drawing Study Room

Burling Library, 1111 6th Ave., Grinnell, IA 50112-0811

Tel: (515) 269-3371

Fax: (515) 269-4283

Internet Address: http://www.grinnell.edu

Director: Ms. Kay Wilson-Jenkins

Admission: free.

Attendance: 4,500 *Established:* 1983 *ADA Compliant:* Y

Parking: lot at 6th Ave. & High St..

Open: **Academic Year**, Monday to Friday, 1pm-5pm; Sunday, 1pm-5pm.

Closed: Academic Holidays, Summer, Between Semesters.

Facilities: **Exhibition Area** (900 square feet); **Print Study Room**.

Activities: **Lectures**; **Temporary Exhibitions**.

Publications: exhibition catalogues.

Temporary exhibitions and selections from the College Permanent Art Collection are displayed in the Print and Drawing Study Room and Burling Gallery, located in the Burling Library. Intended primarily for use as a teaching collection, the permanent collection of paintings, sculpture, drawings and prints includes works by Calder, Chagall, Dürer, Picasso, Rauschenberg, Rembrandt, and Weber among other artists of national and international distinction. Also on campus, student artwork is displayed in the Scheaffer Gallery in the Fine Arts Center and the Terrace Gallery in the College Forum.

Indianola

Simpson College - Farnham Galleries

701 North C St., Indianola, IA 50125

Tel: (515) 961-6251

Fax: (515) 961-1498

Internet Address: http://www.simpson.edu

Director: Dr. Janet Heinicke

Admission: voluntary contribution.

Attendance: 450 *Established:* 1982 *ADA Compliant:* Y

Open: Monday to Friday, 8:30am-4:30pm; Saturday to Sunday, by appointment.

Facilities: **Galleries**.

Activities: **Artist-in-Residence Program**; **Education Programs** (college students); **Gallery Talks**; **Temporary Exhibitions**.

Located in Mary Berry Hall, the Farnham Galleries present a schedule of temporary art exhibitions.

Iowa City

University of Iowa Museum of Art

150 N. Riverside Drive, Iowa City, IA 52242-1789

Tel: (319) 335-1727

Fax: (319) 335-3677

Internet Address: http://www.uiowa.edu/~artmuseum

Director: Dr. Howard Creel Collinson

Admission: free.

Attendance: 35,000 *Established:* 1969 *Membership:* Y *ADA Compliant:* Y

Parking: metered lots across Riverside Drive and north of the museum.

Open: Tuesday to Saturday, 10am-5pm; Sunday, noon-5pm.

Closed: New Year's Day, Thanksgiving Day, Christmas Day.

Facilities: Galleries (12); **Print Study Room; Sculpture Court; Teaching Gallery.**

Activities: **Concerts; Education Programs; Guided Tours** (reserve in advance); **Lectures; Permanent Exhibits; Traveling Exhibitions.**

Publications: exhibition catalogues; newsletter.

Located in the Iowa Center for the Arts complex, the University of Iowa Museum of Art displays selections from its permanent collection and a program of varied temporary exhibitions, many organized by the Museum staff. The Museum strengths are in 20th-century American and European painting and sculpture, including works by Chagall, Gris, Léger, Matisse, and Picasso; Chinese jades; and African art, particularly sculpture. There are notable collections of pre-Columbian, Oceanic, Native American, and Near Eastern art; English and American silver; and contemporary American ceramics, prints, and photography.

Mason City

Charles H. MacNider Museum

303 2nd St., S.E., Mason City, IA 50401-3988

Tel: (515) 421-3666

Director: Mr. Richard E. Leet

Admission: free.

Attendance: 32,000 *Established:* 1964 *Membership:* Y *ADA Compliant:* Y

Parking: on street and nearby municipal lot.

Open: Tuesday, 9am-9pm; Wednesday, 9am-5pm; Thursday, 9am-9pm;
Friday to Saturday, 9am-5pm; Sunday, 1pm-5pm.

Closed: Legal Holidays.

Facilities: **Building** (21,300 square feet); **Classrooms; Galleries; Library** (1,500 volumes, non-circulating); **Reading Room; Sales/Rental Gallery; Shop.**

Activities: **Arts Festival; Concerts; Education Programs** (adults and children, 70 classes/year); **Films; Gallery Talks; Guided Tours; Lectures; Permanent Exhibits; Temporary Exhibitions.**

Publications: annual report; exhibition catalogues; newsletter (bi-monthly).

The MacNider Museum presents selections from its permanent collection and a schedule of temporary exhibitions. The permanent collection of approximately 1,000 works focuses on American art, providing examples of various periods, styles, and artists with a representative sampling of works by Iowan and Midwestern artists. Artists represented include George Bellows, Thomas Hart Benton, Aaron Bohrod, A.T. Bricher, Jasper Cropsey, Stephen de Staebler, Arthur Dove, Sam Francis, Morris Graves, Philip Guston, G.P.A. Healey, Mauricio Lasansky, Jack Levine, John Marin, Maria Martinez, Nathan Oliveira, John Sloan, Paul Soldner, Toshiko Takeazu, Grant Wood, and Henriette Wyeth. Holdings also include the largest collection of the creations of puppeteer Bil Baird to be found anywhere.

Mount Vernon

Cornell College - Armstrong Gallery

Armstrong Hall of Fine Arts, 600 1st St., West, Mount Vernon, IA 52314-1098
Tel: (319) 895-4137
Fax: (319) 895-4492
Internet Address: http://www.cornell-iowa.edu
Department Chairman: Mr. Anthony Plaut
Admission: free.
Attendance: 500 *Established:* 1853
Open: **Academic Year**, Monday to Friday, 9am-4pm; Sunday, 2pm-4pm.
Closed: Academic Holidays.
Facilities: **Exhibition Area.**
Activities: **Education Programs** (undergraduate college students); **Lectures**; **Temporary Exhibitions.**

Located in Armstrong Hall of Fine Arts, the gallery presents monthly student and traveling exhibitions. Armstrong Hall houses the College's art collections, including the Whiting Glass Collection; nearly 200 prints from the collection of Dr. William K. Jacques; the Sonnenshein Collection of drawings by Carlo Dolci, Gustave Doré, and others; a permanent collection of paintings, including works by Richard Anuskiewiscz, Karel Appel, and Larry Rivers; and a slide collection. Also of possible interest on campus is the Commons Gallery (open 8am to midnight), which mounts monthly exhibitions.

Muscatine

Muscatine Art Center

1314 Mulberry Ave., Muscatine, IA 52761
Tel: (319) 263-8282
Fax: (319) 263-4702
Director: Ms. Barbara C. Longtin
Admission: free.
Attendance: 12,000 *Established:* 1965 *Membership:* Y *ADA Compliant:* Y
Parking: on street and Cedar St. parking lot.
Open: Tuesday to Wednesday, 10am-5pm; Thursday, 10am-5pm and 7pm-9pm; Friday, 10am-5pm; Saturday to Sunday, 1pm-5pm.
Closed: Legal Holidays.
Facilities: **Architecture** (Edwardian mansion, 1908); **Auditorium**; **Classrooms**; **Gallery**; **Library** (1,000 volumes, non-circulating).
Activities: **Concerts**; **Education Programs** (adults and children); **Films**; **Gallery Talks**; **Guided Tours** (groups, schedule in advance); **Lectures**; **Permanent Exhibits**; **Temporary Exhibitions.**
Publications: exhibition catalogues; newsletter (bi-monthly).

The Art Center complex includes the Edwardian Musser Mansion and the Stanley Gallery, which presents changing exhibitions and provides space for studio art classes. The permanent collection includes works by American artists Allan Houser, Mauricio Lasansky, Georgia O'Keeffe, John Mix Stanley, and Grant Wood and European artists Boudin, Chagall, Degas, Matisse, and Renoir. The Center's Great River Collection features drawings, prints, and maps of the Mississippi River. Holdings also include decorative arts, furniture, and American art pottery.

Pella

Central College - Mills Gallery

Art and Behavioral Science Building, 812 University, Pella, IA 50219
Tel: (515) 628-9000
Internet Address: http://www.central.edu/camplife/mills.html
Open: Monday to Friday, 9am-4pm.
Facilities: **Exhibition Area.**

Central College - Mills Gallery, cont.
Activities: **Temporary Exhibitions.**

The Gallery maintains a schedule of changing exhibitions including a senior art exhibition. (Each exhibition opens on the first weekday of the month and concludes on the last weekday of the month.) The College's permanent collections focuses on contemporary American drawings and prints.

Sioux City

Sioux City Art Center
225 Nebraska St., Sioux City, IA 51101-1712
Tel: (712) 279-6272 *Ext:* 200
Fax: (712) 255-2921
Internet Address: http://www.sc-artcenter.com
Director: Mr. Ronald Bernier
Admission: free.
Attendance: 70,000 *Established:* 1938
Membership: Y *ADA Compliant:* Y
Parking: metered on street and city lots and free public lot.

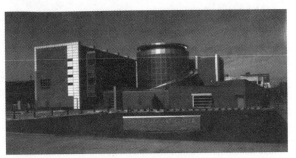

Exterior view of Sioux City Art Center (1996) designed by Skidmore, Owings, & Merrill. Photograph courtesy of Sioux City Art Center, Sioux City, Iowa.

Open: Tuesday to Wednesday, 10am-5pm; Thursday, noon-9pm; Friday to Saturday, 10am-5pm; Sunday, 1pm-5pm.
Closed: Legal Holidays.
Facilities: **Architecture** (1996 design by Skidmore, Owings, & Merrill of Chicago); **Children's Gallery** (Hands On!); **Exhibition Area** (6 galleries); **Lecture Hall** (131 seats); **Library** (non-lending); **Shop** (original art); **Studios** (5).
Activities: **Arts Festival** (Labor Day Weekend, ARTSPLASH); **Education Programs** (adults and children); **film series**; **Gallery Talks**; **Guided Tours** (reserve in advance); **Lectures**; **Permanent Exhibits**; **Temporary Exhibitions**.
Publications: annual report; exhibition catalogues; newsletter, "Artist's Proof" (quarterly).

The Center displays national and regional traveling exhibitions in five galleries and selections from its own holdings in a permanent collection gallery . The permanent collection of approximately 900 pieces includes representative works by such masters as Salvador Dali, David Hockney, James McNeill Whistler, and Grant Wood, as well as artwork from contemporary artists from the Upper Midwest. Works on display in the permanent collection gallery change every four to six months to provide public access over time to the entire collection. The building also features the Hands On! Gallery in which art may be experienced through twelve interactive stations.

Storm Lake

Witter Gallery
609 Cayuga St., Storm Lake, IA 50588
Tel: (712) 732-3400
Director: Ms. Joleen Dentlinger
Admission: voluntary contribution.
Attendance: 9,000 *Established:* 1972
Membership: Y *ADA Compliant:* Y
Open: Monday to Thursday, 1:30pm-4pm;
Friday. 1:30pm-7pm;
Saturday, 10am-noon.
Closed: Legal Holidays.
Facilities: **Gallery.**
Activities: **Arts Festival**; **Demonstrations**; **Education Programs** (adults and children); **Guided Tours** (by appointment); **Juried Exhibits** (December, Holiday Biennial); **Lectures**; **Performances**; **Temporary Exhibitions**; **Traveling Exhibitions**; **Workshops and Art Classes.**

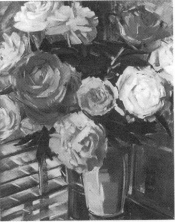

Ella Witter, *Peonies*, early 1950s, oil on canvas. Permanent Collection of Witter Gallery. Photograph courtesy of Witter Gallery, Storm Lake, Iowa.

295

Storm Lake, Iowa

Witter Gallery, cont.

Publications: newsletter (monthly).

Given as a gift to the community by artist and teacher Ella Witter, daughter of one of the founders of Storm Lake, the Witter Gallery offers monthly exhibitions, including solo and group shows by regional artists working in a variety of media as well as touring exhibitions.

Waterloo

Waterloo Museum of Art

Waterloo Center for the Arts
225 Commercial St.
Waterloo, IA 50701
Tel: (319) 291-4491
Fax: (319) 291-4490
Internet Address:
 http://www.waterloo-ia.org/arts
Director: Ms. Cammie V. Scully
Admission: voluntary contribution.
Attendance: 60,000
Membership: Y *ADA Compliant:* Y
Parking: free on site.
Open: Monday to Friday, 10am-5pm;
 Saturday to Sunday, 1pm-4pm.

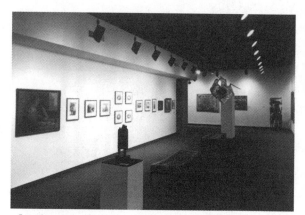

Interior view of a gallery at the Waterloo Museum of Art. Photograph courtesy of Waterloo Museum of Art, Waterloo, Iowa.

Closed: New Year's Day, Memorial Day, Independence Day, Labor Day, Veterans Day, Thanksgiving Day to Thanksgiving Friday, Christmas Day to December 26.

Facilities: **Auditorium** (250 seats); **Children's Gallery** (interactive, based on cultural themes; Sat-Sun, 1pm-4pm); **Classrooms**; **Galleries**; **Library** (2,000 volumes, by appointment); **Sculpture Court**; **Shop** (original art by Midwestern artists, crafts, Haitian art; Sat-Sun, 1pm-4pm); **Theatres** (2; 385 seats and 68 seats).

Activities: **Arts Festival**; **Concerts**; **Education Programs** (adults and children); **Films**; **Gallery Talks**; **Guided Tours**; **Lectures**; **Performances**; **Permanent Exhibits**; **Temporary Exhibitions**; **Traveling Exhibitions**.

Publications: calendar (monthly); class brochures; exhibit/program announcements; exhibition catalogues; newsletter (quarterly).

Located in the Waterloo Center for the Arts, the Museum features regional paintings, sculpture, prints and drawings, including works by Grant Wood, Marvin Cone, and Thomas Hart Benton; an extensive collection of Caribbean folk art with an emphasis on Haitian paintings and sculpture; American decorative art, including pottery, jewelry, glass, textiles and mixed media; and American folk art. The Museum organizes and mounts approximately 35 exhibitions each year. Exhibitions of selections from the permanent collection in the Reuling, Reddington and Grant Wood galleries change twice a year. Exhibitions in the Raymond T. Fosberg Riverside galleries, which interpret and expand upon the permanent collection, change every five weeks. Additionally, small exhibitions of selected permanent collection works and special community outreach exhibits are displayed in the Rotary-Lichty Galleries. The Center also houses the Waterloo Community Theater, Black Hawk Children's Theater, the Waterloo/Cedar Falls Symphony offices, Metropolitan Chorale, and Waterloo Municipal Band.

Kansas

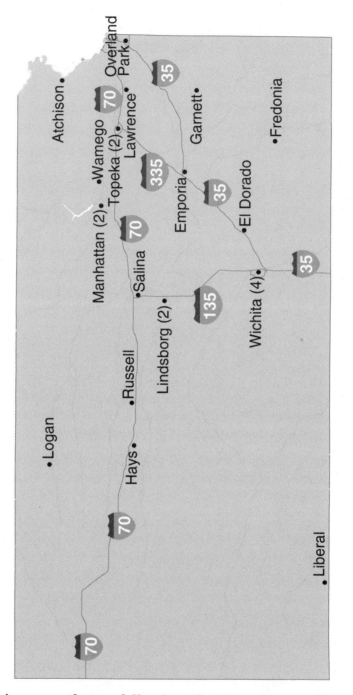

The number in parentheses following the city name indicates the
number of museums/galleries in that municipality. If there is no num-
ber, one is understood. For example, in the text four listings would be
found under Wichita and one listing under El Dorado.

Kansas

Atchison

The Muchnic Gallery

Atchison Art Association, 704 North 4th, Atchison, KS 66002
Tel: (913) 367-4278
Fax: (913) 367-2939
Director and Curator: Ms. Gloria Conkle Davis
Admission: fee-$2.00.
Attendance: 700 *Established:* 1970
Open: Wednesday, 10am-5pm; Saturday to Sunday, 1pm-5pm.
Facilities: **Architecture** (Victorian brick residence, 1885).
Activities: **Guided Tours**; **Permanent Exhibits**; **Traveling Exhibitions**.
Publications: brochure, "Tour Guide of Home".

The Gallery's collection includes paintings and lithographs by John Falter, John Steuart Curry, Thomas Hart Benton, Robert Sudlow, and Jack O'Hara.

El Dorado

Coutts Memorial Museum of Art, Inc.

110 N. Main St, El Dorado, KS 67042-0001
Tel: (316) 321-1212
Fax: (316) 321-1215
Internet Address:
 http://www.kumc.edu/kansas/museums/coutts
C.E.O.: Ms. Rhoda Hodges
Admission: voluntary contribution.
Attendance: 3,000 *Established:* 1970
Membership: N *ADA Compliant:* Y
Open: Mon/Weds/Fri, 1pm-5pm;
 Tues/Thurs, 9am-noon and 1pm-5pm.
Closed: Holidays.
Facilities: **Architecture** (early 20th Century former bank building); **Exhibition Area.**
Activities: **Arts Festival**; **Concerts**; **Gallery Talks**; **Guided Tours** (groups of 12 or more by appointment).

Thomas Hart Benton, *The Music Lesson*, lithograph. Collection of and photograph courtesy of Coutts Memorial Museum of Art, El Dorado, Kansas.

The Museum houses over 1,000 works of art in a variety of media. There are works from Russia, China, France, Holland, England, and South America. American art in the collection includes prints by Seward, Foltz, Capps, Benton, and Sandzen. Contemporary Kansas art is represented by works of Carver, Sanderson, James, Hamil, Rogers, and Fallier. Finally, there is a collection of Western art, including numerous bronzes by Remington, as well as by Hoffman and Russell.

Emporia

Emporia State University - Norman R. Eppink Art Gallery

King Hall, 13th and Market Streets, Emporia, KS 66801
Tel: (316) 341-5246
Fax: (316) 341-6246
Internet Address: http://www.emporia.edu/art/eppink.htm
Director: Mr. Donald Perry
Admission: no admission charge.
Attendance: 11,000 *Established:* 1939 *ADA Compliant:* Y
Open: Monday to Friday, 9am-4pm.
Closed: Academic Holidays.

Emporia, Kansas

Emporia State University - Norman R. Eppink Art Gallery, cont.

Facilities: **Auditorium** (400 seats); **Classrooms**; **Food Services** Cafeteria; **Gallery**; **Library**; **Nature Center**; **Reading Room**; **Theatre**.

Activities: **Education Programs** (graduate and undergraduate college students); **Gallery Talks**; **Guided Tours**; **Lectures**; **Temporary Exhibitions**; **Traveling Exhibitions**.

Publications: catalogue, "Art Faculty Exhibition"; catalogue, "National Invitational Drawing Exhibition Catalogue".

The Gallery features temporary exhibitions. Across the hall from the Gallery is the Gilson Memorial Room, which also displays temporary exhibitions.

Fredonia

Stone House Gallery

Fredonia Arts Council, Inc., 320 North 7th St., Fredonia, KS 66736
Tel: (316) 378-2052
Director: Janice J. Elmore
Admission: free.
Attendance: 10,000 *Established:* 1967 *Membership:* Y
Open: **September to July**, Monday to Friday, 12:30pm-4:30pm.
Closed: New Year's Day, Independence Day, Thanksgiving Day, Christmas Day.
Facilities: **Gallery**.
Activities: **Arts Festival**; **Education Programs** (adults and children); **Films**; **Gallery Talks**; **Guided Tours**; **Lectures**; **Performances**; **Temporary Exhibitions** (monthly); **Traveling Exhibitions**; **Workshops**.
Publications: newsletter (quarterly).

Located in the oldest house in Fredonia, the Gallery presents temporary exhibitions, some of which are traveling.

Garnett

Garnett Public Library - The Mary Bridget McAuliffe Walker Art Collection

125 West 4th Ave., Garnett, KS 66032-1406
Tel: (913) 448-3388
Fax: (913) 448-3936
Internet Address: http://www.kanza.net/garnett
Contact: Mr. Robert Logan
Admission: voluntary contribution.
Attendance: 8,000 *Established:* 1965
Membership: Y *ADA Compliant:* Y
Parking: free on street.
Open: Monday to Tuesday, 10am-8pm;
 Wednesday, 10am-5:30pm;
 Thursday, 10am-8pm;
 Friday, 10am-5:30pm;
 Saturday, 10am-4pm.
Closed: New Year's Day, Memorial Day, Independence
 Day, Thanksgiving Day, Christmas Day,
 Labor Day, Presidents Day, Veterans Day.
Facilities: **Exhibition Area**; **Library**.
Activities: **Guided Tours** (by appointment); **Lectures**; **Permanent Exhibits**; **Temporary Exhibitions**.

John Steuart Curry, *Tobacco Plant*, c. 1934, oil on canvas, 26 x 20 inches. Gift of Maynard Walker, 1951. Collection of and photograph courtesy of Mary Bridget McAuliffe Walker Art Collection, Garnett, Kansas.

Garnett Public Library - The Mary Bridget McAuliffe Walker Art Collection, cont.

The Mary Bridget McAuliffe Walker Art Collection, housed in the Garnett Public Library's Dorothy Archer Room, was established in 1951 by Maynard Walker in honor of his mother. Walker, a Garnett native, was a prominent art dealer in New York. During the 1930s and 1940s, he was the primary promoter of the Regionalist painters -- John Steuart Curry, Grant Wood and Thomas Hart Benton. The Walker Art Collection consists mostly of early twentieth-century American painting, sculpture, prints and drawings, including works by Kenneth Callahan, John F. Carlson, John Steuart Curry, Arthur B. Davies, Robert Henri, Walt Kuhn, Luigi Lucioni, Henry Varnum Poor, Boardman Robinson, and Theodoros Stamos. Artists of the Midwest in the collection include Milruth Busby, John F. Helms, Frederick James, Dwight and John Kirsch, David Overmeyer, Adeline Peers, and Pauline Shirer. England is represented by the animal drawing of John Skeaping and a collection of caricature drawings of cats and dogs by Louis Wain. European artists represented include George Grosz (after he moved to the United States), Edouard Manet, and Jean Baptiste Corot. Recent acquisitions include a glass sculpture by Dale Chihuly, a collection of contemporary ceramics by Karen Karnes, John Glick, Paul Soldner, and Jerry Rothman, among others. There are also works on paper by Josef Albers, Mario Marini, Rufino Tamayo, Hans Burkhardt, and painting by Tom Enman, John Sonsini and Jeff Price in the collection.

Hays

Fort Hays State University - Moss-Thorns Gallery of Art

Department of Art, 600 Park St., Rarick Hall #102, Hays, KS 67601-4099
Tel: (642) 628-4247
Internet Address: http://www.fhsu.edu/htmlpages/arts/gallery.html
Director: Ms. Sondra Schwetman
Admission: free.
Open: **Academic Year**, Monday to Friday, 8:30am-4:30pm.
 Summer, Monday to Thursday, 8am-4:30pm; Friday, 8am-11am.
Facilities: **Exhibition Area.**
Activities: **Temporary Exhibitions.**

The Gallery presents temporary exhibitions including annual Faculty, Student Honors and Graduate Thesis Exhibitions.

Lawrence

University of Kansas - Spencer Museum of Art

University of Kansas, 1301 Mississippi St., Lawrence, KS 66045-2136
Tel: (785) 864-4710
Fax: (785) 864-3112
TDDY: (800) 776-3777
Internet Address: http://www.ukans.edu/~sma
Director: Andrea S. Norris
Admission: voluntary contribution.
Attendance: 75,000 *Established:* 1928 *Membership:* Y *ADA Compliant:* Y
Parking: metered lot north of museum.
Open: Tuesday to Wednesday, 10am-5pm; Thursday, 10am-9pm; Friday to Saturday, 10am-5pm;
 Sunday, noon-5pm.
Closed: New Year's Day, Independence Day, Thanksgiving Day to Thanksgiving Friday,
 Christmas Eve to Christmas Day.
Facilities: **Galleries** (11); **Library** (90,000 volumes); **Shop.**
Activities: **Concerts; Education Programs** (adults and children); **Films; Guided Tours;
 Lectures; Permanent Exhibits; Temporary Exhibitions; Traveling Exhibitions.**
Publications: collection catalogues; exhibition catalogues; journal, "The Register of the Spencer
 Museum of Art" (annual); newsletter (monthly).

Lawrence, Kansas
University of Kansas - Spencer Museum of Art, cont.

The Museum displays works in eleven galleries from a comprehensive collection of over 17,000 objects that spans the history of European, North American, and East Asian art. Areas of special strength include medieval art; European and American paintings, sculpture and prints; photography; Japanese Edo-period paintings and prints; and 20th-century Chinese painting. There are also Western and Asian prints, drawings, textiles, and decorative arts, including a renowned quilt collection.

Liberal

Baker Arts Center

624 N. Pershing, Liberal, KS 67901
Tel: (316) 624-2810
Director: Ms. Laura Smith
Admission: voluntary contribution.
Attendance: 15,000 *Established:* 1986
Membership: Y *ADA Compliant:* Y
Parking: free on site.
Open: Tuesday to Friday, 10am-5pm;
Saturday to Saturday, 2pm-4pm.
Facilities: **Discovery Center for children**; **Exhibition Area** (4 galleries); **Library**.
Activities: **Art Exploration**; **Guided Tours**.

The Center houses a permanent collection of regional art, including a series of lithographs by John Steuart Curry. In addition, it mounts temporary exhibitions every four to six weeks, focusing on the work of locally, regionally, and nationally known artists.

John Steuart Curry, *Our Good Earth*, lithograph. Baker Arts Center collection. Photograph courtesy of Baker Arts Center, Liberal, Kansas.

Lindsborg

Bethany College - Mingenback Art Center Gallery

421 N. 1st St., Lindsborg, KS 67456
Tel: (785) 227-3311 *Ext:* 8244
Internet Address: http://www.bethanylb.edu
Art Chair: Caroline Kahler
Admission: free.
Open: **September to June**, Daily, 8am-5pm.
Facilities: **Exhibition Area**.
Activities: **Lecture Series**; **Temporary Exhibitions**.

Located on the southwest edge of the campus, the Mingenback Art Center Gallery mounts exhibitions year round of student and outside artists work. Also of possible interest, adjacent to the campus is the Birger Sandzen Memorial Gallery, dedicated to the works of the artist-teacher who dominated the art scene at Bethany and in Lindsborg during the first half of the twentieth century.

Birger Sandzen Memorial Gallery

401 North 1st St., Lindsborg, KS 67456
Tel: (913) 227-2220
Fax: (913) 227-4170
Internet Address: http://www.sandzen.org/gallery.htm
Director: Mr. Larry L. Griffis
Admission: free, voluntary contribution.
Attendance: 7,300 *Established:* 1957 *Membership:* Y *ADA Compliant:* Y

Birger Sandzen Memorial Gallery, cont.

Parking: free on site.

Open: Tuesday to Sunday, 1pm-5pm.

Closed: New Year's Day, Memorial Day, Independence Day, Thanksgiving Day, Christmas Day.

Facilities: **Archives; Exhibition Area; Gallery and Recital Area; Sales Desk.**

Activities: **Concerts; Gallery Talks; Guided Tours** (by appointment); **Lectures; Permanent Exhibits; Temporary Exhibitions.**

Publications: book, "Birger Sandzen: An Illustrated Biography".

Birger Sandzen, *Sunset, Estes Park, Colorado*, 1921, oil on canvas. Birger Sandzen Memorial Gallery. Photograph by Jaderborg Photography, courtesy of Birger Sandzen Memorial Gallery, Lindsborg, Kansas.

The Sandzen Gallery is located on the south edge of the Bethany College campus. It houses a collection of works by Birger Sandzen, as well as paintings, prints, ceramics, and sculpture by other artists, both European and American. The Gallery also has an active schedule of temporary exhibitions of the work of local and regional artists.

Logan

Dane G. Hansen Memorial Museum

110 W. Main St., Logan, KS 67646

Tel: (785) 689-4846

Fax: (785) 689-4833

Director: Ms. Jo Ann Sammons

Admission: free.

Attendance: 10,000 *Established:* 1973 *Membership:* Y *ADA Compliant:* Y

Parking: free on site.

Open: Monday to Friday, 9am-noon and 1pm-4pm; Saturday, 9am-noon and 1pm-5pm; Sunday, 1pm-5pm, also Holidays.

Closed: New Year's Day, Thanksgiving Day, Christmas Day.

Facilities: **Exhibition Area.**

Activities: **Arts & Crafts Fair** (3rd Saturday in September); **Guided Tours; Permanent Exhibits; Traveling Exhibitions** (approximately 6/year).

Publications: brochures; newsletter (quarterly).

The collection of the Dane G. Hansen Museum is housed in an impressive structure designed by Kiene and Bradley of Topeka, which also contains offices and a community meeting room. The collection includes works by John Steuart Curry, Birger Sandzen, and Charles Rogers, as well as a collection of works by Kansas artists and Japanese artifacts. The Museum mounts five to seven traveling exhibitions per year from the collection of the Smithsonian, along with other temporary exhibits.

Manhattan

Kansas State University - Marianna Kistler Beach Museum of Art

Kansas State University, 701 Beach Lane, Manhattan, KS 66506

Tel: (785) 532-7718

Fax: (785) 532-7498

Internet Address: http://www.ksu.edu/bma

Admission: voluntary contribution.

Attendance: 22,000 *Established:* 1996 *Membership:* Y *ADA Compliant:* Y

Parking: free on site.

Kansas State University - Marianna Kistler Beach Museum of Art, cont.

Open: Tuesday to Wednesday, 10am-5pm;
Thursday, 10am-8:30pm;
Friday to Saturday, 10am-5pm;
Sunday, 1pm-5pm.

Closed: Major Holidays.

Facilities: **Food Services** Café; **Galleries**; **Shop**.

Activities: **Gallery Talks**; **Guided Tours** (by appointment); **Internships**; **Lecture Series** ("Arts Above the Arch", every other Thursday evening); **Permanent Exhibits**; **Temporary Exhibitions**; **Visiting Artist Program**.

Publications: catalogues; newsletter, "BMA Newsletter" (3 per year).

The Beach Museum of Art houses Kansas State University's 20th-century American art collection. This collection, with its special emphasis on works by regional artists and American printmakers, includes works by John Steuart Curry, Birger Sandzen, and Dale Chihuly. The building , which opened in 1996, has 9,000 square feet of gallery space. The Museum also mounts temporary exhibitions of works from other major institutions, as well as solo and group shows of the work of contemporary artists.

View of entrance, Beach Museum of Art. Photograph by Douglas Kahn, courtesy of Beach Museum of Art, Kansas State University, Manhattan, Kansas.

Manhattan Center for the Arts Galleries

1520 Poyntz Ave., Manhattan, KS 66502

Tel: (785) 537-4420

Fax: (785) 539-3356

Internet Address: http://www.flinthills.com/~arts

Director: Mr. Galen Wixon

Admission: voluntary contribution.

Attendance: 1,000 *Membership:* Y *ADA Compliant:* Y

Parking: free on site.

Open: Monday to Friday, 9am-5pm; Saturday, 1pm-4pm.

Facilities: **Galleries** (2); **Theatre**.

Activities: **Temporary Exhibitions**.

Publications: magazine, "City Arts Magazine" (7 per year).

The Galleries present temporary exhibitions of works by students (e.g., Kansas State University graduate students) and professional artists in a wide variety of media.

Overland Park

Johnson County Community College Gallery of Art

12345 College Blvd., Overland Park, KS 66210-1299

Tel: (913) 469-8500 *Ext:* 3972

Fax: (913) 469-2348

TDDY: (913) 469-3885

Internet Address: http://www.jccc.net/gallery

Director: Mr. Bruce Hartman

Admission: free.

Attendance: 200,000 *Established:* 1969

Membership: Y *ADA Compliant:* Y

Barry Flanagan, *Hare and Bell*, 1988, bronze; 138 x 72 x 108 inches. Oppenheimer-Stein Sculpture Collection. Gift of Jules and Doris Stein Foundation and H. Tony and Marti Oppenheimer. Photograph courtesy of Gallery of Art, Johnson County Community College, Overland Park, Kansas.

Johnson County Community College Gallery of Art, cont.

Parking: free on site.

Open: **Fall to Spring,**
 Monday, 10am-5pm; Tuesday to Wednesday, 10am-7pm; Thursday to Friday, 10am-5pm;
 Saturday to Sunday, 1pm-5pm.
 Summer,
 Monday, 10am-5pm; Tuesday to Wednesday, 10am-7pm; Thursday to Friday, 10am-5pm;
 Saturday, 1pm-5pm.

Closed: Legal Holidays.

Facilities: **Auditoria** (1,400 seats and 400 seats); **Exhibition Area** (3,000 square feet); **Outdoor Sculpture Collection**; **Theatre** (150 seats).

Activities: **Concerts**; **Dance Recitals**; **Education Programs** (adults, undergraduate college students, and children); **Films**; **Guided Tours**; **Lectures**; **Performances**; **Temporary Exhibitions**; **Traveling Exhibitions**.

Publications: exhibition brochures (6 per year).

With 3,000 square feet of exhibition space, the Gallery presents seven major exhibitions of contemporary art each year, drawing on artists, museums, galleries, and private collections, both nationally and internationally. The College houses a permanent collection of contemporary art. In addition, numerous large-scale and site-specific sculptures have been installed on the College grounds.

Russell

Deines Cultural Center

820 N. Main St., Russell, KS 67665

Tel: (785) 483-3742

Fax: (785) 483-4397

Director: Nancy Selbe

Admission: voluntary contribution.

Attendance: 2,500 *Established:* 1990

Membership: Y *ADA Compliant:* Y

Parking: on street in front and behind building.

Open: Tuesday to Sunday, 1pm-5pm.

Facilities: **Exhibition Area**.

Activities: **Temporary Exhibitions**; **Traveling Exhibitions**.

Exterior view, Deines Cultural Center. Photograph courtesy of Deines Cultural Center, Russell, Kansas.

The Deines Center houses the wood engravings of E. Hubert Deines, as well as some fifty works by other artists. The Center also mounts monthly temporary exhibitions in a variety of media, including traveling exhibitions.

Salina

Salina Art Center

242 S. Santa Fe, Salina, KS 67401

Tel: (913) 827-1431

Fax: (913) 827-0686

Internet Address: http://www.salinaartcenter.org

Co-Directors: Heather Smith/Wendy Moshier

Admission: voluntary contribution.

Attendance: 59,522 *Established:* 1978 *Membership:* Y *ADA Compliant:* Y

Parking: free on site.

Open: Tuesday to Wednesday, noon-5pm; Thursday, noon-7pm; Friday to Saturday, noon-5pm; Sunday, 1pm-5pm.

Closed: Legal Holidays.

Facilities: **Classroom**; **Galleries** (3); **Theatre**.

Activities: **Concerts**; **Films**; **Guided Tours**; **Lectures**.

Publications: "Exhibits and Programs Guide" (annual); exhibition catalogues.

Salina, Kansas

Salina Art Center, cont.

The Salina Art Center is a non-collecting contemporary art institution presenting exhibitions of art year-round, both traveling and original.

Topeka

Topeka and Shawnee County Public Library - Alice C. Sabatini Gallery

1515 SW 10th, Topeka, KS 66604-1374
Tel: (913) 231-0527
Fax: (913) 233-2055
Gallery Director: Mr. Larry D. Peters
Admission: free.
Attendance: 18,000 *Established:* 1870
Membership: Y *ADA Compliant:* Y
Parking: free on site.
Open: Closed
 (under construction will reopen January 2002.)
Facilities: **Auditorium** (200 seats); **Exhibition Area**; **Library** (30,000 volumes); **Reading Room**.
Activities: **Gallery Talks**; **Lectures**; **Temporary Exhibitions**.
Publications: exhibition catalogues (occasional).

The permanent collection of the Gallery includes contemporary American ceramics; Art Nouveau glass and ceramics; glass paperweights; George Lopez carving from Cordova, New Mexico; 19th- and 20th-century Chinese decorative arts; prints; regional painting; and West African arts. The facility is currently under construction and the gallery is closed. It will reopen in January 2002.

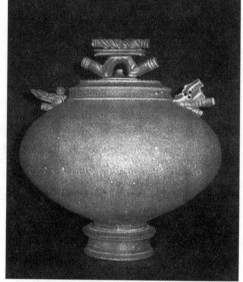

Tim Mather, *Covered Jar*, stoneware, 14¼ inches (h) x 13 1/8 inches (w). Collection of and photograph courtesy of Topeka and Shawnee County Public Library, Topeka, Kansas.

Washburn University of Topeka - Mulvane Art Museum

Washburn University of Topeka, 17th and Jewell Streets, Topeka, KS 66621-1150
Tel: (913) 231-1010 *Ext:* 1324
Fax: (913) 234-2703
Internet Address: http://www.washburn.edu/cas/music/mulvane.html
Director: Robert T. Soppelsa, Ph.D.
Admission: voluntary contribution.
Attendance: 12,000 *Established:* 1922 *Membership:* Y *ADA Compliant:* Y
Parking: free across from museum.
Open: **September to mid-May,**
 Tuesday to Wednesday, 10am-7pm; Thursday to Friday, 10am-4pm;
 Saturday to Sunday, 1pm-4pm.
 mid-May to August,
 Tuesday to Friday, 10am-4pm; Saturday to Sunday, 1pm-4pm.
Closed: Academic Holidays, Exhibit Installation.
Facilities: **Fine Arts Library**; **Food Services** Café; **Print Study Room**; **Shop**.
Activities: **Art Classes** (K-adult); **Arts Festival**; **Concerts**; **Gallery Talks**; **Guided Tours**; **Lectures**; **Readings**.
Publications: brochures; exhibition catalogues; newsletter.

The Museum mounts ten to twelve temporary exhibitions per year and has a permanent collection of classical art, modern European art, Kansas-related art, and prints and drawings.

Wamego

The Columbian Theatre, Museum and Art Center

521 Lincoln, Wamego, KS 66547

Tel: (913) 456-2029

Fax: (913) 456-9498

Co-Directors: Barb Hopper/Scott Kickhoefer

Admission: **Exhibit** requested donation: adult-$3.00, child-free.
 Theatre fee: adult-$15.00, child-$8.00.

Attendance: 50,000 *Established:* 1990 *Membership:* Y *ADA Compliant:* Y

Open: Tuesday to Saturday, 10am-5pm; Sunday, 1pm-5pm.
 (Call for times and reservations for dinner and theatre productions.)

Closed: Easter, Thanksgiving Day, Christmas Day.

Facilities: **Exhibition Area.**

Activities: **Dinner Theatre; Permanent Exhibits, Rotating Exhibits.**

The Columbian Theatre was built in 1895 to display six murals depicting the promise and wealth of the United States that were created for the 1893 Chicago World's Fair by German artist E. Theodore Behr. The Museum mounts temporary exhibitions.

Wichita

Indian Center Museum

650 N. Seneca, Wichita, KS 67203

Tel: (316) 262-5221

Fax: (316) 262-4216

Exec. Director: Mr. Jerry P. Martin

Admission: fee: adult-$2.00, child-$1.00.

Attendance: 70,000 *Established:* 1975

Membership: Y *ADA Compliant:* Y

Parking: free on site.

Open: **January to March,**
 Tuesday to Saturday, 10am-5pm; Sunday, 1pm-5pm.

 April to December,
 Monday to Saturday, 10am-5pm; Sunday, 1pm-5pm.

Closed: New Year's Eve to New Year's Day, Easter,
 Thanksgiving Day, Christmas Day.

Facilities: **Exhibition Area; Library** (1,250 volumes, non-circulating); **Rental Gallery; Shop.**

Activities: **Gallery Talks; Guided Tours; Lectures; Permanent Exhibits; Temporary Exhibitions; Traveling Exhibitions.**

Publications: "The Keeper of the Plains".

Blackbear Bosin, *Keeper of the Plains*, steel; height, 44 feet. Indian Center Museum. Photograph courtesy of Indian Center Museum, Wichita, Kansas.

The Indian Center Museum, located at the Mid-America All-Indian Center, preserves and showcases the heritage of the Native American tribes of North America. Permanent and rotating exhibits of both traditional artifacts and contemporary art depict the Native American cultures of the past and present.

Wichita Art Museum

619 Stackman Drive, Wichita, KS 67203

Tel: (316) 268-4921

Fax: (316) 268-4980

Internet Address: http://www.wichitaartmuseum.org

Director: Mr. Charles K. Steiner

Admission: free.

Attendance: 72,000 *Established:* 1935 *Membership:* Y *ADA Compliant:* Y

Parking: free lot behind building.

Open: Tuesday to Saturday, 10am-5pm; Sunday, noon-5pm.

Wichita Art Museum, cont.

Closed: Legal Holidays.

Facilities: **Food Services** Restaurant (Tuesday-Friday, 11:30am-1:30pm; Sunday, noon-2pm); **Galleries** (25,000 square feet); **Library** (7,900 volumes; by appointment); **Shop.**

Activities: **Permanent Exhibits; Temporary Exhibitions; Traveling Exhibitions.**

Publications: brochures; exhibition catalogues; magazine, "WAMViews" (bi-monthly).

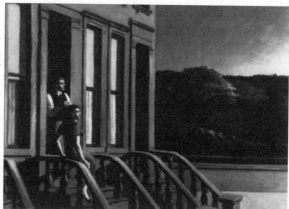

Edward Hopper, *Sunlight on Brownstones*, 1956, oil on canvas. Wichita Art Museum, Roland P. Murdock Collection. Photograph courtesy of Wichita Art Museum, Wichita, Kansas.

The collection of the Wichita Art Museum is housed in an art deco building (1935), with an addition designed by Edward Larrabee Barnes (1977). The Museum focuses on American art, and owns major works by Copley, Eakins, Ryder, Cassatt, Henri, Lawrence, Prendergast, Glackens, Hopper, Marin, Dove, and Russell. There are separate collections of American Impressionism, American and European prints and drawings, British watercolors, and Pre-Columbian Art. The collection also includes Goya's "Los Caprichos" and Blake's "Illustrations of the Book of Job". In addition to displaying its permanent collection, the Museum mounts temporary exhibitions of regional and national significance.

Wichita Center for the Arts (WCA)

9112 E. Central, Wichita, KS 67206

Tel: (316) 634-2787

Fax: (316) 634-0593

Internet Address: http://www.wcfta.com

Director: Mr. Howard W. Ellington

Admission: voluntary contribution.

Attendance: 60,000 *Established:* 1920 *Membership:* Y *ADA Compliant:* Y

Parking: free on site.

Open: Tuesday to Sunday, 1pm-5pm.

Closed: Legal Holidays, 1st week of July, 3rd Thursday in November.

Facilities: **Galleries** (14,000 square feet); **Library** (3,000 volumes, non-circulating); **Studios/Classrooms; Theatre** (484 seats).

Activities: **Concerts; Education Programs** (adults and children); **Films; Lectures; Performances** (6 plays per year); **Permanent Exhibits; Temporary Exhibitions.**

Publications: annual report; bulletins; exhibition catalogues; newsletter, "Center News" (bi-monthly).

Birger Sandzen, *Lake at Sunset*, 1921, 88" x 68". Collection of Wichita Center for the Arts. Photograph courtesy of Wichita Center for the Arts, Wichita, Kansas.

The Wichita Center for the Arts offers a gallery, a professional community theatre, film screenings, a visual arts school, and a creative child preschool. The Center houses four galleries; three are devoted to temporary exhibitions, and the fourth displays the permanent collection. The permanent collection of over 6,000 works of art was established early in the organization's history as faculty, regional artists, and benefactors donated individual works and entire collections to the Center. Of particular note is the Decorative Arts Collection, which is composed largely of purchased prize-winning items from the Wichita National All Media Crafts Exhibition, founded by the Center in 1946 and the first show of its kind.

Wichita State University - Edwin A. Ulrich Museum of Art

1845 Fairmount, Wichita, KS 67260-0046
Tel: (316) 578-3664
Fax: (316) 978-3898
Internet Address: http://www.twsu.edu/~ulrich
Interim Director: Mr. Ted D. Ayres
Admission: voluntary contribution.
Attendance: 10,000 *Established:* 1974
Membership: Y *ADA Compliant:* Y
Parking: free on site.
Open: Daily, noon-5pm.
Closed: Legal Holidays.
Facilities: **Architecture** (mosaic by Joan Miró on museum façade); **Galleries; Sculpture Garden.**
Activities: **Artist-in-Residence Program; Education Programs** (undergraduate and graduate college students); **Gallery Talks; Guided Tours; Lectures; Permanent Exhibits; Temporary Exhibitions; Traveling Exhibitions.**

Left to right: Jesus Morales, "Weave Wall", granite (1995); Sophia Vari, "Danseuse Espagnole", bronze (1992); Joan Miró, "Personnages Oiseaux", Venetian glass and marble (1977-1978); façade of Museum in background. Photograph courtesy of Edwin A. Ulrich Museum of Art, Wichita State University, Wichita, Kansas.

Publications: books; exhibition catalogues.

The Edwin A. Ulrich Museum of Art houses a permanent collection of over 7,500 objects, with 19th- and 20th-century European and American paintings, drawings, sculpture, and prints forming the core of the collection. A major aspect of the collection is the 65-piece outdoor sculpture collection, including works by Rodin, Moore, Nevelson, Rickey, Chadwick, Jimenez, and Miró, among others. There is also an extensive collection of works by the American marine artist, Frederick Judd Waugh. Also of possible interest on campus is the Clayton Staples Gallery (open: Mon-Fri, 9am-5pm, 978-3555) on the second floor of the McKnight Art Center, which presents temporary exhibitions of the work of students and professional artists.

Kentucky

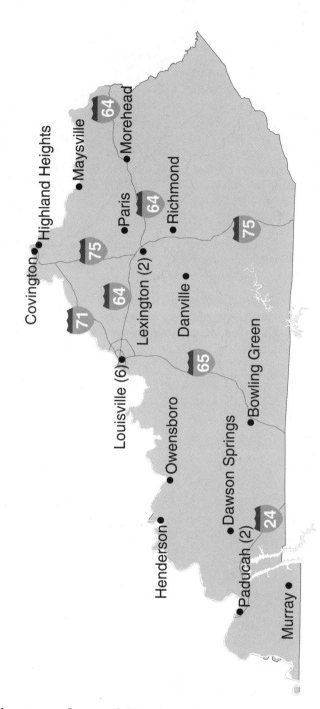

The number in parentheses following the city name indicates the number of museums/galleries in that municipality. If there is no number, one is understood. For example, in the text six listings would be found under Louisville and one listing under Henderson.

Kentucky

Bowling Green

Western Kentucky University - The Kentucky Museum

Western Kentucky University, 1 Big Red Way, Bowling Green, KY 42101

Tel: (502) 745-6258

Fax: (502) 745-4878

Internet Address: http://www.wky.edu/library/museum

Administrator: Mr. Riley D. Handy

Admission: fee: adult-$2.00, child-$1.00, family-$5.00.

Attendance: 25,000 *Established:* 1931 *Membership:* Y *ADA Compliant:* Y

Open: Tuesday to Saturday, 9:30am-4pm; Sunday, 1pm-4pm.

Closed: Academic Holidays.

Facilities: **Galleries**; **Library** (100,000 volumes, use on premises).

Activities: **Guided Tours**; **Lectures**; **Permanent Exhibits**; **Temporary Exhibitions**; **Workshops**.

Publications: brochures; exhibition catalogues; newsletter, "The Fanlight".

The Kentucky museum collects, preserves, and exhibits Kentucky artifacts. Its collections include archeology, art, clothing and textiles, furniture, glassware and ceramics, political memorabilia, quilts, and toys and games. The art collection includes works by Kentucky artists, such as Clement Reeves Edwards, Harlan Hubbard, Alphonse and Juliette Desport, Harvey Joiner, Sarah Gaines Peyton, and Matthew Harris Jouett. There are also prints by Bodmer, Catlin, Dine, Rosenquist, and Motherwell. Finally, there are collections of miniatures and folk art. Also of possible interest on campus, the University Gallery, located on the second floor of the Ivan Wilson Fine Arts Center, presents temporary exhibitions (Open: weekdays, 8:30am-3:30pm).

Covington

Behringer-Crawford Museum

1600 Montague Road, Devou Park, Covington, KY 41012

Tel: (606) 491-4003

Fax: (606) 491-4006

Director: Ms. Laurie Risch

Admission: fee: adult-$3.00, child-$2.00, senior-$2.00.

Established: 1950 *Membership:* Y *ADA Compliant:* Y

Open: Tuesday to Friday, 10am-5pm; Saturday to Sunday, 1pm-5pm.

Closed: Legal Holidays.

Facilities: **Exhibition Area** (2,500 square feet); **Library** (860 volumes); **Shop**.

Activities: **Education Programs** (adults and children); **Guided Tours**; **Lectures**; **Temporary Exhibitions**.

Publications: newsletter (quarterly); program guide (3/year).

The museum has a permanent art collection including the largest public holding of works (74 pieces) by Kentucky artist Harlan Hubbard. It also mounts temporary exhibitions.

Danville

Centre College - Norton Center for the Arts

600 W. Walnut St., Danville, KY 40422

Tel: (606) 236-4692

Internet Address: http://www.centre,edu/web/nortonctr/nortoncenter.html

Admission: free.

Open: call for hours.

Facilities: **Architecture** Norton Center (1974 design by William Wesley Peters); **Exhibition Area**.

Activities: **Education Programs**; **Temporary Exhibitions**.

The Norton Center is home to temporary exhibitions in its Grand Foyer, as well as housing the college's teaching collection of paintings and sculptures. Holdings are particularly strong in contemporary painting, 17th-century Dutch painting, and 19th-century French sculpture.

Dawson Springs

Dawson Springs Museum and Art Center, Inc.

127 S. Main St., Dawson Springs, KY 42408
Tel: (270) 797-3503
Curator: Mr. Claude A. Holeman
Admission: voluntary contribution.
Attendance: 2,200 *Established:* 1986 *Membership:* Y *ADA Compliant:* Y
Open: **February to December**, Tuesday to Saturday, 1pm-5pm.
Closed: Legal Holidays.
Facilities: **Exhibition Area** (535 square feet); **Library** (70 volumes); **Shop**.
Activities: **Temporary Exhibitions**; **Traveling Exhibitions**.
Publications: brochure, "The Dawson Springs Museum and Art Center".

The Museum houses a permanent collection and also mounts temporary and traveling exhibitions.

Henderson

John James Audubon Museum

Audubon State Park
U.S. Highway 41 North
Henderson, KY 42420
Tel: (502) 827-1893
Fax: (502) 826-2286
TDDY: (502) 826-2247
C.E.O.: Ms. Mary Dee Miller
Admission:
 fee: adult-$4.00, child-$2.50, family-$10.00.
Attendance: 17,000 *Established:* 1938
Membership: Y
Open: Call for hours.
Facilities: **Exhibition Area**; **Shop**.
Activities: **Arts Festival**; **Education
 Programs** (children); **Gallery Talks**;
 Guided Tours; **Lectures**.
Publications: "The Warbler".

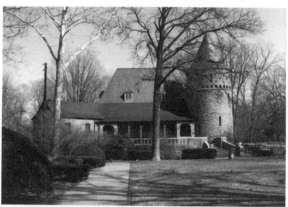

Exterior view of John James Audubon Museum and Nature Center. Photograph courtesy of John James Audubon State Park, Henderson, Kentucky.

The Museum's collection includes paintings, prints, and personal memorabilia of John James Audubon. Adjacent to the Museum is the newly-constructed Nature Center. The northern half of the state park is a nature sanctuary.

Highland Heights

Northern Kentucky University Art Galleries (NKU)

NKU Fine Arts Center
Nunn Drive
Highland Heights, KY 41099
Tel: (859) 572-5148
Fax: (859) 572-6501
Internet Address:
 http://www.nku.edu/~art/gallery.html
Director: Mr. David J. Knight
Admission: voluntary contribution.
Attendance: 18,000 *Established:* 1968

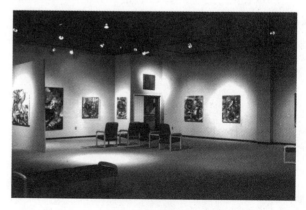

View of main gallery during temporary exhibition. Photograph courtesy of Northern Kentucky University Art Galleries, Highland Heights, Kentucky.

Northern Kentucky University Art Galleries, cont.

ADA Compliant: Y

Open: Monday to Friday, 9am-9pm; Saturday to Sunday, 1pm-5pm.

Closed: Legal Holidays, Spring Break, Between Terms.

Facilities: **Galleries** (2; Main, 2,000 square feet; 3rd Floor, 500 square feet).

Activities: **Lectures**; **Temporary Exhibitions** (12 per year); **Traveling Exhibitions**.

The Department of Art maintains two galleries: The Main Gallery and the Third Floor Gallery. The galleries offer monthly exhibitions of the work of professional artists, as well as weekly shows of student work. The University maintains a permanent collection of 800 pieces, most of which are on view around the campus.

Lexington

Central Bank and Trust Company

Kincaid Towers, Lexington, KY 40588-1360

Tel: (800) 637-6884

Curator, Art Collection: Mr. John G. Irvin

Admission: open to public.

Attendance: 10,000

Parking: free behind building.

Open: Monday to Friday, 8:30am-4:30pm.

The Central Bank and Trust Company presents temporary exhibitions of work by contemporary Kentucky artists in two corridors converted to galleries on the second and third floors. The Bank's permanent collection consists primarily of works in a variety of media by Kentucky artists.

University of Kentucky Art Museum

Rose St. and Euclid Ave., Lexington, KY 40506-0241

Tel: (859) 257-5716

Fax: (859) 323-1994

Director: Dr. Harriet Fowler

Admission: free.

Attendance: 23,000 *Established:* 1976 *Membership:* Y *ADA Compliant:* Y

Parking: Circle in front & University lots on Euclid Ave. & Rose St..

Open: Tuesday to Thursday, noon-5pm; Friday, noon-8pm; Saturday to Sunday, noon-5pm.

Closed: Academic Holidays.

Facilities: **Galleries** (2 levels).

Activities: **Guided Tours** (arrange in advance); **Temporary Exhibitions** (6/year).

Publications: calendar; exhibition catalogues; newsletter, "Educational Materials" (quarterly).

A component of the Otis A. Singletary Center for the Arts, the University of Kentucky Art Museum presents selections from its permanent collection, supplemented by an annual schedule of diverse exhibitions drawn from other museums, private collections, and exhibition services. The Museum also regularly assembles exhibitions of special regional interest and relevance, including retrospectives of work by contemporary Kentucky artists, as well as showings of outstanding local collections. Illustrated catalogues are frequently published to accompany these exhibitions. The Museum maintains a permanent collection of more than 3,500 European and American paintings, sculptures, prints, drawings, photographs, and examples of decorative arts. There are also holdings in the art of the Americas, Africa, and Asia. Selections from the permanent collection are always on view and rotated regularly; works in storage are easily accessible by appointment. Also of possible interest are the Center for Contemporary Art, presenting MFA student thesis work and guest invitational exhibitions and the Downtown Gallery, a downtown Lexington exhibition space featuring the work of students, faculty, alumni, and guest artists.

Louisville

Kentucky Art and Craft Gallery

609 W. Main St., Louisville, KY 40202
Tel: (502) 589-0102
Fax: (502) 589-0154
Director: Ms. Rita H. Steinberg
Admission: free.
Established: 1981 *Membership:* Y *ADA Compliant:* Y
Open: Monday to Saturday, 10am-4pm.
Closed: New Year's Day, Memorial Day, Independence Day, Labor Day, Thanksgiving Day,
 Christmas Day.
Facilities: **Exhibition Area** (2 galleries); **Shop.**
Activities: **Arts Festival**; **Guided Tours**; **Lectures**; **Temporary Exhibitions**; **Traveling
 Exhibitions.**
Publications: exhibition catalogues (annual); newsletter, "Made in Kentucky" (3/year).

Located in a restored 1850's building, the gallery mounts temporary displays of Kentucky arts and crafts, including ceramics, furniture, jewelry, and sculpture.

Louisville Visual Art Association (LVAA)

3005 Upper River Road, Louisville, KY 40207
Tel: (502) 896-2146
Fax: (502) 896-2148
Internet Address: http://www.louvsart.org
Exec. Director: Mr. John P. Begley
Admission: voluntary contribution.
Attendance: 150,000 *Established:* 1909
Membership: Y *ADA Compliant:* Y
Parking: free on site.
Open: Monday to Friday, 9am-5pm;
 Saturday, 9am-3pm;
 Sunday, noon-4pm.
Closed: New Year's Day, Easter, Thanksgiving Day,
 Christmas Eve to Christmas Day.
Facilities: **Architecture** (former waterworks pumping station,
 1860 designed by engineer Theodore Scowden); **Classrooms**;
 Exhibition Area; **Library**; **Sales/Rental Gallery** (Suite 275,
 Louisville Galleria; Mon-Fri 11:30am-3:30pm); **Shop.**
Activities: **Education Programs** (adults and children); **Films**;
 Guided Tours (upon request); **Lectures**; **Studio Art Classes**
 (over 300/year); **Temporary/Traveling Exhibitions** (approx-
 imately 12/year); **Workshops.**
Publications: exhibition catalogues; gallery guides; newsletter,
 "Visual Art Review" (quarterly).

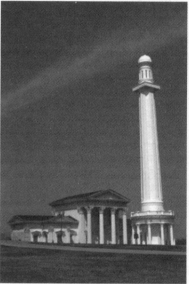

Exterior view from River Road of River Pumping Station #1 (1860), home of Louisville Visual Art Association. Photograph courtesy of Louisville Visual Art Association, Louisville, Kentucky.

Housed in historic Water Pumping Station #1 (1860), a National Historic Landmark, LVAA fosters an appreciation of today's visual arts through temporary art exhibitions, special events, art classes, and educational programs. As a non-collecting institution, LVAA exhibitions feature new art forms and contemporary expression; solo, group, competitive or theme exhibits highlight a schedule that changes every six weeks. LVAA also maintains a slide registry of more than 400 artists.

Spalding University - Huff Gallery

853 Library Lane, Louisville, KY 40203
Tel: (502) 585-7122
Internet Address: http://www.spalding.edu/ugrad/art/huff.html
Contact: Mr. Robert Stagg

Spalding University - Huff Gallery, cont.

Admission: free.

Open: Monday to Thursday, 8am-9pm; Friday to Saturday, 8am-5pm; Sunday, 1pm-5pm.

Facilities: **Exhibition Area**.

Activities: **Temporary Exhibitions** (10/year).

The Gallery presents both solo and groups exhibitions of work in a variety of media by locally and regionally recognized artists. Student exhibitions, as well as shows by graduating seniors, are mounted at the end of each year.

The Speed Art Museum

2035 South 3rd St.
(adjacent to University of Louisville campus)
Louisville, KY 40208

Tel: (502) 634-2700

Fax: (502) 636-2899

TDDY: (502) 634-2706

Internet Address: http://www.speedmuseum.org

Director: Mr. Peter Morrin

Admission: voluntary contribution.

Attendance: 98,000 *Established:* 1926

Membership: Y *ADA Compliant:* Y

Parking: on site, $3.00.

Open: Tuesday to Wednesday, 10:30am-4pm;
Thursday, 10:30am-8pm;
Friday, 10:30am-4pm;
Saturday, 10:30am-5pm;
Sunday, noon-5pm.

Closed: New Year's Day, Kentucky Derby Day;
Memorial Day, Independence Day, Labor Day,
Thanksgiving Day, Christmas Day.

Cornelius de Man (1621-1706), *Interior of the New Church in Delft*, Speed Art Museum. Photograph courtesy of Speed Art Museum, Louisville, Kentucky.

Facilities: **Art Learning Center** (children and families, admission $3.50); **Auditorium** (350 seats); **Food Services** Café Bristol (Tues-Sat, 11:30am-2pm); **Galleries**; **Lecture Rooms**; **Library** (13,000 volumes); **Shop**; **Workshop**.

Activities: **Concert Series**; **Education Programs** (adults and children); **Film & Video Series**; **Gallery Talks**; **Guided Tours** (groups, reserve in advance 634-2725); **Lectures**; **Permanent Exhibits**; **Temporary Exhibitions**; **Traveling Exhibitions**.

Publications: annual report; exhibition catalogues; program guide (bi-monthly).

At the Speed Art Museum one can travel through 6,000 years of creativity from ancient Egypt and medieval England to contemporary New York, and span the globe from Africa to Kentucky or a village in the Sioux Nation. The permanent collection numbers more than 8,000 objects and includes works by Monet, Moore, Picasso, Rembrandt, and Rubens. The Museum also presents an extensive schedule of visiting shows.

University of Louisville - Allen R. Hite Art Institute Galleries

University of Louisville, Belknap Campus
3rd St. and Eastern Parkway, Louisville, KY 40292

Tel: (502) 852-6794

Fax: (502) 852-6791

Internet Address: http://www.louisville.edu/a-s/finearts

Director: Professor James Grubola

Admission: voluntary contribution.

Attendance: 15,000 *Established:* 1946

ADA Compliant: Y

Louisville, Kentucky

University of Louisville - Allen R. Hite Art Institute Galleries, cont.

Open: Monday to Friday, 8:30am-4:30pm;
weekends, by appointment.
Closed: Legal Holidays.
Facilities: **Galleries** (3); **Library** (75,000 volumes).
Activities: **Demonstrations**; **Education Programs**
(undergraduate and graduate college students);
Lectures; **Temporary Exhibitions**;
Workshops.
Publications: exhibition catalogues; journal,
"Parnassus".

The Institute houses the Morris B. Belknap Jr. Gallery, the Dario A. Covi Gallery, and the Student Art League Gallery, as well as an art library, a visual resource center, and an art collection. The galleries feature rotating monthly exhibitions of the work of national and regional artists, craftspeople, and designers, in addition to student and faculty work. The Institute's art collection includes an extensive selection of prints and drawings from the 16th century to the present. The University of Louisville Photographic Archives, one of the largest and most thorough in the Southeast, is listed separately.

Sam Gilliam, *Red Vase, Blue Element*, 1982, acrylic and mixed media on canvas, University of Louisville Art Collection. Photograph courtesy of Allen R. Hite Art Institute, University of Louisville, Louisville, Kentucky.

University of Louisville - Photographic Archives

Ekstrom Library, University of Louisville, Third Street, Louisville, KY 40292
Tel: (502) 852-6752
Fax: (502) 852-8734
Internet Address: http://www.louisville.edu/library/ekstrom/special
Administrator: Mr. James C. Anderson
Admission: Free, contributions welcomed.
Established: 1968 *ADA Compliant:* Y
Open: Monday to Wednesday, 10am-4:00pm; Thursday, 10am-8pm; Friday, 10am-4:00pm.
Facilities: **Exhibition Gallery**; **Library** (1,200 volumes); **Reading Room**.
Activities: **Lectures**; **Temporary Exhibitions**.

The Photographic Archives acquires significant documentary and fine art photographs, organizes them, and makes them available to both the researcher and the casual browser. Its gallery hosts changing exhibitions of prints from the Archives collections and from contemporary photographers. Housing over 1.2 million photographs, the permanent collection is composed of hundreds of discrete collections, including national documentary subjects, local history photographs, and a museum collection of fine prints. The fine art collection includes work by Ansel Adams, Stern J. Bramson, Paul Caponigro, Walker Evans, Arthur Fellig (Weegee), Phillipe Halsman, Dorothea Lange, Lisette Model, Edwin and Louise Rosskam, Arthur Rothstein, Ben Shahn, Edward Weston, Minor White, and Marion Post Wolcott.

Maysville

Mason County Museum

215 Sutton St., Maysville, KY 41056
Tel: (606) 564-5865
Fax: (606) 564-4372
Director: Mrs. Dawn Browning
Admission: fee: adult (research)-$3.50 (tour)-$2.50 (combined)-$5.00, student-$0.50.
Attendance: 3,500 *Established:* 1876 *Membership:* Y *ADA Compliant:* Y
Parking: on street.

Mason County Museum, cont.

Open: **January to March**, Tuesday to Saturday, 10am-4pm.
April to December, Monday to Saturday, 10am-4pm.
Closed: Legal Holidays.
Facilities: **Architecture** (former public library, 1876); **Galleries**; **Library** (7,500 volumes, non-circulating); **Reading Room**; **Shop**.
Activities: **Guided Tours**; **Permanent Exhibits**; **Temporary Exhibitions**; **Traveling Exhibitions**.
Publications: books.

Housed in a former public library built about 1876, the Museum includes an art gallery, a history museum, and a genealogical/history library.

Karl Bodmer/Jean François Millet, *Simon Butler*, hand-colored lithograph, c 1850. Scene is of an incident in which Butler (aka Simon Kenton), Mason County's pioneer settler, was tied to an unbroken colt by the Shawnee. Collection of and photograph courtesy of Mason County Museum, Maysville, Kentucky.

Morehead

Morehead State University - Kentucky Folk Art Center

102 West 1st Street, Morehead, KY 40351
Tel: (606) 783-2204
Fax: (606) 783-5034
Internet Address: http://www.kyfolkart.org
Director: Mr. Garry Barker
Admission: fee: adult-$3.00, senior-$2.00.
Attendance: 5,000 *Established:* 1985
Membership: Y
Parking: free on site.
Open: Monday to Saturday, 9am-5pm;
Sunday, 1pm-5pm.
Facilities: **Auditorium**; **Exhibition Area** (10,000 square feet); **Library**; **Shop** (work from over 50 eastern Kentucky folk artists, books).

Exterior view of Kentucky Folk Art Center, a former wholesale grocery warehouse (c. 1906). Photograph courtesy of Kentucky Folk Art Center, Morehead, Kentucky.

Activities: **Education Programs** (children); **Films**; **Lectures**; **Traveling Exhibitions**; **Workshops**.
Publications: newsletter, "KFAC News" (quarterly); video, "Local Visions".

Housed in a renovated brick grocery warehouse (c 1906), KFAC operates the Kentucky Folk Art Museum on the ground floor and a gallery on the second level. The Museum displays selections from Morehead State University's permanent collection of over 800 works of folk art; the rest of the collection is available for researchers and special exhibitions. The gallery features rotating exhibits.

Murray

Murray State University - University Art Galleries

Price Doyle Fine Arts Center, 6th floor, 15th and Olive Sts., Murray, KY 42071-3342
Tel: (502) 762-3052
Fax: (502) 762-3920
Internet Address: http://www.mursuky.edu/qacd/cfac/art/gallery.htm
Director: Mr. Albert Sperath
Admission: free.
Attendance: 10,000 *Established:* 1971 *Membership:* N *ADA Compliant:* Y

Murray State University - University Art Galleries, cont.

Parking: visitor parking free on campus.

Open: **Fall to Spring**, Monday to Friday, 9am-4pm; Saturday to Sunday, 1pm-4pm.
Summer, Monday to Friday, 9am-4pm.

Closed: Academic Holidays.

Facilities: **Galleries** (3, total 8,292 square feet of exhibition space and support areas); **Lecture Halls** (2).

Activities: **Education Programs** (adults, undergraduate/graduate students, and children); **Gallery Talks**; **Guided Tours**; **Lectures**; **Temporary Exhibitions**; **Traveling Exhibitions**.

Publications: exhibition catalogues.

The University has three galleries, the Main and Upper Level galleries at the Clara M. Eagle Art Gallery in the Doyle Fine Arts Center, and the Curris Center Gallery in the Student Center. The Main Gallery hosts exhibitions of contemporary art by artists working within a 500 mile radius of Murray. The Upper Level and Curris Center galleries present student shows and smaller shows of work by local artists. The University's permanent collection of 1,200 objects consists primarily of works on paper. A collection of 80 Works Progress Administration prints and the H.L. Jackson Print Collection are the most notable.

Owensboro

Owensboro Museum of Fine Art, Inc.

901 Frederica St., Owensboro, KY 42301

Tel: (502) 685-3181

Fax: (502) 685-3181

Director: Ms. Mary Bryan Hood

Admission: suggested contribution: adult-$2.00, child-$1.00.

Attendance: 68,000 *Established:* 1977

Membership: Y *ADA Compliant:* Y

Parking: free on street; parking lot off 9th St..

Open: Tuesday to Friday, 10am-4pm;
Saturday to Sunday, 1pm-4pm.

Closed: New Year's Day, Memorial Day, Independence Day, Labor Day, Thanksgiving Day, Christmas Day.

Facilities: **Architecture** (former Carnegie Library, 1905; John Hampden Smith House, antebellum mansion; post modern style Atrium and Sculpture Court); **Classrooms**; **Library** (2,000 volumes, use by members only); **Shop** (jewelry, decorative art objects, regional artworks).

Activities: **Education Programs** (adults and children); **Films**; **Gallery Talks**; **Guided Tours** (groups, reserve in advance); **Lectures**; **Permanent Exhibits**; **Temporary Exhibitions** (every 6-8 weeks); **Traveling Exhibitions**.

Publications: exhibition catalogues; newsletter.

Interior view of Texas Gas Atrium with installations by Joe Downing. Photograph courtesy of Owensboro Museum of Fine Art, Owensboro, Kentucky.

Housed in a post modern style Atrium and Sculpture Court connecting three wings, including a new exhibition wing, a former Carnegie Library building, and an antebellum mansion, the Museum features works from its permanent collection in combination with exhibitions on loan from major American museums, galleries, and important regional collections. Unique to OMFA is the Stained Glass Gallery, presenting a permanent installation of sixteen turn-of-the-century stained glass windows in 25-foot light towers crafted by the internationally recognized German-American glass maker Emil Frei. Its decorative arts wing is located in the restored antebellum John Hampden Smith House. Collections include 19th- and 20th-century American, English, and French paintings drawings, graphics, and sculpture; 14th- through 18th-century American, English, and Asian decorative arts; contemporary American art; 19th-century stained glass; 20th-century Appalachian folk art; and late 20th-century studio art glass. Highlights include works by Edgar Degas, Thomas Lawrence, Charles Willson Peale, and Frank Duveneck.

Paducah

Museum of the American Quilter's Society (MAQS)

215 Jefferson St., Paducah, KY 42001

Tel: (270) 442-8856

Fax: (270) 442-5448

Exec. Director: Ms. Victoria Faoro

Admission: fee: adult-$5.00, child-free,
 student-$3.00, senior-$5.00.

Attendance: 46,000 *Established:* 1991

Membership: N *ADA Compliant:* Y

Parking: free on site and on street.

Open: **November to March,**
 Monday to Saturday, 10am-5pm.

 April to October,
 Monday to Saturday, 10am-5pm;
 Sunday, 1pm-5pm.

MAQS Collection of quilts from the 1980s and 1990s on display. Photograph courtesy of Museum of the American Quilter's Society, Paducah, Kentucky.

Closed: New Year's Day, Easter, Thanksgiving Day, Christmas Eve and Day.

Facilities: **Exhibition Area** (3 galleries; 13,500 square feet); **Shop** (crafts, books on textiles and fine crafts, books, cards, crafts).

Activities: **Education Programs** (adults and children); **Guided Tours**; **Lectures**; **Temporary Exhibitions**; **Traveling Exhibitions**; **Workshops**.

Publications: newsletter, "Friends of MAQS Newsletter" (bi-monthly).

Founded by Bill and Meredith Schroeder, also co-founders of the American Quilter's Society, this national museum exhibits over 150 antique and contemporary quilts in three exhibition galleries. Selections from the Museum's collection of quilts made in the 1980's and 1990's are always on display, along with temporary exhibits on loan. The Museum's lobby and conference room feature stained glass windows based on quilt designs.

Yeiser Art Center

200 Broadway, Paducah, KY 42001-0732

Tel: (270) 442-2453

Internet Address: http://www.yeiser.org

Director: Mr. Dan Carver

Admission: fee: adult-$1.00, child-$0.50, student-$0.50.

Attendance: 20,000 *Established:* 1957 *Membership:* Y *ADA Compliant:* Y

Parking: free across street.

Open: Tuesday to Saturday, 10am-4pm.

Closed: Legal Holidays.

Facilities: **Exhibition Area**; **Shop** (one-of-a-kind items,).

Activities: **Guided Tours**; **Lectures**; **National Fiber Exhibit** (annual, spring); **Temporary Exhibitions**.

Publications: fiber catalogue; newsletter (monthly).

The Center presents exhibits of contemporary and historical art, competitions, workshops, and educational activities. It nurtures a community of artists and maintains a permanent collection of 300 works of 19th- and 20th-century American, European, Asian, and African art. Eight to ten major exhibits are scheduled each year, including an nationally recognized fibers exhibit, Fantastic Fibers, and a juried exhibition of contemporary art. Center exhibits also include loans from museums in Kentucky, Tennessee, and Indiana.

Paris

Hopewell Museum

800 Pleasant St. (8th and Pleasant Sts.), Paris, KY 40361

Tel: (606) 987-7274

Fax: (606) 987-7274

Paris, Kentucky

Hopewell Museum. cont.

Director: Mr. Robert C. Magrish

Admission: fee: adult-$2.00, child-$1.00, student-$1.00, senior-$1.50.

Attendance: 2,000 *Established:* 1995

Membership: Y *ADA Compliant:* Y

Parking: free on site.

Open: Wednesday to Saturday, noon-5pm;
Sunday, 2pm-4pm.

Closed: Legal Holidays.

Facilities: **Architecture** (Beaux Arts, former Post Office building, 1909); **Exhibition Area** (3 main & 4 exhibition galleries & 1 period room, 5,000 square feet).

Activities: **Guided Tours** (by appointment); **Lectures** (1/month); **Temporary Exhibitions** (2-4/year).

Publications: newsletter, "Hopewell Museum Post" (monthly).

Drawing of Hopewell Museum (1909), originally, the Paris Post Office; on National Register of Historic Places. Photograph courtesy of Hopewell Museum, Paris, Kentucky.

Established by the citizens of Paris and Bourbon County, the Museum's mission is to preserve and present the history and fine arts of the central Kentucky region. The unique and varied collections, including historical artifacts, fine art, decorative arts, and documents, are displayed thematically under the following headings: Civil War, Bourbon County Development, Agriculture, Pre-history, Fine Arts, Decorative Arts, and the Equine Industry in the Bluegrass. Exhibitions change every six months, but the themes, with a few exceptions, remain the same.

Richmond

Eastern Kentucky University - Fred P. Giles Gallery

Jane F. Campbell Building, 521 Lancaster Ave., Richmond, KY 40475

Tel: (606) 622-1629

Internet Address: http://www.art.eku.edu/page2/htm

Open: **Fall to Spring**,
Monday, 11:45am-4:30pm; Tuesday, 1pm-4:30pm; Wednesday, 11:45am-4:30pm;
Thursday, 1pm-4:30pm; Friday, 11:45am-3:15pm; call to confirm.

Closed: Summer.

Facilities: **Exhibition Area**.

Activities: **Temporary Exhibitions**.

The Giles Gallery presents temporary exhibitions including the work of students.

Louisiana

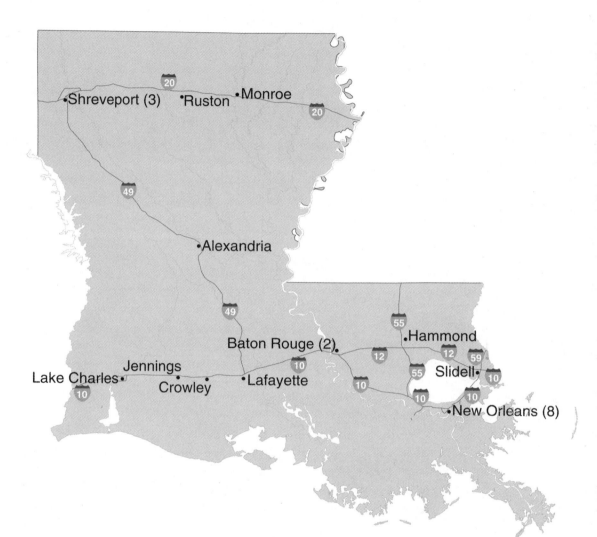

The number in parentheses following the city name indicates the number of museums/galleries in that municipality. If there is no number, one is understood. For example, in the text two listings would be found under Baton Rouge and one listing under Lafayette.

Louisiana

Alexandria

Alexandria Museum of Art (AMoA)

933 Main St., Alexandria, LA 71301
Tel: (318) 443-3458
Fax: (318) 443-3449
Internet Address: http:/www.themuseum.org
Director: Mr. Mark A. Tullos, Jr.
Admission: fee:
 adult-$3.00, child-$1.00, student-$2.00, senior-$2.00.
Attendance: 60,000 *Established:* 1977
Membership: Y *ADA Compliant:* Y
Parking: in front of museum at Main and DeSoto Sts.
Open: Tuesday to Friday, 10am-5pm;
 Saturday to Sunday, 11am-5pm.
Closed: Legal Holidays.
Facilities: **Architecture** (former bank building, 1890; recently expanded); **Atrium Café** (reservations required); **Classrooms**; **Galleries** (7); **Library** (1,800 volumes, by appointment only); **Shop** (publications, jewelry, gift items).

Detail of preliminary drawing for Museum façade by architects Barron, Heinburg & Brocato. Rendering courtesy of the Alexandria Museum of Art, Alexandria, Louisiana.

Activities: **Education Programs** (adults, college students, and children); **Films** (weekends); **Gallery Talks**; **Guided Tours** (reserve in advance, Wednesday-Saturday, 1pm); **Lectures**; **Temporary Exhibitions**.
Publications: annual report; exhibition catalogues; newsletter, "ARTMatters" (quarterly).

The museum has seven galleries. Through its exhibition program of changing collections on loan from around the world, its extensive permanent collection of contemporary Louisiana art, and an extensive collection of north Louisiana folk and outsider art, AMoA addresses diverse aesthetic tastes. Facilities include an orientation gallery and an interactive children's gallery with hands-on exhibits designed by Louisiana artists.

Baton Rouge

Louisiana Arts and Science Center Inc. (LASC)

100 S. River Road, Baton Rouge, LA 70802
Tel: (504) 344-5272
Fax: (504) 344-9477
Exec. Director: Ms. Carol Sommerfeldt Gikas
Admission: fee: adult-$3.00, child-$2.00,
 student-$2.00, senior-$2.00.
Attendance: 115,000 *Established:* 1962
Membership: Y *ADA Compliant:* Y
Parking: free on site.
Open: Tuesday to Friday, 10am-3pm;
 Saturday, 10am-4pm;
 Sunday, 1pm-4pm.
Closed: Legal Holidays.
Facilities: **Architecture** (former railroad depot, 1925, renovated and enlarged, 50,300 square feet); **Auditorium**; **Galleries**; **Sculpture Garden**.

Exterior view of façade of Louisiana Arts and Sciences Center, a former railroad depot. Photograph courtesy of Louisiana Arts and Sciences Center, Baton Rouge, Louisiana.

Activities: **Films**; **Guided Tours**; **Juried Exhibits**; **Permanent Exhibits**; **Temporary Exhibitions**.

Baton Rouge, Louisiana

Louisiana Arts and Science Center Inc., cont.
Publications: books; brochures; calendar; exhibition catalogues.

L ASC presents both permanent and changing exhibits in the arts and sciences, including hands-on children's galleries. Highlights include an Egyptian gallery featuring a recreated Ptolemaic tomb containing two mummies and other artifacts. The permanent collection includes works by American and European artists illustrating examples of stylistic movements of the 18th and 19th centuries.

Louisiana State University Museum of Art
Memorial Tower, Louisiana State University, Baton Rouge, LA 70803
Tel: (504) 388-4003
Internet Address: http://www.indiana@lsu.edu
Admission: voluntary contribution.
Attendance: 5,000 *Established:* 1959 *Membership:* Y
Open: Monday to Friday, 9am-4pm; Saturday, 10am-noon and 1pm-4pm; Sunday, 1pm-4pm.
Closed: Academic Holidays.
Facilities: **Galleries**; **Library** (500 volumes, non-circulating).
Activities: **Films**; **Gallery Talks**; **Guided Tours**; **Lectures**; **Permanent Exhibits**; **Temporary Exhibitions**; **Traveling Exhibitions**.
Publications: exhibition catalogues.

M emorial Tower houses LSU's permanent art collection, which includes many Louisiana-related paintings, prints and drawings, and also mounts changing exhibitions. Also of possible interest on campus are the LSU Union Art Gallery (388-5188) at the corner of Raphael Semmes and Highland Road and the LSU School of Art Gallery (388-5143) in Foster Hall.

Crowley

Crowley Art Association and Gallery
220 N. Parkerson, Crowley, LA 70527
Tel: (318) 783-3747
C.E.O.: Marilyn Shingleton
Admission: free.
Attendance: 10,000 *Established:* 1980
Membership: Y *ADA Compliant:* Y
Parking: metered on street.
Open: Monday to Friday, 10am-4pm.
Closed: New Year's Day, Thanksgiving Day, Christmas Week.
Facilities: **Exhibition Area**; **Library** (for members only); **Shop**.
Activities: **Arts Festival**; **Education Programs** (adults and children); **Guided Tours**; **Juried competition**; **Temporary Exhibitions**; **Workshops**.

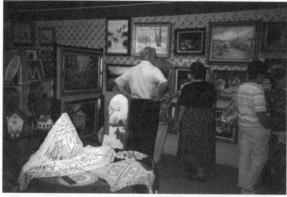

View of gallery during juried art show, 1996. Photograph courtesy of Crowley Art Association and Gallery, Crowley, Louisiana.

Publications: "CAA Yearbook" (annual); newsletter, "CAA Newsletter" (monthly).

T he Gallery mounts temporary exhibitions of art in a variety of media and also displays crafts, including needlework, pottery, and woodcraft.

Hammond

Southeastern Louisiana University - Clark Hall Gallery
N. Pine Street, Hammond, LA 70402
Tel: (504) 549-2193 *Ext:* 5080
Fax: (504) 549-5316
Internet Address: http://www.selu.edu/Academics/Depts/VizArts/ClarkHall/
Director: Mr. Don Marshall
Admission: free.

Southeastern Louisiana University - Clark Hall Gallery, cont.

Attendance: 20,000 *Membership:* N *ADA Compliant:* Y

Open: Monday to Friday, 8am-4:30pm.

Closed: Legal Holidays.

Facilities: **Exhibition Area**.

Activities: **Temporary Exhibitions** (8/year).

The gallery presents temporary exhibitions focusing on artworks in a wide variety of media by Louisiana artists, as well as student and faculty work.

Jennings

The Zigler Museum

411 Clara St., Jennings, LA 70546

Tel: (318) 824-0114

Director: Ms. Dolores Spears

Admission: fee: adult-$2.00, child-$1.00.

Attendance: 7,500 *Established:* 1963

Membership: Y *ADA Compliant:* Y

Parking: free on street.

Open: Tuesday to Saturday, 9am-5pm;
Sunday, 1pm-5pm.

Closed: Legal Holidays.

Facilities: **Galleries; Shop.**

Activities: **Guided Tours; Temporary Exhibitions; Workshops.**

Publications: collection catalogue.

Helen Turner, *Morning*, Zigler Museum Collection. Photograph courtesy of Zigler Museum, Jennings, Louisiana.

The Zigler Museum mounts temporary exhibitions of works by regional artists as well as art from its permanent collection. The permanent collection of the Zigler includes paintings by Van Dyck, Constable, Opie, Blakelock, Bierstadt, Inness, Charles Sprague Pierce, Helen Turner, and William Tolliver, a woodcut by Dürer, etchings by Rembrandt and Whistler, and a number of works by Louisiana artists.

Lafayette

University of Louisiana at Lafayette- University Art Museum

Fletcher Hall Gallery, Art and Architecture Building, E. Lewis and Girard Park Drive
Permanent Collection Building, St. Mary Boulevard and Girard Park Drive
Lafayette, LA 70504

Tel: (337) 482-5326

Fax: (337) 482-5907

Director: Mr. Gil Carner

Admission: free.

Attendance: 30,000 *Established:* 1968

Membership: Y *ADA Compliant:* Y

Parking: free on site with ticket validation.

Open: **Fletcher Hall,**
Monday to Friday, 9am-4pm;
Saturday, 10am-4pm.
Permanent Collection Building,
Monday to Friday, 9am-4pm.

Closed: Academic Holidays.

Exterior view of Permanent Collection Building. Photograph by C.J. Franz, courtesy of University of Louisiana at Lafayette, Lafayette, Louisiana.

Facilities: **Galleries** (2 - Fletcher Hall and Permanent Collection Building).

Activities: **Concerts; Films; Gallery Talks; Guided Tours** (with reservation); **Lectures; Permanent Exhibits; Temporary Exhibitions** (3/year); **Traveling Exhibitions** (3/year).

University of Louisiana at Lafayette - University Art Museum, cont.

Publications: calendar; exhibition catalogues.

The University Art Museum offers visitors art exhibitions of regional, national, and international acclaim. The permanent collection is housed in an 18th-century-style plantation home and includes works by Le Sidaner, Marc, Kneller, Healy, and Rinck, among others. Touring exhibits can be seen in the Fletcher Hall Gallery located on the second floor of the Art and Architecture Building.

Lake Charles

McNeese State University - Abercrombie Gallery

Shearman Fine Arts Center, Ryan and Sale Streets, Lake Charles, LA 70609

Tel: (337) 475-5060

Fax: (337) 475-5927

Internet Address: http://www.mcneese.edu

Director: Mr. Bill Iles

Admission: free.

Attendance: 3,000 **Established:** 1983

Parking: free on site.

Open: Monday to Friday, 9am-4pm.

Facilities: **Exhibition Area** (110 running feet).

Activities: **Lecture Series; Temporary Exhibitions** (monthly).

The Abercrombie Gallery presents monthly temporary exhibitions featuring works by students, faculty, and visiting artists. The Gallery also showcases the Annual McNeese National Works on Paper Exhibition, and the Biennial National Ceramics Invitational.

Mary Campbell, *Spectrum Oval*, 1996, watercolor, 20 x 14 inches. Best of Show Award, 10th Annual McNeese National Works on Paper Exhibition, 1997. Photograph courtesy of Abercrombie Gallery, McNeese State University, Lake Charles, Louisiana.

Monroe

Masur Museum of Art

1400 S. Grand Street, Monroe, LA 71202

Tel: (318) 329-2237

Fax: (318) 329-2847

Exec. Director: Sue Prudhomme

Admission: free.

Attendance: 20,000 **Established:** 1963

Membership: Y **ADA Compliant:** Y

Parking: free on site.

Open: Tuesday to Thursday, 9am-5pm;
Friday to Sunday, 2pm-5pm.

Closed: Legal Holidays.

Facilities: **Architecture** (listed on National Register of Historic Places); **Galleries; Sculpture Garden.**

Activities: **Education Programs** (adults and children); **Gallery Talks; Guided Tours; Juried Exhibits; Lectures; Permanent Exhibits; Temporary Exhibitions; Traveling Exhibitions.**

Raphael Soyer, *Woman*, lithograph. Masur Museum of Art collection, gift of Jason Pankin. Photograph by Ron Alexander, courtesy of Masur Museum of Art, Monroe, Louisiana.

Masur Museum of Art, cont.

Publications: juried competition catalogue (annual); newsletter, "Museum News" (quarterly); temporary exhibit brochures.

The Masur Museum has an active schedule of exhibitions, both self-curated and traveling. Its permanent collection numbers over two hundred works and includes examples by Benton, Cassatt, Chagall, Dali, Gauguin, Picasso, Renoir, and Rodin.

New Orleans

Contemporary Arts Center (CAC)

900 Camp St., New Orleans, LA 70130

Tel: (504) 523-1216

Fax: (504) 528-3828

Internet Address: http://www.cacno.org

Exec. Director: Mr. Jay Weigel

Admission:
 fee: adult-$5.00, student-$2.00, senior-$2.00.

Attendance: 10,000 *Established:* 1976

Membership: Y *ADA Compliant:* Y

Parking: free on site.

Open: Monday to Saturday, 10am-5pm;
 Sunday, 11am-5pm.

Closed: New Year's Day, Mardi Gras,
 Memorial Day, Independence Day,
 Labor Day, Thanksgiving Day,
 Christmas Day.

Exterior view of Contemporary Arts Center (1905; renovated, 1990). Photograph courtesy of Contemporary Arts Center, New Orleans, Louisiana.

Facilities: **Architecture** (renovated tobacco warehouse, 1905); **Galleries** (9,000 square feet.).

Activities: **Concerts**; **Performances**; **Temporary Exhibitions**.

The Contemporary Arts Center is a multi-disciplinary organization dedicated to presenting the works of local, regional, national, and international artists. The Center offers a full schedule of exhibitions, performances, and educational programs.

The Historic New Orleans Collection

533 Royal St., New Orleans, LA 70130

Tel: (504) 523-4662

Fax: (504) 598-7108

Internet Address: http://www.hnoc.org/

C.E.O.: Priscilla Lawrence

Admission: free (temporary exhibitions).

Attendance: 30,000 *Established:* 1966

Membership: N *ADA Compliant:* Y

Open: Tuesday to Saturday, 10am-4:30pm.

Facilities: **Architecture** (Merieult House in French Quarter, 1792; Williams residence, 1889); **Exhibition Area** (2 sites); **Research Center**; **Shop**.

Activities: **Guided Tours** (Tues-Sat, 10am/11am/2pm/3pm, $4); **Permanent Exhibits**; **Temporary Exhibitions**.

Exterior view of The Historic New Orleans Collection complex in the French Quarter (533 Royal Street). Photograph by J. Brantley, courtesy of The Historic New Orleans Collection, New Orleans, Louisiana.

The Historic New Orleans Collection was established by General and Mrs. L. Kemper Williams to maintain and expand their collections of Louisiana history and culture. Facilities include a complex of historic French Quarter buildings at 533 Royal Street and the Williams Research Center located in the renovated former Third District Municipal Court building at 410 Chartres Street (598-7171). In addition to period rooms on permanent exhibit, THNOC presents a schedule of temporary exhibitions at both the Williams Gallery located in the Royal Street complex and the Williams Research Center. In addition to books and manuscripts, it maintains curatorial collections consisting

The Historic New Orleans Collection, cont.

of paintings, maps, architectural drawings, vintage photographs, works on paper, sculpture, decorative arts and memorabilia. Highlights include the collection of photographer Clarence John Laughlin (totaling over 37,000 photographs and negatives) and the Alfred R. Waud collection of about 1,800 drawings made for illustrations in "Harper's Weekly" and "Every Saturday" magazines. THNOC also maintains information on more than 20,000 artists and art organizations of national and local importance.

Louisiana State Museum

751 Chartres St., Jackson Square
New Orleans, LA 70116
Tel: (800) 568-6968
Fax: (504) 568-4995
Internet Address: http://www.crt.statelaus/
crt/museum/lsmnet3.htm
Exec. Director: Mr. James F. Sefcik
Admission:
 fee: adult-$5.00, student-$4.00, senior-$4.00.
Attendance: 300,000 *Established:* 1906
Membership: Y *ADA Compliant:* Y
Parking: commercial adjacent to site.
Open: Tuesday to Sunday, 9am-5pm.
Closed: Legal Holidays.

Exterior view of Cabildo (completed, 1799), a National Historic Landmark. Photograph courtesy of Louisiana State Museum, New Orleans, Louisiana.

Facilities: **Architecture** (Cabildo, Presbytère, 1850 House, Old U.S. Mint, The Arsenal, Madame John's Legacy); **Auditoria** (3); **Exhibition Galleries** (6 landmarks, each with galleries); **Library** (40,000 volumes); **Shop.**

Activities: **Education Programs**; **Gallery Talks** (weekends - monthly); **Guided Tours**; **Lectures**; **Temporary Exhibitions**; **Traveling Exhibitions.**

Publications: collection catalogue; exhibition catalogues; newsletter, "Historical Perspectives" (quarterly).

The Louisiana State Museum is a complex of historic landmarks in New Orleans's French Quarter. Its buildings include the Cabildo, the Presbytere, the Old U.S. Mint, the 1850 House, the Arsenal, and Madame John's Legacy, containing extensive permanent collections of historical artifacts and works of art.

New Orleans Academy of Fine Arts - Academy Gallery

5256 Magazine St., New Orleans, LA 70115
Tel: (504) 899-8111
Director: Ms. Patsy Adams
Open: Monday to Friday, 9am-4pm; Saturday, 10am-4pm.
Facilities: **Exhibition Area.**
Activities: **Temporary Exhibitions.**

The Gallery functions as a teaching adjunct to the school, showing work of local, regional and national artists on a monthly basis.

New Orleans Museum of Art

1 Collins Diboll Circle, City Park, New Orleans, LA 70124
Tel: (504) 488-2631
Fax: (504) 484-6662
TDDY: (504) 488-9562
Internet Address: http://www.noma.org
C.E.O.: Mr. E. John Bullard
Admission: fee: adult-$6.00, child-$3.00, senior-$5.00.
Attendance: 344,000 *Established:* 1910 *Membership:* Y *ADA Compliant:* Y
Parking: free on site.

New Orleans Museum of Art, cont.

Open: Tuesday to Sunday, 10am-5pm.

Closed: Major Holidays, Mardi Gras Day, Good Friday.

Facilities: **Architecture** (Beaux Arts building, 1901 designed by Samuel Marx); **Auditorium** (220 seats); **Food Services** Courtyard Café (Tues-Sun, 10:30am-4:30pm); **Galleries**; **Library** (30,000 volumes, available by appointment); **Shop**; **Studio Classrooms**.

Activities: **Arts Festival**; **Education Programs** (children); **Films**; **Gallery Talks**; **Guided Tours**; **Lectures**; **Permanent Exhibits**; **Temporary Exhibitions**.

Publications: "Arts Quarterly"; permanent collection handbook; exhibition catalogues.

The Museum has 46 permanent collection galleries and three spaces for changing exhibitions. Its permanent collection comprises nearly 40,000 pieces. It is organized into ten separate categories: African Art (a comprehensive collection of works from sub-Saharan Africa's five major art producing regions, including a palace veranda post by Olowe of Ise); American Art (18th- and 19th-century paintings by Copley, Peale, Stuart, West, Durand, Sargent, and many Louisiana artists; 20th-century art by O'Keeffe, Hofmann, Lawrence, Pollock, Rosenquist, and Rauschenberg); Asian Art (250 Edo Period paintings, a survey of Chinese ceramics; Chinese bronzes; Indian art); Decorative Arts (6,000 pieces of glass, from ancient to contemporary; art pottery; silver; porcelain; 18th- and 19th-century French furniture; and also including a fine collection of objects by Peter Carl Fabergé on extended loan from the Matilda Gettings Gray Foundation Collection); European Art (Italian, 13th through 18th centuries, including paintings donated by Samuel H. Kress; Dutch and Flemish, 16th and 17th centuries; French, 17th through 20th centuries, notably 19th-century Salon and Barbizon School painting, and Impressionist and Post-Impressionist painting); Native American Art (Hopi and Zuni Kachina dolls, pottery, baskets, beadwork, and textiles); Oceanic Art (art from the cultures of Polynesia, Melanesia, and Indonesia); Photography (over 7,000 photographs comprising an encyclopedic survey of the history of the medium; works by Adams, Talbot, Bourke-White, Steichen, Cunningham, and many others); Pre-Columbian Art (an outstanding collection of sculpture and ceramics from the cultures of Mexico and Central and South America); and Prints and Drawings (over 3,500 works on paper, primarily by 19th- and 20th-century American and European artists, including Cézanne, Degas, Picasso, Matisse, Miró, Calder, Johns, Rosenquist, Hartley, and O'Keeffe). There is shuttle bus transportation available from the downtown business district during Museum hours.

Southern University at New Orleans - African Art Collection

Southern University Library, 6400 Press Drive, New Orleans, LA 70126

Tel: (504) 286-5207

Fax: (504) 286-5161

Internet Address: http://www.gnofn.org/~zaire/suno1.htm

Curator of CAAAS Collections: Dr. Sara Hollis

Parking: free on site.

Open: Call for hours.

Facilities: **Exhibition Area.**

The Center for African and African American Studies Art Collection at SUNO consists over 900 objects, most of them from Zaire.

Tulane University - Newcomb Arts Complex

Woldenberg Art Center/Tulane University, 6823 St. Charles Ave., New Orleans, LA 70118-5698

Tel: (504) 865-5327

Fax: (504) 862-8710

Internet Address: http://www.tulane.edu

Acting Director: Ms. Sally Main

Admission: free.

Attendance: 1,200 *Established:* 1886 *ADA Compliant:* Y

Open: Monday to Friday, 9am-4:30pm.

Closed: New Year's Eve to New Year's Day, Mardi Gras, Thanksgiving Day, Christmas Day.

Tulane University - Newcomb Arts Complex, cont.

Facilities: **Gallery; Library.**

Activities: **Gallery Talks.**

The Complex contains a large gallery for student and faculty exhibitions and the Pace-Willson Glass Studio, a glassblowing facility. On display are Tiffany stained glass windows from the original Newcomb campus.

University of New Orleans - UNO Fine Arts Gallery

Fine Arts Complex, Lakeshore Drive, New Orleans, LA 70148

Tel: (504) 280-6493

Fax: (504) 280-7346

Internet Address: http://www.uno.edu/~finearts/gallery.html

Admission: free.

Open: Monday to Friday, 8:30am-4:30pm.

Facilities: **Exhibition Area** (2,100 square feet).

Activities: **Rotating Exhibitions.**

Located at the entrance to the Fine Arts Complex, the Gallery displays exhibitions featuring graduate thesis work, undergraduate senior exit shows, faculty work, and special exhibitions of work by noted contemporary artists.

Ruston

Louisiana Tech University Art Galleries

School of Art, Visual Arts Center, Ruston, LA 71272

Tel: (318) 257-3909

Internet Address: http://www.art.latech.edu

Open: **In Session,** Monday to Friday, 9am-4pm.

Facilities: **Galleries** (2).

Activities: **Temporary Exhibitions.**

Two galleries, The Tech Art Gallery and The E.J. Belloc, present exhibitions of work by contemporary artists, focusing especially on that produced in the South and Midwest.

Shreveport

Centenary College - Meadows Museum of Art

2911 Centenary Blvd., Shreveport, LA 71104

Tel: (318) 869-5169

Fax: (318) 869-5730

Internet Address: http://www.centenary.edu

Director: Ms. Judy Godfrey

Admission: voluntary contribution.

Attendance: 19,000 *Established:* 1976 *Membership:* Y *ADA Compliant:* Y

Parking: free behind building.

Open: Tuesday to Friday, noon-4pm; Saturday to Sunday, 1pm-4pm.

Closed: New Year's Day, Easter, 1st 2 weeks in August, Thanksgiving Day, Christmas Day.

Facilities: **Galleries** (8, total 8,500 square feet).

Activities: **Concerts; Films; Gallery Talks; Guided Tours; Lectures; Permanent Exhibits; Temporary Exhibitions.**

Publications: booklet.

The Museum houses the Jean Despujols collection of paintings and drawings of Indochina. Consisting of over 360 oils, watercolors, and drawings, as well as over 1,000 photographs and complemented by the artist's diaries, the collection constitutes a remarkably comprehensive resource on the French colonial experience in Indochina. Also of possible interest on campus is the Turner Art Center Gallery, open Monday-Thursday, 9-9; Friday, 9-5; Saturday-Sunday, 2-5, except during academic holidays. Call 318-869-5260 for information.

R.S. Barnwell Memorial Garden and Art Center

601 Clyde Fant Parkway, Shreveport, LA 71101-3655

Tel: (318) 673-7703

Fax: (318) 673-7707

Admission: voluntary contribution.

Attendance: 71,000 *Established:* 1970

Membership: Y *ADA Compliant:* Y

Open: Monday to Friday, 9am-4:30pm; Saturday to Sunday, 1pm-5pm.

Closed: New Year's Day, Washington's B'day, Good Friday,
Memorial Day, Independence Day, Labor Day,
Thanksgiving Day, Christmas Day.

Facilities: **Auditorium** (200 seats); **Garden**; **Library** (non-circulating); **Shop**.

Activities: **Arts Festival**; **Education Programs** (adults and children);
Films; **Lectures**; **Traveling Exhibitions**; **Workshops**.

Publications: "Barnwell Beacon" (quarterly).

Barnwell Memorial Garden & Art Center has extensive gardens and floral exhibits and also mounts temporary art exhibits. It does not house a permanent collection.

Drawing of exterior of R.S. Barnwell Garden and Art Center. Courtesy of R.S. Barnwell Garden and Art Center, Shreveport, Louisiana.

The R.W. Norton Art Gallery

4747 Creswell Ave., Shreveport, LA 71106

Tel: (318) 865-4201

Fax: (318) 869-0435

Internet Address: http://www.softdisk.com/comp/norton

C.E.O.: Mrs. Richard W. Norton, Jr.

Admission: voluntary contribution.

Attendance: 36,000 *Established:* 1946

Membership: N *ADA Compliant:* Y

Parking: free on site.

Open: Tuesday to Friday, 10am-5pm;
Saturday to Sunday, 1pm-5pm.

Closed: Legal Holidays.

Facilities: **Gallery**; **Library** (6,000 volumes, non-circulating;
Tuesday-Saturday, 1pm-5pm).

Activities: **Education Programs** (adults and children); **Guided Tours**; **Temporary Exhibitions**; **Traveling Exhibitions**.

Publications: brochure, "The R.W. Norton Art Gallery"; collection catalogues; exhibition catalogues.

View of exterior of R.W. Norton Gallery. Photograph by Fletcher Thorne-Thomsen, courtesy of R.W. Norton Gallery, Shreveport, Louisiana.

The R.W. Norton Art Gallery houses an impressive collection of European and American art. The European collection includes works by Bonheur, Corot, Houdon, Piranesi, Reynolds, and van Ruisdael, and some of the American artists represented are Bierstadt, Bingham, Church, Cole, Cropsey, Heade, Inness, Charles Willson Peale, James Peale, Rembrandt Peale, Frederic Remington, Charles M. Russell, Saint-Gaudens, Sully, and Tait. There are also collections of Flemish tapestries, Wedgwood, and Steuben glass, along with antique firearms, dolls, and rare books, including a double elephant folio edition of Audubon's "Birds of America". The Gallery also mounts temporary exhibitions.

Slidell

Slidell Cultural Center

444 Erlanger St., Slidell, LA 70458

Tel: (504) 646-4375

Fax: (504) 646-4231

Director: Brian Hammell

Slidell Cultural Center, cont.

Admission: voluntary contribution.

Attendance: 4,000 *Established:* 1989

ADA Compliant: Y

Open: Monday to Wednesday, 9am-4pm;
Thursday, 9am-4pm and 6pm-8pm;
Friday, 9am-4pm;
Sunday, noon-3pm.

Closed: New Year's Day, ML King Day,
Mardi Gras, Good Friday,
Memorial Day, Independence Day,
Labor Day, Thanksgiving Day,
Christmas Eve to Christmas Day.

Facilities: **Exhibition Area** (1,328 square feet);
Library.

Activities: **Guided Tours**; **Temporary Exhibitions** (7 per year); **Traveling Exhibitions.**

Rolland Golden, *Spring Sisters*, lithograph; exhibited at Slidell Cultural Center, 1998. Photograph courtesy of Slidell Cultural Center, Slidell, Louisiana.

Publications: newsletter, "Bravo!" (quarterly).

The Cultural Center mounts six to seven temporary exhibitions per year, about half of which are juried.

Maine

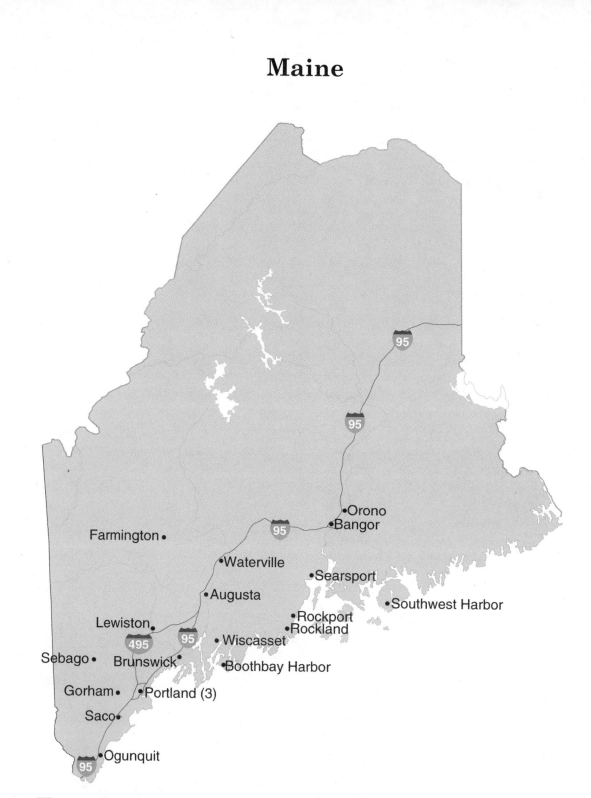

The number in parentheses following the city name indicates the number of museums/galleries in that municipality. If there is no number, one is understood. For example, in the text three listings would be found under Portland and one listing under Boothbay Harbor.

Maine

Augusta

Maine State Museum

Cultural Building, State House Complex
Augusta, ME 04333
Tel: (207) 287-2301
Fax: (207) 287-6633
TDDY: (207) 287-6740
Director: Mr. Joseph R. Phillips
Admission: free.
Attendance: 88,000 *Established:* 1837
Membership: Y *ADA Compliant:* Y
Parking: free on site; somewhat limited.
Open: Monday to Friday, 9am-5pm;
 Saturday, 10am-4pm;
 Sunday, 1pm-4pm.
Closed: New Year's Day, Easter,
 Thanksgiving Day, Christmas Day.

Charles Codman, *Statehouse in 1836*, 1836, (detail). Building designed by Charles Bullfinch and completed in 1832. Maine State Museum. Photograph courtesy of Maine State Museum, Augusta, Maine.

Facilities: **Exhibition Area**; **Library** (2,600 volumes, use on premises); **Bookstore**; **State House** (90 portraits on exhibit).
Activities: **Education Programs** (undergraduate college students and children); **Guided Tours**; **Lectures**; **Permanent Exhibits**; **Temporary Exhibitions**.
Publications: books; newsletter, "Broadside" (quarterly); pamphlets.

The Maine State Museum's exhibits are wide-ranging, giving an overview of the state's natural history, archeology, and manufacturing history. Decorative arts and folk art figure prominently in the collections and exhibits. The State House Collection of portraits is always on view in the State House, and other art works are on display in the Blaine House (Governor's Mansion) next door. Both the Blaine House and the Capitol also feature changing exhibitions of contemporary art.

Bangor

Bangor Historical Society Museum

159 Union St., Bangor, ME 04401
Tel: (207) 942-5766
Exec. Director: Margaret E. Puckett
Admission: fee: adult-$5.00, child-free.
Attendance: 1,200 *Established:* 1864
Membership: Y
Open: **April to December 24,**
 Tuesday to Friday, noon-4pm.
 June to September,
 Saturday, noon-4pm.
Closed: Legal Holidays.
Facilities: **Architecture** (Greek Revival home, 1836, designed by Richard Upjohn).

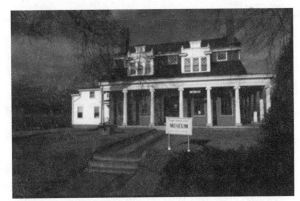

Exterior view of Thomas A. Hill house (1836), designed by Richard Upjohn. Photograph courtesy of Bangor Historical Society, Bangor, Maine.

Activities: **Lectures**; **Permanent Exhibits**; **Temporary Exhibitions**.
Publications: newsletter (semi-annual).

The Museum of the Bangor Historical Society houses historical artifacts, 19th-century furnishings, portraits, and photographs. It also mounts temporary exhibitions.

Boothbay Harbor

Boothbay Region Art Gallery

7 Townsend Ave., Boothbay Harbor, ME 04538
Tel: (207) 633-2703
Director: Mr. Roger E. Roche

Boothbay Harbor, Maine

Boothbay Region Art Gallery, cont.

Admission: voluntary contribution.

Attendance: 10,000 *Established:* 1964

Membership: Y *ADA Compliant:* N

Parking: metered on street and commercial lots.

Open: **Memorial Day to Columbus Day**,
Monday to Sunday, 11am-5pm.

Facilities: **Exhibition Area** (2 floors).

Activities: **Temporary Exhibitions** (4/season).

The Boothbay Region Art Foundation Gallery presents monthly exhibitions of both members work. The Gallery focuses on traditional landscapes, seascapes, and coastal scenes in oil, watercolor, pastel, and drawing. Prints, photographs, and reproductions are also displayed.

Exterior view of Gallery. Photograph courtesy of Boothbay Region Art Foundation, Inc., Boothbay Harbor, Maine.

Brunswick

Bowdoin College Art Museum

Walker Art Building, 9400 College Station, Brunswick, ME 04011

Tel: (207) 725-3275

Fax: (207) 725-3762

Internet Address: http://www.bowdoin.edu/cwis/artmuseum

Director: Katy Kline

Admission: voluntary contribution.

Attendance: 25,000 *Established:* 1811 *ADA Compliant:* Y

Parking: free on Upper Park Row.

Open: Tuesday to Saturday, 10am-5pm; Sunday, 2pm-5pm.

Closed: Legal Holidays.

Facilities: **Architecture** (1894 designed by C.F. McKim; 1975 addition by E.L. Barnes); **Galleries** (Winslow Homer Gallery open only during summer); **Shop**.

Activities: **Education Programs** (adults and undergraduate college students); **Gallery Talks**; **Guided Tours** (reservations 2 weeks in advance); **Lectures**; **Permanent Exhibits**; **Temporary Exhibitions**; **Traveling Exhibitions**.

Publications: collection catalogue; exhibition catalogues.

The Bowdoin College Museum of Art numbers 14,000 objects in its collection. In the rotunda of the Museum building, designed by McKim, Mead & White, are murals of Athens, Rome, Florence, and Venice by John LaFarge, Elihu Vedder, Abbott Thayer, and Kenyon Cox. In addition to displaying its permanent collection, the Museum schedules an active program of temporary exhibitions of art lent by institutions and collectors throughout the United States. The Museum has a large collection of colonial and federal portraits, including works by Smibert, Feke, Blackburn, Copley, Stuart, Trumbull, and Sully; an ancient art collection containing sculpture, vases, terra-cottas, bronzes, and glass, as well as five 9th-century B.C. Assyrian reliefs; a Samuel H. Kress Study Collection of twelve Renaissance paintings; Chinese and Korean ceramics: nineteen paintings by John Sloan: a significant collection of works by Winslow Homer; and other works by 19th- and 20th-century American artists, including Heade, Johnson, Inness, Eakins, Sargent, Glackens, Hartley, Gorky, Kline, Wyeth, and Katz.

Farmington

University of Maine at Farmington - UMF Art Gallery

102 Main St. (Rear), Farmington, ME 04938

Tel: (207) 778-7001

Fax: (207) 778-7075

Internet Address: http://www.umf.maine.edu/gallery

Asst. Professor & Gallery Director: Ms. Sarah Radley Maline

Admission: free.

University of Maine at Farmington - UMF Art Gallery, cont.

Established: 1983
Open: Tuesday to Sunday, Noon-4pm.
Facilities: **Exhibition Area**.
Activities: **Lectures; Temporary Exhibitions** (6/year); **Workshops**.

Occupying a renovated large barn in the rear of 102 Main Street, the Gallery presents a schedule of exhibitions intended to demonstrate the diversity of style and media in contemporary art. Showings, complemented by related lectures and workshops, feature primarily artists who live in Maine. Permanent sculptures are installed on the lawn in front of the Gallery and artwork is also be displayed in Mantor Library, Einar Olsen Student Center, and in other buildings on campus.

Gorham

University of Southern Maine - Art Gallery

Gorham Campus, 37 College Ave., Gorham, ME 04038
Tel: (207) 780-5008
Fax: (207) 780-5759
Internet Address: http://www.usm.maine.edu/~gallery
Director of Exhibitions and Programs: Ms. Carolyn Eyler
Admission: free.
Membership: N
Open: Tuesday to Friday, 11am-4pm; Saturday, 1pm-4pm.
Closed: Academic Holidays.
Facilities: **Exhibition Area** (1,500 square feet).
Activities: **Lectures; Temporary Exhibitions**.

The Gallery presents exhibitions of the work of professional artists and students, including an annual juried student show in the spring. USM also maintains a gallery on its Portland campus. See listing under Portland.

Lewiston

The Bates College Museum of Art

Olin Arts Center
75 Russell St.
Lewiston, ME 04240-6044
Tel: (207) 786-6158
Fax: (207) 786-8335
Internet Address: www.bates.edu/adm/museum
Director: Dr. Genetta McLean
Admission: free.
Attendance: 20,000 *Established:* 1986
Membership: Y *ADA Compliant:* Y
Parking: free on street.
Open: Tuesday to Saturday, 10am-5pm;
 Sunday, 1pm-5pm.
Closed: Legal Holidays.
Facilities: **Galleries**.
Activities: **Gallery Talks; Permanent Exhibits; Temporary Exhibitions; Traveling Exhibitions**.
Publications: exhibition catalogues.

Marsden Hartley, *Georgetown Lighthouse Seascape*, drawing. Bates College Museum of Art. Photograph by Melville McLean, courtesy of Bates College Museum of Art, Lewiston, Maine.

The Museum is home to one of the region's finest collections of masterworks on paper and is known nationally for its significant holdings of drawings by Marsden Hartley. It also houses prints, paintings, photographs, sculpture, and ceramics. The Museum hosts temporary exhibitions as well showings of the permanent collection throughout the year.

Ogunquit

Ogunquit Museum of American Art

183 Shore Road, Ogunquit, ME 03907
Tel: (207) 646-4909
Fax: (207) 646-4909
Director: Mr. John Dirks
Admission: fee: adult-$4.00, child-free, student-$2.00, senior-$3.00, family-$3.00.
Attendance: 10,000 *Established:* 1952
Membership: Y
Parking: free on site.
Open: **July to September**,
 Monday to Saturday, 10:30am-5pm;
 Sunday, 2pm-5pm.
Closed: Labor Day.
Facilities: **Galleries** (5); **Sculpture Garden**; **Shop.**
Activities: **Individual and Group Shows**; **Permanent Exhibits.**
Publications: bulletin; catalogue (annual).

Will Barnet, *Woman with White Cat*, 1966, serigraph. Collection of and photograph courtesy of the Ogunquit Museum of American Art, Ogunquit, Maine.

Set in a beautiful location on the Maine coast, the Ogunquit Museum of American Art displays works from its permanent collection along with an array of temporary exhibitions each year. The permanent collection of the Museum includes works by Bacon, Benton, Barnet, Burchfield, Demuth, Hartley, Hopper, Kent, Kuniyoshi, Kuhn, Lachaise, Marsh, and Zorach, among others.

Orono

University of Maine Museum of Art (UMMA)

109 Carnegie Hall, College Ave., Orono, ME 04469-5712
Tel: (207) 581-3255
Fax: (207) 581-3083
Internet Address: http://www.umaine.edu/artmuseum
Director: Mr. Wally Mason
Admission: free.
Attendance: 12,000 *Established:* 1946 *Membership:* Y
Parking: free with visitor permit available at Museum.
Open: Monday to Saturday, 9am-4:30pm.
Facilities: **Exhibition Areas** (2 galleries in Carnegie Hall).
Activities: **Gallery Talks**; **Guided Tours** (upon request); **Temporary Exhibitions**; **Traveling Exhibitions.**
Publications: exhibition catalogues.

The Museum of Art is located in Carnegie Hall, donated by Andrew Carnegie and designed by Brainerd and Leeds in 1906, with renovations by Cooper Milliken (1947, 1966). The Museum mounts temporary exhibitions as well as displaying its permanent collection. The permanent collection includes works on paper by Audubon, Chagall, Goya, Hassam, Hopper, Tiepolo, and Whistler; paintings by Blakelock, Braque, Cassatt, Inness, Rivera, and Picasso; contemporary works by Beckmann, Dine, Lichtenstein, and Rauschenberg; and works by Maine artists, such as Abbott, Hartley, Homer, Marin, Sprinchorn, and Wyeth.

Portland

Maine College of Art - Institute of Contemporary Art (ICA at MECA)

Porteous Building, 522 Congress St., Portland, ME 04101
Tel: (207) 879-5742
Fax: (207) 780-0816
Internet Address: http://www.meca.edu
Director: Mr. Mark H.C. Bessire
Admission: voluntary contribution.
Attendance: 15,000 *Established:* 1983
Membership: N *ADA Compliant:* Y
Parking: on street.
Open: **September to May**,
> Tuesday to Wednesday, 11am-4pm;
> Thursday, 11am-9pm;
> Friday to Sunday, 11am-4pm.
> **June to August**,
> Wednesday to Saturday, 11am-5pm;
> Thursday, 11am-8pm;
> Friday to Sunday, 11am-5pm.

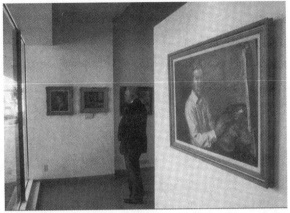

View of gallery during an exhibition. Photograph courtesy of Institute of Contemporary Art at the Maine College of Art, Portland, Maine.

Facilities: **Exhibition Area** (2,100 square feet).
Activities: **Education Programs** (undergraduate and graduate college students); **Films**; **Guided Tours**; **Lectures**; **Traveling Exhibitions**.
Publications: exhibition catalogues.

A non-collecting institution, the ICA maintains an ongoing program of temporary exhibitions, focusing on regional, national, and international developments in contemporary art, and on the art of Maine College of Art students, faculty, and alumni.

Portland Museum of Art

Seven Congress Square (intersection of High, Congress, & Free Sts.), Portland, ME 04101
Tel: (207) 775-6148
Fax: (207) 773-7324
Internet Address: http://www.portlandmuseum.org
Director: Mr. Daniel E. O'Leary
Admission: fee: adult-$6.00, child-$1.00,
 student-$5.00, senior-$5.00.
Attendance: 150,000 *Established:* 1882
Membership: Y *ADA Compliant:* Y
Parking: on street and nearby nearby garages.
Open: **July to Columbus Day**,
> Monday to Wednesday, 10am-5pm;
> Thursday to Friday, 10am-9pm;
> Saturday, 10am-5pm;
> Sunday, noon-5pm.
> **Columbus Day to June**,
> Tuesday to Wednesday, 10am-5pm;
> Thursday to Friday, 10am-9pm;
> Saturday, 10am-5pm;
> Sunday, noon-5pm.

Exterior view of Portland Museum of Art. Photograph by Craig M. Becker, courtesy of Portland Museum of Art, Portland, Maine.

Closed: New Year's Day, Christmas Day.
Facilities: **Architecture** (1983 designed by I. M. Pei & Partners); **Auditorium** (187 seats); **Food Services** Café; **Galleries**; **Shop**.
Activities: **Concerts**; **Education Programs** (adults and children); **Films**; **Gallery Talks**; **Guided Tours** (Daily, 2pm; Thurs, 5:30pm; groups, reserve 3 weeks advance); **Lectures**; **Permanent Exhibits**; **Temporary Exhibitions**; **Traveling Exhibitions**.

Portland Museum of Art, cont.

Publications: brochures; bulletins (monthly); exhibition catalogues.

The state's oldest arts institution, the Portland Museum of Art has an extensive collection of fine and decorative arts dating from the 18th century to the present. Works by Winslow Homer, John Singer Sargent, Rockwell Kent, Marsden Hartley, and Andrew Wyeth showcase the artistic heritage of the United States and Maine. The major European movements, from Impression through Surrealism are represented by the Joan Whitney Payson, Albert Otten, and Scott M. Black collections, which include works by Auguste Renoir, Edgar Degas, Claude Monet, Pablo Picasso, Edvard Munch, and René Magritte. Special exhibitions complement these holdings. The Joan Whitney Payson Collection is on view at the Colby College Museum of Art (see separate listing under Waterville, Maine) one semester every two years.

University of Southern Maine - Area Gallery

Woodbury Campus Center, Bedford St., Portland, ME 04104
Tel: (207) 780-5008
Internet Address: http://www.usm.maine.edu/~gallery
Director of Exhibitions and Programs: Ms. Carolyn Eyler
Admission: free.
Parking: University parkings lots on both sides of street.
Open: Monday to Thursday, 8am-10pm; Friday, 8am-5pm; Saturday, 9am-5pm.
Closed: Academic Holidays.
Facilities: Exhibition Area.
Activities: Lectures; Temporary Exhibitions.

The Gallery presents exhibitions of the work of professional artists and students.

Rockland

William A. Farnsworth Library and Art Museum

352 Main St., Rockland, ME 04841
Tel: (207) 596-6457
Fax: (297) 596-0509
Internet Address: http://www.midcoast.com/~farnsworth or http://www.wyethcenter
Director: Mr. Christopher B. Crosman
Admission: fee: adult-$9.00, child-$3.00, student-$5.00, senior-$8.00.
Attendance: 65,000 *Established:* 1948
Membership: Y *ADA Compliant:* Y
Parking: free on site.
Open: **June to September,**
 Daily, 9am-5pm.
 October to May,
 Tuesday to Saturday, 10am-5pm;
 Sunday, 1pm-5pm.
Facilities: **Architecture** (2 historic home sites); **Exhibition Area** (8 galleries); **Library** (4,000 volumes); **Reading Room; Sculpture Garden; Shops** (2).
Activities: **Concerts; Education Programs; Films; Gallery Talks; Guided Tours; Lectures; Permanent Exhibits; Temporary Exhibitions; Traveling Exhibitions.**

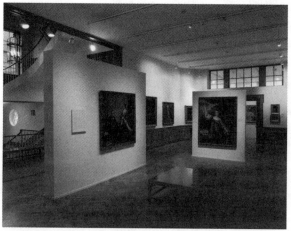

Interior view of main galleries Farnsworth Art Museum. Photograph by Brian Vanden Brink, courtesy of Farnsworth Art Museum, Rockland, Maine.

Publications: annual report; books; exhibition catalogues.

William A. Farnsworth Library and Art Museum, cont.

The Farnsworth Art Museum's permanent collection numbers over 8,000 objects. Works of some of the great names in 18th and 19th-century American art, including Thomas Eakins, Eastman Johnson, Fitz Hugh Lane, Gilbert Stuart, and Thomas Sully, are displayed in the seven main galleries. The Museum's substantial collection of American Impressionism includes canvases by Frank Benson, who lived and worked on Maine's North Haven Island for 40 summers, and by Childe Hassam, Maurice Prendergast, and John Twachtman, among others. The Farnsworth's collection of modern and contemporary art includes works by Milton Avery, George Bellows, Marsden Hartley, Edward Hopper, Robert Indiana, John Marin, and Fairfield Porter. It is anchored by a substantial endowment of works and archival materials of sculptor Louise Nevelson, who grew up in Rockland. Located in a former church across from the Farnsworth Homestead on the Museum's campus, the Farnsworth Museum Center for the Wyeth Family in Maine exhibits and houses Maine-related works from the personal collection of Andrew and Betsy Wyeth. With more than 4,000 artworks and related archival material, it is one of the world's most prominent venues for viewing the art of the Wyeth family (N.C., Andrew, and Jamie Wyeth). The Museum also owns the Olson House in nearby Cushing, Maine, depicted in Andrew Wyeth's "Christina's World", and numerous other works. The house is open to the public from Memorial Day through Columbus Day.

Rockport

Maine Coast Artists - Gallery

162 Russell Ave., Rockport, ME 04856
Tel: (207) 236-2875
Fax: (207) 236-2490
Internet Address: http://www.artsmaine.org
President: Mrs. Sheila Crosby Tasker
Admission: fee-$2.00.
Attendance: 16,000 *Established:* 1952 *Membership:* Y *ADA Compliant:* Y
Open: **June to September,**Tuesday to Saturday, 10am-5pm; Sunday, noon-4pm.
 October to May,Tuesday to Saturday, 10am-5pm.
Facilities: **Exhibition Area** (3 floors, 4 galleries); **Shop** (handcrafted Maine-made objects); **Studio Classrooms.**
Activities: **Artists' Professional Development Programs; Exhibitions; Gallery Talks; Gallery Tours; Juried Exhibition** (biennial); **Lectures; Workshops.**
Publications: exhibition catalogues; newsletter (semi-annual).

Maine Coast Artists Gallery mounts 20 to 30 exhibitions each year in four galleries.

Saco

York Institute Museum of the Dyer Library Association

371 Main St., Saco, ME 04072
Tel: (207) 282-0684 or (207) 283-3861
Fax: (207) 283-0754
Library Executive Director: Marilyn C. Solvay, Ph.D.
Admission: fee: adult-$4.00, child (<6)-free (>6)-$1.00, senior-$3.00, family-$10.00.
Attendance: 8,500 *Established:* 1866 *Membership:* Y *ADA Compliant:* Y
Open: Tuesday to Wednesday, noon-4pm; Thursday, noon-8pm; Friday, noon-4pm.
Closed: Legal Holidays.
Facilities: **Architecture** (Colonial Revival, 1926 design by John Calvin Stevens); **Exhibition Area; Library** (scholars/researchers, non-circulating); **Shop.**
Activities: **Artist-in-Residence Courses; Gallery Talks; Guided Tours; Lecture Series; Permanent Exhibits; Temporary Exhibitions.**
Publications: monographs (occasional); newsletter (quarterly).

York Institute Museum, cont.

The Institute Museum focuses on objects with documented histories of ownership in the Saco Valley in the 18th and 19th centuries. Its galleries are set up to allow changing exhibitions showcasing the permanent collections, special interpretive exhibits, and works by contemporary Maine artists. Permanent exhibits include paintings, furnishings, decorative art, and household objects. Among the artifacts is an 850-foot long "Panorama of Pilgrim's Progress". One of only a handful of 19th-century panoramas to survive, the "Pilgrim's Progress" was painted in New York in 1851 by a group of artists and illustrators associated with the National Academy of Design. The permanent collection contains more than 10,000 artifacts. Its collection of paintings and portraits includes a large group of portraits by John Brewster, Jr. (1766-1854) and works by other regional artists such as Gibeon Elden Bradbury (1833-1904) and Charles Henry Granger (1812-1893). The sculpture collection includes works by Jeanie Akers Bradbury, Charles Granger, Katherine Tupper Prescott, and John Rogers.

Searsport

Penobscot Marine Museum

Church St. at U.S. Route One, Searsport, ME 04974
Tel: (207) 548-2529
Fax: (207) 548-2520
Internet Address:
 http://www.penobscotmarinemuseum.org
Director: Mr. Renny A. Stackpole
Admission: fee:
 adult-$6.00, child-$2.00, senior-$5.00, family-$14.00.
Attendance: 14,000 *Established:* 1936
Membership: Y *ADA Compliant:* Y
Parking: free on site.
Open: **Memorial Day Weekend to October 15,**
 Monday to Saturday, 10am-5pm;
 Sunday, noon-5pm.
 October 16 to Thanksgiving Weekend,
 Friday to Sunday, noon-4pm.
 Monday after Thanksgiving Weekend to Memorial Day,
 Call for hours.

James E. Buttersworth, *Clipper Ship*, oil painting, Thomas and James Buttersworth Collection of marine paintings, Penobscot Marine Museum. Photograph courtesy of the Penobscot Marine Museum, Searsport, Maine.

Facilities: **Architecture** (8 National Register sites); **Gallery**; **Library** (8,000 volumes, non-circulating; Memorial Day-Oct. 15, Mon-Fri, 9am-4pm); **Picnic Area.**
Activities: **Guided Tours**; **Permanent Exhibits**; **Temporary Exhibitions.**
Publications: annual report; catalogues; newsletter, "The Bay Chronicle".

The Penobscot Marine Museum is dedicated to the preservation, documentation, and exhibition of the history of Penobscot Bay and the maritime history of Maine. It is a unique seafaring village comprised of thirteen historic and modern buildings, many of them former sea captains' homes. The campus includes eight buildings on the National Register of Historic Places. Showcased in galleries and historic rooms is one of New England's finest collections of furnishings, artifacts, ship models, paintings, photographs, China Trade art and artifacts, and small craft. The marine painting collection of works by Thomas and James Buttersworth is one of the largest in the country. Other artists represented include Cozzens, Heard, Jacobsen, Salmon, Stubbs, Waldron, and Yorke. Additionally, the Carver Memorial Art Gallery houses special seasonal exhibits. There are also hands-on exhibits for children and a diverse schedule of events and lectures.

Sebago

Jones Museum of Glass and Ceramics

Douglas Mountain Road, Sebago, ME 04029
Tel: (207) 787-3370
Fax: (207) 787-2800
Curator: Miss Dorothy-Lee Jones
Admission: fee: adult-$5.00, child-free, student-$3.00, senior-$3.75.
Attendance: 4,500 *Established:* 1978 *Membership:* Y *ADA Compliant:* Y
Parking: free on site.

Jones Museum of Glass and Ceramics, cont.

Open: **mid-May to mid-November**,
Monday to Saturday, 10am-5pm;
Sunday, 1pm-5pm.

mid-November to mid-May,
by appointment.

Facilities: **Galleries** (8); **Library** (9,000 volumes); **Shop**.

Activities: **Education Programs**; **Gallery Talks**; **Permanent Exhibits**; **Temporary Exhibitions**.

Publications: exhibit notes; newsletter; program of events.

The collection of the Museum contains more than 7,000 objects, dating from 1200 B.C., including Sandwich Glass, Chinese porcelain, Majolica, American art glass, and English porcelain.

Objects from collection of Jones Museum of Glass and Ceramics. Photograph courtesy of Jones Museum of Glass and Ceramics, Sebago, Maine.

Southwest Harbor

Wendell Gilley Museum of Bird Carving

Main St. and Herrick Road, Southwest Harbor, ME 04679

Tel: (207) 244-7555

Internet Address: http://www.acadia.net/gilley

Director: Ms. Nina Z. Gormley

Admission: fee: adult-$3.25, child-$1.00.

Attendance: 19,000 *Established:* 1979

Membership: Y *ADA Compliant:* Y

Parking: lot in front of museum and across street.

Open: **January to April**, groups by appointment.

May, Friday to Sunday, noon-4pm.

June, Tuesday to Sunday, 10am-4pm.

July to August, Tuesday to Sunday, 10am-5pm.

September to October, Tues to Sun, 10am-4pm.

November to December 24, Fri to Sun, noon-4pm.

Closed: Legal Holidays.

Facilities: **Exhibition Area** (3 galleries); **Reading Room**; **Shop** (local bird carvings, tools, books, bird-related items).

Activities: **Demonstrations** (daily); **Education Programs** (adults and children); **Films**; **Guided Tours** (groups, by appointment); **Lectures** (usually 3rd Thurs in month, 7:30pm); **Permanent Exhibits**; **Temporary Exhibitions** (summer wildlife art shows); **Workshops**.

Wendell Gilley, *Bald Eagle*, 1976, polychrome wood carving, life-size, made for David Rockefeller, as gift for his brother, Nelson, upon the latter's retirement from the vice-presidency. Permanent collection of Wendell Gilley Museum. Photograph courtesy of Wendell Gilley Museum, Southwest Harbor, Maine.

Publications: brochures; newsletter, "The Eider" (semi-annual).

The Museum displays bird carvings from miniature woodcocks to life-size owls, many by Southwest Harbor native Wendell Gilley (1904-1983), and changing exhibitions featuring work by historical and contemporary wildlife artists.

Waterville

Colby College Museum of Art

Bixler Art and Museum Center, 5600 Mayflower Hill Drive, Waterville, ME 04901

Tel: (207) 872-3228

Fax: (207) 872-3141

Internet Address: http://www.colby.edu/museum/geninfo.html

Director: Mr. Hugh J. Gourley, III

Colby College Museum of Art, cont.

Admission: free.

Attendance: 10,000 *Established:* 1959 *Membership:* Y *ADA Compliant:* Y

Parking: free in front of museum.

Open: Monday to Saturday, 10am-4:30pm; Sunday, 2pm-4:30pm.

Closed: Legal Holidays.

Facilities: **Galleries; Shop.**

Activities: **Arts Festival; Education Programs** (adults, undergraduate college students, and children); **Gallery Talks; Guided Tours** (on request); **Lectures; Permanent Exhibits; Temporary Exhibitions; Traveling Exhibitions.**

Publications: "Handbook of the Colby College Art Museum"; books; exhibition catalogues.

Located in the Bixler Art and Museum Center, the Museum has an outstanding permanent collection of 18th- through 20th-century American art and an active temporary exhibition program. The Paul Schupf Galleries for the Works of Alex Katz houses over 400 works donated by the artist. Colby's permanent collection also includes works by 18th-century American portrait artists such as Copley, Stuart, Peale; the Jette Collection of American Painters of the Impressionist Period, with works by 76 artists, the American Heritage Collection of primitive paintings, watercolors, and drawings; and The John Marin Collection of 26 paintings, watercolors, drawings and etchings; as well as works by Jennifer Bartlett, Chuck Close, Mark di Suvero, Carroll Dunham, Eric Fischl, Robert Henri, Sol LeWitt, Paul Manship, Louise Nevelson, Fairfield Porter, Joel Shapiro, Neil Welliver, Terry Winters, Andrew Wyeth, and many other 19th- and 20th-century artists who either lived or worked in Maine. Additionally, The Joan Whitney Payson Collection of French Impressionist and post-Impressionist Art, which includes works by Degas, Gauguin, Monet, Picasso, and Renoir, is resident at Colby for one semester every two years.

Wiscasset

Maine Art Gallery

Warren St., Wiscasset, ME 04578

Tel: (207) 882-7511

C.E.O.: Virginia M. Forrest

Admission: voluntary contribution.

Established: 1958

Open: **Summer**, Tuesday to Saturday, 10am-4pm; Sunday, 1pm-4pm.

 Winter, Thursday to Saturday, 10am-4pm; Sunday, 1pm-4pm.

Facilities: **Architecture** (former academy, 1807); **Exhibition Area.**

Activities: **Temporary Exhibitions.**

Publications: catalogue (monthly).

The Gallery presents temporary exhibitions.

Maryland

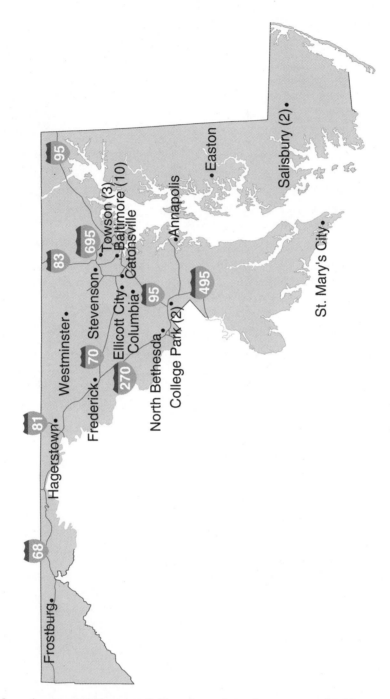

The number in parentheses following the city name indicates the number of museums/galleries in that municipality. If there is no number, one is understood. For example, in the text ten listings would be found under Baltimore and one listing under Easton.

Maryland

Annapolis

St. John's College - Elizabeth Myers Mitchell Art Gallery

60 College Ave., Annapolis, MD 21401
Tel: (410) 626-2556
Fax: (410) 263-4828
Internet Address:
 http://www.eidos.sjca.edu/events/gallery.phtml
Director: Ms. Hydee Schaller
Admission: voluntary contribution.
Attendance: 11,000 *Established:* 1989
Membership: Y *ADA Compliant:* Y
Parking: limited, call in advance.
Open: **Academic Year**,
 Tuesday to Thursday, noon-5pm;
 Friday, noon-5pm and 7pm-8pm;
 Saturday to Sunday, noon-5pm.
Closed: Academic Holidays, between semesters.
Facilities: **Exhibition Area** (1,825 square feet);
 Lecture Room; **Studios**.

Gallery talk by Jonathan Borofsky during his exhibition, "Prints and Multiples by Jonathan Borofsky, 1982-1991" at Mitchell Art Gallery. Photograph by Keith E. Harvey, courtesy of Elizabeth Myers Mitchell Art Gallery, St. John's College, Annapolis, Maryland.

Activities: **Guided Tours** (Tues-Fri, groups 5+ schedule 3 weeks in advance); **Lectures**; **Studio Courses**; **Temporary Exhibitions**; **Traveling Exhibitions**.
Publications: exhibit brochures; exhibition catalogues; exhibition programs; newsletter, "Artline".

The Mitchell Gallery's primary purpose is to establish possible connections between the visual arts and the liberal arts and to promote exhibits of unique historical and regional interest. Through museum-quality exhibitions that include original works by artists such as Rembrandt, Bruegel, Dürer, Tiepolo, Whistler, Renoir, Bonnard, Dove, Moore, Calder, and Lipschitz, as well as historical cartography, Japanese prints, and Picasso ceramics, the Gallery features a wide range of artists and movements. To further explore the visual arts, the Gallery offers educational programs, lectures, tours, and discussions in conjunction with each exhibition.

Baltimore

American Visionary Art Museum

800 Key Highway at Covington, Baltimore, MD 21230-3940
Tel: (410) 244-1900
Fax: (410) 244-5858
Internet Address:
 http://www.doubleclickd.com/avamhome.html
Admission: fee: adult-$6.00, child/student/senior-$4.00.
Attendance: 60,000 *Established:* 1995
ADA Compliant: Y
Parking: metered on street/commercial lot across from site.
Open: Tuesday to Sunday, 10am-6pm.
Closed: Christmas Day, Thanksgiving Day.
Facilities: **Exhibition Areas** (7 galleries); **Food Services** Joy
 America Café (daily, 11:30am-10pm, 80 seats); **Library** (850
 volumes); **Shop**; **Theatre** (150 seats).
Activities: **Films**; **Guided Tours**; **Lectures**; **Temporary Exhibitions**.
Publications: exhibition catalogues.

Vollis Simpson, *Whirligig*. In background, exterior view of American Visionary Art Museum. Photograph courtesy of American Visionary Art Museum, Baltimore, Maryland.

The American Visionary Art Museum focuses on the work of original, self-taught artists. Seven galleries feature works of outsider art. "All seven galleries hold wonders created by farmers, housewives, mechanics, retired folk, the disabled, the

347

American Visionary Art Museum, cont.

homeless, as well as the occasional neurosurgeon - all inspired by the fire within, from carved roots to embroidered rags, tattoos to toothpicks, the visionary transforms, dreams, loss, hopes, and ideals into powerful works of art."

The Baltimore Museum of Art (BMA)

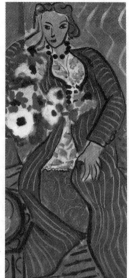

Art Museum Drive (at North Charles and 31st Sts., Wyman Park)
Baltimore, MD 21218
Tel: (410) 396-7100
Fax: (410) 396-7153
TDDY: (410) 396-4930
Internet Address: http://www.artbma.org
Director: Dr. Doreen Bolger
Admission: fee: adult-$6, child-free, student-$4, senior-$4; free, Thursdays.
Attendance: 277,589 *Established:* 1914
Membership: Y *ADA Compliant:* Y
Parking: metered on site and street.
Open: Wednesday to Friday, 11am-5pm; Saturday to Sunday, 11am-6pm;
 1st Thursday in month, 11am-9pm.
Closed: New Year's Day, Independence Day, Thanksgiving Day,
 Christmas Day.
Facilities: **Architecture** (classical revival building, 1929 design by John Russell Pope); **Auditorium**; **Building** (194,000 square feet); **Food Services** Café (Mon-Tues, 11:30am-3pm; Wed-Thurs, 11:30am-9pm; Fri-Sat, 11:30am-10pm; Sun, 10:30am-9pm; High Tea, Tues-Sun, 3pm-5pm); **Galleries**; **Library** (by appointment only, 50,000 volumes); **Sculpture Gardens** (2); **Shop** (Tues-Wed,11am-5pm; Thurs-Sat, 11am-8pm; Sun, 11am-6pm).

Henri Matisse, *Purple Robe and Anemones*, 1937, detail, Cone Collection, Baltimore Museum of Art. Photograph courtesy of Baltimore Museum of Art, Baltimore, Maryland.

Activities: **Concerts**; **Dance Recitals**; **Education Programs** (children); **Films**; **Gallery Talks**; **Guided Tours** (groups by appointment); **Lectures**; **Permanent Exhibits**; **Temporary Exhibitions** (10-12/year).
Publications: brochures; collection catalogues; exhibition catalogues; members magazine, "BMA Today" (bi-monthly); posters.

The Baltimore Museum of Art, Maryland's largest art museum, houses a permanent collection of over 85,000 objects, ranging from ancient mosaics to contemporary art. During the year, the BMA offers many special exhibitions along with diverse performing arts programs, lectures, films, and special events. Known as a "collection of collections," the BMA is recognized for the number of extraordinary private collections that have been donated to the Museum over the years. At its heart is the Cone Collection of approximately 3,000 works; heralded as one of the most outstanding collections of modern art in the world, it includes painting and sculpture by Cézanne, Gauguin, Matisse, Picasso, Renoir, van Gogh, and other masters of early 20th-century French art. The three floors of the BMA's original John Russell Pope Building, which reopened with a new gallery design in Spring 1997, present an outstanding collection of American painting and sculpture before 1900, decorative arts of the 18th through the 20th centuries, and period rooms from six Maryland historic houses. The West Wing for Contemporary Art houses sixteen galleries for the display of the permanent collection of post-1945 art and includes a gallery of major works by Andy Warhol. Highlights of the West Wing installation are objects by Jennifer Bartlett, Scott Burton, James Lee Byars, Willem de Kooning, Grace Hartigan, Jasper Johns, Ellsworth Kelly, Roy Lichtenstein, Barbara Kruger, Brice Marden, Elizabeth Murray, Bruce Nauman, Susan Rothenburg, and Frank Stella, among others. Other areas of strength include the exceptional collection of the arts of Africa, Asia, the Americas, and Oceania; a distinguished selection of Chinese ceramics; notable textile holdings, including several important Baltimore album quilts; eight galleries devoted to European Old Master painting and sculpture; and one of the finest collections of prints, drawings, and photographs in the country. Two sculpture gardens showcase modern and contemporary sculpture with 34 works gracing nearly three acres. Note: The Cone Collection and Old Master galleries are closed through the spring of 2001, though a selection of Old Master paintings is on view elsewhere in the Museum during renovation.

College of Notre Dame of Maryland - Gormley Gallery

Fourier Hall, 4701 N. Charles St., Baltimore, MD 21210-2404

Tel: (410) 532-5520

Fax: (410) 532-5795

Internet Address: http://www.ndm.edu

Department Chair: Domenico G. Firmani, Ph.D.

Admission: free.

Attendance: 1,000 *Membership:* N *ADA Compliant:* Y

Parking: adjacent college lots.

Open: Monday to Friday, 8:30am-5:30pm.

Facilities: **Exhibition Area** (650 square feet).

Activities: **Temporary Exhibitions**.

The gallery presents exhibitions of student and faculty work and juried exhibitions.

Contemporary Museum (Museum for Contemporary Arts)

100 West Centre Street, Baltimore, MD 21201

Tel: (410) 783-5720

Fax: (410) 783-5722

Internet Address: http://www.contemporary.org

Director: Mr. Gary Sangster

Admission: suggested contribution.

Attendance: 13,000 *Established:* 1989 *Membership:* Y *ADA Compliant:* Y

Open: Tuesday to Friday, 10am-5pm; Saturday to Sunday, 11am-5pm.

Closed: Legal Holidays.

Facilities: **Exhibition Area** (3,300 square feet); **Library** (200 volumes); **Shop**.

Activities: **Concerts**; **Education Programs** (adults and children); **Films**; **Guided Tours**; **Lectures**; **Temporary Exhibitions**; **Traveling Exhibitions**.

Publications: newsletter, "Contemporary Art Now" (quarterly).

Originally a "museum without walls" organizing exhibits of contemporary art at locations throughout the city, the Contemporary Museum established a permanent exhibition space in 1999.

The Johns Hopkins University - Evergreen House

4545 N. Charles St., Baltimore, MD 21210

Tel: (410) 516-0341

Fax: (410) 516-0864

Internet Address: http://www.jhu.edu/~evergreen/

Director: Ms. Lili R. Ott

Admission: fee: adult-$6.00, student-$3.00, senior-$5.00.

Attendance: 5,300 *Established:* 1952

Membership: Y *ADA Compliant:* Y

Parking: free on site.

Open: Monday to Friday, 10am-4pm;
Saturday to Sunday, 1pm-4pm.

Facilities: **Architecture** (Italianate 19th century mansion); **Formal Gardens**; **Grounds** (26 acres); **Shop** (pottery and glass, museum jewelry, books).

Activities: **Concerts**; **Guided Tours** (required; groups reserve in advance); **Lectures**.

Publications: annual report; newsletter (quarterly).

View of Greek Revival portico on façade of Evergreen House. The house was built in 1850s and expanded after its purchase by the Garretts in 1878. Photograph courtesy of Johns Hopkins University, Baltimore, Maryland.

The Johns Hopkins University - Evergreen House, cont.

Listed on the National Register of Historic Places, Evergreen House is a magnificent Italianate home on 26 wooded and landscaped acres. Owned by Baltimore's Garrett family from 1878 to 1942, the mansion, carriage house and gardens underwent two generations of adaptations and renovations. The house has functioned as the Rare Book Library and Fine Arts Museum of The Johns Hopkins University since 1952. Highlights of the 48-room mansion include collections of post-Impressionist paintings; rare books; Chinese blue and white porcelain; Japanese netsuke, inro, and lacquer boxes; Tiffany glass; and Baltimore's only private theatre with colorful Russian designs by Leon Bakst. All the collections are seen in the context of the elegant style of life at Evergreen, displayed as they were enjoyed by the Garretts.

Loyola College - Art Gallery

DeChiaro College Center, 2nd Floor, 4501 N. Charles St., Baltimore, MD 21210

Tel: (410) 617-2799

Internet Address: http://www.loyola.edu/gallery/index.html

Admission: free.

Parking: college parking lot off Cold Spring Lane.

Open: Monday to Friday, 11am-5pm; Sunday, 1pm-4pm.

Closed: Academic Holidays.

Facilities: **Exhibition Area**.

Activities: **Temporary Exhibitions**.

Located on the second floor in the Julio Fine Arts Wing of the DeChiaro College Center, the Gallery presents temporary exhibits of the work of contemporary artists.

Maryland Art Place (MAP)

218 W. Saratoga St., Baltimore, MD 21201

Tel: (410) 962-8565

Fax: (410) 244-8017

Internet Address: http://www.mdartplace.org

Exec. Director: Dr. Jack Rasmussen

Admission: free.

Attendance: 25,000 *Established:* 1982 *Membership:* Y *ADA Compliant:* Y

Parking: metered on street and commercial lots.

Open: Tuesday to Saturday, 11am-5pm.

Closed: Legal Holidays.

Facilities: **Exhibition Area** (2 floors exhibit space, 1 floor performance space).

Activities: **Temporary Exhibitions**.

Publications: exhibition catalogues (occasional); newsletter, "Artworks" (quarterly).

MAP is a contemporary non-profit arts center established to develop and maintain a dynamic environment for artists to exhibit their work, to nurture and promote new ideas and new forms, and to facilitate rewarding exchanges between artists and the public through educational leadership. MAP facilitates 12-15 exhibitions of both emerging and established regional artists each year, featuring artwork in all media. The work is selected by independent curators and MAP staff from open calls for submissions. MAP also has an extensive slide registry containing work by over 1,500 artists, funded by a grant from the Maryland State Arts Council.

The Maryland Institute College of Art - Galleries

1300 Mt. Royal Ave., Baltimore, MD 21217

Tel: (410) 669-9200

Fax: (410) 669-9206

Internet Address: http://www.mica.edu/galleries/galleries_main.htm/

Exhibition Director: Mr. Will Hipps

Admission: free.

Established: 1826 *ADA Compliant:* Y

Open: Monday to Wednesday, 10am-5pm; Thursday to Friday, 10am-9pm; Saturday, 10am-5pm; Sunday, noon-5pm.

The Maryland Institute College of Art - Galleries, cont.

Facilities: **Auditorium**; **Classrooms**; **Galleries**; **Library** (39,000 volumes).

Activities: **Concerts**; **Lectures**; **Performances**; **Temporary Exhibitions** (90/year).

Publications: bulletins; exhibition catalogues; posters.

Each year over 90 public exhibitions are presented in MICA galleries. Exhibitions have featured a diverse group of major artists from various disciplines. Programming also includes exhibits of work by graduate and undergraduate students, faculty, and visiting artists. Galleries include three major spaces, the Decker Gallery in the former Mt. Royal Station (corner of Cathedral and Dolphin Sts.), the Meyerhoff Gallery in the Fox Building (1341 Dickson St.), and the Pinkard Gallery in the Bunting Center (1401 West Mt. Royal Ave.). Smaller galleries primarily devoted to the exhibition of student work may be found on the ground floor of Main Building; the first, second and third floors of Fox Building; the first floor of Bunting Center; and in the Student Center. The George A. Lucas Collection of 19th century art is on loan to the Baltimore Museum of Art and the Walters Art Gallery.

Walters Art Gallery

600 North Charles St., Mount Vernon Place, Baltimore, MD 21201

Tel: (410) 547-9000

Fax: (410) 752-4797

Internet Address: http://www.TheWalters.org

Director: Dr. Gary Vikan

Admission: fee: adult-$5.00, child-$1.00, student-$3.00, senior-$3.00.

Attendance: 150,000 *Established:* 1931

Membership: Y *ADA Compliant:* Y

Parking:
 metered on street and nearby commercial lots.

Open: Tuesday to Friday, 10am-5pm;
 Saturday to Sunday, 11am-5pm;
 1st Thursday in month, 10am-8pm.

Closed: New Year's Day, Independence Day, Thanksgiving Day, Christmas Eve, Christmas Day.

View of Ancient Art Galleries, 1974 wing, Walters Art Gallery. Photograph courtesy of Walters Art Gallery, Baltimore, Maryland.

Facilities: **Architecture** (Renaissance Revival, 1904 by Adams & Delano; Mansion, 1850); **Auditorium** (500 seats); **Food Services** Restaurant (Tues-Sun, 11:30am-3:30pm); **Galleries**; **Library** (80,000 volumes, non-circulating by appointment); **Reading Room**; **Shop**.

Activities: **Education Programs** (adults, undergraduate/graduate students and children); **Films**; **Gallery Talks**; **Guided Tours** (Wed & Sun, 2pm; groups call in advance); **Lectures**; **Permanent Exhibits**; **Temporary Exhibitions**; **Traveling Exhibitions**.

Publications: annual report; book, "Catalogues of the Collection"; bulletin (monthly); collection catalogues; exhibition catalogues; journal, "Journal of the Walters Art Gallery" (annual).

Established by father and son collectors William and Henry Walters, who assembled one of the finest of American private collections, the Walters Art Gallery became a public museum in 1934. The Walters houses extensive collections of Western and Eastern art presenting a comprehensive history of art from the third millennium BC to the early 20th century. Among its thousands of objects, the Walters holds a fine collection of ivories, jewelry, enamels, and bronzes and a reserve of medieval and Renaissance illuminated manuscripts. The Walters' Egyptian, Greek and Roman, Byzantine, Ethiopian, and Western medieval art collections are among the best in the nation, as are the museum's holdings of Renaissance art. Every major trend in French painting during the 19th century is represented, including works by Corot, Daumier, Degas, Delacroix, Gérôme, Manet, Monet, and Pissarro. The Hackerman House, a renovated 1850 town house, displays over 1,000 works of Chinese, Japanese, Southeast Asian and Indian art.

Watermark Gallery

Skywalk Level, NationsBank, 100 S. Charles St., Baltimore, MD 21201

Tel: (410) 547-0452

President and Director: Ms. Edie Coffin

Baltimore, Maryland

Watermark Gallery, cont.

Admission: free.
Established: 1984 *Membership:* N
ADA Compliant: Y
Parking: commercial adjacent to site.
Open: Tuesday to Friday, 11am-4pm.
Closed: Legal Holidays.
Facilities: **Gallery** (cooperative).
Activities: **Temporary Exhibitions** (12/year).

Established by the Baltimore Watercolor Society as a cooperative, non-profit gallery, the Watermark maintains a changing exhibits of original artwork by members. Exhibits change the first Sunday of each month.

Exterior view of Watermark Gallery. Photograph courtesy of Watermark Gallery, Baltimore, Maryland.

Catonsville

University of Maryland, Baltimore County - Albin O. Kuhn Library Gallery

University of Maryland-Baltimore County, 1000 Hilltop Circle, Catonsville, MD 21250
Tel: (410) 455-2270
Fax: (410) 455-1153
Internet Address: http://www.research.umbc.edu/aok/main
Chief Curator: Mr. Tom Beck
Admission: voluntary contribution.
Attendance: 15,000 *Established:* 1975 *Membership:* Y *ADA Compliant:* Y
Parking: Parking Lot #10 during the day and in all designated spaces after regular business hours.
Open: Monday to Wednesday, noon-4:30pm; Thursday, noon-8pm; Friday, noon-4:30pm;
 Saturday, 1pm-5pm.
Closed: Legal Holidays, Academic Holidays.
Facilities: **Exhibition Area** (4,000 square feet, plus 420 square feet apart); **Library** (40,000 volumes); **Reading Room**.
Activities: **Education Programs** (college students); **Guided Tours**; **Temporary Exhibitions**; **Traveling Exhibitions**.
Publications: exhibition catalogues.

Located on the first floor of the Albin O. Kuhn Library, the Library Gallery displays items from the Library's Special Collections Department, as well as art and artifacts from all over the world. Traveling exhibitions are occasionally presented. Also of possible interest on campus, the Fine Arts Gallery (open: Tues-Sat, 10am-5pm; tel: 455-3188), located in the Fine Arts Building, presents a series of temporary exhibitions, including a biennial visual arts faculty exhibition.

College Park

University of Maryland - Art Gallery

1202 Art-Sociology Bldg., University of Maryland (Campus Drive, adjacent to Tawes Theater)
College Park, MD 20742
Tel: (301) 405-2763
Fax: (302) 314-7774
Internet Address: http:www.inform.umd.edu/ArtGal
Director: Mr. Scott Habes
Admission: free.
Attendance: 5,532 *Established:* 1966 *Membership:* Y *ADA Compliant:* Y
Parking: metered & parking garage; free Saturdays in Parking Lot #1.
Open: **Fall to Spring**,
 Monday to Wednesday, 11am-4pm; Thursday, 11am-8pm; Friday, 11am-4pm;
 Saturday, 11am-5pm.
Closed: Summer, Legal Holidays, Academic Holidays, Between Exhibitions.
Facilities: **Exhibition Area** (4,000 square feet); **Library** (40,000 volumes).
Activities: **Gallery Talks**; **Lectures**; **Temporary Exhibitions** (5-8/year); **Traveling Exhibitions**.
Publications: exhibition catalogues.

University of Maryland - Art Gallery, cont.

The Gallery presents an exhibition program that complements the University's academic offerings and maintains a permanent art collection for study, research and exhibition. Five to eight exhibitions are produced each year, often accompanied by catalogues, lectures, gallery talks, and panel discussions. The permanent collection consists of traditional African sculpture; 20th-century prints, photographs and paintings by American and European artists; American social realist and regional prints, drawings, and paintings from the 1930s; Chinese ceramics; and mid-20th-century Japanese prints. The Gallery also holds on long-term loan from the National Museum of American Art an important collection of WPA, 1930s mural studies for U.S. Post Offices. Also located in the Art Sociology Building is the student-run West Gallery, featuring the work of University of Maryland students (open: Mon-Fri, 8:30am-4:30pm). Additionally, the Parents' Association Art Gallery, located on the first floor of the Stamp Student Union features the work of local artists (open: Mon-Fri, 10am-6pm and Sat, 11am-5pm). Also of possible interest, the School of Architecture maintains a gallery space on the ground floor of the architecture building for the exhibition of architectural works by faculty, students, and professionals. Geographically adjacent to the College Park Campus, but administered separately is the Gallery at the Center for Adult Education, University of Maryland University College.

University of Maryland University College - Art Program Gallery

UMUC Inn and Conference Center, University Blvd. at Adelphi Road, College Park, MD 20747

Tel: (301) 985-7152

Fax: (301) 985-7678

Internet Address: http://www.umuc.edu

Director: Ms. Dena Crosson

Admission: free.

Established: 1978

Open: Daily, 8am-8pm.

Closed: Christmas Day to New Year's Day.

Facilities: **Exhibition Area**.

Activities: **Temporary Exhibitions**.

UMUC Arts Program maintains the Maryland Artists Collection of local artists, as well as the Mori Gallery and the International Collection, which feature artists from around the world. The Arts Program also sponsors an active temporary exhibition program, showcasing contemporary Maryland artists at three UMUC locations: the Inn and Conference Center in College Park, the Annapolis Center, and the St. Charles Center in Waldorf. The Arts Program permanent collection consists of the Maryland Artist Collection of more than 275 works by Maryland painters, printmakers, photographers, and sculptors; the Mori Collection; and the International Collection. Holdings also include the Herman Maril Collection, the largest number of works by that artist in any one collection. The Maril Collection is on display at UMUC's Inn and Conference Center on Sundays, 11am to 3pm, and during the week by appointment, (301) 985-7822. There are a number of other sites of possible interest on the University of Maryland campus; see separate listing for the Art Gallery of the University of Maryland for additional information.

Columbia

African Art Museum of Maryland

Oakland Manor, 5430 Vantage Point Road, Columbia, MD 21044

Tel: (410) 730-7105

Fax: (410) 715-3047

Internet Address: http://www.africanartmuseum.org

Founder and Director: Doris Hillian Ligon

Admission: fee: adult-$2.00, child-$1.00, senior-$1.00.

Established: 1980 *Membership:* Y *ADA Compliant:* Y (partial)

Open: Tuesday to Friday, 10am-4pm; Sunday, noon-4pm.

Facilities: **Exhibition Area**.

Activities: **Education Programs** (children); **Films**; **Guided Tours** (by appointment); **Lectures**; **Music and Dance Programs**, **Temporary Exhibitions**, **Tours to Africa** (annual).

Columbia, Maryland

African Art Museum of Maryland, cont.

Publications: exhibition program booklets; newsletter, "Museum Memos".

A privately owned and operated museum housed in historic Oakland Manor, AAMM exhibits traditional African art and offers school and community outreach programs.

Easton

Academy of the Arts

106 South St., Easton, MD 21601

Tel: (410) 822-2787

Fax: (410) 822-5997

Exec. Director: Mr. Christopher J. Brownawell

Admission: fee-$2.00.

Attendance: 60,000 *Established:* 1958 *Membership:* Y *ADA Compliant:* Y

Parking: free on site, 2-hour limit.

Open: Monday to Tuesday, 10am-4pm; Wednesday, 10am-9pm; Thursday to Saturday, 10am-4pm.

Closed: New Year's Day, Independence Day, Thanksgiving Day, Christmas Day.

Facilities: **Architecture** (former schoolhouse, 1820); **Darkroom**; **Galleries** (5, 1 permanent, 2 temporary exhibition); **Library** (500 volumes, use on written application); **Studios** (5).

Activities: **Concerts**; **Education Programs** (adults and children); **Films**; **Gallery Talks**; **Lectures**; **Performances**; **Temporary Exhibitions**.

Publications: exhibition catalogues; newsletter.

T he Academy of the Arts presents 26 temporary exhibitions annually focusing on Eastern shore artists, but including works by nationally and internationally known artists. Its permanent collection consists of 19th- and 20th-century American and European works on paper and works by significant Eastern Shore artists.

Ellicott City

Howard County Center for the Arts

8510 High Ridge Road, Ellicott City, MD 21043

Tel: (410) 313-2787

Fax: (410) 313-2790

TDDY: (800) 735-2258

Exec. Director: Ms. Coleen West

Admission: free.

Attendance: 44,000 *Established:* 1983 *Membership:* Y *ADA Compliant:* Y

Open: Monday to Friday, 10am-8pm; Saturday, 10am-4pm.

Facilities: **Black Box Theatre**; **Galleries** (2); **Meeting Room**; **Studios** (dance and visual arts).

Activities: **Classes**; **Performances**; **Summer Camp**; **Temporary Exhibitions** (every eight weeks); **Workshops**.

Publications: calendar (quarterly).

H CC Galleries I & II present exhibitions of work by professional artists on various themes with new exhibits appearing every eight weeks.

Frederick

Hood College - Hodson Gallery

Tatem Arts Center, 401 Rosemont Avenue, Frederick, MD 21701-8524

Tel: (301) 696-3456

Internet Address: http://www/hood.edu/artdept/gallery/gallery.html

Director: Ms. Joyce Michaud

Admission: free.

Open: **Academic Year**, Daily, 9am-7pm.

 Between Semesters, Weekdays, 10am-6pm.

Facilities: **Exhibition Area**.

Activities: **Temporary Exhibitions** (monthly).

Hood College - Hodson Gallery, cont.

The Gallery presents monthly exhibitions of work by professional artists, as well as an annual exhibit of student work. A full range of fine art media including painting, drawing, ceramics, prints, photography, sculpture, fiber, and computer-generated art is represented.

Frostburg

Frostburg State University - Stephanie Ann Roper Gallery

Fine Arts Building, 101 Braddock Road, Frostburg, MD 21532

Tel: (301) 687-4797

Fax: (301) 687-3099

Internet Address: http://www.fsu.umd.edu/dept/art/gall.htm

Director: Mr. Dustin Davis

Admission: free.

ADA Compliant: Y

Parking: adjacent to facility.

Open: Sunday to Wednesday, noon-4pm.

Facilities: **Exhibition Area** (2,000 square feet).

Activities: **Performances**; **Temporary Exhibitions**.

A teaching gallery, the Roper Gallery displays the work of locally, regionally, and nationally recognized artists. Exhibitions include Baltimore Museum presentations, BFA senior thesis exhibitions, juried student exhibitions, faculty shows, and cooperative performance exhibitions.

Hagerstown

Washington County Museum of Fine Arts

City Park, 91 Key St., Hagerstown, MD 21741

Tel: (301) 739-5727

Fax: (301) 745-3741

TDDY: (301) 739-5764

Internet Address: http://www.washcomuseum.org

Director: Ms. Jean Woods

Admission: voluntary contribution.

Attendance: 60,000 *Established:* 1929

Membership: Y *ADA Compliant:* Y

Parking: free on site.

Open: Tuesday to Saturday, 10am-5pm;
Sunday, 1pm-5pm.

Closed: New Year's Eve to New Year's Day, Good Friday, Memorial Day, Independence Day, Thanksgiving Christmas Eve to Christmas Day.

Facilities: **Classrooms** (2); **Galleries** (11); **Library** (4,500 volumes); **Music Gallery**; **Shop**.

Activities: **Art Classes**; **Concerts** (Sunday afternoon, as scheduled); **Education Programs** (children); **Guided Tours** (by appointment two weeks in advance); **Lectures**; **Permanent Exhibits**; **Temporary Exhibitions** (change every six weeks).

George Benjamin Luks, *Portrait of a Young Girl*, oil on canvas. Washington County Museum of and copyrighted by Fine Arts. Photograph courtesy of Washington County Museum of Fine Arts, Hagerstown, Maryland.

Publications: calendar, "News Bulletin" (bi-monthly); exhibition catalogues.

The Museum presents its permanent collection and an active schedule of exhibitions, concerts, lectures, films, art classes and special events throughout the year. Exhibitions are planned to highlight a variety of styles with many shows mounted from the permanent collection. Other exhibitions display works by nationally known artists or present private collections. Each winter local photographers compete in the Cumberland Valley Photographic Salon for the most talented amateur and professional photographers in the area. The Museum's permanent collection is particularly strong in American painting, drawings, prints and sculpture from the 19th century to the present, including

Washington County Museum of Fine Arts, cont.

portrait, landscape, still life and genre works, as well as decorative arts. Artists represented in the collection include Milton Avery, Paul Wayland Bartlett, Albert Bierstadt, James E. Buttersworth, William Merritt Chase, Frederic E. Church, Jasper F. Cropsey, William Glackens, Philip Guston, Childe Hassam, Robert Henri, George Inness, John F. Kensett, John LaFarge, Willard L. Metcalf, the Peales, Norman Rockwell, Severin Roesen, William Louis Sonntag, Thomas Sully, John Henry Twachtman, Benjamin West, James Abbott McNeill Whistler, and Worthington Whittredge, as well as regional and Maryland artists. Holdings also include European works, oriental artifacts, and African art. Paintings and pastels by the Museum's founder, William H. Singer, Jr., an expatriate who worked in the post-Impressionist manner, are also part of the collection.

North Bethesda

Strathmore Hall Art Center

10701 Rockville Pike, North Bethesda, MD 20852

Tel: (301) 530-0540

Fax: (301) 530-9050

Exec. Director: Mr. Eliot Pfanstiehl

Admission: free.

Established: 1983

Open: Call for hours.

Facilities: **Food Services** Tea Room; **Galleries**; **Library**; **Music Hall** (100 seats); **Shop**.

Activities: **Concerts**; **Performances**; **Temporary Exhibitions** (8/year).

Housed in a 1902 mansion, Strathmore Hall is Montgomery County's multidisciplinary art center. Each year it mounts eight exhibitions of work by locally, regionally, and nationally recognized artists.

Saint Mary's City

St. Mary's College of Maryland - Dwight Frederick Boyden Gallery

St. Mary's College of Maryland, Division of Arts & Letters

18952 E. Fisher Road, Saint Mary's City, MD 20686

Tel: (301) 862-0249

Fax: (301) 862-0958

Internet Address: http:www.smcm.edu/academics/gallery

Director: Mr. David Emerick

Admission: free.

Established: 1839

ADA Compliant: Y

Open: **Academic Term**,
Monday to Thursday, 11am-5pm;
Friday, 11am-4pm;
Saturday, noon-3pm.

Closed: Thanksgiving Week,
mid-December to mid-January,
May to August.

Facilities: **Exhibition Area** (1,600 square feet).

Activities: **Lectures**; **Temporary Exhibitions**; **Traveling Exhibitions**.

Publications: exhibition catalogues.

Scott Noel, *Sympathy for the model*, 1996, Exhibited in the exhibition "Embodied Fictions", 1998 at the Boyden Gallery. Photograph courtesy of the Boyden Gallery, St. Mary's College of Maryland, St. Mary's City, Maryland.

The Gallery holds five exhibitions of regional artists, a student show, and senior shows during each academic year. Exhibitions represent a diverse approach to understanding art and its meaning in today's society. Visiting artist's workshops and lectures are often integrated with the exhibitions.

Salisbury

Salisbury State University Galleries

Salisbury State University, 1101 Camden Ave., Salisbury, MD 21801

Tel: (410) 543-6271

Fax: (410) 548-3002

Internet Address: http://www.ssu.umd.edu

Director: Mr. Kenneth Basile

Admission: voluntary contribution.

Attendance: 20,000 *Established:* 1962

Membership: Y *ADA Compliant:* Y

Parking: visitor parking available.

Open: **During Exhibitions**,
> Tuesday to Friday, 10am-4pm;
> Saturday to Sunday, noon-4pm.

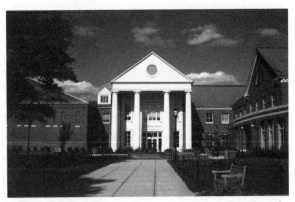

Exterior view of Fulton Hall, which houses the main gallery of University Galleries. Photograph courtesy of Salisbury State University Galleries, Salisbury, Maryland.

Closed: June to August, weekends; Legal Holidays.

Facilities: **Exhibition Area** (2 galleries); **Outside Sculpture** (campus-wide); **Shop**.

Activities: **Temporary Exhibitions**.

Publications: newsletter (quarterly).

The Salisbury State University Galleries sponsor a broad and varied program of art exhibitions including contemporary art by nationally recognized artists, and by emerging artists with significant regional reputations; materials of historical and scientific importance from different cultures and time periods; and the work of Art Department faculty and students. The main gallery, Fulton Hall Gallery is located in Fulton Hall; a second gallery, the Atrium Gallery, is located in Guerrieri University Center.

The Ward Museum of Wildfowl Art

909 Schumaker Drive, Salisbury, MD 21804

Tel: (410) 742-4988

Fax: (410) 742-3107

Exec. Director: Mr. Samuel H. Dyke

Admission: fee: adult-$7.00, child-free, student-$3.00, senior-$5.00, family-$17.00.

Attendance: 35,000 *Established:* 1976

Membership: Y *ADA Compliant:* Y

Open: Monday to Saturday, 10am-5pm; Sunday, noon-5pm.

Closed: Thanksgiving Day, Christmas Day.

Facilities: **Art Galleries** (4); **Education Center**; **Exhibition Area** (31,000 square feet); **Library** (200 volumes, non-circulating); **Shop** (original art, books, gift items); **Video Theatre**.

Activities: **Arts Festival** (Chesapeake Wildfowl Expo, 1st weekend in October); **Education Programs** (adults, undergraduate college students, and children); **Films**; **Gallery Talks**; **Guided Tours**; **Juried Show** (Ward World Championship); **Lectures**; **Permanent Exhibits** (3 galleries); **Temporary Exhibitions** (2 galleries, change quarterly); **Workshops**.

Greg Woodard, *Red-tailed Hawk and Kestrel*, 1997, Best of show in 1997 Ward World Championship Wildfowl Competition. Photograph courtesy of Ward Museum of Wildfowl Art, Salisbury, Maryland.

Publications: magazine, "Wildfowl Art Magazine" (semi-annual); newsletter, "The Ward Foundation News" (quarterly).

The Ward Museum of Wildfowl Art, situated in the heart of the Chesapeake Bay region, is the home to the most comprehensive collection of wildfowl art in the world, ranging from antique working decoys to internationally acclaimed contemporary sculpture and painting. The museum's interpretive galleries and theatre guide visitors through history and heritage, examining the relationship of man and nature, which gave rise first to primitive ingenuity, then to flights of artistic genius. A stylized recreation of Lem and Steve Ward's workshop displays examples of their carving, painting, and memorabilia. Changing exhibits, including both sculptural and flat art, are installed quarterly in the

Salisbury, Maryland

The Ward Museum of Wildfowl Art, cont.

museum. Workshops, seminars and tours for adults feature national experts in wildfowl art and conservation as speakers and leaders. The most visible of the museum's programs is the annual Ward World Championship Wildfowl Carving Competition, which has grown to become the largest and most prestigious juried show of wildfowl wood sculpture in the world. One thousand carvers from countries around the world including Japan, Canada, Mexico, Great Britain and Australia compete. In addition to paintings on exhibit, over two thousand carvings are entered in four levels of accomplishment. The winning entries at the prestigious World level become a part of the Museum's permanent collection. The 1998 competition was held in the Roland E. Powell Convention Center in Ocean City, Maryland. That year also was the inaugural year for the World Fish Carving Competition.

Stevenson

Villa Julie College Gallery

1525 Greenspring Valley Road, Stevenson, MD 21153-0641

Tel: (410) 602-7163

Fax: (410) 486-3552

Internet Address: http://www.vjc.edu/news_and_events/art_gallery/

Director: Ms. Diane DiSalvo

Established: 1997

Parking: free on site.

Open: Monday to Wednesday, 11am-5pm; Thursday, 11am-7pm; Friday, 11am-5pm;
Saturday, 11am-4pm.

Facilities: **Exhibition Area.**

Activities: **Exhibitions**; **Films**; **Lectures.**

Villa Julie presents exhibitions of historic and contemporary art in all media.

Towson

Goucher College - Rosenberg Gallery

Kraushaar Auditorium Lobby, Merrick Hall
1021 Dulaney Valley Road
Towson, MD 21204-2794

Tel: (410) 337-6333

Fax: (410) 337-6405

Internet Address:
http://www.goucher.edu/rosenberg

Exhibitions Director: Ms. Laura Burns

Admission: free.

Attendance: 175,000 *Established:* 1885

Membership: N *ADA Compliant:* Y

Parking: free on site.

Open: **September to May,**
Monday to Friday, 9am-5pm.
Summer, Special Exhibitions

Closed: Christmas Day to mid-January,
Thanksgiving Weekend.

Interior of Rosenburg Gallery in lobby of Kraushaar Auditorium and Merrick Hall during a 1996 exhibition. On left are appliqué quilts by Mary Swann and on right mixed media works by Maria Barbosa. Photograph courtesy of Art Department, Goucher College, Towson, Maryland.

Facilities: **Auditoria** (2; 1,000 seats and 225 seats); **Exhibition Area** (144 running feet of wall space).

Activities: **Lectures** (evenings, 1-2/season); **Temporary Exhibitions** (6-8/year).

Publications: exhibition catalogues (quarterly).

Operating under the auspices of Goucher's Art Department, the Gallery presents exhibitions of contemporary art each academic year. Most exhibits showcase work by regional artists in a wide variety of media; occasionally shows of works by other artists or traveling exhibitions sponsored by other institutions are scheduled. The Gallery has a special interest in providing opportunities for artists who are women, members of ethnic or racial minorities, or who live in rural areas of Maryland.

Towson University - Asian Arts and Culture Center

Center for the Arts (corner Cross Campus and Osler Drives) Towson, MD 21252-0001
Tel: (410) 830-2807
Fax: (410) 830-4032
Internet Address: http://www.towson.edu/tu/asianarts
Director: Mrs. Suewhei Shieh
Admission: free.
Attendance: 6,000 *Established:* 1971
Membership: Y *ADA Compliant:* Y
Parking: metered and on street.
Open: Monday to Friday, 11am-4pm.
Closed: Legal Holidays, Easter, Christmas Day.
Facilities: Exhibition Area (1,000 square feet); Library (100 volumes).
Activities: Arts Festival; Concerts; Dance Recitals; Films; Lectures; Permanent Exhibits; Temporary Exhibitions; Traveling Exhibitions; Workshops.

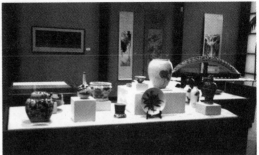

View of section of permanent collection of Asian Arts and Culture Center. Photograph courtesy of Asian Arts and Culture Center, Towson University, Towson, Maryland.

The Asian Arts and Culture Center at Towson University organizes art exhibitions and provides programming in traditional and innovative arts for the benefit of people of diverse cultural backgrounds. It also houses the University's collection of Asian art. The Center's emphasis is on providing the opportunity to meet, see, touch, feel, engage and truly experience the Asian lifestyle in an informal, accessible, and continuing forum.

Towson University - Holtzman Art Gallery

Fine Arts Complex (corner of Cross Campus and Osler Drives), Towson, MD 21204
Tel: (410) 830-2333
Internet Address: http://www.towson.edu
Director: Mr. Christopher Bartlett
Admission: free.
Established: 1973
Open: Tuesday to Wednesday, 10am-5pm and 6pm-9pm; Thursday to Saturday, 10am-5pm..
Facilities: Gallery.
Activities: Temporary Exhibitions.

Located in the Fine Arts Complex of Towson University, the Holtzman Art Gallery presents exhibitions of contemporary art in a broad range of media. Exhibits of well-known American and European artists, group shows, and theme shows are scheduled throughout the year.

Westminster

Western Maryland College - Rice Gallery

2 College Hill, Westminster, MD 21157
Tel: (410) 857-2594
Internet Address: http://www.wmc.car.md.us
Director: Prof. Michael Losch
Facilities: Galleries.

The Rice Gallery exhibits works from the College's permanent collection and presents shows of the work of professional artists.

Massachusetts

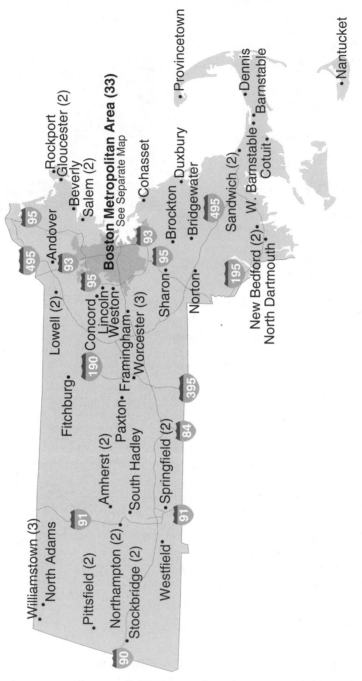

The number in parentheses following the city name indicates the number of museums/galleries in that municipality. If there is no number, one is understood. For example, in the text three listings would be found under Worcester and one listing under North Adams. Cities within the greater Boston metropolitan area will be found on the map on the facing page.

Greater Boston Metropolitan Area

(including Boston, Cambridge, Chestnut Hill, Medford, Newton,
Newtonville, Roxbury (Boston), Waltham, Wellesley, and Winchester)

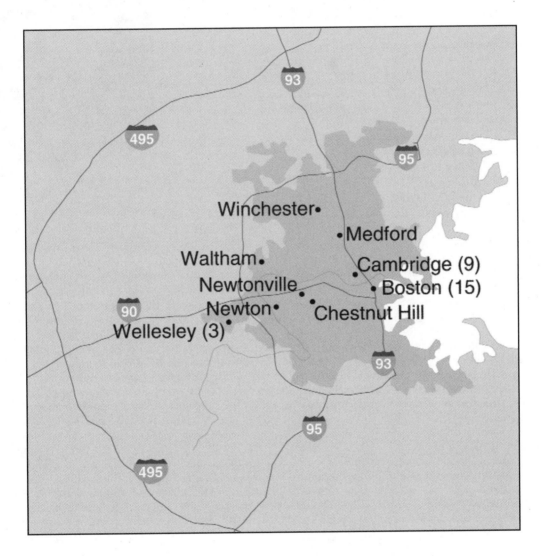

Massachusetts

Amherst

Amherst College - Mead Art Museum

Amherst College (corner of Routes 9 and 116), Amherst, MA 01002
Tel: (413) 542-2335
Fax: (413) 542-2117
Internet Address: http://www.amherst.edu/~mead
Director: Dr. Jill Meredith
Admission: voluntary contribution.
Attendance: 16,000 *Established:* 1950
Membership: Y *ADA Compliant:* Y
Parking: On site, closed for renovation through January 2001.
Open: **September to May,**
 Monday to Wednesday, 10am-4:30pm;
 Thursday, 10am-9pm;
 Friday, 10am-4:30pm;
 Saturday to Sunday, 1pm-5pm.

 late-December to January,
 limited hours during interterm.

 June to August,
 Tuesday to Sunday, 1pm-4pm.

Facilities: **Architecture** (1949, design by McKim, Mead, and White); **Classrooms**; **Galleries**; **Lecture Hall.**
Activities: **Concerts**; **Film Series**; **Gallery Talks** (Tues, 12:15pm); **Guided Tours** (by appointment); **Lectures**; **Temporary Exhibitions** (10-12/year).

Adolphe Bouguereau, *Penelope (Le travail interrompu),* oil on canvas, 63 x 39¼ inches. Museum Purchase, Mead Art Museum. Photograph courtesy of the Mead Art Museum, Amherst College, Amherst, Massachusetts.

Publications: brochures; calendar (semi-annual); exhibition catalogues (occasional).

The Mead Art Museum exhibits and collects works of art from antiquity to the present. In addition to permanent displays, it offers ten to twelve exhibitions yearly, some drawn from the permanent collection, while others are loan exhibitions. The permanent collection of approximately 14,000 art objects is best known in the area of 18th- and 19th-century American art, but also includes important examples of European and Asian art that serve the needs of courses in the fine arts and humanities. The Mead holds Colonial and Federal portraits by John Singleton Copley, the Peale family, and Gilbert Stuart; landscapes by Thomas Cole, Frederic Church, and Asher B. Durand; figural studies by Winslow Homer, Thomas Eakins, and William Merritt Chase; and impressionist landscapes by Childe Hassam. Other American highlights include Robert Henri's "Salome", Ralston Crawford's "Nacelles Under Construction", and Pop portraiture by Andy Warhol. Sculptures range from portraits by Augustus Saint-Gaudens to monumental bronzes by Paul Manship to modernist constructions by Joseph Cornell and Frank Stella. European holdings include early Italian altarpieces and works by Edward Lear, Claude Monet, Joshua Reynolds, Peter Paul Rubens, and Frans Snyders. An extensive collection of works on paper includes over 6,500 prints, drawings, and photographs. Holdings in Classical Antiquities are highlighted by four Assyrian monumental relief sculptures from the palace of Ashurnaisirpal II at Nimrud. Other holdings include African divination ritual objects, pre-Columbian ceramics and textiles, Mexican folk art, Buddhist sculpture, Indian miniatures, and a growing collection of Japanese art, including over 300 woodblock prints and a large group of 20th-century ceramics.

University of Massachusetts at Amherst - University Gallery

Fine Arts Center, North Pleasant Street, University of Massachusetts, Amherst, MA 01003
Tel: (413) 545-3670
Fax: (413) 545-2018
Internet Address: http://www.umass.edu/fac/org/univgallery/index.html
Director: Ms. Betsy Siersma
Admission: free.
Attendance: 15,000 *Established:* 1975 *Membership:* Y *ADA Compliant:* Y

University of Massachusetts at Amherst - University Gallery, cont.

Open: **mid-September to early June**,
Tuesday to Friday, 11am-4:30pm; Saturday to Sunday, 2pm-5pm.

Closed: between terms.

Facilities: **Galleries** (4, total 6,533 square feet); **Sculpture Garden**.

Activities: **Education Programs** (undergraduate and graduate college students); **Films**; **Gallery Talks**; **Guided Tours**; **Lectures**; **Temporary Exhibitions**; **Traveling Exhibitions**.

Publications: exhibition catalogues.

Located on the lower level of the Fine Arts Center, the University Gallery offers an active exhibition schedule that features contemporary art in a range of media by emerging and established artists. The Gallery also houses and exhibits the University's permanent collection of 20th-century American works on paper, and its collection of public art. Additionally, the Hampden Gallery (located in the Southwest Residential Area; open Monday to Friday, 3pm-7pm and Sunday, 2pm-5pm), the Wheeler Gallery (located in the Central Residential Area; open Monday to Thursday, 4pm-8pm and Sunday 2pm-5pm), and the Herter Gallery (located on the main floor of Herter Hall, (413) 545-0976; open Monday to Friday,11am-4pm and Sunday, 2pm-5pm) showcase the work of students, faculty and emerging artists of local and regional importance, complemented by workshops, readings, and performance art. Also of possible interest on campus is the Augusta Savage Gallery (located at 101 New Africa House, (413) 545-5177; open Monday to Tuesday, 1pm-7pm, Wednesday to Friday, 1pm-5pm), a multicultural and multi-arts facility promoting the work of students and artists of color from diverse world cultures. Each year, the Savage Gallery presents five professional and four student exhibitions chosen on their aesthetic integrity and ability to enlighten the viewer about racial and cultural preconceptions. Its permanent collection contains traditional folk art and contemporary works by nationally renowned artists.

Andover

Phillips Academy Andover - Addison Gallery of American Art

Phillips Andover Academy, Andover, MA 01810-4166

Tel: (508) 749-4015

Fax: (508) 749-4025

Internet Address: http://www.andover.edu/addison/home.html

Director: Mr. Adam Weinburg

Admission: voluntary contribution.

Established: 1931 *Membership:* Y *ADA Compliant:* Y

Parking: on street.

Open: **September to July**, Tuesday to Saturday, 10am-5pm; Sunday, 1pm-5pm.

Closed: Legal Holidays, August to Labor Day, Christmas Eve.

Facilities: **Architecture** (1930 design by Charles Platt); **Film and Video Center**; **Galleries** (15); **Sculpture Garden**.

Activities: **Concerts**; **Films**; **Lectures**; **Temporary Exhibitions**.

Publications: collection catalogue, "Addison Gallery of American Art: 65 Years"; exhibition catalogues.

Located on the campus of one of the country's oldest private secondary schools, the Addison Gallery exhibits selected works from its permanent collection on a rotating basis as well as temporary exhibitions. The collection, numbering over 12,000 works, includes significant paintings, works on paper, sculpture, decorative arts, and photography by generations of American artists from Colonial times to the present, among them Calder, Copley, Eakins, Evans, Frank, Hofmann, Homer, Hopper, Judd, LeWitt, Muybridge, O'Keeffe, Prendergast, Revere, Sheeler, Sloan, Stella, Watkins, and Whistler.

Barnstable

Cape Cod Art Association Gallery

3480 Route 6A, Barnstable, MA 02630

Tel: (508) 362-2909

Admission: free.

Cape Cod Art Association Gallery, cont.

Open: **January**, Monday to Friday, 10am-4pm.
February to June, Monday to Saturday, 10am-4pm.
July to August, Monday to Saturday, 10am-4pm; Sunday, noon-4pm.
September to November, Monday to Saturday, 10am-4pm.
December, Monday to Friday, 10am-4pm.

Facilities: **Exhibition Area.**

Activities: **Temporary Exhibitions.**

Anon-profit group of artists and sponsoring members with all levels of skill in the arts, CCAA promotes the visual arts on Cape Cod. The CCAA home in Barnstable houses a series of four inter-connected galleries for exhibition in all media, plus two classrooms. Exhibitions include member shows and open exhibitions.

Beverly

Montserrat College of Art - Galleries

23 Essex St., Beverly, MA 01915
Tel: (978) 922-8222
Fax: (978) 922-4268
Internet Address:
http://www.montserrat.edu/events/events1.html
Director: Ms. Barbara O'Brien
Admission: free.
Established: 1970
ADA Compliant: Y
Parking: on street.
Open: **September to May**,
Monday to Thursday, 11am-7pm;
Friday, 11am-5pm;
Saturday, noon-4pm.
June to July,
Monday to Friday, 9am-4pm.

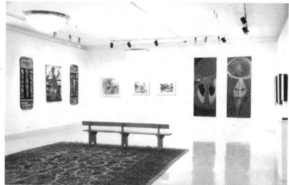

View of the Montserrat Gallery during the exhibition "The Pluralistic Voice" (Works from the African American Master Artists in Residence Program). Photograph courtesy of Montserrat College of Art, Beverly, Massachusetts.

Facilities: **Exhibition Area** (1,500 square feet).

Activities: **Gallery Talks**; **Symposia**; **Temporary Exhibitions** (monthly during academic year, one during June-July); **Visiting Artist Lectures**.

Publications: exhibition brochures.

The Montserrat Gallery features a year-round program of exhibitions of contemporary work by professional artists, usually presented in two-person or thematic exhibitions. In addition, the Alumni Gallery mounts exhibitions of faculty and alumni artwork. A third gallery, the Cabot Studio Building Gallery, focuses on the work of members of the Senior Seminar, as well as community outreach exhibitions.

Boston

The Art Institute of Boston Gallery (AIB Gallery)

700 Beacon St., Boston, MA 02215
Tel: (617) 262-1223 *Ext:* 308
Fax: (617) 437-1226
Internet Address: http://www.aiboston.edu
Director of Exhibitions: Professor. Bonnell Robinson
Admission: free.
Attendance: 6,000 *Membership:* N *ADA Compliant:* Y
Parking: metered on street.
Open: Monday to Friday, 9am-5:30pm; Saturday, 9am-5pm; Sunday, noon-5pm.
Closed: Legal Holidays.
Facilities: **Gallery** (1,000 square feet).
Activities: **Lectures**; **Temporary Exhibitions** (6 per year).

The Art Institute of Boston Gallery, cont.

Publications: catalogue (annual); posters.

The AIB Gallery mounts temporary exhibitions of the work of major national and international artists and presents group shows, including student and faculty work.

Boston Athenæum

10½ Beacon St., Boston, MA 02108-3777
Tel: (617) 227-0270
Fax: (617) 227-5266
Internet Address: http://www.bostonathenaeum.org
Director: Mr. Richard Wendorf
Admission: free.
Established: 1807
Membership: Y *ADA Compliant:* Y
Parking: commercial garages adjacent to site.
Open: **September to May,**
 Monday, 9am-8pm;
 Tuesday to Friday, 9am-5:30pm;
 Saturday, 9am-4pm.
 June to August,
 Monday, 9am-8pm;
 Tuesday to Friday, 9am-5:30pm.
Closed: Legal Holidays.
Facilities: **Architecture** (1847-1849, designed by Edward Clarke Cabot); **Exhibition Area**; **Library** (700,000 volumes, use by request); **Print Study Room**; **Reading Room**; **Shop**.

Jean-Antoine Houdon, *Benjamin Franklin*, c 1778, plaster bust. Boston Athenæum. Photograph courtesy of Boston Athenæum, Boston, Massachusetts.

Activities: **Concerts**; **Guided Tours** (Tues & Thurs, 3pm, reservations 24-hours in advance); **Lectures**; **Permanent Exhibits**; **Temporary Exhibitions**.
Publications: annual report; exhibition catalogues; library newsletter; monographs.

Founded in 1807, the Boston Athenæum is one of the oldest and most distinguished independent libraries in America. Its art gallery, founded in 1827, was a popular predecessor of the Boston Museum of Fine Arts to which a major portion of its art collection was lent when the latter opened in 1876. The Athenæum Gallery is host to a number of exhibitions each year, featuring the work of a variety of artists as well as selections from its own collections. Fine examples of painting and sculpture remain in the Athenæum including, among others, works by Washington Allston, John Frazee, Chester Harding, John Singer Sargent, Gilbert Stuart, and Cephas Thompson. The Charles E. Mason, Jr., Print Room houses an outstanding collection of New England topographical and architectural prints and photographs and collections of drawings, watercolors, posters, and architectural plans, primarily from the 19th century.

Boston Public Library

Copley Square, Boston, MA 02117
Tel: (617) 536-5400 *Ext:* 280
Fax: (617) 236-4306
TDDY: (617) 536-7055
Curator, Fine Arts: Ms. Janice Chadbourne
Admission: free.
Attendance: 2,200,000 *Established:* 1852 *ADA Compliant:* Y
Open: **June to September,**
 Monday to Thursday, 9am-9pm; Friday to Saturday, 9am-5pm, Sunday, 1pm-5pm.
 October to May,
 Monday to Thursday, 9am-9pm; Friday to Saturday, 9am-5pm.
Closed: Legal Holidays.
Facilities: **Architecture** (addition, 1974 design by Philip Johnson; Renaissance-style, 1895 design by Charles Follen McKim); **Exhibition Area**; **Library** (138,000 volumes).
Activities: **Concerts**; **Demonstrations**; **Films**; **Gallery Talks**; **Guided Tours**; **Lectures**; **Temporary Exhibitions**; **Traveling Exhibitions**.

365

Boston Public Library, cont.

Founded in 1848, the Boston Public Library was the first large free municipal library in the United States. The Library has occupied its location in Copley Square since 1895, when the original building, designed by Charles McKim, was completed. In 1972 the Library expanded with the opening of an addition designed by Philip Johnson. The library receives over 2.2 million visitors each year, many in pursuit of research material, others looking for an afternoon's reading, and still others to view the magnificent and unique art and architecture. Among the better known art treasures of the Library are the keystone head of Minerva by Augustus Saint-Gaudens, the murals on the walls of the McKim Building's grand staircase and second floor gallery by French artist Pierre Puvis de Chavannes, Edwin Austin Abbey's 15-panel mural, "Quest of the Holy Grail" in the second floor former Book Delivery Room, and the third floor murals by John Singer Sargent on the theme of the development of the world's religions. The Library also presents temporary exhibits focusing on the history and culture of the city. In addition to its 6.1 million books, the library's collections include over 1.2 million rare books and manuscripts, and extensive holdings in maps, musical scores and prints. The Volunteer Office of the Library offers tours highlighting the architecture as well as artworks, some of which are not readily accessible to the public. Tours are of approximately 1½ hours duration and are scheduled as follows: Monday, 2:30pm; Tuesday and Thursday, 6pm; Friday and Saturday, 11am; and October to May, Sunday, 2pm.

Boston University Art Gallery

855 Commonwealth Ave., Boston, MA 02215
Tel: (617) 353-4672
Fax: (617) 353-4509
Internet Address: http://www.bu.edu/ART/home.html
Director: John Stamberg
Admission: free.
Attendance: 6,000 *Established:* 1960 *ADA Compliant:* Y
Parking: metered on street and nearby commercial lots.
Open: **mid-September to mid-May**,
 Tuesday to Friday, 10am-5pm; Saturday to Sunday, 1pm-5pm.
Closed: Between Semesters, Legal Holidays.
Facilities: **Architecture** (former Buick dealership); **Gallery**.
Activities: **Concerts**; **Education Programs** (undergraduate and graduate college students); **Gallery Talks**; **Lectures**; **Traveling Exhibitions**.
Publications: exhibition catalogues.

The Gallery maintains an ongoing program of four to five temporary exhibitions annually. Exhibitions focus on international, national, and regional art developments, chiefly in the 20th century. The gallery has a particular commitment to offer a culturally inclusive view of art, one that expands the boundaries of museum exhibitions and showcases alternatives to New York-oriented trends. It also has a long-term interest in showing 20th-century figurative art, complementing the traditional focus of the School of the Arts curriculum. Each spring, its season closes with a series of student exhibitions; the MFA candidates in painting, sculpture, and graphic design present their work, as do undergraduates in the School of the Arts. The Gallery does not maintain a permanent collection.

The Copley Society of Boston

158 Newbury St., Boston, MA 02116
Tel: (617) 536-5049
Fax: (617) 267-9396
Gallery Manager: Karen Pfefferle
Admission: free.
Established: 1879 *Membership:* Y
Parking: metered on street; neighboring commercial lots.
Open: Tuesday to Saturday, 10:30am-5:30pm.
Facilities: **Gallery**.

View of entrance of The Copley Society of Boston. Photograph courtesy of The Copley Society of Boston, Boston, Massachusetts.

The Copley Society of Boston, cont.

Activities: **Temporary Exhibitions** (3-4 weeks in duration; all works for sale).

The Copley Society of Boston is America's oldest art association, having been founded in 1879. Its galleries have more than twenty exhibitions each year, and showcase the work of Society members. There are group shows, theme shows, and juried exhibitions.

Federal Reserve Bank of Boston

600 Atlantic Ave., Boston, MA 02106

Tel: (617) 973-3454

Fax: (617) 973-4272

TDDY: (617) 973-4200

Internet Address: http://www.bos.frb.org

Cultural Affairs Coordinator:
 Ms. Anne M. Belson

Admission: gallery open to public.

ADA Compliant: Y

Parking: commercial within walking distance.

Open: Monday to Friday, 10am-4pm.

Facilities: **Architecture** (1978, design by Hugh Stubbins); **Auditorium**; **Exhibition Area** (5,125 square feet).

Activities: **Guided Tours** (permanent collection highlights by prior appointment); **Performances** (30/year, fall & spring, usually Thurs, 12:30pm); **Temporary Exhibitions**.

Publications: collection catalogue.

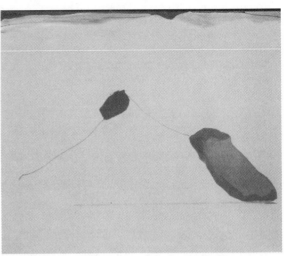

Helen Frankenthaler, *Shepherd*, 1973, acrylic on canvas, 81 x 96 inches, permanent collection, Federal Reserve Bank of Boston. Photograph courtesy of Federal Reserve Bank of Boston, Boston, Massachusetts.

The Federal Reserve Bank of Boston Gallery is used as a public alternative space for New England artists. since 1980, more than 120 exhibitions have been presented by non-profit, professional-level New England-based arts groups. The permanent collection of over 500 original works of art is dispersed throughout the building and integrated into work areas. The collection features the work of American artists, some with close ties to New England. Artists represented in the collection include works by Richard Anuskiewicz, Romare Bearden, Jim Dine, Alejandro Eluchans, Helen Frankenthaler, Ellsworth Kelly, Louis Morris, Lowell Nesbitt, Kenneth Noland, Richard Pousette-Dart, Frank Stella, and Neil Welliver. Highlight tours of the permanent collection may be arranged by prior appointment.

The Institute of Contemporary Art (ICA)

955 Boylston St., Boston, MA 02115-3194

Tel: (617) 927-6620

Fax: (617) 266-4021

TDDY: (617) 927-6622

Internet Address: http://www.primalpub.com/ica

Director: Ms. Jill Medvedow

Admission: fee:
 adult-$5.25, child-$2.25, student-$3.25, senior-$2.25.

Attendance: 25,000 *Established:* 1936 *Membership:* Y

ADA Compliant: Y

Parking: commercial near to site.

Open: Wednesday, noon-5pm;
 Thursday, noon-9pm;
 Friday to Sunday, noon-5pm.

Facilities: **Architecture** (Romanesque Revival, design by H.H. Richardson); **Galleries** (6,000 square feet); **Shop** (exhibition catalogues); **Theatre** (130 seats).

Exterior view of Institute of Contemporary Art, formerly a police station. Photograph by Suara Welitoff, courtesy of Institute of Contemporary Art, Boston, Massachusetts.

The Institute of Contemporary Art, cont.

Activities: **Dance Recitals; Films; Lecture Series; Performances; Readings; Temporary Exhibitions.**

Publications: books; exhibition catalogues (2-3/year); newsletter, "ICA Newsletter" (quarterly).

The oldest non-collecting contemporary art museum in the United States, The ICA presents three to four exhibitions annually. In the past, The ICA has mounted pivotal shows of the work of such artists as Laurie Anderson, Oskar Kokoschka, Roy Lichtenstein, Edward Munch, Robert Rauschenberg, Egon Schiele, and Andy Warhol.

Isabella Stewart Gardner Museum

280 The Fenway, Boston, MA 02115

Tel: (617) 566-1401

Fax: (617) 566-7653

Internet Address: http://www.boston.com/gardner

Director: Ms. Anne Hawley

Admission: fee: adult-$10, child-free, student-$5, senior-$7.

Attendance: 172,000 *Established:* 1900

Membership: Y *ADA Compliant:* Y

Parking: metered on street and nearby commercial garage.

Open: Tuesday to Sunday, 11am-5pm
Holiday Mondays, call for hours.

Closed: New Year's Day, Thanksgiving Day, Christmas Day.

Facilities: **Architecture** (Venetian Renaissance style mansion, 1902); **Food Services** Café (Tues-Fri, 11:30am-4pm; Sat-Sun, 11am-4pm); **Galleries; Library** (by appointment only); **Shop**.

Activities: **Concerts** (late Sept-early May, Sat-Sun, 1:30pm); **Guided Tours** (Fri, 2:30pm); **Lectures**.

Publications: annual report; book, "The Isabella Stewart Gardner Museum: A Companion Guide and History"; catalogues.

View of courtyard, Isabella Stewart Gardner Museum. Photograph by John Kennard, courtesy of Isabella Stewart Gardner Museum, Boston, Massachusetts.

The Isabella Stewart Gardner Museum, designed in the style of a 15th-century Venetian palace, combines architecture, paintings, sculpture, decorative arts, and the color and fragrance of a flowering interior courtyard to create a unique atmosphere and experience. Bearing the name of its creator, Isabella Stewart Gardner, the Museum is the only private art collection in which the building and collection are the creation of one individual. Construction of the Museum began in 1899 and was completed by 1901 after which Isabella Gardner undertook the task of arranging her collection within the Museum walls before finally opening its doors to the public in 1903. The collection of paintings, sculpture, furniture, textiles, tapestries, lace, ceramics, metal work, prints, drawings, rare books, photographs, and correspondence is displayed in galleries on three floors, each room overlooking a central courtyard that is filled with changing flowers, plants, and trees, complemented by marble sculptures and a Roman mosaic tile floor. Particularly rich in Italian Renaissance paintings, the galleries house works by Botticelli, Raphael, and Titian, including the famous "Europa" by Titian. Later French, German, and Dutch masters, such as Rembrandt, are also represented along with more modern artists such as Degas, Matisse, John Singer Sargent, and James McNeill Whistler.

Massachusetts College of Art - Galleries

621 Huntington Ave., Boston, MA 02115

Tel: (617) 232-1555

Internet Address: http://www.massart.edu/campus/events/ex_ev.html

Admission: free.

Open: Monday to Friday, 10am-6pm; Saturday, 11am-5pm.

Facilities: **Galleries**.

Activities: **Temporary Exhibitions**.

Massachusetts College of Art - Galleries, cont.

The Sandra and David Bakalar Gallery and Huntington Gallery present temporary exhibitions. Additionally, there are three spaces for the exhibition of student work. Student shows run for approximately two weeks. The Student Life Gallery, located on the second floor of the Kennedy Building adjacent to the Student Center, can accommodate large scale installations and free-standing work. The Tower Gallery, on the second floor of the Tower Building, presents group student shows. Installation Station is used primarily for solo, large multimedia, interactive, or installation exhibitions.

Massachusetts Historical Society

1154 Boylston St. (at the Fenway, 2 blocks west of Mass Ave.), Boston, MA 02215
Tel: (617) 536-1608
Fax: (617) 859-0074
Internet Address: http://www.masshist.org
Director: Mr. William M. Fowler, Jr.
Admission: free.
Established: 1791 *Membership:* Y
Parking: commercial lots.
Open: Monday to Friday, 9am-4:45pm.
Closed: Legal Holidays, 3rd Mon. in February, 3rd Mon. in April, last Mon. in May.
Facilities: **Architecture** (Renaissance Revival-style, 1899 design by Edmund March Wheelwright); **Exhibition Area**; **Library** (400,000 volumes, non-circulating); **Reading Room**.
Activities: **Lectures**; **Permanent Exhibits**; **Temporary Exhibitions**.
Publications: books; pamphlet, "Massachusetts Historical Society Picture Book" (annual).

The Society's fine and decorative arts holdings include significant collections of portraits and miniatures, silhouettes, portrait busts, and engravings. Among the artists represented are John Singleton Copley, Gilbert Stuart, and John Trumbull. The Society also has many thousands of photographs, including 300 early daguerreotypes. The Oliver Room, located on the second floor, serves as the Society's exhibition gallery.

Mobius

354 Congress Street, Boston, MA 02210
Tel: (617) 542-7416
Fax: (617) 451-2910
Internet Address: www.mobius.org
Director: Jed Speare
Established: 1983 *Membership:* Y
Parking: commercial adjacent to site.
Open: Call for hours.
Facilities: **Gallery and Performance Space**.
Activities: **Performance Art**; **Temporary Exhibitions**.
Publications: newsletter.

Mobius is an artist-run space for experimental work in all media. It sponsors local, regional, and national artists in a season of performances and gallery shows that spans over forty weeks each year. Presenting the work of over one hundred artists each year, Mobius is committed to fostering the alternative arts in Boston.

Museum of Fine Arts, Boston

465 Huntington Ave., Boston, MA 02115
Tel: (617) 267-9300
Fax: (617) 267-0280
TDDY: (617) 267-9703
Internet Address: http://www.mfa.org
Director: Dr. Malcolm Rogers
Admission: fee: adult-$12.00, child-free, student-$10.00, senior-$10.00.

Museum of Fine Arts, Boston, cont.

Established: 1870 *Membership:* Y *ADA Compliant:* Y

Parking: garage and parking lot on Museum Rd. near West Wing entrance.

Open: Monday to Tuesday, 10am-4:45pm; Wednesday to Friday, 10am-9:45pm;
Saturday to Sunday, 10am-5:45pm.

Closed: Thanksgiving Day, Christmas Day.

Facilities: **Architecture** (1909, design by Guy Lowell; Evans Wing, 1918; White Wing, 1928; West Wing, 1981 design by I.M. Pei); **Food Services** (call for times) Courtyard Café, Fine Arts Restaurant, Fraser Garden Court Terrace, Galleria Café; **Galleries**; **Library** (280,000 volumes, non-circulating); **Shop** (six locations around Boston).

Activities: **Arts Festival**; **Concerts**; **Dance Recitals**; **Education Programs** (adults, undergraduate/graduate students and children); **Films**; **Gallery Talks**; **Guided Tours** (Mon-Sat, free); **Lectures**; **Permanent Exhibits**; **Temporary Exhibitions**; **Traveling Exhibitions**.

Publications: "Journal of the Museum of Fine Arts, Boston" (annual); "Preview" (bi-monthly); annual report; collection catalogues; exhibition catalogues.

With collections spanning five continents and the entire history of art, the Museum of Fine Arts is one of the world's major museums. Particular strengths include Egyptian and Classical antiquities, American and European painting and sculpture, Asian and Islamic art, and pre-Columbian ceramics and textiles. Its collection of Monets is the largest outside of Paris and it holdings in Nubian artifacts is the most extensive outside of Africa.

Photographic Resource Center Gallery

Boston University, 602 Commonwealth Ave., Boston, MA 02215

Tel: (617) 353-0700

Fax: (617) 353-1662

Internet Address: http://web.bu.edu/PRC

Exec. Director: Mr. John P. Jacob

Admission: fee: adult-$3.00, child-free, student-$2.00, senior-$2.00.

Attendance: 10,000 *Established:* 1976 *Membership:* Y *ADA Compliant:* Y

Open: Tuesday to Saturday, noon-5pm.

Closed: Legal Holidays.

Facilities: **Gallery**; **Library** (3,250 volumes); **Shop**.

Activities: **Education Programs** (adults and children); **Lectures**; **Temporary/Traveling Exhibitions**; **Workshops**.

Publications: newsletter, "In the Loupe" (monthly).

The Photographic Resource Center is a not-for-profit organization that provides a range of programs and services to the arts community, including a regular schedule of temporary exhibitions of photographic work. PRC's program emphasizes "an ongoing inquiry into the role of photographic media in shaping and interpreting the world, implemented through an annual narrative exhibition examining the range of photographic practices and their impact on human history, five eight-week thematic exhibitions that expand selected topics from the historical narrative, plus accompanying interactive and educational programs."

School of the Museum of Fine Arts-Boston - Barbara & Steven Grossman Gallery

230 The Fenway, Boston, MA 02115

Tel: (617) 369-3718

Fax: (617) 424-6271

Internet Address: http://www.smfa.edu/offices/exhibitions/

Asst. Director: Ms. Lisa Tung

Admission: free.

Open: **Fall to Spring**,
Tuesday, 10am-5pm; Wednesday to Thursday, 10am-8pm; Friday to Saturday, 10am-5pm; Sunday, 1pm-5pm.
Summer, Monday to Friday, 10am-5pm.

School of the Museum of Fine Arts-Boston - Grossman Gallery, cont.

Closed: Holidays.

Facilities: **Gallery.**

Activities: **Temporary Exhibitions.**

The Grossman Gallery presents temporary exhibitions, including shows of work by professional artists, faculty, staff, students, and alumni.

Simmons College - Trustman Art Gallery

Main College Building, Fourth Floor, 300 The Fenway, Boston, MA 02115-5898

Tel: (617) 521-2268

Internet Address: http://www.simmons.edu/resources/trustman/trustman.html

Director: Mr. Robert Oppenheim

Admission: free.

Established: 1982

Open: September to May, Monday to Friday, 10am-4:30pm.

Facilities: **Exhibition Area.**

Activities: **Temporary Exhibitions.**

The Gallery presents exhibitions of work by professional artists, as well as an annual exhibition of student work.

Bridgewater

Bridgewater State College - Wallace L. Anderson Art Gallery

The Art Center (Main Floor), Park Avenue, West Campus, Bridgewater, MA 02325

Tel: (508) 697-1359

Internet Address: http://www.bridgew.edu/DEPTS/ART

Admission: free.

Open: Monday to Friday, 8am-4pm.

Closed: Legal Holidays.

Facilities: **Exhibition Area.**

Activities: **Temporary Exhibitions.**

Located in the oldest existing campus structure, the Gallery offers changing exhibitions throughout the academic year, including an annual student show. A continuing exhibition of works from the College's permanent collection is on view in an adjacent gallery.

Brockton

Fuller Museum of Art

455 Oak St., Brockton, MA 02301-1399

Tel: (508) 588-6000

Fax: (508) 587-6191

Acting Director: Jennifer Atkinson

Admission: fee: adult-$5.00, child (<18)-free, student-$3.00, senior-$3.00.

Attendance: 30,000 *Established:* 1969 *Membership:* Y *ADA Compliant:* Y

Parking: free on site.

Open: Tuesday to Sunday, noon-5pm.

Closed: New Year's Day, Independence Day, Labor Day, Thanksgiving Day, Christmas Day.

Facilities: **Auditorium** (200 seats); **Galleries; Library; Sculpture Garden; Shop; Studios.**

Activities: **Arts Festival; Classes** (during year and summer), **Concerts; Dance Recitals; Education Programs** (adults and children); **Films; Guided Tours; Lectures; Performances; Temporary Exhibitions; Traveling Exhibitions.**

Publications: annual report; exhibition catalogues; newsletter & events calendar (quarterly).

The Museum's collection features 19th- and 20th-century American art and contemporary crafts. The temporary exhibition schedule includes a variety of contemporary and traditional exhibitions, as well as a project space and an annual outdoor sculpture show.

Cambridge

The Cambridge Art Association - Lowell Street Gallery (CAA)

25R Lowell St. (across from Mt. Auburn Hospital)
Cambridge, MA 02138
Tel: (617) 876-0246
Fax: (617) 876-1880
Internet Address: http://cambridgeart.home.mindspring.com
Exec. Director: Ms. Kathryn Schultz
Admission: free.
Established: 1944
Parking: large lot in rear.
Open: Tuesday to Saturday, 11am-5pm; Sunday, 1pm-5pm.
Facilities: Gallery.
Activities: **Membership Exhibits** (10/year); **Open Shows** (2/year).

The Cambridge Art Association supports emerging and developing artists from throughout New England through lectures, workshops, and exhibits in two galleries. Exhibitions include members only shows, open shows, small group shows, and a national prize show. The Association also maintains a gallery in Harvard Square at University Place, see separate listing.

The Cambridge Art Association - University Place Gallery (CAA)

124 Mt. Auburn St. (opposite Harvard Square Post Office)
Cambridge, MA 02138
Tel: (617) 876-0246
Internet Address: http://cambridgeart.home.mindspring.com
Exec. Director: Ms. Kathryn Schultz
Admission: free.
Established: 1944
Parking: pay on site.
Open: Monday to Friday, 9am-6pm; Saturday, 9am-1pm.
Facilities: Gallery.

The Cambridge Art Association supports emerging and developing artists from throughout New England through lectures, workshops, and exhibits in two galleries. Exhibitions include members-only shows, open shows, small group shows, and a national prize show. The Association also maintains a gallery on Lowell Street; see separate listing.

Gallery 57 - Cambridge Arts Council

City Hall Annex, 2nd Floor, 57 Inman St.
Cambridge, MA 02139
Tel: (617) 349-4380
Fax: (617) 349-4669
Internet Address:
 http//www.ci.cambridge.ma.us/~CAC/gallery5.htm
Gallery Director: Sabrina R. Moyle
Open: Monday to Friday, 8:30am-5pm.
Facilities: Gallery.
Activities: **Temporary Exhibitions**.

Gallery 57 is the Arts Council's public gallery space, presenting exhibitions of artists who live or work in Cambridge. Artists are selected through a juried competition each spring for individual exhibitions that take place from September through May.

Eugene Dorgan, *View from Studio Rooftop*, oil on panel, 6 X 8 inches. Photograph courtesy of Gallery 57, Cambridge Arts Council, Cambridge, Massachusetts.

Harvard University Art Museums

32 Quincy St. at Broadway, Cambridge, MA 02138
Tel: (617) 495-9400 *Ext:* 0
Fax: (617) 495-9936
Internet Address: http://www.artmuseums.harvard.edu
Director: James Cuno, Ph.D.
Admission: fee (for all 3 museums): adult-$5.00, child (<18)-free, student-$3.00, senior-$4.00; free, Wednesdays and Saturday mornings.
Attendance: 125,000 *Membership:* Y *ADA Compliant:* Y
Open: Monday to Saturday, 10am-5pm; Sunday, 1pm-5pm.
Closed: Legal Holidays.
Facilities: **Museums** (3).
Activities: **Concerts**; **Education Programs** (graduate and undergraduate college students); **Films**; **Lectures**.
Publications: "Bulletin" (3/year); "Review" (semi-annual); annual report; calendar (quarterly).

The Harvard University Art Museums make up one of the few university museums to have collections ranking with the best art museums anywhere. The approximately 150,000 objects in the Art Museums' collections range from antiquity to the present and come from Europe, North America, North Africa, the Middle East, India, Southeast Asia, and East Asia. The museums consist of three institutions, each with its own focus: Busch-Reisinger Museum, Fogg Art Museum, and The Arthur M. Sackler Museum. General information, applying to all three institutions, is found in this entry. More specific information on a particular institution may be found under its entry.

Harvard University - The Arthur M. Sackler Museum

485 Broadway, (across from the Fogg Art Museum), Cambridge, MA 02138
Tel: (617) 495-9400
Fax: (617) 495-9936
Internet Address:
http://www.artmuseums.harvard.edu
Curators: Mary McWilliams (Islamic Art)
David Mitten (Ancient Art)
Robert D. Mowry (Asian Art)
Admission: fee (for all 3 museums):
adult-$5, under 18-free, student-$3, senior-$4;
free Wednesday and Saturday mornings.
Established: 1985
Membership: Y
Open: Monday to Saturday, 10am-5pm;
Sunday, 1pm-5pm.
Closed: Legal Holidays.
Facilities: **Architecture** (1985 design by British architect James Stirling); **Galleries** (3 floors).
Activities: **Gallery Talks** (dependent on exhibition; Sat, am; Sun, pm); **Guided Tours** (weekdays, 2pm; groups, reserve 3 weeks in advance, 496-8576); **Temporary Exhibitions**.

Interior view of Arthur M. Sackler Museum. Photograph courtesy of Harvard University Art Museums, Cambridge, Massachusetts.

Publications: collection catalogues; exhibition catalogues.

The Sackler houses collections of ancient, Asian, Islamic, and later Indian art. Holdings include important collections of Chinese archaic jades, bronzes, ceremonial weapons, and Buddhist cave-temple painting and sculpture; Korean ceramics and paintings; Japanese woodblock prints (including a particularly fine collection of surimono) and lacquer boxes; paintings, drawings and calligraphy from Iran, India, and Turkey; and Greek and Roman sculpture, Greek vases, and ancient coins. The Sackler

373

Harvard University - The Arthur M. Sackler Museum, cont.

Museum building also contains the Harvard University Art Museums' largest special exhibition gallery, an auditorium, the offices of Harvard's Department of the History of Art and Architecture, and the Rübel Library, a research center for Asian art.

Harvard University - Busch-Reisinger Museum

32 Quincy St. at Broadway, Cambridge, MA 02138
Tel: (617) 495-2317
Fax: (617) 496-2359
Internet Address: http://www.artmuseums.harvard.edu
Curator: Mr. Peter Nisbet
Admission: fee: (for all 3 museums): adult-$5.00, child (<18)-free, student-$3.00, senior-$4.00; free: Wednesday all day and Saturday morning.
Established: 1902
Membership: Y *ADA Compliant:* Y
Open: Monday to Saturday, 10am-5pm;
Sunday, 1pm-5pm.
Closed: Legal Holidays.
Facilities: **Architecture** (Werner Otto Hall, 1991 design by Gwathmey, Siegel, and Associates); **Galleries**; **Study Room** (Tues-Fri, 2pm-4:45pm).
Activities: **Gallery Talks** (vary with each exhibition); **Guided Tours** (weekdays, 1pm; groups, reserve 3 weeks in advance, 496-8576); **Temporary Exhibitions**; **Traveling Exhibitions**.
Publications: collection catalogues; exhibition catalogues.

Interior view of Busch-Reisinger Museum. Photograph courtesy of Harvard University Museums, Cambridge, Massachusetts.

The Busch-Reisinger Museum is devoted to the art of German-speaking countries and related cultures of central and northern Europe. Its collections of German expressionism, Vienna Secession art, and 1920s abstraction rank with the finest in the United States and include works by Beckmann, Beuys, Feininger, Kandinsky, Klee, Kirchner, Kokoschka, Klimt, Kollwitz, Moholy-Nagy, Marc, and Munch. Founded in 1902 as the "Germanic Museum" with a collection exclusively of reproductions, since 1930 the Busch-Reisinger has actively acquired original works of art, in particular, modern art considered "degenerate" by the Nazis. The collections have also been enriched by gifts from artists and designers associated with the famous Bauhaus, including the archives of the celebrated architect Walter Gropius. The Busch-Reisinger Museum also has important collections of late medieval, Renaissance, and baroque sculpture, 16th-century painting, and porcelain. The Busch-Reisinger Museum's permanent display of modern works of art and design is housed in the galleries of its new building, Werner Otto Hall (opened in 1991). Pre-1880 works are presented in appropriate galleries of the Fogg Art Museum. Works that are not normally on view, especially drawings, prints, and photographs, can be viewed in the study room of the Busch-Reisinger or in the special exhibitions gallery. Werner Otto Hall also houses Harvard's Fine Arts Library.

Harvard University - Fogg Art Museum

32 Quincy St. at Broadway, Cambridge, MA 02138
Tel: (617) 495-9400
Fax: (617) 495-9936
Internet Address: http://www.artmuseums.harvard.edu
Director: James Cuno, Ph.D.
Admission: fee (for all 3 museums): adult-$5, under 18-free, student-$3, senior-$4; free Wednesday and Saturday mornings.

Harvard University - Fogg Art Museum, cont.

Established: 1895
Membership: Y *ADA Compliant:* Y
Open: Monday to Saturday, 10am-5pm;
 Sunday, 1pm-5pm.
Closed: Legal Holidays.
Facilities: **Architecture** (Neo-Georgian exterior, 1927 design by Coolidge Bullfinch & Abbott); **Galleries** (2 floors); **Print Study Room** Agnes Mongan Center (Tues-Fri, 2pm-4:45pm; during academic year, Sat, 10am-12:45pm); **Shop** (books, catalogues, reproductions).
Activities: **Gallery Talks** (dependent on exhibition; Sat, am; Sun, pm); **Guided Tours** (weekdays, 11am; groups, reserve 3 weeks in advance, 496-8576); **Temporary Exhibitions**; **Traveling Exhibitions**.
Publications: collection catalogues; exhibition catalogues.

View of courtyard, Fogg Art Museum. Photograph courtesy of Harvard University Museums, Cambridge, Massachusetts.

The Fogg Art Museum is Harvard's oldest art museum. Around its Italian Renaissance courtyard, based on a 16th-century façade in Montepulciano, Italy, are galleries illustrating the history of Western art from the Middle Ages to the present, with particular strengths in Italian early Renaissance, British Pre-Raphaelite, and 19th-century French art. The Wertheim Collection, housed on the second floor of the Fogg, is one of America's finest collections of Impressionist and post-Impressionist work, and contains many famous masterworks. The Boston area's most important collection of Picasso's work is also found at the Fogg. The Agnes Mongan Center houses the collections, study room, and curatorial offices of the Fogg Art Museum's departments of prints, photographs, and drawings. The collections comprise approximately 60,000 prints, 12,000 drawings, and 8,000 photographs by European and American artists from the 14th-century to the present. (The Mongan Center study room is open to the public Tuesday through Friday, 2pm-4:45pm or by appointment, 495-2325. During the academic year, it may also be open Saturday, 10am-12:45pm.)

Harvard University Semitic Museum

6 Divinity Ave., Cambridge, MA 02138
Tel: (617) 495-4631
Fax: (617) 496-8904
Internet Address: http://www.fas.harvard.edu/~semitic/
Assistant Director: Dr. Joseph A. Greene
Admission: voluntary contribution.
Attendance: 5,000 *Established:* 1889
Membership: Y *ADA Compliant:* N
Open: Monday to Friday, 10am-4pm; Sunday, 1pm-4pm.
Closed: University Holidays.
Facilities: **Galleries**; **Shop**.
Activities: **Guided Tours**; **Lectures**; **Permanent Exhibits**; **Temporary Exhibitions**; **Traveling Exhibitions**.
Publications: books, *Harvard Semitic Series*; exhibition catalogues; newsletter.

The Museum, which shares its building with Harvard's Department of Near Eastern Languages and Civilizations, is dedicated to the use of its collections for the investigation and teaching of Near Eastern archaeology, history and culture. Through the collaborative efforts of departmental faculty, curators, museum curatorial staff, and students, the Museum mounts educational exhibits, sometimes in conjunction with courses, that not only serve the needs of the University, but also attract the general public and promote greater understanding of the civilizations of the Near East and its great cultural legacy.

Offering stand in shape of a house (14th century BC) from Harvard's excavations at Nuzi, Iraq, 1927-1931. Photograph courtesy of Harvard University Semitic Museum, Cambridge, Massachusetts.

Cambridge, Massachusetts

MIT-List Visual Arts Center (LVAC)
Weisner Building (MIT Bldg. E-15), 20 Ames St.
Cambridge, MA 02142-1308
Tel: (617) 253-4680
Fax: (617) 258-7265
Internet Address: http://web.mit.edu/lvac/www
Director: Ms. Jane E. Farver
Admission: voluntary contribution.
Attendance: 12,000 *Established:* 1950
ADA Compliant: Y
Parking: corner Main & Ames Sts.,
 in campus lots evenings and weekends.
Open: **October to June**,
 Tuesday to Thursday, noon-6pm;
 Friday, noon-8pm;
 Saturday to Sunday, noon-6pm.
Closed: Legal Holidays.
Facilities: **Architecture** (Wiesner Building, 1985 design by
 I.M. Pei); **Galleries** (3); **Sculpture Collection** (throughout
 campus).
Activities: **Temporary Exhibitions** (3 exhibition periods/year
 with 1-3 exhibitions/period).

Exterior view of Wiesner Building, MIT.
Photograph by Steve Rosenthal, courtesy of
MIT List Visual Arts Center, Cambridge,
Massachusetts.

Publications: brochure, "The MIT List Visual Arts Center"; exhibition catalogues; gallery guides;
 guide, "Art and Architecture at MIT".

Occupying three galleries on the main floor of the Wiesner Building, the List Visual Arts Center mounts approximately twelve exhibitions between October and June each year of current art making in all media: painting, sculpture, photography, video, installations, and experimental works that resist easy classification. Some exhibition examine one artist's work in depth; others bring together a variety of artists to provide different perspectives on a common theme. MIT's permanent collection of 20th-century art, which is particularly noted for major works of outdoor sculpture, is on view at all times throughout the campus.

Chestnut Hill

Boston College - Charles S. and Isabella V. McMullen Museum of Art
Devlin Hall, 140 Commonwealth Ave., Chestnut Hill, MA 02167
Tel: (617) 552-8100
Fax: (617) 552-8577
Internet Address: http://www.bc.edu/bc_org/avp/cas/artmuseum
Director: Dr. Nancy Netzer
Admission: free.
Attendance: 80,000 *Established:* 1976 *Membership:* Y *ADA Compliant:* Y
Parking: two free parking garages.
Open: **September to May**, Monday to Friday, 11am-4pm; Saturday to Sunday, noon-5pm.
 June to August, Monday to Friday, 11am-3pm; Sunday, noon-5pm.
Closed: New Year's Day, ML King Day, Washington's B'day, Good Friday, Easter; Memorial Day,
 Christmas Day.
Facilities: **Architecture** (neo-Gothic, 1924 design by Charles D. Maginnis); **Auditorium** (350
 seats); **Galleries** (2).
Activities: **Education Programs** (undergraduate and graduate college students); **Guided Tours**
 (Fri., 12:30pm; on request for groups); **Lectures**; **Temporary Exhibitions**; **Traveling
 Exhibitions**.
Publications: exhibition catalogues (3/year); newsletter, "Arts Newsletter" (semi-annual).

Boston College - Charles S. and Isabella V. McMullen Museum of Art, cont.

Occupying two floors of Devlin Hall, the Museum presents a notable permanent collection and temporary exhibitions from around the world. The permanent collection is displayed on a rotating basis in the Museum's ground floor galleries, while most temporary or traveling exhibitions are displayed in the special exhibition space on the first floor, and smaller thematic exhibitions are mounted in a gallery on the ground level. Begun in the 19th century, the University's permanent collection contains works that span the history of art from Europe, Asia and the Americas. Outstanding among them are Gothic and Baroque tapestries, Italian paintings of the 16th and 17th centuries, American landscape paintings of the 19th and early 20th centuries, and Japanese prints. For visitors who wish to find out more about the collection, the Museum provides the Micro Gallery, an interactive computer displaying information and images on works in the permanent collection, as well as photographs of related works.

Michele di Ridolfo del Ghirlandaio, *Madonna and Child with Saint John the Baptist*, c. 1560, oil on canvas. Gift of Julie Shaw, McMullen Museum of Art. Photograph courtesy of McMullen Museum of Art, Boston College, Chestnut Hill, Massachusetts.

Cohasset

South Shore Art Center

119 Ripley Road, Cohasset, MA 02025
Tel: (781) 383-2787
Fax: (781) 383-2964
Public Relations Director: Monica McKenney
Open: Monday to Saturday, 10am-4pm; Sunday, noon-4pm.
Facilities: **Exhibition Area.**
Activities: **Temporary Exhibitions.**

The center presents temporary exhibitions of work by regional and national artists.

Concord

Concord Art Association

37 Lexington Road, Concord, MA 01742
Tel: (978) 369-2578
Fax: (978) 371-2496
Curator: Ms. Patsy B. McVity
Admission: voluntary contribution.
Established: 1922
Membership: Y *ADA Compliant:* Y
Parking: free on street.
Open: Tuesday to Saturday, 10am-4:30pm.
Facilities: **Architecture** Historic house (1720); **Exhibition Area** (4 galleries); **Gardens; Shop.**
Activities: **Arts Festival; Outdoor Sculpture Exhibits; Permanent Exhibits; Temporary Exhibitions** (about 10/year).

Woodcut of Concord Art Centre, ca.1922. Rendering courtesy of Concord Art Association, Concord, Massachusetts.

The Arts Centre offers changing exhibitions in a historic setting. Shows include juried and traveling exhibitions.

Cotuit

Cahoon Museum of American Art

4676 Falmouth Road (Route 28), Cotuit, MA 02635
Tel: (508) 428-7581
Fax: (508) 420-3709
Internet Address: http://www.cahoonmuseum.org
Director: Cindy Nickerson
Admission: free.
Attendance: 15,000 *Established:* 1984 *Membership:* Y
Parking: free on site.
Open: **February to December**, Tuesday to Saturday, 10am-4pm.
Closed: Legal Holidays.
Facilities: **Architecture** (late 18th-century farmhouse; former tavern, 1775); **Library** (1,500 volumes); **Shop**.
Activities: **Demonstrations**; **Education Programs** (adults and children); **Gallery Talks** (Fri, 11am); **Guided Tours**; **Lectures**; **Temporary Exhibitions** (6/year).
Publications: brochure; bulletin, "Scuttlebutt" (occasional); exhibition catalogues; newsletter, "Spyglass" (quarterly); posters.

The Museum annually mounts six exhibitions of American art including works by contemporary artists. Between special exhibitions, it displays works from its permanent collection. In addition to the works of Ralph and Martha Cahoon, its permanent collection features American painting and includes folk art portraits by William Matthew Prior, Hudson River School landscapes by Alvan Fischer, marine paintings by James Buttersworth, and works by American Impressionist John Enneking.

Dennis

Cape Museum of Fine Arts, Inc.

Route 6A, Dennis, MA 02638
Tel: (508) 385-4477
Fax: (508) 385-7933
Director: Mr. Gregory Harper
Admission: fee: adult-$3.00, child-free.
Attendance: 35,000 *Established:* 1981 *Membership:* Y *ADA Compliant:* Y
Parking: free on site.
Open: **Memorial Day to Labor Day**, Monday to Saturday, 10am-5pm; Sunday, 1pm-5pm.
 Labor Day to Memorial Day, Tuesday to Saturday, 10am-5pm; Sunday, 1pm-5pm.
Facilities: **Auditorium**; **Galleries**; **Shop**.
Activities: **Arts Festival**; **Films**; **Guided Tours**; **Lectures**; **Permanent Exhibits**; **Studio Arts** (adults and children); **Temporary Exhibitions**; **Workshops**.
Publications: "Art Matters"; brochure (quarterly); exhibition catalogues.

Located on the grounds of the "Cape Playhouse Center for the Arts", the Museum features the work of 20th-century local and regional artists.

Duxbury

The Art Complex Museum

189 Alden St., Duxbury, MA 02331
Tel: (781) 934-6634
Fax: (781) 934-5117
Director/C.E.O.: Mr. Charles A. Weyerhaeuser
Admission: voluntary contribution.
Attendance: 13,000 *Established:* 1967 *ADA Compliant:* Y
Parking: free on site.

The Art Complex Museum, cont.

Open: Wednesday to Sunday, 1pm-4pm.

Closed: Legal Holidays.

Facilities: **Architecture** (c 1970 by architect Robert Owen Abbot based on design by artist Ture Bengtz); **Exhibition Area** (2 galleries); **Japanese Tea House**; **Library** (4,000 volumes); **Sculpture Garden**.

Activities: **Concerts** (Sunday afternoon concert series); **Education Programs** (adults and children); **Gallery Talks**; **Guided Tours** (groups by advance arrangement); **Lectures**; **Permanent Exhibits**; **Tea Ceremony Presentations**; **Traveling Exhibitions**.

Publications: collection catalogue; exhibition catalogues.

George Bellows, *Farm of John Tom*, 1916, The Art Complex Museum collection. Photograph courtesy of The Art Complex Museum, Duxbury, Massachusetts.

Situated in a sylvan setting, The Art Complex Museum was founded as a regional center for the arts and a home for the art collection begun by the Carl A. Weyerhauser family. The Museum presents an exhibition schedule featuring the work of contemporary New England artists and also including occasional group exhibitions and traveling shows. Selections from the permanent collection are exhibited in the Museum's Rotations Gallery. The permanent collection focuses on works of art on paper, particularly European and American prints, but also includes significant holdings in Shaker furniture, American paintings and Asian art.

Fitchburg

Fitchburg Art Museum

185 Elm St., Fitchburg, MA 01420

Tel: (978) 345-4207

Fax: (978) 345-2319

Director: Mr. Peter Timms

Admission: fee: adult-$3.00, child-free, student-free, senior-$2.00.

Attendance: 14,000 *Established:* 1925 *Membership:* Y *ADA Compliant:* Y

Parking: free on site.

Open: Tuesday to Saturday, 11am-4pm; Sunday, 1pm-4pm.

Closed: Legal Holidays.

Facilities: **Classroom**; **Galleries**; **Sculpture Garden**; **Studio**.

Activities: **Education Programs** (adults and children); **Gallery Talks**; **Guided Tours**; **Lectures**; **Permanent Exhibits**; **Regional Arts & Crafts Exhibition** (annual); **Temporary Exhibitions**.

Publications: calendar; exhibition catalogues; newsletter; posters.

Founded through the bequest of artist Eleanor Norcross, the Fitchburg Art Museum offers educational exhibitions, lectures, classes, concerts and special events. Its regional exhibit is one of the oldest exhibitions of its kind in New England. In addition to Miss Norcross's collection and personal papers, the Museum's permanent collection features five paintings by Mark Tobey. It also has on permanent loan from the Boston Museum of Fine Arts paintings of Egyptian ruins.

Framingham

Danforth Museum of Art

123 Union Ave., Framingham, MA 01702

Tel: (508) 620-0050

Fax: (508) 872-5542

Director: Ronald L. Crusan

Admission: fee: adult-$3.00, senior-$2.00.

Attendance: 25,000 *Established:* 1973 *Membership:* Y *ADA Compliant:* Y

Danforth Museum of Art, cont.

Parking: free on site.

Open: Wednesday to Sunday, noon-5pm.

Facilities: **Galleries** (7); **Lecture Room**; **Library**; **Photography Lab**; **Shop**; **Studios** (8).

Activities: **Concerts**; **Education Programs** (adults, undergraduate/graduate students, and children); **Films**; **Gallery Talks**; **Guided Tours**; **Lectures**; **Permanent Exhibits**; **Temporary Exhibitions**; **Traveling Exhibitions**.

Publications: exhibition announcements; exhibition catalogues; newsletter, "Danforth Museum of Art News".

The Museum's permanent collection features the work 19th- and 20th-century American (particularly New England) and European artists.

Gloucester

Cape Ann Historical Museum

27 Pleasant St., Gloucester, MA 01930

Tel: (508) 283-0455

Director: Ms. Judith McCulloch

Admission:
fee: adult-$4.00, student-$2.50, senior-$3.50.

Attendance: 14,000 *Established:* 1873

Membership: Y *ADA Compliant:* Y

Parking: adjacent to museum and metered lot across street.

Open: **March through January**,
Tuesday to Saturday, 10am-5pm.

Closed: February, Legal Holidays.

Facilities: **Auditorium** (175 seats); **Galleries**; **Library** (2,000 volumes, non-circulating); **Shop**.

Fitz Hugh Lane, *The Western Shore with Norman's Woe*, 1862, oil on canvas. Cape Ann Historical Museum Collection. Photograph courtesy of Cape Ann Historical Museum, Gloucester, Massachusetts.

Activities: **Guided Tours** (group tours by appointment only); **Lectures**; **Permanent Exhibits**; **Temporary Exhibitions**.

Publications: "Paintings and Drawings by Fitz Hugh Lane".

The Museum exhibits the largest collection of paintings and drawings by 19th-century Luminist master Fitz Hugh Lane and work by other painters and sculptors associated with Cape Ann, such as Milton Avery, Stuart Davis, Marsden Hartley, Winslow Homer, Maurice Prendergast, and John Sloan. Other exhibits include a furnished Federal period house, American antique furniture, fisheries/maritime galleries, and granite quarrying gallery.

The North Shore Arts Association Gallery

197-Rear E. Main St., Gloucester, MA 01930

Tel: (978) 283-1857

Fax: (978) 283-3342

Internet Address: http://www1.shore.net/~nya/NSAA.html

Gallery Manager: Ms. Ruth A. Brown

Admission: voluntary contribution.

Attendance: 8,000 *Established:* 1922 *Membership:* Y *ADA Compliant:* Y

Open: **June to October**, Monday to Saturday, 10am-5pm; Sunday, 1pm-5pm.

Facilities: **Architecture** (former wharf building, c1870); **Gallery**; **Picnic Area**.

Activities: **Arts Auction**; **Demonstrations** (Sat, 10:30am-12:30pm); **Juried Exhibit**; **Lectures**; **Workshops**.

Publications: newsletter, "Horizons" (3/year).

Each year artists must submit their entries to be judged by a jury composed of fellow Association members. Only those works accepted by jury are displayed.

Lincoln

DeCordova Museum and Sculpture Park

51 Sandy Pond Road, Lincoln, MA 01773
Tel: (781) 259-8355
Fax: (781) 259-3650
Internet Address: http://www.decordova.org
Director and C.E.O.: Paul Master-Karnik, Ph.D.
Admission: fee: adult-$6.00, child-$4.00, student-$4.00, senior-$4.00.
Attendance: 95,000 *Established:* 1948 *Membership:* Y *ADA Compliant:* Y
Parking: free on site.
Open: Tuesday to Sunday, 11am-5pm.
Closed: Legal Holidays.
Facilities: **Amphitheater** (2,000 seats); **Art School** (7 studios); **Exhibition Area** (29,000 square feet); **Food Services** Café @ DeCordova (Wed-Sun,11am-4pm); **Library**; **Sculpture Park** (35 acres, over 50 works); **Shop.**
Activities: **Art Classes** (adults and children); **Arts Festival**; **Concerts**; **Films**; **Guided Tours**; **Lectures**; **Temporary Exhibitions.**
Publications: annual report; calendar; exhibition catalogues; school catalogue.

The DeCordova Museum and Sculpture Park is dedicated to the exhibition, collection, and preservation of works by living New England artists. Its focus is not on objects, but rather on the makers and process of making art. Whenever and wherever possible, the living artist is involved in DeCordova's mission of displaying art. Its schedule of temporary exhibitions includes the DeCordova Annual Exhibition series featuring works by emerging new artists and providing an annual snapshot of regional talent. At the same time Media Space @ DeCordova highlights local video artists. The Museum's 35-acre sculpture park offers over 50 modern and contemporary works by noted regional and national artists, and its Sculpture Terrace serves as an open air gallery for one-person exhibitions. Although the museum collects sculpture and commissions site-specific works, it employs an active replacement program in the park, usually borrowing what it displays for up to two years. With over 2,000 works in its holdings, the Museum features the largest permanent collection of New England contemporary art.

Lowell

New England Quilt Museum

18 Shattuck St., Lowell, MA 01852
Tel: (978) 452-4207
Fax: (978) 452-5405
Internet Address: http://www.nequiltmuseum.org
Director: Ms. Patricia Steuert
Admission: fee: adult-$4, student-$3, senior-$3.
Attendance: 20,000 *Established:* 1987 *Membership:* Y *ADA Compliant:* Y
Parking: metered on street or the L.A. Roy Market Street Garage.
Open: **mid-January to April**, Tuesday to Saturday, 10am-4pm.
 May to November, Tuesday to Saturday, 10am-4pm; Sunday, noon-4pm.
 December, Tuesday to Saturday, 10am-4pm.
Closed: 1st two weeks in January, Legal Holidays.
Facilities: **Classrooms**; **Exhibition Galleries** (6,000 square feet); **Library** (1,200 volumes); **Shop** (gifts, quilt books).
Activities: **Education Programs** (adults and students); **Guided Tours** (reserve in advance); **Lectures**; **Temporary Exhibitions**; **Traveling Exhibitions.**
Publications: book, "New England Quilt Museum Quilts"; newsletter, "New England Quilt Museum Newsletter" (quarterly).

The Museum displays traditional and contemporary quilts.

Lowell, Massachusetts

Whistler House Museum of Art

243 Worthen St., Lowell, MA 01852
Tel: (978) 452-7641
Fax: (978) 454-2421
Internet Address: http://www.whistlerhouse.org
Exec. Director: Tom Edmonds
Admission: fee: adult-$4.00, child-$2.00,
 student-$2.00, senior-$3.00.
Attendance: 7,000 *Established:* 1878
Membership: Y
Parking: free at Visitors Center.
Open: **March to December**,
 Wednesday to Saturday, 11am-4pm;
 Sunday, by appointment.
Closed: January to February, Legal Holidays.
Facilities: **Architecture** (birthplace of American
 artist James Abbott McNeill Whistler, built
 1823); **Auditorium** (100 seats); **Gallery**;
 Library (300 volumes).

Frank W. Benson, *The Children*, Whistler House Museum of Art collection. Photograph courtesy of Whistler House Museum of Art, Lowell, Massachusetts.

Activities: **Arts Festival**; **Concerts**; **Education Programs** (adults and children); **Films**; **Gallery Talks**; **Guided Tours**; **Home of the "Lowell Celebrates Kerouac!" Committee**; **Lectures**; **Permanent Exhibits**; **Temporary Exhibitions**; **Traveling Exhibitions**.
Publications: calendar; exhibition catalogues; newsletter.

In 1908 the birthplace of James Abbott McNeill Whistler became the permanent home of the Lowell Art Association (founded 1878). The Association owns and operates the Museum as an historic site presenting the history and art of Lowell. Works from the Museum's permanent collection are on display in the galleries of the Whistler House. The focus of the collection is late 19th- and early 20th-century American representational art with special emphasis on the artists of New England. Among the artists represented are Frank W. Benson, Aldro T. Hibbard, William Morris Hunt, Thomas B. Lawson, David D. Neal, William M. Paxton, William P. Phelps, Frederick Porter Vinton, and Cullen Yates. Holdings also include a collection of Whistler's etchings. Exhibits of contemporary regional artists are displayed in the adjoining Parker Gallery.

Medford

Tufts University Gallery

Tufts University, Aidekman Arts Center, Talbot Ave., Medford, MA 02155
Tel: (617) 627-3518
Fax: (617) 627-3121
Internet Address: http://www.tufts.edu
Gallery Director: Ms. Susan Masuoka
Admission: free.
Attendance: 16,000 *Established:* 1955 *ADA Compliant:* Y
Parking: free in front of the Arts Center.
Open: **September to mid-May**, Wednesday to Saturday, noon-8pm; Sunday, noon-5pm.
Closed: Thanksgiving Holiday, Between Semesters.
Facilities: **Exhibition Area** (5,700 square feet); **Sculpture Court**.
Activities: **Lectures**; **Temporary Exhibitions**; **Traveling Exhibitions**.
Publications: exhibition catalogues.

Located in the Aidekman Arts Center, the art gallery and sculpture court house permanently installed sculpture as well as rotating shows, including graduate students' work and professional shows, throughout the year.

Nantucket

Artists Association of Nantucket

19 Washington St., Nantucket, MA 02554
Tel: (508) 228-00294
Fax: (508) 325-5251
Internet Address: http://www.nantucketarts.org
Gallery Director: Ms. Beth Powers
Admission: voluntary contribution.
Established: 1945 *Membership:* Y *ADA Compliant:* Y
Open: **April to December,**
 Monday to Saturday, 10am-5pm and 7pm-10pm; Sunday, 1pm-5pm.
Facilities: **Gallery.**
Activities: **Art Auction; Concerts; Films; Lectures; Permanent Exhibits; Temporary Exhibitions; Workshops.**
Publications: brochure; calendar; newsletter.

The Artists' Association of Nantucket presents a full season of changing member exhibitions, as well as classes, demonstrations, juried shows, auctions, and other arts events. The Association's permanent collection includes more than 600 paintings, prints, drawings, photographs, and sculpture by former and current members.

New Bedford

New Bedford Whaling Museum

18 Johnny Cake Hill, New Bedford, MA 02740-6398
Tel: (508) 997-0046
Fax: (508) 997-0018
Internet Address: http://www.whalingmuseum.org/
Director: Ms. Anne B. Brengle
Admission: fee: adult-$6.00, child (6-14)-$4.00,
 student-$5.00, senior-$5.00.
Attendance: 50,000 *Established:* 1903
Membership: Y *ADA Compliant:* Y
Parking: commercial adjacent to site and on street.
Open: **Labor Day to Memorial Day,**
 Daily, 9am-5pm.
 Memorial Day to Labor Day,
 Monday to Wednesday, 9am-5pm;
 Thursday, 9am-8pm;
 Friday to Sunday, 9am-5pm.
Closed: New Year's Day, Thanksgiving Day,
 Christmas Day.
Facilities: **Auditorium** (250 seats); **Exhibition Area; Library; Reading Room; Shop.**
Activities: **Education Programs** (children); **Films; Gallery Talks; Guided Tours; Lectures; Permanent Exhibits; Temporary Exhibitions.**
Publications: books; newsletter, "Bulletin of Johnny Cake Hill".

Unknown Chinese Artist, *Houqua's Garden*, (detail), ca. 1850. New Bedford Whaling Museum, gift of Mrs. Clarkson Hill. Photograph courtesy of New Bedford Whaling Museum, New Bedford, Massachusetts.

The New Bedford Whaling Museum is devoted primarily to the history of whaling. In addition to many historical artifacts pertaining to whaling, the collection includes over 800 paintings, prints, and drawings relating to whaling. There are also over 2,000 examples of scrimshaw in the collection. The Museum also houses a local history collection, with 300 portraits, major paintings by local artists, folk art, textiles, and decorative arts.

The Rotch-Jones-Duff House and Garden Museum, Inc. (R-J-D)

396 County St., New Bedford, MA 02740
Tel: (508) 997-1401
Fax: (508) 997-6846
Exec. Director: Ms. Kate Corkum
Admission: fee: adult-$4.00, child-$2.00,
 student-$3.00, senior-$3.00.
Attendance: 10,000 *Established:* 1984
Membership: Y *ADA Compliant:* Y
Open: **January to May**,
 Tuesday to Saturday, 10am-4pm;
 Sunday, 12:30pm-4pm.
 June to December,
 Monday to Saturday, 10am-4pm;
 Sunday, 12:30pm-4pm.

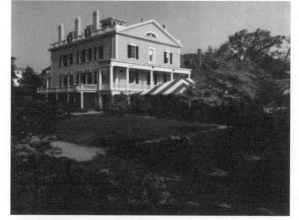

View of Rotch-Jones-Duff House (1834), design attributed to
Richard Upjohn. Photograph courtesy of the Rotch-Jones-Duff
House & Garden Museum, New Bedford, Massachusetts.

Closed: Legal Holidays.
Facilities: **Architecture** (Greek Revival, 1834 -
 design attributed to Upjohn);**Gardens**.
Activities: **Concerts**; **Education Programs** (adults); **Garden Events**; **Guided Tours**; **Lecture Series**.
Publications: exhibition catalogues; newsletter, "The Record" (semi-annual).

Built in 1834 for Quaker whaling merchant William Rotch, Jr., the design of this Greek Revival mansion is attributed to Richard Upjohn. The Museum collections include many original furnishings, art, and décor of the Rotch, Jones, and Duff families, as well as a New Bedford glass collection. The Museum hosts four exhibitions each year.

Newton

Starr Gallery - Leventhal-Sidman Jewish Community Center

Leventhal-Sidman Jewish Community Center, 333 Nahanton St., Newton, MA 02159
Tel: (617) 558-6484
Fax: (617) 527-3104
Admission: free.
Open: Monday, 10am-4pm; Tuesday to Wednesday, 10am-4pm and 6am-9pm;
 Thursday, 10am-4pm; Friday, 10am-2pm; Sunday, 11am-4pm.
Facilities: **Auditorium**; **Classrooms**; **Gallery**.
Activities: **Films**; **Guided Tours**; **Lectures**; **Performances**; **Temporary Exhibitions**.

The Gallery displays Jewish ceremonial art and contemporary fine art.

Newtonville

The New Art Center in Newton

61 Washington Park, Newtonville, MA 02460-0003
Tel: (617) 964-3424
Fax: (617) 630-0081
Exhibit Director: Ms. Pat Kellogg Friedman
Attendance: 2,500 *Established:* 1977 *Membership:* Y *ADA Compliant:* Y
Parking: free on site.
Open: Monday to Friday, 9am-5pm; Sunday, 1pm-5pm.
Facilities: **Architecture** (19th-century stone former church); **Exhibition Area** (2 galleries).
Activities: **Temporary Exhibitions**.

A non-profit, non-collecting organization, the New Art Center in Newton provides educational opportunities for adults and children and operates a mid-sized independent exhibit space. The Center exhibits the work of emerging artists selected through a juried process. Exhibitions may involve works in a single medium, embrace several media, or combine the visual arts with poetry, music, film, dance, or other performances.

North Adams

MASS MoCA (Massachusetts Museum of Contemporary Art)

87 Marshall St., North Adams, MA 01247-9920
Tel: (413) 664-4481
Fax: (413) 663-8548
Internet Address: http://www.massmoca.org
Director: Mr. Joseph C. Thompson
Admission: fee: adult-$8.00,
child (<6)-free (6-16)-$3.00.
Established: 1986 (opened 1999)
Membership: Y *ADA Compliant:* Y
Parking: free on site.
Open: **June to October**,
Daily, 10am-6pm.
November to May,
Wednesday to Monday, 11am-5pm

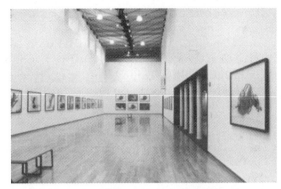

Catherine Chalmers, *The Food Chain*, 1994-96, C-print. Collection of the artist. *Unnatural Science* in MASS Moca's Tall Gallery. Photograph by Arthur Evans, courtesy of MASS MoCA, North Adams, Massachusetts.

Facilities: **Architecture** (19th-century historic mill complex, 13 acres).
Activities: **New Commissions**; **Temporary Exhibitions**; **Site Specific Installations**; **Performing Arts Events**; **Traveling Exhibitions**.

MASS MoCA, the largest center for contemporary visual and performing arts in the United States, is located in the 27-building campus of a renovated 19th-century factory. MASS MoCA focuses on the work of artists charting new territory and works that have seldom, or never, been exhibited because of physical demands such as scale, materials, and fabrication methods. International in scope, MASS MOCA not only presents visual and performing arts programming by established and new artists, but also reveals the creative process - works in progress and rehearsals are often open to the public.

North Dartmouth

University of Massachusetts Dartmouth - University Art Gallery

University of Massachusetts Dartmouth, 285 Old Westport Road, North Dartmouth, MA 02747
Tel: (508) 999-8555
Fax: (508) 999-9279
Internet Address: http://www.umassd.edu
Director: Mr. Lasse B. Antonsen
Admission: free.
Established: 1987 *ADA Compliant:* Y
Open: **September to May**, Monday to Saturday, 2pm-5pm.
Facilities: **Auditorium** (350 seats); **Exhibition Area** (2,600 square feet).
Activities: **Art Auction** (annual); **Arts Festival**; **Concerts**; **Education Programs** (undergraduate and graduate college students); **Films**; **Guided Tours**; **Lectures**; **Traveling Exhibitions**.

UMass Dartmouth is home to several gallery spaces on both the main and the auxiliary campus that feature student and professional works throughout the year. The main gallery features exhibits of national and international artists and also exhibits student work in a juried show and a senior show.

Northampton

Smith College Museum of Art (SCMA)

Elm St. at Bedford Terrace, Northampton, MA 01063
Tel: (413) 585-2760
Fax: (413) 585-2782
TDDY: (413) 585-2786
Internet Address: http://www.smith.edu/artmuseum

Smith College Museum of Art, cont.

Director: Ms. Suzannah Fabing
Admission: voluntary contribution.
Attendance: 32,000 *Established:* 1920 *Membership:* Y *ADA Compliant:* Y
Open: The Museum is entirely closed. It is scheduled to reopen in the fall of 2002.
Facilities: **Galleries**; **Print Study Room** (Sept-May, Tues-Fri, 1pm-4pm); **Shop**.
Activities: **Concerts**; **Education Programs** (undergraduate and graduate college students); **Films**;
 Gallery Talks; **Guided Tours**; **Lectures**; **Temporary Exhibitions**; **Traveling Exhibitions**.
Publications: collection catalogue, "A Guide to the Collections"; exhibition catalogues.

The Smith College Museum of Art has a permanent collection numbering approximately 24,000 objects from a variety of cultures ranging in date from 2500 B.C. to the present. The primary emphasis of the collection, however, is on artists of Europe and America since the French Revolution. The scope of its collection is such that it frequently lends works for exhibitions in major museums. The Museum also has an active exhibition program of works of international importance, both contemporary and historical. American painting at Smith includes works by Copley, Eakins, the Hudson River School, Bierstadt, Sargent, Homer, Whistler, Sheeler, Stella, Motherwell, and Rothko. The print collection contains works by Dürer, Piranesi, Delacroix, Goya, Daumier, Munch, Picasso, Matisse, Hiroshige, and Hokusai. Drawings include examples by numerous Old Masters, as well as Matisse, Cézanne, Prendergast, Audubon, Seurat, Mondrian, and Klee. The Museum's holdings in photography span the history of the medium, from works by Fox and Muybridge to examples by Mapplethorpe. There are also smaller collections of ancient, Asian, African, Oceanic, and Native American art.

Words and Pictures Museum of Fine Sequential Art

140 Main St., Northampton, MA 01060
Tel: (413) 586-8545
Fax: (413) 586-9855
Exec. Director: Ms. Maryann Meeks
Admission: fee: adult-$3.00, child-$1.00, student-$2.00, senior-$2.00.
Attendance: 18,000 *Established:* 1991 *Membership:* Y *ADA Compliant:* Y
Parking: metered lots nearby.
Open: Tuesday to Thursday, noon-5pm; Friday, noon-8pm; Saturday, 10am-8pm;
 Sunday, noon-5pm.
Closed: New Year's Day, Memorial Day, Independence Day, Labor Day, Thanksgiving Day,
 Christmas Day.
Facilities: **Exhibition Area** (5,000 square feet); **Interactive Area** (1,000 square feet); **Library**
 (70,000 volumes); **Shop**.
Activities: **Guided Tours**; **Lectures**; **Temporary Exhibitions**; **Traveling Exhibitions**.
Publications: guidebook (annual); newsletter, "Words about Pictures".

The Museum is dedicated to the collection, study, interpretation, and presentation of fine narrative and fantasy illustration. The permanent collection consists of over 18,000 original works in the comic book and fantasy illustration genre. The third-floor gallery of the Museum is devoted to the presentation of temporary exhibitions of contemporary works in the genre.

Norton

Wheaton College - Watson Gallery

Wheaton College, E. Main St., Norton, MA 02766
Tel: (508) 286-3578
Fax: (508) 286-3565
Internet Address: http://www.wheatonma.edu
Director: Ms. Ann H. Murray
Admission: free.
Attendance: 4,500 *Established:* 1960 *Membership:* Y *ADA Compliant:* Y
Parking: lot across street.

Wheaton College - Watson Gallery. cont.

Open: **Fall to Spring,**
Monday to Saturday, 12:30pm-4:30pm.
Closed: Spring Break, Summer, Columbus Day Weekend,
Thanksgiving Break, Christmas Break,
Academic Holidays.
Facilities: **Exhibition Area** (1,568 square feet).
Activities: **Temporary Exhibitions.**
Publications: exhibition catalogues.

The Watson Gallery features contemporary art in all media and presents thematic exhibitions based on works from the permanent collection, or borrowed from other institutions and private collections. The holdings of the Gallery range from antiquities to contemporary art, emphasizing prints (16th- to 20th-century); drawings (16th- to 20th-century); paintings (19th- and 20th-century); decorative arts; textiles; Native American baskets; and sculpture (antiquities, 19th- and 20th- centuries).

Works from permanent collection, Watson Gallery. Photograph by Jonathan Hoover, courtesy of Watson Gallery, Wheaton College, Norton, Massachusetts.

Paxton

Anna Maria College - The St. Luke's Gallery, Moll Art Center

50 Sunset Lane, Paxton, MA 01612-1198
Tel: (508) 849-3300 *Ext:* 442
Internet Address: http://www.annamaria.edu
Gallery Director: Ms. Elizabeth Killoran
Admission: free.
Attendance: 600 *Established:* 1972
Membership: N *ADA Compliant:* Y
Parking: free on site.
Open: **September to June,**
Monday to Wednesday, 9am-4pm;
Thursday, 9am-7pm;
Friday, 9am-4pm;
Sunday, 2pm-4pm.
Closed: Legal Holidays.
Facilities: **Classrooms; Exhibition Area**
(2,468 square feet); **Lecture Hall; Rental
Gallery; Studios.**
Activities: **Education Programs** (college
students); **Student Exhibits; Temporary
Exhibitions** (local and regional artists).

Annie Sullivan, *Moon Boy Dream*, Work displayed in temporary exhibition at St. Luke's Gallery, September, 1997. Photograph courtesy of Moll Art Center, Anna Maria College, Paxton, Massachusetts.

The Gallery offers changing exhibits of original art in all media by local and regional artists.

Pittsfield

Berkshire Artisans/Lichtenstein Center for the Arts

28 Renne Ave., Pittsfield, MA 01201
Tel: (413) 499-9348
Fax: (413) 442-8043
TDDY: (413) 499-9340
Artistic Director: Mr. Daniel M. O'Connell
Admission: voluntary contribution.

Berkshire Artisans/Lichtenstein Center for the Arts, cont.

Attendance: 20,000 *Established:* 1975 *Membership:* Y *ADA Compliant:* Y
Parking: free on site.
Open: **May to September**, Monday to Saturday, 11am-5pm.
 October to April, Monday to Friday, 11am-5pm.
Closed: Legal Holidays.
Facilities: **Darkroom**; **Exhibition Area** (37,000 square feet, additional 24,000 square feet apart);
 Galleries; **Rental Gallery**; **Workshops**.
Activities: **Guided Tours**; **Lectures**.
Publications: "Berkshire Review" (annual); newsletter, "Back Street Notes" (monthly).

The Center is an historical four-story brownstone housing a gallery, workshop space, and ten artists' studios. The gallery features current works of local and regional artists and craftspeople and a public mural program throughout the community.

The Berkshire Museum

39 South St., Pittsfield, MA 01201
Tel: (413) 443-7171
Fax: (413) 443-2135
Internet Address: http://www.berkshiremuseum.org
Directors: Sharon Bronson and Michael Willson
Admission: call for fee information.
Attendance: 79,000 *Established:* 1903
Membership: Y *ADA Compliant:* Y
Parking: on street.
Open: **September to June**,
 Tuesday to Saturday, 10am-5pm;
 Sunday, noon-5pm.
 July to August,
 Monday to Saturday, 10am-5pm;
 Sunday, noon-5pm.

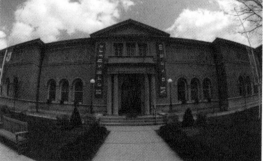

Exterior view of Berkshire Museum. Photograph courtesy of Berkshire Museum, Pittsfield, Massachusetts.

Closed: New Year's Day, Memorial Day,, Labor Day, Thanksgiving Day, Christmas Day.
Facilities: **Auditorium** (293 seats); **Classrooms**; **Galleries** (7 permanent, 2 changing exhibitions);
 Library; **Shop**.
Activities: **Concerts**; **Education Programs** (adults and children); **Films**; **Gallery Talks**;
 Lectures; **Performances**; **Permanent Exhibits**; **Temporary Exhibitions**; **Traveling Exhibitions**.
Publications: calendar (quarterly); exhibition catalogues.

The Berkshire Museum focuses on art, science, and history. The Museum's permanent art collection highlights ancient art and American art of the 18th and 19th centuries. The collection includes works by Bierstadt, Calder, Hudson River School artists, Inness, and Rembrandt Peale.

Provincetown

Provincetown Art Association and Museum

460 Commercial St., Provincetown, MA 02657
Tel: (508) 487-1750
Fax: (508) 487-4372
Internet Address: http://www.capecodaccess.com/gallery/paam.html
Director: Robyn Watson
Admission: fee: adult-$3.00, student-$1.00, senior-$1.00.
Attendance: 40,000 *Established:* 1914
Membership: Y *ADA Compliant:* Y
Parking: free on site.

Provincetown Art Association and Museum, cont.

Open: **Memorial Day to Independence Day,**
Monday to Thursday, noon-5pm;
Fri to Sat, noon-5pm and 8pm-10pm;
Sunday, noon-5pm.
Independence Day to Labor Day,
Mon to Sat, noon-5pm and 8am-10pm;
Sunday, noon-5pm.
Labor Day to September,
Monday to Thursday, noon-5pm;
Fri to Sat, noon-5pm and 8pm-10pm;
Sunday, noon-5pm.
October,
Friday to Sunday, noon-4pm.
November to Memorial Day,
Saturday to Sunday, noon-4pm.

Charles W. Hawthorne, *His First Voyage*, 1915, oil on wood, 48 x 60 inches. Provincetown Art Association and Museum, gift of Joseph Hawthorne, 1949. Photograph courtesy of Provincetown Art Association and Museum, Provincetown, Massachusetts.

Facilities: **Exhibition Area**; **Library** (1,200 volumes, for use by members); **Shop.**
Activities: **Art Classes** (adults and children); **Arts Festival**; **Concerts**; **Education Programs**; **Films**; **Lectures**; **Permanent Exhibits**; **Temporary Exhibitions**; **Traveling Exhibitions.**
Publications: collection catalogue; exhibition catalogues; newsletter.

The Museum displays works from its permanent collection and also mounts temporary exhibitions, including solo shows and members juried shows. The permanent collection of the Museum consists of over 1,500 works of 20th-century art created entirely in Provincetown and its environs. The beginning of the collection was five paintings donated by Charles W. Hawthorne, Ambrose Webster, William Halsall, Oscar Giebrich, and Gerrit Beneker. Since that time, many prominent artists have donated works to the collection.

Rockport

Rockport Art Association

12 Main St., Rockport, MA 01966
Tel: (978) 546-6604
Exec. Director: Ms. Carol Linsky
Admission: voluntary contribution.
Attendance: 50,000 **Established:** 1921 **Membership:** Y
Parking: street.
Open: Tuesday to Saturday, 10am-4pm; Sunday, 1pm-5pm.
Closed: Thanksgiving Day, Christmas Day to New Year's Day.
Facilities: **Galleries** (6); **Library** (500 volumes, for use by members); **Sales Room**; **Shop**; **Studio.**
Activities: **Arts Auction** (annual); **Concerts**; **Gallery Talks**; **Lectures**; **Member and Invitational Exhibits**; **Painting Classes** (adults and children); **Workshops** (adults).
Publications: catalogue (annual); newsletter, "Newsletter & Calendar of Activities" (quarterly).

The Rockport Art Association has 230 artist members (admitted through a jury process), whose works are regularly displayed in the Association's galleries.

Roxbury (Boston)

Museum of the National Center of Afro-American Artists

300 Walnut Ave., Roxbury (Boston), MA 02119
Tel: (617) 442-8614 **Fax:** (617) 445-5525
Director: Mr. Edmund Barry Gaither
Admission: fee: adult-$4.00, student-$3.00, senior-$3.00.
Attendance: 10,000 **Established:** 1969 **Membership:** Y
Open: Tuesday to Sunday, 1pm-5pm.
Facilities: **Architecture** (neo-gothic Victorian mansion, early 1870s); **Exhibition Area.**

Roxbury (Boston), Massachusetts
Museum of the National Center of Afro-American Artists, cont.
Activities: **Guided Tours** (groups, schedule in advance); **Temporary Exhibitions.**
Publications: annual report; newsletter (quarterly).

Dedicated to the promotion, exhibition, collection, and criticism of the black visual arts heritage, the Museum presents exhibitions of contemporary and historical African, African-American, and Caribbean art. In 1994, the Museum opened its first permanent exhibition, "Aspelta: A Nubian King's Burial chamber, featuring the recreation of the coffin, sarcophagus, and burial chamber of that 25th dynasty monarch. Exhibitions are wide ranging, covering photography, painting, sculpture, and graphics. A number of its shows have traveled to other museums. Seven of its exhibitions have been produced in conjunction with the Museum of Fine Arts, Boston, which has provided support to the NCAAA in developing its museum division.

Salem

Peabody Essex Museum
East India Square, Salem, MA 01970
Tel: (978) 745-9500
Fax: (978) 744-6776
Internet Address: http://www.pem.org
Museum Director: Mr. Dan L. Monroe
Admission: fee: adult-$8.50, child-$5.00,
 student-$7.50, senior-$7.50, family-$20.00.
Attendance: 150,000 *Established:* 1799
Membership: Y *ADA Compliant:* Y
Parking: commercial adjacent to site.
Open: Monday to Friday, 10am-5pm;
 Saturday, 10am-5pm;
 Sunday, noon-5pm.
Closed: November to May.

Maritime galleries, Peabody Essex Museum. Photograph by Peter Vanderwarker, courtesy of Peabody Essex Museum, Salem, Massachusetts.

Facilities: **Food Services** Café; **Galleries**; **Library** (400,000 volumes); **Shop.**
Activities: **Concerts**; **Education Programs** (adults and children); **Gallery Talks**; **Guided Tours** (historic house tours daily); **Lectures**; **Permanent Exhibits**; **Temporary Exhibitions** (2 per year).
Publications: "Peabody Essex Museum Collections" (semi-annual); annual report; booklets; calendar (bi-monthly); collection catalogue; exhibition catalogues; journal, "The American Neptune" (quarterly).

The collections of the Peabody Essex Museum are global in scope, ranging from ancient to contemporary times, and touch on virtually all aspects of art and life. The collections consist of maritime art and history, Asian export art, art of Asia, Africa, and the Pacific Islands, Essex County natural history, and American decorative art. Four historic houses owned by the Museum are also open to the public. The Museum campus includes thirty galleries.

Salem State College - Winfisky Gallery
Ellison Campus Center, North Campus, Salem, MA 01970
Tel: (978) 542-6440
Internet Address: http://www.salem.mas.edu/ccpa/artsview_winfisky.htm
Admission: free.
Open: Monday to Friday, 10am-6pm; Saturday to Sunday, by appointment.
Facilities: **Exhibition Area.**
Activities: **Lecture Series**; **Temporary Exhibitions.**

Located in the lobby of the Ellison Campus Center, the Gallery presents a series of art exhibitions by regionally and nationally recognized artists and the annual Student Awards and Student Honors Exhibitions. The Department also hosts an artists lecture series based on topics of current interest.

Sandwich

Heritage Plantation of Sandwich

67 Grove Street, Sandwich, MA 02563
Tel: (508) 888-3300
Fax: (508) 888-9535
Internet Address: www.heritageplantation.org
Director: Mr. Gene A. Schott
Admission: fee: adult-$9.00, child-$4.00, senior-$8.00.
Attendance: 98,000 *Established:* 1969
Membership: Y *ADA Compliant:* Y
Parking: free on site.
Open: **May to October**, Daily, 10am-5pm.
Facilities: **Galleries**; **Grounds**; **Library** (non-circulating); **Shop**.
Activities: **Concerts**; **Education Programs** (children); **Films**; **Lectures**;
 Temporary Exhibitions.
Publications: newsletter, "View form the Cupola" (quarterly).

Heritage Plantation is a diversified museum of Americana. Highlights include a working 1912 carousel, a collection of antique cars, and a military museum. There is also an art museum displaying, among other objects, primitive portraits, landscape and genre paintings, western art, scrimshaw, cigar store figures, weather vanes, trade signs, and Currier and Ives prints.

Cigar store figure, Collection of and photograph courtesy of Heritage Plantation of Sandwich, Sandwich, Massachusetts.

Sandwich Glass Museum

129 Main St., Sandwich, MA 02563
Tel: (508) 888-0251
Fax: (508) 888-4941
Internet Address: http://www.sandwichglassmuseum.org
Director: Mr. Bruce A. Courson
Admission: fee: adult-$3.50, child-$1.00.
Attendance: 54,000 *Established:* 1907
Membership: Y *ADA Compliant:* Y
Open: **February to March**, Wednesday to Sunday, 9:30am-4pm.
 April to December, Daily, 9:30am-5pm.
Closed: Thanksgiving Day, Christmas Day.
Facilities: **Auditorium**; **Exhibition Area** (9,000 square feet); **Library**
 (by appointment only); **Reading Room**; **Shop**.
Activities: **Permanent Exhibits**; **Temporary Exhibitions**.
Publications: "The Acorn" (annual); bulletin, "The Cullet" (quarterly).

The Sandwich Glass Museum consists of fourteen galleries in which over 5,000 pieces of Sandwich glass are displayed. Exhibits describe the transformation of a small farming community into an important center for the manufacture of glass in the 19th century. The Museum also presents glassmaking demonstrations.

Dolphin candlestick, Sandwich Glass Museum. Photograph courtesy of Sandwich Glass Museum, Sandwich, Massachusetts.

Sharon

Kendall Whaling Museum

27 Everett St., Sharon, MA 02067
Tel: (617) 784-5642
Internet Address: http://www.kwm.org/information/home.htm
Director: Stuart M. Frank, Ph.D.

Kendall Whaling Museum, cont.

Admission: fee: adult-$4.00, child-$2.50, student-$3.00, senior-$3.00, family-$10.00.

Attendance: 20,000 *Established:* 1956

Membership: Y *ADA Compliant:* Y

Parking: free; adjacent to site.

Open: Tuesday to Saturday, 10am-5pm;
Sunday, 1pm-5pm.
Federal Holiday Mondays, 10am-5pm.

Closed: New Year's Day, Memorial Day,
Independence Day, Thanksgiving Day,
Christmas Day.

Facilities: **Exhibition Area**; **Library** (15,000 volumes).

Activities: **Education Programs**; **Films**; **Gallery Talks**; **Lectures**; **Permanent Exhibits**; **Temporary Exhibitions**.

Publications: newsletter, "Kendall Whaling Museum Newsletter" (quarterly); various books; monographs.

Ludolf Backhuyzen, *The Amsterdam Whaleship D'Vergulde Walvis Whaling in the Polar Sea*, c. 1700, signed "Backyz"; oil on canvas, 38.5 x 48.5 inches. Kendall Whaling Museum collection. Photograph courtesy of Kendall Whaling Museum, Sharon, Massachusetts.

The Museum's holdings include an extensive collection of nautical art, notably Dutch and Flemish paintings, engravings, and Delft tiles; British and Continental whaling artworks spanning more than ten centuries; Japanese paintings and prints; Pacific Ocean, Eskimo, Northwest Coast Indian and other tribal art; and a large collection of scrimshaw.

South Hadley

Mount Holyoke College Art Museum

Lower Lake Road, South Hadley, MA 01075-1499

Tel: (413) 538-2245

Fax: (413) 538-2144

Internet Address: http://www.mtholyoke.edu/offices/museum

Director: Ms. Marianne Dozema

Admission: voluntary contribution.

Established: 1875 *Membership:* Y *ADA Compliant:* Y

Parking: free on site.

Open: Closed for renovation and expansion.
It is scheduled to reopen in February, 2002.

Closed: Legal Holidays, Academic Holidays.

Facilities: **Galleries**; **Library** (20,000 volumes); **Shop**.

Activities: **Concerts**; **Education Programs**; **Films**; **Gallery Talks**; **Guided Tours**; **Lectures**; **Permanent Exhibitions**; **Temporary Exhibitions**; **Traveling Exhibitions**.

Publications: exhibition catalogues; newsletter; calendar.

The Mount Holyoke College Art Museum, one of the oldest collegiate art museums in the country, maintains a comprehensive collection of approximately 13,000 objects that range from pre-dynastic Egyptian artifacts to contemporary paintings, sculpture, and works of art on paper. Primary strengths include Asian art, 19th- and 20th-century European and American painting and sculpture, Egyptian, Greek, and Roman art, Medieval sculpture, early Renaissance painting, and an extensive collection of prints, drawings, and photographs. In addition to displaying a portion of its permanent collection, the Museum mounts several loan exhibitions each year. While the Museum is closed for renovation and expansion, the Museum offices will remain open.

Dancing Ganesha, Indian, 10th century, sandstone. Mount Holyoke College Art Museum purchase, Belle and Hy Baier Fund, 1996. Photograph courtesy of Mount Holyoke College Art Museum, South Hadley, Massachusetts.

Springfield

George Walter Vincent Smith Art Museum

The Quadrangle, 220 State St. at Chestnut St.
Springfield, MA 01103
Tel: (413) 263-6800 *Ext:* 312
Fax: (413) 263-6889
TDDY: (413) 263-6812
Internet Address: http://www.quadrangle.org
Director: Heather Haskell
Admission: fee: adult-$4.00, child (6-18)-$1.00.
Attendance: 78,050 *Established:* 1896
Membership: Y
Parking: free lots on State and Edwards Streets.
Open: **September to June,**
　　　Wednesday to Sunday, noon-4pm
　　July to August,
　　　Tuesday to Sunday, noon-4pm..

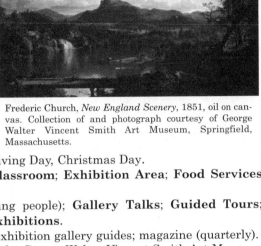

Frederic Church, *New England Scenery*, 1851, oil on canvas. Collection of and photograph courtesy of George Walter Vincent Smith Art Museum, Springfield, Massachusetts.

Closed: New Year's Day, Independence Day, Thanksgiving Day, Christmas Day.
Facilities: **Architecture** (Italianate villa, 1895); **Classroom**; **Exhibition Area**; **Food Services** Café; **Shop**; **Studios.**
Activities: **Education Programs** (adults and young people); **Gallery Talks**; **Guided Tours**; **Lectures**; **Permanent Exhibits**; **Temporary Exhibitions.**
Publications: annual report; exhibition catalogues; exhibition gallery guides; magazine (quarterly).

The oldest building on the Springfield Quadrangle, the George Walter Vincent Smith Art Museum, built in 1895 in the Italianate style, houses the vast collections of its Victorian namesake and his wife. The collection includes Japanese arms and armor, screens, lacquers, textiles, and ceramics; Middle Eastern rugs; and a large collection of Chinese cloisonne. A focal point of the collection is an elaborately carved Shinto shrine. There is also a selection of 19th-century American paintings, including a number by J.G. Brown. The Smith is one of four museums of The Springfield Library and Museums Association. Entry fee is for all four museums at this location.

Museum of Fine Arts (MFA)

The Quadrangle, 220 State St. at Chestnut St.
Springfield, MA 01103
Tel: (413) 263-6800 *Ext:* 312
Fax: (413) 263-6889
TDDY: (413) 263-6812
Internet Address: http://www.quadrangle.org
Director: Heather Haskell
Admission: fee: adult-$4.00, child (6-18)-$1.00.
Attendance: 94,696 *Established:* 1933
Membership: Y
Parking: free in lots on State and Edwards Sts.
Open: **September to June,**
　　　Wednesday to Sunday, noon-4pm
　　July to August,
　　　Tuesday to Sunday, noon-4pm..
Closed: Major Holidays

Erastus Salisbury Field, *Historical Monument of the American Republic*, c. 1876. Photograph courtesy of the Museum of Fine Arts, Springfield, Massachusetts.

Facilities: **Food Services** Café; **Galleries** (14); **Shop.**
Activities: **Education Programs** (adults and young people); **Gallery Talks**; **Guided Tours**; **Lectures**; **Permanent Exhibits**; **Temporary Exhibitions.**
Publications: annual report; exhibition catalogues; gallery guides; magazine (quarterly).

Springfield, Massachusetts
Museum of Fine Arts, cont.

The Museum of Fine Arts is housed in an Art Deco structure built in the 1930's. Significant works by Field, Homer, Copley, Harnett, Remington, and Sargent distinguish the six galleries devoted to American art. Among the European works displayed are notable Italian baroque, Dutch and Flemish, and French collections, which include works by Chardin, Boucher, Gericault, Millet, Courbet, and Gérôme. The Impressionist Gallery contains works by Degas, Pissarro, Caillebotte, and Gauguin, as well as a painting from Monet's Haystack series. There are also 20th-century paintings by Bellows, Sheeler, O'Keeffe, and Feininger, and sculptures by Calder, Stankiewicz, and Sugarman. Holdings also include an fine collection of Japanese woodblock prints, including many by Utagawa Kuniyoshi. The MFA is one of a complex of four museums operated by the Springfield Library and Museums Association. Entrance fee is for all four museums at this site.

Stockbridge

Chesterwood
4 Williamsville Road off Route 183, Glendale Section
Stockbridge, MA 01262
Tel: (413) 298-3579
Fax: (413) 298-3973
TDDY: (413) 298-3579
Director: Mr. Paul W. Ivory
Admission: fee:
 adult-$7.50, child-$2.00, student-$4.00, family-$1700.
Attendance: 35,000 *Established:* 1955
Membership: Y *ADA Compliant:* Y
Parking: free on site.
Open: **May to October**, Daily, 10am-5pm.
Facilities: **Architecture** (summer residence and studio of Daniel Chester French); **Gallery**; **Grounds** (120 acres); **Library** (use by scholars and researchers by appointment); **Shop**.
Activities: **Art Classes**; **Education Programs** (students K-12); **Gallery Talks**; **Guided Tours**; **Landscape Lectures**; **Lectures**; **Permanent Exhibits**; **Temporary Exhibitions**.

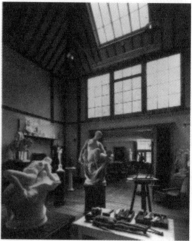

Interior of studio of Daniel Chester French. Photograph courtesy of Chesterwood, Stockbridge, Massachusetts.

Publications: brochures; exhibition catalogues (annual); newsletter (quarterly).

Chesterwood was the summer home of sculptor Daniel Chester French. The residence and studio at Chesterwood were designed by Henry Bacon, while French himself laid out the gardens and woodland walks. The property was donated in 1969 to the National Trust for Historic Preservation. Visitors can view French's studio, the Colonial Revival residence, and exhibits in the Barn Gallery. Chesterwood houses over 500 pieces of sculpture by French.

The Norman Rockwell Museum at Stockbridge
Route 183, Stockbridge, MA 01262
Tel: (413) 298-4100
Fax: (413) 298-4142
TDDY: (413) 298-4137
Internet Address: http://www.nrm.org
Director: Ms. Laurie Norton Moffatt
Admission: fee: adult-$9.00, child (<19 with adult)-free, student-$7.00.
Attendance: 225,000 *Established:* 1967 *Membership:* Y *ADA Compliant:* Y
Parking: free on site.
Open: **May to October**, Daily, 10am-5pm.
 November to April, Monday to Friday, 10am-4pm; Saturday to Sunday, 10am-5pm.
Closed: New Year's Day, Thanksgiving Day, Christmas Day.
Facilities: **Classroom**; **Grounds** (36 acres); **Library** (by appointment only); **Shop**.
Activities: **Education Programs** (children and families); **Guided Tours**; **Lecture Series**; **Permanent Exhibits**; **Photographic Rental Program**; **Temporary Exhibitions**.

The Norman Rockwell Museum at Stockbridge, cont.

Publications: books; newsletter, "The Portfolio" (quarterly).

The Museum features permanent exhibitions of Rockwell's work as well as changing exhibitions of the work of Rockwell and other notable illustrators, both past and present.

Waltham

Brandeis University - Rose Art Museum

Brandeis University, 415 South St.,
Waltham, MA 02254
Tel: (617) 736-3434
Fax: (617) 736-3439
TDDY: (617) 736-8516
Internet Address: http://www.brandeis.edu/rose
Director: Joseph D. Ketner
Admission: voluntary contribution.
Attendance: 7,000 *Established:* 1961
Membership: Y *ADA Compliant:* Y
Parking: visitor parking on campus.
Open: Tuesday to Wednesday, noon-5pm;
 Thursday, noon-9pm;
 Friday to Sunday, noon-5pm.
Closed: Holidays.
Facilities: Exhibition Area.
Activities: Guided Tours; Lectures; Permanent Exhibits; Temporary Exhibitions.
Publications: exhibition catalogues; newsletter.

Willem de Kooning, *Untitled*, 1961, oil on canvas, 80 x 78 inches. Gift of Julian J. and Joachim Jean Aberbach, 1964, Rose Art Museum. Photograph courtesy of Rose Art Museum, Brandeis University, Waltham, Massachusetts.

In the field of contemporary American art, the Rose Art Museum's collections, exhibitions, and publications rank it among the most distinguished academic art museums in the United States. The Museum's collection is particularly strong in the field of American art of the 1960's and 1970's and numbers over 8,000 objects, including works by de Kooning, Johns, Lichtenstein, Louis, and Warhol. Recent Museum acquisitions include works by Ferrara, Frankenthaler, Pfaff, Rothenberg, and Serra.

Wellesley

Babson College - Horn Gallery

Horn Library, Room 100, Forest Street, Wellesley, MA 02157
Tel: (781) 239-5682
Fax: (781) 239-5684
Internet Address: http://www.babson.edu/archives/index.html
Director: Burl Hash
Open: Sunday to Wednesday, 1pm-5pm; Thursday, 4pm-8pm.
Facilities: Gallery.
Activities: Temporary Exhibitions.

Located off the foyer of Horn Library, the Horn Gallery mounts temporary exhibits of artistic, cultural, or historical interest.

Dana Hall School - Dana Art Gallery

Dana Hall School, 45 Dana Road, Wellesley, MA 02482
Tel: (781) 235-3010 *Ext: 3*174
Fax: (781) 237-5949
Internet Address: http://www.danahall.org/gallery.html
Director: Mr. G. A. Scattergood
Open: **Fall to Spring**,
 Monday to Tuesday, 10am-3pm; Wednesday, 9am-1pm; Thursday, 10am-3pm;
 Friday, 9am-1pm.
Closed: School Holidays, Summer Vacation.

Dana Hall School - Dana Art Gallery, cont.

Facilities: Gallery.

Activities: Temporary Exhibitions.

Located on the second floor of the Classroom Building, next to the Art Studio, the Dana Art Gallery offers a schedule of exhibitions and events with emphasis on art work of women and the presentation of feminist themes. Shows include the work of professional artists, alumna, Art Department faculty (either in solo shows or as a group), and a senior student exhibition in the spring.

Wellesley College - Davis Museum and Cultural Center

Wellesley College, 106 Central St., Wellesley, MA 02181-8257

Tel: (781) 283-2051

Fax: (781) 283-2064

Internet Address: http://www.wellesley.edu/DavisMuseum

Interim Director: Dennis McFadden

Admission: free.

Attendance: 30,000 *Established:* 1889 *Membership:* Y *ADA Compliant:* Y

Open: August 16 to June 14,
> Tuesday, 11am-5pm; Wednesday to Thursday, 11am-8pm; Friday to Saturday, 11am-5pm; Sunday, 1pm-5pm.

> **June 15 to August 15,**
> Tuesday to Saturday, 11am-5pm; Sunday, 1pm-5pm.

Facilities: **Architecture** (1993 design by Spanish Architect Rafael Moneo); **Cinema** (167 seats); **Food Services** Collins Café (Mon-Fri, 8:30am-4pm); **Galleries** (17,250 square feet); **Print/Drawing/Photo Study Room**; **Seminar Room**; **Study Gallery**.

Activities: **Education Programs** (undergraduate college students); **Guided Tours** (groups, reserve two weeks in advance); **Lectures**; **Permanent Exhibits**; **Temporary Exhibitions**.

Publications: exhibition catalogues; exhibition handbook.

The permanent collection at the Davis Museum covers the history of art from prehistoric times through the present in Europe, North and South America, Africa, and Asia. Highlights are a small but outstanding African collection, Old Master drawings, modern photographs, and contemporary art. There is a special focus on Western woman artists of all periods. The collection includes works by Degas, Inness, Monet, Cézanne, de Kooning, Léger, Angelica Kaufman, and Sonia Delauney. Also of possible interest are the Jewett Arts Center Gallery, the Jewett Corridor Gallery, and the upstairs Sculpture Court Gallery, three distinct spaces primarily devoted to the exhibition of student work and shows generated by Art Department Students. Exhibitions by professional artists are also presented when the work relates to the educational goals and concerns of the Art Department.

West Barnstable

Cape Cod Community College - The Higgins Art Gallery

2240 Lyanough Road, West Barnstable, MA 02668

Tel: (508) 375-4044

Internet Address: http://www.vsa,cape.com/~neilr/home.htm

Director: Ms. Sara Ringler

Admission: free.

Open: Monday to Tuesday, 10am-4pm; Wednesday, 10am-7pm; Thursday to Friday, 10am-4pm.

Facilities: Exhibition Area.

Activities: Temporary Exhibitions.

The Higgins Art Gallery present temporary exhibitions.

Westfield

Jasper Rand Art Museum - Westfield Athenaeum

6 Elm St., Westfield, MA 01085

Tel: (413) 568-7833

Fax: (413) 568-1558

Director: Ms. Patricia T. Cramer

Jasper Rand Art Museum - Westfield Athenaeum, cont.

Admission: free.

Established: 1927 *ADA Compliant:* Y

Open: **September to June**, Monday to Thursday, 8:30am-8pm; Friday to Saturday, 8:30am-5pm.
July to August, Monday to Thursday, 8:30am-8pm; Friday, 8:30am-5pm.

Facilities: Gallery.

Activities: **Art Classes** (children); **Permanent Exhibits**; **Temporary Exhibitions**; **Traveling Exhibitions**.

The Museum presents monthly showings of art, photography, and crafts, as well as shows by area art organizations and school art classes.

Weston

Regis College - Carney Gallery

Fine Arts Center, 235 Wellesley St., Weston, MA 02193-1571

Tel: (781) 768-7000

Internet Address: http://www.regiscollege.edu/fac/Gallery.html

Director, Fine Arts Center & Gallery Curator: Ms. Rosemary Noon

Admission: free.

Established: 1994

Open: Monday to Friday, 1pm-4pm; Saturday to Sunday, by appointment.

Facilities: **Exhibition Area** (1,000 square feet).

Activities: **Temporary Exhibitions**.

The Carney Gallery displays contemporary art in a variety of styles and media, mainly produced by women.

Williamstown

Sterling and Francine Clark Art Institute

225 South St., Williamstown, MA 01267

Tel: (413) 458-2303

Fax: (413) 458-2318

Internet Address: http://www.clark.williams.edu

Director: Dr. Michael Conforti

Admission: fee: adult-$5.00, child-free.

Attendance: 185,000 *Established:* 1950

Membership: Y *ADA Compliant:* Y

Open: **September to June**,
Tuesday to Sunday, 10am-5pm.
July to August,
Daily, 10am-5pm.

Closed: Thanksgiving Day, Christmas Day, New Year's Day.

Facilities: **Auditorium** (320 seats); **Food Services** Indoor Café (July-August); **Galleries**; **Library** (150,000 volumes, non-circulating); **Reading Room**; **Shop**.

Activities: **Concert Series**; **Education Programs** (post-doctoral fellowships, graduate college students and children); **Film Series**; **Gallery Talks**; **Guided Tours** (July-August: Mon-Sun, 3pm; call for group reservations); **Lecture Series**; **Permanent Exhibits**; **Temporary Exhibitions**; **Traveling Exhibitions**.

Publications: annual journal; calendar (quarterly); collection catalogue; exhibition catalogues; guidebook.

Edgar Degas, *Self-Portrait*, ca. 1857-1858. Collection of and photograph courtesy of Sterling and Francine Clark Art Institute, Williamstown, Massachusetts.

Sterling and Francine Clark Art Institute, cont.

The Clark Art Institute is housed in a marble building designed by Daniel Perry and completed in 1955. A red granite addition, designed by Pietro Belluschi, opened in 1973 and contains five galleries, three of which are used for temporary exhibitions. The permanent collection at the Clark is dominated by late 19th-century French art, particularly Degas, Monet, Pissarro, and Renoir. There are, however, extensive holdings in others areas of Western art: Italian Renaissance (14th-16th century; Piero della Francesca, Ghirlandaio); Netherlandish (15th-16th century; Memling); European (17th-19th century; English, Spanish, Flemish); French (18th-19th century; Fragonard, Boucher, Bouguereau, Gérôme); and American (19th century; Homer, Remington, Sargent, Cassatt).

Williams College - Chapin Library of Rare Books

Williams College, Stetson Hall, Main Street, Williamstown, MA 01267

Tel: (413) 597-2462

Fax: (413) 597-2929

Internet Address: http://www.williams.edu/library

Custodian: Mr. Robert G. Volz

Admission: free.

Attendance: 2,500 *Established:* 1923

Parking: free on site.

Open: Monday to Friday, 10am-noon & 1pm-5pm.

Closed: Most Legal Holidays (except July 4).

Facilities: Exhibition Area.

Activities: Lectures; Permanent Exhibits; Temporary Exhibitions; Tours (by appointment).

Publications: collection catalogues (occasional).

Exterior view of Stetson Hall (1927), designed by Cram and Ferguson), the site of the Chapin Library of Rare Books. Wood-engraving by John DePol, courtesy of Williams College, Williamstown, Massachusetts.

The Chapin Library was formed to document civilization through rare books, manuscripts, and other original materials, and thereby to support the liberal arts curriculum of the College. The Library houses some 50,000 volumes as well as 100,000 manuscripts, letters, prints, maps, bookplates, photographs, stereo views, and other ephemera. The collection ranges from the early 9th to the 20th century and covers most of the interests and accomplishments of humanity. Its strengths include literature, Americana, the history of science, Bibles and liturgical books, the age of discovery and exploration in the Western Hemisphere, women's studies, African-American history, and the graphic and performing arts. Though American and British materials predominate, the Library also contains 40 medieval and Renaissance manuscripts, 550 incunabula (15th-century printed books), and 3,500 early continental imprints. Besides its general collections and ancillary reference books, the Chapin Library collects material by and about individual authors and historical figures, including Walt Whitman (1819-1892), Joseph Conrad (1857-1924), E.A. Robinson (1869-1935), Sir Winston Churchill (1874-1965), T.S. Eliot (1888-1965), William Faulkner (1897-1962), illustrator C.B. Falls (1874-1960), and architect and designer Herman Rosse (1887-1965). Three or four exhibitions are mounted from the Library's collections each year, often with a handlist or illustrated catalogue. Library holdings occasionally appear also in exhibitions at the Williams College Museum of Art and the Sterling and Francine Clark Art Institute (see separate entries). On permanent display in the Library's gallery are the Four Founding Documents of the United States - original printings of the Declaration of Independence, the Articles of Confederation, the Constitution, and the Bill of Rights - together with George Washington's autographed copy of the Federalist Papers. Every 4th of July, the Library sponsors an open house for viewing of the Four Founding Documents and readings by actors from the Williamstown Theatre Festival.

Williams College Museum of Art

15 Lawrence Hall Drive, Suite 2, Williamstown, MA 01267-2566

Tel: (413) 597-2429

Fax: (413) 458-9017

Internet Address: http://www.williams.edu/WCMA

Director: Linda Shearer

Admission: free.

Williams College Museum of Art, cont.
Attendance: 50,000 *Established:* 1926 *Membership:* Y *ADA Compliant:* Y
Parking: limited parking, free on site.
Open: Tuesday to Saturday, 10am-5pm; Sunday, 1pm-5pm.
Facilities: **Architecture** (classical octagon bldg., 1846, by Thomas Tefft); **Auditorium**; **Galleries**;
 Print Study Room.
Activities: **Education Programs**; **Gallery Talks**; **Guided Tours** (July-August: Wed & Sun, 2pm);
 Lectures; **Permanent Exhibits**; **Temporary Exhibitions**; **Traveling Exhibitions.**
Publications: exhibition catalogues (1-2/year).

The Williams College Museum of Art houses some 12,000 works that span the history of art. The collection emphasizes modern and contemporary art, American art from the late 18th century to the present, and non-Western art. In addition to displaying works from the permanent collection, the Museum mounts loan exhibitions of works from other collections. The Museum is housed in an 1846 two-story, brick, octagonal, neoclassical structure designed by Thomas Tefft. Extensive additions designed by Charles Moore were completed in the 1980's. The permanent collection consists of art in the following general categories: Ancient and Non-Western (Indian art, including Rajput and Mughal paintings; Chinese painting and calligraphy; and African art and artifacts); European and Medieval (special strengths in Medieval devotional art, Spanish and Northern Baroque painting, and graphic arts from Dürer to Picasso); American (18th- and 19th-century painting, including works by Copley, Eakins, Harnett, Hunt, Inness, Kensett, LaFarge, and West; and late 19th-century and early modern works by artists such as Avery, Burchfield, Demuth, Feininger, Hartley, Homer, Marin, O'Keeffe, Stella, and Wood); and Contemporary (works by de Kooning, Dine, Guston, LeWitt, Nevelson, Rauschenberg, Ringgold, Rivers, and Warhol; photographs by Arbus, Evans, Hine, Ray, Stieglitz, and Weems).

Winchester

Arthur Griffin Center for Photographic Art

67 Shore Road, Winchester, MA 01890
Tel: (617) 729-1158
Fax: (617) 721-2765
Executive Director: Mr. Whitney Gay
Admission: fee-$3.00.
Attendance: 4,000 *Established:* 1992
Membership: Y *ADA Compliant:* Y
Parking: free on site.
Open: Tuesday to Sunday, noon-4pm.
Closed: New Year's Day, Easter,
 Thanksgiving Day, Christmas Day.
Facilities: **Exhibition Area** (1,500 square feet);
 Rental Gallery; **Shop**; **Theatre** (90 seats).
Activities: **Education Programs** (adults and
 children); **Guided Tours**; **Juried Exhibits**;
 Lectures; **Temporary Exhibitions**;
 Traveling Exhibitions; **Workshops.**

View of Arthur Griffin Center for Photographic Art. Photograph by Arthur Griffin, courtesy of Arthur Griffin Center for Photographic Art, Winchester, Massachusetts.

Publications: newsletter, "The Griffin News" (bi-monthly).

The Center houses the legacy of Arthur Griffin, renowned photojournalist, and offers solo and group exhibitions featuring various photographic artists and subjects. The Center also houses the Griffin Collection, consisting of more than 75,000 negatives, prints, transparencies, and other items associated with Griffin's career.

Worcester

Clark University - University Gallery

Goddard Library Plaza, Downing St., Worcester, MA 01610
Tel: (508) 793-7113
Internet Address: http://www.clarku.edu/clarkarts/university-gallery.html

Clark University - University Gallery, cont.

Open: **Academic Year**, Wednesday to Sunday, noon-5pm.
Closed: Academic Holidays.
Facilities: **Gallery**.
Activities: **Temporary Exhibitions** (3-5/year).

The Gallery mounts solo and group shows of nationally recognized emerging artists. The final show of each year is the Senior Thesis Show, a group exhibition of the best student senior thesis work. Student work is exhibited throughout the academic year in Little Center, the Abrahms Gallery, and in the student pub, Grind Central.

College of the Holy Cross - Iris and B. Gerald Cantor Art Gallery

1 College St., Worcester, MA 01610
Tel: (508) 793-3356
Fax: (508) 793-3030
Internet Address: http://webster.holycross.edu/departments/cantor/website
Director: Ms. Ellen Lawrence
Admission: free.
Attendance: 1,000 *Established:* 1971 *ADA Compliant:* Y
Parking: free on site.
Open: Monday to Friday, 11am-4pm; Saturday to Sunday, 2pm-5pm.
Closed: Academic Holidays.
Facilities: **Classrooms**; **Exhibition Area** (2,000 square feet).
Activities: **Education Programs** (college students); **Juried Student Show**; **Temporary Exhibitions** (5-7/year); **Traveling Exhibitions**.
Publications: exhibition catalogues.

The Gallery offers temporary exhibitions of the work of students and professional artists.

Worcester Art Museum

55 Salisbury St., Worcester, MA 01609-3123
Tel: (508) 799-4406 *Ext:* 3006
Fax: (508) 798-5646
Internet Address: http://www.worcesterart.org
Director: Dr. James A. Welu
Admission: fee:
 adult-$8.00, child-free, student-$6.00, senior-$6.00.
Attendance: 135,000 *Established:* 1896
Membership: Y *ADA Compliant:* Y
Parking: free on site.
Open: Wednesday to Friday, 11am-5pm;
 Saturday, 10am-5pm;
 Sunday, 11am-5pm.
Closed: New Year's Day, Independence Day,
 Thanksgiving Day, Christmas Day.
Facilities: **Classrooms**; **Food Services** Café (Wednesday-Sunday, 11:30am-2pm); **Galleries** (36); **Library** (40,000 volumes, non-circulating); **Reading Room**; **Shop**; **Studios**.
Activities: **Concerts**; **Education Programs** (adults, undergraduate college students, and children); **Films**; **Gallery Talks**; **Guided Tours**; **Lectures**; **Permanent Exhibits**; **Temporary Exhibitions**.
Publications: annual report; exhibition catalogues.

View of Renaissance Court, Worcester Art Museum. Photograph courtesy of Worcester Art Museum, Worcester, Massachusetts.

Worcester Art Museum, cont.

The Worcester Art Museum is the second largest art museum in New England. Its collection of paintings, sculpture, decorative arts, photography, prints, and drawings is displayed in thirty-six galleries and spans 5,000 years of art and culture. There are separate galleries for Egyptian, Greek, Roman, Chinese, Japanese, Indian/Asian, Islamic, and Medieval art, as well as four galleries devoted to Italian painting, and seven others to other European painting. Finally, there are seven galleries devoted to American art.

Michigan

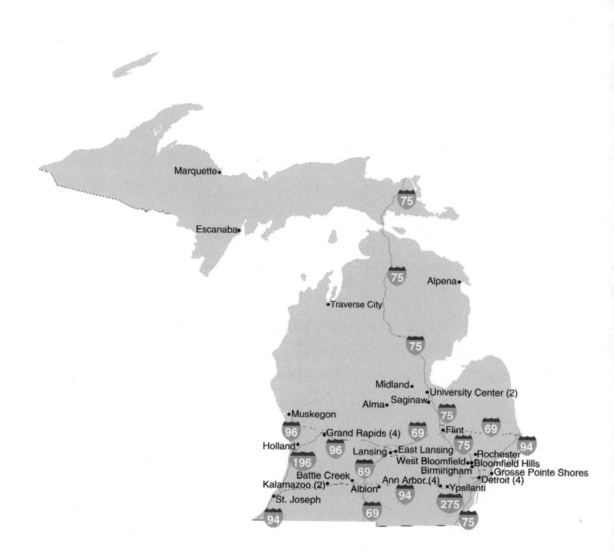

The number in parentheses following the city name indicates the number of museums/galleries in that municipality. If there is no number, one is understood. For example, in the text four listings would be found under Ann Arbor and one listing under Escanaba.

Michigan

Albion

Albion College Art Collection

Albion College, Department. of Visual Arts, 611 E. Porter, Albion, MI 49224
Tel: (517) 629-1000
Internet Address: http://www.albion.edu
Chairman, Department of Visual Arts: Ms. Lynne Chytilo
Admission: free.
Open: September to May,
　　　　Monday to Friday, 9am-4:45pm; Saturday, 10am-4pm; Sunday, 2pm-4pm.
Closed: Academic Holidays, School Vacations.
Facilities: **Exhibition Area**; **Library** (4,500 volumes).
Activities: **Arts Festival**; **Education Programs** (undergraduate college students); **Gallery Talks**; **Guided Tours**; **Lectures**; **Permanent Exhibits**; **Temporary Exhibitions**; **Traveling Exhibitions**.

The Visual Arts Department of the College conducts a continuous exhibition program during the academic year. Art from collectors, artists, and regional museums is exhibited, augmented with selections from the permanent collection and the work of faculty and students. The College has a permanent collection of over 4,000 pieces, over half of which comprise the print collection, including works by Dürer, Rembrandt, Brueghel, Goya, Cassatt, Cézanne, Toulouse-Lautrec, Matisse, Chagall, and Picasso, as well as the work of contemporary printmakers. The collection also contains American and European paintings, ancient and modern glass and ceramics, and African and Native American objects.

Alma

Alma College - Flora Kirsch Beck Gallery

Superior Street, Alma, MI 48801
Tel: (517) 463-7220
Internet Address: http://www.alma.edu/ACInfo/GalleryPage/F98Gallery.html
Admission: free.
Open: Academic Year, Monday to Friday, 9am-5pm; Saturday, 10am-2pm.
Facilities: **Exhibition Area**.
Activities: **Temporary Exhibitions** (7/year).

The Gallery presents temporary exhibitions of work by regional artists, faculty, and students, including an annual statewide print show, an annual juried student show in the fall term, and annual senior show in the spring.

Alpena

Jesse Besser Museum

491 Johnson St., Alpena, MI 49707
Tel: (517) 356-2202
Fax: (517) 356-3133
Internet Address:
　　http://www.owcb.com/upnorth/museum
Exec. Director: Dr. Jan McLean
Admission: fee:
　　adult-$2.00, student-$1.00, senior-$1.00.
Attendance: 30,000 *Established:* 1962
Membership: Y *ADA Compliant:* N
Parking: free on site.

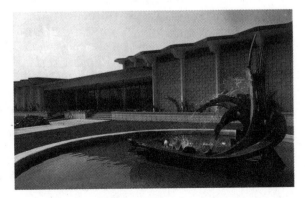

Exterior view of Jesse Besser Museum. Photograph by John Penrod, courtesy of Jesse Besser Museum, Alpena, Michigan.

Alpena, Michigan

Jesse Besser Museum, cont.

Open: Tuesday to Saturday, 10am-5pm; Sunday, noon-5pm.
Closed: Legal Holidays.
Facilities: **Classrooms**; **Exhibition Area** (8 galleries); **Reference Library**.
Activities: **Art Auction**; **Education Programs** (adults and children); **Gallery Talks**; **Guided Tours** (scheduled in advance); **Juried Art Show**; **Permanent Exhibits**; **Temporary Exhibitions** (usually Michigan artists); **Traveling Exhibitions**; **Workshops**.
Publications: brochures.

The Museum mounts temporary and traveling exhibitions in a variety of media and displays objects from its permanent collection of regional art.

Ann Arbor

Artrain USA

Headquarters, 1100 N. Main St., Suite 102, Ann Arbor, MI 48104
Tel: (313) 747-8300
Fax: (313) 747-8530
Exec. Director: Ms. Debra Polich
Admission: free.
Attendance: 100,000 *Established:* 1971 *ADA Compliant:* Y
Open: hours vary by community.
Facilities: **Artist Studio, Railroad Galleries** (5 cars); **Shop**.
Activities: **Demonstrations**; **Education Programs**; **Guided Tours**; **Traveling Exhibitions**.
Publications: brochures; exhibition catalogues.

Artrain USA, the nation's only traveling railroad art museum, visits approximately 35 communities per year, changing its exhibition every two to three years. The current exhibition, Artistry of Space, is a collection of artworks from the National Aeronautics and Space Administration and the National Air and Space Museum and will travel on board through 2002. The exhibition features 78 paintings, prints, and other works by more than 50 American artists, including Peter Max, Norman Rockwell, and Andy Warhol, which reflect the excitement and energy of the U.S. Space Program.

University of Michigan - Kelsey Museum of Archaeology

434 S. State St. (opposite Angell Hall), Ann Arbor, MI 48109-1390
Tel: (734) 764-9304
Fax: (734) 763-8976
Internet Address: http://www.umich.edu/~kelseydb/Home.html
Director: Professor Sharon Herbert
Admission: free.
Attendance: 25,000 *Established:* 1928 *Membership:* Y
Open: Tuesday to Friday, 9am-4pm; Saturday to Sunday, 1pm-4pm.
Closed: Academic Holidays.
Facilities: **Galleries** (4); **Library** (5,000 volumes, by appointment); **Past Exhibitions On-line**.
Activities: **Gallery Talks**; **Guided Tours** (groups, reserve in advance, 647-4167); **Lectures**; **Permanent Exhibits**; **Temporary Exhibitions**.
Publications: "Kelsey Museum Studies"; bulletin, "Bulletin of the Museums of Art and Archaeology"; exhibition catalogues; gallery guide.

The Museum displays artifacts from its holdings of Egyptian, Near Eastern, and classical Greek and Roman objects in its permanent galleries, supplemented by temporary thematic exhibitions.

The University of Michigan Museum of Art

525 S. State St., Ann Arbor, MI 48109-1354
Tel: (734) 764-0395
Fax: (734) 764-3731
Internet Address: http://www.umich.edu/~umma
Interim Director: Ms. Carole McNamara
Admission: voluntary contribution.

The University of Michigan Museum of Art, cont.

Attendance: 80,000 *Established:* 1946

Membership: Y *ADA Compliant:* Y

Parking: metered on street and nearby commercial lots.

Open: **June to August**,
　　　　Tuesday to Wednesday, 11am-5pm;
　　　　Thursday, 11am-9pm;
　　　　Friday to Saturday, 11am-5pm;
　　　　Sunday, noon-5pm.

　　　　　September to May,
　　　　Tuesday to Wednesday, 10am-5pm;
　　　　Thursday, 10am-9pm;
　　　　Friday to Saturday, 10am-5pm;
　　　　Sunday, noon-5pm.

Closed: New Year's Day, Independence Day,
　　　　Thanksgiving Day, Christmas Day.

Facilities: **Architecture** (neo-classical Alumni Memorial Hall, 1910); **Galleries**; **Shop**.

Activities: **Education Programs** (adults and children); **Gallery Talks**; **Guided Tours** (call for group reservations); **Lectures**; **Temporary Exhibitions**; **Traveling Exhibitions**.

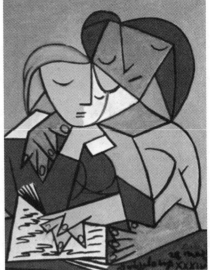

Pablo Picasso, *Two Girls Reading*, 1934, Collection of and photograph courtesy of University of Michigan Museum of Art, Ann Arbor, Michigan.

Publications: bulletin, "Bulletin, Museums of Art and Archaeology"; exhibition catalogues.

The University of Michigan Museum of Art houses the second-largest art collection in the state of Michigan. A community museum in an academic setting, the Museum offers a diverse permanent collection supplemented by a series of special exhibitions and a broad range of interpretive programs. The Museum maintains a collection of nearly 17,000 paintings, sculptures, prints, drawings, photographs, ceramics, and mixed-media works from around the world. From Italian Renaissance panel paintings and Han Dynasty tomb figures to 18th-century textiles and contemporary photography, the Museum is notable for both its range and its quality. Areas of particular strength include old master and contemporary works on paper (including 150 prints and drawings by James McNeill Whistler), 20th-century sculpture, Chinese ceramics and painting, and the art of central Africa.

University of Michigan School of Art and Design - Jean Paul Slusser Gallery

Art and Architecture Building, 2000 Bonisteel Blvd., Ann Arbor, MI 48109-2069

Tel: (313) 936-2082

Fax: (313) 936-0469

Internet Address: http://www.umich.edu/~webteam/soad/

Director: Mr. Jon Rush

Admission: voluntary contribution.

Attendance: 15,000 *Membership:* Y *ADA Compliant:* Y

Open: **Fall to Spring**, Daily, 11am-4pm.

Facilities: **Auditorium** (180 seats); **Classrooms**; **Gallery**; **Library**.

Activities: **Gallery Talks**; **Lectures**; **Temporary Exhibitions**.

Publications: exhibit brochure, "This Month in the School of Art and Design".

Located on the east side of the Art and Architecture Building on the North Campus, the Gallery provides an opportunity for students and faculty to exhibit their work to the public at large. The School also brings in the work of well-known visiting artists. The adjacent plaza often contains sculpture.

Battle Creek

Art Center of Battle Creek

265 E. Emmett St., Battle Creek, MI 49017

Tel: (616) 962-9511

Fax: (616) 969-3838

Battle Creek, Michigan

Art Center of Battle Creek, cont.
Director: Ms. Ann Worth Concannon
Admission: voluntary contribution.
Attendance: 42,000 *Established:* 1948 *Membership:* Y *ADA Compliant:* Y
Parking: free on site.
Open: **September to July**, Tuesday to Friday, 10am-5pm; Saturday to Sunday, 1pm-4pm.
Closed: Legal Holidays.
Facilities: **Galleries; Library; Studios.**
Activities: **Education Programs** (adults and children); **Guided Tours; Temporary Exhibitions; Workshops.**
Publications: class schedules (quarterly); exhibition catalogues; newsletter (bi-monthly).

The Art Center presents the work of Michigan and Midwestern artists, contemporary art, traveling exhibitions, and programs for children. Its permanent collection consists of the work of Michigan artists.

Birmingham

Birmingham Bloomfield Art Association
1516 S. Cranbrook Road, Birmingham, MI 48009
Tel: (248) 644-0866
Fax: (248) 644-7904
Director: Ms. Janet Torno
Admission: voluntary contribution.
Attendance: 10,000 *Established:* 1956 *Membership:* Y *ADA Compliant:* Y
Open: Monday to Thursday, 9am-7pm; Friday to Saturday, 9am-5pm.
Closed: Legal Holidays.
Facilities: **Classrooms; Galleries; Rental Gallery; Shop; Studios.**
Activities: **Arts Festival; Education Programs; Films; Fourth of July Sky Exhibition; Gallery Talks; Guided Tours; Lectures; Workshops.**
Publications: exhibition materials; newsletter (quarterly).

This community arts center exhibits contemporary work by regional artists and craftspeople.

Bloomfield Hills

Cranbrook Academy of Art - Cranbrook Art Museum
39221 Woodward Ave., Bloomfield Hills, MI 48303-0801
Tel: (248) 645-3323
Fax: (248) 645-3324
Internet Address: http://www.cranbrook.edu/museum
Director: Mr. Gregory M. Wittkopp
Admission: museum fee: adult-$5.00, child-$3.00, student-$3.00, senior-$3.00.
Attendance: 30,000 *Established:* 1927 *Membership:* Y *ADA Compliant:* Y
Parking: free on site.
Open: **September to May,**
 Tuesday to Wednesday, 11am-5pm; Thursday, 11am-8pm; Friday to Sunday, 11am-5pm.
 June to August,
 Tuesday to Thursday, 11am-5pm; Friday, 11am-10pm; Saturday to Sunday, 11am-5pm.
Closed: Major Holidays.
Facilities: **Architecture** (home & studio of Eliel and Loja Saarinen, 1930); **Auditorium** (205 seats); **Exhibition Area** (16,000 square feet); **Sculpture Garden; Shop.**
Activities: **Films; Gallery Talks; Guided Tours; Lectures; Permanent Exhibits; Temporary Exhibitions** (of contemporary art); **Traveling Exhibitions.**
Publications: "Saarinen House & Garden: A Total Work of Art"; exhibition catalogues; newsletter, "What's Next" (4/year).

Cranbrook Academy of Art - Cranbrook Art Museum, cont.

Located at the heart of the Cranbrook Educational Community, the Museum examines Cranbrook's influence on 20th-century art through its permanent collection and tours of the campus, as well as mounting changing exhibitions of work by contemporary artists and Academy students. The permanent collection of the Museum highlights the history of Cranbrook, beginning with the Arts and Crafts Movement, and continuing with Art Deco and Modernism. The Museum features the work of Charles and Ray Eames; Duane Hanson; Eliel, Loja, and Eero Saarinen; Harry Bertoia; and Maija Grotell. In addition, there is outdoor sculpture by Carl Milles, Marshall Fredericks, Juhani Pallasmaa, and Richard Nonas. The Cranbrook campus includes the Saarinen House (1930), designed by Eliel Saarinen and which served as his home and studio; and Cranbrook House (1908), designed by Albert Kahn, the Arts and Crafts-style home of George and Ellen Booth, the founders of Cranbrook and the Cranbrook Art Museum.

Detroit

Center for Creative Studies/College of Art and Design - Center Galleries

301 Frederick Douglass, Detroit, MI 48202

Tel: (313) 664-7800

Fax: (313) 664-7880

Internet Address: http://www.ccscad.edu

Director: Ms. Michelle M. Spivak

Admission: free.

Attendance: 10,000 *Established:* 1989 *Membership:* Y *ADA Compliant:* Y

Parking: parking lot.

Open: **September to July**, Tuesday to Saturday, 10am-5pm.

Closed: Independence Day, Thanksgiving Day, Christmas Day.

Facilities: **Exhibition Area** (4,000 square feet).

Activities: **Guided Tours**; **Lectures**; **Temporary Exhibitions**; **Traveling Exhibitions**.

Publications: exhibiting artist brochures.

CCS' Center Galleries present contemporary visual, literary, and performance art from locally, nationally, and internationally recognized artists, faculty, alumni, and students. Included under the Center Galleries umbrella is the student-run U245 Gallery and Alumni/Faculty Hall, a space for regular exhibitions of alumni and faculty work.

The Detroit Institute of Arts

5200 Woodward Ave., Detroit, MI 48202

Tel: (313) 833-7900

Fax: (313) 833-2357

TDDY: (313) 833-1454

Internet Address: http://www.dia.org

C.E.O. and Director: Mr. Graham Beal

Admission: suggested contribution: adult-$4.00, child-$1.00, student-$1.00.

Attendance: 591,000 *Established:* 1885 *Membership:* Y *ADA Compliant:* Y

Parking: at Science Center, underground.

Open: Wednesday to Friday, 11am-4pm; Saturday to Sunday, 11am-5pm.

Closed: Legal Holidays.

Facilities: **Auditorium** (1,200 seats); **Food Services** Café (Wed-Fri, 11am-3:30pm; Sat-Sun, 11am-4:30pm;, Restaurant (Wed-Fri, 11;30am-2pm; Sun, 11am-3pm); **Galleries**; **Library** (150,000 volumes, non-circulating); **Recital/Lecture Hall** (382 seats); **Shop**.

Activities: **Concerts**; **Education Programs**; **Films**; **Gallery Talks**; **Guided Tours** (Wed-Sat, 1pm; Sun, 1pm & 2:30pm; groups, call for reservation); **Lectures**; **Permanent Exhibits**; **Temporary Exhibitions**.

Publications: annual report; collection catalogue; exhibition catalogues; magazine, "DIA" (monthly).

The Detroit Institute of Arts, cont.

The Detroit Institute of the Arts is the fifth-largest fine arts museum in the United States with holdings of over 60,000 works displayed in over 100 galleries. The permanent collection of the Institute is comprehensive. The arts of the ancient Mediterranean world of Egypt, Greece, and Rome, as well as the ancient Near East and Islam are well represented. Categories of art include sculpture, architecture, painting, weapons, armor, jewelry, textiles, and mummies, including Old Kingdom Egyptian tomb reliefs, Greek red- and black-figure ware, Babylonian reliefs, seals, and pottery, Roman sculpture, and Islamic miniature painting and objects of ivory, lacquer, wood, and stone. The American collections provide a comprehensive view of 18th-, 19th-, and 20th-century painting, sculpture, furniture, and other decorative arts, displayed chronologically in nineteen galleries. In addition to a series of period rooms, works from every major phase of American painting are on display. The Asian art collection includes 2,600 objects of Japanese, Chinese, Indian, Korean, Cambodian, Nepalese, Tibetan, Vietnamese, Ryukyuan, and Indonesian art. An area of particular strength in this collection is secular painting and ceramics of China, Japan, and Korea, but there is also an important group of Buddhist sculptures. The European painting collection is also comprehensive, ranging from the early medieval period through the Post-Impressionists. Artists represented include Canaletto, Hals, Brueghel, Rubens, Van Eyck, Rembrandt, Courbet, Monet, Renoir, Degas, Van Gogh, Cézanne, and Seurat. The collection of European sculpture and decorative arts is noteworthy for its holdings of Italian and Northern European sculpture, with examples by della Robbia, Bernini, and Rodin. The graphic arts collection contains more than 20,000 works of art on paper from the 15th through the 20th centuries, and is particularly strong in its holdings of Ingres, Delacroix, Degas, Pissarro, Cézanne, and Matisse, and Americans Thomas Cole, John Marin, Charles, Burchfield, and Charles Demuth. The photography collection includes works by Talbot, Cameron, Stieglitz, Steichen, Sheeler, and Adams. Finally, the collection of modern art encompasses works in all media in the Western tradition. It is rich in European Modernist painting (Picasso, Matisse) and mid-century European painting (Dubuffet, Bacon). There are also works by American Abstract Expressionists and Minimalists, as well as Pop Art and contemporary sculpture.

Pewabic Pottery

10125 E. Jefferson, Detroit, MI 48214
Tel: (313) 822-0954
Fax: (313) 822-6266
Internet Address: http://www.peweabic.com
Exec. Director: Ms. Terese Ireland
Admission: free.
Attendance: 100,000 *Established:* 1903
Membership: Y *ADA Compliant:* N
Parking: free on site.
Open: Monday to Saturday, 10am-6pm.
Facilities: **Consignment Gallery**; **Exhibition Area**; **Shop**.
Activities: **Education Programs** (adults and children); **Guided Tours** ($3.50 adults, $2.00 students/senior citizens); **Temporary Exhibitions** (6-8 per year); **Traveling Exhibitions**.

Exterior view of Pewabic Pottery. Photograph courtesy of Pewabic Society Inc., Detroit Michigan.

Publications: "Pewabic Pottery Newsletter" (semi-annual).

Housed in a 1907 Tudor Revival Structure that is a National Historic Landmark, the Pottery is both a working pottery and a museum that displays Arts and Crafts style tiles and vessels as well as other sculptural, traditional and experimental ceramic forms, in a series of changing exhibitions throughout the year.

Wayne State University - Community Arts Gallery and Elaine L. Jacob Gallery

150 Community Arts Building, Department of Art, Detroit, MI 48202
Tel: (313) 577-2423
Fax: (313) 577-8935
Internet Address: http://www.comm.wayne.edu/cfpca/spaces.html

Wayne State University - Community Arts Gallery and E.L. Jacob Gallery, cont.

Admission: free.

Attendance: 15,000 *Established:* 1997 *ADA Compliant:* Y

Parking: pay on site.

Open: Tuesday to Friday, 10:30am-7pm; Saturday, 11am-5pm.

Facilities: **Auditorium**; **Exhibition Areas** (2 separate galleries).

Activities: **Concerts**; **Education Programs** (adults and students); **Lectures**; **Monthly Exhibitions**.

Publications: calendar (annual); exhibition catalogues.

The Galleries present temporary exhibitions of the work of students, faculty and professional artists, as well as traveling exhibitions.

East Lansing

Michigan State University - Kresge Art Museum

Michigan State University, Farm Lane and Dormitory Road
East Lansing, MI 48824

Tel: (517) 353-9834

Fax: (517) 355-6577

Internet Address: http://www.msu.edu/unit/kamuseum

Director: Dr. Susan J. Bandes

Admission: voluntary contribution.

Attendance: 27,500 *Established:* 1959

Membership: Y *ADA Compliant:* Y

Parking: pay on site.

Open: **mid-September to mid-May**,
 Monday to Wednesday, 10am-5pm;
 Thursday, 10am-8pm;
 Friday, 10am-5pm;
 Saturday to Sunday, 1pm-4pm.

 Summer,
 Monday to Friday, 11am-4pm;
 Saturday to Sunday, 1pm-5pm.

Closed: Holiday Weekends, August, late Dec. to early Jan..

Facilities: **Galleries**; **Sculpture Garden**; **Shop**.

Activities: **Films**; **Gallery Talks**; **Guided Tours**; **Lectures**; **Permanent Exhibits**; **Temporary Exhibitions**.

Head of a Bull, Roman, second century A.D., marble. Kresge Art Museum. Photograph courtesy of Kresge Art Museum, Michigan State University, East Lansing, Michigan.

Publications: bulletin, "Kresge Art Museum Bulletin"; exhibition catalogues; newsletter.

Kresge Art Museum houses Michigan State University's permanent collection of over 6,500 works of art. The collection includes representative examples of art produced over 5,000 years of human history, from ancient Cycladic figures to contemporary mixed-media installations. Greek, Roman, and Egyptian artifacts; medieval and Renaissance illuminations; and European paintings, prints, and sculptures document the intellectual and artistic development of Western civilization. Art and artifacts from African, Asian, Islamic, and pre-Columbian cultures offer insight into non-Western history, beliefs, and artistic traditions.

Escanaba

William Bonifas Fine Arts Center

700 1st Ave. S., Escanaba, MI 49829

Tel: (906) 786-3833

Fax: (906) 786-3840

Exec. Director: Ms. Samantha Gibb Roff

Admission: voluntary contribution.

Attendance: 40,000 *Established:* 1974 *Membership:* Y *ADA Compliant:* Y

Parking: free on site.

Escanaba, Michigan

William Bonifas Fine Arts Center, cont.

Open: Tuesday to Saturday, 10am-5pm.

Closed: Legal Holidays.

Facilities: **Gallery; Studio and Class Areas; Theatre** (240 seat).

Activities: **Arts Festival; Concerts; Education Programs** (adults and children); **Gallery Talks; Performances; Readings.**

Publications: newsletter, "Arts News" (quarterly).

The Fine Arts Center offers programs in the visual and performing arts. Its galleries offer a full schedule of exhibits displaying the works of regional artists and traveling exhibitions from major institutions.

Exterior view of William Bonifas Fine Arts Center. Photograph courtesy of William Bonifas Fine Arts Center, Escanaba, Michigan.

Flint

Flint Institute of Arts

1120 E. Kearsley St., Flint, MI 48503

Tel: (810) 234-1695

Fax: (810) 234-1692

Director: Mr. John B. Henry, III

Admission: voluntary contribution.

Attendance: 60,000 *Established:* 1928

Membership: Y *ADA Compliant:* Y

Parking: free on site.

Open: Tuesday to Saturday, 10am-5pm; Sunday, 1pm-5pm.

Closed: Legal Holidays.

Facilities: **Art Rental Gallery; Auditorium** (500 seats); **Classrooms; Galleries; Library** (3,000 volumes); **Shop.**

Activities: **Arts Festival; Concerts; Education Programs** (adults and children); **Films; Guided Tours; Lectures; Permanent Exhibits; Temporary Exhibitions; Traveling Exhibitions.**

Publications: annual report; calendar (monthly); exhibition catalogues; newsletter (monthly).

The Institute's permanent collection includes a Renaissance-Baroque period room, with a tapestry cycle from the Royal workshop of Raphael de la Planche after a design by Simon Vouet and a panel painting by Rubens. The FIA also holds an extensive collection of American paintings, sculpture, and decorative arts; French Barbizon, Impressionist, and Post-Impressionist art; and contemporary art. Artists represented include Cassatt, Sargent, Degas, Frankenthaler, and Moore.

John Singer Sargent, *Garden Study of the Vickers Children*, c. 1884, oil. Flint Institute of Arts, gift of Viola E. Bray Charitable Trust. Photograph courtesy of Flint Institute of Arts, Flint, Michigan.

Grand Rapids

Calvin College - Center Art Gallery

Calvin College, 3201 Burton St., S.E., Grand Rapids, MI 49546-4388

Tel: (616) 957-6326

Fax: (616) 957-8551

Internet Address: http://www.calvin.edu

Director of Exhibitions: Ms. Virginia Bullock

Admission: free.

Attendance: 12,000 *Established:* 1974 *Membership:* N *ADA Compliant:* Y

Calvin College - Center Art Gallery, cont.

Parking: lot adjacent to site.

Open: Monday to Thursday, 9am-9pm; Friday, 9am-5pm; Saturday, noon-4pm.

Closed: School Vacations.

Facilities: **Auditorium** (350 seats); **Classrooms; Gallery; Library; Theatre.**

Activities: **Films; Guided Tours; Lectures; Permanent Exhibits; Temporary Exhibitions; Traveling Exhibitions.**

Publications: exhibition catalogues.

The Calvin College Center Art Gallery, located in the William Spoelhof College Center, installs an average of ten exhibitions per year. Juried selections, traveling shows, and invitationals of varied media are presented, along with works from the College's permanent collection.

Grand Rapids Art Museum

155 Division North, Grand Rapids, MI 49503

Tel: (616) 459-4676

Fax: (616) 459-8491

Internet Address: http://www.gram.mus.mi.us

Curator: Ms. E. Jane Connell

Admission: fee: adult-$3.00, student-$1.00, senior-$1.50.

Attendance: 49,000 *Established:* 1911 *Membership:* Y *ADA Compliant:* Y

Parking: commercial near site.

Open: Tuesday, noon-4pm; Wednesday, 10am-4pm; Thursday, 10am-9pm; Friday to Saturday, 10am-4pm; Sunday, noon-4pm.

Facilities: **Architecture** (former Federal building, 1910 Beaux Arts design by J.K. Taylor); **Galleries; Library** (7,000 volumes, non-circulating); **Rental/Sales Gallery; Shop.**

Activities: **Concerts; Education Programs** (children); **Gallery Talks; Guided Tours** (call for group reservations); **Lectures; Permanent Exhibits; Temporary Exhibitions.**

Publications: annual report; exhibition catalogues; newsletter (bi-monthly).

The Museum's permanent collection, numbering over 6,000 works of art, includes works by Calder, Cassatt, Diebenkorn, Lichtenstein, Matisse, Miró, Picasso, Rembrandt, Warhol, Whistler and many others. Its furniture collection includes pieces designed by Charles Eames, George Nelson, and Frank Lloyd Wright.

Kendall College of Art and Design - Kendall Gallery

111 N. Division Ave., Grand Rapids, MI 49503

Tel: (616) 451-2787

Fax: (616) 831-9689

Internet Address: http://www.kcad.edu/news_eve_pubs/gallery/gallery_2.html

Director of Exhibitions: Mr. Eric Jay Chad

Admission: free.

Open: Monday to Thursday, 9am-9pm; Friday, 9am-5pm; Saturday, 9am-4pm; Sunday, 1pm-5pm.

Facilities: **Exhibition Area.**

Activities: **Temporary Exhibitions.**

The Gallery offers a schedule of temporary exhibitions.

Urban Institute for Contemporary Art (UICA)

41 Sheldon, S.E., Grand Rapids, MI 49503

Tel: (616) 454-7000

Fax: (616) 454-7013

Internet Address: http://www.uica.org

Exec. Director: Ms. Marjorie Kuipers

Admission: voluntary contribution.

Attendance: 12,000 *Established:* 1977 *Membership:* Y *ADA Compliant:* Y

Open: Tuesday to Friday, 11am-5pm; Saturday, noon-3pm.

Grand Rapids, Michigan

Urban Institute for Contemporary Art, cont.

Facilities: **Exhibition Area** (2,000 square feet); **Library** (1,200 volumes); **Theatre** (100 seats).

Activities: **Concerts; Dance Recitals; Films; Performances; Readings; Temporary Exhibitions.**

Publications: calendar (monthly).

UICA is a non-profit, multidisciplinary contemporary art center focusing on the development and exchange of new cultural expressions.

Grosse Pointe Shores

Edsel & Eleanor Ford House

1100 Lake Shore Road
Grosse Pointe Shores, MI 48236
Tel: (313) 884-4222
Fax: (313) 884-5977
Internet Address: http://www.fordhouse.org
President: Mr. John Franklin Miller
Admission: fee:
 adult-$6.00, child-$4.00, senior-$5.00.
Attendance: 30,000 *Established:* 1978
ADA Compliant: Y
Parking: free on site.
Open: **January to March,**
 Tuesday to Sunday, noon-4pm.
 April to December,
 Tuesday to Saturday, 10am-4pm;
 Sunday, noon-4pm.
Closed: New Year's Day, Thanksgiving Day, Christmas Day.

Exterior view of Edsel & Eleanor House, designed by Albert Kahn. Photograph courtesy of Edsel & Eleanor Ford House, Grosse Pointe Shores, Michigan.

Facilities: **Architecture** (designed by Albert Kahn); **Exhibition Area** (2,500 square feet); **Food Services** (Tea Room); **Gardens & Grounds** (87 acres, designed by Jens Jensen); **Shop.**

Activities: **Children's Programs; Guided Tours; Lectures; Traveling Exhibitions.**

Publications: guidebook, "Edsel & Eleanor Ford House".

The Edsel & Eleanor Ford house is a sixty-room Cotswold-style mansion designed by Albert Kahn and completed in1929. Furnished with English antiques, the house also contains an art collection. The paintings in the collection included original works by Italian Renaissance artists and 18th-century English portraits by Sir Joshua Reynolds and Sir Henry Raeburn. These and many other works were left to the Detroit Institute of Arts by Mrs. Ford in 1976. To preserve intact the atmosphere of the house, however, they and several other paintings (including works by Van Gogh, Renoir, and Degas now in private collections) have been replaced by reproductions. Original works by Cézanne, Matisse, and Diego Rivera may be viewed in the house today as they were when the Fords were in residence.

Holland

Hope College - De Pree Art Center and Gallery

Hope College, 275 Columbia Ave.
Holland, MI 49423
Tel: (616) 395-7000
Fax: (616) 395-7499
Internet Address: http://www.hope.edu
Gallery Director: Dr. John M. Wilson
Admission: free.
Attendance: 20,500 *Established:* 1982
Membership: Y *ADA Compliant:* Y

Exterior view, DePree Art Center Gallery. Photograph courtesy of DePree Art Center Gallery, Hope College, Holland, Michigan.

Hope College - De Pree Art Center and Gallery, cont.

Open: **September to April**, Monday to Saturday, 10am-5pm; Sunday, 1pm-5pm.
May to August, reduced hours.
College Breaks, reduced hours.
Closed: New Year's Day, Memorial Day,
Thanksgiving Day, Christmas Day.
Facilities: **Auditorium** (100 seat); **Classrooms** (2); **Exhibition Area** (1,300 square feet); **Studios** (7).
Activities: **Education Programs** (college students); **Guided Tours**; **Lectures**; **Temporary Exhibitions**; **Traveling Exhibitions**.

The Gallery presents traveling and original exhibitions of fine art in a wide variety of styles, periods, and cultures, both historical and contemporary.

Kalamazoo

Kalamazoo Institute of Arts

314 S. Park St., Kalamazoo, MI 49007-5102
Tel: (616) 349-7775
Fax: (616) 349-9313
Internet Address: http://www.kia.rts.org
Exec. Director: Mr. James A. Bridenstine
Admission: voluntary contribution.
Attendance: 68,000 *Established:* 1924 *Membership:* Y *ADA Compliant:* Y
Parking: free on site.
Open: **September to June**,
Tuesday to Wednesday, 10am-5pm; Thursday, 10am-8pm; Saturday, 10am-5pm; Sunday, noon-5pm.
July to August, Tuesday to Saturday, 10am-5pm.
Closed: Legal Holidays.
Facilities: **Galleries** (5); **Library** (10,000 volumes); **Sculpture Garden**; **School Studios**; **Shop**.
Activities: **Arts Festival**; **Education Programs** (adults and children); **Films**; **Guided Tours**; **Lectures**; **Temporary/Traveling Exhibitions** (25/year).
Publications: annual report; exhibition catalogues; newsletter (bi-monthly); program brochures.

The Kalamazoo Institute of Arts has an active schedule of education programs and also mounts temporary exhibitions showcasing the work of regionally and nationally recognized artists. Selections from KIA's permanent collection of paintings, graphics, photographs, small scale sculptures, and ceramics are exhibited in four exhibition galleries. The collection's emphasis is American art, but also includes holdings of European prints as well as examples of fine art from around the world.

Western Michigan University Art Collection and Galleries

Department of Art, College of Fine Arts, 1201 Oliver St., Kalamazoo, MI 49008-5188
Tel: (616) 387-2455
Fax: (616) 387-2477
Internet Address: http://www.umich.edu/art/exhibitions/exhibitions/index.html
Chairman, Art Department: Mr. Charles Stroh
Admission: free.
Attendance: 60,000 *Established:* 1975 *Membership:* Y *ADA Compliant:* Y
Parking: metered.
Open: **September to mid-April**, see below for hours.
Closed: Academic Holidays.
Facilities: **Galleries** (2).
Activities: **Education Programs** (graduate and undergraduate college students); **Temporary/Traveling Exhibitions**.
Publications: exhibition catalogues.

Kalamazoo, Michigan

Western Michigan University Art Collection and Galleries, cont.

The Department of Art offers opportunities to view exhibitions of work by visiting artists, faculty and students in a number of venues on campus: Gallery II in Sangren Hall (open Mon-Fri, 10am-5pm); Student Art Gallery in East Hall (open Mon-Fri, noon-5pm); the Multi-Media Room in the Dalton Center, and the Sculpture Tour Program, which installs works at sites on campus.

Lansing

Lansing Art Gallery

425 S. Grand Ave., Lansing, MI 48933
Tel: (517) 374-6406
Fax: (517) 484-2564
Gallery Manager: Ms. Mary Spencer
Admission: voluntary contribution.
Attendance: 40,000 *Established:* 1965 *Membership:* Y *ADA Compliant:* Y
Open: Tuesday to Friday, 10am-4pm; Saturday to Sunday, 1pm-4pm.
Facilities: **Galleries** (2); **Lease Purchase Gallery**; **Shop**.
Activities: **Education Programs**; **Lectures**; **Temporary Exhibitions** (monthly); **Workshops**.
Publications: exhibition announcements; newsletter, "IMAGE" (bi-monthly).

The Lansing Art Gallery presents temporary exhibitions and also provides education programs.

Marquette

Northern Michigan University - University Art Museum

1401 Presque Isle Ave., Marquette, MI 49855
Tel: (800) 682-9797
Internet Address: http://www.nmu.edu
Exec. Director: Mr. Wayne Francis
Admission: free.
Established: 1975
Open: Call for hours.
Facilities: **Galleries** (2).
Activities: **Guided Tours**; **Temporary Exhibitions** (15/year); **Visiting Artist Workshops**.

The Museum curates national and regional exhibitions, hosts traveling shows, and exhibits the work of faculty and students. In addition, its permanent collection is occasionally on exhibition.

Midland

Arts Midland: Galleries & School of the Midland Center for the Arts

1801 W. St. Andrews, Midland, MI 48640
Tel: (517) 631-3250
Fax: (517) 631-7890
Director of Arts Midland: Mr. Bruce Winslow
Admission: free.
Attendance: 80,000 *Established:* 1956 *Membership:* Y *ADA Compliant:* Y
Open: Daily, 10am-6pm.
Facilities: **Architecture** (designed by Alden B. Dow); **Auditorium** (1,512 seats); **Exhibition Hall**; **Galleries** (3); **Rental Gallery**; **Studio/Classrooms**.
Activities: **Arts Festival**; **Concerts**; **Dance Recitals**; **Education Programs** (adults and children); **Films**; **Gallery Talks**; **Guided Tours**; **Juried Exhibit** (annual); **Lectures**; **Performances**; **Permanent Exhibits**; **Temporary Exhibitions**; **Traveling Exhibitions**.
Publications: exhibition catalogues; newsletter, "Artscape" (monthly); posters.

The Galleries mount more than two dozen exhibitions per year of the work of students, faculty, and professional artists, as well as an ambitious schedule of traveling exhibitions from other institutions.

Muskegon

Muskegon Museum of Art (MMA)

296 W. Webster Ave., Muskegon, MI 49440

Tel: (616) 722-2600

Fax: (616) 722-3041

Internet Address: http://www.muskegon.k12.mi.us/mma

Director: Susan Talbot-Stanaway

Admission: voluntary contribution.

Attendance: 25,000 *Established:* 1912

Membership: Y *ADA Compliant:* Y

Parking: behind building, on street and adjacent shopping mall lots.

Open: Tuesday to Friday, 10am-5pm; Saturday to Sunday, noon-5pm.

Closed: Legal Holidays.

Facilities: **Auditorium** (200 seats); **Classrooms and Studio**; **Galleries** (5); **Shop** (art books, catalogs, posters, handcrafted jewelry).

Activities: **Gallery Talks**; **Guided Tours**; **Lectures**; **Temporary Exhibitions** (12-14/year).

Publications: collection catalogues (2, American and European); exhibition catalogues.

Edward Hopper, *New York Restaurant* (detail), ca. 1922. Hackley Picture Fund, Muskegon Museum of Art. Photograph courtesy of Muskegon Museum of Art, Muskegon, Michigan.

The Museum's Hackley building galleries feature selections from the permanent collection, while the Walker Wing galleries present a wide range of temporary exhibitions. MMA's permanent collection includes paintings, prints, photography, sculpture, and glass, with works by Blakelock, Cranach, Cassatt, Curry, Degas, Homer, Hopper, Pissarro, Remington, Rodin, Sisley, Whistler, Wyeth, and many others.

Rochester

Oakland University - Meadow Brook Art Gallery

209 Wilson Hall (across from the Meadow Brook Theatre) Rochester, MI 48309-4401

Tel: (248) 370-3005

Fax: (248) 370-4208

Internet Address: http://www.oakland.edu

Manager: Dick Goody

Admission: voluntary contribution.

Attendance: 35,000 *Established:* 1959

Membership: Y *ADA Compliant:* Y

Parking: free on site.

Open: Tuesday to Friday, noon-5pm;
Saturday to Sunday, 1pm-5:50pm.
(Also evenings in conjunction with theatre.)

Facilities: **Concert Hall**; **Gallery**; **Outdoor Music Pavilion**; **Sculpture Garden**; **Theatre**.

Activities: **Arts Festival**; **Education Programs** (undergraduate college students); **Gallery Talks**; **Temporary Exhibitions** (5 major/year).

Publications: exhibition catalogues.

Fernando Botero, *The Temptation of Sante Rita*, 1970, oil on canvas; 42½ x 38 inches. Meadow Brook Art Gallery collection. Photograph courtesy of Meadow Brook Art Gallery, Oakland University, Rochester, Michigan.

The Gallery presents five exhibitions per year that offer a wide range of artistic expression in a relaxed gallery setting. The permanent collection contains over 300 pieces of African art, and examples of pre-Columbian, Oceanic, and Chinese art. The bulk of the collection consists of 20th-century paintings and prints by artists such as Fernando Botero, Alex Katz, Alexander Calder, and Lyonel Feininger. The permanent collection is not always on display in locations that are accessible to the public. Visitors should telephone the Gallery for specific information about accessibility.

Saginaw

Saginaw Art Museum

1126 N. Michigan Ave., Saginaw, MI 48602
Tel: (517) 754-2491
Fax: (517) 754-9387
Internet Address:
 http://members.xoom.com/SaginawArt
Director: Sheila K. Redman
Admission: voluntary contribution.
Attendance: 14,000 *Established:* 1947
Membership: Y *ADA Compliant:* Y
Parking: free on site.
Open: Tuesday to Saturday, 10am-5pm;
 Sunday, 1pm-5pm.
Closed: Legal Holidays.

Charles Demuth, *Provincetown Dunes*, Collection of and photograph courtesy of Saginaw Art Museum, Saginaw, Michigan.

Facilities: **Architecture** (Clark L. Ring home, 1904 designed by Charles Adams Platt); **Formal Garden**; **Galleries** (7, one is hands-on); **Library** (2,000 volumes); **Studio and Classrooms**.
Activities: **Education Programs** (adults and children); **Gallery Talks**; **Guided Tours**; **Lectures**; **Temporary Exhibitions**; **Workshops**.
Publications: exhibition catalogues; newsletter (quarterly).

Housed in a National Register Georgian Revival mansion designed by Charles Adams Platt that was completed in 1905, the Saginaw Art Museum has an active exhibition schedule. It annually presents over twenty art exhibitions, including two regional juried art competitions, traveling shows of statewide and national importance, and exposure to the art of Asian, African-American, and Hispanic cultures. The permanent collection of over 1,500 works is strongest in American 19th- and 20th-century art, with special emphasis on Michigan artists. The collection includes prints by Chagall, Daumier, Estes, Glackens, Kandinsky, Kelly, Lichtenstein, Manet, Matisse, Motherwell, Oldenberg, and Piranesi, and paintings by Corot, Demuth, Hassam, Inness, Kensett, Lawrence, Sully, and Wendt. There are also Japanese woodblock prints by Koitsu, Hasui, and Kawano.

Saint Joseph

Krasl Art Center

707 Lake Blvd., Saint Joseph, MI 49085
Tel: (616) 983-0271
Fax: (616) 983-0275
Internet Address: http://www.krasl.org
Exec. Director: Mr. Darwin R. Davis
Admission: voluntary contribution.
Attendance: 19,000 *Established:* 1963 *Membership:* Y *ADA Compliant:* Y
Parking: free on site.
Open: Monday to Thursday, 10am-4pm;
 Friday, 10am-1pm;
 Saturday, 10am-4pm;
 Sunday, 1pm-4pm.
Closed: Legal Holidays.
Facilities: **Classrooms**; **Galleries**; **Outdoor sculpture**; **Shop**.
Activities: **Education Programs** (adults and children); **Films**; **Gallery Talks**; **Guided Tours**; **Lectures**; **Temporary Exhibitions** (monthly); **Workshops**.
Publications: catalogues (occasional); class schedules; exhibition brochures; newsletter, "Art Insight" (bi-monthly).

Jon Isherwood, *Hidden Legend*, 1994, Granite; 9 x 4 x 3 feet. Krasl Art Center. Photograph courtesy of Krasl Art Center, St. Joseph, Michigan.

Krasl Art Center, cont.

The Krasl Art Center's three galleries are home to numerous exhibitions, which change monthly. Traveling exhibitions include collections from major American institutions, such as the Smithsonian, as well as private collections. The Krasl also sponsors an annual Art Fair that is a juried show featuring national artists, along with numerous shows displaying the work of regional artists. The permanent collection of the Krasl emphasizes both indoor and outdoor sculpture.

Traverse City

Northwestern Michigan College - Dennos Museum Center

1701 E. Front St., Traverse City, MI 49686

Tel: (616) 922-1055

Fax: (616) 922-1597

Internet Address: http://dmc.nmc.edu/

Director: Mr. Eugene A. Jenneman

Admission: fee: adult-$2.00, child-$1.00, student-$1.00, senior-$2.00.

Attendance: 65,000 *Established:* 1991

Membership: Y *ADA Compliant:* Y

Parking: free adjacent to site.

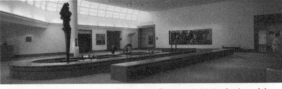

View of gallery, Dennos Museum Center (1991), designed by Robert Holdeman. Photograph by Curtis R. Frook, courtesy of the Dennos Museum Center of Northwestern Michigan College, Traverse City, Michigan.

Open: Monday to Saturday, 10am-5pm; Sunday, 1pm-5pm.

Closed: New Year's Day, , Good Friday, Easter, Memorial Day, Independence Day, Labor Day, Thanksgiving Day, Thanksgiving Friday, Christmas Eve, Christmas Day.

Facilities: **Discovery Gallery**; **Exhibition Area** (8,000 square feet); **Library** (300 volumes, Inuit art and culture); **Sculpture Garden** (to be opened in 1999 or 2000); **Shop**; **Theatre** (367 seats).

Activities: **Concerts**; **Dance Recitals**; **Education Programs** (adults and children); **Films**; **Guided Tours**; **Lectures**; **Performances**; **Temporary Exhibitions**; **Traveling Exhibitions**.

Publications: newsletter, "Inside" (quarterly).

The Dennos Museum Center features three galleries devoted to changing exhibitions, a sculpture court, and an extensive collection of Inuit Art.

University Center

Delta College - Galleria

Central Lobby, Fine Arts Building (S-wing), Hotchkiss & Mackinaw Roads University Center, MI 48710

Tel: (517) 686-9441

Internet Address: http://www.delta.edu/~humaniti/galleria.htm

Contact: Mr. Randal Crawford

Admission: free.

Open: Call for hours.

Facilities: **Exhibition Area**.

Activities: **Temporary Exhibitions**.

The Galleria exhibits works from the college's permanent collection as well as works by professional artists, faculty and students.

Saginaw Valley State University - Marshall M. Fredericks Sculpture Gallery

Saginaw Valley State University, Arbury Arts Center, Bay Road, University Center, MI 48710

Tel: (517) 790-5667

Fax: (517) 791-7721

Internet Address: http://www.svsu.edu/mfsg

Director: Dr. Michael W. Panhorst

Admission: free.

Attendance: 10,000 *Established:* 1988 *Membership:* Y *ADA Compliant:* Y

Parking: free on site.

Open: Tuesday to Sunday, 1pm-5pm.

Closed: Legal Holidays, Academic Holidays.

University Center, Michigan

Saginaw Valley State University - Marshall M. Fredericks Sculpture Gallery, cont.

Facilities: **Exhibition Area** (8,000 square feet: 200 works of sculpture); **Shop**.

Activities: **Education Programs** (children); **Guided Tours**.

Publications: newsletter, "Friends of the MFSG Newsletter".

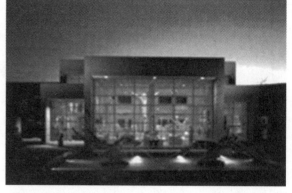

The Gallery contains sculptures, models, drawings and paintings by Marshall M. Fredericks (American, b. 1908). There is also an adjacent sculpture garden with additional bronze works by Fredericks.

Exterior view of Marshall M. Fredericks Sculpture Gallery, with "Night and Day Fountain" by Fredericks in foreground. Photograph by Gary Bublitz, courtesy of Marshall M. Fredericks Sculpture Gallery, Saginaw Valley State University, University Center, Michigan.

West Bloomfield

Janice Charach Epstein Museum Gallery

Jewish Community Center of Metro Detroit
6600 W. Maple Road
West Bloomfield, MI 48322

Tel: (248) 661-7641

Fax: (248) 661-3680

Director: Mrs. Sylvia Jean Nelson

Admission: free.

Attendance: 20,000

Membership: Y *ADA Compliant:* Y

Parking: free on site.

Open: Monday to Wednesday, 11am-6pm;
Thursday, 11am-7pm;
Sunday, 11am-4pm.

Facilities: **Exhibition Area**
(8,000 square feet on two levels).

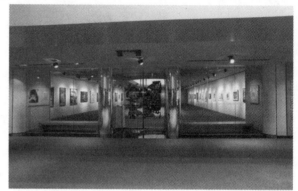

View of first floor gallery, Janice Charach Epstein Museum Gallery. Photograph courtesy of Janice Charach Epstein Museum Gallery, West Bloomfield, Michigan.

Activities: **Guided Tours** (on request); **Lectures**; **Temporary Exhibitions** (every six weeks).

Publications: exhibition catalogues (occasional).

The Museum Gallery present temporary exhibitions of the work of Jewish artists or work with Jewish themes, including an annual emerging Jewish artists exhibit.

Ypsilanti

Eastern Michigan University - Ford Gallery

Ford Hall, Summit St., Ypsilanti, MI 48197

Tel: (734) 487-0465

Internet Address: http://www.art.acad.emich.edu/exhibitions/ford/

Gallery Director: Ms. Barbara Miner

Admission: free.

Open: Daily, 9am-5pm.

Facilities: **Exhibition Area**.

Activities: **Temporary Exhibitions**.

The Ford Gallery presents temporary exhibitions including student MFA Thesis Exhibitions. Also of possible interest on campus, the Intermedia Gallery Group mounts exhibitions of student work in the McKenny Union.

Minnesota

The number in parentheses following the city name indicates the number of museums/galleries in that municipality. If there is no number, one is understood. For example, in the text six listings would be found under Minneapolis and one listing under Mankato.

Minnesota

Bemidji

Bemidji State University - Talley Gallery

Education-Art Building (ground floor), 1500 Birchmont Drive N.E., Bemidji, MN 56601-2699
Tel: (218) 755-3708
Internet Address: http://www.cal.bemidji.msus.edu/VisArts/galleries
Director: Sandy Kaul
Admission: free.
ADA Compliant: Y
Open: **Academic Year**, Monday to Friday, 9:30am-9:30pm; Saturday, 9:30am-6:30pm.
Closed: Holidays, Academic Holidays, Between Exhibitions.
Facilities: **Exhibition Area.**
Activities: **Gallery Talks**; **Temporary Exhibitions**; **Visiting Artist Program.**

The Gallery presents temporary exhibitions of the work of professional artists, faculty and students. Holdings of the Department of Visual Arts include prints (Kleven Collection) and ceramics (Harlow Collection). Another exhibition space presenting temporary shows, Gallery X, is located on the second floor of the Education-Art Building (755-3740). Also of possible interest on campus, the Touché Gallery, located in the Hobson Memorial Union (755-3760), is open Monday to Friday, 8am-4:30pm.

Bloomington

Bloomington Art Center

10206 Penn Ave., South
Bloomington, MN 55431
Tel: (952) 948-8746
Fax: (952) 948-8744
TDDY: (952) 948-8740
Exec. Director: Ms. Susan M. Anderson
Admission: voluntary contribution.
Established: 1976
Membership: Y *ADA Compliant:* Y
Parking: free on site.
Open: Monday to Friday, 9am-5pm;
 Saturday, 10am-1pm.
Closed: Legal Holidays.

View of gallery, Bloomington Art Center, during temporary exhibition, "From the Floor...Up", showing sculpture by Charles Johnson and woven rugs by Wynne Mattila. Photograph courtesy of Bloomington Art Center, Bloomington, Minnesota.

Facilities: **Classrooms**; **Galleries** (one on-site and two off-site; new exhibits every eight weeks); **Shop.**
Activities: **Arts Festival**; **Education Programs** (adults and children); **Gallery Talks**; **Guided Tours** (by appointment); **Lectures**; **Workshops.**
Publications: newsletter.

The Exhibition Program of the Art Center consists of temporary exhibitions of the work of artists residing in Minnesota, South Dakota, North Dakota, Wisconsin, and Iowa.

Collegeville

St. John's University - Galleries

Alice R. Rogers Gallery and Dayton Hudson Gallery, University Art Center, Collegeville, MN 56321
Tel: (320) 363-2701
Fax: (320) 363-2504
Internet Address: http://www.users.csbsju.edu/~museum
Exhibit Director: Lisa Cotton
Admission: free.
Attendance: 10,000 *Established:* 1989
Parking: free on site.

Collegeville, Minnesota

St. John's Abbey and University - Museum at St. John's and Galleries, cont.

Open: **Galleries: Fall to Spring**,
> Monday to Wednesday, 10am-4pm; Thursday, 10am-9pm; Friday to Sunday, 10am-4pm.

Galleries: Summer,
> Monday to Friday, 9am-5pm; Saturday to Sunday, 10am-5pm.

Facilities: **Architecture** Art Center (designed by Hugh Newell Jacobson).

Activities: **Temporary Exhibitions**.

While St. John's does possess an art collection, it does not have a permanent exhibition facility. The Museum mounts occasional temporary exhibits in various facilities of the University. Two spaces presenting a schedule of temporary exhibitions throughout the school year are located in the University Art Center, the Alice R. Rogers Gallery and the Dayton Hudson Gallery. Saint John's University for men is the brother school of the College of Saint Benedict for women (Saint Joseph, Minnesota); exhibitions are coordinated and many of the student exhibitions include work by art students from both schools.

Duluth

Duluth Arts Institute

506 W. Michigan St., Duluth, MN 55802
Tel: (218) 733-7560
Fax: (218) 733-7506
Director: Mr. John Steffl
Admission: fee: adult-$8.00, child-$5.00, family-$12.00.
Attendance: 100,000
Open: **Summer**, Monday to Saturday, 10am-5pm; Sunday, 11am-5pm.
> **Winter**, Monday to Friday, 10am-5pm; Saturday, 11am-5pm; Sunday, 1pm-5pm.

Facilities: **Exhibition Area**.

The Duluth Art Institute offers temporary exhibitions of contemporary art by regional, national, and international artists.

The St. Louis County Historical Society

506 W. Michigan St., Duluth, MN 55802-1505
Tel: (218) 733-7580
Fax: (218) 733-7585
Director: Ms. Jo Anne Coombe
Admission: fee-$8.00.
Attendance: 100,000 *Established:* 1922 *Membership:* Y *ADA Compliant:* Y
Open: **Winter**, Monday to Saturday, 10am-5pm; Sunday, 1pm-5pm.
> **Summer**, Daily, 9:30am-6pm.

Facilities: **Architecture** (1893); **Exhibition Area**.

Activities: **Lectures**; **Temporary Exhibitions**; **Workshops**.

Publications: "Eastman Johnson's Lake Superior Indians"; newsletter (quarterly).

The collection of the historical society includes paintings by Eastman Johnson of local Ojibwe people, Tiffany stained-glass windows, and hand-carved furniture by Herman Melheim.

University of Minnesota at Duluth - Tweed Museum of Art

University of Minnesota at Duluth, 10 University Drive, Duluth, MN 55812
Tel: (218) 726-8222
Fax: (218) 726-8503
Internet Address: http://www.d.umn.edu/tma
Director and Curator: Mr. Martin DeWitt
Admission: suggested contribution: adult-$3.00, child-$1.00, family-$5.00.
Attendance: 50,000 *Established:* 1950 *Membership:* Y *ADA Compliant:* Y
Parking: free on site.
Open: Tuesday, 9am-8pm; Wednesday to Friday, 9am-4:30pm; Saturday to Sunday, 1pm-5pm.
Closed: Legal Holidays, Academic Holidays.

University of Minnesota at Duluth - Tweed Museum of Art, cont.

Facilities: Galleries (8); Lecture Room; Sculpture Conservatory and Courtyard; Shop.

Activities: Film Series; Guided Tours; Permanent Exhibits; Temporary Exhibitions; Traveling Exhibitions.

Publications: exhibition catalogues; newsletter (quarterly).

The Tweed Museum's permanent collection consists of European paintings; American Impressionism (works by Hassam, Twachtman, Robinson, and Weir); Modernist works by Ajay, Biederman, Crawford, Reise, and Soto; and Contemporary works by Viveka Heino, Jun Kaneko, Lucy Lewis, and Steven Woodward.

Elysian

LeSueur County Historical Museum - Chapter 1

N.E. Frank and 2nd St., Elysian, MN 56028

Tel: (507) 267-4620

Internet Address: http://www.lchs.mus.mn.us

C.E.O.: Mr. David K. Wollin

Admission: voluntary contribution.

Attendance: 4,000 *Established:* 1966 *Membership:* Y *ADA Compliant:* Y

Open: **May**, Saturday to Sunday, 1pm-5pm.

June to August, Wednesday to Sunday, 1pm-5pm.

September, Saturday to Sunday, 1pm-5pm.

Facilities: **Exhibition Area; Shop**.

Activities: **Arts Festival; Guided Tours; Lectures**.

Publications: newsletter, "History Abounds".

The permanent collection of the Museum includes original and reproduction works by local artists Adolf Dehn, Lloyd Herfindahl, Albert Christ-Janner, Roger Preuss and David Maass, as well as the work of other local artists.

Mankato

Minnesota State University, Mankato - Conkling Gallery

Maywood Ave., Mankato, MN 56002-8400

Tel: (507) 389-6412

Fax: (507) 389-2816

Internet Address: http://www.mankato.msus.edu/dept/artdept/Gallery/gallery.html

Gallery Coordinator: Mr. Brian Frink

Open: **Call for hours.**

Facilities: **Exhibition Area**.

Activities: **Temporary Exhibitions**.

The Gallery features temporary exhibitions by artists of both national and regional reputation. In addition to professional exhibitions, the Gallery presents exhibitions of work by graduating seniors and thesis exhibitions by graduate students.

Marshall

Southwest State University - William Whipple Gallery

Library, 1st Floor, Highways 19 and 23, Marshall, MN 56258

Tel: (507) 537-7191

Fax: (507) 537-6200

Internet Address: http://www.southwest.msus.edu/AcadSuppServ/whipple

Director: Mr. Edward Evans

Open: Monday to Thursday, 8am-11pm; Friday, 8am-4pm; Saturday, 1pm-5pm; Sunday, 1pm-11pm.

Facilities: **Exhibition Area**.

Activities: **Temporary Exhibitions**.

Located on the first floor of the library, the William Whipple Gallery exhibits the work of students, faculty, and regionally, nationally, and internationally recognized artists.

Minneapolis

Lutheran Brotherhood Collection of Religious Art

Lutheran Brotherhood
625 Fourth Avenue South
Minneapolis, MN 55415
Tel: (612) 340-7000 *Ext:* 8072
Curator, Art Collection: Mr. Richard Hillstrom
Admission: open to public.
Parking: commercial adjacent to site.
Open: Monday to Friday, 9:30am-4:30pm.

Albrecht Dürer, *The Four Riders of the Apocalypse*, 1511, woodcut, from "The Apocalypse" (1511 edition), collection Lutheran Brotherhood. Photograph courtesy of Lutheran Brotherhood, Minneapolis. Minnesota.

A significant portion of the Lutheran Brotherhood Collection of Religious Art is displayed in its gallery adjacent to the second floor lobby in the home office building. Formed over the past several years, the collection consists of approximately one hundred drawings and five hundred prints (etchings, engravings, woodcuts and lithographs) by old and modern European and American masters dating from the 15th through the 20th centuries. Its focus is restricted to art with a Biblical basis, with the goal of establishing a body of Judeo-Christian art of high quality by renowned artists of all nations and periods. The two artists most represented are Albrecht Dürer and Rembrandt van Rijn. For the past several years, portions of the collection have been regularly circulated to colleges, seminaries and congregations of the Lutheran Church as well as to educational and cultural centers in communities from coast to coast. The permanent collection consists solely of works on paper (575 original prints and 125 drawings) featuring Old and New Testament events and personalities.

Minneapolis College of Art and Design Gallery

2501 Stevens Ave., S., Minneapolis, MN 55404
Tel: (612) 874-3785
Fax: (612) 874-3704
TDDY: (612) 874-3800
Internet Address: http://www.mcad.edu/
Gallery Director: Mr. Brian Szott
Admission: free.
Established: 1886 *ADA Compliant:* Y
Open: Monday to Friday, 9am-9pm; Saturday, 9am-5pm; Sunday, noon-5pm.
Closed: Legal Holidays.
Facilities: **Exhibition Area.**
Activities: **Concerts**; **Dance Recitals**; **Education Programs** (undergraduate college students); **Films**; **Gallery Talks**; **Lectures**; **Temporary Exhibitions**; **Traveling Exhibitions.**
Publications: exhibition catalogues.

The Gallery mounts temporary exhibitions of contemporary works by local, regional, and national artists and designers.

The Minneapolis Institute of Arts

2400 3rd Ave., S., Minneapolis, MN 55404
Tel: (612) 870-3131
Fax: (612) 870-3004
TDDY: (612) 870-3132
Internet Address: http://www.artsMIA.org
President and Director: Dr. Evan M. Maurer

The Minneapolis Institute of Arts, cont.

Admission: voluntary contribution.

Attendance: 500,000 *Established:* 1915

Membership: Y *ADA Compliant:* Y

Parking: free on site.

Open: Tuesday to Wednesday, 10am-5pm;
Thursday, 10am-9pm;
Friday to Saturday, 10am-5pm;
Sunday, noon-5pm.

Closed: Independence Day, Thanksgiving Day,
Christmas Day.

Facilities: **Architecture** (neo-classical design by McKim, Mead & White,1915); **Auditorium** (285 seats); **Classrooms** (5); **Exhibition Area** (121,000 square feet); **Food Services** Restaurant (Tues-Sun, 11:30am-2:30pm); **Library** (40,000 volumes, on premise use); **Reading Room**; **Shop**; **Theatre** (50 seats).

Activities: **Education Programs** (adults, undergraduate/graduate college students and children); **Family Days**; **Films**; **Gallery Talks**; **Guided Tours** (Tues-Sun, 2pm; Thurs, 7pm; Sat-Sun, 1pm); **Lectures**; **Permanent Exhibits**; **Temporary Exhibitions**; **Traveling Exhibitions**.

Jean Clouet the Younger, *Princess Charlotte of France*, c. 1522. Ethel Morrison Van Derlip Fund, Minneapolis Institute of the Arts. Photograph courtesy of Minneapolis Institute of the Arts, Minneapolis, Minnesota.

Publications: "A Guide to the Galleries"; bulletin, "The Minneapolis Institute of Arts Bulletin"; exhibition catalogues; magazine, "ARTS" (monthly).

The Institute is a familiar landmark in downtown Minneapolis. Its architecture combines the original 1915 neo-classical structure designed by McKim, Mead and White with 1974 additions by Kenzo Tange. Inside, a visitor can sample a collection of 80,000 objects spanning 4,000 years of cultural history. The Institute's painting collection contains important works of Western art from the 14th to the 20th century, including paintings by Rembrandt, Goya, Poussin, van Gogh, Degas, and Bonnard. It includes works of Impressionism, German Expressionism, and a broad selection of American art. The sculpture collection ranges from Egyptian, Greek, and Roman examples to modern works by Brancusi, Calder, Picasso, and Moore. There are also extensive Chinese (bronzes and jades) and Japanese (18th- and 19th-century Ukiyo-e paintings and woodblock prints) collections. The print and drawing collection contains works by Dürer, Rembrandt, Goya, Blake, Watteau, Ingres, Toulouse-Lautrec, Lichtenstein, and Johns. The photography collection documents the history of the medium from 1836 to the present with more than 10,000 prints, including works by Stieglitz, Steichen, Evans, and Adams. There are also extensive African, Oceanic, Pre-Columbian, and North American Indian collections.

University of Minnesota - Frederick R. Weisman Art Museum (WAM)

333 E. River Road (adjacent to Coffman Memorial Union and Washington Avenue Bridge)
Minneapolis, MN 55455

Tel: (612) 625-9494

Fax: (612) 625-9630

Internet Address: http://www.hudson.acad.umm.edu

Director: Lyndel King

Admission: voluntary contribution.

Attendance: 100,000 *Established:* 1934 *Membership:* Y *ADA Compliant:* Y

Parking: pay on site.

Open: Tuesday to Wednesday, 10am-5pm; Thursday, 10am-8pm; Friday, 10am-5pm;
Saturday to Sunday, 11am-5pm.

Closed: Academic Holidays, Legal Holidays.

Facilities: **Architecture** (1993 designed by Frank Gehry); **Galleries**; **Shop**.

Minneapolis, Minnesota

University of Minnesota - Frederick R. Weisman Art Museum, cont.

Activities: **Art Rental**; **Education Programs** (graduate students); **Gallery Talks**; **Guided Tours**; **Lectures**; **Temporary Exhibitions**; **Traveling Exhibitions**.
Publications: exhibition catalogues.

Housed since 1993 in a striking stainless steel building designed by Frank Gehry, the Museum provides an interdisciplinary approach to the arts and humanities with a program of exhibitions, lectures, and special events. The Museum's holdings feature early 20th-century American artists, including large groups of works by Marsden Hartley and Alfred Maurer, as well as important pieces by their contemporaries Milton Avery, Lyonel Feininger, and Georgia O'Keeffe. The collection is also strong in traditional Korean furniture and American, European, and Asian ceramics, including a large collection of ancient Native American Mimbres pottery.

Marsden Hartley, *One Portrait of One Woman, 1916*, oil on composition board, 30 x 25 inches. Bequest of Hudson Walker from the Ione and Hudson Walker Collection. Photograph courtesy of Frederick R. Weisman Art Museum, University of Minnesota, Minneapolis, Minnesota.

University of Minnesota - Katherine E. Nash Gallery

University of Minnesota, Willey Hall, 225 19th Ave., South, Lower Concourse
Minneapolis, MN 55404
Tel: (612) 624-6518
Fax: (612) 625-0152
Internet Address: http://artdept.umn.edu/nash/genpage.htm
Managing Director: Nicholas B. Shank
Admission: voluntary contribution.
Attendance: 23,000 *Established:* 1973 *ADA Compliant:* Y
Open: Tuesday to Wednesday, 10am-4pm; Thursday, 10am-8pm; Friday, 10am-4pm; Saturday, 11am-5pm.
Closed: Academic Holidays, Semester Breaks.
Facilities: **Exhibition Area**.
Activities: **Temporary Exhibitions**; **Traveling Exhibitions**.

The Gallery presents temporary exhibitions.

Walker Art Center

Vineland Place, Minneapolis, MN 55403
Tel: (612) 375-7622
Fax: (612) 375-7618
TDDY: (612) 375-7585
Internet Address: http://www.walkerart.org
Director: Ms. Kathy Halbreich
Admission: fee: adult-$4.00, student-$3.00, senior-$3.00.
Attendance: 770,000 *Established:* 1879 *Membership:* Y *ADA Compliant:* Y
Parking: metered on street and nearby commercial lot.
Open: Tuesday to Wednesday, 10am-5pm; Thursday, 10am-8pm; Friday to Saturday, 10am-5pm; Sunday, 11am-5pm.
Closed: Legal Holidays.
Facilities: **Architecture** (designed by Edward Larrabee Barnes); **Auditorium** (344 seats); **Food Services** Restaurant (70 seats; Tues-Wed & Fri-Sun, 11:30am-3pm; Thurs, 11:30am-8pm); **Galleries** (8); **Library**; **Sculpture Garden** (6am-midnight; free admission); **Shop**.

426

Walker Art Center, cont.

Activities: **Concerts**; **Dance Recitals**; **Education Programs** (adults, students and children); **Films**; **Gallery Talks**; **Guided Tours** (Thurs, 2pm & 6pm; Sat-Sun, noon & 2pm); **Lectures**; **Performances**; **Permanent Exhibits**; **Temporary Exhibitions**; **Traveling Exhibitions**.

Publications: calendar of events (monthly); exhibition catalogues.

The Walker Art Center, housed in an award-winning building designed by Edward Larrabee Barnes, presents major exhibitions of 20th-century art, both from its own collection and from other major museums. Its permanent collection consists of some 8,000 pieces in a range of styles from figurative to abstract, including major works by Jasper Johns, Agnes Martin, Louise Nevelson, and Andy Warhol. In addition, the Minneapolis Sculpture Garden, a joint project of the Center and the Minneapolis Park and Recreation Board, is adjacent to the Center. It is an eleven-acre site, containing forty works of 20th-century art, including examples by Gehry, Oldenburg and van Bruggen, and Armajani.

Claes Oldenburg and Coosje van Bruggen, *Spoonbridge and Cherry*, 1987-1988. View of Walker Art Center in background. Photograph courtesy of Walker Art Center, Minneapolis, Minnesota.

Moorhead

Concordia College - Cyrus M. Running Gallery

Olin Center, 901 8th St. South, Moorhead, MN 56562

Tel: (218) 294-4000

Internet Address: http://www.cord.edu/dept/art/gallery.html

Director: Ms. Barbara Thill Anderson

Admission: free.

Open: Call for hours.

Facilities: **Exhibition Area** (3,000 square feet, 240 running feet of wall space).

Activities: **Temporary Exhibitions**.

Beginning in the skyway connecting the Olin Center with the Francis Frazier Comstock Theatre building, the Gallery presents a schedule of temporary exhibitions, including annual faculty, senior student, and juried student shows, during the academic year.

New Ulm

Brown County Historical Society Museum

2 N. Broadway, New Ulm, MN 56073-1714

Tel: (507) 233-2616

Fax: (507) 354-1068

Director: Bob Burgess

Admission: fee: adult-$2.00, student-free.

Attendance: 10,000 *Established:* 1930 *Membership:* Y *ADA Compliant:* Y

Open: **Spring to Fall**, Monday to Friday, 10am-5pm; Saturday to Sunday, 1pm-5pm.
 Winter, Monday to Friday, 10am-5pm; Saturday, 1pm-5pm.

Closed: Legal Holidays.

Facilities: **Exhibition Area**; **Library**.

Activities: **Gallery Talks**; **Guided Tours**; **Lectures**; **Permanent Exhibits**; **Temporary Exhibitions**.

Publications: brochures.

The Museum's collection contains works by local artists, including Anton Gag, Wanda Gag, Chris Heller and Alexander Schwendinger.

Northfield

Carleton College Art Gallery

Music and Drama Center, 1st & Winona (NE of Skinner Memorial Chapel), Northfield, MN 55057
Tel: (507) 646-4469 or (507) 646-4342
Internet Address: http://www.carleton.edu/curricular/Art-Gallery_Page.html
Director, Exhibitions and Curator, Collections: Ms. Laurel Bradley
Admission: free.
Open: Daily, noon-5pm; Tuesday to Friday, 7pm-10pm during exhibitions.
Facilities: **Exhibition Area.**
Activities: **Lectures**; **Temporary Exhibitions** (5/year); **Workshops.**

Located downstairs in the Music and Drama Center, the Gallery presents five exhibitions a year on themes connecting fine art to areas of the liberal arts curriculum. For example, *Claiming Title: Australian Aboriginal Artists and the Land* (fall 1999) explored the relationships between art and land rights, ecology, and indigenous identities; *Botanica: Contemporary Art and the World of Plants* (spring 2000) celebrated artists' metaphorical and visual uses of botany. The Carleton Art Collection is featured in at least one exhibition annually. Totaling more than 1,400 works, the College Art Collection comprises prints (European and American works from ca. 1700 to the present; Japanese woodcuts); 20th-century photographs (including a special collection of author portraits); Chinese and Korean artifacts and ancient glass and ceramics; and a relatively small group of paintings and sculptures (including Jacques Lipchitz, *The Reader*).

St. Olaf College - Steensland Art Museum

St. Olaf College, 1520 St. Olaf Ave., Northfield, MN 55057
Tel: (507) 646-3556
Fax: (507) 646-3776
Internet Address: http://www.stolaf.edu/other/steensland/index.html
Director: Ms. Karen Helland
Admission: voluntary contribution.
Attendance: 8,000 *Established:* 1976
Open: **September to June,**
 Monday to Wednesday, noon-5pm; Thursday, noon-8pm; Friday, noon-5pm;
 Saturday to Sunday, 2pm-5pm.
Closed: Easter, Thanksgiving Day, Christmas Day.
Facilities: **Exhibition Area** (2,400 square feet).
Activities: **Education Programs** (undergraduate college students); **Lectures**; **Temporary Exhibitions**; **Traveling Exhibitions.**
Publications: exhibition catalogues.

The Steensland Art Museum maintains a permanent collection of approximately 900 works and presents temporary exhibitions of the work of regional artists.

Park Rapids

North Country Museum of Arts

3rd St. and Court Ave., Park Rapids, MN 56470
Tel: (218) 732-5237
C.E.O. and Curator:
 Ms. Johanna M. Verbrugghen
Admission: fee: adult-$1.00, child-free.
Attendance: 4,500 *Established:* 1977
Membership: Y
Open: **May to October,** Tuesday to Sunday,
 11am-5pm.
Facilities: **Exhibition Area** (4 rooms); **Shop.**

Rendering of North Country Museum of Arts, courtesy of North Country Museum of Arts, Park Rapids, Minnesota.

North Country Museum of Arts, cont.

Activities: Concerts; Guided Tours; Lectures; Readings; Temporary Exhibitions (8 per year); Workshops/Classes.

Publications: newsletter (semi-annual); schedule of events (annual).

The Museum 's permanent collection consists of copies of European Old Master paintings, Nigerian artifacts, Native American children's portraits, and other contemporary works. In addition to its display of the permanent collection, the Museum presents traveling exhibitions from established museums and shows the work of regional artists.

Saint Joseph

College of Saint Benedict - Galleries

Benedicta Arts Center, College Avenue, Saint Joseph, MN 56374

Tel: (320) 363-5777

Fax: (320) 363-6097

Internet Address:
 http://www.users.csbsju.edu/~bac/art/index.html

Director of Exhibitions: Lisa Cotton

Admission: free.

Attendance: 8,125

Parking: lots #4 & #5 west and south (respectively) of Arts Center.

Open: Monday to Thursday,
 8am-4:30pm & 6:30pm-9:30pm;
 Friday to Saturday, 8am-4:30pm;
 Sunday, noon-4:30pm & 6:30pm-9:30pm.

Closed: Academic Holidays, Summer.

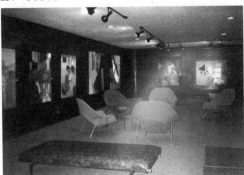

College Lounge Gallery during "Hispanic Southwest", and exhibition of paintings by Florela Buck. Photograph courtesy of Fine Arts Programming, College of St. Benedict.

Facilities: Exhibition Area (gallery, 1,545 square feet; gallery lounge 88 running feet).

Activities: Temporary Exhibitions (every 6 weeks).

Publications: booklets, "CSB/SJU Fine Arts Programming Exhibition Series" (annual); exhibition postcard; newsletter, "Fine Arts Programming Newsletter" (3/year).

Located on the southwest corner of the College of St. Benedict campus, the Benedicta Arts Center offers visual arts exhibitions in two spaces. Exhibitions include selections from the college's permanent collection, work by professional artists, and student work, including an annual senior exhibition and juried student exhibition. The College's permanent collection is housed in the Arts Center, but it is not a part of any ongoing exhibition series. A listing of holdings is not available. The Director of Exhibitions schedules and oversees exhibitions at both the College of Saint Benedict and Saint John's University (see separate listing under Collegeville, Minnesota).

Saint Paul

American Museum of Asmat Art (AMAA)

3510 Vivian Ave., Saint Paul, MN 55126-3852

Tel: (612) 486-7456

Fax: (612) 486-7589

Director: Dr. Robert Gambone

Admission: voluntary contribution.

Attendance: 2,500 *Established:* 1974

Membership: Y *ADA Compliant:* Y

Parking: free on site.

Open: Monday to Thursday, 8am-4:30pm; Friday, 8am-noon.

Closed: New Year's Eve to New Year's Day, Memorial Day, Independence Day, Labor Day, Thanksgiving Day, Christmas Day.

Facilities: Exhibition Area (2,500 square feet); Library (200 volumes).

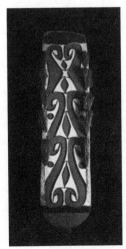

Asmat War Shield, mangrove wood, painted with black charcoal, crushed sea shells, and baked mud; height 70 inches. American Museum of Asmat Art. Photograph courtesy of American Museum of Asmat Art, Saint Paul, Minnesota.

American Museum of Asmat Art, cont.

Activities: **Education Programs** (adults); **Guided Tours; Lectures; Temporary Exhibitions; Traveling Exhibitions.**

Publications: books.

The Museum is dedicated to the preservation and promotion of the art and culture of the Asmat people, a semi-nomadic culture who inhabit the dense coastal rain forest and tribal rivers along the southwest coast of Irian Jaya, Indonesia.

Bethel College - Galleries

Olson Gallery and Johnson Gallery, 3900 Bethel Drive, Saint Paul, MN 55112

Tel: (651) 638-6263

Internet Address: http://www.bethel.edu/Campus_Activities/gallery.html

Admission: free.

Open: Monday to Saturday, 9am-8pm; Sunday, 11am-6pm.

Facilities: **Galleries** (2).

Activities: **Temporary Exhibitions; Visiting Artist Lecture Series.**

The Department of Art maintains two spaces, the Eugene Olson Gallery in the Community Life Center (2nd floor) and the Eugene Johnson Gallery of Art in the Fine Arts Building (2nd floor). The Department offers exhibitions in a wide range of media by regionally, nationally, and internationally recognized artists. Student shows include Senior Thesis Exhibitions and the juried Raspberry Monday Exhibition in the spring.

College of St. Catherine - Catherine G. Murphy Gallery

The Visual Arts Building, 2004 Randolph Ave., Saint Paul, MN 55105

Tel: (612) 690-6637

Internet Address: http://minerva.stkate.edu/PEC.nsf/$$Home

Director: Ms. Kathleen M. Daniels

Open: Call for hours.

Facilities: **Exhibition Area.**

Activities: **Temporary Exhibitions.**

Located in the Visual Arts Building, the Murphy Gallery exhibits works by students, faculty, and local and national artists year-round.

Macalester College Art Gallery

1600 Grand Ave., Saint Paul, MN 55105

Tel: (651) 696-6416

Fax: (651) 696-6266

Internet Address: http://www.macalaster.edu

Curator: Mr. Devin A. Coleman

Admission: free.

Established: 1964

Open: Monday to Friday, 10am-4pm; Saturday to Sunday, noon-4pm.

Closed: Academic Holidays.

Facilities: **Exhibition Area** (2,500 square feet).

The Gallery displays works from the College's permanent collection and mounts temporary exhibitions of a broad range of contemporary art in all media by artists of regional, national, and international reputation, as well as student and faculty shows.

Minnesota Museum of American Art

505 Landmark Center, 75 West 5th St., Saint Paul, MN 55102-1486

Tel: (612) 292-4380

Fax: (612) 292-4340

Internet Address: http://www.mtn.org/MMAA

Director: Bruce Lilly

Admission: voluntary contribution.

Attendance: 125,000 *Established:* 1927 *Membership:* Y *ADA Compliant:* Y

Minnesota Museum of American Art, cont.

Parking: street and nearby commercial lots.

Open: Tuesday to Wednesday, 11am-4pm; Thursday, 11am-7:30pm; Friday to Saturday, 11am-4pm; Sunday, 1pm-5pm.

Closed: Legal Holidays.

Facilities: **Architecture** (former Federal Courts Building, 1902); **Auditorium** (120 seats); **Food Services** Restaurant (Tuesday-Friday, 11:30am-1:30pm; Sun, 11am-1pm); **Galleries**; **Library** (2,000 volumes); **Sculpture Garden**; **Shop**.

Activities: **Education Programs** (adults and children); **Films**; **Gallery Talks**; **Guided Tours** (292-4367 for information); **Temporary Exhibitions**; **Traveling Exhibitions**.

Publications: collection catalogue; exhibition catalogues; gallery guides; newsletter (quarterly).

In the Museum's Permanent Collection Galleries, one can view works by Minnesota sculptor Evelyn Raymond and Saint Paul native Paul Manship, as well as paintings by Robert Henri, Thomas Hart Benton, Jacob Lawrence, and Minnesotans George Morrison, Else Jemne, and Cameron Booth. The Museum also mounts temporary exhibitions.

University of Minnesota - The Goldstein: A Museum of Design

Department of Design, Housing & Apparel, 1985 Buford Ave., 244 McNeal Hall

Saint Paul, MN 55108

Tel: (612) 624-7434

Fax: (612) 624-2750

Internet Address:
 http://www.goldstein.che.umn.edu

Director: Dr. Lindsay Shen

Admission: voluntary contribution.

Attendance: 15,000 *Established:* 1976

Membership: Y *ADA Compliant:* Y

Parking: pay on site.

Open: Monday to Wednesday, 10am-4pm;
 Thursday, 10am-8pm;
 Friday, 10am-4pm;
 Saturday to Sunday, 1:30pm-4:30pm.

Items from collection of Goldstein Gallery. Photograph courtesy of Goldstein Gallery, Saint Paul, Minnesota.

Closed: Holidays.

Facilities: **Gallery**; **Library** (1,000 volumes, available to qualified researchers).

Activities: **Gallery Talks**; **Guided Tours**; **Lectures**; **Temporary Exhibitions** (3-4/year).

Publications: collection catalogue; exhibition catalogues; newsletter (2-3 per year).

The Goldstein is a museum of design. It mounts three to four exhibitions per year that emphasize art in everyday life. The permanent collection of the Gallery consists of historic and designer costumes, textiles, decorative arts, and interior design archives.

University of St. Thomas - Art Space Gallery

Brady Educational Center, 2115 Summit Ave., Saint Paul, MN 55105

Tel: (612) 962-5877

Fax: (612) 962-5640

Internet Address: http://www.stthomas.edu/www/arthist_http/spec.html

Curator, Permanent Collections: Ms. Shelley Nordtorp-Madison

Open: Call for hours.

Facilities: **Exhibition Area**.

Activities: **Temporary Exhibitions**.

The Gallery mounts exhibitions of visual material whose content "explains and/or interprets a concept, a culture, a place, an historical or contemporary style, or the oeuvre/work from a limited period of a particular person or group." Also of possible interest on campus are exhibitions in the O'Shaughnessy-Frey Library Center and the Sculpture Garden at the Frey Science and Engineering Center. Additionally, the University mounts exhibitions on its Minneapolis campus (see separate listing under Minneapolis, Minnesota).

Mississippi

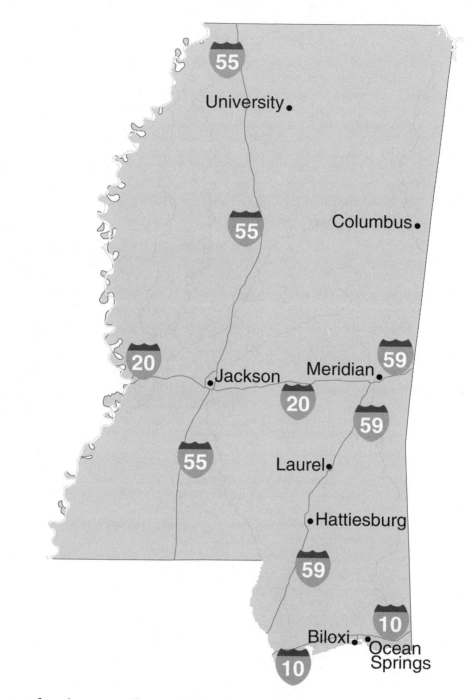

A number in parentheses following a city name indicates the number of museums/galleries in that municipality. If there is no number, one is understood. For example, in the text one listing would be found under each Mississippi city shown on map.

Mississippi

Biloxi

The Ohr-O'Keefe Museum of Art

136 George E. Ohr St., Biloxi, MS 39530
Tel: (228) 374-5547
Fax: (228) 436-3641
Internet Address: http://www.georgeohr.org
Director: Ms. Marjorie E. Gowdy
Admission: fee: adult-$3.00, child-free, senior-$2.00.
Attendance: 25,000 *Established:* 1989
Membership: Y *ADA Compliant:* Y
Parking: free, lot across from museum.
Open: Monday to Saturday, 9am-5pm.
Closed: New Year's Day, Independence Day,
 Thanksgiving Day, Christmas Day.
Facilities: **Exhibition Area**; **Shop.**
Activities: **Concerts**; **Dance Recitals**; **Education Programs**
 (adults, undergraduate/graduate students and children);
 Films; **Guided Tours**; **Lectures.**
Publications: newsletter, "The Crack'd Pot" (bi-monthly).

George E. Ohr, ceramic pitcher, 1899, 3"x6". Photograph courtesy of The Ohr-O'Keefe Museum, Biloxi, Mississippi

The Ohr Museum exhibits more than 325 pieces of work by George Ohr, the self-styled "Mad Potter of Biloxi", ranging from art pottery to utilitarian and whimsical pieces. The Center also mounts temporary exhibitions of the work of regional and national artists.

Columbus

Mississippi University for Women - Art Gallery

Fine Arts Building, 1200 College Street
Columbus, MS 39701
Tel: (662) 329-7341
Fax: (601) 241-7815
Internet Address:
 http://www.muw.edu/fine_arts/ArtEven.html
Director: Mr. Lawrence L. Feeney
Admission: free.
Attendance: 2,700 *Established:* 1960
Membership: N *ADA Compliant:* Y
Parking: free on site, south side of building.
Open:
 Monday to Friday, 9am-noon and 1pm-4:30pm.
Closed: Academic Holidays.
Facilities: **Exhibition Area** (three galleries).
Activities: **Temporary Exhibitions.**

Interior view of Main South Gallery, Mississippi University for Women. Photograph courtesy of Mississippi University for Women, Columbus, Mississippi.

There are three exhibition areas in the Fine Arts Gallery, totaling almost 350 running feet of wall space. The Gallery mounts two major exhibitions each year, as well as additional shows of student art, work of visiting artists, and art having a connection to the curriculum. The permanent collection has a number of WPA prints, other twentieth-century prints, and work by Mississippi artists.

Hattiesburg

University of Southern Mississippi - USM Museum of Art

2701 Hardy Street, Hattiesburg, MS 39406
Tel: (601) 266-5200
Internet Address: http://www.arts.usm.edu/museum
Interim Director: Marvin Kendrick

University of Southern Mississippi - USM Museum of Art, cont.

Admission: free.
Open: Weekdays, 8am-5pm.
Facilities: Exhibition Area.
Activities: Temporary Exhibitions.

The Museum presents exhibits of national shows, in addition to solo and group exhibitions by professional and student artists. Selected works from the Art Department's permanent collection are always on display. Additional exhibits are on view in the Walter Lok Exhibition Lobby. Sculpture is also placed in numerous exterior sites around the campus. The Art Department's holdings consist primarily of prints, including works by Dürer, Rembrandt, and Whistler.

Jackson

Mississippi Museum of Art (MMA)

201 E. Pascagoula St., Jackson, MS 39201
Tel: (601) 960-1515 *Ext:* 2226
Fax: (601) 960-1505
Internet Address: http://www.msmuseumart.org
Director: Mr. R. Andrew Maass
Admission: fee: Call for prices.
Attendance: 82,000 *Established:* 1911
Membership: Y *ADA Compliant:* Y
Parking: pay, lot behind museum.
Open: **Daily**, Call for hours.
Closed: Major Holidays.
Facilities: **Art Instruction Studios**; **Food Services** The Pallette Restaurant (Tues-Fri, 11am-1:30pm); **Galleries** (15,000 square feet); **Library** (3,000 volumes, on premises only); **Shop** (Mon-Fri, 10am-4:30pm; Sat, 10am-5pm; Sunday, noon-5pm).
Activities: **Education Programs** (adults and children); **Guided Tours**; **Lecture Series**.
Publications: exhibition catalogues; newsletter, "Museum Matters" (bi-monthly).

Georgia O'Keeffe, *The Old Maple, Lake George*, 1926, oil on canvas. Mississippi Museum of Art. Purchased with funds from Mississippi Arts Commission and Operation Snowball. Photograph courtesy of Mississippi Museum of Art, Jackson, Mississippi.

The Mississippi Museum of Art is the largest museum in Mississippi and offers a balanced program of both historical and contemporary works of regional, national, and international significance. Through exhibitions organized in-house and those borrowed from other museums, as well as major national and international traveling presentations, the Museum highlights a broad range of artistic traditions for all audiences. The MMA's permanent collection includes more than 3,400 works and is home to the world's largest collection of art by and relating to Mississippians and their culturally diverse heritage. The collection is also strong in 19th- and 20th-century American and European art, Japanese prints, pre-Columbian artifacts, photographs by Southerners and about the South, folk art, and Oceanic artifacts.

Laurel

Lauren Rogers Museum of Art

5th Ave. at 7th St., Laurel, MS 39440
Tel: (601) 649-6374
Fax: (601) 649-6379
Director: Mr. George Bassi
Admission: voluntary contribution.
Attendance: 35,000 *Established:* 1923 *Membership:* Y *ADA Compliant:* Y
Parking: on site.

Lauren Rogers Museum of Art, cont.

Open: Tuesday to Saturday, 10am-4:45pm; Sunday, 1pm-4pm.

Closed: Legal Holidays.

Facilities: **Galleries**; **Library** (20,000 volume, on premises only); **Reading Room**; **Shop**.

Activities: **Concerts**; **Films**; **Gallery Talks**; **Guided Tours**; **Lectures**; **Temporary Exhibitions**; **Traveling Exhibitions**.

Publications: brochure; exhibition catalogues; handbook, "LRMA Handbook of the Collections"; newsletter (quarterly).

In addition to housing a collection of Native American baskets, English silver, and 19th- and 20th-century art, the Museum presents temporary exhibitions.

Meridian

Meridian Museum of Art

25th Ave. and 7th St., Meridian, MS 39302

Tel: (601) 693-1501

Director: Mr. Terence Heder

Admission: voluntary contribution.

Attendance: 11,000 *Established:* 1969 *Membership:* Y

Parking: free on site.

Open: Tuesday to Sunday, 1pm-5pm.

Closed: Legal Holidays.

Facilities: **Architecture** (former Carnegie Library Bldg., built 1912-13); **Classrooms**; **Galleries**; **Lecture Room**.

Activities: **Art Classes** (adults and children); **Lecture Series**; **Workshops**.

Publications: brochure (biennial); newsletter (monthly).

The collection of the Museum includes 18th-century English portraits, 20th-century American art, and the work of Mississippi artists. It also mounts temporary exhibitions.

Ocean Springs

Walter Anderson Museum of Art (WAMA)

510 Washington Ave., Ocean Springs, MS 39564

Tel: (228) 872-3164

Fax: (228) 875-4494

Internet Address: http://www.walterandersonmuseum.org

C.E.O.: Ms. Clayton Bass

Admission:
fee: adult-$5.00, child-$2.00, student-$3.00, senior-$3.00.

Attendance: 30,000 *Established:* 1991

Membership: Y *ADA Compliant:* Y

Parking: free at Community Center and on street.

Open: Monday to Saturday, 10am-5pm;
Sunday, 1pm-5pm.

Closed: New Year's Day, Easter, Thanksgiving Day,
Christmas Day.

Facilities: **Community Center**; **Exhibition Area** (8250 square feet); **Shop**.

Activities: **Arts Festival**; **Concerts**; **Dance Recitals**; **Education Programs** (adults and children); **Films**; **Guided Tours**; **Lectures**; **Performances**; **Temporary Exhibitions**; **Traveling Exhibitions**.

Publications: newsletter, "Motif" (quarterly); newsletter, "Pelican Flyer" (monthly).

Walter Anderson, *Self-Portrait*, watercolor, ca. 1950. Photograph courtesy of Family of Walter Anderson, Inc. and Walter Anderson Museum of Art, Ocean Springs, Mississippi.

Walter Anderson Museum of Art, cont.

WAMA is dedicated to the interdisciplinary work of Walter Inglis Anderson (1903-1965), a Mississippi artist who depicted the plants, animals, and people of the Gulf Coast in watercolors, drawings, oils, ceramics, and murals. Noteworthy among the Anderson works at the Museum is a series of murals Anderson created for the WPA depicting the past and present of Ocean Springs. The Museum also presents temporary exhibitions of the works of other artists.

University

The University of Mississippi - University Museums

The University of Mississippi, University Avenue
University, MS 38677
Tel: (662) 915-7073
Fax: (662) 915-7010
Internet Address: http://www.olemiss.edu/depts/u-museum
Director: Ms. Bonnie J. Krause
Admission: voluntary contribution.
Attendance: 14,000 *Established:* 1977
Membership: Y *ADA Compliant:* Y
Parking: free on site.
Open: Tuesday to Saturday, 10am-4:30pm;
 Sunday, 1pm-4pm.
Closed: Legal Holidays.
Facilities: **Classrooms**; **Exhibition Areas** (8); **Library** (1,500 volumes, on premises only).
Activities: **Education Programs** (children); **Guided Tours**; **Lectures**; **Permanent Exhibits**; **Temporary Exhibitions** (8-10/year); **Traveling Exhibitions**.
Publications: brochures; exhibition catalogues; newsletter (semi-annual).

Apulian Volute Krater, "Heroon with Youth and Old Man", Greek, ca. 330-320 B.C. David M. Robinson Collection, University Museums. Photograph courtesy of University Museums, University, Mississippi.

Located on the main Oxford campus, The University Museums consist of the Mary Buie Museum, the adjoining Kate Skipwith Teaching Museum, the Seymour Lawrence Gallery of American Art, the Fortune Gallery, and the Walton-Young Historic House. The Museums display an important collection of Greek and Roman antiquities, and a large group of paintings by the Oxford folk artist Theora Hamblett, as well as works by other Southern folk artists, World War I posters, and small collections of African and Asian art. The Museums also mount eight to ten temporary exhibitions per year.

Missouri

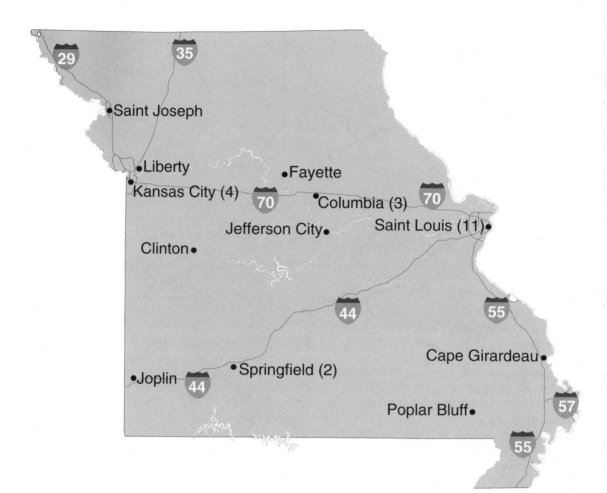

The number in parentheses following the city name indicates the number of museums/galleries in that municipality. If there is no number, one is understood. For example, in the text eleven listings would be found under Saint Louis and one listing under Jefferson City.

Missouri

Cape Girardeau

Southeast Missouri State University Museum

Southeast Missouri State University, 1 University Plaza, MS 4275, Cape Girardeau, MO 63701

Tel: (571) 651-2260
Fax: (571) 651-5103
Internet Address: http://www.semo.edu
Director: Ms. Jenny Strayer
Admission: free.
Attendance: 18,000 *Established:* 1976 *Membership:* Y *ADA Compliant:* Y
Open: Monday to Friday, 9am-4pm.
Closed: Legal Holidays.
Facilities: **Exhibition Area.**
Activities: **Lectures.**
Publications: exhibition brochures.

The Museum holds collections of fine art, regional and American military history, and Mississippian archaeology. A gallery features monthly changing exhibits of art including the Annual Juried Student Assessment Exhibition.

Clinton

Henry County Museum and Cultural Arts Center

203 W. Franklin St., Clinton, MO 64735

Tel: (660) 885-8414
Coordinator: Ms. Barbara Lasswell
Admission: fee-$3.00.
Attendance: 4,600 *Established:* 1974 *Membership:* Y *ADA Compliant:* Y
Open: **April to December**, Tuesday to Saturday, noon-4pm.
Closed: New Year's Day, Thanksgiving Day, Christmas Day.
Facilities: **Exhibition Area.**
Publications: brochures; newsletter (quarterly).

The Museum houses historical documents, war relics, memorabilia, an art gallery, and a turn-of-the-century village.

Columbia

State Historical Society of Missouri

1020 Lowry St., Columbia, MO 65201-7298

Tel: (573) 882-7083
Fax: (573) 884-4950
Internet Address: http://www.system.missouri.edu/shs
Exec. Director: Dr. James W. Goodrich
Admission: free.
Established: 1898 *Membership:* Y *ADA Compliant:* Y
Parking: metered on street.
Open: Monday to Friday, 8:30am-4pm.
Closed: Legal Holidays, including holiday weekends.
Facilities: **Gallery; Library** (453,000 books, maps, photographs, pamphlets and periodicals; newspaper library); **Reading Room.**
Activities: **Guided Tours; Temporary Exhibitions.**
Publications: books & booklets; magazine, "Missouri Historical Review" (quarterly).

State Historical Society of Missouri, cont.

Located on Lowry Mall on the ground floor, east side of the University of Missouri, Columbia's Ellis Library, the State Historical Society of Missouri maintains reference, newspaper and manuscript libraries, and a fine art collection. The art collection focuses on works by Missouri or Missouri-related artists, with creations by George Caleb Bingham and Thomas Hart Benton forming the foundation of the collection. Included are Bingham's "Order No. 11", Missouri's most famous historical painting, as well as over twenty of the artist's portraits and genre paintings. The Thomas Hart Benton Collection contains the "Year of Peril" series, consisting of seven World War II propaganda paintings and two companion pieces, and numerous lithographs and other works. Other Missouri artists, both past and present, are well represented in the Society's holdings. Additional valuable art properties include an extensive editorial cartoon collection with original drawings by Daniel Fitzpatrick, S. J. Ray, Bill Mauldin, Don Hesse, Tom Engelhardt, and others.

Stephens College - Davis Art Gallery

Stephens College, 1220 East Broadway, Columbia, MO 65215
Tel: (573) 876-7173
Internet Address: http://www.stephens.edu
Director: Ms. Rosalind Kimball-Moulton
Admission: voluntary contribution.
Attendance: 500 *Established:* 1962 *ADA Compliant:* Y
Open: Monday to Friday, 10am-4pm.
Closed: Academic Holidays.
Facilities: Gallery.
Activities: Temporary Exhibitions.

The Gallery offers monthly exhibitions of work by professional artists, faculty and students.

University of Missouri-Columbia - Museum of Art and Archaeology

Pickard Hall, Francis Quadrangle
(corner of University Ave. and 9th St.)
Columbia, MO 65211
Tel: (573) 882-3591
Fax: (573) 884-4039
Internet Address:
 http://www.research.missouri.edu/museum/index.htm
Director: Ms. Marlene Perchinske
Admission: voluntary contribution.
Attendance: 32,000 *Established:* 1957
Membership: Y *ADA Compliant:* Y
Parking: visitors garage on University Ave. and 9th St..
Open: Tuesday to Wednesday, 9am-5pm;
 Thursday, 9am-5pm and 6pm-9pm;
 Friday, 9am-5pm;
 Saturday to Sunday, noon-5pm.
Closed: Legal Holidays, Christmas Day to New Year's Day.

Facilities: **Galleries**; **Lecture Hall** (116 seats); **Library** (6,000 volumes); **Shop**.
Activities: **Education Programs** (undergraduate and graduate students); **Gallery Talks** (including "Midday Gallery Events", Wednesday, 12:15pm); **Guided Tours**; **Lectures**; **Permanent Exhibitions**; **Temporary Exhibitions**.

Artist unknown, *Durga on a Lion,* 17th century, cast bronze, Himachel Pradesh, India. Museum of Art and Archaeology. Gift of Dr. and Mrs. Samuel Eilenberg. Photograph courtesy of Museum of Art and Archaeology, University of Missouri-Columbia, Columbia, Missouri.

Publications: "Handbook of the Collections"; bulletin, "Muse, Annual of the Museum of Art and Archaeology"; collection catalogue; exhibition catalogues; newsletter, "The News" (3/year).

University of Missouri-Columbia - Museum of Art and Archaeology, cont.

Museum galleries house art and artifacts from six continents and five millennia. Special exhibitions, lectures, seminars, gallery talks, and educational programs associated with permanent and loan exhibitions provide a wide range of activities. Museum holdings include more than 13,000 objects from a wide variety of civilizations and cultures and spanning all periods from the Paleolithic to the present. Strengths include classical antiquities and Western art from the early Renaissance to contemporary. The cast gallery has casts of classical Greek and Roman sculpture. Also of possible interest is the George Caleb Bingham Gallery, located in the Fine Arts Building, which presents temporary exhibitions of work by professional artists, faculty, and students (573) 882-3555.

Fayette

Central Methodist College - Ashby-Hodge Gallery of American Art

Central Methodist College, 411 Central Methodist College Square, Fayette, MO 65248

Tel: (660) 248-6324 or (660) 248-6304

Fax: (660) 248-2622

Internet Address: http://cmc.edu

Curator: Dr. Sue Geist

Admission: free.

Parking: free on site.

Open: Tuesday to Thursday, 1:30pm-4:30pm;
Sunday, 2:30pm-5pm (during special exhibits).

Facilities: **Exhibition Area**.

The Ashby-Hodge Gallery of American Art is located on the campus of Central Methodist College, which has been designated a National Historic District. The Gallery presents temporary exhibitions, but its principle focus is its permanent collection of oil paintings, watercolors,, lithographs, bronzes, drawings, and acrylics by prominent American Regional artists, such as Thomas Hart Benton (and at least six of his followers), Emile Gruppe, and Birger Sandzen.

Charles Banks Wilson, *As Long As There Are Horses*, 1959, egg tempera on panel, 27 x 30 inches. Collection of and photograph courtesy of Ashby-Hodge Gallery of American Art, Fayette, Missouri.

Jefferson City

Missouri State Museum

Capitol Ave., Missouri State Capitol, Jefferson City, MO 65101

Tel: (573) 751-2854

Fax: (573) 526-2927

Director: Mr. John Cunning

Admission: free.

Attendance: 200,000 *Established:* 1919 *ADA Compliant:* Y

Open: Daily, 8am-5pm.

Closed: New Year's Day, Easter, Thanksgiving Day, Christmas Day.

Facilities: **Exhibition Area**.

Activities: **Guided Tours** (on the hour, 8am-11am and 1pm-4pm; groups reserve in advance); **Permanent Exhibits**; **Temporary Exhibitions**; **Traveling Exhibitions**.

Publications: "The Thomas Hart Benton Mural in the Missouri State Capitol"; pamphlets.

Located on the first floor adjacent to the rotunda of the State Capitol, the Missouri State Museum preserves and interprets the natural and cultural history of the State of Missouri. The Museum has two exhibition areas: the History Hall and the Resources Hall. Thomas Hart Benton's mural, " A Social History of the State of Missouri" (commissioned by the legislature in 1935), is painted on the four walls of the House Lounge, a large meeting room on the third floor in the west wing of the Capitol.

Joplin

George A. Spiva Center for the Arts

222 W. 3rd St. (southeast corner of 3rd St. and Wall Ave.)
Joplin, MO 64801
Tel: (417) 782-2700
Internet Address:
 http://clandjop.com/~artspiva/index.html
Director: Ms. Darlene Brown
Admission: voluntary contribution.
Attendance: 10,000 *Established:* 1947
Membership: Y *ADA Compliant:* Y
Open: Tuesday to Saturday, 10am-5pm;
 Sunday, 1pm-5pm.
Closed: Legal Holidays.
Facilities: **Exhibition Area** (3,000 square feet);
 Library (250 volumes, non-circulating only).
Activities: **Films; Gallery Talks; Guided Tours;
 Lectures; Traveling Exhibitions;
 Workshops.**

Exterior view of George A. Spiva Center for the Arts.
Rendering courtesy of George A. Spiva Center for the Arts,
Joplin, Missouri.

Publications: catalogue, "Photo-Spiva"; exhibition catalogues, "Spiva Annual Competitive".

The Center offers rotating exhibitions, classes for children, lectures, and workshops for adults. The Main Gallery in the ground level of the building is divided into three spacious rooms. Exhibitions include solo and groups shows, an annual national photo contest, a national contemporary craft competition, and a membership show. The Regional Focus Gallery on the second floor is used exclusively to mount monthly exhibits of work by local artists.

Kansas City

Avila College - Thornhill Gallery

11901 Wornall Road, Kansas City, MO 64145
Tel: (816) 942-8400 *Ext:* 2259
Fax: (816) 942-3362
Internet Address: http://www.avila.edu
Director: Ms. Lisa Ann Sugimoto
Admission: free.
Attendance: 2,000 *ADA Compliant:* Y
Open: **August 16 to May 14**, Monday to Friday, 10am-noon and 1pm-5pm.
Closed: New Year's Day, Easter, Thanksgiving Day, Christmas Day.
Facilities: **Exhibition Area** (850 square feet).
Activities: **Temporary/Traveling Exhibitions.**
Publications: annual calendar.

The Gallery presents temporary exhibitions.

Kemper Museum of Contemporary Art

4420 Warwick Blvd. (1 block east of 45th and Main Streets), Kansas City, MO 64111-1821
Tel: (816) 561-3737
Fax: (816) 753-5806
Internet Address: http://www.kemperart.org
Director: Mr. Daniel T. Keegan
Admission: voluntary contribution.
Attendance: 120,000 *Established:* 1994 *Membership:* Y *ADA Compliant:* Y
Parking: free on site.
Open: Tuesday to Thursday, 10am-4pm; Friday, 10am-9pm; Saturday, 10am-5pm.
Closed: New Year's Day, Thanksgiving Day, Christmas Day, Independence Day.

Kemper Museum of Contemporary Art, cont.

Facilities: **Architecture** (1994 designed by Gunnar Birkerts); **Exhibition Area** (10,000 square feet); **Food Services** Café Sebastienne (Tuesday-Sunday, 11am-3pm; also Friday., 6pm-9pm); **Sculpture Garden**; **Shop** (one-of-a-kind artworks, cards, books, posters).

Activities: **Education Programs** (adults, college students and children); **Films**; **Guided Tours** (Sunday, 2pm and by appt.); **Lectures**; **Temporary Exhibitions**; **Traveling Exhibitions**.

Publications: exhibition catalogues; newsletter, "The Kemper Contemporary" (quarterly).

Exterior view of Kemper Museum of Contemporary Art (1994), designed by Gunnar Birkerts. Photograph by Timothy Hursley, courtesy of Kemper Museum of Contemporary Art, Kansas City, Missouri.

Kansas City's contemporary art museum, the Kemper Museum of Contemporary Art boasts a rapidly growing permanent collection of modern and contemporary works by artists from around the world, working in all media. Collection artists include Louise Bourgeois, Dale Chihuly, Helen Frankenthaler, Willem de Kooning, Robert Mapplethorpe, Georgia O'Keeffe, Robert Rauschenberg, Frank Stella, and Wayne Thiebaud. The Museum hosts temporary exhibitions, installations, performance work, film and video series, lectures, concerts, children's workshops, and other creative programs designed both to entertain and to challenge.

The Nelson-Atkins Museum of Art

4525 Oak St. (3 blocks northeast of Country Club Plaza), Kansas City, MO 64111-1873

Tel: (816) 751-1278

Fax: (816) 561-7154

TDDY: (816) 751-1263

Internet Address: http://www.nelson-atkins.org

Director: Mr. Marc F. Wilson

Admission: fee: adult-$5.00, child-$1.00, student-$2.00.

Attendance: 385,000 *Established:* 1933

Membership: Y *ADA Compliant:* Y

Parking: free lot on 45th St..

Open: Tuesday to Thursday, 10am-4pm;
Friday, 10am-9pm;
Saturday, 10am-5pm;
Sunday, noon-5pm.

Closed: New Year's Day, Memorial Day, Independence Day, Thanksgiving Day, Christmas Eve to Christmas Day.

Facilities: **Architecture** (neoclassical building, 1933 design by Wight and Wight of Kansas City); **Auditorium** (510 seats); **Classrooms**; **Food Services** Rozelle Court Restaurant (Tues-Fri, 11am-3pm; Fri, 5pm-9pm; Sat, 11am-3:30pm; Sun, 1pm-3:30pm); **Galleries** (58); **Library** (75,000 volumes, non-circulating); **Period Rooms** (11); **Reading Room**; **Sculpture Garden**; **Shop** (books, unique gift items).

Michelangelo Merisi Da Caravaggio, *Saint John the Baptist,* c. 1604. Nelson-Atkins Museum of Art. Photograph courtesy of Nelson-Atkins Museum of Art, Kansas City, Missouri.

Activities: **Concerts**; **Education Programs** (adults, college students, and children); **Films**; **Gallery Talks**; **Guided Tours** (Tues-Sat, 11am/1pm/2pm; Sat, 10:30am/11am/1pm/1pm; Sun, 1:30pm/2pm/2:30pm); **Lectures**; **Permanent Exhibits**; **Temporary Exhibitions**.

Publications: calendar (10/year).

Kansas City, Missouri

The Nelson-Atkins Museum of Art, cont.

Although the Nelson-Atkins Museum has prestigious collections of European and American art, its principal glory is its Asian Collection consisting of more than 5,000 objects dating from the 13th century B.C.. The Museum's collection of European paintings includes all important schools and periods from the early Italian Renaissance to contemporary art, often complemented by exhibits of furniture, decorative arts, and period rooms. Its American galleries boast the largest public collection of works by Missouri native Thomas Hart Benton. There are also displays of classical antiquities and the arts of Africa, Oceania, and the Americas. Permanent exhibitions are supplemented by temporary exhibits showcasing works from the permanent collection and other institutions. The Kansas City Sculpture Park on the Museum's grounds is home to the largest U.S. collection of monumental bronzes by the British sculptor Henry Moore, as well as works by other modern masters. The permanent collection contains more than 28,000 works of art.

University of Missouri-Kansas City - Gallery of Art

204 Fine Arts, 5100 Rockhill Road, Kansas City, MO 64110-2499
Tel: (816) 235-1502
Fax: (816) 235-5507
Internet Address: http://www.umkc.edu/gallery
Director: Mr. Craig A. Subler
Admission: free.
Attendance: 10,000 *Established:* 1975 *Membership:* Y *ADA Compliant:* Y
Parking: metered parking adjacent to site.
Open: **September to April**, Tuesday to Friday, noon-5pm; Saturday to Sunday, 1pm-5pm.
 May to August, Tuesday to Friday, noon-5pm.
Closed: ML King Day, Memorial Day, Independence Day, Labor Day, Thanksgiving Day,
 Christmas Day to New Year's Day.
Facilities: **Exhibition Area.**
Activities: **Education Programs** (undergraduate and graduate college students); **Guided Tours**
 (upon request); **Lectures** (upon request); **Traveling Exhibitions**.
Publications: exhibition catalogues (quarterly).

A non-collecting facility, the UMKC Gallery of Art presents temporary exhibitions of work by professional artists.

Liberty

William Jewell College - Stocksdale Gallery of Art

Brown Hall, 2nd Floor, 500 College Hill, Liberty, MO 64068
Tel: (816) 781-7700 Ext. 5413
Fax: (816) 415-5027
Internet Address: http://www.jewell.edu/academia/stocksdale
Gallery Director: Nano Nore
Admission: free.
Open: **September to May**, Monday to Friday, 9am-6pm; Saturday, 9am-noon.
Facilities: **Gallery.**
Activities: **Temporary Exhibitions.**

The gallery presents temporary exhibitions of work by regionally and nationally known artists, as well as a biennial faculty exhibition, student art competitions, and a graduating seniors art show.

Poplar Bluff

Margaret Harwell Art Museum

421 N. Main St., Poplar Bluff, MO 63901
Tel: (573) 686-8002
Fax: (573) 686-8017
Internet Address: http://www.webcurrent.com/mham
Director: Ms. Tina M. Magill

Margaret Harwell Art Museum, cont.

Admission: free.

Attendance: 13,000 *Established:* 1981 *Membership:* Y *ADA Compliant:* Y

Parking: behind museum and on street.

Open: Tuesday to Friday, noon-4pm; Saturday to Sunday, 1pm-4pm.

Closed: Legal Holidays.

Facilities: **Architecture** (former residence, 1883); **Exhibition Area** (2 floors); **Shop**.

Activities: **Education Programs** (adults and children); **Guided Tours** (by reservation); **Temporary Exhibitions** (monthly).

Publications: newsletter (quarterly).

Owned by the City of Poplar Bluff, MHAM offers a variety of monthly art exhibitions, tours, education, art instruction, and children's art classes.

Saint Joseph

The Albrecht Kemper Museum of Art (AKMA)

2818 Frederick Ave., Saint Joseph, MO 64506-2998

Tel: (816) 233-7003

Fax: (816) 233-3413

Internet Address: http://www.albrecht-kemper.org

Director: Mr. Terry L. Oldham

Admission: fee: adult-$3.00, child-free, student-$1.00, senior-$2.00.

Attendance: 20,000 *Established:* 1914

Membership: Y *ADA Compliant:* Y

Parking: free on site off Frederick Blvd..

Open: Tuesday to Friday, 10am-4pm;
Saturday to Sunday, 1pm-4pm.

Closed: New Year's Day, Easter, Independence Day,
Thanksgiving Day, Christmas Day.

Facilities: **Architecture** (Colonial/Georgian-style mansion, 1936 design by E.B. Delk and Eugene Meier); **Food Services** Terrace Dining Room (by request); **Galleries** (8); **Grounds** (formal rose garden); **Library** (2,500 volumes); **Reading Room**; **Sculpture Garden**; **Shop** (books, handcrafted jewelry, ceramics); **Theatre/Lecture Hall** (147 seats).

Activities: **Education Programs** (adults and children); **Film Series**; **Gallery Talks**; **Guided Tours** (by reservation 1 week in advance); **Lectures**; **Performances**; **Permanent Exhibits**; **Temporary Exhibitions**.

Publications: exhibition catalogues; newsletter, "Artmail" (3/year).

Wayne Thiebaud, *Man Sitting - Back View*, 1964, oil on canvas, 36 x 29½ inches, purchased with funds from William Toben Memorial fund and donations from Museum friends, Albrecht Kemper Museum of Art. Photograph courtesy of Albrecht Kemper Museum of Art, St. Joseph, Missouri.

The Albrecht-Kemper Museum of Art houses one of the finest collections of 18th-, 19th-, and 20th-century American art in the Midwest. The Museum's collection includes an extraordinary group of colonial portraits, holdings in American landscape painting, examples of American Impressionism and post-Impressionist Boston School painting, urban realist paintings from the Ashcan School, and extensive holdings in 19th- and 20th-century graphic arts. Among other highlights are Mary Cassatt's pastel, "Mother Looking Down Embracing Both of Her Children" and Thomas Hart Benton's "Custer's Last Stand". A wide variety of special programs complement the Museum's exhibitions.

Saint Louis

Craft Alliance Gallery

6640 Delmar, Saint Louis, MO 63130

Tel: (314) 725-1151

Fax: (314) 725-2068

C.E.O.: Ms. Sharon M. McPherron

Admission: free.

Attendance: 12,000 *Established:* 1962 *Membership:* Y *ADA Compliant:* Y

Craft Alliance Gallery, cont.

Open: Monday to Wednesday, 10am-6pm; Thursday to Friday, 10am-8pm; Saturday, 10am-6pm; Sunday, noon-5pm.

Closed: Legal Holidays.

Facilities: **Exhibition Area** (1,500 square feet); **Library** (100 volumes); **Shop** (Tuesday-Saturday, 10am-5pm); **Studios and Workshops**.

Activities: **Education Programs** (adults and children); **Guided Tours**; **Lectures**; **Traveling Exhibitions**.

Publications: newsletter/class brochure (3/year).

The Gallery presents contemporary art in craft media, including ceramics, glass, fiber, metal, and wood.

Forum for Contemporary Art

3540 Washington, Saint Louis, MO 63103

Tel: (314) 535-4660

Fax: (314) 535-1226

Internet Address: www.forumart.org

Director: Ms. Elizabeth Wright Millard

Admission: donations.

Attendance: 17,000 *Established:* 1980 *Membership:* Y *ADA Compliant:* Y

Parking: metered on street or commercial lot.

Open: Tuesday to Saturday, 10am-5pm.

Closed: Legal Holidays.

Facilities: **Galleries** (2,400 square feet).

Activities: **Concerts**; **Education Programs** (adult and children); **Guided Tours**; **Lectures**; **Traveling Exhibitions**.

Publications: brochures; exhibition catalogues; gallery guides; newsletter (quarterly).

The Forum for Contemporary Art presents a broad range of media and topics by today's artists. Its goal is to engage people of all ages in the appreciation and interpretation of contemporary art and ideas. A new building by architect Brad Cloepfil, Allied Works Architecture, is scheduled to open in 2002.

Laumeier Sculpture Park and Gallery

12580 Rott Road, Saint Louis, MO 63127

Tel: (314) 821-1209

Fax: (314) 821-1248

Director: Dr. B.J. Nierengarten-Smith

Admission: free.

Attendance: 450,000 *Established:* 1976

Membership: Y *ADA Compliant:* Y

Parking: free on site.

Open: **Museum,**
 Tuesday to Saturday, 10am-5pm; Sunday, noon-5pm.
 Park,
 Daily, 7am-sunset.

Facilities: **Amphitheater**; **Crafts Gallery**; **Education Center**; **Museum Galleries, Picnic Area**; **Sculpture Garden**; **Shop**.

Activities: **Contemporary Art Fair** (annual, Mother's Day); **Family Festival** (annual, fall); **Outdoor Summer Art Camp**; **Temporary Exhibitions**; **Tours**; **Winter Solstice Program** (annual).

Publications: catalogue; pamphlets.

This 100-acre park exhibits monumental outdoor contemporary sculpture. The collection includes works by Alexander Liberman, Ernest Trova, Jonathan Borofsky, Dan Graham, and many others.

Niki de Saint Phalle, *Ricardo Cat,* 1999, aggregate, ceramic, and mirror tiles. In Laumeier's Children's Sculpture Garden. Photograph by Sarah Carmody, courtesy of Laumeier Sculpture Park, St. Louis, Missouri.

Maryville University - Morton J. May Foundation Gallery

13550 Conway, Saint Louis, MO 63141
Tel: (314) 529-9300
Internet Address: http://www.maryville.edu
Director: Nancy N. Rice, MFA
Admission: free.
Attendance: 1,200 *ADA Compliant:* Y
Parking: free on site.
Open: Monday to Thursday, 8am-10pm; Friday to Saturday, 8am-6pm; Sunday, 2pm-10pm.
Facilities: **Exhibition Area** (400 square feet).
Activities: **Education Programs** (university students); **Guided Tours**; **Lectures**.
Publications: "Maryville Student Art Journal".

The Gallery presents temporary exhibitions of works by students, faculty, and professional artists.

The Saint Louis Art Museum

1 Fine Arts Drive, Forest Park, Saint Louis, MO 63110-1389
Tel: (314) 721-0072
Fax: (314) 721-6172
TDDY: (314) 721-4807
Internet Address: http://www.slam.org
Director: Mr. Brent Benjamin
Admission: free.
Attendance: 480,000 *Established:* 1906 *Membership:* Y *ADA Compliant:* Y
Parking: free on site.
Open: Tuesday, 1:30pm-8:30pm; Wednesday to Sunday, 10am-5pm.
Closed: New Year's Day, Thanksgiving Day, Christmas Day.
Facilities: **Architecture** (designed for World's Fair, 1904); **Auditorium** (479 seats); **Classrooms**;
 Food Services Restaurant (Tues-Sun, 11am-3:30pm & Tues, 5pm-8pm; Sun 10am-2pm);
 Galleries (100); **Library** (70,000 volumes); **Reading Room**; **Sculpture Garden**; **Shop**.
Activities: **Education Programs** (adults and children); **Films**; **Gallery Talks**; **Guided Tours**
 (1:30pm); **Lectures**.
Publications: brochures; bulletin (semi-annual); calendar; exhibition catalogues; magazine
 (quarterly); report (biennial).

The Saint Louis Art Museum ranks among the top ten art museums nationally in attendance, and
it is the oldest publicly supported art museum in the nation. Its collection consists of over 30,000
objects, spanning the centuries from ancient Egypt to the present, displayed in 100 galleries The
Museum structure was designed by Cass Gilbert in the Beaux Arts style, and it was first used as a
part of the 1904 World's Fair. The Museum displays the following collections: African Art (19th- and
20th-century sculpture, as well as ancient works, face masks, headdresses, furniture, portraits, and
free-standing figures, ranging from naturalistic to abstract styles); American Art (portraits, Hudson
river landscapes, scenes from the Western Frontier by George Caleb Bingham and Charles Wimar,
works by American Impressionists such as Twachtman and Frieseke, as well as modern and contem-
porary works by such artists as Rothko, Lichtenstein, and Warhol); Ancient and Islamic Art, Assyrian,
Coptic, Egyptian, Greek, Iranian, Islamic, Near Eastern, Persian, Roman, and Syrian works,
including a Sumerian bearded bull's head, the Egyptian "Striding Man", and a collection of Turkish
rugs); Asian Art (Chinese bronzes, Buddhist sculpture, Chinese calligraphy and painting, a broad
range of ceramics and decorative arts, and Japanese art); Decorative Arts and Design (Renaissance,
Western, and contemporary works, including furniture, silver, glass, weapons and armor, architectur-
al fragments, and examples of industrial design); European Painting and Sculpture (particularly
strong in all major categories of 17th-century Dutch art - landscapes, portraits, and still life and genre
scenes); Modern Art (including works by modern masters such as Beckmann, Cézanne, Degas,
Gauguin, Kandinsky, Matisse, Modigliani, Monet, Picasso, and van Gogh, as well as more recent works
by Bourgeois, Close, Guston, Holzer, Kelly, Kiefer, Kline, Lichtenstein, Marden, Mitchell, Moore,
Oldenburg, Richter, and Stella); Art of Oceania and the Americas (particularly strong in Oceanic and

The Saint Louis Art Museum, cont.

Pre-Columbian pieces); and Prints, Drawings, and Photography (over 10,000 works by artists from all periods, including Dürer, Manet, Matisse, Picasso, and Rembrandt, and photographs by Abbott, Bayer, Simpson, Steichen, Strand, and Watkins).

Saint Louis Artists' Guild

2 Oak Knoll Park, Saint Louis, MO 63105
Tel: (314) 727-6266
Fax: (314) 727-9190
Exec. Director: Ms. Jody Barksdale
Admission: voluntary contribution.
Established: 1886
Membership: Y *ADA Compliant:* Y
Open: Monday, noon-4pm;
Wednesday to Sunday, noon-4pm.
Facilities: **Galleries.**
Activities: **Arts Festival; Concerts; Films; Gallery Talks; Juried Exhibits; Lectures; Performances; Permanent Exhibits; Temporary Exhibitions.**
Publications: membership directory (annual).

Exterior view of Two Oak Knoll Park. Photograph courtesy of St. Louis Artists' Guild, St. Louis, Missouri.

The St. Louis Artists' Guild is located in Two Oak Knoll Park, a large stone mansion built by industrialist Alvin D. Goldman. The Guild sponsors invitational, special, and juried exhibitions of artistic and cultural merit. Over the past 100 years, most professional artists in St. Louis have achieved their first recognition through the Guild's competitive Exhibitions.

Saint Louis University - Museum of Contemporary Religious Art (MOCRA)

3700 John E. Connelly Mall, Saint Louis, MO 63108
Tel: (314) 977-7170
Fax: (314) 977-2999
Internet Address: http://www.slu.edu/the_arts/
Admission: voluntary contribution.
Attendance: 7,500 *Membership:* N *ADA Compliant:* Y
Parking: metered on street.
Open: Tuesday to Sunday, 11am-4pm.
Closed: Academic Holidays.
Facilities: **Exhibition Area.**
Activities: **Guided Tours; Permanent Exhibits; Temporary Exhibitions.**
Publications: exhibition catalogues; gallery guides.

The mission of MOCRA is to be an ongoing forum for the dialogue between contemporary artists and the various religious traditions, as well as a place for greater understanding among various religions. The Museum is located in a spacious chapel, which was renovated to make it suitable for the display of art without eliminating the sense that it was a sacred place. MOCRA is developing its own permanent collection and features group and solo exhibitions three times each year.

View of gallery, Museum of Contemporary Religious Art. Foreground: "Torso with Outstretched Arm", by Stephen DeStaebler (1990), bronze and nickel, 60.5 x 36 inches. Background: "Caelestis, Spatium, Res" (1989-1990), acrylic, canvas, aluminum, 36 x 22.25 inches. Photograph by Cheryl Ungar courtesy of Museum of Contemporary Religious Art, Saint Louis University, Saint Louis, Missouri.

Saint Louis University - Samuel Cupples House

221 North Grand Blvd. (Frost Campus), Saint Louis, MO 63103

Tel: (314) 977-3025

Fax: (314) 977-3581

Internet Address: http://www.slu.edu/the_arts/cupples/index.html

Admission: fee: adult-$4.00, child-free, student-free, senior-$3.00.

Membership: Y

Parking: parking garage at Grand Blvd & Laclede Ave.

Open: Monday, by appointment only; Tuesday to Sunday, 11am-4pm.

Closed: Legal Holidays, January.

Facilities: **Architecture** (Romanesque Revival mansion, 1888).

Activities: **Guided Tours** (groups larger than 20 must reserve; $3.00 per person).

The Samuel Cupples House was acquired by the University in 1942, and restored beginning in 1970. It is a forty-two-room Richardsonian Romanesqe mansion built of purple Colorado sandstone. The House contains Tiffany windows, antique furniture, rare books, and decorative arts (Meissen, Staffordshire, English silver, and 1,000 piece antique art glass collection), as well as the University's art collection, including Northern and Italian Renaissance paintings, and nineteenth-century landscapes.

University of Missouri at Saint Louis - Gallery 210

210 Lucas Hall, 8001 Natural Bridge Road, Saint Louis, MO 63121

Tel: (314) 553-5975

Internet Address: http://www.umsl.edu/~gallery

Director: Terry Suhre

Open: Tuesday to Saturday, 11am-5pm.

Facilities: **Exhibition Area**.

Activities: **Temporary Exhibitions** (6/year).

Located in Lucas Hall, Gallery 210 hosts five exhibitions by outside artists and one student art competition each year.

Washington University Gallery of Art

Steinberg Hall, Forsyth and Skinker Blvds., Saint Louis, MO 63130-4899

Tel: (314) 935-5490

Fax: (314) 935-7282

Internet Address:
http://www.wustl.edu/galleryofart

Director: Mark S. Weil

Admission: voluntary contribution.

Attendance: 30,000 *Established:* 1881

ADA Compliant: Y

Parking: free on site.

Open: **Labor Day to mid-May,**
Monday to Friday, 10am-4:30pm;
Saturday to Sunday, 1pm-4pm.

Closed: Legal Holidays.

Facilities: **Auditorium** (300 seats); **Exhibition Area**; **Library** (50,000 volumes); **Shop**.

Activities: **Films**; **Gallery Talks**; **Guided Tours**; **Lectures**.

Publications: "An Illustrated Checklist of the Collection"; "Calendar of Events" (semi-annual); exhibition catalogues.

Alexander Calder, *Five Rudders*, 1964, painted sheet metal and rods, height 154 inches. Behind sculpture is exterior view of Steinburg Hall (Washington University Gallery of Art) (1960), designed by Fumihiko Maki. Photograph courtesy of Washington University Gallery of Art, St. Louis, Missouri.

Washington University Gallery of Art, cont.

Each year the Gallery organizes special loan exhibitions, presents faculty and student shows, and arranges installations of works from the permanent collection. The Gallery of Art preserves 3,000 objects ranging from Egyptian mummies and Greek vases to contemporary mixed-media constructions. European paintings by Barbizon, Realist, and Academic masters, and American paintings of the Hudson River School reflect 19th-century St. Louis tastes. Works by Dupre, Daumier, Church, and Gifford are highlights of the collection. Twentieth-century art is represented by Picasso, Ernst, and Miró, as well as the post-war painters Pollock, de Kooning, and Gorky, among others.

Webster University - Cecille R. Hunt Gallery

8342 Big Bend Road, Saint Louis, MO 63119
Tel: (314) 968-7171
Internet Address: http://www.websteruniv.edu/depts/finearts/art/news/hunt.html
Admission: free.
Established: 1983
Open: Monday to Friday, 10am-4pm.
Facilities: Gallery.
Activities: Temporary Exhibitions.

The Gallery presents art by local, national, and international artists and hosts visiting artists, scholarly lectures, and seminars relating to each exhibition.

Springfield

Southwest Missouri State University - Art and Design Gallery

333 E. Jefferson Ave. at Walnut St., Springfield, MO 65804
Tel: (417) 866-4861
Internet Address: http://www.smsu.edu/contrib/art/resources/art_design_gallery.html
Admission: free.
Open: Academic Year, Tuesday to Saturday, noon-5pm.
Facilities: Exhibition Area.
Activities: Temporary Exhibitions.

The Gallery presents monthly exhibitions during the school year. Exhibitions have included the work of distinguished artists and designers from all regions of the country, as well as annual shows of faculty and senior students in design.

Springfield Art Museum

1111 E. Brookside Drive, Springfield, MO 65807-1899
Tel: (417) 837-5700
Fax: (417) 837-5704
Director: Mr. Jerry A. Berger
Admission: voluntary contribution.
Attendance: 50,000 *Established:* 1928
Membership: Y *ADA Compliant:* Y
Parking: free on site.
Open: Tuesday to Wednesday, 9am-5pm;
 Thursday, 9am-8pm;
 Friday to Saturday, 9am-5pm;
 Sunday, 1pm-5pm.
Closed: Legal Holidays.
Facilities: **Auditorium** (400 seats); **Classrooms**; **Galleries** (8); **Library** (6,000 volumes); **Reading Room**.

Covered Jar, T'ang Dynasty (China, 618-906 A.D.), date unknown, glazed earthenware. Museum Acquisition Fund, Springfield Art Museum. Photograph courtesy of Springfield Art Museum, Springfield, Missouri.

Springfield Art Museum, cont.

Activities: **Concerts**; **Dance Recitals**; **Education Programs** (adults and children); **Guided Tours**; **Lectures**; **Temporary Exhibitions**.

Publications: bulletin (bi-monthly); exhibition catalogues.

Throughout the year, the Museum schedules a variety of temporary exhibitions of traditional, modern, and contemporary art, including two national competitive exhibitions, Prints U.S.A. and Watercolor U.S.A., and MOAK 4-State Regional Exhibition featuring artists from Missouri, Oklahoma, Arkansas and Kansas. Objects from the permanent collection range from pre-Columbian artifacts, Renaissance etchings, and decorative arts, to contemporary American paintings and prints. The Museum shows works by Rembrandt, Dürer, Benton, Burchfield, Cassat, Lasansky, and Trova, among many others.

Montana

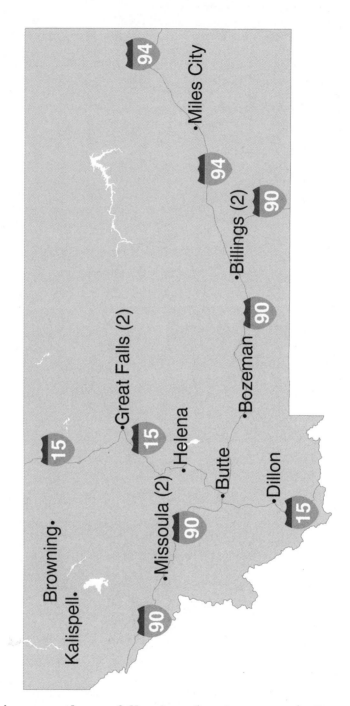

The number in parentheses following the city name indicates the number of museums/galleries in that municipality. If there is no number, one is understood. For example, in the text two listings would be found under Missoula and one listing under Kalispell.

Montana

Billings

Montana State University at Billings - Northcutt Steele Gallery

1500 N. 30th St., Billings, MT 59101
Tel: (406) 657-2324
Internet Address: http://www.msubillings.edu/art
Open: Monday to Friday, 8am-5m.
Facilities: **Exhibition Area.**
Activities: **Temporary Exhibitions.**

The Northcutt Steele Gallery provides a program of six exhibitions each academic year supplemented by visiting artists lectures. The annual Student Independent provides MSU Billings students the chance to showcase their own art work.

Yellowstone Art Museum

401 North 27th St., Billings, MT 59101-1290
Tel: (406) 256-6804
Fax: (406) 256-6817
Internet Address: http://www.yellowstone.artmuseum.org
Exec Director: Marianne Lorenz
Admission: fee: adult-$5.00, child-$2.00, student-$3.00, senior-$3.00.
Attendance: 60,000 *Established:* 1964 *Membership:* Y
Parking: commercial adjacent to site.
Open: Tuesday to Wednesday, 10am-5pm; Thursday, 10am-8pm; Friday to Saturday, 10am-5pm;
 Sunday, noon-5pm.
Closed: Legal Holidays.
Facilities: **Architecture** (addition and renovation, 1998 design by Thomas Hacker of Portland, OR; former Yellowstone County Jail building, 1916); **Auditorium** (100 seats); **Exhibition Area** (14,000 square feet); **Library** (300 volumes, available by request); **Reading Room; Shop**.
Activities: **Arts Festival; Concerts; Education Programs** (adults and children); **Films** (Thurs evenings); **Gallery Talks** (weekend afternoons); **Guided Tours; Lectures** (Thurs evenings); **Temporary/Traveling Exhibitions** (12/year); **"Thursday Night Live" Party** (3rd Thurs in month).
Publications: brochures; exhibition catalogues; newsletter (quarterly).

The Museum exhibits, documents, collects, and preserves contemporary and Western traditional art, with a primary focus on the region. It annually produces twelve to fifteen exhibitions with companion publications. In 1984 the Museum began to build a permanent collection of regional contemporary art. The Montana Collection now totals approximately 3,000 pieces. The Museum has also acquired the Virginia Snook Collection, the largest gathering of drawings, paintings, books and memorabilia of cowboy illustrator Will James. The Snook Collection also contains paintings and drawings by other regional artists including J.H. Sharp, Charles M. Russell, and others.

Bozeman

Montana State University - Museum of the Rockies

Montana State University, 600 W. Kagy Blvd., Bozeman, MT 59717-2730
Tel: (406) 994-2251
Fax: (406) 994-2682
Internet Address: http://www.montana.edu/wwwmor/
Director: Mr. Arthur H. Wolf
Admission: fee: adult-$6.00, child-$4.00.
Attendance: 153,000 *Established:* 1956 *Membership:* Y *ADA Compliant:* Y
Open: **Memorial Day to Labor Day**, Daily, 8am-8pm.
 Labor Day to Memorial Day, Monday to Saturday, 9am-5pm; Sunday, 12:30pm-5pm.
Closed: New Year's Day, Thanksgiving Day, Christmas Day.

Montana State University - Museum of the Rockies, cont.

Facilities: **Auditorium** (220 seats); **Building** (94,000 square feet); **Exhibition Area**; **Food Services** (picnic area); **Photoarchives**; **Shop**.

Activities: **Guided Tours**; **Lectures**.

Publications: newsletter, "MOR News" (quarterly).

Located on the campus of Montana State University-Bozeman, the Museum of the Rockies is a general museum focusing on the natural and cultural history of the Northern Rocky Mountain region. Exhibits encompass art, history and science and include a planetarium. The Exhibition Hall, Main Gallery, and Loft Gallery are reserved for changing exhibitions drawn from the Museum's permanent collection and traveling art, science, or history exhibits. The permanent collection consists of 280,000 objects, primarily in archaeology (45%); archival photographs (36%); history (10%); vertebrate paleontology (8%); and ethnology, geology, and fine arts (1%) Also of possible interest on campus is the School of Art's Helen E. Copeland Gallery (994-2562).

Browning

Museum of the Plains Indian and Crafts Center

U.S. Highways 89 and 2, Browning, MT 59417

Tel: (406) 338-2230

Fax: (406) 338-7404

Curator: Ms. Loretta Pepion

Admission: fee: adult-$4.00, child-free.

Attendance: 80,000 *Established:* 1938

Parking: free on site.

Open: **June to September**,
 Daily, 9am-5pm.
 October to May,
 Monday to Friday, 10am-4:30pm.

Closed: New Year's Day, Thanksgiving Day, Christmas Day.

Facilities: **Exhibition Area** (2 galleries); **Shop** (Native American arts and crafts from the Northern Plains Crafts Association).

Interior view of Museum of the Plains Indian. Photograph courtesy of Museum of the Plains Indian, Browning, Montana.

Activities: **Demonstrations**; **Gallery Talks**; **Guided Tours** (by appointment); **Lectures**; **Permanent Exhibitions**; **Temporary Exhibitions** (featuring native American artists).

Publications: catalogues; exhibition brochures (quarterly).

The Museum of the Plains Indian exhibits the creative achievements of Native American artists and craftspeople, past and present. A permanent exhibit presents the rich diversity of historic arts of the tribal peoples of the Northern Plains. Highlighting the historic exhibitions is a display of traditional costumes. Other historic displays are devoted to the numerous art forms related to the social and ceremonial aspects of tribal cultures of the region. Two special exhibition galleries are devoted to changing presentations promoting the creative work of contemporary Native American artists and craftspeople. The Museum is administered by the Indian Arts and Crafts Board of the Department of the Interior.

Butte

Arts Chateau Museum - Butte-Silver Bow Arts Foundation

321 W. Broadway at Washington, Butte, MT 59701

Tel: (406) 723-7600

Fax: (406) 723-5083

Internet Address: http://www.artschateau.org

Director: Mr. Glenn Bodish

Admission: fee: adult-$3.00, child-$1.00, senior-$2.00, family-$6.00.

Attendance: 15,000 *Established:* 1977 *Membership:* Y

Parking: on street and park & ride from Chamber of Commerce lot.

Arts Chateau Museum - Butte-Silver Bow Arts Foundation, cont.

Open: **September to May**,
> Tuesday to Saturday, 11am-4pm.
> **June to August**,
> Tuesday to Saturday, 10am-5pm;
> Sunday, noon-5pm.

Closed: December 24 to January 7, St. Patrick's Day, Easter, Independence Day, Thanksgiving.

Facilities: **Architecture** (26 room mansion, 1898 design by William Aldritch); **Galleries** (3,300 linear feet); **Art Supply Shop and Sales Gallery** (paintings, prints, pottery, calligraphy, stained glass).

Activities: **Gallery Talks**; **Guided Tours**; **Lectures** (5/year); **Permanent Exhibitions**; **Temporary Exhibitions** (10-15/year); **Workshops**.

Publications: newsletter, "The Griffin" (quarterly); schedule of events.

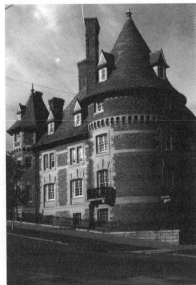

Exterior view of Arts Chateau Museum. Photograph by Bill Rautio courtesy of Arts Chateau Museum, Butte-Silver Bow Arts Foundation, Butte, Montana.

Located in an historic mansion, the Arts Chateau Museum displays a variety of artistic exhibitions, including permanent collection rooms of 18th- and 19th-century furniture and monthly fine arts exhibitions. The Museum operates as a fine and performing arts center promoting educational opportunities for the region's adults and children. The permanent collection includes paintings and drawings by Elizabeth Lochrie and works of regional artists, Victorian clothing and accessories, bells, and antique dolls and figurines. The University of Montana furniture collection and a number of works by Edgar S. Paxson are on permanent loan.

Dillon

Western Montana College Gallery-Museum

710 S. Atlantic, Dillon, MT 59725-3598

Tel: (406) 683-7126

Internet Address: http://www.wmc.edu/academics/finearts/gallery.html

Director: Ms. Eva Mastandrea

Admission: free.

Attendance: 5,000 *Established:* 1986

Open: **In Session**,
> Monday, 10am-3pm; Tuesday, 10am-3pm and 7pm-9pm; Wednesday to Friday, 10am-3pm.

Closed: Academic Holidays.

Facilities: **Exhibition Area** (2 galleries).

Activities: **Temporary Exhibitions**.

The Corr Gallery presents changing exhibitions of works by professional artists, faculty, and students. The Walton Gallery contains artwork from the private collection of the Walton family. Periodically, the Walton Gallery is also used for revolving exhibitions.

Great Falls

C.M. Russell Museum

400 13th St. North at 5th Ave. North, Great Falls, MT 59401-1498

Tel: (406) 727-8787

Fax: (406) 727-2402

Acting Exec. Director: Ms. Elizabeth A. Dear

Admission: fee: adult-$4.00, child (<6)-free, student-$2.00, senior-$3.00.

Attendance: 70,000 *Established:* 1953 *Membership:* Y *ADA Compliant:* Y

Parking: free on site.

C.M. Russell Museum, cont.

Open: **May to September**,
Monday to Saturday, 9am-6pm;
Sunday, noon-5pm.

October to April,
Tuesday to Saturday, 10am-5pm;
Sunday, 1pm-5pm.

Closed: New Year's Day, Easter,
Thanksgiving Day, Christmas Day.

Facilities: **Architecture** (Russell home and log studio); **Exhibition Area**; **Shop** (prints).

Activities: **Guided Tours** (by appointment); **Lectures**; **Temporary Exhibitions**; **Traveling Exhibitions**.

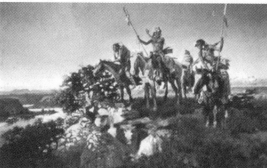

Charles M. Russell, *The Fireboat*, 1918, oil, 15½ x 24½ inches. C.M. Russell Museum. Photograph courtesy of the C.M. Russell Museum, Great Falls, Montana.

Publications: exhibition catalogues; magazine, "Russell's West" (semi-annual); newsletter, "Latch String" (monthly).

The facility consists of Russell's home and log cabin studio, a National Historic Landmark, and the Museum. The log cabin studio displays cowboy and Native American artifacts used by Russell as props and models for his art works, while the Museum houses permanent and changing exhibitions. The permanent collection includes the most comprehensive collection of original Russell art works and personal objects to be found in any one location. In addition to works by Russell, the collection includes works by E.I. Couse, Edward Curtis, E.E. Heikka, Winold Reiss, O.C. Seltzer, Joseph Henry Sharp, and Olaf Wieghorst.

Paris Gibson Square Museum of Art

1400 1st Ave., North, Great Falls, MT 59401-3299

Tel: (406) 727-8255

Fax: (406) 727-8256

Exec. Director: Ms. Bonnie Laing-Malcolmson

Admission: voluntary contribution.

Attendance: 70,000 *Established:* 1976

Membership: Y *ADA Compliant:* Y

Parking: free on site.

Open: Monday, 10am-5pm;
Tuesday, 10am-5pm & 7pm-9pm;
Wednesday to Friday, 10am-5pm;
Saturday to Sunday, noon-5pm.

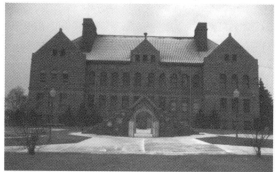

Exterior of Paris Gibson Square Museum of Art; sculpture "Gibson Gateway" (1993) by Richard Harrison. Photograph courtesy of Paris Gibson Square Museum of Art, Great Falls, Montana.

Closed: Legal Holidays.

Facilities: **Architecture** (former High School, 1896); **Exhibition Area** (30,000 square feet); **Food Services** Restaurant (40 seats, Tues-Fri reservation only); **Galleries** (4); **Sales Gallery**.

Activities: **Education Programs** (adults and children); **Guided Tours**; **Lectures**; **Temporary Exhibitions**; **Traveling Exhibitions**.

Publications: activity flier (monthly); calendar; exhibition catalogues; newsletter, "Works" (3/year); posters.

Founded in part to present a cultural alternative to the western art of the C.M. Russell Museum, the Museum's focus is modern and contemporary art from the Northwestern United States. The Museum is devoted to nurturing artists and the arts of the region by providing studio space for resident artists and classroom space, and collaborating with other community arts organizations in artistic programming. It provides a venue for local and regional contemporary artists to exhibit, and affords both artists and the general public access to the work of important regional, national, and international artists. The Museum collects objects in four categories: modern and contemporary art of the Northwest, Native American modern and contemporary art of the Northwest, 20th-century American outsider art, and special collections.

Helena

Holter Museum of Art

12 E. Lawrence St., Helena, MT 59601
Tel: (406) 442-6400
Fax: (406) 442-2404
Director: Mr. Peter Held
Admission: voluntary contribution.
Attendance: 32,000 *Established:* 1987
Membership: Y *ADA Compliant:* Y
Parking: on street and city park/pay lots.
Open: **June to August,**
 Monday to Saturday, 10am-5pm;
 Sunday, noon-5pm.
 September to May,
 Tuesday to Saturday, 11:30am-5pm;
 Sunday, noon-5pm.

Freeman Butts, *Dutton*, 1989, acrylic on canvas. Holter Museum of Art. Photograph courtesy of Holter Museum of Art, Helena, Montana.

Closed: Legal Holidays.
Facilities: **Exhibition Area** (2 galleries, 5,400 square feet); **Sales Gallery.**
Activities: **Classes**; **Guided Tours** (by reservation, 1-2 weeks in advance); **Lectures**; **Temporary Exhibitions** (10-14/year).
Publications: exhibition catalogues (3/year).

The Museum presents ten to 14 shows in a variety of media and styles each year in two spacious galleries. Art work shown ranges from historical through modern to contemporary, with exhibition formats that include one-person shows, group exhibitions, nationally juried shows and retrospectives. In addition, the staff incorporates a variety of educational programming. The main focus of the Museum's permanent collection is the preservation of the Northwest's cultural and artistic heritage. Currently the Museum's holdings number over 1,000 paintings, prints, and sculptures, ranging from representational to abstract art.

Kalispell

Hockaday Museum of Art

2nd Ave. (East at 3rd St.), Kalispell, MT 59903
Tel: (406) 755-5268
Fax: (496) 755-2023
Internet Address:
 http://www.hockadaymuseum.org
Exec. Director: Mr. David Eubank
Admission: fee-$2.00.
Attendance: 29,000 *Established:* 1968
Membership: Y *ADA Compliant:* Y
Parking: free on street, 2 hours.
Open: Tuesday, 10am-6pm;
 Wednesday, 10am-9pm;
 Thursday, 10am-6pm;
 Friday to Saturday, 10am-8pm.

Frank Hagel, *Trapline*, 1977, watercolor. Gift of Kalispell Art Show and Auction, Hockaday Center for the Arts. Photograph courtesy of the Hockaday Center for the Arts, Kalispell, Montana.

Closed: Legal Holidays.
Facilities: **Architecture** (former Carnegie Library building, 1903); **Classroom**; **Darkroom**; **Galleries** (4 exhibition, 1 sales); **Library**; **Shop.**
Activities: **Art Auction** (September); **Arts Festival** (juried art fair, "Arts in the Park", July); **Concerts**; **Education Programs** (adults and children); **Films**; **Gallery Talks** (monthly); **Guided Tours** (by appointment); **Lectures**; **Temporary Exhibitions** (6-8/year); **Traveling Exhibitions**.

Kalispell, Montana

Hockaday Museum of Art, cont.

Publications: exhibition catalogues; newsletter (monthly).

The central focus of the Museum has been to provide exhibitions of both historical and contemporary work in all media. Approximately half of the exhibitions are loaned from other museums, collections, and traveling exhibition services; the remainder are curated by Hockaday staff. Works from the permanent collection are exhibited on a rotating basis in the galleries. The Museum also offers a wide spectrum of educational opportunities in the visual arts and has consistently brought the performing arts to the community. The permanent collection focuses on the work of major regional artists and includes paintings, drawings, original prints and etchings, ceramics, bronze sculptures, and historical photographs of regional interest. Its collection includes works of Montana Arts Council Fellowship artists.

Miles City

Custer County Art Center Waterworks Gallery

Water Plant Road, Miles City, MT 59301
Tel: (406) 232-0635
Fax: (406) 232-0637
Exec. Director: Mr. Mark Browning
Admission: voluntary contribution.
Attendance: 10,000 *Established:* 1975
Membership: Y *ADA Compliant:* Y
Parking: free on site.
Open: Tuesday to Sunday, 1pm-5pm.
Closed: January, Thanksgiving Day,
 Christmas Day.
Facilities: **Architecture** (former holding tanks of old water works); **Galleries** (2; 4,000 square feet); **Pottery Studio**; **Sales Gallery** (regional artwork, pottery, jewelry, books); **Workshops**.
Activities: **Art Auction** (fall); **Gallery Talks**; **Juried Exhibits**; **Lectures**; **Performances**; **Readings**; **Temporary Exhibitions** (7/year); **Traveling Exhibitions**.

Interior view of gallery in former water holding tanks, Custer County Art Center. Photograph courtesy of Carol Highsmith.

Publications: exhibition brochures; newsletter (quarterly).

Housed in the holding tanks of the old Miles City Water Treatment Plant, the Art Center has two galleries, featuring national exhibitions and works from its permanent collection. Artists selected display a wide variety of media and styles through featured solo, group, and theme exhibitions. Annual exhibits include the Southeast Montana Juried Competition, the Art Auction Exhibition, and the Western Art Roundup, which showcases traditional and contemporary western artists. Miniature and student shows are among other regular exhibits. The permanent collection includes Edward S. Curtis' photogravures of the American Indian.

Missoula

The Art Museum of Missoula

335 N. Pattee Street, Missoula, MT 59802
Tel: (406) 728-0447
Fax: (406) 543-8691
C.E.O. and Director: Ms. Laura J. Millin
Admission: fee:
 adult-$2.00, child-free, student-$2.00, senior-$2.00.
Attendance: 30,000 *Established:* 1975 *Membership:* Y

Jan Kies, *Rider up the Bunkhouse*, 1986, silver print photograph. Art Museum of Missoula, permanent collection. Photograph courtesy of Art Museum of Missoula, Missoula, Montana.

The Art Museum of Missoula, cont.

Parking: metered on street.

Open: Tuesday, noon-8pm; Wednesday to Sunday, noon-6pm.

Facilities: **Architecture** (former Carnegie Library building, 1903); **Galleries**; **Research Library**; **Shop**.

Activities: **Concerts**; **Education Programs** (adults and children); **Gallery Talks**; **Lectures**; **Performances**; **Traveling Exhibitions**.

Publications: exhibition catalogues.

The Museum exhibits contemporary art from around the world. Its permanent collection focuses on art from the American West.

University of Montana - Museum of Fine Arts

University of Montana, School of Fine Arts, Missoula, MT 59812

Tel: (406) 243-2019

Fax: (406) 243-5726

Internet Address: http://www.umt.edu/partv/famus/

Director: Ms. Margaret Mudd

Admission: voluntary contribution.

Attendance: 24,000 *Established:* 1956 *ADA Compliant:* Y

Parking: visitor's pass ($1.00).

Open: Monday to Friday, 1pm-5pm.

Closed: Legal Holidays.

Facilities: **Galleries**; **Printroom/Storage Area**.

Activities: **Arts Festival**; **Concerts**; **Dance Recitals**; **Education Programs** (college students and children); **Films**; **Guided Tours**; **Lectures**; **Temporary Exhibitions**; **Traveling Exhibitions**.

The University of Montana Museum of Fine Arts collects, displays, and maintains contemporary and historical works of art for study by an academic community, public exhibition, and loans to other institutions. Objects from the permanent collection are rotated for display at the Henry Meloy Gallery, the Paxson Gallery, and satellite exhibition areas. The permanent collection contains more than 8,500 objects including antiquities, cast bronzes, paintings, drawings, sculpture, textiles, contemporary ceramics, period ceramics, photographs, prints, and student work. Also of possible interest on campus are the UC Gallery, presenting temporary exhibitions of work by professional artists in a wide variety of styles, techniques, and subject matter, and the Gallery of Visual Arts. The UC Gallery and gift shop (243-4991) are located on the 2nd floor of the University Center and are open Monday through Friday, 10am-4pm. The Gallery of Visual Arts (243-2813) is located in the Social Science Building.

Nebraska

The number in parentheses following the city name indicates the number of museums/galleries in that municipality. If there is no number, one is understood. For example, in the text three listings would be found under Omaha and one listing under Cozad.

Nebraska

Cozad

Robert Henri Museum and Walkway

220 E. 8th St., Cozad, NE 69130-1834

Tel: (308) 784-4154

Admission: fee.

Open: **June to Labor Day**, Monday to Saturday, 9am-5pm.

The Museum commemorates native son, artist Robert Henri. In addition to displaying Henri's work, the Museum mounts traveling exhibitions from other institutions.

Kearney

University of Nebraska at Kearney - Museum of Nebraska Art (MONA)

2401 Central Ave. at 24th St. (near entrance to the Kearney Centre), Kearney, NE 68848

Tel: (308) 865-8559

Fax: (308) 865-8104

Internet Address: http://monet.unk.edu/mona

Interim Director: Mr. Gary Zaruba

Admission: voluntary contribution.

Established: 1986 *Membership:* Y *ADA Compliant:* Y

Parking: free on site.

Open: Tuesday to Saturday, 11am-5pm; Sunday, 1pm-5pm.

Closed: Legal Holidays.

Facilities: **Architecture** (former Post Office building, 1911); **Exhibition Area**; **Library** (Nebraska art and artists); **Sculpture Garden**; **Shop** (artwork by Nebraska artists, books, cards, posters).

Activities: **Education Programs** (adults, U of NE graduate/undergraduate students, and children); **Guided Tours**; **Lectures**; **Temporary Exhibitions**; **Traveling Exhibitions**; **Workshops**.

Publications: catalogues (annual); exhibition catalogues; newsletter (quarterly).

MONA is a complementary partnership between the University of Nebraska at Kearney (UNK) and the Nebraska Art Collection Foundation (established 1976). Ranging from the historic artistic reporting of artist-explorers to contemporary regional work, the permanent collection focuses on art depicting Nebraska or by Nebraskans. Major strengths are in the works of Thomas Hart Benton, George Catlin, and Robert Henri. The Grant Reynard Collection comprises the largest single holding of the Museum and documents the career of this Nebraska native.

Lincoln

Nebraska Wesleyan University Galleries

5000 St. Paul Ave., Lincoln, NE 68504-2230

Tel: (402) 466-2371

Fax: (402) 465-2179

Internet Address: http://www.nebrwesleyan.edu/

Director: Dr. Donald Paoletta

Admission: voluntary contribution.

Attendance: 4,000 *Established:* 1965 *ADA Compliant:* Y

Open: Tuesday to Friday, 10am-4pm; Saturday to Sunday, 1pm-4pm.

Closed: Academic Holidays.

Facilities: **Galleries** (2).

Activities: **Gallery Talks**; **Lectures**; **Temporary/Traveling Exhibitions**.

The Art Department at Nebraska Wesleyan maintains two art galleries. The Elder Gallery presents juried, invitational, and student exhibitions. The Kepler Gallery is reserved for student displays.

Lincoln, Nebraska

University of Nebraska-Lincoln - Great Plains Art Collection (GPAC)

University of Nebraska-Lincoln, 215-217 Love Library (13th & R Streets), Lincoln, NE 68588-0475
Tel: (402) 472-6220
Fax: (402) 472-5131
Curator: Ms. Martha H. Kennedy
Admission: voluntary contribution.
Attendance: 7,000 *Established:* 1980
Membership: Y *ADA Compliant:* Y
Parking: metered parking.
Open: Monday to Friday, 9:30-5pm;
 Saturday, 10am-5pm;
 Sunday, 1:30pm-5pm.
Closed: Legal Holidays, Between Semesters,
 Between Exhibits.
Facilities: **Exhibition Area**; **Library** (4,000 volumes).
Activities: **Gallery Talks**; **Guided Tours**; **Temporary Exhibitions**.
Publications: brochures; exhibition catalogues.

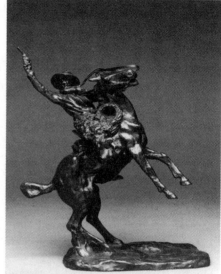

Charles M. Russell, *Smoking Up*, 1904, bronze, height 11 7/8 inches, Christleib Collection, University of Nebraska-Lincoln. Photograph by Roger Bruhn, courtesy of Great Plains Art Collection, University of Nebraska-Lincoln, Lincoln, Nebraska.

A part of the Center for great Plains Studies at the University of Nebraska-Lincoln, GPAC presents five major exhibits each year accompanied by public programs pertaining to the exhibitions or other topics related to great Plains Studies. The permanent collection consists of more than 180 bronzes (including works by Frederic S. Remington and Charles M. Russell), 240 paintings and 390 works on paper (including works by Albert Bierstadt, William Cary, John Clymer, William Henry Jackson, Norman Rockwell, and Olaf Wieghorst).

University of Nebraska-Lincoln - Sheldon Memorial Art Gallery and Sculpture Garden

University of Nebraska-Lincoln, 12th and R Streets, Lincoln, NE 68588-0300
Tel: (402) 472-2461
Fax: (402) 472-4258
Internet Address: http://sheldon.unl.edu
Director: Mr. George Neubert
Admission: free.
Attendance: 150,000 *Established:* 1963 *Membership:* Y *ADA Compliant:* Y
Parking: free on site.
Open: Tuesday to Wednesday, 10am-5pm; Thursday to Saturday, 10am-5pm and 7pm-9pm;
 Sunday, 2pm-9pm.
Closed: New Year's Eve to New Year's Day, Memorial Day, Independence Day, Labor Day,
 Thanksgiving Day, Christmas Day.
Facilities: **Architecture** (International Style, 1963 design by Philip Johnson); **Auditorium**
 (300 seats); **Film Theatre**; **Food Services** Café (Tues-Fri, 9:30am-3:30pm); **Galleries**; **Library**
 (15,000 volumes); **Picnic Areas**; **Sculpture Garden** (15 acres); **Shop** (Tues-Sat, 10am-5pm;
 Sun 2pm-5pm; art, cards, gift items).
Activities: **Concerts**; **Education Programs** (children); **Films**; **Gallery Talks**; **Guided Tours**
 (reservation, 2 weeks in advance); **Lectures**; **Temporary Exhibitions** (20/year);
 Touring Exhibition (annual, statewide); **Traveling Exhibitions**.
Publications: annual report; calendar, "Gallery Notes" (monthly); exhibition catalogues, "Sculpture
 Collection"; exhibition series, "The American Painting Collection of the Sheldon Memorial Art
 Gallery"; newsletter (quarterly).

University of Nebraska-Lincoln - Sheldon Memorial Art Gallery, cont.

Housed in an International Style building designed by architect Philip Johnson, the Sheldon Memorial Art Gallery and Sculpture Garden houses a comprehensive collection of 20th-century American art. Thirty-three monumental sculptures are exhibited in the sculpture garden. Approximately twenty exhibitions are presented each year featuring works in all media, including video and installation art. The exhibition program consists of displays drawn from the permanent collection organized by the curatorial staff and shows organized by peer institutions throughout the United States. The Sheldon houses both the Nebraska Art Association collection, founded in 1888, and the University of Nebraska collection, initiated in 1929. Together they consist of over 12,000 original art works in all media. There are significant holdings in 19th-century landscape and still life, American Impressionism, early Modernism, geometric abstraction, Abstract Expressionism, pop art, minimalism and contemporary art. Monumental sculpture includes works by Mark di Suvero, Michael Heizer, Bryan Hunt, Gaston Lachaise, Jacques Lipchitz, Elie Nadelman, Claes Oldenburg/Coosje van Bruggen, Richard Serra, Judith Shea, David Smith, and William Tucker. Also of possible interest, undergraduate and graduate student work is displayed in the Gallery of the Department of Art and Art History, 102 Richards Hall (472-2631), Monday through Thursday, 9am-5pm.

Omaha

Creighton University - Lied Art Gallery

Lied Education Center for the Arts, 2500 California Plaza, Omaha, NE 68178-0303
Tel: (402) 280-2636
Internet Address: http://leca.creighton.edu/events.html
Admission: free.
Open: Daily, noon-4pm.
Facilities: **Exhibition Area**.
Activities: **Temporary Exhibitions**.

Located in the Lied Education Center for the Arts, the Gallery mounts temporary exhibitions of the work of professional and student artists, including an all-student show each spring.

Joslyn Art Museum

2200 Dodge St., Omaha, NE 68102-1292
Tel: (402) 342-3300
Fax: (402) 342-2376
Internet Address: http://www.joslyn.org
Director: Dr. John E. Schloder
Admission:
 fee: adult-$5.00, child (<5)-free (5-17)-$2.50, student-$3.00,
 senior (>61)-$3.00.
 free: Saturday, 10am-noon.
Attendance: 185,000 *Established:* 1931
Membership: Y *ADA Compliant:* Y
Parking: free on site.
Open: Tuesday to Saturday, 10am-4pm;
 Sunday, noon-4pm.
Closed: New Year's Day, Memorial Day,
 Independence Day, Labor Day,
 Thanksgiving Day, Christmas Day.
Facilities: **Architecture** (Art Deco, 1931 design by John & Alan
 McDonald; 1994 addition, design by Lord Norman Foster);
 Concert Hall (1,000 seats); **Food Services** Café (Tuesday-
 Saturday, 11am-3:30pm; Sunday, noon-3:30pm; 120 seats);
 Galleries; **Lecture Hall** (200 seats); **Research Library**
 (27,000 volumes; Tuesday-Saturday, 10am-4pm); **Shop** (art
 books, jewelry, posters, gifts).

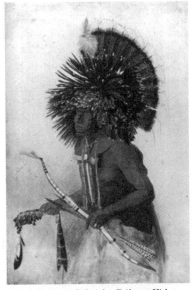

Karl Bodmer, *Péhriska-Rúhpa, Hidatsa Man*, watercolor and pencil on paper, ca. 1832-34, permanent collection, Joslyn Art Museum. Image courtesy of Joslyn Art Museum, Omaha, Nebraska.

Joslyn Art Museum, cont.

Activities: **Concerts**; **Education Programs** (adults and children); **Films**; **Gallery Talks**; **Guided Tours** (Wednesday, 1pm; Saturday, 10am/11am/2pm; Sunday, 1pm); **Lectures**; **Temporary Exhibitions** (12-15/year); **Traveling Exhibitions**.

Publications: brochures; catalogues; newsletter (bi-monthly).

A gift to the people of Omaha from Sarah H. Joslyn in memory of her husband, newspaper service organization executive George A. Joslyn, the Museum presents approximately 15 temporary exhibitions each year. The encyclopedic permanent collection features works from antiquity to the present with special emphasis on 19th- and 20th-century European and American art. European artists represented include Bouguereau, Corot, Courbet, Degas, Delacroix, Doré, El Greco, Gérôme, Claude Lorrain, Matisse, Monet, Pissarro, Renoir, Titian, and Veronese. The Museum is world-renowned for its collection of Swiss artist Karl Bodmer's watercolors and prints of the Missouri River frontier in 1832-34. Works by American artists include Thomas Hart Benton, Albert Bierstadt, Mather Brown, Mary Cassatt, William Merritt Chase, Thomas Cole, Stuart Davis, Thomas Eakins, Helen Frankenthaler, Childe Hassam, Robert Henri, Hans Hofmann, Winslow Hómer, George Inness, Homer Dodge Martin, Thomas Moran, James Peale, Jackson Pollock, George Segal, John Sloan, Thomas Worthington Whittredge, and Grant Wood.

University of Nebraska at Omaha - The UNO Art Gallery

Weber Fine Arts Building, Dodge Street, Omaha, NE 68182

Tel: (402) 554-2796

Internet Address: http://www.unomaha.edu/~fineart/art/gallery/html

Director: Ms. Nancy Kelly

Admission: free.

Open: Monday to Friday, 10am-4:30pm.

Facilities: **Architecture** Fine Arts Building (1992 design by Hardy, Holzman and Pfeiffer Associates, New York); **Exhibition Area** (3 rooms, 2,175 square feet); **Sculpture Garden**.

Activities: **Temporary Exhibitions** (8-10/year).

C onsisting of two large rooms and a hexagonal gallery, the UNO Gallery offers exhibitions of work by professional artists, as well as four student shows (two juried/two BFA thesis) and a biennial faculty show.

Seward

Concordia University - Marxhausen Art Gallery

Jesse Hall, 800 N. Columbia Ave., Seward, NE 68434

Tel: (402) 643-3651

Fax: (402) 643-4073

Internet Address: http://www.cune.edu

Curator of Incoming Exhibitions: Prof. Lynn R. Soloway

Admission: free.

Established: 1951

Open: **September to May,**
 Monday to Friday, 11am-4pm; Saturday to Sunday, 1pm-4pm.
 Summer School, by appointment.

Closed: Academic Holidays.

Facilities: **Exhibition Area**.

Activities: **Gallery Talks**; **Rental Gallery**; **Temporary Exhibitions**; **Traveling Exhibitions**.

T he Gallery offers regional and national exhibitions approximately every month during the academic year. Exhibitions include both group and solo shows in a wide variety of media. The permanent collection is shown twice a year. There are also an annual student exhibition and a biennial faculty show. The permanent collection consists of contemporary original prints (lithographs, intaglios, screenprints, assemblages, aquatints, monotypes, etc.) by American and international artists. Among the artists represented are Baskin, Dine, Grooms, Hockney, Kunc, Lasansky, Lichtenstein, Murray, Nelson, Nevelson, Rauschenberg, Roualt, Salle, Scholder, Serra, and Stella.

Nevada

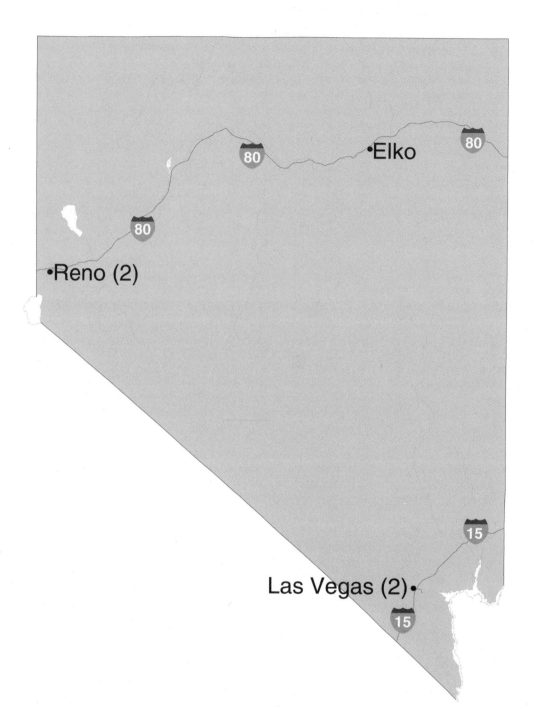

The number in parentheses following the city name indicates the number of museums/galleries in that municipality. If there is no number, one is understood. For example, in the text two listings would be found under Reno and one listing under Elko.

Nevada

Elko

Northeastern Nevada Museum

1515 Idaho St., Elko, NV 89801
Tel: (702) 738-3418
Fax: (702) 778-9318
Director: Ms. Lisa Seymour
Admission: voluntary contribution.
Attendance: 80,000 *Established:* 1968 *Membership:* Y *ADA Compliant:* Y
Open: Monday to Saturday, 9am-5pm; Sunday, 1pm-5pm.
Closed: New Year's Day, Thanksgiving Day, Christmas Day.
Facilities: **Exhibition Area**; **Library** (3,750 volumes); **Reading Room**; **Shop**; **Theatre**.
Activities: **Arts Festival**; **Education Programs** (adults and children); **Films**; **Lectures**; **Temporary Exhibitions**.
Publications: "Northeastern Nevada Historical Society Quarterly".

The Museum features exhibits of regional history, Indian artifacts, natural history, and art. Local artists are featured in changing exhibits.

Las Vegas

Las Vegas Art Museum (LVAM)

Sahara West Library and Fine Arts Museum
9600 West Sahara Ave., Las Vegas, NV 89117
Tel: (702) 360-8000
Fax: (702) 360-8080
Curator: James Mann
Admission: fee: adult-$3.00, child-free,
 student-$1.00, senior-$2.00.
Attendance: 59,000 *Established:* 1950
Membership: Y *ADA Compliant:* Y
Parking: free on site.
Open: Tuesday to Saturday, 10am-5pm;
 Sunday, 1pm-5pm.
Closed: Federal Holidays.

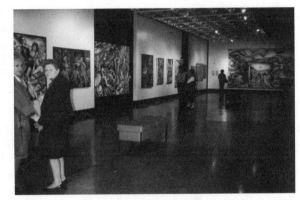

View of main gallery at Las Vegas Art Museum. Photograph courtesy of Las Vegas Art Museum, Las Vegas, Nevada.

Facilities: **Architecture** (1997 design by Meyer, Scherer & Rockcastle of Minneapolis); **Galleries** (4; total 11,000 square feet); **Shop** (art books, original art, reproductions, jewelry).
Activities: **Education Programs**; **Lectures**; **Workshops**.
Publications: exhibition catalogues; newsletter, "ARTBEAT" (bi-monthly).

Nevada's oldest and largest museum, LVAM contains 30,000 square feet of exhibition space, including a large outdoor terrace being developed as a sculpture garden. The Museum emphasizes the exhibition of contemporary art: international, national, and regional, stressing art after post-modernism. LVAM originates and hosts traveling shows and holds two annual juried competitions.

University of Nevada, Las Vegas - Donna Beam Fine Arts Gallery

UNLV, Alta Ham Fine Arts Building, 4505 Maryland Parkway, Las Vegas, NV 89154
Tel: (702) 895-3893
Fax: (702) 895-4194
Internet Address: http://www.nscee.edu/unlv/Art/gallery.html
Director: Mr. Jerry A. Schefcik
Admission: free.
Attendance: 7,500 *Established:* 1960 *ADA Compliant:* Y
Open: Monday to Friday, 9am-5pm.
Closed: Legal Holidays.
Facilities: **Exhibition Area**.

University of Nevada, Las Vegas - Donna Beam Fine Arts Gallery, cont.

Activities: **Education Programs** (undergraduates); **Gallery Talks**; **Lectures**; **Temporary Exhibitions**; **Traveling Exhibitions**.

Publications: brochures; exhibition catalogues.

Located in the Alta Ham Fine Arts Building, the Donna Beam Fine Arts Gallery is dedicated to the exhibition, interpretation, documentation, and preservation of 20th-century visual art. The Gallery offers a variety of temporary exhibitions of four to six weeks duration featuring the work of nationally and internationally recognized artists, as well as works from the permanent collection.

Reno

Nevada Museum of Art - E.L. Wiegand Gallery (NMA)

160 W. Liberty, Reno, NV 89501

Tel: (775) 329-3333

Fax: (775) 329-1541

Internet Address: http://www.nevadaart.org

Director: Mr. Steven High

Admission: fee: adult-$5.00, child-$1.00, student-$3.00, senior-$3.00.

Attendance: 60,000 *Established:* 1931

Membership: Y *ADA Compliant:* Y

Parking: free on site.

Open: Tuesday to Wednesday, 10am-4pm;
Thursday, 10am-7pm;
Friday, 10am-4pm;
Saturday to Sunday, noon-4pm.

Closed: Legal Holidays.

Exterior view of Nevada Museum of Art. Photograph courtesy of Nevada Museum of Art, Reno, Nevada.

Facilities: **Galleries**; **Shop**.

Activities: **Education Programs** (adults and children); **Guided Tours**; **Lectures** (evening lectures for adults); **Temporary Exhibitions**; **Traveling Exhibitions**.

Publications: exhibition catalogues; newsletter (bi-monthly).

NMA provides a forum for the presentation of creative ideas focusing on its collections, exhibitions, education and outreach. Throughout the year, NMA's E.L. Wiegand Gallery hosts a variety of exhibitions, which explore fine art from an historical to a contemporary perspective and are complemented by a wide range of programs and presentations designed for both adults and children. The permanent collection of the NMA features works that relate to the history, cultural diversity, interests, and political issues of Nevada's community with an overall emphasis on the themes of the environment and the West.

University of Nevada, Reno - Galleries

Art Department 224, Reno, NV 89557-0007

Tel: (702) 784-6682

Fax: (702) 784-6655

Internet Address: http://www.unr.edu

Admission: voluntary contribution.

Attendance: 30,000 *Established:* 1960 *Membership:* N *ADA Compliant:* Y

Open: Monday to Friday, 9am-5pm.

Closed: Legal Holidays.

Facilities: **Galleries** (4; Sheppard 2,000 square feet).

Activities: **Concerts**; **Films**; **Gallery Talks**; **Guided Tours**; **Lectures**; **Temporary Exhibitions** (Exit Gallery, 8/year); **Traveling Exhibitions**.

Publications: exhibition catalogues.

University of Nevada, Reno - Galleries, cont.

The Sheppard Gallery, on the first floor of the Church Fine Arts Complex, presents temporary exhibitions of work in a variety of media by professional artists. Past exhibitions have featured artists in solo and group shows of local, regional, and international prominence and annual juried shows of student work. Also located in the Church Fine Arts Building, the McNamara and Front Door Galleries host student exhibitions. In the Photography Department, The Exit Gallery, a nationally curated, photography-only gallery, presents one-month solo exhibitions September through May.

New Hampshire

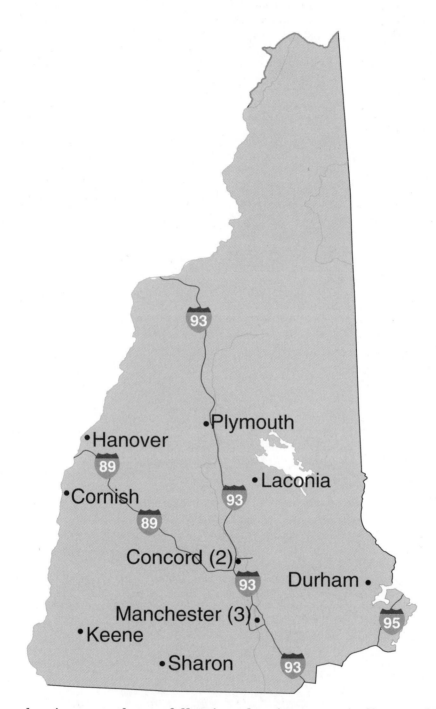

The number in parentheses following the city name indicates the number of museums/galleries in that municipality. If there is no number, one is understood. For example, in the text three listings would be found under Manchester and one listing under Keene.

New Hampshire

Concord

Museum of New Hampshire History

The Hamel Center, 6 Eagle Square, Concord, NH 03301

Tel: (603) 226-3189

Fax: (603) 228-6308

Internet Address: http://www.NHHistory.org

C.E.O.: Mr. John Frisbee

Admission: fee: adult-$5.00, child-$2.50, senior-$4.00, family-$15.00.

Attendance: 37,000 *Established:* 1823

Membership: Y *ADA Compliant:* Y

Parking: free on site.

Open: **January to June 30 and October 16 to November 30,**
Tuesday to Wednesday, 9:30am-5pm;
Thursday, 9:30am-8:30pm;
Friday to Saturday, 9:30am-5pm;
Sunday, noon-5pm.

 July to October 15 and December,
Monday to Wednesday, 9:30am-5pm;
Thursday, 9:30am-8:30pm;
Friday to Saturday, 9:30am-5pm;
Sunday, noon-5pm.

Closed: Thanksgiving Day, Christmas Day.

Sunflower pattern quilt, ca.1900, made by Helen Gertrude Thurley (1874-1976) of Ossipee, New Hampshire. Collection of and photograph courtesy of Museum of New Hampshire History, Concord, New Hampshire.

Facilities: **Auditorium** (125 seats); **Library** (50,000 volumes); **Museum** (20,000 square feet); **Reading Room**; **Shop** (NH history books, crafts).

Activities: **Concerts**; **Family Days**; **Lectures**; **Temporary Exhibitions**.

Publications: "Historical New Hampshire" (quarterly); books; exhibition catalogues; newsletter (semi-annual).

The Museum works to collect, preserve, exhibit, and interpret New Hampshire history. The Museum collection of approximately 28,000 objects includes fine art, decorative arts, and industrial artifacts from 7,000 years ago to the present, primarily made or used in New Hampshire. The Museum presents a permanent exhibition "New Hampshire Through Many Eyes", introducing New Hampshire history, as well as changing exhibitions on various topics in New Hampshire history.

St. Paul's School - The Art Center in Hargate

325 Pleasant St., Concord, NH 03301-2591

Tel: (603) 229-4644

Fax: (603) 229-4649

Director: Ms. Karen Burgess Smith

Admission: free.

Attendance: 3,500 *Established:* 1967

Open: **September to May,** Tuesday to Saturday, 10am-4:30pm.

Closed: March, June to August, December.

Facilities: **Auditorium** (97 seat); **Exhibition Area** (1,600 square feet); **Library** (2,500 volumes).

Activities: **Guided Tours**; **Lectures**; **Temporary Exhibitions**; **Traveling Exhibitions**.

Centrally located on the grounds of St. Paul's School, The Art Center in Hargate presents displays throughout the school year, featuring a variety of works by well-known and up-and-coming artists. As a teaching gallery, the Art Center schedules exhibitions to coincide with art courses in related subjects. Past exhibitions have featured works by artists such as Eugene Atget, Milton Avery, Thomas Buechner, Arthur Dove, Winnie Owens Hart, June Kaneko, Jacob Lawrence, Robert Motherwell, Zhu Qizhan, Fritz Scholder, Joyce Tenneson, Jerry Uelsmann, and Andrew Wyeth.

Cornish

Saint-Gaudens National Historic Site

St. Gaudens Road (off Route 12A), Cornish, NH 03745
Tel: (603) 675-2175
Fax: (603) 675-2701
Internet Address: http://www.nps.gov/saga
Superintendent and Chief Curator:
 Mr. John Dryfhout
Admission: fee: adult-$4.00, child-free.
Attendance: 40,000 *Established:* 1964
Parking: free on site.
Open: late May to October 31,
 Daily, 9am-4:30pm.
Facilities: Architecture (home & studios of sculptor
 Augustus Saint-Gaudens); Galleries; Grounds
 and Gardens (150 acres); Library (2,000 vol-
 umes); Sculpture Garden.
Activities: Concerts; Education Programs; Gallery
 Talks; Guided Tours; Temporary Exhibitions.

Exterior view of Saint-Gaudens' home and studio. Photograph by Jeffrey Nintzel, courtesy of Saint-Gaudens National Historic Site, Cornish, New Hampshire.

Publications: collection catalogue; exhibition catalogues; guide books.

Cornish was the summer residence of American sculptor Augustus Saint-Gaudens from 1885-97 and his permanent home from 1900 until his death in 1907. The site includes his home, gardens, and studios. In addition to displaying examples of Saint-Gaudens work, the site mounts temporary exhibitions in the Picture Gallery.

Durham

University of New Hampshire - The Art Gallery

Paul Creative Arts Center, 30 College Road, Durham, NH 03824-3538
Tel: (603) 862-3712
Fax: (603) 862-2191
Internet Address: http://www.unh.edu
Director: Ms. Vicki C. Wright
Admission: voluntary contribution.
Attendance: 9,000 *Established:* 1960
Membership: Y
Parking: metered.
Open: September to May,
 Monday to Wednesday, 10am-4pm;
 Thursday, 10am-8pm;
 Saturday to Sunday, 1pm-5pm.
Closed: June to August, Academic Holidays.
Facilities: Exhibition Area (4,500 square feet).
Activities: Changing Exhibitions; Concerts;
 Education Programs; Films; Gallery
 Talks; Lectures; Readings (poetry.

John Laurent (American, born 1921), *Artichokes and Lemons*, 1983, acrylic on paper, 7¼ x 9¾ inches. Collection of The Art Gallery, University of New Hampshire. Photograph courtesy of The Art Gallery, University of New Hampshire, Durham, New Hampshire.

Publications: booklets; exhibition catalogues.

The Art Gallery's exhibitions cover a range of periods, styles, and media, including paintings, sculpture, photography, ceramics, prints, and drawings. Focusing on a variety of themes, shows have included the etchings of Dürer and Rembrandt, contemporary work by New Hampshire artists, New England landscape painting, and nineteenth-century Japanese prints, with works often borrowed from public and private collections throughout New England. The Art Gallery also mounts exhibitions of work by the university's art faculty members, alumni, and senior art students, and selections from the permanent collection. The permanent collection, totaling 1,200 works, emphasizes 19th- and 20th-century prints and drawings, including nearly 200 Japanese woodblock prints.

Hanover

Dartmouth College - Hood Museum of Art

Dartmouth College, Wheelock St., Hanover, NH 03755
Tel: (603) 646-2808
Fax: (603) 646-1400
Internet Address: http://www.dartmouth.edu/~hood
Acting Director: Margaret Dyer Chamberlain
Admission: voluntary contribution.
Attendance: 42,000 *Established:* 1772
Membership: Y *ADA Compliant:* Y
Parking: metered parking on site.
Open: Tuesday, 10am-5pm;
Wednesday, 10am-9pm;
Thursday to Saturday, 10am-5pm;
Sunday, noon-5pm.
Facilities: **Architecture** (Post-Modern building, 1985 design by Charles W. Moore/Chad Floyd); **Auditorium** (200 seats); **Food Services** Restaurant; **Galleries** (10; 12,000 square feet); **Shop.**
Activities: **Family Days**; **Gallery Talks**; **Guided Tours**; **Lectures**; **Traveling Exhibitions.**
Publications: exhibition catalogues; handbook, "Treasures of the Hood Museum of Art".

Abbott Handerson Thayer, *Below Mount Monadnock*, c. 1913, oil on panel, 9 x 7 5/16 inches, Hood Museum of Art, purchased through gifts from Class of 1955 and Lathrop Fellows. Photograph courtesy of Hood Museum of Art, Dartmouth College, Hanover, New Hampshire.

The Hood Museum of Art is one of the oldest and largest college museums in the country. The Rev. David McClure gave the College its first artifacts, "a few curious Elephants bones" (actually mastodon fossils), in 1772, just three years after its founding. Since then, Dartmouth's collection of art and artifacts has grown to incorporate more than 60,000 objects. In addition to ongoing displays from its permanent collection, the Museum presents approximately eight changing exhibitions each year, with two new exhibitions on view each term. The Museum also presents two teaching exhibitions per term. The Dartmouth collection represents nearly every area of art history and ethnography and is particularly strong in African art; Oceanic art; Native North American art; early American silver; 19th- and 20th-century American painting; European Old Master, 19th-, and 20th-century prints; and contemporary art. Highlights include 9th-century BC reliefs from the Palace of Ashurnaisirpal II; works by Thomas Eakins, Frederic Remington, Paul Sample, John Sloan, and Gilbert Stuart; works by modern masters including Marc Chagall, Wassily Kandinsky, Fernand Léger, Henri Matisse, Joan Miró, Georgia O'Keeffe, Pablo Picasso, and Mark Rothko; and the Harry A. Franklin Family Collection of Oceanic Art (1,300 artifacts). The largest mural by José Clemente Orozco in the United States, "The Epic of American Civilization", is housed in the Baker Library. Also of possible interest on campus is the Student Art Exhibition Program, which displays student work in five venues.

Keene

Keene State College - Thorne-Sagendorph Art Gallery

Keene State College, Wyman Way, Keene, NH 03435-3501
Tel: (603) 358-2720
Fax: (603) 358-2238
Internet Address: http://www.keene.edu/TSAG
Director: Ms. Maureen Ahern
Admission: voluntary contribution.
Attendance: 5,000 *Established:* 1965 *Membership:* Y *ADA Compliant:* Y
Parking: free on site.
Open: **Fall to Spring**, Monday to Wednesday, noon-4pm; Thursday to Friday, noon-7pm;
Saturday to Sunday, noon-4pm.
Summer, Sunday to Tuesday, noon-4pm.
Closed: Academic Holidays, Semester Breaks.

Keene State College - Thorne-Sagendorph Art Gallery, cont.

Facilities: **Galleries** (4,000 square feet).

Activities: **Education Programs** (children); **Films**; **Gallery Talks**; **Guided Tours**; **Lectures**; **Temporary Exhibitions**; **Traveling Exhibitions**.

Publications: exhibition brochures; exhibition catalogues.

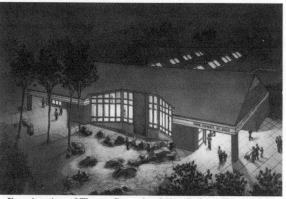

The Gallery is a comprehensive community and campus arts complex with space for programs, lectures, films and slides in concert with exhibits. Committed to local and regional, as well as national and international, art, the Gallery has hosted a retrospective of the work of Jules Olitski, five New Art-New Hampshire exhibits focusing on the best of New Hampshire's own artists, faculty shows, and regional juried

Exterior view of Thorne-Sagendorph Art Gallery, Keene State College. Rendering courtesy of Thorne-Sagendorph Gallery, Keene State College, Keene, New Hampshire.

exhibitions. The Thorne's permanent collection includes an extensive collection of nationally-recognized artists who worked in the Mount Monadnock area at the turn of the century, including Barry Faulkner, Alexander James, Richard Meryman, and Joseph Lindon Smith. The collection has grown through the years to include works by other contemporary artists, such as Vargian Bogosian, Robert Mapplethorpe, Jules Olitski, George Rickey, and Fritz Scholder.

Laconia

The Belknap Mill Society

The Mill Plaza, Laconia, NH 03246

Tel: (603) 524-8813

Exec. Director: Ms. Mary Rose Boswell

Admission: free.

Attendance: 40,000 *Established:* 1970

Membership: Y *ADA Compliant:* Y

Parking: free on site.

Open: Monday to Friday, 9am-5pm.

Closed: New Year's Day, Memorial Day, Independence Day, Labor Day, Christmas Day, Thanksgiving Day.

Facilities: **Architecture** (former textile mill, 1823); **Exhibition Area** (4,650 square feet); **Gallery**; **Library**; **Shop**; **Theatre** (225 seats).

Exterior view of Belknap Mill. Photograph courtesy of the Belknap Mill Society, Laconia, New Hampshire.

Activities: **Arts Festival**; **Concerts**; **Guided Tours**; **Lectures**; **Performances**; **Temporary Exhibitions**; **Traveling Exhibitions**.

Publications: program booklet.

The Belknap Mill Society preserves the Belknap Mill, the oldest unaltered brick textile mill in the U.S. The building contains an art gallery, concert hall, the only museum in the U.S. specializing in industrial knitting with working machines that make socks, and a 1918 hydroelectric power system. Facilities are also available for businesses and community services.

Manchester

The Currier Gallery of Art

201 Myrtle Way, Manchester, NH 03104

Tel: (603) 669-6144

Fax: (603) 669-7194

Internet Address: http://www.currier.org

Director: Ms. Susan E. Strickler

The Currier Gallery of Art, cont.

Admission: fee: adult-$5.00, student-$4.00, senior-$4.00.

Attendance: 40,000 *Established:* 1929

Membership: Y *ADA Compliant:* Y

Parking: on street.

Open: **Museum**,

Monday, 11am-5pm;
Wednesday to Thursday, 11am-5pm;
Friday, 11am-8pm;
Saturday, 10am-5pm;
Sunday, 11am-5pm.

Closed: Legal Holidays.

Facilities: **Architecture** (Zimmerman house, 1950 Usonian design by Frank Lloyd Wright; Beaux Arts Italianate museum building, 1929); **Auditorium** (125 seats); **Food Services** Café (lunch, Mon & Wed-Sat, 11:30am-2pm; coffee/pastries 2pm-4pm); **Galleries**; **Library** (5,000 volumes; Wed-Fri, 1pm-5pm); **Shop**.

Childe Hassam, *The Goldfish Window*, 1916, Currier Gallery of Art. Photograph courtesy of Currier Gallery of Art, Manchester, New Hampshire.

Activities: **Concerts**; **Education Programs** (adults and children); **Films**; **Gallery Talks**; **Guided Tours** Gallery (groups;, Zimmerman House (Mon & Fri, 2pm; Sat-Sun, 1pm & 2:30pm; reservations 626-4158); **Lectures**; **Temporary Exhibitions**.

Publications: annual report; bulletin, "Bulletin of The Currier Gallery of Art"; calendar (quarterly); exhibition brochures; exhibition catalogues.

The Currier Gallery of Art features European and American paintings, decorative arts, and sculpture, including works by Calder, Matisse, Monet, O'Keeffe, Picasso, and Wyeth. The permanent collection is complemented by a schedule of special exhibitions. Additionally, the Gallery offers tours of the Zimmerman House, designed by Frank Lloyd Wright in 1950, complete with original furnishings, and the Zimmermans' collection of fine art.

New Hampshire Institute of Art

148 Concord St., Manchester, NH 03104

Tel: (603) 623-0313 *Ext:* 13

Fax: (603) 641-1832

C.E.O. & President: Andrew J. Svedlow, Ph.D.

Admission: free.

Attendance: 25,000 *Established:* 1898

Membership: Y *ADA Compliant:* Y

Parking: public parking lots.

Open: Monday to Thursday, 9am-7:30pm;
Friday to Saturday, 9am-5pm;
Sunday, 1pm-5pm.

Closed: New Year's Day, ML King Day, Presidents' Day, Memorial Day, Independence Day, Labor Day, Thanksgiving Break, Christmas Eve to day after New Year's.

Interior view of New Hampshire Institute of Art. Photograph courtesy of New Hampshire Institute of Art, Manchester, New Hampshire,

Facilities: **Auditorium** (450 seats); **Exhibition Area** (2 galleries); **Shop** (one-of-a-kind handmade gifts, books, art supplies); **Theatre Companies** (2).

Activities: **Concerts**; **Education Programs**; **Film Series** (7/year).

Publications: course catalogues (1/semester); exhibition catalogues; journal, "Victory Park: The Journal of the New Hampshire Institute of Art" (semi-annual); newsletter (quarterly).

The New Hampshire Institute of Art provides opportunities to learn about and experience the visual arts. Its galleries present artwork from all over the country.

Manchester, New Hampshire

St. Anselm College - Chapel Art Center

St. Anselm College, 100 St. Anselm Drive
Manchester, NH 03102
Tel: (603) 641-7470
Fax: (603) 641-7116
Internet Address: http://www.anselm.edu
Director: Dr. Donald A. Rosenthal
Admission: free.
Attendance: 4,000 *Established:* 1967
ADA Compliant: Y
Open: **September to April**,
 Tuesday to Wednesday, 10am-4pm;
 Thursday, 10am-9pm;
 Friday to Saturday, 10am-4pm.
Closed: Academic Holidays, Legal Holidays.

Facilities: **Architecture** (former college chapel, 1923; ceiling and wall painting ca. 1930); **Exhibition Area** (2,800 square feet).

Interior view, Chapel Art Center, Saint Anselm College. Photograph courtesy of Chapel Art Center, Saint Anselm College, Manchester, New Hampshire.

Activities: **Gallery Talks**; **Lectures**; **Temporary Exhibitions**; **Traveling Exhibitions**.
Publications: exhibition catalogues.

The Chapel Art Center, adjoining Alumni Hall, organizes varied exhibitions of historical and contemporary art that are closely integrated with the curriculum in art history and studio fine arts courses. An important part of the schedule is devoted to displays of the most accomplished recent art works by students. The gallery is located in the former College Chapel, beautifully decorated with mural paintings. Other programs such as lectures, concerts and receptions, usually related to current exhibitions, are scheduled from time to time. The Chapel Art Center also houses a small permanent art collection, consisting mainly of contemporary American paintings and works on paper.

Plymouth

Plymouth State College - Karl Drerup Fine Arts Gallery

Department of Fine Arts, Draper Maynard Building, High St., Plymouth, NH 03264
Tel: (603) 535-2646
Fax: (603) 535-2938
TDDY: (603) 535-2679
Internet Address: http://www.plymouth.ed/psc/gallery/l
Gallery Director: Dr. Catherine S. Amidon
Admission: free.
Attendance: 4,000 *Established:* 1969 *ADA Compliant:* Y
Open: Monday to Tuesday, 10am-5pm; Wednesday, 10am-8pm; Thursday to Friday, 10am-5pm;
 Saturday, noon-5pm.
Closed: Academic Holidays, Thanksgiving Day, Christmas Day.
Facilities: **Exhibition Area**.
Activities: **Education Programs** (undergraduate and graduate students); **Lectures**; **Traveling Exhibitions**.

Located in the Draper Maynard building on the campus of Plymouth State College, the Gallery offers art exhibits, adjunct programs, and lectures. There are additional exhibition sites on campus; maps are available in the Gallery.

Sharon

The Sharon Arts Center, Inc.

457 Route 123, Sharon, NH 03458
Tel: (603) 924-7256
Fax: (603) 924-6074
Internet Address: http://www.sharonarts.org

The Sharon Arts Center, Inc., cont.

President: Mr. Marshall Lawton

Admission: voluntary contribution

Attendance: 22,000 *Established:* 1947 *Membership:* Y *ADA Compliant:* Y

Open: Monday to Saturday, 10am-5pm;
Sunday, noon-5pm.

Facilities: **Exhibition Area**; **Shop** (unique handcrafted objects; located in Sharon Arts Downtown).

Activities: **Concerts**; **Education Programs**; **Films**; **Gallery Talks**; **Guided Tours**; **Lectures**; **Readings**; **Temporary Exhibitions.**

Publications: "25 Wood Engravings".

The Sharon Arts Center (SAC) stimulates, encourages, and promotes education in the theory and practice of the arts and crafts through instruction, exhibition, and assistance to practitioners. Its galleries exhibit fine arts and crafts of regional and international importance. Members exhibit and sell their juried work at the Laws House Gallery. Its shop, presenting the craftwork of over 400 artisans, is located at Sharon Arts Downtown, 7 School Street, Suite E, Peterborough, New Hampshire (924-ARTS).

Nora S. Unwin, *Mexican Women*, 1956, 7 x 8.93 inches, wood engraving, permanent collection of Sharon Art Center. Photograph courtesy of Sharon Arts Center, Peterborough, New Hampshire.

New Jersey

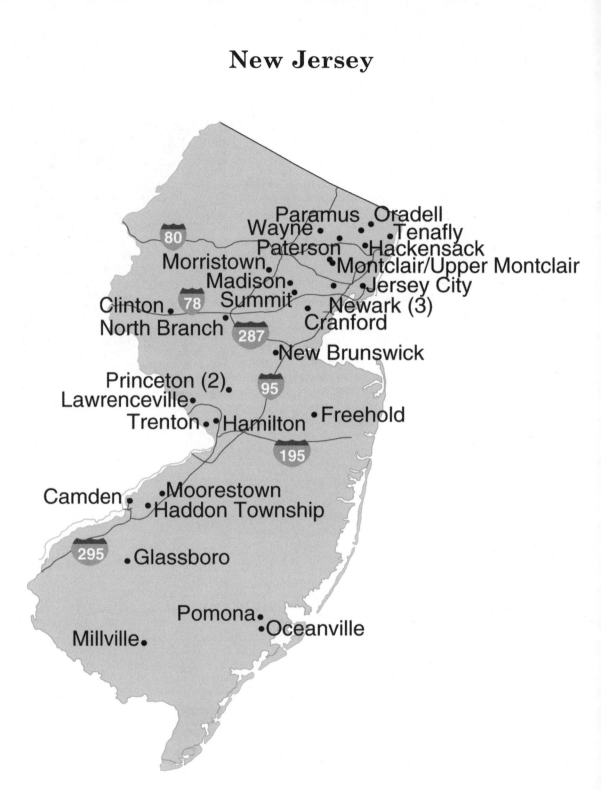

The number in parentheses following the city name indicates the number of museums/galleries in that municipality. If there is no number, one is understood. For example, in the text three would be found under Newark and one listing under Glassboro.

New Jersey

Camden

Rutgers University, Camden - Stedman Gallery

Rutgers-Camden Center for the Arts, 3rd and Pearl Streets, Camden, NJ 08102-1403
Tel: (609) 225-6245
Fax: (609) 225-6330
TDDY: (609) 225-6648
Internet Address: http://camden-www.rutgers.edu
Director: Ms. Virginia Oberlin Steel
Admission: free.
Attendance: 18,500 *Established:* 1975 *Membership:* N *ADA Compliant:* Y
Parking: free on site.
Open: Monday to Wednesday, 10am-4pm; Thursday, 10am-8pm; Friday to Saturday, 10am-4pm.
Closed: Memorial Day, Independence Day, Labor Day, Thanksgiving Day,
 Christmas Eve to January 2, Between Exhibitions.
Facilities: **Galleries.**
Activities: **Concerts; Education Programs** (children); **Films; Lectures; Temporary Exhibitions.**
Publications: exhibition catalogues.

The Gallery mounts a year-round series of temporary exhibitions.

Clinton

Hunterdon Museum of Art

7 Lower Center St., Clinton, NJ 08809
Tel: (908) 735-8415
Fax: (908) 735-8416
Exec. Director: Ms. Marjorie Frankel Nathanson
Admission: donation.
Attendance: 20,000 *Established:* 1952
Membership: Y *ADA Compliant:* Y
Open: Tuesday to Sunday, 11am-5pm.
Facilities: **Architecture** (restored stone grist mill, 1836); **Galleries** (3 exhibition, 1 sales).
Activities: **Education Programs** (adults and children); **Gallery Talks; Guided Tours; Juried Exhibits; Lectures; Temporary Exhibitions; Traveling Exhibitions.**
Publications: brochure; exhibition catalogues; newsletter.

Exterior view, Hunterdon Museum of Art. Photograph by Linda Lodato, courtesy of Hunterdon Museum of Art, Clinton, New Jersey.

The Museum presents approximately twelve exhibitions per year, focusing on the work of established and emerging artists and ranging from the traditional to the cutting edge, including the Annual National Print Exhibition. There is also a permanent collection consisting of more than 200 prints by artists working today and during the last forty years.

Cranford

Union County College - The Tomasulo Gallery

1033 Springfield Ave., Cranford, NJ 07016-1599
Tel: (908) 709-7155
Fax: (908) 709-0527
Internet Address: http://www.ucc.edu
Director: Valeri Larko

Union County College - The Tomasulo Gallery, cont.

Admission: free.

Established: 1974 *Membership:* N

ADA Compliant: Y

Parking: parking available.

Open: Monday, 1pm-4pm;
Tuesday to Thursday, 1pm-4pm and 6pm-9pm;
Saturday, 1pm-4pm.

Facilities: **Exhibition Area** (625 square feet).

Activities: **Temporary Exhibitions** (6 per year - 5 professional & 1 student).

Each year, the Gallery mounts five professional exhibits of contemporary painting, sculpture, and installation art. There is also an annual student exhibit of work in architecture. Usually, there are no exhibits in July and August.

Mary Beth McLenzie, *Self Portrait (yellow background)*, oil on canvas, 18 x 14 inches, from 1998 exhibition of the artist's work, Tomasulo Gallery. Photograph courtesy of Tomasulo Gallery, Union County College, Cranford, New Jersey.

Freehold

Monmouth County Historical Association (MCHA)

70 Court St., Freehold, NJ 07728-1795

Tel: (908) 462-1466

Fax: (908) 462-8346

Director: Lee Ellen Griffith, Ph.D.

Admission: fee: adult-$2.00, child-$1.00, senior-$1.50.

Attendance: 13,000 *Established:* 1898

Membership: Y

Open: **Museum**,
Tuesday to Saturday, 10am-4pm;
Sunday, 1pm-4pm.

Library,
Wednesday to Saturday, 10am-4pm.

Closed: New Year's Eve to New Year's Day, Independence Day, Thanksgiving Day, Christmas Eve to Christmas Day.

Facilities: **Architecture** (4 18th-century houses); **Galleries**; **Library**.

Activities: **Education Programs** (adults and children); **Films**; **Guided Tours** (groups, reserve in advance); **Lectures**; **Temporary Exhibitions**.

Publications: newsletter (quarterly).

Exterior view of Monmouth County Historical Association Museum and Library. Photograph courtesy of Monmouth County Historical Association, Freehold, New Jersey.

MCHA maintains and operates a museum, an extensive library and archives, and four historic sites. The museum collections, remarkable for their quality and scope, are displayed in changing exhibitions at the Museum. Among the Museum's permanent displays are 22 pastel portraits by Micah Williams, circa 1820. In addition, the collections are used to interpret the MCHA's 18th-century historic properties, Coven House in Freehold, Holmes-Hendrickson House in Holmdel, and the Allen House in Shrewsbury. (The MCHA's fourth historic property, Marlpit Hall in Middletown, is currently closed for restoration.) The Museum collections include representation of the fine arts as well as the artifacts of everyday life. Furniture and decorative arts comprise a substantial portion of the collection, which also contains costumes and textiles, ceramics, metals, portraits and paintings, folk art, tools, ephemera and military objects.

Glassboro

Rowan University - Galleries

Route 322, Glassboro, NJ 08028
Tel: (609) 256-4521
Internet Address: http://www.rowan.edu
Director of the Galleries: Ms. Naomi Nelson
Admission: free.
Open: Wilson Art Gallery,
 Monday to Friday, 9am-5pm.
 Westby Art Gallery,
 Tuesday, 10am-4pm; Wednesday, 10am-6:30pm; Thursday to Friday, 10am-4pm.
 Student Art Gallery,
 Monday to Friday, 9am-4pm.
Facilities: Galleries (3).
Activities: Temporary Exhibitions.

The Galleries at Rowan University exhibit traditional and contemporary work by nationally and internationally recognized artists, as well as innovative emerging artists. Rowan students present individual and group exhibitions in the Westby Student Gallery. Wilson Concert Hall's lobby is used for special exhibits, often in collaboration with musical and theatrical presentations.

Hackensack

Fairleigh Dickinson University - Edward Williams Gallery

150 Kotte Place, Hackensack, NJ 07601
Tel: (201) 692-2449
Internet Address: http://www.fdu.edu
Director: Ms. Rachel Friedberg
Open: Monday to Friday, 9am-9pm; Saturday, 9am-2pm.
Facilities: Exhibition Area.
Activities: Temporary Exhibitions.

The gallery presents temporary exhibitions. Also of possible interest on the Teaneck-Hackensack campus are University College Art Gallery (Mon-Fri, 9am-5pm; Sat, noon-5pm, 692-2801), located in Becton Hall, presenting ten professional exhibitions annually, and University College Art Gallery II, The Maples, located next to Becton Hall, featuring student work.

Haddon Township

Hopkins House Gallery

Ebenezer Hopkins House, 250 S. Park Drive, Haddon Township, NJ 08108
Tel: (856) 858-0040
Fax: (856) 869-3548
Director: Ms. Ruth S. Bogutz
Admission: free.
Attendance: 1,500 *Membership:* N *ADA Compliant:* Y
Parking: free on site.
Open: Tuesday to Friday, 10am-1pm and 2pm-4pm; Saturday, noon-4pm.
Facilities: Exhibition Area.
Activities: Gallery Tours (school groups and organizations); Temporary Exhibitions.

Under the aegis of the Camden County Cultural and Heritage Commission, the Hopkins House Gallery is located in the Ebenezer Hopkins House, built ca. 1737, with a harmonious addition built by the W.P.A. in 1939. The Gallery presents changing art exhibits in all media in a historic setting. It sponsors all-media and watercolor juried exhibits through which art is purchased for Camden County Art Bank and displayed in public offices throughout the county. Gallery III exhibits the work of Camden County artists only.

Hamilton

Grounds For Sculpture

18 Fairgrounds Road, Hamilton, NJ 08619
Tel: (609) 586-0616
Fax: (609) 586-0968
Internet Address: http://www. groundsforsculpture.org
Director and Curator: Ms. Brooke Barrie
Admission: fee:
 Tuesday to-Thursday,
 adult-$4.00, child (<13)-free, student/senior-$3.00;
 Friday to Saturday,
 adult-$7.00, child (<13)-$3.00, student/senior-$6.00;
 Sunday, $10.00.

Exterior view of Grounds for Sculpture: Crab Apple Trees, Arbor and Museum, Spring, 1996. Photograph by Ricardo Barros, courtesy of Grounds for Sculpture, Hamilton, New Jersey.

Attendance: 35,000 *Established:* 1992
Membership: Y *ADA Compliant:* P
Parking: free on site.
Open: Tuesday to Sunday (Members Day), 10am-9pm.
Closed: Major Holidays.
Facilities: **Exhibition Area** (20,000 square feet, indoors); **Food Services** Café (50 seats, outdoor; 40 seats, indoors), Gazebo Café (May-November, weather permitting, 22 seats, outdoors), Rat's Restaurant (100 seats indoors, 55 seats outdoors); **Sculpture Park** (22 acres); **Shop** (merchandise focusing on contemporary art and sculpture).
Activities: **Concerts**; **Guided Tours** (by appointment and Saturday, 11am); **Lecture Series**; **Performances**; **Permanent Exhibition**; **Poetry Readings**; **Temporary Exhibitions** (3/year).
Publications: exhibition catalogues (3/year).

Located on a site that was formerly part of the New Jersey State Fairgrounds, Grounds For Sculpture is a 22-acre sculpture park and museum that organizes changing exhibitions of contemporary sculpture by American and internationally renowned artists who work in a wide range of media. Three exhibitions are scheduled per year (Spring, Summer and Fall/Winter), with one-person and group shows alternating in the museum buildings. In addition to the interior exhibition spaces, the facilities offer a variety of sites for placing works on view outdoors. Small-scale to monumental works on long-term loan or from the permanent collection are sited throughout the sculpture park. Among the artists represented are Magdalena Abakanowicz, Bruce Beasley, Anthony Caro, Charles Ginnever, J. Seward Johnson, Jr., Alexander Liberman, Marisol, Karen Petersen, George Sugarman, and Isaac Witkin.

Jersey City

New Jersey City University - Lemmerman and Courtney Galleries

2039 Kennedy Blvd., Jersey City, NJ 07305
Tel: (201) 200-3246
Fax: (201) 200-3224
Internet Address: http://www.njcu.edu
Director of Campus Galleries: Professor Hugo Xavier Bastidas
Admission: free.
Attendance: 7,000 *Established:* 1969 *ADA Compliant:* Y
Parking: Parking lot and on street.
Open: Monday to Friday, 11am-4pm.
Facilities: **Galleries** (2; 700 and 340 square feet).
Activities: **Temporary Exhibitions**.

The University maintains two galleries: the Harold B. Lemmerman Gallery and the Courtney Gallery, both devoted to changing exhibitions of work by professional artists, faculty, and students. The permanent collection is not exhibited in the galleries; however, a potion of the holdings are on display on the third floor of Hepburn Hall.

Lawrenceville

Rider University - University Art Gallery

Student Center, 2083 Lawrenceville Road, Lawrenceville, NJ 08648

Tel: (609) 895-5588

Internet Address: http://www.rider.edu

Director: Professor Harry Naar

Admission: free.

Attendance: 2,000 *ADA Compliant:* Y

Parking: free on site.

Open: **Academic Year**, Monday to Thursday, 2pm-8pm; Friday to Sunday, 2pm-5pm.

Facilities: **Exhibition Area**.

Activities: **Gallery Talks**; **Temporary Exhibitions** (4/year).

Publications: exhibition catalogues.

The Gallery mounts four exhibitions per year (one each in September-October, November-December, January-February, and March-April). Exhibits include work by professional artists, primarily from New Jersey and its immediate region. The permanent collection at Rider focuses primarily on contemporary painting, but it also includes a small but strong collection of African sculpture. These works may be seen in the Presidential Lobby.

Madison

Drew University - Korn Gallery

Brothers College, Route 124

Madison, NJ 07940

Tel: (973) 408-3011

Internet Address:

 http://www.depts.drew.edu/art/gallery.htm

Admission: free.

Parking: free on site.

Open: Tuesday to Friday, 12:30pm-4:00pm,

 or by appointment.

Facilities: **Exhibition Area**.

Activities: **Gallery Talks**; **Lectures**; **Performances**; **Temporary Exhibitions**.

The Gallery hosts temporary exhibitions of work by professional artists, as well as annual student and senior shows. Drew also presents rotating exhibits in the University Library, art receptions and displays in Brothers College, and photography exhibits in the University Center.

Steve Roden, *wandering, the world has become lovelier*, 1998-9, 8 inches x 10 inches, oil and acrylic on canvas. Temporary exhibition, 1999, Korn Gallery, Drew University. Photograph courtesy of Drew University, Madison, New Jersey.

Millville

Wheaton Village, Museum of American Glass

1501 Glasstown Road, Millville, NJ 08332-1566

Tel: (800) 998-4552

Fax: (856) 825-2410

Internet Address: http://www.wheatonvillage.org

Curator: Ms. Gay LeCleire Taylor

Admission: fee: adult-$7.00, child-free, student-$3.50, senior-$6.00.

Membership: Y

Open: **April to December**, Daily, 10am-5pm.

 January to March, Wednesday to Sunday, 10am-5pm.

Closed: Easter, Thanksgiving Day, Christmas Day, New Year's Day.

Facilities: **Exhibition Area** (20,000 square feet); **Library** (2,000 volumes, non-circulating); **Shop**.

Millville, New Jersey

Wheaton Village, Museum of American Glass, cont.

Activities: **Education Programs**; **Guided Tours** (daily, 2:30pm).

The Museum of American Glass is the largest museum in the country dedicated to preserving the history of glass made in the United States. Housed in a structure modeled after a Cape May Victorian hotel, the collection includes over 6,500 pieces of American glass. The collection contains works by Tiffany, Stankard, Chihuly, and Ruffner.

Montclair

The Montclair Art Museum

3 South Mountain Ave., Montclair, NJ 07042-1747

Tel: (973) 746-5555

Fax: (973) 746-9118

Internet Address: http://www.montclair-art.org

Director: Ms. Ellen S. Harris

Admission: suggested contribution: adult-$5.00, child-free, student-$4.00, senior-$4.00.

Attendance: 80,000 *Established:* 1914 *Membership:* Y *ADA Compliant:* Y
Parking: free on site.

Open: Tuesday to Saturday, 11am-5pm; Sunday, 1pm-5pm.

Closed: Legal Holidays.

Facilities: **Architecture** (neo-classic Greek revival, 1914 design by Albert B. Ross); **Building** (25,000 square feet); **Galleries** (7); **Grounds** (3.5 acres, Van Vleck Arboretum); **Library** (14,000 volumes); **Reading Room**; **Shop**.

Activities: **Art Classes** (adults and children); **Concerts**; **Films**; **Gallery Talks**; **Guided Tours**; **Lectures**; **Temporary Exhibitions**.

Publications: calendar; collection catalogue, "Three Hundred Years of American Painting"; exhibition catalogues.

One of the first museums in the nation to devote itself primarily to American Art, the Museum maintains a permanent collection consisting of more that 11,000 works in a variety of media. The American art collection includes paintings, works on paper, sculpture, and costumes from the mid-18th century to the present. Portraits by Gilbert Stuart, Charles Willson Peale and John Singleton Copley; landscapes by Hudson River School artists Thomas Cole, Asher B. Durand, and Jasper Cropsey; an extensive collection of landscapes by Montclair-based landscape painter George Inness; and works by American Impressionists Mary Cassatt, Theodore Robinson, and Julien Alden Weir are among the highlights of the 18th- and 19th-century holdings. Early 20th-century Ashcan School painters George Bellows, Robert Henri and John Sloan and Modernists Oscar Bluemner, Marsden Hartley, John Marin, and Morgan Russell are also represented. Artists of the American Scene movement represented include Philip Evergood, Edward Hopper, and Ben Shahn. American art since World War II is represented by artists such as William Baziotes, Romare Bearden, Jacob Lawrence, Robert Motherwell, Mark Rothko, and Hale Woodruff; and contemporary artist such as Mel Edwards, Lorna Simpson, Nancy Spero, Robert Stackhouse, and Michelle Stuart. The Museum also has an extensive Native American collection of approximately 6,000 objects with particularly fine examples of basketry and jewelry. As well as traditional crafts, the work of such contemporary Native American artists as Dan Namingha, John Nieto, and Jaune Quick-to-See Smith is included. The Museum is undertaking an expansion project. A permanent collection installation is expected to open in the fall of 2001.

Moorestown

Perkins Center of the Arts

395 Kings Highway, Moorestown, NJ 08057-2725

Tel: (856) 235-6488

Fax: (856) 235-6624

Internet Address: http://www.perkinscenter.org

Director: Mr. Alan Willoughby

Admission: voluntary contribution.

Established: 1977 *Membership:* Y *ADA Compliant:* Y

Perkins Center of the Arts, cont.

Open: Thursday to Friday, 10am-4pm; Saturday to Sunday, noon-4pm.

Facilities: **Architecture** (Tudor Revival House, designed by Herbert C. Wise); **Visual Arts Studios**.

Activities: **Concerts**; **Dance Recitals**; **Education Programs** (adults and children); **Guided Tours**; **Lectures**; **Performances**; **Exhibitions** (6/year).

Publications: newsletter, "Perkinsight" (quarterly).

The Center's programs include visual and performing arts classes, exhibitions, music and dance performances, workshops, visiting artist residencies, and outreach programs. Six exhibitions are held annually offering emerging and accomplished artists opportunities to show their work. Juried and curated show draw artists from a six-state area.

Morristown

The Morris Museum

6 Normandy Heights Road, Morristown, NJ 07960

Tel: (973) 538-0454

Fax: (973) 538-0154

Internet Address:
 http://www.morrismuseum.org

Exec. Director: Mr. Steven Klindt

Admission: fee: adult-$5.00, child-$3.00,
 student-$3.00, senior-$3.00.

Attendance: 200,000 *Established:* 1913

Membership: Y *ADA Compliant:* Y

Open: Tuesday to Wednesday, 10am-5pm;
 Thursday, 10am-8pm;
 Friday to Saturday, 10am-5pm;
 Sunday, 1pm-5pm.

Closed: Legal Holidays.

Exterior view of The Morris Museum. Photograph courtesy of The Morris Museum, Morristown, New Jersey.

Facilities: **Building** (75,524 square feet); **Classrooms**; **Galleries** (9 permanent, 4 changing exhibition); **Library** (1,700 volumes); **Shop**; **Theatre** (312 seats).

Activities: **Education Programs** (adults, undergraduates and children); **Lectures**; **Temporary Exhibitions**; **Traveling Exhibitions**.

Publications: exhibition catalogues; newsletter (quarterly).

The Morris Museum presents changing exhibitions and distinctive performances to further the understanding and appreciation of the roles of arts, sciences, and humanities. The permanent collections consist of approximately 48,000 objects, including fine arts, decorative arts, costumes and textiles, dolls and toys, natural science, mineralogy, paleontology, and anthropology. The fine arts collection consists of European and American paintings from the 18th, 19th, and 20th centuries, as well as contemporary prints, drawings, sculpture, and photography. Objects from the permanent collection are presented in the permanent and changing exhibitions.

New Brunswick

Rutgers University - Jane Voorhees Zimmerli Art Museum

Rutgers: The State University of NJ, George and Hamilton Sts., New Brunswick, NJ 08903

Tel: (908) 932-7237

Fax: (908) 232-2444

Internet Address: http://www-rci.rutgers.edu/~zamuseum/

Director and Curator: Mr. Phillip Dennis Cate

Admission: fee: adult-$3.00, child-free.

Attendance: 30,000 *Established:* 1966 *Membership:* Y *ADA Compliant:* Y

Parking: behind museum off George St.

Open: **September to June**, Tuesday to Friday, 10am-4:30pm; Saturday to Sunday, noon-5pm.
 July, Wednesday to Friday, 10am-4:30pm; Saturday to Sunday, noon-5pm.

Closed: August, Memorial Day, Independence Day, Labor Day, Thanksgiving Day,
 Thanksgiving Friday, Christmas Day to New Year's Day.

New Brunswick, New Jersey

Rutgers University - Jane Voorhees Zimmerli Art Museum, cont.

Facilities: **Galleries**; **Library** (3,500 volumes, French fin de siecle books & periodicals).

Activities: **Concerts**; **Education Programs** (children); **Guided Tours** (groups, minimum 10, reserve 4 weeks in advance); **Temporary Exhibitions**.

Publications: exhibition catalogues; newsletter, "Japonisme Newsletter" (semi-annual).

The Museum presents exhibits drawn from the permanent collections and temporary exhibitions. The Museum houses the Rutgers University Art Collection, composed of approximately 50,000 objects. A component, the International Center for Japonisme, displays in the Kusakabe-Griffis Japonisme Gallery. Permanent collections include the Norton and Nancy Dodge Collection of Non-Conformist Art from the Soviet Union (over 10,000 works of art by over 900 artists); the French Graphic Arts Collection (50,000 works on paper from 1870-1918); the Gordon Henderson Collection of Stained Glass Design; the Japonisme Collection (turn-of-the-century French and American art inspired by Japanese aesthetics); the George Riabov Collection of Russian Art (1,100 works from the 18th through 20th centuries); the Rutgers Archives for Printmaking Studios; the Rutgers Collection of Children's Literature; and the Collection of Western Art (2,000 paintings, sculpture, and graphic art).

Newark

The New Jersey Historical Society

52 Park Place, Newark, NJ 07102
Tel: (973) 596-8500
Fax: (973) 596-6957
Exec. Director: Dr. Sally Yerkovich
Admission: free.
Attendance: 20,000 *Established:* 1845 *Membership:* Y
Open: Tuesday to Saturday, 10am-5pm.
Closed: Legal Holidays.

Facilities: **Auditorium** (150 seats); **Galleries** (3); **Library** (65,000 volumes); **Reading Room**; **Shop**.

Activities: **Education Programs**; **Films**; **Gallery Talks**; **Guided Tours**; **Lectures** (Wed, 12:15-1pm;); **Temporary Exhibitions**.

Publications: books; exhibition catalogues; journal, "New Jersey History" (semi-annual); newsletter, "New Jersey Historical Society News"; student newspaper, "Jersey Journeys".

Collections focus on New Jersey and American history and include fine art, decorative arts, tools, costumes, toys, photographs,and maps.

The Newark Museum

49 Washington St. (at Central Ave.)
Newark, NJ 07101
Tel: (973) 596-6550
Fax: (973) 642-0459
TDDY: (973) 596-6355
Internet Address:
 http://www.amn.org/internal/Newkext.htm
Director: Ms. Mary Sue Sweeney Price
Admission: voluntary contribution.
Attendance: 230,000 *Established:* 1909
Membership: Y *ADA Compliant:* Y
Parking: pay on site.
Open: Wednesday to Sunday, noon-5pm.
Closed: New Year's Day, Independence Day, Thanksgiving Day, Christmas Day.

Washington Street view of Newark Museum (with Ballantine House to right). Photograph courtesy of Newark Museum, Newark, New Jersey.

Facilities: **Architecture** (1989 renovation and integration of 4 original buildings by Michael Graves); **Auditorium**; **Food Services** Café (noon-3:30pm); **Galleries** (66; total 60,000 square feet); **Library** (28,000 volumes); **Sculpture Garden**; **Shop** (posters, jewelry, gift items, books).

The Newark Museum, cont.

Activities: **Concerts**; **Education Programs** (adults and children); **Films**; **Gallery Talks**; **Guided Tours** (groups, reserve in advance); **Lectures**; **Performances**; **Temporary Exhibitions**.

Publications: exhibition catalogues; newsletter, "The Newark Museum Exhibitions & Events" (bi-monthly).

The largest museum complex in New Jersey, the Newark Museum includes the 1885 Ballantine House, a restored National Historic Landmark; the Dreyfuss Planetarium; the Mini Zoo; the Junior Museum; the Arts Workshop for Adults; the Billy Johnson Auditorium, the Dreyfuss Memorial Garden; a 1784 schoolhouse; and the Newark Fire Museum. The Newark Museum presents permanent and changing exhibits drawn from its wide-ranging permanent collections. The Museum houses one of the foremost collections of American Art (6,000 works) from the 18th to 20th centuries. Significant holdings include 19th-century landscape and genre painting, early 20th-century American Modernism, American Folk Art, and contemporary works. Artists represented include R. Bearden, J.S. Copley, T. Cole, W. Cole, J. Cropsey, W. Homer, J. Lawrence, F. Ringgold, G. Stuart, H.O. Tanner, H. Woodruff, and folk artists W. Edmondson and D. Butler. Two thousand works on paper from the Works Progress Administration constitute the largest such collection in non-governmental hands. The Decorative Arts collection (16,000 objects) represents all aspects of the decorative arts, from the 16th century to the present with a special emphasis on objects made in New Jersey. It has well-known collections of American silver, furniture, and art pottery, as well as important objects from the Victorian era, many displayed in the Ballantine House. The Asian Collections (20,000 objects) are particularly rich in Chinese, Japanese and Korean ceramics, lacquer, metalwork, and textiles. Its collection of Tibetan artifacts is one of the most comprehensive in the Western Hemisphere. The Classical Collection (5,000 objects) contains Egyptian, Greek, Etruscan, and Roman artifacts, as well as a permanent exhibit of Coptic art. The Arts of Africa, the Americas and the Pacific (5,400 objects) feature the diverse cultures from North and sub-Saharan Africa, Oceania, and North and South America.

Rutgers University - Robeson Center Art Gallery

350 Dr. Martin Luther King Jr. Blvd., Newark, NJ 07102
Tel: (973) 353-5119 *Ext:* 32
Fax: (973) 353-1392
Internet Address: http://newark.rutgers.edu/artgallery/
Admission: free.
Open: Monday to Tuesday, 11:30am-4:30pm; Wednesday, 1:30pm-6:30pm; Thursday, 11:30am-4:30pm.
Facilities: **Exhibition Area**.
Activities: **Temporary Exhibitions**.

Located in the Paul Robeson Campus Center on the Newark Campus of Rutgers University, the Gallery presents temporary exhibitions, including annual fine arts and graphic design senior theses shows.

North Branch

Raritan Valley Community College Art Gallery

Route 28 and Lamington Road, North Branch, NJ 08876
Tel: (908) 218-8876
Fax: (908) 595-0213
Internet Address:
 http://rvcc2.raritanval.edu/~fapa/index.html
Director, Art Gallery: Prof. Ann Tsubota
Admission: free.
Attendance: 700 *Established:* 1985
Membership: N *ADA Compliant:* Y
Parking: free on site.

Interior view of Raritan Valley Community College Art Gallery during "No Apologies", a solo exhibition of work by John Atura in 1998. Photograph courtesy of Raritan Valley Community College, North Branch, New Jersey.

Raritan Valley Community College Art Gallery, cont.

Open: Monday, 3pm-8pm; Tuesday, noon-3pm; Wednesday, 1pm-8pm; Thursday, noon-3pm.

Facilities: **Gallery** (1,575 square feet).

Activities: **Temporary Exhibitions** (8/year).

The Main Gallery, located in the College Center building, presents eight exhibitions each year, including annual student and faculty art exhibits, one to two solo shows, and two to four group exhibitions of work by professional artists (curated by RVCC Art Department faculty). Additionally, an on-going series devoted to current student work is displayed in the Mini Gallery, located in the Art Building. There are also several alternative exhibition spaces on campus, including the theater lobby and the sculpture garden.

Oceanville

The Noyes Museum of Art

Lily Lake Road, Oceanville, NJ 08231

Tel: (609) 652-8848

Fax: (609) 652-6166

TDDY: (800) 852-7899

Internet Address: http://www.noyesmuseum.org

C.E.O./Executive Director: Jane E. Epstein

Admission: fee: adult-$3.00, child (<12)-free, student-$2.00, senior-$2.00.

Attendance: 20,000 *Established:* 1983

Membership: Y *ADA Compliant:* Partial

Open: Wednesday to Sunday, 11am-4pm.
Major Holidays: Call for hours.

Exterior view of Noyes Museum of Art. Photograph courtesy of Noyes Museum of Art, Oceanville, New Jersey.

Facilities: **Galleries** (5); **Shop** (one-of-a-kind crafts, jewelry, books, bird decoys).

Activities: **Concerts** (Sunday); **Gallery Talks**; **Guided Tours** (groups); **Temporary/Traveling Exhibitions** (8-10/year).

Publications: exhibition catalogues; newsletter (quarterly).

Located in a wooded setting on the edge of Lily Lake, adjacent to the Forsythe National Wildlife Refuge, the Noyes Museum displays contemporary American fine art, craft, and folk art, including vintage bird decoys. The Museum's exhibitions each year include traveling exhibits and works by leading American artists.

Oradell

Hiram Blauvelt Art Museum

705 Kinderkamack Road, Oradell, NJ 07649

Tel: (201) 261-0012

Fax: (201) 391-6418

Director: Marijane Singer, Ph.D.

Admission: voluntary contribution.

Attendance: 10,000 *Established:* 1940

Membership: N *ADA Compliant:* Y

Parking: free on site.

Open: Wednesday to Friday, 10am-4pm;
Saturday to Sunday, 2pm-5pm.

Closed: Legal Holidays.

Facilities: **Exhibition Area** (9 galleries; 6 permanent, 3 changing); **Library**; **Sculpture Garden**.

Activities: **Arts Festival** (summer); **Education Programs** (schools); **Guided Tours** (five days a week); **Temporary Exhibitions** (3-4/year).

View of exterior of Hiram Blauvelt Art Museum. Photograph courtesy of Hiram Blauvelt Art Museum, Oradell, New Jersey.

Hiram Blauvelt Art Museum, cont.

Publications: exhibition catalogues.

Located in an 1895 shingle and turret-style carriage house, the Museum is dedicated to bringing awareness of issues facing the natural world and to showcasing the artists who are inspired by it. The exhibits on the main floor feature an Audubon folio, extinct birds, and an ivory collection. On the upper level, the predominant theme is the conservation of big game species. Included in the permanent collection are the works of master and contemporary wildlife artists including a permanent exhibition of works by naturalist Charles Livingston Bull. The James L. Bellis Galleries and Sculpture Garden enable the Museum to mount temporary exhibitions. In addition, an artist-in-residence program offers demonstrations in wildlife/landscape painting, lectures, and artist roundtables.

Paramus

Bergen Museum of Art and Science

327 E. Ridgewood Ave., Paramus, NJ 07652

Tel: (973) 265-1248

Fax: (973) 265-2536

Director: Mr. David J. Messer

Admission: voluntary contribution.

Attendance: 25,000 *Established:* 1956 *Membership:* Y *ADA Compliant:* Y

Open: Tuesday to Saturday, 10am-5pm; Sunday, 1pm-5pm.

Facilities: Galleries.

Activities: **Arts Festival**; **Concerts**; **Education Programs** (adults and children); **Films**; **Guided Tours**; **Lectures**; **Temporary Exhibitions**.

Publications: calendar (quarterly); exhibition catalogues.

The Museum presents a regular schedule of exhibitions featuring the work of contemporary artists working in northern New Jersey and metropolitan New York.

Paterson

Passaic County Community College Gallery

1 College Blvd., Paterson, NJ 07505-1179

Tel: (973) 684-6555

Fax: (973) 684-5843

Internet Address: http://www.pccc.cc.nj.us/

Admission: free.

Attendance: 2,000 *Established:* 1979 *ADA Compliant:* Y

Parking: metered parking.

Open: Monday to Friday, 9am-9pm; Saturday, 9am-5pm.

Facilities: **Exhibition Area** (2 galleries); **Sculpture Garden**.

Activities: **Temporary Exhibitions** (monthly or bi-monthly - local and regional artists).

The college exhibits work of interest and educational value in two galleries: the Broadway and the LRC. The galleries present monthly or bi-monthly exhibitions of work by artists from New Jersey and the tri-state areas.

Pomona

Richard Stockton College of New Jersey - Art Gallery

Room H113, Jim Leeds Road, Pomona, NJ 08240

Tel: (609) 652-4214

Fax: (609) 652-4550

Internet Address: (gallery events listed under "date bar") http://www2.stockton.edu

Admin. Asst: Ms. Denise McGarvey

Attendance: 4,000 *Established:* 1974 *Membership:* N *ADA Compliant:* Y

Parking: two lots on site.

Open: Monday, 11:30am-4pm; Tuesday, 11:30am-8pm; Wednesday to Friday, 11:30am-4pm; Sunday, noon-4pm; 1 hour prior to PAC events.

Richard Stockton College of New Jersey - Art Gallery, cont.

Facilities: **Exhibition Area** (1,500 square feet).

Activities: **Lectures; Temporary Exhibitions.**

Publications: brochures (occasional).

Stockton sponsors five or six professional fine art exhibitions of regionally and nationally known artists each academic year, as well as an equal number of student shows.

Princeton

The Gallery at Bristol-Myers Squibb

Route 206 and Province Line Road, Princeton, NJ 08540

Tel: (609) 252-6275

Fax: (609) 252-6323

Art Program Administrator: Ms. Lisa Russell

Admission: open to public.

Attendance: 8,000 *Established:* 1972 *ADA Compliant:* Y

Parking: free on site.

Open: Monday to Wednesday, 9am-5pm; Thursday, 9pm-7pm; Friday, 9am-5pm;
Saturday to Sunday, 1pm-5pm; Holidays, 1pm-5pm.

Closed: Between Exhibitions.

Facilities: **Gallery** (5,560 square feet).

Activities: **Demonstrations; Lectures; Temporary Exhibitions** (4-6 weeks duration).

Publications: exhibition catalogues.

Overlooking a rooftop garden and 12-acre lake, the Gallery presents temporary exhibitions of both historical and contemporary work from a variety of countries and cultures. Each year four to five professional and two employee shows are mounted. All exhibitions at the Gallery are accompanied by complimentary gallery catalogues, lectures and/or demonstrations.

Princeton University - The Art Museum

McCormick Hall (off Nassau Street)

Princeton, NJ 08544-1018

Tel: (609) 258-3788

Fax: (609) 258-5949

Internet Address: http://www.princeton.edu

Director: Susan M. Taylor

Admission: voluntary contribution.

Attendance: 72,000 *Established:* 1882

Membership: Y *ADA Compliant:* Y

Parking: not available on campus, metered on street and commercial lots.

Open: Tuesday to Saturday, 10am-5pm;
Sunday, 1pm-5pm.

Closed: Major Holidays.

Facilities: **Galleries; Shop.**

Activities: **Gallery Talks; Guided Tours** (groups 6+, by appointment, 258-3043); **Lectures; Temporary Exhibitions.**

Guido da Siena, *Annunciation*, Italian, 13th century. Tempera on panel, 35.1 x 48.8 cm. The Art Museum, Princeton University, Caroline G. Mather Fund (144). Photograph courtesy of The Art Museum, Princeton University, Princeton, New Jersey.

Publications: bulletin, "Record of the Art Museum, Princeton University" (semi-annual); exhibition catalogues; posters.

The founding principle and primary function of the Museum is to give students access to original works of art to complement and enrich the instructional and research activities of the University. The Art Museum also serves a much larger audience as an important cultural resource and as an active participant in the international community of museums. Many exhibitions, drawn from the permanent collection, are organized in conjunction with the curriculum of the Department of Art and Archaeology and programs in other departments of the University. The Museum also originates

Princeton University - The Art Museum, cont.

exhibitions, drawing on works of art from all over the world, with an emphasis on lesser known areas of the history of art deserving scholarly and aesthetic exploration. These exhibitions are often circulated to other museums. The collections range from ancient to contemporary art and concentrate, geographically, on the Mediterranean regions, Western Europe, China, the United States, and Latin America. There is an outstanding collection of Greek and Roman antiquities, including ceramics, marbles and bronzes, and Roman mosaics from Princeton University's excavations in Antioch. Medieval Europe is represented by sculpture, metalwork, and stained glass. The collection of Western European paintings includes important examples from the early Renaissance through the 19th century, and there is a growing collection of 20th-century and contemporary art. Among the greatest strengths in the Museum are the collections of Chinese art, with important holdings in bronzes, tomb figures, painting, and calligraphy; and pre-Columbian art, with remarkable examples of the art of the Maya. The Museum has important collections of old master prints and drawings and a comprehensive collection of original photographs. African art is represented as well as Northwest Coast Indian art, on loan to the Museum from the Department of Geology. Not housed in the Museum but part of the University collection, the John B. Putnam, Jr., Memorial Collection of 20th-century sculpture includes works by such modern masters as Henry Moore, Alexander Calder, Pablo Picasso, and Jacques Lipchitz, located throughout the campus.

Summit

New Jersey Center for the Visual Arts (NJCVA)

68 Elm St., Summit, NJ 07901

Tel: (908) 273-9121

Fax: (908) 273-1457

Internet Address: http://www.njmuseums.com/njcva/index.htm

Exec. Director: Ms. Joan Duffey Good

Admission: fee: adult-$1.00, child-free.

Attendance: 50,000 *Established:* 1933 *Membership:* Y *ADA Compliant:* Y

Parking: free on site.

Open: **Palmer Gallery,**
 Monday to Saturday, noon-4pm; Sunday, 2pm-4pm.

Closed: New Year's Eve to New Year's Day, ML King Jr. Day, Good Friday, Easter, Memorial Day, Independence Day, August, last 2 weeks, Labor Day, Thanksgiving to Thanksgiving Friday, Christmas Eve to Christmas Day.

Facilities: **Art Studios** (5); **Exhibition Area** (2 galleries; 2,000 square feet); **Sculpture Garden**; **Shop** (Mon-Fri, 9am-5pm).

Activities: **Classes**; **Concerts**; **Demonstrations**; **Education Programs** (adults and children); **Guided Tours**; **Lectures**; **Temporary Exhibitions** (change every 6 weeks); **Workshops**.

Publications: class brochure (quarterly); exhibition catalogues; gallery guides; newsletter.

Founded in 1933 as the Summit Art Association, NJCVA is recognized statewide for its arts education and exhibition programs. It is a full-scale art school with two interior galleries and an outdoor exhibition space. The exhibitions mounted in the Fred L. Palmer and Members' galleries change every 4-6 weeks. Exhibition programs include curated exhibitions, an international juried show, the Member's Show, faculty exhibition, regional artists exhibitions, and the New Art Park/Sculpture Garden.

View of Outdoor Art Park during a temporary exhibition of sculptures by Peter Reginato. (Foreground "Greene Street", steel painted with Insl-tron, 1993.) Photograph courtesy of New Jersey Center for Visual Arts, Summit, New Jersey.

Tenafly

African Art Museum of the S.M.A. Fathers

Society of African Missions, Inc., 23 Bliss Ave., Tenafly, NJ 07670

Tel: (201) 567-0450

Fax: (201) 541-1280

Internet Address: http://www.smafathers.org

Director: Mr. Robert J. Koenig

Admission: voluntary contribution.

Attendance: 5,000 *Established:* 1963 *Membership:* Y *ADA Compliant:* Y
Parking: free on site.

Open: Daily, 10am-5pm.

Closed: Legal Holidays.

Facilities: **Galleries** (1,300 square feet); **Grounds** (cloister garden); **Library** (500 volumes); **Reading Room.**

Activities: **Concerts**; **Education Programs** (adults and children); **Film Series** (African); **Gallery Talks**; **Guided Tours**; **Lectures**; **Temporary Exhibitions.**

Publications: brochures; collection catalogue; exhibition catalogues and checklists.

The African Art Museum of the SMA Fathers (Society of African Missions) is dedicated to collecting, preserving, exhibiting and interpreting the traditional arts of sub-Saharan Africa. Its large, high-quality collection includes masks, figure sculptures, musical instruments, architectural elements, tools and household furniture, weapons, textiles, costumes, and jewelry. Initiated by SMA Fathers bringing objects of interest back from Liberia, Nigeria, Ghana, Ivory Coast and East Africa, the museum's collections have been vastly augmented and refined by annual donations of works of art from private collectors in the tri-state metropolitan area. There are SMA museums of African Art in Italy, France, Holland and Poland, as well as smaller collections in England and Ireland.

Trenton

New Jersey State Museum

205 W. State St., Trenton, NJ 08625-0530

Tel: (609) 292-6464

Fax: (609) 599-4098

Internet Address:
http://www.state.nj.us/state/museum/musidx.html

Acting Director: Dr. Lorraine E. Williams

Admission: voluntary contribution.

Attendance: 325,000 *Established:* 1895

Membership: Y *ADA Compliant:* Y

Parking: free near site.

Open: Tuesday to Saturday, 9am-4:45pm;
Sunday, noon-5pm.

Closed: Legal Holidays.

Facilities: **Auditorium**; **Food Services** Café; **Galleries**; **Shop** (handicrafts, jewelry, books; Tues-Sat, 10am-4:15pm; Sun, noon-4:30pm).

Storage Basket, wood splint, Eastern Woodlands Indians, ca.1850-c.1900. Charles A. Philhower Collection. Included in exhibition "Baskets and Brooms: Delaware Adaptation to European Contact" on extended view at New Jersey State Museum. Photograph courtesy of New Jersey State Museum, Trenton, New Jersey.

Activities: **Education Programs** (adults, undergraduates and children); **Films**; **Gallery Talks**; **Guided Tours**; **Lectures**; **Temporary Exhibitions**; **Traveling Exhibitions.**

Publications: collection catalogues; exhibition catalogues; newsletter/calendar (quarterly).

The New Jersey State Museum offers exhibits on ethnology, cultural history, fine art, and natural history. The fine art exhibition explores the development of 20th-century American art, featuring works by Alexander Calder, John Marin, Louise Nevelson, and Georgia O'Keeffe, as well as a special focus on New Jersey and minority artists. The Museum also houses a broad collection of American and European prints, drawings and photographs. New Jersey folk art, furniture, firebacks and silver are the highlights of cultural history collection. The archaeology and ethnology collection includes artifacts of Native North American, pre-Columbian South American, and African cultures.

Upper Montclair

Montclair State University Art Galleries

Life Hall , Room 135, One Normal Avenue, Upper Montclair, NJ 07043
Tel: (973) 655-5113
Fax: (973) 655-7640
Internet Address: http://www.montclair.edu/Pages/FineArts/faevents.htm
Director: Mr. Lorenzo Pace
Open: **September to May**, Monday/Wednesday/Friday, 10am-4pm; Tuesday/Thursday, 10am-6pm.
Facilities: **Exhibition Area.**
Activities: **Artist Residencies; Lectures; Temporary Exhibitions** (7/year).

Located in Life Hall, the University Gallery presents exhibitions of the work of professional artists, as well as the following annuals: BFA Student Exhibition in May, Juried Small Works Show in July, and New Jersey School of the Arts show in August. Additionally, the University Art Gallery manages Gallery One, which mounts exhibitions by professional artists, and undergraduate and graduate students. Also of possible interest on campus, a student-run exhibition space, Gallery 3½, located in the Calcia Fine Arts Building (655-7295), presents shows of student work during the fall and spring semesters.

Wayne

William Paterson University of New Jersey - Ben Shahn Galleries

300 Pompton Road, Wayne, NJ 07470-2103
Tel: (973) 720-2654
Fax: (973) 720-3273
Internet Address: http://www.wpunj.edu/arts_culture/index2.htm
Director: Dr. Nancy Einreinhofer
Admission: free.
Attendance: 10,000 *Established:* 1968 *Membership:* Y
ADA Compliant: Y
Open: Monday to Friday, 10am-5pm;
 Saturday to Sunday, by appointment.
Closed: Legal Holidays.
Facilities: **Exhibition Area** (5,000 square feet, 3 galleries);
 Sculpture Garden (20 contemporary works).
Activities: **Guided Tours; Lectures; Traveling Exhibitions.**
Publications: collection catalogue, "Sculpture on Campus";
 gallery guides.

Exterior view of Ben Shahn Galleries; "Neon", sculpture by Stephen Antonakos. Photograph courtesy of Ben Shahn Galleries, William Paterson University, Wayne, New Jersey.

The Ben Shahn Galleries at William Paterson University mount exhibitions of contemporary art and make these available to the students and faculty and to the residents of the surrounding communities. The Galleries also sponsor lectures on art and various related workshops on a regular basis. The goal of the Galleries' exhibition program is to create an environment that is challenging and that stimulates ideas, discussion, and discovery among the student body, faculty, staff, and the public. Holdings include artists books, decorative art, and the Tobias Collection of African and Oceanic art. Also of possible interest, the University's Sculpture on Campus program has developed a collection of contemporary sculpture displayed in public areas throughout the campus.

New Mexico

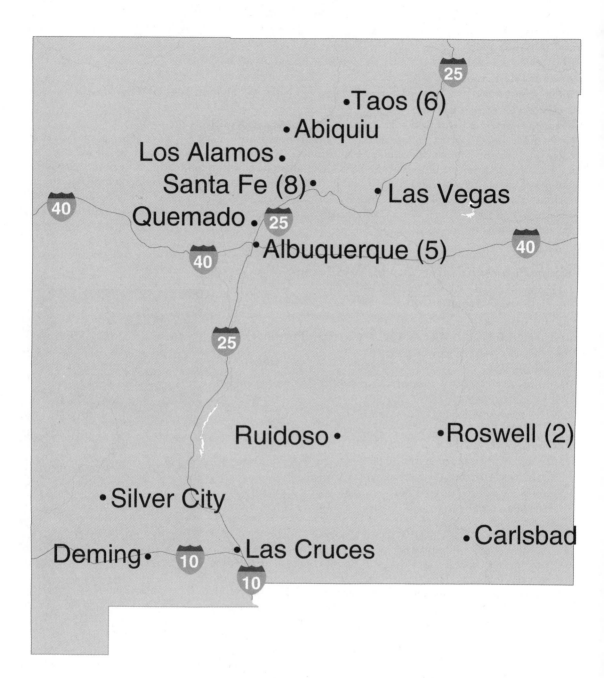

The number in parentheses following the city name indicates the number of museums/galleries in that municipality. If there is no number, one is understood. For example, in the text eight listings would be found under Santa Fe and one listing under Los Alamos.

New Mexico

Abiquiu

The Georgia O'Keeffe Home and Studio

The Georgia O'Keeffe Foundation, Abiquiu Inn, Highway 84, Abiquiu, NM 87510

Tel: (505) 685-4539

Fax: (505) 685-4428

Director: Ms. Judy Lopez

Admission: fee (minimum donation)-$20.00.

Membership: N

Parking: free on site.

Open: by reservation only.

The Georgia O'Keeffe Foundation has opened the Abiquiu home of Georgia O'Keeffe on a limited basis. Small groups are allowed to visit the house and studio where O'Keeffe painted some of her most famous pictures. To the extent possible, the home remains as it was left by O'Keeffe in 1984, when she moved to Santa Fe prior to her death. Tours are conducted by appointment only and must be prepaid one month ahead of tour date. Unescorted visitors are not allowed on the property. Tour groups are limited to a maximum of twelve individuals. Exterior tours may be arranged for larger groups. All tours originate at the Foundation's offices in the Abiquiu Inn. It is requested that visitors arrive at least fifteen minutes prior to their appointment and check in at the tour office. Tours are approximately one-hour in duration. Children under the age of five cannot be accommodated.

Albuquerque

Albuquerque Museum

2000 Mountain Road, N.W. (Old Town, Mountain Road at 19th), Albuquerque, NM 87104

Tel: (505) 243-7255

Fax: (505) 764-6546

TDDY: (505) 764-6556

Director: Mr. James C. Moore

Admission: free.

Attendance: 120,000 *Established:* 1967 *Membership:* Y *ADA Compliant:* Y

Parking: free on site.

Open: Tuesday to Sunday, 9am-5pm.

Closed: Legal Holidays.

Facilities: **Auditorium** (85 seat); **Galleries**; **Sculpture Garden**; **Shop** (traditional crafts, publications, posters, art reproductions).

Activities: **Concerts** (Summer, Fri evening salsa & Sat evening jazz); **Films**; **Gallery Talks**; **Guided Tours**; **Lectures**; **Temporary Exhibitions**.

Publications: exhibition catalogues; newsletter, "Las Noticias".

The museum offers exhibitions and programs in art and history with emphasis on the art and historical artifacts from the middle Rio Grande region of New Mexico. Folk crafts and traditions are presented in a permanent exhibit. Each year the Museum features a selection of art from its permanent collection in a changing exhibition entitled "Common Ground". The Museum's permanent collection includes works from major artists and schools of New Mexico from the early 20th century to the present. Included are works by Oscar Berninghaus, Ernest L. Blumenschein, E. Irving Couse, Andrew Dasburg, William Herbert Dunton, Nicholai Fechin, Betty Hahn, Douglas Kent Hall, Helen Hardin, E. Martin Hennings, Allan Houser, Peter Hurd, Wilson Hurley, Luis Jimenez, Raymond Jonson, Nancy Kozikowski, Beverly Magennis, Sam Maloof, Judy McKie, William Moyers, Michael Naranjo, Georgia O'Keeffe, Bert G. Phillips, Fritz Scholder, Sebastian, Joseph H. Sharp, Luis Tapia, Walter Ufer, and Pablita Velarde. The museum also has a collection of photographic portraits of New Mexico artists taken by contemporary New Mexico photographers.

Indian Pueblo Cultural Center Museum

2401 12th St., N.W. (1 block north of I-40), Albuquerque, NM 87104

Tel: (505) 843-7270

Fax: (505) 842-6959

Albuquerque, New Mexico

Indian Pueblo Cultural Center Museum, cont.

Internet Address: http://hanksville.phast.umass.edu/defs/independent/PCC/facilities.html
President: Mr. Rafael Gutierrez
Admission: fee: adult-$3.00, student-$1.00, senior-$2.00.
Attendance: 97,000 *Established:* 1976 *Membership:* Y *ADA Compliant:* Y
Open: Daily, 9am-5:30pm.
Closed: New Year's Day, January 6, Thanksgiving Day, Christmas Day.
Facilities: **Exhibition Area**; **Food Services** Cafeteria (daily, 7:30am-3:30pm); **Library**; **Shops** (Native American arts and crafts); **Theatre** (250 seats).
Activities: **Arts Festival**; **Demonstrations** (art, Saturday-Sunday, 10am & 3pm); **Education Programs** (adults and children); **Films**; **Guided Tours**; **Lectures**; **Performances** (dance, Saturday-Sunday, 11am & 2pm); **Temporary Exhibitions**; **Workshops**.
Publications: "Pueblo Horizons".

The Center is owned and operated by the 19 Pueblo Tribes of New Mexico. Its Museum focuses on the history and artifacts of the Indian Pueblos with displays of pottery, weaving, jewelry, leatherwork and other crafts. In addition to the permanent exhibitions in the Museum, contemporary exhibits featuring Pueblo artists and craftsmen, Pueblo history and anthropology are frequently mounted.

The University of New Mexico Art Museum

UNM Fine Arts Center (just north of Cornell and Central, NE), Albuquerque, NM 87131-1416
Tel: (505) 277-4001
Fax: (505) 277-7315
Internet Address: http://www.unm.edu%7Efinearts/museum.htm
Director: Mr. Peter Walch
Admission: voluntary contribution.
Attendance: 43,000 *Established:* 1963
Membership: Y *ADA Compliant:* Y
Parking: free behind Jonson Gallery, or pay lot in front of Museum.
Open: Tuesday, 9am-4pm and 5pm-8pm; Wednesday to Friday, 9am-4pm; Sunday, 1pm-4pm.
Closed: UNM Holidays.

Facilities: **Exhibition Area** (2 floors, 5 galleries); **Print and Photography Study Room** (by appointment); **Sculpture Garden**; **Shop** (gifts, jewelry, art books).
Activities: **Education Programs** (school groups and graduate students); **Gallery Talks**; **Guided Tours** (by appointment, reserve two weeks in advance); **Lectures** (during semester, Tuesday, 5:30pm); **Temporary Exhibitions**; **Traveling Exhibitions**.
Publications: calendar (semi-annual); exhibition catalogues; gallery guides.

The University Art Museum, located in the University of New Mexico's Center for the Arts, houses over 28,000 works of art. The permanent collection includes European art from the Renaissance to contemporary times, Hispanic traditions in the Old World and the New, and American 19th- and 20th-century art in the modernist tradition. A special strength is its photography and print collection, one of the finest of university art museums nationwide. The public can enjoy five galleries of changing exhibitions, and a print/photo seminar room, which may be visited by appointment.

Georgia O'Keeffe, *White Flowers*, 1926, oil on canvas. Estate of Georgia O'Keeffe. University Art Museum. Photo by Damian Andrus, courtesy of University Art Museum, University of New Mexico, Albuquerque, New Mexico.

The University of New Mexico Art Museum - Jonson Gallery

1909 Las Lomas, N.E., Albuquerque, NM 87131
Tel: (505) 277-4967
Fax: (505) 277-3188
Internet Address: http://www.unm.edu/~jonsong

The University of New Mexico Art Museum - Jonson Gallery, cont.

Admission: free.
Attendance: 4,000 *Established:* 1950 *Membership:* N *ADA Compliant:* Y
Parking: free in lot behind Gallery.
Open: Tuesday, 9am-4pm and 5pm-8pm; Wednesday to Friday, 9am-4pm.
Closed: Legal Holidays.
Facilities: **Exhibition Areas** (permanent and temporary); **Galleries**; **Library** (400 volumes).
Activities: **Gallery Talks** (during semester, 1st Tuesday in month, 5:30pm); **Permanent Exhibits**; **Temporary Exhibitions**.
Publications: exhibition catalogues.

A branch of the University of New Mexico Museum of Art, the Jonson Gallery, houses works by modernist painter Raymond Jonson, his contemporaries, and his students. For information on the University of New Mexico Art Museum see separate listing.

University of New Mexico - Tamarind Institute Gallery

108-110 Cornell Drive S.E., Albuquerque, NM 87106
Tel: (505) 277-3901
Fax: (505) 277-3920
Internet Address: http://www.unm.edu
Director: Ms. Marjorie Devon
Admission: free.
Established: 1960
Open: Tuesday to Friday, 9am-5pm.
Facilities: **Archive** (3,000 lithographs); **Gallery**.
Activities: **Guided Tours** (1st Friday in month, 1:30pm, reserve in advance).
Publications: lithographs.

Established in Los Angeles in 1960 as the Tamarind Lithography Workshop to preserve the fine art of lithography, it became the Tamarind Institute in 1970, affiliated with the University of New Mexico and relocated to Albuquerque. The Institute engages in education, research, and creative programs funded partially by the University and supplemented by revenue from contract printing and the sale of its published limited edition lithographs. The Gallery, located adjacent to the workshop exhibits a selection of recent prints made at Tamarind by nationally and internationally recognized artists who have been invited to collaborate with Tamarind's master printers. The Institute's archive of approximately 5,000 lithographs is housed in the University of New Mexico Art Museum.

Carlsbad

Carlsbad Museum and Art Center

418 Fox St. (two blocks west of Canal St/Highway 285), Carlsbad, NM 88220
Tel: (505) 887-0276
Fax: (505) 885-8809
Director: Virginia Dodier
Admission: free.
Attendance: 15,000 *Established:* 1931
Membership: Y *ADA Compliant:* Y
Parking: on street.
Open: Monday to Saturday, 10am-5pm.
Closed: New Year's Day, Memorial Day, Independence Day, Labor Day, Thanksgiving Day, Thanksgiving Friday Christmas Day.
Facilities: **Exhibition Area**; **Shop** (books, jewelry).
Activities: **Lecture Series**; **Permanent Exhibits**; **Temporary Exhibitions** (local and regional art).

Exterior view of front entrance of Carlsbad Museum with Glenna Goodacre sculptures, "Ollie" and "Dance Day". Photograph courtesy of Carlsbad Museum and Art Center, Carlsbad, New Mexico.

497

Carlsbad Museum and Art Center, cont.

Publications: newsletter (quarterly).

The Museum features three areas of interest: fine art, regional history, and archaeology. A highlight is the Taos Art Colony Founders' art exhibit, including works by Fremont Ellis, Alfred Morang, Sheldon Parsons, and Joseph Sharp. Also on exhibit are works by Gustave Baumann, Emil Bisttram, LaVerne Black, Naomi Brotherton, Francis De Buda, Jack Drake, Glenna Goodacre, Alan Houser, Peter Hurd, Roderick Mead, Gary Niblett, Gregory Perillo, and Georges Roualt, as well as works by local artists. Additionally, there are large collections of Peruvian and Native American ceramics on view. A large gallery is reserved for temporary exhibits featuring shows ranging from fine art, through local guild and association shows, to special interest exhibitions.

Deming

Deming Luna Mimbres Museum

301 S. Silver St., Deming, NM 88030

Tel: (505) 546-2382

Internet Address: http://www.zianet.com/deming/museum.html

Director: Ms. Ruth Brown

Admission: voluntary contribution.

Attendance: 22,000 *Established:* 1957 *Membership:* Y *ADA Compliant:* Y

Open: Monday to Saturday, 9am-4pm; Sunday, 1:30pm-4pm.

Closed: Thanksgiving Day, Christmas Day.

Facilities: **Architecture** (former armory, 1916); **Exhibition Area**; **Library**; **Shop** (Native American crafts).

Activities: **Guided Tours**; **Lectures**; **Performances**; **Permanent Exhibits**; **Temporary Exhibitions.**

The Museum's Deming/Luna Art Gallery features a continuous changing show of regional art; its Gallery for Mimbres Culture contains pottery and artifacts illustrating the unique art of Mimbres painted pots (circa 1200 AD). Its permanent collection numbers some 100 works. The Museum structure is a converted armory.

View of display in the Gallery for Mimbres Culture, Deming Luna Mimbres Museum. Photograph courtesy of Deming Luna Mimbres Museum, Deming, New Mexico.

Las Cruces

New Mexico State University - University Art Gallery

Williams Hall, University Ave. (east of Solano), Las Cruces, NM 88003-8001

Tel: (505) 646-2545

Fax: (505) 646-8036

Internet Address: http://www.nmsu.edu/campus_life/artgal.html

Director: Mr. Charles Muir Lovell

Admission: free.

Attendance: 18,000 *Established:* 1974

Membership: Y *ADA Compliant:* Y

Parking: spaces reserved for gallery visitors.

Open: Tuesday to Wednesday, 10am-5pm;
Thursday, 10am-7pm;
Friday to Saturday, 10am-5pm;
Sunday, 1pm-5pm.

Closed: Easter, Memorial Day, Labor Day,
Independence Day, Thanksgiving Day,
Christmas Day, University Holidays.

Anonymous, *El Alma de Maria (The Soul of Mary)*, 19th century, oil on tin, 14 x 10 inches, Mexico. University Art Gallery. Photograph by Mike Laurance, courtesy of University Art Gallery, New Mexico State University, Las Cruces, New Mexico.

New Mexico State University - University Art Gallery, cont.

Facilities: **Facility** (12,000 square feet); **Galleries** (4,600 square feet).

Activities: **Films/Videos**; **Gallery Talks**; **Guided Tours** (school/community groups, reservations required, 646-6110); **Lectures**; **Temporary Exhibitions** (8/year); **Traveling Exhibitions**; **Workshops**.

Publications: newsletter, "Visiones" (semi-annual).

The University Art Gallery at New Mexico State University is the largest contemporary art gallery in South Central New Mexico. The Gallery presents eight exhibitions annually of historical and contemporary art in various media, and works from the Gallery's permanent collection. Annual and biennial exhibitions feature the work of undergraduate students, graduate students, and faculty of the Department of Art at NMSU, and the juried "Close To The Border Exhibition" presents artists from the border region of the U.S. and Mexico. The Gallery also sponsors an extensive educational program. A permanent collection of approximately 2,750 objects includes 1,700 19th-century Mexican retablos, one of the largest collections of its kind in the country. Other objects in the collection include contemporary prints, historical and contemporary photographs, paintings, graphics, book arts, and works on paper.

Las Vegas

New Mexico Highlands University - Fine Arts Gallery

National Ave., Las Vegas, NM 87701

Tel: (505) 454-3338

Fax: (505) 454-0026

Internet Address: http://www.nmhu.edu

Director: Mr. Bob Read

Admission: free.

Attendance: 5,000 *Established:* 1982 *ADA Compliant:* P

Open: Monday to Friday, 8am-noon and 1pm-5pm.

Closed: Christmas Day to New Year's Day.

Facilities: **Exhibition Area** (800 square feet).

Activities: **Temporary Exhibitions**.

Publications: "Folklore Printouts".

The Gallery presents temporary exhibitions, including an annual "retablo y bulto" show. NMHU's Donnelly Library collection of fine arts contains more than 100 artworks, including student work as well as that of regionally and nationally known artists. Such painters as Fremont Ellis, a member of Los Cinco Pintores, and Joseph Fleck, a founding member of the Taos Society of Artists, are represented.

Los Alamos

Fuller Lodge Art Center and Gallery

2132 Central Ave. (West Wing/2nd Floor), Los Alamos, NM 87544

Tel: (505) 662-9331

Director: Ms. Gloria Gilmore-House

Admission: voluntary contribution.

Attendance: 12,000 *Established:* 1977 *Membership:* Y *ADA Compliant:* Y

Parking: free on site.

Open: Monday to Saturday, 10am-4pm.

Closed: Major Holidays.

Facilities: **Architecture** (Fuller Lodge, 1928 design by John Gaw Meem); **Exhibition Area**; **Rental/Sales Gallery**.

Activities: **Arts & Crafts Fairs** (2/year); **Temporary Exhibitions**.

Publications: bulletin (quarterly).

Located in the heart of Los Alamos's historic district, the Art Center presents monthly shows of work by local, regional, and national artists and craftsmen. Two arts and crafts fairs are sponsored by the Center each year.

Portales

Eastern New Mexico University - Runnels Gallery

Golden Library, South Avenue K, Portales, NM 88130
Tel: (505) 562-2778
Internet Address: http://www.enmu.edu/~bryant/runnels.html
Admission: free.
Open: **August 15 to June 6**, Monday to Thursday, 7:30am-11pm; Friday, 7:30am-8pm;
 Saturday, 10am-7pm; Sunday, noon-11pm.
 June 7 to August 14, Monday to Thursday, 7am-10pm; Friday, 7am-5pm;
 Saturday, 10am-5pm; Sunday, noon-10pm.
Facilities: **Exhibition Area**.
Activities: **Juried Exhibits; Temporary Exhibitions**.

Located in the University's Golden Library, the Runnels Gallery presents two national juried shows, "Scene/Unscene" and "New Mexico Photographer", along with a Student Art Show, Senior Art Shows, and other exhibits. Other artwork and displays, including sculptures from the Purcell African Art Collection, wood carvings from the Tex Hasse Collection, and numerous paintings, prints, and photographs, are on display at other locations throughout the Library.

Quemado

Dia Center for the Arts - The Lightning Field

Quemado, NM 87048
Tel: (505) 898-3335
Fax: (505) 898-3336
Administrator: Ms. Kathleen Shields
Admission: fee (reservation only): adult-$85.00, student-$65.00.
Open: **May to October**, call for reservations.
Facilities: **Sculpture**.
Activities: **Permanent Exhibit**.

Isolated in and interacting with the high desert of southwestern New Mexico, Walter De Maria's sculpture consists of 400 stainless steel poles situated in a rectangular grid array one mile by one kilometer. A full experience of the "The Lightning Field" depends upon the opportunity to view it over an extended period of time. Therefore, Dia schedules overnight visits in advance. Groups are limited to six or fewer persons.

Roswell

Anderson Museum of Contemporary Art

409 E. College Blvd, Roswell, NM 88202
Tel: (505) 623-5600
Fax: (505) 623-5603
Director: Mr. Donald B. Anderson
Admission: free.
Attendance: 2,000 *Established:* 1994 *Membership:* N *ADA Compliant:* Y
Parking: free on site.
Open: Monday to Friday, 9am-4pm; Saturday, 1pm-4pm.
Facilities: **Exhibition Area** (12,000 square feet).
Activities: **Artist-in-Residence Program**.

The Museum maintains a permanent exhibit of over 120 works by artists who have participated in the Museum's artist-in-residence program.

Roswell Museum and Art Center

100 West 11th St., Roswell, NM 88201
Tel: (505) 624-6744
Fax: (505) 624-6765
Director: Ms. Laurie Rufe

Roswell Museum and Art Center, cont.

Admission: voluntary contribution.

Attendance: 75,500 *Established:* 1937

Membership: Y *ADA Compliant:* Y

Parking: free on site.

Open: Monday to Saturday, 9am-5pm;
Sunday, 1pm-5pm;
Holidays, 1pm-5pm.

Closed: New Year's Day, Thanksgiving Day,
Christmas Day.

Facilities: **Auditorium**; **Galleries**; **Library**
(5,000 volumes; Mon-Fri, 1pm-5pm); **Shop**.

Activities: **Education Programs** (adults and
children); **Films**; **Gallery Talks**; **Guided
Tours**; **Lectures**; **Temporary Exhibitions**;
Traveling Exhibitions.

Publications: "Roswell Museum Bulletin"
(quarterly); exhibition catalogues (monthly).

Georgia O'Keeffe, *Ram's Skull with Brown Leaves*, 1936, oil on canvas, 30 x 36 inches. Permanent Collection of Roswell Museum and Art Center. Photograph courtesy of Roswell Museum and Art Center, Roswell, New Mexico.

The Roswell Museum and Art Center opened in 1937, deriving its initial support from the Works Progress Administration. Federal Arts Project artisans built and furnished the Museum. The mission-style Founders Gallery, with its adobe walls, carved vigas and tin chandeliers, is the original museum structure. This gallery is dedicated to the exhibition of works by regional artists Peter Hurd and Henriette Wyeth. The Museum is known for its collection of New Mexico modernism, which includes examples of work by Andrew Dasburg, Stuart Davis, Marsden Hartley, Victor Higgins, John Marin, and Georgia O'Keeffe. Exhibitions of contemporary art from the Southwest are also on view, focusing on New Mexico's contemporary art scene and on artists who have participated in the Museum's Artist-in-Residence Program. In addition to art, the Museum features displays on regional history and science.

Ruidoso

Museum of the Horse

Highway 70 East, Ruidoso Downs Racetrack, Ruidoso, NM 88346

Tel: (505) 378-4142

Fax: (505) 378-4166

Internet Address: http://www.zianet.com/museum/museum.html

Director: Mr. Bruce Eldredge

Admission: fee: adult-$5.00, child-$3.00, senior-$4.00.

Attendance: 96,000 *Established:* 1992 *Membership:* Y *ADA Compliant:* Y

Open: **Summer**, Daily, 9am-5:30pm.
Winter, Tuesday to Sunday, 10am-5pm.

Closed: Thanksgiving Day, Christmas Day.

Facilities: **Exhibition Area**; **Library** (800 volumes); **Shop**.

The fine arts collection include paintings, bronzes, prints, photographs, posters, and Native American art. Included are works by Eastman Johnson, Frank T. Johnson, Frederic Remington, and Charles M. Russell.

Santa Fe

The Georgia O'Keeffe Museum

217 Johnson St., near the Plaza, Santa Fe, NM 87501

Tel: (505) 995-0785

Fax: (505) 995-0786

Internet Address: http://www.okeeffe-museum.org

Director: Mr. George G. King

Santa Fe, New Mexico

The Georgia O'Keeffe Museum, cont.

Admission: fee: adult-$5.00, child-free.
Established: 1997
Parking: city parking ½ block from facility on Grant St..
Open: Tuesday to Thursday, 10am-5pm; Friday, 10am-8pm; Saturday to Sunday, 10am-5pm.
Closed: New Year's Day, ML King Day, Easter, Thanksgiving Day, Christmas Day.
Facilities: **Exhibition Area.**
Activities: **Permanent Exhibit.**

The Museum features the work of Georgia O'Keeffe. Items exhibited are drawn from the Museum's permanent collection or are on loan.

The Governor's Gallery

State Capitol, 4th Floor, Paseo de Peralta and OSFT, Santa Fe, NM 87503
Tel: (505) 827-3000
Fax: (505) 827-3026
Director: Terry Bumpass
Admission: free.
Attendance: 30,000 *Established:* 1975 *ADA Compliant:* Y
Open: Monday to Friday, 8am-5pm.
Facilities: **Gallery.**
Activities: **Temporary Exhibitions.**

An outreach arm of the Museum of New Mexico, the Governor's Gallery presents temporary exhibitions of art and craft work by New Mexico artists and arts organizations.

Institute of American Indian Arts Museum

108 Cathedral Plaza, Santa Fe, NM 87501
Tel: (505) 988-6281
Fax: (505) 988-6273
Internet Address: http://www.iaiancad.org/
Director: Mr. Charles A. Dailey
Admission: fee: adult-$4.00, child-free, student-$2.00, senior-$2.00.
Attendance: 60,000 *Established:* 1962 *Membership:* Y *ADA Compliant:* Y
Open: Monday to Saturday, 10am-5pm; Sunday, noon-5pm.
Closed: Legal Holidays.
Facilities: **Exhibition Area**; **Library** (400 volumes); **Shop** (Native American art and books).
Activities: **Arts Festival**; **Films**; **Gallery Talks**; **Guided Tours**; **Lectures**; **Temporary Exhibitions**; **Traveling Exhibitions**; **Visiting-Artist-Program**; **Workshops.**
Publications: "Art Winds" (quarterly); books; brochures (quarterly); exhibition catalogues (quarterly).

The Institute of American Indian Arts is a public, two-year, fine arts college focusing on the study and practice of the artistic and cultural traditions of Native American peoples. Its Museum is home to the National Collection of Contemporary Indian Art, over 7,000 pieces representing the best student, faculty, and alumni work since 1962 and includes paintings, sculpture, photography, drawings, prints and other works on paper, textiles, costumes, baskets, jewelry, pottery, ceramics, and beadwork. It is the largest collection curated by Native Americans.

Museum of Fine Arts

107 West Palace Ave., on the Plaza, Santa Fe, NM 87501
Tel: (505) 827-4468
Fax: (505) 827-4473
Internet Address: http://www.nmculture.org
Director: Stuart Ashman
Admission: fee-$5.00.
Attendance: 125,000 *Established:* 1917 *Membership:* Y *ADA Compliant:* Y
Parking: metered on street and municipal lots.

Museum of Fine Arts, cont.

Open: Tuesday to Thursday, 10am-5pm; Friday, 10am-8pm; Saturday to Sunday, 10am-5pm.

Closed: New Year's Day, ML King Day, Easter, Thanksgiving Day, Christmas Day.

Facilities: **Architecture** (Pueblo Revival building, 1917); **Auditorium**; **Galleries**; **Library** (5,000 volumes, 827-4453); **Sculpture Courtyards** (3); **Shop**.

Activities: **Education Programs** (children); **Gallery Talks**; **Guided Tours**; **Juried Exhibits**; **Lectures**; **Temporary/Traveling Exhibitions**.

Publications: exhibition catalogues.

A unit of the Museum of New Mexico, the Museum of Fine Arts houses a distinguished collection of 20th-century American art. The permanent collection of paintings, sculpture, photography, and works on paper focuses primarily on New Mexico and the Southwest. It hosts numerous exhibitions of contemporary art in all media and invites established and emerging artists to exhibit in Alcove Shows and juried competitions.

Museum of Indian Arts and Culture (MIAC/LAB)

710 Camino Lejo (off Old Santa Fe Trail), Santa Fe, NM 87501

Tel: (505) 827-6344

Fax: (505) 827-6497

Internet Address: http://www.nmculture.org

Director: Ms. Patricia House

Admission: fee-$5.00.

Attendance: 96,000 *Established:* 1909 *Membership:* Y *ADA Compliant:* Y

Parking: free on site.

Open: Tuesday to Sunday, 10am-5pm.

Closed: New Year's Day, ML King Day, Easter, Thanksgiving Day, Christmas Day.

Facilities: **Amphitheater**; **Exhibition Area** (10,000 square feet); **Library** (20,000 volumes).

Activities: **Education Programs** (adults, college students and children); **Films**; **Guided Tours**; **Lectures**.

A unit of the Museum of New Mexico (MNM), the Museum of Indian Arts and Culture (MIAC) opened in 1987 to showcase the extensive collections of Indian art and objects from everyday life which MNM has collected since its 1909 founding. The permanent exhibits portraying the continuum of Native American arts and cultures in the Southwest are supplemented by numerous temporary exhibits, juried shows, demonstrations, and educational programs.

Museum of International Folk Art (MOIFA)

706 Camino Lejo (off Old Sante Fe Trail), Santa Fe, NM 87505

Tel: (505) 476-1200

Fax: (505) 476-1300

Internet Address: http://www.moifa.org

Director: Dr. Joyce Ice

Admission: fee-$5.00.

Attendance: 100,000 *Established:* 1953 *Membership:* Y *ADA Compliant:* Y

Parking: free on site.

Open: Tuesday to Sunday, 10am-5pm.

Closed: New Year's Day, ML King Day, Easter, Thanksgiving Day, Christmas Day.

Facilities: **Auditorium** (180 seats); **Exhibition Area** (25,000 square feet); **Library** (16,000 volumes; 476-1210); **Shop** (982-5186).

Activities: **Arts Festival**; **Concerts**; **Education Programs** (adults and children); **Films**; **Guided Tours**; **Lectures**.

A unit of the Museum of New Mexico, MOIFA features two permanent exhibits, "Multiple Visions: A Common Bond", a display of folk art, popular art, and toys from more than 100 nations, and "Familia y Fe/Family and Faith", an introduction to Northern New Mexico's Hispanic culture. Traditional and contemporary crafts exhibited include basketry, textiles, wood carving, and ceramics, all of which display folk art in its cultural context. The "Family Folkways" series brings children and adults together for festivals with an international flavor.

Santa Fe, New Mexico

Museum of New Mexico

113 Lincoln Ave., Santa Fe, NM 87501
Tel: (505) 827-6463
Fax: (505) 827-6427
Internet Address: http://www.nmculture.org
Director: Mr. Thomas A. Livesay
Admission: fee (4-day pass to 5 museums): adult-$5.00, child-free.
Attendance: 624,000 *Established:* 1909 *Membership:* Y *ADA Compliant:* Y
Parking: free on site.
Open: Tuesday to Sunday, 10am-5pm.
Closed: New Year's Day, ML King Day, Easter, Thanksgiving Day, Christmas Day.
Facilities: **Museums** (5); **Shops**.
Publications: books; exhibition catalogues; magazine, "El Palacio" (quarterly); newsletter, "Museum
 of New Mexico Newsletter" (bi-monthly).

The Museum of New Mexico administers the Governor's Gallery and five museums: the Palace of
the Governors, a history museum; the Museum of Indian Arts and Culture; the Museum of
International Folk Art; The Museum of Fine Arts; and Georgia O'Keeffe Museum.

The Wheelwright Museum of the American Indian

704 Camino Lejo, Santa Fe, NM 87505
Tel: (505) 982-4636
Fax: (505) 989-7386
Director and C.E.O.: Mr. Jonathan Batkin
Admission: voluntary contribution.
Attendance: 53,000 *Established:* 1937
Membership: Y *ADA Compliant:* Y
Parking: free on site.
Open: Monday to Saturday, 10am-5pm;
 Sunday, 1pm-5pm.
Closed: New Year's Day, Thanksgiving Day,
 Christmas Day.
Facilities: **Architecture** (1937 designed by
 William Penhallow Henderson); **Galleries**;
 Library (6,000 volumes, by appointment);
 Sculpture Garden; **Shop** Case Trading Post
 (Native American pottery, textiles, jewelry,
 books).

Exterior view of Wheelwright Museum of the American Indian (1937). Sculpture in foreground, "Heading Home" by Allan Houser. Photograph by Yvonne Bond, courtesy of Wheelwright Museum of American Art, Santa Fe, New Mexico.

Activities: **Children Activities**; **Demonstrations**; **Films**; **Gallery Talks**; **Guided Tours**
 (Mon/Tues/Fri, 2pm; Sat, 11am); **Lectures**; **Readings**; **Temporary Exhibitions**.
Publications: newsletter, "The Messenger" (annual).

Established in 1937 by Mary Cabot Wheelwright, working in conjunction with Navajo medicine
man Hastin Klah, for the purpose of preserving the ceremonial heritage of the Navajo people, the
Museum was originally named the Navajo House of Religion and later the Museum of Navajo
Ceremonial Art. In recognition of the continuing vitality of the Navajo ceremonial system, the Museum
returned much of the sacred material to the Navajo Nation in the 1970's and adopted its current name.
A traditional Navajo hogan was the inspiration for the design of the eight-sided building housing the
Museum. Each year three to four changing exhibitions of contemporary and traditional American
Indian art with an emphasis on the Southwest are presented in the Klah Gallery. Hands-on activities
and visits with artisans are an integral part of all exhibits. Additionally, the Skylight Gallery features
approximately six exhibits each year of the work of emerging Native American artists. The Museum
galleries do not display sand paintings. The core of the collection is sand painting reproductions; notes,
photographs, and recordings documenting Navajo ceremony; sandpainting, textiles; and objects from
Navajo everyday life. In recent years the Museum's collection has been broadened to include jewelry,
basketry, pottery; and other objects from throughout the United States; and contemporary art. The
collection is dedicated to documenting the ongoing change and vitality of Native American cultures.

Silver City

Western New Mexico University - Francis McCray Gallery

Western New Mexico University, 1000 W. College Ave., Silver City, NM 88062

Tel: (505) 538-6614

Fax: (505) 538-6155

Internet Address: http://www.wnmu.edu

Director: Ms. Gloria Maya

Admission: free.

Attendance: 2,400 *Established:* 1960 *ADA Compliant:* Y

Open: **September to May**, Monday to Friday, 9am-4pm.

Closed: University Holidays.

Facilities: **Exhibition Area** (1,600 square feet); **Theatre** (990 seats).

Activities: **Arts Festival**; **Concerts**; **Dance Recitals**; **Education Programs** (college students); **Films**; **Lectures**; **Rental Gallery**; **Temporary Exhibitions**; **Traveling Exhibitions**.

Publications: flyer (monthly).

The Gallery presents temporary exhibitions. The University's permanent collections feature 20th-century Japanese printmaking.

Taos

E.L. Blumenschein Home and Museum

222 Ledoux St., Taos, NM 87571

Tel: (505) 758-0505

Admission: fee: adult-$5.00, child-$2.50, family-$10.00.

Open: Daily, 9am-5pm.

Facilities: **Architecture** (former home of artists E.L. & M.G. Blumenschein, 1797); **Exhibition Area**.

Activities: **Permanent Exhibits**.

Edwin L. Blumenschein, one the founders of the Taos Society of Artists, first visited the valley in the fall of 1898. After returning to Taos numerous summers between 1899 and 1919, he, his wife, artist Mary Greene Blumenschein, and daughter Helen purchased a 1797 structure for their permanent home. The Blumenschein Home and Museum is maintained much as it was when the artist and his family occupied it. The home is filled with a collection of the family's art, a representative sampling of works by other famous Taos artists, fine European and Spanish Colonial style antiques, and the family's personal possessions.

Fechin Institute

227 Pueblo Road North, Taos, NM 87571

Tel: (505) 758-1701

Open: **call for hours**.

Facilities: **Architecture** (home of artist Nicolai Fechin); **Exhibition Area**.

Activities: **Concerts** (chamber music); **Permanent Exhibits**; **Temporary Exhibitions** (1/year); **Workshops**.

Russian emigré artists Nicolai Fechin arrived in Taos in 1926. He completely reconstructed the interior of his home between 1927-1933, adding his own distinctly Russian wood carvings; furniture, doors, windows, corbels and beams were all handcrafted by Fechin. In addition to the home, examples of his artwork are on display. A special exhibition is mounted annually at the Institute in conjunction with the Taos Arts Festival. The Institute also hosts exhibits of oriental art.

Millicent Rogers Museum of Northern New Mexico (MRM)

1504 Museum Road (4 miles north of Taos), Taos, NM 87571

Tel: (505) 758-2462

Fax: (505) 758-5751

Exec. Director: Mr. William D. Ebie

Admission: fee: adult-$6.00, child-$1.00, student-$5.00, senior-$5.00, family-$12.00.

Millicent Rogers Museum of Northern New Mexico, cont.

Attendance: 40,000 *Established:* 1953
Membership: Y *ADA Compliant:* Y
Parking: free on site.
Open: **April to October**, Daily, 10am-5pm.
 November to March, Tuesday to Sunday, 10am-5pm.
Closed: New Year's Day, Easter, Independence Day, September 30, Thanksgiving Day, Christmas Day.
Facilities: **Architecture** (adobe home, renovated and expanded by Nathaniel A. Owings in 1980s); **Galleries** (12; total 8,000 square feet); **Library**; **Sculpture Garden**; **Shop** (decorative art, jewelry, books).
Activities: **Gallery Talks**; **Guided Tours** (on written request); **Lecture Series** (winter); **Temporary Exhibitions**; **Workshops**.
Publications: brochure; exhibition catalogues; gallery guides.

Rio Grande blanket, Chimayo Style, Hispanic, ca.1920. Millicent Rogers Museum of Northern New Mexico. Photograph courtesy of Millicent Rogers Museum of Northern New Mexico, Taos, New Mexico.

Housed in a traditional one-story adobe home atop a sagebrush mesa with spectacular views, the Museum was originally established to preserve and display the collections of Southwestern art assembled by Standard Oil heiress Millicent Rogers. Since then, the Museum's collections have grown through donations and purchases. The Millicent Rogers Museum displays collections of Navajo and Pueblo jewelry, Navajo textiles, pueblo pottery, kachina dolls, and basketry from many Southwestern tribes. A highlight is the unique collection of pottery and related works documenting the art and life of Maria Martinez of San Ildefonso Pueblo. Traditional Hispanic culture is well-illustrated by extensive collections of colcha embroideries, furniture, weavings, santos (religious images), and tinwork. The Museum also collects and displays contemporary arts and designs from all cultures in northern New Mexico.

Stables Gallery of Taos Art Association

133 N. Pueblo Road, Taos, NM 87571
Tel: (505) 758-2036
Fax: (505) 751-3305
Interim Exec. Director: Bruce Ross
Admission: voluntary contribution.
Established: 1953 *Membership:* Y *ADA Compliant:* Y
Open: Monday to Saturday, noon-5pm.
Closed: New Year's Day, Easter, Thanksgiving Day, Christmas Day.
Facilities: **Auditorium**; **Gallery**.
Activities: **Arts Festival**; **Concerts**; **Dance Recitals**; **Education Programs** (adults and children); **Films**; **Gallery Talks**; **Lectures**; **Temporary Exhibitions**; **Traveling Exhibitions**; **Workshops**.
Publications: newsletter, "Taos Arts" (bi-monthly).

The Taos Art Association offers an extensive and varied schedule including art exhibitions and performing arts events each year. Located in historic Manby house, the Stables Gallery offers a broad range of visual arts exhibitions featuring regionally recognized artists. Recent exhibitions have included Taos impressionists, Hispanic folk art, contemporary Native American art, non-representational art of Taos, and the annual members show.

The University of New Mexico - The Harwood Museum

238 Ledoux St., Taos, NM 87571-6004
Tel: (505) 758-9826
Fax: (505) 758-1475
Internet Address: http://www.nmculture.org
Director: Mr. Robert M. Ellis

The University of New Mexico - The Harwood Museum, cont.

Admission: fee-$5.00; free-Sunday for New Mexico residents
Attendance: 15,000 *Established:* 1923 *Membership:* Y
Parking: across from museum, lot on Ranchitos Road.
Open: Tuesday to Saturday, 10am-5pm;
 Sunday, noon-5pm.
Closed: Major Holidays.
Facilities: **Architecture** (Pueblo Revival struc-
ture with 1937 expansion by John Gaw
Meem); **Exhibition Area** (7 galleries); **Shop**
(books, catalogues, crafts).
Activities: **Concerts**; **Lectures**; **Permanent
Exhibits**; **Temporary Exhibitions**
(10/year).
Publications: exhibition catalogues; newsletter
(quarterly).

Interior view of Dorothy and Jack Brandenburg Gallery for Early 20th Century Art, Harwood Museum of University of New Mexico. Photograph courtesy of Harwood Museum of University of New Mexico, Taos, New Mexico.

Founded in 1923 and operated by the University of New Mexico since 1936, the Harwood is the second oldest museum in the state and is listed on the State and National Registers of Historic Places. In 1923, Elizabeth Case Harwood and a group of Taos artists created the Harwood Foundation as a private nonprofit organization to serve as a library, museum and educational center. Later the Foundation was given to the University of New Mexico. The Museum features paintings, drawings, prints, sculpture and photography in five galleries by artists who worked in Taos and the southwest . In addition, two changing exhibition galleries mount ten installations per year dealing with traditional and historic issues as well as contemporary artistic trends. The Harwood's permanent collection consists of over 1,500 works of art and a photographic archive of 17,000 images spanning the period from the 19th century to the present. It includes 19th-century retablos (religious paintings on wood) and works by 20th-century artists. Works on view range from the early days of the art colony, including paintings by Victor Higgins, Oscar Berninghaus and other members of the Taos Society of Artists; through the Taos Moderns, a post-World War II group of modernist painters; to contemporary works by artists such as Larry Bell, Bea Mandelman, Louis Ribak, Agnes Martin, and Earl Stroh, as well as a special gallery housing seven paintings given to the Museum by internationally acclaimed artist and Taos resident, Agnes Martin. The Museum also has an important collection of Hispanic works that covers a broad range of the historic traditions of northern New Mexico, including the largest public collection of wood sculptures by Patrociño Barela.

Van Vechten-Lineberry Taos Art Museum

501 N. Pueblo Road, Taos, NM 87571
Tel: (505) 758-2690
Fax: (505) 758-7320
Director: Ms. Novella Lineberry
Admission: fee: adult-$5.00, student-$3.00, senior-$3.00.
Established: 1994 *ADA Compliant:* Y
Open: Tuesday to Friday, 11am-4pm; Saturday to Sunday, 1:30pm-4:30pm.
Facilities: **Exhibition Area**; **Library**.
Activities: **Guided Tours**; **Permanent Exhibits**; **Temporary Exhibitions**.

The permanent collection of 150 Taos artworks features the art of Duane Van Vechten, one of the founding members of the Taos Society of Artists, and also includes works by all the members of the Society, and by other regional artists. Ms. Van Vechten's studio is incorporated in the entrance to the Museum.

507

New York

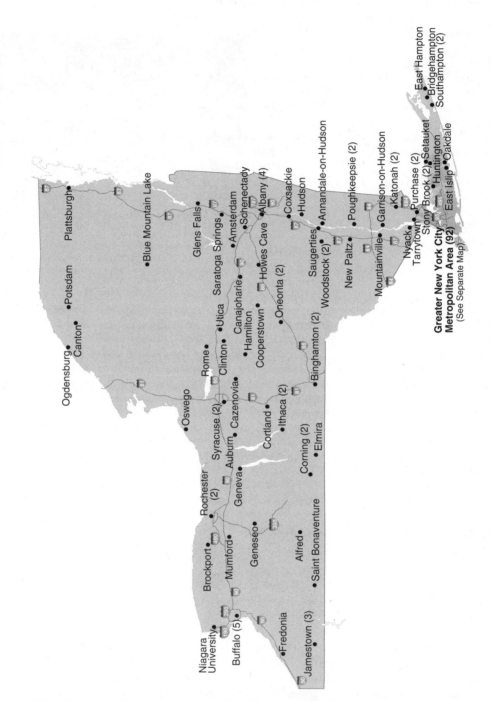

The number in parentheses following the city name indicates the number of museums/galleries in that municipality. If there is no number, one is understood. For example, in the text four listings would be found under Albany and one listing under Annandale-on-Hudson. Cities, boroughs, and communities within the greater New York metropolitan area will be found on the map on the facing page.

Greater New York City Metropolitan Area

(including Astoria, Bayside, Bronx, Brooklyn, Brookville, Flushing, Garden City, Hempstead, Jamaica, Long Island City, Manhattan, New Rochelle, Pelham, Queens, Riverdale, Roslyn Harbor, Staten Island, and Yonkers)

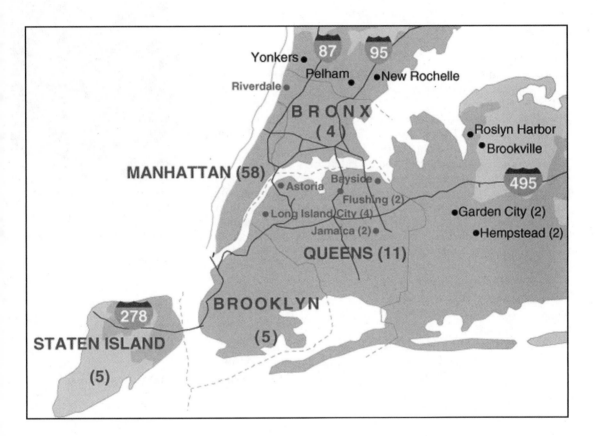

Please note that the boroughs of Bronx, Brooklyn, Manhattan, Queens, and Staten Island appear alphabetically under New York City. Any institution located in New York City not using a borough name in its address will be found under the borough in which the institution is located.

The number in parentheses following a city, borough, or community name indicates the number of museums/galleries in that place. If there is no number, one is understood. For example, in the text two listings would be found under Garden City and one listing under Brookville. The number in parentheses following a borough name represents the total number of institutions in the borough including all institutions located in communities within that borough (i.e. Queens (11) includes institutions in Astoria, Bayside, Flushing, Jamaica, and Long Island City).

New York

Albany

Albany Institute of History & Art

125 Washington Ave., Albany, NY 12210-2296
Tel: (518) 463-4478
Fax: (518) 462-1522
Internet Address: http://www.albanyinstitute.org
Director and C.E.O.: Ms. Christine M. Miles
Admission: fee: adult-$3.00, child-free, student-$2.00, senior-$2.00.
Attendance: 90,000 *Established:* 1791
Membership: Y *ADA Compliant:* Y
Parking: commercial adjacent to site.
Open: Wednesday to Sunday, noon-5pm.
Closed: Legal Holidays.
Facilities: **Auditorium** (250 seats); **Galleries** (17 exhibition, 1 sales/rental, 1 luncheon); **Library** (14,000 volumes); **Reading Room**; **Shop**.
Activities: **Concerts**; **Education Programs** (adults and children); **Films**; **Gallery Talks**; **Guided Tours**; **Lectures**; **Temporary Exhibitions**; **Traveling Exhibitions**.
Publications: annual report; books; calendar; collection catalogue; exhibition catalogues; newsletter.

Nehemiah Partridge, *Ariaantje Coeymans*, oil on canvas, ca. 1722. Bequest of Gertrude Watson. Albany Institute of History & Art. Photograph courtesy of Albany Institute of History & Art, Albany, New York.

The Institute is dedicated to collecting, preserving, interpreting, and promoting interest in the history, art, and culture of Albany and the Upper Hudson Valley region. Its permanent collection of more than 20,000 objects features Hudson River School paintings, limner portraits, sculpture, regional contemporary art, and decorative arts. The Institute also mounts temporary exhibitions of objects from its collection and other institutions.

New York State Museum

Madison Ave., Empire State Plaza, Albany, NY 12230
Tel: (518) 474-5877
Director and Assistant Commissioner: Dr. Clifford Siegfried
Admission: suggested donation: individual-$2.00; family-$5.00.
Attendance: 650,000 *Established:* 1836 *Membership:* Y *ADA Compliant:* Y
Open: Daily, 9:30am-5pm.
Closed: New Year's Day, Thanksgiving Day, Christmas Day.
Facilities: **Food Services** (Café); **Galleries**; **Shop**.
Activities: **Education Programs** (adults, children and families); **Films**; **Lectures**; **Temporary Exhibitions**.

The New York State Museum's New York State Historical Survey administers over 350,000 objects, including Shaker industrial and domestic materials, New York furniture, architectural artifacts, and fine and decorative arts. Exhibits range from fire engines to birds and from mastodons to a life-sized Iroquois longhouse. Special exhibits change frequently and feature items both from the Museum's collection and from other museums. The art collection at the Museum features a broad spectrum of works relating to the State, from the colonial period through 20th century, including a number of works by Edward Lamson Henry (a 19th-century genre painter), John Wesley Jarvis, Daniel Huntington, Henry Inman, Jasper Cropsey, Worthington Whittredge, and Levi Wells Prentice. Its print collection includes over 2,000 art prints executed under the Works Progress Administration in the 1930s. Visitors should be aware that most of the art collection is not on view, but special arrangements may be made to view specific works.

The Sage Colleges - Rathbone Gallery

140 New Scotland Ave., Albany, NY 12208
Tel: (518) 292-1778
Fax: (518) 292-1910
Internet Address:
 http://www.sage.edu/divisions/arts/Rathbone
Director: Mr. Jim Richard Wilson
Admission: free.
Attendance: 2,000
Membership: N *ADA Compliant:* N
Open: **Fall to Spring,**
 Monday, 10am-4pm;
 Tues to Thurs, 10am-4pm & 6pm-8pm;
 Friday, 10am-4pm;
 Sunday, noon-4pm.
 Summer, call for hours.
Closed: between exhibitions.
Facilities: **Galleries** (2 - 575 square feet).
Activities: **Temporary Exhibitions** (6/year).
Publications: exhibition catalogues.

Tony Reinemann, *East 32nd Street*, oil on maisonette, 8 x 12 inches. Alumni Juried Exhibition, 1998, Rathbone Gallery, Photograph courtesy of Rathbone Gallery, The Sage Colleges, Albany, New York.

Housed in Rathbone Hall on the Sage Albany Campus, the Rathbone Gallery is the formal exhibition space of The Sage Colleges. The Gallery mounts six exhibitions during the academic year focusing on the work of professional artists from outside the region. During the summer months, the Gallery hosts exhibitions organized by community-based arts organizations. The Gallery frequently features multi-disciplinary projects and also hosts poetry readings, recitals, and symposia, often in conjunction with its exhibitions

University at Albany, SUNY - University Art Museum

University at Albany, SUNY, 1400 Washington Ave., Albany, NY 12222
Tel: (518) 442-4035
Fax: (518) 442-5075
Internet Address: http://www.albany.edu/museum/
Director: Ms. Marijo Dougherty
Admission: voluntary contribution.
Attendance: 38,000 *Established:* 1967 *ADA Compliant:* Y
Parking: Collins Circle at Washington Ave. campus entrance.
Open: Tuesday to Friday, 10am-5pm; Saturday to Sunday, noon-4pm.
Closed: Legal Holidays.
Facilities: **Galleries** (3).
Activities: **Films**; **Gallery Talks**; **Lectures**; **Temporary Exhibitions**.
Publications: exhibition catalogues.

The Museum's permanent collection consists of some 1,600 works of contemporary art, which it displays in temporary exhibitions.

Alfred

Alfred University - The Schein-Joseph International Museum of Ceramic Art (IMCA)

Ceramics Corridor Innovation Center, 2nd Floor, Main Street (Route 244), Alfred, NY 14802
Tel: (607) 871-2421
Fax: (607) 871-2615
Internet Address: http://www.ceramicsmuseum.alfred.edu
Director and Chief Curator: Dr. Margaret Carney
Admission: free.
Established: 1900 *Membership:* Y *ADA Compliant:* Y
Parking: free behind building.

Alfred University - Schein-Joseph International Museum of Ceramic Art, cont.

Open: Tuesday to Sunday, 10am-5pm.

Closed: Academic Holidays.

Facilities: **Exhibition Area** (3 galleries); **Library** (5,000 volumes).

Activities: **Education Programs** (undergraduate and graduate college students); **Guided Tours** (groups, schedule 2 weeks in advance); **Lectures; Temporary Exhibitions**.

Publications: exhibition catalogues; newsletter, "Ceramophile" (semi-annual).

Charles Fergus Binns, *ovate vase*, 1929, stoneware, glazed, height 19.1 cm. Binns Collection, International Museum of Ceramic Art. Photograph courtesy of The Schein-Joseph International Museum of Ceramic Art, Alfred University, Alfred, New York.

A part of the New York State College of Ceramics at Alfred University, the Schein-Joseph International Museum of Ceramic Art presents exhibitions drawn from its permanent collection, temporary thematic displays on varying topics, and historical exhibits. IMCA houses nearly 8,000 ceramic and glass objects, ranging from small pottery shards recovered from ancient civilizations to contemporary sculpture and installation pieces to modern ceramics reflecting recent advances in ceramic technology. The collection, in addition to graduate thesis ceramics created by Alfred-educated ceramists, includes works by Rosanjin, Leach, Hamada, and Rie, Chinese funerary jars and tomb sculpture from the Neolithic period onward, Roman and Byzantine lamps, Nigerian market pottery, and European dinnerware. IMCA's current location is temporary, the Boston architectural firm of Kallmann, McKinnell and Wood has completed the design for a permanent facility. Also of possible interest at Alfred University, are the Fine Art Department's Fosdick-Nelson Gallery (871-2411) in Charles Harder Hall (open, Mon-Fri, 11am-4pm; Sat, 7pm-9pm; and Sun, 1pm-3pm) and the Student Gallery in Herrick Memorial Library.

Amsterdam

Walter Elwood Museum

300 Guy Park Ave., Amsterdam, NY 12010-2228

Tel: (518) 843-5151

Director: Mrs. Mary Margaret Gage

Admission: voluntary contribution.

Attendance: 7,500 *Established:* 1940 *Membership:* Y

Open: **September to June**, Monday to Friday, 8:30am-4pm.

 July to August, Monday to Thursday, 8:30am-3:30pm; Friday, 8:30am-1pm.

Closed: Legal Holidays.

Facilities: **Children's Museum; Galleries; Library** (1,500 volumes); **Reading Room; Shop**.

Activities: **Education Programs** (children); **Guided Tours; Lectures; Temporary Exhibitions; Traveling Exhibitions**.

Publications: brochures; newsletter.

T he museum presents temporary art exhibitions and permanent displays of a historical nature.

Annandale on Hudson

Bard College - The Center for Curatorial Studies and Art in Contemporary Culture Museum

Bard College (off Route 9G), Annandale on Hudson, NY 12504

Tel: (914) 758-7598

Fax: (914) 758-2442

Bard College - CCSACC Museum, cont.

Internet Address: http://www.bard.edu/
Director: Ms. Amada Cruz
Admission: free.
Attendance: 6,000 *Established:* 1990 *ADA Compliant:* Y
Parking: free on site.
Open: **February to December**, Wednesday to Sunday, 1pm-5pm.
Closed: New Year's Day, Easter, Thanksgiving Day, Christmas Day.
Facilities: **Auditorium** (40 seats); **Exhibition Area** (9,500 square feet); **Library** (11,000 volumes).
Activities: **Education Programs** (adults, undergraduate & graduate college students); **Lectures**;
 Temporary Exhibitions.

The Museum presents an extensive schedule of exhibitions of works by internationally important contemporary artists. The Center, the only accredited program in the nation offering a graduate degree in curatorial studies, also sponsors a lecture series and public programs. The Center's permanent collection, The Marieluise Hessel Collection of Late Twentieth-Century Art, consists of nearly 1,000 works by over 200 artists including paintings, sculptures, photographs, works on paper, videos, and video installations from the mid-1960s to the present. The collection is international in scope with works from Europe, Japan, Latin America, the Middle East, and the United States. Works in the Rivendell Collection are available to graduate students, faculty, and guest curators for study and for use in exhibitions at the Center, including students' master's degree exhibitions.

Auburn

Schweinfurth Memorial Art Center

205 Genesee St., Auburn, NY 13021
Tel: (315) 255-1553
Exec. Director: Donna Lamb
Admission: suggested donation: $3.00.
Attendance: 24,000 *Established:* 1975 *Membership:* Y *ADA Compliant:* Y
Parking: free on site.
Open: Tuesday to Saturday, 10am-5pm; Sunday, 1pm-5pm.
Closed: January, Thanksgiving, Christmas.
Facilities: **Galleries**; **Shop**.
Activities: **Classes** (adults and children); **Lectures; Performing Arts Events; Temporary Exhibitions; Tours**.
Publications: calendar of events; newsletter.

The Art Center has no permanent collection, but presents temporary exhibitions of fine art, contemporary craft, and folk art.

Binghamton

Roberson Museum and Science Center

30 Front St., Binghamton, NY 13905
Tel: (607) 772-0660
Fax: (607) 771-8905
Internet Address: http://www.roberson.org
Exec. Director: Mr. David E. Chesebrough
Admission: fee: adult-$6.00, student-$4.00,
 senior-$4.00, family-$20.00.
Attendance: 50,000 *Established:* 1954
Membership: Y *ADA Compliant:* Y
Parking: free on site.
Open: Tuesday to Saturday, 10am-5pm;
 Sunday, noon-5pm.

Exterior view of Roberson Mansion, Italian Renaissance Revival-style, ca. 1907. Photograph courtesy of Roberson Museum and Science Center, Binghamton, New York.

Binghamton, New York

Roberson Museum and Science Center, cont.
Facilities: **Galleries**; **Shop** (exhibit-related items); **Theatre** (300 seat).
Activities: **Exhibit-related Public Programming.**
Publications: exhibition catalogues.

Roberson Museum and Science Center is a museum of 19th- and 20th- century fine and decorative arts, history, folk life, science, natural history and technology. The fine arts collection primarily consists of local and regional artists such as Henry Wolcott Boss, Catherine Bartoo, and Douglas Arthur Teed, with select examples of nationally known artists such as William Merritt Chase, Levi Wells Prentice and Susan Waters. The diverse decorative arts and history collections include two centuries of international fans, snuff boxes, pressed glass, ceramics, furniture, silver, dolls, tools, costumes, advertising items, toys, Ansco cameras, architectural drawings, quilts, coverlets, carpets, Native American artifacts, and archaeological materials. The collections of the Broome County Historical Society are also housed on site and document nearly 200 years of Broome County history in all disciplines. Changing exhibits are presented in the Ahearn and Dickenson West galleries.

State University of New York at Binghamton - University Art Museum
SUNY at Binghamton, Fine Arts Building (off Route 434 E., 1 mile west of Binghamton), Binghamton, NY 13902-6000
Tel: (607) 777-2634
Fax: (607) 777-4000
Internet Address: http://www.binghamton.edu
Director: Lynn Gramwell
Admission: free.
Established: 1967
Open: Tuesday to Friday, 1pm-4pm.
Closed: Academic Holidays.
Facilities: **Exhibition Area**; **Library** (50,000 volumes).
Activities: **Lectures**; **Temporary Exhibitions.**
Publications: calendar; exhibition catalogues; newsletter.

The University Art Museum has an Asian Art Gallery and a permanent collection of art representing many periods and styles. On regular display are special traveling and loan exhibits as well as works of University artists.

Blue Mountain Lake

Adirondack Museum
Route 28 North and 30, Box 99, Blue Mountain Lake, NY 12812
Tel: (518) 352-7311 *Ext:* 101
Fax: (518) 352-7653
Director: Jackie Day
Admission: fee: adult-$10.00, child-$6.00, senior-$9.00.
Attendance: 83,000 *Established:* 1952 *Membership:* Y *ADA Compliant:* Y
Parking: free on site.
Open: **Memorial Day to mid-October**, Daily, 9:30am-5:30pm.
Facilities: **Buildings** (23); **Food Services** Restaurant; **Library**; **Outdoor Exhibits.**
Activities: **Education Programs**; **Temporary Exhibitions.**
Publications: book, "Fair Wilderness: American Paintings in the Collection of the Adirondack Museum"; exhibition catalogues; monographs.

The Adirondack Museum is known for its exhibits reflecting life in the Adirondack region over the last two centuries. In addition to exhibits on logging, mining, boating, hunting, and camping, the Museum displays an art collection consisting of over 500 works by over 145 artists, including Thomas Cole, Asher B. Durand, Winslow Homer, Frederic Remington, Rockwell Kent, A.F. Tait, and others. Its collection of over 66,000 photographs, while primarily documentary, includes works by Edward Bierstadt, Margaret Bourke-White, Alfred Stieglitz, and Seneca Ray Stoddard. There are also extensive collections of rustic furniture and folk art.

Bridgehampton

Dia Center for the Arts - Dan Flavin Art Institute

Corwith Ave. (off Main St.), Bridgehampton, NY 11932
Tel: (516) 537-1476
Internet Address: http://diacenter.org
Admission: suggested contribution-$3.00.
Open: May to September, Thursday to Sunday, noon-6pm.
Facilities: Exhibition Area.
Activities: Permanent Exhibits; Temporary Exhibitions.

Nine works in fluorescent light by Dan Flavin from 1971 to 1981 are on view in this renovated firehouse. Established in 1983 to exhibit a permanent installation of Flavin's work, the Gallery also houses changing exhibitions of contemporary art.

Brockport

State University of New York, Brockport - Tower Fine Arts Gallery

SUNY at Brockport, Tower Fine Arts Center, Holley St., Brockport, NY 14420-2985
Tel: (716) 395-2209
Fax: (716) 395-2588
Internet Address: http://cc.brockport.edu/~art001/arthome.htm
Admission: free.
Attendance: 6,000 *Established:* 1964 *ADA Compliant:* Y
Parking: free on site (temporary visitors parking permit required during academic year.).
Open: Tuesday to Wednesday, noon-5pm and 7pm-9pm; Thursday to Saturday, noon-5pm.
Facilities: Exhibition Area (1,500 square feet).
Activities: Arts Festival; Exhibits (7/year); Lectures.

The Gallery mounts temporary exhibitions of the work of both students and professional artists.

Brookville

C.W. Post Campus of Long Island University - Hillwood Art Museum

Long Island University, C.W. Post Campus, 720 Northern Blvd., Brookville, NY 11548-1300
Tel: (516) 299-4073
Fax: (516) 299-2787
Internet Address: http://www.liu.edu/cwis/cwp/but06/hillwood/museum.html
Director of Operations: Mr. Barry Stern
Admission: free.
Attendance: 12,500 *Established:* 1973 *Membership:* Y *ADA Compliant:* Y
Parking: free on site.
Open: September to July,
 Monday, 9:30am-4:30pm; Tuesday, 9:30am-7:30pm; Wednesday to Friday, 9:30am-4:30pm;
 Saturday to Sunday, 11am-3pm.
 Summer, Weekdays, 9:30am-4:30pm.
Facilities: Exhibition Area (numerous galleries); Food Services Restaurant; Sculpture Garden;
 Shop.
Activities: Guided Tours (by appointment only, groups limited to 30); Lectures; Performances;
 Temporary Exhibitions (4-5 major shows/year).
Publications: exhibition catalogues.

The Museum presents a schedule of temporary exhibitions, lectures and demonstrations emphasizing ethnic and cultural diversity. Its permanent collection consists of over 3,500 works, including pre-Columbian artifacts, contemporary American and European prints, Asian art, Persian bronzes, Islamic glass, and contemporary photography, as well as a large portion of the archives of early abstract expressionist artist Esphyr Slobokina. The Museum mounts temporary exhibitions of works from its collection and from other institutions.

Buffalo

Albright-Knox Art Gallery

1285 Elmwood Ave., Buffalo, NY 14222

Tel: (716) 882-8700

Fax: (716) 882-1958

Internet Address: http://www.albrightknox.org

Exec. Director: Mr. Douglas G. Schultz

Admission: fee: adult-$4.00, child-free, student-$3.00, senior-$3.00, family-$8.00.

Attendance: 140,000 *Established:* 1862

Membership: Y *ADA Compliant:* Y

Parking: pay on site.

Open: Tuesday to Saturday, 11am-5pm;
Sunday, noon-5pm; Holidays, noon-5pm.

Closed: New Year's Day, Thanksgiving Day, Christmas Day.

Facilities: **Architecture** (Greek Revival-style, 1905 design by Edward B. Green; Later addition, 1962 design by Gordon Bunshaft); **Auditorium** (345 seat); **Food Services** Garden Restaurant; **Galleries**; **Library** (30,000 volumes); **Print Study Room**; **Rental/Sales Gallery** (works by regional and national artists); **Sculpture Garden**; **Shop** (gifts, books, posters).

Vincent Van Gogh, *The Old Mill*, 1888, oil on canvas, 64 x 54 cm. Albright-Knox Art Gallery. Photograph courtesy of Albright-Knox Art Gallery, Buffalo, New York.

Activities: **Concerts**; **Education Programs** (adults, college students, and children); **Films**; **Guided Tours** (Wed & Thurs, 12:15pm; Sat, 11:30am & 1:30pm; Sun, 1:30pm); **Lectures**; **Temporary Exhibitions**; **Traveling Exhibitions**.

Publications: annual report; calendar (bi-monthly); collection catalogues; exhibition catalogues.

The Albright-Knox Art Gallery is an important center of modern art as well as a major comprehensive art museum. Housed in a Greek Revival structure designed by Edward B. Green with an addition by Gordon Bunshaft, the Albright-Knox boasts important examples of Abstract Expressionism, Pop Art, and art of the 1970's, 1980's, and 1990's, along with Renaissance painting and sculpture and American and European art of the 18th and 19th centuries. Impressionism and Post-Impressionism are well-represented by nearly all the leading French artists of the 19th century. In addition, there are significant works by Picasso, Braque, Matisse, Derain, Mondrian, and others.

The Benjamin and Dr. Edgar R. Cofeld Judaic Museum of Temple Beth Zion

805 Delaware Ave., Buffalo, NY 14209

Tel: (716) 836-6565

Fax: (716) 831-1126

Director: Mr. Mortimer Spiller

Admission: free.

Established: 1981

ADA Compliant: Y

Open: Monday to Friday, 9am-4pm;
Saturday, 11am-noon.

Closed: Jewish Holidays.

Facilities: **Auditorium** (1000 seats); **Exhibition Area** (2,000 square feet); **Library** (12,000 volumes).

Activities: **Education Programs** (adults and children); **Films**; **Guided Tours** (by appointment); **Permanent Exhibits**; **Traveling Exhibitions**.

Interior view, Temple Beth Zion. Photograph courtesy of the Benjamin and Dr. Edgar R. Cofeld Judaic Museum of Temple Beth Zion, Buffalo, New York.

The Benjamin and Dr. Edgar R. Cofeld Judaic Museum of Temple Beth Zion, cont.

Publications: brochures; collection catalogue; pamphlets.

The Museum houses a permanent collection of over 1,000 items of Judaica, dating from the 10th century to the present.

Center for Exploratory and Perceptual Art (CEPA Gallery)

Market Arcade Complex
617 Main Street, Suite 201
Buffalo, NY 14203
Tel: (716) 856-2717
Fax: (716) 856-2720
Internet Address: http://www.cepa.buffnet.net
C.E.O., Director & Curator: Mr. Robert Hirsch
Admission: suggested contribution: adult-$1.00, student-$1.00.
Established: 1974
Membership: Y *ADA Compliant:* Y
Open: CEPA Gallery,
 Monday to Friday, 10am-5pm.
 Passageway Gallery,
 Daily, 7am-9pm.

Interior view of Upper Gallery, Center for Exploratory and Perceptual Art. Photograph courtesy of Center for Exploratory and Perceptual Art, Buffalo, New York.

Facilities: **Exhibition Area** (7,500 square feet); **Library**.
Activities: **Art Auction**; **Films**; **Temporary Exhibitions**.
Publications: journal, "CEPA Journal".

CEPA's mission is to present contemporary photographic art, to support artists working in photography and related media, and to promote a greater understanding of contemporary photography and its related cultural and aesthetic issues. CEPA is particularly committed to supporting projects and artists from groups that have been traditionally under-represented in cultural spaces.

State University College at Buffalo - Burchfield-Penney Art Center

State University College at Buffalo, 1300 Elmwood Ave., Rockwell Hall, Buffalo, NY 14222
Tel: (716) 878-6011
Fax: (716) 878-6003
Internet Address:
 http://www.burchfieldpenney.org
Director: Mr. Ted Pietrzak
Admission: voluntary contribution.
Attendance: 50,000 *Established:* 1966
Membership: Y *ADA Compliant:* Y
Parking:
 lot behind Rockwell Hall off Iroquois Drive.
Open: Tuesday to Saturday, 10am-5pm;
 Sunday, 1pm-5pm.
 Also many Wednesdays, 10am-7:30pm,
 call to confirm.
Closed: Legal Holidays.

Charles E. Burchfield, *Windblown Asters*, 1951, watercolor, 29 5/8 x 39 5/8 inches. Anonymous gift, 1967, Burchfield-Penney Art Center. Photograph courtesy of Burchfield-Penney Art Center, State University College at Buffalo, Buffalo, New York.

Facilities: **Exhibition Area** (10 galleries; main gallery 3,060 square feet); **Library** (2,500 volumes); **Shop**.
Activities: **Artist-in-Residence Program**; **Concerts**; **Education Programs** (adults, college students and children); **Gallery Talks** (monthly); **Guided Tours** (by appointment); **Lectures** (monthly); **Permanent Exhibitions**; **Readings** (poetry); **Special Events** (including trips and tours); **Temporary Exhibitions** (8 major/year).
Publications: exhibition catalogues; newsletter, "Burchfield-Penney Art Center" (bi-monthly).

517

State University College at Buffalo - Burchfield-Penney Art Center, cont.

Located on the third floor of Rockwell Hall on the campus of State University College at Buffalo (directly across from the Albright-Knox Art Gallery), the Art Center celebrates the excellence of contemporary and historic art from throughout the region. It organizes approximately eight major exhibitions a year for its main gallery, with rotating temporary installations and exhibitions of the permanent collection being held in the remaining galleries. Specific galleries are dedicated to water-colorist Charles E. Burchfield, beaux-arts sculptor Charles Cary Rumsey, craft art, and Roycroft objects. The Museum's holdings total more than 5,400 items, including the world's largest collection of the work of celebrated watercolorist Charles E. Burchfield and augmented by works of his colleagues and contemporaries. The Center's collection includes paintings, prints, drawings, photographs, sculpture, and media art representing a broad spectrum of established and emerging Western New York artists. Temporary exhibitions include annual presentations of architecture/design and emerging artists and a biennial exhibition of craft art.

University at Buffalo Art Gallery (UBAG)

SUNY at Buffalo, North (Amherst) Campus, 201A Center for the Arts (off Coventry St)
Buffalo, NY 14260-6000
Tel: (716) 645-6912 *Ext:* 1420
Fax: (716) 645-6753
Internet Address:
 http://www.artgallery.buffalo.edu
Director and Curator: Mr. Al Harris
Admission: free.
Attendance: 25,000 *Established:* 1994
Membership: N *ADA Compliant:* Y
Parking: free after 3pm and weekends.
Open: **Fall to Spring**,
 Wednesday to Saturday, 10:30am-8pm;
 Sunday, noon-5pm.
 Summer,
 Monday to Sunday, noon-5pm.
Closed: Independence Day, Labor Day,
 Thanksgiving Day, Christmas Break.

Harvey Breverman, *Cabal II* (center panel of triptych), 1987-1988, pastel on paper. Gift of Will and Nan Clarkson, University of Buffalo Art Gallery. Photograph courtesy of University of Buffalo Art Gallery, Buffalo, New York.

Facilities: **Exhibition Area** (10,000 square feet); **Library**.
Activities: **Education Programs** (adults and college students); **Temporary Exhibitions** (6-8/year); **Traveling Exhibitions**.
Publications: books; compilation (annual); exhibition brochures (8/year).

The Gallery emphasizes temporary exhibitions of contemporary art that reflect the diversity of issues and practices found in current art. Its core program consists of six to eight exhibitions per year, occasionally featuring work from the University's permanent collection. The Gallery is housed in the Center for the Arts, designed by Gwathmey and Siegel.

Canajoharie

Canajoharie Library and Art Gallery

2 Erie Blvd., Canajoharie, NY 13317
Tel: (518) 673-2314
Fax: (518) 673-5243
Director: Mr. Eric Trahan
Admission: voluntary contribution.
Attendance: 557,000 *Established:* 1914
ADA Compliant: Y
Parking: free on site.

Winslow Homer, *Watching the Breakers-A High Sea*, 1896, oil on canvas, 24 x 38 inches. Canajoharie Library and Art Gallery. Photograph courtesy of Canajoharie Library and Art Gallery, Canajoharie, New York.

Canajoharie Library and Art Gallery, cont.

Open: Monday to Wednesday, 10am-4:45pm; Thursday, 10am-8:30pm; Friday, 10am-4:45pm; Saturday, 10am-1:30pm.

Closed: Major Holidays.

Facilities: **Gallery**; **Library**; **Sculpture Garden**; **Shop**.

Activities: **Concerts**; **Gallery Talks**; **Guided Tours**; **Lectures**.

Publications: collection catalogue; newsletter (quarterly).

The Canajoharie Library and Art Gallery houses a collection of over 600 works of art, acquired by Bartlett Arkell, President of Beech-Nut Packing Company. New York and New England landscapes, Victorian portraits, and American Impressionist works are abundantly represented in the collection. The Gallery's holdings include works by Copley, Stuart, Trumbull, Doughty, Kensett, Whistler, Sargent, Homer, Cassatt, Duveneck, Chase, Bierstadt, Prendergast, Luks, Lawson, Shinn, Glackens, Henri, Davies, Blakelock, Ryder, Bellows, O'Keeffe, Benton, Burchfield, Tarbell, Marsh, Moses, Kane, Koch, Remington, St. Gaudens, Frishmuth, and Wyeth. Changing exhibits featuring works from the permanent collection are presented throughout the year.

Canton

St. Lawrence University - Richard F. Brush Art Gallery & Permanent Collection

Griffiths Art Center, Romoda Drive, Canton, NY 13617

Tel: (315) 229-5174

Fax: (315) 229-7425

Internet Address: http://www.stlawu.edu/gallery

Director: Ms. Catherine L. Tedford

Admission: free.

Attendance: 10,000 *Established:* 1967 *ADA Compliant:* Y

Open: Monday to Thursday, noon-8pm; Friday to Saturday, noon-5pm.

Closed: Academic Recesses.

Facilities: **Auditorium** (75 seat); **Galleries** (3).

Activities: **Arts Festival**; **Films**; **Gallery Talks**; **Lectures**; **Temporary Exhibitions**; **Traveling Exhibitions**.

Publications: exhibition brochures; "Developing a Vision: Photographs at St. Lawrence University".

The Gallery's permanent collection includes nearly 7,000 art objects and artifacts, with particular strengths in 20th-century American and European works on paper, including photographs, prints, drawings, and artists' books. The Gallery also mounts rotating exhibitions accompanied by related educational activities.

Cazenovia

Cazenovia College - Gertrude T. Chapman Art Center Gallery (CACG)

Nickerson St. (between Sullivan and Lincklaen Sts.), Cazenovia, NY 13035

Tel: (315) 655-7162

Fax: (315) 655-2190

Internet Address: http://www.cazcollege.edu or http://www.JAistars@cazcollege.edu

Director: Mr. John Aistars

Admission: free.

Attendance: 600 *Established:* 1978

Parking: on campus.

Open: **Academic Year**,
 Monday to Thursday, 1pm-4pm and 7pm-9pm; Friday, 1pm-4pm
 Saturday to Sunday, 2pm-6pm.

Closed: Academic Holidays.

Facilities: **Exhibition Area** (1,064 square feet).

Activities: **Lectures** (occasional, by artists); **Temporary Exhibitions**.

The gallery houses a small permanent collection. In addition, it mounts one- and two-person exhibitions, as well as invitational and juried shows (e.g., student and faculty shows). Also of possible

Cazenovia, New York

Cazenovia College - Gertrude T. Chapman Art Center Gallery, cont.

interest on campus is the Chapman Cultural Center Gallery (Tel 655-9446). A 1,000-square foot, bi-level gallery with a balcony overlooking a main exhibit hall, the Gallery presents seven to eight exhibitions of the work of local and regional artists each year. Holdings are minimal, with most artwork displayed on campus.

Clinton

Hamilton College - Emerson Gallery

Hamilton College, 198 College Hill Road, Clinton, NY 13323
Tel: (315) 859-4396
Fax: (315) 859-4687
Internet Address: http://www.hamilton.edu
Director: Ms. Lise Holst
Admission: free.
Attendance: 5,500 *Established:* 1982 *Membership:* Y *ADA Compliant:* Y
Parking: free on site.
Open: **Fall to Spring**, Monday to Friday, noon-5pm; Saturday to Sunday, 1pm-5pm.
 Summer, Monday to Friday, 1pm-5pm.
Facilities: **Galleries** (3).
Activities: **Concerts**; **Films**; **Guided Tours**; **Lectures**; **Temporary Exhibitions** (6-7/year).
Publications: exhibition catalogues.

Located on the first floor of Christian A. Johnson Hall, the Emerson Art Gallery has an active schedule of temporary exhibitions. Its permanent collection is strong in American and British works on paper and also includes paintings and sculpture, collections of Greek vases, Roman glass and Native American objects.

Cooperstown

Fenimore House Museum

Lake Road (New York State Route 80), Cooperstown, NY 13326
Tel: (888) 547-1450
Internet Address: http://www.cooperstown.net/nysha/
Admission: fee: adult-$9.00, child-$4.00, senior-$8.00.
Attendance: 41,000 *Membership:* Y *ADA Compliant:* Y
Open: **April to May**, Tuesday to Sunday, 10am-4pm.
 June to September, Daily, 9am-5pm.
 October to November, Tuesday to Sunday, 10am-4pm.
Closed: January to March, New Year's Day, Thanksgiving Day, Columbus Day.
Facilities: **Architecture**; **Exhibition Area**; **Food Services** Fenimore Café; **Library** (80,000 volumes; $3 daily fee); **Shop** (books, art).
Activities: **Guided Tours** (daily); **Permanent Exhibits**; **Temporary Exhibitions**.
Publications: collection catalogue; magazine (quarterly).

Housed in a neo-Georgian building overlooking Otsego Lake, the Museum offers exhibits on art and historical themes, including the Thaw Collection of American Indian Art, American fine and folk art, and James Fenimore Cooper memorabilia. The museum also presents traveling exhibitions of national importance.

Corning

The Corning Museum of Glass

One Museum Way, Corning, NY 14830-2253
Tel: (607) 937-5371
Fax: (607) 937-3352
Internet Address: http://www.cmog.org
Director: Dr. David B. Whitehouse
Admission: fee: adult-$7.00, child-$4.00, student-$5.00, senior-$6.00, family-$16.00.

The Corning Museum of Glass, cont.
Attendance: 310,000 *Established:* 1951 *Membership:* Y *ADA Compliant:* Y
Parking: free on site.
Open: **September to June**, Daily, 9am-5pm.
 July to August, Daily, 9am-8pm.
Closed: New Year's Day, Thanksgiving Day,
 Christmas Eve to Christmas Day.
Facilities: **Food Services** Snack Bar;
 Galleries; **Library** (50,000 volumes; Mon-
 Fri, 9am-5pm); **Shops**.
Activities: **Education Programs** (children);
 Films; **Gallery Talks**; **Lectures**; **Self-guid-
 ed Tours**; **Temporary Exhibitions**.
Publications: "Journal of Glass Studies" (annu-
 al); "New Glass Review" (annual); books.

The Corning Museum of Glass is dedicated to
the art, history, research, and exhibition of
glass and glassmaking. The Museum houses more
than 30,000 objects representing 3,500 years of
glass craftsmanship and design. In addition to

Exterior view of Corning Museum of Glass (1980), designed by
Gunnar Birkerts. Photograph by Timothy Hursley, courtesy of
Corning Museum of Glass, Corning, New York.

the Masterpiece Gallery, the Museum's seven galleries are arranged to show the evolution of glass-
making. The Museum also mounts temporary exhibitions that are frequently international in stature.

Rockwell Museum
111 Cedar St., Corning, NY 14830-2694
Tel: (607) 937-5386
Fax: (607) 974-4536
Internet Address: http://www.rockwellmuseum.org
Director: Mr. Stuart A. Chase
Admission: fee: adult-$5.00, child (6-17)-$2.50,
 senior-$4.50, family-$12.50.
Attendance: 28,000 *Established:* 1976
Membership: Y *ADA Compliant:* Y
Parking: municipal lot adjacent to site on Cedar St..
Open: Monday to Saturday, 9am-5pm;
 Sunday, noon-5pm.
Closed: New Year's Day, Thanksgiving Day,
 Christmas Eve, Christmas Day.
Facilities: **Architecture** (former City Hall, 1893);
 Galleries; **Library** (2,500 volumes, non-circulat-
 ing); **Shop** (Native American jewelry, crafts from
 the Southwest).

James E. Fease, *End of the Trail*, 1908, sculpture.
Rockwell Museum. Photograph courtesy of Rockwell
Museum, Corning, New York.

Activities: **Education Programs** (children); **Guided Tours**; **Lectures**; **Temporary Exhibitions**.
Publications: annual report; brochures; exhibition catalogues; posters.

The Rockwell Museum houses a collection of 750 works of American Western art, including works
by Bierstadt, Moran, Hill, Catlin, and Bodmer, and works by the Taos Society of Artists, wildlife
artists, and popular illustrators like N.C. Wyeth. In addition, the museum possesses works by both
C.M. Russell and Frederic Remington. Other collections include firearms and Native American art.

Cortland

State University of New York at Cortland - Dowd Fine Arts Gallery
SUNY at Cortland, Dowd Fine Arts Center (off State Route 222), Cortland, NY 13045
Tel: (607) 753-4216
Fax: (607) 753-5999
Internet Address: http://www.cortland.edu
Director: Ms. Janet B. Steck

State University of New York at Cortland - Dowd Fine Arts Gallery, cont.

Admission: voluntary contribution.

Attendance: 15,000 *Established:* 1967 *ADA Compliant:* Y

Parking: free adjacent to site.

Open: **Academic Year**, Tuesday to Saturday, 11am-4pm.

Closed: Academic Holidays, Thanksgiving Weekend.

Facilities: **Exhibition Area** (2,500 square feet); **Sculpture Garden**.

Activities: **Guided Tours**; **Lectures**; **Temporary Exhibitions**; **Visiting Artist Program**.

The Gallery presents a diverse program of exhibitions, visiting artists, and lecturers.

Coxsackie

Bronck Museum

Route 9W (south of Coxsackie), Coxsackie, NY 12051

Tel: (518) 731-6490

Museum Manager: Ms. Shelby Mattice

Admission: fee: adult-$4.00, child-$1.00, student-$2.00, senior-$3.50.

Attendance: 1,780 *Established:* 1939

Membership: Y *ADA Compliant:* Y

Parking: free on site.

Open: **Memorial Day Weekend to October 15**, Tuesday to Saturday, 10am-4pm; Sunday, 1pm-5pm.

Legal Holidays, Monday, 10am-4pm.

Facilities: **Architecture** (homes, 1663 and 1738 and several barns); **Library** (5,000 volumes, Tues-Wed, 10am-4pm); **Picnic Area**.

Exterior view (east façade) of 1663 and 1738 dwellings. Photograph courtesy of Bronck Museum, Coxsackie, New York.

Activities: **Guided Tours**; **Lectures**; **Temporary Exhibitions**.

Publications: books; journal (quarterly).

The Bronck Museum is a complex of Dutch colonial dwellings and associated barns including the oldest surviving dwelling in the Hudson Valley. The dwellings are furnished with Bronck family art, furniture, silver, and textiles from the 18th and 19th centuries. The art collection includes works by Thomas Cole, Ammi Phillips, Ezra Ames, and John Frederick Kensett.

East Hampton

Guild Hall Museum

158 Main St., East Hampton, NY 11937

Tel: (516) 324-0806

Fax: (516) 324-2722

Internet Address: http://www.guildhall.org

Exec. Director: Ruth Stevens Appelhof, Ph.D.

Admission: suggested contribution-$3.00.

Attendance: 50,000 *Established:* 1931 *Membership:* Y *ADA Compliant:* Y

Open: **Memorial Day to Labor Day**, Monday to Saturday, 10am-5pm; Sunday, noon-5pm.
Labor Day to Memorial Day, Wednesday to Saturday, 11am-5pm; Sunday, noon-5pm.

Closed: New Year's Day, Thanksgiving Day, Christmas Day.

Facilities: **Galleries**; **Library**; **Sculpture Garden**; **Shop**; **Theatre**.

Activities: **Arts Festival**; **Concerts**; **Dance Recitals**; **Education Programs** (adults and children); **Films**; **Gallery Talks**; **Lectures**; **Readings**; **Temporary Exhibitions**; **Traveling Exhibitions**; **Workshops**.

Publications: pocket calendar; exhibition catalogues; season program guide.

Guild Hall Museum, cont.

The Guild Hall Museum presents temporary exhibitions in four galleries focusing on local artists and its permanent collection. The permanent collection of approximately 1,600 works consists of American art, the art of Long Island artists, and art of the New York School.

East Islip

Islip Art Museum

50 Irish Lane, East Islip, NY 11730
Tel: (631) 224-5402
Fax: (631) 224-5440
Internet Address: http://www.islipartmuseum.org
Exec. Director: Ms. Mary Lou Cohalan
Admission: voluntary contribution.
Attendance: 12,000 *Established:* 1973 *Membership:* Y *ADA Compliant:* Y
Open: Wednesday to Saturday, 10am-4pm; Sunday, 2pm-4:30pm.
Closed: New Year's Day, Easter, Memorial Day, Independence Day, Labor Day, Thanksgiving Day, Christmas Day.
Facilities: **Carriage House**; **Exhibition Area** (3,500 square feet); **Library** (5,000 volumes); **Shop**.
Activities: **Arts Festival**; **Concerts**; **Education Programs** (adults and children); **Guided Tours**; **Lectures**; **Traveling Exhibitions**.
Publications: exhibition brochures (bi-monthly).

Located on the grounds of Brookwood Hall estate, the Islip Art Museum focuses on the avant-garde art of Manhattan and Long Island, presenting approximately seven exhibitions annually. The Museum's Carriage House space, a center for experimental art, features site-specific installations by new and emerging artists. The Museum operates a satellite gallery, the Anthony Giordano Gallery, on the campus of Dowling College. (See listing under Oakdale, New York.)

Elmira

Arnot Art Museum

235 Lake St. at Gray St., Elmira, NY 14901
Tel: (607) 734-3697
Fax: (607) 734-5687
Director and Curator: Mr. John D. O'Hern
Admission: fee; free on weekends: adult-$2.00, child-$0.50, senior-$1.00.
Attendance: 11,000 *Established:* 1913
Membership: Y *ADA Compliant:* Y
Parking: free, rear of building on Baldwin St..
Open: Tuesday to Saturday, 10am-5pm;
Sunday, 1pm-5pm.
Closed: New Year's Day, Independence Day, Thanksgiving Day, Christmas Day.
Facilities: **Architecture** (neo-classical mansion, 1833); **Galleries**; **Shop** (work by regional artists, reproductions, publications).
Activities: **Concerts**; **Education Programs** (children); **Films**; **Gallery Talks**; **Guided Tours** (schedule two weeks in advance); **Lectures**; **Temporary Exhibitions**.

Stanton McDonald Wright, *Cyclamen and Fruit*, 1920, Arnot Art Museum. Photograph courtesy of Arnot Art Museum, Elmira, New York.

Publications: collection catalogue; exhibition catalogues; newsletter, "The Column" (bi-monthly).

The museum displays the permanent collection of 17th- to 19th-century European paintings, 19th- and 20th-century American art, and collections of Asian, Egyptian, pre-Columbian, and Native American art. Temporary exhibitions highlight various aspects of the collections and include works from museums around the world. Its nationally recognized biennial exhibition, "Re-presenting

Elmira, New York

Arnot Art Museum, cont.

Representation", features the best in contemporary representational art and complements the museum's growing collection of contemporary work. The Museum collection includes works by the following European artists: Claude, Murillo, Brueghel, Teniers, Breton, Gérôme, Meissonier, Daubigny, Rousseau, Troyon, Millet, and Courbet; and the following American artists: Cole, Bierstadt, Cropsey, Richards, Sully, Henri, Davies, Metcalf, Burchfield, and Cadmus.

Fredonia

State University of New York at Fredonia - Michael C. Rockefeller Arts Center Galleries

SUNY at Fredonia (off Central Ave.), Fredonia, NY 14063
Tel: (716) 673-3538
Internet Address: http://www.fredonia.edu
Director: Mr. Marvin Bjurlin
Admission: free.
Attendance: 2,000 *Established:* 1826 *ADA Compliant:* Y
Open: Wednesday to Sunday, 2pm-8pm.
Closed: Legal Holidays, Academic Holidays.
Facilities: **Architecture** Rockefeller Art Center (1969 design by I.M. Pei and Associates); **Galleries** (Main Gallery, 2,000 square feet; Christian Gallery, 600 square feet).
Activities: **Temporary Exhibitions**; **Traveling Exhibitions**.

The Rockefeller Arts Center (RAC) contains two galleries administered by the College's Department of Art. On the first floor, the Main Gallery presents temporary exhibitions of student work as well as faculty shows and group shows by off campus artists in a wide variety of media. The annual student exhibition program features three groups shows of work by graduating seniors (one at the end of the fall semester and two at the end of the spring semester) and a show each spring drawn from the best work created in fall semester art courses. The Emmitt Christian Gallery, located on the second floor, mounts small group and solo shows of student art work.

Garden City

Adelphi University Art Galleries

Ruth S. Harley University Center Art Gallery (off South Ave.), Garden City, NY 11530
Tel: (516) 877-4460
Internet Address: http://www.adelphi.edu
Director: Professor Richard Vaux
Open: Monday to Saturday, 8am-7pm.
Facilities: **Exhibition Area.**
Activities: **Temporary Exhibitions**.

The Gallery presents a schedule of temporary exhibitions including professional invitational, faculty and alumni shows. Also of possible interest on campus is The Swirbul Library Gallery located on South Avenue. Additionally, the Adelphi University SoHo Center Gallery is located in Manhattan (see separate listing under New York City).

Nassau Community College - Firehouse Art Gallery

1 Education Drive, Garden City, NY 11530
Tel: (516) 572-7165
Fax: (516) 572-7302
Internet Address: http://www.sunynassau.edu
Curator: Lynn Rozzi Casey
Admission: free.
Attendance: 12,000 *Established:* 1965 *Membership:* N *ADA Compliant:* Y
Parking: student lot in front of building.
Open: **September to May**, Call for hours.
Closed: Academic Holidays, Summer.

Nassau Community College - Firehouse Art Gallery, cont.
 Facilities: Exhibition Area (2 gallery rooms).
 Activities: **Guided Tours** (available upon request); **Lectures** (monthly); **Temporary Exhibitions**.
 Publications: calendar; exhibition catalogues (monthly).
 The Gallery presents six temporary exhibits during the school year in conjunction with art courses being taught at Nassau.

Garrison-on-Hudson

Boscobel Restoration, Inc.
 1601 Route 9D, Garrison-on-Hudson, NY 10524
 Tel: (845) 265-3638
 Fax: (845) 265-4405
 Internet Address: http://www.boscobel.org
 Exec. Director: Mr. Charles T. Lyle
 Admission: fee:
 adult-$8.00, child-$5.00, senior-$7.00.
 Attendance: 38,097 *Established:* 1955
 Membership: Y
 Open: **April to October**,
 Monday, 9:30am-5pm;
 Wednesday to Sunday, 9:30am-5pm.
 November to December,
 Monday, 9:30am-4pm;
 Wednesday to Sunday, 9:30am-4pm.
 Closed: Thanksgiving Day, Christmas Day.

Exterior view of Boscobel. Photograph by Charles T. Lyle, courtesy of Boscobel Restoration, Inc., Garrison-on-Hudson, New York.

 Facilities: **Architecture** (Dyckman Family Home, 1808); **Carriage House Reception Center;
 Herb Garden, Orangerie, and Rose Garden; Shop; Woodland Trail**.
 Activities: **Guided Tours**.
 Publications: booklet, "History of Boscobel"; brochure; catalogue, "Federal Furniture and Decorative
 Arts at Boscobel".
 Boscobel is an important example of Federal domestic architecture, carefully restored and furnished with period decorative arts. In addition to New York Federal-style furniture by Phyfe, Allison, and Lannuier, china, silver, crystal, and lighting fixtures, there are paintings by Benjamin West and John Watson, as well as English prints.

Geneseo

State University of New York College at Geneseo - Bertha V.B. Lederer Fine Arts Gallery
 SUNY at Geneseo, 1 College Circle, Brodie Fine Arts Building, Geneseo, NY 14454
 Tel: (716) 245-5814
 Fax: (716) 245-5815
 Internet Address: http://www.geneseo.edu
 C.E.O.: Ms. Janet Jackson
 Admission: free.
 Attendance: 2,000 *Established:* 1967 *ADA Compliant:* Y
 Open: Monday to Wednesday, 2pm-5pm; Thursday, noon-8pm; Friday to Sunday, 2pm-5pm.
 Facilities: **Architecture** (Brodie Fine Arts Building, 1967 design by Edgar Tafel); **Exhibition Area;
 Library** (100 volumes).
 Activities: **Temporary Exhibitions**.
 Publications: bulletins.
 The Gallery presents temporary exhibitions of the work of students, faculty, and regional artists.

Geneva

Hobart and William Smith Colleges - Houghton House Gallery

Houghton House (south of Jay St. between Route 14 and Kings Lane), Geneva, NY 14456
Tel: (315) 781-3487
Fax: (315) 781-3689
Internet Address: http://www.hws.edu/aca/depts/art/art_gallery.html
Gallery Director: Ms. Linda K. Karol
Admission: free.
Established: 1970 *Membership:* N
Parking: free on site.
Open: Monday to Saturday, 9am-5pm.
Facilities: **Architecture** (Eclectic Victorian mansion, 1880); **Exhibition Area.**
Activities: **Temporary Exhibitions**.

Housed in a former summer residence, the Gallery each year presents 5-6 exhibitions of the work of guest artists, faculty, and students.

Houghton House, home of the Colleges' Art Department. Photograph courtesy of Hobart and William Smith Colleges, Geneva, New York.

Glens Falls

The Hyde Collection

161 Warren St., Glens Falls, NY 12801
Tel: (518) 792-1761
Fax: (518) 792-8187
Internet Address:
 http://www.hydeartmuseum.org
Director: Ms. Kathleen M. Monaghan
Admission: voluntary contribution.
Attendance: 31,000 *Established:* 1963
Membership: Y *ADA Compliant:* Y
Parking: on Warren Street and behind museum.
Open: Tuesday to Wednesday, 10am-5pm;
 Thursday, 10am-7pm;
 Friday to Saturday, 10am-5pm;
 Sunday, noon-5pm.
Closed: National Holidays.

Georges Seurat, *Banks of the Seine near Courbevoie*, 1883, oil on wood panel, 6 7/32 x 9 13/16 inches, The Hyde Collection. Photograph by Joseph Levy, courtesy of The Hyde Collection, Glens Falls, New York.

Facilities: **Architecture** (Renaissance Florentine-style residence, 1912); **Auditorium** (144 seats); **Galleries**; **Sculpture** (outdoor, 5 works on grounds); **Shop.**
Activities: **Concerts**; **Films**; **Gallery Talks**; **Guided Tours** (daily, between 1pm and 3pm); **Lectures**; **Traveling Exhibitions**; **Workshops.**
Publications: booklet, "Rembrandt's Christ in Thirteen Paintings and One Etching"; collection catalogue, "The Hyde Collection Catalogue"; exhibition catalogues.

The Hyde Collection is a world-class museum that spans the history of western art from the 4th century BC through the 20th century. Included in the collection are such noted European Old Masters as Botticelli, da Vinci, Raphael, Rembrandt, and Rubens, as well as modern works by such masters as Cézanne, Picasso, Renoir, and van Gogh. Also featured are the works of American artists such as Eakins, Hassam, Homer, Peto, Ryder, and Whistler. These remarkable pieces, along with an important selection of Italian Renaissance and 18th-century French antiques, are displayed in Hyde House, an Italianate Renaissance villa built in 1912. The Education Wing added in 1989 includes four galleries that showcase temporary exhibitions, an art studio, auditorium, and museum shop.

Hamilton

Colgate University - The Picker Art Gallery

Charles A. Dana Center for the Creative Arts
13 Oak Drive, Hamilton, NY 13346-1380
Tel: (315) 824-7746
Fax: (315) 228-7932
Internet Address: http://picker.colgate.edu
Director: Mr. Dewey F. Mosby
Admission: free.
Attendance: 12,000 *Established:* 1966
Membership: Y *ADA Compliant:* Y
Parking: free on site.
Open: **In Session**, Daily, 10am-5pm.
 Academic Holidays,
 Mon to Fri, 9am-noon & 1pm-4pm,
 walk in request.
Closed: National Holidays.

Sam Francis, *Untitled*, monotype. Gift of Dr. Luther W. Brady, DFA '88. Picker Art Gallery. Photograph courtesy of Picker Art Gallery, Colgate University, Hamilton, New York.

Facilities: **Architecture** (Dana Arts Center, designed by Paul Rudolph); **Galleries** (3); **Graphic Arts Study Room**; **Sculpture Court** (outdoor).
Activities: **Films**; **Gallery Talks**; **Guided Tours**; **Lectures**; **Temporary Exhibitions**; **Traveling Exhibitions**.
Publications: bulletin; exhibition catalogues; journal (annual).

Located in the Dana Arts Center on the campus of Colgate University, the Gallery has collections in all media and from all periods of art history from Egyptian bronzes and Old Master paintings to African masks and Abstract Expressionist sculpture. Works from the permanent collection are displayed in the Inner and Outer galleries and on the Sculpture Court, while special exhibitions are usually on view in the Upper Gallery. Five to six exhibitions, many of them showing works borrowed from national and international sources, are held each year with themes chosen to complement or highlight strengths of the permanent collection and the Colgate University curriculum. Holdings exceed 12,000 works. Highlights include the Dr. Luther W. Brady DFA '88 Collection of 20th-Century Works on Paper, the Gary M. Hoffer '74 Memorial Photography Collection, the Herman Collection of Chinese Woodcuts, the Luis de Hoyos '43 Guerrero Stones Collection, and the Evgeny Khaldei Collection of photographs.

Hempstead

Fine Arts Museum of Long Island

295 Fulton Ave., Hempstead, NY 11550
Tel: (516) 481-5700
Fax: (516) 481-0903
Director: Jamie Ellin Forbes
Admission: suggested contribution: adult-$2.00, child-$1.00, student-$1.00, senior-$1.00.
Attendance: 20,000 *Established:* 1978 *Membership:* Y *ADA Compliant:* Y
Open: Wednesday to Saturday, 10am-4:30pm.
Closed: Legal Holidays.
Facilities: **Galleries**.
Activities: **Art Auction**; **Art Workshops**; **Arts Festival**; **Concerts**; **Dance Recitals**; **Education Programs** (adults and children); **Films**; **Gallery Talks**; **Guided Tours**; **Juried Exhibits**; **Lectures**; **Temporary Exhibitions**; **Traveling Exhibitions**.
Publications: brochures; calendar (monthly); exhibition catalogues; newsletter.

The Museum offers temporary exhibits of contemporary art and features an interactive computer center.

Hempstead, New York

Hofstra University - Hofstra Museum

Emily Lowe Gallery, Lowe Hall (off Hempstead Turnpike), Hempstead, NY 11549

Tel: (516) 463-5671

Fax: (516) 463-4743

Internet Address: http://www.hofstra.edu/museum

Director: Mr. David C. Christman

Admission: voluntary contribution-$2.00.

Attendance: 15,000 *Established:* 1963

Membership: Y *ADA Compliant:* Y

Parking: free on site.

Open: **September to May,**
Tuesday to Friday, 10am-5pm;
Saturday to Sunday, 1pm-5pm.
June to August,
Monday to Thursday, 10am-4pm.

Closed: Legal Holidays.

Facilities: **Arboretum** (240 acres); **Exhibition Areas** (3); **Library** (university library 1.4 million volumes); **Outdoor Sculpture Area** (encompassing most of the campus arboretum); **Shop** (Gift Counter).

Activities: **Films**; **Gallery Talks**; **Guided Tours** (by arrangement); **Lectures**; **Temporary Exhibitions** (over 15/year).

Publications: exhibition catalogues.

Paul Gauguin, *Portrait of a Woman/The Model Julliette*, 1881-82. Hofstra Museum. Photograph courtesy of Hofstra Museum, Hofstra University, Hempstead, New York.

With three exhibition areas and a sculpture park on the 240-acre Hofstra University campus, the Museum presents over fifteen exhibitions each year. In addition to the Lowe Gallery and Museum Offices located at the above address, exhibits may be mounted in the Rochelle and Irwin A. Lowenfeld Conference and Exhibition Hall on the 10th Floor of the Axinn Library (open; Mon-Fri, 10am-9pm; Sat-Sun, 1pm-5pm) and the David Filderman Gallery located on the 9th Floor of the Axinn Library (open; Mon-Fri, 10am-9pm; Sat-Sun, 1pm-5pm). On permanent display are more than 65 sculptures. The permanent collection holds slightly more than 4,000 paintings, drawings, prints, sculptures, and photographs, as well as ethnographic and decorative art objects. These works are grouped as follows: European paintings, drawings, and prints from the 16th to 20th centuries; American paintings, drawings, and sculpture of the 20th century; African and Oceanic artifacts; pre-Columbian ceramic bowls and figurines; Asian stone and bronze work of the 10th to 19th centuries; Japanese Edo period woodblock prints, as well as scrolls and finger masks; 19th-and 20th-century Puerto Rican santos; paintings and prints by Latino, South American, and Israeli artists; Russian paintings of the 19th and 20th centuries; photographs, mostly 20th-century American; and American prints, the largest collection area, which includes the 19th-century Currier and Ives series, works by regionalists, social realists, and artists from the 1960's and 1970's.

Howes Cave

Iroquois Indian Museum

Caverns Road, P.O. Box 7, Howes Cave, NY 12092

Tel: (518) 296-8949

Fax: (518) 296-8955

C.E.O. and Director: Mr. Thomas M. Elliott

Admission: fee: adult-$7.00, child-$4.00, student-$5.50, senior-$5.50.

Attendance: 30,000 *Established:* 1980 *Membership:* Y *ADA Compliant:* Y

Parking: free on site.

Open: **April to June,** Tuesday to Saturday, 10am-5pm; Sunday, noon-5pm.
July to Labor Day Weekend, Monday to Saturday, 10am-6pm; Sunday, noon-6pm.
after Labor Day to December, Tuesday to Saturday, 10am-5pm; Sunday, noon-5pm.

Closed: January to March, Easter, Thanksgiving Day, Christmas Eve to Christmas Day.

Iroquois Indian Museum, cont.

Facilities: **Exhibition Area**; **Library** (1,000 volumes); **Shop** (contemporary art and books).

Activities: **Demonstrations**; **Festivals**; **Guided Tours**; **Lecture Series**; **Temporary Exhibitions**.

Publications: exhibition catalogues; newsletter, "Museum Notes" (quarterly).

The Museum has an extensive collection of Iroquois contemporary art and also features archaeological holdings from the Schoharie County area. It also maintains archival records on 750 Iroquois artists.

Hudson

Olana State Historic Site

5720 State Route 9G, Hudson, NY 12534

Tel: (518) 828-0135

Fax: (518) 828-6742

C.E.O.: Ms. Linda E. McLean

Admission:
 fee: adult-$3.00, child-$1.00, senior-$2.00.

Attendance: 278,000 *Established:* 1967

Membership: Y *ADA Compliant:* Y

Parking: free on site.

Open: **April to Labor Day,**
 Wednesday to Sunday, 10am-4pm.
 September to November,
 Reduced hours or visitor center only.
 December,
 Holiday celebration.

Closed: January to April.

Exterior view of southwest façade of Olana. Photograph courtesy of New York State Office of Parks, Recreation and Historic Preservation, Olana State Historic Site, Hudson, New York.

Facilities: **Architecture** (Home of artist Frederic Church, Moorish-style villa, 1870-76); **Grounds** (250 acres); **Picnic Area**; **Shop**.

Activities: **Concerts**; **Family and Children's Events**; **Guided Tours** (house or grounds, reserve in advance); **Lectures**; **Self-guiding Grounds Tour**; **Symposia**.

Publications: journal/newsletter, "The Crayon".

Olana, the home created by Hudson River School artist Frederic E. Church, was developed as a unique three- dimensional work of art composed of romantic landscape design with river vistas and exotic architecture. While Olana was designed by the architect Calvert Vaux, Church was intimately involved in the process, choosing room colors, decoration, and even furniture placement. Insight into the life of the artist is offered through a wide variety of programs. Collections include Hudson River School drawings, sketches, studies, and finished paintings; Old Master paintings; Camille Pissarro and Fritz Melbye sketches; Indian teakwood carvings and furniture; 19th-century aesthetic movement furnishings; and Middle Eastern and Mexican decorative arts.

Huntington

Heckscher Museum of Art

2 Prime Ave., Huntington, NY 11743-7702

Tel: (631) 351-3250

Fax: (631) 423-2145

C.E.O.: Dr. John E. Coraor

Admission: suggested contribution: adult-$3.00, child-$1.00.

Attendance: 40,000 *Established:* 1920

Membership: Y *ADA Compliant:* Y

Parking: free on site.

Open: Tuesday to Friday, 10am-5pm; Saturday to Sunday, 1pm-5pm;
 First Friday of month, 10am-8:30pm.

Closed: Thanksgiving Day, Christmas Day.

Huntington, New York

Heckscher Museum of Art, cont.

Facilities: Galleries; Library (2,900 volumes); Shop.

Activities: Education Programs (children); Gallery Talks; Guided Tours; Lectures; Traveling Exhibitions.

Publications: brochures; collection catalogue; exhibition catalogues; newsletter (bi-monthly).

With a small but distinguished selection of works spanning five hundred years of European and American art, including works by Renaissance masters to the most recent contemporary artists, the Heckscher Museum has been described by the New York Times as "one of the primary small museums in the country with an international reputation." The Museum's collection is particularly noted for its 19th- and early 20th- century American landscape paintings. An ongoing schedule of special exhibitions and rotating permanent collections installations combine to offer a broad and balanced perspective of historical, modern, and contemporary art, including many artists and works of special significance to Long Island.

Romare Bearden, *Mississippi Monday*, 1972, paper collage on plywood. Heckscher Museum. Photograph courtesy of Heckscher Museum, Huntington, New York.

Ithaca

Cornell University - Herbert F. Johnson Museum of Art

Cornell University
(corner of Central and University Aves.)
Ithaca, NY 14853-4001
Tel: (607) 255-6464
Fax: (607) 255-9940
Internet Address: http://www.museum.cornell.edu
Director: Mr. Franklin W. Robinson
Admission: voluntary contribution.
Attendance: 70,000 *Established:* 1973
Membership: Y *ADA Compliant:* Y
Parking: metered adjacent to building site.
Open: Tuesday to Sunday, 10am-5pm.
Closed: Memorial Day, Independence Day, Labor Day, Thanksgiving Day, Christmas Day to New Year's Day.
Facilities: Architecture (1973 design by I.M. Pei); Galleries; Library (4,000 volumes); Reading Room; Sculpture Garden.
Activities: Education Programs (adults, students, children and families); Film Series; Gallery Talks; Guided Tours; Lectures; Performances; Temporary Exhibitions; Traveling Exhibitions; Workshops.
Publications: exhibition catalogues.

Exterior view of Herbert F. Johnson Museum of Art, designed by I.M. Pei. Photograph courtesy of Herbert F. Johnson Museum of Art, Cornell University, Ithaca, New York.

Located on the northwest corner of the Cornell University campus, the Johnson Museum was designed by I.M. Pei and opened to the public in 1973. Spanning the history of art, the Museum's collections are especially strong in Asian art, 19th- and 20th-century American art, and the graphic arts. Special exhibitions complement the Museum's diverse collections and present a broad range of media and cultural and historical perspectives. The American collection includes works by Stuart Davis, Willem de Kooning, Red Grooms, Hans Hofmann, and Georgia O'Keeffe, as well as members of the Hudson River School and the American Impressionists. European holdings range from Old Master

Cornell University - Herbert F. Johnson Museum of Art, cont.

drawings and 17th-century Dutch landscapes and portraiture to 19th-century French Impressionist and academic painting. The Museum also owns works by such modern masters as Henri Matisse and Alberto Giacometti. The print collection, selections from which are always on exhibition, consists of more than 13,000 works in all media from the 15th century to the present, with major examples by Dürer, Rembrandt, and Whistler, among others. Photography holdings include works by a number of acclaimed artists, including Berenice Abbott, Robert Frank, Alfred Stieglitz, and Garry Winogrand. The collection also has examples of African and pre-Columbian art.

Ithaca College - Handwerker Gallery

Ithaca College, 1170 Gannett Center, Ithaca, NY 14850-7276

Tel: (607) 274-3018

Fax: (607) 274-1774

Internet Address: http://www.ithaca.edu/handwerker

Director: Associate Prof Jalena Stojanovic

Admission: free.

ADA Compliant: Y

Open: **September to May**,
Monday to Wednesday, 10am-6pm; Thursday, 10am-9pm Friday, 10am-6pm;
Saturday, 10am-2pm; Sunday, 2pm-6pm.

Closed: Vacation Breaks.

Facilities: **Exhibition Area.**

Activities: **Temporary Exhibitions.**

Situated on the ground floor of the Caroline Wener Gannett Center on the Ithaca College campus, the Gallery addresses the needs of students and the larger community. Gallery activities revolve around three basic components: a contemporary art series, critical and theoretical interpretation of images, and the permanent collection.

Jamestown

James Prendergast Library Art Gallery

509 Cherry St., Jamestown, NY 14701

Tel: (716) 484-7135

Fax: (716) 487-1148

Director: Mr. Murray L. Bob

Admission: free.

Attendance: 5,000 *Established:* 1880 *ADA Compliant:* Y

Open: **Labor Day to Memorial Day**,
Monday to Friday, 9am-8:30pm; Saturday, 9am-5pm; Sunday, 1pm-3:30pm.

 Memorial Day to Labor Day,
Monday to Friday, 9am-8:30pm; Saturday, 9am-4:30pm.

Facilities: **Galleries (2); Library.**

Activities: **Films; Recitals; Temporary/Traveling Exhibitions** (9/year).

Publications: exhibition catalogues.

The Prendergast Library has two art galleries. The larger houses the permanent collection; the smaller displays changing exhibits in varied media. Nine changing exhibits are scheduled each year, and most run for five weeks and open with a reception. The permanent collection of late 19th- and early 20th-century paintings hangs in the Fireplace Room (the reading room of the original library). These paintings may be viewed on the library tour. A collection of Prendergast family portraits by Daniel Huntington are displayed in the library itself.

Jamestown Community College - Weeks Gallery

Community Cultural Center, Jamestown Campus, Falconer St., Jamestown, NY 14701

Tel: (716) 665-9107

Fax: (716) 665-9110

Internet Address: http://www.sunyjcc.edu/jamestown/aca_arts/art

Jamestown Community College - Weeks Gallery, cont.
Director, Community Cultural Center: Mr. James D. Colby
Admission: free.
Attendance: 7,000 *Established:* 1969 *Membership:* Y *ADA Compliant:* Y
Open: Tuesday to Wednesday, 11am-5pm; Thursday, 11am-7pm; Friday, 11am-5pm;
 Saturday, 11am-1pm.
Closed: Academic Holidays.
Facilities: **Auditorium**; **Exhibition Area** (1,000 square feet).
Activities: **Education Programs** (adults and undergraduate/graduate college students); **Lectures**;
 Temporary/Traveling Exhibitions.
Publications: exhibition catalogues.

The Weeks Gallery, located in the Community Cultural Center, presents temporary exhibitions of contemporary art, including an annual juried student art exhibition in the spring.

Roger Tory Peterson Institute of Natural History (RTPI)
311 Curtis St., Jamestown, NY 14701
Tel: (716) 665-2473
Fax: (716) 665-3794
Internet Address: http://www.rtpi.org
President: Mr. James M. Berry
Admission:
 fee: adult-$3.00, child-$2.00, family-$10.00.
Attendance: 20,000 *Established:* 1984
Membership: Y *ADA Compliant:* Y
Open: Tuesday to Saturday, 10am-4pm;
 Sunday, 1pm-5pm.
Closed: Legal Holidays.
Facilities: **Architecture** (designed by Robert A.
 M. Stern); **Auditorium** (150 seats); **Exhibition
 Area** (400 square feet); **Library** (4,000 vol-
 umes); **Shop**.

Exterior view of Roger Tory Peterson Institute. Photograph courtesy of Roger Tory Peterson Institute, Jamestown, New York.

Activities: **Education Programs** (adults and children); **Lectures**; **Temporary Exhibitions**.
Publications: newsletter, "The Guide" (quarterly).

RTPI, a world class facility designed by architect Robert A.M. Stern, is situated of 27 wooded acres. In addition to regular wildlife art and photography exhibitions, RTPI displays and permanently houses the lifetime body of work of artist and naturalist Roger Tory Peterson.

Katonah

Caramoor Center for Music and the Arts, Inc.
149 Girdle Ridge Road (off Route 22)
Katonah, NY 10536
Tel: (914) 232-5035
Fax: (914) 232-5521
Internet Address: http://www.caramoor.com
Exec. Director: Mr. Howard Herring
Admission: fee: adult-$6.00, child-$3.00.
Attendance: 60,000 *Established:* 1946
Membership: Y *ADA Compliant:* Y
Parking: free on site.
Open: **May to October**,
 Wednesday to Sunday, 1pm-4pm
 (last tour at 3pm).

 December to May,
 Tuesday to Friday, by appointment.
Closed: January to February.

View of Spanish Courtyard, Caramoor House Museum. Photograph by Marilynne Herbert for Harrison Edwards, Inc., courtesy of Caramoor Center for Music and the Arts, Katonah, New York.

Caramoor Center for Music and the Arts, Inc., cont.

Facilities: **Architecture** (Mediterranean-style palazzo, 1929-39); **Auditorium**; **Grounds** (100 acres, 7 specialty gardens); **Picnic Facilities and Snack Bar**; **Sculpture Garden**; **Shop**; **Theatres** (2 outdoor, 1 indoor recital hall).

Activities: **Concerts** (Spring and Fall concert series, also Wednesday morning recitals); **Festival** (annual, summer, International Music Festival); **Guided Tours** (museum and garden); **Lectures**; **Teas and Wine Tastings**.

Publications: book, "A Guide to the Collections of Caramoor"; brochures; newsletter (semi-annual); pamphlets.

Caramoor is the site of an international music festival each summer and numerous concerts and recitals during the rest of the year. Its heart is the House Museum, built in the style of a Mediterranean palazzo by Lucie Bigelow Dodge Rosen and Walter Tower Rosen, Caramoor's founders. Completed in 1939, the house was constructed to accommodate their collection of Eastern, Medieval, and Renaissance art and artifacts, one of the last important private art collections that remains intact. The Museum contains entire rooms from European villas and palaces, including the palatial Music Room, which contains 16th-century tapestries, Ming sculpture, 16th-century stained glass, and Russian icons. The 17th-century Burgundian Library features period furniture and a painted wood vaulted ceiling illustrating 13 biblical scenes. Twenty period rooms are open to the public.

The Katonah Museum of Art

Route 22 at Jay St., Katonah, NY 10536

Tel: (914) 232-9555

Fax: (914) 232-3129

Internet Address: http://www.katonah-museum.org

Exec. Director: Mr. George G. King

Admission: fee: adult-$2.00, child-free.

Attendance: 50,000 *Established:* 1953 *Membership:* Y *ADA Compliant:* Y

Parking: free on site.

Open: Tuesday to Friday, 1pm-5pm; Saturday, 10am-5pm; Sunday, 1pm-5pm.

Facilities: **Children's Workshop**; **Exhibition Area**; **Food Services** Snack Bar; **Sculpture Garden**; **Shop**.

Activities: **Education Programs** (schools); **Films**; **Guided Tours** (Tues Thurs & Sun, 2:30pm; groups by appointment); **Lectures**.

Publications: exhibition catalogues.

The Katonah Museum of Art does not have a permanent collection. It focuses on temporary exhibitions, mounting seven to ten per year, ranging from historical to contemporary in theme.

Mountainville

Storm King Art Center

Old Pleasant Hill Road, Mountainville, NY 10953

Tel: (914) 534-3115

Fax: (914) 534-4457

Internet Address: http://www.stormking.org

Director: Mr. David R. Collens

Admission: fee:
adult-$7.00, child (<6)-free, student-$3.00, senior-$5.00.

Attendance: 44,000 *Established:* 1960

Membership: Y *ADA Compliant:* Y

Open: **April to mid-November**, Daily, 11am-5:30pm.

Closed: mid-November to March.

Facilities: **Architecture** (Normandy-style building, 1935); **Galleries** (9); **Library** (2,000 volumes); **Picnic Area**; **Sculpture Park/Outdoor Museum** (500 acres); **Shop**.

David Smith, *XI Books III Apples*, 1959, stainless steel, 94 x 35 x 16¼ inches. Gift of the Ralph E. Ogden Foundation, Inc., Storm King Art Center. Photograph by Jerry L. Thompson, courtesy of Storm King Art Center, Mountainville, New York.

Mountainville, New York

Storm King Art Center, cont.

Activities: **Concerts; Family Programs; Guided Tours; Temporary Exhibitions**.

Publications: exhibition catalogues; guides to outdoor sculpture; newsletter.

Storm King Art Center has a large collection of sculptures on display in a 500-acre park, The works, many of them monumental in scale, are by sculptors as Magdalena Abakanowicz, Siah Armajani, Alexander Calder, Mark di Suvero, Andy Goldsworthy, Henry Moore, Louise Nevelson, Isamu Noguchi, Richard Serra, and David Smith.

Mumford

Genesee Country Village and Museum - Gallery of Sporting Art

1410 Flint Hill Road, Mumford, NY 14511

Tel: (716) 538-6822

Fax: (716) 538-6927

Internet Address: http://www.history.rochester.edu/gcmuseum

Curator: Ms. Diane Jones

Admission: fee (gallery only): adult-$5.00, child-$3.00, senior-$4.00.

Attendance: 120,000 *Established:* 1966 *Membership:* Y *ADA Compliant:* Y

Parking: free on site.

Open: **May to June**,
 Tuesday to Friday, 10am-4pm; Saturday to Sunday, 10am-5pm; Holidays, 10am-5pm.
 July to Labor Day,
 Tuesday to Sunday, 10am-5pm.
 Labor Day to mid-October,
 Tuesday to Friday, 10am-4pm; Saturday to Sunday, 10am-5pm; Holidays, 10am-5pm.

Facilities: **Architecture; Food Services** Restaurant and Cafeteria; **Gallery; Library** (2,000 volumes); **Sculpture Garden; Shop**.

Activities: **Guided Tours** (groups 20+, reserve two weeks in advance); **Permanent Exhibits; Temporary Exhibitions**.

Publications: collection catalogue, "Four Centuries of Sporting Art" (quarterly); newsletter, "Genesee Country Companion".

The Gallery of Sporting Art is one of the few major fine art museums in North America specializing in sporting and wildlife art. It is a showcase for several hundred paintings and sculptures, the result of forty years of collecting by Genesee Country Museum founder John L. Wehle. It also exhibits a collection of art of the American Southwest as well as an outdoor sculpture garden. A part of the Genesee Country Village and Museum, the Gallery may also be visited under the general admission fee.

New Paltz

State University of New York at New Paltz - Samuel Dorsky Museum of Art

75 S. Manheim Blvd., New Paltz, NY 12561

Tel: (914) 257-3844

Fax: (914) 257-3854

Internet Address:
http://www.newpaltz.edu/artgallery

Director: Mr. Neil C. Trager

Admission: voluntary contribution.

Attendance: 15,000 *Established:* 1963

ADA Compliant: Y

Parking: free on site.

Open: **September to May**,
 Tuesday, 11am-4pm and 7pm-9pm;
 Wednesday to Thursday, 11am-4pm;
 Saturday to Sunday, 1pm-4pm.

Closed: January, Academic Holidays.

Architectural rendering of Central Gallery, Samuel Dorsky Museum of Art. Rendering courtesy of State University of New York at New Paltz, New Paltz, New York.

SUNY New Paltz - Samuel Dorsky Museum of Art, cont.

Facilities: **Galleries** (4 permanent collection, 2 temporary; total 9,000 square feet).

Activities: **Concerts**; **Dance Recitals**; **Lectures**; **Permanent Exhibits**; **Temporary Exhibitions**; **Traveling Exhibitions**.

Publications: exhibition catalogues (semi-annual).

The Museum operates two galleries dedicated to changing temporary exhibitions and four galleries devoted to the exhibition of the permanent collection. Relevant publications and interpretive programming complement the exhibitions. The temporary exhibition program includes exhibitions of works of art by faculty, alumni, and students in the Art Department, and exhibitions, installations, and projects by nationally and internationally recognized artists. Each summer the Museum sponsors thematic exhibitions featuring works by artists living in the mid-Hudson Valley and Catskill Mountain regions. The Museum is dedicated to collecting, housing, researching, interpreting, and exhibiting works of art from diverse cultures. The collection of approximately 4,000 works of art is encyclopedic, spanning a period of almost 4,000 years. Areas of specialization include 20th-century prints and paintings, Asian art, pre-Columbian art and artifacts, metals, and photographs. The Museum has a special commitment to collecting important works of art created by artists (past and present) who have lived and worked in the Hudson Valley and Catskill Mountain regions. A 5,000-square-feet new exhibition space adjoining the existing galleries was scheduled to open to the public in October 2000.

New Rochelle

The College of New Rochelle - Castle Gallery

29 Castle Place (Leland Castle, Main Campus), New Rochelle, NY 10805

Tel: (914) 654-5423

Internet Address: http://www.cnr.edu/cg.htm

Director: Wennie Huang

Admission: free.

Established: 1980

Open: Tuesday to Friday, 10am-5pm; Saturday to Saturday, noon-4pm.

Closed: Holidays.

Facilities: **Exhibition Area**.

Activities: **Guided Tours**; **Temporary Exhibitions** (four per year).

The Castle Gallery presents temporary exhibitions of contemporary art, applied design, fine craft, and material culture.

New York City - Bronx

The Bronx Museum of the Arts

1040 Grand Concourse at 165th St., Bronx, NY 10456

Tel: (718) 681-6000 *Ext:* 129

Fax: (718) 681-6181

Exec. Director: Ms. Jenny Dixon

Admission: fee: adult-$3.00, child-free, student-$2.00, senior-$1.00.

Attendance: 30,000 *Established:* 1971

Membership: Y *ADA Compliant:* Y

Parking: commercial adjacent to site.

Open: Wednesday, 3pm-9pm;
Thursday to Friday, 10am-5pm;
Saturday to Sunday, 1pm-6pm.

Closed: New Year's Day, Thanksgiving Day, Christmas Day.

Facilities: **Galleries** (4 at site, satellite galleries throughout borough); **Shop**.

View of gallery, Bronx Museum of the Arts. Photograph courtesy of Bronx Museum of the Arts, Bronx, New York.

The Bronx Museum of the Arts , cont.

Activities: **Arts Festival**; **Concerts**; **Demonstrations**; **Education Programs** (adults and children); **Films** (Wednesday nights); **Gallery Talks**; **Lectures**; **Temporary Exhibitions** (6/year); **Traveling Exhibitions.**

Publications: brochures; exhibition catalogues; gallery guides.

The Bronx Museum of the Arts mounts a seasonal cycle of 20th-century and contemporary art exhibitions concerning themes of special interest and cultural significance to the community. In addition to sponsoring major exhibitions and works of established artists, the Museum is committed to providing venues for emerging and mid-career artists and curators. Its permanent collection consists of over 600 paintings, prints, photographs and mixed-media works primarily by artists of African, Asian, and Latin American ancestry. Selections from the permanent collection are exhibited annually. In addition to its main facility, the Museum maintains several satellite galleries in public spaces throughout the Bronx. These galleries present a changing schedule of work primarily by Bronx artists. Call the Museum for information on current satellite exhibitions.

The Hebrew Home for the Aged

Elma and Milton A Gilber Pavillion, 5901 Palisade Ave., Riverdale (Bronx), NY 10471

Tel: (718) 549-8700 *Ext:* 330

Fax: (718) 601-6125

Curator: Ms. Susan Putterman

Admission: free.

Open: Sunday to Friday, 10am-4pm.

Facilities: **Exhibition Area**; **Sculpture Garden.**

Activities: **Permanent Exhibits**; **Temporary Exhibitions** (12/year).

On a 19-acre campus overlooking the Hudson River, the Home maintains an exhibition area, open to the public, in which temporary exhibitions and rotating selections from its permanent collection are displayed. Contemporary American art is featured. A large sculpture garden is maintained on the back lawn. Artists represented in the Home's permanent collection include Alexander Calder, Marc Chagall, Herbert Ferber, Ernest Fiene, Stephanie Brody Lederman, Pablo Picasso, Frank Stella, Andy Warhol, and William Wegman. Also administered by the Home, the Judaica Museum, which houses the Ralph and Leuba Baum collection of over 800 ritual objects, is located at 5961 Palisade Avenue (548-1006).

Hostos Community College of CUNY - Hostos Art Gallery

Hostos Center for the Arts and Culture, 450 Grand Concourse at 149th St., Bronx, NY 10451

Tel: (718) 518-4455

Internet Address: http://www.hostos.cuny.edu/culture/gallery.html

Open: Call for hours.

Facilities: **Gallery.**

Activities: **Temporary Exhibitions.**

Located on the campus of one of the colleges in the City University system, the Center consists of a museum-grade art gallery, a 367-seat theatre, and 906-seat concert hall. The Hostos Gallery presents temporary exhibitions of the work of artists of national and international reputation, as well as emerging and established local artists.

Lehman College Art Gallery

250 Bedford Park Blvd. W. & Goulden Ave., Bronx, NY 10468-1589

Tel: (718) 960-8731

Fax: (718) 960-8935

Internet Address: http://ca80.lehman.cuny.edu/gallery/web/AG

Director: Ms. Susan Hoeltzel

Admission: voluntary contribution.

Attendance: 15,000 *Established:* 1985 *Membership:* Y *ADA Compliant:* Y

Open: **September to June**, Tuesday to Saturday, 10am-4pm.
 July to August, by appointment.

Facilities: **Exhibition Area.**

Lehman College Art Gallery, cont.

Activities: **Education Programs** (children); **Films**; **Guided Tours**; **Lectures**; **Temporary Exhibitions**.

Publications: exhibition catalogues; exhibition notes (bi-monthly).

Housed in a building designed by architect Marcel Breuer on the campus of Lehman College, a branch of City University of New York, the Gallery presents a range of temporary exhibitions and arts education programs, primarily in contemporary art.

New York City - Brooklyn

Brooklyn College/CUNY - Art Gallery

LaGuardia Hall (under the bell tower), 2900 Bedford Ave., Brooklyn, NY 11210

Tel: (718) 951-5181

Internet Address: http://www.brooklyn.cuny.edu/bc/calendar/art/artcal.htm

Admission: free.

Open: Monday to Friday, 12:30pm-4:30pm.

Facilities: **Exhibition Area**.

Activities: **Lectures**; **Temporary Exhibitions**.

Located on the main floor of LaGuardia Hall, the Gallery presents several exhibitions featuring the work of nationally and internationally recognized artists each year. Also of possible interest on campus, the Art Department's Meier Bernstein Art Library and its Graduate Art Student Union sponsor lectures and slide presentations throughout the academic year by visiting artists, art historians, critics, museum curators, writers on art, gallery owners, and other art-world figures.

Brooklyn Museum of Art

200 Eastern Parkway, Brooklyn, NY 11238-6052

Tel: (718) 638-5000

Fax: (718) 638-5931

TDDY: (718) 783-6501

Internet Address: http://www.brooklynart.org

Director: Dr. Arnold L. Lehman

Admission: fee: adult-$4.00, student-$2.00, senior-$2.00.

Established: 1823 *Membership:* Y *ADA Compliant:* Y

Parking: pay on site.

Open: Wednesday to Friday, 10am-5pm; Saturday to Sunday, 11am-6pm;
1st Saturday in month, 11am-11pm.

Closed: New Year's Day, Thanksgiving Day; Christmas Day.

Facilities: **Architecture** (Beaux Arts building, 1893 designed by McKim, Meade & White); **Food Services** Restaurant (weekdays until 4pm); **Galleries**; **Library** (125,000 volumes); **Sculpture Garden**; **Shop**.

Activities: **Concerts**; **Dance Recitals**; **Education Programs** (adults, students and children); **Films**; **Gallery Talks**; **Guided Tours**; **Lectures**; **Temporary Exhibitions**.

Publications: annual report; exhibition catalogues; gallery guides; handbooks; monographs.

The Brooklyn Museum of Art is one of the largest art institutions in the United States. The Museum collection is housed in a 560,000-square-foot Beaux Arts facility designed by McKim, Meade and White. The Museum's collection of ancient Egyptian art includes a chronological presentation ranging from 1350 B.C. during the reign of Akhenaton and his wife Nefertiti, through the regime of Cleopatra VII. It also has on view Roman, ancient Greek, Assyrian, and Coptic art. The collection of painting and sculpture includes European and American works from the 14th century through the present day. There are American works by, among others, Bierstadt, Bingham, Church, Cole, Davis, Diebenkorn, Hartley, Homer, Inness, Johnson, O'Keeffe, Peale, Rothko, Sargent, and Stuart, and European works by Rodin (58 pieces), Nardo di Cione, Courbet, Degas, Matisse, Monet, Morisot, and Pissarro. There are also extensive holdings in works on paper, photography (Steichen, Weston, Bourke-White), arts of the Pacific (Polynesia, Melanesia, and Indonesia), Africa (250 artifacts), the Americas (pre-Columbian and Native American objects), and Asia. The latter is highlighted by a complete set of Hiroshige's woodblock prints, "100 Famous Views of Edo".

Long Island University Galleries

1 University Plaza, Brooklyn, NY 11201
Tel: (718) 488-1198
Fax: (718) 488-1372
Internet Address: http://www.brooklyn.liunet.edu/cwis/bklyn/art/artEXHIBITS.htm
Open: Monday to Friday, 10am-6pm; Saturday to Sunday, 10am-5pm.
Facilities: **Exhibition Area** (2 galleries).
Activities: **Temporary Exhibitions.**

The University Art Department mounts temporary exhibitions in two galleries in the LLC Building, the Selena Gallery on the ground floor and the Resnick Showcase on the third floor.

Pratt Institute - The Rubelle and Norman Schafler Gallery

Pratt Institute, 200 Willoughby Ave., Brooklyn, NY 11205
Tel: (718) 636-3517
Fax: (718) 636-3455
Internet Address: http://www.pratt.edu/exhibitions
Director: Ms. Eleanor Moretta
Admission: free.
Attendance: 10,000 *Established:* 1985
Parking: metered on street.
Open: Monday to Friday, 9am-5pm.
Closed: Legal Holidays.
Facilities: **Exhibition Area** (2,300 square feet); **Food Services** Restaurant; **Library** (185,000 volumes); **Multi-media Center; Studios and Classrooms.**
Activities: **Education Programs** (undergraduate and graduate students); **Lectures; Performances.**
Publications: calendar (semi-annual); exhibition announcements.

The Gallery presents temporary exhibitions of student, faculty, and alumni work, as well as curated shows of contemporary art, design, and architecture. The Pratt Institute presents a similar program of exhibitions at Pratt Manhattan Gallery (see separate listing under Manhattan).

The Rotunda Gallery

33 Clinton St., Brooklyn, NY 11201
Tel: (718) 875-4047
Fax: (718) 488-0609
Internet Address: http://www.brooklynx.org/rotunda
Director: Ms. Janet Riker
Admission: free.
Attendance: 14,000 *Established:* 1981
Membership: N *ADA Compliant:* Y
Parking: metered on street and commercial lots.
Open: **September to June,**
 Monday to Friday, noon-5pm;
 Saturday, 11am-4pm.
Facilities: **Exhibition Area.**
Activities: **Education Programs** (adults, college students and children).
Publications: brochures; exhibition catalogues.

Interior view of Rotunda Gallery. Photograph courtesy of Rotunda Gallery, Brooklyn, New York.

The Gallery, a project of BRIC/Brooklyn Information and Culture, presents temporary exhibitions of contemporary art by Brooklyn artists. It also maintains an artists slide registry of over 800 artists who were born, live or work in the borough.

New York City - Manhattan

Adelphi University SoHo Center Gallery

75 Varick St., 2nd Floor, New York, NY 10013
Tel: (516) 431-5161
Internet Address: http://www.adelphi.edu
Director: Professor Richard Vaux
Open: Monday to Friday, 9am-5pm.
Facilities: **Exhibition Area.**
Activities: **Changing Contemporary Exhibitions.**

The Gallery presents a schedule of temporary exhibitions. For Adelphi University's on-campus Art Galleries, see separate listing under Garden City, New York.

The Alternative Museum

594 Broadway, Suite 402, New York, NY 10012
Tel: (212) 966-4444
Fax: (212) 226-2158
Internet Address:
 http://www.alternativemuseum.org
C.E.O.: Geno Rodriguez
Admission: suggested contribution-$3.00.
Attendance: 70,000 *Established:* 1975
Membership: Y *ADA Compliant:* Y
Parking: commercial adjacent to site.
Open: Wednesday to Saturday, 11am-6pm.
Closed: Legal Holidays,
 August, during installations.
Facilities: **Exhibition Area** (3,500 square feet).
Activities: **Concerts; Guided Tours;
 Lectures; Temporary Exhibitions** (7-
 9/year).
Publications: exhibition catalogues.

View of Alternative Museum's gallery space during exhibition of works of Maureen Connor entitled "Discreet Objects", 1995. Photograph courtesy of Alternative Museum, New York, New York.

Founded and operated by artists, TAM's primary functions are to provide a professional showcase for artists, leadership with an "artist perspective" within the Museum profession, and an atmosphere wherein ideas may be presented and challenged. The Museum presents seven to nine thematic and solo exhibitions each year, including the Annual National Showcase Exhibition featuring the work of 30-50 emerging artists from across the nation.

American Craft Museum

40 West 53rd St., New York, NY 10019
Tel: (212) 956-3535
Fax: (212) 459-0926
Internet Address: http://www.americas-society.org
Director: Ms. Holly Hotchner
Admission: fee: adult-$5.00, student-$2.50, senior-$2.50.
Attendance: 100,000 *Established:* 1956 *Membership:* Y *ADA Compliant:* Y
Open: Tuesday to Sunday, 10am-6pm.
Facilities: **Exhibition Area; Shop.**
Activities: **Guided Tours; Lectures; Workshops.**
Publications: exhibition catalogues.

The Museum features 20th-century American craft of clay, metal, glass fiber, and wood offering a regular schedule of exhibitions exploring both traditional craft and innovative works by contemporary craft artists. The permanent collection focuses on the post-World War II era.

Americas Society - Art Gallery

680 Park Ave., New York, NY 10021
Tel: (212) 249-8950 *Ext:* 360
Fax: (212) 249-5868
Internet Address: http://www.americas-society.org
President: Ambassador Everett Ellis Briggs
Admission: voluntary contribution.
Attendance: 10,000 *Established:* 1967 *Membership:* Y *ADA Compliant:* Y
Parking: very limited street parking and numerous commercial garages.
Open: Tuesday to Sunday, noon-6pm.
Closed: Independence Day, Thanksgiving Day, Christmas Day.
Facilities: **Architecture** (designed by McKim, Mead & White); **Exhibition Area**; **Library and Slide Repository** (Latin American, Caribbean, and Canadian art); **Shop** (AS publications, exhibition catalogues, magazines).
Activities: **Concerts**; **Education Programs**; **Guided Tours** (groups, by appointment only); **Lecture Series**; **Temporary Exhibitions** (3/year).
Publications: "Review: Latin American Literature and Arts" (semi-annual); exhibition catalogues.

The Americas Society Art Gallery, located on the ground floor of an historic McKim Mead and White mansion on Park Avenue, presents three exhibitions a year with a special focus on Latin American art. A comprehensive program of bilingual lectures, symposia, and gallery tours is offered in conjunction with each exhibition. The library houses an important collection of art books, monographs, magazines, and an archive that contains biographical and bibliographical documentation and slides of more than 4,000 artists of the Americas.

Art Students League of New York

215 West 57th St., 2nd Floor
New York, NY 10019
Tel: (212) 247-4510
Fax: (212) 541-7024
Director: Joanne Kuebler, Ph.D.
Established: 1875
Open: Monday to Friday, 9am-8pm;
 Saturday, 9am-3pm.
Facilities: **Exhibition Area.**
Activities: **Temporary Exhibitions.**

The Art Students League Gallery maintains a continuous series of exhibitions, including works from the League's permanent collection, and work by prominent League artists, instructors, and students.

Exterior view, Arts Students League. Photograph courtesy of Arts Students League, New York, New York.

The Asia Society Galleries

725 Park Ave. at 70th St., New York, NY 10021
Tel: (212) 288-6400
Fax: (212) 517-8315
Internet Address: http://www.asiasociety.org
Director: Ms. Vishakha N. Desai
Admission: fee: adult-$4.00, student-$200, senior-$2.00.
Established: 1956 *Membership:* Y *ADA Compliant:* Y
Open: Under construction/renovation; scheduled to reopen Fall 2001. (See text for interim location)
Closed: Major holidays.

The Asia Society Galleries, cont.

Facilities: **Auditorium** (258 seats); **Exhibition Area**; **Shop** (Mon-Fri, 1pm-6:30pm; Sat, 11am-6pm; Sun, noon-5pm).

Activities: **Films**; **Guided Tours** (Tues-Sat, 12:30pm; Thurs, 6:30pm; Sun, 2:30pm); **Lectures**; **Performances**; **Traveling Exhibitions**.

Publications: "Archives of Asian Art"; collection catalogue; exhibition catalogues.

The Asia Society mounts exhibitions of ancient and modern art assembled from public and private collections in Asia and the West, as well as from the Society's permanent collection. These exhibitions travel to museums throughout the United States and Asia. In recent years the Society has launched a new program to present contemporary Asian and Asian American art, with the help of leading scholars, curators, and critics in Asia and the U.S. The Society also presents public programs on the arts and publishes exhibition catalogues and a journal on Asian art. The Society Galleries are closed for renovation. Until they reopen in the fall of 2001, an interim location has been established at 502 Park Ave., New York, NY 10022 (open: Monday to Saturday, 10am-6pm).

Asian American Art Centre

26 Bowery St., 3rd Floor, New York, NY 10013
Tel: (212) 233-2154
Fax: (212) 766-1287
C.E.O. and Curator: Mr. Robert Lee
Admission: voluntary contribution.
Attendance: 15,000 *Established:* 1974
Open: Monday to Friday, noon-6pm.
Facilities: **Exhibition Area**; **Library** (350 volumes).
Activities: **Temporary Exhibitions** (fall).
Publications: booklets, "Artspiral" (annual).

The Asian American Arts Centre promotes the preservation and creative vitality of Asian American cultural identity through the arts. In the visual arts, it offers contemporary art exhibitions and an annual Chinese folk arts exhibition. It also maintains the Asian American Artists Slide Archive, a permanent research archive of over 600 entries documenting the history of Asian American artists in the United States.

The Bard Graduate Center for Studies in the Decorative Arts (BGC)

18 West 86th St., New York, NY 10024
Tel: (212) 501-3000
Fax: (212) 501-3079
TDDY: (212) 501-3012

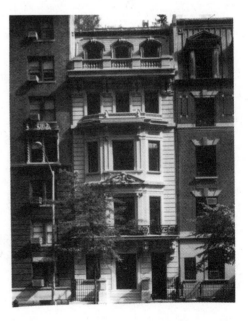

Internet Address: http://www.bgc.bard.edu
Director: Dr. Susan Weber Soros
Admission: fee: adult-$2.00, student-$1.00, senior-$1.00.
Established: 1992 *Membership:* N *ADA Compliant:* Y
Parking: nearby commercial garages.
Open: Tuesday to Wednesday, 11am-5pm;
Thursday, 11am-8:30pm;
Friday to Sunday, 11am-5pm.
Closed: New Year's Day, ML King Jr. Day,
Memorial Day, Independence Day,
Labor Day, Thanksgiving Day,
Thanksgiving Friday, Christmas Day.
Facilities: **Exhibition Area** (2 floors in town house); **Library** (25,000 volumes, by appointment, call 501-3035).

Exterior view of façade of Bard Graduate Center for Studies in the Decorative Arts. Photograph courtesy of Bard Graduate Center for Studies in the Decorative Arts, New York, New York.

The Bard Graduate Center for Studies in the Decorative Arts, cont.

Activities: **Education Programs**; **Guided Tours** (for information call 501-3023); **Lectures**.

Publications: exhibition catalogues; journal, "Studies in the Decorative Arts" (semi-annual).

The BGC is primarily an educational institution offering both the Masters degree and Ph.D. in the decorative arts. It also presents 2-3 exhibitions each year on a diverse roster of subjects that could include architecture, jewelry, furniture, glass, and porcelain, among others. There are extensive public programs and continuing education programs as well.

Baruch College - Sidney Mishkin Gallery

135 East 22nd St., New York, NY 10010

Tel: (212) 802-2690

Internet Address: http://www.cuny.edu/colleges/tpoframe-baruch.html

Director: Dr. Sandra Kraskin

Admission: free.

Established: 1981 *ADA Compliant:* Y

Parking: commercial adjacent to site.

Open: **September to May**,
> Monday to Wednesday, noon-5pm; Thursday, noon-7pm; Friday, noon-5pm.

Closed: January, June to August, Academic Holidays.

Facilities: **Architecture** (former Federal Courthouse, 1939); **Exhibition Area** (1,800 square feet).

Activities: **Education Programs** (undergraduate and graduate students); **Temporary Exhibitions**; **Traveling Exhibitions**.

Publications: brochures; exhibition catalogues.

Located on the ground floor of Baruch College's Administrative Center, the Gallery presents temporary exhibitions in a variety of media featuring scholarly, multicultural, one-person and group shows, and exhibitions out of the American mainstream. Three hundred artworks (primarily modern and contemporary paintings, sculpture, prints and photographs) comprise the Gallery's permanent collection. The core of the Gallery's holdings is the Mishkin Collection, which includes painting and sculpture by Surrealists Max Ernst, Andre Masson, and Man Ray, as well as works by Alexander Calder, Marsden Hartley, and Barbara Hepworth.

The Chaim Gross Studio Museum

526 LaGuardia Place (between West 3rd & Bleeker Sts.)
New York, NY 10012

Tel: (212) 529-4906

Fax: (212) 529-4906

Director: Ms. Renee N. Gross

Admission: free.

Attendance: 4,000 *Established:* 1989

Membership: Y *ADA Compliant:* Y

Parking: commercial adjacent to site.

Open: Tuesday to Saturday, noon-6pm.

Closed: Legal Holidays.

Facilities: **Architecture** (Chaim Gross' home & studio, 1904); **Exhibition Area** (2,500 square feet); **Library** (2,500 volumes).

Activities: **Films** (video viewing room); **Guided Tours** (by appointment); **Lectures** (by invitation); **Temporary Exhibitions** (monthly); **Traveling Exhibitions**.

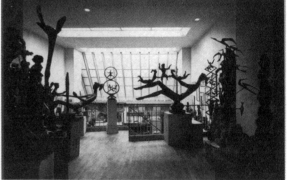

View of first floor gallery overlooking studio at Chaim Gross Studio Museum. Photograph courtesy of Chaim Gross Studio Museum, New York, New York.

Publications: exhibit brochure, "The Chaim Gross Studio Museum"; exhibition catalogue, "Chaim Gross: Fantasy Drawings"; exhibition catalogue, "Chaim Gross: sixty Years of Sculpture" (biennial).

The Chaim Gross Studio Museum, cont.

At the Chaim Gross Museum, where the sculptor Chaim Gross lived and worked for over thirty years, the visitor may examine the artist's creations in special gallery settings, as well as view the studio in which the artist worked. On the first floor is an array of his wood and stone carvings ranging in date from the early 1920s to his final wood sculpture of 1988-89. Beneath the skylight in the studio can be seen his tools, an unfinished carving still in a vise, and on surrounding shelves examples of his portrait busts and preparatory maquettes. On the second floor are displayed his later bronzes, as well as changing installations devoted to his watercolors and drawings.

China Institute Gallery

China Institute in America, 125 East 65th St., New York, NY 10021
Tel: (212) 744-8181 *Ext:* 147
Fax: (212) 628-4159
Gallery Director: Willow Hai Chang
Admission: fee: adult-$3.00, student-$2.00, senior-$2.00; free: Tuesday and Thursday, 6pm-8pm.
Attendance: 10,000 *Established:* 1926 *Membership:* Y
Parking: metered on street and commercial adjacent to site.
Open: Monday, 10am-5pm; Tuesday, 10am-8pm; Wednesday, 10am-5pm; Thursday, 10am-8pm;
 Friday to Saturday, 10am-5pm; Sunday, 1pm-5pm.
Closed: Legal Holidays.
Facilities: **Exhibition Area** (1,000 square feet); **Library** (5,000 volumes); **Shop**.
Activities: **Concerts**; **Education Programs** (adults, courses in calligraphy and painting); **Films**;
 Guided Tours (Mon-Fri; Sat, appointment necessary); **Lectures**; **Traveling Exhibitions**.
Publications: exhibition catalogues.

Changing exhibitions feature the fine arts and folk traditions of China.

The Cloisters

Fort Tryon Park, New York, NY 10040
Tel: (212) 923-3700
Fax: (212) 795-3640
TDDY: (212) 879-0421
Internet Address: http://www.metmuseum.org
Chairman: Mr. William D. Wixom
Admission: suggested contribution:
 adult-$10.00, child (<12)-free, student-$5.00,
 senior-$5.00.
Attendance: 235,000 *Established:* 1938
Membership: Y *ADA Compliant:* Y
Parking: free on site.
Open: **March to October**,
 Tuesday to Sunday, 9:30am-5:30pm.
 November to February,
 Tuesday to Sunday, 9:30am-4:45pm.

Saint Michel-de-Cuxa Cloister at The Cloisters in Fort Tryon Park, 1997. Photograph by Pat Mazza, courtesy of Metropolitan Museum of Art, New York, New York.

Facilities: **Library** (12,000 volumes); **Shop**.
Activities: **Concerts** (Dec-Apr); **Education Programs** (adults, graduate students and children);
 Gallery Talks (Sat, noon & 2pm); **Guided Tours** (Tues-Fri, 3pm; Sun, noon); **Lectures**;
 Performances; **Permanent Exhibitions**; **Temporary Exhibitions**.
Publications: "A Walk Through the Cloisters"; collection catalogue.

The Cloisters is a branch of The Metropolitan Museum of Art devoted to the art and architecture of medieval Europe. It is located in upper Manhattan's Fort Tryon Park, overlooking the Hudson River. Opened in 1938, this modem structure in medieval style incorporates chapels, sections of monastic cloisters, a chapter house and other architectural elements. Known particularly for its Romanesque and Gothic architectural sculpture, The Cloisters collection also includes illuminated manuscripts, stained glass, metalwork, enamels, ivories and paintings, both religious and secular, dating from the 12th through the 15th century. Its holdings include the renowned Unicorn Tapestries,

The Cloisters, cont.

a series of seven South Netherlandish tapestries created around 1500; the Belles Heures de Jean, Duc de Berry, a 15th-century illuminated book of hours; and an ornately carved ivory cross attributed to the English abbey of Bury Saint Edmunds. Also among the highlights are the beautiful flower and herb gardens, with more than 250 species of plants grown in the Middle Ages.

Columbia University - Miriam and Ira D. Wallach Art Gallery

Columbia University., Schermerhorn Hall, 8th Fl, 116th St. and Broadway, New York, NY 10027

Tel: (212) 854-6800

Fax: (212) 854-7329

Internet Address: http://www/columbia.edu/cu/wallach/

Director and Curator, Art Properties: Ms. Sarah Elliston Weiner

Admission: free.

Attendance: 2,800 *Established:* 1986 *ADA Compliant:* Y

Parking: commercial adjacent to site.

Open: Wednesday to Saturday, 1pm-5pm.

Closed: Academic Holidays.

Facilities: **Exhibition Area** (2,300 square feet).

Activities: **Education Programs** (undergraduate and graduate college students); **Films**; **Lectures**.

Publications: exhibition catalogues.

The Wallach Art Gallery presents exhibitions that complement the educational mission of the University. Works are drawn from public and private collections as well as from University collections.

Cooper-Hewitt National Design Museum, Smithsonian Institution

2 East 91st St. at 5th Ave., New York, NY 10128

Tel: (212) 849-8300

Fax: (212) 849-8401

TDDY: (212) 849-8386

Internet Address: http://www.si.edu/ndm

Director: Ms. Diane H. Pilgrim

Admission: fee: adult-$5.00, student-$3.00, senior-$3.00.

Attendance: 140,000 *Established:* 1897

Membership: Y

Parking: commercial near site.

Open: Tuesday, 10am-9pm;
 Wednesday to Saturday, 10am-5pm;
 Sunday, noon-5pm.

Closed: Federal Holidays.

Facilities: **Architecture** (Andrew Carnegie mansion, 1902 design by Baab, Cook & Willard); **Galleries**; **Garden**; **Library** (50,000 volumes, by appointment); **Shop** (books, ceramics, glass, jewelry).

Activities: **Education Programs** (adults, undergraduates and children); **Films**; **Gallery Talks**; **Guided Tours**; **Lectures**; **Temporary Exhibitions**; **Traveling Exhibitions**.

Exterior view of Cooper-Hewitt National Design Museum, Smithsonian Institution. Photograph courtesy of Cooper-Hewitt National Design Museum, Smithsonian Institution, New York, New York.

Publications: book, "The Smithsonian Illustrated Library of Antiques"; exhibition catalogues; magazine.

Housed in the historic Andrew Carnegie Mansion on 5th Avenue, the Museum's collection is one of the largest of its kind in the world. Collecting activities are defined by four curatorial departments: drawings and prints, industrial design and applied arts, textiles, and wallcoverings. Through an active program of exhibitions, educational programs, and publications, the Museum presents perspectives on the social, environmental, and economic impact of design. Founded in 1897, the National Design Museum has been part of the Smithsonian Institution since 1967.

Cooper Union School of Art - Arthur A. Houghton, Jr. Gallery

Cooper Union Foundation Building, 2nd Floor, 7 East 7th St. (3rd Ave. and 7th St.)
New York, NY 10003
Tel: (212) 353-4203
Internet Address: http://www.cooper.edu/art
Director: Mr. Robert Rindler
Open: Monday to Friday, noon-7pm; Saturday, noon-5pm.
Facilities: **Exhibition Area.**
Activities: **Temporary Exhibitions.**

The Gallery presents temporary exhibitions. Also located on the second floor, The Herb Lubalin Study Center of Design and Typography (353-4214) mounts exhibitions related to the history and theory of graphic design.

Dahesh Museum

601 5th Ave. (between 48th and 49th Sts.), New York, NY 10017
Tel: (212) 759-0606
Fax: (212) 759-1235
Internet Address: http://www.daheshmuseum.org
Director: Mr. J. David Farmer
Admission: free.
Attendance: 18,000 *Established:* 1995 *Membership:* Y *ADA Compliant:* Y
Parking: commercial adjacent to site.
Open: Tuesday to Saturday, 11am-6pm.
Facilities: **Exhibition Area.**
Activities: **Concerts**; **Gallery Talks** (noontime); **Lectures.**
Publications: exhibition brochures; exhibition catalogues.

The Dahesh Museum presents loan exhibitions of European academic art of the 19th century as well as exhibitions based on the collection of Dr. Dahesh (1909-1984), an influential Lebanese writer and philosopher with a passion for European art. The permanent collection includes landscapes, "oriental" scenes, and images of history and everyday life as depicted by such artists as Bonheur, Bouguereau, Picou, Troyon, Ward, and Wardle.

Dia Center for the Arts - Exhibition Galleries

548 West 22nd St., New York, NY 10011
Tel: (212) 989-5912
Fax: (212) 989-4055
Internet Address: http://www.diacenter.org
Exec. Director: Mr. Michael Govan
Admission: suggested contribution: adult-$6.00, child-free, student-$3.00, senior-$3.00.
Attendance: 96,000 *Established:* 1974 *Membership:* Y
Parking: on street or nearby commercial lots.
Open: **September to June**, Wednesday to Sunday, noon-6pm.
Closed: New Year's Day, Thanksgiving Day, Christmas Day.
Facilities: **Exhibition Area** (40,000 square feet); **Food Services** Café and Video Salon; **Library** (2,800 volumes); **Shop** (books).
Activities: **Guided Tours** (groups, by appointment); **Lectures**; **Readings** (poetry series); **Temporary Exhibitions** (4/year, 6-18months duration).
Publications: calendar, "Dia Calendar of Events" (semi-annual); exhibition brochures; exhibition catalogues.

Dia's first major projects, undertaken in the late 1970's, included long-term sited works of art not likely to be accommodated by conventional museums because of their nature or scale. Projects included Walter De Maria's "The Broken Kilometer" at 393 W. Broadway and "The New York Earth Room" at 141 Wooster Street. (See also listings under Dia Center for the Arts in Bridgehampton, New

Dia Center for the Arts - Exhibition Galleries, cont.

York and Quemado, New Mexico and under the Chinati Foundation, Marfa, Texas.) Since 1987, Dia has presented three major new installations each year at its exhibition galleries, a four-story renovated warehouse building. Dia emphasizes the direct role of the artist in carefully developed, long-term presentations of his or her work. Artists are typically invited to develop ambitious new work for an entire floor (approximately 9,000 square feet), and each exhibition usually remains on view for one year. Dia also collaborated on the development of the Cy Twombly Gallery in Houston, Texas and the Andy Warhol Museum in Pittsburgh. Dia's collection, formed between 1976 and 1984, is composed of large holdings by some twelve artists, all key figures in the 1960s and 1970s, including Joseph Beuys, John Chamberlain, Walter De Maria, Don Flavin, Donald Judd, Blinky Palermo, Fred Sandback, Cy Twombly, and Andy Warhol.

The Drawing Center

35 Wooster St., New York, NY 10013
Tel: (212) 219-2166
Fax: (212) 966-2876
Exec. Director: Ms. Ann Philbin
Admission: voluntary contribution.
Attendance: 100,000 *Established:* 1977
Membership: Y *ADA Compliant:* Y
Parking: commercial adjacent to site.
Open: **September to July**,

Tuesday to Friday, 10am-6pm; Saturday, 11am-6pm.
Closed: August, Thanksgiving Day

Christmas Day to New Year's Day.
Facilities: **Exhibition Area** (3,000 square feet); **Shop**.
Activities: **Education Programs** (undergraduates, graduate students and children); **Lectures**; **Performances**; **Reading Series** (adults and children); **Traveling Exhibitions**.
Publications: brochures; exhibition catalogues.

Exterior view of The Drawing Center. Photograph courtesy of The Drawing Center, New York, New York.

The Drawing Center is the only not-for-profit institution in the country to focus on the exhibition of drawings, both contemporary and historic. It was established to provide opportunities for emerging and under-recognized artists; to demonstrate the significance and diversity of drawings throughout history; and to stimulate public dialogue on issues of art and culture. Central to the Center's purpose are its historical exhibitions, which offer insight into the art of acknowledged masters as well as less-celebrated artists whose work merits greater attention. At least one historical exhibition is presented annually and is accompanied by a comprehensive, scholarly catalogue. The Center's contemporary exhibition programs are committed to presenting innovative and challenging work that explores and affirms the range of drawing in contemporary art. The Center seeks out emerging and under-represented artists to form the core of its exhibition programs. Four to five contemporary exhibitions are mounted annually. Exhibitions are frequently accompanied by moderated symposia with the exhibiting artists and curators. The Center regularly presents readings, lectures, panels, performances, and paper conservation workshops, which enhance the exhibition programs and address issues related to art and culture.

The Equitable Gallery

787 7th Ave. at 51st St. (Atrium of Equitable Tower), New York, NY 10019
Tel: (212) 554-4818
Fax: (212) 554-2456
Internet Address: http://www.equitable.com
Gallery Director: Ms. Pari Stave
Admission: free.
Attendance: 86,000 *Established:* 1992 *ADA Compliant:* Y

The Equitable Gallery. cont.

Parking: commercial lots adjacent to site.

Open: Monday to Friday, 11am-6pm; Saturday, noon-5pm.

Closed: New Year's Day, Memorial Day, Independence Day, Labor Day, Thanksgiving Day, Christmas Day.

Facilities: **Food Services** Restaurants (3); **Gallery Space** (3,000 square feet); **Shop**.

Activities: **Lectures**; **Temporary Exhibitions**.

The Equitable Gallery, sponsored by The Equitable Life Assurance Society of the U.S., presents works from all fields of the visual arts, including exhibitions originating outside New York that would not otherwise have a presence in the city, as well as works from New York collections that would benefit from preservation and public presentation. The Equitable Center also houses a number of major works of art in its public spaces. Scott Burton, Sandro Chia, Barry Flanagan, Sol LeWitt, and Roy Lichtenstein are among the artists featured.

The Frick Collection

1 East 70th St., New York, NY 10021

Tel: (212) 288-0700

Fax: (212) 628-4417

Internet Address: http://www.frick.org

Director: Mr. Samuel Sachs II

Admission: fee: adult-$5.00, student-$3.00, senior-$3.00.

Attendance: 270,000

Established: Opened to the public 1935.

Membership: Y *ADA Compliant:* Y

Parking: commercial adjacent to site.

Open: Tuesday to Saturday, 10am-6pm;
Sunday, 1pm-6pm;
Holidays, 1pm-6pm.

Closed: New Year's Day, Independence Day, Thanksgiving Day, Christmas Eve, Christmas Day.

Facilities: **Architecture** (former residence of H.C. Frick, 1914 design by Thomas Hastings); **Frick Art Reference Library** (200,000 volumes); **Library** (3,000 volumes, in house); **Sculpture Garden** (garden designed by Russell Page); **Shop**.

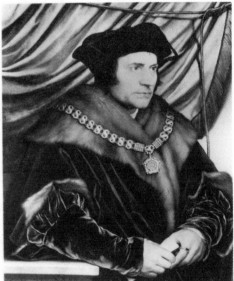

Hans Holbein The Younger, *Sir Thomas More*, 1527, oil on canvas, 29½ x 23¾ inches. The Frick Collection, acquired in 1912. Photograph courtesy of and copyright The Frick Collection, New York, New York..

Activities: **Acoustiguide** (free in 6 languages); **Concerts**; **Education Programs** (graduate students); **Lectures**; **Temporary Exhibitions**.

Publications: "A Guide to Works of Art on Exhibition"; "Art in The Frick Collection"; "The Frick Art Reference Library: The Early Years"; collection catalogue, "The Frick Collection: An Illustrated Catalogue, vols. I-VIII"; "The Frick Collection: A Tour".

Displayed within his former residence, The Frick Collection is composed of the former private collection of Henry Clay Frick (1849-1919) with subsequent additions made by purchase or received as gifts. A total of 1,100 objects, the collection includes some of the best-known paintings by the greatest European artists such as El Greco, Holbein, Rembrandt, Velazquez, Vermeer, Whistler; major works of sculpture (among them one of the finest groups of small bronzes in the world); and 18th-century French furniture and porcelain, Limoges enamels, oriental carpets, and other decorative arts objects.

Guggenheim Museum Soho

575 Broadway at Prince St., New York, NY 10012

Tel: (212) 423-3500

Fax: (212) 423-3650

TDDY: (212) 423-3607

Director: Mr. Thomas Krens

Admission: free.

Guggenheim Museum Soho, cont.

Established: 1975 *Membership:* Y *ADA Compliant:* Y
Parking: on street parking.
Open: Thursday to Monday, 11am-6pm.
Closed: New Years Day, Thanksgiving Day, Christmas Day.
Facilities: **Architecture** (museum design by Arata Isozaki); **Shop** (next door).
Activities: **Education Programs** (children); **Guided Tours**; **Lectures**; **Traveling Exhibitions**.
Publications: magazine, "Guggenheim Museum Magazine" (quarterly).

The Guggenheim Museum SoHo opened in 1992 in a former commercial loft building, converted to a museum pursuant to a design by Arata Isozaki and Associates. It exhibits international contemporary art. The main facility, the Solomon R. Guggenheim Museum, is listed below.

The Hispanic Society of America

Audubon Terrace, Broadway between 155th and 156th Sts.
New York, NY 10032
Tel: (212) 926-2234
Fax: (212) 690-0743
Internet Address: http://www.hispanicsociety.org
Director: Mr. Mitchell A. Codding
Admission: free.
Attendance: 25,000 *Established:* 1904
ADA Compliant: N
Parking: limited metered parking on Broadway; free
 parking on 155th St. between Broadway & Riverside Dr.;
 commercial adjacent to site.
Open: Tuesday to Saturday, 10am-4:30pm;
 Sunday, 1pm-4pm.
Closed: **Museum**, New Year's Day, February 12 & 22, Good
 Friday, Easter Sunday, Memorial Day, Independence
 Day, Thanksgiving, Christmas Day.
Facilities: **Exhibition Area**; **Library** (350,000 volumes);
 Reading Room; **Sculpture Garden**; **Shop**.
Activities: **Groups** (call X254), **Temporary Exhibitions**.
Publications: books; collection catalogue; exhibition cata-
 logues.

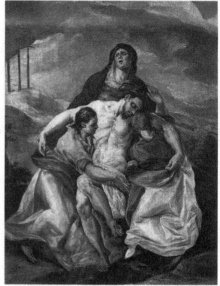

El Greco, *Pieta*, 1575-1577. The Hispanic Society of America. Photograph courtesy of The Hispanic Society of America, New York, New York.

The Hispanic Society of America was founded in 1904 by Archer Milton Huntington in order to establish a museum and library for the study of the cultures of Spain and Latin America. In addition to mounting permanent museum displays, it organizes temporary exhibitions. The painting collection includes works by Goya, El Greco, Murillo, Joaquin Sorolla y Bastida, Velázquez, and Zurbarán, as well as many other important 19th- and 20th-century artists. Highlights of the sculpture on view include Phoenician ivories, Roman marbles, Cuellar tomb sculptures from ca. 1500, and 17th-century polychrome sculpture. Decorative arts on view include an extensive collection of Spanish ceramics, 13th- through 15th-century Hispano-Moresque textiles, and 15th- through 18th-century Chistian vestments, as well as examples of Medieval, Renaissance, and Baroque silver, furniture, ironwork, and glasswork. There is also an important collection of archaeological antiquities, encompassing objects from the bronze age through the Roman period.

Hunter College - Bertha and Karl Leubsdorf Art Gallery

West Building, 68th St. & Lexington Ave. (SW corner, street level), New York, NY 10021
Tel: (212) 772-4991
Fax: (212) 772-4554
Internet Address: http://Hunter.cuny.edu/artgalleries
Director: Mr. Sanford Warmfeld
Admission: free.
Attendance: 10,000 *Established:* 1984 *Membership:* Y *ADA Compliant:* Y

Hunter College - Bertha and Karl Leubsdorf Art Gallery, cont.

Open: **September to June**, Monday to Saturday, 1pm-6pm.
Closed: New Year's Day, Memorial Day, Independence Day, Labor Day, Columbus Day,
Thanksgiving Day, Christmas Day, Academic Holidays.
Facilities: **Exhibition Area** (1,500 square feet).
Activities: **Temporary Exhibitions** (6/year).
Publications: exhibition catalogues (4/year)

The Leubsdorf Art Gallery presents professionally-organized exhibits that support the educational programs of the Hunter College Art Department.

Hunter College - Times Square Gallery

450 West 41st St. (between 9th & 10th Aves. at Dyer St.)
New York, NY 10036
Tel: (212) 772-4991
Fax: (212) 772-4554
Internet Address: http://www.hunter.cuny.edu/artgalleries
Open: **September to June**, Tuesday to Saturday, 1pm-6pm.
Facilities: **Exhibition Area** (5,000 square feet).
Activities: **Temporary Exhibitions** (6/year).
Publications: exhibition catalogues (4-6/year).

Each semester, the Gallery mounts three major exhibitions organized by faculty, students, or alumni. There is also an end-of-semester MFA projects show.

International Center of Photography (ICP)

1130 5th Ave. (at 94th St.), New York, NY 10128
Tel: (212) 860-1777
Fax: (212) 360-6490
Internet Address: http://www.icp.org
Director: Mr. Willis Hartshorn
Admission: fee:
 adult-$6.00, child (<12)-$1.00, student-$4.00, senior-$4.00.
Attendance: 155,000 *Established:* 1974
Membership: Y *ADA Compliant:* Y
Parking: commercial near site.
Open: Tuesday to Thursday, 10am-5pm;
 Friday, 10am-8pm
 Saturday to Sunday, 10am-6pm.
Closed: New Year's Day, Independence Day,
 Thanksgiving Day, Christmas Day.
Facilities: **Architecture** (Georgian-style mansion, 1915 by
 Delano & Aldrich); **Exhibition Area** (adults, college stu-
 dents, and children); **Library** (10,000 volumes);
 Screening Room; **Shop** (books, posters); **Tropical
 Conservatory**.
Activities: **Education Programs** (adults and children);
 Lectures; **School Tours** (free); **Seminars**; **Temporary
 Exhibitions** (20/year); **Travel Programs**; **Workshops**.

Exterior view of International Center of Photography. Photograph courtesy of International Center of Photography, New York, New York. Copyright, ICP.

Publications: annual report; books; brochures; exhibition catalogues; posters; program guides.

ICP, a museum and school dedicated to the understanding and appreciation of photography, creates programs to advance knowledge of the medium. Exhibitions have featured the work of Berenice Abbot, Ansel Adams, Margaret Bourke-White, Mathew Brady, Harry Callahan, Robert Capa, Henri Cartier-Bresson, David Hockney, Annie Leibovitz, David Leventhal, James Nachtwey, Man Ray, Sebastio Salgado, Weegee (Arthur Fellig), Edward Weston, and Clarence White. The ICP Traveling Exhibitions program is the largest circulating museum program devoted exclusively to photography in the United States. ICP's holdings total more than 45,000 images by more than 1,000 photographers. ICP also maintains a satellite site (see International Center of Photography Midtown).

New York City (Manhattan), New York

International Center of Photography Midtown

1133 Avenue of the Americas (at 43rd St.), New York, NY 10036
Tel: (212) 860-1777
Director: Mr. Willis Hartshorn
Admission: fee: adult-$8.00, child (<12)-free; student-$5.00, senior-$5.00.
Established: 1989
Parking: commercial garages nearby.
Open: Tuesday, 11am-8pm; Wednesday to Sunday, 11am-6pm.
Facilities: **Exhibition Area.**
Activities: **Temporary Exhibitions.**

A satellite site of the International Center of Photography (see above).

Japan Society Gallery

333 East 47th St., New York, NY 10017
Tel: (212) 832-1155
Fax: (212) 715-1262
Internet Address: http://www.japansociety.org
Director: Ms. Alexandra Munroe
Admission: fee-$5.00.
Attendance: 12,000 *Established:* 1907 *Membership:* Y *ADA Compliant:* Y
Parking: commercial adjacent to site.
Open: Tuesday to Friday, 11am-6pm; Saturday to Sunday, 11am-5pm.
Facilities: **Auditorium** (289 seats); **Galleries**; **Library** (4,500 volumes); **Sculpture Garden**; **Shop**.
Activities: **Arts Festival**; **Concerts**; **Dance Recitals**; **Films**; **Gallery Talks**; **Guided Tours**; **Lectures**; **Performances**; **Traveling Exhibitions.**
Publications: exhibition catalogues.

The Society has a permanent collection of Japanese art.

The Jewish Museum

1109 5th Ave., New York, NY 10128
Tel: (212) 423-3200
Fax: (212) 423-3232
Internet Address: http://www.thejewishmuseum.org
C.E.O.: Ms. Joan Rosenbaum
Admission: fee:
 adult-$8.00, child-free, student-$5.50, senior-$5.50.
Attendance: 225,000 *Established:* 1904
Membership: Y *ADA Compliant:* Y
Parking: commercial adjacent to site.
Open: Sunday to Monday, 11am-5:45pm;
 Tuesday, 11am-8pm;
 Wednesday to Thursday, 11am-5:45pm.
Closed: Jewish Holidays, Thanksgiving Day, MLKing Day.
Facilities: **Architecture** (Warburg Mansion, 1908); **Auditorium** (232 seats); **Food Services** Café; **Shop**.

Ron B. Kitaj, *Study for the Jewish School (Joe Singer as a Boy)*, 1980, pastel and charcoal on paper. Jewish Museum purchase, through funds provided by Abraham A. Mitchell Charitable Foundation, Joshua Lowenfish Bequest, and an Anonymous Gift. Photograph courtesy of Jewish Museum, New York, New York.

The Jewish Museum, cont.

Activities: **Concerts; Family Programs, Films; Guided Tours; Lecture Series; Temporary Exhibitions.**

Publications: biennial report; brochures; calendar; exhibition catalogues; newsletter; posters.

The Jewish Museum is housed in the landmark Warburg Mansion (1908), designed by C.P.H. Gilbert, which has been renovated pursuant to a design by Kevin Roche. The Permanent Exhibition of the Museum is displayed in seventeen galleries and is entitled "Culture and Continuity". It examines, through artworks and artifacts, the dynamic interaction between continuity and change within Jewish culture. The Museum also mounts temporary exhibitions.

Judaica Museum of Central Synagogue

123 East 55th St., New York, NY 10022

Tel: (212) 838-5122

Fax: (212) 644-2168

Curator: Ms. Cissy Freedman

Admission: free.

Established: 1926

Open: Monday to Friday, 9am-4:30pm.

Closed: Legal Holidays, Jewish Holidays.

Facilities: **Exhibition Area.**

Activities: **Temporary Exhibitions.**

Located in a historic synagogue, the Museum maintains an active schedule of temporary exhibitions. Its permanent collection includes Jewish ceremonial art, paintings, drawings, and sculpture.

Korean Cultural Service/Gallery Korea

460 Park Ave. (corner of 57th St. and Park Ave.), 6th Floor, New York, NY 10022

Tel: (212) 759-9550

Fax: (212) 688-8640

Internet Address: http://www.koreanculture.org

Established: 1979

Open: Monday to Friday, 10am-4:30pm.

Facilities: **Art Gallery** (2,000 square feet).

Activities: **Cultural Performances; Films; Temporary Group Exhibitions.**

Gallery Korea provides a public forum for art exhibitions to promote inter-cultural exchange. The annual calendar of events consists of group shows of artists of varied background and nationalities. The gallery accommodates artworks in all media from painting and sculpture to multi-media and video art. It also offers the general public an opportunity to experience Korean culture by showcasing many Korean cultural performances as well as Korean film nights.

Marymount Manhattan College - MMC Gallery (MMC Gallery)

Marymount Manhattan College, 221 East 71st St., New York, NY 10021

Tel: (212) 517-0692

Fax: (212) 517-0541

Internet Address: http://marymount.mmm.edu

Director: Professor M. Burns

Open: Monday to Sunday, 9am-9pm.

Facilities: **Exhibition Area.**

Activities: **Temporary Exhibitions.**

Located in the esplanade of the College, the MMC Gallery features exhibitions of new and innovative work by professional artists. Also of possible interest, student work is displayed in smaller galleries throughout the college.

New York City (Manhattan), New York

The Metropolitan Museum of Art

5th Ave. at 82nd St., New York, NY 10028
Tel: (212) 879-5500
Fax: (212) 570-3879
TDDY: (212) 879-0421
Internet Address: http://www.metmuseum.org
Director: Mr. Philippe de Montabello
Admission: suggested contribution:
 adult-$10.00, child (<12)-free, student-$4.00, senior-$4.00.
Attendance: 5,500,000 *Established:* 1870
Membership: Y *ADA Compliant:* Y
Parking: pay on site.
Open: Tuesday to Thursday, 9:30am-5:30pm;
 Friday to Saturday, 9:30am-9pm;
 Sunday, 9:30am-5:30pm.
Closed: New Year's Day, Thanksgiving Day, Christmas Day.
Facilities: **Architecture** (designed by Richard Morris Hunt);
 Auditoriums (708 & 246 seats); **Food Services** Cafeteria,
 Restaurant; **Galleries**; **Library** (350,000 volumes);
 Sculpture Gardens (8); **Shop**.
Activities: **Concerts**; **Education Programs** (children); **Films**;
 Guided Tours; **Lectures**; **Permanent Exhibitions**;
 Temporary Exhibitions; **Traveling Exhibitions**.
Publications: annual report; books; brochures; bulletin (quarterly); calendar (bi-monthly); collection catalogues; exhibition catalogues; journal (annual).

Johannes Vermeer, *Young Woman with a Water Jug*, Gift of Henry G. Marquand, 1889, Metropolitan Museum of Art. Photograph by Metropolitan Museum of Art Photograph Studio, courtesy of Metropolitan Museum of Art.

The Metropolitan Museum of Art is one of the world's largest and finest art museums. Its collections include more than two million works of art spanning 5,000 years of world culture, from prehistory to the present and from every part of the globe. Founded in 1870, the Museum is located in New York City's Central Park along 5th Avenue (from 80th to 84th streets). The Museum's 1.5 million square-foot building has vast holdings comprising a series of collections, each of which ranks in its category among the finest in the world. The American Wing, for example, houses the world's most comprehensive collection of American paintings, sculpture, and decorative arts, presently including 24 period rooms that offer an unparalleled view of American history and domestic life. The Museum's more than 3,000 European paintings form one of the greatest such collections in the world - the Rembrandts and Vermeers alone are among the choicest, as is the collection of Impressionist and Post-Impressionist canvases. Virtually all of the 50,000 objects constituting the greatest collection of Egyptian art outside Cairo are on display, while the Islamic art collection is one of the world's finest. Other major collections at to the Museum include arms and armor, Asian art, costumes, European sculpture and decorative arts, medieval and Renaissance art, musical instruments, primitive art, drawings, prints, antiquities from around the ancient world, photography, and 20th-century art. In recent years, several major gallery areas have opened, greatly enhancing the presentation of collections: the Florence and Herbert Irving Galleries for the arts of South and Southeast Asia (1994); the Robert and Renée Belfer Court for prehistoric and early Greek art (1996); Arts of Korea Gallery (1998); the seven newly-renovated Beaux-Arts galleries devoted to archaic and classical Greek art, originally created by McKim Mead & White between 1912 and 1917 and including a magnificent barrel-vaulted space - now known as the Mary and Michael Jaharis Gallery (1999); the Galleries for Ancient Near Eastern Art (1999); the Cypriot Galleries (2000); the Velez Blanco Patio (2000); and the Mary and Michael Jaharis Galleries for Byzantine Art (2000).

El Museo del Barrio

1230 5th Ave. at East 104th St., New York, NY 10029
Tel: (212) 831-7272
Fax: (212) 831-7927
Internet Address: http://www.elmuseo.org
Director: Ms. Susanna Torruella-Leval
Admission: suggested contribution: adult-$4.00, student-$2.00, senior-$2.00.

El Museo del Barrio. cont.

Established: 1969 *Membership:* Y *ADA Compliant:* Y
Parking: commercial lot on East 107th Street.
Open: Wednesday to Sunday, 11am-5pm.
Closed: Legal Holidays.
Facilities: **Exhibition Area.**
Activities: **Education Programs** (adults and children); **Guided Tours**; **Lectures**; **Temporary Exhibitions**; **Workshops.**
Publications: newsletter (quarterly).

El Museo del Barrio is dedicated to presenting and preserving the art and culture of Puerto Ricans and all Latin Americans in the United States. El Museo's mission is reflected in its permanent collection of 8,000 objects and its varied contemporary and historical exhibitions, public programs, publications, educational activities, and special events.

Norberto Cedeño, *The Powerful Hand*, c. 1950, El Museo Del Barrio. Photograph by Ken Showell, courtesy of El Museo del Barrio, New York, New York.

The Museum for African Art

593 Broadway, New York, NY 10012
Tel: (212) 966-1313
Fax: (212) 966-1432
Internet Address: http://www.africanart.org
President: Ms. Elsie Crum McCabe
Admission: fee: adult-$5.00, child-$2.50, student-$2.50, senior-$2.50.
Attendance: 75,000 *Established:* 1982 *Membership:* Y *ADA Compliant:* Y
Parking: commercial adjacent to site.
Open: Tuesday to Friday, 10:30am-5:30pm; Saturday, noon-6pm; Sunday, noon-6pm.
Closed: Legal Holidays.
Facilities: **Architecture** (Iron Front Bldg., redesigned by Maya Lin); **Exhibition Area**; **Shop.**
Activities: **Education Programs** (adults and children); **Guided Tours**; **Lectures**; **Temporary Exhibitions**; **Traveling Exhibitions.**
Publications: brochures; exhibition catalogues.

Located along the "SoHo Museum Row", the Museum is housed in a facility the interior of which was re-designed by Maya Lin. The mission of the Museum is to present temporary exhibitions focusing on African art and culture, thereby to increase the public's understanding and appreciation of them.

Museum of American Folk Art

2 Lincoln Square (Columbus Ave. between 65th & 66th Sts.)
New York, NY 10023-6214
Tel: (212) 977-7170
Fax: (212) 595-6759
TDDY: (800) 662-1220
Internet Address: http://www.folkartmuse.org
Director and C.E.O.: Mr. Gerard C. Wertkin
Admission: voluntary contribution.
Attendance: 100,000 *Established:* 1961
Membership: Y *ADA Compliant:* Y
Open: Tuesday to Sunday, 11:30am-7:30pm.
Facilities: **Galleries**; **Library**; **Shop.**
Activities: **Gallery Talks** (usually Wed. or Thurs. evenings); **Guided Tours** (with advance reservation); **Temporary Exhibitions** (approx. 6 per year); **Traveling Exhibitions.**

Ammi Phillips, *Girl in Red Dress with Cat and Dog*, 1834-1836; oil on canvas, 30 x 25 inches. Promised anonymous gift, Museum of American Folk Art. Photograph courtesy of Museum of American Folk Art, New York, New York.

Museum of American Folk Art, cont.

Activities: **Gallery Talks** (usually Wed. or Thurs. evenings); **Guided Tours** (with advance reservation); **Temporary Exhibitions** (approx. 6 per year); **Traveling Exhibitions**.

Publications: books; collection catalogue; exhibition catalogues; journal, "Folk Art" (quarterly).

The Museum has an outstanding collection of 3,500 artworks from the 18th, 19th, and 20th centuries. The principles guiding its formation have been to strike a balance among encyclopedic ambitions, historical and cultural context, and artistic merit. The collection is particularly strong in 19th-century portraiture, 19th- and 20th-century sculpture, and quilts and bedcovers (400 examples). The Museum also mounts temporary exhibitions and lends objects from its collection for display around the world.

The Museum of Modern Art (MOMA)

11 W. 53rd St., New York, NY 10019

Tel: (212) 708-9480

Fax: (212) 708-9889

TDDY: (212) 247-1230

Internet Address: http://www.moma.org

Director: Mr. Glenn Lowry

Admission: fee: adult-$9.50, child-free, student-$6.50, senior-$6.50.

Attendance: 1,500,000 *Established:* 1929 *Membership:* Y *ADA Compliant:* Y
Parking: commercial adjacent to site.

Open: Saturday to Tuesday, 10:30am-6pm; Thursday, 10:30-6pm; Friday, 10:30am-8:30pm.

Closed: Thanksgiving Day, Christmas Day.

Facilities: **Architecture** (International Style, 1939 by Goodwin and Stone); **Auditoriums** (460 & 225 seats); **Food Services** Restaurant and Café; **Galleries**; **Library** (100,000 volumes); **Reading Room**; **Sculpture Garden**; **Shop**.

Activities: **Brown Bag Lunch Lectures**; **Films**; **Gallery Talks**; **Lectures**; **Saturday Morning Family Programs**; **Temporary Exhibitions**; **Traveling Exhibitions**.

Publications: books; brochures (quarterly); calendar (monthly); collection catalogue; exhibition catalogues; posters.

The MOMA houses the most comprehensive collection of 20th-century art in the world. Founded in 1929, the Museum is embarking on a renovation and expansion plan to increase the size of the facility by 230,000 square feet and it has selected Yoshio Taniguchi as architect for the project. The collection of the Museum is organized into six categories: Architecture and Design (architectural models, drawings, and photographs; 3,000 objects ranging from appliances to tools to sports cars, and a 4,000-work graphic design collection); Drawings (6,000 works on paper); Film and Video (14,000 films and four million film stills, including all periods and genres); Painting and Sculpture (3,200 works dating from the late 19th century to the present, including, for example, Cézanne's "The Bather" and Van Gogh's "The Starry Night"); Photography (25,000 works dating from 1840 to the present, including the work of artists, journalists, scientists, and amateurs); and Prints and Illustrated Books (nearly 40,000 historical and contemporary prints and books).

Museum of the City of New York (MCNY)

Fifth Avenue at 103rd St., New York, NY 10029

Tel: (212) 534-1672

Fax: (212) 423-0758

Internet Address: http://www.mcny.org

Director: Mr. Robert R. MacDonald

Admission: suggested contribution:
 adult-$7.00, child-$4.00, student-$4.00, senior-$4.00, family-$12.00.

Attendance: 227,000 *Established:* 1923 *Membership:* Y *ADA Compliant:* Y
Open: Wednesday to Saturday, 10am-5pm; Sunday, 1pm-5pm.

Closed: Legal Holidays.

Facilities: **Auditorium** (248 seats); **Galleries**; **Shop**.

Museum of the City of New York, cont.

Activities: **Education Programs**; **Gallery Talks**; **Guided Tours** (by appointment); **Lectures**; **Performances**; **Permanent Exhibits**; **Temporary Exhibitions**; **Traveling Exhibitions**.

Publications: magazine (quarterly); research publications (occasional).

The mission of MCNY is to collect, preserve, and present original cultural materials related to the history of New York City. The Museum has a wide range of exhibits, educational programs, and six curatorial departments, including decorative arts, paintings and sculpture, prints and photographs, costumes and textiles, theater, and toys. The art collection includes the work of many significant painters, and there are large collections of New York silver and a very large collection of Currier and Ives prints.

National Academy of Design Museum

1083 5th Ave. and East 89th St., New York, NY 10128

Tel: (212) 369-4880

Fax: (212) 360-6795

Director: Dr. Annette Blaugrund

Admission: fee:
adult-$8.00, child (<12)-free, student-$4.50, senior-$4.50.

Attendance: 50,000 *Established:* 1825

Membership: Y *ADA Compliant:* Y

Parking: commercial adjacent to site.

Open: Wednesday to Thursday, noon-5pm;
Friday, 10am-6pm;
Saturday to Sunday, noon-5pm.

Facilities: **Architecture** (Beaux Arts residence, designed by Ogden Codman, Jr.); **Bookstore**; **Exhibition Area** (2 floors of galleries); **Library** (7,000 volumes).

Activities: **Classes and Workshops**; **Lectures**; **Temporary Exhibitions**.

Publications: bulletin (semi-annual); exhibition catalogues.

Interior view, National Academy of Design Museum. Photograph courtesy of National Academy of Design, New York, New York.

The National Academy Museum maintains one of the foremost collections of American art in the world. All National Academicians (currently there are approximately 425) contribute examples of their work upon election to the Academy, which was founded in 1825. There are in addition to significant holdings in European art, a permanent collection of over 5,000 works of 19th- and 20th-century American art in the collection, including works by Bellows, Bierstadt, Cassatt, Church, Cole, Hassam, Henri, Homer, Inness, Johns, Kahn, Rauschenberg, and Whistler, among many others. This rich collection, along with exhibitions from other institutions, is the source for special exhibitions at the Museum. The building housing the Museum is the former Huntington mansion, a Beaux-Arts town house on Fifth Avenue.

National Arts Club

15 Gramercy Park South, New York, NY 10003

Tel: (212) 475-3624

Fax: (212) 475-3692

Curator of the Permanent Collection: Ms. Carol Lowrey

Admission: free.

Established: 1898

Parking: metered on street and nearby commercial lots.

Open: Daily, 1pm-6pm.

Facilities: **Exhibition Area**; **Library** (personal library of Robert Henri, on request).

Activities: **Temporary Exhibitions**.

Publications: "Exhibiting Members Newsletter"; brochures.

The permanent collection of the National Arts Club consists of American painting, sculpture, and works on paper.

New York City (Manhattan), New York

National Museum of the American Indian, Smithsonian Institution

George Gustav Heye Center
1 Bowling Green, New York, NY 10004
Tel: (212) 514-3888
Fax: (212) 514-3800
Internet Address: http://www.si.edu/nmai
Director: Mr. W. Richard West, Jr.
Admission: free.
Attendance: 600,000 *Established:* 1994
Membership: Y *ADA Compliant:* Y
Parking: commercial adjacent to site.
Open: Monday to Tuesday, 10am-5pm.
 Wednesday, 10am-8pm
 Thursday to Sunday, 10am-5pm.
Facilities: **Architecture** (U.S. Customs House,
 1907 designed by Cass Gilbert); **Galleries**
 (20,000 square feet); **Library** (40,000 volumes);
 Shop.

Rachel Nampeyo, *Hopi / Tewa Bowl*, 1950-1960. National Museum of the American Indian. Photograph by David Heald, courtesy of National Museum of the American Indian, New York, New York.

Activities: **Guided Tours**; **Temporary Exhibitions**; **Traveling Exhibitions**.
Publications: books; brochures; exhibition catalogues; magazine, "Native Peoples" (quarterly); newsletter, "Smithsonian Runner"; recordings.

The Smithsonian Institution's National Museum of the American Indian is dedicated to the preservation, study, and exhibition of the life, languages, literature, history, and arts of Native Americans. The Museum works in collaboration with the native peoples of the Western Hemisphere to protect and foster their cultures by reaffirming traditions and beliefs, encouraging contemporary artistic expression, and empowering the Indian voice. The Museum's collections span more than 10,000 years of native heritage, from ancient stone clovis points to modern silkscreen prints. There are one million objects in the collections, and eventually the Museum will include three facilities. The Museum opened in1994 in the Alexander Hamilton Custom House, a Beaux Arts building designed by Cass Gilbert, which was completed in 1907. On the building's entrance pedestals are four large sculptures by Daniel Chester French, and inside, the rotunda dome is decorated with murals created by Reginald Marsh. The collections of the former Museum of the American Indian, Heye Foundation form the cornerstone of the new museum. They are distinguished by thousands of masterworks, including intricate wood, horn, and stone carvings from the Northwest coast of North America; painted hides and garments from the North American plains; pottery and basketry from the southwestern United States; archeological objects from the Caribbean; carved jade from the Olmec and Maya peoples; textiles and gold from the Andean cultures; featherwork from the peoples of Amazonia; and paintings by contemporary Native American artists.

National Sculpture Society Gallery

Americas Tower, 15th Floor, 1177 Avenue of the Americas, New York, NY 10036
Tel: (212) 764-5645
Fax: (212) 764-5651
Internet Address: http://www.nationalsculpture.org
Exec. Director: Ms. Gwen Pier
Admission: free.
Established: 1893
Open: Monday to Friday, 10am-5pm, by appointment.
Facilities: **Gallery**.
Activities: **Temporary Exhibitions**.
Publications: magazine, "Sculpture Review" (quarterly).

Founded in 1893 the National Sculpture Society is the oldest organization of professional sculptors in the United States. The Society presents exhibitions of the work of its members in its gallery and in the lobby of the Americas Tower. The Society should be contacted in advance of visiting the NSS Gallery, so that passes may be left at the lobby reception desk.

The Neustadt Museum of Tiffany Art

Offices: 251 West 81st St, New York, NY 10024
Tel: (212) 875-0693
Fax: (212) 874-0872
Exec. Director: Nicholas Cass-Hassol
Admission: free.
Established: 1969
Facilities: **Exhibition Area** (800 square feet, additional 2,400 square feet apart); **Library** (35 volumes).
Activities: **Lectures**; **Temporary Exhibitions** (At Queens Museum of Art); **Traveling Exhibitions**.

The Neustadt Museum of Tiffany Art was founded in 1969 by the private collector, Dr. Egon Neustadt. The Museum's holdings today include over 200 Tiffany lamps and windows, plus an extensive collection of Tiffany glass. The Museum's mission is to exhibit and interpret its collection to the widest possible audience. It pursues this mission through a traveling collection (46 objects) available to museums throughout the country and other rotating exhibits. In New York City, a selection from the collection (with interpretive objects and information) is on exhibit at the Queens Museum of Art in Flushing Meadow, Corona Park, Queens (see separate listing). The Queens Museum offers a wide range of supportive programs, including guided tours of the exhibit and the surrounding area, where Louis Comfort Tiffany worked at the Tiffany Studios in Corona. Children's programs are also offered there.

Louis C. Tiffany, *Apple Blossom Table Lamp*, c.1900-1910. Collection of and photograph courtesy of Neustadt Museum of Tiffany Art, New York, New York.

New School University/Parsons School of Design - Exhibition Center & Galleries

2 West 13th St., New York, NY 10011
Tel: (212) 229-8987
Fax: (212) 229-8975
Internet Address: http://newschool.edu
Director or Exhibitions: Mr. Clinton Kuopus
Open: **Exhibition Center**, Monday to Friday, 9am-9pm; Saturday, 10am-6pm.
 Aronson Gallery, Monday to Friday, 9am-9pm; Saturday, 10am-6pm.
 Student Gallery, Monday to Friday, 8am-11pm; Saturday, 9am-8pm; Sunday, 10am-10pm.
Facilities: **Galleries**.
Activities: **Temporary Exhibitions**.

An affiliate of the New School University, the Parsons School of Design features design and fine art in its Exhibition Center, as well as the work of student BFA and MFA candidates. Exhibitions may also be found at 66 5th Avenue in the Arnold and Sheila Aronson Gallery on the ground floor and in the PSD Student Gallery on the fourth floor.

The New-York Historical Society

2 West 77th St. at Central Park West
New York, NY 10024
Tel: (212) 873-3400
Fax: (212) 874-8706
Exec. Director: Ms. Betsy Gotbaum
Admission: suggested contribution: adult-$5.00, child-$3.00, student-$3.00, senior-$3.00.
Attendance: 125,000 *Established:* 1804
Membership: Y *ADA Compliant:* Y

Thomas Cole, *The Course of Empire: Arcadian State*, 1836, Collection of and photograph courtesy of The New-York Historical Society, New York, New York.

The New-York Historical Society, cont.

Parking: commercial adjacent to site.

Open: **Museum**, Tuesday to Sunday, 11am-5pm.
Library, Thursday to Saturday, 11am-5pm.

Closed: Legal Holidays.

Facilities: **Auditorium** (300 seats); **Exhibition Area** (3 floors); **Library** (700,000 volumes); **Shop**.

Activities: **Guided Tours**; **Lectures**; **Temporary Exhibitions**.

Publications: books; collection catalogues; exhibition catalogues.

Since 1804, the Historical Society has served as the collective memory of New York, accumulating vast collections in American painting, sculpture, books, manuscripts, decorative arts, architectural materials, prints, photographs, and ephemera. The Historical Society mounts thematic temporary exhibitions using objects from the collection. Highlights of the collection include over 500,000 photographs from 1850 to the present; one of the country's most fascinating collections of folk art; the Luman Reed Collection of paintings by Thomas Cole, Asher Durand, and William Sidney Mount; the nation's largest collection of Louis Comfort Tiffany lamps; and the original watercolors for John James Audubon's *The Birds of America.*

The New York Studio School of Drawing, Painting and Sculpture

8 West 8th St., New York, NY 10011

Tel: (212) 673-6466

Fax: (212) 777-0996

Dean: Mr. Graham Nickson

Admission: voluntary contribution.

Attendance: 10,000 *Established:* 1964

Open: **Gallery**, Monday to Saturday, 10am-6pm.

Closed: Legal Holidays, Academic Holidays.

Facilities: **Exhibition Area** (1,000 square feet); **Library** (3,700 books, 5,700 catalogues, 3,000 journals; lecture archives; 200 rare books).

Activities: **Education Programs** (adults); **Lecture Series** (Tuesday and Wednesday, 6:30pm-8pm); **Temporary Exhibitions**.

Publications: newsletter, "New York Studio School" (annual).

The Gallery presents exhibitions of modern and contemporary painting, sculpture, and drawing and an annual fall benefit exhibition of historical masterworks..

New York University - The Grey Art Gallery

100 Washington Square East, New York, NY 10003-6688

Tel: (212) 998-6780

Fax: (212) 995-4024

Internet Address: http://www.nyu.edu/greyart

Director: Ms. Lynn Gumpert

Admission: suggested contribution-$2.50.

Attendance: 25,000 *Established:* 1975

Parking: commercial adjacent to site.

Open: Tuesday, 11am-6pm; Wednesday, 11am-8pm; Thursday to Friday, 11am-6pm;
Saturday, 11am-5pm.

Closed: Legal Holidays.

Facilities: **Galleries**.

Activities: **Education Programs** (adults, college students and children); **Films**; **Gallery Talks**; **Lectures**; **Temporary Exhibitions**; **Traveling Exhibitions**.

Publications: exhibition catalogues.

The Gallery mounts temporary exhibitions of works from the University's collection as well as hosting traveling exhibitions. The University has two main collections: the New York University Art Collection, consisting of 6,000 works, primarily late-19th- and 20th-century art, with particular strengths in American painting from 1940 to the present and 20th-century European prints; and the Grey Collection of Contemporary Asian and Middle Eastern Art, totaling some 1,000 works in various

New York University - The Grey Art Gallery, cont.

media. The University also maintains the following branch galleries: 80 Washington Square East Galleries (thesis exhibitions of masters candidates); Broadway Windows (at 10th Street; installations); Washington Square Windows (installations); and Rosenberg Gallery (student work).

Nicholas Roerich Museum

319 West 107th St., New York, NY 10025-2799
Tel: (212) 864-7752
Fax: (212) 864-7704
Internet Address: http://www.roerich.org/
Exec. Director: Mr. Daniel Entin
Admission: voluntary contribution.
Attendance: 10,000 *Established:* 1949 *Membership:* Y
Open: Tuesday to Sunday, 2pm-5pm.
Closed: New Year's Day, Easter Sunday, Independence Day, Thanksgiving Day, Christmas Day.
Facilities: **Exhibition Area**.
Activities: **Concerts; Gallery Talks; Lectures; Poetry Readings**.
Publications: books.

The Museum is devoted to the exhibition of paintings by Nicholas Roerich (1874-1947), a Russian-born artist, and makes available many reproductions of his art and numerous books about his life and work. The Museum is also a cultural center, presenting a broad program of concerts and poetry readings. The major aim of the Museum's activities is to promote awareness of Roerich's ideas about art and culture, as embodied in the Museum's motto, "Pax Cultura", Peace Through Culture.

PaineWebber Group - Art Gallery

1285 Avenue of the Americas (between 51st and 52nd Sts.), New York, NY 10019
Tel: (212) 713-2885 *Fax:* (212) 713-9739
Director, Art Gallery: Mr. Colin H. Thomson
Admission: open to public.
Attendance: 600,000 *Established:* 1985
ADA Compliant: Y
Parking: commercial adjacent to site.
Open: Monday to Friday, 8am-6pm.
Facilities: **Galleries** (4,000 square feet).
Activities: **Temporary Exhibitions** (4/year).
Publications: exhibition brochures (quarterly).

Located on the ground floor in PaineWebber's headquarters building, the Gallery presents four exhibitions each year. Exhibitions are mounted by local not-for-profit groups and museums, thereby providing these institutions with the opportunity to acquaint a mid-town New York audience with their collections and activities.

View of Paine Webber Art Gallery during an exhibition organized by New-York Historical Society. Photograph courtesy of PaineWebber Incorporated, New York, New York.

Pen and Brush

16 East 10th St., New York, NY 10003-5904
Tel: (212) 475-3669
Fax: (212) 475-6018
President: Ms. Vinni Marie D'Ambrosio
Admission: free.
Attendance: 3,000 *Established:* 1893
Membership: Y *ADA Compliant:* N
Parking: commercial adjacent to site.
Open: **September to June**, Tuesday to Sunday, 2pm-6pm.
Closed: Summer.
Facilities: **Gallery; Library** (1,500 volumes; members only).

Drawing of entrance to Pen and Brush clubhouse. Courtesy of The Pen and Brush, Inc., New York, New York.

Pen and Brush, cont.

Activities: **Concerts**; **Demonstrations**; **Lectures**; **Workshops**.

Publications: bulletin (10/year).

The Pen and Brush, Inc. is an organization of women in the arts - writers, painters, sculptors, musicians, and artists in crafts. Located in a New York town house built in 1848, the organization mounts temporary exhibitions in its two galleries, including juried exhibitions of members' work, and solo and group shows in a variety of media.

The Pierpont Morgan Library

29 East 36th St., New York, NY 10016

Tel: (212) 685-0610

Fax: (212) 481-3484

Internet Address: http://www.morganlibrary.org

Director: Mr. Charles E. Pierce, Jr.

Admission: fee: adult-$8.00, child-free, student-$6.00, senior-$6.00.

Attendance: 200,000 *Established:* 1924

Membership: Y *ADA Compliant:* Y

Parking: commercial adjacent to site.

Open: Tuesday to Thursday, 10:30am-5pm;
Friday, 10:30am-8pm;
Saturday, 10:30am-6pm;
Sunday, noon-6pm.

Closed: Legal Holidays.

Facilities: **Architecture** (Italian-style mansion, 1906 design by C.F. McKim); **Collections** (available for scholarly use upon written request); **Food Services** Café (luncheon and tea); **Garden Court**; **Period Rooms**; **Reading Room**; **Shop**.

Gaston Phebus, *Livre de la Chasse*, (detail), ca. 1410. Bequest of Clara S. Peck, 1983 Pierpont Morgan Library. Photograph by David A. Loggie, courtesy of Pierpont Morgan Library, New York, New York.

Activities: **Concerts**; **Lectures**; **Temporary Exhibitions**.

Publications: books; exhibition catalogues; guide to collection; pamphlets.

Located in the heart of New York City, the Morgan Library, both a museum and a center for scholarly research, is an extraordinary complex of buildings occupying half a block. Among the world's greatest treasuries of seminal artistic, literary, musical, and historical works, the Library's renowned collection of rare books, manuscripts, and drawings have as their principal focus the history, art, and literature of Western civilization from the Middle Ages to the twentieth century. Changing exhibitions, drawn from the permanent collection and from other museums and libraries in this country and abroad, provide visitors access to some of the Western world's most significant cultural artifacts. Collection highlights include the ninth-century Lindau Gospels, a rare vellum copy of the Gutenberg Bible, the Hours of Catherine of Cleves, Albrecht Dürer's Adam and Eve, drawings by Leonardo da Vinci, Peter Paul Rubens and Hilarie-Germain-Edgar Degas, the autograph manuscript of Mozart's Haffner Symphony, original manuscripts by Charlotte Bronte and John Steinbeck, and several hundred letters from George Washington and Thomas Jefferson.

Pratt Manhattan Gallery

295 Lafayette St., 2nd Floor, New York, NY 10012

Tel: (718) 636-3517

Fax: (718) 636-3455

Director: Ms. Eleanor Moretta

Admission: free.

Attendance: 30,000 *Established:* 1975

Parking: commercial adjacent to site.

Open: Monday to Saturday, 10am-5pm.

Closed: Legal Holidays.

Facilities: **Architecture** (Puck Building); **Exhibition Area** (1,200 square feet).

Pratt Manhattan Gallery, cont.

Activities: **Continuing Education Programs; Lectures.**

Publications: exhibition & events calendar (semi-annual); exhibition announcements.

The Gallery presents exhibitions of undergraduate and graduate student work in a range of media, including painting, sculpture, computer graphics, and photography. The Pratt Institute also operates the Schafler Gallery at its campus in Brooklyn (see separate listing).

Salmagundi Museum of American Art

47 5th Ave., New York, NY 10003

Tel: (212) 255-7740

Fax: (212) 229-0172

President: Mr. Richard C. Pionk

Admission: free.

Attendance: 150 *Established:* 1871

Parking: commercial adjacent to site.

Open: Daily, 1pm-5pm.

Facilities: **Architecture** (Town house on National Register);
 Exhibition Area; Library.

Activities: **Temporary Exhibitions.**

Publications: exhibition brochures.

Founded in New York in 1871, the Salmagundi Club is the oldest organization of artists in the United States. It presents exhibitions by artist-members as well as juried shows open to non-members worldwide.

Exterior view of Salmagundi Club. Photograph by T.N. Flournoy, courtesy of Salmagundi Club, New York, New York.

School of Visual Arts - Visual Arts Museum

School of Visual Arts, 209 East 23rd St.

New York, NY 10010

Tel: (212) 592-2144

Fax: (212) 592-2095

Internet Address: http://www.schoolofvisualarts.edu

Director: Francis Di Tommaso

Admission: free.

Established: 1971

Membership: N *ADA Compliant:* Y

Parking: metered on street.

Open: Monday to Wednesday, 9am-6:30pm;
 Thursday, 9am-8pm;
 Friday, 9am-6:30pm;
 Saturday, 10am-5pm.

View of gallery during "The Masters Series: Tony Palladino" October, 1999. Photograph courtesy of Visual Arts Museum, New York, New York.

Facilities: **Auditorium** (180 seats); **Exhibition Area** (2,000 square feet).

Activities: **Juried Exhibits; Lectures; Traveling Exhibitions.**

The Museum holds exhibitions each year to promote public awareness and appreciation of the visual arts. By invitation of the Board of Directors, affirmed professionals and renowned artists exhibit their work and hold lectures at the School of Visual Arts. Since its inception in 1971, the Visual Arts Museum has exhibited the work of David Hockney, Willem de Kooning, Roy Lichtenstein, Agnes Martin, Robert Motherwell, Robert Rauschenberg, Larry Rivers, Richard Serra, Frank Stella, Cy Twombly and many others. Graphic designers and illustrators who have exhibited include Marshall Arisman, Etienne Delessert, Pierre Mendell, Robert Weaver, Henry Wolf, and others. In 1988, the School initiated The Masters Series to honor the great visual communicators of our time. Past honorees include Saul Bass, Seymour Chwast, Ivan Chermayeff, Paul Davis, Lou Dorfsman, Milton Glaser, George Lois, Mary Ellen Mark, Tony Palladino, Paul Rand, Deborah Sussman, George Tscherny, and Massimo Vignelli. The recipient of the 2000 Masters Series Award is Duane Michals.

School of Visual Arts - Visual Arts Museum, cont.

Since 1993 the Museum has held the New York Digital Salon, an annual international exhibition of computer art, which features installations, prints, photographs, CD-ROMS, animations, sculpture and works on the Internet. Also of possible interest are the Visual Arts Gallery, SOHO (137 Wooster Street, Tues-Fri, 11-6); the SVA Gallery (209 E. 23rd Street); the Eastside Gallery (214 E. 21st Street); and the Westside Gallery (141 W. 21st Street). The latter three galleries are open Mon-Thurs, 9-8, and Sat-Sun, 9-5. Information: 592-2010.

Society of Illustrators - Museum of American Illustration

128 East 63rd St., New York, NY 10021-7303

Tel: (212) 838-2560

Fax: (212) 838-2561

Director: Mr. Terrence Brown

Admission: free.

Attendance: 30,000 *Established:* 1981 *Membership:* Y

Parking: commercial adjacent to site.

Open: Tuesday, 10am-8pm; Wednesday to Friday, 10am-5pm; Saturday, noon-4pm.

Closed: Legal Holidays, August.

Facilities: **Exhibition Area**; **Library** (by appointment only); **Shop**.

Activities: **Lectures**; **Temporary Exhibitions**.

Publications: "Annual of American Illustration"; newsletter, "Library of American Illustration" (monthly).

The Society of Illustrators was founded in New York in 1901 by a group of prominent illustrators. It has mounted exhibitions since its founding, and in 1981 it established a museum, which today houses 1,500 works of art by such artists as Rockwell, Pyle, Wyeth, Kent, Peak, Fuchs, and Holland.

Solomon R. Guggenheim Museum

1071 5th Ave. at 88th St., New York, NY 10128

Tel: (212) 423-3500

Fax: (212) 423-3650

TDDY: (212) 423-3607

Internet Address: http://www.guggenheim.org

Director: Mr. Thomas Krens

Admission: fee: adult-$8.00, student-$5.00, senior-$5.00.

Attendance: 925,000 *Established:* 1937 *Membership:* Y *ADA Compliant:* Y

Parking: commercial adjacent to site.

Open: Sunday to Wednesday, 10am-6pm; Friday to Saturday, 10am-8pm.

Facilities: **Architecture** (1950 designed by Frank Lloyd Wright); **Auditorium**; **Food Services** Restaurant; **Library** (20,000 volumes, by appointment only); **Sculpture Garden**; **Shop**.

Activities: **Concerts**; **Films**; **Gallery Talks**; **Guided Tours**; **Lectures**; **Performances**; **Temporary Exhibitions**; **Traveling Exhibitions**.

Publications: brochures; calendar (quarterly); collection catalogue; exhibition catalogues; pamphlets.

The Guggenheim houses one of the world's finest collections of Modern and contemporary art. In 1943, Solomon Guggenheim commissioned Frank Lloyd Wright to design the Guggenheim Museum, and Wright responded with a design that embodies his vision of fluid and organic architecture. The building, completed in 1959, is itself one of the greatest works of the Guggenheim Collection. A two-year restoration and expansion project by Gwathmey Siegel & Associates was completed in 1992. Guggenheim began collecting abstract art in the 1920's and acquired works by Brancusi, Calder, Chagall, Delauney, Klee, Miró, Picasso, and many others and set up the foundation in 1937. Later, through bequests from the Tannhauser family, the collection came to include masterworks by such artists as Cézanne, Degas, Gauguin, Manet, Toulouse-Lautrec, and Van Gogh. In 1976, the Peggy Guggenheim Collection of Cubist, Surrealist, and Abstract Expressionist works was transferred to the Guggenheim Foundation and is housed in a palazzo on the Grand Canal in Venice. In 1990 the Museum received the Panza di Biumo collection of American Minimalist Art, and in 1993 the Museum received a gift from the Robert Mapplethorpe Foundation of nearly 200 photographs and objects by the artist. A branch gallery, the Guggenheim Museum Soho, is listed separately.

The Studio Museum in Harlem

144 West 125th St., New York, NY 10027
Tel: (212) 864-4500
Fax: (212) 666-5753
Director: Lowery Stokes Sims, Ph.D.
Admission: fee: adult-$5.00, child-$1.00, student-$3.00, senior-$3.00.
Attendance: 100,000 *Established:* 1967 *Membership:* Y *ADA Compliant:* Y
Parking: commercial across street from the site (entrance on 126th Street).
Open: Wednesday to Thursday, noon-6pm; Friday, noon-8pm; Saturday to Sunday, 10am-6pm.
Facilities: **Exhibition Area**; **Sculpture Garden**; **Shop**.
Activities: **Guided Tours**; **Lectures**; **Temporary Exhibitions**; **Traveling Exhibitions**.
Publications: exhibition catalogues.

The permanent collection of the SMH includes works by important artists such as Romare Bearden, Jacob Lawrence, and Faith Ringgold. It also holds a collection of African and Caribbean art, both traditional and contemporary. The Museum's Artist in Residence Program allows visitors to see the work of selected artists who are working on site. There is also a sculpture garden devoted exclusively to the work of artists of African descent.

Whitney Museum of American Art

945 Madison Ave. at 75th, New York, NY 10021
Tel: (212) 157-3600
Fax: (212) 570-1807
Internet Address: http://www.echonyc.com/~whitney
Director and C.E.O.: Mr. Maxwell L. Anderson
Admission: fee: adult-$8.00, child-free, student-$7.00, senior-$7.00.
Attendance: 274,000 *Established:* 1930 *Membership:* Y *ADA Compliant:* Y
Parking: commercial adjacent to site.
Open: Wednesday, 11am-6pm; Thursday, 1pm-8pm; Friday to Sunday, 11am-6pm.
Closed: New Year's Day, Independence Day, Thanksgiving Day, Christmas Day.
Facilities: **Architecture** (1966 designed by Marcel Breuer); **Film and Video Gallery** (120 seats); **Food Services** Restaurant (Tues, noon-3:30pm; Wed-Fri, 11am-4:30pm; Sat-Sun, 10am-4:30pm); **Galleries**; **Library** (13,000 volumes, by appointment only); **Shop** (next door, 943 Madison Ave.).
Activities: **Education Programs** (undergraduate and graduate students); **Films and Videos**; **Gallery Talks**; **Guided Tours**; **Lectures**; **Temporary Exhibitions**; **Traveling Exhibitions**.
Publications: books; brochures; bulletin; calendar (quarterly); exhibition catalogues; gallery guides; posters.

The Whitney is devoted exclusively to American art. Its collection is particularly rich in the works of Alexander Calder, Edward Hopper, and Georgia O'Keeffe, but there are also important works by Bellows, Bourgeois, Davis, Demuth, Dove, Driggs, Glackens, Gorky, Hartley, Henri, Lawrence, Marin, Marsh, Nadelman, Prendergast, Ray, Shahn, Joseph Stella, Weber, and many others.

Whitney Museum of American Art at Philip Morris

120 Park Ave. at 42nd St., New York, NY 10017
Tel: (212) 878-2550
Fax: (212) 907-5770
Open: Monday to Wednesday, 11am-6pm; Thursday, 11am-7:30pm; Friday, 11am-6pm.
Facilities: **Exhibition Area**.
Activities: **Guided Tours** (call 212-878-2349 for appointment); **Temporary Exhibitions**.

The Whitney Museum of American Art at Philip Morris is a branch of the Whitney Museum of American Art. Five exhibitions are presented annually in a 900-square-foot exhibition space, with an emphasis on solo exhibitions by contemporary living artists. Each year, one or two projects are also organized for the sculpture court at Philip Morris.

Yeshiva University Museum (YUM)

Center for Jewish History, 15 West 16th St., New York, NY 10011
Tel: (212) 294-8330
Fax: (212) 295-8335
Internet Address: http://www.yu.edu/museum
Director: Ms. Sylvia A. Herskowitz
Admission:
 fee: adult-$3.00, student-$2.00, senior-$2.00.
Attendance: 35,000 *Established:* 1973
Membership: Y *ADA Compliant:* Y
Parking: metered on street and pay lots.
Open: September to July,
 Tuesday to Thursday, 10:30am-5pm;
 Sunday, noon-6pm.
Closed: Jewish Holidays.
Facilities: **Exhibition Spaces** (YUM at CJH,
 15,000 square feet; Campus Galleries, 8,000
 square feet); **Food Services**, Café (kosher);
 Library (15,000 volumes); **Sculpture
 Garden**; **Shop**.

View of gallery installation, "Sacred Realm: The Emergence of the Synagogue in the Ancient World", February - December, 1996, Yeshiva University Museum. Photograph courtesy of Yeshiva University Museum, New York, New York.

Activities: **Arts Festival**; **Concerts**; **Education Programs** (adults, undergraduates and children);
 Guided Tours; **Lectures**; **Temporary Exhibitions**; **Traveling Exhibitions**.
Publications: books; exhibition catalogues.

Yeshiva University Museum is a teaching museum that serves both Jewish and non-Jewish audiences with exhibitions, public programs, and publications focusing on Jewish themes. The Museum collects, preserves, and interprets Jewish life, history, art, and culture. Exhibitions explore a wide variety of topics from histories of diverse communities to the most current contemporary art. Its offices, four main galleries, outdoor sculpture garden, and children's art discovery room are located in the Center for Jewish History on West 16th Street. Additional exhibits from YUM's interdisciplinary collections are featured in its Campus Galleries, located at 2520 Amsterdam Avenue at 185th Street on the main campus of Yeshiva University in upper Manhattan's Washington Heights district.

New York City - Queens

American Museum of the Moving Image

35th Ave. at 36th St., Astoria (Queens), NY 11106
Tel: (718) 784-4520
Fax: (718) 784-4681
Director: Ms. Rochelle Slovin
Admission:
 fee: adult-$8.00, child-$4.00, student-$5.00, senior-$5.00.
Attendance: 80,000 *Established:* 1981
Membership: Y *ADA Compliant:* Y
Parking: nearby commercial and on street.
Open: Monday, (school tours only)
 Tuesday to Friday, noon-5pm;
 Saturday to Sunday, 11am-6pm.
Facilities: **Exhibition Area** (15,000 square feet); **Food Services**
 Café; **Galleries**; **Screening Rooms** (2); **Shop**; **Theatre** (200
 seats).
Activities: **Education Programs**; **Film and Video Screenings**;
 Lectures; **Temporary Exhibitions**.
Publications: calendar, "Calendar of Exhibitions and Programs"
 (quarterly); exhibition catalogues.

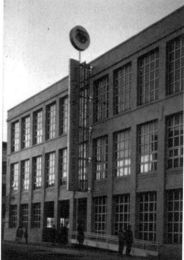

Exterior view of American Museum of the Moving Image. Photograph by Peter Aron/ESTO, courtesy of American Museum of the Moving Image, Astoria, New York.

American Museum of the Moving Image, cont.

The AMMI is devoted exclusively to film, television, video, and digital media. The Museum's core exhibition, "Behind the Screen", takes visitors step by step through the process of producing, marketing, and exhibiting moving images through a combination of artifacts, texts, live demonstrations, and video screenings. The Museum also screens a wide variety of films each weekend. The AMMI is located in the historic Astoria Studios complex, the East Coast facility for Paramount Pictures from 1919 to 1932. The adaptive reuse of the loft-style building was designed by Gwathemy Siegel & Associates.

Fisher Landau Center

38-27 30th St., Long Island City (Queens), NY 11101
Tel: (718) 937-0727
Fax: (718) 937-9397
Open: Monday to Thursday, 10am-4pm, by appointment.
Facilities: **Architecture** (design by Max Gordon, 25,000 square feet).

The Center was established for the study of the contemporary art collection of Emily Fisher Landau. Holding, totaling over 900 objects, includes works by Artschwager, Baechler, Fischl, Gornick, Innerst, Johns, Kruger, Ligon, Rauschenberg, Rosenquist, Lorna Simpson, Kiki Smith, and Twombly.

The Institute for Contemporary Art - P.S. 1 Contemporary Art Center and
Clocktower Gallery

22-25 Jackson Ave. at Jackson Ave., Long Island City (Queens), NY 11101-5324
Tel: (718) 784-2084
Fax: (718) 482-9454
Internet Address: http://www.ps1.org
Managing Director: Mr. Dennis Szakacs
Admission: suggested contribution-$4.00.
Attendance: 40,000 *Established:* 1971 *Membership:* Y
Open: **P.S. 1 CA Center**, Wednesday to Sunday, noon-6pm.
 Clocktower Gallery, Wednesday, 1pm-7pm.
Closed: New Year's Day, Memorial Day, Independence Day, Thanksgiving Day, Christmas Day.
Facilities: **Architecture** (Romanesque former public school building); **Auditorium** (200 seats); **Exhibition Area** (125,000 square feet); **Food Services** Café; **Sculpture Courtyard**; **Shop** (books).
Activities: **Concerts**; **Dance Recitals**; **Education Programs** (adults and children); **Films**; **Guided Tours**; **Traveling Exhibitions**.
Publications: exhibition catalogues; newsletter (3/year).

Established by the Institute for Contemporary Arts in 1976, P.S. 1 Contemporary Art Center presents temporary exhibitions including large scale installations. The Institute also presents thematic exhibitions at its Clocktower Gallery in Manhattan (TriBeCa at 108 Leonard St., 13th Floor - 233-1096). In March, 1999 P.S.1 announced its intention to merge with the Museum of Modern Art.

Isamu Noguchi Garden Museum

32-37 Vernon Blvd., Long Island City (Queens), NY 11106
Tel: (718) 204-7088
Fax: (718) 278-2348
Internet Address: http://www.noguchi.org
Exec. Director: Shoji Sudao
Admission: suggested contribution: adult-$4.00, student-$2.00, senior-$2.00.
Attendance: 20,000 *Established:* 1985 *Membership:* Y
Parking: on street.
Open: **April to October**, Wednesday to Friday, 10am-5pm; Saturday to Sunday, 11am-6pm.
Facilities: **Architecture** (designed by Isamu Noguchi); **Galleries** (13); **Sculpture Garden**; **Shop**.
Activities: **Guided Tours** (daily, 2pm); **Video Programs**.
Publications: collection catalogue.

Isamu Noguchi Garden Museum, cont.

Housed in 13 galleries within a converted factory building, and encircling a garden containing major granite and basalt sculptures, the Museum displays a comprehensive collection of artwork by Isamu Noguchi. On exhibition are more than 250 works, including stone, bronze, and wood sculptures, models for public projects and gardens, elements of dance sets designed for choreographer Martha Graham, and Noguchi's well-known Akari lanterns. On Saturdays and Sundays (11:30am-4:30pm) on the half hour, a shuttle bus runs to the museum from the corner of 70th Street and Park Avenue in Manhattan; round trip fare, $5.00.

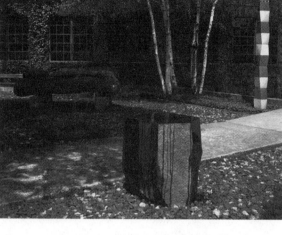

View of garden (Area 2) at Isamu Noguchi Garden Museum. Photograph by John Berens (1997), courtesy of the Isamu Noguchi Foundation, Inc., Long Island City, New York..

La Guardia Community College Galleries

31-10 Thompson, Long Island City (Queens), NY 11101
Tel: (718) 482-5709
Fax: (718) 875-6957
Internet Address: http://lagcc.cuny.edu
Director: Mr. Gary Vollo
Open: Monday to Saturday, 8am-9pm.
Facilities: **Galleries.**
Activities: **Temporary Exhibitions.**

Exhibition areas include LSG East (Atrium), LSG West, Fourth Floor East (Dean's Gallery), Fifth Floor East (President's Gallery), and the East Stairwell Gallery.

Queensborough Community College-CUNY - QCC Art Gallery

Queensborough Community College/CUNY, 222-05 56th Ave., Bayside (Queens), NY 11364-1497
Tel: (718) 631-6396
Fax: (718) 631-6620
Internet Address: http://www.qcc.cuny.edu
Director: Mr. Faustino Quintanilla
Admission: free.
Attendance: 35,000 *Established:* 1966 *Membership:* Y *ADA Compliant:* Y
Open: Monday to Friday, 9am-5pm.
Facilities: **Exhibition Area**; **Library.**
Activities: **Education Programs** (adults, graduates and undergraduates); **Guided Tours**; **Lectures**; **Temporary Exhibitions.**
Publications: exhibition catalogues.

The Gallery presents temporary exhibitions.

Queens College Art Center

Benjamin S. Rosenthal Art Library, 65-30 Kissena Blvd., Flushing (Queens), NY 11367-1597
Tel: (718) 997-3770
Fax: (718) 997-3753
Internet Address: http://www.qc.edu/Library/art/center/
Director: Dr. Suzanna Simor
Admission: free.
Membership: N
Parking: metered parking around campus; parking lot available only on day/time of reception.

Queens College Art Center, cont.

Open: **Academic Sessions**, Monday to Thursday, 9am-8pm; Friday, 9am-5pm.

Intersession/Spring Break/Summer, Monday to Friday, 9am-5pm.

Closed: Major Holidays.

Facilities: **Exhibition Area** (1,200 square feet).

Activities: **Gallery Talks**; **Lectures**; **Temporary Exhibitions** (6-7/year).

Located on the sixth floor of the Benjamin S. Rosenthal Library, the Queens College Art Center organizes in its gallery a continuous program of exhibitions of work by emerging and established artists supplemented by related gallery talks, lectures, and symposia. The Center, a part of the Art Library, focuses on artists who reflect the cultural diversity of New York City and the College. Spanish and Latin American art has been a special feature. The Art Center complements and cooperates with the College's Frances Godwin-Joseph Ternbach Museum (see separate listing). Also of possible interest within the Art Department, a separate student gallery is active.

Queens College - Frances Godwin and Joseph Ternbach Museum

Queens College, Paul Klapper Hall, 65-30 Kissena Blvd., Flushing (Queens), NY 11367

Tel: (718) 997-5000 *Ext:* 4747

Fax: (718) 997-5738

Internet Address: http://www.qc.edu

Director: Mr. Jerald Green

Admission: free.

Established: 1957 *Membership:* Y

Parking: free, on campus.

Open: Monday to Thursday, 11am-7pm.

Facilities: **Gallery**; **Library** (20,000 volumes).

Activities: **Education Programs** (undergraduate and graduate students); **Lecture Series**; **Temporary Exhibitions** (4/year).

Publications: brochure, "Queens College Art Collection"; exhibition catalogues.

The collection of the Museum consists of 2,500 works in a variety of media from ancient to contemporary art. It mounts four temporary exhibitions each year. Also of possible interest on campus is the Queens College Art Center Gallery in the Benjamin S. Rosenthall Library; see separate listing.

Queens Library Gallery

89-11 Merrick Blvd., Jamaica (Queens), NY 11432

Tel: (718) 990-8665

Fax: (718) 291-8936

Internet Address: http://www.queenslibrary.org/gallery

Library Director: Mr. Gary E. Strong

Admission: free.

Attendance: 90,000

Open: **September to May**,

Monday to Friday, 10am-9pm; Saturday, 10am-5:30pm; Sunday, noon-5pm.

June to August,

Monday to Friday, 10am-9pm; Saturday, 10am-5:30pm

Facilities: **Exhibition Area** (2,000 square feet).

Activities: **Temporary Exhibitions**.

The Gallery presents temporary exhibitions.

The Queens Museum of Art

New York City Building, Flushing Meadows Corona Park, Queens, NY 11368-3398

Tel: (718) 592-9700

Fax: (718) 592-5778

TDDY: (718) 592-2847

Internet Address: http://www.queensmuse.org

Exec. Director: Laurene Buckley

The Queens Museum of Art, cont.

Admission: suggested donation: adult-$5.00, child-$2.50, student-$2.00, senior-$2.00.

Attendance: 200,000 *Established:* 1972

Membership: Y *ADA Compliant:* Y

Parking: free on site.

Open: Tuesday to Friday, 10am-5pm;
Saturday to Sunday, noon-5pm.

Closed: New Year's Day, Thanksgiving Day,
Christmas Day.

Facilities: **Architecture** (New York City Building, built for 1939 World's Fairs); **Galleries** (3 permanent, 3 temporary exhibition); **Shop** (books, Tiffany-style items, World's Fair memorabilia); **Theatre** (107 seats).

Activities: **Education Programs** (adults and children); **Film Series**; **Guided Tours**; **Lectures**; **Temporary Exhibitions** (5-8/year); **Workshops**.

Publications: brochures; exhibition catalogues; newsletter, "QMA News" (quarterly).

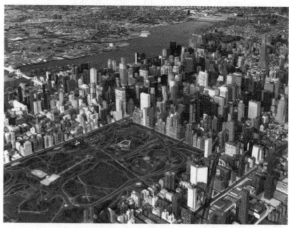

Panorama of City of New York at Queens Museum of Art. Photograph by Kim Keever, courtesy of Queens Museum of Art, New York, New York.

The Museum presents 20th-century and contemporary art exhibitions with a diverse, global outlook, reflective of the different ethnic and cultural communities of Queens and the larger New York City metropolitan area. The Contemporary Currents series features site-specific installations by internationally recognized artists. The permanent exhibition, "Tiffany in Queens: Selection from the Egon and Hildegard Neustadt Museum Collection", features art glass made at the Tiffany Studios, located in Corona, Queens, from 1893 to 1938. The Casts Gallery highlights plaster casts of Classical and Renaissance sculpture on long-term loan from the Metropolitan Museum of Art. The gallery spaces surround a freestanding enclosure containing the "Panorama of the City of New York". Built for the 1964 New York World's Fair, the Panorama, at 9,335 square feet, is the world's largest architectural scale model. The Museum's permanent collection includes 20th-century art by Joseph Cornell, Reginald Marsh and others, as well as recent acquisitions by Luis Camnitzer, Nassos Daphnis, and Grace Hartigan.

St. John's University - University Gallery

8000 Utopia Parkway, Jamaica (Queens), NY 11439

Tel: (718) 990-7476

Internet Address: http://www.stjohns.edu/libraries/services/gallery/index.html

Director: Mr. Ross Barbera

Admission: free.

Established: 1994

Open: Monday to Thursday, 10am-3pm; Friday, 11am-2pm.

Facilities: **Exhibition Area**.

Activities: **Temporary Exhibitions** (7/year).

The gallery presents exhibitions of contemporary art in a variety of media by well-known and emerging artists of regional, national, and international repute. Categories of shows include an invitational, a juried national, theme, annual faculty and annual student exhibitions.

New York City - Staten Island

Jacques Marchais Museum of Tibetan Art

338 Lighthouse Ave., Staten Island, NY 10306-1217

Tel: (718) 987-3478

Fax: (718) 351-0402

Director/Curator: Ms. Elizabeth Rogers

Admission: fee: adult-$3.00, child-$1.00, student-$2.50, senior-$2.50.

Attendance: 10,000 *Established:* 1945 *Membership:* Y

Jacques Marchais Museum of Tibetan Art, cont.

Open: **April to mid-November**,
Wednesday to Sunday, 1pm-5pm.
December to March, by appointment.

Facilities: **Galleries**; **Library** (2,000 volumes); **Sculpture Garden**; **Shop**.

Activities: **Education Programs** (children); **Guided Tours** (groups, by appointment, $6/person); **Lectures/Demonstrations** (selected Sun, 2pm-3pm); **Performances** (selected Sun, 2pm-3pm); **Workshops**.

Publications: booklet, "The Dalai Lama at the Jacques Marchais Tibetan Museum"; brochure; calendar; collection catalogue, "Treasures of Tibetan Art"; posters.

The Jacques Marchais Museum of Tibetan Art fosters, promotes and encourages interest, study and research in the art and culture of Tibet and other Asian civilizations. Designed like a small Tibetan Mountain temple, the museum building was constructed specifically to house the collections of Jacques Marchais (Mrs. Jacqueline Klauber). The collection consists of Tibetan, Tibeto-Chinese, Nepalese, and Mongolian objects dating primarily from the 17th to 19th centuries. It is particularly rich in figurines of deities and lamas, as well as thangka (meditational) paintings.

Maitreya Bodhisattva (Byang chub sems dpa'byams pa), China, 17th- early 18th century, gilded metal alloy with semiprecious stone inlays, 58 x 28 x 20 cm. Collection of and photograph courtesy of Jacques Marchais Museum of Tibetan Art, Staten Island, New York.

The John A. Noble Collection

1000 Richmond Terrace, Staten Island, NY 10301
Tel: (718) 447-6490
Fax: (718) 447-6056
Internet Address: http://mcns10.med.nyu.edu/noble/noble/collection.html
Exec. Director: Ms. Erin M. Urban
Admission: voluntary contribution.
Attendance: 10,000 *Established:* 1986
Membership: Y *ADA Compliant:* Y
Parking: large lots at East Gate and West Gate entries.
Open: Monday to Friday, 9am-2pm.
Closed: Thanksgiving Day, Christmas Day.
Facilities: **Architecture** (Greek Revival building, 1844 designed by Minard LaFever); **Food Services** Snack Bar; **Galleries**; **Library** (4,900 volumes); **Printmaking Studio**; **Shop**.
Activities: **Education Programs** (children); **Films**; **Guided Tours**; **Lectures**; **Temporary Exhibitions**; **Traveling Exhibitions**.

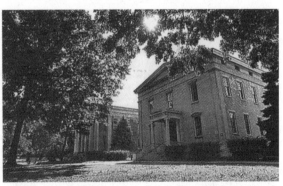

Exterior view of Building D at Sailor's Snug Harbor, home of John A. Noble Collection. Photograph by Mike Falco, courtesy of John A. Noble Collection, Staten Island, New York.

Publications: books; newsletter, "Hold Fast!".

Located on the grounds of Snug Harbor Cultural Center, the John A. Noble Collection is a museum and maritime study center with holdings in art and maritime history. It is housed in Building D, a Greek Revival former dormitory of Sailor's Snug Harbor retirement home. The collection includes Noble's series of 79 lithographs depicting 20th-century maritime endeavors; his "rowboat drawings", sketched from the stern of his rocking yawl; his 6,000-plus photographs; and a small sampling of both his and his father's work in oil. Collections also include archival materials, artifacts and memorabilia documenting the maritime history of New York harbor, and a reconstruction of Noble's houseboat studio. Snug Harbor Cultural Center is also home the Newhouse Center for Contemporary Art (see separate listing), the Staten Island Botanical Garden, and almost 70 other organizations. Its 83-acre campus includes 28 historic buildings, a collection of 19th-century Greek Revival, Beaux Arts, Second Empire, and Italianate architecture.

New York City (Staten Island), New York

Newhouse Center for Contemporary Art

Snug Harbor Cultural Center, 1000 Richmond Terrace, Staten Island, NY 10301
Tel: (718) 448-2500
Fax: (718) 442-8534
Director of Visual Arts: Olivia George
Admission: suggested contribution-$1.00.
Attendance: 250,000 *Established:* 1976 *Membership:* Y *ADA Compliant:* Y
Parking: free on site.
Open: Wednesday to Sunday, noon-5pm.
Facilities (Snug Harbor): **Architecture** (19th century home for retired seamen on 80 acres);
 Auditorium; Galleries; Outdoor Theatre; Recital Hall (250 seats); **Shop.**
Activities: **Arts Festival; Concerts; Dance Recitals; Education Programs** (school children);
 Films; Gallery Talks; Guided Tours; Lectures, Temporary Exhibitions (6/year).
Publications: book, "Sailors Snug Harbor"; calendar; exhibition catalogues.

Located on the campus of Snug Harbor Cultural Center, the Newhouse Center for Contemporary Art offers exhibitions of emerging and mid-career artists working in all media, contemporary craft art, and interdisciplinary programs that embrace diverse cultures and art forms. Exhibitions include an annual outdoor sculpture festival. Snug Harbor Cultural Center is also home to The John A. Noble Collection (see separate listing), the Staten Island Botanical Garden, and almost 70 other organizations. Its 83-acre campus includes 28 historic buildings, a collection of 19th-century Greek Revival, Beaux Arts, Second Empire, and Italianate architecture.

Staten Island Institute of Arts and Sciences (SIIAS)

75 Stuyvesant Place, Staten Island, NY 10301
Tel: (718) 727-1135
Fax: (718) 273-5683
President and C.E.O.: Michael Botwinick
Admission: suggested contribution: adult-$2.50,
 student-$1.50, senior-$1.50.
Attendance: 100,000 *Established:* 1881
Membership: Y
Parking: parking lot on site.
Open: Monday to Saturday, 9am-5pm;
 Sunday, 1pm-5pm.
Closed: New Year's Day, Memorial Day,
 Independence Day, Thanksgiving Day,
 Christmas Day.

Jasper Francis Cropsey, *Looking Oceanward from Todt Hill*, 1895, Staten Island Institute of Arts and Sciences. Photograph courtesy of Staten Island Institute of Arts and Sciences, Staten Island, New York.

Facilities: **Auditorium** (60 seats); **Galleries** (3); **Library** (16,000 volumes); **Shop.**
Activities: **Demonstrations; Education Programs** (adults and children); **Guided Tours;**
 Lectures; Temporary Exhibitions; Workshops.
Publications: exhibition catalogues; newsletter (quarterly).

One of New York City's oldest and most diverse cultural institutions, SIIAS's exhibitions, programs and collections focus on art, science, and history. Exhibitions explore the region's heritage and feature objects from the Institute's collections of over 2 million objects. The art collection includes works from ancient to contemporary, including local and internationally renowned art, furniture, clothing, textiles, ethnographic art, paintings, sculptures, craft, prints, drawings, and decorative art. The SIIAS maintains a branch, the Staten Island Ferry Collection, in the St. George Ferry Terminal. The Museum is constructing a 170,000-square-foot waterfront museum linked to the Staten Island Ferry terminal. Designed by architect Peter Eisenman, the facility will include 60,000 square feet of gallery space, restaurants, classrooms, a library/archive, and a 200-seat auditorium.

Niagara University

Niagara University - Castellani Art Museum

Senior Drive (center of campus), Niagara University, NY 14109
Tel: (716) 286-8200
Internet Address: http://www.niagara.edu/~cam

Niagara University - Castellani Art Museum, cont.

Director: Dr. Sandra H. Olsen
Admission: voluntary contribution.
Attendance: 100,000 *Established:* 1973 *Membership:* Y *ADA Compliant:* Y
Parking: free on site.
Open: Wednesday to Saturday, 11am-5pm; Sunday, 1pm-5pm.
Closed: Good Friday, Easter, Thanksgiving Day, Christmas Day, Academic Holidays.
Facilities: **Auditorium** (196 seats); **Exhibition Area** (10 galleries).
Activities: **Arts Festival**; **Concerts**; **Education Programs**; **Films**; **Gallery Talks**; **Guided Tours**; **Lectures**; **Temporary Exhibitions**; **Traveling Exhibitions**.
Publications: exhibition catalogues; newsletter, "Arcadia Revisited".

This 23,000-square-foot facility houses a collection that ranges from the Hudson River School landscapes of Jasper Cropsey and Albert Bierstadt to 20th-century constructions by Louise Nevelson and Robert Rauschenberg. Contemporary works by Susan Rothenberg, Arnold Mesches, Judy Pfaff, Roger Brown, and others provide a survey of major movements in today's art world, while there is also a pre-Columbian collection. The Museum also houses contemporary sculpture, as well as drawing, photography, print, and folk art collections.

Nyack

Hopper House Art Center

82 N. Broadway, Nyack, NY 10960
Tel: (914) 358-0774
Exec. Director: Ms. Paula Madawick
Admission: suggested contribution-$1.00.
Attendance: 2,000 *Established:* 1971 *Membership:* Y *ADA Compliant:* Y
Open: Thursday to Sunday, noon-5pm.
Facilities: **Architecture** (Hopper's boyhood home); **Exhibition Area** (950 square feet); **Shop**.
Activities: **Jazz Concerts** (summer).
Publications: pamphlet.

The Hopper House Art Center is located in the birthplace and childhood home of the American painter Edward Hopper. A room in the Art Center is devoted to an examination of the artist's developing style. There are also group and solo art exhibits, national juried competitions, and art lectures.

Oakdale

Dowling College - Anthony Giordano Gallery

Dowling College, Visual Arts Center (Idle Hour Blvd. at Biltmore Ave.), Oakdale, NY 11769
Tel: (631) 244-3016
Internet Address: http://www.dowling.edu
Gallery Director: Ms. Catherine Valenza
Admission: free.
Open: Wednesday to Saturday, 10am-4pm; Sunday, 2pm-4:30pm.
Facilities: **Gallery**.
Activities: **Temporary Exhibitions**.

A subsidiary gallery of the Islip Art Museum (see listing under East Islip, New York), the Gallery features installations, site-specific works, and theme shows.

Ogdensburg

Frederic Remington Art Museum

303 Washington St., Ogdensburg, NY 13669
Tel: (315) 393-2425
Fax: (313) 393-4464
Internet Address: http://www.fredericremington.org
Exec. Director: Mr. Lowell McAllister

Ogdensburg, New York

Frederic Remington Art Museum, cont.

Admission: fee: adult-$4.00, child (<6)-free, student (6-22)-$3.00, senior (>64)-$3.00.

Attendance: 15,000 *Established:* 1923 *Membership:* Y *ADA Compliant:* Y

Open: **May to October**,
Monday to Saturday, 9am-5pm; Sunday, 1pm-5pm.
November to April,
Wednesday to Saturday, 11am-5pm; Sunday, 1pm-5pm.

Closed: New Year's Day, Easter, Thanksgiving, Christmas.

Facilities: **Architecture** (mansion, 1809-10); **Galleries**; **Remington's Personal Library** (4,500 volumes); **Shop**.

Activities: **Gallery Talks**; **Guided Tours**; **Lectures**; **Temporary Exhibitions**.

Publications: collection catalogue, "Frederic Remington Memorial Collection"; exhibition catalogues.

The Museum is devoted exclusively to the works of Frederic Remington. It has a collection of 77 oil paintings and 16 bronze sculptures. The collection is particularly strong in Remington's later works and his works from the Northern New York area. Also on display are the artist's furniture, tools, and art that he owned. Located near Remington's birthplace, the Museum is central to three homes he occupied and his grave.

Oneonta

Hartwick College - The Yager Museum

Hartwick College, West St., Oneonta, NY 13820-4020

Tel: (607) 431-4480

Fax: (607) 431-4468

Internet Address: http://www.hartwick.edu

Director: Mr. George H.J. Abrams

Admission: free.

Attendance: 30,000 *Established:* 1928 *ADA Compliant:* Y

Parking: free on site.

Open: Tuesday, 11am-5pm; Wednesday, 11am-9pm; Thursday to Saturday, 11am-5pm; Sunday, 1pm-5pm.

Closed: Academic Holidays.

Facilities: **Auditorium** (392 seats); **Galleries** (Yager Museum and The Foreman Gallery, Fine Arts Center); **Shop**.

Activities: **Temporary Exhibitions**; **Traveling Exhibitions**.

In addition to mounting temporary exhibitions of the work of students and professional artists, the Museum houses a permanent collection of artifacts of Native Americans of the Northeastern woodlands, 19th-century landscapes, ethnographic and archaeological collections, a herbarium, ornithological collections and a malacological collection.

State University of New York, Oneonta - Fine Arts Gallery

Fine Arts Building, Room #155, Ravine Pkwy., Oneonta, NY 13820

Tel: (607) 436-2445

Internet Address: http://www.oneonta.edu

Associate Professor: Ms. Yolanda R. Sharpe

Admission: free.

Open: Monday to Friday, 11am-4pm.

Facilities: **Exhibition Area**.

Activities: **Temporary Exhibitions**.

The Gallery offers diverse exhibitions focusing on a range of contemporary critical issues and featuring the work of locally, regionally, and nationally recognized artists. Often the work of students, exploring the media presented by the professional artists in the main gallery, is presented concurrently in the Student Mini Gallery and the Quad Gallery.

Oswego

State University of New York College of Arts and Sciences at Oswego - Tyler Art Gallery

SUNY Oswego, 126 Tyler Hall, Oswego, NY 13126

Tel: (315) 341-2113

Fax: (315) 341-3439

Internet Address: http://www.oswego.edu/other_campus/tylerart/index

Director: David Kwasigroh

Admission: voluntary contribution.

Attendance: 20,000

Membership: N *ADA Compliant:* Y

Parking: free on site.

Open: **September to May,**
 Monday to Friday, 9:30am-4:30pm;
 Saturday to Sunday, 12:30am-4:30pm.
 June to July,
 Monday to Friday, noon-4pm.

Closed: College Vacations.

Facilities: **Exhibition Area** (3,750 square feet).

Activities: **Gallery Talks; Lectures; Temporary Exhibitions; Traveling Exhibitions.**

View of gallery during exhibition, Tyler Art Gallery. Photograph courtesy of Tyler Art Gallery, Oswego, New York, New York.

Publications: brochures; posters.

Tyler Art Gallery, located in Tyler Hall, presents approximately twelve art exhibitions each year in two gallery spaces, including traveling exhibitions, locally-produced loan exhibitions, and the best work of students and faculty. Exhibitions are usually inter-disciplinary in nature so that the Gallery's programs will be of relevance to a wide range of campus interests as well as the public at large. The Gallery has a permanent collection of European, African, and American drawings, prints, paintings, ceramics, and sculpture from the 18th century to the present.

Pelham

Pelham Art Center

155 5th Ave., Pelham, NY 10803

Tel: (914) 738-2525

Fax: (914) 738-2686

Director: Ms. Alison Paul

Admission: free.

Attendance: 18,000 *Established:* 1975 *Membership:* Y *ADA Compliant:* Y

Open: Tuesday to Friday, 10am-5pm; Saturday, 10am-4pm.

Closed: New Year's Day, Memorial Day, Independence Day, Columbus Day, Thanksgiving Day, Christmas Day.

Facilities: **Exhibition Area** (900 square feet); **Shop.**

Activities: **Concerts; Education Programs** (adults and children); **Guided Tours; Lectures; Traveling Exhibitions.**

Publications: newsletter, "Up-date" (3/year).

The Pelham Art Center is a community art center that organizes seven changing exhibitions per year of a wide variety of art, from the work of local artists to thematic shows featuring artists of national renown.

Plattsburgh

State University of New York at Plattsburgh - Plattsburgh Art Museum

SUNY at Plattsburgh, 101 Broad St., Plattsburgh, NY 12901

Tel: (518) 564-2474

Fax: (518) 564-2473

Internet Address: http://www.plattsburgh.edu/museum/

Director: Mr. Edward R. Brohel

Admission: voluntary contribution.

Established: 1952 *ADA Compliant:* Y

Parking: free on site.

Open: Monday to Wednesday, noon-4pm; Thursday, noon-8pm; Friday to Sunday, noon-4pm.

Closed: University Holidays.

Facilities: **Galleries** (2, permanent and changing); **Sculpture Court**; **Shop**.

Activities: **Education Programs** (undergraduates); **Gallery Talks**; **Guided Tours**; **Temporary Exhibitions** (24/year).

Publications: calendar (semi-annual); exhibition announcements (monthly); exhibition catalogues; journal, "Kent Collector".

The Plattsburgh Art Museum is actually a number of venues for art located throughout the campus. The Rockwell Kent Gallery houses the Museum's permanent collection, including works of Rockwell Kent. The Burke Gallery presents a wide variety of changing exhibitions. The Winkel Sculpture Court displays the work of Nina Winkel in an indoor garden sanctuary. The Sculpture Park has both permanent installations and changing exhibitions. The Slatkin Study Room displays a decorative glass collection.

Potsdam

State University of New York College at Potsdam - Roland Gibson Gallery

SUNY College at Potsdam, Brainerd Hall (off Pierrepont Ave., Route 56), Potsdam, NY 13676

Tel: (315) 267-2250

Fax: (315) 267-4884

Internet Address: http://www.potsdam.edu

Director: Mr. Dan Mills

Admission: voluntary contribution.

Attendance: 15,000 *Established:* 1968 *Membership:* Y *ADA Compliant:* Y

Parking: free on site.

Open: Monday/Wednesday/Friday, noon-5pm; Tuesday/Thursday, noon-5pm and 7pm-9pm;
 Saturday to Sunday, noon-4pm.

Closed: Academic Holidays.

Facilities: **Galleries**; **Sculpture Garden**.

Activities: **Arts Festival**; **Concerts**; **Education Programs**; **Films**; **Lectures**; **Temporary Exhibitions**; **Traveling Exhibitions**; **Workshops**.

Publications: brochures; bulletin (monthly); exhibition catalogues; newsletter; posters.

The Gallery hosts temporary exhibitions featuring both traditional and contemporary art, including student, faculty, and alumni work.

Poughkeepsie

Marist College Art Gallery

290 North Road, Poughkeepsie, NY 12601-1387

Tel: (914) 575-3000 *Ext:* 2903

Internet Address: http://www.academic.marist.edu/art/gallery/gallery.html

Contact: Donise English

Admission: free.

Open: **Fall to Spring**, Monday to Friday, noon-5pm; Saturday, noon-4pm.
 Summer, Call for hours.

Purchase, New York

Marist College Art Gallery, cont.
Facilities: **Exhibition Area** (3,230 square feet, 223 linear feet).
Activities: **Changing Exhibitions** (6/year); .

The Gallery presents changing exhibitions of contemporary works by artists from New York City and the Hudson Valley. All types of media are exhibited including painting, drawing, sculpture, photography, digital, multi-media, and installation. Faculty and student shows are also scheduled.

Vassar College - The Frances Lehman Loeb Art Center
Vassar College, 124 Raymond Ave., Poughkeepsie, NY 12604-0023
Tel: (914) 437-5237
Fax: (914) 437-7304
Internet Address: http://www.vassun.vassar.edu/~fllac/
Director: Mr. James Mundy
Established: 1864 *Membership:* Y *ADA Compliant:* Y
Parking: free on site.
Open: Tuesday to Saturday, 10am-5pm; Sunday, 1pm-5pm.
Closed: Easter, Thanksgiving Day, Christmas Eve to New Year's Day.
Facilities: **Galleries**; **Library** (25,000 volumes); **Shop**.
Activities: **Gallery Talks**; **Temporary Exhibitions**.
Publications: exhibition catalogues; newsletter (quarterly).

Designed by Cesar Pelli, the Art Center houses a museum, home to one of the finest teaching collections in the country, consisting of 14,000 objects. Some 400 of the most important works from the collection are on view, arranged chronologically, with selections from the Asian collection in a separate section of the main Gallery. The exhibition includes Egyptian, Greek, and Roman antiquities, 15th- and 16th-century Italian painting (Giordano, Rosa), Northern Renaissance painting (Brueghel the Younger, van Cleve), 19th-century French painting (Cézanne, Delacroix, Doré), British and American art (Copley, Fuseli, Hamilton, Inness), and 20th-century works (Calder, Miró, Bacon, Hartley, O'Keeffe, Rothko, Miró, Pollock). There is also an extensive collection of works on paper, a sculpture court, and a sculpture garden.

Purchase

The Donald M. Kendall Sculpture Gardens at Pepsico
700 Anderson Hill Road, Purchase, NY 10577
Tel: (914) 253-2082
Admission: free.
Open: Daily, 9am-dusk.
Facilities: **Corporate Headquarters** (designed by Edward Durrell Stone); **Sculpture Garden** (168 acres).

The sculpture garden, set among the buildings of PepsiCo's corporate headquarters, features 45 modern sculptures. Artist include Judith Brown, Alexander Calder, Jean Dubuffet, Richard Erdman, Albert Giacometti, Barbara Hepworth, Henri Laurens, Jacques Lipchitz, Seymour Lipton, Aristide Malliol, Marino Marini, Joan Miró, Henry Moore, Louise Nevelson, Isamu Noguchi, Claes Oldenburg, Arnoldo Pomodoro, George Rickey, Auguste Rodin, George Segal, David Smith, and David Wynne.

Purchase College, State University of New York - Neuberger Museum of Art
Purchase College, State U. of New York, 735 Anderson Hill Road, Purchase, NY 10577-1400
Tel: (914) 251-6100
Fax: (914) 251-6101
Internet Address: http://www.neuberger.org
Director: Dr. Lucinda H. Gedeon
Admission: fee: adult-$4.00, child-$2.00, senior-$2.00.
Attendance: 54,000 *Established:* 1974 *Membership:* Y *ADA Compliant:* Y
Parking: free on site.
Open: Tuesday to Friday, 10am-4pm; Saturday to Sunday, 11am-5pm.
Closed: Legal Holidays.

Purchase College, State University of New York - Neuberger Museum of Art, cont.

Facilities: **Exhibition Area** (30,000 square feet); **Food Services** Café; **Shop**.

Activities: **Art Workshops**; **Biennial Sculpture Exhibition**; **Changing Exhibitions**; **Concerts**; **Dance Performances**; **Education Programs** (elementary and secondary students); **Films**; **Guided Tours**; **Lectures**.

Publications: "CD ROM of Selected Works in Collection"; calendar (quarterly); exhibition catalogues.

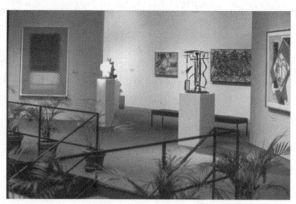

View of gallery. Photograph courtesy of Neuberger Museum of Art, Purchase, New York.

The Neuberger Museum of Art is a major visual arts center and cultural resource; the Neuberger combines the scale and excitement of a city museum with the charm of a country setting. It is among the ten largest art museums in New York State and it is the eighth largest university art museum in the country. The Museum, a 65,000 square foot facility designed by Philip Johnson and John Burgee, houses a permanent collection of over 6,000 objects in various media, including 20th-century American and European art, and works of art in the tradition of Constructivism. Artists represented include Avery, Bearden, de Kooning, Diebenkorn, Frankenthaler, Hartigan, Hopper, Lipton, Noguchi, and Pollock. It also houses a distinguished collection of African and ancient art. The Museum mounts between fifteen and twenty changing exhibitions each year, and hosts numerous exhibition-related lectures, concerts, workshops, and tours.

Rochester

George Eastman House/International Museum of Photography and Film

900 East Ave., Rochester, NY 14607-2298

Tel: (716) 271-3361

Fax: (716) 271-3970

TDDY: (716) 271-3362

Internet Address: http://www.eastman.org

Director: Dr. Anthony Bannon

Admission: fee: adult-$6.50, child-$2.50, student-$5.00, senior-$5.00.

Attendance: 134,000 *Established:* 1947

Membership: Y *ADA Compliant:* Y

Parking: free on site.

Open: Tuesday to Wednesday, 10am-4:30pm;
Thursday, 10am-8pm;
Friday to Saturday, 10am-4:30pm;
Sunday, 1pm-4:30pm.

Closed: New Year's Day, Thanksgiving Day, Christmas Day.

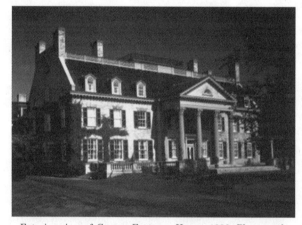

Exterior view of George Eastman House, 1992. Photograph courtesy of George Eastman House Museum/International Museum of Photography and Film, Rochester, New York.

Facilities: **Architecture** (colonial revival mansion, 1905 design by J. Foster Warner); **Auditorium** (500 seats); **Food Services** The Tea Room (Tues-Sat, 11am-4pm; Sun, 1pm-4pm); **Galleries** (11); **Grounds** (12.5 acres; historically restored gardens); **Library** (44,000 volumes, Mon-Fri); **Photographic Archive/Reading Room** (by appointment); **Shop**; **Seasonal Garden Store**; **Theatre** (535 seats).

Activities: **Concerts** (Musicale Series, Sun, 3pm); **Education Programs**; **Films** (Tues-Sun, 8pm); **Gallery Talks** (Tues-Sun, 1:15pm); **Guided Tours** General (Tues-Sat, 10:30am and 2pm; Sun, 2pm); **Traveling Exhibitions**.

Publications: books; exhibition catalogues.

George Eastman House/International Museum of Photography and Film, cont.

George Eastman House International Museum of Photography and Film combines one of the world's leading collections of photography and film with stately pleasures of the landmark Colonial Revival mansion and gardens that George Eastman, founder of the Eastman Kodak, called home from 1905 to 1932. With nearly a dozen galleries and display areas, the Museum hosts a wide variety of exhibitions drawn from its own collections and from other museums. Much of the collections is on display in the galleries, including photography and technology (cameras); films are shown six times a week throughout the year. The library is open weekdays for walk-in visitors, but an appointment is necessary for access to the photography and motion picture study centers. Collections include photography (more than 400,000 photographic prints and negatives); motion pictures (more than 25,000 motion picture titles from 1895 to the present; 10,000 movie posters; more than 5 million film stills, including 12,000 star portraits; and personal film collections of Cecil B. DeMille and Martin Scorcese); and technology (more than 15,000 pieces of camera equipment and related technology, including 4,000 still cameras). Ansel Adams, Manuel Alvarez-Bravo, Margaret Bourke-White, Julia Margaret Cameron, Louis J.M. Daguerre, Lewis Hines, Eikoh Hosoe, May Ellen Mark, László Moholy-Nagy, Eadweard Muybridge, Aaron Siskind, Edward Steichen, Alfred Stieglitz, and Edward Weston are among the more than 8,000 photographers represented in the permanent collection.

University of Rochester - Memorial Art Gallery (MAG)

500 University Ave. at Goodman Ave., Rochester, NY 14607

Tel: (716) 473-7720

Fax: (716) 473-6266

TDDY: (716) 473-6152

Internet Address: http://www.rochester.edu/MAG/

Director: Mr. Grant Holcomb, III

Admission: fee: adult-$5.00, child (<5)/UofR students-free, student-$4.00, senior-$4.00.

Attendance: 260,000 *Established:* 1913

Membership: Y *ADA Compliant:* Y

Parking: free on site.

Open: Tuesday, noon-9pm; Wednesday to Friday, 10am-4pm; Saturday, 10am-5pm; Sunday, noon-5pm.

Closed: New Year's Day, Independence Day, Thanksgiving Day, Christmas Day.

Facilities: **Auditorium** (300 seats); **Food Services** Cutler's Restaurant (lunch, dinner, Sunday brunch); **Galleries**; **Library** (13,000 volumes; Tues, 1pm-8:30pm; Wed-Fri, 1pm-4pm; Sun, 12:30pm-4pm); **Reading Room**; **Sculpture Garden**; **Shop** (hand-crafted jewelry, ceramics, books, catalogues).

Activities: **Concerts**; **Crafts Festival** (weekend after Labor Day); **Education Programs** (adults and children); **Gallery Talks**; **Guided Tours** (Tues, 7:30pm; Fri & Sun, 2pm); **Lectures**; **Rental Gallery**; **Temporary Exhibitions**; **Traveling Exhibitions**.

Hans Hofmann, *Ruby Gold*, 1959, Memorial Art Gallery. Photograph courtesy of Memorial Art Gallery, University of Rochester, New York.

Publications: calendar; exhibition catalogues; newsletter, "MAGazine" (bi-monthly); scholarly bulletin, "Porticus" (semi-annual).

Located on the original campus of the University of Rochester, MAG houses more than 5,000 years of world art, from ancient relics to the works of contemporary masters. The Museum presents approximately 15 temporary exhibitions a year, featuring the permanent collection, art from other collections, or the work of contemporary regional artists. MAG's permanent collection of over 10,000 objects includes European and American painting and sculpture, as well as art and artifacts from the ancient world, Asia, Africa, Native America, and Meso-America. Among the European and American artists represented in the collection are Thomas Hart Benton, Albert Bierstadt, Mary Cassatt, Paul Cézanne, Stuart Davis, Edgar Degas, El Greco, Hans Hofmann, Winslow Homer, Jacob Lawrence, Henri Matisse, Claude Monet, Henry Moore, Albert Paley, Rachel Ruysch, John Sloan, and Lilly Martin Spencer.

Rome

Rome Art and Community Center

308 W. Bloomfield St., Rome, NY 13440
Tel: (315) 336-1040
Fax: (315) 336-1090
Exec. Director: Ms. Maureen Dawn Murphy
Admission: voluntary contribution.
Attendance: 27,000 *Established:* 1967
Membership: Y *ADA Compliant:* Y
Parking: on street and free lot on site.
Open: Monday to Thursday, 9am-9:30pm;
Friday to Saturday, 9am-5pm.
Closed: Legal Holidays.

Exterior view of Rome Art and Community Center.
Photograph courtesy of Rome Art and Community Center,
Rome, New York.

Facilities: **Galleries** (2); **Shop** (original artwork, art supplies, gifts).
Activities: **Concerts**; **Education Programs** (adults and children); **Gallery Talks** (winter, chamber music; summer, outdoor blues and jazz); **Guided Tours** (by appointment); **Lectures**; **Temporary Exhibitions** (10/year); **Workshops**.
Publications: class schedules, "Community Cultural Calendar" (quarterly); newsletter, " RACC Facts" (monthly).

Housed in a 1923 Tudor-style mansion, RACC is a multi-disciplinary community art center. Three second-floor galleries feature fine arts exhibitions of work from Central New York and across the country.

Roslyn Harbor

Nassau County Museum of Fine Art

1 Museum Drive, Roslyn Harbor, NY 11576
Tel: (516) 484-9338
Fax: (516) 484-0710
Internet Address: http://www.nassaumuseum.org
Director and Chief Curator: Ms. Constance Schwartz
Admission: fee: adult-$4.00, child-$2.00, student-$2.00.
Attendance: 225,000 *Established:* 1975 *Membership:* Y *ADA Compliant:* Y
Parking: free on site.
Open: Tuesday to Sunday, 11am-5pm.
Closed: Legal Holidays.
Facilities: **Architecture** (neo-Georgian mansion, 1900); **Formal Gardens, Lawns & Woods** (145 acres); **Galleries** (10); **Sculpture Garden**; **Shop**.
Activities: **Education Programs** (adults, college students and children); **Gallery Talks**; **Guided Tours**; **Lectures**; **Temporary Exhibitions**; **Traveling Exhibitions**.
Publications: exhibition catalogues (quarterly); newsletter.

The Museum presents four to five changing exhibitions annually featuring historical, modern, and contemporary art and accompanied by diverse educational programs. Additionally the Museum features selections from an extensive permanent collection of work by both European and American artists, over 30 works of outdoor sculpture situated in the formal gardens and throughout the 145 acres of landscaped grounds, and 26 miniature rooms in the Tee Ridder Miniatures Museum. The permanent collection contains over 600 works of art from both the 19th and 20th centuries, encompassing all types of media. Pierre Bonnard, Georges Braque, Audrey Flack, Frederick Warren Freer, Chaim Gross, Alex Katz, Roy Lichtenstein, Robert Rauschenberg, Larry Rivers, Auguste Rodin, George Segal, Moses Soyer, Edouard Vuillard, and Irving Ramsey Wiles are some of the artists represented. Among the outdoor sculptures are works by Fernando Botero, Jose DeCreeft, Mark di Suvero, Red Grooms, Ann Hyatt Huntington, Roy Lichtenstein, Marino Marini, Ruben Nakian, Barnett Newman, Peter Reginato, Richard Serra, Tony Smith, and William Tucker.

Saint Bonaventure

St. Bonaventure University Galleries

Regina A. Quick Center for the Arts, Route 417,
Saint Bonaventure, NY 14778
Tel: (716) 375-2684
Fax: (716) 375-2690
Internet Address: http://www.sbu.edu/~qac
Curator: Miles A. Bingham
Admission: free.
Attendance: 5,000 *Established:* 1856
Membership: N *ADA Compliant:* Y
Parking: in Hopkins parking lot.
Open: **Fall to Spring,**
> Thursday to Sunday, 1pm-5pm.
>
> **Summer,**
> Call for hours.

Closed: Easter, Thanksgiving Day,
Christmas Day.
Facilities: **Exhibition Area** (3 galleries);
Library (200,000 volumes); **Reading Room;**
Theatre.

Exterior view of entrance to Regina A. Quick Center for the Arts, St. Bonaventure University. Photograph courtesy of St. Bonaventure University, St. Bonaventure, New York.

Activities: **Guided Tours**; **Temporary Exhibitions** (8/year).

The Regina A Quick Center for the Arts contains two galleries. The Paul W. Beltz Gallery houses and exhibits the University's diverse permanent collection of art and artifacts. Four exhibits throughout the year each feature an aspect of art collecting. The Dresser Foundation Gallery hosts visiting artists' exhibitions and traveling shows.

Saratoga Springs

Skidmore College - The Schick Art Gallery

Skidmore College, 815 N. Broadway, Saratoga Springs, NY 12866-1632
Tel: (518) 580-5049
Fax: (518) 581-8386
Internet Address: http://www.skidmore.edu/art/
Director: Mr. David Miller
Admission: free.
Attendance: 18,000 *Established:* 1926
Membership: N *ADA Compliant:* Y
Parking: free on campus.
Open: **September to May,**
> Monday to Friday, 9am-5pm;
> Saturday to Sunday, 1pm-3:30pm.
>
> **Summer,**
> Monday to Friday, 9am-4pm;
> Saturday, 1pm-3:30pm.

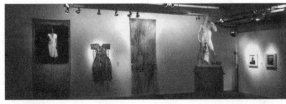

Interior view of Schick Art Gallery, Skidmore College. Photograph courtesy of Schick Art Gallery, Skidmore College, Saratoga Springs, New York.

Facilities: **Gallery** (1,200 square feet).
Activities: **Films**; **Gallery Talks**; **Lectures**; **Temporary Exhibitions** (10/year).
Publications: catalogue (occasional).

The Gallery presents temporary exhibitions of contemporary art by nationally recognized artists, student shows, and faculty exhibits. Group shows are theme-oriented and are often curated by Skidmore faculty. Skidmore is building a new facility, the Frances Young Tang Teaching Museum and Art Gallery. Designed by architect Antoine Predock and scheduled for completion in 2000, the Museum will house Skidmore's permanent collection of historical and contemporary art and host temporary exhibits.

Saugerties

OPUS 40

50 Fite Road, Saugerties, NY 12477
Tel: (914) 246-3400
Fax: (914) 246-1997
C.E.O.: Pat Richards
Admission: fee: adult-$5.00, child-free, student-$4.00, senior-$4.00.
Attendance: 15,000 *Established:* 1978 *Membership:* Y
Open: **Memorial Day to October**, Friday to Sunday, noon-5pm; Holiday Mondays, noon-5pm.
Facilities: **Environmental Bluestone Sculpture** (6.5 acres); **Gallery**; **Grounds** (12 acres); **Performing Arts Center**; **Shop**.
Activities: **Concerts**; **Guided Tours**; **Lectures**; **Performances**; **Readings**.
Publications: brochure; monograph, "Harvey Fite's OPUS 40".

Built on the site of an old bluestone quarry, Opus 40 is a 6.5 acre "environmental sculpture" constructed by sculptor Harvey Fite over a period of 37 years. Fite originally intended to create a setting for his large stone carvings; however, the site became a work in itself and Fite removed the sculptures.

Schenectady

Union College - Mandeville Gallery

Union College, Union St.
The Nott Memorial (between North and South Lane)
Schenectady, NY 12308
Tel: (518) 388-6004
Fax: (518) 388-6173
Internet Address: http://www.union.edu/PUBLIC/GALLERY/
Director/Curator: Ms. Rachel Seligman
Admission: free.
ADA Compliant: Y
Open: **September to June**,
Monday to Thursday, 9am-10pm;
Friday, 9am-5pm;
Saturday, noon-5pm;
Sunday, noon-10pm.
July to August,
Daily, 9am-5pm.

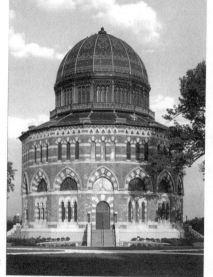

Exterior view of Nott Memorial (1870s), designed by Edward Tuckerman Potter. Photograph courtesy of Union College, Schenectady, New York.

Facilities: **Architecture** Nott Memorial (Victorian Gothic 1870's, designed by Edward Tuckerman Potter); **Exhibition Area**.
Activities: **Temporary Exhibitions** (seven per year).
Publications: exhibition catalogues (7 per year).

The Gallery is located on the second floor of the historic Nott Memorial, a National Historic Landmark, in the center of the Union campus. The Gallery hosts traveling exhibitions, mounts exhibits drawn from the Union College collection, and displays work by faculty and students. A frequent theme of Gallery exhibitions is the exploration of links between art and science. Exhibitions are also mounted in The Arts Atrium (Arts Building, ground level) and in the Photo Gallery (Arts Building, 2nd floor).

Setauket

Gallery North

90 North Country Road, Setauket, NY 11733
Tel: (631) 751-2676
Fax: 631) 751-0180
Admission: free.

Gallery North, cont.

Attendance: 11,000 *Established:* 1965

Membership: Y

Parking: along street and small parking lot.

Open: Tuesday to Saturday, 10am-5pm;
Sunday, 1pm-5pm.

Closed: New Year's Day, Easter,
Thanksgiving Day, Christmas Day.

Facilities: **Exhibition Area** (1,200 square feet);
Shop (handcrafts, unframed prints, unique toys).

Activities: **Guided Tours**; **Lectures**; **Outdoor Art Show** (fall); **Temporary Exhibitions** (8/year); **Workshops**.

Publications: newsletter, "Gallery North News" (quarterly).

Joseph Reboli, *Greenhouse Reflections*, oil on canvas, 29 x 72 inches. Gallery North. Photograph courtesy of Gallery North, Setauket, New York.

Founded to exhibit the work of contemporary Long Island artists, Gallery North is a not-for-profit gallery presenting regularly changing exhibitions in all media.

Southampton

Ossorio Foundation

164 Mariner Drive, Southampton, NY 11968

Tel: (631) 287-2020

Fax: (631) 287-2020

Internet Address: http://www.ossorio.org

Curator/Director: Mr. Mike Solomon

Admission: voluntary contribution.

Membership: N

Open: **June to August**, Thursday-Saturday 10am-4pm, or by appointment.

Facilities: **Exhibition Area** (2,000 square feet).

Activities: **Annual Exhibits**.

Publications: brochures.

The Ossorio Foundation exhibits selections from its holdings of the work of the artist Alfonso Ossorio. Ossorio was a colleague of Jean Dubuffet and Jackson Pollock and an early collector of their work, as well as the work of Willem de Kooning, Lee Krasner, and Clyfford Still, among others. The Foundation's collection contains numerous art objects made by Ossorio. This includes assemblages, sculptures, paintings, works on paper, prints, photographs, notebooks, drawings, studies and ephemera. The Foundation maintains an archive of Ossorio's historic records and photographs regarding his life and work. This includes Ossorio's own

Alfonso Ossorio, *Untitled*, 1950, ink, wax, and watercolor on cut out paper, 29¼ x 22 inches. Collection of Ossorio Foundation. Photograph courtesy of Ossorio Foundation, Southampton, New York.

extensive photographic documentation of his residence, The Creeks, as well as original photographs by Hans Namuth and George Platt Lynes. The Foundation also maintains records and photographs of Ossorio's collection of art by other artists. This includes original documents of correspondence from Jean Dubuffet, Jackson Pollock, Lee Krasner, Clyfford Still, Betty Parsons, Marcel Duchamp, Louise Nevelson, Barnett Newman, Dorothy Norman, Frieda Lawrence, and Phillip Johnson, among others. All visits are arranged by appointment.

The Parrish Art Museum

25 Job's Lane, Southampton, NY 11968

Tel: (516) 283-2118 *Ext:* 12

Fax: (516) 283-7006

Internet Address: http://www.thehamptons.com/museum

The Parrish Art Museum, cont.

Director: Ms. Trudy C. Kramer
Admission: fee: adult-$2.00, child-free, student-free, senior-$1.00.
Attendance: 34,000 *Established:* 1898
Membership: Y *ADA Compliant:* Y
Parking: free on site.
Open: **mid-June to mid-September**,
 Monday to Tuesday, 11am-5pm;
 Thursday to Saturday, 11am-5pm;
 Sunday, 1pm-5pm.
 mid-September to mid-June,
 Monday, 11am-5pm;
 Thursday to Saturday, 11am-5pm;
 Sunday, 1pm-5pm.
Closed: New Year's Day, Easter, Independence Day,
 Thanksgiving Day, Christmas Day.
Facilities: **Arboretum** (250 trees and shrubs); **Architecture** (Italianate structure, 1898 designed by Grosvenor Atterbury); **Auditorium** (250 seats); **Galleries**; **Library** (5,300 volumes); **Sculpture Garden**; **Shop**.
Activities: **Concerts**; **Education Programs** (adults and children); **Films**; **Guided Tours**; **Performances**; **Temporary Exhibitions**.
Publications: annual report; exhibition catalogues; newsletter (quarterly).

Fairfield Porter, *Anne in a Striped Dress*, 1967, Parrish Art Museum. Photograph by Richard P. Meyer, courtesy of Parrish Art Museum, Southampton, New York.

Housed in an Italianate structure built in 1898, The Parrish Art Museum is dedicated to the collection, preservation, interpretation, and dissemination of American art and art of the region. The permanent collection traces the work of Eastern Long Island artists from its roots in an emerging national landscape tradition of the mid-1800s, through the influences of European modernism, to contemporary artists working in both the non-representational and figurative traditions. The Museum is particularly proud of its extensive holdings of the artists William Merritt Chase and Fairfield Porter. A wide range of changing exhibitions, with special emphasis on the artists of Eastern Long Island, and innovative educational programs are presented. The collection also includes works by significant 19th-century artists such as Thomas Doughty, Winslow Homer, Mary Nimmo Moran, Thomas Moran, William Sidney Mount, Albert Pinkham Ryder, and John Sloan; the landscape painters Asher B. Durand and Martin Johnson Heade; the American Impressionists Childe Hassam and John H. Twachtman; and the Dunnigan collection of more than 500 19th-century prints. Succeeding generations of artists who have maintained studios in the region since the 1950s are also represented, including Lynda Benglis, James Brooks, Chuck Close, Elaine de Kooning, Eric Fischl, Jane Freilicher, April Gornik, Lee Krasner, Barbara Kruger, Roy Lichtenstein, Alfonso Ossorio, Larry Rivers, Joan Snyder, Esteban Vicente, and Joe Zucker.

Stony Brook

The Museums at Stony Brook - The Art Museum

1208 Route 25A, Stony Brook, NY 11790-1992
Tel: (631) 751-0066
Fax: (631) 751-0353
Internet Address: http://www.museumsatstonybrook.org
President and C.E.O.: Ms. Deborah J. Johnson
Admission: fee: adult-$4.00, child-free, student-$2.00, senior-$3.00.
Attendance: 80,000 *Established:* 1939 *Membership:* Y *ADA Compliant:* Y
Parking: free on site.

The Museums at Stony Brook - The Art Museum, cont.

Open: **January to June**,
 Wednesday to Saturday, 10am-5pm;
 Sunday, noon-5pm.
 July to August,
 Monday to Saturday, 10am-5pm;
 Sunday, noon-5pm.
 September to November,
 Wednesday to Saturday, 10am-5pm;
 Sunday, noon-5pm.
 December,
 Monday to Saturday, 10am-5pm;
 Sunday, noon-5pm.

Closed: New Year's Day, Thanksgiving Day,
 Christmas Eve to Christmas Day.

Facilities: **Galleries**; **Grounds** (9 acres);
 Library (2,000 volumes); **Shop**.

Robert Bruce Crane, *A Long Island Farm, Spring Time*, 1880's. The Museums at Stony Brook. Photograph courtesy of The Museums at Stony Brook, Stony Brook, New York.

Activities: **Education Programs** (adults, children and families); **Temporary Exhibitions**; **Traditional Music Festival**.

Publications: annual report; books; brochures; exhibition catalogues; newsletter (quarterly).

In addition to the Art Museum, the Museums at Stony Brook complex includes the History Museum, Carriage House, an 18th-century barn, blacksmith shop, one room school, and an herb garden. Special exhibitions highlight themes developed from the permanent collection, from other museums, and private collections. The art collection contains the works of 19th- and 20th-century American artists, many of whom were closely connected to Long Island, including an extensive collection of paintings and drawings by the 19th-century artist William Sidney Mount.

State University of New York at Stony Brook - University Art Gallery

Staller Center for the Arts, Center Drive, Stony Brook, NY 11794-5425
Tel: (516) 632-7240
Fax: (516) 632-7354
Internet Address: http://www.staller.sunysb.edu
Director: Ms. Rhonda Cooper
Admission: free.
Attendance: 12,000 *Established:* 1975 *ADA Compliant:* Y
Parking: pay parking garage on site.
Open: **early-September to July**, Tuesday to Friday, noon-4pm; Saturday, 6pm-8pm.
Closed: Legal Holidays.
Facilities: **Exhibition Area** (4,700 square feet).
Activities: **Education Programs**; **Temporary Exhibitions** (5-6/year).
Publications: exhibition catalogues (5/year).

The University Gallery at the Staller Center for the Arts offers a diverse schedule that includes an MFA Exhibition every February, a senior show of undergraduate work every May, a biannual faculty exhibition, and a variety of solo and group professional exhibitions. Most exhibitions are accompanied by an illustrated catalogue, which is offered free of charge to Gallery visitors. Additionally, the Department of Art sponsors the "Art History and Criticism Lecture Series".

Syracuse

Everson Museum of Art of Syracuse and Onondaga County

401 Harrison St., Syracuse, NY 13202
Tel: (315) 474-6064
Fax: (315) 474-6943
Director: Ms. Sandra Trop
Admission: voluntary contribution.
Attendance: 80,000 *Established:* 1896 *Membership:* Y *ADA Compliant:* Y

Everson Museum of Art of Syracuse and Onondaga County, cont.

Parking: metered on street and adjacent commercial lots.

Open: Tuesday to Friday, noon-5pm; Saturday, 10am-5pm; Sunday, noon-5pm.

Closed: New Year's Day, Independence Day, Thanksgiving Day, Christmas Day.

Facilities: **Architecture** (first museum deigned by I.M. Pei); **Auditorium** (299 seats); **Food Services** Restaurant (Tues-Fri,11:30am-2pm); **Galleries** (10); **Library** (10,000 volumes); **Rental Gallery**; **Sculpture Garden**; **Shop** (art books, handcrafted jewelry).

Activities: **Arts Festival** (Community Day in June); **Concerts**; **Dance Recitals**; **Education Programs**; **Films** (monthly contemporary film series); **Gallery Talks**; **Guided Tours**; **Lectures**; **Temporary Exhibitions**; **Traveling Exhibitions**.

Publications: calendar, "Bulletin" (quarterly); exhibition catalogues; guides to collections; handbooks.

Exterior view of Everson Museum of Art (1968), designed by I.M. Pei. Photograph courtesy of Everson Museum of Art, Syracuse, New York.

The first museum designed by I.M. Pei, the Everson offers a wide variety of work in ten galleries on three levels. One can explore works that range from 18th-century American portraits to avant-garde sculpture, from photography to some of the earliest examples of video art. The extensive, internationally recognized collection of ceramics spans ancient sculpture and Ming dynasty porcelain to contemporary works. The Everson's permanent collection and temporary exhibitions offer a thought-provoking look at art - from the traditional to the cutting edge.

Syracuse University - Joe and Emily Lowe Art Gallery

Syracuse University, Shaffer Art Building, Sims Drive, Syracuse, NY 13244-1230

Tel: (315) 443-3127

Internet Address: http://students.syr.edu:80/events/artsadv/lave/html

Director: Dr. Edward A. Aiken

Admission: free.

Established: 1952 *ADA Compliant:* Y

Open: **Academic Year**, Tuesday, noon-5pm; Wednesday, noon-8pm; Thursday to Sunday, noon-5pm. **Summer**, Tuesday to Friday, 2pm-4pm.

Closed: National Holidays, During Installations.

Facilities: **Galleries**; **Library** (30,000 volumes).

Activities: **Gallery Talks**; **Lectures**; **Temporary Exhibitions**; **Traveling Exhibitions**.

Publications: exhibition catalogues.

Centrally located in the Shaffer Art Building in the southeast corner of the main quadrangle on the campus of Syracuse University, the Gallery cooperates closely with the Syracuse University Art Collection, which contains more than 45,000 objects. Exhibitions from the Collection can be found in the Lowe and in the University Art Collection space immediately adjacent to the Gallery. (For further information regarding the University Art Collection, please call (315) 443-4097.) Also of possible interest is The Gallery, located on the second floor of Joseph I. Lubin House, which presents exhibitions of faculty and student art and selections from the University Art Collection.

Tarrytown

Historic Hudson Valley - Kykuit

150 White Plains Road, Tarrytown, NY 10591

Tel: (914) 631-8200

Fax: (914) 631-0089

TDDY: (800) 662-1220

Internet Address: http://www.hudsonvalley.org

Historic Hudson Valley - Kykuit, cont.

President and C.E.O.: Mr. John H. Dobkin
Admission: fee: adult-$18.00, student-$16.00, senior-$16.00.
Established: 1951 *Membership:* Y
Open: Call for hours.
Facilities: **Architecture** (Rockefeller house); **Gardens**; **Sculpture Garden**.

Situated above the Hudson River amidst terraces and gardens, Kykuit has been home to four generations of Rockefellers. Tours include the main floor of the house, the art galleries, and the gardens, which include former New York Governor Nelson A. Rockefeller's collection of 20th-century sculpture with works by Alexander Calder, Henry Moore, and Louise Nevelson among others. Visits to Kykuit are arranged through Historic Hudson Valley and originate at Philipsburg Manor on Route 9 in North Tarrytown, NY. Reservations are strongly recommended. Tours, lasting approximately two hours, include the main floor of the house, the art galleries and gardens. [Boat trips to Kykuit originating in Manhattan and New Jersey are available; for information call (800) 533-3779.]

Utica

Munson-Williams-Proctor Arts Institute - Museum of Art

310 Genesee St., Utica, NY 13502
Tel: (315) 797-0000
Fax: (315) 797-5608
TDDY: (315) 797-0000
Director: Dr. Paul D. Schweizer
Admission: voluntary contribution.
Attendance: 110,000 *Established:* 1919 *Membership:* Y *ADA Compliant:* Y
Parking: free on site.
Open: Tuesday to Saturday, 10am-5pm;
 Sunday, 1pm-5pm.
Closed: Legal Holidays.
Facilities: **Architecture** (Italianate mansion, 1850 design by William L. Woolett, Jr.; modernist museum, 1958-60 design by Philip Johnson); **Auditorium** (271 seat); **Children's Room**; **Galleries**; **Library** (24,000 volumes; Tues-Fri, 10am-5pm; Sat, 2pm-5pm); **Rental Gallery**; **Sculpture Courtyard**; **Shop** (handmade jewelry, fine art original & reproductions).
Activities: **Arts Festival**; **Concerts**; **Dance Recitals**; **Education Programs**; **Films**; **Gallery Talks**; **Guided Tours**; **Lectures**; **Performances**; **Temporary Exhibitions**; **Traveling Exhibitions**.

Interior view of Munson-Williams -Proctor Museum of Art. Photograph courtesy of Munson-Williams-Proctor Institute, Utica, New York.

Publications: exhibition catalogues.

Munson-Williams-Proctor is an internationally recognized fine arts center serving diverse audiences through three program divisions: Museum of Art, Performing Arts, and School of Art. The Museum of Art features 18th- and 19th-century American art; 20th-century American and European painting and sculpture; American, European, and Asian works on paper; and 19th-century American decorative arts. The Phillip Johnson-designed modernist main museum is linked by a connecting wing to "Fountain Elms", a mid-19th-century mansion, containing the Institute's furniture and decorative arts collection. The permanent collection totals 20,000 objects. Works by American artists include Ida Applebroog, Louise Bourgeois, Thomas Cole, John Singleton Copley, Katherine Driver, Mel Edwards,Helen Frankenthaler, Edward Hopper, Reginald Marsh, Georgia O'Keeffe, Jackson Pollock, Katherine Porter, Maurice Prendergast, Frank Stella, Bob Thompson, James McNeill Whistler, and Jerome Witkin; among the European artists represented are Giorgio de Chirico, Salvador Dali, Vasili Kandinsky, Paul Klee, Piet Mondrian, Henry Moore, and Pablo Picasso.

Woodstock

Center for Photography at Woodstock Galleries

59 Tinker St., Woodstock, NY 12498
Tel: (914) 679-9957
Fax: (914) 679-6337
Internet Address: http://www.cpw.org
Exec. Director: Ms. Colleen Kenyon
Admission: free.
Attendance: 50,000 *Established:* 1977
Open: Wednesday to Sunday, noon-5pm.
Facilities: **Darkroom; Exhibition Area, Library; Permanent Print Collection.**
Activities: **Artist-in-Residence Program; Educational Outreach; Fellowships; Lectures; Slide Registry; Workshops.**
Publications: "Photography Quarterly" (quarterly).

The Center provides educational and support services to photographers. Its galleries present a schedule of solo, group, and thematic exhibitions.

Woodstock Artists Association

28 Tinker St., Woodstock, NY 12498
Tel: (914) 679-2940
Fax: (914) 679-2940
Gallery Manager: Ms. Lisa Williams
Admission: suggested contribution-$2.00.
Attendance: 10,000 *Established:* 1920
Open: Monday, noon-5pm; Thursday to Sunday, noon-5pm.
Facilities: **Exhibition Area.**
Activities: **Temporary Exhibitions.**

Located in the center of the village, the WAA exhibits and collects work in all media by area artists. Each year the Association presents a schedule of concurrent solo and group exhibitions, juried and non-juried, of local artists. The Main Gallery features monthly group expositions of work by active members of the Association, the Downstairs Gallery mounts solo shows of contemporary artists, and the Tomlin Wing displays art from the permanent collection.

Yonkers

The Hudson River Museum

511 Warburton Ave., Yonkers, NY 10701-1899
Tel: (914) 963-4550
Fax: (914) 963-8558
Internet Address: http://www.hrm.org
Director: Mr. Philip Verre
Admission: fee: adult-$4.00, child-$3.00, senior-$3.00.
Attendance: 100,000 *Established:* 1919
Membership: Y *ADA Compliant:* Y
Parking: free on site.
Open: **October to April,**
 Wednesday to Sunday, noon-5pm.
 May to September,
 Wednesday to Thursday, noon-5pm;
 Friday, noon-9pm;
 Saturday to Sunday, noon-5pm.
Closed: New Year's Day, Easter Sunday, Memorial Day, Independence Day,
 Labor Day, Columbus Day, Thanksgiving Day, Christmas Day.

Interior view of Glenview's Great Hall (1876), designed by Charles Clinton. Photograph courtesy of Hudson River Museum, Yonkers, New York.

The Hudson River Museum, cont.

Facilities: **Architecture** (Victorian aesthetic movement mansion, 1876 design by Charles Clinton); **Auditorium** (300 seat); **Food Services** Hudson River Café (overlooking Hudson; lunch, snacks); **Galleries**; **Library**; **Planetarium**; **Sculpture Courtyard**; **Shop**.

Activities: **Concerts** (Summer Sounds Concerts, July); **Dance Recitals**; **Family Workshops**; **Guided Tours** (by appointment only); **Lectures**; **Temporary Exhibitions**; **Traveling Exhibitions**.

Publications: brochures; calendar, "Currents" (3/year); exhibition catalogues; newsletter.

A contemporary museum complex including a Victorian mansion overlooking the Hudson River and Palisades in northwest Yonkers, The Hudson River Museum interweaves themes of 19th- and 20th-century American art, history, and science. With a special emphasis on family programs, the Museum celebrates the artistic legacy and cultural diversity of the Lower Hudson River Valley using its extensive collection of paintings (including Hudson River landscapes), sculpture, decorative arts, costumes, and photographs. The Museum complex includes modern galleries, a National Register Site (Glenview Mansion), an education center, and a planetarium. The whimsical Red Grooms Gift Shop, constructed in 1979 by Pop Artist Red Grooms, is both art installation and retail shop.

North Carolina

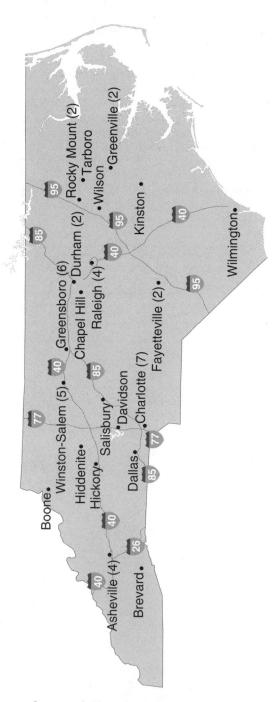

The number in parentheses following the city name indicates the number of museums/galleries in that municipality. If there is no number, one is understood. For example, in the text four listings would be found under Raleigh and one listing under Chapel Hill.

North Carolina

Asheville

Asheville Art Museum

2 S. Pack Square, Asheville, NC 28801

Tel: (828) 253-3227

Fax: (828) 251-5652

Internet Address: http://www.ashevilleart.org

Exec. Director and C.E.O.: Ms. Pamela L. Myers

Admission: fee: adult-$4.00, child-$3.00, student-$3.00, senior-$$3.00.

Attendance: 65,000 *Established:* 1948 *Membership:* Y *ADA Compliant:* Y

Parking: metered on street parking and convenient parking garages.

Open: Tuesday to Saturday, 10am-5pm; Sunday, 1pm-5pm.

Closed: New Year's Day, Independence Day, Labor Day, Thanksgiving Day, Christmas Day.

Facilities: **Architecture** (Beaux-Arts former library building, 1926); **Galleries** (8); **Shop** (exhibition-related books, prints, art); **Theatre** (520 seats).

Activities: **Education Programs** (adults and children); **Films** (Southern Circuit Film Series); **Guided Tours**; **Lectures**; **Temporary Exhibitions** (10-14/year).

Publications: newsletter, "Profile" (quarterly).

The Museum collects, preserves, and interprets 20th-century American art, with a focus on the Southeast, through a schedule of diverse exhibitions and programs. It is a collecting institution and currently has stewardship of 1,600 works of art, including paintings, prints, drawings, photographs, sculpture, and craft objects. In order to provide an overview of 20th-century American art, approximately 15% of its permanent collection is on view at all times. Special exhibitions highlight and juxtapose regional contributions. As one of five institutions in the Pack Place Education, Art and Science Center, the Museum initiates collaborations with the other partners, develops programs and utilizes common spaces, including a state-of-the-art theater, exterior courtyards, general purpose rooms and galleries. The collection contains examples of the Hudson River School, Luminism, Social Realism, Regionalism, and early Modernism, including paintings by James Chapin, Alexander Drysdale, J.J. Enneking, George Inness, George Luks, John Marin, D.W. Tryon, and Max Weber; and prints by Thomas Hart Benton, John Steuart Curry, Arthur B. Davies, and Grant Wood. Post World War II genres from Abstract Expressionism to Minimalism are represented with paintings by Arshile Gorky, Kenneth Noland, and Jules Olitski; a sculpture by Louise Nevelson; and prints by Helen Frankenthaler, Frank Stella, and Donald Sultan. Contemporary art is presented with a look at Conceptual Art, Pop Art, and the return to representation including works by Romare Bearden, Elizabeth Catlett, Jasper Johns, Alex Katz, Jacob Lawrence, Alice Neel, and Ed Ruscha.

Biltmore Estate and Garden

1 N. Pack Square, Asheville, NC 28801

Tel: (704) 255-1776

Fax: (704) 255-1111

Internet Address: http://www.biltmore.com

C.E.O.: Mr. William A.V. Cecil, Jr.

Admission: fee: adult-$30.00, child-$22.50.

Attendance: 720,000 *Established:* 1930

Membership: Y *ADA Compliant:* Y

Open: Daily, 9am-5pm.

Closed: Thanksgiving Day, Christmas Day.

Facilities: **Architecture** (Biltmore House, 1895); **Conservatory**; **Food Services** Restaurants (3); **Grounds** (8,000 acres); **Shops** (7); **Winery**.

Exterior view of Biltmore House (1895), designed by Richard Morris Hunt for George Vanderbilt. Photograph courtesy of Biltmore Estate, Asheville, North Carolina.

Biltmore Estate and Garden, cont

Activities: **Concerts** (Chamber Music, Summer Concert Series, & Winery Jazz Weekends); **Festival of Flowers** (spring); **Guided Tours** (Rooftop and Behind the Scenes); **Self-guided Tours**.
Publications: guidebook.

Biltmore Estate is a privately-owned, self sufficient estate - a leader in historic preservation through private enterprise. The 250-room house features carvings by Karl Bitter, portraits by John Singer Sargent, and works by Dürer and Renoir, as well as 16th-century Flemish tapestries.

Southern Highland Craft Guild (Folk Art Center)

Milepost 382, Blue Ridge Parkway
Asheville, NC 28805
Tel: (828) 298-7928
Fax: (828) 298-7962
Internet Address:
 http://www.southernhighlandguild.org
Exec. Director: Ms. Ruth Summers
Admission: voluntary contribution.
Attendance: 350,000 *Established:* 1930
Membership: Y *ADA Compliant:* Y
Parking: free on site.
Open: **January to March**, Daily, 9am-5pm.
 April to December, Daily, 9am-6pm.
Closed: New Year's Day, Thanksgiving Day,
 Christmas Day.

Exterior view of Folk Art Center. Photograph courtesy of Southern Highland Craft Guild, Asheville, North Carolina.

Facilities: **Auditorium**; **Galleries** (2); **Library** (2,000 volumes); **Shop** (books and crafts).
Activities: **Demonstrations** (April-December); **Lectures**.
Publications: newsletter, "Highland Highlights" (quarterly).

The Folk Art Center, the Guild's headquarters, provides educational opportunities through changing exhibitions of works by craftspeople from nine states, a craft library, craft demonstrations, and lectures. The Center houses two exhibition galleries. The Main Gallery features fine craft exhibitions of regional and national scope. The Focus Gallery represents the best of members' work, illustrating the diversity of styles and media within the Guild.

University of North Carolina at Asheville - Owen Galleries

Owen Hall, 1 University Heights, Asheville, NC 28804-3299
Tel: (828) 251-6559
Internet Address: http://www.unca.edu/art/gallery/gallery.html
Director, University Gallery: Mr. Robert Tynes
Admission: free.
Open: Weekdays, 9am-6pm.
Facilities: **Exhibition Area**.
Activities: **Temporary Exhibitions**.

Located on the main floor of Owen Hall, the Art Department's main gallery features, in addition to work by professional artists, solo exhibitions by BFA candidates, an annual juried student show, and an annual faculty exhibition. Also, the Second Floor gallery mounts BA candidate exhibitions and faculty-curated exhibitions of student course work. Also of possible interest on campus, Ramsey Library often displays the work of senior students, faculty, and visiting artists in its exhibition space.

Boone

Appalachian State University - Catherine J. Smith Gallery

Farthing Auditorium, 733 Rivers St., Boone, NC 28608
Tel: (828) 262-3017
Fax: (828) 262-6370
Internet Address: http://www.oca.appstate.edu/csg/
Gallery Director: Mr. Hank Foreman

Appalachian State University - Catherine J. Smith Gallery, cont.

Admission: free.
ADA Compliant: N
Parking: in front of building.
Open: **Academic Year**, Monday to Friday, 10am-5pm.
Closed: Academic Holidays.
Facilities: **Exhibition Area** (2 floors).
Activities: **Gallery Talks** (reserve in advance); **Guided Tours of campus sculpture** (reserve in advance); **Temporary Exhibitions** (monthly).
Publications: exhibition brochures; exhibition catalogue, "Rosen Outdoor Sculpture Competition and Exhibition" (annual).

Located in Farthing Auditorium, the Smith Gallery presents a schedule of exhibitions by locally, regionally, and nationally recognized artists. Annually, it hosts the Rosen Outdoor Sculpture Competition and Exhibition with works selected for the exhibition remaining on campus for one year. Tour maps for the outdoor sculpture on campus are available in the gallery. The Gallery also hosts the Halpert Biennial 2-D Competition and Exhibition. The permanent collection consists of 20th-century American works. Many of the two-dimensional works are on loan to various college offices and organizations, while the growing collection of permanent outdoor sculptures is sited around the campus. A new Visual Arts Center, which will include several galleries, is scheduled for opening in 2001.

Brevard

Brevard College - Spiers Gallery

Brevard College, Sims Art Center
400 N. Broad St.
Brevard, NC 28712
Tel: (704) 883-8292
Fax: (704) 884-3790
Internet Address: http://www.brevard.edu
Director: Tim Murray
Admission: free.
Attendance: 800
ADA Compliant: Y
Parking: free on site.
Open: **September to May**,
 Monday to Friday, 9am-3pm.
Closed: June to August,
 December 15 to January 15.

Exterior view of Sims Art Center (site of Spiers Gallery). Photograph courtesy of Spiers Gallery, Brevard College, Brevard, North Carolina.

Facilities: **Exhibition Area** (2,000 square feet).
Activities: **Arts Festival**; **Lectures**; **Musical Performances**; **Readings**; **Temporary Exhibitions**.
Publications: exhibition notices.

The Spiers Gallery at Brevard College presents temporary exhibitions of work from regional artists and Brevard College students. Works by Thomas Sully and Walter Darby Bannard are in the College's collection.

Chapel Hill

The University of North Carolina - Ackland Art Museum

Columbia and Franklin Sts., Chapel Hill, NC 27599-3400
Tel: (919) 966-5736
Fax: (919) 966-1400
TTY: (919) 962-0837
Internet Address: http://www.ackland.org
Director: Dr. Gerald D. Bolas
Admission: free.

Chapel Hill, North Carolina

The University of North Carolina - Ackland Art Museum, cont.

Attendance: 40,000　　*Established:* 1958　　*Membership:* Y　　*ADA Compliant:* Y
Parking: on street.
Open: Wednesday to Saturday, 10am-5pm; Sunday, 1pm-5pm.
Facilities: **Exhibition Area**; **Library** (39,000 volumes).
Activities: **Gallery Talks; Guided Tours; Lectures; Temporary Exhibitions.**
Publications: newsletter (quarterly).

The Museum's permanent collection includes European painting, Indian miniature paintings and sculpture, Japanese paintings, Chinese ceramics, Thai sculpture, African art, and contemporary American art. The Museum also mounts temporary exhibitions. Also of possible interest on campus are the John and June Allcott Gallery (962-2015), located in the Hanes Art Center; the Alumni Sculpture Garden; the Carolina Union Gallery (996-3834); and the General Administration Building Gallery (962-1000).

Emile Bernard, *Breton Woman and Haystacks*, Ackland Art Museum. Photograph courtesy of Ackland Art Museum, University of North Carolina, Chapel Hill, North Carolina.

Charlotte

Afro-American Cultural Center

401 N. Myers St., Charlotte, NC　28202
Tel: (704) 374-1565
Fax: (704) 374-9273
Interim Exec. Director: Mr. Harry Harrison
Admission: voluntary contribution.
Attendance: 30,000　　*Established:* 1974　　*Membership:* Y　　*ADA Compliant:* Y
Open: Tuesday to Saturday, 10am-6pm; Sunday, 1pm-5pm.
Closed: New Year's Day, Easter, Independence Day, Thanksgiving Day, Christmas Day.
Activities: **Education Programs.**

Located in a historic former church, the Afro-American Cultural Center is the region's showcase for African-American art, music, theater, film, and cultural education. The Center's permanent collection gallery displays African artifacts, and a second gallery features changing exhibitions of local, state, and national artists, and presents painting, sculpture, photography, and mixed-media shows. A particular emphasis of the temporary exhibits is their appeal to children.

Central Piedmont Community College - Pease Auditorium Art Gallery

Pease Building, 1201 Elizabeth Ave., Charlotte, NC　28204
Tel: (704) 330-2722　Ext. 3110
Internet Address: http://www..cpcc.cc.nc.us
Admission: free.
Open: Monday to Thursday, 11am-3pm; Friday, noon-2pm.
Facilities: **Gallery**.
Activities: **Lectures; Temporary Exhibitions.**

The CPCC Art Gallery exhibits works in a variety of media by students and professional artists. The gallery seeks to promote an understanding of and an appreciation for all areas of the visual arts as well as our multicultural society. Whenever possible, gallery lectures are scheduled concurrently with exhibitions.

The Light Factory

809 West Hill St., Charlotte, NC　28208
Tel: (704) 333-9755
Fax: (704) 333-5910
Internet Address: http://www.lightfactory.org/

The Light Factory, cont.

Exec. Director: Mr. Bruce Lineker

Admission: voluntary contribution.

Attendance: 25,000 *Established:* 1972

Membership: Y

Parking: free on site.

Open: Wednesday, 10am-6pm;
 Thursday, 10am-8pm;
 Friday, 10am-6pm;
 Saturday to Sunday, noon-6pm.

Facilities: **Galleries.**

Activities: **Temporary Exhibitions.**

Publications: newsletter, "Framework" (quarterly).

View of Light Factory installation, "A Delicate Balance: Six Israeli Photographers" (1996); from left works by, Judith Guetta, Michal Rovner, and Oded Yedaya. Photograph courtesy of Light Factory, Charlotte, North Carolina.

An artist-run, non-collecting organization, The Light Factory functions as a laboratory for the education about and presentation of photographic art and current issues. Its galleries offer presentations of both new art forms and historical works that often address aspects of race, ethnicity, gender and place. The Light Factory stimulates this dialogue about contemporary photography through exhibitions, lectures, symposia, classes and workshops. Its programs are provided for artists, arts professionals, students and the general public; many involve new techniques and technologies such as digital imaging, video and the Internet. The Light Factory's darkroom and classes also allow for hands-on experiences in making art.

Mint Museum of Art (Mint)

2730 Randolph Road, Charlotte, NC 28207

Tel: (704) 337-2000

Fax: (704) 337-2101

TDDY: (704) 337-2096

Internet Address: http://www.mintmuseum.org

C.E.O. and Director: Mr. Bruce H. Evans

Admission: fee (entry to both museums):
 adult-$6.00, child (<13)-free, student-$4.00, senior-$4.00.

Attendance: 130,000 *Established:* 1933

Membership: Y *ADA Compliant:* Y

Parking: free on site.

Open: Tuesday, 10am-10pm;
 Wednesday to Saturday, 10am-5pm;
 Sunday, noon-5pm.

Closed: New Year's Day, Thanksgiving Day,
 Christmas Eve to Christmas Day.

Exterior view of Mint Museum of Art. Photograph by John West, courtesy of Mint Museum of Art, Charlotte, North Carolina.

Facilities: **Architecture** (1st branch of U.S. Mint, 1836); **Auditorium** (180 seats); **Galleries** (22); **Library** (Tues-Fri, 10am-5pm; 14,000 volumes; non-circulating); **Picnic Area**; **Shop** (books, posters, jewelry, pottery).

Activities: **Concerts; Education Programs** (adults and children); **Films; Gallery Talks; Guided Tours** (daily, 2pm; groups reserve 4 weeks in advance, 337-2032); **Lectures; Temporary Exhibitions; Traveling Exhibitions.**

Publications: exhibition catalogues; newsletter, "Mint Museum Member News." (bi-monthly).

The Mint Museum of Art is a general art museum with holdings in European painting and American painting and decorative arts. Nationally regarded collection groups include pre-Columbian art, historic pottery and porcelain from China and the European continent, and North Carolina native pottery. The collection presentation focuses on the arts of the Americas, with influences from Europe, Asia, and Africa. The museum also mounts temporary exhibitions from its permanent collection and other institutions. The Mint Museum of Craft and Design is listed separately.

Mint Museum of Craft + Design

220 N. Tryon St., Charlotte, NC 28207
Tel: (704) 337-2000
Fax: (704) 337-2101
TDDY: (704) 337-2096
Internet Address: http://www.mintmuseum.org
C.E.O. and Director: Mr. Bruce H. Evans
Admission: fee (entry to both museums): adult-$6.00, child (<13)-free, student-$4.00, senior-$4.00.
Attendance: 110,000 *Established:* 1999 *Membership:* Y *ADA Compliant:* Y
Parking: free in the 7th St. Station parking deck (90 minutes).
Open: Tuesday to Thursday, 10am-7pm; Friday, 10am-9pm; Saturday, 10am-7pm;
 Sunday, noon-5pm.
Closed: New Year's Day, Thanksgiving Day, Christmas Eve to Christmas Day.
Facilities: **Exhibition Area**; **Shop** (books, posters, jewelry, pottery).
Activities: **Education Programs** (adults and children); **Guided Tours**; **Temporary Exhibitions**.
Publications: exhibition catalogues; newsletter, "Mint Museum Member News." (bi-monthly).

Housed in the renovated former Montaldo's department store, the Mint Museum of Craft + Design showcases the work of the designer or artist who both conceives and fabricates original and unique objects in the traditional craft media of ceramic, fiber, glass, metal, or wood. The Museum's permanent collection documents contemporary studio craft, tracing the movement's historical roots in the 19th century and its relationship to traditional decorative arts and industrial design. The Mint Museum of Art is listed separately above.

North Carolina Blumenthal Performing Arts Center (Spirit Square Center)

345 North College Street, Charlotte, NC 28202
Tel: (704) 333-4686
Fax: (704) 376-2289
Internet Address: http://www.performingartsctr.org
President: Ms. Judith Allen
Admission: free.
Attendance: 25,000 *Established:* 1976 *Membership:* N *ADA Compliant:* Y
Open: Tuesday to Friday, 11am-6pm; Saturday, 11am-5pm; Sunday, 1pm-4pm.
Facilities: **Galleries** (3); **Library**; **Studios** (13); **Theatres** (2; 700 seats and 180 seats).
Activities: **Education Programs**; **Temporary Exhibitions**.

Temporary exhibitions, usually lasting two months, of works by local, regional, and national artists are presented in three galleries.

University of North Carolina at Charlotte - UNC Charlotte Galleries

9201 University City Blvd., Charlotte, NC 28223
Tel: (704) 547-2473
Internet Address: http://www.uncc.edu
Director: Mr. Donald R. Byrum
Open: **Cone Center Gallery**,
 Monday-Friday, 9am-11pm; Saturday, noon-1am; Sunday, 1pm-11pm.
 Rowe Gallery,
 Call for hours..
Facilities: **Exhibition Area**.
Activities: **Temporary Exhibitions**.

Galleries are located on the first floor of Rowe Arts Center and in the Bonnie E. Cone University Center. The Cone Center Gallery exhibitions include art by regionally, nationally, and internationally recognized artists, as well as work by student, faculty, staff, and alumni. The Cone Center permanent collection is displayed throughout the building and in the C.A. McKnight interior lobby. The North Carolina Print Drawing Society's permanent collection is shown in the northwest lounge.

Dallas

Gaston County Museum of Art and History

131 W. Main St., Dallas, NC 28034
Tel: (704) 922-7681
Fax: (704) 922-7683
Director: Ms. Barbara Brose
Admission: voluntary contribution.
Attendance: 50,000 *Established:* 1975 *Membership:* Y *ADA Compliant:* Y
Parking: free on site.
Open: Tuesday to Friday, 10am-5pm; Saturday, 1pm-5pm; Sunday, 2pm-5pm.
Closed: Legal Holidays.
Facilities: **Architecture** (former Hoffman Hotel, 1852); **Galleries**; **Library** (350 volumes); **Reading Room**; **Sculpture Garden**; **Shop**.
Activities: **Education Programs** (adults and children); **Guided Tours**; **Lectures**; **Temporary/Traveling Exhibitions**.
Publications: newsletter (bi-monthly).

Located in the restored Hoffman Hotel on historic Dallas Courthouse Square, the Museum presents Victorian period rooms and changing exhibits of American art and history.

Davidson

Davidson College - William H. Van Every Gallery and Edward M. Smith Gallery

Davidson College Visual Arts Center, Main St. & Concord Rd, Davidson, NC 28036-1720
Tel: (704) 892-2344
Fax: (704) 892-2691
Internet Address: http://www.davidson.edu/academic/art/vac/ARTVAC.HTM
Director: Ms. Perry Nesbit
Admission: free.
Attendance: 12,000 *Established:* 1962 *ADA Compliant:* Y
Parking: free on site.
Open: **September to January**, Monday to Friday, 10am-4pm; Saturday to Sunday, 2pm-5pm.
Closed: Legal Holidays, Academic Holidays.
Facilities: **Galleries**.
Activities: **Gallery Talks**; **Lecture Series**; **Temporary Exhibitions**.

The work featured in the Van Every Gallery consists of contemporary art from throughout the United States, as well Davidson faculty work. In addition, selections from the College's permanent collection of 2,500 objects are shown occasionally in the space. The Edward M. Smith Gallery is used for one-person exhibitions required of every Davidson studio art major and for smaller temporary exhibitions.

Durham

Duke University Museum of Art

Buchanan Boulevard at Trinity Street, Durham, NC 27708
Tel: (919) 684-5135
Fax: (919) 681-8624
Internet Address: http://www.duke.edu/web/duma/
Director: Dr. Michael P. Mezzatesta
Admission: free.
Attendance: 30,000 *Established:* 1969 *Membership:* Y *ADA Compliant:* Y
Parking: free on site.
Open: Tuesday to Friday, 9am-5pm; Saturday, 11am-2pm; Sunday, 2pm-5pm.
Closed: Legal Holidays.

Duke University Museum of Art, cont.

Facilities: Galleries.

Activities: **Concerts**; **Films**; **Gallery Talks**; **Guided Tours** (Tues-Fri, between 9:30am and 4pm, reserve 3 weeks in advance); **Lectures**; **Performances**; **Readings**; **Temporary Exhibitions**.

Publications: exhibition catalogues; posters.

Since its founding in 1969, Duke University Museum of Art has assembled an impressive collection - from ancient to modern, from Old Master and American paintings to African, Asian, and contemporary Russian art. Highly regarded collection groups at the Museum include Medieval art and pre-Columbian art from Central and South America. Special exhibitions and programs complement the permanent collection.

Oleg Kudryashov, *Icon Composition*, 1994, drypoint, watercolor, 102 x 72 cm. Duke University Museum of Art. Photograph courtesy of Duke University Museum of Art, Durham, North Carolina.

North Carolina Central University - NCCU Art Gallery

Lawson St. (adjacent to Edwards Music Building.), Durham, NC 27707

Tel: (919) 560-6211

Fax: (919) 560-5012

Internet Address: http://www.nccu.edu

Director: Mr. Kenneth Rodgers

Admission: free.

Established: 1977 *Membership:* Y *ADA Compliant:* Y

Open: Tuesday to Friday, 9am-5pm; Sunday, 2pm-5pm.

Facilities: **Exhibition Area**.

Activities: **Education Programs** (undergraduate students); **Gallery Talks**; **Lectures**; **Temporary Exhibitions** (5/year); **Traveling Exhibitions**.

Publications: field guides.

The NCCU Art Museum presents temporary exhibitions and houses the University's growing art collection with selections on display in the Carol G. Belk Gallery. Primarily a teaching facility, the Gallery's collections and exhibitions are chosen to reflect diversity in style, technique, media, and subject. While focusing on American art, particularly works by African American artists, holdings also include works by European artists, traditional African objects, and some Oceanic examples.

Fayetteville

Arts Council of Fayetteville/Cumberland County (Arts Center)

301 Hay St., Fayetteville, NC 28301

Tel: (910) 323-1776

Fax: (910) 323-1727

Administrative Director: Ms. Violet Galloway

Admission: free.

Attendance: 50,000 *Established:* 1974 *ADA Compliant:* Y

Open: Monday to Thursday, 8:30am-5pm; Friday, 8:30am-noon; Saturday, 10am-2pm.

Closed: New Year's Day, Easter, Memorial Day, Independence Day, Labor Day, Thanksgiving Day, Christmas Day.

Facilities: **Architecture** (former post office (1910)); **Exhibition Area**.

Activities: **Artists In Schools Program**; **Arts Festival**; **Self-guided Tours**; **Temporary Exhibitions** (monthly).

The Arts Center is located in a former post office built in 1910 that is now on the National Register. It presents temporary exhibitions in two galleries and provides grants, programs, and services for the Fayetteville/Cumberland County area.

Fayetteville Museum of Art

839 Stamper Road, Fayetteville, NC 28303-0134
Tel: (910) 485-5121
Fax: (901) 485-5233
Internet Address: http://www.foto.com/community/fmastar
Exec. Director: Mr. Tom Grubb
Admission: voluntary contribution.
Attendance: 80,000 *Established:* 1971 *Membership:* Y *ADA Compliant:* Y
Parking: free on site.
Open: Monday to Friday, 10am-5pm; Saturday to Sunday, 1pm-5pm.
Closed: New Year's Day, ML King, Jr. Day, Easter, Memorial Day, Independence Day,
 Thanksgiving Day, December 16 to January 2.
Facilities: **Galleries**; **Garden** (6 acres); **Library**; **Sculpture Garden**; **Shop**.
Activities: **Arts Festival**; **Education Programs** (adults and children); **Lectures**; **Temporary Exhibitions**.
Publications: brochures; bulletin.

The permanent collection of the Museum includes two- and three-dimensional works primarily by contemporary North Carolina artists, as well as a collection of African art. The Museum also mounts approximately ten temporary exhibitions per year, focusing primarily on the work of contemporary North Carolina artists.

Greensboro

Green Hill Center for North Carolina Art

Greensboro Cultural Center, 200 N. Davie St. at Friendly St., Greensboro, NC 27401
Tel: (336) 333-7460
Fax: (336) 333-2612
Internet Address: http://www.ncart.org
Director: Ms. Jennifer Moore
Admission: suggested contribution-$2.00.
Attendance: 55,000 *Established:* 1974
Membership: Y *ADA Compliant:* Y
Parking: commercial adjacent to site.
Open: Tuesday, 10am-5pm;
 Wednesday, 10am-7pm;
 Thursday to Saturday, 10am-5pm;
 Sunday, 2pm-5pm.
Closed: Legal Holidays.
Facilities: **Galleries** (5, 10,000 square feet; plus ArtQuest Interactive Gallery); **Shop** (one-of-a-kind works by North Carolina artists).

View of gallery, Green Hill Center for North Carolina Art. Photograph courtesy of Green Hill Center for North Carolina Art, Greensboro, North Carolina.

Activities: **Education Programs** (adults, students and children); **Guided Tours** (333-1007); **Lectures**.
Publications: calendar; exhibition catalogues (occasional); newsletter (quarterly).

The mission of Green Hill Center is to present exhibitions that focus on North Carolina art and to promote art awareness through educational programs. Located in the Greensboro Cultural Center, it presents temporary exhibitions of the work of North Carolina artists, and in 1996 it opened an interactive art gallery for children.

Greensboro Artists' League Gallery

Greensboro Cultural Center, 200 N. Davie St. at Friendly St., Greensboro, NC 27401-2892
Tel: (910) 333-7485
Exec. Director: Ms. Susan Andrews
Admission: free.
Attendance: 90,000 *Established:* 1956 *Membership:* Y *ADA Compliant:* Y

Greensboro, North Carolina

Greensboro Artists' League Gallery, cont.
Open: Tuesday, 10am-5pm; Wednesday, noon-7pm; Thursday to Friday, 10am-5pm;
Saturday, noon-5pm; Sunday, 2pm-5pm.
Closed: Legal Holidays.
Facilities: Gallery; Sales Gallery.
Activities: Education Programs; Gallery
Talks; Juried Exhibits; Lectures.
Publications: newsletter, "Art Lines" (monthly).

The Greensboro Artists' League is a member-
ship organization open to any visual artist in
the Piedmont area. Located in the Greensboro
Cultural Center, the League mounts approxi-
mately ten exhibitions per year of the work of its
members and other artists, as well as numerous
educational and outreach programs and work-
shops. The Greensboro Artists' League is located
in the Greensboro Cultural Center. Also located in
the Center are the Green Hill Center for North
Carolina Art (see above) and a satellite gallery of
the Mattye Reed African Heritage Center.

View of gallery, Greensboro Artists' League. Photograph cour-
tesy of Greensboro Artists' League, Greensboro, North
Carolina.

Greensboro College - Irene Cullis Gallery
Cowan Building, 815 W. Market St., Greensboro, NC 27401-1875
Tel: (910) 272-7102
Internet Address: http://www.gborocollege.edu
Director: Mr. Robert Kowski
Admission: free.
Established: 1838 *ADA Compliant:* Y
Open: September to April, Monday to Friday, 10:30am-4pm; Sunday, 2pm-5pm.
Closed: Academic Holidays.
Facilities: Gallery.
Activities: Gallery Talks; Temporary Exhibitions.

Located in the Cowan Building on the Greensboro College Campus, the Gallery mounts six exhibi-
tions per year.

Guilford College Art Gallery
Hege Library, 5800 W. Friendly Ave., Greensboro, NC 27410
Tel: (336) 316-2438
Fax: (336) 316-2950
Internet Address:
http://www.guilford.edu/original/libraryart/artgallery
Director and Curator: Ms. Theresa N. Hammond
Admission: free.
Attendance: 6,000 *Established:* 1990
ADA Compliant: Y
Parking: free on site.
Open: Main Gallery (during academic year),
Monday to Friday, 9am-5pm;
Sunday, 2pm-5pm.
Closed: Academic Holidays.
Facilities: Exhibition Area (main enclosed gallery, 8 atrium
galleries; 3,500 square feet).

Jusepe de Ribera, *St. Jerome Hearing the Trumpet of the Last Judgement,* c.
1621, etching and engraving. Gift of Rachel and Allen Weller. Guilford College
Art Gallery. Photograph courtesy of Guilford College Art Gallery, Greensboro,
North Carolina.

Guilford College Art Gallery, cont.

Activities: **Guided Tours** (by appointment, 316-2438); **Temporary Exhibitions**.

Located in the Hege Library, the Guilford College Art Gallery houses a permanent collection consisting of more than 1,000 works by more than 450 artists. Although 20th-century American art is emphasized, the collection also includes works by Rembrandt, Picasso, and Dali, works from the Renaissance and Baroque periods, contemporary Polish etchings, and works by Josef and Anni Albers.

North Carolina A&T State University - Mattye Reed African Heritage Center

North Carolina A&T State University, 1601 E. Market St., Greensboro, NC 27411

Tel: (910) 334-7874

Internet Address: http://www.ncat.edu

Director and C.E.O.: Ms. Conchita F. Ndege

Admission: free.

Established: 1968 *Membership:* Y

Open: Monday to Friday, 9am-5pm.

Facilities: **Exhibition Area**; **Library** (1,200 volumes); **Reading Room**.

Activities: **Arts Festival**; **Education Programs** (college students and children); **Films**; **Guided Tours**; **Lectures**; **Temporary Exhibitions**; **Traveling Exhibitions**.

Publications: calendar; exhibition catalogues.

The Center has a long history of sponsoring events related to African culture. It presents exhibits drawn from its extensive collection of artifacts from Africa and its diaspora. It also presents traveling exhibits from other museums. The permanent collection includes of 3,500 artifacts from more than 30 African nations. The Center also mounts temporary exhibitions at a satellite gallery in the Greensboro Cultural Center located at 200 N. Davie Street at Friendly Street, Charlotte 27401 (open: Tuesday to Friday, 10am-5pm; Saturday to Sunday, 1pm-5pm; 334-7108). Also of possible interest on campus is the H.C. Taylor Gallery (334-7784).

University of North Carolina at Greensboro - Weatherspoon Art Gallery

University of North Carolina at Greensboro, Spring Garden and Tate St., Greensboro, NC 27412

Tel: (336) 334-5770

Fax: (336) 334-5907

Internet Address: http://www.uncg.edu/wag

Director: Ms. Nancy Doll

Admission: free.

Attendance: 23,000 *Established:* 1942

Membership: Y *ADA Compliant:* Y

Parking:
 free on site (request parking permit at Welcome Desk).

Open: Tuesday, 10am-5pm;
 Wednesday, 10am-8pm;
 Thursday to Friday, 10am-5pm;
 Saturday to Sunday, 1pm-5pm.

Closed: Academic Holidays.

Facilities: **Architecture** (designed by Romaldo Giurgola); **Galleries** (6); **Lecture Hall**; **Sculpture Courtyard**; **Shop** (limited edition prints, books, unique crafts).

Activities: **Education Programs** (undergraduate and graduate students); **Gallery Talks**; **Guided Tours** (1st Sun in month, 2pm; groups reserve 2 weeks in advance); **Lectures**; **Performances**; **Temporary Exhibitions**; **Traveling Exhibitions**.

Publications: bulletin (semi-annual); exhibition catalogues; newsletter.

Willem De Kooning, *Woman*, 1949-1950, oil on canvas. Lena Kernodle McDuffie Memorial Gift, 1954. Weatherspoon Art Gallery. Photograph courtesy of Weatherspoon Art Gallery, University of North Carolina, Greensboro, Greensboro, North Carolina.

University of North Carolina at Greensboro - Weatherspoon Art Gallery, cont.

Weatherspoon Art Gallery is the contemporary art museum of the University of North Carolina at Greensboro. Its permanent collection includes over 5,000 works by such 20th-century American artists as Calder, de Kooning, Nevelson, Rauschenberg, and Warhol; the Cone Collection of Henri Matisse prints and bronzes; the Dillard Collection of works on paper; and the Lenoir C. Wright Collection of traditional Japanese woodblock prints and scroll paintings. A series of temporary exhibitions by professional artists, faculty and students is mounted in six galleries in the facility.

Greenville

East Carolina University - Wellington B. Gray Gallery

East Carolina University, Jenkins Fine Art Center, Elm & 10th Streets, Greenville, NC 27858-4353
Tel: (919) 328-6336
Fax: (919) 328-6441
Internet Address: http://www.ecu.edu/art/home.html
Director: Mr. Gilbert Leebrick
Admission: free.
Attendance: 23,000 *Established:* 1978 *ADA Compliant:* Y
Parking: free on site with pass.
Open: Monday to Wednesday, 10am-5pm; Thursday, 10am-8pm; Friday, 10am-5pm;
 Saturday, 10am-3pm.
Closed: Academic Holidays.
Facilities: **Exhibition Area** (6,000 square feet); **Sculpture Garden**.
Activities: **Films**; **Gallery Talks**; **Lectures**; **Temporary Exhibitions**; **Traveling Exhibitions**.
Publications: exhibition catalogues.

The Gallery has an extensive collection of African art. It also mounts temporary exhibitions of the work of students, faculty, and artists from outside the school community.

Greenville Museum of Art

802 S. Evans St., Greenville, NC 27834
Tel: (919) 758-1946
Internet Address: http://gma.greenvillenc.com
C.E.O. and Director: C. Barbour Strickland, III
Admission: voluntary contribution.
Attendance: 30,000 *Established:* 1956 *Membership:* Y *ADA Compliant:* Y
Parking: free on site.
Open: Tuesday to Friday, 10am-4:30pm; Sunday, 1pm-4pm.
Closed: Legal Holidays.
Facilities: **Galleries** (6); **Studios**.
Activities: **Concerts**; **Education Programs**; **Gallery Talks**; **Performances**.
Publications: booklet, "A Visit to the GMA"; brochures, "First Look"; exhibition announcements (monthly); newsletter (quarterly).

The Greenville Museum of Art houses a collection of American art, including works by Henri, Nevelson, Shahn, and Soyer.

Hickory

The Hickory Museum of Art

Arts and Science Center of Catawba Valley, 243 3rd Ave., N.E., Hickory, NC 28601
Tel: (704) 327-8576
Fax: (704) 327-7281
C.E.O. and Director: Mr. Arnold Cogswell, Jr.
Admission: fee: adult-$2.00, child(<12)-free, student-$1.00, senior-$1.00.
Attendance: 80,000 *Established:* 1944 *Membership:* Y *ADA Compliant:* Y
Parking: free on site.

The Hickory Museum of Art, cont.

Open: Tuesday to Wednesday, 10am-5pm;
 Thursday, 10am-8pm;
 Friday, 10am-5pm;
 Saturday, 10am-4pm;
 Sunday, 1pm-4pm.

Closed: New Year's Day, Easter, Independence
 Day, Thanksgiving Day, Christmas Day.

Facilities: **Galleries** (10); **Garden**; **Library**
 (1,200 volumes); **Sculpture Garden**; **Shop**
 (books, posters, pottery).

Activities: **Films**; **Gallery Talks**; **Guided
 Tours**; **Lectures**; **Temporary Exhibitions**.

Publications: calendar; collection catalogue;
 exhibition announcements; exhibition cata-
 logues; newsletter (quarterly).

Interior view, Mildred Coe Gallery, Hickory Museum of Art.
Photograph courtesy of Hickory Museum of Art, Hickory,
North Carolina.

The Hickory Museum of Art collects and exhibits primarily 19th- and 20th-century American art and also has a small amount of Oriental and European art objects for comparison. Represented in the permanent collection are works by Gilbert Stuart, Thomas Cole, Asher B. Durand, J. Frederick Kensett, and William Merritt Chase. The Museum also presents temporary exhibitions of works by contemporary artists and collections on loan from other institutions.

Hiddenite

Hiddenite Center, Inc.

313 Church St., Hiddenite, NC 28636

Tel: (828) 632-6966

Fax: (828) 632-3783

Exec. Director: Mr. dwaine c. coley

Admission: fee:
 adult-$2.50, student-$1.50, senior-$1.50.

Attendance: 55,000 *Established:* 1981

Membership: Y *ADA Compliant:* Y

Parking: adjacent to building.

Open: Monday to Friday, 9am-4:30pm;
 Saturday to Sunday, 2pm-4:30pm.

Closed: Easter Sunday, Independence Day,
 Labor Day, Thanksgiving Day,
 Christmas Day.

Exterior view of Hiddenite Center. Photograph by Glenn Fox,
courtesy of Hiddenite Center, Hiddenite, North Carolina.

Facilities: **Auditorium** (250 seat); **Exhibition Area**; **Shop**; **Theatre**.

Activities: **Arts Festival**; **Concerts** (outdoor); **Dance Recitals**; **Education Programs** (adults and children); **Guided Tours** (of 1st floor only); **Lectures**; **Performances**; **Temporary Exhibitions**.

Publications: newsletter, "Friendsletter" (monthly).

The Center, located in the former Lucas Mansion, a turn-of-the-century Victorian home, was established to preserve local history and culture. The second floor of the Center is a gallery in which temporary art exhibits are presented. The third floor houses an extensive doll collection.

Kinston

Community Council for the Arts

400 N. Queen St., Kinston, NC 28501

Tel: (919) 527-2517

Exec. Director: Mrs. Sandy Landis

Admission: free.

Established: 1965 *Membership:* Y *ADA Compliant:* Y

Open: Tuesday to Friday, 10am-6pm; Saturday, 10am-2pm.

Kinston, North Carolina

Community Council for the Arts, cont.

Closed: Legal Holidays.

Facilities: **Children's Gallery; Galleries** (4);
Meeting Room; Sculpture Garden; Shop.

Activities: **Guided Tours** (upon request);
Juried Exhibits; Temporary Exhibitions.

Publications: newsletter, "Kaleidoscope" (bi-monthly).

The Center maintains six separate gallery spaces and one outdoor sculpture garden. Each gallery houses temporary exhibitions that change about every six weeks.

Exterior view of Community Council for the Arts. Drawing courtesy of Community Council for the Arts, Kinston, North Carolina.

Raleigh

The Contemporary Art Museum

P.O. Box 66, Raleigh, NC 27602

Tel: (919) 836-0088

Fax: (919) 836-2239

Internet Address: http://www.camnc.org

Exec. Director: Ms. Denise N. Dickens

Admission: voluntary contribution.

Attendance: 60,000 *Established:* 1983 *Membership:* Y *ADA Compliant:* Y

Open: Call for hours and locations.

Facilities: **Exhibition Area.**

Activities: **Education Programs; Temporary/Traveling Exhibitions.**

Publications: exhibition catalogues.

The Contemporary Art Museum is a non-collecting museum, its mission is to display the visual arts of the present and recent past; to document new directions in art through changing exhibitions and publication; to engage the public in a dialogue; and to encourage a greater understanding of contemporary art through educational programs. Supporting new and innovative works by regional, national, and international artists and designers, the Museum presents and interprets contemporary art and design through a schedule of diverse exhibitions that explore aesthetic, cultural, and ideological issues. Currently the Museum does not have a permanent display space, but mounts exhibitions at a variety of venues. A new building, located at 409 W. Martin Street, is scheduled for completion in 2001.

Meredith College - Art Galleries

Gaddy-Hamrick Art Center, 3800 Hillsborough St.
Raleigh, NC 27607-5298

Tel: (919) 829-8465

Fax: (919) 829-2347

Internet Address: http://www.meredith.edu

Director: Ms. Maureen Banker

Admission: free.

Established: 1891

Parking: free on site.

Open: Monday to Friday, 9am-5pm; Saturday to Sunday, 2pm-5pm.

Facilities: **Galleries** (2; Weems Gallery 1,320 square feet).

Activities: **Juried Exhibits; Temporary Exhibitions.**

Exterior view of the Gaddy-Hamrick Art Center, which houses the Frankie G. Weems Gallery. Photograph courtesy of Meredith College, Raleigh, North Carolina.

Meredith College - Art Galleries, cont.

The College presents a schedule of temporary exhibitions of work by professional artists, faculty, alumna, and students in two galleries: Frankie G. Weems Gallery, located in the Gaddy-Hamrick Art Center, and Rotunda Gallery, located the administration building. Annual exhibitions include North Carolina Photographers Exhibition, Raleigh Fine Arts Society Juried Exhibition, and Juried Student Exhibition.

North Carolina Museum of Art

2110 Blue Ridge Road, Raleigh, NC 27607-6494

Tel: (919) 839-6262

Fax: (919) 733-8034

Internet Address:
 http://www.ncartmuseum.com

Director: Dr. Lawrence J. Wheeler

Admission: free.

Attendance: 250,000 *Established:* 1956

Membership: Y *ADA Compliant:* Y

Parking: free on site.

Open: Tuesday to Thursday, 9am-5pm;
 Friday, 9am-9pm;
 Saturday, 9am-5pm;
 Sunday, 11am-6pm.

Closed: New Year's Day, Independence Day, Thanksgiving Day, Christmas Eve, Christmas Day.

Aerial view of Museum Park at North Carolina Museum of Art, November 4, 1997. Photograph courtesy of North Carolina Museum of Art, Raleigh, North Carolina.

Facilities: **Food Services** Blue Ridge: The Museum Restaurant (Tues-Fri, 11:30am-2:30pm; Fri, 5:30pm-8:30pm: Sat-Sun 11am-3pm); **Galleries** (180,000 square feet); **Library** (16,500 volumes); **Sculpture Garden**; **Shop** (books, posters, jewelry, toys).

Activities: **Concerts**; **Films**; **Guided Tours** (Tues-Sun, 1:30pm; groups, reserve 3 weeks in advance); **Lectures**; **Temporary Exhibitions**; **Workshops**.

Publications: brochures; bulletin, "NCMA Calendar"; collection catalogue; exhibition catalogues; magazine.

The North Carolina Museum of Art is housed in a structure designed by Edward Durrell Stone and completed in 1983. The permanent collection of the Museum includes Egyptian and Roman art, Renaissance painting (works by Botticelli and Raphael), European painting (works by Rubens and van Dyck), American painting (works by Homer and O'Keeffe), and contemporary art. There are also African, New World, and Oceanic collections, and a Judaic Gallery. Each year, the Museum hosts several major traveling exhibitions.

North Carolina State University - The Gallery of Art & Design

Talley Student Center, Cates Ave., Raleigh, NC 27695

Tel: (919) 515-3503

Fax: (919) 515-6163

Internet Address: http://ACS.NCSU.edu/visual art/

Director: Dr. Charlotte V. Brown

Admission: free.

Attendance: 26,000 *Established:* 1979

Membership: Y *ADA Compliant:* Y

Parking: free on site.

Open: Wednesday to Friday, noon-8pm;
 Saturday to Sunday, 2pm-8pm.

Closed: Academic Holidays.

Facilities: **Auditorium**; **Exhibition Area** (2 galleries); **Food Services** Cafeteria; **Theatre**.

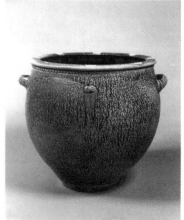

Mark Hewitt, *Chub*, 1994, Two-handled planter, alkaline glaze. Gallery of Art and Design. Photograph by R. Jackson Smith, courtesy of Gallery of Art and Design, North Carolina State University, Raleigh, North Carolina.

North Carolina State University - The Gallery of Art & Design, cont.

Activities: **Education Programs** (graduate and undergraduate students); **Guided Tours** (on request); **Temporary Exhibitions**; **Traveling Exhibitions**.

Publications: exhibition catalogues.

The Gallery of Art and Design produces a series of exhibitions bringing regional, national and international design to the campus. The Gallery is also responsible for the development, conservation, and presentation of North Carolina State University's collections of architectural drawings and works on paper, ceramics, paintings, photography, textiles and furniture. Notable holdings include extensive collections of textiles (American, Asian, European, historical, contemporary), ceramics (19th- and 20th-century American and international pottery), photography (Adams, Abbot, Arbus, Bourke-White, Mapplethorpe), and outsider art (Hooper, Burwell, Blizzard).

Rocky Mount

North Carolina Wesleyan College - Art Galleries

3400 N. Wesleyan Blvd., Rocky Mount, NC 27804

Tel: (252) 985-5268

Internet Address: http://www.ncwc.edu

Curator, Lynch Collection: Mr. Everett Adelman

Admission: free.

Open: **Mimms Gallery**, Monday to Friday, 9am-5pm & 1 hour before performances.

 Four Sisters Art Gallery, Monday to Friday, 9am-5pm, Saturday, 9am-noon.

Facilities: **Exhibition Area** (2 galleries).

Activities: **Permanent Exhibits**; **Temporary Exhibitions**.

The College maintains two galleries. Located in the Dunn Center for the Performing Arts, the Mims Gallery presents temporary exhibitions of contemporary art. The Four Sisters Art Gallery, located in the Thomas J. Pearsall, Jr. building, is dedicated to displaying the Robert Lynch Collection of Outsider Art, and the College's Pre-Columbian Art Collection. The Lynch Collection consists of over 130 pieces of folk art created by artists from eastern North Carolina. Donated by the Wesleyan Archaeological Society, the Pre-Columbian collection contains over 600 artifacts from a variety of North and South American native cultures.

Rocky Mount Arts Center

1173 Nashville Road, Rocky Mount, NC 27803

Tel: (919) 972-1163

Fax: (919) 972-1163

Director: Ms. Marlene Payne

Admission: free.

Attendance: 35,000 *Established:* 1956 *Membership:* Y *ADA Compliant:* Y

Open: Monday to Friday, 8:30am-5pm.

Closed: New Year's Day, Memorial Day, Labor Day, Christmas Day.

Facilities: **Auditorium** (110 seats); **Gallery**; **Theatre** (300 seats).

Activities: **Arts Festival**; **Concerts**; **Education Programs** (adults and children); **Films**; **Gallery Talks**; **Guided Tours**; **Lectures**; **Performances**; **Temporary Exhibitions**; **Traveling Exhibitions**.

Publications: newsletter, "Arty Facts".

Located in a converted railroad pumping station and water storage tank, the Rocky Mount Arts Center mounts temporary exhibitions in its four galleries. The works exhibited are varied: student art, photography, area artists' work, and traveling exhibitions.

Salisbury

Waterworks Visual Arts Center

1 Water St., Salisbury, NC 28144-4261

Tel: (704) 636-1882

Fax: (704) 636-1892

Internet Address: http://www.waterworks.org.

Waterworks Visual Arts Center, cont.

Internet Address: http://www.waterworks.org.
Exec. Director: Ms. Denny Mecham
Admission: voluntary contribution.
Attendance: 30,000 *Established:* 1959
Membership: Y *ADA Compliant:* Y
Open: Monday to Friday, 9am-5pm;
 Saturday, 10am-4pm; Sunday, 1pm-4pm.
Closed: New Year's Day, Independence Day,
 Labor Day, Thanksgiving Day,
 Christmas Eve to Christmas Day.
Facilities: **Architecture** (former waterworks,
 1913); **Galleries** (4); **Library** (1,000 vol-
 umes); **Sensory Garden.**
Activities: **Education Programs** (adults, spe-
 cial populations and children); **Gallery
 Talks**; **Guided Tours** (upon request);
 Lectures.

Exterior view of Waterworks Visual Arts Center. Photograph courtesy of Waterworks Visual Arts Center, Salisbury, North Carolina.

Publications: exhibition catalogues.

The Center presents 15-20 exhibitions per year in all media in four galleries. In addition, the Center maintains a sensory garden for the visually impaired as well as the general public.

Tarboro

Blount-Bridgers House/Hobson Pittman Memorial Gallery

130 Bridgers St., Tarboro, NC 27886
Tel: (252) 823-4159
Fax: (252) 823-6190
Internet Address: http://www2.coastalnet.com/~g3f3w5rm
Director: Ms. Meade B. Horne
Admission: fee-$2.00.
Attendance: 8,000 *Established:* 1982 *Membership:*
Y *ADA Compliant:* Y
Parking: free on street.
Open: Monday to Friday, 10am-4pm;
 Saturday to Sunday, 2pm-4pm.
Closed: New Year's Day, Good Friday, Easter, Memorial Day,
 Independence Day, Labor Day, Thanksgiving Day,
 Christmas Day.

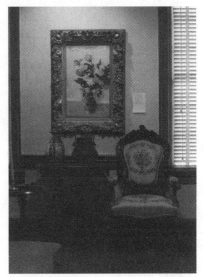

Facilities: **Architecture** (plantation house, 1808); **Exhibition
 Area** (3,400 square feet); **Library** (1,000 volumes); **Shop.**
Activities: **Arts Festival** (1st Sundays in May & November);
 Education Programs (adults and children); **Guided
 Tours**; **Lectures**; **Permanent Exhibitions**; **Temporary
 Exhibitions.**
Publications: annual report; brochures; newsletter; book,
 "The Poet's Palette, Selected Works by Hobson Pittman".

Floral still life painting by Hobson Pittman, shown with 19th-century decorative arts. Blount-Bridgers House. Photograph courtesy of Blount-Bridgers House, Tarboro, North Carolina.

The Blount-Bridgers House is an early 19th-century plantation house that has been restored adaptively, to serve as a community arts center, art museum, and as a museum of local history and decorative arts. The museum houses a collection of American 19th- and 20th- century paintings, drawings, and prints as well as decorative arts. The most important group of objects in the collection is a body of work by native artist Hobson Pittman (1899-1972), who was on the faculty of the Pennsylvania Academy of Fine Arts.

Wilmington

St. John's Museum of Art

114 Orange St. at 2nd St., Wilmington, NC 28401
Tel: (910) 763-0281
Fax: (910) 341-7981
Internet Address: http://www.stjohnsmuseum.com
Director: C. Reynolds Brown
Admission: fee: adult-$3.00, child-$1.00.
Attendance: 48,000 *Established:* 1962 *Membership:* Y *ADA Compliant:* Y
Parking: on street.
Open: Tuesday to Saturday, 10am-5pm; Sunday, noon-4pm.
Facilities: **Architecture** (former Masonic Lodge, 1804-1805); **Galleries**; **Gardens**; **Library**; **Shop**.
Activities: **Concerts**; **Education Programs** (adults and children); **Films**; **Gallery Talks**; **Guided Tours**; **Lectures**; **Temporary Exhibitions**.
Publications: calendar, "St. John's Calendar"; exhibition catalogues.

St. John's Museum of Art is dedicated to collecting, preserving, and exhibiting North Carolina art. In addition, its American collection features works by Henry Bacon, Romare Bearden, Mary Cassatt, and Daniel Chester French.

Wilson

Barton College - Barton Museum

Barton College, Whitehead and Woodard Sts., Wilson, NC 27893
Tel: (919) 399-6477
Internet Address: http://www.barton.edu
Director: Mr. J. Chris Wilson
Admission: free.
Established: 1965 *ADA Compliant:* Y
Parking: free on site.
Open: **September to May**, Monday to Friday, 10am-3pm.
Closed: Spring Recess, Thanksgiving Holiday, Christmas Holiday.
Facilities: **Exhibition Area**; **Library** (4,000 volumes).
Activities: **Education Programs** (undergraduates); **Gallery Talks**; **Lectures**; **Scholastic Art Awards for Eastern North Carolina**; **Temporary Exhibitions**.
Publications: exhibition announcements, exhibition catalogues; gallery guides.

The Museum mounts about eight exhibitions per year, focusing on important regional artists. The Museum also has a permanent collection, which is periodically displayed.

Winston-Salem

Museum of Early Southern Decorative Arts (MESDA)

924 S. Main St., Winston-Salem, NC 27101
Tel: (336) 721-7360
Fax: (336) 721-7367
Internet Address: http://www.mesda.org
President: Mr. Hobart Cawood
Admission: fee: adult-$10.00, child-$6.00.
Attendance: 16,000 *Established:* 1965 *Membership:* Y *ADA Compliant:* Y
Parking: free on site.
Open: Monday to Saturday, 9:30am-3:45pm; Sunday, 1:30pm-3:45pm.
Closed: Thanksgiving Day, Christmas Eve to Christmas Day.
Facilities: **Auditorium**; **Galleries** (6); **Library**; **Period Rooms** (24); **Research Center**; **Shop**.

Museum of Early Southern Decorative Arts, cont.

Activities: **Education Programs** (adults and students); **Guided Tours** (Mon-Sat, 9:30am-3:30pm; Sun, 1:30pm-3:30pm); **Lectures**; **Temporary Exhibitions**.

Publications: books, " Frank L. Horton Book Series"; collection catalogue, "The Regional Arts of the Early South"; journal, "Journal of Early Southern Decorative Arts"; newsletter, "The Luminary".

The MESDA is dedicated to exhibiting the regional decorative arts of the early South. With more than twenty period rooms and six galleries, MESDA showcases the furniture, paintings, textiles, ceramics, silver, and other metalwares made and used in Maryland, Virginia, the Carolinas, Georgia, Kentucky, and Tennessee through 1820.

Charles Willson Peale, *Mrs. George Grundy*, 1789, oil on canvas. Collection of and photograph courtesy of Museum of Early Southern Decorative Arts, Winston-Salem, North Carolina.

Reynolda House, Museum of American Art

2250 Reynolda Road, Winston-Salem, NC 27106

Tel: (336) 725-5325

Fax: (336) 721-0991

Internet Address: http://www.reynoldahouse.org

Admission: fee:
 adult-$6.00, student-$3.00, senior-$5.00.

Attendance: 55,000 *Established:* 1967

Membership: Y *ADA Compliant:* Y

Parking: free on site.

Open: Tuesday to Saturday, 9:30am-4:30pm; Sunday, 1:30pm-4:30pm.

Closed: New Year's Day, Thanksgiving Day, Christmas Day.

Facilities: **Architecture** (house designed by Charles Barton Keen, 1917); **Botanical Gardens**; **Library**; **Shop**.

Activities: **Arts Festival**; **Concerts**; **Education Programs** (adults, college students and children); **Films**; **Guided Tours**; **Lectures**; **Performances**; **Temporary Exhibitions**.

Exterior view of Reynolda House. Photograph courtesy of Reynolda House Museum of American Art, Winston-Salem, North Carolina.

Publications: calendar (quarterly); newsletter.

Reynolda House was built between 1912 and 1917 by R.J. Reynolds, founder of the R.J. Reynolds Tobacco Company. Recently named to the National Register of Historic Places, the house adjoins formal gardens and the estate's support buildings, now converted to specialty shops and restaurants. The Museum houses an important collection of 18th-, 19th-, and 20th-century American paintings, prints, and sculptures, including works by Copley, Stuart, Church, Cassatt, Eakins, Wyeth, and Lawrence.

Southeastern Center for Contemporary Art (SECCA)

750 Marguerite Drive, Winston-Salem, NC 27106

Tel: (336) 725-1904

Fax: (336) 722-6059

Internet Address: http://www.secca.org

Director: Ms. Michele Rowe-Shields

Winston-Salem, North Carolina

Southeastern Center for Contemporary Art, cont.

Admission: fee: adult-$3.00, student-$2.00.

Established: 1956 *Membership:* Y *ADA Compliant:* Y

Parking: free on site.

Open: Tuesday to Saturday, 10am-5pm; Sunday, 2pm-5pm.

Closed: Legal Holidays.

Facilities: **Auditorium**; **Galleries**; **Library**; **Picnic Area**; **Wooded Grounds with Sculpture Sites** (32 acres).

Activities: **Education Programs** (adults and children); **Films**; **Guided Tours**; **Lectures**; **Performances**.

Publications: exhibition catalogues; gallery guides; newsletter (quarterly).

SECCA occupies a 32-acre former estate. With 39,000 square feet of exhibition space, the Center focuses on temporary exhibitions of nationally recognized contemporary artists.

Wake Forest University Fine Arts Gallery

Wake Forest University, Scales Fine Art Center, Wake Forest Road, Winston-Salem, NC 27109

Tel: (336) 758-5795

Fax: (336) 758-6014

Internet Address: http://www.wfu.edu/academic-departments/art/gall_index.html

Director: Mr. Victor Faccinto

Admission: free.

Attendance: 6,500 *Established:* 1976 *Membership:* N *ADA Compliant:* Y

Parking: directly behind Fine Arts Center, entrance off Allen Easley Street.

Open: **September to May**,
 Monday to Friday, 10am-5pm;
 Saturday to Sunday, 1pm-5pm.

Closed: Academic Holidays.

Facilities: **Exhibition Area** (3,600 square feet).

Activities: **Lectures**; **Temporary Exhibitions** (approximately 8/year); **Traveling Exhibitions**.

Publications: exhibition catalogues.

The Fine Arts Gallery at Wake Forest is located in the theater lobby on the first floor of the Scales Fine Arts Center. The Gallery mounts temporary exhibitions. In addition there are six permanent collections at the University, but they are spread among twenty-six buildings on campus.

Exterior view of Scales Fine Arts Center (1976), designed by Caudill Rowlett Scott. Photograph courtesy of Wake Forest University, Winston-Salem, North Carolina.

Winston Salem State University - Diggs Gallery

601 Martin Luther King Jr. Drive, Winston-Salem, NC 27110

Tel: (336) 750-2458

Fax: (336) 750-2463

Internet Address: http://www.wssu.edu/diggs/home.htm

Director & Curator: Ms. Belinda A. Tate

Admission: voluntary contribution.

Attendance: 15,000 *Established:* 1990 *Membership:* N *ADA Compliant:* Y

Parking: free on site.

Open: Tuesday to Saturday, 11am-5pm.

Closed: ML King Jr. Day, Good Friday, Memorial Day, Independence Day, Labor Day, Veterans Day, Thanksgiving Day, Christmas Day to New Year's Day.

Facilities: **Exhibition Area** (6,000 square feet); **Library**.

Activities: **Concerts** (20-25 per year); **Education Programs** (adults, college students and children); **Films**; **Guided Tours** (schedule in advance); **Lectures**; **Temporary Exhibitions** (6/year); **Traveling Exhibitions** (6/year).

Publications: exhibition catalogues.

Winston Salem State University - Diggs Gallery, cont.

The Diggs Gallery offers ten to fifteen visual art exhibitions per year, half of which are curated by and originate from Winston-Salem State University. The exhibitions cover a broad range of artistic expression, with special concentration on African, African-American, and regional art. Visitors should also see the murals of John Biggers in the O'Kelly Library and the sculpture garden, boasting works by Mel Edwards, Beverly Buchanan, Tyrone Mitchell, and Dennis Pacock.

Tyrone Mitchell, *Po Tolo*, 1985, stone, steel, and granite, 8 feet x 40 feet. Funded by National Endowment for the Arts and Gordon Hanes. Diggs Gallery. Photograph by Richard Hackel, courtesy of Diggs Gallery at Winston-Salem State University, Winston-Salem, North Carolina.

North Dakota

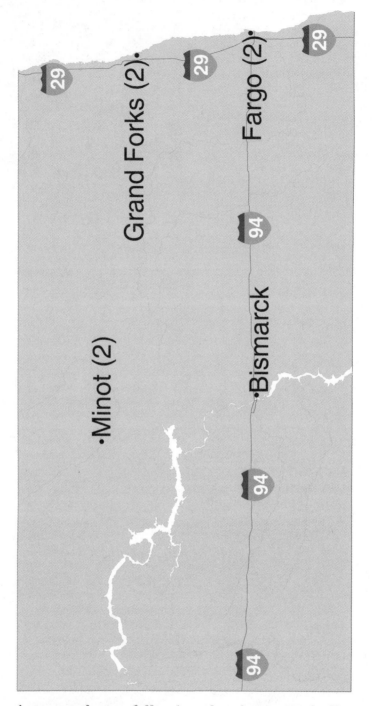

The number in parentheses following the city name indicates the number of museums/galleries in that municipality. If there is no number, one is understood. For example, in the text two listings would be found under Minot and one listing under Bismarck.

North Dakota

Bismarck

Bismarck State College - Clell and Ruth Gannon Gallery

1500 Edwards Ave., Bismarck, ND 58501
Tel: (701) 224-5520
Fax: (701) 224-5550
Internet Address: http://www.bsc.nodak.edu/Library/Libgann.htm
Director: Ms. Michelle Lindblom
Admission: free.
Established: 1981
Open: Call for hours.
Facilities: Exhibition Area.
Activities: Temporary Exhibitions.

Located in the study, periodicals, and reference areas of the BSC Library, the Gallery presents temporary art exhibits ranging from traveling exhibits of works by nationally known artists to shows by local and regional artists and exhibits of student works.

Fargo

North Dakota State University Memorial Union Art Gallery

Memorial Union, North Dakota State University, 1301 N. University, Fargo, ND 58105
Tel: (701) 231-8239
Fax: (701) 231-8043
Internet Address: http://www.ndsu.nodak.edu/memorial_union/gallery
Visual Arts and Gallery Coordinator: Peg Furshong
Admission: free.
Attendance: 7,200 *Established:* 1975 *ADA Compliant:* Y
Parking: visitor lot at south entrance.
Open: **September to May 14**,
 Monday to Thursday, 9:30am-6pm; Friday, 9:30am-noon; Sunday, 5:30pm-9pm
 .**May 15-July 15**,
 Monday to Friday, 10am-2pm
Closed: Legal Holidays.
Facilities: Exhibition Area (1,000 square feet).
Activities: **Concerts; Gallery Talks; Guided Tours; Lectures; Readings; Temporary Exhibitions; Traveling Exhibitions**.
Publications: calendar (biennial); exhibition notifications; postcards.

The Gallery houses a permanent collection of 350 pieces, primarily American contemporary art. The Gallery also mounts temporary exhibitions.

Plains Art Museum

704 First Avenue North, Fargo, ND 58102
Tel: (701) 232-3821
Fax: (701) 293-1082
Exec. Director: Ben Clapp
Admission: fee: adult-$3.00, child-$2.50,
 student-$2.50, senior-$2.50.
Attendance: 35,000
Membership: Y *ADA Compliant:* Y
Parking: free on site.
Open: Tuesday, 10am-8pm;
 Wednesday, 10am-6pm;
 Thursday, 10am-8pm;
 Friday to Saturday, 10am-6pm;
 Sunday, noon-6pm.

View of permanent collection gallery, Plains Art Museum.
Photograph by Anne Lennox courtesy of Plains Art Museum,
Fargo North Dakota.

Fargo, North Dakota

Plains Art Museum, cont.

Closed: New Year's Day, Memorial Day, Independence Day, Labor Day, Thanksgiving Day,
Christmas Day

Facilities: **Architecture** (1904 International Harvester warehouse); **Exhibition Area** (9,000 square
feet); **Food Services** Restaurant; **Shop**.

Activities: **Guided Tours**; **Performances**; **Temporary Exhibitions**.

Housed in a thoughtfully restored and adapted (by Hammel Green & Abrahamson, Inc.) turn-of-the-century warehouse in downtown Fargo, the Museum focuses on regional art, traditional American art, contemporary art, and traditional folk art, and maintains a permanent collection of some 2,400 objects, including the work of almost 300 artists. The Museum presents temporary exhibitions of works from the collection, as well as regional and traveling exhibitions.

Grand Forks

North Dakota Museum of Art

Centennial Drive, Grand Forks, ND 58202

Tel: (701) 777-4195

Fax: (701) 777-4425

Internet Address: http://www.ndmuseum.com

C.E.O. and Director: Laurel J. Reuter

Admission: voluntary contribution.

Attendance: 40,000 *Established:* 1970

Membership: Y *ADA Compliant:* Y

Parking: metered on street.

Open: Monday to Friday, 9am-5pm;
Saturday to Sunday, 1pm-5pm.

Facilities: **Food Services** Coffee Bar (serves lunch);
Galleries (4); **Lecture Room**; **Sculpture Garden**;
Shop (crafts, art objects, books, posters).

Activities: **Concerts**; **Films**; **Guided Tours**;
Performances; **Readings**.

Publications: exhibition catalogues (biennial);
newsletter (quarterly).

View of gallery, North Dakota Museum of Art.
Photograph by Jamie Penual, courtesy of North
Dakota Museum of Art, Grand Forks, North Dakota.

The North Dakota Museum of Art collects contemporary international art, starting with the early 1970s (coinciding with the founding of the Museum) onward, objects pertaining to the visual history of the region, and contemporary Native American art, starting with the early 1970s. The Museum has commissioned permanent installations in public spaces within the Museum. Artists have also created the Museum Garden.

University of North Dakota - Witmer Art Gallery

2950 5th Ave. North (opposite the Newman Center), Grand Forks, ND 58201

Tel: (701) 746-4211

Internet Address: http://www.operations.und.nodak.edu

Director: Ms. Sharon Webb

Admission: free.

Open: Monday to Friday, 9:30am-4:30pm; Saturday to Sunday, noon-3pm.

Facilities: **Exhibition Area**.

Activities: **Temporary Exhibitions**.

The Witmer Art Gallery represents the work of over 40 regional artists, many of whom are UND faculty, staff, and students, as well as those who have received degrees from UND. Also of interest, the University Art Gallery is housed in North Dakota Museum of Art located on Centennial Drive.

Minot

Minot State University - Northwest Art Center Galleries (NAC Galleries)

500 University Ave., West, Minot, ND 58707

Tel: (701) 858-3264

Fax: (701) 858-3894

Internet Address: http://www.misu.nodak.edu

Director: Ms. Carol Fielhaber

Admission: free.

Established: 1970 *Membership:* Y *ADA Compliant:* Y

Parking: free on site.

Open: **Hartnett Gallery**, Monday to Friday, 8am-4:30pm.
 Library Gallery, regular library hours.

Closed: Academic Holidays.

Facilities: **Exhibition Area** (2 galleries).

Activities: **Guided Tours** (selected exhibitions); **Temporary Exhibitions**.

NAC presents exhibitions of contemporary and traditional art by local, regional, national, international artists in two galleries: the Library Gallery (located in the Gordon B. Olson Library) and the Hartnett Hall Gallery. Both galleries are located on the Minot State University campus along 11th Avenue Northwest. The exhibition schedule includes a biennial faculty exhibition and juried student exhibitions. NAC annually sponsors the Americas 2000 competitions: Paper Works, and All Media. The permanent collection consists of 350 pieces on, or of, paper and few canvases.

Taube Museum of Art

2 North Broadway, Minot, ND 58702

Tel: (701) 838-4445

C.E.O.: Ms. Jeanne Rodgers

Admission: suggested contribution.

Attendance: 8,000 *Established:* 1970 *Membership:* Y *ADA Compliant:* Y

Parking: on street.

Open: Monday to Saturday, 11am-5pm.

Closed: New Year's Day, Easter, Memorial Day, Independence Day, Labor Day, Thanksgiving Day, Christmas Day.

Facilities: **Architecture** Building (on National Register); **Exhibition Area** (800 square feet); **Shop**.

Activities: **Art Auction**; **Art Show**; **Guided Tours**; **Juried Exhibits**; **Temporary Exhibitions**.

Publications: newsletter, "Minot Art Association News" (bi-monthly).

The Taube Museum is located in a building listed on the National Register of Historic Places. It mounts temporary exhibitions of the work of local, regional, and national artists and has a permanent collection of pieces selected from national juried shows at the Museum.

Ohio

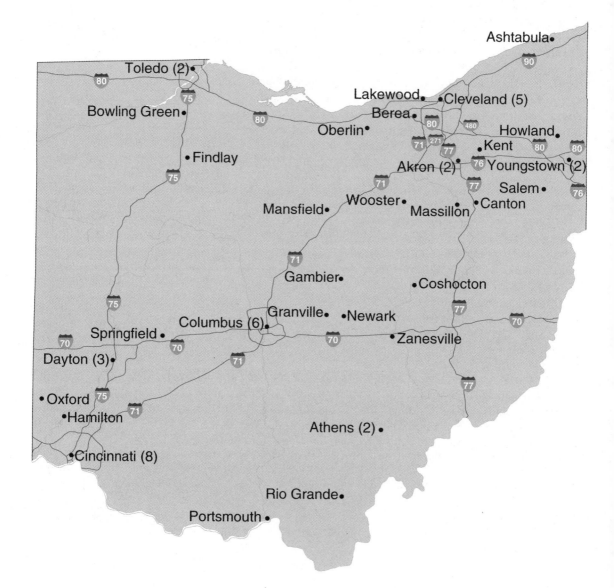

The number in parentheses following the city name indicates the number of museums/galleries in that municipality. If there is no number, one is understood. For example, in the text eight listings would be found under Cincinnati and one listing under Rio Grande.

Ohio

Akron

Akron Art Museum

70 E. Market St., Akron, OH 44308-2084
Tel: (330) 376-9185
Fax: (330) 376-1180
Internet Address: http://www.akronartmuseum.org
Director: Mr. Mitchell Kahan
Admission: voluntary contribution.
Attendance: 50,000 *Established:* 1922
Membership: Y *ADA Compliant:* Y
Parking: pay on site.
Open: Tuesday to Friday, 11am-5pm;
Saturday, 10am-5pm;
Sunday, noon-5pm.
Closed: Legal Holidays.

Exterior view of Akron Art Museum, which occupies the Old Post Office building, and is listed on the National Register of Historic Places. Photograph by Richman Haire, courtesy of Akron Art Museum, Akron, Ohio.

Facilities: **Architecture** (former Post Office building, 1899); **Auditorium** (200 seat); **Library** (4,000 volumes); **Reading Room**; **Sculpture Garden**; **Shop**.
Activities: **Concerts**; **Education Programs** (adults and children); **Films**; **Gallery Talks**; **Guided Tours**; **Lectures**; **Temporary Exhibitions**; **Traveling Exhibitions**.
Publications: annual report; calendar (bi-monthly); exhibition catalogues.

Housed in the Old Post Office Building, restored and redesigned by Peter van Dijk, Johnson & Partners, Cleveland, the museum's collection offers a distinctive look at some of the finest regional, national, and international art from 1850 to the present. Recent works by Andy Warhol, Frank Stella, and Helen Frankenthaler offer an exciting contrast to the elegant portraits and Impressionist landscapes by turn-of-the-century artists William Merritt Chase and Childe Hassam. The extensive photography collection includes works by Robert Frank, Margaret Bourke-White, and Harry Callahan. The Myers Sculpture Courtyard serves as an outdoor gallery space where major large-scale sculptures are on permanent view. Every ten weeks, the Museum presents new temporary exhibitions drawn from important art collection across the country and abroad.

University of Akron - Emily Davis Gallery

Folk Hall, 150 E. Exchange St., Akron, OH 44325-7801
Tel: (330) 972-5950
Internet Address: http://www.uakron.edu/faa/schools/art/galleries/edgallery/index.html
Director: Mr. Rod Bengston
Admission: free.
Open: Monday to Tuesday, 10am-5pm; Wednesday to Thursday, 10am-9pm;
Friday to Saturday, 10am-5pm.
Facilities: **Exhibition Area**.
Activities: **Temporary Exhibitions**.

The Emily Davis Gallery presents challenging exhibitions of contemporary art complemented by events that showcase the most current expressions and criticism evolving in today's visual arts; mounts regional and national traveling exhibitions; and hosts Meyers School of Art student, juried student, and scholarship exhibitions. In addition to the Projects and Atrium galleries also located in Folk Hall, works are exhibited in the Bierce Library, the Guzzetta Hall Atrium, and temporary spaces throughout the campus and community.

Ashtabula

Ashtabula Arts Center

2928 West 13th St., Ashtabula, OH 44004
Tel: (216) 964-3396
Fax: (216) 964-3396
Exec. Director: Ms. Elizabeth Koski

Ashtabula, Ohio

Ashtabula Arts Center, cont.

Admission: free.

Attendance: 15,000 *Established:* 1953 *Membership:* Y *ADA Compliant:* Y

Open: Monday to Thursday, 9am-9pm; Friday, 9am-7pm; Saturday, 9am-5pm.

Closed: Legal Holidays.

Facilities: **Exhibition Area; Theatre.**

Activities: **Arts Festival; Dance Recitals; Education Programs** (adults and children); **Gallery Talks; Lectures; Temporary Exhibitions** (monthly); **Traveling Exhibitions.**

Publications: annual report; newsletter (bi-monthly).

The Center hosts monthly temporary solo and group exhibits of local and regional artists. The Center owns a small permanent collection.

Athens

The Dairy Barn

Southeastern Ohio Cultural Arts Center, 8000 Dairy Lane, Athens, OH 45701

Tel: (740) 592-4981

Fax: (740) 592-5090

Internet Address: http://www.dairybarn.org

Exec. Director: Ms. Susan C. Urano

Admission: fee: adult-$5.00, student-$3.50, senior-$3.50.

Established: 1978 *Membership:* Y

Open: Tuesday to Wednesday, 11am-5pm; Thursday, 11am-8pm; Friday to Sunday, 11am-5pm.

Facilities: **Gallery** (6,500 square feet); **Grounds** (36 acres).

Activities: **Arts Festival; Education Programs; Temporary and Traveling Exhibitions.**

The Dairy Barn Cultural Arts Center is located in a converted dairy barn built in 1914 and now listed on the National Register of Historic Places. The Center promotes the arts, crafts, and cultural heritage of southeastern Ohio and brings the arts of the rest of the world to the region.

Ohio University - Kennedy Museum of Art

Ohio University, Lin Hall, The Ridges

Athens, OH 45701

Tel: (614) 593-1304

Fax: (614) 593-1305

Internet Address: http://www.cats.ohiou.edu/museum

Director: Mr. Kent Ahrens

Admission: free.

Established: 1993

Membership: Y *ADA Compliant:* Y

Parking: free on site.

Open: Tuesday to Wednesday, noon-5pm;
Thursday, noon-8pm;
Friday, noon-5pm;
Saturday to Sunday, 1pm-5pm.

Exterior view of Lin Hall, location of Kennedy Museum of Art. Photograph courtesy of Kennedy Museum of Art, Ohio University, Athens, Ohio.

Facilities: **Architecture** (renovated college hall); **Galleries.**

Activities: **Gallery Talks; Guided Tours** (by appointment); **Temporary/Traveling Exhibitions.**

Publications: brochures; exhibition catalogues; newsletter.

Located in a recently renovated Victorian building overlooking the campus, the Kennedy Museum of Art at Ohio University offers varied exhibitions and diverse learning opportunities for both adults and children. Selections from its permanent collection are exhibited periodically. Holdings include a major collection of southwest Native American weaving and jewelry and an important collection of contemporary works on paper by internationally recognized artists. The permanent collection also includes American painting and sculpture, and ceramics. The Foster Harmon Collection of Art is held on long-term loan. Selections from the Ohio University African Art Collection, owned and maintained by the Kennedy Museum, are displayed separately on the third floor of the Alden Library.

Ohio University - Kennedy Museum of Art, cont.

Also of possible interest on campus are the galleries under the aegis of the School of Art (593-0796). The Ohio University Art Gallery, located on the fifth floor of Siegfred Hall (open, Tues-Sat, 10am-4pm), focuses primarily on the work of regionally and nationally recognized artists with occasional displays of faculty and student work. The Trisolini Gallery, located at 48 E. Union St. (open, Tues-Sat, 10am-4pm), features student work, as well as exhibitions by nationally recognized artists. Student work is also on display in the Dungeon Gallery, located on the third floor of Siegfred Hall (open, daily, 8am-5pm), and the student-run Undergraduate Art League (UAL) Gallery.

Berea

Baldwin-Wallace College - Thomas L. Fawick Art Gallery

Kleist Center for Art and Drama, 95 E. Bagley Road at Beech St., Berea, OH 44017

Tel: (216) 826-2152

Internet Address: http://www.baldwinw.edu

Director: Mr. Jean Drahos

Admission: free.

Open: Monday to Friday, 2pm-5pm.

Facilities: Exhibition Area.

Activities: Temporary Exhibitions.

Located in the Kleist Center for Art and Drama, the Fawick Gallery presents temporary exhibitions and changing displays of works from its permanent collection in four exhibition areas.

Bowling Green

Bowling Green State University Fine Arts Center Galleries

Fine Arts Center (between Ridge and Wooster Streets), Bowling Green, OH 43403-0211

Tel: (419) 372-2786

Fax: (419) 372-2544

Internet Address: http://www.bgsu.edu/welcome/artshows.html

Exhibition Program Administrator: Ms. Jacqueline S. Nathan

Admission: voluntary contribution.

Attendance: 9,000 *Established:* 1960

Membership: Y *ADA Compliant:* Y

Parking: metered lot or visitor's parking pass.

Open: September to April,
 Tuesday to Saturday, 10am-4pm;
 Sunday, 2pm-5pm.

Closed: Academic Holidays, Yom Kippur,
 December 1.

Facilities: Galleries (3).

Activities: Guided Tours; Lectures;
 Temporary/Traveling Exhibitions (change monthly).

Publications: exhibition catalogues.

Exterior view of Fine Arts Building Addition, Bowling Green State University. Photograph courtesy of Fine Arts Center Galleries, Bowling Green State University, Bowling Green, Ohio.

The Fine Arts Center contains two galleries that present changing monthly exhibitions and a Japanese Ceremonial Arts Gallery. Exhibitions include the following annual shows: the New Music & Art Festival, Faculty/Staff, Undergraduate Art & Design, and MFA Thesis/BFA Senior Thesis. The Galleries are open only September through April when exhibitions are scheduled.

Canton

The Canton Museum of Art

1001 Market Ave. North, Canton, OH 44702

Tel: (330) 453-7666

Fax: (330) 453-1034

Internet Address: http://www.cantonart.org

C.E.O.: M.J. Albacete

The Canton Museum of Art, cont.

Admission: fee-$2.50.

Attendance: 53,000 *Established:* 1935 *Membership:* Y *ADA Compliant:* Y

Parking: free on site.

Open: Tuesday to Thursday, 10am-5pm and 7pm-9pm; Friday to Saturday, 10am-5pm; Sunday, 1pm-5pm.

Closed: New Year's Day, Memorial Day, Independence Day, Labor Day, Thanksgiving Day, Christmas Day.

Facilities: **Galleries** (7); **Library** (2,500 volumes); **Sculpture Courtyard**; **Shop**.

Activities: **Arts Festival**; **Education Programs** (adults and children); **Films**; **Lectures**; **Temporary Exhibitions**; **Traveling Exhibitions**.

Publications: annual report; exhibition catalogues.

The Museum presents changing exhibitions drawn from the permanent collection and temporary or traveling exhibitions. The Museum also offers three semesters of studio art classes and workshops throughout the year. The permanent collection totals over 1,200 two- and three-dimensional works. The collection focus is on watercolors and works on paper by 19th- and 20th-century American artists. A secondary focus is on contemporary ceramics.

Cincinnati

Art Academy of Cincinnati - Chidlaw Gallery

951 Eden Park Drive, Cincinnati, OH 45202

Tel: (513) 562-8777

Fax: (513) 562-8778

Internet Address: http://www.artacademy.edu

Admission: free.

Membership: N *ADA Compliant:* Y

Open: Monday to Thursday, 9am-9pm;
Friday, 9am-5pm;
Saturday to Saturday, noon-5pm.
Academic Holidays, Call for information.
Legal Holidays, Call for information.

The Art Academy of Cincinnati is an independent college of art and design that offers both undergraduate and advanced degrees. Its exhibition facility, the Chidlaw Gallery, presents temporary exhibitions of national and international works of art, alumni exhibits, and student exhibits.

Work of Joe Newton, graduate student, on exhibition in Chidlaw Gallery. Photograph by Cal Kowal, courtesy of Art Academy of Cincinnati, Cincinnati, Ohio.

Cincinnati Art Museum (CAM)

953 Eden Park Drive, Cincinnati, OH 45202-1596

Tel: (513) 721-2787

Fax: (513) 6392888

Internet Address: http://www.cincinnatiartmuseum.org

Director: Mr. Timothy Rub

Admission: fee: adult-$5.00, student-$4.00, senior-$4.00.

Attendance: 265,000 *Established:* 1881 *Membership:* Y *ADA Compliant:* Y

Parking: free on site.

Open: Tuesday to Saturday, 10am-5pm; Sunday, noon-6pm.

Closed: Thanksgiving Day, Christmas Day.

Facilities: **Architecture** 1886 (Richardsonian-Romanesque, design by James McLaughlin), 1907 (Greek Revival Schmidlapp Wing, design by D.H. Burnham), 1910 (Beaux-Arts Ropes Wing, design by Garber & Woodward); **Auditorium**; **Exhibition Area** (permanent collection, 88 galleries, temporary exhibits, 10,000 square feet); **Food Services** Café (Tues-Fri, 10am-3pm; Sat, 10am-4pm; Sun, noon-4pm); **Library** (53,000 volumes, Tues-Fri, 10am-4:45pm); **Sculpture Garden**; **Shop** (art-related and exhibition-related merchandise).

Cincinnati Art Museum, cont.

Activities: **Education Programs** (adults and children); **Gallery Talks**; **Guided Tours** (Tues-Fri, 1pm; Sat-Sun, 2pm; groups 10+ by appointment); **Lectures**; **Temporary Exhibitions**.

Publications: brochures; collection catalogues; exhibition catalogues; handbook, "Cincinnati Art Museum Handbook"; magazine, "Canvas" (bi-monthly).

John Singer Sargent, *Italian Girl with Fan*, 1882, oil, 93¾ x 52½ inches. Cincinnati Art Museum. Photograph courtesy of Cincinnati Art Museum, Cincinnati, Ohio.

The Cincinnati Art Museum, renovated in 1993, presents in three floors of galleries a rich variety of exhibitions and educational programs for adults and children. The permanent collection spans 6,000 years of world art and totals over 100,000 works. In addition to the art of ancient Egypt, Greece, and Rome, there are extensive galleries of Near and Far Eastern art, Native American and African art, furniture, glass, silver, costumes, and folk art. The painting collection includes works by European old masters such as Gainsborough, Hals, Mantegna, Rubens, Titian, and Van Dyck; 19th-century works by Cassatt, Cézanne, Monet, and van Gogh; as well as 20th-century works by Braque, Chagall, Miró, Modigliani, and Picasso. The American collection holds works by Copley, Cole, Harnett, Hopper, Wood, and Wyeth, as well as Richard Diebenkorn, Jim Dine, Mark Rothko, Julian Schnabel, Sean Scully, Frank Stella, and Donald Sultan. Areas of special or unique strength include the only collection of ancient Nabateaen art outside of Jordan, the renowned Herbert Greer French collection of old master prints, and a fine collection of European and American portrait miniatures. The Museum holds and displays many paintings from Cincinnati's "Golden Age" (1830-1900) as well as Cincinnati's own Rookwood pottery and Cincinnati carved furniture. In addition to the permanent collection the Museum offers a schedule of temporary and traveling exhibitions.

College of Mount Saint Joseph - Studio San Giuseppe Art Gallery

College of Mount Saint Joseph, 5701 Delhi Road, Cincinnati, OH 45233-1670

Tel: (513) 244-4314

Fax: (513) 244-4222

Internet Address: http://www.msj.edu

Director: Mr. Gerald M. Bellas

Admission: voluntary contribution.

Attendance: 4,500 *Established:* 1962 *Membership:* Y *ADA Compliant:* Y

Open: **Academic Year**, Monday to Friday, 10am-5pm; Saturday to Sunday, 1:30pm-4:30pm.

Closed: Legal Holidays.

Facilities: **Exhibition Area** (1,500 square feet).

Activities: **Films**; **Guided Tours**; **Lectures**; **Temporary Exhibitions**.

Publications: newsletter, "The Arts" (semi-annual).

Studio San Giuseppe presents temporary exhibitions.

The Contemporary Arts Center (CAC)

115 East 5th St., Cincinnati, OH 45202-3998

Tel: (513) 345-8400

Fax: (513) 721-7418

Internet Address: http://www.spiral.org

Director: Mr. Charles Desmarais

Admission: fee: adult-$3.50, child-free, student-$2.00, senior-$2.00.

Attendance: 65,000 *Established:* 1939 *Membership:* Y *ADA Compliant:* Y

Parking: commercial near site.

Open: Monday to Saturday, 10am-6pm; Sunday, noon-5pm.

Closed: New Year's Eve to New Year's Day, Thanksgiving Day, Christmas Day.

Facilities: **Library** (1,000 volumes); **Shop** (art, architecture, and photography books).

The Contemporary Arts Center, cont.

Activities: **Dance Recitals; Films/Video; Gallery Talks; Guided Tours; Lectures; Traveling Exhibitions.**

Publications: brochures; exhibition catalogues; gallery guides; newsletter, "Center Beat" (quarterly).

As one of the first contemporary art museums in the United States, Cincinnati's Contemporary Arts Center has long been a progressive cultural force for both the tri-state region and the nation. Founded in 1939, the Center continues to surprise, challenge, educate, and entertain audiences by presenting and exploring the art of today. The Center presents ten to fifteen exhibitions per year, focusing on all facets of the contemporary arts. CAC is in the process of selecting an architect for a proposed new building to be constructed in the "backstage" district of downtown Cincinnati. The 65,000 square foot building will triple current gallery space and will include a one-of-a-kind "Un-Museum" for children.

Front entrance of Contemporary Arts Center. Photograph courtesy of Contemporary Arts Center, Cincinnati, Ohio.

Hebrew Union College - Skirball Museum, Cincinnati

3101 Clifton Ave., Cincinnati, OH 45220

Tel: (513) 221-1875

Fax: (513) 221-1842

Internet Address: http://www.huc.edu

Admission: free.

Open: Monday to Thursday, 11am-4pm; Sunday, 2pm-5pm.

Closed: Legal Holidays, Jewish Holidays.

Facilities: **Exhibition Area.**

Activities: **Temporary Exhibitions.**

The permanent collection at the Skirball Museum includes archeological artifacts, a special Torah and decorative ornaments, paintings, textiles, objects of Jewish celebration, and Israeli art. The museum also mounts three temporary exhibitions per year.

Taft Museum of Art

316 Pike St., Cincinnati, OH 45202-4293

Tel: (513) 241-0343

Fax: (513) 241-7762

Internet Address: http://www.taftmuseum.org

Director and C.E.O.: Mr. Phillip C. Long

Admission: fee: adult-$4.00, student-$2.00, senior-$2.00.
 free: Wednesday and Sunday.

Attendance: 50,000 *Established:* 1932 *Membership:* Y *ADA Compliant:* Y
Parking: free on site.

Open: Monday to Saturday, 10am-5pm; Sunday, 1pm-5pm; Holidays, 1pm-5pm.

Closed: New Year's Day, Thanksgiving Day, Christmas Day.

Facilities: **Architecture** (Palladian Baum-Longworth-Taft House, 1820); **Library** (1,000 volume); **Shop.**

Activities: **Concerts; Education Programs** (adults, students and children); **Gallery Talks; Guided Tours; Lectures; Temporary Exhibitions.**

Publications: collection catalogue; exhibition catalogues; cookbook.

The Taft Museum of Art displays its permanent collection in the Federal period rooms of the Baum-Longworth-Taft House. Holdings include European and American master paintings, such as works by Corot, Gainsborough, Hals, Rembrandt, Ruisdael, Sargent, and Turner; Chinese ceramics, primarily porcelains of the Kangxi reign; and European decorative arts, featuring an extensive collection of French Renaissance Limoges enamels and 17th- and18th-century watches. A National Historic

Taft Museum of Art, cont.

Landmark, the Baum-Longworth-Taft House (1820) is an excellent example of American Palladian architecture, and the room settings are enhanced by selections of early 19th-century New York furniture. In addition to the permanent collection, the Garden and Keystone galleries house changing special exhibitions of art, history, or community interest throughout the year.

University of Cincinnati - DAAP Galleries

College of Design, Architecture, Art & Planning
West Campus, DAAP Building, College Court
Cincinnati, OH 45221
Tel: (513) 556-4933
Fax: (513) 556-3288
Internet Address:
 http://www.daap.uc.edu/Gallery/gallery.html
Director: Ms. Anne Timpano
Admission: free.
Attendance: 10,000 *Established:* 1993
Membership: N *ADA Compliant:* Y
Parking: visitor parking in Brodie Garage.
Open: **January to May**,
 Monday to Friday, 10am-5pm.
 September to November,
 Monday to Friday, 10am-5pm.
Closed: Academic Holidays.
Facilities: **Galleries** (3).

Guy Carlton Wiggins, *Brooklyn Bridge in Winter*, 1920, oil on canvas, 20½ x 24¼ inches. Gift of W.T.S. Johnson, University of Cincinnati Fine Arts Collection. Photograph courtesy of DAAP Galleries, University of Cincinnati, Cincinnati, Ohio.

Activities: **Lectures; Temporary Exhibitions; Traveling Exhibitions.**
Publications: brochures; calendar; exhibition catalogues.

A unit of the College of Design, Architecture, Art, and Planning of the University of Cincinnati, DAAP Galleries administers three exhibition spaces: the Dorothy W. and C. Lawson Reed, Jr. Gallery at the Aronoff Center for Design, the Tangeman Fine Arts Gallery in the Tangeman University Center on the main campus, and the Machine Shop Gallery at Walnut Street and Central Parkway. All three galleries present temporary exhibitions. DAAP Galleries also administers the University of Cincinnati Fine Arts Collection of some 3,600 objects. International in scope, the permanent collection encompasses the art of the United States, Europe, pre-Columbian Ecuador, ancient Greece, and other cultures. A large portion of the collection consists of work by artists from the United States, many of whom were active in Cincinnati for at least a part of their careers. Perhaps the most well-known Cincinnati artist, Elizabeth Nourse, is represented by 32 works including oils, watercolors, and pastels. Other Cincinnati artists represented in some depth are Lewis Henry Meakin, Frank Harmon Myers, Herman Henry Wessel, Louis Charles Vogt, and John Ellsworth Weis.

Xavier University Art Gallery

3800 Victory Parkway, Cohen Center, Cincinnati, OH 45207-7311
Tel: (513) 745-3811
Fax: (513) 745-1098
TDDY: (513) 745-3811
Internet Address: http://www.xu.edu
Director: Ms. M. Katherine Uetz
Admission: free.
Attendance: 1,800 *Established:* 1831 *Membership:* N *ADA Compliant:* Y
Parking: free on site.
Open: **Academic Year**, Monday to Friday, 10am-4pm.
Closed: Legal Holidays, Academic Holidays.
Facilities: **Exhibition Area.**
Activities: **Films.**

The University Art Gallery presents temporary exhibitions, including shows of work by faculty, students, and nationally recognized artists.

621

Cleveland

Cleveland Center for Contemporary Art

8501 Carnegie Ave. (in the Cleveland Playhouse Complex), Cleveland, OH 44106

Tel: (216) 421-8671

Fax: (216) 421-0737

Internet Address: http://www.contemporaryart.org

Admission: free.

Attendance: 12,000 *Established:* 1968 *Membership:* Y *ADA Compliant:* Y

Open: Tuesday to Thursday, 11am-6pm; Friday, 11am-9pm; Saturday to Sunday, noon-5pm.

Closed: New Year's Day, Independence Day, Thanksgiving Day, Christmas Day.

Facilities: **Exhibition Area**; **Food Services** Café; **Gallery**; **Museum Store**.

Activities: **Concerts**; **Education Programs** (adults and children); **Gallery Talks**; **Lectures**; **Readings**; **Temporary Exhibitions**.

Publications: calendar; exhibition catalogues; newsletter (quarterly).

The Cleveland Center for Contemporary Art is committed to bringing the most important developments in contemporary visual art to Cleveland. During its history, the Center has shown the work of thousands of established and emerging artists and has received national recognition for its publication of scholarly exhibition catalogues. Through educational programs, outreach events, and publications that reflect artistic and cultural diversity, the Center celebrates regional, national, and international artistic achievements.

Cleveland Institute of Art - Reinberger Gallery

11141 E. Boulevard, Cleveland, OH 44106

Tel: (216) 421-7403

Internet Address: http://www.cia.edu/gallery_reinberger.html

Director: Mr. Bruce Checefsky

Admission: free.

Open: Monday, 9:30am-4pm; Tuesday to Saturday, 9:30am-9pm; Sunday, 1pm-4pm.

Facilities: **Gallery**.

Activities: **Temporary Exhibitions**.

In addition to gallery exhibitions featuring the work of professional artists, faculty and students, the Cleveland Institute of Art frequently offers slide lectures and symposia by visiting artists.

The Cleveland Museum of Art

11150 East Blvd. in University Circle, Cleveland, OH 44106-1797

Tel: (216) 421-7350

Fax: (216) 421-0411

TDDY: (216) 421-0018

Internet Address: http://www.clevelandart.org

Admission: free.

Attendance: 630,000 *Established:* 1913

Membership: Y *ADA Compliant:* Y

Parking: pay on site, next to north entrance.

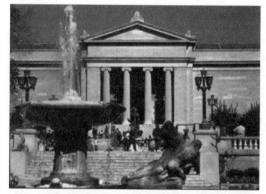

Open: Tuesday, 10am-5pm;
Wednesday, 10am-9pm;
Thursday, 10am-5pm;
Friday, 10am-9pm;
Saturday to Sunday, 10am-5pm.

Closed: New Year's Day, Independence Day,
Thanksgiving Day, Christmas Day.

View of south façade of Cleveland Museum of Art.
Photograph by Howard Agriesti, courtesy of Cleveland
Museum of Art, Cleveland, Ohio.

Facilities: **Auditorium** (765 seats); **Food Services** Still Lifes Café (Tues, Thurs, Sat, & Sun, 10am-4pm; Wed & Fri, 10am-8pm); **Galleries** (70); **Grounds** Fine Arts Gardens (15 acres); **Halls** (2,160 seats); **Library** (215,000 volumes); **Shop**.

The Cleveland Museum of Art, cont.

Activities: **Education Programs** (adults, college students, and children); **Films**; **Gallery Talks**; **Guided Tours** (Tues, Thurs, Fri, & Sat, 1:30pm); **Lectures**; **Performances**; **Temporary Exhibitions**; **Traveling Exhibitions**.

Publications: annual report; exhibition catalogues; gallery guides; magazine, "Members Magazine" (monthly); "Cleveland Studies" (annual).

The Cleveland Museum of Art is regarded worldwide for the quality of its permanent collection of nearly 40,000 works of art. On display in 70 galleries, its comprehensive holdings range over 5,000 years of history from ancient Egyptian statues and Renaissance armor to Impressionist masterpieces by Monet, Degas, Renoir, and van Gogh. Particularly notable are its extensive Asian collection of some 4,800 works, its medieval European art, and its pre-Columbian holdings. In addition, several major exhibitions and numerous smaller shows are scheduled each year.

Cleveland State University Art Gallery

2307 Chester Ave., Cleveland, OH 44114
Tel: (216) 687-2103
Fax: (216) 687-2275
Internet Address: http://www.csuohio.edu
Director and Curator: Mr. Robert Thurmer
Admission: voluntary contribution.
Attendance: 31,000 *Established:* 1973
Membership: Y *ADA Compliant:* Y
Parking: metered on street and garage on East 21st St.
Open: Monday to Saturday, 10am-4pm.
Closed: Legal Holidays, Academic Holidays.
Facilities: **Exhibition Area** (4,500 square feet).
Activities: **Education Programs** (undergraduate and graduate college students); **Guided Tours**; **Lectures**; **Performances**; **Traveling Exhibitions**.
Publications: exhibition catalogues; exhibition schedule (annual).

Art Gallery, Cleveland State University during exhibition, "The Anxious Image: New Psychological Realism". Sculpture in foreground by Carole Jeanne Feuerman, polychrome polyester resin. Painting in background by Lawrence Krause, oil on canvas. Photograph courtesy of Art Gallery, Cleveland State University, Cleveland, Ohio.

Located on the ground floor of the Art Building, the Art Gallery features world-class thematic art exhibitions and related educational programs, including guided tours, lectures, and publications. Community based exhibitions, student shows, and programs dealing with important social and critical issues round out the gallery program.

The Temple Museum of Religious Art

1855 Ansel Road, University Circle at Silver Park, Cleveland, OH 44106
Tel: (216) 831-3233
Fax: (216) 831-4216
Director: Ms. Claudia Z. Fechter
Admission: voluntary contribution.
Attendance: 4,000 *Established:* 1950
Open: By appointment only.
Closed: Legal Holidays, Jewish Holidays.
Facilities: **Library** (5,000 volumes).
Activities: **Guided Tours**; **Temporary Exhibitions**.
Publications: bulletin, "The Temple".

The Museum features antique ritual objects, fabrics, and Judaica. It also maintains a second venue in the east building of Temple Tifereth Israel, 26000 Shaker Boulevard.

Columbus

Capital University - The Schumacher Gallery

Capital University Library, 4th Floor, 2199 E. Main St., Columbus, OH 43209-2394
Tel: (614) 236-6319
Fax: (614) 236-6490
Internet Address: http://www.capital.edu

Capital University - The Schumacher Gallery, cont.

Director: Dr. Cassandra Tellier
Admission: free.
Attendance: 7,400 *Established:* 1964 *ADA Compliant:* Y
Parking: free on site.
Open: **September to May**, Monday to Friday, 1pm-5pm; Saturday, 2pm-5pm.
Facilities: **Galleries; Library.**
Activities: **Concerts; Education Programs** (undergraduate and graduate college students); **Films; Gallery Talks; Guided Tours** (groups by appointment); **Lectures; Performances; Temporary Exhibitions; Traveling Exhibitions.**

Capital University's Schumacher Gallery offers the university and the community an extensive program of exhibitions, lectures, and arts-related events. It maintains a permanent collection of over 1,600 objects and features exhibits of Asian Art (traditional and contemporary art including Ming porcelain and Tang sculpture); Painting and Sculpture by notable artists (including Marin, Henry Moore, Nevelson, and Rodin); Ethnic Art featuring traditional art from many cultures (notably Inuit, Oceanic Islands, Haitian, African, and American Southwestern); Graphic Arts (including original works by Cassatt, Chagall, Dine, Gauguin, Picasso, Renoir, Toulouse-Lautrec, and Warhol); 16th-19th Century Period Works, a combination of paintings, prints, and tapestries (including works by Dürer, Jordaens, Willem Key, Rembrandt, and Goya); and Ohio Artists (focusing on prominent Ohio artists such as Elijah Pierce, Charles Burchfield, Edward Potthast, Alice Schille, and George Bellows). In addition to the permanent exhibits, the Gallery presents special focus exhibits, juried shows and displays of work by students.

Columbus College of Art & Design - Canzani Center Galleries (CCAD)

Canzani Center, Cleveland Ave. and E. Gay Street, Columbus, OH 43215
Tel: (614) 222-4002
Fax: (614) 222-4040
Internet Address: http://www.ccad.edu
Director: Mr. Richard Aschenbrand
Admission: free.
Established: 1879
Open: Monday to Wednesday, 11am-4pm; Thursday, 11am-9pm; Friday, 11am-4pm;
 Saturday, 10am-5pm.
Facilities: **Exhibition Area.**
Activities: **Student Art Sales** (held annually, December & in the Spring); **Temporary Exhibitions.**

The Canzani Center Gallery and Acock Gallery, located on the second floor of the Canzani Center, present temporary exhibitions, including work by professional artists, an annual student exhibition, and a biennial faculty show. Thesis shows by fine arts students are on display throughout the year in three on-campus locations: Beaton Hall (44 North 9th St.), V-Hall (470 E. Gay St.); and the Canzani Center Gallery (second floor).

Columbus Cultural Arts Center (CAC)

139 W. Main St., Columbus, OH 43215
Tel: (614) 645-7047
Fax: (614) 645-5862
TDDY: (614) 645-3317
Director: Ms. Jennifer L. Johnson
Admission: voluntary contribution.
Attendance: 50,000 *Established:* 1978 *Membership:* Y *ADA Compliant:* Y
Parking: none.
Open: Monday to Thursday, 8am-5pm and 7pm-9:30pm; Friday, 8am-5pm;
 Saturday to Sunday, 1pm-5pm.
Facilities: **Exhibition Area; Studios.**
Activities: **Concerts; Readings; Temporary Exhibitions; Traveling Exhibitions.**
Publications: catalogue (quarterly).

Columbus Cultural Arts Center, cont.

CAC presents a variety of visual and performing arts programming for adults and children.

The Columbus Museum of Art

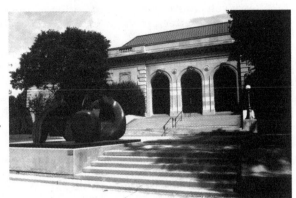

480 E. Broad St., Columbus, OH 43215
Tel: (614) 221-6801
Fax: (614) 221-0226
Internet Address:
 http://www.columbusart.mus.oh.us
Exec. Director: Mr. Irvin M. Lippman
Admission: suggested contribution: adult-$3.00,
 student-$2.00, senior-$2.00.
Attendance: 155,000 *Established:* 1878
Membership: Y *ADA Compliant:* Y
Parking: pay on site.
Open: Tuesday to Wednesday, 10am-5:30pm;
 Thursday, 10am-8:30pm;
 Friday to Sunday, 10am-5:30pm.

Exterior view of Columbus Museum of Art. Photograph courtesy of Columbus Museum of Art, Columbus, Ohio.

Closed: New Year's Day, Independence Day, Thanksgiving Day, Christmas Day.
Facilities: **Auditorium** (300 seat); **Food Services** Palette Café (outdoor dining in Spring and Summer); **Sculpture Garden**; **Shops** (2, one especially for children).
Activities: **Concerts**; **Films**; **Gallery Talks**; **Guided Tours**; **Lectures**; **Temporary/Traveling Exhibitions.**
Publications: annual report; calendar; collection catalogue; exhibition catalogues.

The Museum displays its collections of European, American, and Asian painting, sculpture, and photography in its Renaissance revival building. It also offers special exhibitions and educational programs for children and adults.

Ohio Arts Council - Riffe Gallery

77 S. High St., Columbus, OH 43215
Tel: (614) 644-9624
Director: Ms. Mary Gray
Admission: free.
Open: Monday to Wednesday, 11am-4pm; Thursday to Friday, 11am-7:30pm;
 Saturday to Sunday, noon-4pm.
Facilities: **Gallery.**
Activities: **Temporary Exhibitions** (8 to 9 weeks duration).

The Riffe Gallery, operated by the Ohio Arts Council, mounts temporary exhibitions that showcase the work of Ohio's artists and the collections of the State's museums and galleries.

Ohio State University - Wexner Center for the Arts

The Ohio State University, N. High St. at 15th Ave., Columbus, OH 43210-1393

Tel: (614) 292-0330
Fax: (614) 292-3369
Internet Address:
 http://www.cgrg.ohio.state.edu/wexner
Director: Ms. Sherri Geldin
Admission: fee:
 adult-$3.00, child-free, student-$2.00, senior-$2.00.
Attendance: 205,000 *Established:* 1989
Membership: Y *ADA Compliant:* Y
Parking: at Ohio Union Parking Ramp on High St.

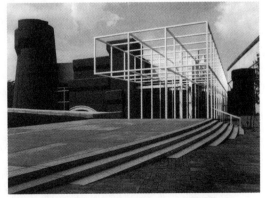

View of Wexner Center for the Arts from the south. Photograph by Kevin Fitzsimons, courtesy of Wexner Center for the Arts, Ohio State University, Columbus, Ohio.

Ohio State University - Wexner Center for the Arts, cont.

Open: Tuesday to Wednesday, 10am-6pm; Thursday, 10am-9pm; Friday to Sunday, 10am-6pm.

Facilities: **Architecture** (post-modern building, 1989 design by Peter Eisenman); **Cartoon Research Library**; **Film and Video Center** (278 seat theater); **Food Services** Café (Mon-Fri, 7am-4pm); **Galleries**; **Print Study Room**; **Shop** (books, periodicals, handcrafted jewelry, gifts); **Theatres** (3; Weigel Hall, the Performance Space, and Mershon Auditorium).

Activities: **Concerts** (jazz and world music); **Education Programs** (college students and general public); **Films** (weekly screenings); **Gallery Talks**; **Lectures**; **Performances** (dance and theater); **Temporary Exhibitions**.

Publications: calendar (bi-monthly); exhibition catalogues; gallery guides.

The Wexner Center for the Arts, Ohio State's multidisciplinary contemporary arts center, presents visual arts exhibitions, performing arts, films, videos, and educational programs for audiences of all ages. Visual arts exhibitions include contemporary painting, sculpture, architecture, photography, and multimedia installations featuring major modern artists and emerging talents. Also of possible interest on campus, the Hopkins Hall Gallery of the College of the Arts features faculty, student, and departmental exhibitions and quarterly shows of the work of visiting artists.

Coshocton

Johnson-Humrickhouse Museum

Roscoe Village, 300 N. Whitewoman St., Coshocton, OH 43812

Tel: (740) 622-8710

Directors: Patti Malenke and Terry Reddick

Admission: fee: adult-$2.00, child-$1.00, senior-$1.50, family-$5.00.

Attendance: 16,000 *Established:* 1931

Membership: Y *ADA Compliant:* Y

Parking: free on site.

Open: **May to October**,
Daily, noon-5pm.
November to April,
Tuesday to Sunday, 1pm-4:30pm.

Closed: New Year's Day, Easter, Thanksgiving Day, Christmas Eve to Christmas Day.

Facilities: **Galleries** (5); **Shop**.

Activities: **Education Programs** (children); **Gallery Talks**; **Guided Tours** (groups by appointment); **Lectures**; **Temporary Exhibitions**.

Publications: newsletter (quarterly).

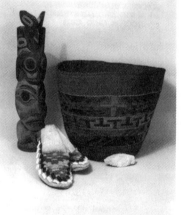

Haida totem, Tlingit basket, Cheyenne moccasins, and prehistoric flint point from the Native American Indian collection, Johnson-Humrickhouse Museum. Photograph courtesy of Johnson-Humrickhouse Museum, Coshocton, Ohio.

The Museum presents its permanent collection in four galleries devoted to Native American artifacts; early American pioneer life; Chinese and Japanese art and artifacts; and an eclectic collection of 19th- and 20th-century American and European decorative art objects. Additionally, approximately five special exhibits, either traveling exhibitions from national and regional sources or special displays of local origin and interest, are offered each year in the Montgomery Gallery.

Dayton

Dayton Art Institute

456 Belmonte Park North, Dayton, OH 45405

Tel: (937) 223-5277

Fax: (937) 223-3140

Internet Address: http://www.daytonartinstitute.org

Director: Mr. Alexander Lee Nyerges

Admission: free.

Attendance: 300,000 *Established:* 1919 *Membership:* Y *ADA Compliant:* Y

Dayton Art Institute, cont.

Parking: free adjacent to site.

Open: Monday to Wednesday, 10am-5pm;
Thursday, 10am-9pm;
Friday to Sunday, 10am-5pm.

Facilities: **Auditorium** (500 seat); **Food Services** Café Monet (daily, 11am-4pm and Thursday, 5pm-8:30pm); **Library** (31,000 volumes; Monday-Friday, 8am-5pm); **Shop** (art gifts, books, greeting cards).

Activities: **Arts Festival**; **Concerts** (classical, jazz, gospel, rock); **Education Programs** (adults and children); **Gallery Talks** (Sat-Sun, 1pm); **Guided Tours** (groups by appointment); **Lectures**; **Temporary Exhibitions**; **Traveling Exhibitions**.

Publications: annual report; exhibition catalogues; member quarterly.

View of new entrance of Dayton Art Institute, designed to mirror the Italian Renaissance style of original building. Photograph courtesy of Dayton Art Institute, Dayton, Ohio.

After an 18-month, $17 million renovation and expansion of the galleries and educational spaces, the Dayton Art Institute reopened in 1997. With nearly 40% more gallery space and completely redesigned permanent collection exhibitions, the Museum is open 365 days a year. In addition to the permanent collection, the museum presents special exhibitions, a broad spectrum of musical events, and educational programs. The permanent collection contains more than 12,000 pieces. The museum is known for its outstanding Asian collection, 17th-century Baroque paintings, 18th-and 19th-century American art, and contemporary art. Among the artists represented are Bouguereau, Cassatt, Degas, Monet, O'Keeffe, Reynolds, Rothermel, Rothko, Roualt, and Rubens.

University of Dayton - Rike Center Gallery

Rike Fine Arts Center (near St. Mary's Hall and the Post Office)), Dayton, OH 45469

Tel: (937) 229-3237

Internet Address: http:www.as.udayton.edu/visualarts/links.html

Gallery Manager: Mr. Jeff Jones

Admission: free.

Open: Tuesday to Wednesday, 10am-4pm; Thursday, 10am-7pm; Friday, 10am-2pm.

Facilities: **Exhibition Area.**

Activities: **Temporary Exhibitions.**

The Gallery presents exhibitions of work by nationally and internationally recognized artists using a variety of media, as well as a juried exhibition of student works. Also of possible interest on campus, the Narrow Gallery, located in the Mechanical Engineering Building adjacent to the photography and video facilities, features exhibitions by artists using photographic methods and materials.

Wright State University Art Galleries

Creative Arts Center, 3640 Colonel Glenn Highway, A128-CAC, Dayton, OH 45435

Tel: (513) 775-2978

Internet Address: http://www.wright.edu/artgalleries

Gallery Coordinator: Mr. Craig Martin

Admission: free.

Attendance: 14,000 *Established:* 1974 *ADA Compliant:* Y

Open: **Academic Year**, Monday to Friday, 10am-4pm; Saturday to Sunday, noon-5pm.

Closed: Legal Holidays.

Facilities: **Galleries** (4).

Activities: **Education Programs** (student and public); **Films**; **Gallery Talks**; **Lectures**.

Publications: exhibition catalogues; cd-roms.

The galleries present contemporary exhibitions of work by professional artists, faculty, and students.

Findlay

The University of Findlay - Mazza Collection Galleria

Virginia B. Gardner Fine Arts Pavilion, 1000 N. Main St., Findlay, OH 45840-3695

Tel: (419) 424-4560

Internet Address: http://www.findlay.edu/mazzaweb/mazzahm.htm

Open: Wednesday to Friday, noon-5pm; Sunday, 1pm-4pm; by appointment, 424-4777.

Closed: Legal Holidays.

Facilities: Galleries (5).

Activities: Education Programs; Guided Tours; Permanent Exhibits; Temporary Exhibitions.

With over 1,800 works, the Mazza Collection is the first and largest teaching gallery in the world specializing in children's book illustration.

Gambier

Kenyon College - Olin Art Gallery

Kenyon College, Olin Library, East Gambier Street, Gambier, OH 43022

Tel: (740) 417-5000

Internet Address: http://www.kenyon.edu

Admission: free.

Open: Monday to Saturday, 8:30am-midnight; Sunday, 9:30am-midnight.

Facilities: Gallery.

Activities: Lectures; Temporary Exhibitions.

Located in the Olin Library on the Middle Way, the Olin Gallery at Kenyon features temporary exhibitions of the work of both students and professional artists.

Granville

Denison University Art Gallery

Burke Hall of Music and Art (Cherry and Broadway), Granville, OH 43023

Tel: (740) 587-6255

Fax: (740) 587-5701

Internet Address: http://www.denison.edu

Acting Director: Merijn van der Heijden

Admission: free.

Established: 1946 *ADA Compliant:* Y

Open: mid-September to May, Daily, 1pm-4pm.

Closed: Academic Holidays.

Facilities: Galleries (4).

Activities: Guided Tours; Lectures; Traveling Exhibitions.

Publications: exhibition catalogues.

Consisting of a large gallery, three small galleries and a seminar room, the Fine Arts Gallery displays parts of Denison University's permanent collection as well as temporary exhibitions of contemporary art. The University's permanent collection is noted for one of the largest accumulations of Burmese art outside Myanmar; Chinese ceramics, textiles, and works on paper; and other small but significant collections of Eastern art. Western art is represented by a print collection, Baroque drawings of the Roman school, paintings on wood and canvas, and sculpture in all media.

Hamilton

Pyramid Hill Sculpture Park and Museum

1659 Hamilton-Cleves Road (U.S. Route 128), Hamilton, OH 45011

Tel: (513) 868-8336

Fax: (513) 896-3750

Director: Mr. Harry T. Wilks

Admission: fee: Weekdays: adult-$3.00, child (>12)-$1.50.
 Saturday-Sunday: adult-$4.00, child (>12)-$1.50.

Pyramid Hill Sculpture Park and Museum, cont.

Attendance: 95,000 *Established:* 1997 *Membership:* Y *ADA Compliant:* Y

Parking: throughout park.

Open: **Summer**, Tuesday to Sunday, 10am-6pm.

Facilities: **Amphitheater** (1,000 capacity); **Food Services** Tea Room; **Grounds** (265 acres; arboretum, gardens, hiking trails); **Sculpture Park**; **Shop**.

Activities: **Children's Programs**; **Concert Series** (outdoor); **Education Programs**; **Guided Tours**.

Pyramid Hill is an outdoor museum focusing on monumental pieces of sculpture in an environment of lakes, meadows, forests, and gardens. Among the 40 pieces of sculpture on display are works by Harold Betz, John Hock, John Isherwood, Alexander Liberman, Clement Meadmore, John Parker, Joel Perlman, Michael Tearney, and many others. Educational programs are offered in art, horticulture, geology, and the environment.

Alexander Liberman, *Abracadabra*, steel and paint, 30 x 40 feet. Pyramid Hill Sculpture Park and Museum. Photograph courtesy of Pyramid Hill Sculpture Park and Museum, Hamilton, Ohio.

Howland

The Butler Institute of American Art - Trumbull County Branch

9350 E. Market St., Howland, OH 44484

Tel: (330) 609-9900

Admission: free.

Established: 1996

Open: Thursday to Friday, 11am-4pm; Saturday, 10am-3pm; Sunday, noon-4pm.

Facilities: **Gallery**; **Shop**.

Activities: **Temporary Exhibitions**.

Established with the assistance of the Medici Foundation of Trumbull County, the Gallery presents temporary exhibitions. The Institute's main facility is located in Youngstown, Ohio.

Kent

Kent State University - School of Art Galleries

Kent State University, School of Art Building (near Van Duesen Hall), Summit St., Kent, OH 44242

Tel: (216) 672-7853

Fax: (216) 672-4729

Internet Address: http://www.kent.edu/art/soa_gall.html

Director: Prof. Fred T. Smith

Admission: voluntary contribution.

Attendance: 18,000 *Established:* 1950 *Membership:* Y *ADA Compliant:* Y

Open: Monday to Friday, 10am-4pm; Sunday, 2pm-5pm.

Closed: Academic Holidays.

Activities: **Education Programs** (undergraduate and graduate students); **Guided Tours**; **Lectures**; **Performances**; **Temporary Exhibitions** (6 major/year).

Publications: booklets.

The School of Art galleries (The Art Gallery, Gallery 138, Michener Gallery) hold a permanent collection of paintings, sculpture, prints, and graduate theses. Also of possible interest on campus, The Kent State University Museum, located in Rockwell Hall, features an international collection of costume and decorative arts in nine galleries. At a remove from the campus, the School of Art maintains a branch gallery, the William H. Eells Art Gallery, on the grounds of the Blossom Music Center, summer home of the Cleveland Orchestra, just north of Akron.

Lakewood

Cleveland Artist Foundation Gallery (CAF)

Beck Center for the Arts, 17801 Detroit Ave., Lakewood, OH 44107
Tel: (216) 464-1902
Fax: (216) 227-9507
Director, CAF: Ms. Leslie Gibbs
Admission: free, before 5pm.
Attendance: 70,000 *Established:* 1984
Membership: Y *ADA Compliant:* Y
Parking: free on site.
Open: Wednesday to Sunday, 2pm-5pm.
Closed: Legal Holidays.
Facilities: **Auditorium**; **Gallery**; **Theatre**.
Activities: **Arts Festival**; **Concerts**; **Dance Recitals**; **Education Programs** (adults, undergraduates and children); **Gallery Talks**; **Temporary Exhibitions** (6-8/year, rotating exhibitions of 50-80 works).
Publications: exhibition catalogues; monographs, "Ohio Artists Now"; posters.

William Sommer, *The Three Graces*, 1916, watercolor. Cleveland Artists Foundation. Photograph courtesy of Cleveland Artists Foundation, Cleveland, Ohio.

CAF is dedicated to the exhibition, preservation, and research of visual arts produced in northeast Ohio. The foundation mounts regular exhibitions of works in a variety of media at its permanent gallery in the Beck Center for the Arts and plans programs in collaboration with other arts organizations. Exhibitions are complemented by a public lecture program. CAF's permanent collection consists of over 300 works on paper produced in the greater Cleveland area, including works by early artists of the Western Reserve, artists known as the "Cleveland School", and contemporary established artists of northeast Ohio.

Mansfield

The Mansfield Art Center

700 Marion Ave., Mansfield, OH 44903
Tel: (419) 756-1700
Director: Mr. H. Daniel Butts, III
Admission: voluntary contribution.
Established: 1946 *Membership:* Y
Open: Tuesday to Saturday, 11am-5pm; Sunday, noon-5pm.
Closed: Legal Holidays.
Facilities: **Architecture** (wood and glass building, design by Don Hisaka); **Galleries**; **Shop** (jewelry, glass, ceramics, textiles).
Activities: **Concerts** (chamber music); **Education Programs** (adults and children); **Films**; **Gallery Talks**; **Guided Tours** (groups); **Juried Exhibits**; **Lectures**; **Traveling Exhibitions**.
Publications: class schedules (quarterly); newsletter (monthly).

The Center's annual exhibition schedule includes two juried shows and four invitational theme shows that combine the newest work in all media by contemporary Ohio artists, one special exhibition of works borrowed from museums, and a holiday fair.

Massillon

The Massillon Museum

121 Lincoln Way, East, Massillon, OH 44646-6633
Tel: (330) 833-4061
Fax: (330) 832-2925
Director and C.E.O.: Mr. John Klassen
Admission: free.

The Massillon Museum, cont.

Attendance: 25,000 *Established:* 1933
Membership: Y *ADA Compliant:* Y
Open: Tuesday to Saturday, 9:30am-5pm;
Sunday, 2pm-5pm.
Closed: Independence Day,
Christmas Eve to Christmas Day,
New Year's Eve to New Year's Day.
Facilities: **Architecture** (art deco, former retail
building, 1931); **Library**; **Shop** (local history
books, decorative arts by regional artists).
Activities: **Arts Festival**; **Education
Programs** (adults and children); **Guided
Tours** (reserve in advance); **Lectures**;
Temporary Exhibitions (approximately
7/year); **Traveling Exhibitions.**
Publications: exhibition catalogues.

Exterior view of Massillon Museum, art deco, former retail building (1931). Photograph courtesy of Massillon Museum, Massillon, Ohio.

The Museum features changing exhibitions of contemporary art, a long-term exhibition of local history, a sports gallery, the Immel Circus display, and a photography gallery. The permanent collections represent a cross section of life in the Massillon area from Native American time through this century. The photograph, quilt, costume, Massillon glass, and circus collections are notable.

Newark

Ohio State University at Newark - Art Gallery

1179 University Drive (off Crain Pkwy.), Newark, OH 43055
Tel: (740) 366-9369
Internet Address: http://www.newark.ohio-state.edu
Contact: Ms. Kathleen Keys
Open: **Call for hours.**
Facilities: **Exhibition Area.**
Activities: **Temporary Exhibitions.**

The Art Gallery is committed to exhibiting locally, nationally, and internationally recognized artists in all media. The Gallery has exhibited such prominent artists as Roy Lichtenstein.

Oberlin

Oberlin College - Allen Memorial Art Museum (AMAM)

87 N. Main St. at E. Lorain St., Oberlin, OH 44074
Tel: (440) 775-8665
Fax: (440) 775-8799
Internet Address:
http://www.oberlin.edu/~allenart
Director: Sharon F. Patton
Admission: voluntary contribution.
Attendance: 35,000 *Established:* 1917
Membership: Y *ADA Compliant:* Y
Parking: free on site.
Open: Tuesday to Saturday, 10am-5pm;
Sunday, 1pm-5pm.
Closed: Legal Holidays.

Paul Cézanne, *The Viaduct at L'Estaque*, c. 1882, oil on canvas, 45.1 cm x 53.5 cm. © Allen Memorial Art Museum. Photograph courtesy of Allen Memorial Art Museum, Oberlin College, Oberlin, Ohio.

Oberlin College - Allen Memorial Art Museum, cont.

Facilities: **Architecture** Main building (designed by Cass Gilbert, 1917), subsequent addition (1977, designed by Venturi, Rauch & Scott Brown), Usonian House (by Frank Lloyd Wright, 1948-50); **Galleries** (5 permanent, 3 temporary exhibition); **Library** (43,000 volumes); **Print Study Room**; **Sculpture Garden**.

Activities: **Concerts**; **Education Programs** (adults and children); **Films**; **Gallery Talks** (2nd Tuesday in month, 2:30pm); **Guided Tours** (by request, 775-8671); **Lectures** (2-6/year); **Temporary Exhibitions** (8-10/year).

Publications: brochures; collection catalogue; exhibition catalogues; journal, "Allen Memorial Art Museum Bulletin" (annual); newsletter, "Allen Memorial Art Museum News" (semi-annual).

AMAM contains one of the nation's finest college or university art collections. Each year the Museum presents a variety of special exhibitions organized from its own collection, as well as loan exhibitions organized by the Museum staff or other institutions. In addition to the works on exhibit in the galleries, a number of sculptures from the Museum are located on the grounds around the building. The Museum collection of some 11,000 objects covers many cultures and time periods, and has particular strengths in Dutch and Flemish paintings of the 17th century, Islamic carpets, Old Master prints, Japanese prints, late 19th- and 20th-century European painting and sculpture, and modern and contemporary American art. Some of AMAM's finest works of art include "The Finding of Erichthonius" by Rubens, "Self Portrait" by Sweerts, "St. Sebastian Attended by Irene" by Terbrugghen, "View of Venice: Ducal Palace, Dogana, with Part of San Giorgio" by J.M.W. Turner, "Wisteria" and "The Garden of the Princess, Louvre" by Monet, "The Viaduct at L'Estaque" by Cézanne, "The Plough and the Song" by Gorky, and "Laocoön" by Eva Hesse.

Oxford

Miami University Art Museum

Patterson Ave. (U.S. Route 27 between Western Dr. & Chestnut St.)
Oxford, OH 45056
Tel: (513) 529-2232
Fax: (513) 529-6555
TDDY: (513) 529-1541
Internet Address: http://www.muohio.edu/artmuseum/
Director: Mr. Robert A. Kret
Admission: free.
Attendance: 51,000 *Established:* 1978
Membership: Y *ADA Compliant:* Y
Parking: free on site.
Open: Tuesday to Sunday, 11am-5pm.
Closed: Legal Holidays, Academic Holidays.
Facilities: **Architecture** (1978 designed by Walter Netsch of Skidmore, Owings & Merrill); **Auditorium** (184 seats); **Galleries** (5); **Library**; **Sculpture Park**; **Shop**.
Activities: **Concerts**; **Education Programs**; **Films**; **Gallery Talks**; **Guided Tours** (by appointment, reserve two weeks in advance); **Lectures**; **Temporary Exhibitions**; **Traveling Exhibitions**.

George Bottini, *Addresse Sagot*, 1898, color lithograph on paper, 28.5 x 18.5 cm, Miami University Art Museum Purchase, Patrick A. Spensley Memorial Fund. Photograph courtesy of Art Museum, Miami University, Oxford, Ohio.

Publications: annual report; brochure, "Calendar of Events"; exhibition catalogues; newsletter (quarterly).

Located on the southern edge of the campus, the Art Museum houses five galleries of changing exhibitions, a growing permanent collection of approximately 16,000 art works, a lecture hall, and a library study room. Exhibitions feature historical and contemporary art, decorative arts, and art from diverse cultures of the world drawn from other museums, private and corporate collections, and national traveling exhibitions, as well as the University's permanent collection. Exhibitions are complemented by more than thirty public programs each year. The permanent collection is broad and eclectic with strengths in many fields from all parts of the world. Major holdings include European and American paintings, prints, drawings, watercolors and photographs; ancient art; European and

Miami University Art Museum, cont.

American glass; ceramics (including Islamic, European, and Chinese porcelain); sculpture (including Gandharan, African, Oceanic, 19th century and contemporary works); a worldwide collection of textiles; folk art; and Leica cameras and accessories. Among the painters represented are Audrey Flack, Leon Golub, Hans Hofmann, Robert Indiana, Josef Israels, John Everett Millais, Ad Reinhardt, Miriam Schapiro, and Francesco Solimena. Sculptors include Fletcher Benton, Mark di Suvero, Nancy Holt, Richard Hunt, Marisol, and Claes Oldenburg. Prints include works by Josef Albers, Paul Cadmus, Marc Chagall, Francesco Clemente, Henri deToulouse-Lautrec, Jim Dine, Albrecht Dürer, Paul Gauguin, Käthe Kollwitz, Le Corbusier, Pablo Picasso, Odilon Redon, Georges Rouault, David Alfaro Sequeiros, Rufino Tamayo, June Wayne, Andy Warhol, and James McNeill Whistler.

Portsmouth

Southern Ohio Museum

825 Gallia St., Portsmouth, OH 45662

Tel: (740) 354-5629

Fax: (740) 354-4090

Administrative Director: Ms. Kay Bouyack

Admission: fee:
 adult-$1.00, child-$0.75, student-$0.75.

Attendance: 15,000 *Established:* 1977

Membership: Y *ADA Compliant:* Y

Parking: Free on street and municipal lot.

Open: Tuesday to Friday, 10am-5pm;
 Saturday to Sunday, 1pm-5pm.

Closed: Major Holidays.

Painting by Will Reader of Southern Ohio Museum and Cultural Center (1918), beaux-arts style former bank building. Photograph courtesy of Southern Ohio Museum, Portsmouth, Ohio.

Facilities: **Architecture** (Beaux Art bank building, 1918); **Galleries** (4); **Library**; **Reading Room**; **Shop**; **Theatre** (96 seats).

Activities: **Concerts**; **Education Programs**; **Films**; **Guided Tours** (groups 10+, reserve in advance, free); **Lectures** (noon); **Performances**; **Temporary/Traveling Exhibitions** (5-6/year).

Publications: field guides; newsletter (quarterly).

The Southern Ohio Museum is primarily a visual arts museum, which displays in the main Kricker Gallery five or six major exhibitions each year, focusing on artists of regional or national acclaim. Additional display space in the Richards and Mezzanine galleries is given to smaller one- or two-person exhibitions and the Museum's permanent collection of paintings, watercolors and prints by Portsmouth native and nationally known artist Clarence Carter. The Museum also holds an extensive collection of local historic photographs from which exhibitions on a variety of themes are curated. A biennial juried exhibition provides an opportunity to view current local creative expression. Accompanying exhibitions are performing arts programs by professional touring artists, as well as concerts organized by the museum's musician-in-residence, artists' lectures, classes and workshops for various ages, artist-in-residence projects, family films and many other kinds of special programs. The Museum also holds a sizable antique doll head collection.

Rio Grande

University of Rio Grande - Sculpture Park and Esther Allen Greer Museum

218 North College Avenue, Rio Grande, OH 45674-3131

Tel: (800) 282-2801

Internet Address: http://www.rio.edu

Curators: Kevin Lyles and James Allen

Admission: free.

Open: **Greer Museum**, Tuesday to Saturday, 1pm-5pm.
 Sculpture Park, always open.

Facilities: **Exhibition Area**; **Sculpture Park**.

Rio Grande, Ohio

University of Rio Grande - Sculpture Park and Esther Allen Greer Museum, cont.

There are more than a dozen monumental outdoor sculptures located throughout the Rio Grande campus. All works are by professional sculptors from throughout the United States, including Fletcher Benton. Additionally, the Esther Allen Greer Museum displays rotating contemporary exhibitions in a variety of media.

Salem

The Butler Institute of American Art - Salem Branch

343 E. State St., Salem, OH 44460-2846

Tel: (330) 332-8213

Admission: free.

Established: 1991

Open: Call for hours.

Facilities: **Gallery**; **Shop**.

Activities: **Temporary Exhibitions.**

Established with the assistance of the Salem Community Foundation, the Gallery presents temporary exhibitions. The Institute's main facility is located in Youngstown, Ohio.

Springfield

Springfield Museum of Art

107 Cliff Park Road (between Fountain Ave. and Plum St.), Springfield, OH 45501

Tel: (937) 325-4673

Fax: (937) 325-4674

Internet Address: http://www.spfld-museum-of-art.org

Director: Mr. Mark Chepp

Admission: voluntary contribution.

Attendance: 53,000 *Established:* 1946

Membership: Y *ADA Compliant:* Y

Parking: free in adjacent municipal lot.

Open: Tuesday, 9am-5pm;
Wednesday, 9am-9pm;
Thursday to Friday, 9am-5pm;
Saturday, 9am-3pm; Sunday, 2pm-4pm.

Closed: Thanksgiving Day, Christmas Eve to New Year's Day.

Facilities: **Classrooms**; **Galleries** (5 permanent, 2 temporary exhibition); **Library** (4,300 volumes); **Shop** (unique gift items, original works by local artists).

Activities: **Education Programs** (adults and children); **Gallery Talks**; **Lectures** (reserve in advance 324-3729); **Temporary Exhibitions** (8-10/year).

George Luks, *A Man*, Springfield Museum of Art. Photograph courtesy of Springfield Museum of Art, Springfield, Ohio.

Publications: exhibition catalogues (occasional); gallery guides (occasional); newsletter (monthly).

The Museum offers five permanent exhibition galleries and two galleries for eight to ten temporary exhibitions a year. Its art school with ten multi-purpose classrooms provides studio instruction in a wide range of media. The Museum's collection of over 1,400 objects is based in 19th- and 20th-century American and European art.

Toledo

The Toledo Museum of Art (TMA)

2445 Monroe St. at Scottwood Ave., Toledo, OH 43620

Tel: (419) 255-8000

Fax: (419) 255-5638

TDDY: (419) 255-8000

Internet Address: http://www.toledomuseum.org

The Toledo Museum of Art, cont.

Director: Roger M. Berkowitz

Admission: voluntary contribution.

Attendance: 340,000 *Established:* 1901 *Membership:* Y *ADA Compliant:* Y

Parking: commercial adjacent to site.

Open: Tuesday to Thursday, 10am-4pm;
Friday, 10am-10pm;
Saturday, 10am-4pm;
Sunday, 11am-5pm.

Closed: New Year's Day, Independence Day,
Thanksgiving Day, Christmas Day.

Facilities: **Architecture** (classical-style, 1912 design by Edward B. Green); **Food Services** Café (daily, 10am-2pm, also Fri., 5:30pm-9:30pm); **Galleries** (30); **Glass Study Room**; **Lecture Hall** (200 seats); **Library** (60,000 volumes, design by Frank Gehry); **Peristyle Concert Hall** (1,750 seats, home of the Toledo Symphony); **Print Study Room**; **Reading Room**; **Rental Gallery**; **Shop** (original work by regional artists).

View of exterior Toledo Museum of Art. Photograph courtesy of Toledo Museum of Art, Toledo, Ohio.

Activities: **Concerts**; **Education Programs** (adults and children); **Films**; **Gallery Talks** Art & Ideas (Thurs, 1:30pm); **Guided Tours** (by appointment); **Lectures**; **Temporary Exhibitions**; **Traveling Exhibitions**.

Publications: annual report; book, "Guide to the Collection"; calendar (bi-monthly); collection catalogue.

With 30,000 works of art, the Museum is internationally recognized for the quality of its collections. Notable holdings include glass, Greek vases, European and American paintings, decorative arts, and graphic arts, including illustrated artists' books. Special exhibitions and performing arts events complement the Museum's own collections and form the basis for a wide range of programming.

University of Toledo - Center for the Visual Arts Galleries

620 Grove Place (adjacent to the Toledo Museum of Art), Toledo, OH 43620

Tel: (419) 530-8300

Fax: (419) 530-8337

Internet Address: http://www.cva.utoledo.edu

Open: Daily, 9am-10pm.

Facilities: **Galleries** (3).

Activities: **Lectures**; **Temporary Exhibitions**.

The Center for the Visual Arts houses two galleries, the CVA Gallery and the Clement Gallery, which display the work of both students and professional artists. Also of possible interest on campus is the Eberly Center Gallery in Tucker Hall, which shows work created by woman artists.

Wooster

College of Wooster Art Museum

Ebert Art Center, 1220 Beall Ave. (south of Wayne Ave.), Wooster, OH 44691

Tel: (330) 263-2495

Fax: (330) 263-2633

Internet Address: http://www.wooster.edu/Art/artmuseum.html

Director: Ms. Thalia Gouma-Peterson

Admission: free.

Established: 1930

Open: Monday to Friday, 11am-5pm; Sunday, 2pm-5pm.

Facilities: **Galleries** (3; one large, two smaller).

Activities: **Films**; **Gallery Talks**; **Lectures**; **Temporary Exhibitions**.

Wooster, Ohio
College of Wooster Art Museum, cont.
Publications: exhibition catalogues.

The College of Wooster Art Museum exhibits the work of nationally known artists and has achieved a national reputation for exhibitions celebrating the works of contemporary woman artists. The College's permanent collection contains about 6,000 items, including the William Mithoefer Collection of African Art and the John Taylor Arms collection of prints and drawings, some of which date from the Renaissance.

Youngstown

The Butler Institute of American Art

524 Wick Ave., Youngstown, OH 44502

Tel: (330) 743-1711

Fax: (330) 743-9567

Internet Address: http://www.butlerart.com

Director: Mr. Louis A. Zona

Admission: voluntary contribution.

Attendance: 145,000 *Established:* 1919

Membership: Y *ADA Compliant:* Y

Parking: free on site.

Open: Tuesday, 11am-4pm;
Wednesday, 11am-8pm;
Thursday to Saturday, 11am-4pm;
Sunday, noon-4pm.

Winslow Homer, *Snap the Whip*, 1872, oil on canvas, 22 x 36 inches. Butler Institute of American Art. Photograph courtesy of Butler Institute of American Art, Youngstown, Ohio.

Closed: New Year's Day, Easter, Independence Day, Thanksgiving Day, Christmas Day.

Facilities: **Architecture** (Italian Renaissance Revival, 1919 by McKim, Mead & White); **Building** (72,000 square feet); **Galleries** (9 permanent); **Library** (reference); **Sculpture Garden**; **Shop** (pottery, jewelry, unique items, reproductions).

Activities: **Art Classes** (adults and children); **Concerts** (Wed, noon, when Dana School of Music is in session); **Films**; **Gallery Talks**; **Guided Tours** (as scheduled); **Lectures**; **Readings** (1st Wed in month); **Temporary Exhibitions**.

Publications: biennial report (biennial); brochures; catalogue, "National Midyear Show Catalog"; collection catalogue, "Master Paintings from the Butler Institute of American Art"; collection catalogue, "The Butler Institute of American Art/Index to the Permanent Collection".

In 1919 philanthropist Joseph G. Butler, Jr., one of the first American collectors to concentrate solely on the art of his countrymen, selected the architectural firm of McKim, Mead & white to create the first building in the United States specifically constructed as a Museum of American Art. At its dedication Mr. Butler gave the collection and the building to the public. Now on the Register of National Historic Places, the Institute continues to concentrate solely on American art. The permanent collection is exhibited in historical sequence throughout the nine first floor galleries of the Institute. The large second floor gallery surrounding Beecher Court is used for special exhibitions of the collection based on topical or historic theme. The Mesaros Print Gallery houses, protects, and exhibits the Institute's collection of works on paper. Numbering over 12,500 works of art (paintings, works on paper, sculpture, ceramics, photographs, movie stills, and pieces in special collections), the Museum's collection includes a broad spectrum of works by American visual artists. Included are such masterpieces as Winslow Homer's *Snap the Whip*, Robert Vonnoh's *In Flanders Field*, William Harnett's *After the Hunt*, Albert Bierstadt's *Oregon Trail*, William Merritt Chase's *Did You Speak to Me*, Charles Sheeler's *Steam Turbine*, and Edward Hopper's *Pennsylvania Coal Town*. Also located on the Youngstown campus is the Beecher Center for Technology in Art, a joint undertaking with Youngstown State University for study, experimentation and teaching. The Institute maintains branch galleries in Howland and Salem, Ohio (see separate listings).

Youngstown State University - The John J. McDonough Museum of Art

One University Plaza (across from The Butler Institute), Youngstown, OH 44555

Tel: (330) 742-1400

Internet Address: http://www.ysu.edu/colleges/f&pa/art/mcd.htm

Director: Sandy Kreisman

Youngstown State University - The John J. McDonough Museum of Art, cont.

Open: Tuesday, 11am-4pm; Wednesday, 11am-8pm; Thursday to Saturday, 11am-4pm.
Facilities: **Architecture** (design by Charles Gwathmey); **Exhibition Area**; **Sculpture Terraces**.
Activities: **Temporary Exhibitions** (15-20/year).

Funded in large part by the sale of a donated Childe Hassam painting, "Gloucester Harbor", the John J. McDonough Museum of Art was designed by New York architect Charles Gwathmey. It serves as a professional exhibition venue for graduating BFA students in Studio Art, as well as for studio faculty. It presents visual arts programs of educational and artistic significance, and exhibits works of established and emerging artists as well as loaned works and/or collections from larger museums. The annual exhibition season is a balance of in-house curatorial efforts, touring temporary exhibits, and student and faculty shows. The Museum facility has three traditional galleries, a raw-space gallery and a two-story, sky-lit large installation gallery. Experimental galleries have plywood walls and concrete floors-intentionally designed to accommodate installation works constructed on site. The outdoor sculpture terraces and grounds are used for site-specific works and special projects by artists.

Zanesville

Zanesville Art Center

620 Military Road, Zanesville, OH 43701-1533
Tel: (740) 452-0741
Fax: (740) 452-0797
Director: Mr. Philip Alan LaDouceur
Admission: voluntary contribution.
Attendance: 8,500 *Established:* 1936
Membership: Y *ADA Compliant:* Y
Parking: free on site.
Open: Tuesday to Wednesday, 10am-5pm;
Thursday, 10am-8:30pm;
Friday, 10am-5pm;
Saturday to Sunday, 1pm-5pm.
Closed: Legal Holidays.

Exterior view of Zanesville Art Center. Photograph courtesy of Zanesville Art Center, Zanesville, Ohio.

Facilities: **Auditorium** (160 seats); **Galleries** (10); **Library** (8,000 volumes); **Reading Room**; **Shop**.
Activities: **Arts Festival**; **Concerts**; **Education Programs** (adults and children); **Gallery Talks**; **Guided Tours** (on request); **Lectures**; **Performances**; **Temporary Exhibitions**; **Traveling Exhibitions**.
Publications: brochures; bulletin (monthly).

The Zanesville Art Center has twelve galleries of American, European and Oriental art. Rotating selections from the permanent collections are always on exhibition. Included in the galleries is a 17th-century spruce panel room (1695) from the site of Hatton Gardens, London. Exhibitions of the permanent collection are supplemented by monthly traveling exhibitions of contemporary and 20th century art. Emphasizing 20th-century Ohio and area artists, but including a number of nationally known artists, the Center's permanent collection is widely varied. European artists represented include Cézanne, Delacroix, Dürer, Gainsborough, Granacci, Matisse, Parmigiano, Picasso, Rembrandt, Renoir, Rubens, Teniers, Tiepolo, Toulouse-Lautrec, Turner and Van Dyck. Among the American artists included are Bierstadt, Blakelock, William Merritt Chase, Thomas Lindsay, Samuel F.B. Morse, Rembrandt Peale, and Hiram Powers. Besides Old Master and modern paintings, graphics, and sculpture, the Center has an extensive collection of Ohio ceramics and glass, as well as Meissen, Staffordshire, Steuben, Tiffany and Wedgwood decorative arts. The Center also houses one of the oldest collections of children's art; pre-Columbian artifacts; Mexican folk art; Inuit prints; and Chinese, Japanese, Thai, Burmese, and Indian art and artifacts.

Oklahoma

The number in parentheses following the city name indicates the number of museums/galleries in that municipality. If there is no number, one is understood. For example, in the text four listings would be found under Tulsa and one listing under Norman.

Oklahoma

Anadarko

Southern Plains Indian Museum

715 E. Central Blvd. (Highway 62, East)
Anadarko, OK 73005
Tel: (405) 247-6221
Fax: (405) 247-7593
Chief Curator: Rosemary Ellison
Admission: fee: adult-$3.00, child-$1.00.
Attendance: 38,000 *Established:* 1947
Membership: Y *ADA Compliant:* Y
Parking: free on site.
Open: **October to May**,
 Tuesday to Saturday, 9am-5pm;
 Sunday, 1pm-5pm.
 June to September,
 Monday to Saturday, 9am-5pm;
 Sunday, 1pm-5pm.
Closed: New Year's Day, Thanksgiving Day,
 Christmas Day.

Barry D. Belindo, *Peyote Fan*, 1997, pheasant feathers, rolled buckskin fringe, thread wrapping, size 13 cut beads, 27 inches. Southern Plains Indian Museum. Photograph courtesy of Southern Plains Indian Museum, Anadarko, Oklahoma.

Facilities: **Exhibition Area**; **Shop** (operated by Oklahoma Indian Arts and Crafts Cooperative).
Activities: **Gallery Talks**; **Guided Tours**; **Lectures**; **Temporary Exhibitions**.
Publications: exhibition brochures (quarterly); exhibition catalogues.

A permanent exhibition gallery presents the richness and diversity of historic arts created by the tribal people of western Oklahoma including the Kiowa, Comanche, Kiowa-Apache, Southern Cheyenne, Southern Arapaho, Wichita, Caddo, Delaware, and Ft. Sill Apache. Highlighting the historic exhibition is a display of traditional costumes. Other historic displays are devoted to the art forms related to the social and ceremonial aspects of the tribal cultures of the region. In its changing exhibition gallery, SPIM organizes and presents in cooperation with the Oklahoma Indian Arts and Crafts Cooperative a variety of special exhibitions featuring the work of contemporary Native American and Alaskan Native artists and craftsmen. The Museum is administered by the Department of Interior's Indian Arts and Crafts Board.

Ardmore

Charles B. Goddard Center for Visual and Performing Arts

1st Ave. & D St. SW, Ardmore, OK 73401
Tel: (405) 226-0909
Director: Mort Hamilton
Admission: free.
Attendance: 10,000 *Established:* 1969 *Membership:* Y *ADA Compliant:* Y
Parking: free on site.
Open: Monday to Friday, 9am-4pm; Saturday to Sunday, 1pm-4pm.
Closed: Legal Holidays.
Facilities: **Exhibition Area**.
Activities: **Temporary Exhibitions**.
Publications: newsletter (bi-monthly).

The Center offers exhibits of Western and Native American art.

Bartlesville

Woolaroc

State Highway 123 (14 miles southwest of Bartlesville), Bartlesville, OK 74003
Tel: (918) 336-0307

Woolaroc, cont.

Fax: (913) 336-0084

Director: Robert R. Lansdown

Admission: fee: adult-$5.00, child (<12)-free, senior-$4.00.

Attendance: 150,000 *Established:* 1929 *Membership:* Y *ADA Compliant:* Y

Open: **Memorial Day to Labor Day**, Monday to Sunday, 10am-5pm.
 Day after Labor Day to Day before Memorial Day, Tuesday to Sunday, 10am-5pm.

Closed: Thanksgiving Day, Christmas Day.

Facilities: **Architecture** (log lodge, 1926-27); **Food Services** Concession Stand and 2 Picnic Grounds; **Museum; Native American Heritage Center; Shops** (2); **Wildlife Preserve.**

Publications: book, "Woolaroc"; booklets; guidebook.

Woolaroc, derived from "woods, "lakes:, and "rocks", was founded by oilman Frank Phillips. The collection is housed mainly in the museum and to a lesser extent, the Lodge. It includes Western paintings and sculptures, Native American artifacts, Americana, and Colt firearms. Among the artists represented are Remington, Russell, Leigh, Johnson, and Moran.

Edmond

University of Central Oklahoma - Museum of Art and Design

Art and Design Building (south corner), 100 N. University Drive, Edmond, OK 73034

Tel: (405) 974-5931

Internet Address: http://www.libarts.ucok.edu/visual/html/museum.html

Admission: free.

Open: Monday to Wednesday, 9am-5pm; Thursday, 9am-8pm; Friday, 9am-5pm; Sunday, 1pm-5pm.

Facilities: **Exhibition Area.**

Activities: **Temporary Exhibitions.**

The Museum presents exhibitions of the work of professional artists, faculty and students.

Muskogee

The Five Civilized Tribes Museum

Agency Hill on Honor Heights Drive, Muskogee, OK 74401

Tel: (918) 683-1701

Fax: (918) 683-3070

Internet Address: http:www.fivetribes.com

Exec. Director: Clara Reekie

Admission: fee: adult-$2.00, child-free, student-$1.00, senior-$1.75.

Attendance: 38,000 *Established:* 1966 *Membership:* Y *ADA Compliant:* Y

Parking: free on site.

Open: Monday to Saturday, 10am-5pm; Sunday, 1pm-5pm.

Closed: New Year's Day, Thanksgiving Day, Christmas Day.

Facilities: **Architecture** (1875); **Exhibition Area; Library; Shop** (traditional Indian arts and crafts, fine art).

Activities: **Art Shows; Education Programs** (children); **Gallery Talks; Guided Tours** (groups, reserve in advance).

Publications: books; newsletter; prints.

Housed in the original Indian Agency building built in 1875, the Museum is dedicated to preserving and encouraging the cultures and traditions of the Cherokee, Chickasaw, Choctaw, Muscogee (Creek), and Seminole peoples. The Museum tells their story through displays of artifacts, special annual art exhibits, a permanent art collection, a spring outdoor Indian Market, a research library, and educational programming throughout the year. Architectural plans for a new $10 million museum have been adopted by the board of directors of the Museum. The new 53,000 square-foot art museum, educational center, and interpretive park, designed by Hammel Green & Abrahamson, Inc. (Minneapolis, MN), will be located on a 38-acre site at the junction of US Highways #69 and #62.

Norman

University of Oklahoma - The Fred Jones Jr. Museum of Art

University of Oklahoma, 410 W. Boyd St.
Norman, OK 73019-3002
Tel: (405) 325-3272
Fax: (405) 325-7696
Internet Address: http://www.ou.edu/fjjma
Admission: free.
Established: 1936
Membership: Y *ADA Compliant:* Y
Parking: free on site.
Open: **Academic Year,**
 Tuesday to Wednesday, 10am-4:30pm;
 Thursday, 10am-9pm;
 Friday, 10am-4:30pm;
 Saturday to Sunday, noon-4:30pm.
 Summer,
 Tuesday to Sunday, noon-4:30pm.
Closed: Legal Holidays, Academic Holidays.
Facilities: **Library** (3,000 volumes); **Shop.**
Activities: **Concerts**; **Films**; **Gallery Talks**; **Guided Tours**; **Lectures**; **Temporary Exhibitions**; **Traveling Exhibitions**.
Publications: brochures; calendar (3/year); exhibition catalogues; posters.

Ernest L. Blumenschein, *Taos Valley and Mountain*, oil on panel, 22 x 25½ inches. Fred Jones Jr. Museum of Art, University of Oklahoma. Purchase, Richard H. and Adeline J. Fleischaker Collection, 1996. Photograph courtesy of Fred Jones Jr. Museum of Art, University of Oklahoma, Norman, Oklahoma.

The Fred Jones Jr. Museum of Art is the art museum of The University of Oklahoma and reflects the University's commitment to research and scholarship in the visual arts. Its mission is to provide the best possible object-based learning experience through excellence in the collection, preservation, exhibition and interpretation of works of art. The museum strives to be a leader in fostering appreciation of the visual arts and serves as a resource center for the public, university, and scholarly communities. Strengths of the permanent collection include 20th-century American painting and sculpture, contemporary art, traditional and contemporary Native American art, photography, art of the Southwest, ceramics, Asian art, and European graphics from the 16th century to the present.

Oklahoma City

City Arts Center - Eleanor B. Kirkpatrick Gallery

3000 General Pershing Blvd., Oklahoma City, OK 73107-6202
Tel: (405) 951-0000
Fax: (405) 951-0003
Internet Address: http://www.cityartscenter.com/programs.html
Director: Lyn Adams
Open: Monday to Thursday, 9am-10pm; Saturday, 9am-5pm; Sunday, 1pm-5pm.
Facilities: **Exhibition Area.**
Activities: **Temporary Exhibitions.**

The Gallery presents temporary exhibitions highlighting the work of emerging Oklahoma and nationally regarded artists.

National Cowboy Hall of Fame and Western Heritage Center

1700 N.E. 63rd St., Oklahoma City, OK 73111
Tel: (405) 478-2250
Fax: (405) 478-4714
Internet Address: http://www.cowboyhalloffame.org
Exec. Director: Mr. Kenneth W. Townsend
Admission: fee: adult-$8.50, child-$4.00, senior-$7.00.
Attendance: 300,000 *Established:* 1954 *Membership:* Y *ADA Compliant:* Y

National Cowboy Hall of Fame and Western Heritage Center, cont.

Open: **Labor Day to Memorial Day**, Daily, 9am-5pm.

Memorial Day to Labor Day, Daily, 8:30am-6pm.

Closed: New Year's Day, Thanksgiving Day, Christmas Day.

Facilities: **Botanical Garden**; **Library** (9,000 volumes); **Shop**.

Activities: **Guided Tours** (groups 10+, by appointment); **Temporary Exhibitions**; **Traveling Exhibitions**.

Publications: magazine, "Persimmon Hill" (quarterly).

Established as a memorial to the men and women who pioneered the western United States, the Museum's collections of 19th- and 20th-century western American art and Native American art and artifacts are among the most extensive anywhere. The paintings and sculpture in these galleries reflect a diversity of artistic vision from early landscapes and images of Native Americans to depictions of modern ranch life in the southwest. The Galleries also chronicle the development of artistic colonies in the Southwest and the rise in recent years of organizations devoted solely to western artists.

Oklahoma City Art Museum

The Fairgrounds, 3113 Pershing Blvd., Oklahoma City, OK 73107

Tel: (405) 946-4477

Fax: (405) 946-7671

Internet Address: http://www.okcartmuseum.com

Admission: fee: adult-$3.50, student-$2.50, senior-$2.50.

Attendance: 41,000 *Established:* 1989 *Membership:* Y *ADA Compliant:* Y

Parking: free on site.

Open: Tuesday to Wednesday, 10am-5pm; Thursday, 10am-9pm; Friday to Saturday, 10am-5pm; Sunday, 1pm-5pm.

Closed: New Year's Day, Easter, Independence Day, Thanksgiving Day, Christmas Day.

Facilities: **Exhibition Area** (18,000 square feet); **Food Services** Restaurant; **Lecture Hall**; **Library** (5,000 volumes); **Sculpture Garden**; **Shop**.

Activities: **Arts Festival**; **Concerts**; **Education Programs** (adults and children); **Films**; **Guided Tours** (groups 10-50, by appointment two weeks in advance); **Lectures**; **Rental Gallery**; **Temporary Exhibitions**; **Traveling Exhibitions**.

Publications: annual report; exhibition catalogues; newsletter (quarterly).

The Museum is a privately-funded modern art museum. Selections from the permanent collection are always on display, supplemented by temporary and traveling expositions. The permanent collection totals over 3,000 works. One of its cornerstones is the Washington Gallery of Modern Art Collection, obtained in 1968 by the Oklahoma Art Center for $110,000 on the merger of the Washington Gallery with the Corcoran Gallery of Art. While the collection represents a diversity of styles, many of the paintings, sculpture, drawings, and prints are characteristic of abstract expressionism. It includes works by Richard Diebenkorn, Grace Hartigan, Robert Indiana, Ellsworth Kelly, Roy Lichtenstein, and Takeo Yamaguchi. Values of many of the individual works now far surpass the collective purchase price.

Omniplex - Kirkpatrick Art Galleries

2100 N.E. 52nd, Oklahoma City, OK 73111

Tel: (405) 602-6664

Fax: (405) 602-3766

Internet Address: http://www.omniplex.org

Admission: fee: adult-$6.50, child-$5.25, senior-$5.75.

Attendance: 350,000 *Established:* 1978 *Membership:* Y *ADA Compliant:* Y

Open: **Labor Day to Memorial Day**,
Tuesday to Friday, 9am-5pm; Saturday, 9am-6pm; Sunday, 11am-6pm.
Summer,
Tuesday to Saturday, 9am-6pm; Sunday, 11am-6pm.
Some Holiday Mondays.

Closed: Thanksgiving Day, Christmas Day.

Omniplex - Kirkpatrick Art Galleries, cont.

Facilities: **Food Services** Café; **Galleries** (17); **Gardens and Greenhouse**; **Shop**; **Theatre**.

Activities: **Education Programs** (adults and children); **Group Tours**; **Lectures**; **Temporary Exhibitions**; **Traveling Exhibitions**.

Publications: newsletter, "Explorer" (quarterly).

The Kirkpatrick Art Galleries currently showcases its African, Oklahoma State Arts, Berlin Wall, and George Sutton Museum Bird collections in the permanent galleries. Five additional galleries are devoted to temporary and traveling exhibitions. In addition to the Art Galleries, the Kirkpatrick Center Museum Complex includes the Kirkpatrick Gardens and greenhouse, Kirkpatrick Planetarium, Air Space Museum, Hands-on Science Museum, and a large format, dome-screen theater, OmniDome Theater. The International Photography Hall of Fame and Red Earth Indian Center are also located in the Omniplex Museum.

View of entrance to Omniplex. Photograph courtesy of Omniplex, Oklahoma City, Oklahoma.

Shawnee

Mabee-Gerrer Museum of Art

1900 W. MacArthur, Shawnee, OK 74804

Tel: (405) 878-5300

Fax: (405) 878-5198

Interim Director: Sharla Hall

Admission: fee: adult-$3.00, child (<12)-free, student-free, senior-$2.00.

Established: 1917 *Membership:* Y *ADA Compliant:* Y

Parking: free on site.

Open: Tuesday to Saturday, 10am-4pm; Sunday, 1pm-4pm.

Closed: Major Holidays.

Facilities: **Exhibition Area**; **Library** (1,500 volumes); **Sculpture Garden**; **Shop**.

Activities: **Education Programs** (children); **Films**; **Guided Tours** (groups 10-60, reserve two weeks in advance); **Lectures**; **Temporary Exhibitions**.

Publications: exhibition catalogues; newsletter, "Visions" (quarterly).

Located on the grounds of St. Gregory's Abbey and University (although not part of the University), the Mabee-Gerrer Museum of Art features Egyptian, Babylonian, Greco-Roman, and ancient Asian art; medieval and early Renaissance painting and sculpture; Baroque and 18th-century painting; 19th- and early 20th-century European and American painting and sculpture; and Native American art. In addition, changing exhibitions may feature other parts of the permanent collection not regularly on exhibit, regional artists, and traveling exhibits.

Stillwater

Oklahoma State University - Maude Gardiner Art Gallery

Oklahoma State University, 107 Bartlett Center for the Studio Arts, Stillwater, OK 74078

Tel: (405) 744-6016

Fax: (405) 744-5767

Internet Address: http://www.cas.okstate.edu/art/gallery.html

C.E.O. and Director: Dr. Nancy B. Wilkinson

Admission: free.

Attendance: 10,000 *Established:* 1965 *ADA Compliant:* Y

Open: Monday to Friday, 8am-5pm; Sunday, 1pm-4pm.

Closed: Legal Holidays.

Facilities: **Gallery**.

Activities: **Temporary Exhibitions**.

Publications: calendar; exhibition catalogues (occasional).

Oklahoma State University - Maude Gardiner Art Gallery, cont.

The Gallery is located in the Bartlett Center on the Southeast corner of the campus. Exhibitions vary from local shows, such as the annual student juried exhibitions and faculty exhibition, to national shows like the biennial Cimarron National Works on Paper Exhibition, to displays of traditional art of other cultures. The permanent collection began with graphic prints of the art department founder, Doel Reed, and has since grown to include over 240 pieces by such artists as Alexander Calder, Salvador Dali, Jasper Johns, Robert Motherwell, Robert Rauschenberg, and Larry Rivers.

Tulsa

The Gershon and Rebecca Fenster Museum of Jewish Art

1223 East 17th Place, Tulsa, OK 74120

Tel: (918) 582-3732

Fax: (918) 583-1970

Exec. Director: Ms. Diana Aaronson

Admission: voluntary contribution.

Established: 1966 *Membership:* Y *ADA Compliant:* Y

Open: Sunday to Thursday, 10am-4pm.

Closed: Legal Holidays, Jewish Holidays.

Facilities: **Auditorium**; **Galleries** (4, 2,500 square feet); **Library** (1,000 volumes).

Activities: **Education Programs** (children); **Guided Tours** (groups, reserve two weeks in advance); **Lectures**; **Temporary Exhibitions**.

Publications: brochures; collection catalogue, "Judaic Treasures"; newsletter (quarterly).

The Museum is housed in space leased from Congregation B'nai Emunah, a Conservative synagogue. The exhibits explore the history of the diaspora from Biblical times to the present. The objects displayed include both the sacred and the mundane - those associated with worship, those marking significant life cycle events, and distinctive items used in everyday activity. The collection of 1,500 objects spans 4,000 years of Jewish culture. A Holocaust Education Center is sponsored by the Tulsa Chapter of the National Council of Jewish Women.

Gilcrease Museum

1400 Gilcrease Museum Road, Tulsa, OK 74127-2100

Tel: (918) 596-2700

Fax: (918) 596-2770

Internet Address: http://www.gilcrease.org

Director: Mr. J. Brooks Joyner

Admission:
 suggested contribution-$3.00, family-$5.00.

Attendance: 135,000 *Established:* 1949

Membership: Y *ADA Compliant:* Y

Parking: free on site.

Open: **Memorial Day to Labor Day**,
 Monday to Saturday, 9am-5pm;
 Sunday, 11am-5pm.

 Labor Day to Memorial Day,
 Tuesday to Saturday, 9am-5pm;
 Sunday, 11am-5pm;
 Holidays, 11am-5pm.

Albert Bierstadt, *Sierra Nevada Morning*, oil, 56 x 84 inches. Gilcrease Museum. Photograph courtesy of Gilcrease Museum, Tulsa, Oklahoma.

Closed: Christmas Day.

Facilities: **Auditorium** (220 seat); **Food Services** Restaurant (11am-2pm when museum is open); **Grounds** (440 acres, including 23 acres of historic theme gardens); **Library** (111,000 volumes, by appointment); **Reading Room**; **Shop** (prints, reproductions jewelry, pottery).

Activities: **Education Programs** (adults, undergraduate students and children); **Films**; **Gallery Talks**; **Guided Tours** (daily, 2pm); **Lectures**; **Temporary Exhibitions**.

Publications: collection catalogue; exhibition catalogues; magazine, "Gilcrease Journal" (semi-annual); newsletter, "Gilcrease Association Newsletter" (quarterly).

Gilcrease Museum, cont.

The Gilcrease collection was amassed by Tulsa oil man Thomas Gilcrease, one of the first major collectors of Western American art. The collection spans the period from 10,000 BC to the present day, and includes artifacts and historical documents in addition to the extensive collection of Western American art. Albert Bierstadt, George Caitlin, Thomas Moran, Frederic Remington, and Charles Russell are among the more than 400 artists whose paintings, drawings, prints, and sculptures are in the permanent collection. Holdings also include extensive collections of Native American art and artifacts, historical manuscripts, documents, and maps. The Museum's 440-acre grounds include historic theme gardens, natural meadows and woodlands, and Stuart Park. Located on the grounds, Thomas Gilcrease's home is also open to the public.

The Philbrook Museum of Art

2727 S. Rockford Road (1 block east of Peoria Ave. at 27th Place), Tulsa, OK 74114-4104
Tel: (918) 749-7941
Fax: (918) 743-4230
TDDY: (918) 749-7941
Internet Address: http://www.philbrook.org
C.E.O./Exec. Director: Ms. Marcia Y. Manhart
Admission: fee:
 adult-$5.00, child-free, student/senior-$3.00.
Attendance: 120,000 *Established:* 1938
Membership: Y *ADA Compliant:* Y
Parking: free on site.

Exterior view of Philbrook Museum of Art. Photograph by Scott Miller, Miller Photography, Inc., courtesy of Philbrook Museum of Art, Tulsa, Oklahoma.

Open: Tuesday to Wednesday, 10am-5pm; Thursday, 10am-8pm; Friday to Saturday, 10am-5pm; Sunday, 11am-5pm.
Closed: Major Holidays.
Facilities: **Architecture** (Italianate villa, 1927 designed by Edward Buehler Delk); **Auditorium** (250 seats); **Building** (175,000 square feet); **Food Services** La Villa Restaurant (Tuesday-Sunday, 11am-2pm; Thursday, 5pm-7pm); **Galleries** (30); **Gardens** (23 acres); **Library** (18,000 volumes, non-circulating); **Sculpture Garden**; **Shop** (art-related books, gifts, souvenirs).
Activities: **Concerts**; **Education Programs** (adults and children); **Films**; **Gallery Talks**; **Guided Tours** (Sunday, 2pm; reserve 2 weeks in advance to schedule a tour); **Lectures**; **Temporary Exhibitions**; **Traveling Exhibitions**.
Publications: "A Guide to the Villa and Gardens"; bulletin (quarterly); collection catalogue, "Handbook to The Collections"; exhibition catalogues.

The unusual combination of a historical home, art collections, and gardens, Philbrook was donated in 1938 by Waite and Genevieve Phillips as the city's first art museum. More than 8,500 works from around the world make up the Museum's permanent collection with particularly extensive collections of Italian Old Master works, American paintings, and Native American art. The main level is devoted to European art, including Italian paintings and sculpture, 14th- through 18th-century European paintings and decorative art, and British paintings. The American collections, with emphasis given to the museum's holdings of 19th-century landscape painting, 20th-century American art, and contemporary art, craft, and decorative art, are located on the upper level; as are the collections of Antiquities and Asian art. Also to be found on this level are the Works on Paper Gallery, featuring exhibitions from Philbrook's collection of more than 900 works, and A Closer Look Interpretive Gallery where various works form the permanent collection are exhibited to illustrate themes or styles in art. On the lower level African and Native American art and artifacts are displayed. Also in the lower level is the Culture and Creativity Gallery, a participatory gallery concentrating on the Museum's non-western collection. Major special exhibitions are presented in the Helmerich Gallery. The Floyd Education Center offers classes for adults and children.

University of Tulsa - Alexandre Hogue Gallery

School of Art, Phillips Hall, 600 S. College Ave., Tulsa, OK 74104
Tel: (918) 631-2202
Fax: (918) 631-3423
Internet Address: http://www.utulsa.edu/arts/artfacilities.html

University of Tulsa - Alexandre Hogue Gallery, cont.

Director: Mr. Stephen Sumner

Open: **September to July**, Monday to Friday, 8:30am-4:30pm; Saturday, 1pm-4pm.

Facilities: **Exhibition Area.**

Activities: **Temporary Exhibitions.**

Used year-round for the exhibition of arts, crafts, performance art, and special events, the Alexandre Hogue Gallery provides flexible lighting and display areas for student, faculty, and touring art exhibitions. It is also the site of the annual Herbert Gussman Student Art Competition, the National Scholastic Art Awards Competition, and numerous shows by prominent artists, and can be comfortably used for poetry readings and chamber music performances. In addition, student work is displayed campus-wide in public areas and administrative offices.

Oregon

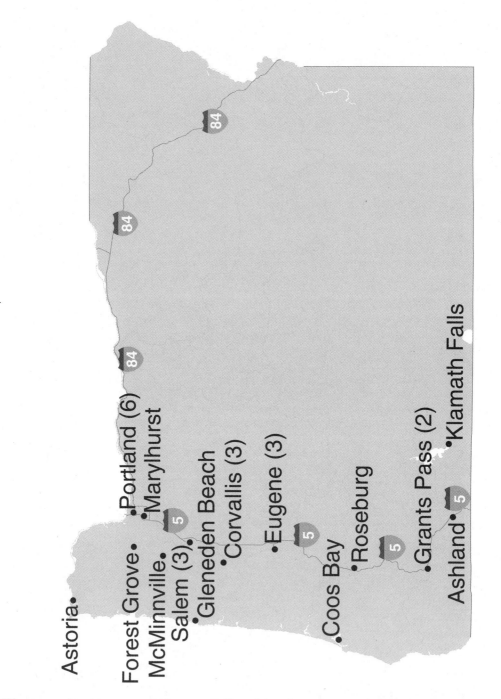

The number in parentheses following the city name indicates the number of museums/galleries in that municipality. If there is no number, one is understood. For example, in the text six listings would be found under Portland and one listing under Coos Bay.

Oregon

Ashland

Southern Oregon University - Schneider Museum of Art

Southern Oregon University, 1250 Siskiyou Blvd., Ashland, OR 97520-5095

Tel: (541) 552-6245

Fax: (541) 552-8241

Internet Address: http://www.sou.edu/schneider

Director: Mr. Sanford Shaman

Admission: suggested contribution-$2.00.

Attendance: 30,000 *Established:* 1986 *Membership:* Y *ADA Compliant:* Y

Parking: 1 hour free, directly in front of museum.

Open: **Academic Year**, Tuesday to Saturday, 11am-5pm; 1st Friday in month, 11am-7pm.
 Summer, Tuesday to Sunday, 10am-4pm.

Closed: Legal Holidays, Thanksgiving Weekend, December 18 to January 4.

Facilities: **Architecture** (post-modernist building, 1985 design by Will Martin); **Galleries** (4).

Activities: **Guided Tours** (arrange in advance); **Lectures** (1st Friday in month and for specific exhibitions).

Publications: bulletin (quarterly); exhibition catalogues and brochures.

A small fine arts museum with four galleries at Southern Oregon University, the Museum hosts an eclectic program of contemporary art exhibitions, lectures, gallery talks and workshops. It is home to a permanent collection of paintings, drawings, original prints and Native American objects. Also of possible interest on campus: The Gallery at Stevenson Union (552-6465) presents temporary exhibits of contemporary art by regionally and nationally recognized artists and an annual juried competition for SOU students in the spring. Galleries in the Center for the Visual Arts also present exhibitions of work by professional artists and by advanced students. Student work is also displayed in the Central Art Gallery in Central Hall and in the lobby of the Dorothy Stolp Theatre.

Astoria

Clatsop Community College - Art Center Gallery

1653 Jerome, Astoria, OR 97103

Tel: (541) 325-0910

Fax: (541) 325-5738

Internet Address: http://www.clatsopcollege.com/Activities/actframe.html

Admission: free.

Open: Monday to Thursday, 9am-5pm and 7pm-10pm; Friday, 9am-5pm.

Facilities: **Gallery**.

Activities: **Temporary Exhibitions**.

Located at the southeast corner of the campus, the Art Center Gallery presents exhibitions of work in a variety of media and styles by professional artists, as well as a juried exhibit of student work at the end of the spring term.

Coos Bay

Coos Art Museum

235 Anderson, Coos Bay, OR 97420

Tel: (541) 267-3901

Internet Address: http://www.coos.or.us/~cam

Administrator: Ms. Helen Scully

Admission: voluntary contribution.

Attendance: 12,000 *Established:* 1965 *Membership:* Y *ADA Compliant:* Y

Parking: free on site.

Open: Tuesday to Friday, 10am-4pm; Saturday, 1pm-4pm.

Closed: Major Holidays.

Coos Bay, Oregon

Coos Art Museum, cont.

Facilities: **Architecture** (art deco former Post Office building); **Galleries**; **Rental/Sales Gallery** (paintings, prints, photographs); **Shop**.

Activities: **Education Programs**; **Films**; **Guided Tours**; **Lectures**.

Publications: class schedules; exhibition announcements.

CAM presents both permanent and temporary exhibitions. The permanent collection includes works by Northwest artists in many media. Central to the collection are prints by nationally known artists. Other collections include the Victor West Collection of Historic Maritime Photographs (West Coast maritime history) and the Steve Prefontaine Memorial (memorabilia of the Olympian runner).

Corvallis

Corvallis Art Center

700 S.W. Madison, Corvallis, OR 97333

Tel: (541) 754-1551

Internet Address: http://www.caclbca.org

Director: Mr. Fred Pearson

Attendance: 40,000 *Established:* 1968

Open: Tuesday to Sunday, noon-5pm.

Facilities: **Exhibition Area** (2); **Shop**.

Activities: **Temporary Exhibitions** (21/year).

Publications: newsletter, "Artspirit" (bi-monthly).

The Center presents temporary exhibitions in two exhibit spaces: the Main Gallery and the Guild Gallery. The Main Gallery mounts a variety of solo and group shows, juried and invitation presentations, and an annual community Open Exhibition. The Guild Gallery offers monthly exhibits of the work of affiliated area art guilds.

Oregon State University - Fairbanks Gallery

Fairbanks Hall: Jefferson Way and NW 26th St., LSC: College Drive and Western Blvd.

Corvallis, OR 97331-3702

Tel: (541) 737-5009

Internet Address: http://www.orst.edu

Director: Douglas E. Russell

Admission: free.

Open: Monday to Friday, 8am-5pm.

Facilities: **Gallery**.

Activities: **Temporary Exhibitions**.

The Fairbanks Gallery, located in Fairbanks Hall on the OSU campus, exhibits monthly shows of contemporary art by local, regional and national artists. Exhibits rotate approximately every month with a show by senior art majors featured each spring. The University's Fine Arts Collection consists of medieval illuminated manuscript pages, older European and Japanese prints, 20th-century paintings, prints, mosaics, sculpture, and crafts. Selections from the collection are exhibited occasionally in the Fairbanks Gallery.

Oregon State University Memorial Union Gallery

Oregon State University, Memorial Union Building, Jefferson St., Corvallis, OR 97331-5004

Tel: (503) 737-6371

Fax: (503) 737-1565

Internet Address: http://www.orst.edu

Director: Mr. Kent Sumner

Admission: free.

Attendance: 50,000 *Established:* 1927 *ADA Compliant:* Y

Open: Daily, 9am-5pm.

Closed: Legal Holidays.

Oregon State University Memorial Union Gallery, cont.

Facilities: **Exhibition Area.**

Activities: **Permanent Exhibits; Temporary Exhibitions.**

The Memorial Union Gallery includes collections of landscapes and marine paintings by William Henry Price and Leo Fairbanks. A permanent collection displays American Indian portraits by Carrie M. Gilbert and prints by Gordon Gilkey. Throughout the year temporary exhibits of cultural and social interest are displayed in the main concourse of the Union.

Eugene

Lane Community College Art Gallery

4000 East 30th Ave., Eugene, OR 97405

Tel: (541) 747-4501

Internet Address: http://www.lanecc.edu

Director: Mr. Harold Hoy

Admission: free.

Attendance: 6,000 *Established:* 1970 *ADA Compliant:* Y

Open: **September to June**, Monday to Thursday, 8am-10pm; Friday, 8am-5pm.

Closed: New Year's Day, Presidents' Day, Memorial Day, Labor Day, Thanksgiving Day, Christmas Day.

Facilities: **Exhibition Area** (875 square feet).

Activities: **Lectures.**

The Art Department Gallery presents temporary exhibitions including annual faculty, studio assistants, juried student and second-year graphic design student graduation shows.

Maude I. Kerns Art Center

1910 East 15th Ave., Eugene, OR 97403

Tel: (541) 345-1571

Fax: (541) 345-6248

Internet Address: http://www.premierelink.com/clients/mkac

Interim Exec. Director: Ms. Sandra Dominguez

Admission: suggested contribution-$2.00, family-$5.00.

Attendance: 60,000 *Established:* 1962

Membership: Y *ADA Compliant:* Y

Open: Monday to Tuesday, 9am-5pm;
Wednesday, 9am- 6pm;
Thursday to Friday, 9am-5pm;
Saturday, noon-5pm.

Facilities: **Galleries** (3).

Activities: **Arts Festival** (Art & the Vineyard, annual, Independence Day Weekend); **Education Programs** (adults and children); **Guided Tours; Lectures.**

Publications: class schedules (quarterly); newsletter (quarterly).

Housed in a historic former church, the Center features regular changing exhibitions showcasing the talents of both local and national artists and ongoing quarterly exhibits of the work of Maude I. Kerns. Educational programs and slide presentations often complement the exhibitions. Classes for adults and children are offered year-round. There are two artists cooperatives on site: Oregon Printmakers Studio and Club Mud Ceramics Studio, as well as a photography darkroom.

Exterior view of Maude I. Kerns Art Center (1895), former sanctuary of Fairmont Presbyterian Church. Photograph courtesy of Maude I. Kerns Art Center, Eugene, Oregon.

University of Oregon Museum of Art

1430 Johnson Lane, Eugene, OR 97403

Tel: (541) 346-3027

Fax: (541) 346-0976

Internet Address: http://uoma.uoregon.edu

University of Oregon Museum of Art, cont.

Director: Mr. David A. Robertson
Admission: suggested contribution-$3.00.
Attendance: 60,000 *Established:* 1930 *Membership:* Y *ADA Compliant:* Y
Open: Wednesday, noon-8pm; Thursday to Sunday, noon-5pm.
Closed: Academic Holidays, Major Holidays.
Facilities: **Architecture**; **Exhibition Area**; **Garden and Sculpture Court**; **Shop**.
Activities: **Gallery Talks**; **Guided Tours** (groups 10+ call in advance); **Temporary Exhibitions**.
Publications: brochures; exhibition catalogues; newsletter.

The Museum is widely recognized for its outstanding collection of Asian art. The collection also contains significant holdings of contemporary art from the Pacific Northwest, as well as 19th- and 20th-century European and American art and photography. Temporary exhibitions include an annual exhibition featuring the work of MFA graduate students. Also of possible interest on campus is the Erb Memorial Union Gallery.

Forest Grove

Pacific University - Kathrin Cawein Gallery of Art

2043 College Way, Forest Grove, OR 97116
Tel: (503) 357-6151
Internet Address: http://www.pacificu.edu
Admission: free.
Open: **September to May**, Weekdays, 8am-5pm.
Facilities: **Gallery**.
Activities: **Temporary Exhibitions**.

The Gallery features temporary exhibitions of work by regionally recognized artists.

Gleneden Beach

Salishan Lodge

7760 Hwy 101, Gleneden Beach, OR 97388
Tel: (541) 764-3610
Fax: (541) 764-3698
Internet Address: http://www.salishan.com
Art Coordinator: Ms. Niki Price
Admission: open to public.
Established: 1965 *ADA Compliant:* Y
Parking: free on site.
Facilities: **Resort hotel** (art in public areas).
Activities: **Self-Guided Tours**.
Publications: bulletin, "Art at Salishan".

Salishan Lodge is a four-star resort with a 650-piece Northwest art collection. Most of the collection (wood sculpture, paintings, and outdoor works) is accessible to the public during most hours of the day.

Grants Pass

Grants Pass Museum of Art

304 S.E. Park St., Riverside Park, Grants Pass, OR 97526
Tel: (541) 479-3290
Director: Hatje Joswick
Admission: voluntary contribution.
Attendance: 9,000 *Established:* 1979 *Membership:* Y *ADA Compliant:* Y
Open: Tuesday to Saturday, noon-4pm.
Closed: Easter, Independence Day, Thanksgiving Weekend, December 19 to New Year's Day.

Grants Pass Museum of Art, cont.

Facilities: **Exhibition Area**; **Shop**.

Activities: **Education Programs** (children); **Films**; **Guided Tours**; **Lectures**; **Traveling Exhibitions**.

Publications: newsletter (monthly).

The museum presents exhibitions of work in a variety of media by local, regional and national artists. Student and membership shows are also regularly scheduled.

Rogue Community College Galleries

3345 Redwood Highway, Grants Pass, OR 97527

Tel: (541) 956-7359

Fax: (541) 471-3588

Internet Address: http://www.rogue.cc.or.us

Director: Ms. Tommi Drake

Admission: voluntary contribution.

Attendance: 19,000 *Established:* 1988 *Membership:* N *ADA Compliant:* Y

Parking: free on site.

Open: **Wiseman Gallery**,
　　　　Fall-Spring,
　　　　　Monday to Thursday, 8am-9pm; Friday, 8am-5pm; Saturday, 9am-4pm.
　　　　Summer,
　　　　　Reduced hours. Call for hours.
　　　　Fire House Gallery,
　　　　　Tuesday to Friday, 11:30am-4:30pm; Saturday, 11am-2pm.

Closed: Academic Holidays, Legal Holidays.

Facilities: **Galleries** (2); **Theatre** (250 seats).

Activities: **Education Programs** (adults and children); **Gallery Talks**; **Reception** (1st Friday in month, 6pm-8pm); **Temporary Exhibitions**; **Traveling Exhibitions**; **Workshops**.

Publications: "Northwest Women's Catalogue" (annual); exhibits schedule (annual).

The RCC galleries display contemporary art that deals with significant themes of the modern world. Representing a wide range of aesthetic styles, the exhibits originate from throughout the region, the nation, and the world. The Wiseman Gallery is located on the Redwood Campus of Rogue Community College. The Firehouse Gallery is located in the Historic Grants Pass City Hall at the corner of H and 4th streets.

Klamath Falls

Favell Museum of Western Art and Indian Artifacts

125 W. Main St., Klamath Falls, OR 97601

Tel: (541) 882-9996

Fax: (589) 882-9996

Owner and Director: Mr. Gene H. Favell

Admission: fee:
　adult-$4.00, child-$2.00, senior-$3.00.

Attendance: 14,000 *Established:* 1972

Membership: Y *ADA Compliant:* Y

Parking: free on site.

Open: Monday to Saturday, 9:30am-5:30pm.

Facilities: **Art Show** (annual in April); **Auditorium** (150 seats); **Exhibition Area**; **Shop** (original western art and limited edition prints).

Activities: **Gallery Talks**; **Lectures**.

Publications: book, "The Favell Museum: A Treasury of Our Western Heritage".

Exterior view of Favell Museum. Photograph courtesy of Favell Museum of Western Art and Indian Artifacts, Klamath Falls, Oregon.

653

Favell Museum of Western Art and Indian Artifacts, cont.

The Favell Museum is "dedicated to the Indians who roamed and loved this land before the coming of the white man and to those artists who truly portray the inherited beauty which surrounds us." The permanent collection features Indian artifacts from all the Western States, British Columbia and Mexico and contemporary Western American realistic two- and three-dimensional art. There are works in the Museum by over 300 artists including fourteen members of the Cowboy Artists of America. The permanent collection includes Western art in a wide variety of media. Artists represented include Jerry Anderson, James Bama, John Clymer, Jerry Crandall, Don Crook, Don Crowley, Jerry Dollar, Bev Doolittle, Arnold Fireberg, Grace Hudson, Harvey Johnson, Mort Kunstler, Dave Manuel, Frank McCarthy, Edgar Paxson, Don Polland, Charles M. Russell, and Russ Vickers. An additional attraction is a collection of miniature firearms.

Marylhurst

Marylhurst University - The Art Gym

Marylhurst University, 17600 Pacific Highway, Marylhurst, OR 97036
Tel: (503) 636-8141
Fax: (503) 636-9526
Internet Address: http://www.marylhurst.edu
Director and Curator: Ms. Terri M. Hopkins
Admission: voluntary contribution.
Attendance: 4,500 *Established:* 1980 *Membership:* Y *ADA Compliant:* Y
Parking: free on site.
Open: **September to June**, Tuesday to Sunday, noon-4pm.
Closed: Major Holidays, July to August, Thanksgiving Weekend, December 10 to January 5.
Facilities: **Exhibition Area** (2,500 square feet).
Activities: **Education Programs** (graduate and undergraduate students); **Guided Tours** (by arrangement); **Lectures**; **Temporary Exhibitions** (6-8/year).
Publications: exhibition announcements (bi-monthly); exhibition catalogues (semi-annual).

The goal of the Art Gym's program is to increase public understanding of contemporary art of the Pacific Northwest. Since 1980, the Art Gym has shown the work of more than 500 artists in many types of exhibitions, produced more than 50 exhibition catalogues, and sponsored numerous artist's talks and forums. Exhibitions include career retrospectives, mid-career surveys, thematic exhibitions, and large-scale sculpture exhibitions. Also of possible interest on campus, the Streff Gallery in Schoen Library displays exhibits of art by students and professional artists.

McMinnville

Linfield College - Renshaw Gallery

900 SE Baker Street, McMinnville, OR 97128
Tel: (503) 434-2275
Internet Address: http://www.linfield.edu
Open: Monday to Friday, 8am-5pm.
Facilities: **Galleries** (1600 square feet).

Each year, the Gallery presents exhibitions of regional, national, and international stature, as well as student work.

Portland

Oregon College of Art and Craft - Hoffman Gallery

8245 SW Barnes Road, Portland, OR 97225
Tel: (503) 297-5544
Internet Address: http://www.ocac.edu/exhibitions.html
Admission: free.
Open: Daily, 10am-5pm.
Facilities: **Exhibition Area**.
Activities: **Temporary Exhibitions**.

Oregon College of Art and Craft - Hoffman Gallery, cont.

The Hoffman Gallery brings the work of regional, national, and international artists to the campus of the Oregon College of Art and Craft. The Gallery has a varied program of exhibits that range from traditional craft and ethnic art to work that challenges accepted concepts of craft and art. Student exhibitions include an annual juried show and a show of thesis work.

Pacific Northwest College of Art - Feldman Gallery

1241 N.W. Johnson St., Portland, OR 97209

Tel: (800) 818-7622

Fax: (503) 226-3587

Internet Address: http://www.pnca.edu/

V. President, Academic Affairs: Greg Ware

Admission: free.

Attendance: 20,000 *Established:* 1990

ADA Compliant: Y

Parking: on street.

Open: Tuesday to Saturday, 10am-6pm.

Facilities: **Exhibition Area** (3 spaces).

Activities: **Temporary Exhibitions**.

The Gallery presents temporary exhibitions of the work of nationally recognized contemporary artists and students in three spaces: the main gallery, the project room, and the student gallery. Also of possible interest at PNCA the 3-D Exhibition Space (3-D Annex), located in the Sculpture/Ceramics Building next to the main campus, showcases 3-dimensional work organized by the faculty of that department.

Elizabeth Olbert, *Rod*, 1997, pigment in urethane on canvas, 24 inches by 17 inches. Photograph courtesy Caren Goldens.

Portland Art Museum

1219 S.W. Park Ave., Portland, OR 97205

Tel: (503) 226-2811

Fax: (503) 226-4842

Internet Address: http://www.pam.org

C.E.O.: Mr. John E. Buchnan, Jr.

Admission: fee: adult-$5.00, student-$2.50, senior-$3.50, family-$10.00.

Attendance: 350,000 *Established:* 1892 *Membership:* Y *ADA Compliant:* Y

Open: Tuesday to Sunday, 10am-5pm; 1st Thursday in month, 10am-9pm.

Closed: Legal Holidays.

Facilities: **Architecture** (designed by Pietro Belluschi); **Auditorium** (480 seats); **Film Study Center**; **Library**; **Print Study Room** (by appointment); **Shop**.

Activities: **Education Programs** (adults and children); **Films** (Northwest Film Center, five nights/week); **Gallery Talks** (3rd Thurs in month, 9:30am; selected Wednesdays, 6pm); **Guided Tours** (Sun, 2pm & 3pm); **Lectures** Docent (selected Mondays, 9:30am;, Lunchbox Series (Thurs, noon-1pm); **Performances**; **Temporary Exhibitions**; **Traveling Exhibitions**.

Publications: calendar (monthly); exhibition catalogues.

The region's oldest and largest visual and media arts center, the Portland Art Museum houses a diverse collection of more than 32,000 works of art. The collections can be divided roughly into two areas: one of Eurocentric origins that also incorporates art from regions of the Pacific Rim, including Northwest Coast Native American art; and the other made up of works from three major Asian cultures. Facilities include the Vivian and Gordon Gilkey Center for Graphic Arts, which houses over 22,000 prints, drawings, and photographs. The Gilkey Collection combines a wealth of works by great masters of the past (such as Cézanne, Dürer, Goya, Matisse, Miró, Picasso, and Rembrandt) with a comprehensive body of work by artists, both famous and obscure, who have lived and worked in the Pacific Northwest. Its photography collection incorporates a history of creative photography in Oregon with leading examples of work by major photographers of the 19th and 20th centuries. The Northwest Film Center provides a variety of film and video exhibition, education, and information programs.

Portland Community College - Northview Gallery

Communications Technology Building, Room 214, 12000 SW 49th St. (Sylvania Campus)
Portland, OR 97219
Tel: (503) 977-4264
Admission: free.
Open: Monday to Thursday, 8am-5pm; Friday, 8am-4pm.
Facilities: **Exhibition Area.**
Activities: **Temporary Exhibitions.**

L ocated on the second floor in the Communications Technology Building on PCC's Sylvania Campus, the Northview Gallery presents temporary exhibitions of work by contemporary Northwest artists and occasional thematic shows of educational importance.

Portland State University - Autzen Gallery and Gallery 299

Neuberger Hall, 724 S.W. Harrison, Portland, OR 97207
Tel: (503) 725-3344
Internet Address: http://www.fpa.pdx.edu/art.html
Contact: Ms. Mary McVein
Admission: free.
Open: Monday to Thursday, 8am-6pm; Friday, 8am-5pm.
Facilities: **Galleries.**
Activities: **Temporary Exhibitions.**

T he Autzen Gallery (205 Neuberger Hall) and Gallery 299 (299 Neuberger Hall) present the work of regional and student artists, including MFA Thesis Exhibitions in the Spring. New exhibitions open on the first Thursday of each month. Also of possible interest on campus are the Littman and White Galleries on the second floor of Smith Memorial Center located at 1825 S.W. Broadway. The Littman Gallery (Mon-Wed, noon-4pm; Thurs, noon-7pm) features painting, sculpture, and mixed media. The White Gallery (Mon-Fri, 7am-9pm; Sat-Sun, 9:30am-5pm) specializes in photography.

Reed College - The Douglas F. Cooley Memorial Art Gallery

Reed College, 3203 S.E. Woodstock Blvd., Portland, OR 97202-8199
Tel: (503) 777-7790
Fax: (503) 777-7798
Internet Address: http://web.reed.edu/resources/gallery/index.html
Director: Ms. Susan Fellin-Yeh
Admission: free.
Attendance: 5,500 *Established:* 1989 *Membership:* Y *ADA Compliant:* Y
Open: Tuesday to Sunday, noon-5pm.
Closed: Legal Holidays.
Facilities: **Galleries.**
Activities: **Gallery Talks; Lectures; Temporary Exhibitions; Traveling Exhibitions.**
Publications: exhibition catalogues.

T he Gallery functions as a venue for scholarly exhibitions curated both in-house and by other museums. Four major exhibitions of contemporary and historical work are displayed each school year. As a teaching gallery, it often links exhibitions to course offerings and other activities through-out the College's calendar year. Elsewhere on campus, the Vollum Lounge Gallery often exhibits the work of senior art majors.

Roseburg

Umpqua Valley Arts Association

1624 W. Harvard Ave., Roseburg, OR 97470
Tel: (541) 672-2532
Fax: (541) 672-7696
Internet Address: http://www.coos.or.us/~uvaa/index/html
Contact: Ms. Eileen Paul

Umpqua Valley Arts Association, cont.

Admission: free.

Open: Monday to Friday, 10am-5:30pm; Saturday, noon-4pm.

Facilities: **Exhibition Area.**

Activities: **Temporary Exhibitions.**

U VAA presents temporary exhibitions in three spaces: The Hallie Ford Brown Gallery, Gallery II, and the Corner Gallery.

Salem

Chemeketa Community College Art Gallery

4000 Lancaster Drive, N.E., Salem, OR 97309

Tel: (503) 399-2533

Internet Address: http://www.chemeketa.cc.or.us/arts/gallery.html

Contact: Tom Creelan

Admission: free.

Open: Monday to Thursday, 9:30am-5:30pm; Friday, 9:30am-4:30pm.

Facilities: **Gallery.**

Activities: **Temporary Exhibitions.**

T he gallery presents temporary exhibitions of contemporary art in all media, including an annual juried student exhibition.

Salem Art Association - Bush Barn Art Center and Bush House Museum

600 Mission St., S.E., Salem, OR 97302

Tel: (503) 581-2228

Fax: (503) 371-3342

Exec. Director: Mr. David Cohen

Admission: fee for museum (center free): adult-$2.50, child-$1.00, student-$2.00, senior-$2.00.

Established: 1919

Membership: Y *ADA Compliant:* Y

Parking: free on site.

Open: **Art Center:,**
 Tuesday to Friday, 10am-5pm;
 Saturday to Sunday, 1pm-5pm.
 Museum: October to April,
 Tuesday to Sunday, 2pm-5pm.
 Museum: May to September,
 Tuesday to Sunday, noon-5pm.

Facilities: **Architecture** (Italianate-style Bush House, 1877-78); **Galleries** (4 exhibit); **Sales/Rental Gallery** (ceramics, paintings, prints, woodwork, jewelry); **Studios** (including printmaking and ceramic).

Exterior view of Bush House Museum (1878). Photograph courtesy of Salem Art Association, Salem, Oregon.

Activities: **Arts Festival** (annual, 3rd full weekend in July, juried art fair); **Education Programs** (adults, undergraduate students and children); **Gallery Talks; Guided Tours; Lectures; Temporary Exhibitions; Workshops.**

Publications: brochures; exhibit announcements; newsletter, "Art Matters".

I n 1953 the Salem Art Association (SAA) was entrusted with the Asahel Bush House, a Victorian mansion with an extensive collection of 19th-century fine and decorative arts. Reputed to be the finest residence in Salem at the time of its construction, the House is open for guided tours. The Bush family barn, located at the north end of Bush's Pasture Park, was remodeled in 1965 and became the Bush Barn Art Center, which houses four exhibit galleries (A.N. Bush Gallery, Corner Gallery, Focus Gallery, and Artist Feature Gallery), a sales/rental gallery, as well as the administrative offices of SAA. Both exhibit galleries host monthly shows of contemporary work ranging in scope from national competitions to one-person exhibits. SAA programs include classes in most art disciplines, professional artist residencies for schools and institutions, and the Salem Art Fair & Festival.

Salem, Oregon

Willamette University - Hallie Ford Museum of Art

700 State St., Salem, OR 97301

Tel: (503) 370-6855

Fax: (503) 375-5458

Internet Address:
 http://www.willamette.edu/museum_of_art

Director: Mr. John Olbrantz

Admission: fee: adult-$3.00, child-free,
 student-$2.00, senior-$2.00.

Attendance: 24,000 *Established:* 1998

Membership: Y *ADA Compliant:* Y

Parking: metered on street.

Open: **Academic Year**,
 Tuesday to Saturday, noon-5pm.

Closed: Legal Holidays.

Facilities: **Galleries** (5); **Print Study Room.**

Activities: **Guided Tours**; **Permanent Exhibits; Temporary Exhibitions.**

Jean-Baptiste Camille Corot, *A Balmy Afternoon*, c. 1865, oil on canvas, 16 3/8 x 23 3/8 inches. Permanent collection, Hallie Ford Museum of Art. Photograph courtesy of Hallie Ford Museum of Art, Willamette University, Salem, Oregon.

Publications: brochures (occasional); exhibition catalogues (occasional); newsletter/calendar, "Brushstrokes" (semi-annual).

The Museum is housed in an International Style building and consists of five galleries reflecting the range of the university's developing permanent art collection and its mission. Exhibitions focus on historic as well as contemporary art and present works from the permanent collection, as well as pieces loaned to the museum, and the work of locally and regionally recognized artists, University faculty, and students. The University's collections include extensive holdings of native American art (featuring Pacific northwest and southwest basketry, as well as both traditional and contemporary native arts), American painting and sculpture (particularly historical and contemporary art of the Pacific northwest), several French Barbizon paintings, European and American prints and photographs, and the Sponenburgh Study Collection of Art (featuring examples of Ancient, European, Middle Eastern, and Asian art).

Pennsylvania

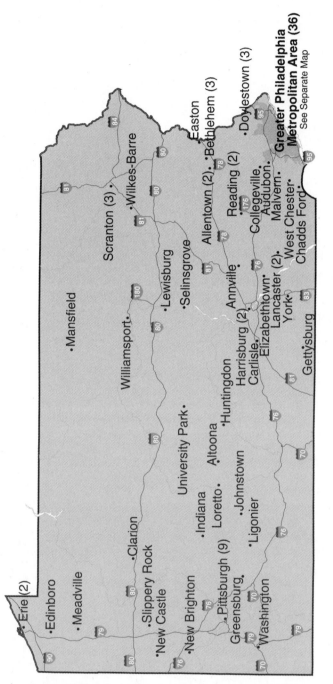

The number in parentheses following the city name indicates the number of museums/galleries in that municipality. If there is no number, one is understood. For example, in the text nine listings would be found under Pittsburgh and one listing under Greensburg. Cities within the greater Philadelphia metropolitan area will be found on the map on the facing page.

Greater Philadelphia Metropolitan Area

(including Bryn Athyn, Chester, Glenside, Haverford, Jenkintown,
Merion, Philadelphia, Rosemont, Swarthmore,and Villanova.)

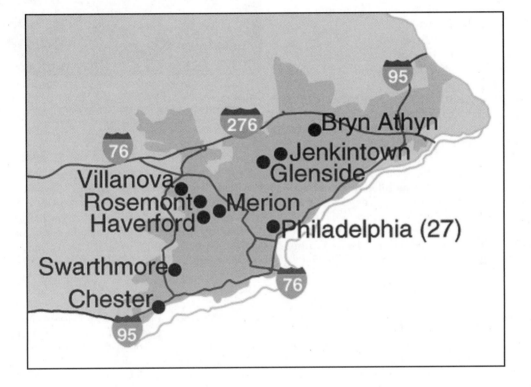

Pennsylvania

Allentown

Allentown Art Museum

5th and Court Sts., (between Hamilton and Linden Sts.)
Allentown, PA 18101
Tel: (610) 432-4333
Fax: (610) 434-7409
Internet Address: http://www.regionline/
C.E.O. and Director: Mr. Peter F. Blume
Admission: fee: adult-$3.50, child-$2.00,
 student-$2.00, senior-$3.00.
Attendance: 40,000 *Established:* 1934
Membership: Y *ADA Compliant:* Y
Parking: municipal lot behind museum at
 Penn and Court Streets.
Open: Tuesday to Saturday, 11am-5pm;
 Sunday, noon-5pm.
Closed: Legal Holidays.
Facilities: **Auditorium** (200 seat); **Food
 Services** Café; **Library** (14,000 volumes);
 Shop.
Activities: **Art Identification Days** (monthly);
 Concerts; **Films**; **Gallery Talks**; **Guided
 Tours**; **Lectures**; **Temporary Exhibitions**;
 Traveling Exhibitions.

Interior view of Allentown Art Museum, showing "Charles Sheeler in Doylestown: American Modernism and the Pennsylvania Tradition", a traveling exhibition organized for Allentown Art Museum. Photograph courtesy of Allentown Art Museum, Allentown, Pennsylvania.

Publications: exhibition catalogues; newsletter (quarterly).

The heart of the Museum's collection is the European late Gothic, Renaissance and Baroque paintings installed in the Museum's Founders' Gallery. This provides a survey of major developments in western art from 1350 through the late 16th century in Italy and Northern Europe and includes major works by Giovanni del Biondo, Giuliano Bugiardini, Lorenzo Lotto, Lucas Cranach, and Hans von Kulmbach. A group of seventeenth-century Dutch and Flemish pictures includes portraits by Rembrandt, Frans Hals, Paulus Moreelse; genre paintings by Jan Steen, Adriaen van Ostade, Frans van Mieris; and still lifes by Cornelis de Heem and Frans Snyders. The installation of American Art includes paintings, sculpture, and decorative arts. The Museum's survey of American art dates from the mid-18th century through the 1980s. This survey is tempered by a bias toward artists who have a link to Pennsylvania, including Gilbert Stuart and Severin Roesen as well as the painters of the New Hope School, William Lathrop, Edward Redfield and Daniel Garber. In the corridor leading to the 1910 Francis Little House Library, designed by Frank Lloyd Wright, is a selection of furniture, silver, ceramics, and glass made by some of Wright's most celebrated contemporaries, including chairs designed by Frank Furness, Gustav Stickley, Wharton Esherick and Wright himself. A recent gift of nineteen examples of Favrile glass from Tiffany Studios is on display, as well as ceramics from the Moravian Tileworks, Fulper Pottery and Weller Pottery, among other Arts and Crafts era potters. Comprised of nearly 300 faceted gemstones from more than twenty countries, the James C. Fuller Gem Collection is one of the Museum's most popular exhibits. The Museum's collection is complemented by temporary exhibits including a biennial juried show.

Muhlenberg College - Martin Art Gallery

Dorothy and Dexter Baker Center for the Arts, 2400 Chew St.
Allentown, PA 18104-5586
Tel: (610) 821-3466
Internet Address: http://www.srt.net/mc/
Director: Lori Verderame, Ph.D.
Open: Tuesday to Saturday, noon-5pm.
Facilities: **Exhibition Area.**
Activities: **Permanent Exhibits**; **Temporary Exhibitions.**

662

Muhlenberg College - Martin Art Gallery, cont.

Located in the Baker Center for the Arts, the Martin Art Gallery presents temporary exhibitions and changing selections from the permanent collection including a senior student art exhibition each spring.. Among the artists represented in the Florence Foerderer Tonner Print Collection are Heinrich Aldegrever, Richard Anuskiewicz, Harry Bertoia, William Blake, Mary Cassatt, Marc Chagall, Imogen Cunningham, Edward S. Curtis, Salvador Dali, Mark di Suvero, Albrecht Dürer, Philip Evergood, Leon Golub, Francisco Goya, Edward Hopper, Louis Kurz, Seymour Lipton, Ludwig Mies van der Rohe, Rembrandt van Rijn, Diego Rivera, Norman Rockwell, George Roualt, Andy Warhol, James Abbott McNeill Whistler, and William Zorach.

Altoona

Southern Alleghenies Museum of Art at Altoona (SAMA at Altoona)

Brett Building,
1210 11th Ave.
Altoona, PA 16602
Tel: (814) 946-4464
Fax: (814) 946-3131
Coordinator: Ms. Noel Feeley
Admission: free.
Established: 1979
Membership: Y *ADA Compliant:* Y
Parking: on street and parking garage.
Open: Monday to Friday, 10am-4pm;
Saturday, 11am-3pm.
Facilities: Galleries (3).
Activities: Education Programs; Lectures; Temporary Exhibitions.

Exterior view of Southern Alleghenies Museum of Art at Altoona. Photograph courtesy of Southern Alleghenies Museum of Art, Altoona, Pennsylvania.

A branch of Southern Alleghenies Museum of Art, the Museum offers a varied schedule of temporary exhibitions. The permanent collection, housed at the Loretto facility, includes 19th- and 20th-century paintings, sculpture, drawings, photography and prints, highlighted by works of Cassatt, Frankenthaler, Warhol, Stieglitz, Bourke-White, and Sloan. Headquartered in Loretto, Pennsylvania (see separate listing), the Southern Alleghenies Museum of Art maintains three branch facilities. In addition to Altoona, branches are located in Johnstown and Ligonier (see separate listings).

Annville

Lebanon Valley College - Suzanne H. Arnold Art Gallery

Lebanon Valley College, 101 N. College Ave., Annville, PA 17003
Tel: (717) 867-6397 *Fax:* (717) 867-6124
Internet Address: http://www.lvc.edu/www/facilities/gallery_arnold.html
Assistant Professor, Art/Director: Dr. Leo Mazow
Admission: free.
Established: 1994
Open: **Academic Year**, Thurs to Sun, 1pm-4:30pm.
Closed: Academic Holidays.
Facilities: Exhibition Area (1001 square feet).
Activities: Temporary Exhibitions (6/year).
Publications: Exhibition catalogues (occasional); brochures (occasional).

A former Lutheran Church built in 1868, "The Gallery at Lebanon Valley College" includes the Suzanne H. Arnold Art Gallery, an intimate viewing area incorporating the highest standards of environmental and security controls, and the Zimmerman

Interior view of the Gallery in 1997, during the exhibition "Defining American Modernisms". Photograph courtesy of the Arnold Gallery, Lebanon Valley College, Annville, Pennsylvania.

Annville, Pennsylvania

Lebanon Valley College - Suzanne H. Arnold Art Gallery, cont.

Recital Hall, a venue for small musical presentations. The Gallery presents temporary exhibitions and an annual juried student exhibition in the spring. Exhibitions have included the work of well-known artists, such as Joseph Cornell, Degas, Toulouse-Lautrec, O'Keeffe, Hopper, and Homer; as well as a more recent generation of artists including José Bedia, Patricia Bellan-Gillen, Susan Leopold, G. Daniel Massad, Kate Moran, and Rebecca Purdum.The Gallery also oversees the permanent collection of Lebanon Valley College. Among the highlights of this modest-sized collection are works on paper by such artists as Calder, Chagall, Miró, and Picasso. Audrey Flack's monumental sculpture, *Cuewe-Pehelle* (1997), graces the academic quadrangle.

Audubon

Mill Grove, the Audubon Wildlife Sanctuary

1201 Audubon & Pawling Roads, Audubon, PA 19407-7125

Tel: (610) 666-5593

Fax: (610) 666-1490

C.E.O.: Linda S. Boice.

Admission: suggested contribution.

Attendance: 30,000 *Established:* 1951

Membership: N

ADA Compliant: Partial (1st Floor)

Parking: free on site.

Open: Tuesday to Saturday, 10am-4pm;
Sunday, 1pm-4pm.

Closed: New Year's Eve to New Year's Day,
Easter,
Independence Day,
Thanksgiving Day,
Christmas Eve to Christmas Day.

John James Audubon, *Eagle and the Lamb*, 1828, oil on canvas. Mill Grove Museum. Photograph by Joseph F. Morsello, courtesy of Mill Grove Museum, Audubon, Pennsylvania.

Facilities: **Architecture** (1st John James Audubon home in America, built 1762); **Galleries**; **Shop**.

Activities: **Education Programs**; **Guided Tours** (adult and children); Seasonal Special Events.

Mill Grove was built in 1762 and acquired by Audubon's father in 1789. The artist lived there from 1804 to 1806. Today, Mill Grove, a National Register property since 1972, serves as a wildlife sanctuary and museum. It features paintings by Audubon as well as all the major works published by him. In addition, the museum contains murals by George M. Harding depicting Audubon's local adventures and scenes of bird life in various parts of America.

Bethlehem

Kemerer Museum of Decorative Arts

427 N. New St. (one block north of City Center Plaza), Bethlehem, PA 18018

Tel: (610) 882-0450

Fax: (610) 882-0460

Internet Address: http://www.historicbethlehem.org/decor.htm

Director: Tony Hanna

Admission: fee-$3.00.

Attendance: 14,000 *Established:* 1954 *Membership:* Y *ADA Compliant:* Y

Open: Tuesday to Sunday, noon-5pm.

Closed: Legal Holidays.

Facilities: **Library** (750 volumes); **Shop**.

Activities: **Education Programs**; **Guided Tours** (Tues-Sun, noon-5pm; groups call 691-0603); **Lectures**; **Temporary Exhibitions**.

Publications: newsletter (quarterly).

Housed in two historic buildings, the Museum's permanent collection includes examples of fine, folk, and decorative arts from the 18th to the 19th centuries.

Lehigh University Art Galleries (LUAG)

Zoellner Arts Center, 420 E. Packer Ave., Bethlehem, PA 18015-3007

Tel: (610) 758-3615
Fax: (610) 758-4580
Internet Address: http://www.lehigh.edu
Director and Curator: Prof. Ricardo Viera
Admission: free.
Attendance: 120,000 *Established:* 1864
ADA Compliant: Y
Parking: metered and parking garage ($1.00).
Open: **Zoellner Gallery,**
 Wednesday to Saturday, 11am-5pm;
 Sunday, 1pm-5pm.
 DuBois Gallery,
 Monday to Friday, 9am-10pm;
 Saturday, 9am-noon.
 Siegel Gallery,
 Monday to Thursday, 9am-10pm;
 Friday, 9am-5pm.
 Girdler Gallery,
 Daily, 8am-10pm.
Closed: Academic Holidays.

Maurice Prendergast, *La Rouge: Portrait of Miss Edith King*, c. 1910-1913, oil on canvas. Lehigh University Permanent Collection, gift of Ralph L. Wilson, '22. Photograph courtesy of Lehigh University Art Galleries, Bethlehem, Pennsylvania.

Facilities: **Galleries** (2 additional galleries on campus); **Sculpture Garden**; **Shop**.

Activities: **Education Programs** (undergraduate college students); **Gallery Talks**; **Guided Tours**; **Lectures**; **Temporary Exhibitions**; **Traveling Exhibitions**.

Publications: calendar (semi-annual); exhibition catalogues; posters.

The Lehigh University Art Galleries maintain and develop the university's permanent art collection and present temporary exhibitions designed to make visual literacy a result of the university learning experience. More than twenty exhibitions a year in three campus galleries are planned to supplement formal classroom study in the visual arts, to create educational opportunities for the student body, and to enrich the cultural life of the campus and community at large. The annual schedule includes the exhibition of works from the permanent collection, the use of borrowed objects, and traveling exhibitions. The exhibition schedule is supplemented by gallery talks, lectures, films, workshops and research opportunities in the permanent collection. The art galleries occupy exhibition, storage, office, and workshop space in several campus locations. Permanent exhibitions are in the Zoellner Arts Center, Upper Gallery and Lower Gallery. Maginnes Hall houses the DuBois Gallery, and the Siegel Gallery is in Iacocca Hall on the mountaintop campus. The Muriel and Philip Berman Sculpture Gardens are located in the courtyard of Mudd, Mart, Whitaker and Sinclair buildings; on the mountaintop campus; and Saucon Field on the Murray H. Goodman campus. The Ralph L. Wilson Study Gallery and Open Storage Facility, accessible by appointment only, is located in Building J on the mountaintop campus. The permanent art collection is a work/study collection intended as a resource for students pursuing formal study in the visual arts and/or museum studies, for the faculty, and interested members of the community. The permanent art collection consists of a variety of works by old masters and contemporary artists. Important collection groups include the M. B. Grace Collection of European Paintings (Gainsborough, Reynolds, Goya, and others); the Dreyfus Collection of French Paintings (Bonnard, Sisley, Vuillard, Courbet); the Ralph L. Wilson Collection of American Art (paintings by Prendergast, Sloan, Henri, Lawson, Bellows, Davies, Burchfield; prints by Whistler, Hassam, Benton, Kent, Sloan, Davies, Frasconi); the Prasse Collection of Prints (Delacroix, Matisse, Renoir, Kunyoshi, Rivera, Orozco); the Muriel and Philip Berman Collection of Contemporary Sculpture (Kadishman, Unger, Tumarkin, Henry Moore, Bertoia, Shaw); the Fearnside Collection of European Old Master Prints and Drawings; the Baker Collection of Chinese Porcelains; the Berman Collection of Japanese Prints (Eishi, Hiroshige, Hokusai, Onshi, Sekino, Utamaro, Yoshika); the Folk and Outsider Art Collection (Finster, Adkins, Sperger, Kinney, Pickle, R.A.Miller, Tolliver); the Puerto Rican Poster Collection; Collection of Philatelics and Numismatics; Langermann Collection of Pre-Columbian Sculpture; Mr. and Mrs. Franklin H. Williams African Collection (gold weights of the Akan

Lehigh University Art Galleries, cont.

and West African objects); the Lehigh University Photography Collection (Fox-Talbot, Fenton, Cameron, Jackson, Atget, Rau, Kasebier, Sander, Bourke-White, Brassai, Brandt, Bravo, Callahan, Siskind, Fink, Porter, Hahn, Clark, Martinez-Canas, Serrano) and the Lehigh University Contemporary Prints Collection (Bearden, Rivers, Anuszkiewicz, Soto, Roth, Chryssa, Ruscha, Tobey, Calder, Kitaj, Marca-Relli, Genoves, Cruz Azaceta, Golub, Jimenez, Piper, Serrano, Simpson).

Moravian College - Payne Gallery

Main and Church Sts., Bethlehem, PA 18018

Tel: (610) 861-1680

Fax: (610) 861-1682

Internet Address: http://www.moravian.edu

Director: Dr. Diane Radycki

Admission: free.

Membership: N *ADA Compliant:* Y

Parking: free on site.

Open: Tuesday to Sunday, 11am-4pm.

Closed: Legal Holidays.

Facilities: **Gallery**.

Activities: **Permanent Exhibits**; **Temporary Exhibitions**.

Publications: exhibition catalogues (occasional).

The permanent collection at Moravian is particularly strong in late 19th- and early 20th-century American art, including works by Albert Bierstadt, John Marin, Cecilia Beaux, Susan MacDowell Eakins, and the New Hope School of American Impressionism (works by Coppedge, Badura, Garber, Redfield, and Schofield). In the collection and in situ on campus are works by Gustavus Grunewald. Also, the college owns the complete set of Edward S. Curtis' *The Native American Indian*.

Bryn Athyn

Bryn Athyn College of the New Church - Glencairn Museum

1001 Cathedral Road, Bryn Athyn, PA 19009

Tel: (215) 938-2600

Fax: (215) 914-2986

Internet Address: http://www.glencairnmuseum.org

Director: Mr. Stephen H. Morley

Admission: fee:

adult-$5.00, child (<5)-free, student-$2.00, senior-$4.00.

Attendance: 18,000 *Established:* 1878

Parking: free on site.

Open: **September to May**,

Monday to Friday, 8:30am-4:30pm;

2nd Sunday in month, 2pm-5pm.

June to August,

Monday to Friday, 8:30am-4:30pm.

Closed: Legal Holidays.

Facilities: **Architecture** (Romanesque structure built in the 1930s as residence for the Raymond Pitcairn family); **Cloister Garden**; **Library** (1,000 volumes).

Activities: **Concerts**; **Education Programs** (students); **Guided Tours**; **Temporary Exhibitions**.

Publications: journal; newsletter.

Madonna and Child, polychromed oak, France (Lorraine?), 14th century. Photograph by Michael Pitcairn courtesy of Glencairn Museum, Bryn Athyn, Pennsylvania.

Founded in the 1870s by the Academy of the New Church, the Glencairn Museum's essential mission has remained the education of visitors about the history of religion, using art and artifacts from a variety of cultures and time periods. Holdings include an internationally recognized collection of medieval stained glass and sculpture, as well as galleries devoted to Ancient Near Eastern, Classical, Ancient Egyptian, Asian, Native American, and New Church Studies.

Carlisle

Dickinson College - The Trout Gallery

Dickinson College, High St., Carlisle, PA 17013-2896
Tel: (717) 245-1344
Fax: (717) 245-1937
Internet Address: http://www.dickinson.edu/departments/trout
Director: Dr. Peter Lukehart
Admission: free.
Attendance: 12,000 *Established:* 1983
Membership: Y *ADA Compliant:* Y
Parking: free on site.
Open: late August to mid-June, Tuesday to Saturday, 10am-4pm.
 late June to mid-August, Wednesday, 10am-4pm.
Closed: Legal Holidays.
Facilities: Auditorium (250 seat); Print Study Room.
Activities: Concerts; Education Programs; Films; Guided Tours; Lectures; Temporary Exhibitions; Traveling Exhibitions.
Publications: calendar (semi-annual); exhibition catalogues (biennial).

The Trout Gallery, along with housing Dickinson College's permanent collections of art (which range in time from Classical Greece to the 20th Century) maintains a varied and frequently changing exhibition schedule of historical, contemporary, and multicultural materials. The Trout Gallery is, at once, an educational branch of the College and a fine arts museum for the Carlisle/Greater Harrisburg area. The Gallery serves the college community as an interdisciplinary resource for studio art, art history, modern language, international studies, and classical archaeology courses.

Auguste Rodin, *St. John the Baptist Preaching*, bronze, 1878-1880. Gift of Doctors Meyer P. and Vivian O. Potamkin. The Trout Gallery collection. Photograph courtesy of Trout Gallery, Dickinson College, Carlisle, Pennsylvania.

Chadds Ford

Brandywine River Museum

U.S. Route 1 at PA Route 100, Chadds Ford, PA 19317
Tel: (610) 388-2700
Fax: (610) 388-1197
Internet Address: http://www.brandywinemuseum.org
C.E.O. and Director: Mr. James H. Duff
Admission:
 fee: adult-$5.00, child-$2.50, student-$2.50, senior-$2.50.
Attendance: 180,000 *Established:* 1971
Membership: Y *ADA Compliant:* Y
Parking: free on site.
Open: Daily, 9:30am-4:30pm.
Closed: Christmas Day.
Facilities: Auditorium (150 seat); Food Services Restaurant (120 seat); Library (6,000 volumes, by appointment); Shop.
Activities: Concerts; Education Programs; Gallery Talks; Guided Tours; Temporary Exhibitions.
Publications: collection catalogue, "Catalogue of the Permanent Collection"; exhibition catalogues; newsletter, "Catalyst" (quarterly).

Showcasing American art in a restored 19th-century grist mill, the Brandywine River Museum is internationally known for its collection of works by three generations of Wyeths (N.C., Andrew, and Jamie) and its fine collection of American illustration, still life, and landscape painting by other artists. Wildflower gardens featuring plants native to the Brandywine Valley surround the museum.

Andrew Wyeth, *Roasted Chestnuts*, 1956, tempera. Brandywine River Museum. Photograph courtesy of Brandywine River Museum, Chadds Ford, Pennsylvania.

Chester

Widener University Art Collection and Gallery

One University Place, Chester, PA 19013
Tel: (610) 499-1189
Fax: (610) 499-4425
Internet Address: http://www.widener.edu
Collections Manager: Ms. Rebecca Warda
Admission: free.
Established: 1970 *ADA Compliant:* Y
Open: Tuesday, 10am-7pm; Wednesday to Saturday, 10am-4:30pm.
Closed: Legal Holidays, 2nd & 3rd weeks of July.
Facilities: **Exhibition Area**.
Activities: **Lectures**; **Temporary Exhibitions**.
Publications: brochures.

The Widener University Art Collection and Gallery features the Alfred O. Deshong Collection of 19th-century American and European paintings and 18th- and 19th-century Asian art. The paintings are mostly genre scenes by European-trained artists. The Oriental art includes Japanese carved ivory figures, Chinese carved hardstone vessels, lacquerware and bronzes. The Gallery also displays paintings by American Impressionists Edward Redfield, Robert Spencer, George L. Noyes, and others. Along with the permanent collection, a series of exhibitions of contemporary art is mounted from September to May.

Clarion

Clarion University of Pennsylvania - Sandford Gallery

Clarion University of Pennsylvania, Marwick-Boyd Fine Arts Building, Clarion, PA 16214
Tel: (814) 226-2412
Fax: (814) 226-2723
Internet Address: http://vaxa.clarion.edu
Exec. Director: Ms. Carol B. Wickkiser
Admission: free.
Established: 1982 *Membership:* Y
Open: Call for hours.
Closed: Academic Holidays.
Facilities: **Exhibition Area** (1,000 square feet).
Activities: **Education Programs** (students); **Lectures**; **Temporary Exhibitions**; **Traveling Exhibitions**.

The Gallery presents temporary exhibition throughout the year.

Collegeville

Ursinus College - Philip and Muriel Berman Museum of Art

Main St., Collegeville, PA 19426
Tel: (610) 409-3500
Fax: (610) 409-3664
Internet Address: http://www.ursinus.edu/ berman/berman_exhibits.html#LOC
C.E.O.: Ms. Lisa Tremper Hanover
Admission: voluntary contribution.
Attendance: 35,000 *Established:* 1987 *Membership:* Y *ADA Compliant:* Y
Parking: adjacent to the museum on campus.
Open: Tuesday to Friday, 10am-4pm; Saturday to Sunday, noon-4:30.
Closed: Academic Holidays.
Facilities: **Library** (1,200 volumes); **Shop**.

Ursinus College - Philip and Muriel Berman Museum of Art, cont.

Activities: **Education Programs** (undergraduate and graduate students); **Films; Guided Tours; Lectures; Temporary Exhibitions; Traveling Exhibitions.**

Publications: "Friends of the Museum Newsletter" (quarterly); calendar (quarterly); exhibition catalogues.

The Philip and Muriel Berman Museum of Art at Ursinus College, located in a classic Georgian facility adapted to house the museum, offers 12 exhibitions annually, both historical and contemporary in nature. Lectures, film series, symposia, and other programming are offered in conjunction with exhibitions. The permanent collection numbers approximately 3,500 pieces, including paintings, prints, drawings, sculpture, and historical artifacts. Strengths of the collection include 18th-, 19th-, and 20th-century American art, 19th-century European landscapes, Japanese woodcuts, contemporary sculpture, and Pennsylvania German artifacts. The Museum holds the largest private collection of Lynn Chadwick sculpture in the United States.

Lynn Chadwick, *Diamond Seated Couple*, 1984, Bronze, each figure 78 x 40 x 96 inches. Collection of Philip and Muriel Berman Museum of Art, Ursinus College. Photograph courtesy of Ursinus College, Collegeville, Pennsylvania.

Doylestown

Fonthill Museum

E. Court St., Doylestown, PA 18901
Tel: (215) 348-9461
Fax: (215) 348-9462
Exec. Dir. of Bucks Co. Historical Society:
 Mr. Douglas C. Dolan
Admission:
 fee: adult-$5.00, student-$1.50, senior-$4.50.
Attendance: 24,000 *Established:* 1930
Membership: Y *ADA Compliant:* N
Open: Monday to Saturday, 10am-5pm;
 Sunday, noon-5pm.
Closed: New Year's Day, Thanksgiving Day,
 Christmas Day.
Facilities: **Library** (5,000 volumes); **Shop.**
Activities: **Education Programs** (children);
 Guided Tours.

Exterior view of Fonthill Museum. Photograph by Barry Halkin, courtesy of Fonthill Museum, Doylestown, Pennsylvania.

Henry Mercer (1856-1930) built Fonthill as his home between 1908 and 1912 and designed it from the interior, the exterior not being considered until all the rooms had been laid out. The castle-like structure, a National Historic Landmark, is built of poured concrete. The interior walls are adorned with an array of Mercer's original handcrafted tiles. The building also contains tiles and prints from around the world.

James A. Michener Art Museum

138 S. Pine St., Doylestown, PA 18901
Tel: (215) 340-9800
Fax: (215) 340-9807
Internet Address: http://www.michenerartmuseum.org
Exec. Director: Mr. Bruce Katsiff
Admission: fee: adult-$5.00, child (<12)-free, student-$1.50, senior (>59)-$4.50.
Attendance: 90,000 *Established:* 1987 *Membership:* Y *ADA Compliant:* Y
Parking: free on site.

Doylestown, Pennsylvania

James A. Michener Art Museum, cont.

Open: Tuesday, 10am-4:30pm;
Wednesday, 10am-9pm
Thursday to Friday, 10am-4:30pm;
Saturday to Sunday, 10am-5pm.

Closed: Legal Holidays.

Facilities: **Exhibition Area** (29,000 square feet); **Food Services** Restaurant; **Sculpture Gardens**; **Shop**.

Activities: **Arts Festival**; **Concerts**; **Education Programs** (adults and children); **Films**; **Guided Tours**; **Lectures**; **Temporary Exhibitions**.

Publications: brochures (quarterly); exhibition catalogues.

Exterior view of James A. Michener Art Museum. Photograph by Jeff Hurwitz, courtesy of James A. Michener Art Museum, Doylestown, Pennsylvania.

Housed in a renovated historic site, the James A. Michener Art Museum features an extensive collection of Pennsylvania Impressionist paintings including the 22-foot mural, *A Wooded Watershed*, by Daniel Garber. Also on view is the Museum's collection of important regional contemporary and figurative art and changing exhibitions. Other highlights include a multi-media interactive exhibit "Creative Bucks County: A Celebration of Art and Artists", a reading room featuring furniture by George Nakashima, outdoor sculpture gardens, and a permanent exhibit on author James A. Michener.

Mercer Museum of the Bucks County Historical Society

84 S. Pine St., Doylestown, PA 18901
Tel: (215) 345-0210
Fax: (215) 230-0823
Internet Address: http://www.mercermuseum.org
Exec. Director: Mr. Douglas C. Dolan
Admission: fee:
adult-$5.00, student-$1.50, senior-$4.50.
Attendance: 60,000 *Established:* 1916
Membership: Y *ADA Compliant:* Partial
Open: Monday, 10am-5pm;
Tuesday, 10am-9pm
Wednesday to Friday, 10am-5pm;
Saturday to Sunday, noon-5pm.

Closed: New Year's Day, Thanksgiving Day, Christmas Day.

Exterior view of Mercer Museum. Photograph by Milton Rutherford, courtesy of Mercer Museum, Doylestown, Pennsylvania.

Facilities: **Library** (20,000 volumes); **Shop**.

Activities: **Craft Festival**; **Education Programs** (adults and children); **Lectures**; **Temporary Exhibitions**.

Publications: newsletter, "Penny Lots" (quarterly).

As one of the founders of the Bucks County Historical Society, Henry Mercer saw that the objects our early American ancestors used were being discarded, and so Mercer amassed a huge collection of these, donated them to the Historical Society, and built a special building to house them. Built of poured concrete (like its companion facility, Fonthill), the Museum contains more than 50,000 antique objects representing life in the pre-industrial age, including tools, furnishings, and folk art.

Easton

Lafayette College Art Gallery

Williams Center for the Arts, Hamilton and High Sts., Easton, PA 18042
Tel: (610) 250-5361
Fax: (610) 559-4042
Internet Address: http://www.lafayette.edu
Director, Williams Center for the Arts: Mr. H. Ellis Finger

Lafayette College Art Gallery, cont.

Admission: free.
Attendance: 6,500 *Established:* 1983 *ADA Compliant:* Y
Open: **September to May**, Tuesday to Friday, 10am-5pm; Sunday, 2pm-5pm.
Closed: Academic Holidays.
Facilities: **Exhibition Area** (1,000 square feet).
Activities: **Lectures**; **Temporary Exhibitions**.
Publications: brochures; exhibition catalogues.

The Gallery presents exhibitions in a wide variety of media and genres each year.

Edinboro

Edinboro University of Pennsylvania - Bruce Gallery of Art

Doucette Hall, 1st Floor (near Diebold Center), Meadville Street, Edinboro, PA 16444-0001
Tel: (814) 732-2513
Fax: (814) 732-2629
Internet Address: http://www.edinboro.edu/cwis/Art/gallery.html
Gallery Director: Mr. William Mathie
Admission: free.
Parking: Visitors must obtain parking pass from campus police.
Open: **September to April**,
 Monday to Tuesday, 3pm-6pm;
 Wednesday, 3pm-6pm and 7pm-9pm;
 Thursday to Saturday, 3pm-6pm.
 Summer,
 Tuesday, 3pm-6pm;
 Wednesday, 3pm-6pm and 7pm-9pm;
 Thursday to Saturday, 3pm-6pm.
Facilities: **Exhibition Area** (1,400 square feet).
Activities: **Temporary Exhibitions** (7/year).

The Gallery mounts exhibitions of work by professional, faculty and student artists, including an annual faculty show, an annual juried student exhibition, and a biennial juried regional high school exhibition. Shows are generally of 3½ weeks duration. Shows during the academic year generally consist of the work of professional artists chosen from a national pool of applicants, while summer exhibitions are usually M.F.A. thesis shows.

Drew Thorne Dodson, *Segmented Oval Vase*, Vase exhibited in thesis exhibition, 1999. Photograph courtesy of Edinboro University of Pennsylvania, Edinboro, Pennsylvania.

Elizabethtown

Elizabethtown College - Galleries

Department of Fine and Performing Arts, 1 Alpha Drive, Elizabethtown, PA 17022
Tel: (717) 361-1212 *Ext:* 1385
Internet Address:
 http://www.etown.edu/~fapa/art
Director: Prof. Milt D. Friedly
Admission: free.
Attendance: 6,000 *Established:* 1990
Membership: N *ADA Compliant:* Y
Parking: free on site.
Open: **September 1 to December 15**,
 Daily, 9am-9pm.
 January 15 to May 15,
 Daily, 9am-9pm.
Closed: Academic Holidays.

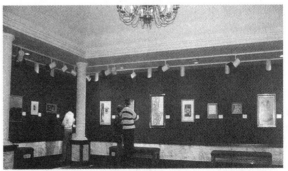

View of gallery, Elizabethtown College. Photograph courtesy of Elizabethtown College, Elizabethtown, Pennsylvania.

Elizabethtown College - Galleries, cont.

Facilities: Galleries (3).

Activities: **Temporary Exhibitions**.

There are three gallery spaces at Elizabethtown where one-month exhibitions are presented, including works by local and regional artists, traveling exhibits, juried shows, and student work. The permanent collection is housed in the High Library and consists of early twentieth-century illustrations and paintings, African art, and contemporary art.

Erie

Erie Art Museum

411 State St., Erie, PA 16501

Tel: (814) 459-5477

Fax: (814) 452-1744

Internet Address:
 http://www.erieartmuseum.org

Exec. Director: Mr. John L. Vanco

Admission: fee: adult-$2.00, child-$0.50, student-$1.00, senior-$1.00.

Attendance: 45,000 *Established:* 1898

Membership: Y *ADA Compliant:* Y

Parking: metered on street and public lot on east 3rd (between State and French Streets).

Open: Tuesday to Saturday, 11am-5pm; Sunday, 1pm-5pm.

Closed: Legal Holidays.

Exterior view of Erie Art Museum. Photograph by Emilio Di Valerio, courtesy of Erie Art Museum, Erie, Pennsylvania.

Facilities: **Architecture** (1839, Greek Revival building); **Exhibition Area**.

Activities: **Concerts**; **Education Programs** (adults and children); **Gallery Talks**; **Guided Tours**; **Juried Exhibits**; **Lectures**; **Temporary Exhibitions**; **Traveling Exhibitions**.

Publications: bulletin (monthly); exhibition catalogues; newsletter.

The Erie Art Museum is located in a Greek Revival building designed by William Kelly and built in 1839 that was formerly used as a custom house. The collection of more than 4,000 objects includes paintings, photographs, folk art, American ceramics, Japanese prints, Chinese porcelains, Tibetan thangkas, and Indian bronzes. The Museum will also use new gallery space, made possible through the development of the Discovery Square complex, to display both significant works from the Museum's permanent collection as well as temporary exhibits.

Gannon University - The Schuster Gallery

Nash Library, 3rd Floor, 619 Sassafras St. (at 7th St.), Erie, PA 16541

Tel: (814) 871-7332

Fax: (814) 871-5859

Internet Address: http://www.gannon.edu/resource/schuster/index.html

Director: Ms. Lisa Campbell

Admission: free.

Attendance: 1,000 *Established:* 1979 *Membership:* N *ADA Compliant:* Y

Parking: commercial adjacent to site.

Open: **Fall to Spring**, Monday to Thursday, 8am-midnight; Friday, 8am-9pm;
 Saturday, 9am-4:30pm; Sunday, 12:30pm-midnight.
 Summer, restricted hours.

Closed: Independence Day Weekend.

Facilities: **Exhibition Area**.

Activities: **Temporary Exhibitions**.

The Gallery exhibits both student and faculty work. It has no permanent collection.

Gettysburg

Gettysburg College - Schmucker Hall Art Gallery

Schmucker Hall, Lincoln Avenue, Gettysburg, PA 17325
Tel: (717) 337-6121
Internet Address: http://www.gettysburg.edu/academics.hold/visual_arts/art/Gallery.htm
Director: Mr. Mark Warwick
Admission: free.
Open: **September to May**, Monday to Friday, 9am-4pm; Saturday, 1pm-4pm, Sunday, 1pm-4pm.
June to August, Monday to Friday, 9am-4pm; Saturday, 1pm-4pm.
Facilities: **Exhibition Area** (1,600 square feet).
Activities: **Temporary Exhibitions** (9-10/year).

The gallery presents works by invited professional artists and traveling exhibits of work from public and private collections, as well as an annual faculty show, an annual student show, and several senior art major shows.

Glenside

Beaver College Art Gallery

Spruance Fine Arts Center, Church & Easton Roads, Glenside, PA 19038
Tel: (215) 572-2131
Fax: (215) 881-8774
Internet Address: http://www.beaver.edu
Director: Mr. Richard Torchia
Admission: free.
Attendance: 3,750 *Established:* 1974
Membership: Y
Parking: free near gallery.
Open: **Academic Year**,
Monday to Friday, 10am-3pm;
Saturday to Sunday, noon-4pm.
Closed: Academic Holidays, Thanksgiving Day,
Christmas Day.
Facilities: **Exhibition Area** (1,200 square feet);
Theatre (150 seats).
Activities: **Guided Tours** (available upon request
and by appointment); **Lectures** (directly related to
exhibitions, usually weekdays at 6:30pm).
Publications: exhibition catalogues (2-3/year).

Amy Hauft, *Period Room*, 1998, plywood, caning (machine and hand woven), fluorescent fixtures, hardware, 1,200 square feet, 37 inches high. Detail from site-integrated project. Photograph by Aaron Igler courtesy of Beaver College Art Gallery, Glenside, Pennsylvania.

Housed in an historic 1893 power plant on the college campus, the Gallery provides a forum for contemporary art, offering a program of exhibitions and educational events of local to international scope. During its twenty-five year history, the Gallery has presented over one hundred exhibitions, bringing to the Philadelphia area the work of such artists as John Coplans, Mary Heilmann, Donald Lipski, Michael Lucero, Robert Morris, Elizabeth Murray, Alice Neel, Ken Price, Richard Prince, Kay Rosen, William Wegman, Fred Wilson, Yukinori Yanagi, and many others. Recent thematic group exhibitions have explored endurance-related performance, feminist practice, contemporary photorealist painting, and conceptual fiber works. Exhibitions also include a biennial juried exhibition for regional artists, a biennial show of student work selected by the faculty, and annual alumni and senior thesis exhibitions.

Greensburg

Westmoreland Museum of American Art

221 N. Main St., Greensburg, PA 15601
Tel: (724) 837-1500
Fax: (724) 837-2921
Director and C.E.O.: Ms. Judith H. O'Toole
Admission: voluntary contribution.
Attendance: 29,000 *Established:* 1949 *Membership:* Y *ADA Compliant:* Y

Westmoreland Museum of American Art, cont.

Parking: free on site.
Open: Wednesday, 11am-5pm; Thursday, 11am-9pm; Friday to Sunday, 11am-5pm.
Closed: Legal Holidays.
Facilities: **Library** (3,500 volumes); **Shop**.
Activities: **Education Programs; Gallery Talks; Lectures; Temporary Exhibitions.**
Publications: exhibition catalogues; gallery guides; newsletter, "Viewer" (quarterly).

The Westmoreland Museum of American Art has an important collection of over 3,400 objects of American fine and decorative arts from the 18th century through the present, with particular strengths in 19th- and early 20th-century art and works created by Southwestern Pennsylvania artists. Paintings and watercolors in the collection include works by Rembrandt Peale, Cassatt, Copley, West, Sloan, Chase, Homer, Sargent, Glackens, and Hassam.

William Merritt Chase, *Lady in a Pink Dress*, c. 1892. Oil on canvas, 22 x 18 inches. Westmoreland Museum of American Art, Gift in memory of G. Albert Shoemaker by his wife, Mercedes. Photograph courtesy of Westmoreland Museum of American Art, Greensburg, Pennsylvania.

Harrisburg

Art Association of Harrisburg (AAH)

21 N. Front St., Harrisburg, PA 17101
Tel: (717) 236-1432
Fax: (717) 236-6631
Internet Address: http://www.ezonline.com/aah
President: Ms. Carrie Wissler-Thomas
Admission: free.
Attendance: 12,000 *Established:* 1926
Membership: Y
Parking: adjacent parking available, evenings and weekends.
Open: Monday to Thursday, 9am-9pm;
Friday, 9am-4pm;
Saturday, 10am-4pm;
Sunday, noon-3pm.
Closed: New Year's Day, Independence Day,
Thanksgiving, Christmas Day.
Facilities: **Architecture** (1810 Federal- style; modified to Italianate, 1860); **Library** (400 volume); **Shop**.
Activities: **Concerts; Education Programs** (adults and children); **Guided Tours; Exhibits** (10/year).
Publications: newsletter, "AAH News" (bi-monthly).

Exterior view of Art Association of Harrisburg. Photograph courtesy of Art Association of Harrisburg, Harrisburg, Pennsylvania.

The Art Association of Harrisburg is located in the Governor Findlay Mansion, a town house built in 1810 in the Federal style after a design by Stephen Hill. It was expanded and remodeled in the Italianate style in 1865 by architect Stephen Hoxie. The AAH mounts ten in-house exhibitions per year, presenting art in all styles and media by artists of regional and national reputation. The permanent collection consists of works by past and present members of the AAH, as well as paintings and graphics by well-known American and European artists.

The State Museum of Pennsylvania

3rd and North Sts., Harrisburg, PA 17108
Tel: (717) 787-4980
Fax: (717) 783-1073
TDDY: (800) 654-5984
Internet Address: www.statemuseumpa.org

The State Museum of Pennsylvania, cont.

Director: Ms. Anita D. Blackaby
Admission: free.
Attendance: 280,000 *Established:* 1905
Membership: Y *ADA Compliant:* Y
Parking: metered on street; free on weekends.
Open: Tuesday to Saturday, 9am-5pm;
Sunday, noon-5pm.
Closed: New Year's Day, M.L. King Day,
Presidents' Day, Columbus Day,
Veterans' Day, Thanksgiving Day,
Christmas Day.

Peter Frederick Rothermel, *The Battle of Gettysburg*, 1879, oil on canvas, 32 x 18¾ feet. The State Museum of Pennsylvania. Photograph by Joseph F. Morsello, courtesy of The State Museum of Pennsylvania, Harrisburg, Pennsylvania.

Facilities: **Auditorium** (402 seats); **Library** (25,000 volumes); **Sculpture Garden**; **Shop**.
Activities: **Arts Festival**; **Concerts**; **Education Programs** (adults and children); **Films**; **Gallery Talks**; **Lectures**; **Self-guided Tours**; **Temporary Exhibitions**.
Publications: calendar, "Calendar of Events" (quarterly); newsletter, "The Welcome" (quarterly).

The State Museum of Pennsylvania is a general museum with exhibits of fine and decorative arts that are a part of Pennsylvania's cultural heritage.

Haverford

Haverford College - Cantor Fitzgerald Gallery

Whitehead Campus Center, 370 Lancaster Avenue, Haverford, PA 19041
Tel: (610) 896-1287
Internet Address: http://www.haverford.edu
Exhibitions Coordinator: Ms. Hilarie Johnston
Admission: free.
Attendance: 1,200 *Established:* 1994 *Membership:* Y *ADA Compliant:* Y
Parking: free on site.
Open: **September to May**, Monday to Friday, 11am-4pm; Saturday to Sunday, noon-4pm.
June to August, Monday to Friday, 11am-4pm.
Closed: major holidays.
Facilities: **Exhibition Area** (1,600 square feet).
Activities: **Gallery Talks**; **Temporary Exhibitions** (monthly).

The Cantor-Fitzgerald Gallery presents well-reviewed exhibitions each month by serious working artists, who give a gallery talk at some point during the exhibition. There are also occasional historical exhibitions in a variety of media. Small exhibitions are also mounted in the Fine Art Building.

Huntingdon

Juniata College Museum of Art

17th and Moore Sts., Huntingdon, PA 16652
Tel: (814) 641-3505
Fax: (814) 641-3695
Internet Address: http://www.juniata.edu/museum
Director: Dr. Phillip J. Earenfight
Admission: free.
Established: 1998
Membership: Y *ADA Compliant:* Y
Parking: lot behind museum, entrance off Mifflin Street.
Open: **Fall to Spring**,
Monday to Friday, 10am-4pm;
Saturday, noon-4pm.
Summer, reduced hours, contact Museum.

Charles Cromwell Ingham, *Portrait of Valentine Blanchard*, c. 1836, 1 5/6 inches x 1 3/8 inches portrait miniature. The Worth B. Stottlemyer Collection, Juniata College Museum of Art. Photograph courtesy of Juniata College Museum of Art, Huntingdon, Pennsylvania.

Huntingdon, Pennsylvania

Juniata College Museum of Art, cont.

Closed: Major Holidays.

Facilities: **Architecture** (Beaux-Arts former Carnegie Library Building, 1907, by Edward Tilton); **Exhibition Area**.

Activities: **Permanent Exhibits**; **Temporary Exhibitions**.

The Museum houses a significant permanent collection, as well as hosting regional, national, and international exhibitions. The permanent collection includes paintings, prints, drawings, textiles, and photographs that date from the 17th century to the present. Of particular significance are landscapes by American painters Asher B. Durand, Thomas Cole, Arthur Fitzwilliam Tait, Jervis McEntee, and John Casilear. Holdings also include numerous 18th and 19th century American portrait miniatures; paintings by Sebastiano Conca and Egbert van Heemskerk; prints by Rembrandt, Whistler, and Hiroshige; and a collection of drawings and paintings by the German artist and humanist, Günther Spaltmann. There is also a significant collection of 20th-century Navajo textiles, as well as photographic materials relating to the history of the college and the surrounding area.

Indiana

Indiana University of Pennsylvania - The University Museum

John Sutton Hall,Room 111, 1011 South Drive, Indiana, PA 15705-1087

Tel: (724) 357-6495

Fax: (724) 357-7778

Director: Richard Hennina Field, Ph.D.

Admission: free.

Attendance: 12,500 *Established:* 1981 *Membership:* Y *ADA Compliant:* Y

Parking: free on site.

Open: **Academic Year**, Tuesday to Wednesday, 11am-4pm; Thursday, 11am-4pm & 7pm-10pm; Friday, 11am-4pm; Saturday to Sunday, 1pm-4pm.

Summer, Call for hours.

Closed: Academic Holidays.

Facilities: **Galleries** (7).

Activities: **Guided Tours**; **Lectures**; **Temporary Exhibitions**.

Publications: newsletter, "Friends of the Museum Newsletter".

The University Museum presents twelve exhibitions per year, featuring art in all media by local, regional, and international artists. The permanent collection focuses on fine and folk arts and native arts of North and Central America, The Museum is located in John Sutton Hall, a National Register building built in 1875. Additionally, exhibitions are presented in the Department of Art's Kipp Gallery in Sprowls Hall (Monday-Friday 11:30am-2:30pm).

Jenkintown

Abington Art Center

515 Meetinghouse Road, Jenkintown, PA 19046

Tel: (215) 887-4882

Fax: (215) 887-5789

Exec. Director: Ms. Laura Burnham

Admission: free.

Attendance: 58,000 *Established:* 1939

Membership: Y *ADA Compliant:* Y

Parking: free on site.

Open: Monday to Saturday, 10am-5pm.

Closed: Presidents' Day, Passover, Good Friday, Memorial Day, Independence Day, Labor Day, Rosh Hashanah, Yom Kippur, Veterans Day, Thanksgiving Day, Christmas Day to New Year's Day.

Facilities: **Galleries** (3); **Sculpture Garden**; **Shop**.

Alice Aycock, *Fantasy Sculpture II*, 1990, sculpture. Abington Art Center. Photograph courtesy of Abington Art Center, Jenkintown, Pennsylvania.

Abington Art Center, cont.

Activities: Arts Festival; **Education Programs** (adults and children); **Guided Tours**; **Lectures**.
Publications: exhibition & class listing (monthly); newsletter& schedule (3/year).

The AAC presents temporary exhibitions of contemporary art and features a sculpture garden.

Johnstown

Southern Alleghenies Museum of Art at Johnstown (SAMA at Johnstown)

Pasquerilla Performing Arts Center, University of Pittsburgh at Johnstown, Johnstown, PA 15904
Tel: (814) 269-7234
Fax: (814) 269-7240
Curator: Ms. Nancy Ward
Admission: free.
Attendance: 40,000 **Established:** 1982 **ADA Compliant:** Y
Parking: university parking.
Open: Monday to Friday, 9:30am-4:30pm.
Closed: Legal Holidays.
Facilities: **Gallery** (2,130 Square feet).
Activities: **Art Film Festival**; **Guided Tours**; **Lectures**; **Performances**.
Publications: exhibition catalogues.

A branch of Southern Allegheny Museum of Art, SAMA at Johnstown mounts exhibitions regularly, consisting of art from its collection, as well as works on loan to the Museum. Its goal is to stimulate interest in and an understanding of American art among the people of the southwestern region of central Pennsylvania. The permanent collection, housed at the Loretto facility, includes 19th- and 20th-century paintings, sculpture, drawings, photography and prints, highlighted by works of Bourke-White, Cassatt, Frankenthaler, Sloan, Stieglitz, and Warhol. Headquartered in Loretto, Pennsylvania (see separate listing), the Southern Alleghenies Museum of Art maintains three branch facilities. In addition to Johnstown, branches are located in Altoona and Ligonier, Pennsylvania (see separate listings).

Lancaster

Demuth Foundation

120 E. King St., Rear
(one block east of Penn Square)
Lancaster, PA 17602
Tel: (717) 299-9940
Fax: (717) 299-9749
Director: Ms. Corinne Woodcock

Admission: free.
Attendance: 8,000 **Established:** 1981
Membership: Y **ADA Compliant:** N
Parking: metered on street, parking lot on weekends.
Open: **February to December**,
 Tuesday to Saturday, 10am-4pm;
 Sunday, 1pm-4pm.
Closed: January, Major Holidays.

Charles Demuth, *Pink Tulips*, 1930, watercolor, 13½ x 19½ inches, Collection of Demuth Foundation. Photograph courtesy of Demuth Foundation, Lancaster, Pennsylvania.

Facilities: **Architecture** (18th-century home of Charles Demuth); **Exhibition Area** (3 rooms);
 Library/Archive; **Shop** (books, reproductions).
Activities: **Permanent Exhibits**; **Temporary Exhibitions**.

Housed in the restored home of modernist artist Charles Demuth (1883-1935), the Foundation presents historical exhibits relating to the artist and temporary exhibitions of local and regional artists. Although he studied and painted in Philadelphia, New York, Provincetown, Paris and Bermuda, Demuth created most of his art in the home where he worked in a small second-floor studio in the rear wing overlooking the garden. The second floor parlor is now used as a gallery for art and educational exhibits. The permanent collection contains over 20 original watercolors, paintings and drawings by Demuth.

Lancaster, Pennsylvania

Lancaster Museum of Art

135 North Lime St., Lancaster, PA 17602
Tel: (717) 394-3497
Fax: (717) 394-0101
Exec. Director: Ms. Cindi Morrison
Admission: voluntary contribution.
Attendance: 10,000 *Established:* 1965 *Membership:* Y *ADA Compliant:* Y
Open: Monday to Saturday, 10am-4pm; Sunday, noon-4pm.
Closed: Legal Holidays.
Facilities: **Architecture** (Greek Revival town house, 1846.); **Shop.**
Activities: **Arts Festival**; **Concerts**; **Education Programs** (adults and children); **Guided Tours**; **Lectures**; **Temporary Exhibitions.**
Publications: newsletter, "Collage".

The museum presents changing exhibitions of contemporary art and maintains a permanent collection.

Lewisburg

Bucknell University - The Center Gallery

Elaine Langone Center, 3rd Floor, 7th St. and Moore Ave., Lewisburg, PA 17837
Tel: (717) 524-3792
Fax: (717) 524-3480
Internet Address: http://www.departments,bucknell.edu/center_gallery
Director: Ms. Johann J.K. Reusch
Admission: free.
Attendance: 3,200 *Established:* 1979 *ADA Compliant:* Y
Parking: free on site.
Open: **June to August**, Monday to Friday, 11am-5pm; Saturday to Sunday, 1pm-4pm.
Closed: Legal Holidays.
Facilities: **Auditorium** (125 seat); **Food Services** Restaurant; **Shop.**
Activities: **Arts Festival**; **Concerts**; **Dance Recitals**; **Education Programs** (adults, college students and children); **Films**; **Guided Tours**; **Lectures**; **Temporary Exhibitions**; **Traveling Exhibitions.**
Publications: exhibition catalogues.

The Center Gallery presents temporary exhibitions centered on both its permanent collection and works on loan. The collection numbers approximately 7,500 objects. It features 24 items from the Samuel H. Kress Foundation, including works by Pontormo, Tintoretto, Veronese, and Sansovino. There are also collections of musical instruments and Japanese art. The museum's collection of American art includes works by Kensett, Prendergast, Burchfield, Shahn, and Benton. Its photographs include works by Mapplethorpe and Bravo, while works by Johns and Rauschenberg are found in its print collection.

Ligonier

Southern Alleghenies Museum of Art at Ligonier (SAMA at Ligonier)

1 Boucher Lane, Ligonier, PA 15658-2110
Tel: (724) 238-6015
Fax: (724) 238-6281
Curator: Ms. Madelon Sheedy
Admission: free.
Established: 1997
Membership: Y *ADA Compliant:* Y
Parking: free on site.

Drawing of exterior of Southern Alleghenies Museum of Art at Ligonier Valley by Chas Fagan, courtesy of Southern Alleghenies Museum of Art at Ligonier Valley, Ligonier, Pennsylvania.

Southern Alleghenies Museum of Art at Ligonier, cont.

Open: Monday to Friday, 10am-4pm; Saturday to Sunday, 1:30pm-4:30pm.
Closed: Major holidays.
Facilities: **Galleries** (2); **Gardens.**
Activities: **Concerts** (in garden); **Demonstrations**; **Films**; **Gallery Talks** (on request); **Lectures**; **Workshops.**
Publications: collection catalogue; exhibition catalogues (8/year).

A branch of the Southern Alleghenies Museum of Art, SAMA at Ligonier incorporates four donated log cabins in a design by Michele Rudolph of Riverside Design (New York City) and is surrounded by extensive gardens and landscaping. The Museum presents changing exhibitions and provides educational activities. The Walter Carlyle Shaw Paperweight Collection, a comprehensive and historic collection of approximately 170 objects spanning 150 years, is the only permanent installation. The permanent collection, housed at the Loretto facility, includes 19th- and 20th-century paintings, sculpture, drawings, photography and prints, highlighted by works of Cassatt, Frankenthaler, Warhol, Stieglitz, Bourke-White, and Sloan. Headquartered in Loretto, Pennsylvania (see separate listing), the Southern Alleghenies Museum of Art maintains three branch facilities. In addition to Ligonier, branches are located in Altoona and Johnstown, Pennsylvania (see separate listings).

Loretto

Southern Alleghenies Museum of Art at Loretto (SAMA at Loretto)

St. Francis College Mall, Loretto, PA 15940
Tel: (814) 472-3920
Fax: (814) 472-4131
Internet Address: http://www.sama-sfc.org
Exec. Director: Dr. Michael Tomor
Admission: free.
Attendance: 50,000 *Established:* 1976
Membership: Y *ADA Compliant:* Y
Parking: free on site.
Open: Monday to Friday, 10am-4pm;
 Saturday to Sunday, 1:30pm-4:30pm.
Closed: Legal Holidays.
Facilities: **Auditorium** (250 seat); **Food Services** Restaurant (on campus); **Galleries** (2); **Sculpture Garden.**

View of interior of gallery, Southern Alleghenies Museum of Art at Loretto. Photograph courtesy of Southern Alleghenies Museum of Art, Loretto, Pennsylvania.

Activities: **Concerts**; **Education Programs** (adults, college students and children); **Guided Tours**; **Lectures**; **Temporary Exhibitions.**
Publications: calendar; collection catalogue; exhibition catalogues; newsletter.

The Southern Alleghenies Museum of Art was founded to bring museum services to a geographically isolated region. In its first two decades, SAMA has developed a significant permanent collection, curated special exhibitions, organized four facilities, and implemented education programs for the people of the region. The permanent collection, totaling over 3,000 art works, includes 19th- and 20th-century painting, sculpture, drawings, prints and photography highlighted by works of Margaret Bourke-White, Mary Cassatt, Helen Frankenthaler, John Sloan, Alfred Stieglitz, and Andy Warhol. Headquartered in Loretto, SAMA branch museums are located in Altoona, Johnstown, and Ligonier Valley, Pennsylvania (see separate listings).

Malvern

The Wharton Esherick Museum

1520 Horseshoe Trail, Malvern, PA 19355
Tel: (610) 644-5822
Internet Address: http://www.levins.com/esherick.html
Director: Mr. Robert Leonard
*Admission:*fee: adult-$6.00, child-$3.00, senior-$5.00.
Attendance: 6,000 *Established:* 1972 *Membership:* Y *ADA Compliant:* Y

Malvern, Pennsylvania

The Wharton Esherick Museum, cont.

Parking: free on site.
Open: **Groups only**,
 Monday to Friday, 10am-4pm;
 Individuals & Groups,
 Saturday, 10am-5pm;
 Sunday, 1pm-5pm.
Closed: Legal Holidays, January and February.
Facilities: **Architecture** (artist's handcrafted home and studio).
Activities: **Guided Tours** (by reservation); **Temporary Exhibitions**.
Publications: newsletter (quarterly); museum catalogue.

Exterior view of Wharton Esherick Studio, designed by Wharton Esherick. Photograph courtesy of Wharton Esherick Museum, Malvern, Pennsylvania.

Wharton Esherick created a distinctive sculpture style early in the 20th century. Working primarily in wood, he extended his sculptural forms to furniture, furnishings, and interiors. More than 200 examples of his work - paintings, sculpture, furniture, furnishings, utensils, and models - are exhibited in the Studio, which was itself designed by Esherick and is a National Historic Landmark.

Mansfield

Mansfield University - North Hall Gallery

Mansfield University, Junction Routes 6 and 15, Mansfield, PA 16933
Tel: (570) 662-4000
Internet Address: http://www.mnsfld.edu
Open: Call for hours.
Facilities: Gallery.
Activities: Lectures.

Located in North Hall Library, the North Hall gallery presents several exhibits each year, featuring the work of both students and professional artists.

Meadville

Allegheny College Art Galleries

Doane Hall of Art, N. Main St.
Meadville, PA 16335
Tel: (814) 332-4365
Fax: (814) 724-6834
Internet Address: http://www.alleg.edu
Director: Mr. Robert Raczka
Admission: free.
Attendance: 5,000 *Established:* 1970
Membership: N *ADA Compliant:* Y
Parking: free on site.
Open: Tuesday to Friday, 12:30pm-5pm;
 Saturday, 1:30pm-5pm;
 Sunday, 2pm-4pm.

Installation view, Allegheny College Art Galleries. Photograph courtesy of Allegheny College, Meadville, Pennsylvania.

Facilities: **Exhibition Area** (3 galleries, 4,000 square feet).
Activities: **Guided Tours** (groups, on request); **Lectures** (usually five per year); **Temporary Exhibitions** (seven per year); **Traveling Exhibitions**.

The Galleries, Bowman, Megahan, and Penelec, are all located in Doane Hall of Art. Exhibitions consist mostly of contemporary art, but occasionally historical artworks are displayed. The permanent collection consists of 650 works, the majority being modern and contemporary.

Merion

Barnes Foundation

300 N. Latch's Lane, Merion, PA 19066

Tel: (610) 667-0290

Fax: (610) 664-4026

Exec. Director and C.E.O.: Kimberly Camp

Admission: fee-$5.00, by advance reservation only.

Established: 1925

Parking: in lot, by reservation, $10.00.

Open: **September to June**, Friday to Sunday, 9:30am-5pm (by advance reservation only);
.**July to August**, Wednesday to Friday, 9:30am-5pm (by advance reservation only).

Facilities: **Arboretum**; **Galleries**; **Shop**.

Activities: **Guided Tours** (available upon request).

The Barnes Foundation was established by Dr. Albert Coombs Barnes, a physician/manufacturer, who loved art and believed in nondiscriminatory access to it. He began collecting in the early years of this century, rapidly amassed a large number of important works, and retained French architect Paul Cret to design a gallery for his collection, completed in 1925. He worked to expand the Gallery's collection for the rest of his life. The Barnes Foundation Gallery houses one of the finest collections of early French modern and post-Impressionist paintings in the entire world. For example, the Foundation holds 60 works by Matisse, 69 by Cézanne, and 180 by Renoir. The collection also includes works by Picasso, Seurat, Rousseau, Modigliani, Soutine, Monet, Manet, Degas, and others. The Gallery also displays ceramics, Native American jewelry, antique furniture, and other objects.

New Brighton

The Merrick Art Gallery

5th Ave. & 11th St., New Brighton, PA 15066

Tel: (412) 846-1130

Director: Ms. Cynthia A. Kundar

Admission: voluntary contribution.

Attendance: 5,000 *Established:* 1880

Membership: Y *ADA Compliant:* Y

Open: **Winter,**
Tuesday to Saturday, 10am-4:30pm;
Sunday, 1pm-4pm.

Summer,
Wednesday to Saturday, 10am-4pm;
Alternate Sundays 1pm-4pm.

Closed: New Year's Day, Memorial Day, Independence Day, Labor Day, Thanksgiving Day, Christmas Day to mid-January, Holiday Weekends.

Birge Harrison, *Shipwrecked*, oil on canvas, 43 x 58 inches. Merrick Art Gallery. Photograph courtesy of Merrick Art Gallery, New Brighton, Pennsylvania.

Facilities: **Library** (1,200 volumes).

Activities: **Arts Festival**; **Concerts**; **Education Programs** (adults and children); **Guided Tours**; **Lectures**; **Temporary Exhibitions**.

Publications: brochures; collection catalogue; newsletter, "Merrick Gallery Associates Newsletter" (quarterly).

The Main Gallery of the Merrick Art Gallery contains mostly 19th-century European and American paintings, while the American Room displays works created by the founders and followers of, and those influenced by, the Hudson River School.

New Castle

The Hoyt Institute of Fine Arts

124 E. Leasure Ave., New Castle, PA 16101

Tel: (412) 652-2882

Fax: (412) 657-8786

New Castle, Pennsylvania

The Hoyt Institute of Fine Arts, cont.

C.E.O. and Exec. Director: Ms. Kimberly Koller-Jones
Admission: voluntary contribution.
Attendance: 15,000 *Established:* 1965 *Membership:* Y *ADA Compliant:* Partial (1st Floor)
Open: Tuesday to Saturday, 9am-5pm.
Closed: New Year's Day, Easter, Independence Day, Thanksgiving Day, Christmas Day.
Facilities: **Library** (1,000 volumes).
Activities: **Arts Festival**; **Concerts**; **Education Programs** (adults and children); **Guided Tours**;
 Lectures; **Temporary Exhibitions**; **Traveling Exhibitions**.
Publications: newsletter (quarterly).

The Hoyt Institute of Fine Arts consists of two 1917 mansions housing classrooms, studios, galleries, meeting facilities, and period rooms.

Philadelphia

African-American Museum in Philadelphia

701 Arch St., NW corner of 7th and Arch Sts.), Philadelphia, PA 19106-1557
Tel: (215) 574-0380
Fax: (215) 574-3110
President and C.E.O.: Terrie S. Rouse
Admission: fee: adult-$6.00, child-$3.00, student-$3.00, senior-$3.00.
Attendance: 100,000 *Established:* 1976 *Membership:* Y *ADA Compliant:* Y
Parking: commercial adjacent to site.
Open: Tuesday to Saturday, 10am-5pm; Sunday, noon-5pm.
Closed: Legal Holidays, Good Friday.
Facilities: **Auditorium** (200 seat); **Galleries** (4); **Library** (1,500 volumes); **Shop**.
Activities: **Arts Festival**; **Concerts**; **Films**; **Guided Tours**; **Lectures**; **Temporary Exhibitions**;
 Traveling Exhibitions.
Publications: brochures; exhibition catalogues.

The Museum offers permanent exhibits of African-American art and historical photographs from throughout the Americas complemented by temporary art shows and historic exhibits.

The Athenæum of Philadelphia

219 South 6th St., E. Washington Square, Philadelphia, PA 19106
Tel: (215) 925-2688
Fax: (215) 925-3755
Internet Address:
 http://www.libertynet.org/~athena
Exec. Director: Dr. Roger W. Moss
Admission: free.
Attendance: 22,000 *Established:* 1814
Membership: Y
Open: Monday to Friday, 9am-5pm.
Closed: Bank Holidays.
Facilities: **Architecture** (architect John Notman, 1845-47); **Library** (75,000 volumes) and **Architectural Archive** (180,000 drawings); **Shop**.
Activities: **Lectures**; **Temporary Exhibitions**.

View of Reading Room, Athenaeum of Philadelphia. Photograph courtesy of Athenaeum of Philadelphia, Philadelphia, Pennsylvania.

Publications: newsletter, "Athenæum Annotations" (quarterly).

The Athenæum of Philadelphia is housed in a Italian Revival-style building designed by John Notman, which is now a National Historic Landmark. The building is furnished with 19th-century fine and decorative arts. Temporary exhibitions of works from the permanent collection are presented on a regular basis.

Cigna Museum and Art Collection

Two Liberty Place, 1601 Chestnut Street, Philadelphia, PA 19192-2078
Tel: (215) 761-4907
Fax: (215) 761-5596
Chief Curator: Ms. Melissa E. Hough
Admission: open to public by prior appointment.
Attendance: 5,000
Open: Monday to Friday, 9am-5pm, by appointment.
Facilities: Exhibition Area (gallery).
Activities: Guided Tours; Temporary Exhibitions.
Publications: exhibition catalogues.

The permanent collection, numbering over 10,000 objects, focuses on American fine and decorative art. Strengths include 19th- and 20th-century landscape painting, American Impressionism (particularly Old Lyme and New Hope Schools), contemporary painting, 20th-century sculpture, and 19th-century prints.

Drexel University-Nesbitt College of Design Arts - Design Arts Gallery

Drexel University (northeast corner of 33rd and Market Sts.), Philadelphia, PA 19104
Tel: (215) 895-2548
Fax: (215) 895-4917
Internet Address: http://www.post.drexel.edu/gallery
Director: Dr. Joseph Gregory
Attendance: 6,000 *Established:* 1986
ADA Compliant: Y
Parking: on and off street parking.
Open: Monday to Friday, 11am-5pm.
Facilities: Gallery (480 square feet).
Activities: Temporary Exhibitions.

Located on the ground floor of Nesbitt Hall, the Design Arts Gallery presents eight shows annually featuring contemporary fine and applied arts, including architecture, interior design, fashion design, photography, painting, sculpture, and drawing. Historical surveys are sometimes showcased, especially in connection with the Historic Costumes Collection, which is housed in the College. Faculty and student work is exhibited as well as that of regionally, nationally, and internationally recognized artists and designers.

View of the entrance to Design Arts Gallery, Nesbitt College of Design Arts. Photograph by Will Brown, courtesy of Design Arts Gallery, Nesbitt College of Design Arts, Drexel University, Philadelphia, Pennsylvania.

Esther M. Klein Art Gallery/University City Science Center

University City Science Center, 3600 Market St. and Esther Klein's Way
Philadelphia, PA 19104
Tel: (215) 387-2262
Fax: (215) 382-0056
Curator/Director: Ms. Libby Newman
Admission: free.
Attendance: 15,000 *Established:* 1976 *ADA Compliant:* Y
Parking: commercial adjacent to site and on-street parking.
Open: Monday to Saturday, 9am-5pm.
Facilities: Gallery (1000 square feet).
Activities: Permanent Exhibits; Temporary Exhibitions.
Publications: brochures; exhibition catalogues.

James Carpenter, *Refractive Light Spine*, 1989, 54 x 22 x 5 feet, in Gallery entrance (1989), designed by Vitteta Group. Photograph courtesy of Esther M. Klein Gallery, Philadelphia, Pennsylvania.

Esther M. Klein Art Gallery/University City Science Center, cont.

Located in the University City Science Center in West Philadelphia, the Klein Art Gallery helps fulfill part of the Center's mission by bringing together the humanities and sciences. The Gallery provides artists (such as Buckminster Fuller) with an atmosphere that fosters creativity and an opportunity to exhibit their works. It also presents temporary exhibitions of works by artists that represent the range of Philadelphia's cultural heritage.

The Fabric Workshop and Museum

1315 Cherry St., 5th Floor, Philadelphia, PA 19107

Tel: (215) 568-1111

Fax: (215) 568-8211

Artistic Director and Chairman: Marion Boulton Stroud

Admission: voluntary contribution.

Established: 1977 *Membership:* Y *ADA Compliant:* Y

Open: Monday to Friday, 9am-6pm; Saturday, noon-4pm.

Closed: Legal Holidays.

Facilities: **Exhibition Area** (1,200 square feet); **Shop**; **Studios**.

Activities: **Education Programs** (Adults, students and children); **Guided Tours**; **Lectures**; **Temporary Exhibitions**; **Traveling Exhibitions**.

Publications: exhibition catalogues.

The Fabric Workshop and Museum is devoted to experimental fabric design and printing by emerging and nationally-known artists.

Fleisher Art Memorial - Dene M. Louchheim Galleries

709-721 Catharine St., Philadelphia, PA 19147-2811

Tel: (215) 922-3456 *Ext:* 18

Fax: (215) 922-5327

Open: Monday to Friday, 11am-5pm.

Facilities: **Galleries**.

Activities: **Temporary Exhibitions**.

The Samuel S. Fleisher Art Memorial is a free art school and gallery administered by the Philadelphia Museum of Art. The Memorial's facility consists of a group of 19th-century buildings that have been placed on the National Register of Historic Places. The galleries present temporary exhibitions, including small group shows of emerging regional artists. There is also a permanent collection of European paintings and sculpture.

Fred Wolf, Jr. Gallery - Klein Branch Jewish Community Center

10100 Jamison Ave., Philadelphia, PA 19116

Tel: (215) 698-7300

Fax: (215) 673-7447

Director: Mrs. Phyllia E. Gerson Actman

Admission: free.

Attendance: 45,000 *Established:* 1975 *ADA Compliant:* Y

Parking: free on site.

Open: Monday to Thursday, 9am-9pm; Friday to Sunday, 9am-5pm.

Closed: Jewish Holidays.

Facilities: **Auditorium** (250 seat); **Exhibition Area** (150 square feet); **Food Services** Restaurant; **Shop**; **Theatre** (400 seats).

Activities: **Education Programs** (adults); **Gallery Talks**; **Lectures**; **Temporary Exhibitions**.

Publications: calendar; newsletter, "Impact".

The Fred Wolf, Jr. Gallery mounts a variety of exhibits throughout the year, displaying secular as well as Jewish art.

Historical Society of Pennsylvania

1300 Locust St., Philadelphia, PA 19107
Tel: (215) 732-6200
Fax: (215) 732-2680
President: David Moltke-Hansent
Admission: gallery admission: adult-$6.00, child-free, student-$3.00.
Attendance: 13,000 *Established:* 1824 *Membership:* Y *ADA Compliant:* Y
Parking: commercial adjacent to site.
Open: Tuesday, 10am-4:45pm; Wednesday, 1pm-8:45pm; Thursday to Saturday, 10am-4:45pm.
Closed: Legal Holidays.
Facilities: **Exhibition Area**; **Library**; **Research Room**.
Activities: **Education Programs**; **Guided Tours**; **Temporary Exhibitions**.
Publications: "Guide to the Manuscript Collections of the Hist. Soc. of Pennsylvania"; journal, "The Pennsylvania Magazine of History and Biography" (quarterly); newsletter, "Pennsylvania Correspondent".

The Historical Society of Pennsylvania is primarily a special collections library for historical research. It does house an extensive collection of Philadelphia-related engravings, prints, lithographs, photographs, and watercolors.

La Salle University Art Museum

20th and Olney Ave., Philadelphia, PA 19141
Tel: (215) 951-1221
Fax: (215) 951-1488
Internet Address: http://www.lasalle.edu/services/art-mus
Director: Brother Daniel Burke
Admission: free.
Attendance: 10,000 *Established:* 1975
Membership: Y *ADA Compliant:* Y
Parking: free on site.
Open: **September to July**,
 Tuesday to Friday, 11am-4pm; Sunday, 2pm-4pm.
Closed: Academic Holidays.
Facilities: **Galleries** (5); **Special Exhibition Gallery**.
Activities: **Concerts**; **Gallery Talks**; **Guided Tours**; **Lectures**; **Temporary Exhibitions**.
Publications: collection catalogue; exhibition catalogues.

The permanent collection of the Art Museum at La Salle University manifests its basic goal: to document the major styles and themes of Western art since the Middle Ages. The collection is highlighted by works by Provost, Van Cleve, Bourdon, Tintoretto, Ruisdael, Raeburn, Lawrence, West, Eakins, Corot, Degas, Pissarro, Boudin, Vuillard, and Rouault. The Museum also presents temporary exhibitions of works from its and other museums' collections.

Georges Rouault, *The Last Romantic*, 1937, oil on canvas, 26½ x 19½ inches. Collection of La Salle University Art Museum. Photograph courtesy of La Salle University, Philadelphia, Pennsylvania.

Moore College of Art and Design - Galleries

20th St. and The Parkway, Philadelphia, PA 19103
Tel: (215) 568-4515 *Ext.* 4048
Fax: (215) 568-5921
Internet Address: http://www.thegalleriesatmoore.org
Director: Molly Dougherty and Lisa Melandri, Interim Co-Directors
Admission: voluntary contribution.
Attendance: 50,000 *Established:* 1844 *Membership:* Y *ADA Compliant:* Y

Moore College of Art and Design - Galleries, cont.

Open: **Academic Year**,
Tuesday to Friday, 10am-5pm;
Saturday to Sunday, noon-4pm.
Closed: Academic Holidays, Legal Holidays.
Facilities: **Galleries** (2); **Library** (50,000 volumes).
Activities: **Concerts; Films; Gallery Talks; Guided Tours; Lectures; Temporary Exhibitions; Traveling Exhibitions.**
Publications: exhibition catalogues.

The Goldie Paley Gallery presents work by national and international artists who have made a distinctive contribution to their field, but have not always had mainstream exposure. The Gallery's exhibitions are linked by an underlying educational objective: to present traditional art in a contemporary context for reevaluation and contemporary art in an art-historical context for critical review. Moore College of Art and Design also maintains the Levy Gallery, which presents temporary exhibitions of the work of students, faculty, and alumnae.

Pennsylvania Academy of Fine Arts - Museum (PAFA)

118 N. Broad St. at Cherry St., Philadelphia, PA 19102
Tel: (215) 972-7600
Fax: (215) 972-5564
Internet Address: http://www.pafa.org
Exec. Director and Provost: Derek Gillman
Admission: fee:
adult-$5.00, child-$3.00, student-$4.00, senior-$4.00.
Attendance: 75,000 *Established:* 1805
Membership: Y *ADA Compliant:* Y
Parking: commercial adjacent to site and metered on street.
Open: Monday to Saturday, 10am-5pm;
Sunday, 11am-5pm.
Closed: Legal Holidays.
Facilities: **Architecture** (Centennial Exhibition Bldg., 1876); **Auditorium** (130 seat); **Exhibition Area; Food Services** Café; **Library** (9,000 volumes); **Shop**.
Activities: **Concerts; Guided Tours; Lectures; Temporary Exhibitions; Traveling Exhibitions.**
Publications: annual report; brochures; exhibition catalogues; newsletter.

View of gallery, Museum of Art of Pennsylvania Academy of Fine Arts (1876), designed by Frank Furness and George W. Hewitt. Photograph courtesy of Pennsylvania Academy of Fine Arts, Philadelphia, Pennsylvania.

The Museum is housed in a striking Victorian Gothic building designed by Philadelphia architect Frank Furness. It was designated a National Historic Landmark in 1975. The permanent collection of the Museum constitutes one of the finest and most comprehensive collections of American art in the United States and is especially strong in 19th-century genre and narrative paintings; 18th- and 19th-century portraiture; 18th- and 19th-century landscape painting; American Impressionist paintings; neoclassical sculpture; and works by "The Eight".

The Philadelphia Art Alliance

251 South 18th St., Philadelphia, PA 19103
Tel: (215) 545-4302
Fax: (215) 545-0767
Internet Address: http://www.liberty-net.org/~paa
Exec. Director: Mr. James McClelland
Admission: suggested contribution-$3.00.
Attendance: 27,000 *Established:* 1915 *Membership:* Y
Parking: commercial adjacent to site.

The Philadelphia Art Alliance, cont.

Open: Tuesday, 11am-5pm;
Wednesday, 11am-8pm;
Thursday to Sunday, 11am-5pm.

Closed: Legal Holidays.

Facilities: **Exhibition Area** (3 floors of gallery space).

Activities: **Concerts; Gallery Talks; Lectures; Readings; Temporary Exhibitions.**

Publications: newsletter (internal news only, quarterly).

Founded in 1915, the Philadelphia Art Alliance is committed to exploring the visual, performing and literary arts within a setting that encourages spirited exchange among all those whose lives have been enriched by the arts. To this end, the Philadelphia Art Alliance presents forty exhibitions, performances and educational programs throughout its season in a social environment that encourages dialogue among artists of all disciplines and between artists and the public. The Philadelphia Art Alliance was one of the first institutions in the country to show African American artists with exhibitions of works by Henry O. Tanner and Horace Pippin; Stravinsky made his only Philadelphia appearance here as lecturer and pianist; Andrew Wyeth's first public exhibition was here; and Frank Lloyd Wright made his only public appearance in Philadelphia at the Art Alliance. The Art Alliance maintains a satellite gallery on Rittenhouse Square (see separate listing).

View of entrance, Philadelphia Art Alliance. Photograph courtesy of Philadelphia Art Alliance, Philadelphia, Pennsylvania.

Philadelphia Art Alliance - Rittenhouse Satellite Gallery

210 W. Rittenhouse Square, Third Floor, Philadelphia, PA 19103

Tel: (215) 545-4302

Exec. Director: Mr. James McClelland

Admission: free.

Membership: Y *ADA Compliant:* Y

Parking: commercial adjacent to site.

Open: Daily, 10am-7pm.

Facilities: **Gallery**.

Activities: **Temporary Exhibitions**.

The Art Alliance has no permanent collection. It mounts seven rotating exhibits annually. The principal gallery of the Art Alliance is at 251 South 18th Street (see separate listing).

Philadelphia Museum of Art

26th St. and Benjamin Franklin Parkway.
Philadelphia, PA 19130

Tel: (215) 763-8100

Fax: (215) 236-4465

Internet Address: http://www.philamuseum.org

President and C.E.O.: Ms. Anne d'Harnoncourt

Admission: fee: adult-$8.00, child/student/senior-$5.00.

Attendance: 800,000 *Established:* 1876

Membership: Y *ADA Compliant:* Y

Parking: pay on site.

Open: Tuesday, 10am-5pm;
Wednesday, 10am-8:45pm;
Thursday to Sunday, 10am-5pm.

Closed: Legal Holidays.

Henri Matisse, *Woman in Blue*, 1937, Philadelphia Museum of Art. Photograph courtesy of Philadelphia Museum of Art, Philadelphia, Pennsylvania.

Philadelphia Museum of Art, cont.

Facilities: **Architecture**; **Auditorium** (395 seats); **Food Services** Restaurant and Cafeteria; **Library** (140,000 volumes); **Sculpture Garden**; **Shop**.

Activities: **Arts Festival**; **Concerts**; **Education Programs** (adults, children, families & the disabled); **Films**; **Gallery Talks**; **Guided Tours**; **Lectures**; **Temporary Exhibitions**; **Traveling Exhibitions**.

Publications: collection catalogue; newsletter, "Mummers Museum News" (monthly).

Founded in 1876, the Museum houses in its striking neoclassical building an extraordinary collection unique for its integrated presentation of both fine and applied arts from Asia, Europe, and the United States. Spanning more than 2,000 years, the collection includes masterpieces of painting, sculpture, prints, drawings, and architectural elements. The collections include Medieval and Renaissance art (a French medieval cloister, a 14th-century chapel, tapestries, stained glass, and stone carving); European art 1500-1850 (examples in the collection trace the development of styles and themes); arts of Asia (jade carvings, porcelains, paintings, and sculptures; American art (masterworks by Peale and Eakins, Philadelphia silver and furniture, and rural arts, such as Pennsylvania German painted furniture and Shaker furniture); and 19th- and 20th-century art (Matisse, Rodin, Degas, Brancusi, Cubism, Abstract Expressionism, Pop Art, and contemporary art.

Philadelphia Museum of Judaica

615 N. Broad St., Philadelphia, PA 19123
Tel: (215) 627-6747
Fax: (215) 627-1313
Director: Ms. Joan C. Sall
Admission: free.
Attendance: 5,000 *Established:* 1975
Membership: Y *ADA Compliant:* N
Open: Monday to Friday, 10am-4pm; Sunday, 10am-noon.
Facilities: **Exhibition Area** (440 square feet).
Activities: **Guided Tours**; **Temporary Exhibitions**.

The Museum is located in a Byzantine-style synagogue built in 1927. Its permanent collection includes contemporary Jewish art (with works by Gross, Vaadia, Kirili, and Kahn) and the Leon and Julia Obermayer Collection of Jewish Ceremonial Art. It also mounts three temporary exhibitions per year of traditional and contemporary art in a variety of media, including traveling exhibitions from Jewish museums nationwide.

Chaim Gross, *Jacob's Dream*, 1976, sculpture. Collection of Philadelphia Museum of Judaica. Photograph courtesy of Philadelphia Museum of Judaica, Philadelphia, Pennsylvania.

Philadelphia University - Paley Design Center

4200 Henry Ave., Philadelphia, PA 19144
Tel: (215) 951-2860
Internet Address: http://www.philacol.edu/paley
Director: Ms. Anne R. Fabbri
Admission: free.
Established: 1978 *Membership:* Y *ADA Compliant:* Y
Parking: free, opposite main entrance.
Open: Tuesday to Friday, 10am-4pm; Saturday to Sunday, noon-4pm.
Closed: National Holidays.
Facilities: **Architecture** (former residence, 1952 design by architect Earl Bolten); **Exhibition Area**; **Shop** (original hand-crafted work).
Activities: **Permanent Exhibits**; **Temporary Exhibitions**.

Located on the campus of the Philadelphia University (formerly Philadelphia College of Textiles and Science), the Paley Center serves as the central repository for the University's collection of textiles and textile-related artifacts and presents them in temporary exhibitions. The Center's permanent collection of over 1.5 million items documents the history of textiles with particular focus

Philadelphia University - Paley Design Center, cont.

on the American textile industry and the Philadelphia region in particular. Objects in the collection include fragments of 4th-century (A.D.) Egyptian Coptic textiles, 17th- to 20th-century lace, 18th- and 19th-century quilts, 19th- and 20-century American and European clothing and accessories including designer-wear and 19th-century undergarments, traditional ethnic costumes from throughout the world, and 19th-century Philadelphia textiles.

The Rodin Museum

Benjamin Franklin Parkway at 22nd St.
Philadelphia, PA 19101
Tel: (215) 763-8100
Fax: (215) 236-4465
TDDY: (215) 684-7600
Internet Address: http://www.rodinmuseum.org
Director: Ms. Anne d'Harnoncourt
Admission: suggested contribution-$3.00.
Attendance: 58,000 *Established:* 1926
Membership: Y *ADA Compliant:* Y
Parking: pay on site.
Open: Tuesday to Sunday, 10am-5pm.
Closed: Legal Holidays.

Auguste Rodin, *The Thinker*, 1880, sculpture at front entrance to Rodin Museum (1929), designed by Paul Cret and Jacques Greber. Photograph courtesy of Rodin Museum, Philadelphia, Pennsylvania.

Facilities: **Architecture** (designed Paul Cret and Jacques Greber); **Sculpture Garden**; **Shop**.
Activities: **Gallery Talks**; **Guided Tours**; **Lectures**.
Publications: collection catalogue, "The Sculpture of August Rodin".

The Museum houses the largest collection of Rodin sculptures and drawings outside Paris, including "The Thinker", "The Burghers of Calais", and "The Gates of Hell".

The Rosenbach Museum and Library

2010 DeLancey Place, Philadelphia, PA 19103
Tel: (215) 732-1600
Fax: (215) 545-7529
Internet Address: http://www.rosenbach.org
Director: Derick Dreher
Admission: fee: adult-$5.00, child-$3.00, student-$3.00, senior-$3.00.
Attendance: 12,000 *Established:* 1954
Membership: Y *ADA Compliant:* Y
Parking: commercial adjacent to site.
Open: Tuesday to Sunday, 11am-4pm.
Closed: Legal Holidays, August to Labor Day.
Facilities: **Exhibition Area**; **Garden**; **Shop**.
Activities: **Guided Tours**; **Lectures**; **Temporary Exhibitions**.
Publications: "The Rosenbach Newsletter" (occasional); brochure; collection catalogue; exhibition catalogues.

Thomas Sully, *Portrait of Rebecca Gratz*, 1831, oil on panel. Rosenbach Museum and Library. Photograph courtesy of Rosenbach Museum and Library, Philadelphia, Pennsylvania.

Founded in 1954, the Rosenbach Museum and Library is housed in an elegant DeLancey Place town house built in 1865 and listed on the National Register of Historic Places. The Museum houses one of the largest collections of oil painted portrait miniatures in the United States, American paintings by such artists as Thomas Sully and Bass Otis, and sculpture ranging from ancient Egyptian statuary to Henri Matisse, as well as a fine collection of decorative arts and rare books and manuscripts. While not yet fully accessible by wheelchair, the Museum is very sensitive to those visitors with special needs. It has also scheduled a major renovation in 2000 in order to make its facilities fully accessible.

Saint Joseph's University - University Gallery

5600 City Line Ave., Boland Hall, Lapsley Lane, Philadelphia, PA 19131
Tel: (610) 660-1840
Internet Address: http://www.sju.edu/~corpus
Chairman, Fine & Performing Arts Dept.: Mr. Dennis Weeks
Admission: voluntary contribution.
Attendance: 600
Open: September to May, Monday to Friday, 10am-4pm.
Closed: Legal Holidays.
Activities: Arts Festival; Concerts; Films; Lectures.

The University Gallery hosts eight shows from September through May. The first five feature professional artists, usually from the Philadelphia area. The last three display student work.

Temple University - Temple Gallery

45 North 2nd St., Philadelphia, PA 19106
Tel: (215) 925-7379
Fax: (215) 782-2799
Internet Address: http://www.temple.edu
Director: Mr. Donald Desmett
Open: Wednesday to Thursday, 11am-6pm; Friday, 11am-9pm; Saturday, 11am-6pm.
Facilities: Exhibition Area.
Activities: Temporary Exhibitions.

The Temple Gallery presents exhibitions of contemporary art.

Temple University - Tyler and Penrose Galleries

Tyler School of Art, Beech and Penrose Aves., Elkins Park, Philadelphia, PA 19027
Tel: (215) 782-2776
Fax: (215) 782-2799
Internet Address: http://www.temple.edu/tyler/home/exhibmain.html
Director: Mr. Donald Desmett
Open: Tuesday to Saturday, 10am-5pm.
Facilities: Exhibition Area.
Activities: Temporary Exhibitions.

The galleries at the Tyler School of Art present temporary exhibitions, including an annual student exhibit in the spring.

University of Pennsylvania - Arthur Ross Gallery

220 South 34th St., Philadelphia, PA 19104
Tel: (215) 898-2083
Fax: (215) 573-2045
Internet Address: http://www.upenn.edu/ARG/index/html
Director: Dr. Dilys V. Winegrad
Admission: free.
Attendance: 10,000 *Established:* 1983 *Membership:* Y *ADA Compliant:* Y
Open: Tuesday to Friday, 10am-5pm; Saturday to Sunday, noon-5pm.
Closed: New Year's Day, Easter, Independence Day, Thanksgiving Day, Christmas Day.
Facilities: Exhibition Area (1,700 square feet).
Activities: Education Programs (children); Lectures; Temporary Exhibitions.
Publications: calendar (annual); exhibition catalogues.

Housed on the campus of the University of Pennsylvania in an historic building designed by Frank Furness, the Gallery presents temporary exhibitions, displaying objects from the University's collections and other major public and private collections. The Gallery also presents traveling exhibitions with an interdisciplinary appeal and an international focus.

University of Pennsylvania - Institute of Contemporary Art

University of Pennsylvania, 118 S. 36th St. at Sansom, Philadelphia, PA 19104-3289
Tel: (215) 898-7108
Fax: (215) 898-5050
Internet Address: http://www.upenn.edu/ica
Director: Mr. Patrick T. Murphy
Admission: fee: adult-$3.00, child-$2.00, student-$2.00, senior-$2.00.
Established: 1963 *Membership:* Y
ADA Compliant: Y
Parking:
 commercial adjacent to site and metered on street.
Open: Wednesday, 10am-5pm;
 Thursday, 10am-7pm;
 Friday to Sunday, 10am-5pm.
Closed: New Year's Day, Easter, Thanksgiving Day,
 Christmas Day.
Facilities: **Auditorium**.
Activities: **Concerts**; **Education Programs** (children);
 Films; **Guided Tours**; **Lectures**; **Performances**;
 Readings; **Temporary Exhibitions**.
Publications: calendar; exhibition catalogues.

Established in 1963, the ICA is the only museum in Philadelphia committed to exhibiting only contemporary art. Through the presentation of individual, group, and thematic exhibitions that change throughout the year, the ICA has an international reputation for identifying artists of promise who later emerge in the national and international spotlight. Artists who had their first museum exhibition at the ICA include Andy Warhol, Robert Mapplethorpe, and Andres Serrano.

Exterior view of Institute of Contemporary Art, designed by Adele Naude Santos. Photograph courtesy of Institute of Contemporary Art , Philadelphia, Pennsylvania.

The University of Pennsylvania Museum of Archaeology and Anthropology

33rd and Spruce Sts.
Philadelphia, PA 19104-6324
Tel: (215) 898-4000
Fax: (215) 898-0657
Internet Address:
 http://www.upenn.edu/museum
Director: Dr. Jeremy A. Sabloff
Admission:
 fee: adult-$5.00, student-$2.50, senior-$2.50.
Attendance: 140,000 *Established:* 1887
Membership: Y *ADA Compliant:* Y
Parking: nearby pay lots.
Open: **Labor Day to Memorial Day**,
 Tuesday to Saturday, 10am-4:30pm;
 Sunday, 1pm-5pm.
 Memorial Day to Labor Day,
 Tuesday to Saturday, 10am-4:30pm.
Closed: Legal Holidays.
Facilities: **Food Services** Cafeteria (overlooking inner gardens); **Sculpture Garden**; **Shops** (one for adults and one for children).

Sphinx Ramses II, 19th Dynasty, c.1293-1185 B.C., red granite, Memphis, Egypt; and pillars and gateways of Palace of Merenptah, ca. 1236-1223 B.C., Memphis, Egypt. Collection of University of Pennsylvania Museum of Archeology and Anthropology. Photograph by Terry Wild, courtesy of University of Pennsylvania, Philadelphia, Pennsylvania.

Activities: **Concerts**; **Family Days**; **Films**; **Gallery Talks**; **Guided Tours**; **Lectures**; **Temporary Exhibitions**; **Traveling Exhibitions**; **Workshops** (children).

691

The University of Pennsylvania Museum of Archaeology and Anthropology, cont.

Publications: collection catalogue; exhibition catalogues; magazine, "Expedition" (quarterly); monograph series; newsletter (quarterly).

The University of Pennsylvania Museum of Archaeology and Anthropology houses more than 30 galleries of material from Egypt, Mesopotamia, Meso-America, Asia, and the Greco-Roman world, as well as artifacts from native peoples of North America, Africa, and Polynesia.

The University of the Arts - Rosenwald-Wolf Gallery

The University of the Arts, 333 S. Broad St. at Pine St., Philadelphia, PA 19107

Tel: (215) 717-6480

Fax: (215) 717-6632

Internet Address: http://www.uarts.edu/events/rosenwolf.html

Director: Sid Sachs

Admission: free.

Established: 1876 *ADA Compliant:* Y

Parking: commercial adjacent to site and metered parking on street.

Open: Monday to Tuesday, 10am-5pm; Wednesday, 10am-8pm; Thursday to Friday, 10am-5pm; Saturday to Sunday, noon-5pm.

Closed: Academic Holidays, August.

Facilities: **Gallery** (2,000 square feet).

Activities: **Gallery Talks**; **Guided Tours**; **Lectures**; **Performances**; **Temporary Exhibitions**.

Publications: brochures; exhibition catalogues.

The Gallery is a non-collecting facility that features temporary exhibitions of contemporary art. Exhibitions are also mounted by the College of Art and Design (717-6300) in the Mednick Gallery (open: Mon-Fri, 10am-4:30pm).

Woodmere Art Museum

9201 Germantown Ave., Philadelphia, PA 19118

Tel: (215) 247-0476

Fax: (215) 247-2387

C.E.O., Director, & Curator:
 Dr. Michael W. Schantz

Admission: suggested contribution:
 adult-$5.00, child-free, student/senior-$3.00.

Attendance: 30,000 *Established:* 1940

Membership: Y *ADA Compliant:* Y

Parking: free on site.

Open: Tuesday to Saturday, 10am-5pm;
 Sunday, 1pm-5pm.

Closed: Legal Holidays.

Exterior view of Woodmere Art Museum. Photograph courtesy of Woodmere Art Museum, Philadelphia, Pennsylvania.

Facilities: **Children's Gallery** (exhibitions from local schools and special projects focusing on contemporary social issues); **Galleries** (8); **Grounds** (6 acres); **Library** (1,000 volumes; open to qualified researchers, members, and staff); **Shop**.

Activities: **Concerts**; **Gallery Talks**; **Guided Tours**; **Juried Exhibit and Members Show** (annually); **Lectures**; **Temporary Exhibitions**.

Publications: annual report; exhibition catalogues; exhibition schedule (annual); newsletter, "Woodmere Muse" (3/year).

Housed in a 19th-century Victorian mansion, Woodmere features eight galleries focusing on the art and artists of the Philadelphia region. The Museum mounts eight to twelve special exhibitions per year, also featuring work of local and regional artists. Woodmere's permanent collection of over 300 paintings and sculpture includes works by Anschutz, Birch, Herzog, James, Moran, Nicholson, Oakley, Redfield, Rosenthal, Shanks, Weber, West, and N.C. Wyeth, as well as Pennsylvania Impressionists Scholfield, Sotter, and Garber. Woodmere also possesses over 1,000 works on paper, primarily American prints and drawings and including items by Horter, Leighton, Pullinger, Riggs, and J.W. Smith.

Pittsburgh

The Andy Warhol Museum

117 Sandusky St., Pittsburgh, PA 15212-5890

Tel: (412) 237-8300

Fax: (412) 237-8340

Internet Address: http://www.warhol.org

Director: Mr. Thomas Sokolowski

Admission: fee:
 adult-$7.00, child-$4.00, student-$4.00, senior-$6.00.

Attendance: 70,000 *Established:* 1994

Membership: Y *ADA Compliant:* Y

Parking: commercial adjacent to site.

Open: Wednesday to Thursday, 10am-5pm;
 Friday, 10am-10pm;
 Saturday to Sunday, 10am-5pm.

Closed: Legal Holidays.

Facilities: **Architecture**; **Coffee Shop**; **Exhibition Area**;
 Shop; **Theatre.**

Activities: **Education Programs** (adults and children);
 Films; **Lectures**; **Temporary Exhibitions.**

Publications: annual report; collection catalogue.

Exterior view of entrance way, Andy Warhol Museum, with self portrait by Andy Warhol (1986). Photograph courtesy of Andy Warhol Museum, Pittsburgh, Pennsylvania.

The collection of The Andy Warhol Museum includes drawings, prints, paintings, sculpture, audio and video tapes, and an extensive archive. More than 500° works are displayed and offer the visitor an integrated presentation of the development of Warhol's work, with emphasis on specific thematic concerns. The Museum also mounts temporary exhibitions of the work of Warhol and other artists.

Associated Artists of Pittsburgh Gallery - Gallery 937

937 Liberty St., Pittsburgh, PA 15222

Tel: (412) 263-2710

Fax: (412) 232-1930

Exec. Director: Ms. Frances Frederick

Admission: free.

Established: 1910

Open: Wednesday, 11am-3pm.

Facilities: **Exhibition Area** (2).

Activities: **Temporary Exhibitions.**

Publications: newsletter, "AAPropos" (semi-annual).

AAP presents exhibitions of contemporary art at two venues: Gallery 937 at the above address, and at the Pittsburgh Center for the Arts, 6300 5th Ave., Pittsburgh, 15232 - Tel: (412) 361-4235.

Carnegie Mellon University Galleries

Carnegie Mellon University, 5000 Forbes Ave., Pittsburgh, PA 15213

Tel: (412) 268-3618

Internet Address: http://www-art.cfa.cmu.edu/exhibit

Admission: free.

Open: **Hewlett Gallery**, Monday to Friday, 11:30am-5pm; Saturday to Sunday, 11:30am-4pm.
 Ellis Gallery, Monday to Friday, 9am-5pm.

Facilities: **Exhibition Areas.**

Activities: **Temporary Exhibitions.**

CMU has a number of exhibition spaces showing student work. Hewlett Gallery (268-3618), is located on the first floor of the College of Fine Arts. Ellis Gallery, located on the third floor of the Center for Fine Arts, presents one-week exhibits. The University Center Gallery is located just off Kirr Commons in the University Center and features weekly shows. The University's student-run gallery, The Frame (268-2081 - formerly Forbes Gallery), is located at 5200 Forbes Ave., Oakland.

Pittsburgh, Pennsylvania

Carnegie Museum of Art

4400 Forbes Ave., Pittsburgh, PA 15213-4080
Tel: (412) 622-3131
Fax: (412) 622-3112
Internet Address: http://www.clpgh.org
Director: Mr. Ellsworth H. Brown
Admission: fee: adult-$6.00, child-$4.00, student-$4.00, senior-$5.00.
Attendance: 860,000 *Established:* 1896 *Membership:* Y *ADA Compliant:* Y
Parking: commercial adjacent to site.
Open: **September to June,**Tuesday to Saturday, 10am-5pm; Sunday, 1pm-5pm.
 July to August, Monday, 10am-5pm: Tuesday to Saturday, 10am-5pm; Sunday, 1pm-5pm
Closed: Legal Holidays.
Facilities: **Architecture** (1895, by Longfellow, Alden & Harlow; addition by E.L. Barnes); **Food Services** Café; **Galleries**; **Sculpture Garden**; **Shop**; **Theatre**.
Activities: **Arts Festival**; **Films**; **Gallery Talks**; **Guided Tours**; **Lectures**; **Temporary Exhibitions**; **Traveling Exhibitions**.
Publications: "Carnegie Magazine"; annual report; brochures; collection catalogue; exhibition catalogues.

When Andrew Carnegie founded the Carnegie Museum of Art, he envisioned a museum collection consisting of "the old masters of tomorrow". Thus, he acquired then-contemporary works by artists such as Homer, Whistler, and Pissarro, thereby creating what is arguably the first modern art museum in the United States. Today, the strengths of the Museum's collection lie in American art from the late 19th century to the present, French Impressionist and post- Impressionist works, and late 20th-century works. There are also collections of architect-designed decorative arts and Asian and African art.

The Frick Art Museum

7227 Reynolds St., Pittsburgh, PA 15208-2923
Tel: (412) 371-0600
Fax: (412) 241-5393
Internet Address: http://www.frickart.org
Exec. Director: Mr. DeCourcy E. McIntosh
Admission: **Art Museum**: free; **Clayton**: fee.
Attendance: 33,000 *Established:* 1969
Membership: Y *ADA Compliant:* Y
Parking: free on site.
Open: Tuesday to Saturday, 10am-5pm;
 Sunday, noon-6pm.
Closed: Legal Holidays.
Facilities: **Auditorium** (165 seat); **Exhibition Area**; **Food Services** Café; **Shop**.
Activities: **Concerts**; **Education Programs**; **Films**; **Guided Tours**; **Lectures**; **Temporary Exhibitions**.
Publications: collection catalogue; exhibition catalogues.

Peter Paul Rubens, *Charlotte-Marguerite de Montmorency, Princess of Conde*, oil on canvas. Frick Art Museum. Photograph courtesy of Frick Art and Historical Center, Pittsburgh, Pennsylvania.

The Frick Art & Historical Center is located on 5.5 acres of beautifully landscaped grounds in the East End of Pittsburgh. It includes Clayton, the restored Victorian home of Henry Clay Frick; the Frick Art Museum, which includes fine and decorative arts from the 13th through the 19th centuries; The Car and Carriage Museum; and a working Alden and Harlow Greenhouse. The collection includes Italian, French, and Flemish paintings, sculptures, and decorative objects, highlighted by works by Rubens, di Paolo, Boucher, and Houdon.

La Roche College - Cantellops Art Gallery

College Center, 9000 Babcock Blvd., Pittsburgh, PA 15237
Tel: (412) 536-1071
Internet Address: http://www.laroche.edu/TOC/student/art.html
Open: Call for hours.
Facilities: Exhibition Area.
Activities: Temporary Exhibitions.

Located in the College Center, the Gallery presents exhibitions of work by students in graphic design, interior design, and communication design, as well as the work of professional artists.

Mattress Factory, Ltd.

500 Sampsonia Way, Pittsburgh, PA 15212
Tel: (412) 231-3169
Fax: (412) 322-2231
Internet Address: http://www.mattress.org
Director: Ms. Barbara Luderowski
Admission: fee:
 adult-$6.00, child (<12)-free, student-$4.00, senior-$4.00.
Attendance: 24,000 *Established:* 1977
Membership: Y *ADA Compliant:* Y
Parking: free on site.
Open: September to July,
 Tuesday to Saturday, 10am-5pm;
 Sunday, 1pm-5pm.
Closed: New Year's Day, Easter, Memorial Day,
 August, Thanksgiving Day, Christmas Day.
Facilities: Architecture; Sculpture Garden; Shop.
Activities: Guided Tours.

The Mattress Factory is a research and development lab for artists. As a museum of contemporary art, it commissions new site-specific works, presents them to the widest possible audience, and maintains selected installations for its growing permanent collection.

Yayoi Kusama, *Repetitive Vision*, 1996, installation. Photograph by John Charlev, courtesy of Mattress Factory, Pittsburgh, Pennsylvania.

Pittsburgh Center for the Arts (PCA)

6300 5th Ave., Pittsburgh, PA 15232
Tel: (412) 361-0873
Fax: (412) 361-8338
Internet Address:
 http://www.artsnet.org/PghCtrArts
Exec. Director: Ms. Laura Willumsen
Admission: voluntary contribution-$3.00.
Attendance: 100,000 *Established:* 1945
Membership: Y *ADA Compliant:* Y
Parking: on street parking/metered on site.
Open: Monday to Saturday, 10am-5:30pm;
 Sunday, noon-5pm.
Closed: Legal Holidays.
Facilities: Galleries (6); Shops (4, handcrafted
 items by local artists).
Activities: Education Programs (adults and
 children); Guided Tours; studio art class-
 es; Temporary Exhibitions.

Exterior view of Pittsburgh Center for the Arts. Photograph courtesy of Pittsburgh Center for the Arts, Pittsburgh, Pennsylvania.

695

Pittsburgh Center for the Arts, cont.

Publications: class schedule; magazine, "For the Arts" (quarterly); newsletter (bi-monthly).

Housed in a Millionaires Row mansion in Mellon Park, the Center offers six galleries exhibiting regional, national and international contemporary visual art on a rotating basis with an emphasis on the work of area artists. Exhibitions include the Pittsburgh Biennial juried show and the Artist of the Year solo show. The Center offers studio art classes in over 20 disciplines. In addition to the main shop at Fifth and Shady avenues, it operates three other shops in the area: One Oxford Centre downtown, The Shops at Station Square on the South Side, and the Galleria in Mount Lebanon.

University of Pittsburgh - University Art Gallery (UAG)

Frick Fine Arts Building, Schenley Drive (across from the Carnegie Library), Pittsburgh, PA 15260

Tel: (412) 648-2423

Fax: (412) 648-2792

Internet Address: http://www.pitt.edu/~arthome/department/uag.html

Interim Director: Ms. Josienne Piller

Admission: free.

Established: 1966 *ADA Compliant:* Y

Open: Academic Year,

Monday to Wednesday, 10am-6pm; Thursday, 10am-8pm; Friday to Saturday, 10am-4pm.

Closed: Academic Holidays, Easter, Christmas Day.

Facilities: Auditorium (200 seat); Exhibition Area.

Activities: Lectures; Temporary Exhibitions.

The University Art Gallery (UAG) at the University of Pittsburgh has acquired works of art for nearly thirty years and the University's acceptance of valuable art and objects began even earlier. In addition to the permanent collection, specially curated shows occur annually. The permanent collection's strengths are works on paper dating from ca. 1500 to the end of the 20th century with a distinguished assemblage of Callot and Callot-related prints. Paintings include works by Gilbert Stuart, Rembrandt Peale, George Hetzel, Aaron Gorson, and William Gropper, as well as selected works from past Carnegie Internationals. The permanent collection's Asian objects cover a variety of media and styles and include paintings by the modern Chinese artist, Ch'i Pai Shih. Special collections include the Nicholas Lochoff frescos of the 1930's located in the Frick Fine Arts Building Cloister; an extensive array of watercolors by Dr. Andrei Avinoff in the Cathedral of Learning's original 1938 Nationality Rooms, augmented by other drawings, prints and photographs of these unique, ethnically inspired classrooms; and the Gimbel Collection, scenes of western Pennsylvania from 1947 that celebrate its post-World War II technology heritage.

Reading

Albright College - Freedman Gallery

Albright College, 13th and Bern Sts., Reading, PA 19604

Tel: (610) 921-2381

Fax: (610) 921-7530

Internet Address: http://www.alb.edu

Director: Mr. Christopher Youngs

Admission: free.

Attendance: 11,000 *Established:* 1976 *Membership:* Y *ADA Compliant:* Y

Parking: free on site.

Open: Academic Year, Tuesday to Wednesday, noon-6pm; Thursday, noon-8pm;

Friday, noon-6pm; Saturday to Sunday, noon-4pm.

Summer, Tuesday to Sunday, noon-4pm.

Closed: Legal Holidays.

Facilities: Auditorium (250 seats); Exhibition Area (2,800 square feet).

Activities: Films; Guided Tours; Lectures; Temporary Exhibitions; Traveling Exhibitions.

Publications: brochures; exhibition catalogues.

The Freedman Gallery presents monthly exhibitions of nationally and regionally significant contemporary art.

Reading Public Museum

500 Museum Road, Reading, PA 19611-1425
Tel: (610) 371-5850 *Ext:* 250
Fax: (610) 371-5632
Internet Address:
 http://www.berks.net/museum/
Director and C.E.O.: Robert P. Metzger, Ph.D.
Admission: fee: adult-$3.00, child-$2.00.
Attendance: 160,000 *Established:* 1904
Membership: Y *ADA Compliant:* Y
Parking: free on site.
Open: Tuesday, 11am-5pm;
 Wednesday, 11am-8pm;
 Thursday to Saturday, 11am-5pm;
 Sunday, noon-5pm.
Closed: Christmas Day.

Exterior view of Reading Public Museum. Photograph courtesy of Reading Public Museum, Reading, Pennsylvania.

Facilities: **Auditorium** (200 seat); **Galleries** (16, art and science); **Library** (18,000 volumes); **Shop**.
Activities: **Arboretum**; **Concerts**; **Education Programs** (adults and children); **Films**; **Gallery Talks**; **Guided Tours**; **Lectures**; **Permanent Exhibits**; **Temporary Exhibitions**; **Traveling Exhibitions**.
Publications: exhibition catalogues; field guides.

Originally administered by the Reading Public School District, the Museum became an independent entity in 1992 while retaining a strong commitment to its tradition of using the collection for teaching and research. With collections in natural history, anthropology, history and art, the Museum serves as a regional resource providing an artistic and educational venue for south central and southeastern Pennsylvania. The Museum offers a full schedule of temporary exhibitions and educational and cultural programming. While the art of many nations and peoples is represented in the permanent collection, special emphasis has been placed on painting. The fine art collection includes more than seven hundred oil paintings by American and foreign artists such as Milton Avery, George Bellows, Frederic Church, Edgar Degas, Julien Dupré, Raphaelle Peale, Henry Raeburn, Joshua Reynolds, John Singer Sargent, Benjamin West, and N.C. Wyeth. The Museum possesses over one hundred sculptures, thousands of graphics, and more than two hundred watercolors. Additionally, among the 30,000 objects in the anthropological and history collections are sculpture from Southeast Asia, ivory and jade from China, Greek vases, an extensive collection of Roman glass, Incan gold, and a large and comprehensive collection of sculpture and textile work of American Indians

Rosemont

Rosemont College - Lawrence Gallery

1400 Montgomery Ave., Rosemont, PA 19010
Tel: (610) 527-0200
Internet Address: http://www.rosemont.edu
Public Relations: Mr. Evan Welsh
Open: Monday to Friday, 9am-5pm.
Facilities: **Gallery**.
Activities: **Temporary Exhibitions**.

The Gallery presents temporary exhibitions of the work of students and professional artists.

Scranton

Everhart Museum

1901 Mulberry St., Scranton, PA 18510
Tel: (717) 346-7186
Fax: (717) 346-8370
Internet Address: http://www.northeastweb.com/everhart
Director: Mr. Daniel K. Perry

Scranton, Pennsylvania

Everhart Museum, cont.

Admission: fee: adult-$3.00, child-$1.00, student-$1.00, senior-$2.00.
Attendance: 79,000 *Established:* 1908 *Membership:* Y *ADA Compliant:* Y
Parking: free on site.
Open: April 1 to October 13,
 Monday to Wednesday, noon-5pm;
 Thursday, noon-8pm;
 Friday to Sunday, noon-5pm.
 October 14 to March 31,
 Wednesday, noon-5pm;
 Thursday, noon-8pm;
 Friday to Sunday, noon-5pm.
Closed: Some Holidays.
Facilities: **Shop**.
Activities: **Education Programs** (adults and children); **Gallery Talks**; **Lectures**; **Temporary Exhibitions**.
Publications: brochures; exhibition catalogues; newsletter, "Everhart Museum Quarterly".

Exterior view of Everhart Museum. Photograph courtesy of Everhart Museum, Scranton, Pennsylvania.

Since its founding, the Everhart Museum has been a center of the arts in northeastern Pennsylvania. Located in Nay Aug Park, the Museum houses a variety of collections, including American folk art, 19th- and 20th-century American art, and arts of the African, Oriental, and Oceanic societies. It also present temporary exhibitions.

Marywood University Art Galleries

Visual Arts Bldg., 2300 Adams Ave., Scranton, PA 18509
Tel: (717) 348-6278
Fax: (717) 348-1817
Internet Address: http://www.marywood.edu/art/gallery.htm
Director: Ms. Sandra Ward
Admission: free.
Attendance: 8,000 *Established:* 1924 *ADA Compliant:* Y
Open: **Contemporary Gallery**, Monday to Wednesday, 9am-8pm; Thursday to Friday, 9am-5pm; Saturday to Sunday, 1pm-4pm.
 Suraci Gallery, Wednesday to Thursday, 10am-3pm; Friday, 10am-3pm and 5pm-8pm; Saturday to Sunday, 1pm-4pm.
Facilities: **Exhibition Area** (5,500 square feet).
Activities: **Arts Festival**; **Guided Tours**; **Juried Exhibits**; **Lectures**; **Temporary Exhibitions**.

Marywood University maintains two exhibition spaces in the Visual Arts Center: the Contemporary Gallery and the Suraci Gallery. The Contemporary Gallery offers a varied program of group and solo shows by visiting artists, juried regional competitions, Marywood art faculty and student shows, and curated national exhibitions. Presenting the work of both emerging and established, well-known artists, exhibitions explore different media, stylistic approaches, issues, themes and techniques. Featured exhibitions are accompanied by artists' slide lectures, gallery talks, studio visits, workshops or demonstrations. The Suraci Gallery, located on the second floor, displays Marywood's permanent collection of fine and decorative arts from the 19th and 20th centuries. The Asian Collection consists of paintings, furniture, ivories, tapestries and ceramics. Bronze and marble sculptures, furniture and paintings comprise the American Collection. In addition, European ceramics, glass and other decorative arts are displayed and feature exhibitions are presented throughout the year.

University of Scranton - University Art Gallery

Gallery Building, Floor 2F, Linden Street and Madison Ave., Scranton, PA 18510-4585
Tel: (717) 941-4214
Internet Address: http://www.uofs./edu/admin/exhibition.html

University of Scranton - University Art Gallery, cont.
Director: Darlene Miller-Lanning, Ph.D.
Admission: free.
Open: Sunday to Tuesday, noon-4pm; Wednesday, noon-4pm and 7pm-9pm;
 Thursday to Friday, noon-4pm.
Facilities: **Exhibition Area.**
Activities: **Lectures**; **Temporary Exhibitions** (5-7/year).

Located in a building named in honor of former University President Eugene Gallery, S.J., the University Art Gallery presents exhibitions "designed to complement the university curriculum, encourage campus and community collaborations, support regional artists, provide art in education programming, and showcase student art work."

Selinsgrove

Susquehana University - Lore Degenstein Gallery
Susquehana University, 514 University Ave., Selinsgrove, PA 17870-1001
Tel: (717) 372-4058
Fax: (717) 372-2745
Internet Address: http://www.susqu.edu/ac_depts/finearts/art_gall
Director and Curator: Dr. Valerie Livingston
Admission: free.
Attendance: 6,000 *Established:* 1993 *ADA Compliant:* Y
Open: **September to mid-May**, Monday to Sunday, 1pm-4pm.
Facilities: **Auditorium** (450 seat); **Exhibition Area** (2,500 square feet).
Activities: **Guided Tours**; **Lectures**; **Temporary Exhibitions**; **Traveling Exhibitions**.
Publications: exhibition catalogues.

The Gallery presents temporary exhibitions.

Slippery Rock

Slippery Rock University - Martha Gault Art Gallery
Art Department, Maltby Avenue, Slippery Rock, PA 16057
Tel: (724) 738-2020
Internet Address: http://www.sru.edu/depts/artsci/art/margau.htm
Gallery Coordinator: Dr. Kurt Pitluga
Admission: free.
Open: **Fall to Spring**, Monday/Wednesday/Friday, 11am-3pm; Tuesday/Thursday, 3pm-7pm.
 Other Times & Summer, by appointment.
Facilities: **Exhibition Area.**
Activities: **Temporary Exhibitions** (8/academic year, plus single summer-long exhibition).

The Gallery offers a schedule of exhibitions in a wide variety of media during the academic year and supplemented by a single summer-long exhibition. Shows include the work of professional artists, who range from those of special local interest to those of regional and national reputation, as well as an annual faculty exhibition in September and a juried student show in April.

Swarthmore

Swarthmore College - List Gallery
Lang Performing Arts Center, 500 College Ave., Swarthmore, PA 19081-1397
Tel: (610) 328-8488
Fax: (610) 328-7793
Internet Address: http://www.swarthmore.edu/Humanities/art/ Gallery/
Gallery Director: Ms. Andrea Packard
Admission: free.
Established: 1991 *ADA Compliant:* Y
Parking: DuPont visitors lot at College north entrance.

Swarthmore College - List Gallery, cont.

Open: Wednesday, noon-4pm;
Friday, 1pm-5pm;
Saturday to Sunday, 1pm-4pm;
or by appointment.

Facilities: **Exhibition Area** (1,200 square feet).

Activities: **Permanent Exhibits; Temporary Exhibitions** (6/year).

Publications: exhibition brochures (1/year).

The Gallery presents exhibitions of the work of both emerging and nationally known artists and occasional historical exhibitions, as well as displaying works from the permanent collection. One-person exhibitions have featured such artists as Glenn Goldberg, Max and Joyce Kozloff, Alan Gussow, Mel Chin, Judy Moonelis, Alison Saar, and Varjuan Boghosian. Curated exhibitions include "History, Memory and Representation: Responses to Genocide"; a traveling survey of

Edward Hicks, *Peaceable Kingdom*, Photograph courtesy of List Gallery, Swarthmore College, Swarthmore, Pennsylvania.

works by Leslie Dill; and "The Mystical Arts of Tibet". The months of April and May feature a series of thesis exhibitions by senior art majors. A special exhibition is mounted for Alumni Weekend in June. The college's permanent collection includes works by Edward Hicks, John Steuart Curry, Robert Henri, and Benjamin West.

University Park

Pennsylvania State University - Palmer Museum of Art

The Pennsylvania State University
Curtin Road
University Park, PA 16802-2507

Tel: (814) 865-7672

Fax: (814) 863-8608

Internet Address:
http://www.psu.edu/dept/palmermuseum

Director: Mrs. Jan Keene Muhlert

Admission: free.

Attendance: 54,000 *Established:* 1972

Membership: Y *ADA Compliant:* Y

Parking:
metered on street and commercial lot nearby.

Open: Tuesday to Saturday, 10am-4:30pm;
Sunday, noon-4pm.

Closed: Legal Holidays,
Christmas Day to New Year's Day.

Exterior view of Palmer Museum of Art (1983), designed by Charles W. Moore in association with Arbonies King Vlock. Photograph courtesy of Palmer Museum of Art, State College, Pennsylvania.

Facilities: **Auditorium** (150 seat); **Galleries** (10); **Sculpture Garden; Shop.**

Activities: **Guided Tours; Lectures; Temporary Exhibitions; Traveling Exhibitions.**

Publications: brochures; exhibition catalogues; newsletter (3/year).

The Palmer Museum of Art presents selections from a permanent collection that comprises thirty-five centuries of painting, sculpture, ceramics, and works on paper from the United States, Europe, Asia, and South America. The Museum also maintains a comprehensive schedule of special exhibitions. The permanent collection at the Museum includes antiquities (ancient Greek earthenware pots, Phoenician glass, Roman bronzes), medieval art (Gothic architectural fragments, manuscripts), northern and southern European Renaissance painting, Baroque painting (works by Vanni, Boncori, van Mierevelt, Master Jacomo), nineteenth-century European painting (mostly in the academic manner), Asian art (third century B.C. to nineteenth-century ceramics and sculpture from China, Korea, Japan, and Cambodia), African art (sub-Saharan sculpture, masks, and textiles), American art

Pennsylvania State University - Palmer Museum of Art, cont.

(works by Rembrandt Peale, Stuart, Duveneck, Eakens, Kensett, Richards, Roesen, Frieseke, Marsh, Sloan, Henri, Shinn, Prendergast, Glackens, and others), and contemporary art (examples by Diebenkorn, Bischoff, Goodnough, Delfino, Marisol, deForest, Quick-to-See Smith, and others). There is also a separate gallery devoted to contemporary ceramics.

Villanova

Villanova University Art Gallery

Connelly Center, 800 Lancaster Ave., Villanova, PA 19085
Tel: (610) 519-4612
Fax: (610) 519-6046
Internet Address: http://www.artgallery.villanova.edu
Admission: free.
Attendance: 2,000 *Established:* 1979
ADA Compliant: Y
Parking: free on site.
Open: Monday to Friday, 9am-5pm.
Facilities: **Gallery**.
Activities: **Temporary Exhibitions** (6 per year).

The Gallery presents approximately six changing exhibitions per year, in a variety of media, which have included international exhibitions. The University has a small collection of 20th-century art.

Jay J. Dugan (American 1919-1990), *Cosmos*, marble, 5 x 4 feet, located in Atrium of Connelly Center, Villanova University. Photograph courtesy of Villanova University, Villanova, Pennsylvania.

Washington

Washington and Jefferson College - Olin Fine Arts Gallery

E. Wheeling St., Washington, PA 15301
Tel: (412) 222-4400
Fax: (412) 223-5271
Internet Address: http://www.washjeff.edu
Acting Director: Prof. Hugh Taylor
Admission: free.
Attendance: 5,300 *Established:* 1982 *ADA Compliant:* Y
Parking: public parking adjacent to site.
Open: **Academic Year**, Daily, noon-7pm.
Facilities: **Exhibition Area** (1,925 square feet); **Theatre** (488 seats).
Activities: **Lectures; Student Art Shows; Temporary Exhibitions**.
Publications: exhibition catalogues.

The Olin Art Gallery has specialized lighting and supports for the display of three-dimensional and hanging works. In recent years the gallery has presented works by such nationally and internationally acclaimed artists as Malcolm and Evans Parcell and Nat Youngblood. The gallery is also the home of the W&J National Painting Show. The show contributes directly to the enlargement of college's permanent art collection through purchase awards. A senior art majors show is held each spring.

West Chester

West Chester University - Art Galleries

North Campus, Mitchell Hall, S. Church St. (between Sharpless & Union), West Chester, PA 19383
Tel: (610) 436-2755
Internet Address: http://www.wcupa.edu
Department Chairperson: John Baker

West Chester University - Art Galleries, cont.

Admission: free.

Open: Call for hours.

Facilities: Exhibition Area.

Activities: Temporary Exhibitions.

The galleries present temporary exhibitions of work from all areas of the visual arts, including a senior student art show.

Wilkes-Barre

Wilkes University - Sordoni Art Gallery

150 S. River St., Wilkes-Barre, PA 18766-0001

Tel: (570) 408-4325

Fax: (570) 408-7733

Internet Address: http://www.wilkes.edu

Director: Dr. Stanley I. Grand

Admission: free.

Attendance: 13,000 *Established:* 1973 *Membership:* Y *ADA Compliant:* Y

Parking: free on site.

Open: Daily, noon-4:30pm.

Closed: Legal Holidays.

Facilities: Exhibition Area (1,600 square feet).

Activities: Gallery Talks; Guided Tours; Lectures; Temporary Exhibitions; Traveling Exhibitions.

Publications: exhibition catalogues.

The Sordoni Art Gallery houses a permanent collection featuring 19th- and 20th-century American art and a print collection including work of Old Masters and contemporary artists.. It also mounts temporary exhibitions.

Williamsport

Lycoming College - Art Gallery

John D. Snowden Library, 700 College Place, Williamsport, PA 17701

Tel: (570) 321-4000

Fax: (570) 321-4090

Internet Address: http://www.lycoming.edu/dept/art/gallery/gallery.htm

Chair, Art Dept.: Ms. B. Lynn Estomin

Admission: free.

Attendance: 700 *Established:* 1968 *Membership:* N *ADA Compliant:* Y

Parking: free on site.

Open: Monday to Thursday, 11am-8pm; Friday, 8am-4:30pm; Saturday, 9am-5pm;
 Sunday, 1pm-11pm.

Closed: Academic Holidays.

Facilities: Exhibition Area (30 feet by 40 feet).

Activities: Gallery Talks; Temporary Exhibitions.

The Gallery features five to six temporary exhibitions each year of works by artists of regional or national reputation, as well as a show of the work of senior art majors.

York

York College of Pennsylvania - Art Galleries

Music, Art & Communication Center, 1st Floor (off Country Club Road), York, PA 17405-7199

Tel: (717) 815-1354

Internet Address: http://www.ycp.edu/artgallery

Gallery Coordinator: Ms. Pamela Hemzik

Admission: free.

York College of Pennsylvania - Art Galleries, cont.

ADA Compliant: Y

Parking: free adjacent to site.

Open: **Academic Year**,
 Monday to Tuesday, 10am-4pm; Wednesday, 10am-9pm; Thursday to Friday, 10am-4pm;
 Saturday to Sunday, noon-4pm.

Closed: Academic Holidays.

Facilities: **Galleries** (2).

Activities: **Gallery Talks**; **Guided Tours** (groups by appointment, 815-1402); **Temporary Exhibitions**; **Workshops**.

Comprising two contiguous venues, the Cora Miller Gallery and the Brossman Gallery, the York College Galleries feature a varied program of juried and invitational exhibits, student and faculty shows, and touring exhibitions.

Puerto Rico

The number in parentheses following the city name indicates the number of museums/galleries in that municipality. If there is no number, one is understood. For example, in the text two listings would be found under San Juan and one listing under Ponce.

Puerto Rico

Ponce

Museo de Arte de Ponce

Avenida Las Americas, #25
Ponce, PR 00732
Tel: (787) 848-0505
Fax: (787) 841-7309
Director: Dr. Carmen T. Ruiz-Fischler
Admission: fee:
 adult-$4.00, child-$2.00, student/senior-$1.00.
Attendance: 70,000 *Established:* 1959
Membership: Y
Open: Daily, 10am-5pm.
Facilities: **Architecture** (building designed by
 Edward Durell Stone); **Exhibition Area;**
 Library (non-circulating); **Reading Room;**
 Shop.
Activities: **Concerts; Education Programs**
 (undergraduate college students and chil-
 dren); **Films; Guided Tours; Lectures;**
 Permanent Exhibits; Temporary
 Exhibitions; Traveling Exhibitions.
Publications: books; collection catalogues; exhi-
 bition catalogues.

Frederic Lord Leighton, *Flaming June*, 1895, oil on canvas, 119 x 119 cm. Museo de Arte de Ponce, Luis A. Ferre Foundation, Inc. Photograph by Antonio de Jesus courtesy of Museo de Arte de Ponce, Ponce, Puerto Rico.

The Museum hosts frequent traveling exhibitions. Its permanent collection includes works by most of the important Latin American painters. In addition, there is a large Pre-Raphaelite collection and works by such artists as Murillo, Rubens, Strozzi, Furini, Le Brun, Cranach, West, Delacroix, Campeche, and Pou.

San German

Museum of Religious Art

Ramas Street, San German, PR 00683
Tel: (787) 892-5845
Fax: (787) 892-5845
Administrator: Guido Barletta
Admission: fee-$1.00.
Attendance: 8,500 *Established:* 1951
Membership: N
Parking: adjacent to site.
Open: Wednesday to Sunday, 9am-4:15pm.
Facilities: **Architecture** (17th century chapel);
 Exhibition Area.
Activities: **Concerts; Guided Tours.**
Publications: brochures.

Exterior view of Museum of Religious Art. Photograph courtesy of Museum of Religious Art, San German, Puerto Rico.

Housed in a Spanish Renaissance former chapel and convent dating from 1607, the permanent collection of the Museum includes Puerto Rican religious paintings and sculptures, from the 16th through the 19th centuries.

San Juan

University of Puerto Rico - Museum of Anthropology, History and Art

University of Puerto Rico, San Juan, PR 00931
Tel: (787) 763-3939
Fax: (787) 763-4799
Internet Address: http://www.upr.clu.edu

San Juan, Puerto Rico

University of Puerto Rico - Museum of Anthropology, History and Art, cont.

Curator, Art Collections: Ms. Flavia Marichal
Admission: free.
Attendance: 20,000 *Established:* 1940 *ADA Compliant:* Y
Open: Monday to Friday, 9am-4:30pm; Saturday to Sunday, 9am-3pm.
Closed: Legal Holidays.
Facilities: **Exhibition Area** (4,582 square feet); **Library** (non-circulating).
Activities: **Concerts**; **Guided Tours**; **Permanent Exhibits**; **Temporary Exhibitions**; **Traveling Exhibitions**.
Publications: exhibition catalogues.

The Museum houses a collection of 17th- to 20th-century Puerto Rican paintings, sculpture, prints, and drawings.

University of the Sacred Heart - Museum of Contemporary Art

Universidad del Sagrado Corazón, Edif. Baralt, San Antonio, Santurce, San Juan, PR 00914
Tel: (787) 268-0049
Internet Address: http://www.museocontemporaneopr.org
Exec. Director: Dr. Maria Emilia Somoza
Established: 1984 *Membership:* Y
Open: Monday to Friday, 9am-4pm.
Facilities: **Exhibition Area**.
Activities: **Temporary Exhibitions**.

The Museum features the work of contemporary Puerto Rican artists. Its permanent collection includes contemporary work by artists from Puerto Rico, the Caribbean, Central and South American. Also of possible interest on campus are the Galeria de Arte (728-1515 x2561) and the Galeria José "Pepin" Mendez (728-1515 x2566), which features student work.

Rhode Island

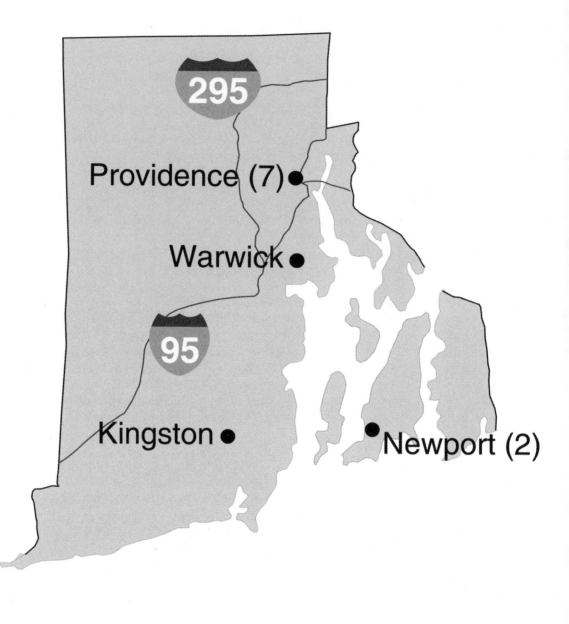

The number in parentheses following the city name indicates the number of museums/galleries in that municipality. If there is no number, one is understood. For example, in the text seven listings would be found under Providence and one listing under Kingston.

Rhode Island

Kingston

University of Rhode Island Fine Arts Center Galleries

105 Upper College Road, Kingston, RI 02881-0820

Tel: (401) 874-2775 or (401) 874-2627

Fax: (401) 874-2729

Internet Address: http://nick.uri.edu/artsci/art/URI_Art_FAC_Galleries.html

Director: Ms. Judith E. Tolnick

Admission: voluntary contribution.

Attendance: 40,000 *Established:* 1968 *ADA Compliant:* Y

Parking: free on site.

Open: **Main Gallery,**
> Tuesday to Friday, noon-4pm & 7:30pm-9:30pm; Saturday to Sunday, 1pm-4pm.

> **Photography Gallery,**
> Tuesday to Friday, noon-4pm; Saturday to Sunday, noon-4pm..

> **Corridor Gallery,**
> Daily, 9am-9pm.

Facilities: **Exhibition Areas** (3; 1,424 square feet); **Library** (21,000 volumes); **Recital Hall** (525 seats); **Theatre** (550 seats).

Activities: **Temporary Exhibitions** (18/year).

Publications: exhibition brochures; catalogues.

The Fine Arts Center Galleries offers temporary exhibitions at three venues: Main Gallery, Photography Gallery, and Corridor Gallery. The Corridor Gallery is reserved for exhibitions of work by faculty of the Department of Art, University of Rhode Island, and regional, invited guests. All exhibitions are curated by the institution from a national palette.

Newport

Newport Art Museum

76 Belleview Ave., Newport, RI 02840

Tel: (401) 848-8200

Fax: (401) 848-8205

Director: Ms. Judith Sobol

Admission: fee: adult-$5.00, student-$4.00, senior-$4.00.

Attendance: 42,000 *Established:* 1912 *Membership:* Y *ADA Compliant:* Y

Parking: free on site.

Open: **September 15 to June**, Tuesday to Saturday, 10am-4pm; Sunday, 1pm-5pm.
July to September 14, Daily, 10am-5pm.

Facilities: **Architecture** (house, designed by Richard Morris Hunt, 1862-64); **Galleries** (6); **Shop.**

Activities: **Lectures**; **Temporary Exhibitions.**

Publications: annual report; collection catalogue; exhibition catalogues; newsletter.

The Museum presents temporary exhibitions of contemporary and historical art focusing on Newport and New England.

Redwood Library and Athenæum (Redwood)

50 Bellevue Ave., Newport, RI 02840-3292

Tel: (401) 847-0292

Fax: (401) 841-5680

Internet Address: http://www.redwood1747.org

C.E.O.: Cheryl V. Helms

Admission: voluntary contribution.

Exterior view of Redwood Library and Athenæum (1750). Statue of George Washington in foreground was copied from Houdon. Photograph by John T. Hopf, courtesy of Redwood Library and Athenæum, Newport, Rhode Island.

Redwood Library and Athenæum, cont.

Established: 1747
Membership: Y *ADA Compliant:* Y
Parking: free on site.
Open: Monday, 9:30am-5:30pm; Tuesday to Thursday, 9:30am-8pm;
 Friday to Saturday, 9:30am-5:30pm; Sunday, 1pm-5pm.
Closed: Legal Holidays.
Facilities: **Architecture** (oldest U.S. library building still in use, 1748-50, Peter Harrison architect);
 Library (155,000 volumes).
Activities: **Guided Tours**; **Permanent Portraiture Exhibition**; **Temporary Exhibitions**.
Publications: annual report; exhibition catalogues; newsletter, "&c.".

Established in 1747 by Abraham Redwood and a group of his friends and associates, Redwood was the first public neo-classical structure erected in the colonies and is the oldest lending library in the country. The Library is open without charge to qualified scholars and researchers and to those making occasional use of the collections. The changing exhibitions, drawn primarily from the Library's collections, are open free to the public. The Library's painting collection consists primarily of 18th- and 19th-century portraits, among them an important group of works by Gilbert Stuart; there is also a small sculpture collection. The Library's decorative arts collection includes outstanding examples of 18th-century Newport furniture by members of the Goddard and Townsend families and a rare William Claggett clock. The Library's present gardens were designed by John Russell Pope in the mid-1930s.

Providence

Brown University - David Winton Bell Gallery

Brown University, List Art Center, 64 College St., Providence, RI 02912
Tel: (401) 863-2932
Fax: (401) 863-1680
Internet Address: http://www.brown.edu/Facilities/David_Winton_Bell_Gallery/Bell.html
Director: Ms. Jo-Ann Conklin
Admission: voluntary contribution.
Attendance: 17,000 *Established:* 1971 *ADA Compliant:* Y
Parking: metered on street.
Open: **September to July**, Monday to Friday, 11am-4pm; Saturday to Sunday, 1pm-4pm.
Closed: New Year's Day, Thanksgiving Day, Christmas Day.
Facilities: **Architecture** (List Art Center, designed by Philip Johnson); **Auditorium** (250 seat);
 Gallery.
Activities: **Films**; **Gallery Talks**; **Lectures**; **Temporary Exhibitions**; **Traveling Exhibitions**.
Publications: calendar; exhibition catalogues.

Located in the List Art Center, the David Winton Bell Gallery presents six exhibitions per year focusing on contemporary art. Recent exhibitions have explored works by Ilya Kabakov, Annette Messager, Jana Sterbak, Sally Mann, and Masami Teraoka among others.

Moses Brown School - Krause Gallery

Moses Brown School, 250 Lloyd Ave., Providence, RI 02906
Tel: (401) 831-7350 *Ext:* 174
Fax: (401) 455-0084
Internet Address: http://www.mosesbrown.org/KRAUSE.HTML
Director: Ms. Kriss Street
Open: **Fall to Spring**, Monday to Friday, 8am-4pm.
Closed: Summer.
Facilities: **Gallery**.
Activities: **Temporary Exhibitions**.

Located in Friends Hall on the campus of Moses Brown School, the Krause Gallery presents temporary exhibitions of the work of professional artists and students.

Providence Art Club Galleries

11 Thomas St., Providence, RI 02903
Tel: (401) 331-5522
Fax: (401) 521-0195
Director: Ms. Regina Scully
Admission: free.
Established: 1880
Membership: Y *ADA Compliant:* N
Parking: small lot.
Open: **Main Gallery**,
 Monday to Friday, 10am-4pm;
 Saturday, noon-3pm;
 Sunday, 3pm-5pm.
 Dodge House Gallery,
 Monday to Friday, 11am-4pm;
 Saturday, noon-3pm;
 Sunday, 3pm-5pm.
Closed: Legal Holidays, 3 weeks in summer.
Facilities: **Architecture** (circa 1790); **Galleries** (2).
Activities: **Temporary Exhibitions** (every two weeks).

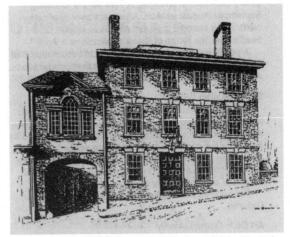

Exterior view of Providence Art Club, formerly the Obadiah Brown House (c. 1790). Rendering courtesy of Providence Art Club, Providence, Rhode Island.

The second oldest art club in the United States (after the Salmagundi Club in New York City), the Providence Art Club presents temporary exhibitions in two small galleries located in historic buildings near Brown University and the Rhode Island School of Design. Members may apply for an exhibition of their work in the Main Gallery, located on the second floor of the Club House, every other season. Main Gallery exhibits are of two or three weeks duration. The Dodge House Gallery mounts exhibitions of the work of member and non-member artists.

Providence College - Hunt/Cavanagh Art Gallery

East Campus, Hunt/Cavanagh Building
549 River Ave., Providence, RI 02918
Tel: (401) 865-1000
Internet Address: http://www.providence.edu/art/gallery1.html
Admission: free.
Open: Call for hours.
Facilities: **Exhibition Area.**
Activities: **Temporary Exhibitions.**

The Gallery presents exhibitions of the work of professional artists, as well as the work of senior students. There is also sculptural work by Thomas McGlynn, O.P., on campus.

Rhode Island Black Heritage Society

202 Washington St., Providence, RI 02903
Tel: (401) 751-3490
Fax: (401) 751-0040
Interim Director: Ms. Joaquina Bela Teixeira
Admission: voluntary contribution.
Established: 1974 *Membership:* Y *ADA Compliant:* Y
Parking: free on site.
Open: Monday to Friday, 10am-5pm; Saturday, 10am-2pm.
Closed: Legal Holidays.
Facilities: **Library** (2,500 volumes); **Reading Room**; **Shop.**
Activities: **Concerts**; **Education Programs** (children); **Films**; **Guided Tours**; **Lectures**;
 Temporary Exhibitions; **Traveling Exhibitions.**
Publications: newsletter, "Rhode Island Black Heritage Society Bulletin" (quarterly).

Rhode Island Black Heritage Society, cont.

The Society focuses on art, culture, and the role that African Americans have had in influencing the history of Rhode Island. The Society's gallery displays artworks and historical artifacts concentrating primarily on the history of Rhode Island.

Rhode Island College - Bannister Gallery

600 Mt. Pleasant Ave., Providence, RI 02908
Tel: (401) 456-9765
Fax: (401) 456-8379
Internet Address: http://www.ric.edu/bannister
Director: Mr. Dennis O'Malley
Admission: free.
Established: 1978
Open: **September to May,**
 Tuesday, 11am-4pm and 6pm-9pm; Wednesday, 11am-4pm;
 Thursday, 11am-4pm and 6pm-9pm; Friday to Saturday, 11am-4pm.
Closed: Holidays.
Facilities: **Exhibition Area** (1,450 square feet).
Activities: **Temporary Exhibitions** (8-10/year).

The Gallery was initially developed as a teaching forum for the department of art, the scope of exhibitions has expanded in recent years to include major shows addressing college and worldwide issues. It mounts eight to ten exhibitions annually and provides a forum for diverse selections of contemporary art. Exhibits range from student and faculty shows to presentations by internationally renowned artists and scholars.

Rhode Island School of Design - Museum of Art (RISD Museum)

224 Benefit St., Providence, RI 02903-2723
Tel: (401) 454-6500
Fax: (401) 454-6556
TDDY: (800) 745-5555
Internet Address: http://www.risd.edu/museum
Director: Mr. Phillip Johnston
Admission: fee:
 adult-$5.00, child-$1.00, student-$2.00, senior-$4.00.
Attendance: 95,000 *Established:* 1877
Membership: Y *ADA Compliant:* Y
Parking: commercial lot at N. Main and Steeple Sts..
Open: Tuesday to Sunday, 10am-5pm;
 Third Thursday in month, 10am-9pm.
Closed: New Year's Day, Easter, Independence Day,
 Thanksgiving Day, Christmas Day.
Facilities: **Exhibition Area**; **Sculpture Garden**; **Shop**.
Activities: **Concerts**; **Education Programs** (adults, college students and children); **Guided Tours**; **Lectures**; **Readings**; **Temporary Exhibitions**; **Traveling Exhibitions**.
Publications: calendar (bi-monthly); exhibition catalogues.

Edouard Manet, *Le Repos*, c. 1870. Rhode Island School of Design Museum. Photograph courtesy of Rhode Island School of Design Museum, Providence, Rhode Island.

With more than 88,000 works of art ("some of the finest examples of their kind from every part of the world"), RISD Museum is Rhode Island's leading museum of fine and decorative arts. The collection is displayed in 45 galleries on three floors. The history of Western art from antiquity to the 20th century fills the main floor. Galleries housing Greek and Roman antiquities lead to the Medieval gallery. A sequence of European galleries with painting, sculpture, and decorative arts ranging from the Renaissance to the 20th century follows. Highlights include works by Cézanne, Corot, Degas, Delacroix, Manet, Matisse, Monet, Poussin, Renoir, Rodin, and Tiepolo. Braque, Matisse, and Picassoare but a few of the 20th-century European painters in the collection. Pendleton House showcases American furniture, silver and decorative arts in period rooms, as well as paintings by American

Rhode Island School of Design - Museum of Art, cont.

masters, such as Chase, Cassatt, Copley, Stuart, Cole, Homer and Sargent. Significant works by Franz Kline, Hans Hoffman, Neel, Nevelson, O'Keeffe, Pollock, Rothko, and Twombly represent the achievements of 20th century American art. The Museum's Egyptian gallery is located on the upper floor, along with galleries devoted to the art of Africa, pre-Columbian cultures of Central and South America, India, Iran, China, and Japan. A nine-foot wooden Buddha from a medieval temple west of Kyoto occupies one gallery; extensive, rotating collections of Asian textiles and Japanese prints are also on view. Special exhibitions are presented on the Museum's lower floor, where selections from the more than 20,000 prints, drawings, and photographs are often featured. Exhibitions focusing on particular themes or periods, including contemporary crafts, complete the annual schedule. Handicapped access is available through the ramp entrance of the Farago Wing.

Warwick

Warwick Museum of Art, Inc. (WMA)

Kentish Artillery Armory, 3259 Post Road, Warwick, RI 02886

Tel: (401) 737-0010

Fax: (401) 737-0087

Administrator: Ms. Joan V. Spranger

Admission: suggested contribution-$3.00.

Attendance: 8,000 *Established:* 1974 *Membership:* Y *ADA Compliant:* Y

Parking: on street and lot in rear of building.

Open: Wednesday, 4pm-8pm; Thursday to Friday, noon-4pm.
During Exhibits, Saturday to Sunday, 1pm-3pm.

Closed: Memorial Day, Labor Day, Rosh Hashanah, Thanksgiving Day, Christmas Week to New Year's Day.

Facilities: **Architecture** (armory, 1912); **Gallery; Shop; Studio Classrooms.**

Activities: **Education Programs** (adults and children); **Films; Guided Tours; Lectures; Musical Performances; Temporary Exhibitions; Traveling Exhibitions.**

Publications: exhibition catalogues; newsletter.

Founded in 1976 as a Bicentennial Project, Warwick Museum of Art has evolved into a flourishing center for the arts. The Museum presents fine arts exhibitions and provides educational programming, including studio art classes.

South Carolina

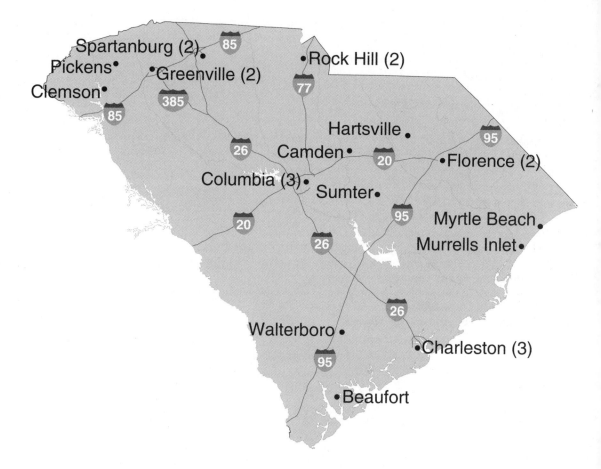

The number in parentheses following the city name indicates the number of museums/galleries in that municipality. If there is no number, one is understood. For example, in the text three listings would be found under Columbia and one listing under Sumter.

South Carolina

Beaufort

University of South Carolina-Beaufort - Gallery at the Performing Arts Center

(USCB Art Gallery)

801 Carteret St., Beaufort, SC 29902
Tel: (803) 521-4144
Internet Address: http://vm.sc.edu/~beaulib/gallery.html
Admission: voluntary contribution.
Established: 1992
Parking: free on site.
Open: Monday to Friday, 9am-5pm.
Facilities: **Gallery** (2 rooms).
Activities: **Gallery Talks**; **Guided Tours**; **Temporary Exhibitions**.
Publications: magazine, "Arts Council Art News" (bi-monthly).

The Art Gallery mounts temporary exhibitions of the work of USCB students and professional artists. It also serves as the venue for exhibitions organized by the Arts Council of Beaufort County, the Beaufort Art Association, and Taste of the Arts.

Exterior view of University of South Carolina-Beaufort Performing Arts Center, site of the Art Gallery. Photograph courtesy of University of South Carolina-Beaufort Art Gallery, Beaufort, South Carolina.

Camden

Fine Arts Center of Kershaw County - Bassett Gallery

810 Lyttleton St., Camden, SC 29020
Tel: (803) 425-7676
Fax: (803) 425-7679
Exec. Director: Ms. Susan F. Harper
Admission: free.
Attendance: 50,000 *Established:* 1976 *Membership:* Y *ADA Compliant:* Y
Open: Monday to Friday, 9am-5pm.
Closed: Easter, Memorial Day, Independence Day, Labor Day, Thanksgiving Day,
 Christmas Eve to Christmas Day.
Facilities: **Gallery**.
Activities: **Temporary Exhibitions**.
Publications: newsletter (monthly).

The Center presents temporary exhibitions in the Bassett Gallery and has a permanent collection of bronzes and sculpture.

Charleston

City Hall Council Chamber Gallery

Broad and Meeting Sts., Charleston, SC 29401
Tel: (803) 724-3799
Fax: (803) 720-3827
Curator: Ms. Carol Ezell-Gilson
Admission: free.
Attendance: 22,000 *Established:* 1818 *ADA Compliant:* Y
Parking: metered parking and nearby garage.
Open: Monday to Friday, 9am-5pm.
Closed: Legal Holidays.
Facilities: **Architecture** (former First Bank of the US building, 1801); **Gallery**; **Library**.
Activities: **Guided Tours** (advance reservation required).
Publications: collection catalogue.

City Hall Council Chamber Gallery, cont.

Designed by Gabriel Manigault as a branch of the First Bank of the United States in 1801 and the seat of municipal government since 1818, City Hall houses the second oldest council chamber in continual use in the United States. The Chamber also serves as an art gallery in which are displayed original oil portraits of figures important to state and national history, including portraits of four United States Presidents. The figures exhibited have a particular association with Charleston, beginning in the pre-Revolutionary era and continuing through the War of Independence, the Antebellum period, the Civil War, Reconstruction era, and the Civil- Rights movement.

City Hall Council Chamber Gallery. Photograph courtesy of City Hall Council Chamber Gallery, Charleston, South Carolina.

College of Charleston - Halsey Gallery

College of Charleston, School of the Arts, Simons Center for the Arts, St. Philip St. Charleston, SC 29424

Tel: (803) 953-5680

Fax: (803) 953-8212

Internet Address: http://www.cofc.edu

Director: Mr. Mark Sloan

Admission: free.

Attendance: 5,000 *Established:* 1978 *Membership:* Y *ADA Compliant:* Y

Open: **September to June**, Monday to Saturday, 11am-4pm.

Facilities: **Auditorium** (125 seat).

Activities: **Education Programs** (undergraduate students); **Gallery Talks**; **Guided Tours**.

Publications: exhibition catalogues.

Located on the first and second floors of the Simons Center for the Arts, the Gallery offers a schedule of temporary exhibitions.

Gibbes Museum of Art

135 Meeting St., Charleston, SC 29401-2297

Tel: (843) 722-2706

Fax: (843) 720-1682

Internet Address: http://www.gibbes.com

Director: Mr. Paul C. Figueroa

Admission: fee: adult-$6.00, child-$3.00, student-$5.00, senior-$3.00, military-$5.00.

Attendance: 50,000 *Established:* 1858 *Membership:* Y *ADA Compliant:* Y

Parking: adjacent municipal parking.

Open: Tuesday to Saturday, 10am-5pm; Sunday, 1pm-5pm.

Facilities: **Galleries**; **Library**; **Shop**.

Activities: **Education Programs** (adults and children); **Films**; **Guided Tours**; **Lectures**; **Temporary Exhibitions**.

Publications: collection catalogue; exhibition catalogues.

The Gibbes Museum of Art presents exhibits drawn from its permanent collection. Throughout the year, special exhibitions in the Alice Smith, Garden, and Balcony galleries afford viewers an opportunity to see a variety of original art forms. These exhibitions include works by artists of regional, national, international stature, and explore contemporary as well as traditional themes in painting sculpture, and other media. The Museum also offers an extensive schedule of adult and children's classes. The permanent collection holds over 10,000 American paintings, prints, and drawings from the 18th century to the present. Also of note are the Japanese print collection of approximately 700 ukiyo-e wood-block prints of the 18th to the19th century, the Elizabeth Wallace Miniature Rooms, and the Miniature Portrait Collection containing 500 pieces ranging from the earliest miniatures produced in Charleston in 1740 to works by 20th-century artists.

Clemson

Clemson University - Rudolph E. Lee Gallery

Arts and Humanities, Lee Hall, Fernow St., Clemson, SC 29634

Tel: (864) 656-3881

Fax: (864) 656-0204

Internet Address: http://hubcap.clemson.edu/aah/arch/leegall.html

Director: Mr. David Houston

Admission: free.

Established: 1956

Open: Monday to Friday, 9am-4:30pm.

Closed: Legal Holidays.

Facilities: **Exhibition Area** (2,400 square feet).

Activities: **Temporary Exhibitions**.

Publications: "Clemson National Print and Drawing Catalogue"; posters.

The full-time director and staff of the Lee Gallery organize regional, national, and international exhibitions, including the Clemson National Print and Drawing Exhibition. In addition, the Art Department has a small gallery space operated by the students for flexible short-term exhibitions and experimental works.

Columbia

Columbia Museum of Art

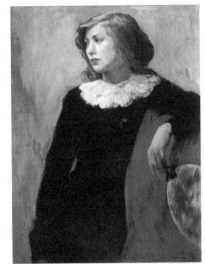

Corner of Main and Hampton Sts., Columbia, SC 29201

Tel: (803) 799-2810

Fax: (803) 343-2150

Internet Address: http://www.colmusart.org

Director and C.E.O.: Mr. Salvatore G. Cilella, Jr.

Admission: fee: adult-$4.00, student-$2.00, senior-$2.00.

Attendance: 100,000 *Established:* 1950

Membership: Y *ADA Compliant:* Y

Parking: available.

Open: Tuesday, 10am-5pm;
Wednesday, 10am-9pm;
Thursday to Saturday, 10am-5pm;
Sunday, 1pm-5pm.

Closed: New Year's Day, Memorial Day, Independence Day,
Labor Day, Thanksgiving Day, Christmas Day.

Hattie Saussy, *Portrait of a Young Woman with Fan.* Columbia Museum of Art. Photograph courtesy of Columbia Museum of Art, Columbia, SC.

Facilities: **Architecture** (Thomas Taylor Mansion, 1908); **Auditorium** (100 seat); **Children's Gallery**; **Library** (12,000 volumes); **Shop**.

Activities: **Concerts** (classical); **Films**; **Gallery Talks**; **Guided Tours** (available to groups 15+, reserve 2 weeks in advance); **Lecture Series**.

Publications: "Renaissance Art"; "Southern Art"; exhibition catalogues; newsletter, "Collections".

Permanent collections and changing exhibitions at the Columbia Museum of Art appeal to a variety of artistic, historic and social interests. Exhibitions from the Museum's diverse collection of European and American paintings, sculpture, prints, drawings, and decorative arts provide visitors with a range of works from ancient times to the present. During the year, 15 to 20 temporary exhibitions can be seen on a rotating basis in several galleries. A variety of important changing exhibitions, events and public programs are offered throughout the year. The Museum's permanent collection consists of American and European fine and decorative art dating from the 15th century to the present. Samuel H. Kress, founder of the S.H. Kress dime stores, created a world-renowned collection of Baroque and Renaissance art which he later dispersed to museums and universities across the country. Through the generosity of the Kress Foundation and additional private gifts, the Columbia Museum of Art is the home of an extensive collection of Baroque and Renaissance paintings, sculpture and furniture.

Columbia, South Carolina

South Carolina State Museum

301 Gervais St., Columbia, SC 29201-3107
Tel: (803) 737-4595
Fax: (803) 737-4969
Internet Address:
 http://www.museum.state.sc.us
Exec. Director: Dr. Overton G. Ganong
Admission: fee: adult-$4.00, child-$1.50,
 student-$3.00, senior-$3.00.
Attendance: 220,000 *Established:* 1973
Membership: Y *ADA Compliant:* Y
Parking: free on site.
Open: Monday to Saturday, 10am-5pm;
 Sunday, 1pm-5pm.
 New Year's Day, 1pm-5pm.
Closed: Easter, Thanksgiving Day,
 Christmas Day.

Lipscomb Art Gallery in South Carolina State Museum. Photograph courtesy of South Carolina State Museum, Columbia, South Carolina.

Facilities: **Architecture** (former Columbia Cotton Mill building, 1894); **Auditorium** (236 seats); **Exhibition Area** (4 floors); **Shop** Cotton Mill Exchange.
Activities: **Films**; **Guided Tours** (available for groups 10+, reserve in advance (803) 737-4999); **Lectures**; **Temporary Exhibitions** (15/year); **Traveling Exhibitions**.
Publications: brochures; bulletin; newsletter, "Images".

A general museum, the South Carolina State Museum focuses on art, history, natural history, science, and technology. The Lipscomb Art Gallery on the first floor offers a variety of temporary exhibits selected to demonstrate the diversity of art in modern, and historic, South Carolina.

University of South Carolina - McKissick Museum

Pendleton and Bull Sts., Columbia, SC 29208
Tel: (803) 777-7251
Fax: (803) 777-2829
Internet Address: http://www.cla.sc.edu/MCKS/index.html
Exec. Director: Lynn Robertson
Admission: free.
Attendance: 150,000 *Established:* 1976
Membership: Y *ADA Compliant:* Y
Parking: parking garage and on street.
Open: Monday to Friday, 9am-4pm;
 Saturday to Sunday, 1pm-5pm.
Closed: Independence Day, Labor Day, Thanksgiving Day,
 Christmas Day to New Year's Day.
Facilities: **Exhibition Area**; **Library**.
Activities: **Concerts**; **Demonstrations**; **Guided Tours**; **Lectures**; **Temporary Exhibitions**; **Traveling Exhibitions**.
Publications: brochures; exhibition catalogues; gallery guides; magazine.

Exterior view of McKissick Museum. Photograph courtesy of McKissick Museum, University of South Carolina, Columbia, South Carolina.

Located in the historic part of the University of South Carolina campus in the center of downtown Columbia, the McKissick boasts two floors of galleries featuring national and local exhibitions devoted to art ranging from centuries-old cultural traditions to modern art forms. Permanent exhibitions include decorative arts and extensive natural science collections. The McKissick has received national recognition for its work in documenting and presenting the multicultural heritage of the Southeast. Exhibitions and public programs feature items from its permanent collection including Native and African American artifacts, traditional pottery, baskets,

Columbia Museum of Art, cont.

and quilts, and also draw on the resources of artists and communities throughout the region. The Museum is devoted to the University's educational mission and promotes it through a variety of workshops, classes, lectures, films, and travel programs throughout the year. In addition, the Museum frequently publishes catalogs, posters, and other materials.

Florence

Florence Museum of Art, Science and History

558 Spruce St., Florence, SC 29501

Tel: (843) 662-3351

Director: Betsy Olsen

Admission: voluntary contribution.

Attendance: 17,000 *Established:* 1924

Membership: Y *ADA Compliant:* N

Open: Tuesday to Saturday, 10am-5pm; Sunday, 2pm-5pm.

Closed: New Year's Day, Easter Sunday, Independence Day,
 Thanksgiving, Christmas Day.

Facilities: **Exhibition Area**; **Library** (not open to the public).

Activities: **Art Openings**; **Arts Festival,** Fall Festival (1st Sunday in October); **Gallery Talks**; **Lectures**; **Oyster Roast** (annual);**Workshops** (adult and children).

Publications: "Express" (quarterly).

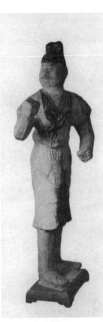

Chinese Boxer, ceramic, T'ang Dynasty. Florence Museum collection. Photograph courtesy of Florence Museum, Florence, South Carolina.

The Florence Museum was established to promote the arts and sciences; to collect, to preserve, and to exhibit objects of historic, artistic, and scientific interest. In 1953 it moved to its present location, an art deco style building, built as a private home in 1939 and surrounded by the grounds of Timrod Park. The Museum's collection has grown to include a large number of Asian pieces representing almost every Chinese dynasty. Items of historic interest to the Pee Dee area are featured in the History Hall. African artifacts, Greek and Roman archeology pieces, and American art round out the collection. The museum presents changing exhibits, from regional art competitions to local history, including three annual juried competitions. Public programs include exhibit openings, art and craft workshops for both adults and children, and a lecture series.

Francis Marion University - Art Galleries

Hyman Fine Arts Center and Smith University Center, Route 301 North, Florence, SC 29501-0012

Tel: (843) 661-1385

Internet Address:
 http://alpha1.fmarion.edu/famc/gallery.htm

Admission: free.

Established: 1971

Parking: free on site.

Open: **September to April**,
 Monday to Friday, 8:30am-6pm.

Closed: Academic Holidays.

Facilities: **Architecture** Hyman Fine Arts Center (Post-Modern building, 1980 designed by Boston firm of Perry, Dean, Stahl & Rogers); **Galleries** (3).

Activities: **Temporary Exhibitions** (monthly).

Interior view, Hyman Fine Arts Center Gallery. Photograph courtesy of Francis Marion University, Florence, South Carolina.

Art galleries may be found in both the Hyman Fine Arts Center and the Smith University Center. The Fine Arts Center Gallery and the lobby adjacent to the theater and recital hall display both two and three-dimensional works, while

719

Francis Marion University - Art Galleries, cont.

the University Center Gallery, located in the main commons area, is best suited for the display of large two-dimensional work. Senior shows are required of all art majors. Additionally, at the end of each semester, the galleries display student work produced in studio art classes. Exhibitions of work by regional artists are selected to fill out the schedule in order to have two- and three-dimensional shows changing monthly throughout the academic year. Whenever possible, gallery openings are timed to coincide with First Tuesday Arts Event concerts, a series of chamber music recitals.

Greenville

Bob Jones University Museum & Gallery, Inc.

1700 Wade Hampton Blvd., Greenville, SC 29614-0001
Tel: (864) 242-5100 *Ext:* 1050
Fax: (864) 233-9829
Internet Address: http://www.bju.edu/art_gallery
Director: Mrs. Erin Jones
Admission: fee:
 adult-$5.00, children (6-12)-free, student-$3.00, senior-$4.00.
Attendance: 22,000 *Established:* 1951
Parking: adjacent to site.
Open: Tuesday to Sunday, 2pm-5pm.
Closed: New Year's Day, Commencement Day, Independence Day,
 December 20 to Christmas.
Facilities: **Galleries** (27); **Shop**.
Activities: **Education Programs** (elementary to adult); **Guided
 Tours** (Nov-Apr, Tues-Fri, 1pm; groups 10-50, by reservation only,
 contact Events Coordinator)).
Publications: collection catalogue, "Bob Jones University Collection of
 Religious Art: Italian Paintings, Furniture in Bob Jones
 University".

The Museum displays European sacred art from the 13th through the 19th centuries, including important works of many major artists such as Botticelli, Cranach, Gerard David, della Robbia, Doré, Honthorst, Murillo, Sebastiano del Piombo, Rembrandt, Ribera, Rubens, Tintoretto, Titian, van Dyck, and Veronese. Also worthy of note are the Museum's collections of Russian icons and European furniture.

Cranach (1472-1553), *Salome with Head of John the Baptist*, Bob Jones University Art Collection. Photograph courtesy of Bob Jones University Museum and Gallery, Inc., Bob Jones University, Greenville, South Carolina.

Greenville County Museum of Art

420 College St., Heritage Green (corner of Academy &
College Sts.), Greenville, SC 29601
Tel: (864) 271-7570
Fax: (864) 271-7579
Director: Mr. Thomas W. Styron
Admission: free.
Attendance: 100,000 *Established:* 1963
Membership: Y *ADA Compliant:* Y
Parking: metered lot behind building.
Open: Tuesday to Saturday, 10am-5pm; Sunday, 1pm-5pm.
Closed: Legal Holidays.
Facilities: **Exhibition Area** (4 floors); **Shop** (handmade
 crafts, jewelry, books, toys); **Theatre** (150 seat).
Activities: **Education Programs** (adults, students and chil-
 dren); **Films**; **Gallery Talks**; **Guided Tours**; **Lectures**;
 Temporary Exhibitions; **Traveling Exhibitions**.

Helen Turner, *Girl with Lantern*, 1904, 44" x 34". Collection of Greenville County Museum of Art. Photograph courtesy of Greenville County Museum of Art, Greenville, South Carolina.

Greenville County Museum of Art, cont.

Publications: brochures; collection catalogue, "Greenville County Museum of Art: The Southern Collection"; exhibition catalogues; newsletter (quarterly).

Housed in a modern, reinforced concrete structure built in 1974, the Museum has four floors of exhibition space, an art school, gift shop, and a theater. The Museum's Southern Collection, which has brought the Museum national recognition, traces the history of American art from the colonial period to the present through works of art that relate to the South. From a 1726 pastel by Henrietta Johnston, the first professional woman artist in America, to a recent work by South Carolina's own Jasper Johns, the collection includes an example from every major movement in American art. The Museum also has a growing collection of 20th century American art, the Contemporary Collection, including works by such masters as Georgia O'Keeffe, Hans Hofmann, Josef Albers and Andy Warhol. The Museum has also recently acquired 23 paintings by Andrew Wyeth. Selections from the Southern Collection and the Contemporary Collection are always on view. The Museum's collections are complemented by 12-15 changing exhibitions each year. Some exhibitions focus on an important artist or period in art history, while others feature the work of the most original contemporary artists. The Museum School of Art operates year round, offering credit and non-credit courses for adults and children.

Hartsville

Coker College - Cecilia Coker Bell Gallery

Coker College, Gladys Coker Fort Art Bldg. (corner of Home Ave. & Campus Drive)
Hartsville, SC 29550
Tel: (803) 383-8152
Fax: (803) 383-8048
Internet Address: http://www.coker.edu/gallery/index.html
Exhibition Director: Mr. Larry Merriman
Admission: free.
Attendance: 4,000 *Established:* 1983 *ADA Compliant:* Y
Open: **September to mid-May**, Monday to Friday, 10am-4pm.
Closed: New Year's Day, Easter, Labor Day, Thanksgiving Day, Christmas Day.
Facilities: **Exhibition Area** (750 square feet).
Activities: **Guided Tours.**

Coker College uses the Cecelia Coker Bell Gallery to broaden its students' exposure to artists with regional, national, and international reputations. Presenting four to five one-person shows each year, the exhibition review committee selects thought-provoking works of art by artists who desire exposure in an academic setting. The focus is on the educational value provided to students, faculty, and the Coker college community. There are also annual shows of student and faculty work.

Murrells Inlet

Brookgreen Gardens

1931 Brookgreen Gardens Drive
(US 17 between Murrells Inlet & Pawleys Island)
Murrells Inlet, SC 29576
Tel: (843) 235-6000
Fax: (843) 237-1014
President and C.E.O.: Mr. Lawrence Henry
Admission: fee: adult-$8.50, child-$4.00.
Attendance: 185,000 *Established:* 1931
Membership: Y *ADA Compliant:* Y
Parking: free on site.
Open: Daily, 9:30am-4:45pm;
 Also Special Evening Hours in summer.
Closed: Christmas Day.

Anna Hyatt Huntington, *Youth Taming the Wild*, 1927, limestone. Brookside Gardens collection. Photograph courtesy of Brookside Gardens, Murrells Inlet, South Carolina.

Brookgreen Gardens, cont.

Facilities: **Architecture** (former plantation); **Botanical Garden**; **Food Services** Terrace Café; **Galleries**; **Sculpture Garden & Court**; **Shop** (books, garden items, sculpture, educational toys); **Wildlife Park**.

Activities: **Guided Tours**; **Temporary Exhibitions**; **Wildlife Park Programs**.

Publications: "Brookgreen Journal" (semi-annual); collection catalogue; newsletter, "Garden Path" (semi-annual).

Created in the 1930's on the site of an abandoned 18th-century rice plantation by sculptor Anna Hyatt Huntington and her husband, Archer Huntington, Brookgreen Gardens has introduced visitors from around the world to a showcase of sculpture and nature. Set on a 300 acre parcel in the heart of a 9,100-acre preserve that stretches from the Atlantic Ocean to the historic rice fields of the Waccamaw River, Brookgreen Gardens is home to more than 550 works of American sculpture, 2,000 species and subspecies of native plants, and a six-exhibit wildlife park. In addition to monumental sculptures, the collection includes a number of smaller works, many of them housed in the Brown Sculpture Court. Brookgreen Gardens was the first public sculpture garden built in the United States and is a National Historic Landmark. Brookgreen's permanent collection of American representational sculpture includes 560 works by 240 artists including Charles Parks, Daniel Chester French, Carl Milles, Augustus Saint-Gaudens, and Anna Hyatt Huntington.

Myrtle Beach

Franklin G. Burroughs-Simeon B. Chapin Art Museum

3100 S. Ocean Blvd., Myrtle Beach, SC 29577
Tel: (803) 238-2510
Fax: (803) 238-2910
General Manager: Ms. Anne Mullen
Admission: fee:
 adult-$4.00, student-$3.00, senior-$4.00.
Established: 1997
Membership: Y *ADA Compliant:* Y
Parking: free on site.
Open: Tuesday to Saturday, 10am-4pm;
 Sunday, 1pm-4pm.
Closed: Holidays, call for schedule.
Facilities: **Galleries** (11); **Lecture Room**; **Library**; **Shop**.

View of Burroughs-Chapin Art Museum at Springmaid Beach. Photograph courtesy of Franklin G. Burroughs-Simeon B. Chapin Art Museum, Myrtle Beach, SC.

Activities: **Education Programs** (adults and children); **Guided Tours**; **Lectures/Workshops**; **Temporary Exhibitions**.

Publications: newsletter, "Villa Voice" (bi-monthly).

A visual arts museum on the Grand Strand, the Museum presents permanent and rotating exhibits.

Pickens

Pickens County Museum

307 Johnson St., Pickens, SC 29671
Tel: (864) 898-5963
Fax: (864) 898-5947
Exec. Director: Mr. C. Allen Coleman
Admission: free.
Attendance: 17,000 *Established:* 1976
Membership: Y *ADA Compliant:* Y
Parking: parking for 60 cars.
Open: Tuesday, 8:30am-8:30pm;
 Wednesday to Friday, 8:30am-5pm;
 Saturday, noon-4pm.

Pickens Museum, formerly the County Gaol (1902). Rendering courtesy of Pickens County Museum, Pickens, SC.

Pickens County Museum, cont.

Facilities: **Architecture** (former jail building, 1902); **Galleries** (4; total 5,000 square feet); **Shop** (local arts and crafts).

Activities: **Concerts**; **Education Programs** (adults and children); **Films**; **Gallery Talks**; **Guided Tours** (by appointment); **Heritage Day Festival** (annual); **Lectures**; **Performances**; **Temporary Exhibitions** (every 6-8 weeks); **Visual Arts Competition and Exhibition** (annual, South Carolina artists).

Publications: newsletter, "The Old Gaol Gazette" (quarterly).

The Pickens County Museum, devoted to art and history, was built in 1902 to serve as the county jail. The distinctive building, built from hand-rolled brick and complete with crenellated turret, is on the National Register of Historic Places. The Museum's Permanent Heritage Collections, housed in the first floor galleries, are representations of the significant periods of transition within the region. In addition, there are displays on Pickens County natives, Revolutionary War General Andrew Pickens and John C. Calhoun. The upstairs galleries feature changing temporary exhibitions of visual art as well as history. The Museum also operates a water-powered, fully restored gristmill, the Historic Hagood Mill.

Rock Hill

Museum of York County (MYCO)

4621 Mount Gallant Road, Rock Hill, SC 29732-9905

Tel: (803) 329-2121

Fax: (803) 329-5249

Internet Address: http://www.yorkcounty.org

Director: Mr. Van Shields

Admission: fee: adult-$4.00, student-$3.00, senior-$3.00.

Attendance: 45,000 *Membership:* Y *ADA Compliant:* Y

Open: Monday to Saturday, 10am-5pm; Sunday, 1pm-5pm.

Facilities: **Amphitheater**; **Auditorium**; **Galleries**; **Picnic Area**; **Planetarium**; **Shop** (Catawba Indian pottery, local crafts, educational toys).

Activities: **Arts Festival**; **Education Programs** (adults, undergraduate college students, and children); **Films**; **Gallery Talks**; **Guided Tours**; **Lectures**; **Permanent Exhibits**; **Temporary Exhibitions**; **Traveling Exhibitions**.

A general museum, the MYCO's collections reflect the arts, culture, history, and natural sciences of Africa and the York County region. Science, art, and history are displayed in the Alternative Gallery; contemporary art in the Springs Gallery; and Carolina artists in the Local Accents Gallery. Examples of the work of illustrator Vernon Grant occupy a gallery of their own. The permanent collection contains approximately 500 artworks, mostly Vernon Grant works on loan. The art collection focuses on works created in or dealing with the York County region, and contemporary sub-Saharan African art.

Winthrop University - Winthrop Galleries

College of the Visual and Performing Arts, 133 McLaurin, Rock Hill, SC 29733

Tel: (803) 323-2323

Internet Address: http://www.winthrop.edu/wingall.html

Established: 1998

Open: Call for hours.

Facilities: **Galleries** (3).

Activities: **Temporary Exhibitions** (9/year).

The Winthrop Galleries offer nine challenging professional exhibitions of work by established artists and designers throughout the year. Student work is featured in the Edmund D. Lewandowski Gallery, one of three exhibition spaces, located on the first floor of McLaurin.

Spartanburg

Converse College - Milliken Gallery

580 E. Main St., Spartanburg, SC 29302
Tel: (864) 596-9181
Internet Address: http://www.converse.edu
Director: Mayo Mac Boggs
Admission: free.
Attendance: 1,700 *Established:* 1971 *ADA Compliant:* Y
Open: September to May, Monday to Friday, 11am-4pm.
Closed: New Year's Day, Thanksgiving Day, Christmas Day.
Facilities: Gallery.
Activities: Temporary Exhibitions.

The Gallery presents temporary exhibitions in a variety of disciplines showcasing the work of regionally, nationally, and internationally recognized artists as well as an annual faculty art exhibition, juried student show, and senior BA/BFA shows.

Spartanburg County Museum of Art

385 S. Spring St., Spartanburg, SC 29306
Tel: (803) 582-7616
Fax: (803) 948-5353
TDDY: (803) 583-2776
Exhibition Coordinator: Ms. Theresa Mann
Admission: voluntary contribution.
Attendance: 25,000 *Established:* 1969
Membership: Y *ADA Compliant:* Y
Parking: adjacent to building.
Open: Monday to Friday, 9am-5pm;
Saturday, 10am-2pm;
Sunday, 2pm-5pm.
Closed: New Year's Day, Easter Monday, Memorial Day,
Independence Day, Labor Day, Thanksgiving Day,
Christmas Eve to Christmas Day.
Facilities: Arts Center (46,000 square feet); Exhibition
Area (apart from museum); Shop (original art, local and
regional pottery, jewelry, crafts).
Activities: Arts Festival (sidewalk art show, annual);
Films; Guided Tours; Lectures; Traveling
Exhibitions.
Publications: brochures; calendar, "Art Calendar"
(quarterly).

Robert Henri, *The Girl with Red Hair*, 1902, oil on canvas, 31¼ x 25½ inches. Spartanburg County Museum of Art. Photograph courtesy of Spartanburg County Museum of Art, Spartanburg, South Carolina.

The Museum features visual arts exhibitions in the Ernest Burwell, Nita Milliken and Vera Davis Parsons Galleries of the work of international, national, and regional artists. Exhibitions premier with receptions, and visiting artists often present gallery talks and/or lectures. The Museum's Art School is a program for studio and on-location art instruction offering a wide range of classes and workshops throughout the year. "The Girl with Red Hair" by Robert Henri is the centerpiece of the collection, which also includes several works by Southern artist Margaret Law and an extensive collection of works by upstate South Carolina artists.

Sumter

Sumter Gallery of Art

421 N. Main St., Sumter, SC 29150
Tel: (803) 775-0543
Fax: (803) 778-2787
Exec. Director: Ms. Priscilla Haile

724

Sumter Gallery of Art, cont.

Admission: free.
Attendance: 14,000 **Established:** 1970
Membership: Y **ADA Compliant:** Y
Open: **August to June**,
 Tuesday to Friday, noon-5pm;
 Saturday to Sunday, 2pm-5pm.
 July, by appointment.
Closed: Easter, Thanksgiving Day,
 Christmas Day.
Facilities: **Architecture** (Greek Revival home
 and studio of Elizabeth White); **Galleries** (2);
 Shop (work of regional artists).
Activities: **Education Programs** (adults and
 children); **Gallery Talks**; **Receptions** ("Meet
 the Artist", 1st Friday in month, 5pm-7pm).

Exterior view of Sumter Gallery of Art. Photograph courtesy of Sumter Gallery of Art, Sumter, South Carolina.

Publications: brochures; gallery guides (monthly); newsletter (quarterly).

From August through June two exhibiting galleries present changing exhibits of the most current local, regional and national examples on the visual arts scene. The Gallery's foyer exhibits feature works from the permanent Elizabeth White collection as well as works of amateur and student artists and/or works of timely interest. Annually, the Gallery hosts the NBSC Oil Painters' Open Invitational, a juried exhibition open to South Carolina artists, which tours statewide under the auspices of the South Carolina State Museum. Art classes and workshops are taught throughout the year. The Sumter Gallery of Art is located in the former home of artist Elizabeth White. The Greek Revival cottage, built in the 1850s, is listed on the National Register of Historic Places. The Gallery houses a permanent collection of Elizabeth White works and touchable art for blind and visually impaired audiences.

Walterboro

South Carolina Artisans Center

334 Wichman St., Walterboro, SC 29488
Tel: (803) 549-0011
Fax: (803) 549-7734
Exec. Director: Mrs. Denise P. Simmons
Admission: free.
Attendance: 26,500 **Established:** 1994
Membership: Y **ADA Compliant:** Y
Parking: parking available behind facility.
Open: Monday to Saturday, 9am-6pm;
 Sunday, 1pm-6pm.

Exterior view of South Carolina Artisans Center. Rendering courtesy of South Carolina Artisans Center, Walterboro, South Carolina.

Closed: New Year's Day, Easter, Independence Day, Thanksgiving Day, Christmas Day.
Facilities: **Exhibition Area** (2,500 square feet in center, additional 2,500 separate); **Shop** (hand-crafts).
Activities: **Arts Festival**; **Demonstrations**; **Education Programs** (adults and children); **Guided Tours**.
Publications: newsletter, "Hands On" (monthly).

Housed in an eight room Victorian cottage, the Center, a non-profit entity, provides a showcase and market for juried South Carolina artisans. Emphasizing traditional and indigenous folk art, as well as contemporary crafts, the Center presents interpretive displays of southern folk-life, artist demonstrations, and educational and informative programs to increase understanding and appreciation of the state's diverse cultural heritage.

South Dakota

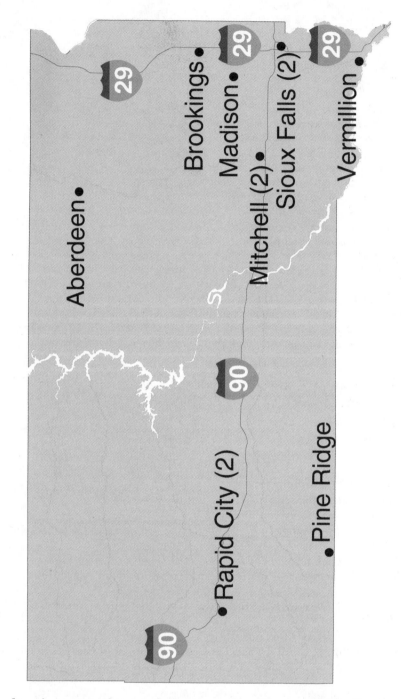

The number in parentheses following the city name indicates the number of museums/galleries in that municipality. If there is no number, one is understood. For example, in the text two listings would be found under Rapid City and one listing under Pine Ridge.

South Dakota

Aberdeen

Northern State University - NSU Galleries

1200 South Jay Street, Aberdeen, SD 57401

Tel: (605) 626-2263

Internet Address: http://www.northern.edu

Gallery Director: Mr. Bill Hoar

Open: Call for hours.

Facilities: Galleries (3).

Activities: Temporary Exhibitions.

The work of professional artists is exhibited in the Isaac Lincoln Gallery, which is also a setting for guest artist workshops, conferences, and other cultural events. Professional artists and students also exhibit in the President's Gallery and the Memorial Union Gallery. Student work is also displayed in the Dakota Hall Gallery and the Johnson Fine Arts Center. Additionally, the Gladys and Edgar Light Collection of the work of Paul "Warcloud" Grant and Tino Walking Bull is on permanent exhibition in Spafford Hall.

Brookings

South Dakota Art Museum at South Dakota State University (SDAM)

1000 Medary Ave. at Harvey Dunn St.
Brookings, SD 57007-0899

Tel: (605) 688-5423

Fax: (605) 688-4445

Internet Address:
 http://www.sdstate.edu/~wsam/http/art1.html

Director: Ms. Lynda K. Clark

Admission: voluntary contribution.

Attendance: 69,000 *Established:* 1970

Membership: Y *ADA Compliant:* Y

Parking: free on site.

Open: Monday to Friday, 8am-5pm;
 Saturday, 10am-5pm;
 Sunday, 1pm-5pm.
 Legal Holidays, 1pm-5pm.

Closed: New Year's Day, Thanksgiving Day,
 Christmas Day.

Facilities: **Auditorium** (150 seat); **Library** (2,000 volumes); **Reading Room; Sculpture Garden; Shop.**

Activities: **Films; Gallery Talks; Guided Tours; Temporary/Traveling Exhibitions** (approximately 30/year).

Man's Beaded Vest (Ojibwa and Blackfeet), c 1915. Frank and Adam Dudeck Memorial Collection of Native American Art, South Dakota Art Museum. Photograph courtesy of South Dakota Art Museum, Brookings, South Dakota.

Publications: exhibition catalogues; newsletter (quarterly).

South Dakota State University was instrumental in the founding of the Museum (originally the Memorial Art Center) and continues to provide assistance, particularly in funding, management, and advocacy. In 1986, the name was changed to the South Dakota Art Museum to reflect its extensive collections and broad programming. Works from the Harvey Dunn, Oscar Howe, Native American Tribal, and Marghab Linen collections are on permanent display in their respective galleries. Other galleries feature temporary exhibitions representing a wide spectrum of themes, styles and media. SDAM serves South Dakota and the region with approximately thirty exhibitions per year, public programs, and educational outreach. When it opened, the museum's collection consisted of 50 paintings by Harvey Dunn. It now houses 4,579 works of art in the Harvey Dunn Collection (94 works, photographs, personal possessions, memorabilia); the Oscar Howe Collection; the Native American Tribal Collection (640 artifacts, primarily the work 18th- and 19th-century Sioux

South Dakota Art Museum at South Dakota State University, cont.

artisans); the South Dakota Collection (including works by Arthur Amiotte, Karl Bodmer, Don Boyd, Charles Greener, Carol Hepper, Myra Miller, Dorothy Morgan, Robert Penn, Signe Stuart, and Michael Warrick); the American Collection (including works by artists of national and international stature such as Thomas Hart Benton, Sidney Chafetz, Eric Fischl, Marsden Hartley, Robert Mangold, James McNeill Whistler, and outstanding regional artists); the Marghab Linen Collection (1,800 pieces); and the Paul Goble Collection. Also of possible interest on campus, the Ritz Gallery (698-4103) exhibits art and design works by students, faculty, and visiting artists throughout the year.

Madison

Dakota State University - Mundt Library Gallery

Karl E. Mundt Library, 1st Floor, Madison, SD 57042-1799
Tel: (605) 256-5270
Fax: (605) 256-5208
Internet Address: http://www.departments.dsu.edu/library/gallery.html
Curator: Rick Janssen
Admission: free.
Open: **Fall to Spring**,
 Monday to Thursday, 8am-10pm; Friday, 8am-5pm; Saturday, 1pm-5pm;
 Sunday, 2pm-10pm.
 Summer,
 Monday to Thursday, 7:30am-5:30pm; Friday, 7:30am-4:30pm.
 Holidays & Breaks,
 Call for hours.
Facilities: **Exhibition Area**.
Activities: **Temporary Exhibitions**.

The Gallery presents a series of temporary exhibitions of work by students and professional artists. Since 1991 DSU has purchased the best student art work created in studio art classes in order to create the DSU Sudent Permanent Collection.

Mitchell

Middle Border Museum of American Indian and Pioneer Life

1311 S. Duff St., Mitchell, SD 57301
Tel: (605) 996-2122
Fax: (605) 996-0323
Exec. Director: Mr. Chris Hanson
Admission: fee: adult-$3.00, student-$1.25, senior-$2.00.
Attendance: 10,000 *Established:* 1939 *Membership:* Y
Parking: free on site.
Open: **May**, Monday to Friday, 9am-5pm; Saturday to Sunday, 1pm-5pm.
 June to August, Monday to Saturday, 8am-6pm; Sunday, 10am-6pm.
 September, Monday to Friday, 9am-5pm; Saturday to Sunday, 1pm-5pm.
 October to April, by appointment.
Facilities: **Architecture** (five buildings with decorative art); **Galleries**.
Activities: **Education Programs** (adults and children); **Guided Tours**; **Lectures**.
Publications: bulletin, "Middle Border".

The Middle Border Museum focuses on American Indian and settlement life in the upper Missouri River valley. It includes the Case Dakota Art Gallery, best known for *Dakota Woman* by Harvey Dunn. Holdings include works by Gutzon Borglum, Ada Caldwell, James Earle Fraser, Nancy Coonsman Hahn, Charles Hargens, Oscar Howe, Anne Hyatt Huntington, John Innes, and Marilyn Sunderman. The American Indian Gallery exhibits artifacts dating from the 1600s through the 1800s, including fine examples of quill and bead work.

Oscar Howe Art Center

119 W. 3rd Ave., Mitchell, SD 57301

Tel: (605) 996-4111

Curator: Andrea Nussbaum

Admission: voluntary contribution.

Established: 1972 *Membership:* Y

Parking: on street.

Open: Call for hours.

Closed: Legal Holidays.

Facilities: **Architecture** (former Carnegie library building, 1902); **Galleries** (1 permanent, 3 changing exhibits); **Shop** (regional art, prints, pottery, jewelry).

Activities: **Arts Festival**; **Concerts**; **Guided Tours**; **Lectures**; **Temporary Exhibitions**.

Publications: annual report; exhibition catalogues; newsletter.

Oscar Howe, *Sun and Rain Clouds over the Hills*, 1940, oil paint mural, in dome of Mitchell Carnegie Library, now Oscar Howe Art Center. Photograph courtesy of Oscar Howe Art Center, Mitchell, South Dakota.

The Center contains a permanent collection of the Sioux artist, Oscar Howe. The mural in the Dome Gallery, "Sun and Rain Clouds over the Hills", was painted by Dr. Howe in 1940 as a WPA project. In the other three galleries, temporary exhibitions are displayed. Many of the exhibitions focus on Native American art.

Pine Ridge

Red Cloud Indian School - The Heritage Center, Inc.

Red Cloud Indian School, Pine Ridge, SD 57770

Tel: (605) 867-5491 *Ext:* 218

Fax: (605) 867-1104

Director and C.E.O.: Brother C.M. Simon

Admission: voluntary contribution.

Attendance: 12,000 *Established:* 1967

Membership: Y *ADA Compliant:* Y

Parking: free on site.

Open: Monday to Friday, 9am-5pm.

Facilities: **Library** (900 volumes); **Reading Room**; **Shop** (fine Indian arts and literature).

Activities: **Arts Festival** (annual Red Cloud Indian Art Show); **Guided Tours**; **Temporary Exhibitions**.

Publications: exhibition catalogues (annual).

Robert Freeman, *Beyond*, etching, limited edition. The Heritage Center. Photograph courtesy of The Heritage Center, Inc., Pine Ridge, South Dakota.

Located in a historic brick building (1888) on the Red Cloud Indian School campus, the Heritage Center has an excellent collection of Native American fine art including paintings, sculpture, and limited edition prints from many different artists and tribes. Holdings also include an extensive collection of Sioux traditional artifacts featuring two beadwork collections gathered on the Pine Ridge Reservation between 1885 and 1930. These collections are supplemented by a display of contemporary beadwork and porcupine quill work.

Rapid City

Dahl Arts Center

713 7th St., Rapid City, SD 57701
Tel: (605) 394-4101
Fax: (605) 394-6121
Director: Don Hotalling
Admission: voluntary contribution.
Attendance: 48,000 *Established:* 1974 *Membership:* Y *ADA Compliant:* Y
Parking: metered on street.
Open: Monday to Saturday, 9am-5pm; Sunday, 1pm-5pm.
Closed: Legal Holidays.
Facilities: **Galleries** (3); **Theatre** (150 seat).
Activities: **Concerts**; **Gallery Talks**; **Guided Tours**; **Performances**; **Temporary Exhibitions**.
Publications: brochures; exhibition catalogues; newsletter.

The Dahl Center houses a unique 180-foot oil-on-canvas panorama spanning 200 years of U.S. history in the Cyclorama Gallery. Enhanced by special lighting and narration, the work was designed and painted by muralist Bernard P. Thomas. In addition to the Cyclorama Gallery, the Center includes galleries for temporary exhibitions and sales. Artists from the area, region, and nation participate in group and solo artist exhibitions. The schedule also includes national touring exhibitions. The Center is a community arts facility, which also houses a 150-seat theater, arts organizations offices, and classroom spaces.

The Journey Museum

222 New York Street, Rapid City, SD 57701
Tel: (605) 394-6923
Fax: (605) 394-6940
Internet Address: http://www.sdsmt.edu/journey
Chairman: Mr. Joe Rovere
Admission: fee: adult-$6.50, child-free,
 student-$4.00, senior-$5.00, family-$13.00.
Established: 1997
Membership: Y *ADA Compliant:* Y
Open: **June to October 15**,
 Monday to Saturday, 9am-8pm;
 Sunday, 10am-6pm.
 October 16 to May,
 Monday to Saturday, 10am-4pm;
 Sunday, 11am-4pm.
Closed: Thanksgiving Day, Christmas Day,
 January-2 weeks.

Façade of Journey Museum. Photograph courtesy of Journey Museum, Rapid City, South Dakota.

Facilities: **Galleries**; **Grounds** (landscaped with traditional American plants); **Shop**; **Theatre**.
Activities: **Demonstrations**; **Films**; **Guided Tours**; **Lectures**; **Performances**; **Traveling Exhibitions**.
Publications: brochures; exhibition catalogues; newsletter.

This $13 million facility is a multi-media journey through time, using sight, sound, and touch to tell the story of the Black Hills. Included within the 48,000 square feet of The Journey are four separate museum collections featuring exhibits on geology, paleontology, archaeology, Sioux Indian art and culture, and pioneer history, as well as a fine art gallery and gift shop. The Journey captures and preserves the spirit not only of western South Dakota, but also of the entire frontier period of this country's history.

Sioux Falls

Augustana College - Eide/Dalrymple Art Gallery
29th and S. Summit Ave., Sioux Falls, SD 57197
Tel: (605) 336-4609
Fax: (605) 336-4368
Internet Address: http://www.augie.edu
Director: Dr. Adrien Hannus
Admission: free.
Open: Tuesday to Sunday, noon-5pm.
Facilities: **Gallery**.
Activities: **Temporary Exhibitions**.

The Gallery presents temporary exhibits by professional artists. Its permanent collection consists of fine art prints and ethnographic works. Also of possible interest on campus is the Center for Western Studies, whose permanent collection includes wildlife art by Roger Pruess, photographs by Fred Farrar, watercolors by Herb Fisher, sculpture by Palmer Eide, and paintings by Belva Curtis, Robert Wood, and Oscar Howe. (Hours: Mon-Fri, 8am-5pm; tel: 605-336-4007.)

Washington Pavilion of Arts and Science - Visual Arts Center
301 S. Main Ave., Sioux Falls, SD 57104
Tel: (605) 367-7397 or (877) 927-4728
Fax: (605) 731-2402
Internet Address: http://www.washpavilion.org
Director: Mr. Shirley Sneve
Admission: free on weekends; special exhibitions, suggested donation: adult-$3.00, child-$100.
Established: 1961 *Membership:* Y *ADA Compliant:* Y
Parking: free on site.
Open: Monday to Wednesday, 10am-5pm; Thursday to Friday, 10am-8pm; Saturday, 10am-5pm;
 Sunday, noon-5pm.
Closed: Thanksgiving Day, Christmas Day.
Facilities: **Architecture** (former high school building, 1906); **Children's Studio (hands-on)**;
 Galleries (6); **Library**; **Shop**.
Activities: **Arts Festival**; **Gallery Talks**; **Guided Tours**.
Publications: newsletter.

Formerly the Civic Fine Arts Center, the Center adopted its new name upon relocation to new space along 11th Street in the Washington Pavilion. The Center features the work of South Dakota and regional artists. Its holdings total approximately 300 works, including 200 works by South Dakota artists such as Charles Greener, Oscar Howe, and Lova Jones. Other artists represented include Bassano, Moore, and Renoir, as well as contemporary artists Carl Grupp, Terry Mulkey, and Signe Stuart.

Vermillion

University of South Dakota - University Art Galleries
Warren M. Lee Center for Fine Arts, 414 E. Clark St., Vermillion, SD 57069
Tel: (605) 677-5481
Fax: (605) 677-5988
Internet Address: http://www.usd.edu/cfa/Art/gallery.html
Director: Mr. John A. Day
Admission: free.
Attendance: 20,000 *Established:* 1976 *ADA Compliant:* Y
Parking: free on site.
Open: **Main Gallery**, Monday to Friday, 10am-4pm; Saturday to Sunday, 1pm-5pm.
 Gallery 110, Monday to Friday, 8am-5pm.
 Oscar Howe Gallery, Monday to Sunday, 1pm-4:30pm.

University of South Dakota - University Art Galleries, cont.

Closed: Legal Holidays.

Facilities: **Galleries; Library.**

Activities: **Films; Gallery Talks; Lectures; Temporary Exhibitions; Traveling Exhibitions.**

Publications: exhibition catalogues.

The University Art Galleries' primary purpose is to support the formal educational process of the University, but its impact extends beyond the academic community to serve artists and audiences in South Dakota and the region. UAG's Main Gallery, located in the Warren M. Lee Center for the Fine Arts, is a large modern exhibition facility, which presents twelve to fifteen art shows annually. Also located in the Lee Center, Gallery 110 is a small exhibition space for solo and group shows. In the recently renovated historic Old Main building at the heart of the University campus, the Oscar Howe Gallery is home to the largest collection of works by this celebrated American Indian artist, who taught at USD for over twenty-five years. The University Art Galleries program is also responsible for developing and maintaining the Permanent Art Collection of the University of South Dakota, which currently numbers over 1,000 pieces, emphasizing South Dakota artists, contemporary art, and Asian and African study collections.

Tennessee

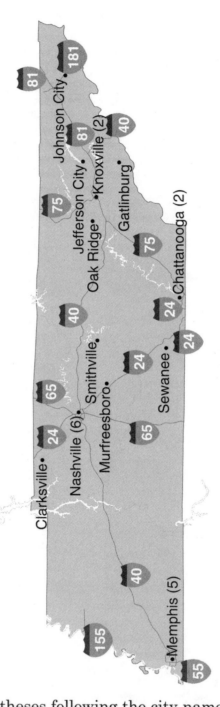

The number in parentheses following the city name indicates the number of museums/galleries in that municipality. If there is no number, one is understood. For example, in the text six listings would be found under Nashville and one listing under Sewanee.

Tennessee

Chattanooga

Hunter Museum of American Art

10 Bluff View, Chattanooga, TN 37403-1197
Tel: (423) 267-0968
Fax: (423) 267-9844
Internet Address: http://www.huntermuseum.org
C.E.O. and Director: Mr. Cleve K. Scarbrough
Admission: fee: adult-$5.00, child-$2.50,
 student-$3.00, senior-$4.00.
Attendance: 55,000 *Established:* 1951
Membership: Y *ADA Compliant:* Y
Parking: free on site.
Open: Tuesday to Saturday, 10am-4:30pm;
 Sunday, 1pm-4:30pm.
Closed: Legal Holidays.
Facilities: **Architecture** (classical revival mansion, 1904 with 1975 addition); **Auditorium** (180 seat); **Library** (1,000 volumes); **Shop**; **Theatre.**
Activities: **Films**; **Gallery Talks**; **Guided Tours** (groups by appointment); **Lectures**; **Temporary Exhibitions**; **Traveling Exhibitions.**

Exterior of Hunter Museum of American Art. Photograph courtesy of Hunter Museum of American Art, Chattanooga, Tennessee.

Publications: collection catalogue, "A Catalogue of the American Collection, Hunter Museum of American Art"; exhibition catalogues; magazine, "Artview" (quarterly).

Built on a ninety-foot limestone bluff overlooking the Tennessee River, the Hunter Museum displays a permanent collection focusing on the history of American art from the colonial period to the present day in a wide variety of media including painting, sculpture, contemporary studio glass, and crafts. To complement the permanent collection, the Hunter offers a diverse schedule of approximately thirty changing exhibitions annually. The Hunter also schedules a wide range of educational programs, both at the museum and in the community, designed to bring art education and a knowledge of the Hunter collection to the public.

University of Tennessee at Chattanooga - The George Cress Gallery of Art

University of Tennessee at Chattanooga, Fine Arts Center, Vine and Palmetto Sts.
Chattanooga, TN 37403
Tel: (423) 755-4178/4087
Fax: (423) 785-2101
Internet Address: http://www.utc.edu
Gallery Curator: Ms. Ruth Grover
Admission: free.
Established: 1952
Open: Monday to Friday, 9am-4pm.
Closed: Academic Holidays.
Facilities: **Exhibition Area.**
Activities: **Gallery Talks**; **Temporary Exhibitions**; **Traveling Exhibitions.**

The Cress Gallery offers an annual schedule of temporary exhibitions of both contemporary and historically significant art and design. Regularly scheduled events include three biennial shows (Chattanooga Area Art Instructors, Department of Art Faculty Exhibition, and Juried Student Exhibition), as well as an annual spring senior exhibition for graduating art majors.

Clarksville

Austin Peay State University - Trahern Gallery

Margaret Fort Trahern Art and Drama Building, College and 8th Sts., Clarksville, TN 37044
Tel: (931) 221-7333
Fax: (931) 221-7432
Internet Address: http://www.apsu.edu
Director: Ms. Bettye Holte
Admission: free.
Attendance: 7,000 *Established:* 1974 *ADA Compliant:* Y
Open: Monday to Friday, 9am-4pm; Saturday, 10am-2pm; Sunday, 1pm-4pm.
Closed: Academic Holidays.
Facilities: Gallery.
Activities: **Education Programs** (adults); **Temporary Exhibitions**; **Traveling Exhibitions**.
Publications: exhibition catalogues.

Each year the Gallery hosts the Annual Student Art Exhibition and an annual schedule featuring regionally, nationally, and internationally recognized artists. The Larson Drawing Collection is housed separately The Mabel Larson Fine Arts Gallery located in Harned Hall.

Gatlinburg

Arrowmont School of Arts and Crafts Gallery

556 Parkway, Gatlinburg, TN 37738
Tel: (865) 436-5860
Fax: (865) 430-4101
Internet Address: http://www.arrowmont.org
C.E.O. and Director: Ms. Sandra J. Blain
Admission: voluntary contribution.
Attendance: 4,150 *Established:* 1945
ADA Compliant: Y
Open: Monday to Saturday, 8:30am-4:30pm.
Closed: Thanksgiving Day,
 Christmas Day to New Year's Day.
Facilities: **Auditorium** (175 seat); **Exhibition Area** (2,700 square feet, plus 1,000 square feet apart); **Food Services** Restaurant (175 seat); **Library** (1,500 volumes); **Shop** (regional crafts); **Studios**.

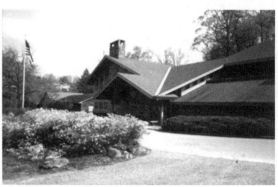

Arrowmont School of Arts and Crafts, exterior of the main education building (1970). Photograph courtesy of Arrowmont School of Arts and Crafts, Gatlinburg, Tennessee.

Activities: **Concerts**; **Education Programs** (adults, university students, and children); **Guided Tours**; **Lectures**; **Temporary Exhibitions**; **Traveling Exhibitions**.
Publications: newsletter, "The Arrow" (quarterly); newsletter, "Visions" (annual); poster; workshop schedule (annual).

Arrowmont has evolved from the Pi Beta Phi Settlement School, established in 1912 to provide education and health care for families in the east Tennessee region of the Smoky Mountains, into a comprehensive art and craft school. The Arrowmont Gallery offers an active schedule of juried, invitational, theme, and media-oriented major exhibitions. Arrowmont's permanent collection of contemporary art and craft objects is frequently displayed in the gallery. An auditorium provides space for community programs, lectures, and demonstrations.

Jefferson City

Carson-Newman College - Omega Gallery

Warren Building, CNC Box 71995, South Branner Avenue, Jefferson City, TN 37760
Tel: (865) 471-3572
Internet Address: http://www.cn.edu/academics/departments/art/exhibitions.html
Director: Mr. David Underwood
Open: **College Class Days**, Monday to Friday, 8am-4pm.

Carson-Newman College - Omega Gallery, cont.

Facilities: **Exhibition Area.**

Activities: **Temporary Exhibitions.**

The Art Department presents temporary exhibitions in two galleries: the Omega Gallery and the Student Gallery.

Johnson City

East Tennessee State University - B. Carroll Reece Memorial Museum

Gilbreath Drive, Johnson City, TN 37614-0660

Tel: (423) 439-4392

Fax: (423) 461-7075

Internet Address: http://cass.etsu.edu/museum

Co-Director: Ms. Margaret Carr

Admission: voluntary contribution.

Attendance: 16,000 *Established:* 1965

Membership: Y *ADA Compliant:* Y

Parking: free on site.

Open: Monday to Saturday, 9am-4pm;
 Sunday, 1pm-4pm.

Closed: ML King Day, Easter Weekend,
 Independence Day, Labor Day,
 Christmas Day to New Year's Day.

Facilities: **Galleries.**

Exterior view of B. Carroll Reece Memorial Museum. Photograph courtesy of B. Carroll Reece Memorial Museum, East Tennessee State University, Johnson City, Tennessee.

Activities: **Education Programs** (adults and children); **Gallery Talks**; **Guided Tours**; **Lectures**; **Temporary Exhibitions**; **Traveling Exhibitions**.

Publications: brochures; calendar (quarterly); exhibition catalogues; newsletter (quarterly).

Centrally located behind Sherrod Library on the campus of East Tennessee State University, the Museum houses approximately 10,000 objects ranging from prints by Picasso and other masters to frontier artifacts, musical instruments, costumes, and furniture. The galleries feature permanent and changing exhibits of historical significance, fine art and craft items. Also of possible interest on campus are the Slocumb Galleries, located in Ball Hall (open Mon-Fri, 9am-4pm; tel 439-7078). The Galleries offer a series of temporary and traveling exhibitions including a visiting artist series and MFA/BFA candidates exhibitions.

Knoxville

Knoxville Museum of Art (KMA)

Clayton Building, 1050 World's Fair Park Drive,
Knoxville, TN 37916-1653

Tel: (865) 525-6101

Fax: (865) 546-3635

Internet Address: http://www.knoxart.org

Admission: fee: adult-$4.00, child (<12)-free,
 student-$2.00, senior-$3.00.

Attendance: 90,000 *Established:* 1961

Membership: Y *ADA Compliant:* Y

Parking: free, adjacent to site.

Open: Tuesday to Thursday, 10am-5pm;
 Friday, 10am-9pm;
 Saturday, 10am-5pm;
 Sunday, noon-5pm.

Closed: New Year's Day, Thanksgiving Day,
 Christmas Day.

Exterior view of Knoxville Museum of Art (1990), designed by Edward Larrabee Barnes. Photograph courtesy of Knoxville Museum of Art, Knoxville, Tennessee.

737

Knoxville Museum of Art, cont.

Facilities: **Architecture** (1990, design by Edward Larrabee Barnes); **Library**; **Shop** (art books, gift items).

Activities: **Arts Festival**; **Concerts** (including jazz series, "Alive After Five", Friday evenings); **Education Programs**; **Film Series**; **Guided Tours**; **Lectures**; **Performances** (Theatre Knoxville); **Permanent Exhibition**; **Temporary Exhibitions** (10-12/year); **Workshops** (adults and children).

Publications: annual report; newsletter, "Canvas" (bi-monthly).

KMA presents 10 to 12 exhibitions each year reflecting art of different cultures, periods and styles in a variety of media. The Museum's collection of nearly 1,000 objects features contemporary paintings, works on paper, and mixed media that represent the dynamic currents in American art during the 20th century. KMA is fully handicapped accessible, and wheelchairs are available.

University of Tennessee, Knoxville-C. Kermit Ewing Gallery of Art & Architecture

Art and Architecture Building, 1st Floor, 1715 Volunteer Blvd., Knoxville, TN 37996

Tel: (423) 974-3200

Fax: (423) 974-3198

Internet Address: http://funnelweb.utcc.utk.edu/~spangler/owlfo.html

Director: Mr. Sam Yates

Admission: free.

Established: 1981

Open: **Fall to Spring**,

 Monday to Thursday, 8:30am-8pm; Friday, 8:30am-4:30pm; Sunday, 1pm-4pm.

Facilities: **Exhibition Area** (3,000 square feet).

Activities: **Films**; **Lectures**; **Temporary Exhibitions**; **Workshops**.

Administered jointly by the Department of Art and the School of Architecture, the Gallery presents programming that emphasizes historic and current trends in art and architecture and stresses exhibits on subjects not frequently dealt with in the immediate area. The Gallery schedule reflects various media and disciplines taught in the academic programs and provides opportunities for students, faculty, and regional artists to exhibit their work. The permanent collection consists of approximately 3,000 objects, focusing on contemporary works in all media, Asian art, graphic design/illustration, and architectural drawings/photographs.

Memphis

The Dixon Gallery and Gardens

4339 Park Ave. (between Getwell and Perkins), Memphis, TN 38117-4698

Tel: (901) 761-2409

Fax: (901) 682-0943

Internet Address: http://www.dixon.org

Admission: fee:

 adult-$5.00, child-$1.00, student-$3.00, senior-$4.00.

Established: 1976

Membership: Y *ADA Compliant:* Y

Parking: free on site.

Open: Monday, 1pm-5pm (gardens only);

 Tuesday to Saturday, 10am-5pm;

 Sunday, 1pm-5pm.

Facilities: **Architecture**; **Auditorium** (250 seats); **Grounds** (17 acres, landscaped with formal gardens); **Library** (3,000 volumes); **Sculpture Garden**; **Shop**.

Activities: **Films**; **Gallery Talks**; **Guided Tours**; **Lectures**; **Performances**; **Permanent Exhibits**; **Temporary Exhibitions**.

Exterior view of Dixon Gallery and Gardens. Photograph courtesy of Dixon Gallery and Gardens, Memphis, Tennessee.

The Dixon Gallery and Gardens, cont.

Publications: exhibition catalogues (occasional); newsletter, "Members Quarterly" (quarterly).

The Dixon Gallery and Gardens, located on seventeen acres of gardens and woodlands, is the legacy of the late Margaret and Hugo Dixon. Their Georgian-style residence, which is the original building in the current gallery complex, houses the Margaret and Hugo Dixon Collection of Paintings. In 1977, one year after the museum opened to the public, a wing was added to house the growing permanent collection. In 1986, a second addition more than doubled the size of the complex. To complement and interpret its permanent collection, the Dixon maintains a diverse schedule of special exhibitions drawn from some of the finest private and public collections of art in the world. The original Dixon collection is devoted to French and American Impressionists, Post-Impressionists and related schools. The museum has continued to build on Margaret and Hugo Dixon's interest in Impressionism with acquisitions such as the Montgomery H. W. Ritchie Collection, which has expanded the holdings to include French and American art from the 19th- and early 20th-centuries. The permanent collection includes works by Bonnard, Braque, Cassatt, Cézanne, Chagall, Daumier, Degas, Fantin-Latour, Forain, Gauguin, Matisse, Monet, Morisot, Munch, Pissarro, Renoir, Rodin, Seurat, Signac, Sisley, and Vuillard. The Museum recently acquired 56 works by Jean-Louis Forain, making the Dixon a major international repository of the artist's work. There are also extensive collections of decorative arts, including the Stout Collection of over 600 pieces of 18th-century German porcelain, 18th- and 19th-century French porcelain and other decorative arts, English porcelain, the Adler Pewter Collection, and period furniture.

Memphis Brooks Museum of Art (Brooks)

1934 Poplar Ave., Overton Park (off Poplar Ave., adjacent to Zoo), Memphis, TN 38104-2765

Tel: (901) 722-3500

Fax: (901) 722-3522

Internet Address: http://www.brooksmuseum.org

Interim Director: Mr. Chuck Beegle, Jr.

Admission: fee: adult-$5.00, child-$1.00, student-$2.00, senior-$4.00.

Attendance: 115,000 *Established:* 1913

Membership: Y *ADA Compliant:* Y

Parking: free on site.

Open: **October to April**,
 Tuesday to Friday, 9am-4pm;
 Saturday, 9am-5pm;
 Sunday, 11:30am-5pm.

 May to September,
 Monday to Wednesday, 9am-4pm;
 Thursday, 11am-8pm;
 Friday, 9am-4pm;
 Saturday, 9am-5pm;
 Sunday, 11:30am-5pm.
 Thanksgiving Day, 10am-1pm.

Exterior view of Memphis Brooks Museum of Art. Photograph courtesy of Memphis Brooks Museum of Art, Memphis, Tennessee.

Closed: New Year's Day, Independence Day, Christmas Day.

Facilities: **Architecture** (original Beaux-Arts building, 1916 design by J.G. Rogers); **Auditorium** (273 seats); **Food Services** Brushmark Restaurant (Tues-Sat, 11:30am-2:30pm & selected Thurs, 5pm-8pm); **Library** (3,500 volumes); **Print Study Room** (5,000 works on paper); **Shop**; **Theatre**.

Activities: **Concerts**; **Demonstrations**; **Films** (Thurs, 7pm; Sun, 2pm); **Gallery Talks**; **Guided Tours** (Sat, 10:30am/1:30pm; Sun, 1:30pm); **Lectures**; **Temporary/Traveling Exhibitions**.

Publications: exhibition catalogues; magazine, "The Brooks" (semi-annual); magazine, "The Column" (bi-monthly).

The Memphis Brooks Museum of Art was founded with funds donated by Bessie Vance Brooks in memory of her husband, Samuel Hamilton Brooks. The oldest and largest fine arts museum in Tennessee, the Brooks features a permanent collection of over 7,000 works dating from antiquity to the present. The permanent collection is supplemented by changing exhibitions. Programs and activities for both adults and children are offered throughout the year. Housed in its original Beaux

Memphis Brooks Museum of Art, cont.

Arts style building, the Brooks has expanded three times during the past eighty years, culminating in 1989, with the dedication of an award-winning addition to the original 1916 building. The Brooks Permanent Collection of paintings features works by Italian Renaissance and Baroque, British, French Impressionist, and 20th-century artists. Strengths include The Kress Collection, a magnificent assembly of Renaissance paintings, and a collection of English portraiture with works by Gainsborough, Reynolds, Lawrence and Romney, and Impressionist works by Pissarro, Sisley, and Renoir. Winslow Homer, Thomas Hart Benton, Childe Hassam and Robert Henri are among the Americans with works at the Brooks, and many well-known figures in contemporary art are represented in the Fogelman Collection, including Kenneth Noland, Robert Motherwell and Nancy Graves. In addition, one of the more noted collections is that of regional artist, Carroll Cloar. There are also holdings in ancient Greek and Mediterranean, pre-Columbian, and African art. Sculpture in the museum ranges from Rodin bronzes to a special "touching" gallery for visually handicapped patrons. There is an impressive selection of decorative arts, including period furniture and textiles.

Memphis College of Art - Tobey Gallery

1930 Poplar St., Overton Park, Memphis, TN 38104
Tel: (901) 272-5000
Fax: (901) 272-5104
Internet Address: http://www.mca.edu.
President: Mr. Jeffrey D. Nesin
Admission: free.
Attendance: 20,000 *Established:* 1936
ADA Compliant: Y
Parking: in front of school.
Open: Monday to Friday, 8:30am-4:30pm;
Saturday, 10am-3pm.
Closed: Academic Holidays.

Exterior view of Memphis College of Art. Photograph courtesy of Memphis College of Art, Memphis, Tennessee.

Facilities: **Auditorium** (342 seats); **Galleries** (2); **Library** (16,000 volumes); **Shop**.
Activities: **Arts Festival**; **Education Programs** (adults, undergraduates and children); **Films**; **Guided Tours**; **Lectures**; **Temporary Exhibitions** (10-12/year).
Publications: exhibition catalogues.

Located in historic Overton Park in a nationally-acknowledged, design-award building, MCA presents temporary exhibitions in two galleries. Regularly scheduled exhibitions include shows of the work of student MFA and BFA candidates and faculty.

Rhodes College - Clough-Hanson Gallery

2000 North Parkway, Memphis, TN 38112
Tel: (901) 843-3442
Fax: (901) 843-3727
Internet Address: http://artslides2.art.rhodes.edu/gallery.html
Director: Ms. Marina Pacini
Admission: free.
Attendance: 2,800 *Established:* 1970
Membership: N *ADA Compliant:* Y
Open: Tuesday to Saturday, 11am-5pm.
Closed: Academic Holidays, Summer.
Facilities: **Exhibition Area**.
Activities: **Gallery Talks**; **Lectures**; **Temporary Exhibitions**.
Publications: in-house exhibit publication (annual).

The Gallery presents temporary exhibitions of the work of professional artists as well as annual juried student and senior thesis exhibits.

View of the Clough-Hanson Gallery through entry door. Photograph courtesy of Clough-Hanson Gallery, Rhodes College, Memphis, Tennessee.

University of Memphis - Art Museum

3750 Norriswood (opposite McWherter Library), Communication and Fine Arts Building
Memphis, TN 38152-6540
Tel: (901) 678-2224
Fax: (901) 678-5118
Internet Address: http://www.people.memphis.edu/~artmuseum/Amhome.html
Director: Leslie Luebbers
Admission: suggested contribution-$2.00.
Attendance: 17,000
Membership: Y
Parking: parking garage at Norriswood and Deloach.
Open: Monday to Saturday, 9am-5pm.
Facilities: **Exhibition Area** (5,000 square feet); **Library**
 Institute of Egyptian Art & Archaeology (6,000 volumes).
Activities: **Guided Tours; Lectures; Temporary
 Exhibitions; Traveling Exhibitions.**
Publications: collection catalogue; exhibition catalogues;
 newsletter, "AM Edition"; newsletter, "Annual Egyptian
 Institute of Art and Archeology".

Gail Rothschild, *"Muted Belles" - A Monument to the Women of Memphis*, 1994, sculpture, located in front of CFA Building, Art Museum. Photograph courtesy of Art Museum of University of Memphis, Memphis, Tennessee.

Located on the campus of The University of Memphis, the Museum holds the permanent collection of the Institute of Egyptian Art and Archaeology, over 150 objects ranging in date from 3500 BC to 700 AD. There are permanent exhibits of Egyptian antiquities, West African Art, and miniature furniture. Each year the Museum also produces several exhibitions of primarily contemporary art in the main gallery, including the annual MAX (Memphis Art Exhibition), juried student, and MFA thesis exhibitions. Selections from the print collection are regularly displayed in conjunction with art classes.

Murfreesboro

Middle Tennessee State University - Baldwin Photographic Gallery

Middle Tennessee State University, McWherter Learning Resources Center
Murfreesboro, TN 37132
Tel: (615) 898-2085
Fax: (615) 898-5682
Internet Address: http://www.mtsu.edu
Curator: Mr. Tom Jimison
Admission: free.
Attendance: 30,000 *Established:* 1961 *ADA Compliant:* Y
Parking: Free, adjacent to site.
Open: **Academic Year**, Monday to Friday, 8am-4:30pm; Saturday, 8am-noon; Sunday, 6pm-10pm.
 July to August, by appointment.
Closed: Academic Holidays.
Facilities: **Photographic Archive.**
Activities: **Lectures; Temporary Exhibitions.**
Publications: posters; show announcements (monthly).

The Gallery, focusing on contemporary photography, presents temporary exhibitions. Its permanent collection totals approximately 1,000 photographs. Also of possible interest on campus is the Art Barn Gallery, which presents temporary exhibitions, including juried student and senior BFA candidate shows. (Hours: Mon-Fri, 8am-4:30pm; tel 898-5653.)

Nashville

Cheekwood Botanical Garden and Museum of Art

1200 Forrest Park Drive, Nashville, TN 37205-4242

Tel: (615) 356-8000

Fax: (615) 353-2156

Internet Address: http://www.cheekwood.org

C.E.O. and President: Ms. Jane Jerry

Admission: fee:
 adult-$8.00, child-$5.00, student-$7.00, senior-$7.00.

Attendance: 150,000 *Established:* 1957

Membership: Y *ADA Compliant:* Y

Parking: free on site.

Open: Monday to Saturday, 9:30am-4:30pm;
 Sunday, 11am-4:30pm.

Closed: New Year's Day, 2nd Sat in June,
 Thanksgiving Day, Christmas Day.

Facilities: **Architecture** (former residence, 1929 designed by Bryant Fleming); **Auditorium**; **Food Services** Pineapple Room Restaurant; **Galleries**; **Grounds** (55 acres, botanical gardens); **Library** (9,000 volumes); **Sculpture Trail** (woodland); **Shop** (books, gifts, Tennessee crafts).

Activities: **Education Programs** (adults and children); **Films**; **Gallery Talks**; **Guided Tours** (groups reserve in advance, 353-9827); **Lectures**; **Temporary Exhibitions**; **Traveling Exhibitions**.

Exterior view of Cheekwood. Photograph by Richard Cheek, courtesy of Cheekwood, Nashville, Tennessee.

Publications: book; brochures; calendar (monthly); exhibition catalogues; posters.

Once the private estate of the Leslie Cheek family of the Maxwell House coffee fortune, Cheekwood now houses an art museum and 55-acres of botanical gardens. The Museum showcases a prestigious collection of American art from the 19th and 20th centuries, a famous collection of Worcester porcelain, European and American silver, and Asian snuff bottles. The Stallworth galleries host major traveling exhibitions. The mile-long Woodland Sculpture Trail is the only one of its kind in the United States.

Fisk University Galleries

1000 17th Ave. North, Nashville, TN 37208-3051

Tel: (615) 329-8720

Fax: (615) 329-8544

Internet Address:
 http://www.fisk.edu/~gallery/arthome.html

Director: Ms. Opal K.C. Baker

Admission: suggested contribution-$3.50.

Attendance: 40,000 *Established:* 1949

ADA Compliant: Y

Parking: free on site.

Open: **Academic Year**,
 Tuesday to Friday, 10am-5pm;
 Saturday to Sunday, 1pm-5pm.
 Summer,
 Tuesday to Friday, 10am-4pm.

Facilities: **Architecture** (first Fisk University gymnasium, 1888); **Library** (4,500 volumes); **Shop**.

Exterior view of Carl Van Vechten Gallery of Art at Fisk University, former gymnasium (1888), converted to present use in 1949 to house Alfred Stieglitz Collection of Modern Art. Photograph courtesy of Fisk University, Nashville, Tennessee.

Fisk University Galleries, cont.

Activities: Arts Festival; Films; Gallery Talks; Guided Tours; Lectures; Traveling Exhibitions.

Publications: calendar; exhibition catalogues.

Fisk University, founded in 1866 as the Fisk Free School, has been a collecting institution almost since its beginning. Its first faculty members had been, before joining Fisk, missionary educators among the Mende people of West Africa, and they brought with them to Nashville examples of the indigenous arts and crafts of the Mende. Since then, Fisk has built extensive collections of African American art, as well as collections of work by the photographer Carl Van Vechten, the painter/designer/teacher Winold Reiss, and artist/ethnographer Cyrus L. Baldridge. In 1949, American painter Georgia O'Keeffe donated a collection of 101 paintings, sculptures and works on paper from the collection of her late husband, photographer Alfred Stieglitz. The collection, in addition to 18 photographs by Stieglitz, includes work by O'Keeffe; American artists Charles Demuth, Arthur Dove, Marsden Hartley, John Marin, and Alfred Maurer; and such prominent artists as Cézanne, George Grosz, Picasso, Renoir, Rivera, Gino Severini, and Toulouse-Lautrec. The Carl Van Vechten Gallery of Art, Fisk's first gymnasium (1888), houses a considerable part of the Alfred Stieglitz Collection of modern art. Also on campus, the Aaron Douglas Gallery (329-8685) features rotating exhibits.

The Parthenon

Centennial Park (across from Vanderbilt University), Nashville, TN 37201

Tel: (615) 862-8431

Fax: (615) 880-2265

Internet Address: http://www.parthenon.org

Director: Ms. Wesley M. Paine

Admission: fee: adult-$2.50, child-$1.25, senior-$1.25. (Fees may change during special exhibitions.)

Attendance: 100,000 *Established:* 1897 *Membership:* Y *ADA Compliant:* Y

Parking: free on site.

Open: **April to September**, Tuesday to Saturday, 9am-4:30pm; Sunday, 12:30pm-4:30pm.

October to May, Tuesday to Saturday, 9am-4:30pm.

Facilities: **Architecture**.

Activities: **Guided Tours** (by reservation); **Temporary Exhibitions**; **Traveling Exhibitions**.

Publications: collection catalogue, "The Cowan Collection"; "A Tale of Two Parthenons; "Winslow Homer: An American Genius at the Parthenon".

A full-scale replica of the Athenian temple, the Parthenon features the Cowan Collection: 63 oil paintings by 57 American artists. The paintings (51 landscapes, four seascapes, and eight portraits) were donated to the Parthenon in the 1920s. Albert Bierstadt, John George Brown, Emil Carlsen, Frederic Church, Sanford Gifford, Jonas Lie, and Thomas Moran are among the artists represented.

Tennessee State Museum

505 Deaderick St., Nashville, TN 37243-1120

Tel: (615) 741-2692

Fax: (615) 741-7231

Exec. Director: Ms. Lois S. Riggins-Ezzell

Admission: voluntary contribution.

Attendance: 185,000 *Established:* 1937 *Membership:* Y

Open: Tuesday to Saturday, 10am-5pm; Sunday, 1pm-5pm.

Closed: New Year's Day, Easter, Thanksgiving Day, Christmas Day.

Facilities: **Library** (5,000 volumes); **Shop**.

Activities: **Gallery Talks**; **Lectures**; **Temporary Exhibitions**; **Traveling Exhibitions**.

Publications: newsletter (quarterly).

The Museum collects, preserves, and exhibits the historical and material culture of Tennessee. The Museum has extensive holdings of Tennessee silver, paintings and contemporary art, ceramics, textiles. furniture, and firearms. It also offers changing exhibits on art and culture three to four times a year.

Vanderbilt University Fine Arts Gallery

Fine Arts Building (Old Gym), 23rd and West End Aves., Nashville, TN 37203
Tel: (615) 322-0605
Fax: (615) 343-1382
Internet Address: http://www.vanderbilt.edu/AnS/finearts/gallery.html
Art Curator: Mr. Joseph S. Mella
Admission: free.
Attendance: 5,000 *Established:* 1961 *Membership:* N
Parking: metered parking on street adjacent to gallery.
Open: **Academic Year**, Monday to Friday, noon-4pm; Saturday to Sunday, 1pm-5pm.
 Summer, Tuesday to Friday, noon-4pm; Saturday, 1pm-5pm.
Closed: Academic Holidays.
Activities: **Gallery Talks & Special Tours** (arrange with curatorial staff in advance, 343-1704);
 Lectures; **Temporary Exhibitions**; **Traveling Exhibitions**.
Publications: exhibition catalogues.

The Vanderbilt University Fine Arts Gallery features six exhibitions each year that represent the diversity of artistic production throughout the history of Eastern and Western art. In addition to thematic exhibitions drawn from the permanent collection, traveling exhibitions are presented. Beginning with Anna C. Hoyt's generous donation of 105 Old Master and modern prints more than a century ago, the collection has continued to flourish and increase the depth, diversity, and number of its holdings. Now 5,000 works, the collection has grown to include works of East Asian art with the Harold P. Stern Collection and the Herman D. Doochin Collection; European Old Master paintings with the Kress Study Collection; paintings from the Barbizon school; and African, Oceanic, and pre-Columbian art and artifacts from the Marjorie and Leon Marlowe Collection. Also of possible interest on campus is the Sarratt Student Center Gallery (open: Mon-Sat, 9am-9pm, Sun, 11am-9pm; reduced hours in summer; tel: 322-2471). The Gallery, located in the main lobby of the Sarratt Student Center, is known for its unique exhibits featuring paintings, sculpture, drawings, photography, prints and multi-media works of the mid-South's contemporary artists. Student and faculty/staff shows, lectures and discussions by the artists, plus poster sales and special craft sales highlight the year's schedule.

Watkins Institute College of Art and Design

601 Church St., Nashville, TN 37219
Tel: (615) 242-1851
Fax: (615) 242-4278
Internet Address: http://www.watkinsinstitute.org
Director of Exhibitions: Professor Madeline Reed
Admission: free.
Established: 1885
ADA Compliant: Y
Open: Monday to Thursday, 9am-8pm;
 Friday, 9am-3pm.
Closed: New Year's Day, Independence Day,
 Labor Day, Thanksgiving Day,
 Christmas Day.
Facilities: **Galleries**.
Activities: **Arts Festival**; **Education Programs** (adults and children); **Lectures**; **Traveling Exhibitions**.
Publications: exhibition catalogues.

The Institute displays the Tennessee All-State Art Collection, artwork by Tennessee artists from 1954 to the present, in its library, reception area and student lounge. Changing exhibitions are mounted in the John A. Hood auditorium. Seven works in pastel and oil by Elihu Vedder are in the President's office.

Bruce Matthews, oil painting, Tennessee All-State Art Collection. Photograph courtesy of Watkins Institute, Nashville, Tennessee.

Oak Ridge

Oak Ridge Art Center

201 Badger Ave., Oak Ridge, TN 37830
Tel: (423) 482-1441
Fax: (423) 482-1441
Director: Ms. Leah Marcum-Estes
Admission: voluntary contribution.
Attendance: 50,000 *Established:* 1952 *Membership:* Y *ADA Compliant:* Y
Parking: free on site.
Open: Monday, 1pm-4pm; Tuesday to Friday, 9am-5pm; Saturday to Sunday, 1pm-4pm.
Closed: Legal Holidays.
Facilities: **Exhibition Area**; **Library**.
Activities: **Art Rental Program**; **Arts Festival**; **Concerts**; **Education Programs** (adults, undergraduates and children); **Lectures**; **Temporary Exhibitions**.
Publications: calendar (monthly); newsletter (monthly).

The Center presents monthly exhibits of work by regional, national, and international artists. It also features an educational program of classes, workshops, and seminars.

Sewanee

University of the South - University Gallery

735 University Ave. at Georgia Ave., Sewanee, TN 37383-1000
Tel: (931) 598-1708
Fax: (931) 598-1145
Internet Address: http://www.sewanee.edu/Gallery/websitegfb/galinfo
Gallery Director: Mr. Geof Bowie
Admission: voluntary contribution.
Attendance: 3,500 *Established:* 1965 *ADA Compliant:* Y
Open: Tuesday to Friday, 10am-5pm; Saturday to Sunday, noon-5pm.
Closed: Academic Holidays.
Activities: **Education Programs** (undergraduate and graduate students); **Films**; **Gallery Talks**; **Guided Tours**; **Lectures**; **Temporary Exhibitions**; **Traveling Exhibitions**.
Publications: bulletin.

The gallery features temporary exhibitions of contemporary artwork.

Smithville

Tennessee Technological University - Joe L. Evins Appalachian Center for Crafts

Tennessee Tech University, 1560 Craft Center Drive
Smithville, TN 37166
Tel: (615) 597-6801
Fax: (615) 597-6803
Internet Address:
 http://www.tntech.edu/www/life/orgs/vas
Director: Mr. Ward Doubet
Admission: voluntary contribution.
Attendance: 150,000 *Established:* 1979
ADA Compliant: Y
Open: Daily, 9am-5pm.
Closed: Easter, June 29-30, Thanksgiving Day, Christmas Day to New Year's Day.
Facilities: **Exhibition Area** (1,500 square feet); **Food Services** Restaurant (70 seat); **Library**; **Sales Gallery**.

Exterior view of Appalachian Center for Crafts. Photograph courtesy of Appalachian Center for Crafts, Tennessee Technological University, Smithville, Tennessee.

Tennessee Technological University - Evins Appalachian Center for Crafts, cont.

Activities: **Education Programs** (adults and graduate students); **Guided Tours; Lectures.**

A component of Tennessee Technological University, The Joe L. Evins Appalachian Center for Crafts is dedicated to expanding the boundaries of contemporary art while sustaining the vitality of traditional crafts. In two exhibition areas adjacent to the sales gallery, works of national, regional, and historic interest are on view. The Sales Gallery showcases the work of Tennessee craftspersons and Craft Center faculty and students, along with that of artisans from 13 Appalachian states. Traditional Appalachian crafts of quilting, basketry, woodworking, and pottery are offered, as well as a selection of contemporary works including jewelry and hand blown glass. Also of possible interest, the Joan Derryberry Art Gallery is located in the University Center on the campus of TTU in Cookeville, Tennessee.

Texas

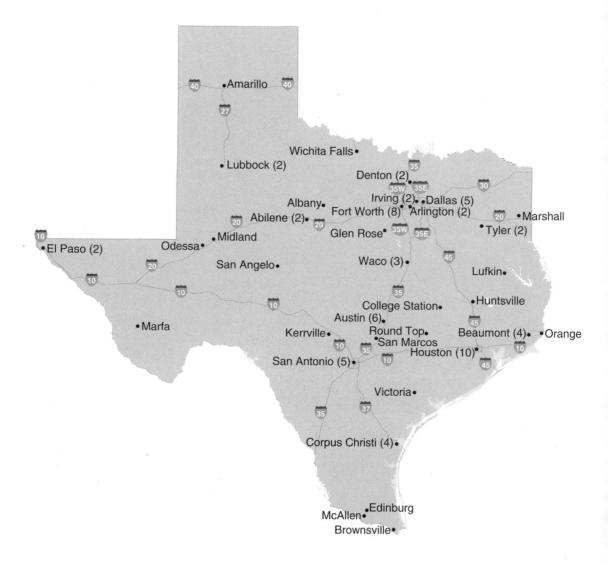

The number in parentheses following the city name indicates the number of museums/galleries in that municipality. If there is no number, one is understood. For example, in the text eight listings would be found under Fort Worth and one listing under Marshall.

Texas

Abilene

Abilene Christian University - Virginia Clover Shore Art Gallery

142 Don H. Morris Center, North Wing (near Moody Coliseum), Abilene, TX 79699-7987

Tel: (915) 674-2085

Internet Address: http://www.acu.edu/academics/art/htmlpages/gallery

Director: Jack Maxwell

Admission: free.

Open: **Academic Year**, Monday to Friday, 8am-5pm.

Facilities: **Exhibition Area** (1,500 square feet).

Activities: **Gallery Talks**; **Temporary Exhibitions** (7/year); **Visiting Artist Program**.

The Shore Gallery presents temporary exhibitions of work by regionally and nationally recognized artists, faculty, alumni, and students. An annual juried student competitions is held during the spring semester. The Department's growing holdings are stored in the gallery's permanent collection storage room.

Grace Museum

102 Cypress, Abilene, TX 79601

Tel: (915) 673-4587

Fax: (915) 675-5993

Internet Address: http://www.abilene.com/grace

Exec. Director: Ms. Judith Godfrey

Admission: fee: adult-$3.00, child-$1.00, student-$2.00, senior-$2.00.

Attendance: 70,000 *Established:* 1937

Membership: Y *ADA Compliant:* Y

Parking: free on site.

Open: Tuesday to Wednesday, 10am-5pm;
Thursday, 10am-8:30pm;
Friday to Saturday, 10am-5pm.

Closed: Legal Holidays.

Façade of Grace Museum. Photograph courtesy of Grace Museum, Abilene, Texas.

Facilities: **Architecture** (mission revival-style former railroad hotel, 1909).

Activities: **Arts Festival**; **Films**; **Gallery Talks**; **Guided Tours**; **Lectures**; **Temporary Exhibitions**; **Traveling Exhibitions**.

Publications: annual report; brochures; newsletter, "Artifacts" (quarterly).

Located in the Grace Cultural Center, a mission revival-style former hotel, the Grace Museum includes four galleries and houses three separate museums: an art museum, an historical museum, and a "hands-on" children's museum. The art museum offers temporary exhibits each season, as well as a diverse permanent collection of paintings, photographs, sculpture, and textiles gathered from across Texas.

Albany

The Old Jail Art Center

201 South 2nd St., Albany, TX 76430

Tel: (915) 762-2269

Fax: (915) 762-2260

Internet Address: http://www.albanytexas.com

Director: Ms. Anne Allen

Admission: free.

Attendance: 23,000 *Established:* 1980 *Membership:* Y *ADA Compliant:* Y

Parking: free on site.

Open: Tuesday to Saturday, 10am-5pm; Sunday, 2pm-5pm.

Closed: Legal Holidays.

The Old Jail Art Center, cont.
Facilities: **Architecture** (jail, 1878); **Bookstore**; **Library**; **Sculpture Garden**.
Activities: **Concerts**; **Guided Tours**; **Lectures**; **Performances**; **Temporary Exhibitions**; **Traveling Exhibitions**.
Publications: newsletter, "The Old Jail Art Center Newsletter" (annual).

Exterior view of Old Jail Art Center (1877). Photograph courtesy of Old Jail Art Center, Albany Texas.

Partially housed in a 19th-century Classic-style former jail (listed on the National Register of Historic Places), the Old Jail Art Center maintains a yearly schedule that includes four or five temporary exhibitions, rotating selections from the permanent collection, guided tours, public lectures, special events, an active docent program, and ongoing art education programs for children, teenagers and adults. One of the aims of the Old Jail Art Center is to encourage both by exhibition and purchase the work of young artists. The museum has over 1,700 works in its permanent collection. The OJAC collection is strong in many areas with the majority of its works created in the 20th-century. While the permanent collection of American and European paintings, watercolors, drawings, and graphics include pieces by such artists as Thomas Hart Benton, Georges Braque, Charles Demuth, Paul Klee, John Marin, Joan Miró, Henri Matisse, Amedeo Modigliani, Henry Moore, Pablo Picasso, and Grant Wood, it also includes works by lesser-known artists. In addition, the museum has a strong representation of works from artists of the Fort Worth School (1945-55) and Taos modernist artists. The outdoor sculpture collection of the Old Jail is installed throughout the grounds with the most important works situated in the Marshall R. Young Courtyard. Jesus Bautista Moroles' granite "Sun Symbol" dominates as the centerpiece. Also located in the courtyard are Pericle Fazzini's "Conversation" and several other important post World War II figurative bronze works. This large body of the collection is coupled with the Asian art collection, including 37 Chinese terra-cotta tomb figures, a pan-cultural pre-Columbian collection of 172 works, plus smaller collections of African and East Indian art, American Indian art, modern ceramics, photographs, fine furniture and rare books. The Old Jail Art Center presents a remarkable scope of art and art history for a museum in a small rural community.

Amarillo

Amarillo Museum of Art
2200 S. Van Buren at 22nd St., Amarillo, TX 79109
Tel: (806) 371-5050
Fax: (806) 373-9235
Internet Address: http://www.amarilloart.org
Director: Mr. Patrick McCracken
Admission: free.
Attendance: 56,000 *Established:* 1972 *Membership:* Y *ADA Compliant:* Y
Parking: free on site.
Open: Tuesday to Friday, 10am-5pm; Saturday to Sunday, 1pm-5pm.
Closed: New Year's Day, Memorial Day, Independence Day, Labor Day, Thanksgiving Day, Christmas Eve to Christmas Day.
Facilities: **Architecture** (late International-style building, designed by Edward D. Stone, 24,000 square feet); **Bookstore**; **Galleries** (6); **Library**; **Sculpture Courtyard**.
Activities: **Arts Festival**; **Education Programs** (adults and children); **Films**; **Gallery Talks**; **Guided Tours**; **Lectures**; **Performances**; **Temporary Exhibitions** (16/year); **Traveling Exhibitions**.
Publications: exhibition catalogues; gallery guides; newsletter (quarterly); posters.

750

Amarillo Museum of Art, cont.

Located on the campus of Amarillo College, a two-year community college, the Museum features loan exhibitions and art from the Museum's permanent collection. Museum holdings including works of mid-20th-century modernists (Frankenthaler, Kline, Marin, Nevelson, and O'Keeffe), photography (particularly the work Russell Lee, but also including representative examples of the work of Delano, Lange, Rothstein, Steichen, Stieglitz, Strand, Wolcott, and Weston), 17th- to 19th-century European paintings (including two paintings by Francesco Guardi), 18th- through 20th-century Middle Eastern textiles, Japanese Edo period woodblock prints, and South and Southeast Asian sculpture (Buddhist and Hindu works ranging from 2nd-century B.C. Gandharan to 9th-century Java and 14th-century Khmer pieces).

Arlington

Arlington Museum of Art

201 W. Main St., Arlington, TX 76010

Tel: (817) 275-4600

Fax: (817) 275-1474

Director, Curator and Public Relations: Ms. Joan Davidow

Admission: free.

Attendance: 10,000 *Membership:* Y *ADA Compliant:* Y

Parking: free on site.

Open: Wednesday to Saturday, 10am-5pm.

Closed: Legal Holidays, Christmas Day to January 2.

Facilities: **Exhibit Space** (10,000 square feet); **Library**; **Shop**.

Activities: **Education Programs** (adults and children); **Guided Tours**; **Lectures**.

Publications: newsletter, "Artifax" (quarterly).

The Museum presents eight exhibitions of contemporary artists annually. A non-collecting museum, it focuses on emerging Texas artists, but also presents challenging regional, national, and international exhibitions.

University of Texas at Arlington - The Gallery at UTA

Fine Arts Building, 700 West 2nd St., Arlington, TX 76019

Tel: (817) 272-3143

Fax: (817) 272-2805

Internet Address: http://www.uta.edu/art/

Director: Mr. Benito Huerta

Admission: free.

Attendance: 5,000 *Established:* 1976 *ADA Compliant:* Y

Open: Monday to Friday, 10am-5pm; Saturday, noon-5pm.

Closed: Academic Holidays.

Facilities: **Gallery** (4,000 square feet).

Activities: **Films**; **Lectures**; **Temporary Exhibitions** (6/year).

Publications: announcements; brochures; posters.

Located on the first floor of the Fine Arts building, The Gallery at UTA presents works by regionally, nationally, and internationally recognized contemporary artists in a critical and creative context. Also of possible interest on campus are Gallery 171, operated by the Student Art Association and featuring primarily the work of student artists, and The Gallery in the University Center, presenting the work of student, faculty and community artists.

Austin

Austin Museum of Art - Downtown

823 Congress Ave., Austin, TX 78701

Tel: (512) 495-9224

Fax: (512) 495-9029

Internet Address: http://www.amoa.org

Director: Ms. Elizabeth Ferrer

Austin Museum of Art - Downtown, cont.

Admission: fee: adult-$3.00, child-free, student-$2.00, senior-$2.00.

Open: Tuesday to Wednesday, 11am-7pm; Thursday, 11am-9pm; Friday to Saturday, 11am-5pm; Sunday, 1pm-5pm.

Closed: Legal Holidays.

The Austin Museum of Art - Downtown occupies 12,000 square feet on the ground floor of the 823 Congress Building. The Museum offers visitors the opportunity to view nationally recognized exhibitions representative of an array of artistic expression from the United States, Mexico, and the Caribbean. The Austin Museum of Art - Downtown is a branch of the Austin Museum of Art at Laguna Gloria (see below).

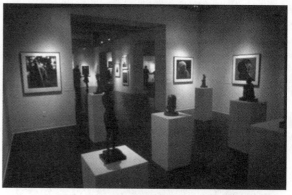

View of gallery, Austin Museum of Art - Downtown. Photograph courtesy of Austin Museum of Art, Austin, Texas.

Austin Museum of Art - Laguna Gloria

3809 West 35th St., Austin, TX 78703

Tel: (512) 458-8191

Fax: (512) 454-9408

Internet Address: http://www.amoa.org

Director: Ms. Elizabeth Ferrer

Admission: fee:
 adult-$2.00, child-free, student-$1.00, senior-$1.00.

Attendance: 75,000 *Established:* 1961

Membership: Y *ADA Compliant:* Y

Parking: free on site.

Open: Tuesday to Wednesday, 10am-5pm;
 Thursday, 10am-9pm;
 Friday to Saturday, 10am-5pm;
 Sunday, 1pm-5pm.

Closed: Legal Holidays.

Facilities: **Amphitheater**; **Arboretum**; **Architecture** (Driscoll Estate, 1916); **Exhibition Area**; **Sculpture Garden**.

Activities: **Arts Festival**; **Concerts**; **Education Programs** (adults and children); **Films**; **Lectures**; **Performances**.

Publications: brochures; collection catalogue; exhibition catalogues; newsletter (quarterly).

Exterior view of Austin Museum of Art at Laguna Gloria. Photograph courtesy of Austin Museum of Art, Austin, Texas.

The Austin Museum of Art - Laguna Gloria has operated since 1961 in a converted Mediterranean-style villa built by Hal Sevier, founder of the local newspaper, and his wife, Clara Driscoll, best known for saving the Alamo from destruction in 1904. The Museum maintains a downtown branch at 823 Congress Avenue (see above).

Elisabet Ney Museum

304 East 44th St. (between Avenues G & H in Hyde Park), Austin, TX 78751

Tel: (512) 458-2255

Fax: (512) 472-2174

Curator: Ms. Mary Collins Blackmon

Admission: free.

Attendance: 18,000 *Established:* 1911 *ADA Compliant:* Y

Open: Wednesday to Saturday, 10am-5pm; Sunday, noon-5pm.

Facilities: **Architecture** (studio of 19th-century sculptor Elisabet Ney); **Exhibition Area**.

Activities: **Permanent Exhibits**.

Elisabet Ney Museum, cont.

The Museum is housed in "Formosa", the 1892 studio of German-born sculptress Elisabet Ney (1833-1907), whose sculptures of prominent personages may also be found in state and national capitols and the Smithsonian Institution's National Museum of American Art. A National Historic Site, the Museum contains over 50 of her sculptures, including earlier sculptures of European notables, and personal memorabilia on permanent loan from the University of Texas Harry Ransom Humanities Research Center.

Mexic-Arte Museum

419 Congress Ave., Austin, TX 78701

Tel: (512) 480-9373

Fax: (512) 480-8626

Internet Address: http://www.main.org/mexic-arte/

Exec. Director: Ms. Sylvia Orozco

Admission: suggested contribution-$2.00.

Attendance: 50,000 *Established:* 1984 *Membership:* Y *ADA Compliant:* Y

Parking: street parking and pay lot.

Open: Monday to Saturday, 10am-6pm.

Closed: Legal Holidays.

Facilities: **Galleries** (over 6500 square feet); **Library**; **Shop**.

Activities: **Education Programs**; **Lectures**; **Performances**; **Permanent Exhibits**; **Temporary Exhibitions**.

Publications: newsletter (monthly).

The Mexic-Arte is a community-based museum located in downtown Austin. Since 1983, the Museum has been a leader in the community for its promotion of Mexican and Latino art. The museum strives to preserve culture and tradition as well as promote evolving contemporary art. It has produced hundreds of exhibitions featuring regional, national, and international artists, including Diego Rivera, Frida Kahlo, David Medallo, and Juan Soriano. To promote local emerging artists, it presents regular exhibitions of their work. The Museum has eight permanent exhibitions, which are shown on a rotating basis: Prints from the Workshop of Popular Graphics; the Agustan Carasola Archive: Photos from the Mexican Revolution; Jose Guadalupe Posada Prints; William Prettyman: Photographs of Plains Tribes; Tzotziles and Tzontales; History and Humanities of the Mexican American Culture in Austin; Masks from Guerrero; and Pre-Columbian Artifacts.

Umlauf Sculpture Garden & Museum

605 Robert E. Lee Road, Austin, TX 78704

Tel: (512) 445-5582

Fax: (512) 445-5583

Internet Address: http://www.io.com/~tam/umlauf

Director: Nelie Plourde

Admission: fee: adult-$3.00, child-free, student-$1.00, senior-$2.00.

Attendance: 27,000 *Established:* 1991

Membership: Y *ADA Compliant:* Y

Parking: next to museum.

Open: **September to May**,
Wednesday to Friday, 10am-4:30pm;
Saturday to Sunday, 1pm-4:30pm.

June to August,
Wednesday to Saturday, 10am-4:30pm;
Sunday, 1pm-4:30pm.

Charles Umlauf, *Lotus*, 1960, Bronze sculpture. Umlauf Sculpture Garden & Museum. Photograph courtesy of Umlauf Sculpture Garden & Museum, Austin, Texas.

Closed: New Year's Day, Independence Day, Thanksgiving Day, Christmas Day.

Facilities: **Archives**; **Exhibition Area** (3,500 square feet); **Library**; **Sculpture Garden**; **Shop**; **Xeriscape Garden**.

Activities: **Arts Festival**; **Education Programs** (children); **Guided Tours**; **Lectures**; **Performances**; **Temporary Exhibitions**.

Umlauf Sculpture Garden and Museum, cont.

Publications: newsletter, "Garden Grapevine" (semi-annual).

In 1985 Charles Umlauf, professor emeritus of sculpture at the University of Texas, donated to the City of Austin nearly 200 pieces of sculpture he had created. In 1991 the Umlauf Sculpture Garden and Museum was completed to house the collection.

University of Texas at Austin - Jack S. Blanton Museum of Art

Harry Ransom Humanities Research Center
21st & Guadalupe Streets
Austin, TX 78712-1205
Tel: (512) 471-7324
Fax: (512) 471-7023
Internet Address: http://www.utexas.edu/cofa/bma
Director: Ms. Jessie Otto Hite
Admission: voluntary contribution.
Attendance: 100,000 *Established:* 1963
Membership: Y *ADA Compliant:* Y
Parking: free on site.
Open: Monday/Wednesday/Friday, 9am-5pm;
Thursday, 9am-9pm;
Saturday to Sunday, 1pm-5pm.
Closed: Legal Holidays.
Facilities: **Exhibition Spaces** (2).
Activities: **Education Programs** (children); **Films**; **Guided Tours**; **Lectures**; **Temporary Exhibitions**; **Traveling Exhibitions**.
Publications: exhibition catalogues; newsletter.

Thomas Hart Benton, *Romance*, 1932, tempera and oil varnish glazes on gesso panel. Archer M. Huntington Art Gallery, University of Texas at Austin, gift of Mari and James A. Michener, 1991. Photograph by George Holmes, courtesy of University of Texas, Austin, Texas.

The Jack S. Blanton Museum of Art, formerly known as the Archer M. Huntington Art Gallery, is the fine arts museum of the University of Texas at Austin. With a collection of over 13,000 objects, a full-time staff of 30, and an operating budget of approximately $1.8 million, the Blanton describes itself as one of the top five university museums in this country. Housed at two separate locations, the Museum's permanent collection, on view in the Harry Ransom Center, includes Ancient Art, European Art, 19th- and 20th-Century American Art, and Contemporary Latin American Art. The Collection of Prints and Drawings is exhibited in the Museum in the Art Building at 23rd and San Jacinto Streets. Each year over 15,000 people participate in programs at the Blanton, which include two public school outreach programs. The Museum hosts the best public collection of post-60's Latin American art in the U.S. Its Prints and Drawings Collection, with over 11,000 works on paper, is the best collection in the Southwest. Works range from Old Masters like Rembrandt and Dürer, to 18th century European, to contemporary American. The Mari and James A. Michener Collection is the core of the Museum's 20th-century American art exhibit. It consists of 375 paintings dating from 1907 to the present. The Museum is in the process of building a new 150,000 square foot building at the corner of Martin Luther King Boulevard and Speedway, scheduled to open in 2004. The permanent collection galleries in the Ransom Center will be closed in late 2000. Selections from the permanent collection will be reinstalled in the Art Building exhibition space and accessible to the public beginning in late August 2000.

Beaumont

Art Museum of Southeast Texas

500 Main St., Beaumont, TX 77704
Tel: (409) 832-3432
Fax: (409) 832-8508
Exec. Director: Mr. Jeffrey J. York
Admission: suggested contribution-$2.00.
Attendance: 70,000 *Established:* 1950 *Membership:* Y *ADA Compliant:* Y
Parking: free on site.

Art Museum of Southeast Texas, cont.

Open: Monday to Friday, 9am-5pm;
　　　Saturday, 10am-5pm;
　　　Sunday, noon-5pm.

Closed: Legal Holidays.

Facilities: **Auditorium** (135 seats); **Food Services** Restaurant (Weekdays, 11am-2pm); **Galleries** (4); **Library** (1,500 volumes); **Sculpture Garden** (2); **Shop.**

Activities: **Arts Festival; Concerts; Education Programs; Films; Gallery Talks; Guided Tours** (by advance appointment); **Lectures; Temporary Exhibitions; Traveling Exhibitions.**

Publications: exhibition catalogues; newsletter, "Museum Magic" (quarterly).

Exterior view of Art Museum of Southeast Texas. Photograph courtesy of Art Museum of Southeast Texas, Beaumont, Texas.

The Art Museum of Southeast Texas occupied its newly-constructed, 24,000-square foot facility in 1987. The interior is stately, clean, and well-patterned for changing exhibits, high-volume traffic, and educational presentations. The Museum collects 19th- and 20th-century fine, folk, and decorative arts with a concentration on contemporary artists of the region. The permanent collection consists of 963 pieces.

The Art Studio, Inc. (TASI)

720 Franklin St., Beaumont, TX 77701

Tel: (409) 838-5393

Internet Address: http://www.artstudio.org

C.E.O. and Director: Mr. Greg Busceme

Admission: voluntary contribution.

Attendance: 5,000　　*Established:* 1983　　*Membership:* Y　　*ADA Compliant:* Y

Open:　Monday to Friday, 10am-5pm; Saturday, by appointment.

Facilities: **Exhibition Area** (20,000 square feet); **Shop.**

Activities: **Education Programs** (adults and children); **Guided Tours; Lectures.**

Publications: alternative press, "Issue" (bi-monthly); newsletter, "Studio Ink" (bi-monthly).

The Art Studio is an artists' cooperative of the Southeast Texas community of artists. It presents approximately ten exhibitions per year.

Beaumont Art League

2675 Gulf St., Fairgrounds, Beaumont, TX 77703

Tel: (409) 833-4179

Admission: voluntary contribution.

Attendance: 2,000　　*Established:* 1943　　*Membership:* Y　　*ADA Compliant:* Y

Open:　Tuesday to Friday, 10am-4pm.

Closed: New Year's Day, Independence Day, October (2 weeks), state fair, Thanksgiving Day Christmas Day.

Facilities: **Exhibition Area** (4,750 square feet); **Sales Gallery.**

Activities: **Education Programs** (adults and children).

Publications: newsletter, "Beaumont Art League" (monthly).

The Beaumont Art League is an artists' cooperative.

Lamar University - Dishman Art Gallery

Lamar University, 1030 Lavaca, Beaumont, TX 77705

Tel: (409) 880-8959

Fax: (409) 880-1799

Internet Address: http://www.lamar.edu

Director: Dr. Lynn Lokensgard

Beaumont, Texas

Lamar University - Dishman Art Gallery, cont.

Admission: voluntary contribution.

Attendance: 4,000 *Established:* 1983 *Membership:* N *ADA Compliant:* Y

Parking: free parking next to building.

Open: Monday to Friday, 8am-5pm.

Closed: New Year's Day, Good Friday, Memorial Day,
 Independence Day, Labor Day,
 Thanksgiving Day to Thanksgiving Friday,
 Christmas Day, between semesters.

Facilities: **Exhibition Area** (3,000 square feet); **Library**.

Activities: **Arts Festival**; **Lectures**.

Publications: exhibition catalogues.

The Dishman Art Gallery presents monthly exhibitions of
the work of contemporary artists, in addition to its
permanent collection. The permanent collection of the
Dishman Art gallery consists of the Eisenstadt Collection:
147 paintings from the 17th- through the 20th century,
including works by Lawrence, Ladell, Moran, and Gisson, as
well as over 250 porcelains, and eight sculptures. The
Eisenstadt Collection may be viewed on Tuesday, 1pm-3pm,
and Wednesday, 2pm-4pm.

Sir Thomas Lawrence, *Portrait of a Young Lady (Lady Emily Cowper)*,
1814, oil on canvas. Dishman Art Gallery, Heinz and Ruth Eisenstadt
Collection. Photograph courtesy of Dishman Art Gallery, Beaumont, Texas.

Brownsville

Brownsville Art League

230 Neale Drive, Brownsville, TX 78520

Tel: (956) 542-0941

Fax: (956) 542-7094

President, Board of Directors:
 Mr. Nick Marks Reyna

Admission: voluntary contribution.

Attendance: 8,000 *Established:* 1935

Membership: Y *ADA Compliant:* Y

Parking: parking for 50+ cars.

Drawing, exterior view of Brownsville Art League Complex.
Courtesy of Brownsville Art League, Brownsville, Texas.

Open: Monday to Friday, 9:30am-3pm; Sunday, 1pm-5pm.

Closed: Thanksgiving Day, Christmas Day, New Year's Day.

Facilities: **Architecture** (Neale House, 1836); **Library**; **Reading Room**.

Activities: **Arts Festival**; **Education Programs** (adults); **Gallery Talks**; **Guided Tours**;
 Lectures; **Temporary Exhibitions**; **Traveling Exhibitions**.

Publications: newsletter, "Brushstrokes" (quarterly).

The Brownsville Art League features a permanent collection, temporary exhibitions, art shows, and
studio classes. The permanent collection of the Art League features works by Alexander Calder,
Marc Chagall, Honoré Daumier, William Hogarth, James McNeill Whistler, and N.C. Wyeth.

College Station

Texas A&M University - MSC Forsyth Center Galleries

Texas A&M University, Memorial Student Center, Joe Routt Blvd., College Station, TX 77844-9081

Tel: (409) 845-9251

Fax: (409) 845-5117

Internet Address: http://charlotte.tamu.edu/services/Forsyth

Curator: Mr. Timothy Novak

Admission: free.

Texas A&M University - MSC Forsyth Center Galleries, cont.

Attendance: 30,000 *Established:* 1989 *ADA Compliant:* Y
Parking: free on site.
Open: Monday to Friday, 9am-5pm; Saturday to Sunday, noon-5pm.
Closed: Independence Day, Thanksgiving Day, Christmas Day to New Year's Day.
Facilities: **Exhibition Area** (9,000 square feet).
Activities: **Films**; **Guided Tours**; **Lectures**; **Traveling Exhibitions**.
Publications: exhibition catalogues.

The Galleries are located in the Memorial Student Center of Texas A&M University and schedule tours, receptions, and other events. The permanent collection of the Galleries includes art glass (English cameo glass, and works by Louis Comfort Tiffany, Frederick Carder, and many others), and works by American artists such as Frederic Remington, Charles Russell, Mary Cassatt, Winslow Homer, and Grandma Moses. Also of possible interest on campus are the J. Wayne Stark University Center Galleries (open: Tues-Fri, 9am-8pm, and Sat-Sun, noon-6pm; tel: 845-8501).The Galleries focus on works by 20th-century Texas artists.

Corpus Christi

Asian Cultures Museum and Educational Center

1809 N. Chaparral, Corpus Christi, TX 78401
Tel: (361) 882-2641
Fax: (361) 882-5718
Exec. Director: Dongwol Kim Roberson
Admission: fee: adult-$2.00, child-free.
Attendance: 6,000 *Established:* 1973 *Membership:* Y *ADA Compliant:* Y
Parking: metered on street.
Open: Tuesday to Saturday, 10am-5pm.
Closed: Legal Holidays, Easter.
Facilities: **Exhibition Area**; **Library** (6,000 volumes); **Reading Room**; **Shop**; **Zen Garden**.
Activities: **Arts Festival**; **Education Programs**; **Guided Tours**; **Lectures**.
Publications: newsletter (quarterly).

Designated by the Texas Legislature as the official state museum of Asian cultures, the focus of the Asian Cultures Museum and Educational Center is on educating it visitors about the art and culture of Asian civilizations. The permanent collection of the Museum, totaling over 8,000 objects, includes a five-foot bronze Amida Buddha; over 2,800 Japanese Hakata dolls and paintings; Chinese porcelain, lacquer ware, and opera costumes; Korean textiles, costumes, and ceramics; Indian brass artifacts; and collections from the Philippines, Vietnam, and Indonesia.

Del Mar College - Joseph A. Cain Memorial Art Gallery

East Campus, Fine Arts Center (off Ayers St.), Corpus Christi, TX 78404-3897
Tel: (361) 698-1216
Internet Address: http://www.delmar.edu/art/artdept.html
Director: Mr. William E. Lambert
Open: **Fall to Spring**, Monday to Thursday, 9am-4pm; Friday, 9am-noon.
 Summer, Monday to Thursday, 10am-4pm; Friday, 10am-noon.
Facilities: **Exhibition Areas** (Cain Gallery, 1,750 sqare feet; hallway gallery space, 450 linear feet).
Activities: **Temporary Exhibitions**.

The Joseph A. Cain Memorial Art Gallery presents temporary exhibitions focusing on issues in the academic study of contemporary art. Exhibitions include the annual National Drawing and Small Sculpture Show (the only such competition and show to be held at a community college), an annual student exhibition, and an annual stone carving sculpture exhibition.. The permanent collection, begun in 1967 by former Art Department Chairman Joseph A. Cain, constitutes a solid body of work by emerging artists.

Texas A&M University-Corpus Christi - Art Museum of South Texas

1902 N. Shoreline, Corpus Christi, TX 78401

Tel: (512) 884-3844

Fax: (512) 980-3500

Director: Dr. William G. Otton

Admission: fee: adult-$3.00, child-$1.00,
student-$2.00, senior-$2.00.

Established: 1960 *Membership:* Y

ADA Compliant: Y

Parking: free on site.

Open: Tuesday to Saturday, 10am-5pm;
Thursday, 10am-9pm;
Friday to Saturday, 10am-5pm;
Sunday, 1pm-5pm.

Closed: New Year's Day, Independence Day,
Thanksgiving Day, Christmas Day.

Facilities: **Architecture** (designed by Philip
Johnson); **Auditorium** (231 seats); **Food
Services** Restaurant; **Gift Shop**; **Library**
(2,500 volumes).

Exterior view of South Texas Institute for the Arts, designed
by Philip Johnson (1972). Photograph courtesy of South Texas
Institute for the Arts, Corpus Christi, Texas.

Activities: **Concerts**; **Education Programs** (adults and children); **Films**; **Gallery Talks**; **Guided
Tours**; **Lectures**; **Temporary Exhibitions**; **Traveling Exhibitions**.

Publications: exhibition catalogues.

Affiliated with Texas A&M University-Corpus Christi, the Art Museum of South Texas has as its
mission the collection and exhibition of visual art, with particular emphasis on the art of
the Americas and of the region, and to provide educational programs in support of visual art. The
collection of the Museum emphasizes the region, including Texas, surrounding states, and Northern
Mexico. Its holdings include works by Edward Laning, Lahib Jaddo, Alexander Hogue, Antonio E.
Garcia, Ricardo Ruiz, Bruno Andrade, Lucas Johnson, David Bates, Ken Holder, and Dennis Blagg.

Texas A&M University-Corpus Christi - Weil Gallery

6300 Ocean Drive, Corpus Christi, TX 78412

Tel: (512) 994-2314

Fax: (512) 994-6097

Internet Address: http://www.tamucc.edu

Director: Mr. Jim Edwards

Admission: free.

Open: Monday, 10am-4pm; Tuesday, 10am-7pm; Wednesday to Thursday, 10am-4pm;
Friday, 10am-3pm.

Facilities: **Exhibition Area.**

Activities: **Temporary Exhibitions.**

The Gallery presents temporary exhibitions of contemporary art including an annual student
exhibition. Exhibitions are often coordinated with related shows at the South Texas Institute for
the Arts.

Dallas

African American Museum

3536 Grand Ave., Dallas, TX 75210

Tel: (214) 565-9026

Fax: (214) 421-8204

C.E.O. and President: Mr. Harry Robinson, Jr.

Admission: free.

Attendance: 100,000 *Established:* 1974 *Membership:* Y *ADA Compliant:* Y

Parking: free on site.

African American Museum, cont.

Open: Tuesday to Friday, noon-5pm, Saturday, 10am-5pm; Sunday, 1pm-5pm.

Closed: Legal Holidays.

Facilities: **Auditorium** (100 seats); **Food Services** Restaurant; **Library** (5,000 volumes); **Sculpture Garden; Shop.**

Activities: **Education Programs** (adults and children); **Guided Tours; Lectures; Temporary Exhibitions; Traveling Exhibitions.**

Publications: newsletter (quarterly).

The Museum houses African and African American art, and features one of the largest folk art collections in the United States. The African collection includes masks, sculpture, gold, and textiles, while the African American collection consists of contemporary individual works by local, national, and internationally recognized artists, including folk artists Clementine Hunter, David Butler, and George White.

Edward Mitchell Bannister, *Landscape Scene*, 1879, oil on canvas, 16 x 24 inches. African American Museum collection. Photograph courtesy of African American Museum, Dallas, Texas.

Biblical Arts Center

7500 Park Lane, Dallas, TX 75225

Tel: (214) 691-4661

Fax: (214) 691-4752

Internet Address: http://www.biblicalarts.org

Director: Ronnie Lee Roese

Admission: fee: adult-$4.00, child-$2.50, student-$3.00, senior-$3.50.

Attendance: 48,000 *Established:* 1966

ADA Compliant: Y

Parking: free on site.

Open: Tuesday to Wednesday, 10am-5pm;
Thursday, 10am-9pm;
Friday to Saturday, 10am-5pm;
Sunday, 1pm-5pm..

Closed: New Year's Day, Thanksgiving Day,
Christmas Eve to Christmas.

Facilities: **Auditorium; Galleries; Shop; Theatre.**

Activities: **Education Programs; Lectures; Performing Arts Program; Temporary Exhibitions.**

View of gallery, Biblical Arts Center. Photograph courtesy of Biblical Arts Center, Dallas, Texas.

Housed in a Romanesque-style structure, the Biblical Arts Center utilizes the arts as a means to help people of all faiths more clearly envision the places, events, and people of the Bible. The collection of the Arts Center features art on Biblical subjects, from Old Masters to contemporary works. A highlight of the collection is "Miracle at Pentecost" by Torger Thompson, a mural 124 feet by 20 feet, which is a historical interpretation of the day of Pentecost.

Dallas Museum of Art (DMA)

1717 N. Harwood, Dallas, TX 75201

Tel: (214) 922-1200

Fax: (214) 954-0174

TDDY: (214) 922-1355

Internet Address: http://www.unt.edu/dfw/dma

Director: Mr. Jay Gates

Admission: free.

Dallas, Texas

Dallas Museum of Art, cont.

Attendance: 400,000 *Established:* 1903

Membership: Y *ADA Compliant:* Y

Parking: underground parking facility.

Open: Tuesday to Wednesday, 11am-4pm;
Thursday, 11am-9pm;
Friday, 11am-4pm;
Saturday to Sunday, 11am-5pm;
Holidays, 11am-5pm.

Closed: New Year's Day, Thanksgiving Day, Christmas Day.

Facilities: **Auditorium** (350 seats); **Food Services** Restaurants (one formal; one casual); **Library** (50,000 volumes); **Reading Room**; **Sculpture Garden**; **Shop**.

Activities: **Concerts**; **Education Programs** (adults and children); **Films**; **Gallery Talks**; **Guided Tours**; **Lectures**; **Temporary Exhibitions**; **Traveling Exhibitions**.

Publications: "President's Newsletter"; calendar (bi-monthly); collection catalogue; exhibition catalogues.

Coffin (detail), Egypt, ca. 700 B.C., wood, gesso, paint, obsidian, calcite, and bronze. Green Estate Acquisition Fund, Dallas Museum of Art. Photograph courtesy of Dallas Museum of Art, Dallas, Texas.

The Dallas Museum of Art currently occupies a 370,000-square-foot facility designed by Edward Larrabee Barnes and completed in 1983. The museum provides stimulating cultural opportunities and entertainment via the visual arts, as well as lectures, concerts, films, and other programming. The Museum's permanent collection is distinguished by major holdings in a large number of areas: Arts of Asia, Africa, and the Pacific (an extensive group of Egyptian and Nubian art, including sculptures of gods and kings, funerary objects, jewelry, and a stele; art of the African Senufo, Yoruba, Ibo, and Luba peoples; Buddhist and Hindu sculptures, bronzes and ceramics from China and Japan, and Japanese paintings and decorative arts; and Indonesian and Melanesian art, including textiles, and sculpture); Contemporary Art (a comprehensive collection from abstract expressionism of the 1940's through installation art of the 1980's, including works by Pollock, Rothko, Kline, Motherwell, Rosenquist, Johns, Rauschenberg, Oldenburg, Warhol, Moore, and Kelly); European Art (Greek and Roman funerary sculpture, and Greek, Roman, and Etruscan gold jewelry; paintings by Canaletto, Fuseli, Turner, Burne-Jones, Lawrence, Monet, Degas, Cézanne, Van Gogh, Gauguin, Vuillard, Toulouse-Lautrec, Pissarro, Mondrian, and Léger); and the American Collection (representing a continuum of civilizations of the Western Hemisphere from 1000 B.C. to A. D. 1945, including ceramics, textiles, and decorative arts from the Chavin, Nasca, Chimu, Calima, Olmec, Maya, Aztec, and Anasazi cultures; Spanish Colonial works; and American art, including works by Copley, Cole, Church, Sargent, Hassam, O'Keeffe, and Wyeth).

Dallas Visual Art Center (DVAC)

2917 Swiss Ave., Dallas, TX 75204-5987

Tel: (214) 821-2522

Fax: (214) 821-9103

Exec. Director: Ms. Katherine Wagner

Admission: voluntary contribution.

Attendance: 50,000 *Established:* 1981

Membership: Y *ADA Compliant:* Y

Open: Monday, 9am-5pm;
Tuesday, 9am-9pm;
Wednesday to Friday, 9am-5pm;
Saturday, noon-4pm.

Closed: Legal Holidays.

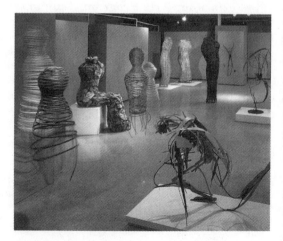

Frances Bagley, exhibition of sculptural works, "La Piazza", 1996, Dallas Visual Arts Center. Photograph courtesy of Dallas Visual Arts Center, Dallas, Texas.

Dallas Visual Art Center, cont.

Facilities: **Auditorium** (with performance stage); **Galleries** (5); **Shop**.
Activities: **Arts Festival**; **Juried Exhibits**; **Lectures**.
Publications: exhibition catalogues; newsletter, "Visual Exchange" (bi-monthly).

Housed in a 24,000-square-foot renovated warehouse in the Wilson Historic District adjacent to downtown Dallas, the Dallas Visual Arts Center features year-round exhibitions of the work of regional artists, from the emerging to the accomplished, as well as seminars, classes, lectures, and performances. The Center also shares its exhibition space with other arts organizations.

Southern Methodist University - The Meadows Museum

SMU School of the Arts, Bishop Blvd., Dallas, TX 75275-0357
Tel: (214) 768-2516
Fax: (214) 768-1688
Internet Address:
 http://www.smu.edu/meadows/museum
Admission: suggested contribution-$3.00.
Attendance: 30,000 *Established:* 1965
Membership: Y *ADA Compliant:* Y
Parking: free on site.
Open: Monday to Tuesday, 10am-5pm;
 Thursday, 10am-8pm;
 Friday to Saturday, 10am-5pm;
 Sunday, 1pm-5pm.
Closed: New Year's Day, Easter,
 ML King Birthday, Memorial Day,
 Independence Day, Thanksgiving Day,
 Christmas Day.

Murillo, *Jacob Laying Peeled Rods before the Flocks of Laban*, c. 1665. Meadows Museum. Photograph courtesy of Meadows Museum, Dallas, Texas.

Facilities: **Sculpture Garden**; **Shop**.
Activities: **Guided Tours**.
Publications: brochures.

The Meadows Museum was founded in 1965, after Texas philanthropist and oil financier Algur H. Meadows donated his collection of paintings and prints to Southern Methodist University. Meadows had begun to acquire the collection, which is particularly strong in Spanish art, after a series of visits to the Prado in 1950. The Meadows presents major works from the Middle Ages to the present, including masterpieces by Velasquez, Ribera, Zurburan, Murillo, Goya, Miró, and Picasso. The sculpture garden displays works by Rodin, Maillol, Moore, Noguchi, and Lipchitz.

Denton

Texas Woman's University Fine Arts Gallery

Texas Woman's University, 1 Circle Drive, Denton, TX 76204
Tel: (817) 898-2530
Fax: (817) 898-3198
Internet Address: http://www4.twu.edu/as/art/gallery
Director: Ms. Correy Stuckenbruck
Admission: free.
Established: 1901 *ADA Compliant:* Y
Open: Monday to Friday, 9am-4pm.
Closed: Legal Holidays.
Activities: **Education Programs** (adults, students and children); **Films**; **Gallery Talks**; **Guided Tours**; **Lectures**; **Temporary Exhibitions**.

The Fine Arts Gallery presents temporary exhibitions of student and faculty work, as well as that of artists from outside the University community.

Denton, Texas

University of North Texas Art Gallery

School of Visual Arts, Mulberry at Welch, Denton, TX 76203
Tel: (940) 565-4005
Fax: (940) 565-4717
Internet Address: http://www.art.unt.edu/sova/galleries/index.html
Director: Ms. Diana Block
Admission: voluntary contribution.
Attendance: 5,000 *Established:* 1972
ADA Compliant: Y
Open: **September to May,**
　　　Monday to Tuesday, noon-8pm; Wednesday to Saturday, noon-5pm.
　　　June to August,
　　　Call for hours.
Closed: Between Semesters, Spring Break.
Facilities: **Exhibition Area** (2,250 square feet).
Activities: **Temporary Exhibitions.**
Publications: exhibition catalogues.

　The University of North Texas Art Gallery presents temporary exhibitions, with emphasis on curatorial projects in contemporary art. Also of possible interest on campus is the Cora Stafford Gallery.

Edinburg

University of Texas-Pan American - Galleries

1201 West University Drive, Edinburg, TX 78539-2999
Tel: (956) 381-2655
Fax: (956) 384-5072
Internet Address: http://www.panam.edu/dept/art/gallery.htm
Director: Ms. Valerie Innella
Admission: free.
Attendance: 15,000 *Established:* 1973
Membership: N *ADA Compliant:* Y
Parking: parking lots nearby.
Open: Monday to Friday, 9am-4pm.
Closed: Academic Holidays.
Facilities: **Galleries** (3, total of 4,400 square feet).
Activities: **Guided Tours** (by appointment); **Lectures** (by exhibiting artists).

　The University of Texas-Pan American has three galleries on its main campus: the Clark, University, and Lamar Galleries. The Clark and University galleries offer temporary exhibitions by award-winning contemporary artists from the United States and Mexico, as well as BFA student shows. The Permanent Collection is housed in the Lamar Gallery and includes works by Josef Albers, Salvador Dali, Eduardo Garcia, Man Ray, Francis Picabia, Georges Roualt, and Francisco Goya.

Maria Alba Gonzalez, *Dancers*, 1999, exhibited as part of a bachelor of fine art exhibition, 1999, University of Texas-Pan American Art Gallery. Photograph courtesy of University of Texas-Pan American, Edinburg, Texas.

El Paso

El Paso Museum of Art

1211 Montana Ave., El Paso, TX 79902
Tel: (915) 541-4040
Fax: (915) 533-5688
Director: Ms. Becky Duval Reese
Admission: voluntary contribution.
Attendance: 96,000 *Established:* 1959 *Membership:* Y *ADA Compliant:* Y
Parking: free on site.

El Paso Museum of Art, cont.

Open: Tuesday to Wednesday, 9am-5pm; Thursday, 9am-9pm; Friday to Saturday, 9am-5pm; Sunday, 1pm-5pm.

Closed: Legal Holidays.

Facilities: **Auditorium** (168 seats); **Library** (2,000); **Shop**.

Activities: **Arts Festival**; **Education Programs** (adults and children); **Films**; **Gallery Talks**; **Guided Tours**; **Lectures**; **Temporary Exhibitions**; **Traveling Exhibitions**.

Publications: exhibition catalogues; newsletter (quarterly).

The El Paso Museum of Art exhibits the Kress Collection of 13th- to 18th-century painting and sculpture, American art, including paintings of the Taos and Santa Fe Schools, and Mexican retablo painting.

University of Texas at El Paso - University Art Galleries

Fox Fine Arts Center (off Sun Bowl Drive), El Paso, TX 79968

Tel: (915) 747-7837

Fax: (915) 747-6749

Internet Address: http://www.utep.edu/arts/calendar.htm

Director: Mr. Gene Flores

Open: Monday to Friday, 10am-5pm.

Facilities: **Galleries**.

Activities: **Temporary Exhibitions**; **Visiting Artists Series**.

The Gallery maintains two galleries in the Fox Fine Arts Center. The Main Gallery mounts temporary group exhibitions of work by visiting artists, faculty and students; the Glass Gallery presents the work of professional artists as well as MA and BA exhibitions. Past exhibitions have included work by Eric Avery, Robert Colescott, Dan Flavin, Gronk, Donald Judd, and Hermann Nitsch.

Fort Worth

Amon Carter Museum

3501 Camp Bowie Blvd., Fort Worth, TX 76107

Tel: (817) 738-1933

Fax: (817) 246-3373

Internet Address: http://www.cartermuseum.org

Director: Dr. Rick Stewart

Admission: voluntary contribution.

Attendance: 100,000 *Established:* 1961

Membership: Y *ADA Compliant:* Y

Parking: free on site.

Open: Closed for expansion.
 Scheduled to reopen in fall 2001.

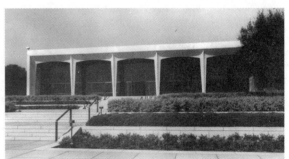

Exterior view of Amon Carter Museum (1961), designed by Philip Johnson. Photograph courtesy of Amon Carter Museum, Fort Worth, Texas.

Closed: New Year's Day, Independence Day, Thanksgiving Day, Christmas Day.

Facilities: **Library** (38,000 volumes); **Reading Room**; **Shop**; **Theatre** (170 seat).

Activities: **Films**; **Guided Tours**; **Lectures**; **Temporary Exhibitions**; **Traveling Exhibitions**.

In 1961, the Amon Carter Museum opened in order to house the collection of paintings and sculpture by Frederic Remington and Charles M. Russell acquired by Fort Worth publisher and philanthropist Amon G. Carter, Sr. (1879-1955). Since its inception, its collection of American art has grown from 400 works to over 300,000. The space necessary to store and display these holdings has forced the Museum to close for expansion. When the Museum reopens, there will be galleries devoted to the works of Remington and Russell, as well as rooms featuring views of the American West as depicted by 19th- and 20th-century artists. Among the Museum's painting collection are 19th-century landscapes by Frederic Church, Thomas Cole, and Albert Bierstadt; trompe l'oeil still lifes by William Harnett and John Frederick Peto; and examples of American impressionism and modernism with masterworks by William Merritt Chase, Stuart Davis, and Georgia O'Keeffe. The Carter's collection of works on paper includes over 600 watercolors and drawings and more than 5,700 prints, including complete sets of prints by George Bellows and Stuart Davis. In addition to over 100 works by Remington and Russell, holdings in sculpture include works by Robert Laurent, Elie Nadelman,

Fort Worth, Texas

Amon Carter Museum, cont.

Augustus Saint-Gaudens, and Bessie Potter Vonnoh. Its photography collection covers the medium from its advent to the present. The Museum's collections, exhibitions, public programs, and publications support the study and appreciation of American art. One of the most active publishers among art museums in the country, the Amon Carter Museum has published over 100 books, both independently and in conjunction with major publishers. While the Amon Carter Museum is closed for expansion, visitors may still view works of American Art from the Museum's collection at The Carter Downtown (see separate listing). The new Museum building will open in fall 2001 with three times the exhibition space.

Amon Carter Museum/The Carter Downtown

500 Commerce St., Sundance Square
(across from the Bass Performance Hall)
Fort Worth, TX 76102
Tel: (817) 738-1933
Fax: (817) 246-3373
Internet Address: http://www.cartermuseum.org
Director: Dr. Rick Stewart
Admission: voluntary contribution.
Attendance: 100,000 *Membership:* Y
ADA Compliant: Y
Parking: on street or adjacent commercial lots.
Open: Tuesday to Wednesday, 10:30am-5pm
 Thursday to Saturday, 10:30am-8pm;
 Sunday, noon-5pm.
Closed: New Year's Day, Independence Day,
 Thanksgiving Day, Christmas Day.

William J. McCloskey, *Wrapped Oranges*, 1889, oil on canvas. Acquisition in memory of Katrine Deakins, Trustee, Amon Carter Museum, 1961-1985 (1985.251). Photograph courtesy of Amon Carter Museum, Fort Worth, Texas.

Facilities: **Gallery** (2,700 square feet); **Shop** (books, postcards, posters).
Activities: **Guided Tours** (Fri, noon; Sat-Sun, 2pm); **Lectures**; **Rotating Exhibitions**.

While the Amon Carter Museum main facility (see separate listing above) is closed for expansion, the Carter Downtown displays approximately 30 works of art at a time from the collection. In addition to the paintings, sculpture, photographs, and works on paper in the gallery, the space includes models, architectural renderings, computer-aided design graphics, and site elevations of architect Philip Johnson's expansion plans.

The Contemporary Art Center of Fort Worth

500 Commerce St., Suite 104, Fort Worth, TX 76102
Tel: (817) 877-5550
Fax: (817) 870-0312
Director: Mr. Carl McQueary
Admission: free.
Attendance: 10,000 *Established:* 1996 *Membership:* Y
Open: Wednesday to Thursday, 11am-6pm; Friday to Saturday, 11am-8pm; Sunday, noon-5pm.
Facilities: **Exhibition Area**; **Shop**.
Activities: **Temporary Exhibitions**.

The Art Center presents temporary exhibitions of works by local and regional artists.

Kimbell Art Museum

3333 Camp Bowie Blvd., Fort Worth, TX 76107
Tel: (817) 332-8451
Fax: (817) 877-1264
Internet Address: http://www.kimbellart.org
Director: Dr. Timothy Potts
Admission: free.
Attendance: 284,000 *Established:* 1972 *Membership:* Y *ADA Compliant:* Y

Kimbell Art Museum, cont.

Parking: free on site.

Open: Tuesday to Thursday, 10am-5pm;
Friday, noon-8pm;
Saturday, 10am-5pm;
Sunday, noon-5pm.

Closed: New Year's Day, Thanksgiving Day,
Christmas Day.

Facilities: **Architecture** (designed by Louis I.
Kahn); **Auditorium** (180 seats); **Food
Services** Restaurant; **Library** (37,000 volumes); **Reading Room**; **Shop**.

Activities: **Concerts**; **Education Programs**
(adults, students and children); **Films**;
Gallery Talks; **Guided Tours**; **Lectures**;
Temporary Exhibitions.

Publications: calendar; exhibition catalogues.

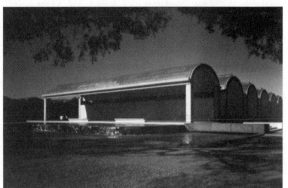

Kimbell Art Museum (1972), designed by Louis I. Kahn. Photograph courtesy of Kimbell Art Museum. Fort Worth, Texas.

The Kimbell Art Foundation was established by Kay Kimbell, a successful entrepreneur in the grain business, retailing, real estate, and petroleum, his wife, Velma Fuller Kimbell, and Mr. Kimbell's sister and her husband, Dr. and Mrs. Coleman Carter, in the 1930's shortly after Mr. and Mrs. Kimbell purchased their first paintings. The Kimbells continued to collect artworks, and when Mr. Kimbell died in 1964, he bequeathed his art collection and entire personal fortune to the Foundation to establish and maintain a public art museum of the first rank in Fort Worth. By 1966, the Kimbell Art Foundation board of directors had appointed Dr. Richard F. Brown as the Museum's first director and adopted the policy to "form collections of the highest aesthetic quality, derived from any and all periods in man's history, and in any medium or style." They envisioned a small assembly of objects that exemplified the highest aspirations of past generations enshrined under natural light in modestly scaled galleries of fine materials that would "charm" as well as enrich the visitor. The Kimbell Art Museum's holdings range in period from antiquity to the 20th-century, including masterpieces from Fra Angelico and Caravaggio to Cézanne and Matisse. The Museum has a substantial collection of Asian art, and has also assembled small but select groups of Meso-American and African pieces, as well as Mediterranean antiquities.

Modern Art Museum of Fort Worth

1309 Montgomery St., Fort Worth, TX 76107

Tel: (817) 738-9215

Fax: (817) 735-1161

Internet Address: http://www.mamfw.org

Director: Dr. Marla J. Price

Admission: free.

Attendance: 80,000 *Established:* 1892

Membership: Y *ADA Compliant:* Y

Parking: free on site.

Open: Tuesday to Friday, 10am-5pm;
Saturday, 11am-5pm;
Sunday, noon-5pm.

Closed: Legal Holidays.

Facilities: **Library**; **Print Study Room**.

Activities: **Education Programs**; **Films**; **Gallery Talks**;
Guided Tours; **Lectures**; **Temporary Exhibitions**.

Publications: brochures; calendar (bi-monthly); exhibition
catalogues; posters.

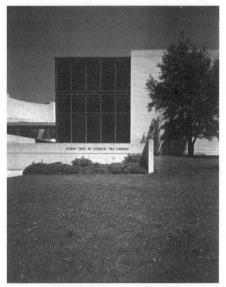

Exterior view of The Modern Art Museum of Fort Worth (1954), designed by Herbert Bayer, addition (1974), designed by O'Neil Ford and Associates. Photograph courtesy of The Modern Art Museum of Fort Worth, Fort Worth, Texas.

Chartered in 1892, the Modern Art Museum of Fort Worth is the oldest art museum in Texas. The Museum's permanent collection focuses on modern and contemporary American and European art, including

765

Modern Art Museum of Fort Worth, cont.

paintings, sculpture, works on paper, and international contemporary photography. The Museum has selected Japanese architect Tadao Ando to design a new facility. The Museum maintains a branch, the Modern at Sundance Square, located in downtown Fort Worth (see below).

The Modern at Sundance Square

410 Houston St., Fort Worth, TX 76102

Tel: (817) 335-9215

Fax: (817) 335-9220

Internet Address: http://www.mamfw.org

Admission: free.

Attendance: 90,000 *Established:* 1995

Membership: Y *ADA Compliant:* Y

Parking: commercial adjacent to site.

Open: Monday to Thursday, 11am-6pm;
Friday to Saturday, 11am-10pm;
Sunday, 1pm-5pm.

Closed: Legal Holidays.

Facilities: **Architecture** (Sanger Building, 1929; renovation by Ames Fender).

Activities: **Temporary Exhibitions.**

Interior view, The Modern at Sundance Square. Photograph by David Woo, courtesy of The Modern Art Museum of Fort Worth, Fort Worth, Texas.

An annex of the Modern Art Museum of Fort Worth located in downtown Fort Worth in the historic Sanger Building, the Gallery is listed on the National Register of Historic Places. The facility contains space for exhibiting works from the Museum's permanent collection of modern and contemporary American and European painting, sculpture, works on paper, and photography, as well as a museum store. See listing above for the Modern Art Museum of Fort Worth.

Sid Richardson Collection of Western Art

309 Main St., Fort Worth, TX 76102

Tel: (817) 332-6554

Fax: (817) 332-8671

Internet Address: http://www.sidrmuseum.org

Director: Jan Brenneman

Admission: free.

Attendance: 50,000 *Established:* 1982

ADA Compliant: Y

Parking: free, 3 hours at Chisholm Trail Lot.

Open: Tuesday to Wednesday, 10am-5pm;
Thursday to Friday, 10am-8pm;
Saturday, 11am-8pm;
Sunday, 1pm-5pm.

Closed: Legal Holidays.

Facilities: **Shop** (books, cards, prints, posters).

Frederic Remington, *Buffalo Runners - Big Horn Basin*, 1909, oil on Canvas, 30 1/8 x 51 1/8 inches. Sid Richardson Collection of Western Art. Photograph courtesy of Sid Richardson Collection of Western Art, Fort Worth, Texas.

Activities: **Education Programs**; **Guided Tours** (by appointment).

Publications: brochures; collection catalogue; gallery guides.

The Sid Richardson Collection of Western Art is located in Sundance Square, an area of restored turn-of-the-century buildings containing shops, restaurants, theatres, and museums in the heart of downtown Fort Worth. The building is a replica of the original 1895 structure, which was rebuilt after it was damaged by fire in 1980. The Museum features a collection of paintings by the premier artists of the American West, Frederic Remington and Charles M. Russell. On display are 56 paintings from the personal collection of the late oilman and philanthropist Sid W. Richardson.

Texas Christian University - Moudy Exhibition Hall

University Drive and Cantey, Fort Worth, TX 76129

Tel: (817) 257-7643

Fax: (817) 257-7399

Texas Christian University - Moudy Exhibition Hall, cont.

Internet Address: http://www.tcu.edu
Director and Chairman: Mr. Ronald Watson
Admission: free.
Established: 1874 *ADA Compliant:* Y
Open: Academic Year,
 Monday, 11am-6pm; Tuesday to Friday, 11am-4pm; Saturday to Sunday, 1pm-4pm.
Closed: Spring Break, Easter, Summer, Christmas Break.
Activities: **Education Programs** (adults and students); **Lectures**.

During the academic year, the Moudy Exhibition Hall presents juried shows of community and student work as well as exhibitions by students, faculty, and national and international artists, relating to the programs of the Department of Art and Art History.

Glen Rose

Barnard's Mill Art Museum

307 S.W. Barnard St., Glen Rose, TX 76043
Tel: (817) 897-2611
Director: Mr. Richard H. Moore
Admission: voluntary contribution.
Attendance: 600 *Established:* 1989
Open: Saturday, 10am-5pm; Sunday, 1pm-5pm.
Closed: Christmas Eve to Christmas Day.
Facilities: **Library**.
Activities: **Education Programs** (students);
 Guided Tours.

Exterior view of grist mill (1860), Barnard's Mill Art Museum. Photograph courtesy of Barnard's Mill Art Museum, Glen Rose, Texas.

Barnard's Mill Art Museum is a part of historic Barnard's Mill, the first permanent structure in the Glen Rose area. The Mill is on both the Texas and the National Registers of Historic Places. The Museum contains paintings by Jewell Miears Fielder, Amy Miears Jackson, Robert Summers, Jack Bryant, R. Kleinfelder, and Morris Henry Hobbs.

Houston

Art League of Houston

1953 Montrose Blvd., Houston, TX 77006-1243
Tel: (713) 523-9530
Fax: (713) 523-4053
Exec. Director: Ms. Linda Haag Carter
Admission: voluntary contribution.
Attendance: 5,000 *Established:* 1948 *Membership:* Y *ADA Compliant:* Y
Open: Monday to Friday, 9am-5pm.
Closed: Legal Holidays.
Facilities: **Gallery**.
Activities: **Education Programs** (adults and children); **Juried Exhibits**; **Lectures**;
 Traveling Exhibitions.
Publications: newsletter (bi-monthly).

The Art League of Houston is one of the city's oldest alternative exhibition spaces. Its mission is to encourage and support the visual arts through exhibition, education, and outreach.

Bayou Bend Collection and Gardens

1 Wescott St., Houston, TX 77007-7009
Tel: (713) 639-7750
Fax: (713) 639-7770
Director: Mr. David B. Warren
Admission: fee, house & gardens.

Bayou Bend Collection and Gardens, cont.

Attendance: 62,000 *Established:* 1956 *Membership:* Y *ADA Compliant:* Y

Open: **House Guided Tours** (reservation only),
Tuesday to Friday, 10am-2:45am; Saturday, 10am-11:15am.

House Self-Guided,
Saturday to Sunday, 1pm-5pm.

Garden,
Tuesday to Saturday, 10am-5pm.

Facilities: **Architecture**; **Gardens** (14 acres); **Library** (5,000 volumes).

Activities: **Education Programs** (adults, students and children); **Guided Tours** (house and garden); **Lectures**.

Edward Hicks, *Peaceable Kingdom*, c. 1826-28, oil on canvas. Bayou Bend Collection, gift of Miss Ima Hogg. Photograph courtesy of Museum of Fine Arts, Houston, Texas.

A subsidiary institution of The Museum of Fine Arts, Houston (see below), Bayou Bend exhibits a remarkable collection of American fine and decorative arts. Its 28 room settings trace the evolution of style from 1620 to 1870. Masterworks of painting are on view, including portraits by John Singleton Copley and Charles Willson Peale. The gardens reflect the evolution of style over six decades.

Contemporary Arts Museum

5216 Montrose Blvd., Houston, TX 77006-6598

Tel: (713) 284-8250

Fax: (713) 284-8275

Internet Address: http://www.camh.org

Director: Marti Mayo

Admission: free.

Attendance: 100,000 *Established:* 1948

Membership: Y *ADA Compliant:* Y

Parking: on street.

Open: Tuesday to Wednesday, 10am-5pm;
Thursday, 10am-9pm;
Friday to Saturday, 10am-5pm;
Sunday, noon-5pm.

Closed: New Year's Day,, Thanksgiving Day, Christmas Day.

Exterior view of Contemporary Arts Museum (1971), designed by Gunnar Birkerts; renovation (1997) by William F. Stern and Associates. Photograph courtesy of Contemporary Arts Museum, Houston, Texas.

Facilities: **Galleries** (2); **Shop**.

Activities: **Films**; **Gallery Talks**; **Guided Tours**; **Lectures**; **Temporary Exhibitions**; **Traveling Exhibitions**.

Publications: exhibition catalogues.

The Museum does not maintain a permanent collection. Rather, it presents a continuing series of carefully curated temporary exhibitions of significant international, national and regional contemporary art.

Cy Twombly Gallery - The Menil Collection

1501 Branard St., Houston, TX 77006

Tel: (713) 525-9400

Fax: (713) 525-9444

Admission: free.

Attendance: 30,000

Open: Wednesday to Sunday, 11am-7pm.

Cy Twombly Gallery - The Menil Collection, cont.

In February 1995, The Menil Collection (see below), in collaboration with the artist Cy Twombly and Dia Center for the Arts, New York, opened the Cy Twombly Gallery, an exhibition annex housing a permanent installation of Twombly's art. In the mid-1950s, following travels in Europe and Africa, Twombly emerged as a prominent figure among a group of artists working in New York that included Robert Rauschenberg and Jasper Johns. In 1959, Twombly settled permanently in Italy. He has had numerous one-person exhibitions internationally and has been the subject of major retrospectives in both Europe and America. Twombly's painting combines elements of gestural abstraction, drawing, and writing in a very personal expression. At once epic and intimate, his work is infused with references to literature and aspects of the

Exterior view of entrance, Cy Twombly Gallery, designed by Renzo Piano. Photograph by Hickey-Robertson, courtesy of The Menil Collection, Houston, Texas.

Mediterranean and Near-Eastern worlds. The building houses more than thirty of Twombly's paintings, sculptures, and works on paper, dating from 1954 to 1994. Among these are a number of his large-scale masterworks such as "The Age of Alexander", 1959-60, "Triumph of Galatea", 1961, and the monumental painting "Untitled (Say Goodbye Catallus, to the Shores of Asia Minor", 1994. The gallery, designed by Renzo Piano, has a sophisticated roofing system that allows for an even diffusion of natural light. An external canopy of fixed louvers first breaks the sunlight over a sloping, hipped glass roof. Passing through ultraviolet filtering glass, the light is controlled by mechanical louvers, and finally dispersed within the galleries by the stretched cotton fabric ceiling.

The Menil Collection

1515 Sul Ross, Houston, TX 77006-6589

Tel: (713) 525-9400

Fax: (713) 525-9444

Internet Address: http://www.menil.org

Director: Mr. Ned Rifkin

Admission: free.

Attendance: 100,000 *Established:* 1980

Membership: Y *ADA Compliant:* Y

Parking: free on site.

Open: Wednesday to Sunday, 11am-7pm.

Closed: Legal Holidays.

Facilities: Bookstore.

Activities: Temporary Exhibitions; Traveling Exhibitions.

Publications: collection catalogue.

View of Oceanic Gallery and garden atrium, The Menil Collection, designed by Piano & Fitzgerald. Photograph courtesy of The Menil Collection, Houston, Texas.

The Menil Collection opened in 1987 to house the art collection of John and Dominique de Menil. Considered one of the most important privately assembled collections of the 20th century, The Menil Collection houses approximately 15,000 paintings, sculptures, prints, drawings, photographs, and rare books. Masterpieces from antiquity, the Byzantine and medieval worlds, the tribal cultures of Africa, Oceania, and the American Pacific Northwest, and the 20th century are particularly well represented. Among the highlights of the museum are its Surrealist holdings, widely regarded as one of the world's foremost collections of its kind. The Menil Collection displays selections from its permanent collection and regularly offers special exhibitions and programs to the public. Acclaimed by critics as a triumph of modern architecture, The Menil Collection building was designed by a joint venture of Renzo Piano/Building Workshop, Genoa, Italy and Richard Fitzgerald & Partners, Houston. The museum's ingenious roof and skylight system, interior atrium gardens, and large windows fill the galleries with natural light, reflecting subtle changes of weather, season, and time of day. The Menil

Houston, Texas

The Menil Collection, cont.

Collection's exterior, a long, understated facade of white steel and gray cypress siding, stands in harmony with the surrounding 1920s-era bungalows. Within immediate walking distance of The Menil Collection are the museum's Cy Twombly Gallery (see entry above) and two other independent institutions of interest to visitors - the Rothko Chapel (see entry below) and Byzantine Fresco Chapel Museum.

The Museum of Fine Arts, Houston

1001 Bissonnet, Houston, TX 77005

Tel: (713) 639-7300

Fax: (713) 639-7399

TDDY: (713) 639-7390

Internet Address: http://www.mfah.org

Director: Mr. Peter C. Marzio

Admission: fee: adult-$3.00, child-$1.50, student-$1.50, senior-$1.50.

Attendance: 1,100,000 *Established:* 1900

Membership: Y *ADA Compliant:* Y

Parking: free on site.

Open: Tuesday to Wednesday, 10am-5pm;
Thursday, 10am-9pm;
Friday to Saturday, 10am-5pm;
Sunday, 12:15pm-6pm.

Closed: Labor Day, Thanksgiving Day, Christmas Day.

Lyonel Feininger, *Zirchow I*, 1912, Oil on canvas. Sarah Campbell Blaffer Foundation. Museum of Fine Arts. Photograph courtesy of Museum of Fine Arts, Houston, Texas.

Facilities: **Architecture** (original building, 1924 design by William Ward Watkin; addition in 2 stages by Mies van der Rohe completed in 1974; addition by Rafael Moneo completed 2000) **Auditorium**; **Food Services** Restaurant; **Library** (90,000 volumes); **Sculpture Garden**; **Shop**.

Activities: **Concerts**; **Education Programs** (adults and children); **Films**; **Gallery Talks**; **Guided Tours**; **Lectures**; **Temporary Exhibitions**; **Traveling Exhibitions**.

Publications: exhibition catalogues; magazine, "MFA Today" (bi-monthly).

The Museum of Fine Arts, Houston was the first art museum in Texas. Its encyclopedic collection of over 35,000 works ranks as the largest and most outstanding in the Southwest. Highlights include the Straus, Kress, and Blaffer collections of Renaissance and Baroque works, the Beck Collection of Impressionist and Post-Impressionist art, and the Glassell Collection of African Gold. In addition, the Museum features the Cullen Sculpture Garden, created by Isamu Noguchi, which provides a setting for major 19th- and 20th- century sculpture, including works by Matisse, Giacometti, Marini, Rodin, Smith, Kelly, Bourgeois, and Stella. The Museum also operates Bayou Bend Collection and Gardens.

Rice University Art Gallery

6100 S. Main St., Sewall Hall, Houston, TX 77005

Tel: (713) 348-6069

Fax: (713) 713-5980

Internet Address: http://www.rice.edu/ruag

Director: Ms. Kimberly Davenport

Admission: free.

Established: 1968 *ADA Compliant:* Y

Parking: free on site.

Open: Monday to Wednesday, 11am-5pm.
Thursday, 11am-8pm;
Friday to Saturday, 11am-5pm;
Sunday, noon-5pm.

Closed: Academic Holidays, Summer.

Facilities: **Auditorium**; **Library** (36,000 volumes).

Activities: **Gallery Talks**; **Lectures**; **Temporary Exhibitions**.

Exterior view of Rice University Art Gallery. Photograph courtesy Rice University Art Gallery, Houston, Texas.

Rice University Art Gallery, cont.

Publications: brochures; exhibition catalogues.

The mission of Rice University Art Gallery is to stimulate the creation and understanding of contemporary art for the benefit of Rice University and the larger community. Gallery personnel describe it as Houston's primary public space for the creation of new installation works by artists of national and international reputation. It also presents occasional group exhibitions organized around provocative themes.

Rothko Chapel

3900 Yupon at Sul Ross, Houston, TX 77006

Tel: (713) 524-9839

Fax: (713) 524-7461

Exec. Director: Nabila Drooby

Admission: free.

Attendance: 30,000

Open: Daily, 10am-6pm.

Facilities: Chapel.

Rothko Chapel, founded by John and Dominique de Menil, who also established the Menil Collection (see above), was dedicated in 1971 as an intimate sanctuary available to people of every belief. A modem meditative environment inspired by the paintings of American abstract expressionist Mark Rothko, the Chapel welcomes thousands of visitors each year, people of every faith and from all parts of the world. It retains the support of its surrounding neighborhood and has become a spiritual landmark, central in the lives of many members of a large and diverse urban community

University of Houston - Blaffer Gallery

Fine Arts Building, UH Entrance #16 (off Cullen Blvd.), Houston, TX 77204-4891

Tel: (713) 743-9530

Fax: (713) 743-9525

Internet Address:
 http://www.hfax.uh.edu/blaffer/

Director/Chief Curator: Terrie Sultan

Admission: voluntary contribution.

Attendance: 35,000 *Established:* 1973

Membership: Y *ADA Compliant:* Y

Parking: pay on site, 1st lot on left after
 Entrance #16.

Open: Tuesday to Friday, 10am-5pm;
 Saturday to Sunday, 1pm-5pm.

Closed: Academic Holidays, New Year's Day,
 Independence Day, Thanksgiving Day,
 Christmas Day.

Interior view, Blaffer Gallery. Photograph courtesy of Blaffer Gallery, Houston, Texas.

Facilities: **Exhibition Area** (6,500 square feet).

Activities: **Education Programs** (adults and children); **Guided Tours**; **Lectures**; **Traveling Exhibitions**.

Publications: newsletter, exhibition catalogues.

Through exhibitions, programs, and publications, the Blaffer Gallery, the Art Museum of the University of Houston presents art that is visually stimulating and relevant to the university and the Community. It presents temporary exhibitions of student work, as well as that of professional artists. Shows include the Houston Area Exhibition. The Blaffer Gallery is a non-collecting institution.

University of Houston-Downtown - O'Kane Gallery

University of Houston-Downtown, One Main St., Suite 323 South, Houston, TX 77002

Tel: (713) 221-8042

Fax: (713) 226-5207

Internet Address: http://www.dt.uh.edu/studaff/803oka.htm

Director: Ms. Ann Trask

University of Houston-Downtown - O'Kane Gallery, cont.

Parking: on Girard.

Open: Monday to Friday, 10am-5pm.

Facilities: Gallery.

Activities: Temporary Exhibitions.

Located on the third floor of the One Main Street building, the Gallery offer exhibits mixed media works by Houston and Texas professional artists and faculty, as well as an annual student show.

Huntsville

Sam Houston State University - Gaddis Geeslin Gallery

Art Building F, 1028 21st St. (SW Corner of Campus), Huntsville, TX 77341

Tel: (409) 294-1315

Internet Address: http://www.shsu.edu/~pin_www/T@S/gallery.html

Admission: free.

Open: Monday to Friday, noon-5pm.

Facilities: Exhibition Area.

Activities: Temporary Exhibitions.

The Gaddis Geeslin Gallery presents temporary exhibitions of work by professional artists, as well as faculty and student shows. Also of possible interest on campus is the Student Organization of Fine Art (SOFA) Gallery, located in Art Building A (open: Mon-Fri, 8am-5pm) and the Lowman Student Center (LSC) Gallery, adjacent to the Student Center's main lobby.

Irving

Irving Arts Center

3333 N. MacArthur Blvd., Irving, TX 75062

Tel: (972) 252-7558 ˌ

Fax: (972) 570-4962

Internet Address: http://www.ci.irving.tx.us

Open: Monday to Wednesday, 9am-5pm;Thursday, 9am-8pm; Friday, 9am-5pm;
 Saturday, 10am-5pm; Sunday, 1pm-5pm.

Facilities: Galleries (4); Sculpture Garden; Theaters (3).

Activities: Temporary Exhibitions.

A visual and performing arts center, the Irving Arts Center presents 20-30 exhibitions each year showcasing contemporary art by established and emerging artists, including an annual exhibition of sculpture in the recently opened sculpture garden.

North Lake College - Gallery

5001 N. MacArthur Blvd., Irving, TX 75038

Tel: (972) 273-3574

Internet Address: http://www.dccd.edu/nlc/vparts/art/gal-sch.htm

Gallery Director: Mr. Bob Nunn

Admission: free.

Open: Call for hours.

Facilities: Exhibition Area.

Activities: Temporary Exhibitions.

North Lake is one of seven campuses that make up the Dallas County Community College District. The Gallery presents temporary exhibitions.

Kerrville

Cowboy Artists of America Museum (CAAM)

1550 Bandera Highway, Kerrville, TX 78028

Tel: (830) 896-2553

Fax: (830) 896-2556

TDDY: (830) 896-2556

Internet Address: http://www.caamuseum.com

Cowboy Artists of America Museum, cont.

Exec. Director: Ms. Natalee Nunn
Admission: fee: adult-$5, child-$1, senior-$3.50.
Attendance: 45,000 *Established:* 1983
Membership: Y *ADA Compliant:* Y
Parking: free on site.
Open: Monday to Saturday, 9am-5pm;
　　　　Sunday, 1pm-5pm.
Closed: New Year's Day, Easter, Thanksgiving Day.
Facilities: **Architecture**; **Auditorium** (80 seats);
　　Library (2,500 volumes); **Sculpture Garden**;
　　Shop.
Activities: **Gallery Talks**; **Guided Tours**; **Lectures**;
　　Temporary Exhibitions.
Publications: exhibition catalogues; newsletter,
　　"Visions West" (quarterly).

Fred Fellows, CA, *An Honest Day's Work*, sculpture. Cowboy Artists of America Museum. Photograph courtesy of Cowboy Artists of America Museum, Kerrville, Texas.

The Cowboy Artists of America Museum provides the visitor with an opportunity to relive the Western heritage through Western art. Housed in a gallery resembling a fortressed hacienda, the Museum's collection consists of painting and sculpture created by members of the Cowboy Artists of America.

Lubbock

Texas Tech University - Landmark Arts: The Galleries of Texas Tech

School of Art, 18th and Flint Streets
Lubbock, TX 79409-2081
Tel: (806) 742-1947
Fax: (806) 742-1971
Internet Address: http://www.art.ttu.edu/
　　artdept/artdepinfo/lndmrk.html
Director: Mr. Ken Bloom
Admission: free.
Attendance: 5,000 *Established:* 1983
ADA Compliant: Y
Parking: free on site.
Open: Monday to Friday, 10am-5pm;
　　　　Saturday, 10am-2pm.
Facilities: **Exhibition Area** (6 galleries).
Activities: **Temporary Exhibitions**.
Publications: collection catalogue (2-3/year).

View of temporary exhibition at Landmark Arts, " Four in Glass" (1997). Photograph courtesy of Landmark Arts, Lubbock, Texas.

As the exhibitions outreach arm of Texas Tech University School of Art, the Landmark Arts Program promotes fine arts growth and development through a comprehensive program of exhibitions, symposia and workshops, publications, and hands-on experience with working artists. Temporary exhibitions are presented in six galleries: Landmark Gallery (displaying contemporary art by recognized professional artists); Folio Gallery (exhibiting works on paper; drawings, prints, and photographs by professional artists or drawn from the Department of Art color print study collection); Studio Gallery and South Gallery (presenting a changing series of exhibitions in all media by MFA/BFA students and alumni as well as the annual undergraduate juried competition); SRO-Photo (a continuing series of photographic displays by a national selection of professional artists); and Sculpture Alternative (an ongoing series of experimental projects by graduate and undergraduate students in sculpture, ceramic and electronic media).

Texas Tech University - Museum of Texas Tech University (MoTTU)

4th St. and Indiana Ave., Lubbock, TX 79409-3191
Tel: (806) 742-2490
Fax: (806) 742-1136
Internet Address: http://www.ttu/~museum/

Texas Tech University - Museum of Texas Tech University, cont.

Exec. Director: Mr. Gary Edson

Admission: free.

Attendance: 175,000 *Established:* 1929 *Membership:* Y *ADA Compliant:* Y

Open: Tuesday to Wednesday, 10am-5pm; Thursday, 10am-8:30pm; Friday to Saturday, 10am-5pm; Sunday, 1pm-5pm.

Closed: New Year's Day, ML King Day, Independence Day, Thanksgiving Day, Christmas Day.

Facilities: **Exhibition Area**; **Shop**.

Activities: **Films**; **Gallery Talks**; **Guided Tours** (information: (806) 742-2456); **Temporary Exhibitions**; **Traveling Exhibitions**.

Publications: journal, "The Museum Journal"; newsletter, "MuseNews".

MoTTU is a general museum with collections in the arts, the humanities, and the sciences, primarily focusing on natural and cultural material from Texas, the Southwest, and other regions related by natural history, heritage and climate. Temporary and permanent exhibitions in the social and natural sciences, and visual arts are presented in the main museum building on both the first and second floors. A new wing was constructed in 1995 to house the Diamond M Fine Art Collection (painting and sculpture of the American West; American illustration; jade, ivory, and porcelain objects; and Eskimo carvings). The Museum's collections number approximately two million objects.

Lufkin

The Museum of East Texas

503 N. 2nd St. (2nd and Paul Streets, downtown), Lufkin, TX 75901

Tel: (936) 639-4434

Fax: (936) 639-4435

Exec. Director: Ms. J.P. McDonald

Admission: voluntary contribution.

Attendance: 50,000 *Established:* 1976 *Membership:* Y *ADA Compliant:* Y

Parking: free on site.

Open: Tuesday to Friday, 10am-5pm; Saturday to Sunday, 1pm-5pm.

Closed: Legal Holidays.

Facilities: **Architecture** (former St. Cyprians Episcopal Church, 1906; addition, 1990); **Auditorium** (200 seat); **Exhibition Area** (14,000 square feet; Children's Gallery); **Library** (2,000 volumes); **Shop**.

Activities: **Concerts**; **Docent Guided Tours**; **Education Program** (adult and children); **Family Programs**; **Lectures**; **Summer Art Camp**; **Traveling Exhibitions**.

Publications: exhibition catalogues; newsletter; gallery worksheets .

The museum presents changing exhibits in art and history.

Marfa

Chinati Foundation/La Fundacion Chinati

One Cavalry Row, Marfa, TX 79843

Tel: (915) 729-4362

Fax: (915) 729-4597

Internet Address: http://www.chinati.org/

Director: Dr. Marianne Stockebrand

Admission: voluntary contribution: Thursday to Saturday;
 fee: Monday to Wednesday-$10/person.

Attendance: 10,000 *Established:* 1986 *Membership:* Y

Parking: free on site.

Open: **mid-January to mid-December**,
 Monday to Wednesday, tours by appointment; Thursday to Saturday, tours 1pm and-3pm.
 mid-December to mid-January,
 Call for schedule.

Closed: New Year's Day, Christmas Day.

Chinati Foundation/La Fundacion Chinati, cont.

Facilities: **Exhibition Areas** (indoor and outdoor).

Activities: **Artist Residencies**; **Arts Festival** (open house in October); **Classes** (summer for students); **Guided Tours** (collection is accessible by tour only); **Temporary Exhibitions**.

Publications: newsletter (annual).

Donald Judd, 1980-1984, untitled works in concrete, 15 groups with several units, each unit 2.5 x 2.5 x 5 meters, stretched along a one-kilometer north-to-south axis, fabricated on site, 1980-84. Chinati Foundation. Photograph by Robert Wilson, courtesy of Chinati Foundation, Marfa, Texas.

Located on 340 acres of land on the site of former Fort D.A. Russell on the outskirts of Marfa, Texas, the Chinati Foundation/La Fundacion Chinati is a museum of contemporary art devoted to the creation and preservation of permanent installations of large-scale works, and large groups of work by a small number of artists. The emphasis is on installations in which art and the space around it are inextricably linked. Construction and installation at the site began in 1979 with initial assistance from the Dia Art Foundation in New York. The Foundation opened to the public in 1986 as an independent, non-profit, publicly funded institution. Chinati sponsors related art and education programs, establishing close links to the local community, other cultural institutions and universities throughout Texas and the United States. Temporary exhibitions are held regularly and have included modern and contemporary art as well as native crafts. Originally conceived to exhibit the work of Donald Judd, John Chamberlain and Dan Flavin, it has expanded to include work by other artists. Today the permanent collection consists of 15 outdoor concrete works by Donald Judd, 100 aluminum works by Judd housed in two converted artillery sheds, 25 sculptures by John Chamberlain, a large outdoor piece by Claes Oldenburg, an installation by Ilya Kabakov, poems by Carl Andre and drawings and paintings by Ingólfur Arnarsson. A permanent installation by Dan Flavin will be inaugurated in October, 2000 and will occupy six former barracks on the museum grounds. Each artist's work is installed in a separate building on the grounds.

Marshall

Michelson Museum of Art

216 N. Bolivar, Marshall, TX 75671

Tel: (903) 935-9480

Fax: (903) 935-1974

Director: Susan Spears

Admission: free.

Attendance: 8,000 *Established:* 1985 *Membership:* Y *ADA Compliant:* Y

Parking: free on site.

Open: Tuesday to Friday, noon-5pm; Saturday to Sunday, 1pm-4pm.

Closed: Easter, Independence Day, Thanksgiving Day, Christmas Day.

Facilities: **Exhibition Area** (4,000 square feet).

Activities: **Guided Tours**; **Temporary Exhibitions**; **Traveling Exhibitions**.

Publications: newsletter.

The Museum focuses on the work of Leo Michelson (1887-1978). Other artists represented in the permanent collection include Milton Avery, John Edward Costigan, David Burliuk, and Abraham Walkowitz. The Museum also hosts traveling exhibitions.

McAllen

McAllen International Museum (MIM)

1900 Nolana, McAllen, TX 78504

Tel: (956) 682-1564 *Ext:* 104

Fax: (956) 686-1813

McAllen, Texas

McAllen International Museum, cont.

Director: Mr. John R. Mueller

Admission: fee:

adult-$2.00, child-$1.00, student-$1.00, senior-$1.00.

Attendance: 110,000　　*Established:* 1967

Membership: Y　　*ADA Compliant:* Y

Parking: free on site.

Open: Tuesday to Saturday, 9am-5pm; Sunday, 1pm-5pm.

Closed: Legal Holidays.

Facilities: **Children's Discovery Area; Food Services** Café; **Galleries** (4); **Library** (2,000 volumes); **Picnic Area; Sculpture Park; Shop** (toys, ethnic artifacts, jewelry, books).

Activities: **Demonstrations; Films; Gallery Talks; Guided Tours; Lectures; Performances; Traveling Exhibitions.**

Publications: annual report; exhibition catalogues; newsletter (bi-monthly).

The McAllen International Museum presents art and science exhibitions for the people of South Texas and its many visitors. Exhibitions are developed from the museum's collections as well as other resources. Related programs, educational outreach, and classes throughout the year enhance exhibits. Individual and group exhibitions feature artworks in various media by Texan artists and from Texan institutions and those from other states and other countries. Many are drawn from the museum's permanent collection of American and European fine art and Latin American folk art.

Dance of the Negritos Totonac, patrón costume, Papantia, Vera Cruz. From exhibition, "The Painted Face: The Art of the Mask" at McAllen International Museum. Photograph courtesy of McAllen International Museum, McAllen, Texas.

Midland

Museum of the Southwest

1705 W. Missouri Ave., Midland, TX　79701-6516

Tel: (915) 683-2882

Fax: (915) 570-7077

C.E.O. and Director: Mr. Thomas W. Jones

Admission: free.

Attendance: 85,000　　*Established:* 1965

Membership: Y　　*ADA Compliant:* Y

Parking: free on site.

Open: Tuesday to Saturday, 10am-5pm; Sunday, 2pm-5pm.

Closed: Legal Holidays.

Facilities: **Architecture** (post-Eclectic former residence, 1936 design by A.F. Korn, Jr.); **Exhibition Area.**

Exterior view of Turner Mansion, a part of Museum of the Southwest. Photograph courtesy of Museum of the Southwest, Midland Texas.

Activities: **Arts Festival** (Septemberfest, 1st weekend after Labor Day); **Concerts** (June-August, Sun, 7:45pm on lawn); **Films; Lectures; Temporary Exhibitions; Traveling Exhibitions.**

Publications: gallery guides; newsletter.

The Museum complex includes the Thomas Gallery, an exhibition hall, a planetarium, and a children's museum. The Museum's sculptures, paintings, prints, photographs, decorative arts, and archaeological materials primarily focus on the identity and mythology of the Southwest. The permanent collection includes works by such diverse artists as Karl Bodmer, Frederic Remington, Doug Hyde, Fritz Scholder, T.C. Cannon, Allan Houser, and John Woodhouse Audubon. Special exhibitions are mounted featuring works drawn from the permanent collections. The Museum also hosts traveling exhibitions. The Turner home, listed on the National Register of Historic Places, was designed and built by architect Anton F. Korn, Jr. in 1936-37. A stylistic adaptation of the Eclectic Movement, it is a two-storey brick structure.

Odessa

The Ellen Noël Art Museum of the Permian Basin

4909 E. University Blvd. (between Loop 338 and Parkay Boulevard)
Odessa, TX 79762
Tel: (915) 368-7222
Fax: (915) 368-9226
Exec. Director: Ms. Marilyn Bassinger
Admission: voluntary contribution.
Attendance: 20,000 *Established:* 1985
Membership: Y *ADA Compliant:* Y
Parking: free on site.
Open: Tuesday to Saturday, 10am-5pm; Sunday, 2pm-5pm.
Closed: Legal Holidays.
Facilities: **Sculpture and Sensory Gardens**; **Shop** (art-related
 books, cards, educational toys, gift items).
Activities: **Concerts**; **Education Programs** (adults and children);
 Films; **Guided Tours** (sight-assisted tours of sculpture garden
 and sensory garden with advance notice); **Lectures**;
 Temporary/Traveling Exhibitions (10-20/year).
Publications: exhibition catalogues; newsletter (quarterly).

Giacomo Manzu, *The Grande Striptease*, Entrance to Ellen Noël Art Museum of the Permian Basin in background. Photograph courtesy of Ellen Noël Art Museum of the Permian Basin, Odessa, Texas.

The major focus of the permanent collection is American art from 1850 to the present. Several special collections, however, contain modern European art as well. The Rhodus Sculpture Garden features five bronzes donated by the Meadows Foundation of Dallas. Three galleries are devoted to changing exhibitions of artwork in a variety of media. Exhibitions range from juried shows by area artist groups to work by artists of historical importance and international reputation.

Orange

Stark Museum of Art

712 Green Ave., Orange, TX 77630
Tel: (409) 883-6661
Fax: (409) 883-6361
C.E.O. and Chairman: Eunice Beckenstein
Admission: free.
Attendance: 7,000 *Established:* 1978 *ADA Compliant:* Y
Open: Wednesday to Saturday, 10am-5pm;
 Sunday, 1pm-5pm.
Closed: New Year's Day, Easter, Independence Day,
 Thanksgiving Day, Christmas Day.
Facilities: **Library** (2,500 volumes); **Shop**.
Activities: **Gallery Talks**; **Guided Tours**.
Publications: collection catalogue, "The Western
 Collection"; exhibition catalogues.

William Herbert Dunton (1878-1936), *McMullin, Guide*, oil on canvas, 60 x 56 inches. Stark Museum of Art. Photograph courtesy of Stark Museum of Art, Orange, Texas.

The Stark Museum of Art houses a large and diverse collection of Western American paintings, sculptures, textiles, and Indian artifacts. The major genres represented among the paintings include 19th-century landscape paintings, paintings by the Taos Society of Artists, and other 19th-century frontier artists such as George Catlin, Karl Bodmer, Paul Kane, and John James Audubon. The sculpture collection includes representative works from Russell and Remington as well as a comprehensive collection of porcelain works featuring the birds of North America by Dorothy Doughty and Edward Marshall Boehm. The Museum also houses a rich and diverse collection of Indian rugs depicting ceremonial figures and a wide array of Indian artifacts ranging from clothing to various ceremonial items.

Round Top

Festival-Institute at Round Top

State Highway 237, Round Top, TX 78954
Tel: (979) 249-3129
Fax: (979) 249-5078
Internet Address: http://www.festivalhill.org
Founder, Director and President: Mr. James Dick
Admission: fee-$5.00.
Established: 1971 *Membership:* Y *ADA Compliant:* Y
Open: Monday to Saturday, by appointment.
Closed: Thanksgiving Day, Christmas Day.
Facilities: **Auditorium** (1,000 seats); **Library** (5,000 volumes); **Shop**.
Activities: **Concerts**; **Education Programs**; **Films**; **Guided Tours**; **Lectures**; **Temporary Exhibitions**.
Publications: exhibition catalogues.

Located on a 200 acre campus, the Festival-Institute was established by concert pianist, James Dick. It is both a teaching institute, where students pursue their musical studies under the guidance of an international faculty, and a venue for live concerts. The Festival-Institute Museum and Library exhibits its art collections in the Festival Concert Hall and its historic house restorations. The David W. Guion Archives and Americana Collection and the Anders and Josephine Oxehufwud Swedish and European Collection have galleries in the Festival Concert Hall.

San Angelo

San Angelo Museum of Fine Arts (SAMFA)

704 Burgess Ave. (Fort Concho Grounds)
San Angelo, TX 76903
Tel: (915) 658-4084
Fax: (915) 659-2407
Internet Address: http://web2.airmail.net/samfa
Director: Mr. Howard Taylor
Admission: free: adult-$2.00, student-$1.00, senior-$1.00.
Attendance: 58,000 *Established:* 1981
Membership: Y *ADA Compliant:* Y
Parking: free on site.
Open: Tuesday to Saturday, 10am-4pm;
 Sunday, 1pm-4pm.
Closed: Legal Holidays.
Facilities: **Architecture** (1999 building, 22,600 square feet, designed by Hardy Holzman Pfeiffer Associates of New York City); **Children's Art Museum** (Tues-Fri, 1pm-5pm; Sat, 10am-5pm; Sun, 1pm-5pm); **Galleries** (4); **Sculpture Garden**; **Shop**.
Activities: **Concerts**; **Education Programs** (adults and children); **Films**; **Guided Tours**; **Lectures**.
Publications: exhibition catalogues; gallery guides; newsletter.

Bruce M. Wynn, *Bottle Form*, 1992, Purchase from the 1992 San Angelo Annual National Ceramic Competition. Photograph courtesy of San Angelo Museum of Fine Arts, San Angelo, Texas.

A small museum in West Texas, The San Angelo Museum of Fine Arts presents changing exhibitions of historical and contemporary art, including an annual national ceramic competition. Collections include contemporary ceramics; sculpture; and contemporary Texas art, architecture and photography. SAMFA also operates a Children's Art Museum with a creative, hands-on area, art gallery, picture book library and gift shop in the former Cactus Hotel (1929) at 36 E. Twohig.

San Antonio

Marion Koogler McNay Art Museum

6000 N. New Braunfels Ave. (corner N. New Braunfels Ave. & Austin Hwy.), San Antonio, TX 78209

Tel: (210) 824-5368

Fax: (210) 824-0218

Internet Address: http://www.mcnayart.org

Director: Mr. William C. Chiego

Admission: voluntary contribution.

Attendance: 100,000 *Established:* 1950 *Membership:* Y *ADA Compliant:* Y

Parking: free on site.

Open: Tuesday to Saturday, 10am-5pm; Sunday, noon-5pm.

Closed: New Year's Day, Independence Day, Thanksgiving Day, Christmas Day.

Facilities: **Architecture**; **Gardens**; **Library** (30,000 volumes, non-circulating); **Reading Room**; **Sculpture Garden**; **Shop** (Tues-Sat, 10am-5pm; (210) 805-1732.).

Activities: **Concerts**; **Films**; **Gallery Talks**; **Guided Tours**; **Lectures**.

Publications: annual report; exhibition catalogues; newsletter.

The McNay's permanent collection features art of the 19th and 20th centuries, including French post-impressionist paintings, American paintings before World War II, and European and American art after World War II. Other strengths include medieval and Renaissance European sculpture and painting, 19th- and 20th-century prints and drawings, and theatre arts. Changing exhibitions include works from the permanent collection, temporary shows of works from public and private collections organized by the McNay, and traveling exhibitions.

San Antonio Art League Museum (SAALM)

130 King William St., San Antonio, TX 78204

Tel: (210) 223-1140

Fax: (210) 223-2826

Internet Address: http://www.saalm.org

Administrative. Director: Mary Hickey

Admission: voluntary contribution.

Attendance: 5,000 *Established:* 1912

Membership: Y

Parking: free on street.

Open: Tuesday to Saturday, noon-6pm.

Facilities: **Galleries**.

Activities: **Permanent Collection** (2nd floor), 20th-century Texas and regional art; **Temporary Exhibitions** (1st floor), San Antonio artists, 12 shows/year.

Publications: book on permanent collection.

Located in the King William Historic District, the San Antonio Art League mounts exhibitions from its permanent collection of early 20th-century Texas and regional art, and also presents shows of the works of San Antonio artists.

View of gallery, San Antonio Art League. Photograph courtesy of San Antonio Art League, San Antonio, Texas.

San Antonio College - Visual Arts Instructional Gallery

Visual Arts and Technology Building, 950 Lewis Street, San Antonio, TX 78212-4299

Tel: (210) 733-2894

Internet Address: http://www.accd.edu

Fine Arts Coordinator: Prof. Mark Pritchett

Admission: free.

Open: Monday to Thursday, 7am-9:45pm; Friday, 7am-4pm; Saturday, 9am-noon.

Closed: Legal Holidays.

San Antonio College - Visual Arts Instructional Gallery, cont.

Facilities: **Exhibition Area.**

Activities: **Temporary Exhibitions.**

The Gallery presents an annual schedule of approximately six temporary exhibitions by professional artists as well as the work of students.

San Antonio Museum of Art

200 W. Jones Ave. (just off Broadway), San Antonio, TX 78215

Tel: (210) 978-8100

Fax: (210) 978-8134

Internet Address: http://www.samuseum.org

Interim Director: Dr. Gerry Scott

Admission: fee: adult-$4.00, child-$1.75, student-$2.00, senior-$2.00.

Attendance: 90,000 *Established:* 1981

Membership: Y *ADA Compliant:* Y

Parking: free on site.

Open: Tuesday, 10am-9pm;
Wednesday to Saturday, 10am-5pm;
Sunday, noon-5pm.

Closed: Thanksgiving Day, Christmas Day.

Facilities: **Architecture** (former Lone Star Brewery, ca.1884); **Auditorium** (188 seat); **Exhibition Area** (85,000 square feet); **Sculpture Garden**; **Shop** (art books, jewelry, gift items, 978-8140).

Activities: **Concerts**; **Education Programs** (children); **Films**; **Gallery Talks**; **Guided Tours** (groups reserve in advance, 978-8158); **Lectures**; **Temporary Exhibitions**; **Traveling Exhibitions.**

Nun's Emblem, 18th-century, Mexico, oil on copper/tortoise shell frame. Nelson A. Rockefeller Center for Latin American Art, San Antonio Museum of Art. Photograph courtesy of San Antonio Museum of Art, San Antonio, Texas.

Publications: exhibition catalogues; handbook; newsletter (quarterly).

Located in the historic Lone Star Brewery building, the San Antonio Museum of Art houses extensive collections of Antiquities, Asian, Contemporary and Latin American art. The Nelson A. Rockefeller Center for Latin American Art, a 30,000-square-foot wing dedicated to the study and appreciation of Latin American art, opened in October 1998. The Center provides exhibit and storage space for the Museum's extensive collections of Latin American art, including pre-Columbian, Spanish Colonial/Republican, modern/contemporary art, and folk art. The Egyptian and Classical holdings of the Museum span 5,000 years and include examples from most major periods of the Mediterranean world from prehistory to the Byzantine, with special emphasis given to Egyptian, Greek, and Roman art and sculpture. A strong ancient glass collection is displayed in one of America's few galleries devoted exclusively to ancient glass, chronicling glassmaking's history and inception in the Near East. The Museum's permanent Asian galleries feature a large group of Chinese ceramics as well as Chinese paintings, sculptures, and decorative arts. Japanese, Korean, and East Asian art and sculpture are also represented. The Museum's 18th- and 19th-century collection reflects many of the artistic, historical, political, and religious events occurring during the formative years of United States history. The collection features works by John Singleton Copley, Benjamin West, Jasper Cropsey, and Gilbert Stuart. A significant portion of the Museum's 20th-century collection is devoted to the post-World War II American painting and sculpture, beginning with the works of leading abstract painters, first and second generations of the New York School. It features such exemplary paintings as Hans Hoffman's "Liberation" and other large-scale works by Helen Frankenthaler, Philip Guston, and Frank Stella. Also of importance is the Museum's commitment to the collection of contemporary Texas art. Focusing on painting and sculpture produced by Texans from the late 1960s to the present, the collection shows the diversity of expression of local artists. The collection reflects the Museum's commitment to exhibit, document, and collect outstanding works by Texas artists.

University of Texas at San Antonio - UTSA Art Gallery

6900 N. Loop 1604 West, San Antonio, TX 78249-0641
Tel: (214) 581-4391
Fax: (512) 691-4347
Internet Address: http://www.utsa.edu
Director: Mr. Ron Boling
Admission: free.
Established: 1982 *ADA Compliant:* Y
Open: Monday to Friday, 10am-4pm; Sunday, 2pm-4pm.
Closed: Academic Holidays.
Facilities: **Gallery.**
Activities: **Temporary Exhibitions.**
Publications: exhibition catalogues.

Changing exhibitions at the Gallery feature aspects of contemporary and historical art. Additionally, undergraduate works are displayed in the UTSA Satellite Space (open Friday-Sunday, noon-6pm). Occasional gallery talks, lectures, and poetry readings are presented for the UTSA and San Antonio communities.

San Marcos

Southwest Texas State University - University Art Gallery

SW Texas State University, Art Building, University Drive, San Marcos, TX 78666
Tel: (512) 245-2611
Internet Address: http://www.swt.edu
Admission: free.
Open: Monday to Friday, 7:30am-4pm.
Facilities: **Exhibition Area.**
Activities: **Juried Exhibits; Temporary Exhibitions.**

The Gallery presents exhibitions of work in a variety of media and styles by prominent artists, faculty, alumni, and students. The Art Department also sponsors Works on Paper, an annual international juried competition and The Creative Summit Conference and Exhibition. Also of possible interest on campus, is the Special Collections Gallery, located on the seventh floor of the Alkek Library.

Tyler

Tyler Museum of Art (TMA)

1300 S. Mahon Ave., Tyler, TX 75701
Tel: (903) 595-1001
Fax: (903) 595-1055
Director: Mr. Wendell L. Ott
Admission: voluntary contribution.
Attendance: 16,000 *Established:* 1969
Membership: Y *ADA Compliant:* Y
Parking: free on site.
Open: Tuesday to Saturday, 10am-5pm;
 Sunday, 1pm-5pm.
Closed: Legal Holidays.
Facilities: **Exhibition Area; Library** (1,500 volumes).
Activities: **Concerts** (seasonal); **Education Programs** (adults, college students and children); **Films; Gallery Talks; Guided Tours; Lectures; Temporary Exhibitions; Traveling Exhibitions.**

Exterior view of Tyler Museum of Art, designed by E. Davis Wilcox. Photograph courtesy of Tyler Museum of Art, Tyler, Texas.

Publications: exhibition catalogues; newsletter (quarterly).

Tyler, Texas

Tyler Museum of Art, cont.

Located on land leased from Tyler Junior College, the Tyler Museum of Art serves the diverse population of East Texas by providing for the collection, study, exhibition, and interpretation of 19th- and 20th-century art. The Museum collection includes paintings, sculpture, prints, and photographs by some of Texas's best known artists. Photography is one of the collection's special emphases. The print collection includes examples by American artists of national reputation.

University of Texas at Tyler - Art Galleries

3900 University Blvd., Tyler, TX 75799

Tel: (903) 566-7250

Internet Address: http://www.uttyler.edu/arts/studioarts

Director: Mr. Peter Calvert

Admission: free.

Open: Monday to Friday, 9am-5pm.

Facilities: Galleries (2).

Activities: Temporary Exhibitions.

University of Texas-Tyler maintains two galleries: the Meadows Gallery, located in the R. Don Cowan Fine and Performing Arts Center, and the University Gallery. Exhibitions include work by professional artists, the annual National Works on Paper, selections from the Department of Art's permanent collection of prints and drawings, and an annual student competition and exhibition. The Department of Art's permanent collection includes prints and drawings by nationally recognized artists.

Victoria

Royston Nave Museum

306 W. Commercial St. (at Moody St.), Victoria, TX 77901

Tel: (512) 575-8227

Fax: (512) 575-8228

Internet Address: http://www.viptx/net/museum

Director & Curator: Ms. Emma Hale Burnett

Admission: fee: adult-$2.00, child-$1.00.

Attendance: 5,000 *Established:* 1976

Membership: Y *ADA Compliant:* Y

Parking: on street.

Open: Tuesday to Sunday, 1pm-5pm.

Closed: New Year's Eve to New Year's Day,
 Easter, Thanksgiving Day,
 Christmas Eve to Christmas Day.

Facilities: Sculpture Garden; Shop.

Activities: Concerts; Education Programs
 (adults and children); Films; Guided Tours;
 Lectures; Temporary Exhibitions.

Publications: newsletter, "VRMA Newsletter".

Façade of Royston Nave Museum (1930), designed by Atlee Ayres. Rendering courtesy of Victoria Regional Museum Association, Victoria, Texas.

The Royston Nave Museum is a fine arts museum serving Victoria and the surrounding region. It schedules new exhibitions every six to ten weeks. Exhibits are selected with a broadly educational goal of displaying contemporary work that explores the possibilities of a certain medium or style, and artwork from the past that adds to the viewer's understanding of art. The Nave Museum was designed in 1930 by San Antonio architect Atlee Ayres to serve as a memorial for Texas artist Royston Nave and to house the Bronte Public Library. (Nave painted extensively in and around Victoria in the 1920s after a distinguished art career in New York City in the 1910s.) Since 1976, it has served exclusively as a fine arts museum under the operational control of the Victoria Regional Museum Association (VRMA). VRMA also oversees a regional historic house museum, the McNamara House Museum.

782

Waco

The Art Center of Waco

1300 College Drive, Waco, TX 76708
Tel: (817) 752-4371
Fax: (817) 756-0934
Director: Mr. Joseph L. Kagle
Admission: suggested contribution.
Attendance: 186,000 *Established:* 1972 *Membership:* Y *ADA Compliant:* Y
Parking: free on site.
Open: Tuesday to Saturday, 10am-5pm; Sunday, 1pm-5pm.
Closed: New Year's Day, ML King Day, Memorial Day, Independence Day, Labor Day,
 Thanksgiving Day, Christmas Day.
Facilities: **Exhibition Area**; **Library** (non-circulating); **Reading Room**; **Sculpture Garden**;
 Shop.
Activities: **Education Programs**; **Films**; **Guided Tours**; **Lectures**; **Traveling Exhibitions**.
Publications: exhibition catalogues; newsletter.

Located on the campus of McLennan Community College, the Art Center mounts 6-8 changing exhibitions annually. Its sculpture path/garden featuring Robert Wilson's "The Waco Door" is accessible day and night.

Baylor University - Martin Museum of Art and University Art Gallery

Hooper-Schaefer Fine Arts Center, 1401 S. University Ave., Waco, TX 76798-7263
Tel: (254) 710-1867
Fax: (254) 710-1566
Internet Address: http://www.baylor.edu/
Director, Martin Museum of Art: Heidi J. Hornik, Ph.D.
Admission: free.
Open: Tuesday to Friday, 10am-5pm; Saturday, noon-5pm; during Baylor Theatre performances.
Facilities: **Exhibition Area**.
Activities: **Temporary Exhibitions**.

Located in the Hooper-Schaefer Fine Arts Center, both the Martin Museum of Art and the University Art Gallery, a teaching gallery, present changing exhibits of work by nationally and internationally recognized artists, as well as student and faculty shows.

Jose Perez Art Museum

221 J.H. Kultgen Freeway, Waco, TX 76706-1008
Tel: (254) 714-2093
Fax: (254) 714-2514
Internet Address: http://www.rmaclub.com/perezpgs/museum.html
Director: Wayman R. Spence, M.D.
Admission: fee: adult-$2.00, child-free, student-free.
Attendance: 15,000 *Established:* 1996 *Membership:* N
Open: Daily, 10am-5pm.
Closed: Christmas Day.
Facilities: **Galleries** (5,000 square feet); **Shop**.
Activities: **Education Programs**; **Guided Tours**; **Lectures**; **Traveling Exhibitions**.

The Jose Perez Art Museum is devoted exclusively to the work of Jose Perez (born 1929), whose work focuses on political satire, in the style of the old masters. The collection consists of 150 paintings and drawings by Jose Perez.

Wichita Falls

Wichita Falls Museum and Art Center

2 Eureka Circle, Wichita Falls, TX 76308
Tel: (817) 692-0923
Fax: (817) 696-5358
Internet Address: http://www.wf.net/~wfmuseum/index.html
Exec. Director: Ms. Carole Borgman
Admission: fee: adult-$3.00, child-$2.00.
Attendance: 80,000 *Established:* 1965 *Membership:* Y *ADA Compliant:* Y
Parking: free on site.
Open: Tuesday to Saturday, 10am-5pm.
Closed: New Year's Day, Easter, Independence Day, Labor Day, Thanksgiving Day, Christmas Day.
Facilities: **Auditorium** (250 seat); **Galleries** (5); **Library** (1,500 volumes); **Shop**.
Activities: **Arts Festival**; **Films**; **Gallery Talks**; **Guided Tours**; **Lectures**; **Temporary Exhibitions**; **Traveling Exhibitions**.
Publications: newsletter, "Muse News Quarterly" (quarterly).

The Museum offers changing art, history and science exhibits.

Utah

The number in parentheses following the city name indicates the number of museums/galleries in that municipality. If there is no number, one is understood. For example, in the text four listings would be found under Salt Lake City and one listing under Provo.

Utah

Brigham City

Brigham City Museum-Gallery

24 N. 300 W., Brigham City, UT 84302

Tel: (801) 723-6769

Fax: (801) 723-5011

C.E.O. and Director: Mr. Larry Douglass

Admission: free.

Attendance: 6,000 *Established:* 1970

Membership: N *ADA Compliant:* Y

Open: Tuesday to Friday, 11am-6pm;
 Sunday, 1pm-5pm.

Facilities: **Gallery** (2,900 square feet).

Activities: **Films**; **Lectures**; **Temporary Exhibitions**.

Publications: booklet, "Brigham City Historic Tour"; brochures.

The Museum presents rotating art and history exhibits, a permanent display focusing on early Brigham City history, and occasional national touring exhibits. The rotating art space features monthly temporary exhibits of photography, painting, printmaking, ceramics, crafts, and computer art.

Handcrafted bed ca. 1870, originally owned by William Gardner of Brigham City. Brigham City Museum-Gallery. Photograph courtesy of Brigham City Museum-Gallery, Brigham City, Utah.

Cedar City

Southern Utah University - Braithwaite Fine Arts Gallery

Southern Utah University, 351 W. Center St., Cedar City, UT 84720

Tel: (435) 586-5432

Fax: (435) 865-8012

Director: Ms. Lydia Johnson

Admission: free.

Attendance: 20,000 *Established:* 1976 *Membership:* Y *ADA Compliant:* Y

Parking: Call for directions.

Open: **September to May**, Monday to Friday, noon-7pm.
 July to August, Monday to Saturday, noon-8:30pm.

Closed: Academic Holidays, Legal Holidays.

Facilities: **Exhibition Area** (2 galleries, total 2,000 square feet); **Reading Room**.

Activities: **Films**; **Guided Tours**; **Lectures**.

The Gallery is dedicated to providing varied visual arts experiences for a broad rural area of southern Utah. The Gallery mounts educational exhibits throughout the year, offers related programs, preserves and collects fine art, and serves as a resource center for the visual arts. The Braithwaite Gallery permanent collection consists of paintings, prints, photographs, sculpture, and weavings by artists of the Colorado Plateau and the Great Basin, including works by Mary Bastow, Allen Bishop, Maynard Dixon, Edith Hamlin, Julius Moessel, Paul Salisbury, and A.B. Wright. There is also a variety of public sculpture on the campus of SUU, including works by Frank Adams, Jerry Anderson, Jim DeVore, and Nolan Johnson.

Fairview

Fairview Museum of History and Art

85 North 100 East, Fairview, UT 84629

Tel: (435) 427-9216

Director: Mr. Ron Staker

Admission: voluntary contribution.

Fairview Museum of History and Art, cont.

Attendance: 22,000 *Established:* 1966
Membership: Y *ADA Compliant:* Y
Parking: ample street parking.
Open: **Summer,**
 Monday to Saturday, 10am-6pm;
 Sunday, 2pm-6pm.
 Winter,
 Monday to Saturday, 10am-5pm;
 Sunday, 2pm-5pm.
Facilities: **Buildings** (2); **Galleries**; **Garden**
(with historic farm implements); **Library**
(local family history); **Shop.**
Activities: **Guided Tours**; **Lace Day Festival**
(mid-July).
Publications: newspaper supplement (annual).

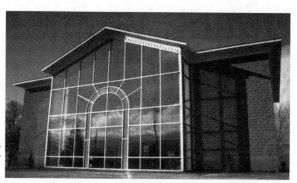

Horizon Building (1995), Fairview Museum of History and Art. Photograph courtesy of Fairview Museum of History and Art, Fairview, Utah.

Two buildings comprise the Fairview Museum of History and Art. The Heritage Building, a former school, houses historic domestic and agricultural artifacts, lace and fashions, miniature carriages/coaches, and the gallery of Mormon sculpture featuring works by Dr. Avard T. Fairbanks. The Horizon Building, built in 1995, presents five galleries of paintings by regional artists, additional Fairbanks sculptures, and natural history and geology exhibits. The Museum's permanent collection includes works of regional artists and the Theodore Milton Wassmer Collection of over 350 works.

Logan

Utah State University - Nora Eccles Harrison Museum of Art

650 North 1100 East, Logan, UT 84322-4020
Tel: (801) 797-0163
Fax: (801) 797-3423
Internet Address: http://www.usu.edu
C.E.O. and Director: Mr. Steven W. Rosen
Admission: voluntary contribution.
Attendance: 24,000 *Established:* 1982
Membership: Y *ADA Compliant:* Y
Parking: commercial adjacent to site.
Open: Tuesday, 10:30am-4:30pm;
 Wednesday, 10:30am-9pm;
 Thursday to Friday, 10:30am-4:30pm;
 Saturday to Sunday, 2pm-5pm.
Closed: Legal Holidays.
Facilities: **Architecture** (1982 design by
Edward Larrabee Barnes, 23,000 square
feet); **Food Services** Restaurant; **Gallery**;
Sculpture Plaza; **Temporary Exhibition**
Space.

John Ferren, *Untitled*, Nora Eccles Harrison Museum of Art collection. Photograph courtesy of Nora Eccles Harrison Museum of Art, Utah State University, Logan Utah.

Activities: **Guided Tours**; **Lectures**; **Temporary Exhibitions** (14/year).
Publications: "ARTSPECS"; brochures; exhibition catalogues; newsletter.

Specially designated exhibition spaces, including the Marie Eccles Caine Gallery, the Nora Eccles Harrison Ceramics Gallery, and the Boyden Collection of Native American Materials in the Chase Fine Arts Center, present continuing exhibitions of artworks from the permanent collection. The Museum also mounts temporary exhibitions each year, including important traveling exhibitions. The permanent collection numbers 3,400 pieces and consists chiefly of 20th-century art by artists living or working in the western half of America. The 500-piece collection of the Museum's benefactor, Nora Eccles Treadwell Harrison, serves as the basis of an extensive ceramics collection, currently numbering over 1,200 works.

Ogden

Weber State University Art Gallery

Art Department, 2001 University Circle, Ogden, UT 84408-2001
Tel: (801) 626-7689
Fax: (801) 626-6976
Internet Address: http://www.weber.edu/dova
Director: H. Barendse
Admission: free.
Established: 1960 *ADA Compliant:* Y
Open: **Academic Year**, Monday to Thursday, 9am-9pm; Friday, 9am-4pm.
Closed: Summer.
Facilities: **Gallery** (2,000 square feet).
Activities: **Education Programs** (undergraduate & graduate students); **Films**; **Lecture Series** (visiting artists).

The Gallery presents temporary exhibitions and a visiting artist lecture series, "Issues in Contemporary Art".

Park City

Kimball Art Center

638 Park Ave., Park City, UT 84060-1478
Tel: (435) 649-8882
Fax: (435) 649-8889
Director: Sarah Behrens
Admission: suggested contribution:
 adult-$3.00, child-$1.00.
Established: 1976
Membership: Y *ADA Compliant:* Y
Parking: commercial adjacent to site.
Open: Monday, 10am-6pm
 Wednesday to Saturday, 10am-6pm;
 Sunday, noon to 6pm.
Closed: Thanksgiving Day, Christmas Day,
 New Year's Day.

Exterior view of Kimball Art Center. Photograph courtesy of Kimball Art Center, Park City, Utah.

Facilities: **Galleries** (3; Main Gallery, Garage Gallery, Badami Gallery).
Activities: **Arts Festival** (annual, 1st weekend in August); **Education Programs**; **Temporary Exhibitions**.

The Kimball Art Center is a community art center dedicated to providing quality visual art experiences through local, regional, and national exhibits, including the annual Reinventing the West exhibit (June to August) and the Park City Arts Festival. Art education classes for adults and children are held in the Center's ceramics, photography, and jewelry studios, which are available for the use of members, or for a daily fee.

Price

College of Eastern Utah - Gallery East

451 East 400 North, Price, UT 84501
Tel: (801) 637-2120 *Ext:* 5297
Fax: (801) 637-4102
Internet Address: http://www.ceu.edu/Academics/DivisionB/FineArts/galleryeast
Department Chairman: Mr. James L. Young
Admission: free.
Attendance: 2,250 *Established:* 1937 *ADA Compliant:* Y
Parking: nearby lot with space for 200 cars.
Open: **September 15 to May**, Monday to Friday, 8:30am-5pm.

College of Eastern Utah - Gallery East, cont.

Closed: Legal Holidays.

Facilities: **Gallery** (3,000 square feet); **Library** (college).

Activities: **Education Programs**; **Gallery Talks** (on request); **Guided Tours** (on request); **Lectures** (7/year); **Temporary/Traveling Exhibitions**.

The Gallery presents temporary exhibitions.

Provo

Brigham Young University - Museum of Art

N. Campus Drive, Provo, UT 84602-1400

Tel: (801) 378-8287

Fax: (801) 378-8222

Internet Address: http://www.byu.edu/moa

Director: Dr. Campbell Gray

Admission: free (to select exhibits).

Attendance: 300,000 *Established:* 1993 *ADA Compliant:* Y

Parking: in front of museum.

Open: Monday, 10am-9pm; Tuesday to Wednesday, 10am-6pm; Thursday, 10am-9pm; Friday, 10am-6pm; Saturday, noon-5pm.

Facilities: **Food Services** Café ((Mon-Fri, 11am-2:30pm)); **Library** (Mon-Fri, 10am-4pm; 378-8213); **Print Study Room** (Mon-Fri, 10am-4pm; 378-8272); **Tours** (schedule at convenience).

Activities: **Education Programs** (undergraduate, graduate and adult); **Gallery Talks**; **Lectures**; **Temporary Exhibitions**; **Traveling Exhibitions**.

Publications: exhibition catalogues; gallery guides.

The Museum presents changing exhibitions drawn from the permanent collection and elsewhere. Also of possible interest on campus are the Brimhill Gallery, located in the George H. Brimhill Building; Gallery 303, located in F303, Harris Fine Arts Center (378-3882); and the B.F. Larsen Gallery, also located in the Harris Fine Arts Center.

Saint George

Saint George Art Museum

47 East 200 North, Saint George, UT 84770

Tel: (801) 634-5942

Fax: (801) 634-5946

Internet Address: http://www.ci.st-george.ut.us/artmuseum.htm

Director: Mr. David W. Pursley

Admission: free.

Attendance: 22,000 *Established:* 1997 *Membership:* Y *ADA Compliant:* Y

Parking: free on site.

Open: Monday, 6pm-8pm; Tuesday to Thursday, 10am-5pm; Friday, 10am-8pm; Saturday, 10am-5pm.

Facilities: **Exhibition Area** (3 galleries with fountain plaza).

Activities: **Concerts**; **Guided Tours**; **Lectures**; **Temporary Exhibitions**.

The Museum features temporary exhibitions of traditional and contemporary art.

Salt Lake City

Chase Home Museum of Utah Folk Art

Center of Liberty Park, Salt Lake City, UT 84102

Tel: (801) 533-5760

Fax: (801) 236-7556

TDDY: (800) 346-4128

Internet Address: http://www.arts.utah.org

Director: Ms. Carol Edison

Chase Home Museum of Utah Folk Art, cont.

Admission: free.

Attendance: 15,000 *Established:* 1986

Open: **April to May,**
Saturday to Sunday, noon-5pm.
Memorial Day to Labor Day,
Daily, noon-5pm.
September to October,
Saturday to Sunday, noon-5pm.

Facilities: **Architecture** (adobe building, 1853).

Activities: **Concerts** (ethnic and folk music); **Festivals**; **Guided Tours**; **Permanent Collection.**

The Museum presents exhibits and performances which feature contemporary folk and ethnic artists from Utah's cultural communities. Nearly 200 objects from the state-owned Utah State Folk Art Collection are on display. The Utah State Folklife Library and Archive is also housed on site.

Interior, Chase Home Museum, Navajo basketry exhibit, 1994. Photograph courtesy of Chase Home Museum of Utah Folk Art, Salt Lake City, Utah.

Museum of Church History and Art (LDS Church Museum)

45 N. West Temple St., Salt Lake City, UT 84150-1003

Tel: (801) 240-3310

Fax: (801) 240-5342

Director: Mr. Glen M. Leonard

Admission: free.

Attendance: 293,000 *Established:* 1869

ADA Compliant: Y

Parking: free parking at 103 North West Temple.

Open: Monday to Friday, 9am-9pm;
Saturday to Sunday, 10am-7pm;
Holidays, 10am-7pm.

Closed: New Year's Day, Easter,
Thanksgiving Day, Christmas Day.

Facilities: **Architecture** (1847 log house in court-yard); **Auditorium** (180 seats); **Library**; **Museum Store** (catalogues, posters, gifts).

Façade, Museum of Church History and Art. Photograph courtesy of Museum of Church History and Art, Salt Lake City, Utah.

Activities: **Education Programs** (adults and children); **Films**; **Gallery Talks**; **Guided Tours** (Mon-Sat, groups reserve two weeks in advance); **Lectures**; **Permanent Exhibits**; **Temporary Exhibitions.**

Publications: brochures; exhibition catalogues; posters.

The Museum of Church History and Art presents the story of the Church of Jesus Christ of Latter-day Saints in educational exhibits and programs. The Museum collects and displays Latter-day Saint historical and contemporary art and artifacts from all over the world as part of an ongoing effort to preserve and understand Latter-day Saint history and art from all cultures and eras. The Museum offers permanent exhibits, changing exhibits on special themes, and programs for children and adults.

Salt Lake Art Center

20 S.W. Temple (adjacent to Salt Palace Convention Complex), Salt Lake City, UT 84101

Tel: (801) 328-4201

Fax: (801) 322-4323

Interim Director: Mr. Allen Dodworth

Admission: voluntary contribution.

Attendance: 62,000 *Established:* 1931 *Membership:* N *ADA Compliant:* Y

Salt Lake City, Utah

Salt Lake Art Center, cont.

Parking: metered on street.

Open: Tuesday to Thursday, 8am-5pm; Friday, 8am-9pm; Saturday, 10am-5pm; Sunday, 1pm-5pm.

Closed: Legal Holidays.

Facilities: **Auditorium**; **Food Services** Restaurant; **Gallery**; **Shop**.

Activities: **Education Programs** (adults and children); **Films** (Friday evening).

Publications: bulletin (quarterly); calendar (monthly); exhibition catalogues.

The Center present exhibitions of contemporary art.

University of Utah - Utah Museum of Fine Arts

370 South 1530 East South Campus Drive

Salt Lake City, UT 84112

Tel: (801) 581-7332

Fax: (801) 585-5198

Internet Address: http://www.utah.edu/umfa

Director and Curator: E.F. Sanguinetti

Admission: free.

Attendance: 120,000 *Established:* 1951

Membership: Y *ADA Compliant:* Y

Parking: free on site.

Open: Monday to Friday, 10am-5pm;
 Saturday to Sunday, noon-5pm.

Closed: Legal Holidays.

Facilities: **Auditorium** (450 seat); **Library**; **Shop** (gifts, stained glass, lacquerware, jewelry, folk art).

Activities: **Concerts**; **Education Programs** (children and undergraduate); **Films**; **Gallery Talks**; **Guided Tours**; **Lectures**; **Temporary Exhibitions**; **Traveling Exhibitions**.

Publications: collection catalogue, "Selected Works of the Museum of Fine Arts"; exhibition catalogues.

Ambrosius Benson, *Elegant Couples Dancing in a Landscape*, 1495-1550. Gift of Howard J. and Jenny Creer Stoddard in honor of John Preston and Mary Elizabeth Brockbank Creer, Utah Museum of Fine Arts. Photograph courtesy of Utah Museum of Fine Arts, University of Utah, Salt Lake City, Utah.

The Utah Museum of Fine Arts, University of Utah, is Utah's primary cultural resource in the visual arts. It is the state's only public institution with the goal of collecting and exhibiting a general collection of art objects selected for quality and representation of the principal art styles and periods of civilization. The Museum's collections have long since outgrown available gallery space. Preliminary plans for a new wing with additional galleries and other required facilities have been completed. Meanwhile, the permanent collection is subject to regular rotation. The Museum presents approximately fifteen changing exhibitions each year drawn from other museums here and abroad. Temporary exhibitions are selected to complement or expand the permanent collections. Temporary exhibits present material not otherwise available to the public, or they respond to current events (Bicentennial of the French Revolution, Quinquecentennial of the discovery of America, Soviet Art, Contemporary Chinese Painting, etc.) The permanent collection consists of over 10,000 objects. A partial overview of the Museum's collections is available through the following list of galleries: the Jennie Creer Stoddard Entrance Gallery, 17th- and 18th-century French works of art; the Helen Druke Shaw Gallery, Dutch and Flemish art; the Natacha Rambova Collection (Gallery 6), Egyptian artifacts; the Bert G. Clift Gallery, Chinese porcelains; the LaReta Creer Madsen Kump Gallery, English art; the William H. and Wilma T. Gibson Gallery, Italian art; the Herbert I. and Elsa Bamberger Michael Gallery, late 18th- and early 19th- century American art; the E. Parry and Peggy Chatterton Thomas Gallery, art of Utah and the West; Gallery 2, traditional arts of Africa, Oceania, Indonesia, and the Americas; the Beatrice M. Hansen Gallery, decorative arts; and the Sculpture Court.

Springville

Springville Museum of Art

126 East 400 South, Springville, UT 84663

Tel: (801) 489-2727

Fax: (801) 489-2739

Internet Address:
 http://www.shs.nebo.edu/museum/museum.html

Director: Dr. Vern G. Swanson

Admission: free.

Attendance: 130,000 *Established:* 1903

Membership: Y *ADA Compliant:* Y

Parking: free on site.

Open: Tuesday, 10am-5pm;
 Wednesday, 10am-9pm;
 Thursday to Saturday, 10am-5pm;
 Sunday, 3pm-6pm.

Closed: New Year's Day, Christmas Day,
 Major Holidays.

Facilities: **Architecture** (Spanish Colonial Revival, 1937 design by Claud S. Ashworth); **Courtyard**; **Galleries** (9 permanent and 4 changing); **Library**; **Shop**.

Lee Greene Richards, *Dreaming of Zion*, 1931, Oil on canvas. Springville Museum of Art. Photograph courtesy of Springville Museum of Art, Springville, Utah.

Activities: **Arts Festival**; **Concerts**; **Films**; **Gallery Talks**; **Guided Tours** (Tues-Fri, 10am-4pm; groups 8+, reserve 2 weeks in advance); **Lectures**; **Temporary/Traveling Exhibitions**.

Publications: bulletin (quarterly); collection catalogue; exhibition catalogues.

Utah's oldest museum for the visual fine arts, the Springville Museum is noted for its collection of Utah art, documenting the art of the state from pioneer days to the present. Most major styles and artists of Utah are represented in nine permanent galleries on the second floor. These galleries display about 275 pieces, arranged in chronological order. The collection features over 250 artists including Dan Weggeland, J.T. Harwood, Mahonri Young, Minerva Teichert, LeConte Stewart, Don Olson, Doug Snow, Robert Marshall and Lee U. Bennion. The Museum's permanent collection totals over 1500 works. In addition to the work of Utahn artists, holdings include collections of American and Soviet art. Four main floor galleries display temporary shows offering a wide variety of styles and media dealing with historical and contemporary art of Utah. The Museum has a full program of lectures, guided tours, videos, publications and a research library. Popular exhibitions include the Spring Salon, the Autumn Exhibit and the All-State High School Show.

Vermont

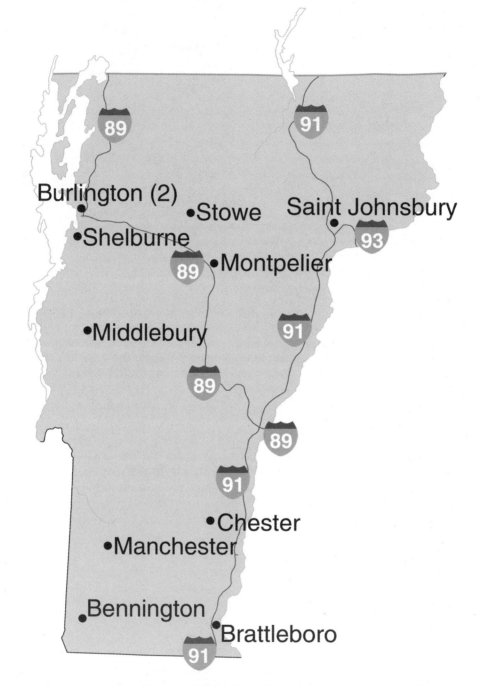

The number in parentheses following the city name indicates the number of museums/galleries in that municipality. If there is no number, one is understood. For example, in the text two listings would be found under Burlington and one listing under Montpelier.

Vermont

Bennington

Bennington Museum

W. Main St., Bennington, VT 05201
Tel: (802) 447-1571
Fax: (802) 442-8305
Internet Address: http://www.bennington.museum.com
Exec. Director: Mr. Steven Miller
Admission: fee: adult-$6.00, child (<12)-free, senior-$5.00, family-$13.00.
Attendance: 50,000 *Established:* 1876 *Membership:* Y *ADA Compliant:* Y
Parking: free on site.

Open: November to Memorial Day,
 Daily, 9am-5pm.
 June 1 to October 31,
 Daily, 9am-6pm.
Closed: New Year's Day, Thanksgiving Day,
 Christmas Day.
Facilities: **Architecture** (former St. Francis de
 Sales Church, 1855); **Library** (4,000 vol-
 umes); **Museum Shop**; **Nature Trail and
 Pavilion**; **Reading Room**.
Activities: **Guided Tours**; **Lectures**;
 Temporary Exhibitions; **Traveling
 Exhibitions**.

Mantel Figures, United States Pottery Company, Bennington, Vermont. Photograph by A. Blake Gardiner III, courtesy of Bennington Museum, Bennington, Vermont.

Publications: "Highlights from the Bennington Museum"; annual report, "The Bennington Museum Notes."; exhibition catalogues.

The Museum is one of the oldest and largest in the region. Collections document the early years of Vermont, as well as adjacent areas of New York and Massachusetts. Special strengths focus on Vermont decorative and fine arts, Bennington pottery, military history, and the art and life of Anna Mary Robertson Moses (Grandma Moses). The Museum organizes education programs on diverse subjects and has an active annual schedule of special events and changing exhibitions. Among the works on display are portraits by American artists Eurastus Salisbury Field, William Jennings, and Ammi Phillips, and Ralph Earl's "Townscape of Bennington" (1798). The Museum also holds the largest public collection of the works of Grandma Moses. Included among over 30 examples is the tilt-top table which she decorated in the 1920s with six rustic scenes and used as her easel. Of note among the decorative art collections are holdings of Vermont furniture; the largest collection of Bennington pottery in existence, including many one-of-a-kind presentation pieces and encyclopedic holdings of production work; free blown stemware; and pressed glass. The Museum is also home to the Bennington Flag, thought to be one of the oldest 'stars and stripes' in existence.

Brattleboro

Brattleboro Museum and Art Center

Union Railroad Station, Vernon & Main Sts.
Brattleboro, VT 05301
Tel: (802) 257-0124
Fax: (802) 257-0124
C.E.O.: Ms. Mara Williams
Admission: fee: adult-$3.00, child-free,
 student-$2.00, senior-$2.00.
Attendance: 21,000 *Established:* 1972
Membership: Y *ADA Compliant:* Y

Façade of Brattleboro Museum and Art Center, showing in foreground lawn sculpture, "Land Lift" by Bob Boernig. Photograph by Greg Bolosky, courtesy of Brattleboro Museum and Art Center, Brattleboro, Vermont.

Brattleboro Museum and Art Center, cont.

Parking: 12 parking spaces at facility; 250 at next building.

Open: **mid-May to November**, Tuesday to Saturday, noon-6pm.

Closed: December to April, Legal Holidays.

Facilities: **Architecture** (Union Railroad Station); **Galleries** (5).

Activities: **concerts**; **Demonstrations**; **Family Events**; **Lectures**.

Publications: brochures; exhibition catalogues; posters.

The BMAC presents exhibits that chronicle the region's history and display the work of internationally and locally known artists.

Burlington

University of Vermont - Francis Colburn Gallery

University of Vermont, Williams Hall, University Place Road, Burlington, VT 05405

Tel: (802) 656-2014

Fax: (802) 656-2064

Internet Address: http://www.uvm.edu/~colburn/index.html

Admission: free.

Established: 1975

Parking: visitor's pay parking lot on College Street.

Open: **September to May**, Monday to Friday, 9am-5pm.

Closed: June to August.

Facilities: **Galleries**.

Activities: **Education Programs**; **Films**; **Gallery Talks**; **Lectures**; **Temporary Exhibitions**.

Publications: exhibition announcements.

The Francis Colburn Gallery, located on the second floor of Williams Hall, is a teaching gallery with exhibitions by visiting artists, faculty, and honor students. Occasionally there are talks connected with the current exhibition. All shows are during the academic year and are primarily directed toward the student community.

University of Vermont - Robert Hull Fleming Museum

University of Vermont, 61 Colchester Ave., Burlington, VT 05405

Tel: (802) 656-2090

Fax: (802) 656-8059

Internet Address: http://www.uvm.edu/~fleming

Director: Ms. Ann Porter

Admission: fee: adult-$3.00, child (<7)-free, student-$2.00, senior-$2.00, family-$5.00.

Established: 1931 *Membership:* Y *ADA Compliant:* Y

Parking: metered lot on site; Sat-Sun, free in lot on west side of Museum.

Open: **Labor Day to April 30**, Tuesday to Friday, 9am-4pm; Saturday to Sunday, 1pm-5pm.
 May to Labor Day, Tuesday to Friday, noon-4pm; Saturday to Sunday, 1pm-5pm.

Closed: Legal Holidays.

Facilities: **Architecture** (designed by McKim, Mead & White, 1931); **Auditorium**; **Library** (2,000 volumes); **Museum Shop** (books, educational items for children, jewelry); **Reading Room**.

Activities: **Arts Festival**; **Concerts**; **Films**; **Gallery Talks**; **Guided Tours** (groups, reserve in advance); **Lectures**; **Temporary Exhibitions**; **Traveling Exhibitions**.

Publications: brochures; calendar; exhibition catalogues; posters.

Located on the University of Vermont campus, the Museum houses Vermont's most comprehensive collection of art and anthropological artifacts. Ongoing exhibits from the permanent collection include displays of African, American, ancient Egyptian, Asian, European, and Middle Eastern art, and paintings by 20th-century Vermont artists.

Chester

Chester Art Guild

The Green, Main St., Chester, VT 05143

Tel: (802) 875-3767

Chester Art Guild, cont.

President: Ms. Doris Ingram

Admission: free.

Established: 1960 *Membership:* Y

Open: June 15 to October 15,
Thursday, 1pm-5pm; Friday to Saturday, 10am-5pm; Sunday, 1pm-5pm.

Facilities: **Galleries** (2, each 400 square feet); **Library**.

Activities: **Education Programs**; **Lectures**.

The Art Guild exhibits paintings by local artists.

Manchester

Southern Vermont Art Center (SVAC)

West Road, Manchester, VT 05254

Tel: (802) 362-1405

Fax: (802) 362-3274

Internet Address: http:www.svac.org

Exec. Director: Mr. Christopher Madkour

Admission: fee: adult-$3.00, student-$0.50.

Attendance: 10,000 *Established:* 1929 *Membership:* Y *ADA Compliant:* Y

Parking: free on site.

Open: **Summer**, Wednesday to Saturday, 10am-5pm; Sunday, noon-5pm.
Winter, Monday to Saturday, 10am-5pm.

Facilities: **Architecture** (Georgian-style house, 1917; Wilson Museum, 2000 design by Hugh Newell Jacobsen); **Food Services** Restaurant; **Grounds**, (450 acres); **Library** (1,000 volumes); **Museum Shop**; **Sculpture Garden**.

Activities: **Films**; **Gallery Talks**; **Guided Tours**; **Lectures**; **Music Festival**; **Temporary Exhibitions**; **Traveling Exhibitions**.

Publications: brochures; collection catalogue, "Festival of the Arts" (annual).

Consisting of a Georgian revival mansion listed on the National Register of Historic Places, a performing arts pavilion, and a new fine arts museum, the SVAC presents programs in the visual, performing, and studio arts. The Elizabeth de C. Wilson Museum, which opened in July 2000, houses the Art Center's permanent collection of over 700 paintings, sculptures, and works on paper and provides a venue for traveling shows from major museums. SVAC also presents an annual members show, as well as other temporary exhibitions.

Middlebury

Middlebury College Museum of Art (MCMA)

Middlebury College, Center for the Arts

Route 30 (½ mile from junction with Route 7)

Middlebury, VT 05753-6177

Tel: (802) 443-5007

Fax: (802) 443-2069

Internet Address: http://www.middlebury.edu/~museum

Director: Mr. Richard H. Saunders

Admission: free.

Attendance: 12,000 *Established:* 1968

Membership: Y *ADA Compliant:* Y

Parking: free lot behind building.

Open: Tuesday to Friday, 10am-5pm;
Saturday to Sunday, noon-5pm.

Closed: Academic Holidays, last 2 weeks in Aug.

Circle of the Antimenes painter. Greek, attic black figure amphora, height 15½ inches, ca. 539-520 BC. Purchase of the Friends of Art Acquisition Fund, The Christian A. Johnson Memorial Fund, the Walter Cerf Acquisition Fund and the Memorial Fund, Middlebury College Museum of Art. Photograph courtesy of Middlebury College Museum of Art, Middlebury, Vermont.

Middlebury, Vermont

Middlebury College Museum of Art, cont.

Facilities: **Architecture** (postmodern, 1992 design by Hardy Holzman Pfeiffer Associates); **Food Services** Café (adjacent to entrance, light fare); **Galleries** (5, total 4,800 square feet); **Shop** (catalogues, posters, cards).

Activities: **Gallery Talks**; **Guided Tours** (reserve in advance); **Lectures**; **Traveling Exhibitions**; **Videos**.

Publications: annual report; brochures (semi-annual); exhibition catalogues.

Located in the Middlebury College Center for the Arts, the Museum houses the permanent collection of the college as well as the Christian A. Johnson Memorial Gallery, a space designated for traveling exhibitions. Since its inception, the Museum has endeavored to be a forum for the visual arts in the college community and a catalyst for widely varied forms of artistic expression and criticism. In addition, it has striven to create a rich and diverse collection that is an integral component in the teaching of art and art history. The Museum displays works from the permanent collection and special exhibitions throughout the year. A senior studio art majors show is scheduled each spring. The collection of several thousand objects ranges from antiquities through contemporary art and includes distinguished collections of Cypriot pottery, 19th-century European and American sculpture, and contemporary prints.

Montpelier

Vermont College - T.W. Wood Gallery and Arts Center

Vermont College, College Hall
Montpelier, VT 05602
Tel: (802) 828-8743
Fax: (802) 828-8855
Internet Address:
 http://www.norwich.edu/vermontcollege
Director: Mr. Phillip A. Robertson
Admission: fee-$2.00.
Attendance: 7,000 *Established:* 1897
Membership: Y *ADA Compliant:* Y
Parking: on street.
Open: Tuesday to Sunday, noon-4pm.
Closed: Legal Holidays.
Facilities: **Architecture** (19th century college campus); **Museum Shop.**
Activities: **Classes**; **Films**; **Guided Tours**; **Lectures**; **Traveling Exhibitions.**

Thomas Waterman Wood, *A Southern Cornfield*, 1861, oil on canvas, 28 x 40 inches. T.W. Wood Art Gallery. Photograph courtesy of T.W. Wood Gallery and Art Center, Montpelier, Vermont.

In 1895, the portrait and genre painter, Thomas Waterman Wood (1823-1903) contributed his personal art collection to the citizens of his home town, Montpelier, and in 1897 the T.W. Wood Gallery was opened. In addition to his own work, his collection included the work of his contemporaries Asher B. Durand, J.G. Brown, W.H. Beard, and Alexander Wyant. Paintings from the Works Progress Administration, completed during the depression era, are an especially interesting element of the Gallery's holdings and include the work of artists such as Yasuo Kunioshi, Reginald Marsh, and Joseph Stella. The Gallery also presents contemporary shows by local and regional artists and sculptors and national exhibits.

Saint Johnsbury

St. Johnsbury Athenæum Public Library and Art Gallery

1171 Main St., Saint Johnsbury, VT 05819
Tel: (802) 748-8291
Fax: (802) 748-8086
Internet Address: http://www.stjathenaeum.org
Library Director: Lisa von Kann
Admission: free.
Attendance: 8,000 *Established:* 1871 *Membership:* Y *ADA Compliant:* Y

St. Johnsbury Athenæum Public Library and Art Gallery, cont.

Parking: free on site (limited).

Open: Monday, 10am-8pm;
Tuesday, 10am-5:30pm;
Wednesday, 10am-8pm;
Thursday to Friday, 10am-5:30pm;
Saturday, 9:30am-4pm.

Closed: Legal Holidays.

Facilities: **Architecture** (Public Library, 1871 design by John Davis Hatch of New York); **Library**; **Reading Room**.

Activities: **Guided Tours**.

Publications: collection catalogue.

Albert Bierstadt, *Domes of the Yosemite*, 1867, oil on canvas, 9'8" x 15'. St. Johnsbury Athenæum. Photograph courtesy of St. Johnsbury Athenaeum, St. Johnsbury, Vermont.

Designated a National Historic Landmark, the St. Johnsbury Athenæum was built as a public library and presented to the townspeople of St. Johnsbury by Horace Fairbanks in 1871. The building is characterized by high cathedral ceilings, tall windows that brighten the interior, elaborate woodwork, floors with alternating strips of ash and walnut, and spiral staircases. In 1873, an art gallery was added to the main building. The design of the gallery itself was determined by the purchase of an enormous ten by fifteen-foot painting by Albert Bierstadt, *Domes of the Yosemite*. In 1965, Time Magazine described the gallery as "the United States' oldest unaltered art gallery still standing", and there has been an effort to retain its original style and atmosphere. Paintings in the heavy gilded frames of that era hang one above another. White marble statues and busts sit atop pedestals. Oak bookcases contain gold tooled leather bound books. This gallery is truly an authentic period piece. In the permanent collection of approximately 100 paintings are examples of the work of William-Adolphe Bourguereau, J.G. Brown, W.M. Brown, Samuel Colman, Jasper F. Cropsey, Asher B. Durand, Sanford Gifford, Seymour J. Guy, James Hart, William Hart, Emilie Preyer, Arthur F. Tait, Thomas Waterman Wood, and Worthington Whittredge. The library's book collection, originally consisting of 8,000 finely bound volumes selected with the advice of the noted bibliographer W.F. Poole, has been augmented and now includes approximately 45,000 volumes.

Shelburne

Shelburne Museum

U.S. Route 7, Shelburne, VT 05482

Tel: (802) 985-3346

Fax: (802) 985-2331

TDDY: (800) 253-1091

Internet Address: http://www.shelburnemuseum.org

President: Ms. Hope Alswang

Admission: fee: adult-$17.50, child-$7.00, student-$10.50.

Attendance: 155,000 *Established:* 1947

Membership: Y *ADA Compliant:* Y

Parking: free on site.

Open: **April 1 to late May**,
Daily, 1pm-4pm.
late May to October 15,
Daily, 10am-5pm.
October 16 to December 31,
Daily, 1pm-4pm.

Facilities: **Architecture** (37 structures on 45 acres); **Food Services** Restaurant; **Grounds** (45 acres with perennial, herb and lilac gardens); **Library** (10,000 volumes); **Museum Shop**.

Activities: **Gallery Talks**; **Guided Tours**.

Overview of the grounds of Shelburne Museum. Photograph courtesy of Shelburne Museum, Shelburne, Vermont.

Shelburne Museum, cont.

Publications: annual report; calendar; catalogues; newsletter.

The Museum focuses on American folk art, artifacts, and architecture. With 37 structures on 45 acres, the historic buildings and collections reflect the transition from an agricultural to industrial nation. Exhibits include three galleries of American paintings and decorative arts, seven furnished historic houses, and a gathering of Vermont community buildings. Fine and decorative arts collections include American prints and paintings; old master and impressionist paintings; New England furniture; ceramics, pewter, and blown and pressed glass. Among the folk art displayed are quilts, decoys, weather vanes, trade signs, hooked rugs, and scrimshaw and ship carvings.

Stowe

Helen Day Art Center

School St., Stowe, VT 05672-0411

Tel: (802) 253-8358

Fax: (802) 253-2703

Internet Address: http://www.helenday.com

Exec. Director: Ms. Mickey Myers

Admission: fee: adult-$2.00, child-$0.50, student-$0.50, senior-$1.00.

Attendance: 20,000 *Established:* 1981 *Membership:* Y *ADA Compliant:* Y

Parking: in front of facility and public lot across street.

Open: **Summer**, Tuesday to Sunday, noon-5pm.

 Winter, Tuesday to Saturday, noon-5pm.

Closed: New Year's Day, Presidents' Day, Easter, Memorial Day, Independence Day,

 Thanksgiving Day, Thanksgiving Friday, Christmas Day.

Facilities: **Architecture** (former school building, Greek Revival, 1863).

Activities: **Arts Festival**; **Concerts**; **Education Programs**; **Films**; **Guided Tours**; **Lectures**.

Publications: exhibition catalogues; newsletter (seasonal).

Located on the second floor of a restored 1863 Greek Revival village school, the Helen Day is a regional arts center serving north central Vermont. Programs are primarily dedicated to the visual arts with a strong educational emphasis. Exhibits include traditional and avant-garde fine arts as well as historical, cultural and craft exhibitions by local, national, and international artists. The East Gallery features rotating displays of work by local artists.

Virginia

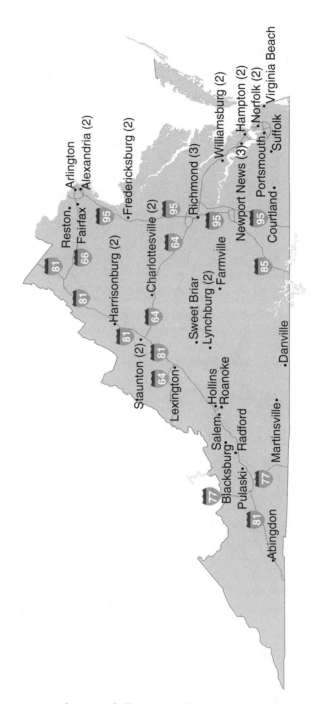

The number in parentheses following the city name indicates the number of museums/galleries in that municipality. If there is no number, one is understood. For example, in the text three listings would be found under Richmond and one listing under Arlington.

Virginia

Abingdon

William King Regional Arts Center

415 Academy Drive, Abingdon, VA 24212
Tel: (540) 628-5005
Fax: (540) 628-3922
Internet Address: http://www.wkrac.org
Director: Betsy K. White
Admission: free.
Attendance: 30,000 *Established:* 1979 *Membership:* Y
Parking: side of building.
Open: Tuesday, 10am-9pm; Wednesday to Friday, 10am-5pm; Saturday to; Sunday, 1pm-5pm.
Closed: New Year's Day, Easter Sunday, Memorial Day, Independence Day, Labor Day, Thanksgiving Day, Christmas Day.
Facilities: **Architecture** (former high school and Fields-Penn House, 1860); **Exhibition Space** (4,500 square feet); **Shop** The Looking Glass (arts, crafts, books, cards, art supplies).
Activities: **Education Programs**; **Guided Tours** (reserve 2 weeks in advance); **Traveling Exhibitions**.
Publications: catalogues; gallery guides; newsletter, "The Mirror" (quarterly).

The Arts Center offers rotating museum exhibitions in the Main Galleries, changing exhibits in the Cultural Heritage Galleries (featuring the material culture of southwest Virginia and east Tennessee), and the work of local artists in the Regional Artists Gallery.

Alexandria

The Athenæum

201 Prince St., Alexandria, VA 22314
Tel: (703) 548-0035
Fax: (703) 768-7471
Exec. Director: Ms. Mary Gaissert Jackson
Admission: free.
Attendance: 30,000 *Established:* 1964
Membership: Y
Parking: metered on street or nearby commercial facilities.
Open: Wednesday to Friday, 11am-3pm;
Saturday, call for hours;
Sunday, 1pm-4pm.
Closed: January to February.
Facilities: **Architecture** (Greek Revival former bank building, 1851-52); **Gallery**; **Sculpture Garden**.
Activities: **Juried Exhibits**; **Lectures**; **Temporary Exhibitions** (4/year).
Publications: brochures; newsletter, "Behind the Columns" (quarterly).

Façade of The Athenæum. Photograph courtesy of Northern Virginia Fine Arts Association, Alexandria, Virginia.

Owned by the Northern Virginia Fine Arts Association, the Athenæum offers four annual art exhibits, presenting primarily the work of greater Washington, DC artists.

Torpedo Factory Art Center

105 N. Union St. (on Potomac river front ½ block north of King St.), Alexandria, VA 22314
Tel: (703) 838-4565
Internet Address: http://www.torpedofactory.org.
Director: Taylor C. Wells
Admission: free.
Attendance: 800,000 *Established:* 1974 *Membership:* Y *ADA Compliant:* Y

Alexandria, Virginia

Torpedo Factory Art Center, cont.

Parking: commercial adjacent to site and on street parking.
Open: **Art Center**,
 Daily, 10am-5pm.
 Archaeology Museum,
 Monday to Friday, 10am-3pm;
 Saturday, 10am-5pm;
 Sunday, 1pm-5pm.
Closed: New Year's Day, Easter, Independence Day,
 Thanksgiving, Christmas.
Facilities: **Architecture** (former naval torpedo factory); **Galleries** (6); **Public Hall** (1,200 capacity); **Studios** (83).
Activities: **Lectures**; **Tours** (group, by appointment).
Publications: "Torpedo Factory Visitor's Guide"; brochure, "Art in Action".

More than 160 professional artists work here in studios, and the work of an additional 2,000 artists is exhibited in the galleries. The Torpedo Factory Art Center also houses the Art League School with year-round art classes. Additionally the City's Archaeology Museum and Research Laboratory, located on the third floor, is open for visitors.

Façade of Torpedo Factory Art Center. Photograph courtesy of Torpedo Factory Art Center, Alexandria, Virginia.

Arlington

Marymount University - Barry Art Gallery

Reinsch Library, 2807 N. Glebe Road, Arlington, VA 22207-4299
Tel: (703) 284-1561
Internet Address: http://www.mu.marymount.edu
Curator: Ms. Judy Bass
Open: Monday to Thursday, 10am-8pm; Friday to Saturday, 10am-6pm.
Facilities: **Exhibition Area**.
Activities: **Temporary Exhibitions**.

The Gallery offers a schedule of temporary exhibitions, including an annual juried Student Art and Design Exhibition.

Blacksburg

Virginia Polytechnic Institute - Armory Art Gallery

201 Draper Road, Blacksburg, VA 24061-7623
Tel: (540) 231-5200
Internet Address: http://www.art.vt.edu
Admission: free.
Open: Tuesday to Friday, noon-5pm; Saturday, noon-4pm.

Formerly a gymnasium, the Armory Art Gallery presents work by students, faculty, and artists of regional and national reputation. Also of possible interest on campus is the XYZ Gallery, which shows work by students and local artists.

Charlottesville

Second Street Gallery

McGuffey Art Center, 201 2nd St., NW, Charlottesville, VA 22902
Tel: (804) 977-7284
C.E.O.: Mr. Paul Wright
Admission: free.
Attendance: 12,000 *Established:* 1973 *Membership:* Y *ADA Compliant:* Y
Parking: metered on street.

Second Street Gallery, cont.

Open: Tuesday to Saturday, 10am-5pm; Sunday, 1pm-5pm.
Closed: Legal Holidays.
Facilities: **Exhibition Area.**
Activities: **Gallery Talks**; **Lectures**; **Temporary Exhibitions.**
Publications: brochures; exhibition catalogues.

Second Street Gallery, central Virginia's first artist-run alternative art space, was founded in 1973 for the purpose of presenting contemporary visual art to the local community. In 1978 the artist cooperative administration was discontinued in favor of a board-run nonprofit organization with an executive staff. In 1991, Second Street Gallery was selected by the NEA as one of two model art organizations in the country, and was recognized as a vibrant visual art space that provides the community with a forum for the exchange of innovative ideas and objects. Each season, Second Street Gallery presents the work of talented local, regional, and national artists working in a variety of media. In addition to its program of monthly exhibitions and gallery talks, the Gallery serves the community at large through its educational outreach programs, tours, workshops and special events. It has no permanent collection. The Gallery, a former elementary school building, also contains artists' studios.

University of Virginia - Bayly Art Museum

Rugby Road, Thomas H. Bayly Memorial Building, Charlottesville, VA 22903-2427
Tel: (804) 924-3592
Fax: (804) 924-6321
Internet Address: http://www.virginia.edu/~bayly/bayly.html
Director: Ms. Jill Hartz
Admission: free.
Attendance: 30,000 *Established:* 1935 *Membership:* Y *ADA Compliant:* Y
Parking: behind museum (limited) and university visitor lots.
Open: Tuesday to Sunday, 1pm-5pm.
Closed: Thanksgiving Day, Christmas Day to New Year's Day.
Facilities: **Exhibition Area**; **Shop**.
Activities: **Concerts**; **Gallery Talks**; **Guided Tours** (group tours by appointment, (804) 924-7458); **Permanent Exhibits**; **Temporary Exhibitions** (8-10/year); **Traveling Exhibitions.**
Publications: exhibition catalogues (occasional); newsletter (semi-annual).

The Bayly Art Museum at the University of Virginia exhibits art from around the world dating from ancient times to the present. Each year the Museum presents eight to ten temporary exhibitions drawn both from the Museum's collections and from a multitude of other sources nationwide. Installations of the permanent collection rotate throughout the year. Extensive programming, including lectures and symposia conducted by visiting scholars and artists, and publications, from brochures to major catalogues, enhance the critical interpretation offered by the exhibitions. The Museum's permanent collection is wide ranging. The Western tradition is represented by painting and sculpture of the 15th- to 19th-centuries with emphasis on American art and art from the Age of Thomas Jefferson (1775-1825). An important collection of old master and later prints spanning five centuries continues to be augmented. Highlights of the collection of 20th-century painting, sculpture and works on paper include American figurative art and photography. Art from ancient Mediterranean, pre-Columbian, American Indian, Asian, and African cultures affords Museum visitors access to a rich variety of human cultural achievements.

Courtland

Rawls Museum Arts

22376 Linden St., Courtland, VA 23837
Tel: (757) 653-0754
Fax: (757) 653-0341
Internet Address: http://www.geocities.com/rawls_museum_arts
Administrator: Ms. Barbara Easton Moore
Admission: free.
Established: 1958 *Membership:* Y *ADA Compliant:* Y

Courtland, Virginia

Rawls Museum Arts, cont.

Open: Wednesday to Friday, 10am-4pm; Saturday, 10am-1pm.

Facilities: **Exhibition Area**; **Shop**; **Studios.**

Activities: **Changing Exhibitions**; **Classes**; **Concerts**; **Education Programs**; **Lectures**; **Special Events**; **Workshops.**

Publications: newsletter (quarterly).

Rawls Museum Arts is a non-profit regional arts organization dedicated to making the arts come alive for those who create as well as those who enjoy and admire artistic creations. Among the exhibitions regularly presented are a regional juried art exhibition open to all area amateur and professional artists; a juried photography exhibition for serious and recreational photographers; a high school student art show; a Christmas Gallery Show and Sale, featuring paintings by the Blackwater Art League; and a NASCAR art-oriented exhibition.

Danville

Danville Museum of Fine Arts and History

975 Main St., Danville, VA 24541

Tel: (804) 793-5644

Fax: (804) 799-6145

Exec. Director: Ms. Nancy S. Perry

Admission: suggested contribution-$2.00.

Attendance: 25,000 *Established:* 1974

Membership: Y *ADA Compliant:* Y

Parking: free on site.

Open: Tuesday to Friday, 10am-5pm;
Saturday to Sunday, 2pm-5pm.

Closed: Legal Holidays.

Facilities: **Architecture** (Italian Villa-style residence, 1857); **Auditorium**; **Galleries**; **Shop** (books, original art, prints, Civil War items).

Activities: **Gallery Talks**; **Guided Tours** (groups 10+ reserve in advance); **Performances.**

Publications: exhibition catalogues; newsletter (quarterly).

Exterior view of Danville Museum of Fine Arts and History. Photograph courtesy of Danville Museum of Fine Arts and History, Danville, Virginia.

Housed in an 1857 Italian villa-style mansion, the Museum interprets the home and the history of the city of Danville during the years it was occupied by the Sutherlin family. Two modern wings, added to the rear of the original building, include three art galleries for changing exhibitions. In addition to exhibitions from its permanent holdings, the Museum features shows organized with loans from public and private collections as well as traveling exhibitions of national significance. Regularly scheduled exhibitions of various art forms by widely recognized artists and emerging new talent complement the Museum's varied exhibition schedule. The primary collection is of 18th- and 19th-century American decorative arts, which includes furniture, textiles, and a variety of other objects. Paintings representing a wide range of artists and periods are among the Museum's fine art holdings and are displayed throughout the Museum.

Fairfax

George Mason University - University Fine Arts Galleries

4400 University Drive, Fairfax, VA 22030

Tel: (703) 993-1010

Internet Address: http://www.gmu.edu/gallery

Director: Mr. Kirby Malone

Admission: free.

Parking: Visitor Parking garage off Mason Drive.

Open: Weekdays, 9am-5pm.

Facilities: **Galleries** (2).

George Mason University - University Fine Arts Galleries, cont.

Activities: **Temporary Exhibitions** (6/year).

Managed by GMA's Institute for the Arts, the University maintains two gallery spaces: the Center Gallery, located in the main atrium of the George W. Johnson Center and Gallery FAB, located in the adjacent Fine Arts Building, Room B104. The galleries present the work of artists not associated with GMU, an annual student exhibition at the end of the spring semester, and a biennial faculty exhibition. The campus also has several outdoor sculpture sites.

Farmville

Longwood College - Longwood Center for the Visual Arts (LCVA)

Longwood College, 129 N. Main St., Farmville, VA 23901

Tel: (804) 395-2206

Fax: (804) 392-6441

TDDY: (800) 828-1120

Internet Address:
http://web.lwc.edu/administrative/visualart/index.htm

Interim Director: Susanne Arnold

Admission: free.

Attendance: 8,000 *Established:* 1978

Membership: Y *ADA Compliant:* Y

Open: Monday to Saturday, 11am-4:30pm.

Closed: Memorial Day, Thanksgiving Day, Christmas Day.

Facilities: **Galleries** (3).

Activities: **Education Programs; Gallery Talks; Lectures; Traveling Exhibitions.**

Publications: exhibition catalogues.

Nell Blaine, *Sunlit Room with Figure*, 1963, oil on canvas, 36 x 25 inches. Longwood College purchase for the Contemporary Virginia Artists Collection. Photograph courtesy of the Longwood Center for the Visual Arts, Farmville, Virginia.

The Longwood Center for the Visual Arts is the art museum of Longwood College. Each year the Center presents six to eight exhibitions drawn both from its collections and from other sources accompanied by related publications and education programs. Collections focus on Virginia art and crafts and 19th-century American art. Initiated in 1951, the Virginia Collection of Contemporary Artists is the cornerstone of the Center, and the focus of new acquisitions and exhibitions. Also of note is the collection of paintings by the 19th-century American portrait painter Thomas Sully and his contemporaries. Additional artwork and art objects from around the world are collected and maintained in the Study Collection, including extensive collections of Chinese ceramics and African masks.

Fredericksburg

Belmont, The Gari Melchers Estate and Memorial Gallery

224 Washington St., Fredericksburg, VA 22405

Tel: (540) 654-1015

Fax: (540) 654-1785

Internet Address: http://www.mwc.edu/belmont

Director: Mr. David S. Berreth

Admission: fee: adult-$4.00, student-$1.00, senior-$3.00.

Attendance: 15,000 *Established:* 1975

Membership: Y *ADA Compliant:* Y

Parking: free on site.

Open: **March to November,**
Monday to Saturday, 10am-5pm; Sunday, 1pm-5pm.

December to February,
Monday to Saturday, 10am-4pm; Sunday, 1pm-4pm.

Gari Melchers, *The Fencer*, 1895, Belmont, The Gari Melchers Estate and Memorial Gallery. Photograph courtesy of Belmont, The Gari Melchers Estate and Memorial Gallery, Mary Washington College, Fredericksburg, Virginia.

Belmont, The Gari Melchers Estate and Memorial Gallery, cont.

Closed: New Year's Eve to New Year's Day, Thanksgiving Day, Christmas Eve to Christmas Day.
Facilities: **Architecture** (estate, 18th-century); **Gallery**; **Grounds** Formal Gardens; **Shop**.
Activities: **Guided Tours**; **Temporary Exhibitions**.
Publications: brochures; catalogues; newsletter (quarterly).

Belmont was the home of American artist Gari Melchers (1860-1932), who lived and worked at the 18th-century Falmouth estate from 1916 until his death. Administered by Mary Washington College, it is dedicated as a memorial to the artist and his work, and to serving the college community and the general public as an art museum. The house is furnished with a rich selection of antiques, most of which were collected by the Melchers during their residences and travels abroad. Painting and prints by the artist and his American and European contemporaries, and older masters, decorate the walls. A stone studio, built by Melchers in 1924, houses the largest repository of his work. The north-lit studio room remains outfitted with the artist's tools and accoutrements. Two adjoining galleries feature a selection of the artist's paintings and are the site of special exhibitions devoted to the art of Melcher's era. After his death, Melcher's wife, Corinne, set about establishing Belmont as a memorial to her husband and his work. At her death in 1955, she bequeathed to the state of Virginia the 27 acre estate and all of their possessions, including over 600 of Melcher's paintings and 1,200 works on paper, plus over 400 works by other artists. Also included were all of their personal belongings, including antique furniture, carpets, decorative arts, and books. Their personal papers and correspondence made up another large collection.

Mary Washington College Galleries

College Ave., Fredericksburg, VA 22401-5358
Tel: (540) 654-2120
Fax: (540) 654-1070
TDDY: (540) 654-1104
Internet Address: http://www.mwc.edu/gallery/
Director: Dr. Forrest McGill
Admission: free.
Attendance: 5,000 *Established:* 1956 *ADA Compliant:* Y
Parking: free in area designated for gallery in lot on College Ave.
Open: **During Exhibitions**,
 Monday/Wednesday/Friday, 10am-4pm; Saturday to Sunday, 1pm-4pm.
Closed: New Year's Day, Thanksgiving Day, Christmas Day.
Facilities: **Galleries** (2).
Activities: **Education Programs**; **Guided Tours**; **Lectures**; **Temporary Exhibitions**.

The Ridderhof Martin Gallery (College Avenue at Seacobeck Street) hosts exhibitions brought in from museums around the country, or drawn from the permanent collection. The duPont Gallery (College Avenue at Thornton Street) features painting, drawing, sculpture, photography, ceramics, and textiles by art faculty and students as well as other contemporary artists. The permanent collection of over 5,000 works is strongest in mid-20th-century and Asian art. Milton Avery, Nicholas P. Brigante, Hans Burkhardt, Sue Coe, Werner Drewes, Arshile Gorky, Karl Knaths, William Lathrop, Helen Lundeberg, Roger Mühl, Robert Andrew Parker, Ben Shahn. William Thon, Theo Tobiasse, John Twachtman, and Andy Warhol are among the artists represented in the permanent collection. The College also holds extensive collections of the artwork and personal papers of artists Phyllis Ridderhof Martin and Margaret Sutton.

Hampton

Charles H. Taylor Arts Center

4205 Victoria Blvd., Hampton, VA 23669-4297
Tel: (757) 722-2787
Fax: (757) 727-1167
Director: Mr. Michael P. Curry
Admission: free.
Attendance: 32,000 *Established:* 1989 *Membership:* Y *ADA Compliant:* Y
Open: Tuesday to Friday, 10am-6pm; Saturday to Sunday, 1pm-5pm.

Charles H. Taylor Arts Center, cont.

Closed: New Year's Day, Memorial Day,
 Independence Day, Thanksgiving Day,
 Christmas Day.

Facilities: **Galleries.**

Activities: **Demonstrations; Education Programs**
 (adults and children); **Guided Tours** (on request);
 Lectures; Workshops.

Publications: magazine, "Diversions" (bi-monthly).

Located in the original Hampton Public Library building, the Charles H. Taylor Arts Center is administered by the Hampton Arts Commission, which presents changing exhibitions by nationally, regionally and locally recognized artists in the Armstrong and Chapman Galleries, as well as educational programs.

Ron Adams, *All Things Are Possible*, 1990, Charles H. Taylor Arts Center. Courtesy of The Hampton Arts Commission, Hampton, Virginia.

Hampton University Museum

Hampton University, Huntington Building, Hampton, VA 23668

Tel: (757) 727-5308

Fax: (757) 727-5170

Internet Address:
 http://www.hamptonu.edu/other/museum/index.htm

Director: Ms. Jeanne Zeidler

Admission: free.

Attendance: 50,000 *Established:* 1868

Membership: Y *ADA Compliant:* Y

Parking: free on site.

Open: Monday to Friday, 8am-5pm;
 Saturday to Sunday, noon-4pm.

Closed: Legal Holidays, Academic Holidays.

Facilities: **Exhibition Area** (12,000 square feet); **Library**
 (1,000 volumes); **Shop** (handcrafted ethnic works of art,
 books, prints).

Activities: **Education Programs; Gallery Talks; Guided
 Tours** (by appointment); **Lectures; Permanent Exhibits;
 Temporary Exhibitions; Traveling Exhibitions.**

Publications: journal, "International Review of African
 American Art" (quarterly); monographs.

Henry Ossawa Tanner, *The Banjo Lesson*, 1893, oil on canvas. Hampton University Museum. Photograph courtesy of Hampton University Museum, Hampton, Virginia.

The Hampton University Museum is the oldest African American museum in the United States and one of the oldest museums in Virginia. The Museum has over 12,000 square feet of exhibition space, including permanent galleries for the fine arts collection. Its holdings feature over 9,000 objects such as traditional African, Native American, Asian and Pacific Island art; fine arts; and objects relating to the history of the University. The fine arts collection consists of some 1,500 paintings, works on paper, and sculpture. The Museum's holdings in the art of the Harlem Renaissance period are among the finest in the nation. The Museum also has a significant collection of works by 19th-century artist Henry Ossawa Tanner, including the "The Banjo Lesson" (1893). Artists represented in the holdings also include Ron Adams, Edward Mitchell Bannister, Romare Bearden, Dr. John T. Biggers, Elizabeth Catlett, Aaron Douglas, Robert Scott Duncanson, Joseph Gilliard, Persis Jennings, Joshua Johnson, Malvin G. Johnson, Sargent Claude Johnson, William Henry Johnson, Lois Mailou Jones, Gwendolyn Knight, Jacob Lawrence, Dr. Samella Sanders Lewis, Archibald Motley, Jr., Charles Ethan Porter, Augusta Savage, Albert Alexander Smith, James Lesesne Wells, and Charles White. The African collection consists of approximately 3,500 objects representing nearly 100 ethnic groups and cultures, including one of the finest collections of Kuba art in the world. The Native American collection features over 1,600 objects from approximately 93 Native American tribes.

Harrisonburg

James Madison University - Art Galleries

Duke Hall and Zirkle House, 800 S. Main St., Harrisonburg, VA 22807

Tel: (540) 568-6407

Fax: (540) 568-6598

Internet Address: http://www.jmu.edu

Coordinator: Mr. Stuart Downs

Admission: free.

Attendance: 10,000 *Established:* 1967 *ADA Compliant:* Y

Open: September to April,
 Monday to Friday, 10:30am-4:30pm; Saturday to Sunday, 1:30pm-4:30pm.

Facilities: Galleries.

Activities: Temporary Exhibitions.

Sawhill Gallery, located in Duke Hall, features art of international, national and regional interest. New Image Gallery in Zirkle House focuses on contemporary photography. The Zirkle House Student Galleries present the work of JMU graduate and undergraduate students.

Virginia Quilt Museum

301 S. Main St., Harrisonburg, VA 22801

Tel: (540) 433-3818

Fax: (540) 433-3818

Director: Ms. Joan Knight

Admission: fee: adult-$4.00, child-$2.00, student-$3.00, senior-$3.00.

Membership: Y

Parking: free lot, between Main and Liberty Sts..

Open: Thursday to Saturday, 10am-4pm; Sunday, 1pm-4pm.

Closed: Major Holidays.

Facilities: Exhibition Area.

Activities: Classes/Workshops; Education Programs; Permanent Exhibits; Temporary Exhibitions.

The Museum collects, preserves, and interprets quilts, related artifacts and documentation. The Museum displays its permanent collection as well as hosting temporary exhibitions.

Hollins

Hollins University - Art Gallery

7916 Williamson Road, Hollins, VA 24020

Tel: (540) 362-6468

Internet Address: http://www.hollins.edu/html/art/artexhibit/artexhibit.htm

Admission: free.

Open: Monday to Friday, 9am-9pm; Saturday to Sunday, 1pm-4pm.

Facilities: Exhibition Area.

Activities: Temporary Exhibitions (9/year).

Located in the Art Annex, the gallery presents exhibitions of work by regionally and nationally recognized artists, as well as by faculty and students. Exhibitions are also mounted in the Ballator Gallery, located in the Moody Center.

Lexington

Washington and Lee University - The Reeves Center

Back Campus, Lexington, VA 24450

Tel: (540) 463-8744

Fax: (540) 463-8741

Internet Address: http://liberty.uc.wlu.edu

Director: Mr. Thomas V. Litzenburg, Jr.

Washington and Lee University - The Reeves Center, cont.
Admission: free.
Attendance: 5,000 *Established:* 1982 *ADA Compliant:* Y
Open: Monday to Friday, 9am-4:30pm; Saturday to Sunday, by appointment.
Closed: New Year's Eve to New Year's Day, Thanksgiving Day, Christmas Eve to Christmas Day.
Facilities: **Architecture** (1840 Greek Revival house and Palladian-style pavilion); **Exhibit Spaces** (2 - 3,500 square feet); **Library** (900 volumes).
Activities: **Education Programs**; **Guided Tours**; **Temporary Exhibitions**; **Traveling Exhibitions**.
Publications: catalogues.

The Reeves Center presents loan exhibitions and temporary exhibitions of objects from its own collection, which includes Chinese ceramics, European ceramics, and 17th- to 19th-century paintings. Also of possible interest on campus is the duPont Gallery (open Mon-Fri, 9am-5pm during academic year; tel 463-8861). Located on the Back Campus, the Gallery presents temporary exhibitions of work by contemporary artists of regional and national reputation. Student work is also presented.

Lynchburg

Lynchburg College - Daura Gallery
Dillard Fine Arts Center, 1501 Lakeside Drive, Lynchburg, VA 24501
Tel: (804) 544-8343
Internet Address: http://www.lynchburg.edu/daura/
Director: Ms. Barbara Rothermel
Admission: free.
Established: 1974
Open: **Academic Year**, Monday to Friday, 9am-2pm; Sunday, 1pm-5pm.
 Summer, by appointment
Closed: Academic Holidays.
Facilities: **Exhibition Area**.
Activities: **Gallery Talks**; **Guided Tours** (by appointment, reserve two weeks in advance); **Lectures**; **Temporary Exhibitions**.

Located in the Dillard Fine Arts Center on the campus of Lynchburg College, the Gallery presents changing exhibitions of works drawn from its permanent collection and from public and private sources and features a permanent exhibit of the work of Catalan-American artist Pierre Daura. Established in 1974, the Gallery was dedicated in 1990 to the memory of Daura, who taught at Lynchburg College, and his wife Louise Blair Daura. The permanent collection consists of more than 1,000 paintings, sculpture, and works on paper focusing on Virginia artists, including 150 works by Daura.

Randolph Macon Woman's College - Maier Museum of Art
Randolph-Macon Woman's College, 2500 Rivermont Ave., Lynchburg, VA 24503
Tel: (804) 947-8136
Fax: (804) 947-8726
Internet Address: http://www.rmwc.edu/Maier
Director: Dr. Karol Lawson
Admission: free.
Attendance: 8,000 *Established:* 1920 *Membership:* Y
ADA Compliant: Partial (parking and galleries are accessible, but rest rooms are not)
Parking: free on site (limited).
Open: **late August to late May**, Tuesday to Sunday, 1pm-5pm.
 late May to late August, Wednesday to Sunday, 1pm-4pm.
Closed: Academic Holidays, Late December to mid-January.
Facilities: **Galleries** (6); **Shop** (catalogues, cards).
Activities: **Concerts**; **Education Programs**; **Gallery Talks**; **Guided Tours** (group tours reserve in advance); **Lectures**; **Temporary Exhibitions**.

Lynchburg, Virginia

Randolph Macon Woman's College - Maier Museum of Art, cont.

Publications: collection catalogue, "American Art: American Vision"; exhibition catalogues (2-3/year); newsletter (semi-annual).

The Maier Museum of Art at Randolph-Macon Woman's College houses a growing collection of over 2,000 objects, with a focus on 19th- and 20th-century American paintings and works on paper. The Museum serves the academic community as well as the general public and offers changing exhibitions, permanent displays and special programs, including lectures and oncerts. Virtually unique among college and university collections for its exclusive focus on American art, the Maier Museum's strengths lie in American Impressionism, as seen in paintings such as Childe Hassam's "Early Evening after Snowfall", and early-20th-century Realism, exemplified by Bellows's "Men of the Docks". Works by woman artists such as Marion Boyd Allen's "Portrait of Anna Vaughn Hyatt" play

George Bellows, *Men of the Docks*, 1912, oil on canvas, 45 x 63½ inches. Maier Museum of Art, Randolph-Macon Woman's College. Photograph courtesy of Maier Museum of Art, Randolph-Macon Woman's College, Lynchburg, Virginia.

important roles in the collection. Early American portraiture is represented by Gilbert Stuart's "Portrait of Mrs. Polly Hooper", and among Hudson River School landscapes is John Frederick Kensett's "On the Connecticut Shore". Also included are works by Thomas Cole, Thomas Eakins, Robert Henri, Edward Hicks, Winslow Homer, Edward Hopper, George Inness, Georgia O'Keeffe, and James McNeill Whistler. A large collection of paintings and works on paper by Arthur B. Davies make the Museum an important center for the study of his works. Other works on paper include selections by Mary Cassatt, Childe Hassam, John Marin, and Maurice Prendergast. Images by Sally Mann, William Eggleston, and Abelardo Morrell number among a small, but growing, collection of American photographs.

Martinsville

Piedmont Arts Association (PAA)

215 Starling Ave., Martinsville, VA 24112
Tel: (540) 632-3221
Fax: (540) 638-3963
Internet Address: http://www..piedmontarts.org
Interim Exec. Director: Ms. Toy L. Cobbe
Admission: free.

Rendering of newly renovated and expanded Piedmont Arts Association facility. Courtesy of Piedmont Arts Association, Martinsville, Virginia.

Attendance: 15,000 *Established:* 1961 *Membership:* Y *ADA Compliant:* Y
Parking: free adjacent to site.
Open: Tuesday to Friday, 9am-5pm; Saturday, 10am-3pm; Sunday, 1:30pm-4:30pm.
Closed: New Year's Eve to New Year's Day, Memorial Day, Independence Day, Labor Day, Thanksgiving Day, Christmas Eve to Christmas Day.
Facilities: **Architecture** (M.R. Schotland estate, 1900); **Classroom**; **Galleries** (4); **Performance Hall**; **Shop**; **Studios** (Loom Room).
Activities: **Arts Festival**; **Concerts** (performing arts series); **Education Programs** (children, classes, discovery room); **Films**; **Guided Tours**; **Lectures**; **Temporary Exhibitions** (6/year).
Publications: brochures; exhibition catalogues; newsletter, "The Arts and You" (monthly).

An affiliate of the Virginia Museum of Fine Arts, PAA offers programming in both the visual and performing arts that targets viewers with a broad range of ages, interests and backgrounds.

Newport News

Christopher Newport University - Falk Art Gallery

University Place (off Route 60), Newport News, VA 23606
Tel: (757) 594-7089
Internet Address: http://www.cnu.edu

Christopher Newport University - Falk Art Gallery, cont.

Art Department Chairman: Lawrence Barron Wood, Jr.
Admission: free.
Open: Monday to Friday, 1pm-4pm.
Facilities: **Exhibition Area**.
Activities: **Temporary Exhibitions**.

The Gallery presents seven temporary exhibitions each year.

The Mariners' Museum

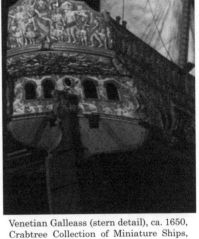

100 Museum Drive (Warwick & J. Clyde Morris Blvds.)
Newport News, VA 23606-3759
Tel: (757) 596-2222
Fax: (757) 591-7311
Internet Address: http://www.mariner.org
President: Mr. John B. Hightower
Admission:
 fee: adult-$5.00, child-free, student-$3.00, family-$13.00.
Attendance: 200,000 *Established:* 1930
Membership: Y *ADA Compliant:* Y
Open: Daily, 10am-5pm.
Closed: Thanksgiving, Christmas Day.
Facilities: **Exhibition Area** (13 galleries, 77,000 square feet);
 Grounds (550 acres - park with lake, picnic areas); **Lecture
 Room** (270 seats); **Library and Archives** (75,000 volumes,
 600,000 historic photographs, 1 million archival items);
 Orientation Theatre (50 seats); **Reading Room**; **Shop**
 (maritime books, prints, gifts, educational toys).
Activities: **Education Programs** (adults, undergraduate/grad-
 uate students, and children); **Gallery Talks**; **Guided Tours**;
 Lectures; **Permanent Exhibits**; **Temporary Exhibitions**
 (constantly changing).

Venetian Galleass (stern detail), ca. 1650, Crabtree Collection of Miniature Ships, Mariners' Museum. Photograph courtesy of Mariners' Museum, Newport News, Virginia.

Publications: "NewsCalendar" (quarterly); books, "Guide to the Mariners' Museum"; brochures;
 monographs; newsletter.

The Mariners' Museum, one of the largest and most comprehensive maritime museums in the world, houses more than 35,000 objects documenting or inspired by man's experiences with the sea. Its diverse collection of maritime artifacts include figureheads, scrimshaw, hand-crafted ship models, decorative arts, prints, paintings, and small craft from around the world. The permanent collection includes the August Crabtree Collection of Miniature Ships; maritime paintings by American, Flemish, French, and Chinese artists; scrimshaw; and historic photographs.

Peninsula Fine Arts Center (PFAC)

101 Museum Drive, Newport News, VA 23606-3758
Tel: (757) 596-8175
Fax: (757) 596-0807
Internet Address: http://www.pfac-va.org/c
Exec. Director: Ms. Lisë C. Swensson
Admission: varies with exhibition.
Attendance: 72,000 *Established:* 1962
Membership: Y *ADA Compliant:* Y
Parking: free on site.
Open: Monday to Saturday, 10am-5pm;
 Sunday, 1pm-5pm.

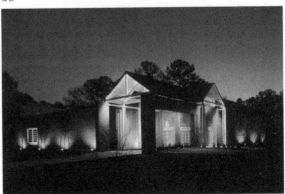

Exterior view of Peninsula Fine Arts Center, located in Mariners' Museum Park. Photograph courtesy of Peninsula Fine Arts Center, Newport News, Virginia.

Peninsula Fine Arts Center., cont.

Closed: New Year's Day, Thanksgiving Day, Christmas Day, Christmas Eve.

Facilities: **Galleries**; **Gardens**; **Shop** (closes 4pm daily; artwork, jewelry, and crafts); **Studios**.

Activities: **Education Programs and Studio Art School** (adults and children); **Guided Tours**; **Lectures**; **Performing Arts Presentations**; **Special Events**.

Publications: exhibition catalogues; newsletter, "Articles" (quarterly).

The Peninsula Fine Arts Center (PFAC), an affiliate of the Virginia Museum of Fine Arts, is a non-profit organization dedicated to promoting art appreciation and education. The Center offers a diverse schedule of changing exhibitions, featuring local, regional, and national collections of contemporary and historical art. The "Hands On For Kids" gallery is a permanent installation space designed for children and adults to interact in an enjoyable educational environment encouraging participation with art materials and concepts. Each year PFAC's Studio Art School offers three sessions of classes and workshops for children (5 and up) and adults in a variety of media. Guided tours of the galleries may be arranged upon request.

Norfolk

The Chrysler Museum of Art

245 W. Olney Road at Mowbray Arch, Norfolk, VA 23510-1587

Tel: (757) 664-6200

Fax: (757) 664-6201

TDDY: (804) 623-5976

Internet Address: http://www.chrysler.org

Director: Dr. William J. Hennessey

Admission: fee: adult-$5.00, child-free, student-$3.00, senior-$3.00.

Attendance: 250,000 *Established:* 1933

Membership: Y *ADA Compliant:* Y

Parking: free on site.

Open: Tuesday to Saturday, 10am-5pm; Sunday, 1pm-5pm.

Closed: New Year's Day, Independence Day, Thanksgiving Day, Christmas Day.

Facilities: **Food Services** Restaurant (Tues-Sat, 11am-3pm; Sun, noon-3pm); **Library** (80,000 volumes; Tues & Thurs, 10am-4:45pm; Sat, noon-4pm); **Shop**; **Theatre** (300 seats).

The Chrysler Museum, exterior view from The Hague. Photograph by Peter Aaron, courtesy of The Chrysler Museum, Norfolk, Virginia.

Activities: **Concerts**; **Education Programs** (families); **Films**; **Gallery Talks**; **Guided Tours** ((757) 664-6269); **Juried Exhibits** (students); **Lectures**; **Temporary Exhibitions**.

Publications: "Calendar of Events" (monthly); bulletin (monthly); program/exhibition schedules (quarterly).

With more than 30,000 objects spanning more than 5,000 years of art history, the Chrysler Museum of Art houses one of America's premier collections. The skylit Impressionist Gallery includes works of such masters as Cassatt, Cézanne, Degas, Gauguin, Monet, Renoir, Rodin and Sisley. The Glass Galleries are a Chrysler mainstay and include what is considered one of the finest selection of Tiffany creations in the world. Other galleries include European painting and sculpture from the 14th- to the 20th-century; 19th- and 20th-century American art; the James H. Ricau Collection of 19th-century American sculpture; decorative arts; and photography. Changing exhibitions are frequent and original exhibitions developed by the Museum have traveled widely. These offerings are accompanied by educational, cultural and art travel programming, which include workshops, lectures, tours, and films. The Museum also administers three Historic Houses: the Adam Thoroughgood, the Moses Myers, and the Willoughby-Baylor, and the living history programs that represent and illuminate their respective 17th, 18th and 19th centuries milieux.

Old Dominion University - University Gallery

350 West 21st St., Norfolk, VA 23517
Tel: (757) 683-2355
Fax: (757) 683-5923
Internet Address: http://web.odu.edu/al/artsand letters/gallery
Director: Katherine Huntoon
Admission: free.
Attendance: 2,100 *Established:* 1971 *Membership:* Y
Open: Monday to Thursday, noon-3pm; Saturday to Sunday, noon-4pm.
Closed: Academic Holidays.
Activities: **Lectures**; **Performances**.
Publications: catalogues; newsletter; postcards, posters.

The Gallery presents a schedule of temporary exhibitions.

Portsmouth

Portsmouth Museums - Courthouse Galleries

420 High St. (corner of Court and High Streets)
Portsmouth, VA 23704-3622
Tel: (757) 393-8983
Fax: (757) 393-5228
Director: M.E. Burnell
Admission: fee-$1.00.
Established: 1980 *Membership:* Y
ADA Compliant: Y
Open: Tuesday to Saturday, 10am-5pm;
 Sunday, 1pm-5pm.
Closed: New Year's Day, Thanksgiving Day,
 Christmas Day.
Facilities: **Architecture** (former courthouse,
 1846); **Galleries**.
Activities: **Films**; **Guided Tours**; **Lectures** (1st
 Sun in month); **Performances**.
Publications: newsletter (quarterly).

Located in the historic 1846 Courthouse in Olde Towne Portsmouth, the Courthouse Galleries are part of a complex of museums run by the City of

Façade of the Courthouse Galleries of the Portsmouth Museums. Photograph courtesy of Courthouse Galleries of the Portsmouth Museums, Portsmouth, Virginia.

Portsmouth, also including a lightship, a naval shipyard, and a children's participatory museum. As a non-collecting institution, the Courthouse Galleries are devoted to offering educational, cultural, and aesthetic experiences in the arts through rotating visual art exhibits, lectures, classes, and performances. The exhibits encompass eastern, western, multi-cultural, traditional, and contemporary art forms that inspire interest in and understanding of our rich and diverse global heritage. The Courthouse Galleries are an affiliate member of the Virginia Museum of Fine Arts.

Pulaski

Fine Arts Center for the New River Valley

21 W. Main St., Pulaski, VA 24301
Tel: (540) 980-7363
Fax: (540) 994-5631
Director: Mr. Michael B. Dowell
Admission: free.
Attendance: 16,000 *Established:* 1978 *Membership:* Y *ADA Compliant:* Y
Open: Monday to Friday, 10am-5pm; Saturday, 11am-3pm.
Closed: Legal Holidays.
Facilities: **Gallery**; **Shop** (work of regional artisans).

Fine Arts Center for the New River Valley, cont.

Activities: **Concerts**; **Education Programs** (adults and children); **Lectures**; **Temporary Exhibitions** (monthly).

Publications: newsletter, "The Centerpiece" (bi-monthly).

The Fine Arts Center for the New River Valley supports and provides activities, programs, and facilities that increase the understanding and enjoyment of the fine arts. It also recognizes, encourages, and supports original work by area artists, craftspeople, and musicians. The Center is located in two facilities. The primary location at 21 West Main Street includes the gallery, gift shop, class space, and offices. The second location, the Women's Club Annex at 44 West Fourth Street, includes a hall where a variety of public functions, performances, and classes are scheduled.

Radford

Radford University Art Museum

200 Powell Hall, Adams St., Radford, VA 24142

Tel: (703) 831-5754

Fax: (540) 831-6799

Internet Address: http://www.runet.edu/~rumuseum

Director: Dr. Steve Arbury

Admission: free.

Attendance: 10,000 *Established:* 1985 *Membership:* Y *ADA Compliant:* Y

Parking: free on street and metered parking in lot off Norwood St..

Open: **September to 1st week in May**, Monday to Friday, 10am-5pm; Sunday, noon-4pm.

2nd week in May to July, Monday to Friday, 10am-4pm.

Closed: Legal Holidays and August.

Facilities: **Exhibit Space** (3,500 square feet); **Sculpture Garden** (16,000 square feet).

Activities: **Lectures**; **Temporary Exhibitions**.

Publications: brochures; exhibition catalogues.

The Radford University Art Museum presents an extensive schedule of exhibitions and events. A traveling exhibition of the works of Dorothy Gillespie from the permanent collection is scheduled on national tour through 2002. The Flossie Martin and Spotlight Galleries and the Burdé Sculpture Courtyard are located at Powell Hall, one block off Norwood Street on Adams Street. The RU Art Museum Downtown is located at the Bondurant Center at 1115 Norwood Street. On-going exhibits of student work may be viewed in Tyler and Muse Halls.

Reston

Greater Reston Arts Center (GRACE)

One Fountain Square, 11911 Freedom Drive, Suite 110, Reston, VA 20190

Tel: (703) 471-9242

Fax: (703) 471-0952

Exec. Director: Ms. Anne Brown

Admission: free.

Attendance: 20,000 *Established:* 1974 *Membership:* Y *ADA Compliant:* Y

Parking: free in lot across street.

Open: Tuesday to Saturday, 11am-5pm.

Closed: New Year's Day, Easter, Thanksgiving Day, Christmas Day.

Facilities: **Galleries**; **Shop**.

Activities: **Arts Festival** (June); **Education Programs** (adults and children); **Gallery Talks**; **Guided Tours** (on request); **Lectures**.

Publications: newsletter, "Visions" (tri-a).

GRACE exhibits a broad range of styles, themes, and media, providing opportunities for both emerging and mature artists. Promoting community involvement and multiculturalism, exhibitions appear not only at GRACE's Town Center location, but also in the extended community at restaurants, corporate offices, and outreach sites. Additionally, the Center presents monthly salon-style artist forums for GRACE member-artists. Panel discussions, lectures, and behind-the-scenes art-related tours introduce members to innovative ideas and trends in contemporary art.

Richmond

University of Richmond - Marsh Art Gallery

George M. Modlin Center for the Arts, Keller Road
Richmond, VA 23173
Tel: (804) 289-8276
Fax: (804) 287-6006
Internet Address: http://chemweb.urich.edu/~marshart
Director: Mr. Richard Waller
Admission: free.
Attendance: 12,000 *Established:* 1968
ADA Compliant: Y
Parking: ample free parking in Center parking lot.
Open: **September to April**,
 Tuesday to Saturday, 1pm-5pm.
 May to August,
 Thursday to Saturday, 1pm-5pm.
Closed: Spring Break, Fall Break, Thanksgiving Week,
 Christmas Day to New Year's Day.
Facilities: **Exhibit Space**; **Shop**.
Activities: **Concerts**; **Education Programs** (undergraduate
 and graduate students); **Films**; **Gallery Talks**; **Guided
 Tours** (reserve in advance); **Lectures**; **Temporary
 Exhibitions**; **Traveling Exhibitions**.

Reginald Marsh, *Star Burlesk*, 1933, etching, 11¾ x 8¾ inches. I. Webb Surratt, Jr. Print Collection, Marsh Art Gallery. Photograph by Katherine Wetzel, courtesy of Marsh Art Gallery, University of Richmond, Richmond, Virginia.

Publications: brochures; exhibition catalogues; posters.

The Gallery offers a schedule of temporary exhibitions, including an annual juried student exhibition. The Gallery also organizes the National Works on Paper Biennial juried exhibition.

Virginia Commonwealth University - Anderson Gallery, School of the Arts (AG)

Virginia Commonwealth University, 907½ W. Franklin St, Richmond, VA 23284-2514
Tel: (804) 828-1522
Fax: (804) 828-8585
TDDY: (804) 367-0100
Internet Address: http://www.vcu.edu/artweb/gallery
Acting Director: Mr. Charles F. Bleick
Admission: free.
Attendance: 14,000 *Established:* 1969 *Membership:* Y
Parking: metered on street.
Open: Tuesday to Friday, 10am-5pm; Saturday to Sunday, 1pm-5pm.
Closed: Academic Holidays, Legal Holidays.
Facilities: **Exhibition Space** (6 spaces, total 10,000 square feet); **Shop**.
Activities: **Films**; **Gallery Talks**; **Guided Tours**; **Lectures**; **Temporary Exhibitions**; **Traveling
 Exhibitions**.
Publications: exhibition catalogues; posters.

Exhibitions at the Gallery focus on contemporary art of national and international importance. Similar to other contemporary art museums, the AG concentrates on emerging art and new ideas, showing artists who have not been presented in major venues and creating a forum for ideas that have not yet been fully appreciated. The Museum concentrates on showing work that challenges and expands concepts in art. Exhibitions embrace a diverse range of media from glass to video. Some exhibitions show works that are not traditionally shown in museums, such as fashion, interior design, and graphic design, or focus on works that push the boundaries of the museum environment, such as installations and electronic media. Annual faculty focus exhibitions present works by School of the Arts professors in fine art and design. Students exhibit in two large annual shows and in MFA thesis exhibitions. With more than 2,000 objects, the Anderson Gallery's collection is available for teaching and research for the School of the Arts and VCU as well as for loan to other museums and

Virginia Commonwealth University - Anderson Gallery, School of the Arts, cont.

art institutions. The areas of greatest concentration are prints, photography, drawings, paintings and sculptures. The print collection encompasses examples from the 15th century through the present, including works by Albrecht Dürer, Henri Matisse, Rembrandt van Rijn, and Vincent van Gogh, as well as contemporary works, including pieces by Andy Warhol and David Salle. Photography is strongly represented, including works by Larry Clark, Thomas Florschuetz, and Garry Winogrand. The AG owns works by contemporary artists Ross Blechner and Francesc Torres and many works by lesser-known artists, including former members of the School of the Arts faculty and local artists. Works of folk art include examples by Miles Carpenter and Sister Gertrude Morgan. The AG also has a collection of Asian art that is an excellent resource for the Department of Art History and supplements the extensive Asian art holdings of the Virginia Museum.

Virginia Museum of Fine Arts

2800 Grove Ave. at Boulevard
Richmond, VA 23221-2466
Tel: (804) 367-0844
Fax: (804) 367-9393
TDDY: (804) 367-0844
Internet Address: http://vmfa.state.va.us
Director: Ms. Katharine C. Lee
Admission: suggested contribution-$4.00.
Attendance: 368,000 *Established:* 1934
Membership: Y *ADA Compliant:* Y
Parking: free on site.
Open: Tuesday to Wednesday, 11am-5pm;
Thursday, 11am-8pm;
Friday to Sunday, 11am-5pm.
Closed: New Year's Day, Independence Day,
Thanksgiving Day, Christmas Day.

Exterior view of Virginia Museum of Fine Arts. Photograph by Katherine Wetzel, courtesy of Virginia Museum of Fine Arts, Richmond, Virginia.

Facilities: **Auditorium** (350 seat); **Exhibition Space and Galleries** (95,000 square feet); **Food Services** Arts Café (110 seats); **Library** (70,000 volumes); **Reading Room**; **Sculpture Garden**; **Shop**; **Theatre** (500 seat).

Activities: **Arts Festival**; **Concerts**; **Dance Recitals**; **Education Programs** (adults, students and children); **Films**; **Gallery Talks**; **Guided Tours** (Tues-Sun, 2:30pm; Thurs, 6pm & 7pm; free); **Lectures**; **Performances**; **Temporary Exhibitions**; **Traveling Exhibitions**.

Publications: annual report; calendar (bi-monthly); collection catalogue; exhibition catalogues.

The Virginia Fine Arts Museum complex presents a panorama of architecture ranging from the 1936 Georgian Revival original building to the contemporary style of the West Wing, opened in 1995. In addition to displays from the permanent collection, the Museum offers an extensive schedule of temporary and traveling exhibitions, artist presentations, concerts, lectures, tours, films, and videos. The museum's 17,500 objects range in time from the third millennium before Christ to the most recent work of artists in the U.S. and abroad. Outstanding features are the Mellon collections of British sporting art and French impressionist and post-impressionist art; the Lewis collections of American and European art since World War II; art nouveau, arts and crafts, art deco, and modem design decorative arts; an extensive collection of English silver; the Pratt Collection of Russian imperial Easter eggs and objects of fantasy from the workshops of master jeweler Peter Carl Fabergé; European and American masterpieces of painting, including works by Francisco Goya, Claude Monet, and John Singer Sargent; the collection of ancient, classical, and Egyptian art, including a rare, life-sized marble statue from the first century AD of the Roman emperor Caligula; and one of the world's leading collections of the art of India, Nepal, and Tibet.

Roanoke

The Art Museum of Western Virginia

Center in the Square, One Market Square, 2nd Floor, Roanoke, VA 24011-1436
Tel: (540) 342-5760
Fax: (540) 342-5798

The Art Museum of Western Virginia, cont.

Admission: free.

Attendance: 110,000 *Established:* 1951

Membership: Y *ADA Compliant:* Y

Parking: parking garage adjacent to site.

Open: Tuesday to Saturday, 10am-5pm;
Sunday, 1pm-5pm.

Closed: New Year's Day, Christmas Day.

Facilities: **Children's Art Center; Exhibit Space; Lecture Hall; Library** (2,000 volumes); **Sculpture Court; Shop** (art by western Virginians, crafts of the southern highlands).

Activities: **Education Programs** (adults, students and children); **Family Days; Films; Gallery Talks; Guided Tours** (reserve in advance); **Lectures; Sidewalk Art Show; Temporary Exhibitions; Traveling Exhibitions.**

Publications: annual report; exhibition catalogues; newsletter (quarterly).

View of gallery in Art Museum of Western Virginia. Photograph courtesy of Art Museum of Western Virginia, Roanoke, Virginia.

The Art Museum of Western Virginia is an educational institution whose mission is to foster an appreciation and understanding of art. It exhibits, collects, preserves, and interprets significant works of art with a special focus on regional art. Changing exhibitions include works by regionally, nationally, and internationally known artists. In the early summer, the Museum hosts the Roanoke City Art Show, an annual exhibition organized by the Arts Council of the Blue Ridge. Objects from the permanent collection are also on display, featuring 19th- and 20th-century painting, sculpture, and graphic art. The Museum's endowment has enabled it to build a significant collection of art from around the world. Holdings include 19th-century American paintings and decorative art; 20th-century American and southern prints, paintings, photographs, regional art, and sculpture; 19th-century Japanese prints; 19th and early 20th century European paintings, prints, and decorative art; and the Cesnola Collection of eastern Mediterranean antiquities. In addition, the Horace G. Fralin charitable Trust has made possible several significant 19th-century acquisitions, including works by Winslow Homer, Childe Hassam, John Twachtman, and Maria Oakey-Dewing.

Salem

Roanoke College - Olin Hall Galleries

F.W. Olin Hall, Thompson Memorial Blvd., Salem, VA 24153

Tel: (540) 375-2354

Internet Address: http://www2.roanoke.edu/finearts/Galleries/main.htm

Director: Ms. Linda Atkinson

Admission: free.

Open: Daily, 1pm-4pm.

Closed: Legal Holidays, Academic Holidays.

Facilities: **Galleries.**

Activities: **Temporary Exhibitions.**

The Olin Gallery, supplemented by The Smoyer Gallery and Corridor Gallery, present traveling and invitational exhibits along with the rotational display of the College's permanent collection. Each spring, graduating studio and art history majors mount an exhibition in the Olin Gallery. Also of possible interest are several works by the illustrator Walter Biggs displayed on the main floor in the Fintel library.

Staunton

Mary Baldwin College - Hunt Gallery

Market and Vine Sts,, Staunton, VA 24401

Tel: (540) 887-7196

Mary Baldwin College - Hunt Gallery, cont.

Internet Address: http://www.mbc.edu

Director: Mr. Paul Ryan

Admission: free.

Attendance: 1,100 *ADA Compliant:* Y

Parking: parking lot behind Hunt Hall.

Open: **September to May**, Monday to Friday, 9am-5pm.

Facilities: Gallery.

Activities: **Education Programs** (adults); **Lectures**; **Temporary Exhibitions** (regionally and nationally known artists).

The Hunt Art Gallery exhibits the works of professional, contemporary artists of emerging or established regional, national, or international reputation. It seeks to exhibit work that reflects a wide variety of media and artistic intentions. The Annual Juried MBC Student Art Exhibition and most senior project exhibitions are held in Hunt Gallery. Also of possible interest on campus is the Deming Gallery, an exhibition space that is used primarily for student work.

Staunton Augusta Art Center

1 Gypsy Hill Park, Staunton, VA 24401

Tel: (540) 885-2028

Fax: (540 885-6000

Internet Address: http://www.staunton.com/art

Exec. Director: Marco McGirr

Admission: free.

Attendance: 13,000 *Established:* 1961 *Membership:* Y *ADA Compliant:* Y

Open: Monday to Friday, 9am-5pm; Saturday, 10am-2pm.

Closed: New Year's Eve to New Year's Day, Memorial Day, Independence Day, Labor Day, Thanksgiving Day, Christmas Eve to Christmas Day.

Facilities: **Gallery** (1,600 square feet; in public park).

Activities: **Arts Festival** ("Art in the Park" outdoor art show, May); **Education Programs** (adults and children); **Films**; **Gallery Talks**; **Lectures**; **Temporary Exhibitions** (duration, 6-7 weeks).

Publications: newsletter (quarterly).

The Staunton Augusta Art Center is a non-profit arts organization. As an affiliate of the Virginia Museum of Fine Arts, the Arts Center brings traveling exhibitions, lectures, films, and workshops to its constituency. It also mounts at least six individual or group art exhibitions annually and offers educational programs throughout the year.

Suffolk

The Suffolk Museum

118 Bosley Ave., Suffolk, VA 23434

Tel: (757) 925-6311

Fax: (757) 538-0833

Museum Coordinator: Ms. Lisa W. Mizelle

Admission: free.

Attendance: 6,000 *Established:* 1986

Membership: N *ADA Compliant:* Y

Parking: free on site.

Open: Tuesday to Saturday, 10am-5pm; Sunday, 1pm-5pm.

Closed: Legal Holidays.

Facilities: **Exhibit Space** (3,000 square feet); **Studio Classroom.**

Exterior view of Suffolk Museum. Pen and ink rendering by Miriam Birdsong, courtesy of Suffolk Museum, Suffolk, Virginia.

Activities: **Concerts**; **Demonstrations**; **Education Programs** (adults and children); **Guided Tours** (groups 10+, reserve 10 days in advance); **Lectures**; **Temporary/ Traveling Exhibitions.**

The Suffolk Museum, cont.
Publications: brochure, "The Museums of Suffolk"; exhibition program (monthly); newsletter, "Suffolk Art League" (quarterly).

Located in the former Morgan Memorial Library building, the Museum offers programs exploring the visual and performing arts. The Museum houses the Drs. L.T. and Margaret Reid African Art Collection and a collection of photographs on the history of Suffolk. A full schedule of changing exhibitions include works by local and regional artists and traveling exhibitions from other institutions. The Suffolk Art League (SAL), an affiliate of the Virginia Museum of Fine Arts, holds many of its programs at the Museum and maintains its office there [(757) 925-0448].

Sweet Briar

Sweet Briar College Art Galleries
Sweet Briar College, Sweet Briar, VA 24595
Tel: (804) 381-6248
Fax: (804) 381-6173
Internet Address: http://www.artgallery.sbc.edu/
Director: Ms. Rebecca Massie Lane
Admission: free.
Attendance: 6,000 *Established:* 1901 *Membership:* Y *ADA Compliant:* Y
Parking: free on site.
Open: **Pannell**, Monday to Thursday, noon-9:30; Friday to Sunday, noon-5pm.
 Babcock, Daily, 9am-9pm.
Closed: Academic Holidays.
Facilities: **Food Services** Campus Restaurant; **Library**; **Sculpture Garden**; **Book Shop**.
Activities: **Guided Tours**; **Traveling Exhibitions**).
Publications: exhibition catalogues; newsletter.

The Sweet Briar College Art Gallery is dedicated to the enrichment of cultural life on campus, in the community, and throughout central Virginia. The Gallery program supports the educational mission of Sweet Briar College through its active education program and through the collecting, preservation, and formal exhibition of works of art at the three campus galleries: Pannell, Babcock, and Benedict. Centrally located, the Pannell Center houses the Sweet Briar Gallery and the College's permanent art collection. As a dynamic learning tool, the gallery supports diverse hands-on learning projects throughout the year. Students help organize and publicize exhibits, learn curatorial practice, work as docents in the gallery, or undertake research. The Babcock Gallery, located in the lobby of the Babcock Fine Arts Center, is host to several exhibitions of contemporary artists works throughout the year. The Benedict Gallery, located in the main lobby of Benedict Hall, is host to several exhibitions during the academic year, most of which place an emphasis on the humanities. Sweet Briar's survey collection numbers more than 1,000 pieces, ranging from medieval illuminated manuscripts to post-modern prints. Of particular note are six Hudson River School paintings by Albert Bierstadt, John William Casilear, Sanford Robinson Gifford, Daniel Huntington, David Johnson, and Arthur Fitzwilliam Tait. other artists with representative works in the collection include Louise Bourgeois, Charles Burchfield, Vija Celmins, Jon Corbino, Mary Cassatt, Albrecht Dürer, Andy Goldsworthy, Roy Lichtenstein, Sally Mann, Pablo Picasso, Miriam Schapiro, Pat Steir, and Rembrandt van Rijn.

Virginia Beach

Contemporary Art Center of Virginia
2200 Parks Ave., Virginia Beach, VA 23451
Tel: (757) 425-0000
Fax: (757) 425-8186
Exec. Director: Kevin Grogan
Admission: free.
Attendance: 80,000 *Established:* 1952 *Membership:* Y *ADA Compliant:* Y
Parking: free on site.
Open: Tuesday to Saturday, 10am-4pm; Sunday, noon-4pm.
Closed: Legal Holidays.

Virginia Beach, Virginia

Contemporary Art Center of Virginia, cont.

Facilities: **Auditorium**; **Exhibition Galleries**; **Sculpture Garden**; **Shop**.
Activities: **Arts Festival**; **Education Programs** (adults and children); **Gallery Talks**; **Lectures**; **Performances**; **Temporary Exhibitions**; **Traveling Exhibitions**.
Publications: annual report; exhibition catalogues; newsletter (quarterly).

The Contemporary Art Center of Virginia is a non-profit, non-collecting institution that exists to foster awareness, exploration, and understanding of the significant art of our time. Through diversity in its exhibitions and educational programming, the Center stimulates individual thinking and dialogue throughout the Hampton Roads, Virginia community. Its exhibitions are dedicated exclusively to the presentation of contemporary art. Additional activities include a full schedule of studio art classes for all ages and levels and the annual Boardwalk Art Show and Festival.

Williamsburg

Abby Aldrich Rockefeller Folk Art Museum (AARFAM)

307 S. England St.
(across from Williamsburg Inn)
Williamsburg, VA 23185
Tel: (757) 220-7698
Fax: (757) 221-8915
Internet Address:
 http://www.colonialwilliamsburg.org
C.E.O.: Mr. Colin Campbell
Admission: fee: adult-$11.00, child-$7.50.
Attendance: 250,000 *Established:* 1939
Membership: Y *ADA Compliant:* Y
Parking: free on site.
Open: Daily, 10am-5pm.
Facilities: **Galleries** (18, total 19,000 square feet); **Library** (3,000 volumes); **Reading Room**; **Shop**.

Exterior view of Abby Aldrich Rockefeller Folk Art Museum. Photograph courtesy of Abby Aldrich Rockefeller Folk Art Museum, Williamsburg, Virginia.

Activities: **Guided Tours**; **Lectures**; **Temporary Exhibitions**; **Traveling Exhibitions**.
Publications: collection catalogue; exhibition catalogues; gallery guide.

The Abby Aldrich Rockefeller Folk Art Museum is the oldest institution in the U.S. dedicated to the collection and preservation of American folk art. Its paintings, whirligigs, weather vanes, carvings, toys, embroideries and other folk works represent many diverse cultural traditions and geographic regions. John D. Rockefeller Jr. established the center in 1957 in honor of his wife, Abby, and her love of folk art. The core of the collection is 424 objects given to Colonial Williamsburg in 1939 by Mrs. Rockefeller, in addition to other items dating from the 1720s to the present. The Center offers a selection of changing exhibitions.

College of William and Mary - Muscarelle Museum of Art

College of William and Mary, Jamestown Road, Williamsburg, VA 23187-8795
Tel: (757) 221-2700
Fax: (757) 221-2711
Internet Address:
 http://www.wm.edu/muscarelle
Director: Dr. Bonnie G. Kelm
Admission: free.
Attendance: 40,000 *Established:* 1983
Membership: Y *ADA Compliant:* Y
Parking: free on site.

South façade of Muscarelle Museum of Art at dusk, showing "Sun Sonata", a solar painting by Gene Davis. Photograph by Fred Miller, courtesy of Muscarelle Museum of Art, College of William and Mary, Williamsburg, Virginia.

College of William and Mary - Muscarelle Museum of Art, cont.

Open: Monday to Friday, 10am-4:45pm; Saturday to Sunday, noon-4pm.

Closed: Legal Holidays, Academic Holidays.

Facilities: **Exhibition Galleries** (permanent and temporary); **Print Study Room**; **Shop**.

Activities: **Gallery Talks**; **Guided Tours**; **Lectures**; **Temporary Exhibitions**.

Publications: calendar; exhibition catalogues; newsletter (3/year).

The Joseph and Margaret Muscarelle Museum of Art, an integral part of the College of William and Mary, is dedicated to enriching cultural life on campus while also serving the general public of Williamsburg and the Tidewater area. A selection of the permanent collection is always on display in the second-floor galleries. Opportunities for close study of selected works on paper are offered in the Herman Graphic Arts Study Room of the Museum on the first floor. The permanent collections are supplemented by special temporary exhibitions in the first floor galleries. These exhibitions include national traveling shows from other institutions and works lent from distinguished private and corporate collections. Every year, many varied educational offerings are scheduled. Exhibitions are frequently the subject of coordinated symposia, lectures, demonstrations, films, and gallery talks. Studio art classes, workshops, a variety of travel tours, and special events are offered throughout the year. When the Museum was established in 1983, it assumed responsibility for the College art collection, which began in 1732 with a gift from the third Earl of Burlington. In the intervening 250 years, a substantial number of works of art had been acquired by the College and were housed in various buildings on the campus. Objects were relocated to the Museum's protective environment where works of art could be given appropriate care. The Museum also embarked upon an ambitious program to increase the permanent collection, and the number of objects has since grown to over 3,000 paintings, sculptures, works on paper, and decorative objects. A particular strength of the permanent collection is the large number of 17th-, 18th- and 19th-century portraits of important historical individuals by distinguished English and American painters. The Museum also has a notable collection of Old Master prints and Inuit drawings. The contemporary section of the permanent collection has also grown significantly and includes painting, sculpture, and works on paper by major 20th-century American artists.

Washington

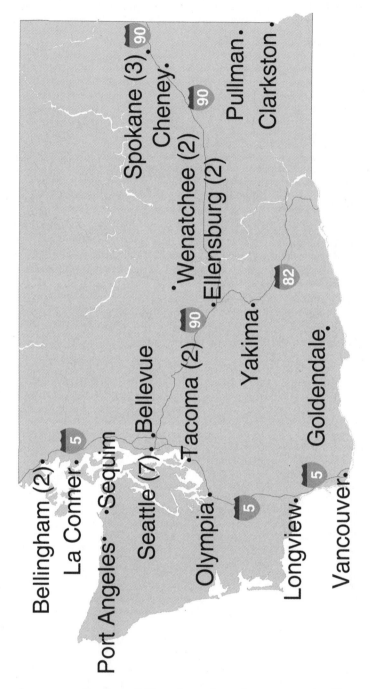

The number in parentheses following the city name indicates the
number of museums/galleries in that municipality. If there is no num-
ber, one is understood. For example, in the text seven listings would
be found under Seattle and one listing under Olympia.

Washington

Bellevue

Bellevue Art Museum (BAM)

510 Bellevue Way, NE (at NE 6th Street), Bellevue, WA 98004
Tel: (425) 454-6021
Fax: (425) 637-1799
Internet Address: http://www.bellevueart.org
Director: Ms. Diane M. Douglas
Admission: fee: adult-$3.00, child-free, student-$2.00, senior-$2.00.
Attendance: 340,000 *Established:* 1975 *Membership:* Y *ADA Compliant:* Y
Parking: free parking in any Bellevue Square garage.
Open: Tuesday, noon-8pm; Wednesday to Friday, 10am-5pm; Saturday, noon-8pm;
 Sunday, noon-5pm.
Closed: Between Exhibitions, New Year's Day, Easter, Memorial Day, Independence Day, Labor Day,
 Thanksgiving Day, Christmas Day.
Facilities: **Architecture (**2000, design by Stephen Hall) **Classroom/Lecture Facility**; **Gallery**
 (3,500 square feet); **Shop** (items relevant to current exhibition).
Activities: **Docent Program**; **Education Program** (children, "Super Saturday" hands-on program
 grades 1-6); **Guided Tours** (daily, 2pm; groups reserve in advance); **Lectures**; **Temporary and
 Traveling Exhibitions**.
Publications: exhibition catalogues; newsletter, "Calend'art" (quarterly).

Housed in a new 40,000 square feet facility, the Bellevue Art Museum presents traveling and specially curated exhibitions. The Museum focuses on contemporary Northwest art and the national and international influences that shape it. It does not maintain a permanent collection. Please note that the Museum will be closing its old location on September 3, 2000; its new facility, listed above, is scheduled to open to the public on January 6, 2001.

Bellingham

Western Washington University - Western Gallery and Sculpture Collection

Western Washington University, Fine Arts Complex, Bellingham, WA 98225-9068
Tel: (360) 650-3900
Fax: (360) 650-6878
Internet Address: http://www.wwu.edu
Director and C.E.O.: Sarah Clark-Langager, Ph.D.
Admission: voluntary contribution.
Attendance: 55,000 *Established:* 1950 *Membership:* Y *ADA Compliant:* Y
Parking: parking passes available at visitor's center.
Open: **Academic Year**, Monday to Friday, 10am-4pm; Saturday, noon-4pm.
Closed: Academic Holidays, Between Sessions.
Facilities: **Gallery Space** (4,500 square feet); **Sculpture Collection** (throughout campus, brochure
 available).
Activities: **Education Program** (undergraduate and graduate students); **Guided Tours** (by
 appointment); **Lectures**; **Temporary/Traveling Exhibitions**.
Publications: exhibition catalogues.

The Western Gallery and its plaza stand as a central focus between the northern and southern parts of campus. Through historical, contemporary, and experimental art exhibitions, through publications and interpretive interdisciplinary programs, and through its outdoor collection of contemporary sculpture, the Gallery acts as a focus for the display, discussion, and exchange of ideas on critical issues in contemporary art from the regional, national, and international art scenes. Extending from the Western Gallery's plaza and integrated with other campus buildings, quadrangles, lawns, and playing fields is Western's Outdoor Sculpture Collection featuring works by major international, national, and regional artists. The sculpture collection includes works by Magdalena Abakanowicz, Alice Aycock, Fred Bassetti, Richard Beyer, Anthony Caro, Mark di Suvero, James Fitzgerald, Lloyd

Bellingham, Washington

Western Washington University - Western Gallery and Sculpture Collection, cont.

Hamrol, Nancy Holt, Donald Judd, John Keppelman, Robert Maki, Michael McCafferty, Robert Morris, Bruce Nauman, Isamu Noguchi, Tom O'Herness, Beverly Pepper, Mia Westerlund Roosen, Richard Serra, Steve Tibbetts, George Trakas, and Norman Warsinske.

Whatcom Museum of History and Art

121 Prospect St. (between Champion St. and Central Ave.), Bellingham, WA 98225

Tel: (360) 676-6981

Fax: (360) 738-7409

Internet Address: http://city-govt.ci.bellingham.wa.us/museum.htm

C.E.O. and Director: Ms, Patti Imhof

Admission: free.

Established: 1940 **Membership:** Y **ADA Compliant:** Y

Open: Tuesday to Sunday, noon-5pm.

Closed: Legal Holidays.

Facilities: **Architecture** (former City Hall, 1892); **Museum Shop**; **Photo Archives** (1pm-4:45pm, appointment recommended); **Sculpture Garden**.

Activities: **Concerts**; **Education Program** (children); **Films**; **Gallery Talks**; **Guided Tours**; **Lectures**; **Temporary/Traveling Exhibitions**.

Publications: exhibition catalogues.

The Museum presents both permanent and changing exhibitions. Permanent exhibitions focus on the natural and cultural history of the Northwest. The museum offers several changing history exhibitions throughout the year. Temporary exhibitions also highlight a broad range of American and contemporary art, crafts, and photography with an emphasis on contemporary regional art. Its campus is composed of four buildings: the main Museum building (Old City Hall), the Syre Education Center, the Whatcom Children's Museum, and the Arco Exhibitions Gallery. The Arco Exhibits Building at 206 Prospect Street is used for major changing exhibitions of contemporary art, history and topical issues. Contemporary art may also be found on the second floor of the main building. The permanent Fine Arts collection emphasizes the work of contemporary Northwest artists and includes nearly 1,000 examples of painting, sculpture, photography, and crafts. The Archives houses a photography collection of over 150,000 images of local history, including the Darius Kinsey Collection of Northwest landscape and logging photographs.

Cheney

Eastern Washington University - University Galleries

Gallery of Art, Art Building. (Main Floor) and Digital Gallery of Art, Art Building. (Room 129) Cheney, WA 99004-2453

Tel: (509) 359-9707

Fax: (509) 359-4841

Internet Address: http://www.visual.arts.ewu.edu/galleries/galleries.html

Director, University Galleries:
 Mr. Richard L. Twedt

Admission: free.

Attendance: 5,000 **ADA Compliant:** Y

Open: Monday to Friday, 8am-5pm.

Facilities: **Exhibition Area**.

Activities: **Temporary Exhibitions**.

The Gallery of Art presents exhibitions of work in all media by locally, regionally, and nationally recognized artists, faculty shows, and an annual juried student exhibition. It also sponsors the biennial National Computer Art Invitational traveling exhibition and occasionally sponsors other national juried shows. The Digital Gallery of Art mounts monthly exhibitions spanning the spectrum of digital

Joseph Grigely, *Conversations with the Hearing*, 1993, Installation. Photograph courtesy of Eastern Washington University Gallery of Art, Cheney, Washington.

826

Eastern Washington University - University Galleries, cont.

art from collage pieces to infra-red black and white prints. University holdings include The Anne Harder MacKenzie Wyatt print collection of "Modern American Masters", the Percent-for-Art collection, the Ceramics collection, the National Computer Art collection, the Andy Warhol "Endangered Species" collection, many pre-Columbian artifacts, and a variety of works by regional artists including Ruben Trejo, Karen Guzak, Tom Askman, Mel McCuddin, and Richard Twedt. Also of possible interest on campus is the Student Gallery, located in the Art Department, which exhibits the work of student artists, including BFA and MFA Thesis Exhibitions. Off campus, the University's "Modern American Masters" Collection is located on the second floor of Eastern's Spokane Center in downtown Spokane (see separate listing). EWU's Exhibit Touring Services program, also part of the University Galleries, provides a wide variety of exhibitions internationally to museums; college, university, and community galleries; arts and cultural centers; and libraries.

Clarkston

Valley Art Center, Inc.

842 6th St., Clarkston, WA 99403
Tel: (509) 758-8331
Director and Chairman: Pat Rosenberger
Admission: free.
Attendance: 8,500 *Established:* 1968
Membership: Y *ADA Compliant:* Y
Parking: municipal parking lot behind building.
Open: Monday to Friday, 9am-4pm.
Closed: New Year's Day, Independence Day,
Thanksgiving Day,
December 24 to January 2.
Facilities: **Architecture** (early 1920's commer-
cial building); **Classroom**; **Galleries** (2);
Museum Shop.

Interior, Valley Art Center. Photograph courtesy of Valley Art Center, Clarkston, Washington.

Activities: **Arts Festival** (Northwest Heritage Art Festival); **Classes/Workshops**; **Education Program** (children and adults, summer workshop for children); **Gallery Talks**; **Temporary Exhibitions.**
Publications: artist's registry; calendar (quarterly).

The Center exhibits visual art in all its forms and conducts Walla Walla Community College-sponsored art classes.

Ellensburg

Central Washington University - Sarah Surgeon Gallery

Randall Hall, Ellensburg, WA 98926
Tel: (509) 963-2665
Fax: (509) 963-1918
Internet Address: http://www.cwu.edu
Open: Call for hours.
Facilities: **Exhibition Area.**
Activities: **Lectures**; **Temporary Exhibitions**.

With the assistance of the Associated Students of Central, the gallery features exhibitions of contemporary art throughout the year.

The Clymer Museum of Art

416 N. Pearl St., Ellensburg, WA 98926
Tel: (509) 962-6416
Fax: (509) 962-6424
Director: Ms. Diana Tasker
Admission: free.
Attendance: 18,000 *Established:* 1988 *Membership:* Y *ADA Compliant:* Y
Parking: metered on street.

Ellensburg, Washington

The Clymer Museum of Art, cont.

Open: Monday to Friday, 10am-5pm; Saturday to Sunday, noon-5pm.

Closed: New Year's Day, Easter, Independence Day, Thanksgiving Day, Christmas Day.

Facilities: **Architecture** (former hardware store, 1901); **Exhibition Space** (7,100 square feet); **Museum Shop.**

Activities: **Docent Program**; **Education Program** (adults and children); **Guided Tours**; **Lectures.**

Publications: newsletter.

The Museum presents a variety of solo and thematic temporary exhibitions designed to offer a wide spectrum of topics and artistic media. Temporary shows are offered in concert, with up to three exhibitions at one time. The Museum's permanent collection is devoted to the works of Ellensburg native, artist and illustrator John Clymer, including examples of his early work as an illustrator and his later paintings of western Americana and wildlife scenes.

Exterior view of Clymer Museum. Photograph courtesy of Clymer Museum, Ellensburg, Washington.

Goldendale

Maryhill Museum of Art

35 Maryhill Museum Drive, Goldendale, WA 98620

Tel: (509) 773-3733

Fax: (509) 773-6138

Internet Address: http://www.maryhillmuseum.org

Director: Ms. Josie E. De Falla

Admission: fee:
 adult-$6.50, child (<6)-free, child (6-12)-$1.50, senior-$6.00.

Attendance: 83,000 *Established:* 1923

Membership: Y *ADA Compliant:* Y

Parking: free on site.

Open: **March 15 to November 15**, Daily, 9am-5pm.

Facilities: **Architecture** (full scale replica of Stonehenge); **Food Services** Café Maryhill (10am-4:30pm); **Library** (1,500 volumes); **Photo Archives**; **Picnic Grounds**; **Sculpture Garden**; **Shop** (books jewelry, gift items).

Activities: **Classes/Workshops** (adults and youth); **Docent Program**; **Guided Tours**; **Lectures**; **Temporary and Traveling Exhibitions.**

Publications: "The Maryhill Quarterly"; collection catalogue; exhibition catalogues.

Auguste Rodin, *Jean de Fiennes (Study for the Burghers of Calais)*, 1886, plaster, height 15 inches. Maryhill Museum of Art. Photograph courtesy of Maryhill Museum of Art, Goldendale, Washington.

Maryhill Museum of Art, a national historic site, is located at the east entrance to the Columbia River Gorge National Scenic Area on Washington Scenic Route 14 (Lewis & Clark Trail), about 100 miles east of Portland, Oregon. The Museum's grounds include a sculpture garden for contemporary Northwest art, 35 acres of lawn, flower gardens and trees, 6,000 acres of ranchlands, a complete full-scale replica of England's neolithic Stonehenge, and the Historic Loops Road. Each year the Museum presents a variety of exhibitions that highlight parts of the Maryhill permanent collection, offer new exhibitions of work from private collections and other institutions, and showcase the work of several regional artists. Collections include Auguste Rodin sculptures and watercolors, European and American classical realism paintings and drawings, Russian icons, Fabergé artifacts, Theatre de la Mode 1946 French Fashions, Native American art and artifacts, Queen Marie of Romania royal regalia, international chess sets, and Sam Hill memorabilia.

La Conner

Museum of Northwest Art (MoNA)

121 South 1st St., La Conner, WA 98257
Tel: (360) 466-4446
Fax: (360) 466-7431
C.E.O.: Ms. Susan Parke
Admission: fee-$3.00.
Attendance: 20,000 *Established:* 1981 *Membership:* Y *ADA Compliant:* Y
Parking: underground garage.
Open: Tuesday to Sunday, 10am-5pm.
Facilities: **Exhibition Space** (12,000 square feet); **Museum Shop**.
Activities: **Education Program** (children and adults); **Guided Tours**; **Lectures**; **Temporary/Traveling Exhibitions**.
Publications: newsletter (quarterly).

MoNa is the only museum in the nation devoted solely to the visual art produced by Northwest artists of the 20th-century. Originally focusing on works in the "Northwest Tradition" (Mark Tobey, Morris Graves, Kenneth Callahan, Guy Anderson and their school), the Museum now offers exhibitions of a broad spectrum of the art of our time, including studio glass.

Longview

Lower Columbia College - Art Gallery

1600 Maple St., Longview, WA 98632
Tel: (360) 577-2314
Fax: (360) 577-3400
Internet Address: http://lcc.ctc.edu/events/cultural
Advisor: Ms. Trudy Woods
Admission: free.
Attendance: 5,437 *Established:* 1978 *ADA Compliant:* Y
Parking: free on site.
Open: **September to June**,
 Monday to Tuesday, 10am-4pm; Wednesday to Thursday, 10am-8pm; Friday, 10am-4pm.
Closed: July to August.
Activities: **Lectures/Workshops Series**; **Temporary/Traveling Exhibitions**.

The Gallery presents a series of scheduled temporary exhibitions.

Olympia

The Evergreen State College - Evergreen Galleries

The Evergreen State College, 2700 Evergreen Parkway., Olympia, WA 98505-0002
Tel: (360) 866-6000 *Ext:* 6488
Fax: (360) 866-6794
Internet Address: http://www.evergreen.edu/user/galleries/
Director: Mr. Peter Ramsey
Admission: free.
Established: 1970 *ADA Compliant:* Y
Open: **Gallery II**,
 Monday to Friday, 8:45am-10:45pm; Saturday, 10:45am-6pm; Sunday, noon-6pm.
 Gallery IV,
 Monday to Friday, noon-5pm; Saturday, 1pm-4pm.
Closed: Academic Holidays.
Facilities: **Exhibition Space**; **Galleries** (2).
Activities: **Gallery Talks**; **Temporary/Traveling Exhibitions**.

Olympia, Washington

The Evergreen State College - Evergreen Galleries, cont.

Located in the Evans Library Building on the campus of The Evergreen State College, Gallery II is in the second floor foyer of the library proper, and Gallery IV is on the fourth floor. The mission of the two galleries is to supplement the current programs offered by the academic faculty. Exhibitions are developed from a variety of sources, including purchase from museums and galleries, works of visual arts faculty and staff, senior thesis or program shows, and other student work. Evergreen maintains a permanent collection, although only a small portion of it is on view at any one time. It consists of some 200 works of both two-dimensional and three-dimensional art. The majority of the collection was acquired during the 1970s and reflects the work of both nationally recognized artists and local artists. Photographs in the collection include work by Dianne Arbus, Marsha Burns, Judy Dater, Ralph Meatyard, Karen Truzak, Jerry Uelsman, and Edward Weston. In addition to photography the collection includes hand-woven wall hangings, ceramics, off-hand glass works, ceramic sculpture, paintings, drawings, and prints.

Port Angeles

Port Angeles Fine Arts Center (PAFAC)

1203 E. Lauridsen Blvd.
Port Angeles, WA 98362
Tel: (360) 457-3532
Fax: (360) 457-3532
Internet Address:
 http://www.olympus.net/community/pafac
C.E.O.: Mr. Jake Seniuk
Admission: voluntary contribution.
Attendance: 11,000 *Established:* 1986
Membership: Y *ADA Compliant:* Y
Parking: lot at grounds entrance,
 limited parking at building.
Open: Tuesday to Sunday, 11am-5pm.
Closed: Between Exhibits, New Year's Day,
 Thanksgiving to Thanksgiving Friday,
 Christmas Eve to Christmas Day,
 New Year's Eve.

Trimpin, *Liquid Percussion*, interactive sound sculpture as it appeared in the artist's solo exhibition at Port Angeles Fine Arts Center, 1995. (Prompted by computer driven score or activated by viewer through synchronized keyboard, amplified by resonators made from objects of Northwest art glass by Dale Chihuly, Dante Marioni, and others.) Photograph courtesy of Port Angeles Fine Arts Center, Port Angeles, Washington.

Facilities: **Architecture** (modernist former residence, 1951 design by Paul Hayden Kirk); **Galleries** (2); **Grounds** (5 acres with trails); **Sculpture Garden**.
Activities: **Lectures**; **Performances**; **Readings**; **Temporary/Traveling Exhibitions** (6/year).
Publications: exhibition announcements; newsletter, "On Center" (bi-monthly); posters.

The Port Angeles Fine Arts Center (PAFAC) is the "Olympic Peninsula's art museum". The Center presents six exhibitions annually, most of which are originated and curated by Center staff. These include in-depth exhibitions of master artists such as Leo Kenney, Dale Chihuly, Charles Stokes, and Basil Milovsorof, and significant mid-career artists such as Trimpin, Gayle Bard, Nöle Giulini and Cris Bruch. Complementing these solo shows are thematic multi-artist exhibitions and the ongoing Strait Art series, investigating art-making on both sides of the Strait of Juan de Fuca. Concerts, lectures, readings and performances supplement the visual fare. The Center occupies five wooded acres laced with walking trails and outdoor sculptures.

Pullman

Washington State University - Museum of Art

Washington State University, Wilson Road (across from Martin Stadium), Pullman, WA 99164-7460
Tel: (509) 335-1910
Fax: (509) 335-1908
Internet Address: http://www.wsu.edu/artmuse
Admission: free.
Attendance: 28,639 *Established:* 1973 *Membership:* Y *ADA Compliant:* Y
Parking: beneath the Fine Arts Center after 5pm and on weekends.

Washington State University - Museum of Art, cont.

Parking: beneath the Fine Arts Center after 5pm and on weekends.

Open: Monday to Wednesday, 10am-4pm;
Thursday, 10am-10pm;
Friday, 10am-4pm;
Saturday to Sunday, 1pm-5pm.

Closed: Academic Holidays, During Installation.

Facilities: **Auditorium** (145 seat); **Gallery** (5,000 square feet).

Activities: **Concerts**; **Education Program** (high school, undergraduate and graduate students); **Films**; **Gallery Talks**; **Guided Tours**; **Lectures** (including a noon-time program - "Art à la carte"); **Performances**; **Temporary Exhibitions** (6-7/year); **Workshops** (children, on Saturdays).

Publications: exhibition catalogues; posters.

View of gallery during annual Fine Arts Graduate Thesis Exhibition at Museum of Art. Photograph courtesy of Museum of Art, Washington State University, Pullman, Washington.

The Museum strives to provide a diverse and balanced range of offerings, including photography, design, ceramics, and textiles, as well as painting and sculpture. Shows of wide appeal alternate with more challenging exhibitions. The schedule includes exhibitions examining issues in contemporary art, an annual exhibit series focusing on art of the Northwest, exhibitions that examine the history of art, shows elaborating on works in the permanent collection, displays of art and artifacts from diverse cultures, and exhibits by faculty and graduate students. Each summer an exhibition is drawn from the museum's permanent collection. The Museum houses a small, but significant collection of American paintings, including works by such artists as William Merritt Chase, Frank Duveneck, William Glackens, Robert Henri, George Inness, Ernest Lawson, and Maurice Prendergast, and a selection of paintings by Northwest artists. The print collection includes historical works by European masters Goya, Hogarth, and Daumier, as well as contemporary prints by British and American artists, among them Leon Golub, Stanley William Hayter, David Hockney, R.B. Kitaj, Robert Motherwell, Robert Rauschenberg, Frank Stella, and Andy Warhol.

Seattle

Cornish College of the Arts - Art Galleries

710 E. Roy St., Seattle, WA 98102

Tel: (206) 726-5066

Internet Address: http://www.cornish.edu/admin/events.htm

Admission: free.

Open: Call for hours.

Facilities: Galleries (2).

Activities: **Temporary Exhibitions**.

The college maintains three exhibition spaces. The Behnke Gallery, located on the third floor of Cornish North (1501 10th Ave. East), exhibits student work throughout the year, including the fall juried student exhibition and BFA candidates thesis exhibits in May. Exhibitions in the Fisher Gallery and Annex, located Kerry Hall (710 E. Roy St.), focus on work by Northwest artists, as well as Cornish faculty, students, and staff. The Alumni Exhibition Gallery, located in Harvard House 1 (723 Harvard Ave. East), presents artwork by alumni. Also of possible interest the SOS Gallery, located in Cornish North (1501 10th Ave. East), features the work of current students.

Frye Art Museum

704 Terry Ave. at Cherry St., Seattle, WA 98104

Tel: (296) 622-9250

Fax: (206) 223-1707

Internet Address: http://www.fryeart.org

Director: Mr. Richard V. West

Admission: free.

Attendance: 50,000 *Established:* 1952 *Membership:* Y *ADA Compliant:* Y

Frye Art Museum, cont.

Parking: Free parking available the street.

Open: Tuesday to Wednesday, 10am-5pm;
Thursday, 10am-9pm;
Friday to Saturday, 10am-5pm;
Sunday, noon-5pm.

Closed: New Year's Day, Thanksgiving Day,
Christmas Day.

Facilities: **Architecture** (1997 expansion and renovation by Richard Sundberg; 1952 design by Paul Thiry); **Auditorium** (142 seats); **Collection of Art Books**; **Exhibition Space** (12,580 square feet); **Food Services** Gallery Café (Tues-Sat, 11am-4pm; Sun, noon-4pm and Thurs, 11am-7:30pm); **Shop** (original arts and crafts, books, posters).

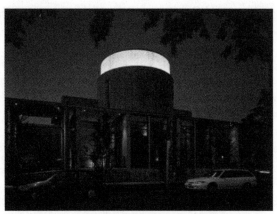

Exterior view of Frye Art Museum. Photograph courtesy of Frye Art Museum, Seattle, Washington.

Activities: **Concerts**; **Education Programs** (adults and children); **Gallery Talks**; **Guided Tours** (Sunday, 12:30pm; group tours reserve two weeks in advance); **Lectures**; **Readings**; **Workshops**.

Publications: newsletter, "Frye Vues" (quarterly).

The Charles and Emma Frye Collection, the Museum's founding bequest, is one of the nation's most extensive concentrations of 19th-century German, Munich School painting. Additionally, the Museum has acquired an array of art by American masters from the colonial period to the present. Works by artists such as Mary Cassatt, John Singleton Copley, Thomas Eakins, Robert Henri, Winslow Homer, John Singer Sargent, and Andrew Wyeth are periodically on display in the three permanent collection galleries. To complement the permanent collections, three changing galleries display touring exhibitions and work by significant contemporary artists working in all styles of representational art, as well as works by Northwest regional artists and Alaskan painters. Natural light, as required in Charles Frye's will, is a unique and unifying feature of the Museum. Once inside the circular lobby, visitors are guided by natural light from an off-center skylight imbedded in the rotunda ceiling. The skylight provides a visual orientation that directs visitors into the galleries and on to the two-story education wing, Gallery Café, and garden courtyard. The Frye's two-story educational wing hosts a variety of classes, workshops, and demonstrations in all media, with an emphasis on the traditional skills of drawing, painting, and the ceramic arts. Artwork by students and instructors is displayed regularly in the education wing. Classical music, traditional jazz, films, lectures, and readings are offered regularly in the museum auditorium.

Photographic Center Northwest Gallery

Photographic Center Northwest, 900 12th Ave., Seattle, WA 98122-4412

Tel: (206) 720-7222

Fax: (206) 720-0306

Internet Address: http://www.pcnw.org

Gallery Director: Ms. Ann Pallesen

Open: Monday, noon-9:30pm; Tuesday to Sunday, 9am-9:30pm.

Facilities: **Exhibition Area.**

Activities: **Temporary Exhibitions.**

The gallery features the work of nationally recognized and emerging Northwest photographic artists.

Seattle Art Museum (SAM)

100 University St., Seattle, WA 98101-2902

Tel: (206) 654-3100

Fax: (206) 254-3135

TDDY: (206) 654-3137

Internet Address: http://www.seattleartmuseum.org

Director: Ms. Mimi Gardner Gates

Admission: suggested admission: adult-$6.00, student-$4.00, senior-$4.00.

Seattle Art Museum, cont.

Attendance: 400,000 *Established:* 1917 *Membership:* Y *ADA Compliant:* Y

Parking: pay on site (limited).

Open: Tuesday to Wednesday, 10am-5pm;
Thursday, 10am-9pm;
Friday to Sunday, 10am-5pm;
Holiday Monday, 10am-5pm.

Closed: New Year's Day, Thanksgiving Day,
Christmas Day.

Facilities: **Architecture** (1991 design by Robert Venturi); **Auditorium & Lecture Hall**; **Conservation Facilities**; **Darkroom**; **Food Services** Café SAM; **Galleries** (38,000 square feet); **Library & Slide Library** (non-circulating, call for hours (206) 654-3220); **Rental/Sales Gallery** (adjacent, 1334 1st Ave., call for hours (206) 625-8997); **Shop** (art books, jewelry, games, toys); **Studios**.

Exterior view of Seattle Art Museum. Photograph by Susan Dirk, courtesy of Seattle Art Museum, Seattle Washington.

Activities: **Concerts**; **Demonstrations/Workshops**; **Education Program** (adults, children, seniors & students); **Family Programs**; **Films**; **Gallery Talks**; **Guided Tours** (daily; group tours reserve two weeks in advance); **Lectures**; **Temporary/Traveling Exhibitions**.

Publications: annual report; collection catalogues; exhibition brochures; exhibition catalogues; gallery guides; newsletter (quarterly).

The Seattle Art Museum (SAM) offers a variety of changing exhibitions. The collections number approximately 21,000 objects representing a wide range of art, from ancient Egyptian reliefs to contemporary American installations using photography and video. The Collections are particularly strong in five areas: Asian (for details, see the Seattle Asian Art Museum listing), African, Northwest Coast Native American, modern art, and European painting and decorative arts. Founded on the acquisition of the Katherine White Collection in 1991, the African collection numbers 3,000 objects, highlighted by sculpture, masks, textiles, basketry, and decorative arts. The collection is expanding to include contemporary African artwork. In 1991 the museum acquired the John H. Hauberg Collection, considered one of the finest Collections of Northwest Coast Native American art in the world. Today, the museum's holdings consist of a collection of almost 200 Native American masks, sculpture, textiles and decorative and household objects from the Pacific Northwest, British Columbia and Alaska. The modern art collection focuses on American and European paintings, sculpture, drawings, prints, photographs, and installation works. The 5,800 artworks include over 2,000 works of contemporary Pacific Northwest artists such as Dale Chihuly, Morris Graves, and Jacob Lawrence, and over 2,100 photographic prints. Twentieth-century paintings include work by Max Beckmann, Willem de Kooning, and Eduard Vuillard. Extensive post-1945 holdings include works by Roy Lichtenstein, Agnes Martin, Jackson Pollock, Martin Puryear, and Andy Warhol. The museum possesses over 1,600 European paintings, prints, drawings and sculpture from the 14th- through the 19th-century. A collection of 18th-century porcelain, numbering over 3,000 objects, is internationally recognized. There is a small collection of Greek, Hellenistic, and Etruscan art and coins. The museum also has collections of Egyptian, Mesopotamian and Islamic sculpture, ceramics, metalwork and painting. There are 700 works of Central, South American and Ancient American art in the collection. The Museum's collections are housed in two locations: the Seattle Art Museum (SAM) downtown and the Seattle Asian Art Museum (SAAM) in Volunteer Park (see separate listing). SAAM houses the majority of the museum's Asian holdings. While the SAM downtown houses the museum's other collections, it also includes examples of its Asian art holdings. The price of admission includes one visit to both museums within a one-week period.

Seattle Asian Art Museum (SAAM)

Volunteer Park, 1400 E. Prospect St, Seattle, WA 98112

Tel: (206) 654-3100
Fax: (206) 654-3191
TDDY: (206) 654-3137
Internet Address: http://www.seattleartmuseum.org

Seattle Asian Art Museum, cont.

Director: Ms. Mimi Gardner Gates

Admission: fee: $3.00.

Attendance: 70,000 *Established:* 1917

Membership: Y *ADA Compliant:* Y

Parking: free on site.

Open: Tuesday to Wednesday, 10am-5pm;
 Thursday, 10am-9pm;
 Friday to Sunday, 10am-5pm.

Closed: Legal Holidays.

Facilities: **Architecture** (art moderne museum building, 1933 design by Carl F. Gould); **Auditorium**; **Library** (3,500 volumes, call for hours 654-3220); **Shop**.

Activities: **Classes/Workshops**; **Docent Program**; **Education Program** (adults, children, students, seniors); **Films**; **Guided Tours** (daily; groups reserve two weeks in advance); **Lectures**; **Temporary/Traveling Exhibitions**.

Southeast Asian Sculpture and Ceramics Gallery at Seattle Asian Art Museum. Photograph courtesy of Seattle Art Museum, Seattle, Washington.

Publications: brochures; collection catalogue; exhibition catalogues; gallery guides; newsletter (quarterly).

Located in the original Seattle Art Museum facility in Volunteer Park, the Seattle Asian Art Museum (SAAM) features exhibitions of Japanese, Chinese, Korean, Indian, Himalayan and Southeast Asian art. An internationally-recognized center for Asian art and culture, SAAM's holdings rank in the top ten outside of Asia. The Asian collection of over 7,000 objects contains significant holdings in nearly all areas. The Japanese collection is considered one of the top five in the U.S. and among the most distinguished outside of Japan. The far-reaching holdings include significant examples of ink painting, calligraphy, Buddhist sculpture, metalwork, and folk textiles. The Chinese collection spans the Neolithic period through the 19th century and includes tomb figures, ceramics, ritual bronzes, sculpture, painting, lacquers, textiles, jade carvings, snuff bottles and over 350 Chinese puppets. The museum's large-scale Chinese Buddhist sculpture is particularly noteworthy. The Korean collection contains folding screens, celadons and early stoneware ceramics. The South and Southeast Asian collection includes Buddhist and Hindu sculpture in stone and bronze, painting, and decorative arts, as well as an extensive collection of early Thai ceramics. Some examples from the Asian art collection are on display at the Seattle Art Museum (SAM) downtown. SAAM houses the majority of the Seattle Art Museum's Asian holdings. While SAM downtown houses the museum's other collections, it also includes examples of its Asian art collections.

University of Washington - Henry Art Gallery

Faye G. Allen Center for the Visual Arts, 15th Ave. NE & NE 41st St., Seattle, WA 98195-3070

Tel: (206) 543-2280

Fax: (206) 685-3123

Internet Address: http://www.henryart.org

Director: Mr. Richard Andrews

Admission: fee: adult-$5.00, child-free, student-free, senior-$3.50.

Attendance: 65,000 *Established:* 1927

Membership: Y *ADA Compliant:* Y

Parking: underground UW Central Parking garage at NE 41st Street.

Open: Tuesday, 11am-5pm; Wednesday to Thursday, 11am-8pm; Friday to Sunday, 11am-5pm.

Closed: New Year's Day, Independence Day, Thanksgiving Day, Christmas Day.

Facilities: **Architecture** (modernist expansion, 1997 design by Charles Gwathmey; collegiate gothic building, 1927 design by Carl F. Gould); **Exhibition Area** (14,000 square feet); **Food Services** Henry Café (pastries, beverages & light fare); **Print Study Room**; **Sculpture Court**; **Shop** (books and local artist-made products).

University of Washington - Henry Art Gallery, cont.

Activities: **Gallery Talks** (2/month mid-day curatorial talks); **Guided Tours** (for information call 616-8782); **Lectures**; **Temporary/Traveling Exhibitions**.

Publications: exhibition catalogues.

Since its inception, the Henry Art Gallery, the art museum of the University of Washington, has been best known for its progressive exhibition program. The Gallery has presented significant exhibitions and provocative public programs on modern and contemporary art and organized nationally-prominent exhibitions. By the early 1990s, given the range and depth of the museum's programming and exhibitions, the Henry had far exceeded the physical capacity of its building, which provided less than 5,000 square feet of exhibition space. Driven by the critical success of its programs and a growing public and student audience, the Henry initiated a renovation and expansion that increased its overall size from 10,000 to 46,000 square feet. The interior space is sequential, leading visitors through exhibitions of the permanent collection in the renovated galleries of the original building down to special installations and exhibitions of modern and contemporary art in the new galleries on the lower levels. The concept behind this descending procession is to frame the experience of exhibitions of contemporary art with the historical precedents of the permanent collection. The lowest level features the primary exhibition areas. The main 6,000 square-foot gallery is a lofty and expansive sky-lit space, specifically conceived to accommodate large-scale works and installations. An additional 1,000-square-foot gallery was designed for artist projects or small exhibitions, and a 700-square-foot multimedia gallery will support a wide range of technologically-based art installations. Approximately 19,000 objects comprise the museum's permanent collection. Among the holdings in paintings are late 19th-

Henri Matisse, *Nu au bracelet*, 1940, linoleum cut on Arches paper, 9 5/8 x 7 inches. Gift of Mr. and Mrs. Frank L. Dobbins, Jr. Henry Art Gallery. From the 1997-1998 exhibition "Unpacking the Collection: 70 Years of Collections at the Henry". Photograph courtesy of Henry Art Gallery, University of Washington, Seattle Washington.

and early 20th-century American and French paintings by such artists as Ralph Albert Blakelock, William Merritt Chase, Charles Daubigny, and Winslow Homer; modern works by artists including Stuart Davis, Lionel Feininger, Jacob Lawrence, and Robert Motherwell; and works by Northwest artists including Guy Anderson, Kenneth Callahan, Morris Graves, Walter Isaacs, Helmi Juvonen, and Mark Tobey. Other media are represented by an extensive photography collection from the 1840s to the 1970s, with works by such photographers as Diane Arbus, Ansel Adams, Imogen Cunningham, Man Ray, and Garry Winogrand; prints by such artists as Seymour Hayden, William Hogarth, Giovanni Piranesi, Robert Rauschenberg, Georges Rouault, Rembrandt van Rijn, and James McNeill Whistler; a wide range of contemporary Japanese prints and woodblocks; and a significant collection of ethnic costumes and textiles, dating from 1500 BC to the present. Recent acquisitions of photography (including the core portion of the Joseph and Elaine Monsen Collection), sculpture, and video have strengthened these areas of the collection.

Wing Luke Asian Museum

407 7th Ave. (between S. Jackson and S. King Streets), Seattle, WA 98104

Tel: (206) 623-5124

Fax: (206) 623-4559

Internet Address: http://www.wingluke.org

Exec. Director: Mr. Ron Chew

Admission: fee: adult-$2.50, child-$0.75, student-$1.50, senior-$1.50.

Attendance: 40,000 *Established:* 1966 *Membership:* Y *ADA Compliant:* Y

Parking: on street and commercial parking lots.

Open: Tuesday to Friday, 11am-4:30pm; Saturday to Sunday, noon-4pm.

Seattle, Washington

Wing Luke Asian Museum, cont.

Facilities: Exhibition Area; Library (500 volumes).

Activities: Education Program (adults and children); Films; Gallery Talks; Lectures; Readings; Temporary and Traveling Exhibitions.

Publications: newsletter (quarterly).

The Wing Luke Asian Museum is devoted to preserving and presenting the history, art, and culture of Asian Pacific Americans. Permanent exhibits depict the history of immigration and settlement by Asians and Pacific Islanders in Washington State and Seattle's International District. Changing exhibits, drawing on community resources for inspiration, focus on history and art.

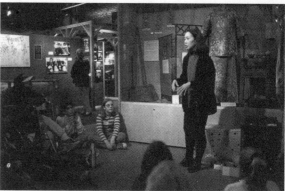

Education coordinator leading a school tour group at Wing Luke Asian Museum. Photograph by John D. Pai, courtesy of Wing Luke Asian Museum, Seattle, Washington.

Sequim

Museum and Arts Center in the Sequim Dungeness Valley

175 W. Cedar (between N. Sequim and 2nd Ave.), Sequim, WA 98382-3318

Tel: (360) 683-8110

Fax: (360) 683-8364

Exec. Director: Ms. Margaret DeWitt

Admission: voluntary contribution.

Attendance: 6,700 *Established:* 1992 *Membership:* Y *ADA Compliant:* Y

Parking: parking available adjacent to facility.

Open: Daily, 9am-4pm.

Closed: New Year's Day, Easter, Memorial Day, Independence Day, Labor Day, Thanksgiving Day, Christmas Day.

Facilities: Exhibition Area; Shop (locally crafted ware, art, souvenirs).

Activities: Arts Festival; Concerts; Education Program (adults); Films; Gallery Talks; Lectures; Temporary/Traveling Exhibitions; Workshops.

Publications: newsletter (monthly); newspaper, "Peninsula Arts & History" (quarterly).

The Museum and Art Center's rotating exhibits focus on the area's early agricultural and timber industries, shipping and water transport, Native American artifacts, early medicine, and pioneer families.

Spokane

Cheney Cowles Museum

Eastern Washington State Historical Society, 2316 West 1st Ave., Spokane, WA 99204

Tel: (509) 456-3931

Fax: (509) 363-5330

Internet Address: http://www.cheneycowles.org

C.E.O.: Jane A. Johnson

Admission: fee: adult-$4.00, child-$2.50, student-$2.50, senior-$3.00, family-$10.00.

Attendance: 85,000 *Established:* 1916 *Membership:* Y *ADA Compliant:* Y

Parking: free on site.

Open: Tuesday, 10am-5pm; Wednesday, 10am-9pm; Thursday to Saturday, 10am-5pm; Sunday, 1pm-5pm.

Closed: Legal Holidays.

Facilities: Architecture (Tudor Revival house, 1898 design by Kirtland Kelsey Cutter); Auditorium (180 seat); Gallery; Library/Archives (12,000 volumes; by appointment; Tues-Thurs, 10am-5pm); Shop (arts & crafts by local artists, books, children's books/games).

Cheney Cowles Museum, cont.

Activities: **Arts Festival**; **Concerts**; **Docent Program**; **Education Program** (elementary through graduate levels); **Films**; **Guided Tours**; **Lectures**; **Rental Program**; **Temporary/Traveling Exhibitions**.

Publications: "Museum Notes" (quarterly); exhibition catalogues.

The primary purpose of the Cheney Cowles Museum is to collect, preserve, and interpret the history of eastern Washington, the Inland Northwest, American Indian Cultures, and the visual arts. Exhibits in the Museum's Main Gallery are changed frequently to present a wide variety of media, styles, and periods, ranging from contemporary to traditional expressions. Featured are artists of international, national, and regional reputation, as well as exhibits of major collections. The Museum also offers a range of events related to exhibits and programming, including a regular weekly lecture series, tours, workshops and symposia. The Museum's library and archives provide a variety of resources for use by the general public on the premises. The adjacent 1898 Campbell House, designed by architect Kirtland K. Cutter in the Tudor Revival style, offers tours that reflect the turn-of-the-century lifestyle, architecture, and decorative arts through the rich detail of family history and household operations.

Exterior view of Cheney Cowes Museum. Photograph courtesy of Cheney Cowes Museum, Spokane, Washington

Eastern Washington University - Spokane Center Gallery

Spokane Center, West 705 1st St., Spokane, WA 99204

Tel: (509) 458-6401

Internet Address: http://visual.arts.ewu.edu/ galleries/spokane-center/spokane-center.htm

Curator: Mr. Richard L. Twedt

Admission: free.

Attendance: 10,000

ADA Compliant: Y

Open: Monday to Thursday, 8am-10pm;
Friday, 8am-5pm.

Facilities: **Exhibition Area.**

Activities: **Permanent Exhibits.**

The Center Gallery is home to the Anne Harder MacKenzie Wyatt Collection of "Modern American Masters". Initially developed over a period of eighteen months, the Collection features prints by American artists who were in the forefront of the major art movements since the 1940's. Included are works by Dine, Sam Francis, Lichtenstein, Oldenburg, Rauschenberg, Ruscha, Stella, Thiebaud, and LeWitt. For information on other Eastern Washington University galleries and collections, see the University's listing under Cheney, Washington.

Buky Schwartz, *Video Space for a Blue House*, 1990, Installation at Spokane Center Gallery. Photograph courtesy of Eastern Washington University, Cheney, Washington.

Gonzaga University - Jundt Art Museum (JAM)

Gonzaga University (Southeast Corner of Desmet Ave. & Pearl St.)
Spokane, WA 99258-0001

Tel: (509) 323-6611

Fax: (509) 323-5525

Internet Address: http://www.gonzaga.edu/jundt/index.html

Director and Curator: Mr. J. Scott Patnode

Spokane, Washington

Gonzaga University - Jundt Art Museum, cont.

Admission: free.

Established: 1995 *ADA Compliant:* Y

Open: Monday to Friday, 10am-4pm; Saturday, noon-4pm.

Closed: Academic Holidays, Summer Session.

Facilities: **Auditorium** (118 seat); **Exhibition Space** (3 areas, total 5,538 square feet); **Print Study Room**.

Activities: **Gallery Talks**; **Lectures**.

The Museum provides space for traveling exhibits and houses Gonzaga University's art collection. The collection includes prints from the Bolker, Baruch, and Jacobs collections; major pieces of glass art by Dale Chihuly, bronze sculptures by Auguste Rodin, and paintings, ceramics, photographs and tapestries. Exhibits of permanent holdings are periodically rotated. The Museum also includes a print study room for Gonzaga's print collection.

Jundt Art Museum Lobby and Reception area with installation of Dale Chihuly glass collection and Red Chandelier, 1995. Photograph by J. Craig Sweat, courtesy of Jundt Art Museum, Spokane, Washington.

Tacoma

Tacoma Art Museum (TAM)

12th St. and Pacific Ave., Tacoma, WA 98402

Tel: (253) 272-4258

Fax: (253) 627-1898

Internet Address: http://www.TacomaArtMuseum.org

Director: Ms. Janeanne Upp

Admission:

fee: adult-$5.00, child (<6)-free, student-$4.00, senior (>65)-$4.00.

free: 3rd Thursday in month.

Attendance: 80,000 *Established:* 1891

Membership: Y *ADA Compliant:* Y

Parking: on street and commercial lots.

Open: Tuesday to Wednesday, 10am-5pm;
Thursday, 10am-8pm;
Friday to Sunday, 10am-5pm.
Holiday Mondays, 10am-5pm.

Closed: New Year's Day, Independence Day, Thanksgiving Day, Christmas Day.

Family before Thomas Hart Benton painting in Tacoma Art Museum collection. Photograph courtesy of Tacoma Art Museum, Tacoma, Washington.

Facilities: **Auditorium** (200 seat); **Exhibition Space** (9,000 square feet); **Library** (2,000 volumes); **Museum Shop**.

Activities: **Concerts** (occasional); **Education Program** (adults, children and students); **Guided Tours** (1-2 /week); **Lectures**; **Temporary/Traveling Exhibitions**.

Publications: bulletin (quarterly); exhibition catalogues; gallery guides.

Located in downtown Tacoma, the Museum attracts over 80,000 people annually to its galleries for innovative, challenging, and popular exhibitions and programs. Education programs, serving all ages, place art in a broad context, and center around artmaking inspired by exhibitions on view. TAM organizes and presents exhibitions of 19th and 20th century art. It is actively committed to the art of the Northwest as a collector and presenter. The "12th Street Series", inaugurated in 1992, is dedicated to contemporary exhibitions, performances and site-specific installations by Northwest artists. The Northwest Biennial, held every other summer, is an important juried competition for artists in Washington, Oregon, Idaho and Montana. The Museum's collection concentrates on paintings and works on paper of the 19th and 20th century, with an emphasis on art of the Northwest. Special

838

Tacoma Art Museum, cont.

collections include a selection of French Impressionist paintings, American paintings and prints, a rare set of Japanese woodblock prints, 19th century Chinese textiles, one of the largest public collections in the world of glass art by Tacoma-native Dale Chihuly, and other art from the Northwest. In June 1997, TAM launched a campaign for a new 50,000 square-foot facility for the city of Tacoma, next to historic Union Station and across from the new University of Washington Tacoma campus, slated to open in summer, 2003.

University of Puget Sound - Kittredge Gallery

1500 N. Lawrence, Tacoma, WA 98416
Tel: (253) 879-2806
Fax: (253) 879-3500
Internet Address: http://www.ups.edu
Director: Greg Bell
Admission: free.
Attendance: 900 *Established:* 1950 *ADA Compliant:* Y
Open: **September 1 to May 15**, Monday to Friday, 10am-4pm; Sunday, 1pm-4pm.
Facilities: **Exhibition Space** (2,100 square feet).
Activities: **Lectures; Temporary/Traveling Exhibitions**.

The Gallery presents a series of community and regional art shows, as well as exhibitions of student work. Exhibiting artists generally present public lectures on their work.

Vancouver

Clark College - The Archer Gallery

1800 E. McLoughlin Blvd., Vancouver, WA 98663
Tel: (360) 992-2246
Fax: (360) 992-2828
Internet Address: http://www.clark.edu
Director: Ms. Marjorie Hirsch
Admission: free.
Established: 1978
ADA Compliant: Y
Parking: free adjacent to site.
Open: Tuesday to Thursday, 9am-8pm;
 Friday, 9am-4pm;
 Saturday to Sunday, 1pm-5pm.
Facilities: **Gallery** (2,400 square feet).
Activities: **Films; Lectures; Temporary Exhibitions**
 (6/year).

Archer Gallery interior. Photograph courtesy of Archer Gallery, Clark College, Vancouver, Washington,

Each year, the Gallery hosts six exhibits by regional and nationally-recognized artists, and at least one faculty/student show. The Archer Gallery has evolved from its inception in 1978 into a showcase for Northwest artists. Focusing on Washington state, the gallery presents the work of established artists as well as emerging talent working in a wide variety of media, including paintings, prints, photography, and sculpture, as well as site-specific installations and video work. Recognized as an alternative venue, the Archer Gallery serves the Clark College faculty and student body as well as the Vancouver-Portland public at large.

Wenatchee

North Central Washington Museum

127 S. Mission (between Kittitas and Yakima Streets), Wenatchee, WA 98801
Tel: (509) 664-3340
Fax: (509) 664-3356

North Central Washington Museum, cont.

Director & C.E.O.: Dr. Keith Williams
Admission: fee: adult-$3.00, child-$1.00, family-$5.00.
Attendance: 41,000 *Established:* 1939 *Membership:* Y *ADA Compliant:* Y
Parking: parking lot and on-street parking.
Open: Monday to Friday, 10am-4pm; Saturday to Sunday, 1pm-4pm.
Facilities: **Auditorium**; **Gallery**; **Picnic Area & Playground**; **Shop** (books, prints, apple labels); **Theatres** (2).
Activities: **Concerts**; **Demonstrations/Workshops**; **Guided Tours** (groups 10+ reserve in advance); **Lectures**; **Permanent Exhibits**; **Temporary/Traveling Exhibitions**.
Publications: magazine, "Confluence" (quarterly); newsletter, "The Museum Connection" (quarterly).

The Museum is housed in two historic buildings (four floors of exhibits-about 40,000 square feet) at 127-125 South Mission in downtown Wenatchee. Permanent exhibits are diverse, with a focus on the Native American and pioneering heritage of the region, the historic apple industry, and the Great Northern Railroad. The museum also has a large auditorium and meeting rooms, a fully-functional 1919 theater pipe organ, a changing art and natural history gallery, a gift shop and a variety of multimedia programs.

Wenatchee Valley College - Gallery '76

Wenatchee Valley College, Sexton Hall, 9th St., Wenatchee, WA 98801
Tel: (509) 664-2521
Fax: (509) 664-2538
Internet Address: http://wvc.ctc.edu
Coordinator: Ms. Rae Dana
Admission: voluntary contribution.
Attendance: 3,000 *Established:* 1976 *Membership:* Y *ADA Compliant:* Y
Open: Monday to Tuesday, 10am-2pm; Wednesday to Thursday, 10am-2pm & 7pm-9pm; Friday, 10am-2pm.
Activities: **Education Program** (undergraduate); **Gallery Talks**; **Lectures**; **Temporary/Traveling Exhibitions**.
Publications: newsletter, "Gallery '76 News" (quarterly).

Gallery '76 is a community supported non-profit art gallery located on the campus of Wenatchee Valley College in Sexton Hall off Ninth Street. North Central Washington's first public art gallery, Gallery '76, promotes the visual arts in North Central Washington through exhibitions, workshops, lectures, tours, and children's classes. The gallery provides a vehicle for the exhibition of work by talented local artists and craftspeople, Wenatchee Valley College art students, and artists of national and international repute. In addition the Gallery also brings visual artists to the community to speak about their art so that the public may better understand the artist's motivations and role in society.

Yakima

Yakima Valley Community College - Larson Museum and Gallery

Yakima Valley Community College, South 16th Ave. & Nob Hill Blvd.
Yakima, WA 98902
Tel: (509) 574-4875
Fax: (509) 574-6826
TDDY: (509) 575-2350
Internet Address: http://www.rfttc.org/~yvcc
Director: Ms. Carol Hassen
Admission: voluntary contribution.
Attendance: 10,000 *Established:* 1949 *Membership:* Y *ADA Compliant:* Y
Parking: free lot on site.
Open: **Academic Sessions**, Monday to Friday, 10am-5pm; Saturday to Sunday, 1pm-5pm.
Activities: **Arts Festival**; **Education Program** (children); **Guided Tours**.

Yakima Valley Community College - Larson Museum and Gallery, cont.

Publications: exhibition catalogues, "Central Washington Artists Exhibition" (annual); newsletter, "ARTicles" (quarterly).

The Larson Gallery presents monthly temporary exhibitions representing a broad range of interests, promotes art education through tours, and provides workshops and lectures. The Gallery also conducts three annual juried exhibitions: the Central Washington Artists Exhibition (restricted to local artists), the Art to Wear exhibit (open to residents of Washington, Oregon, and Idaho), and the National Photography Juried Exhibit.

West Virginia

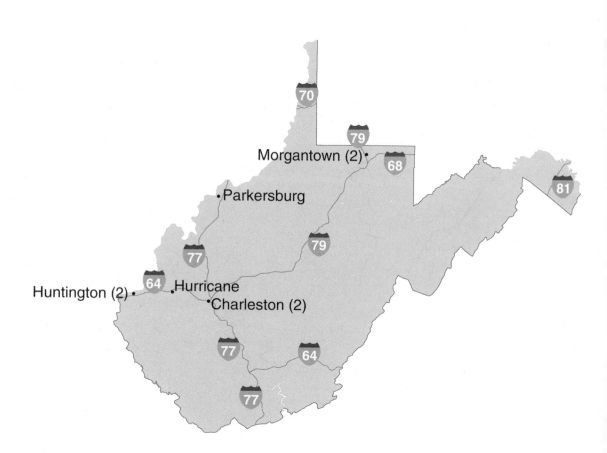

The number in parentheses following the city name indicates the number of museums/galleries in that municipality. If there is no number, one is understood. For example, in the text two listings would be found under Morgantown and one listing under Parkersburg.

West Virginia

Charleston

Sunrise Museums

746 Myrtle Road, Charleston, WV 25314

Tel: (304) 344-8035
Fax: (304) 344-8038
Director: Dr. Judy Wellington
Admission: fee: adult-$3.50, student-$2.50, senior-$2.50.
Attendance: 60,000 *Established:* 1961 *Membership:* Y *ADA Compliant:* Y
Parking: free on site.
Open: Tuesday to Saturday, 10am-5pm; Sunday, 2pm-5pm.
Closed: Legal Holidays.
Facilities: **Architecture** (Torquilstone House & Sunrise Mansion); **Gallery**; **Museum Shop**; **Sculpture Garden**.
Activities: **Demonstrations**; **Education Program**; **Films**; **Guided Tours**; **Lectures**; **Temporary/Traveling Exhibitions**.
Publications: newsletter (bi-monthly).

The Museums are housed in two mansions, each on on the National Register of Historic Places. The Torquilstone House exhibits 19th and 20th century paintings. A children's museum and planetarium are housed in the Sunrise Mansion.

West Virginia State Museum

Capitol Complex, Cultural Center, Charleston, WV 25305

Tel: (304) 558-0220
Fax: (304) 558-2779
TDDY: (304) 558-0220
Internet Address: http://www/wvlc.wvnet.edu/culture/front.html
Commissioner: Mr. Bill Drennen
Admission: free.
Attendance: 250,000 *Established:* 1905 *Membership:* Y *ADA Compliant:* Y
Open: Monday to Friday, 9am-5pm; Saturday to Sunday, 1pm-5pm.
Facilities: **Exhibition Space**; **Library**; **Theatre**.
Activities: **Arts Festival**; **Concerts**; **Films**; **Guided Tours**; **Performances**.

The Museum collects, preserves, and exhibits the ideas, arts and artifacts of West Virginia heritage.

Huntington

Huntington Museum of Art, Inc.

2033 McCoy Road, Huntington, WV 25701-4999

Tel: (304) 529-2701
Fax: (304) 529-7447
TDDY: (304) 522-2243
Internet Address: http://www.hmoa.org
Exec. Director: Margaret A. Skove
Admission: free.
Attendance: 65,000 *Established:* 1947 *Membership:* Y *ADA Compliant:* Y
Parking: free on site.
Open: Tuesday, 10am-9pm; Wednesday to Saturday, 10am-5pm; Sunday, noon-5pm.
Closed: New Year's Day, Independence Day, Thanksgiving Day, Christmas Day.
Facilities: **Architecture** (addition designed by Walter Gropius); **Auditorium** (270 seat); **Food Services**, Café Bauhaus; **Galleries** (11); **Library** (13,000 volumes); **Open Air Stage**; **Plant Conservatory** (3,000 square feet); **Sculpture Garden**; **Shop** (regional art and crafts, jewelry, books).
Activities: **Arts Festival**; **Concerts**; **Education Program** (adults and children); **Films**; **Gallery Talks**; **Guided Tours** (groups 10+, arrange in advance); **Lectures**; **Temporary/Traveling Exhibitions**.

Huntington Museum of Art, Inc., cont.

Publications: annual report; collection catalogue; exhibition catalogues; members magazine.

Opened to the public in 1952, The Huntington Museum of Art is West Virginia's largest art museum. The Museum Collection reveals a range of artistic interests: American and European paint-

ings, Near Eastern art, British silver, antique firearms, contemporary prints and Appalachian folk art. Through changing exhibitions the Museum shares its collection and offers a panorama of traveling exhibitions from international sources. Sculpture is displayed on the Museum grounds. The Education Gallery features a participatory experience for children in an interactive environment. The Museum is home to the C. Fred Edwards Conservatory, the region's only conservatory, featuring year-round displays of subtropical palms, shrubs, ground covers, orchids, and seasonal flowers. The Daywood Collection features American and European paintings, prints and bronzes from the 19th and early 20th-century. The Museum houses fine examples of American furniture and decorative arts. The collection also features historic glass from the Ohio River Valley and The Wilbur E. Myers Art Glass Collection of rare New England and European art glass of the late 19th- and early 20th centuries.

Childe Hassam, *Figures in Sunlight,* oil on canvas. Gift of Mr. Herbert Fitzpatrick, Huntington Museum of Art. Photograph courtesy of Huntington Museum of Art, Huntington, West Virginia.

Marshall University - Birke Art Gallery

Third Avenue, Smith Hall, Marshall University, Huntington, WV 25755-2222
Tel: (304) 696-2296
Internet Address: http://www.marshall.edu
Director: Ms. Beverly Marchant
Open: Monday to Friday, 10am-4pm; Monday, 7pm-9pm; Saturday, 1pm-4pm.

The Birke Art Gallery presents a series of temporary exhibitions each year, including the work of both students and professional artists.

Hurricane

Museum in the Community

3 Valley Park Drive, Hurricane, WV 25526
Tel: (304) 562-0484
Fax: (304) 562-5375
Exec. Director: Ms. Bobbie Hill
Admission: suggested contribution: adult-$3.00,
 child-$0.50, student-$0.50.
Attendance: 39,000 *Established:* 1983
Membership: Y *ADA Compliant:* Y
Parking: free lot on site.

Museum in the Community new facility. CAD drawing courtesy of Museum in the Community, Hurricane, West Virginia.

Open: Tuesday to Wednesday, 10am-5pm; Thursday, 10am-8pm; Friday to Saturday, 10am-5pm;
 Sunday, 1pm-5pm.
Closed: New Year's Day, Easter, Independence Day, Thanksgiving Day, Christmas Day.
Facilities: Galleries (2); Garden; Shop.
Activities: Concerts; Education Program (adults and children); Films; Guided Tours; Lectures;
 Temporary/Traveling Exhibitions.
Publications: brochure (annual); newsletter/calendar, "Museum in the Community" (quarterly).

Occupying a new facility inspired by Japanese folk architecture, the Museum in the Community presents temporary exhibitions.

Morgantown

West Virginia University - Paul and Laura Mesaros Galleries (CAC)

College of Creative Arts, West Virginia Univ., Creative Arts Center, Evansdale Campus
Morgantown, WV 26506-6111
Tel: (304) 291-2140 *Ext:* 3210
Fax: (304) 293-5731
Internet Address: http://www.wvu.edu/~ccarts
Dean & Director: Mr. Philip Faini
Admission: free.
Attendance: 16,000 *Established:* 1968 *ADA Compliant:* Y
Parking: guest parking available.
Open: Monday to Saturday, noon-9:30pm.
Closed: Academic Holidays.
Facilities: **Auditorium** (1,500 seat); **Classrooms**; **Exhibition Space** (2 galleries, total 1,100 square feet); **Studios.**
Activities: **Education Program** (undergraduate and graduate students); **Guided Tours** (available on request); **Lectures**; **Temporary Exhibitions** (change monthly).
Publications: exhibition catalogues (biennial).

The Galleries focus on individual and group exhibitions of contemporary artists of regional, national, and international reputation working in all media. Additionally, the galleries host yearly exhibitions of the work undergraduate senior BFA candidates and graduate student MFA thesis work during the spring semester. Also of possible interest on campus, exhibitions are mounted the Grandview Gallery, located above the main entrance on the second floor of the Mountainlair. Grandview Gallery is operated by The Student Art Association under the guidance of the Division of Art.

West Virginia University - West Virginia Historical Art Collection

Colson Hall Library, Downtown Campus (University Ave. at Hough St.), Morgantown, WV 26506
Tel: (304) 293-3536
Director, Historical Art Collection: Mr. John Cuthbert
Admission: free.
Open: Call for hours.

While most of the University's permanent collection is held by the College of Creative Arts, the regional/historical art component is a unit of the WVU Libraries. The University Main Library is creating dedicated exhibition space, which is scheduled to open in 2002. Until that time the Collection's home is in Colson Hall Library. Exhibitions are occasional and temporary.

Parkersburg

Parkersburg Art Center (PAC)

220 8th St., Parkersburg, WV 26101
Tel: (304) 485-3859
Fax: (304) 485-3850
Exec. Director: Ms. Jill M. Chidester
Admission: fee: adult-$1.00, child-$0.50.
Attendance: 18,000 *Established:* 1938 *Membership:* Y *ADA Compliant:* Y
Parking: on street parking.
Open: Tuesday to Friday, 10am-4pm; Saturday to Sunday, 1pm-4pm.
Closed: Legal Holidays.
Facilities: **Classrooms** (2); **Library** (lending); **Reading Room**; **Shop** (work of local artists).
Activities: **Education Program** (adults and children); **Guided Tours** (groups 10+); **Juried Exhibits**; **Lectures**; **Temporary/Traveling Exhibitions** (9/year).
Publications: brochure, "Preview of Events" (annual); newsletter, "ARTCenter News" (bi-monthly).

The Center presents nine exhibitions each year including fall regional and spring national juried exhibitions.

Wisconsin

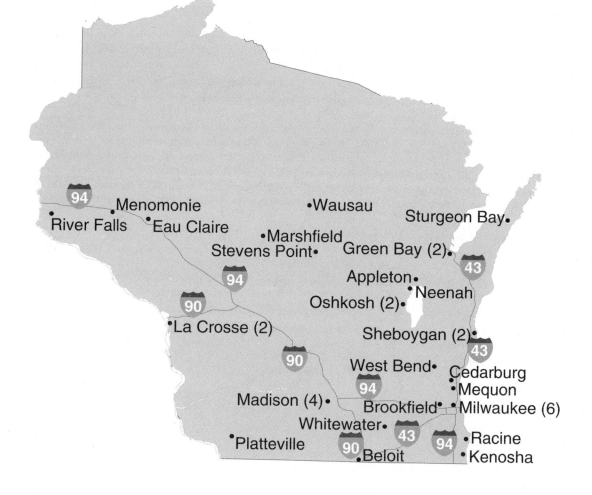

The number in parentheses following the city name indicates the number of museums/galleries in that municipality. If there is no number, one is understood. For example, in the text four listings would be found under Madison and one listing under Kenosha.

Wisconsin

Appleton

Lawrence University - Wriston Art Center Galleries

Lawrence University, 613 E. College Ave.
Appleton, WI 54911
Tel: (920) 832-6621
Fax: (920) 832-7362
Internet Address:
 http://www.lawrence.edu/news/wriston/shmtl
Curator: Frank Lewis
Admission: free.
Attendance: 5,000 *Established:* 1989
Membership: N *ADA Compliant:* Y
Parking: next to university's Memorial Chapel
 - access via Lawe St.
Open: **October to May**,
 Tuesday to Friday, 10am-4pm;
 Saturday to Sunday, noon-4pm.
 June to September,
 Tuesday to Friday, 10am-4pm;
 Saturday, noon-4pm.
Closed: Memorial Day, Independence Day,
 Thanksgiving Weekend,
 December 15 to January 2.
Facilities: **Architecture** (1989 design by
 Jefferson Riley); **Exhibition Area** (3
 galleries).

Lower Lobby, Wriston Art Center (1989), designed by Jefferson Riley, Centerbrook Architects. Photograph courtesy of Henry M. and Ruth B. Wriston Art Center, Appleton, Wisconsin.

Activities: **Education Program** (undergraduate students); **Films**; **Guided Tours** (by appointment, 48 hour notice required); **Lectures**; **Temporary/Traveling Exhibitions** (5-6 shows/year).
Publications: exhibition catalogues.

Located in the heart of the campus, the upper level of the Henry M. and Ruth B. Wriston Art Center, devoted to art history and exhibition, includes a serpentine galleria for the display of study reproductions and transitory exhibits, a 150-seat auditorium, and a visual resources suite for an extensive collection of slides. The west side of the lobby features three galleries of increasing size (the Leech Gallery, Hoffmaster Gallery, and Kohler Gallery), each leading into the next. Adjacent to these is the Quirk Print Gallery, a print study room. The Center's lower level is devoted to studios and opens onto an amphitheater. The Galleries coordinate an exhibition schedule of 5-6 shows per year while maintaining a permanent collection of approximately 1,800 works. The collection, which consists primarily of works of art on paper, contains a number of Japanese prints, graphic work from the 1930s, and the LaVera Pohl Collection of German Expressionist Art. The Wriston Art Center also houses the Ottilia Buerger Collection of Ancient and Byzantine Coins. Artwork from the collection can be made available for public inspection with advance notice. Please allow four working days to process any request.

Beloit

Beloit College - Wright Museum of Art

Beloit College, 700 College St., Beloit, WI 53511-5595
Tel: (608) 363-2677
Fax: (608) 363-2248
Admission: free.
Attendance: 20,000 *Established:* 1892 *Membership:* Y *ADA Compliant:* Y
Parking: free on site.

Beloit College - Wright Museum of Art, cont.

Open: Tuesday to Sunday, 11am-4pm.

Closed: Academic Holidays.

Facilities: **Auditorium; Classrooms.**

Activities: **Art Classes** (children); **Artist-in-Residence Program; Concerts; Education Program** (undergraduate students); **Films; Guided Tours; Juried Exhibit; Lectures; Temporary/Traveling Exhibitions.**

Publications: exhibition catalogues; newsletter.

The Museum offers both thematic and solo temporary and traveling exhibitions. An annual juried show for regional artists and a student show are held in the spring. The Museum's permanent collection includes 15th- to 20th-century paintings, works on paper, sculpture, photographs, and Asian art (e.g., imperial Chinese robes, Korean celadon ceramics, and Japanese sagemono), as well as the collection of plaster casts from the Greek government exhibit at the Columbian Exposition.

Brookfield

Milwaukee Art Museum/West

18900 W. Bluemound Road, Brookfield, WI 53045

Tel: (414) 827-0444

Open: Call for hours.

Facilities: **Shop.**

Activities: **Programs.**

A satellite of the Milwaukee Art Museum. (For the main listing of the Milwaukee Art Museum, see listing below, under Milwaukee.)

Cedarburg

Ozaukee Art Center

W. 62 N. 718 Riveredge Drive, Cedarburg, WI 53012

Tel: (414) 377-8230

Director: Mr. Paul J. Yank

Admission: voluntary contribution.

Established: 1971 *Membership:* Y *ADA Compliant:* Y

Open: Wednesday to Sunday, 1pm-4pm.

Closed: Legal Holidays.

Facilities: **Darkroom; Fine Arts Printing Department; Sculpture Garden; Studio.**

Activities: **Education Program** (adults and children); **Guided Tours; Lectures; Studio Art Classes.**

Publications: newsletter (monthly).

The Art Center maintains a collection of paintings, sculpture, prints, ceramics, jewelry, and glass.

Eau Claire

University of Wisconsin-Eau Claire - Foster Gallery

121 Water St., Eau Claire, WI 54702-4004

Tel: (715) 836-2328

Fax: (715) 836-4882

Internet Address: http://www.uwec.edu/Academic/Art/featuresc.htm

Director: Thomas K.. Wagener

Admission: free.

Attendance: 25,000 *Established:* 1970 *Membership:* N *ADA Compliant:* Y

Parking: permit required weekdays 8am-4pm.

Open: Monday to Friday, 10am-4:30pm; Saturday to Sunday, 1pm-4:30pm.

Closed: Academic Holidays.

Facilities: **Exhibition Area** (2 galleries, 3,200 square feet).

University of Wisconsin-Eau Claire - Foster Gallery, cont.

Activities: **Education Program** (undergraduate and graduate students); **Lectures**; **Temporary/Traveling Exhibitions**.

Publications: exhibition brochures.

The Foster Gallery mounts four major shows annually during the University's academic year. These shows may feature the work of a single artist or pieces by a group of artists from a major commercial gallery. Exhibitions have included the work of both established and emerging artists. Exhibitions of the permanent collection, work of faculty and BFA degree candidates, and an annual juried student art show are also scheduled. The permanent collection consists of over 700 works ranging from 19th-century oriental to late 20th-century modern art, including prints, paintings, pen and ink, sculpture, ceramics, photography, fibers, and computer graphics. Its founding collection, the Emil J. Arnold Collection, includes works by Elliott Green, Chaim Gross, Hiroshige, Karl Knaths, Roy Lichtenstein, I. Rice Pereira, Joseph Solman, Raphael Soyer, and Theodore Stamos.

Green Bay

Neville Public Museum of Brown County

210 Museum Place, Green Bay, WI 54303

Tel: (414) 448-4460

Fax: (414) 448-4458

Director: Ms. Ann L. Koski

Admission: free.

Attendance: 65,000 *Established:* 1915 *Membership:* Y *ADA Compliant:* Y

Open: Tuesday, 9am-4pm; Wednesday, 9am-9pm; Thursday to Saturday, 9am-4pm;
 Sunday, noon-4pm.

Closed: New Year's Day, Thanksgiving Day, Christmas Day.

Facilities: **Classrooms**; **Food Services** Lunch Room; **Galleries** (6); **Learning Center** (132 seats); **Library** (6,000 volumes, non-circulating); **Shop**.

Activities: **Education Programs**; **Films**; **Gallery Talks**; **Guided Tours**; **Lectures**; **Permanent Exhibits**; **Temporary Exhibitions**; **Traveling Exhibitions**.

Publications: brochures; newsletter.

The Museum displays exhibits of art, history, and science in its six galleries. There are temporary exhibitions of the work of regional artists.

University of Wisconsin-Green Bay - Galleries

2420 Nicolet Drive, Green Bay, WI 54302

Tel: (920) 465-2271

Internet Address: http://www.uwgb.edu

Director: Mr. Dan Hatton

Open: Tuesday to Saturday, 10am-3pm.

Facilities: **Exhibition Area** (2 galleries).

Activities: **Temporary Exhibitions**.

Two display galleries are maintained: Lawton Gallery (located at 249 Theater Hall) and 407 Gallery (located in Studio Arts Building, Room 407).

Kenosha

Kenosha Public Museum

5608 10th Ave., Kenosha, WI 53140

Tel: (414) 653-4140

Fax: (414) 653-4143

Director: Ms. Paula Touhey

Admission: free.

Attendance: 55,000 *Established:* 1933 *Membership:* Y *ADA Compliant:* Y

Open: Monday to Friday, 9am-5pm; Saturday, 9am-4pm; Sunday, 1pm-4pm.

Kenosha Public Museum, cont.

Closed: Legal Holidays.
Facilities: **Auditorium** (200 seat); **Exhibition Area**; **Library** (3,000 volumes); **Shop.**
Activities: **Education Programs** (adults and children); **Guided Tours.**
Publications: newsletter.

Located Kenosha's Civic Center Historic District, the Museum offers special exhibits.

La Crosse

Pump House Regional Arts Center

119 King St., La Crosse, WI 54601
Tel: (608) 785-1434
Fax: (608) 785-1432
Business Manager: Ms. Jodi Bente
Admission: free.
Attendance: 5,000 *Established:* 1977
Membership: Y *ADA Compliant:* Y
Parking: lots on side and rear of building.
Open: Tuesday to Friday, noon-5pm;
 Saturday, 10am-4pm.
Closed: New Year's Day, Memorial Day,
 Labor Day, Thanksgiving Day,
 Christmas Day.

Exterior view of Pump House Regional Arts Center.
Photograph courtesy of Pump House Regional Arts Center,
Inc., La Crosse, Wisconsin.

Facilities: **Architecture** (19th-century pumping building.); **Galleries** (3); **Library** (50 volume);
 Theatre (140 seat).
Activities: **Concerts** (Sept-May); **Education Program** (adults, children, and students); **Hobby**
 Workshops; **Juried Exhibits**; **Performances**; **Rental Gallery.**
Publications: magazine, "Revue" (bi-monthly).

The Pump House has four main exhibit areas: The Kader Room, the Festival Balcony, the Eastbank display, and the LSAC display. The Eastbank display is leased by Eastbank Artists, a local artists cooperative. The LSAC display is also leased on an annual basis to the La Crosse Society of Arts and Crafts, another association for local artists. The Kader Room and Festival balcony exhibits are managed by the Pump House. Artists wishing to exhibit their work in the Kader Room submit their work for evaluation. From September through May, monthly exhibits of work from local elementary schools are featured on The Festival Balcony. The Pump House has also sponsored a variety of art classes for adults and children. The building is on the National Register of Historic Places.

University of Wisconsin-La Crosse - University Art Gallery

Center for the Arts, 16th and Vine Streets, La Crosse, WI 54601
Tel: (608) 785-8237
Internet Address: http://www.uwlax.edu
Director: Mr. Joel Eigin
Admission: free.
Open: Monday, 10am-9pm; Tuesday to Thursday, 10am-6pm; Friday to Saturday, 11am-3pm.
Activities: **Demonstrations**; **Lectures** (by visiting artists).

The Gallery displays works by students, faculty, and regionally- and nationally-known artists in all media.

Madison

Edgewood College - DeRicci Gallery

DeRicci Hall 1000 Edgewood College Drive., Madison, WI 53711-1997
Tel: (608) 663-2881
Fax: (608) 663-3291
Internet Address: http://www.edgewood.edu/news/gallery.htm
Gallery Director: Dr. Melanie Herzog

Edgewood College - DeRicci Gallery, cont.

Admission: free.
Attendance: 2,000 *Established:* 1986
Membership: N *ADA Compliant:* Y
Open: **Daily**, 8am-7pm.
 Holidays/Special Events,
 Call for hours.
Facilities: **Gallery.**
Activities: **Temporary Exhibitions.**

The DeRicci Gallery exhibits works in a full range of media by contemporary regional artists, college art faculty, and students.

View of DeRicci Gallery during student art show (1991). Photograph courtesy of DeRicci Gallery, Madison, Wisconsin.

Madison Art Center

211 State St., Madison, WI 53703
Tel: (608) 257-0158
Fax: (608) 257-5722
Internet Address:
 http://www.madisonartcenter.org
Director: Mr. Stephen Fleischman
Admission: voluntary contribution.
Established: 1901
Membership: Y *ADA Compliant:* Y
Parking: pay on site.
Open: Tuesday to Thursday, 11am-5pm;
 Friday, 11am-9pm;
 Saturday, 10am-9pm;
 Sunday, 1pm-5pm.
Closed: Legal Holidays.
Facilities: **Auditorium**; **Shop**; **Workshop.**
Activities: **Docent Program; Family Programs**; **Films/Videos**; **Guided Tours** (contact Education Department for availability/appointment); **Lectures.**

Ursula von Rydingsvard, *Krasavica*, 1992-93, cedar and graphite, 54" x 205¾" x 59", collection of the Madison Art Center, Madison Art Center Purchase Fund. Photograph by David Allison, courtesy of Madison Art Center, Madison, Wisconsin.

Publications: annual report; exhibition catalogues; newsletter (quarterly).

The Madison Art Center exhibits, collects, preserves, and interprets visual art with a focus on modern and contemporary art. It serves the community by creating opportunities for the direct experience of art, by providing a forum for the exchange of ideas about art, and by offering programs that enhance the appreciation and understanding of art. One of the city's oldest cultural organizations, it began as the Madison Art Association in 1901. The Art Center offers an average of ten exhibitions annually. The Museum has presented the work of modern masters such as Frank Lloyd Wright and Georgia O'Keeffe, as well as emerging artists such as Julia Fish and Martin Kersels. Exhibitions such as the Wisconsin Triennial, a survey of work in all media by artists from throughout the state, and Surreal Wisconsin (1998) reflect its commitment to artists of the region. Major exhibitions organized by the Art Center, including Jim Dine: Drawing from the Glyptothek (1993) and Claes Oldenburg: Printed Stuff (1997), have traveled to museums throughout the nation. The Art Center's permanent collection contains more than 4,500 works. With a solid core of American drawings and prints, the collection includes a wide variety of paintings, photographs, sculptures, and other works. Among the artists represented are Romare Bearden, Alexander Calder, John Steuart Curry, Paul Gauguin, Frida Kahlo, Jin Soo Kim, Henri Matisse, Louise Nevelson, Claes Oldenburg, Ed Paschke, and John Wilde. Much of the permanent collection can be viewed in the rotating exhibition, "Highlights from the Permanent Collection". Artworks from the collection are also used to create temporary exhibitions. Portions of the collection not on view masy be seen by appointment.

Madison, Wisconsin

University of Wisconsin-Madison - Elvehjem Museum of Art (LVM)

University of Wisconsin-Madison, 800 University Ave. (between Murray & Park Streets.)
Madison, WI 53706
Tel: (608) 263-2246
Fax: (608) 263-8188
Internet Address: http://www.lvm.wisc.edu
Director: Dr. Russell Panczenko
Admission: voluntary contribution.
Attendance: 70,824 *Established:* 1970
Membership: Y *ADA Compliant:* Y
Parking: university lots #46 and #47 and
nearby municipal ramps.
Open: Tuesday to Friday, 9am-5pm;
Saturday to Sunday, 11am-5pm.
Closed: New Year's Day, Thanksgiving Day,
Christmas Eve to Christmas Day.

Exterior view of Elvehjem Museum of Art. Photograph courtesy of Elvehjem Museum of Art, Madison, Wisconsin.

Facilities: **Architecture** (designed by Chicago architect Harry Weese); **Auditoriums** (4); **Classrooms**; **Exhibition Area** (11 galleries, 26,000 square feet); **Library** (120,000 volumes); **Print Center** (Mayer Print Center - by appointment (608) 263-4421); **Shop** (arts-related items, books, posters, jewelry).

Activities: **Concerts** (September-May, Sunday, 12:30pm, chamber music, free); **Docent Program**; **Education Program** (adults and undergraduate/graduate students); **Films**; **Guided Tours** (Thursday, 12:20pm, permanent collection; Sunday, 2pm, temp exhibits; group tours schedule in advance 263-4421); **Lectures**; **Temporary/Traveling Exhibitions**.

Publications: bulletin; calendar, "Artscene" (semi-annual); exhibition catalogues (occasional).

The Elvehjem (pronounced L-V-M) Museum of Art was founded in 1970 to conserve, study and exhibit the art collections of the University of Wisconsin-Madison. It serves as an active educational and cultural center for the campus and surrounding communities. Painting, sculpture and decorative arts ranging from Egyptian tomb sculpture to contemporary artwork are on view in the permanent collection galleries. The Museum also provides a schedule of temporary exhibitions to supplement the installations from the permanent collection. Catalogues and gallery notes are regularly published to accompany exhibitions. The Elvehjem also presents numerous educational programs for the public. These include lectures, tours, trips, films, a chamber music series on Sunday afternoons, and other performances. In 1991, the Elvehjem commissioned and installed in front of the museum "Generations", a large, outdoor sculpture and plaza designed by Richard Artschwager. The Kohler Art Library on the ground level houses over 100,000 volumes and maintains subscriptions to over 300 periodicals, which can be used by the public, although only staff, faculty, and university students may check out materials. The Mayer Print Center houses the Museum's 6,000 works of art on paper, including old master and contemporary prints, watercolors, Japanese prints and Indian miniature paintings. (The Center is available for research and study by appointment.) The Elvehjem has a permanent collection of over 15,500 works of art ranging from 2300 BC to the present. The primary focus is on the collection of western European and American paintings, sculpture, drawings, prints, and photographs, with examples by Eugène Boudin, Jean Baptiste Corot, Helen Frankenthaler, Hendrick Goltzius, Hans Hofmann, Henri Matisse, Louise Nevelson, Auguste Rodin, David Smith, Bernardo Strozzi, Rembrandt van Rijn, and Giorgio Vasari. Specialized collections offer in-depth studies of printmaking with a focus on Japanese prints (the Edward Burr Van Vleck collection), Russian and Soviet paintings (the Joseph E. Davies collection), 18th- and 19th-century British watercolors, 20th-century painting and sculpture, Indian sculpture and Indian miniature painting (the Earnest C. and Jane Werner Watson collection), ancient Greek vases and coins, European and Chinese export porcelain, European medals (the Vernon Hall collection), Lalique glass, and North American Indian baskets. Several hundred works of art are added each year by gift, bequest, or purchase.

University of Wisconsin-Madison - The Wisconsin Union Galleries

800 Langdon St., Madison, WI 53706

Tel: (608) 262-5969

Fax: (608) 262-5487

Internet Address: http://www.wisc.edu/union

Director: Mr. Ralph Russo

Admission: free.

Attendance: 85,000 *Established:* 1928 *Membership:* Y

Open: **Porter Butts Gallery & Class of 25 Gallery**, Daily, 10am-8pm.
 Theater Gallery, Daily, during Theater Wing building hours.

Closed: Christmas Eve to New Year's Day.

Facilities: **Food Services** Restaurant; **Reading Room**; **Theatre**.

Activities: **Arts Festival**; **Classes/Workshops**; **Concerts**; **Dance Recitals**; **Education Program** (adults, children, and students); **Films**; **Guided Tours**; **Lectures**; **Temporary/Traveling Exhibitions**.

The Wisconsin Union Galleries present exhibitions by a variety of artists as well as touring exhibitions. Exhibitions are sponsored and arranged by the Art Committee and usually changed monthly. The Porter Butts Gallery and the Class of 25 Gallery are located on the second floor; the Theater Gallery is on the first and second floors of the Theater Wing. More than 800 works of art by over 500 artists with Wisconsin roots make up the collection of the Wisconsin Union Galleries.

Marshfield

New Visions Gallery, Inc.

1000 N. Oak Ave., Marshfield Clinic, Marshfield, WI 54449

Tel: (715) 387-5562

C.E.O. and Director: Ms. Ann Waisbrot

Admission: voluntary contribution.

Attendance: 30,000 *Established:* 1975 *Membership:* Y *ADA Compliant:* Y

Parking: Marshfield Clinic lots.

Open: Monday to Friday, 9am-5:30pm; Saturday, 11am-3pm.

Closed: Legal Holidays.

Facilities: **Gallery** (1,500 square feet); **Shop**.

Activities: **Arts Festival** (annual Marshfield Art Fair on Mother's Day); **Classes/Workshops**; **Guided Tours** (by appointment); **Lectures**; **Temporary Exhibitions** (8-10/year).

Publications: brochures (monthly); exhibition catalogues (occasional); newsletter, "Canvas" (semi-annual).

Located in the lobby of the Marshfield Clinic, New Visions gallery presents a series of 4-6 week, changing exhibitions drawn from national traveling exhibitions, significant works on loan from private and public collections, high-quality regional art, and selections from the permanent collection. In late winter, Marshfield student art is exhibited. Each spring the Gallery organizes a national invitational exhibition of art on agricultural themes. On Mother's Day New Visions sponsors the Marshfield Art Fair, a juried fine art festival held in the Marshfield High School Fieldhouse. The permanent collection includes contemporary prints, Japanese prints, fine art posters, Haitian paintings, Australian Aboriginal art and West African sculpture and masks.

Menomonie

University of Wisconsin-Stout - John Furlong Gallery

Micheels Hall (3rd St. East, between 10th and 13th Aves.), Menomonie, WI 54751-0790

Tel: (715) 232-2261 *Fax:* (715) 232-1346

Internet Address: http://www.uwstout.edu

Admission: voluntary contribution.

Established: 1965 *ADA Compliant:* Y

University of Wisconsin-Stout - John Furlong Gallery, cont.

Open: Monday, 10am-4:30pm; Tuesday to Thursday, 10am-4:30pm & 6pm-9pm;
Friday, 10am-4:30pm; Saturday, noon-3pm.

Closed: Legal Holidays.

Facilities: **Gallery.**

Activities: **Temporary/Traveling Exhibitions.**

The John Furlong Gallery and a student gallery, along with other exhibit spaces on campus, provide student, faculty, and outside exhibitions throughout the school year. Also of possible interest on campus is the Brich Gallery, located in the Memorial Student Center.

Mequon

Concordia University-Wisconsin - Art Gallery

12800 N. Lake Shore Drive, Mequon, WI 53097

Tel: (262) 243-4242

Fax: (262) 243-4351

Internet Address: http://www.cuw.edu

Director: Professor Jeffrey Shawhan

Admission: free.

Attendance: 600 *Membership:* N *ADA Compliant:* Y

Parking: parking lots throughout campus.

Open: **September to May 15**,
Tuesday to Wednesday, noon-4pm; Thursday, noon-4pm & 5pm-7pm; Friday, noon-4pm;
Sunday, noon-4pm.

Closed: Legal Holidays.

Facilities: **Exhibition Area.**

Activities: **Education Program** (undergraduate and graduate students); **Lectures**; **Temporary/Traveling Exhibitions** (7-8/year).

The Concordia University Gallery hosts 7-8 temporary exhibits per year, mostly featuring regional artists. The permanent collection includes a number of Russian bronzes, the Great Human Race series by John Doyle, and a large collection of Seidel porcelain.

Milwaukee

Charles Allis Art Museum

1801 N. Prospect Ave., Milwaukee, WI 53202

Tel: (414) 278-8295

Fax: (414) 278-0335

Exec. Director: Ms. Susan Modder

Admission: fee: adult-$2.00, child-free.

Attendance: 28,000 *Established:* 1947

Membership: Y *ADA Compliant:* Y

Open: Wednesday to Sunday, 1pm-5pm.

Closed: Legal Holidays.

Facilities: **Architecture** Mansion (1909 design by Alexander Eschweiler, on National Register); **Auditorium**; **Classrooms**; **Terraced Gardens.**

Activities: **Arts Festival**; **Concerts**; **Films**; **Guided Tours**; **Lectures**; **Temporary/ Traveling Exhibitions.**

View of the French Parlor in Charles Allis Art Museum. Photograph by Jon, courtesy of Charles Allis Art Museum, Milwaukee, Wisconsin.

Publications: calendar (monthly); exhibition catalogues.

The Charles Allis Art Museum is housed in a Tudor-style mansion designed by Alexander Eschweiler and completed in 1911, having been the residence of Charles Allis, founder of the Allis Chalmers Company. Spanning 2,000 years, the collection includes Chinese, Japanese, Korean,

Charles Allis Art Museum, cont.

Persian, Greek, and Roman art objects; fine French, English, and American period furniture; Renaissance bronzes; and landscapes by major 19th- and 20th-century French and American painters, including Corot, Daubigny, Meissonier, Rousseau, Troyon, Inness, Blakelock, Wyant, Martin, Murphy, and the Morans, Thomas and Edward.

Marquette University - The Patrick and Beatrice Haggerty Museum of Art

Marquette University, 13th and Cylbourn Sts., Milwaukee, WI 53233-1881

Tel: (414) 288-1669

Fax: (414) 288-5415

Internet Address: http://www.mu.edu/haggerty

Director: Dr. Curtis L. Carter

Admission: free.

Attendance: 43,500 *Established:* 1955

Membership: Y *ADA Compliant:* Y

Parking: free at Lot J, 11th & Wisconsin Ave..

Open: Monday to Wednesday, 10am-4:30pm;
Thursday, 10am-8pm;
Friday to Saturday, 10am-4:30pm;
Sunday, noon-5pm.

Closed: New Year's Day, Easter,
Thanksgiving Day, Christmas Day.

Exterior view of Patrick and Beatrice Haggerty Museum of Art. Photograph courtesy of Patrick and Beatrice Haggerty Museum of Art, Marquette University, Milwaukee, Wisconsin.

Facilities: **Architecture** (designed by O'Neil Ford and David Kahler); **Library**; **Museum Store**; **Sculpture Garden**.

Activities: **Concerts**; **Docent Program**; **Education Program** (adults and students); **Films**; **Guided Tours** (schedule in advance, free); **Lectures**; **Temporary/Traveling Exhibitions**.

Publications: exhibition catalogues.

Located in a striking building on the campus of Marquette University, the Haggerty Museum's educational program incorporates special exhibitions, visiting scholars, and visiting artists in various media. In addition to the pictorial arts, the museum presents programs that include dance, music, poetry, performance art, film, and video. The permanent collection of over 6,000 objects contains a substantial body of works not typical of other museums in the region. Included are works by Chagall, Dali, Dürer, Wilhelm Lehmbruck, Miró, Picasso, Rouault, Trevisani, and an important collection of Barbara Morgan photographs. The collection is still growing, the most recent acquisitions being Louis Valtat's " Au Cabaret", and Albrecht Dürer's "The Presentation of the Temple".

Milwaukee Art Museum (MAM)

At the War Memorial Center, 750 North Lincoln Memorial Drive, Milwaukee, WI 53202

Tel: (414) 224-3200

Fax: (414) 271-7588

TDDY: (414) 271-6678

Internet Address: http://www.mam.org

Director: Mr. Russell Bowman

Admission: fee:
adult-$5.00, child-free, student-$3.00, senior-$3.00.

Attendance: 367,551 *Established:* 1888

Membership: Y *ADA Compliant:* Y

Parking: pay lot south of museum.

Open: Tuesday to Wednesday, 10am-5pm;
Thursday, noon-9pm;
Friday to Saturday, 10am-5pm;
Sunday, noon-5pm.

Closed: New Year's Day, Thanksgiving Day,
Christmas Day.

Jean Honoré Fragonard, *A Shepherdess*, c. 1750-52. Bequest of Leon and Marion Kraumheimer, Milwaukee Art Museum. Photograph courtesy of Milwaukee Art Museum, Milwaukee, Wisconsin.

Milwaukee Art Museum, cont.

Facilities: Architecture (1957 design by Eero Saarinen, 1975 addition by David Kahler, 2001 addition by Santiago Calatrava); **Food Services** Art of Coffee; **Learning Center** (children); **Library** (15,000 volumes); **Sculpture Garden**; **Shop**.

Activities: Arts Festival; Docent Program; Education Program (adults and children); **Guided Tours; Lectures; Temporary/Traveling Exhibitions**.

Publications: annual report; exhibition catalogues.

The Milwaukee Art Museum had its origin in two institutions, the Layton Art Gallery established in 1888 and the Milwaukee Art institute, founded in the early 1900s. These two institutions joined in 1957 to form the private, non-profit Milwaukee Art Center (now the Milwaukee Art Museum), and moved to its current location. The museum offers changing exhibitions, tours, classes for children and adults, special events, and the Art Museum Store. The collection comprises more than 20,000 works of art including 15th- to 20th-century European and American painting, sculpture, prints, drawings, photography, and decorative arts. The collection is especially strong in contemporary European works and American works such as abstract expressionism, pop, new realism, minimalism and neo-expressionism. Highlights include the Bradley Collection of early modern masters, the Flagg collection of Haitian art, the Frank Lloyd Wright Prairie School Collection, the Michael and Julie Hall Collection of American Folk Art, and the Landfall Press Archives. Among the painters represented are Edgar Degas, Winslow Homer, Joan Miró, Claude Monet, Georgia O'Keeffe, Pablo Picasso, Auguste Rodin, Mark Rothko, Henri de Toulouse-Lautrec, Andy Warhol, Francisco de Zurbarán, and the School of the Eight. A major expansion designed by Spanish architect Santiago Calatrava is scheduled to open in 2001. The Museum also maintains a satellite branch in Brookfield, Wisconsin (see separate listing).

Milwaukee Institute of Art and Design - Galleries (MIAD)

273 E. Erie St., Milwaukee, WI 53202
Tel: (414) 276-7889
Fax: (414) 291-8077
Internet Address: http://www.miad.edu
Director of Galleries: Mr. Mark Lawson
Admission: free.
Attendance: 10,000 **Established:** 1974
Membership: N **ADA Compliant:** Y
Parking: metered on street.
Open: Tuesday to Saturday, 10am-5pm.
Facilities: Exhibition Area.
Activities: Temporary Exhibitions.
Publications: brochures (biennial).

MIAD's Frederick Layton Gallery features changing exhibitions of traditional and contemporary fine art by artists of regional and national reputation, including MIAD faculty, alumni, and students. The Brooks Stevens Gallery features year-long exhibitions of work by nationally- and internationally-known industrial designers.

View of Frederick Layton Gallery during 1999 Student Exhibition. Photograph courtesy of Milwaukee Institute of Art and Design, Milwaukee, Wisconsin.

University of Wisconsin-Milwaukee - Institute of Visual Arts (Inova)

3253 N. Downer Ave., Milwaukee, WI 53211
Tel: (414) 229-5070
Fax: (414) 229-6785
Internet Address: http://www.uwm.edu:80/Dept/inova
Director: Mr. Peter Doroshenko
Admission: free.
Attendance: 18,000 **Established:** 1982 **ADA Compliant:** Y
Parking: metered on street.

University of Wisconsin-Milwaukee - Institute of Visual Arts, cont.

Open: **Gallery One & Video to Video Gallery**, Wednesday to Sunday, noon-5pm.

Galleries Two & Three, Tuesday to Saturday, noon-5pm.

Closed: Legal Holidays.

Facilities: **Print Study Room.**

Activities: **Lectures.**

Publications: calendar; exhibition catalogues; newsletter.

Opened in September 1982 as the UWM Art Museum, the museum and its associated galleries (Art History and Fine Arts Gallery) have been combined under the umbrella of the new Institute of Visual Arts (Inova). Inova focuses on one-person exhibitions of local, national, and international contemporary artists complemented by lectures and gallery talks. The institute also features a monthly video program, screenings of films by artists, adjunct curators, and guest critics. In addition, the gallery spaces have been reorganized. "Gallery One" is the main Inova building (formerly the UWM Art Museum) in Vogel Hall, 3253 N. Downer Ave. "Gallery Two" (formerly the Art History Gallery) has newly renovated space in Mitchell Hall, 3203 N. Downer Ave. "Gallery Three" consists of two distinct areas in the Fine Arts Center, 2400 E. Kenwood Blvd. One space features rotating exhibitions of work by various artists; the other, work by UWM fine arts undergraduate students. "Gallery Four" describes all site-specific, non-traditional projects throughout the campus and city. "Gallery Video" is located in various places in Vogel Hall.

University of Wisconsin-Milwaukee - Union Art Gallery

2200 E. Kenwood Blvd., Milwaukee, WI 53201

Tel: (414) 229-6310

Fax: (414) 229-6709

Internet Address: http://www.aux.uwm.edu/union/artcraft.htm

Director: Ms. Patricia Kozik

Admission: free.

Attendance: 13,000 *Established:* 1972 *ADA Compliant:* Y

Open: Monday, noon-3pm; Tuesday, 11am-3pm; Wednesday, noon-3pm; Thursday, 11am-7pm; Friday to Saturday, noon-3pm.

Closed: Academic Holidays, Legal Holidays.

Facilities: **Exhibition Area.**

Activities: **Classes/Workshops**); **Dance Recitals**; **Films**; **Temporary/Traveling Exhibitions.**

Publications: newsletter (monthly).

The Union Gallery hosts art exhibitions and special events throughout the year. The Gallery also features a sales area, Artworks, for the sale of original art and crafts. The art exhibitions and special events are usually complemented by public receptions.

Neenah

Bergstrom-Mahler Museum

165 N. Park Ave., Neenah, WI 54956

Tel: (920) 751-4658

TDDY: (920) 751-4658

Director: Mr. Alex D. Vance

Admission: free.

Attendance: 21,000 *Established:* 1954

Membership: Y *ADA Compliant:* Y

Parking: free on site.

Open: Tuesday to Wednesday, 10am-4:30pm;
Thursday, 10am-8pm;
Friday, 10am-4:30pm;
Saturday to Sunday, 1pm-4:30pm.

Ranftbecher (detail), painted with enamel. Mahler Collection of Germanic Glass, Bergstrom-Mahler Museum. Photograph courtesy of Bergstrom-Mahler Museum, Neenah, Wisconsin.

Bergstrom-Mahler Museum, cont.

Closed: Legal Holidays.

Facilities: **Exhibition Area**; **Shop** (glass menagerie); **Study Room** (by appointment).

Activities: **Arts Festival**; **Education Programs** (adults and children); **Films**; **Gallery Talks**; **Guided Tours** (groups 10+, reserve in advance); **Lectures**; **Temporary Exhibitions**; **Traveling Exhibitions**.

Publications: annual report; brochure; collection catalogue, "The Mahler Collection of Germanic Glass"; exhibition catalogues; newsletter (quarterly).

With over 2,100 objects, the Museum's collections focus on antique paperweights and related glass objects. In addition to exhibiting objects from its collections, the Museum hosts guest exhibitions, which feature a wide variety of art forms including contemporary glass, painting, photography, sculpture, and textiles. The Glass Paperweight Collection, consisting of more than 1,900 objects, is the most comprehensive collection of its kind. Pieces in the Germanic Glass Collection are representative of Northern European glassmaking skills from the 16th- to the 19th-century.

Oshkosh

The Paine Art Center and Arboretum

1410 Algoma Blvd.
(intersection of Hwys. 21 and 110)
Oshkosh, WI 54901-7708
Tel: (920) 235-6903
Fax: (920) 235-6303
Internet Address: http://focol.org/~paineart
Exec. Director: Ms. Barbara Hirschfield
Admission: fee:
 adult-$5.00, student-$2.00, senior-$2.50.
Attendance: 36,000 *Established:* 1947
Membership: Y *ADA Compliant:* Y
Parking: on street.
Open: **Labor Day to Memorial Day**,
 Tuesday to Friday, 11am-4pm;
 Saturday to Sunday, 11am-4pm.

 Memorial Day to Labor Day,
 Tuesday to Thursday, 11am-4pm;
 Friday, 11am-7pm;
 Saturday to Sunday, 11am-4pm.

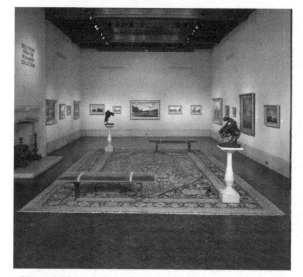

View of Main Gallery, Paine Art Center and Arboretum. Photograph courtesy of Paine Art Center and Arboretum, Oshkosh, Wisconsin.

Closed: Legal Holidays.

Facilities: **Architecture** (Tudor Revival house, 1920 design by Bryant Fleming); **Classrooms/Studios**; **Grounds** Arboretum and Gardens (rose garden, formal English garden); **Library** (5,000 volumes, art and horticultural research); **Museum Store**; **Reading Room**; **Sales Gallery**; **Sculpture Garden**.

Activities: **Concerts**; **Docent Program**; **Education Program** (adults and children); **Films**; **Guided Tours** (reserve two weeks in advance); **Lectures**; **Temporary/Traveling Exhibitions**.

Publications: annual report; exhibition catalogues; newsletter (quarterly).

Originally designed as a residence for Oshkosh lumber baron, Nathan Paine, but never occupied, the building and its contents were donated as an Art Center. In the Main Gallery on the first floor, the Museum exhibits works from its permanent collection, as well as frequently changing temporary exhibitions. Three other galleries, displaying specialized collections, are located on the upper and lower levels. Among the highlights of the permanent collection are works by the French Barbizon masters, including Corot and Rousseau; American paintings by Ralph Blakelock, Maurice Braun, John Costigan, James McDougal Hart, Winslow Homer, George Inness and Grant Wood; etchings by Whistler and Dürer; and sculpture by Frederic Remington.

University of Wisconsin-Oshkosh - Galleries

Priebe Gallery: 800 Algoma Blvd.

Reeve Memorial Union Art Gallery: 748 Algoma

Oshkosh, WI 54901

Tel: (414) 424-2235

Internet Address: http://www.uwosh.edu

Director: Mr. Jeff Lipschutz

Open: **Priebe Gallery**, Monday to Thursday, 10:30am-3pm and 7pm-9pm; Friday, 10:30am-3pm; Saturday to Sunday, 1pm-4pm.

Reeve Memorial Union, Daily, during building hours.

Facilities: Galleries (2).

Activities: Temporary Exhibitions.

Exhibitions are regularly scheduled in the Allen Priebe Art Gallery. There is also an annex gallery in which student work is displayed. The Reeve Memorial Union Art Gallery, located on the second floor, seeks to integrate art into the daily lives of students through exhibits, and educational and enrichment activities. Exhibits consist primarily of work by locally and regionally recognized professional artists, as well as works by students, faculty and staff. The Union also houses a collection of modern art, which are on view in public areas throughout the building. Holdings include works by Denny Dent, Robert Indiana, LeRoy Neiman, George Segal, Ernst Trova, and Victor Vassarely.

Platteville

University of Wisconsin-Platteville - Harry and Laura Nohr Gallery

Ullsvik Center, One University Plaza, Platteville, WI 53818

Tel: (608) 342-1398

Fax: (608) 342-1478

Internet Address: http://www.uwplatt.edu

Admission: free.

Attendance: 6,000

Parking: parking lot across street.

Open: Monday to Thursday, 11am-7pm; Friday, 11am-3pm; Saturday to Sunday, noon-3pm.

Facilities: Exhibition Area (4,500 square feet of gallery with 1,200 square feet classroom).

Activities: Temporary Exhibitions.

The Gallery presents temporary exhibitions of the work of professional artists and university faculty, staff, and students.

Racine

Charles A. Wustum Museum of Fine Arts

2519 Northwestern Ave., Racine, WI 53404

Tel: (262) 636-9177

Fax: (262) 636-9231

C.E.O. and Director: Mr. Bruce W. Pepich

Admission: free.

Attendance: 39,417 *Established:* 1941

Membership: Y *ADA Compliant:* Y

Parking: free on site.

Open: Monday, 11am-9pm;
Tuesday to Wednesday, 11am-5pm;
Thursday, 11am-9pm;
Friday to Saturday, 11am-5pm;
Sunday, 1pm-5pm.

Closed: Legal Holidays, Exhibit Installation.

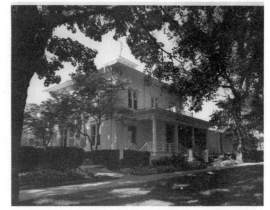

Exterior view of Charles A. Wustum Museum of Fine Arts. Photograph courtesy of Wustum Museum Art Association, Inc., Racine, Wisconsin.

Facilities: **Architecture** (Italianate-style farmhouse, 1856); **Classrooms/Workshops/Studios**; **Grounds** park and Formal Garden (formal garden designed by landscape architect Alfred Boerner); **Library** (4,000 volumes); **Museum Store**; **Sculpture Garden**.

Racine, Wisconsin
Charles A. Wustum Museum of Fine Arts, cont.
Activities: **Arts Festival**; **Education Program** (adults and children, studio art classes); **Guided Tours** (groups of 6+, reserve in advance, free); **Lectures**; **Rental Gallery**; **Temporary/Traveling Exhibitions**.

Publications: education schedule, "Art Agenda" (quarterly); exhibition brochures; exhibition catalogues; newsletter, "Vue" (bi-monthly).

The nucleus of the museum is the former residence of the Wustums, an 1856 Italianate-style farmhouse, and the complex includes thirteen acres of park, a one-acre formal garden, and a 1966 classroom/studio addition. Wustum is known for its support of active, living, regional artists and for its focus on and regular displays of artworks on paper and contemporary crafts. These exhibitions include solo shows of both emerging artists and those with national reputations; group juried competitions, such as the annual Watercolor Wisconsin show, inaugurated in 1966; and invitational thematic exhibitions in which all pieces are created by the artists to deal with a specific theme or topic determined by the Wustum. The Museum currently maintains a 3,000 piece permanent collection. While these works are too numerous to exhibit in their entirety, pertinent pieces are selected by staff to accompany changing exhibitions throughout the year. In this way the public can review objects from the collection in the context of the regular temporary exhibits. The collection is also available for study and research by collectors and scholars, and individual works are loaned to reputable galleries and museums nationwide for inclusion in retrospectives of prominent artists. Unlike most medium-sized museums, Wustum did not begin its public life as a showplace for the art collection amassed by the original donors of the facility. In 1943 the museum became the recipient of long-term loans and gifts of nearly 300 artworks created under the Works Progress Administration's Federal Art Project, creating one of the largest public groupings of WPA-era art in the Midwest. Since the 1940s the museum has actively added to its collection. Concentrating on 20th-century American artists, the collection has particular strengths in watercolors, photographs, and graphics by artists with national reputations. In 1990 the Museum established a crafts specialization within its general fine arts program. This crafts collection now numbers over 1,300 works, and the collection's present focus includes ceramics, fibers, glass, metals, and artists' books. The result is an exhibit and study collection of contemporary crafts from the late 1960s through today that is of regional importance.

River Falls
University of Wisconsin-River Falls - Gallery 101
Kleinpell Fine Arts Building, Cascade Ave., River Falls, WI 54022
Tel: (715) 425-3266
Fax: (715) 425-0657
Internet Address: http://www.uwrf.edu
Art Department Chairman: Mr. Michael Padgett
Admission: free.
Established: 1973 *ADA Compliant:* Y
Open: **September to May**, Monday to Friday, 9am-5pm & 7pm-9pm; Sunday, 2pm-4pm.
Facilities: **Exhibition Area**.
Activities: **Arts Festival** (annual student and faculty outdoor art exhibition); **Temporary Exhibitions**.

The Gallery maintains a collection of WPA graphics, contemporary prints, and regional art.

Sheboygan
John Michael Kohler Arts Center (JMKAC)
608 New York Ave. (between 6th and 7th Streets), Sheboygan, WI 53081
Tel: (920) 458-6144
Fax: (920) 458-4473
Director: Ms. Ruth DeYoung Kohler
Admission: free.
Attendance: 150,000 *Established:* 1967 *Membership:* Y *ADA Compliant:* Y
Parking: free on site.

John Michael Kohler Arts Center, cont.

Open: Monday/Wednesday/Friday, 10am-5pm;
Tuesday/Thursday, 10am-8pm;
Saturday to Sunday, 10am-4pm.

Closed: New Year's Eve, New Year's Day, Easter,
Memorial Day, Thanksgiving Day,
Christmas Eve, Christmas Day.

Facilities: Architecture (villa, 1860's and contemporary); **Classrooms/Studios; Food Services,**
Café; **Galleries** (11); **Library; Multi-Arts Space;
Shops** (2); **Sculpture Garden; Studios** (visual
and performing arts); **Theatre.**

**Activities: Arts Festival; Classes/Workshops;
Docent Program; Education Program** (adults
and children); **Guided Tours** (reserve two weeks
in advance); **Lectures; Performances;
Temporary/Traveling Exhibitions.**

J.M. Kohler Arts Center Expansion Plans. Watercolor by
Tom Kubala, Photograph courtesy of J.M. Kohler Arts
Center, Sheboygan, Wisconsin.

Publications: annual report; exhibition catalogues; newsletter (bi-monthly).

John Michael Kohler Arts Center (JMKAC) presents contemporary American art with emphasis on craft-related forms, folk traditions, new genres, and the work of self-taught artists. JMKAC offers a regular schedule of changing exhibitions in eleven galleries. One gallery presents works from JMKAC's Arts/Industry program, which brings artists to work in studios in the Kohler Co. factory, and another is an interactive gallery especially for children. Of special note are six rest rooms that are commissioned works of art. JMKAC's permanent holdings include collections of the work of self-taught artists, over 100 major sculptures and murals created by Arts/Industry artists, and Hmong textiles. JMKAC also offers five performing arts series, including a series that presents internationally recognized artists, another that presents regional artists, and summer theatre.

Lakeland College - Bradley Gallery of Art

Lakeland College, Sheboygan, WI 53082

Tel: (920) 565-1280

Internet Address: http://www.lakeland.edu

Co-Director: Ms. Denise Presnell-Weidner

Admission: free.

Established: 1988 **ADA Compliant:** Y

Open: September to May, Monday to Friday, 1pm-5pm.

Closed: Easter Week, Thanksgiving Day, Christmas Day.

Facilities: Exhibition Area.

Activities: Lectures; Temporary Exhibitions (5/year).

The Gallery presents temporary exhibitions of work by faculty, students, and non-resident artists.

Stevens Point

University of Wisconsin-Stevens Point - Edna Carlsten Gallery

College of Fine Arts Building., 2nd Floor, 900 Reserve Street, Stevens Point, WI 54481

Tel: (715) 346-4797

Internet Address: http://www.uwsp.edu

Director: Ms. Suzanne Woods

Admission: free.

Open: Monday to Friday, 10am-4pm; Saturday to Sunday, 1pm-4pm.

Facilities: Exhibition Area.

Activities: Temporary Exhibitions (10/year).

The Gallery presents a schedule of temporary exhibitions.

Sturgeon Bay

Miller Art Museum

107 South 4th Ave., Sturgeon Bay, WI 54235

Tel: (920) 746-0707

Fax: (920) 746-0865

Director: Ms. Bonnie Hartmann

Admission: voluntary contribution.

Attendance: 17,000 *Established:* 1975 *Membership:* Y *ADA Compliant:* Y

Parking: adjacent city and county lots.

Open: Monday to Thursday, 10am-5pm & 7pm-9pm; Friday to Saturday, 10am-5pm.

Facilities: **Classrooms**; **Exhibition Area**; **Shop**.

Activities: **Classes/Workshops**; **Docent Program**; **Guided Tours** (reserve in advance); **Lectures**; **Performing Arts Programs**; **Temporary/Traveling Exhibitions**.

Publications: exhibition catalogues.

The Museum features seven changing exhibits on its main floor each year, and the mezzanine galley displays works from the permanent collection on a rotating basis. Throughout the year the Museum also provides programming in the performing arts, music, and art appreciation. The permanent collection of over 350 works is primarily devoted to paintings, drawing, and graphics by 20th-century Wisconsin artists.

Wausau

Leigh Yawkey Woodson Art Museum

Franklin and 12th Street

Wausau, WI 54403-5007

Tel: (715) 845-7010

Fax: (715) 845-7103

Internet Address: http://www.lywam.org

Director: Kathy Kelsey Foley

Admission: free.

Attendance: 50,479 *Established:* 1973

Membership: Y *ADA Compliant:* Y

Parking: free on site.

Open: Tuesday to Friday, 9am-4pm;
 Saturday to Sunday, noon-5pm.

Closed: Legal Holidays.

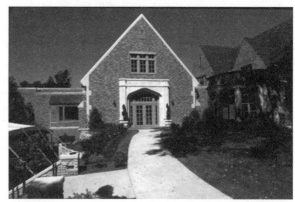

View of main entrance. Leigh Yawkey Woodson Art Museum. Photograph courtesy of Leigh Yawkey Woodson Art Museum, Wausau, Wisconsin.

Facilities: **Galleries/Museum** (35,000 square feet); **Library** (2,000 volumes, by appointment only); **Sculpture Garden** (1½ acres).

Activities: **Concerts**; **Demonstrations**; **Docent Program**; **Films**; **Guided Tours** (10-50 people, reserve 3 weeks in advance, $1/person); **Lectures**; **Temporary Exhibitions** (8-10/year); **Traveling Exhibitions**; **Workshops**.

Publications: "Birds in Art" (annual); exhibition catalogues.

Located in a residential area on Wausau's east side, the Leigh Yawkey Woodson Art Museum has been enhanced over the years with a welcome center, gallery additions, and an outdoor sculpture garden, making it a vibrant showcase that invites the visitor to discover and enjoy art. Portions of the permanent collection are on view throughout the year. Large-scale works like Deborah Butterfield's *Kua* from the permanent collection, as well as thematic works from annual changing exhibitions, are displayed in the Margaret Woodson Fisher Sculpture Gallery, a landscaped 1.5-acre garden. Additionally, each year the Woodson presents temporary exhibitions in its galleries. Works by nationally and internationally recognized artists span a wide range of historical and contemporary themes. Its best-known exhibition, *Birds in Art*, is presented each fall with a new roster of artists annually. The Woodson's permanent collection includes paintings, drawings, prints, photographs, sculpture, and decorative art objects. The Museum specializes in depictions of birds and avian-related subject matter.

West Bend

West Bend Art Museum

300 South 6th Ave., West Bend, WI 53095
Tel: (262) 334-9638
Fax: (262) 334-8080
Internet Address: http://www.wbartmuseum.com
Exec. Director: Mr. Thomas D. Lidtke
Admission: free.
Attendance: 15,000 *Established:* 1961
Membership: Y *ADA Compliant:* Y
Parking: free on site.
Open: Wednesday to Saturday, 10am-4:30pm;
 Sunday, 1pm-4:30pm.
Closed: Legal Holidays.

Robert Von Newmann, *Boat Scene*, oil on board. West Bend Art Museum Collection. Photograph courtesy of West Bend Art Museum, West Bend, Wisconsin.

Facilities: **Classrooms**; **Galleries**; **Early Wisconsin Art Archives** (3,500 artists).
Activities: **Classes/Workshops**; **Concerts**; **Education Program** (adults and children); **Films**; **Guided Tours**; **Lectures**; **Temporary/Traveling Exhibitions**.
Publications: newsletter (monthly).

The museum exhibits an extensive late-19th century and early 20th-century collection of paintings and drawings, with the work of German-American artist Carl von Marr being featured in two galleries. The Exhibition Selection Committee strives to develop an annual schedule of 10-14 exhibitions that is both challenging and diverse. From classical fine arts to animation art, and from Renaissance to contemporary art, the schedule reflects the varied genres that makes up the world of visual arts. A broad spectrum of events complements the exhibitions and collections throughout the year. The staff curates local and regional exhibitions. National touring exhibitions are borrowed from such institutions as the National Gallery of Art, Washington, D.C. The Museum's permanent collection focuses on Carl von Marr (1858-1936) with over 300 of his works. In 1988, the Museum began to broaden its holdings by developing a secondary collection of art work by Wisconsin's earliest Euro-American residents. Selections from the Wisconsin Art History Collection include portraits, still lifes, artifacts, sculptures, landscapes, and images of historic villages by leading Wisconsin artists of the mid-19th- to mid-20th-centuries.

Whitewater

University of Wisconsin-Whitewater - Crossman Gallery

Center for the Arts, 800 W. Main St., Whitewater, WI 53190
Tel: (262) 472-5708
Internet Address: http://www.uww.edu
Director: Mr. Michael Flanagan
Admission: free.
Attendance: 9,000 *Established:* 1970 *Membership:* Y
Open: **Academic Year**, Monday to Wednesday, 10am-5pm and 6pm-8pm;
 Thursday to Friday, 10am-5pm; Saturday, 1pm-4pm.
 Summer, Call for hours.
Closed: Academic Holidays.
Facilities: **Auditorium** (1,300 seats); **Gallery** (2,400 square feet); **Studios**; **Theatres** (2; 425 seats and 160 seats).
Activities: **Temporary/Traveling Exhibitions**.

The Gallery features changing exhibits of contemporary and historic works of art. The curatorial focus in on thematic offerings which present to the campus and the region examples of thought-provoking creative work. The gallery also serves as a teaching laboratory for faculty and students. The permanent collection features 20th-century American folk art.

Wyoming

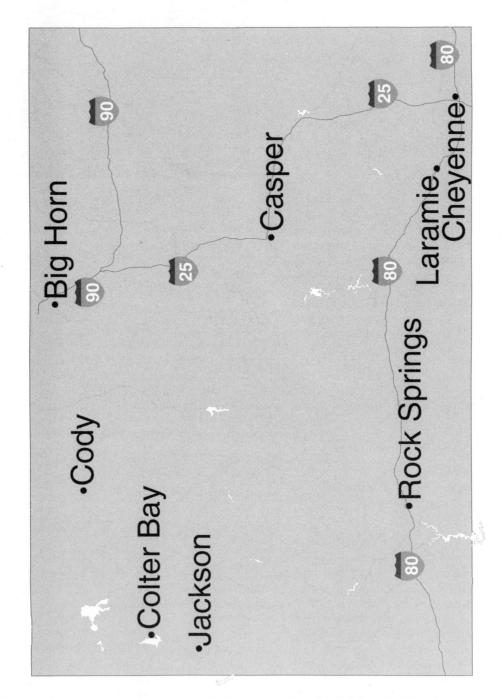

The number in parentheses following the city name indicates the
number of museums/galleries in that municipality. If there is no num-
ber, one is understood. For example, in the text one listing would be
found under each Wyoming city shown on the map.

Wyoming

Big Horn

Bradford Brinton Memorial Museum

239 Brinton Road, Big Horn, WY 82833
Tel: (307) 672-3173
Fax: (307) 672-3258
Director and Chief Curator: Mr. Kenneth L. Schuster
Admission: fee: adult-$3.00, student-$2.00, senior-$2.00.
Attendance: 14,000 *Established:* 1961
Membership: Y
Open: **May 15 to Labor Day**, Daily, 9:30am-5pm.
 September to May, by appointment.
Facilities: **Architecture** (ranch house, 1892); **Gallery**; **Shop**.
Activities: **Lectures**.
Publications: exhibit catalogue (annual).

Charles M. Russell, *The Cowboy and The Lady Artist*. Bradford Brinton Memorial Museum. Photograph courtesy of Bradford Brinton Memorial Museum, Big Horn, Wyoming.

The Quarter Circle A Ranch, originally built in 1892 and enlarged by Bradford Brinton after his purchase in 1923, was established as a memorial to Western art and culture in 1961. It now houses his collection of over 600 oils, watercolors, and sketches by American artists, including John J. Audubon, Frank W. Benson, Edward M. Borein, Joe De Yong, E.W. Gollings, Will James, Frank Tenney Johnson, Hans Kleiber, Winold Reiss, Frederic Remington, and Charles M. Russell. In addition to the works displayed in the house, an annual art exhibit is featured in the reception gallery.

Casper

Nicolaysen Art Museum (NIC)

400 E. Collins Drive, Casper, WY 82601-2815
Tel: (307) 235-5247
Fax: (307) 235-0923
Internet Address: http://www.thenic.org
Director: Mr. Alex Efimoff
Admission: fee: adult-$2.00, child-$1.00.
Attendance: 34,000 *Established:* 1936
Membership: Y *ADA Compliant:* Y
Parking: free on site.
Open: Tuesday to Wednesday, 10am-5pm;
 Thursday, 10am-8pm;
 Friday to Sunday, 10-am-5pm.
Closed: New Year's Day, Thanksgiving Day,
 Christmas Eve to Christmas Day.
Facilities: **Discovery Center**; **Gallery**;
 Museum Store.
Activities: **Art Auction** (annual); **Concerts**;
 Education Program; **Films**; **Gallery
 Talks**; **Juried Exhibits** (Wyoming artists
 and Casper artists); **Lectures**; **Temporary
 Exhibitions**.

Conrad Schwiering, *High Mountain Meadows*, 1973, oil on board. Gift of the Jack Rosenthal Family, 1990, Nicolaysen Art Museum. Photograph courtesy of Nicolaysen Art Museum, Casper, Wyoming.

The NIC is a regional museum that emphasizes on education, acquisitions, self discovery, and exhibitions. The Museum presents temporary exhibitions including one-person, juried, and thematic shows. An area adjacent to the gallery is used to exhibit works of local artists on a regular basis. The Museum's diverse permanent collection is occasionally exhibited.

Cheyenne

Wyoming Arts Council Gallery

2320 Capitol Ave., Cheyenne, WY 82002
Tel: (307) 777-7742
Fax: (307) 777-5499
TDDY: (307) 777-5964
Internet Address: http://commerce/state/us/wy/cr/arts
Gallery Curator: Liliane Francuz
Admission: voluntary contribution.
Attendance: 4,500 *Established:* 1990 *ADA Compliant:* Y
Parking: includes wheelchair parking.
Open: Monday to Friday, 8am-5pm.
Closed: Legal Holidays.
Facilities: **Architecture** (Kendrick House); **Gallery**.
Activities: **Lectures**; **Temporary/Traveling Exhibitions**.
Publications: newsletter, "All Arts Newsletter".

Located in the Capitol Complex area of the Capitol building and the State Museum, the WAC Gallery features up to five varied exhibitions each year, from Native American crafts to contemporary work in painting, drawing, sculpture, installation, and mixed media. Exhibitions focus exclusively on artists living and working in Wyoming. The Council has no permanent collection.

Cody

Buffalo Bill Historical Center - Whitney Gallery of Western Art

720 Sheridan Ave., Cody, WY 82414
Tel: (307) 587-4771
Fax: (307) 587-5714
Internet Address: http://www.bbhc.org
Exec. Director: Mr. B. Byron Price
Admission: fee: adult-$10.00, youth-$4.00, student-$6.00.
Attendance: 250,000 *Established:* 1959 *Membership:* Y *ADA Compliant:* Y
Parking: free on site.
Open: **November to March**, Thursday to Monday, 10am-3pm.
 April, Daily, 10am-5pm.
 May, Daily, 8am-8pm.
 June to September 19, Daily, 7am-8pm.
 September 20 to October, Daily, 8am-5pm.
Facilities: **Food Services** Restaurant; **Library** (20,000 volumes, western Americana); **Museum Store**.
Publications: annual report; exhibition catalogues; newsletter, "Points West" (quarterly).

One of four museums comprising the Buffalo Bill Historical Center, the Whitney Gallery of Western Art presents the creative accomplishments of artists who explored, documented, celebrated, and interpreted the American West. Housing one of the most extensive collections of American Western art, the Whitney gives a comprehensive overview of the development of Western art from the early 19th-century to the present.

Colter Bay

Colter Bay Indian Arts Museum - Grand Teton National Park

Colter Bay, WY 83012
Tel: (307) 739-3594
TDDY: (307) 739-3544
Admission: free.
Established: 1972 *ADA Compliant:* Y

Colter Bay Indian Arts Museum - Grand Teton National Park, cont.

Parking: free on site.

Open: **mid-May to early June**, Daily, 8am-5pm.

early June to Labor Day, Daily, 8am-8pm.

September, Daily, 8am-5pm.

Closed: October to mid-May.

Facilities: **Museum Store.**

Activities: **Education Programs** (3/week, ranger-led); **Guided Tours** (June-Labor Day, 2/day; Labor Day to Sept 30, 1/day).

Artifacts exhibited at the CBIAM are vivid examples of the diverse art forms used by American Indians, manifesting religious significance in addition to beauty and function. Exhibits include blanket strips, toys, headdresses and masks, necklaces and other jewelry, pipes and accessories, shields, buffalo-related artifacts, horse-related artifacts, baskets, moccasins and other clothing, tipi furnishings and tools. Large photomurals on wood and plexiglas panels highlight the exhibit area. The Colter Bay Indian Arts Museum displays artifacts in the David T. Vernon collection. Vernon collected artifacts from a variety of native peoples of North America and eventually sold his collection to the Rockefeller family, which in turn donated much of the collection to the National Park Service.

Jackson

National Museum of Wildlife Art

2820 Rungius Road (2 miles north of Jackson Town Square on Highway 89), Jackson, WY 83001

Tel: (307) 733-5771

Fax: (307) 733-5787

Internet Address: http://www.wildlifeart.org

Director: Francine Carraro

Admission: fee: adult-$6.00, child (<6)-free, student-$5.00, senior-$5.00, family-$14.00.

Attendance: 130,000 *Established:* 1987

Membership: Y *ADA Compliant:* Y

Parking: free on site.

Open: Daily, 9am-5pm.

Closed: Thanksgiving Day, Christmas Day.

Facilities: **Architecture** (1994, designed by C.W. Fentress, J.H. Bradburn & Assocs.); **Auditorium** (200 seat); **Classrooms** (2); **Food Services** Rising Sage Café (45 seat); **Library** (1,500 volumes); **Shop** (books, gifts, art, artifacts).

Exterior view of National Museum of Wildlife Art. Photograph courtesy of National Museum of Wildlife Art, Jackson, Wyoming.

Activities: **Docent Program**; **Education Program**; **Films**; **Guided Tours**; **Lectures**; **Temporary/Traveling Exhibitions.**

Publications: newsletter (semi-annual).

The National Museum of Wildlife Art (NMWA) is home to an extensive collection of fine art that depicts wildlife. Six galleries that change exhibits two to three times a year house a variety of special traveling exhibits that can include Native American and western historical material. A wide array of multidisciplinary programs is offered throughout the year for adults and children. During the winter, sleigh rides on the National Elk Refuge are available. More than 100 artists and over 2,000 paintings, sculptures, photographs, and works on paper are represented in the Museum's collections. The Museum holds the largest public collection of the work of Carl Rungius and the John Clymer Studio collection. Other featured artists include John J. Audubon, Robert Bateman, Albert Bierstadt, Antoine-Louise Barye, Karl Bodmer, George Catlin, John Clymer, Albrecht Dürer, Bob Kuhn, Alfred Jacob Miller, Titian Peale, Phimister Proctor, and Charles M. Russell.

Laramie

The University of Wyoming Art Museum

Centennial Complex, 2111 Willett Drive, Laramie, WY 82071

Tel: (307) 766-6622

Fax: (397) 766-3520

Internet Address: http://www.uwyo.edu/legal/artmus/index.htm

Director: Mr. Charles Guerin

Attendance: 50,000 *Established:* 1968 *Membership:* Y *ADA Compliant:* Y

Open: **Fall to Spring**,

 Monday to Saturday, 10am-5pm; Sunday, noon-4:30pm.

 Summer,

 Tuesday to Friday, 9:30am-4:30pm; Saturday, 10am-4:30pm; Sunday, noon-4:30pm.

Closed: University Holidays.

Facilities: **Galleries** (8; Rotunda Gallery); **Sculpture Terrace** (20,000 square feet); **Shop**.

Activities: **Education Programs** (adults and students); **Films**; **Gallery Talks**; **Lectures**; **Permanent Exhibits**; **Temporary Exhibitions**; **Traveling Exhibitions**.

Publications: exhibition catalogues.

The University of Wyoming Art Museum has a diverse collection of over 7,000 objects. Significant holdings include European and American paintings, prints, and drawings; 19th-century Japanese prints; 18th- and 19th-century Persian and Indian miniature paintings; 20th-century photography; decorative arts; crafts; and African and Native American artifacts.

Rock Springs

Community Fine Arts Center (CFAC)

400 C St., Rock Springs, WY 82901

Tel: (307) 362-6212

Fax: (307) 382-4101

Director: Mr. Gregory Gaylor

Admission: voluntary contribution.

Attendance: 10,000 *Established:* 1938

ADA Compliant: Y

Parking: adjacent to site.

Open: Monday to Tuesday, 9am-noon and 1pm-5pm;
 Wednesday, 9am-noon;1pm-5pm and 6pm-9pm;
 Thursday to Friday, 9am-noon and 1pm-5pm;
 Saturday, 10am-noon and 1pm-5pm.

Closed: Legal Holidays.

Facilities: **Galleries**.

Activities: **Concerts** (Utah Symphony Christmas Concert); **Education Program**; **Films**; **Guided Tours**; **Lectures**; **Temporary Exhibitions** (every 4-6 weeks).

Publications: newsletter, "CFAC" (quarterly).

Peter Hougard, *The Kent Sisters of Rock Springs*, Oil on board, 21 x 29 inches. Community Fine Arts Center. Photograph courtesy of Community Fine Arts Center, Rock Springs, Wyoming.

The Halseth Gallery in the Center houses a permanent collection of over 400 original American paintings, prints, works on paper, and photography owned by the Rock Springs High School. Works by Illya Bolotowsky, Alexander Calder, Edward Chavez, Paul Horiuchi, Loren McGiver, Anna Mary Robertson Moses (Grandma Moses), Elliott Orr, Norman Rockwell, Chauncey Ryder, Raphael Soyer, and Rufino Tamayo are included in the permanent collection, along with paintings by well-known Western, Wyoming, and local artists. Also to be found among its holdings is a large collection of drawings by Carl Link. The collection continues to grow through purchases and donations. CFAC also features temporary exhibitions of local, regional, and national painters, sculptors, printers, photographers, and craft artists and hosts traveling exhibitions that rotate on a monthly basis.

Index

Index

873

Index

Index

Index

Index

Index

Index

Index

Index

Index